THE ENCYCLOPEDIA OF
NOVELS INTO FILM

THE ENCYCLOPEDIA OF
NOVELS INTO FILM

Second Edition

FOREWORD BY ROBERT WISE

JOHN C. TIBBETTS
JAMES M. WELSH

Additional Research by
RODNEY HILL, BRUCE HUTCHINSON, GENE PHILLIPS, *et al.*

Checkmark Books®
An imprint of Facts On File, Inc.

The Encyclopedia of Novels into Film, Second Edition

Checkmark Books
An imprint of Facts On File, Inc.
132 West 31st Street
New York NY 10001

Library of Congress Cataloging-in-Publication Data

Tibbetts, John C.
The encyclopedia of novels into film / John C. Tibbetts, James M. Welsh;
additional research by Rodney Hill. . . [et al.]—2nd ed.
p. cm.
Includes bibliographical references and index.
ISBN 0-8160-5449-5 (hard.: alk. paper); ISBN 0-8160-6381-8 (pbk.)
1. Film adaptations—Catalogs. 2. Film adaptations.
I. Welsh, James Michael. II. Title.
PN1997.85.T54 2005
791.43'6—dc22 2004003317

Checkmark Books are available at special discounts when purchased in bulk
quantities for businesses, associations, institutions, or sales promotions.
Please call our Special Sales Department in New York at
(212) 967-8800 or (800) 322-8755.

You can find Facts On File on the World Wide Web at
http://www.factsonfile.com

Text design by Cathy Rincon
Cover design by Nora Wertz
Illustrations by John C. Tibbetts

Printed in the United States of America

VB FOF 10 9 8 7 6 5 4 3 2 1

This book is printed on acid-free paper.

This book is dedicated to Dr. Richard Dyer MacCann, a true pioneer in bringing cinema studies to the university curriculum, and to the memory and spirit of Dr. Edward L. Ruhe, who taught us how to think about the narrative potential of the cinema.

Contents

Acknowledgments

The editors of this volume wish especially to thank the following for their invaluable assistance and contributions in the preparation of this encyclopedia: first and foremost, to editors Hilary Poole and James Chambers of Facts On File, whose tireless efforts, patience, and consistent good humor helped us over many rough spots. To Jamie Warren, formerly of Facts On File, who first approved and supported the project four years ago. To Paul Scaramazza, long-time friend and boon companion, whose painstaking attention to the manuscript enabled us to correct errors too numerous to mention. To Joe Yranski, movie devotee and enthusiast, who unselfishly donated many stills from his extensive private collection. And to the members of the Literature/Film Association, founded in 1988 by the editors of *Literature/Film Quarterly*. This organization's annual national conferences, activities, and publications have in large measure both inspired this book and brought it to completion. Thanks are also due to Thomas L. Erskine of Salisbury State University, who was present at the inception of this project; to Anne Welsh, for her understanding and continued support; and the contributing editors of *Literature/Film Quarterly*, who participated in the writing of many entries. Particular thanks are in order to the four senior research assistants of this book: Father Gene D. Phillips, S.J., of Loyola University of Chicago, enjoys a continued productive career writing about films and filmmakers and literary adaptations. Heather Addison, Bruce Hutchinson, and Rodney Hill are currently doctoral candidates in the Theater and Film Department at the University of Kansas, Lawrence; their enthusiasm, research skills and computer savvy were enormously helpful. For many years we have enjoyed the close friendship and continuing support of many friends and colleagues at the University of Kansas, including Katherine Giele, former director of Student Union Activities (who also generously assisted in the organization of the KU Film Society) and Chuck Sack, friend and collaborator on many film projects; Professors Harold Orel, Marilyn Stokstad, Charles M. Berg, Jo Anderson, Edward Small, the late Edward L. Ruhe, and, finally, John Gronbeck-Tedesco, chairman of the Department of Theater and Film and editor of *Journal of Dramatic Theory and Criticism*. Lastly, a grateful tip of the hat is in order to Richard Dyer Mac-Cann, professor emeritus of the University of Iowa, formerly of the University of Kansas, whose pioneering efforts on behalf of academic film studies have been and continue to be an inspiration to us and to many other students and teachers of cinema studies.

The photos in this book were originally distributed to publicize and/or promote films made or distributed by the following companies, to whom we gratefully offer acknowledgment: Argos/Comei/Pathé/Daiei; Artcraft; Cinema Center Films; Columbia; David O. Selznick; Dino De Laurentiis Cinematographica S.P.A.; Elmer Enterprises; Eon; Epoch, Famous Players-Lasky; Fantasy Films; Films du Carrouse/SEDIF; Filmways; Fox Film Corporation; Gainsborough; General Production; Island Alive; Landau-Unger; Long Road Productions; Metro; MGM; Newdon Company; NSW Film Corporation; Omni Zoetrope; Orion; Palomar/Chartoff-Winkler-Pollack; Panorama/Nordisk/Danish Film Institute; Picnic Productions; Paramount; Polaris; Prana; RKO; Samuel Goldwyn; Saul Zaentz Company; Speva/Ciné Alliance/Filmsonor; SRO; TCF/Rockley. Cacoyannis; Twentieth Century Fox; UFA; United Artists; Universal; Vanadas; Warner Brothers; World Entertainment.

—*John C. Tibbetts*, The University of Kansas
—*James M. Welsh*, Salisbury State University

How to Use This Book

This encyclopedia is intended as a convenient reference for those seeking basic information about significant novels adapted to the screen and significant film adaptations of novels that may be of secondary importance as literature but have nonetheless achieved a certain popularity on their own or as a consequence of their being filmed.

The entries are arranged alphabetically, according to the titles under which the novels were published. In instances where the film title differs from the title of the novel—*Huck Finn*, for example, instead of *The Adventures of Huckleberry Finn*—the film title has been cross-referenced for easy access. Head notes provide production information that relates to the process of film adaptation, listing the director and screenwriter(s) in all instances, the date of the film's release, the production company, and the releasing company. Because some novels are better known by their foreign-language titles, for example, *La Bête humaine* (instead of The Human Beast), we have listed them by that title.

Production information is then followed by a plot synopsis and an assessment of the novel's standing and importance. The latter part of the entry will detail the particular problems of adapting the work—length, point of view, interior monologues, and verbal pyrotechnics, for example—and a description of the changes or modifications made to dramatize the story and to deliver it within the time limitations of a typical feature film (90 minutes to two hours, ordinarily). Finally, there will be a brief list of references to direct the user to more detailed resources.

We have endeavored to make the writing as clear and readable as possible and to banish the foolish and obscure jargon that students in film school are obliged to learn and master. This is a book for the common reader, not for a small tribe of narrow specialists. To achieve that end we have had to reject and reassign some entries and to rewrite many others. In some instances we had to add information to cover multiple adaptations that were either not well known or not easily available. For the most part we have not attempted full coverage of made-for-television adaptations. Not only are many of them of inferior quality, but they are usually difficult to obtain (either for general viewers or for researchers). Nonetheless, we have occasionally cited a few, and for specific reasons: Viewers seeking *From Here to Eternity*, for example, will be disappointed if they rent the Buzz Kulack television treatment with William Devane rather than the Academy Award-winning Fred Zinnemann film with Burt Lancaster, Deborah Kerr, and Frank Sinatra.

Our selection of titles has been ambitious and eclectic. More novels would have been covered had we been able to assemble a larger book. In fact more entries were collected than we were able to use, but a worthy assortment of novels and films is represented here. The encyclopedic entries are followed by an appendix which considers the role of representative screenwriters in Hollywood. There is also a selected bibliography that lists centrally important books in the field. Though the book may not be as comprehensive as we might have wished, it is, we believe, the only reference work of its kind. We hope it may be useful to readers.

—*J.C. Tibbetts and J.M. Welsh*

Foreword

I've been directing movies for half a century. It's more through the accident of circumstances than anything else that so many of them come from literary sources. With only a few exceptions, I didn't seek them out; rather, most of these projects have been brought to me by various studio story departments, or occasionally by other writers.

Some have been science fiction subjects, such as *The Day the Earth Stood Still* (adapted from Harry Bates' short story "Farewell to the Master") and *The Andromeda Strain* (adapted from Michael Crichton's novel); war stories, for example *The Sand Pebbles* (adapted from Richard McKenna's novel) and *Run Silent, Run Deep* (adapted from Commander Edward L. Beach's novel); westerns, like *Tribute to a Bad Man* (from Jack Schaefer's short story); dramas, such as *Executive Suite* (from Cameron Hawley's novel); and several supernatural films, including *The Body Snatcher* (from Robert Louis Stevenson's short story), *The Haunting* (from Shirley Jackson's novel), and *Audrey Rose* (from Frank De Felitta's novel). I've even made a movie from a narrative poem by Joseph Moncure March, called *The Set-Up*.

What attracted me and my screenwriters in every instance was simply the quality of the storytelling, which is something movies and books should have in common. That's why I have always insisted that my movies remain as faithful as possible to the spirit of each novel or story. Some critics have attacked me for that, claiming my work changes in style from film to film, that I don't have a consistent stamp on my films, like Hitchcock does. My answer to that is I believe in putting the spirit of each story first and my own approach second. That's why each of my films is different from the other. That's the way it should be.

The editors of this book, *Novels into Film*, have asked me to consider a very basic question: Is the mating of a novel and a film a natural marriage or a shotgun wedding? Well, there's no denying that many books have been successfully made into films. I can't imagine not considering them as prime source materials. Filmmakers always have, since the very beginning of films. It's true that there are things the writer can do that you might think would be difficult for a filmmaker to bring off. This can include things like graphic sex and violence—which, only a few years ago, the movies could not touch. At the same time, a writer can suggest in words things that are seemingly impossible to convey in pictures. Moreover, the novelist can provide such density of detail and a multiplicity of episodes that it's

quite impossible for the filmmaker to include it all. You have to condense and boil things down.

On the face of these challenges, a book such as Shirley Jackson's *The Haunting of Hill House* might seem to be unfilmable. For example, she made it pretty clear there was a lesbian implication to the relationship between the characters of Eleanor and Theodora. Jackson was also able to get *inside* the character of Eleanor, whose inner monologues color and flavor the story. And finally, Jackson was able to suggest in her imaginative prose the intangible spirits and disturbances haunting the house. In the adaptation I did with screenwriter Nelson Gidding of that novel, called *The Haunting*, we had to face all these challenges. We were very restricted in how much of the lesbian implications we could include, but they're there if you're sensitive to that. Although the film medium doesn't enjoy the privilege of interior monologue, you can at least approximate that with the device of the voice-over (there was no other way I could get over what was going on in the mind of Julie Harris' character of Eleanor). As for all those intangible spirits haunting the house, we were able to convince the viewers they were seeing things that weren't there at all by means of sound effects, half-heard voices, a little image distortion, that sort of thing. I've lost count of the many times people have come up to me and said, "You've made the scariest movie I've ever seen"—but then I remind them what they thought they saw wasn't there at all! That's a lesson I learned from Val Lewton, with whom I worked in the 1940s.

Lewton was a film producer for RKO and he was an important influence on my work. He was a marvelous talent. He taught me how to evaluate a script, to visualize its potentials. I don't think there was a single film he worked on where he didn't write the final shooting script himself. He never took screen credit for that, however. He didn't want to take away from the writer. I remember when I directed *The Body Snatcher* for him, Philip MacDonald was called in to work on the script. But the Writers Guild decided MacDonald didn't deserve full credit and insisted Lewton take a co-writing credit. So Lewton placed the name "Carlos Keith" on it, his pseudonym.

You see, the question of authorship can be a complicated issue in a literary adaptation. You always know who wrote the novel, but how do you determine just who is most responsible for the movie version—the original author, the screenwriter, or a producer and/or director

who also may collaborate on the screenplay? You have to consider each film, one at a time.

*** * * ***

Believe it or not, it's not really all that important that a director read a lot and keep up with all the literature out there. In my time, all the major studios had story departments to cover all the established and upcoming books. They provided directors with all the information they needed, like synopses. But it's always a special thing when I find a book myself that appeals immediately to me. Again, I think of Shirley Jackson's *The Haunting of Hill House*. I remember when it had just come out and I was sitting in my office, reading it. And right in the middle of a really hair-raising scene, Nelson Gidding burst into my office, and I jumped several feet off my chair. I thought, my God, if the book can do that, it ought to make a hell of a picture!

Nelson Gidding is one of two screenwriters that I have especially enjoyed working with. Ernest Lehman is the other. I think some screenwriters are better at original work; others are better at adapting material by somebody else. Lehman, I think, was in the latter camp: He did scripts of *Executive Suite, Somebody Up There Likes Me, West Side Story*, and *Sound of Music* for me. He always has had such respect for story properties by other writers that he does all he can to retain the best of their writing for the screen. Nelson Gidding fits into the first camp, although he also has done many literary adaptations with me, such as *Odds Against Tomorrow, I Want to Live, The Haunting, The Andromeda Strain*, and *The Hindenburg*.

*** * * ***

I've heard that old adage, "The better the book, the worse the movie adaptation; the worse the book, the better the movie." I don't believe that makes sense. How could it? We can all think of hundreds of great films that came from classic novels. But you know, there's a problem here: Studios and filmmakers keep falling in to the temptation of remaking the tried-and-true books, such as Dickens'. I often wonder, why not seek out the lesser-known stories? That's what happened with *The Day the Earth Stood Still*. Julian Blaustein, the producer, did the legwork on that one. He found this story by Harry Bates, "Farewell to the Master," and had Edmund H. North write the first draft of a script. Darryl Zanuck then told me about the project, and I read it and flipped over it.

Michael Crichton was an unknown writer when I worked on his *The Andromeda Strain*. In those days he was "J. Michael Crichton," and he didn't have the clout he enjoys now. Besides, I didn't want him to write the screenplay. I don't ever want the writer of the original work to do the screenplay. That's because he's too tied in to the material and can't see where it needs to be changed and cut and adapted for the screen. I can recall only one time when the original novelist wrote his own screenplay for one of my films. That was Frank De Felitta for *Audrey Rose*.

Scriptwriters in general are not given as much credit as they should get for their work, whether it's original material or adaptations from another source. Reviewers rarely give them more than a passing nod. But when you have a solid script, the quality of your movie is assured. I absolutely believe in getting the script in order before starting to film. On one occasion, on *Star Trek: The Motion Picture*, we had only the first half of the script ready when we had to start shooting. It was slated to be a TV movie initially, but the decision was made to go for a theatrical feature. In the meantime, there were delays after delays. Finally, I had to start shooting. The script rewrites kept on coming until the last day of shooting. That was not a satisfactory way to work, and I think the film shows it.

*** * * ***

I understand that there are a few educators who sometimes use a movie as a substitute in the classroom for the book itself. That can be very dangerous. A lazy educator might be tempted to do this. It's so much better to compare the book and film and see how each has its own "spin" on the central concept or story. It can be fascinating to know what was kept and what was rejected in the adaptation process, and why. But the tricky question is, which should come first? Read the book, then see the movie? See the film, then read the book? Or is it *see* the book and *read* the film? Maybe that's not as silly as it sounds! Changes from book to film can occur for all kinds of reasons. I remember when I was making *The Andromeda Strain*, Nelson Gidding suggested that I take one of the original four male scientists and make him into a woman. I said, "Get the hell out of here! It sounds like some Raquel Welch–type character in a submarine, or something." But Nelson explained he thought it would create a different, more interesting kind of balance among the scientists. I called some scientists who were friends of mine, and they told me there were many, many female scientists in their profession. I was convinced. Kate Reid was our actress, and she turned out to be the most interesting character of the four!

*** * * ***

There are several projects that for one reason or another never got off the ground. Years ago I wanted to do a film of a book by Jack Finney called *Time and Again*, for instance. It was a fantasy about time travel, a marvelous story. But you have to re-create New York City in the 1880s, which called for a very high budget. I pitched it to several studios, but there was just no interest. I know that other directors have also wanted to do it, but so far no one has. Other might-have-beens included an Anaïs Nin novel, *A Spy in the House of Love*. And I've always thought a particularly lovely project would have been an adaptation of *The Bobbsey Twins* novels. Back in the mid-1960s we planned to make a musical version with songs by Sammy Fain and Paul Francis Webster, but it never came off.

These and so many other stories are still waiting to be made into movies. But stick around, their time may come yet—and then they can be included in yet another revision of *Novels into Film*.

Happy reading! And happy viewing!

Introduction

WHY STUDY FILM ADAPTATIONS OF NOVELS?

> The novel is a narrative that organizes itself in the world, while the cinema is a world that organizes itself into a narrative.
>
> —*Jean Mitry*

Literature and film: Is this a natural marriage or a shotgun wedding? Do the partners have much in common? The conjunction is not necessarily conjugal and the word *and* is deceptive, for it functions to link opposing elements and mentalities—art and commerce, individual creativity and collaborative fabrication, culture and mass culture, the verbal and the visual. Stanley Kauffmann, the American theater critic who turned to film criticism in the pages of *The New Republic* and gave a name to the "film generation" of the 1960s, concluded years ago that it was relatively pointless to adapt literary classics to the screen since at best the cinema could hope only to approximate what our best writers had created in print.

Of course, filmmakers can tell stories by means of visualizing spectacular action and dramatizing overwrought passion and desire, as in adapting *Gone With the Wind*, a windy and repetitive historical novel that was obscenely popular but fell a bit short, perhaps, of what Tolstoy had achieved in *War and Peace*. Regardless, both novels were destined to become grist for the Hollywood mill. Kauffmann might perhaps tolerate the former, but certainly he would not embrace King Vidor's film version of the latter. Is Tolstoy simply too great for the cinema? Maybe so.

By taking the high road, Kauffmann made a valid point, but the artistic idealist cannot ignore the reality that Hollywood *will* make a literary adaptations, and that many of these will exploit legitimate and popular sources. This encyclopedia intends to take that adaptive process seriously.

The novel as a narrative form—whether it be deemed "artistic" or a mass consumer attraction—can be traced back to at least the 18th century and the writings of Samuel Richardson, Daniel Defoe, and Henry Fielding. Indeed, some literary historians would trace it back to antiquity and the writings of Petronius. By contrast, motion pictures have existed for merely a hundred years. Even so, even during the first 20 years, up to D. W. Griffith's *The Birth of a Nation* (1915), early filmmakers turned to literary properties for inspiration. In America, for example, Edwin S. Porter and D. W. Griffith were busily grafting their uniquely cinematic methods of storytelling onto Harriet Beecher Stowe's *Uncle Tom's Cabin* and Frank Norris's *The Pit* in 1903 and 1909, respectively. In France, Georges Méliès adapted Jules Verne's *A Trip to the Moon* (1902); and the Film d'Art Studios from 1908 to 1913 produced numerous versions of literary properties of Dickens, Goethe, Bulwer-Lytton, Dumas, and Balzac. In Britain, Cecil Hepworth made a 16-scene version of *Alice in Wonderland* (1903). A version of Robert Louis Stevenson's *Dr. Jekyll and Mr. Hyde* appeared in Denmark in 1909.

In general, during the pre–World War I era, before the extensive use of intertitles, dialogue titles, and sound technology, the silent film was truly an international medium. To take one example among countless others, between 1906 and 1914 Arthur Conan Doyle's *The Hound of the Baskervilles* appeared in numerous versions in America, Denmark, France, Germany, and elsewhere. Silence—not to mention the limitations of the one- and two-reel-length formats—flattened and compressed these works into brief fragments and pitifully two-dimensional narratives. They were, at best, simplifications and substitutes for a viewing public that was, in many quarters, at least semi-literate; but a trend had begun that persists to this day. The movies could bring literary properties to a public that otherwise would not bother to read them.

But first filmmakers had to learn the possibilities of film narrative. While Griffith was perfecting his cinematic techniques for the emotional and melodramatic

manipulation of viewers through parallel montage and extending narrative possibilities, Charles Chaplin and Buster Keaton were also developing their own techniques of silent comedy, constructing plots that were at first mainly situation framing devices for comedy rather than well-developed stories. Other great artists of the so-called silent cinema, such as Abel Gance, Sergei Eisenstein, F. W. Murnau, and Erich Von Stroheim, would not hit their artistic stride until after World War I.

Significantly enough, many of the early scenarists who adapted literary properties to the screen were women. Indeed, from 1911 to 1925, almost one-quarter of the working screenwriters were women, accounting for one-half of the 25,000 films copyrighted during that period. The reasons are varied: It has been argued, for example, that because the industry was still "tumbling up," to appropriate Charles Dickens's phrase, no one took it sufficiently seriously to block women's attempts to gain entry. "Women's chances of making a living have been increased by the rise of the cinematographic machines," said Alice Guy Blaché, an important French pioneer director of the day. "For these women the arts-oriented professions were the most accessible, and cinema, the newest art form, seemed to provide them with a multitude of opportunities." Moreover, they were *literate*, unlike many of the unlettered men currently active in the industry. Those that were experienced writers naturally seized fresh outlets for their work and for adaptations of the work of others. After all, weren't their short stories flooding the pages of the popular magazines, and weren't women readers rapidly becoming the majority of moviegoers?

When Gene Gauntier, a pioneering woman writer/director of adventure serials and social-problem films, adapted Lew Wallace's *Ben-Hur* in 1907 for the Kalem film company, she touched off a controversy whose implications would forever affect the course of literary adaptation. At issue were not the alterations and deletions she made in order to squeeze the story into a one-reel format. Rather, because Kalem had not sought permission to adapt the book, the Wallace estate sued Kalem for copyright infringement. Five years later Kalem lost the case and was ordered to pay the Wallace estate reparations of $25,000. From then on, all films produced in the United States had to be registered at the Copyright Office at the Library of Congress. The days were over when filmmakers had a free hand to appropriate any literary property they chose.

Nonetheless, the box-office success of Gauntier's film inspired other women scenarists. They brought (legally) thousands of novels to the screen. It was Jeanie Macpherson who first adapted Owen Wister's *The Virginian* in 1914; Frances Marion who adapted some of the most popular juvenile novels of the day—*Rebecca of Sunnybrook Farm, Pollyanna, Stella Maris,* and *A Little Princess*—for Mary Pickford; June Mathis who adapted Blasco Ibáñez's *The Four Horsemen of the Apocalypse* (1921) and *Blood and Sand* (1922) for Rudolph Valentino; Bess Meredyth, who wrote the remake of *Ben-Hur* for MGM in 1925. And when Samuel Goldwyn became convinced that it was *stories*, not *stars*, that audiences flocked to see, he lured Mary Roberts Rinehart and Gertrude Atherton to Hollywood in 1919 to adapt their own works for a new production unit called Eminent Authors, Inc. (In retaliation, Adolph Zukor signed up Elinor Glyn!)

We do not wish to denigrate the achievements of the first 20 years of cinema, during which time the plotless "actualities" of the Lumière brothers and the "cinema of attractions" of Méliès and other magicians-turned-filmmakers astonished naive audiences, who were later initiated to crudely developing story films of the nickelodeon type. If nothing else, they, like the adaptations of operas, stage plays, and pantomimes, brought a much-desired legitimacy to the fledgling film medium. They gave filmmakers the incentive, opportunity, and example to develop complexities of narrative, characterization, and theme to extend the movies' appeal to an ever-widening mass audience. Moreover, they brought with them an established mass recognition.

To those convinced that novels and movies are mutually exclusive endeavors, each with its own incontestably unique properties and effects, it is useful to remember that the modern novel actually anticipated many effects and storytelling techniques, like temporal, causal, and spatial disjunctions, that we are all too accustomed—sometimes erroneously—to regard as essentially "cinematic."

Charles Dickens has long been held up as a model for the consummate novelist as well as a visionary prophet of photographic—and by extension, cinematic—effects. His contemporary, the philosopher Hippolyte Taine, and the 20th-century Russian filmmaker and theorist Sergei Eisenstein, have both noted that Dickens wrote with a kind of "camera eye," realizing his scenes with ultra-sharp focus and clarity, achieving the literary equivalent of close-ups, long shots, aerial perspectives, soft focus—and this at a time when modern photography was still in its infancy! In a more "cinematic" sense, space and time are fluid, essentially nonlinear. Scenes change quickly in what nowadays we would describe as dissolves and straight cuts, moving back and forth through time and space (the editing device in cinema called "parallel montage"), and revealing a striking sense of accelerated and slow motion (time-lapse photography). Although Eisenstein chooses to cite examples from *Martin Chuzzlewit*, we are even more impressed with *A Christmas Carol*, which abounds in "cinematic" effects. Consider this description of the first ghost to visit Ebenezer Scrooge. The passage reads like a series of quick dissolves:

> The figure itself fluctuated in its distinctness: being now a thing with one arm, now with one leg now with twenty legs, now a pair of legs without a head, now a head without a body: of which dissolving parts, no out-

line would be visible in the dense gloom wherein they melted away.

When this apparition escorts Scrooge into his past, the scenes flash by, like instantaneous transformations in space and time. One moment Scrooge is in his chambers, the next on a country road bound for his boyhood school. An instant later the schoolroom changes, as if photographed in a time-lapse technique: "the room became a little darker and more dirty. The pannels [sic] shrunk, the windows cracked; fragments of plaster fell out of the ceiling . . ." The image blurs. Scrooge, a few years older, is talking with his sister, Fan. Another blur. Scrooge, now a young man, walks in the city streets of London. After a quick succession of scenes at the Fezziwig party (the rapidity of which seems like the accelerated motions of a Mack Sennett silent comedy), the action shifts to a bare room where an older Scrooge sadly bids farewell to the beautiful Belle (the action this time protracted in a slow-motion effect). Then, another image of Belle, older now, with children by her side. Capping it all is the moment when Scrooge, back in his chambers, falls back into an exhausted sleep (a final fade).

These effects are everywhere. In a long passage when Scrooge is escorted by the Ghost of Christmas Present across the moors, through a village, into a hut, past a lighthouse, and on far out to sea, the results may be compared to a powerful, uncut tracking shot. Indeed, for much of its length the novel reads like a screenplay. Scrooge himself describes this fluidity of space and time: "I will live in the Past, the Present, and the Future. The Spirits of all Three shall strive within me." Of course, Dickens did not invent the cinema, but he had an uncanny talent for thinking and writing in a cinematic way. Later, another Englishman, H.G. Wells, did indeed preside over the development of the cinema; and he was in a position to write about it as well. It was in 1895 that he published his first novel, *The Time Machine*. Not only may it fairly be regarded as a prototype of the modern science fiction novel, but also it certainly is one of the first literary works to directly consider and exploit the effects and implications of the cinema. Descriptions of the machine unmistakably evoke the mechanisms of camera and projector. The effects of time travel—the alterations of normal motion (reverse action, accelerated action), the intermittent flashes of light (recalling the projector's shutter mechanism), and the stasis of the frozen moment (the freeze-frame)—are precisely those of cinematic montage (which was not lost on filmmaker George Pal when he adapted Wells's book in 1960). And the "Traveller," as he is called, is not just a scientist sitting in the saddle of a machine, but a moviegoer ensconced in the seat of a movie theater. Moreover, as long as he participates in time travel, he is virtually *ageless*—just like the unchanging images frozen on the strip of film. Proof of this is easily obtained. As a close friend and collaborator of the English film innovator, Robert Paul, Wells was entirely conversant with the mechanisms and effects of cameras and projectors. At the time of the writing of *The Time Machine*—precisely when the first experiments in projecting movies to audiences were occurring in France, England, and America—the two men even applied for a patent that envisioned a working version of this fictional machine, a kind of movie viewing theater that would function as a *time machine*, that is, a vehicle in which viewers might view images of "past," "present," and "future" on screens positioned on all sides of them. The idea that the film medium afforded not only special manipulations in space and time, but was also a kind of "thrill ride" anticipated the spectacles and novelties of 3-D, Cinerama, and today's virtual reality rides.

Similar claims would later be made for James Joyce and John Dos Passos, but, unlike Dickens, they had the advantage of experiencing the cinema firsthand. John Dos Passos, one of the most gifted, albeit neglected literary figures of our century, leaves us in no doubt of that when he structures many of the passages in *U.S.A.* as "newsreels."

The reverse of this occurs when filmmakers reveal literary techniques and effects in their work. A major example of a filmmaker clearly influenced by a particular literary method may be found during the mid-1920s at a major American studio, MGM, which contracted Erich Von Stroheim, an independent artist of extravagant habits and ambitions, to make a film of Frank Norris's naturalistic novel *McTeague, A Story of San Francisco* (1899). Von Stroheim believed that since Norris's method was to structure narratives upon the accumulation of concrete details, these could be captured accurately and exactly on film; and that justice could therefore be done to the original work. What the director did not take into account was the inordinate cost and excessive length (estimated at more than 10 hours) of making such a film. Norris himself was borrowing from an important literary precedent, Gustave Flaubert's *Madame Bovary* (1857), a narrative realized in a totally concretized form. As Alan Spiegel has explained in his book, *Fiction and the Camera Eye*, concretized form "is a way of transcribing the narrative, not as a story that is told, but as an action that is portrayed and presented, that seems to reveal itself to the reader apart from the overt mediations of the author."[1] Flaubert's naturalism then influenced a whole movement of writers—Zola, Bennett in England, Moore in Ireland, and Norris, London, and Dreiser in America. In turn, filmmakers like Griffith and Von Stroheim followed the naturalistic imperative in the careful recording of detail. Von Stroheim in making *Greed* also replicated the fatalistic psychology of the naturalists, whose characters were defined by environment and heredity.

Irving Thalberg, the new head of production at MGM, ordered the director to scale down his expectations. The film had been shot over-budget for seven months, but the dispute between the producer and director continued on into the film editing process. Von Stroheim first demanded seven and one-half hours, then five hours, until, finally, Thalberg turned the film over to studio editor June

Mathis, who shortened the 42 reels down to 10, against the director's howling protests, bringing the picture in at just over the usual two-hour running time. The final product was a failed masterpiece involving a huge artistic compromise and simplifying the novel to its bare essentials, as is symbolically suggested by the film's title, *Greed* (1924). Ironically, the movie ran aground on the rocks of its own superior capacity to meticulously capture the surfaces of reality—a reality that Norris could only approximate on the printed page.

A comparison of the extant two-hour film to the Norris novel is still interesting as an example of abridgment—and by no means incidentally as an early example of the industry censorship that so often bedevils literary adaptation—but it does not provide a valid index of what the film might have been as an adaptation. The director wanted to do an appropriate treatment of the novel; the studio, on the other hand, had no interest in the novel other than its drawing-power as an American "classic" and its box-office potential as a spectacle of "greed" and depravity. For the record, one might add that in the late 1920s the same studio, MGM, shortened Abel Gance's French epic *Napoléon* from over five hours to an hour and a half for its American release in 1928, corrupting another cinematic masterpiece. Kevin Brownlow was able to reconstruct *Napoléon* to its five-hour length, but in the case of *Greed*, all that survives of the lost footage are the still photographs collected and published by Herman G. Weinberg.[2] Obviously the MGM factory was not congenial to independent-minded directors with grandiose projects intending to create "artistic" cinema.

Clearly, a number of potential obstacles stand between intent and result: the pressures of mass consumption; the Hollywood studio system; censorship.

The adaptation process throws these obstacles into high relief. This is one reason we can usefully study adaptations of novels into film. It is precisely the point that Hollywood distorts and corrupts serious literature for the entertainment pleasures of a mass audience. But that doesn't excuse the fact that adaptations may replace novels for students who are either not disposed to read or who simply find it more convenient to locate inferior Hollywood adaptations on videotape rather than take the time to read the originals. (Predictably, a consequence of this is regarding the novel as one more disposable commodity in a throwaway society.) How much better, at the very least, to challenge these students by comparing both novel and film, not just as an exercise to discover similarities and discrepancies, but also as an investigation into the understanding of the shared and unique characteristics of the two media and their respective possibilities of narrative.

In this way, viewers may discover on their own what a good novel such as *The Great Gatsby* can accomplish through a well-crafted first-person narrative and then understand that such a film as the adaptation that starred Robert Redford and Mia Farrow in 1974 cannot begin to approximate that narrative approach, let alone capture its nuances, when it turns into an objective visual narrative. The novelistic narrator mediates the meaning of the novel for the reader, and that continuing mediation cannot be captured by the film's minimal voiceover narration in Nick Carraway's voice.

The question of narrative voice is absolutely crucial here. Film theorists who prefer images to words have been skeptical of voiceover narration as a device that is "literary" rather than cinematic. Brian Henderson objects to this "borrowed" device as merely a convenient substitute for "the novelistic 'I.'"[3] There are other common objections to voiceover narration as it may result in audio-visual pleonasm; but even though voiceover may seem redundant, verbal articulation can also explain and interpret in a way that goes far beyond simply repeating information. Bernard Dick in his *Anatomy of Film* (1990) has scorned voiceover as "one of the most abused techniques in film," an easy solution for unimaginative filmmakers "unable to think of another way to convey information."[4] But Sarah Kozloff in her book *Invisible Storytellers: Voice-Over Narration in American Fiction Film* (1988) does not consider voiceover "the last resort of the incompetent" and argues that "voice-over narration's reputation has suffered from the advantages it offers, such as its facility in conveying expositional information."[5] The device is more complicated than it at first seems, moreover. In his book *Narrated Films: Storytelling Situations in Cinema History* (1992), Avrom Fleishman defines four "classes" of voiceover commentary: "*voice-off* (heard and seen), *interior monologue* (not heard by others even when the character is on-screen with them), the *acousmêtre* (heard but not seen), and *voice-over* (neither heard nor seen by [other] characters)."[6]

We believe, for example, that in adapting Edith Wharton's *The Age of Innocence* to the screen in 1993, the film director Martin Scorsese used the "voiceover" narrative technique—that is, not as a first-person narrator but as a means of conveying the novelist's voice and therefore reconstructing the social atmosphere of New York during the 1870s and beyond. Joanne Woodward's voiceover passages function solely to remind the viewer of the complicated social and moral codes of the novel. She speaks with the omniscient authority of the novelist. In this instance, the Woodward narrator is not identified as she narrates, but her omniscient voice is readily identifiable to the spectator familiar with Wharton. Unlike some filmmakers, Scorsese charitably assumes his viewers will be sufficiently familiar with the novel to understand this narrative device.

Filmmakers like Scorsese notwithstanding, the fact remains that even such well-meaning adaptations as *Gatsby* and *Age of Innocence* can never be interchangeable with the original literary texts that may have—let's say—"inspired" them. In general Hollywood is not at all interested in this kind of integrity or in the issue of fidelity.

But how about those instances when novelists take an active part in the adaptation of their works to the screen? There are many recent examples. Michael Crichton has

turned producer to protect his proprietary interests in the film adaptations of books like *Disclosure*. His own experience as a director and screenwriter has enabled him to better understand the exigencies of the filmmaking process. The Chinese-American film director Wayne Wang worked closely with novelist Amy Tan in adapting *The Joy Luck Club* to the screen in 1993. Also in 1993, the Australian director Peter Weir directed Rafael Yglesias's own adaptation of his novel *Fearless*. Yet even here, certain structural and atmospheric changes are evident, even, perhaps, inevitable—all in the service of retaining the essential meaning of each story.

Movies do not "ruin" books, but merely misrepresent them. James M. Cain's novel *Mildred Pierce*, for example, was a satire directed against bourgeois values, vulgar social striving, and flawed parenthood. The film made by producer Jerry Wald in 1945 was completely revamped by a score of writers great and small, including William Faulkner, who redesigned the story as a Joan Crawford comeback vehicle and turned it into a family melodrama that ennobled the heroine's crass struggle to make money and buy the love of her monstrous daughter Veda. Wald turned Cain's satire into a film noir that opened with a murder and then attempted to imitate the flashback structure of *Citizen Kane*. Wald's reworking of Cain's novel is not exactly a bad film, but it's not an excellent adaptation either, Oscar nominations notwithstanding.

In some instances, moreover, Hollywood has improved novels that were popular but not critical successes. Such was the case with *The Bridges of Madison County*, which was faithful to the original story but improved the aging and insufferably romantic lead, Robert Kincaid, by remaking him in the image of Clint Eastwood, whose laconic treatment dignified the character. The story is effectively dramatized, clarified, and intensified, and stripped of the novel's often foolish and embarrassing dialogue. This adaptation is a very good demonstration of what Hollywood could achieve in treating the obscenely popular effusions of a third-rate writer.

Of course, this is more the exception than the rule. Consider, for example, the 1995 adaptation of *The Scarlet Letter* with Demi Moore as Hester Prynne, and a newly conceived ending that allows her to retire to Florida with the Rev. Mr. Dimmesdale. The late Nathaniel Hawthorne could lodge no protest about what Hollywood had done to his novel, in contrast to novelists who live to see their work corrupted, like John Updike.

For motion pictures in America the ultimate failure is commercial, and when box-office revenues fail to cover production costs, Hollywood gets the message. As the saying goes in the Industry, "You're only as good as your last picture," and "goodness" in this context has nothing to do with fidelity or art. Although most filmed adaptations may be critical failures—a common complaint is that "the book was better"—not all of these fail at the box-office as spectacularly as did *The Bonfire of the Vanities*, a remarkably bad adaptation.

Consider, for example, Updike's *The Witches of Eastwick*, a wickedly impish and often amusing fable about three discontented middle-aged women in contemporary New England who discover they have the power to channel their combined energies and influence events. In short, they are modern-day witches who can hex and vex anyone who crosses them. What Updike seemed to be suggesting was that any mature, intelligent, sensitive, and creative woman might have this power, if she chooses to use it. The three "witches" in the novel, all of them divorced or separated from their husbands, out of boredom combine their powers and conjure up the devil himself, who rolls into town in the personage of one Darryl Van Horne and shortly thereafter manages to seduce all three of the witches. But ultimately their combined power exceeds his, and they manage to drive him out of town, so long as they are able to maintain their "sisterhood" focus. The novel often seems to be a satire of feminism.

Not so the film. In the later 1980s Hollywood decided to take on this novel. The rights were duly purchased from the novelist, who had no further involvement with the project. A screenwriter was commissioned, as well as an Australian director, who confided to one reporter that he had not even bothered to read the novel. Obviously, the integrity of the original text was not considered of primary importance here. What then happened was all too typical of Hollywood. The casting department began working its magic to ensure the success of the project. Three gifted and charismatic actresses were contracted to play the three witches—Susan Sarandon, Michelle Pfeiffer, and Cher, who got the role of Alexandra, the leader of the coven and the principal character in the novel. So far, so good.

But the ultimate insurance for this production was the final casting coup, which gave the role of the devil figure, Darryl Van Horne, to the manic Jack Nicholson, who got both the role and the top billing. As a consequence, the balance among the main characters was seriously disturbed, if not entirely destroyed, as Nicholson's flamboyant overacting and posturing became the focal point of the whole picture. Moreover, major subplots were jettisoned from the novel in the interest of economy and the conclusion was greatly simplified, though in this simplified form the ending was still roughly the same as the novel's. The adaptation was not a critical success, but the film found an audience on the strength of Jack Nicholson's reputation and performance, even though the picture no longer qualified to be called *The Witches of Eastwick*.

So what did John Updike think about what Hollywood had done to his book? Though he did not comment directly on the project, he was not apparently outraged. About the time the film was released, he published a piece in *The New York Times* (June 28, 1987) discussing in general terms the proprietary interest of novelists who sell the movie rights to their works to Hollywood. In this journalistic essay Updike took the stoic high ground, contending that once the rights are sold, the artist has relinquished

control and has no legitimate basis for complaint. He went on to speculate wistfully, however, that books would live on, regardless of the way they might be commercially exploited and distorted by Hollywood, and that perhaps movie versions would stimulate viewers to seek out the original works, so as to discover what the novelists might have originally intended or achieved.

Now this is a pleasant thought. One would like to believe that movies might serve as a stimulus to reading—even if viewers ended up reading the likes of Stephen King or Michael Crichton—for they might then graduate to more serious and demanding authors, some of whom, like Charles Dickens, anticipated the narrative possibilities of the cinema.

Two contrasting examples deserve extended comment, Tom Wolfe's *The Right Stuff*, faithfully adapted to the screen by writer-director Philip Kaufman in 1983, and *The Bonfire of the Vanities*, made into a wretched film by the Hitchcock imitator Brian De Palma in 1991, attempting to adapt Wolfe's best-selling satiric novel about shameless egotism and corporate greed during the Reagan era, the economic boom years of the early 1980s that widened the gap between the haves and have-nots in America.

The Right Stuff reads like a novel and is written in novelistic style, but it is a flamboyant journalistic narrative, patriotically embellished, about the American space program and the first cadre of seven astronauts made up of hot-shot test pilots trained to meet the Russian challenge in space after the Soviet cosmonaut Yuri Gagarin orbited the planet in April of 1961 and became the first man in space. Alan Shepard became the first American launched into space in May 1961, and *The Right Stuff* is partly, but not entirely, his story. Wolfe's paradigm of "The Right Stuff," a man representing the courage, determination, and skill to conquer the frontier of space, was the West Virginia test pilot Chuck Yeager, who first broke the sound barrier in the X-1 rocket plane on October 14, 1947. According to *Newsweek* critic David Ansen (October 30, 1983), the first screen treatment of the book was written by William Goldman (considered to be one of Hollywood's very best) "in a burst of patriotism at the time of the [Iranian] hostage crisis," concentrating "on the triumph of the astronauts" and entirely omitting Chuck Yeager, "the spiritual heart of Wolfe's story."

Director Philip Kaufman rewrote the screenplay, recentering the story, as Wolfe had done, on the remarkable Chuck Yeager, who was played by the magnificently laconic actor-playwright Sam Shepard as an archetypal western hero. The film effectively contrasted old-fashioned 19th-century traditional American notions of character, embodied by Yeager, with more recent 20th-century notions of personality and celebrity, embodied by the seven younger astronauts. The film intelligently dramatized and visualized this contrast while also capturing the verbal exuberance of the book.

In the film Yeager is first seen on horseback, a man of the Old Frontier, in contrast to his younger colleagues fac-

ing the New Frontier of space. Astronaut Gordon Cooper (played by the actor Dennis Quaid) is first seen in his flashy 1953 red-and-white Chevrolet convertible, a hotdog show-off and the perfect embodiment of an ambitious and arrogant young man of the 20th century. At the end of the film as the astronauts are being transformed into media celebrities in Dallas, Texas, after John Glenn's flight, the film offers soaring images of the ignored individualist Chuck Yeager, the true hero of the story, quietly setting a new altitude record as a test pilot.

The purpose of Wolfe's narrative was not merely to tell the story of the American space race but to define that essential ingredient for its success, the "right stuff," in flamboyant verbal terms. Philip Kaufman's film adaptation, which has a running time of three hours and 13 minutes (about an hour longer than most American feature films), meets the challenge of telling the story, defining and balancing the characters appropriately, and creating its own visually flamboyant style to compensate for Wolfe's lost words.

Kaufman has not always been entirely consistent, however, in his adaptations. Ten years later, when he adapted Michael Crichton's novel *Rising Sun* to the screen, the writer-director presumed to change both the novel's message and its carefully balanced characters. Kaufman began writing this screenplay with Crichton, and it was extensively criticized for alleged Japan-bashing in its telling of the story of an American call girl murdered in the executive boardroom of a Japanese corporation located in Los Angeles and also for its criticism of Japanese business practices. Kaufman and Crichton soon parted ways on this collaboration, and Kaufman remade the novel in such a way that its cultural context was softened and made "politically correct." Even so, *Rising Sun* seems an almost agreeable adaptation in comparison to the next film adaptation of the work of Thomas Wolfe.

If the film of *The Right Stuff* was faithfully adapted, *The Bonfire of the Vanities* is another "story" altogether. In this instance Hollywood was interested merely in exploiting a hugely popular best-seller, exploiting the story (while changing it absurdly) rather than exploring the satiric substance intelligently. The novel concerns the fall from grace of a New York capitalist named Sherman McCoy, a capitalist who absurdly considers himself a "Master of the Universe." One night while driving his mistress from the airport into New York City, McCoy makes a wrong turn, ends up in a tough ghetto neighborhood, panics, and runs down a black youth with his Mercedes in a hit-and-run accident. Politically correct sympathy builds for the victim, and the tabloid newspapers sensationalize the incident and scream for justice. Pressure is brought to bear on the mayor, the police, and the district attorney, until the culprit McCoy is tracked down, caught, and prosecuted. Though "justice" is done in this novel, ironically those who work for it are mean-spirited churls primarily motivated by self-interest. The novel is a grand exposé of greed, self-aggrandizing power,

and exploitation. To elaborate his story properly with devastating satiric embellishment, Tom Wolfe requires over a thousand pages of text.

Brian De Palma gets it all wrong, making one bad decision after another. He decides to make the true villain of the story, a sleazy, alcoholic tabloid journalist, the controlling consciousness of his film; but he also turns this flawed and repulsive character, who was British in the novel, into an American (played terribly by Bruce Willis). Julie Salamon, the film reviewer for *The Wall Street Journal*, had obtained permission to observe the making of this film from behind the scenes, and her book, *The Devil's Candy: The Bonfire of the Vanities Goes to Hollywood*, chronicles the process from start to finish, the extravagance and the millions of dollars wasted on a film that proved to be not only a critical failure, but a box-office disappointment as well.[7] The corporate thinking, according to Salamon, was that any problem could be solved by throwing money at it. The intention here was merely to exploit the novel and its popularity, not to replicate its satiric substance. Watching the film, one might reasonably conclude that the filmmakers were not clever enough to determine what the novel was truly about. The film sanitizes the satire and pulls its punches. It attempts to make a racial statement by casting Morgan Freeman as the judge who finally brings McCoy to justice. The film trivializes the novel and misunderstands the novelist's method and intent. It was a terrible adaptation that deserved to fail, and did. Can one say, however, that it ruined the book? No, the book survives in its own medium.

Fidelity is an important consideration, no doubt, but changes made by the screenwriter and director might not necessarily destroy the original. In the best adaptations, narratives are translated and effectively transformed into the medium of film. A splendid example of artistic transformation is Anthony Minghella's adaptation of Michael Ondaatje's *The English Patient* (1996). For four years Minghella labored over the screenplay, trying "to make transparent what was delicately oblique in the prose." Michael Ondaatje was sympathetic and supportive of what Minghella had accomplished, despite the fact that the focus of the original novel had been seriously shifted in the film and that characters had been emphasized differently. The novelist was not bothered by the fact that the film developed a second story parallel to the original: "Each has its own organic structure," he wrote as a tribute to the film. "There are obvious differences and values, but somehow each version deepens the other." After his screenplay had been nominated for an Academy Award, Minghella remarked to *The Washington Post* (February 12, 1997): "This is a film we've had to struggle with at every stage; no one thought [the book] was adaptable. But I just felt strongly that there was a film to be carved from that book to reach the hearts and minds of people," and he was surely right. This adaptation was especially encouraging in the way it demonstrated that intelligent and perceptive filmmakers are still inventing new methods of adapting literature to film. Complicated interior narratives no longer seem necessarily out of reach as the cinema enters its second century.

Finally, we must add a modest disclaimer. We realize that this encyclopedia falls short of being truly encyclopedic because we were forced to make choices for practical reasons. We were not able to include everything that we might have wanted to include, so our approach has been selective; but we believe it is also eclectic, including many of the obvious classics, but also some works that certain readers might consider obscure. *Wilhelm Meister's Apprenticeship* is surely a classic, for example (though its film version might be considered obscure), as is Theodore Fontane's *Effi Briest*, which has rightly been compared to Flaubert's *Madame Bovary* and to Tolstoy's *Anna Karenina* for its masterful probing of feminine psychology. We believe a case can also be made for Peter Handke's *The Left-Handed Woman* by that same logic, but the more recent the novel, the more problematic becomes the justification. We have included *The Old Gringo*, for example, not because the film adaptation is particularly outstanding but because we did not want to ignore Carlos Fuentes, a Mexican novelist who has been described as a writer waiting for a Pulitzer Prize to happen.

We are aware that we doubtless have missed some novels that deserved to be included. It's a matter of limited space and editorial choice as well as taste and judgment. We hope that our choices may be judged reasonable, albeit at times idiosyncratic. As far as we know, nothing of this scope has yet been attempted in English. We beg our readers' indulgence and good will.

AUTHORS IN DISTRESS: ABOUT THE SECOND EDITION

Since the appearance in 1998 of the first edition of *Novels into Film*, and since the release in 1999 of the abridged, paperback version, critics have continued to puzzle over the concept of "authorship," and many have challenged what they call "fidelity criticism." Or, to paraphrase author Susan Orlean, books have been undergoing a sea change into the "nonlinear, eccentric storytelling" of contemporary screen practice. "It's not what I expected," Orlean said upon viewing *Adaptation*, the Spike Jonze/Charlie Kaufman adaptation of her book *The Orchid Thief*, "but it's terrific. And please just change my name." Moreover, never would Orlean have envisioned herself as a character on screen, a character, moreover, who "gets kind of . . . unhinged," as she puts it. "Isn't that everybody's dream," she goes on, "to be a famous movie character? Would you want to be a character in a movie?"

For many years authors have suffered far worse consequences in the adaptation process than finding themselves characters in their own stories. Some, like Stephen King's fictional, albeit autobiographical, writer-protagonists Paul Sheldon, Thad Beaumont, and Mort Rainey in, respectively, *Misery*, *The Dark Half*, and *The Secret Window*—not to mention the main character in the recent television

series, *Kingdom Hospital*—have been harassed and brutalized not only by the mania of their fans and the crass expectations of their publishers, but even by the mayhem exerted by the characters in their books (King himself confesses to this triple menace). And look at what happened to Barton Fink in the eponymous Coen Brothers film!

Indeed, a different kind of "death of the author" has been pronounced by that doyen of postmodernism, Roland Barthes. Writing in 1964, Barthes had a go at that old "intentional fallacy" notion and advised us to forget that an author gives meaning to a literary work. It is the language that speaks, not the author; and, conversely, it is the reader who gives birth to the work. (What a concept: Heaven help authors who consider themselves creators!) At best, the author nourishes a work; but there is no secret and ultimate meaning for readers to get hung up on. Readers can forget about the old burden of trying to capture what an author "was really trying to say" and instead focus joyfully on creating their own meanings. In Derridean terms, it is a matter of decentering the authorial presence and centering our own engagement with the text. Let us not forget, however, that in the process of privileging either element in this binary system, we necessarily exclude the other—and that is not acceptable in the postmodern sensibility. Should we not be capable of entertaining both at the same time?

Meanwhile, take note of the many more "novels into films" that have either been released since the first edition of *Novels into Film*, or were, for a variety of reasons, including neglect, ignorance, and space limitations, excluded from the earlier edition. Among the more than 60 significant new literary adaptations are films based on novels by Graham Greene, Charles Dickens, Edith Wharton, Victor Hugo, Henry James, James M. Barrie, John Grisham, J. R. R. Tolkien, and others—*Adaptation, The Bourne Identity, Ciderhouse Rules, Cold Mountain, Captain Corelli's Mandolin, Crouching Tiger, Hidden Dragon, The Dancer Upstairs, The End of the Affair, The Golden Bowl,* the *Harry Potter* titles, *The Hours, House of Mirth, The Lord of the Rings, Master and Commander: The Far Side of the World, Mystic River, Nicholas Nickleby, Possession, Red Dragon, The Shipping News, Schindler's List, Stuart Little, The Tailor of Panama, A Thousand Acres, Tuck Everlasting,* and *Whale Rider*. In addition, we have included classic literary adaptations of the past that hitherto slipped through the net, such as *Peter Pan, Ethan Frome, Forrest Gump, The Four Feathers, The Children,* and *The Iron Giant*. And other perennially popular titles have undergone recent new adaptations, including updates of *Tarzan, The Count of Monte Cristo, The Quiet American, Lolita,* and *Treasure Island*.

We hope this new edition of *Novels into Film* continues to demonstrate that despite the slings and arrows that afflict the authors of these and other works examined in this volume, we readers and viewers may happily forge on, either assiduously seeking out authorial intentions, or energetically creating our own texts and our own meanings. Regardless of our choices, we think it proper to heed Susan Orlean's own words: "The answer to everything might indeed be adaptation."

—*John C. Tibbetts*, University of Kansas
—*James M. Welsh*, Salisbury University
April 23, 2004

NOTES

1. Alan Spiegel, *Fiction and the Camera Eye* (University of Virginia Press, 1976), 6.
2. Herman G. Weinberg, *The Complete Greed of Erich von Stroheim* (E.P. Dutton, 1973).
3. Brian Henderson, "Tense, Mood and Voice in Film," *Film Quarterly* 36:4 (1983): 16–17.
4. Bernard Dick, *Anatomy of Film*, 2nd ed. (St. Martin's Press, 1990), 21–22.
5. Sarah Kozloff, *Invisible Storytellers* (University of California Press, 1988), 22.
6. Avrom Fleishman, *Narrated Films* (Johns Hopkins University Press, 1992), 75.
7. Julie Salamon, *The Devil's Candy* (Houghton Mifflin, 1991).

ADAPTATION (1876)

See THE ORCHID THIEF.

ADVENTURES OF HUCKLEBERRY FINN (1884)

MARK TWAIN

Huckleberry Finn (1920), U.S.A., directed by William Desmond Taylor, adapted by Julia Crawford Ivers; Famous Players-Lasky/Paramount.

Huckleberry Finn (1931), U.S.A., directed by Norman Taurog, adapted by Grover Jones and William Slavens McNutt; Paramount.

The Adventures of Huckleberry Finn (1939), U.S.A., directed by Richard Thorpe, adapted by Hugo Butler; MGM.

The Adventures of Huckleberry Finn (1960), U.S.A., directed by Michael Curtiz, adapted by James Lee; MGM.

Huckleberry Finn (1974), U.S.A., directed by J. Lee Thompson, adapted by Richard M. Sherman and Robert B. Sherman; Apjac International.

The Adventures of Huck Finn (1993), U.S.A., directed and adapted by Stephen Sommers; Walt Disney.

The Novel

Samuel Langhorne Clemens, better known by his pen name Mark Twain, began his writing career as a frontier humorist and ended it as a bitter satirist. The range of experiences from which he drew was vast—a childhood in Hannibal, Missouri, apprenticeship as a printer, success as a Mississippi steamboat pilot, fame as an itinerant journalist, and travel as a lecturer.

Since the publication of *Adventures of Tom Sawyer* in 1876, the first notice that there would be further chronicles concerning Huck came in an episode entitled "Tom Sawyer's Comrade," in chapter three of *Life on the Mississippi* in 1883, when the outcast Huck takes to the river and is captured by the crew of a river barge. A year later, *Adventures of Huckleberry Finn* was published, ending eight years of sporadic labor on the project.

Narrated by Huck, the story begins with a brief recounting of the ending of *Tom Sawyer,* in which Huck and Tom each acquired a considerable sum of robber's loot. Huck's money is now in the care of the Widow Douglas who, with her sister, Miss Watson, is endeavoring to "sivilize" him. Huck's "Pap" appears and takes him away to an island cabin. Pap is a drunken, greedy wretch who abuses his son and connives to steal his money. Huck escapes and fakes his own death. Together with Miss Watson's runaway slave, Jim, he starts down the river on a raft. The two are separated when a steamboat wrecks the raft. Huck takes temporary refuge with the Grangerford family and inadvertently finds himself involved in their feud with the nearby Shepherdsons. Reuniting with Jim (who by now is suspected by the townspeople of having murdered Huck), the two set out again on the raft down the river. Presently they give refuge to two fugitives from the law, the "Duke of Bridgewater" (an itinerant printer and fraud) and the "Dauphin, Louis XVII of France" (an actor and sham evangelist). During stops along the river they give theatrical performances, including some hilarious bowdlerizations of Shakespeare. At the next town, the Duke and the

Mark Twain

tion. (Hemingway even claimed that American literature started with *Huck Finn*.)

All too often, author Mark Twain's admonition to the reader of *Adventures of Huckleberry Finn*—"Persons attempting to find a motive in this narrative will be prosecuted; persons attempting to find a moral in it will be banished; persons attempting to find a plot in it will be shot."—is taken at its word. Indeed, there was a time, as critic Leslie Fiedler has noted, when the efforts of some hapless commentator to "explicate the book's levels of terror and evasion" condemned him to be dismissed as "a busybody and scandalmonger." Nonetheless, more recently, tracking and exhuming the book's innermost significances has become something of a cottage industry. Maxwell Geismar has noted, for example, that if *Tom Sawyer* satirized the conventional values of maturity, social success, and social power, *Huckleberry Finn* defied all the proprieties, including wealth, success, social position, and conventional religion. As novelist E.L. Doctorow has noted, civilization was no longer that of Tom Sawyer's world, where a prim maiden aunt washes an unruly boy's neck; rather, in Huck's world, "Civilization is buying and selling people, and working them to death." And because Huck, unlike the shrewd, more worldly Tom, is self-reliant and unremittingly rebellious, he becomes an effective spokesperson for Twain's savage attacks on that society. No other character in American fiction would have better voiced a defiance of civil taboos and moral hypocrisy than Huck, who, upon deciding to rescue Jim, utters those immortal (and hair-raising) words, "All right, then, I'll *go* to Hell!"

In the opinion of commentators like Henry Nash Smith and Maxwell Geismar, the brilliant improvisation and acute satire that to this point has constituted *Huckleberry Finn* lapses into conventional farce after this moment. However, concludes Smith, "the wise reader will shrug his shoulders and console himself with the reflection that *Adventures of Huckleberry Finn* would change the course of American literature by bringing the fresh energies of native humor into the mainstream. That is more than enough for one book to accomplish."

The Films

To date, the movies have yet to catch up with Huck's essentially lawless nature and Twain's brutal dissection of racist society. Rather, Huck is usually portrayed as a spunky barefoot lad who takes up with a kindly, grinning black man named Jim. As if uncertain about Huck's "marquee value," some versions pair him up with his pal, Tom Sawyer. (Indeed, Twain's resorting to injecting Tom into the last portion of the novel opens up the author to the same charge.) Moreover, they all are inevitably limited by the absence of Huck's distinctive narrative "voice"—what novelist Bobbie Ann Mason describes as an exaggerated "whang"—"a language that functions through its potential

Dauphin impersonate the two long-absent brothers of the recently deceased Peter Wilks in an attempt to claim his inheritance. Huck intervenes on behalf of Wilks's three daughters and the scheme is foiled by the arrival of the real brothers. Meanwhile, Huck discovers that the Duke and the King have sold Jim to Mrs. Phelps, who, it turns out, is Tom Sawyer's Aunt Sally! After wrestling with his conscience and discovering that "you can't pray a lie," Huck decides to rescue Jim. He goes to the Phelps farm and impersonates Tom. When Tom arrives, he in turn masquerades as his brother Sid. In a fantastic rescue, Tom is accidentally shot and the slave is recaptured. It is then that the recuperating Tom reveals that Jim has already been set free in the provisions of the will of the recently deceased Miss Watson. Moreover, Huck's fortune is safe since his father has died. For his part, Huck rejects the whole situation and decides to leave and head westward: "I reckon I got to light out for the territory ahead of the rest, because Aunt Sally she's going to adopt me and sivilize me, and I can't stand it. I been there before."

Huck's inventive, deadpan vernacular captures the horrors and poetry of river life with rugged insight and precision. It was from this example that modern writers like Gertrude Stein and Ernest Hemingway purportedly achieved their "plain Western rhythms" in their own fic-

for inventiveness just as the necessities of the frontier called for ingenious solutions."

The first major film adaptation, *Huckleberry Finn*, was directed by William Desmond Taylor for Famous Players-Lasky in 1920. Although it is unavailable for screening, the *American Film Institute Catalogue of Feature Films, 1911–1920* notes the basic story line is intact as Huck (Lewis Sargent) escapes his shiftless father and joins Jim (George Reed), a runaway slave, on a trip down the Mississippi in a raft. After adventures with the fugitives, the Duke and the King, Jim is sold to Mr. Phelps and subsequently rescued by Huck with the aid of his pal, Tom Sawyer (Gordon Griffith). In what is to become a standard alteration in subsequent adaptations, the film ends with Huck's cheerful return to the Widow Douglas.

Three people sail the raft downriver in the 1931 adaptation, directed by Norman Taurog. The star power of Jackie Coogan as Tom Sawyer dictated that he share top billing with Huck (Junior Durkin) and Jim (Clarence Muse). Little remains of the complex plot, save the incidents with the Duke and the King (Eugene Pallette and Oscar Apfel) and the plot to rob orphaned sisters of their brother's inheritance. Again, Huck's rebellious nature is sanitized to the extent that he is tamed by one of the sisters and smitten by her, dutifully returns home to the Widow Douglas to resume his schooling.

The tables are turned in the 1939 adaptation, directed by Richard Thorpe, when the star power of Mickey Rooney returns Huck Finn to center stage. (Indeed, Tom Sawyer is nowhere to be found in this version.) Up to the point where Huck and Jim (Rex Ingram) encounter the Duke and the King (William Frawley and Walter Connolly) and meet the orphaned daughters, the story line is followed relatively closely. However, the concluding action is pure Hollywood: After Jim has been returned home under suspicion of the murder of Pap, he faces a mob. Huck, with the assistance of Captain Brandy and his paddleboat, braves a terrific storm and in a last-minute rescue prevents Jim from being lynched. After Jim is freed, Huck then reunites with the Widow Douglas (Elizabeth Risdon) and obligingly returns to school.

Of the two versions in 1960 and 1974, little information is extant. Eddie Hodges and Jeff East, respectively, portray Huck, and Archie Moore and Paul Winfield appear as Jim. The character of Tom Sawyer is absent in both. The absence of information is especially regrettable in the instance of the 1960 film, in that it was one of Michael Curtiz's last directoral efforts and features the music of the esteemed composer Jerome Moross (*The Big Country, Rachel, Rachel*).

Regarding the 1993 Disney version, there has been some critical dispute. While the basic story line was retained, critics disagreed sharply about the film's more intrinsic merits. Roger Ebert applauded Elijah Wood's Huck, "mercifully free of cuteness and other affectations of child stars," and Courtney B. Vance's Jim, "who

embodies the enormous tact with which Jim guides Huck out of the thickets of prejudice . . ." He doesn't seem to mind the fact that, while the script by Stephen Sommers spends more screen time on Huck's racial "conversion" than any previous version, it ironically sanitizes issues by consciously avoiding altogether the racist epithet "nigger." Critic Hal Hinson of the *Washington Post* strenuously objects to this omission, accusing the movie of presenting merely a "Little Golden Book bowdlerization of a great book."

Indeed, the expunging of such troublesome epithets plagues not only this film, but also continues on the agenda of certain social leaders who want to remove them entirely from Twain's original! Such a crusade, comments novelist William Styron, "is an extreme example of the animus that has coalesced around the novel." As long as the book remains in this "continuous vortex of discord," concludes Styron, surely a film that unflinchingly adapts it is at best only a remote possibility.

REFERENCES

Geismar, Maxwell, *Mark Twain: An American Prophet* (Houghton Mifflin, 1970); "Huck, Continued," *The New Yorker,* June 26/July 3, 1995, 130–33; Vidal, Gore, "Twain on the Grand Tour," *The New York Review of Books,* May 23, 1996, 25–28.

—*J.C.T.*

THE ADVENTURES OF TOM SAWYER (1876)

MARK TWAIN

Tom Sawyer (1917), U.S.A., directed by William Desmond Taylor, adapted by Julia Crawford Ivers; Paramount.

Tom Sawyer (1930), U.S.A., directed by John Cromwell, adapted by Sam Mintz, Grover Jones, and W.S. McNutt; Paramount.

The Adventures of Tom Sawyer (1938), U.S.A., directed by Norman Taurog, produced by David O. Selznick, adaptation by John Weaver; Selznick/United Artists.

Tom Sawyer (1973), U.S.A., directed by Don Taylor, adapted by Robert B. Sherman and Richard M. Sherman; Reader's Digest/United Artists.

The Novel

In the 1870s, journalist/humorist Samuel Langhorne Clemens under the pen name Mark Twain settled in Hartford, Connecticut, and began writing longer prose works, both fiction and nonfiction. *The Adventures of Tom Sawyer* is an early novel from this period. *Tom Sawyer* was not particularly well-received on its original publication, but it soon became a popular book for adolescents and adults. By the mid-20th century, it was also part of the canon of American literature, much discussed by critics and a staple of school and college courses.

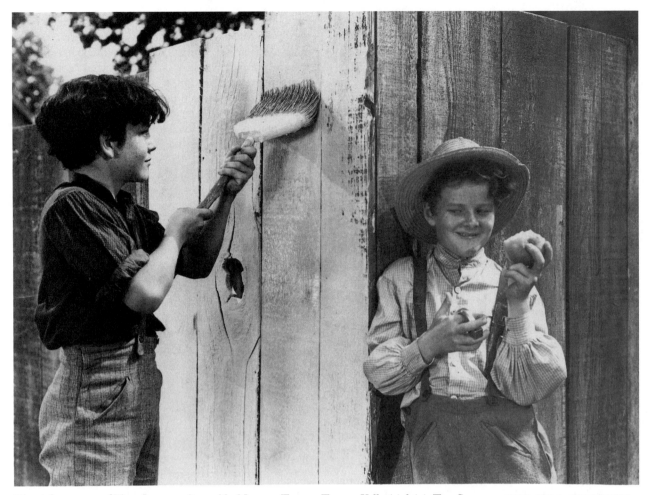

The Adventures of Tom Sawyer, *directed by Norman Taurog. Tommy Kelly (right) is Tom Sawyer.* (1938, U.S.A.; SELZNICK/ MUSEUM OF MODERN ART FILM STILLS ARCHIVE)

The Adventures of Tom Sawyer begins with a detailed evocation of life in the (fictional) Mississippi River town of St. Petersburg, Missouri, and then moves to a series of episodes involving the young Tom Sawyer, his friends Joe Harper and Huckleberry Finn, his sometime sweetheart Becky Thatcher, and such adults as town drunk Muff Potter and the much-feared Injun Joe. Walter Blair has described four major plots in the novel: Tom and Becky, Muff Potter's trial, Injun Joe, and McDougal's Cave. *Tom Sawyer* ends with two exciting scenes—Tom and Becky escape from the cave, Tom and Huck find Injun Joe's treasure—plus the comic relief of Huck trying to adapt to the Widow Douglas's prim and proper household.

The Films

The Adventures of Tom Sawyer has been the basis for four American-made feature films: a silent film of 1917, and sound films made in 1930, 1939, and 1973. Additionally, at least three television versions of the story have been made. In recent years, there have been several odd spinoffs from

Tom Sawyer, including a cartoon series for television, a Soviet version of the story, and an adaptation in which Tom and Huck become California surfers! This essay will discuss only the four American feature films made between 1917 and 1973.

Paramount's 1917 silent version of *Tom Sawyer,* a five-reel (50-minute) feature starring Jack Pickford, is unabashedly a comedy of youth that avoids the darker moments of Twain's novel. After a fanciful introduction featuring Twain writing at his desk with a tiny, brightly illuminated Tom sitting near him, the silent film moves to a series of leisurely vignettes. This version of *Tom Sawyer* ends with Tom, Huck, and Joe returning to town in the midst of their own funeral. Scenes of crisis and doubt, such as Doc Robinson's death, Muff Potter's trial, and Tom and Becky's experience in the cave, are all omitted.

In 1930 Paramount remade *Tom Sawyer* as a sound film directed by John Cromwell and starring the famous child actor Jackie Coogan. This version does a good job of balancing the various plot strands of the novel. But Cromwell's film avoids the theme of maturation, of the

gradual change from boy to adult; here Tom Sawyer is a mischievous young lad from start to finish. In Tom's scenes with Becky, for example, the moviemakers insist on Tom's unease with the "adult" courtship situation. The Cromwell film also shortens the McDougal's Cave subplot, which in the book demonstrates Tom's courage and resourcefulness as well as his feelings for Becky. The cave scene becomes a mildly frightening diversion, rather than an ordeal in which Tom proves his mettle.

David O. Selznick's 1938 production of *Tom Sawyer* begins with flowery intertitles—"Out of the heart of Mark Twain into the heart of the world"—that set the tone for a heavily nostalgic adaptation. Several of the characters seem artificial and prettified, and the art direction has a Victorian, sentimental quality. Tom Sawyer (played by Tommy Kelly) is something of a dandy, but at least he is able to present a credible boy of great energy and imagination.

Like the Cromwell version, the Selznick version achieves a good balance between the various subplots. Tom and Becky, Jackson's Island, the trial, the cave—all are present, none overshadows the others. The Selznick film does a good job with Twain's more satirical scenes, using Tom's point of view to show the foibles and inconsistencies of the adult world. It also allows the cave scene to be truly horrifying and stresses Tom's heroism.

The Technicolor nostalgia of Selznick's film is in many ways too sentimental and too perfect. But Selznick and company do nicely catch the novel's blend of humor and adventure. The 1938 *Adventures of Tom Sawyer* is an entertaining Hollywood film, and the best *Tom Sawyer* adaptation we have seen to date.

The 1973 musical version of *Tom Sawyer*, starring Johnny Whitaker, was produced by *Reader's Digest* and distributed by United Artists. A musical adaptation of a novel is at least potentially a good idea, because musical numbers provide an opportunity to explore the inner feelings of the characters. This happens occasionally in the 1973 *Tom Sawyer*, but the musical numbers also serve as a vehicle of the producers' ideology. For example, the whitewashing scene becomes a musical tribute to the pleasures of hard work, which is hardly what Twain had in mind. "Oh, how good it feels, with your shoulder to the wheel," sing the boys in unison. Similarly, the Thatchers' private picnic in the novel becomes a lavish Fourth of July parade in the musical. This provides an occasion for pageantry and patriotism, very important to *Reader's Digest* but lampooned by Twain.

The musical does provide some pleasures of casting. Red-haired Johnny Whitaker is a more-than-adequate Tom, and Warren Oates does a fine job as Muff Potter (whose part is built up to fit Oates's star billing). But the great pleasure of the film is gap-toothed, blonde-haired Jodie Foster as Becky Thatcher. The script sometimes condescends to this character, but in visual terms Foster is certainly the most interesting screen Becky.

This much-loved classic is surprisingly troublesome to adapt, for two reasons. First, despite its loose structure, *Tom Sawyer* is crammed with incident, and in leaving this out one risks distorting the novel in one way or another. Second, it is difficult to match the novel's acerbic yet indulgent narrative "voice." For example, without Twain's half-cynical tone, the whitewashing scene can become a hymn to hard work.

REFERENCES

Blair, Walter, "On the Structure of *Tom Sawyer*," *Modern Philology* 37 (1939): 75–89; Fuller, Dan, "*Tom Sawyer:* Saturday Matinee," in *The Classic American Novel and the Movies*, eds. Gerald Peary and Roger Shatzkin (Ungar, 1977); Scharnhorst, Gary ed., *Critical Essays on the Adventures of Tom Sawyer* (G.K. Hall, 1993).

—*P.A.L.*

THE AFRICAN QUEEN (1935)

C.S. FORESTER

The African Queen (1951), U.S.A., directed by John Huston, adapted by James Agee and John Huston; S.P. Eagle [Sam Spiegel] for Horizon Pictures/Romulus Films, released by United Artists.

The Novel

C.S. Forester, best known for his "Horatio Hornblower" novels, published *The African Queen* in 1935. The novel relates the unusual 1914 romance of Rose Sayer, a trade-class spinster and a Methodist missionary's sister, and Charles Allnutt, the Cockney pilot of the *African Queen*, a broken-down steam-powered river boat. When Rose's brother dies of fever after Germans attack the central African village where Sayers's church is, Charlie helps Rose to flee. To the surprise of both, they become deeply involved. Gradually Rose persuades him to assist her, first, in escaping Central Africa; and second, in sabotaging the *Königin Luise*, the German gunboat patrolling the vast lake at the end of the Ulanga River. Against all odds, Rose and Charlie navigate uncharted jungle rivers to the lake and convert the *African Queen* into a makeshift torpedo—only to have the boat sink in a storm just before they reach their objective. Rose and Charlie are rescued by the Germans, who release them to the British under a flag of truce. Once British vessels have sunk the *Luise*, Rose and Charlie resolve to be married by the British consul.

The Film

Tony Huston once remarked that his father typically filmed one story: that of a man who gave everything in pursuit of one objective, only to learn that the objective was not what he expected. This archetype is apparent in many Huston narratives, especially *The Maltese Falcon, Moby Dick, The Treasure of the Sierra Madre, The Misfits, The Red Badge of*

Courage, Wise Blood, and *The Dead.* Huston's adaptation of *The African Queen* begins with a sequence introducing the characters of the Rev. Samuel Sayer (Robert Morley), Rose (Katharine Hepburn), and Allnutt (Humphrey Bogart), including the comic addition of Allnutt's struggles with a persistent growling stomach at tea. This establishing sequence sets a comic tone for a narrative that, in Forester's novel, had begun with Samuel's death.

The film's Allnutt is adapted for Bogart in several ways. First, he is Canadian, not Cockney Second, while Forester's Allnutt is not a heavy drinker (his overindulgence leading to Rose's ire is portrayed as an aberration), Bogart's Allnutt mirrors Bogart's popular reputation as a hard drinker. Hence Bogart's sincere angst when Rose disposes of the gin supply is an embellishment on the original Allnutt's malady, which was simply a severe hangover.

Hepburn's portrayal of Rose is, at first, more akin to stereotypes of ministers' spinster sisters than Forester's characterization demands. The novel's Rose lacks religious conviction, having accompanied her brother virtually by default. Moreover, Forester's physical descriptions of Rose tend toward the voluptuous, and she is said to have been "made for love." Predictably, scenes from the novel in which Rose and Charlie consummate their relationship are treated subliminally in this 1951 film. Whereas Forester's Charlie and Rose have sex for the first time after their first encounter with the rapids, Hepburn's Rose responds by losing her hat and operating a boat pump with extraordinary vigor.

The most radical adaptation is in the film's ending: Instead of the peaceful release of Charlie and Rose before the British sink the *Luise,* the film's captain sentences both Charlie and Rose to death by hanging (a sentence that, for reasons the novel explains clearly, would be not only unlikely but also unthinkable). Charlie and Rose persuade the captain to marry them before carrying out his sentence. Just before Rose and Charlie are to be hanged, the *African Queen* floats to the surface for a deus ex machina conclusion in which Charlie and Rose succeed in sinking the *Luise* and escape. While Forester's narrator concludes, "Whether or not they lived happily ever after is not easily decided," the Huston film barters suspension of disbelief for an unequivocally romantic ending.

Forester's novel is pointedly concerned with two unremarkable people: Rose lacks intelligence and religious conviction, but circumstances arouse her patriotic fervor, which, in turn, inspires the otherwise feckless Charlie to provisional heroism. Huston's adaptation converts Rose and Charlie into characters more intelligent than Forester's, and the film brings out sustained humor that is, at best, latent in the novel. Katharine Hepburn frequently recalled Huston's helping her develop her characterization with the advice "you 'put on' a smile. Whatever the situation. Like Mrs. Roosevelt," which Hepburn called "the goddamnedest best piece of direction I have ever heard." While the deus ex machina ending might be faulted (particularly since Forester has already played that card by hav-

ing the rain conveniently arrive to float the *Queen* out of the swamp, a plot twist Huston retains), the principals' superb character performances and remarkable chemistry have made this film one of Huston's more enduring successes, and, from a comic standpoint, a more complex and satisfying narrative than Forester's novel. The comic plot is effectively supported by Allan Gray's bright, rollicking score.

REFERENCES

Fultz, James R., "A Classic Case of Collaboration: *The African Queen,*" *Literature/Film Quarterly* 10 (1982): 13–24; Grobel, Lawrence, *The Hustons* (Scribner's, 1989), 362–82; Hepburn, Katharine, *The Making of the African Queen: How I Went to Africa with Bogart, Bacall and Huston and Almost Lost My Mind* (Knopf, 1993); Huston, John, *An Open Book* (Knopf, 1980), 187–205; Viertel, Peter, *White Hunter, Black Heart* (Dell, 1953).

—M.O.

THE AGE OF INNOCENCE (1920)

EDITH WHARTON

The Age of Innocence (1924), U.S.A., directed by Wesley Ruggles, adapted by Olga Pritzlau; Warner Bros.

The Age of Innocence (1934), U.S.A., directed by Phillip Moeller, adapted by Sarah Mason and Victor Heerman; RKO.

The Age of Innocence (1993), U.S.A., directed by Martin Scorsese, adapted by Martin Scorsese and Jay Cocks; Columbia.

The Novel

Serialized in *The Pictorial Review* without chapter divisions, *The Age of Innocence* was significantly revised by Wharton, as was her habit, before its book publication by Appleton the same year. The novel was critically and commercially successful, earning Wharton about $70,000 by 1922, and was awarded the Pulitzer Prize (the first for a woman). R.W.B. Lewis argues that in this novel Edith Wharton reflects two impulses: to "search imaginatively" for the America that had disappeared after World War I and to reflect on her own past self, through Archer, in whom "she brought back the restive and groping member of society she had once been" and through Olenska, her "intense and non-conformist self."

At the opera, Newland Archer meets Countess Ellen Olenska, cousin of his fiancée, May. Ellen excites controversy by her separation from the wealthy count, her escape with his secretary, and her willingness to flout social conventions. Meanwhile, Newland urges May, a pretty but unimaginative and conventional girl, to marry him soon; initially she refuses and touchingly asks whether he has other ties. Ellen seeks advice from Archer's law firm about her possible divorce; he agrees with her family that the resulting scandal is too great a risk, and she agrees. Ellen flees, asking Newland to come after her; he believes her

husband is pursuing her, but really it is Beaufort, a banker who is barely tolerated in New York society and reputed to have mistresses. Caught up in the excitement of Ellen, Archer decides to break his engagement, but a message arrives from May that she has convinced her parents to move up their wedding date.

After their wedding, Archer and May take a three-month wedding tour, meeting, among others, M. Rivière, a French tutor. They then summer in Newport, where May wins an archery prize. Still fascinated by Ellen, Archer makes excuses to meet her, even after she leaves town. Archer discovers that Rivière, the secretary with whom Ellen fled her husband, has brought a message to Ellen that Count Olenska wants her back, but Rivière urges Archer to keep her from returning to Poland. After Catherine Mingott has a stroke, Ellen agrees to come live with her, and Archer is hopeful; then May tells him Ellen has decided to return to Europe, but not to her husband. After Ellen's going-away party, May reveals that she told Ellen several days earlier what she only now reveals to her husband: She is pregnant.

The affair now at an end, Archer is treated by his family as a prodigal returned. Decades pass and Archer, now a widower and a respected participant in liberal politics, travels to Paris at the behest of his grown son, Dallas. After Dallas reveals to his father that he has known all along about Ellen Olenska, they visit her apartment. But Archer decides to remain behind on a park bench, while sending Dallas to pay his respects. Archer watches the lights in Ellen's apartment, and then walks slowly back to his hotel, alone.

The Films

The 1924 silent version, which starred Beverly Bayne as Countess Olenska and Elliott Dexter as Newland Archer, has been lost. Phillip Moeller's 1934 version, starring Irene Dunne as Olenska and John Boles as Newland Archer, has been unavailable since its first release because of legal difficulties. It is noted mainly for the opening montage, which seeks to depict 1870s New York, and its framing device, in which an elderly Archer rides up in front of Olenska's residence after many years and retells his story, casting a patina of sacrifice and regret over the entire film.

Critics are predictably divided in their response to Scorsese's 1993 film, which marks a significant departure from his usual controversial subject matter and style. Stuart Klawans complains that Scorsese is "almost deferential," using "style . . . as repressed as the characters themselves," which is "so decorous, so dreamy, so dull." Scorsese himself reveals he "never really found the right thing for romance because . . . I don't know it in the modern world. I can't sense it . . . so therefore I wanted to do something very lush and sensual from a period where the texture was stronger." From this explanation, Andrew Delbanco infers that this film is a deliberate change from more explicit passion, "a work about salvation through renunciation."

Edith Wharton

The film is quite faithful to the novel, with some characters combined or omitted. Voiceover narrative provides the original tone, and often Wharton's exact words. Scorsese employs a range of expressionistic effects, which seem intrusive, however, including iris lighting of Archer and May when he reveals sending her yellow roses; a wipe to the center representing all, like inviting the tutor to dinner, that Archer's marriage would require him to relinquish; and a 360 shot at the party for the Blenkers.

Scorsese's film is visually arresting and attentive to fine details that render 1870s New York society compelling to contemporary viewers. Unfortunately voiceover from the novel, as Linda Costanza Cahir correctly observes, both remind us of how well written the novel is and "reduce to a pantomimesque performance" the actors, who seem "visual inserts, writ large, much like sign-language performers who translate a television show for the hearing impaired." Although Scorsese's use of this device is understandable, since Wharton's characters often communicate paragraphs worth of meaning in a finely honed glance, Joanne Woodward's voice serves to underscore the gap in subtlety and artistry between Wharton's rendering and the film's.

REFERENCES

Delbanco, Andrew, *The New Republic*, October 25, 1993; Klawans, Stuart, *The Nation*, October 25, 1993; Cahir, Linda Costanza, "The Perils

of Politeness in a New Age: Edith Wharton, Martin Scorsese and *The Age of Innocence*," *Edith Wharton Review* 10:2 (1993): 12–14, 19.

—*K.R.H.*

ALICE ADAMS (1921)

BOOTH TARKINGTON

Alice Adams (1923), U.S.A., directed and adapted by Rowland V. Lee, Encore Pictures.

Alice Adams (1935), U.S.A., directed by George Stevens, adapted by Dorothy Yost, Mortimer Offner, and Jane Murfin; RKO Radio Pictures.

The Novel

Alice Adams won the Pulitzer Prize for fiction in 1921. Along with his other masterpiece, *The Magnificent Ambersons* (1918), also a Pulitzer Prize winner, Booth Tarkington presented a perceptive picture of small-town Midwestern life in the first decades of the 20th century. Although less ambitious in scope than the earlier novel, *Alice Adams* is superior in its direct, supple prose and tightly controlled storytelling. It originally appeared as a serial in *The Pictorial Review* and was later published in its entirety in May 1921. Because it was not as humorous as Tarkington's previous novels, some critics objected. "Oh gosh," exclaimed Tarkington, "*A.A.* was intended to be about as humorous as tuberculosis." Defending its objective portrayal of the desperately pretentious Alice, he further declared: "The girl is drawn without any liking or disliking of her by the writer who is concerned only with making a portrait of her insides and outsides."

Once active in the smart set of her small Midwestern town, Alice Adams watches in dismay as her friends go off to college while the straitened finances of her family force her to stay home. The headstrong, social-climbing Alice is dissatisfied with her family's modest means and embarrassed by her coarse brother. When she meets handsome, wealthy Arthur Russell at a dance, she sets her cap for him and invents a personal history she thinks is more "acceptable" to him. Meanwhile, in order to further Alice's social ambitions, her mother convinces her father to leave his job at a drug manufacturer, Lamb and Company, and go into business for himself. Against his better sense, he invests all his money in a glue factory. Trouble quickly follows: It is discovered that Alice's brother has embezzled money from the business accounts at Lamb and Company; and he skips town. Mr. Adams is left with his debts. When he attempts to borrow against his new factory, he discovers his former employer, Mr. Lamb, has erected a competing glue factory nearby. The new business is now worthless, and Mr. Adams is forced to sell out to Mr. Lamb. Adams suffers a stroke and leaves the family in desperate straits. Mrs. Adams is forced to take in boarders, and Alice, all her dreams of money, marriage, and position shattered (her flirtation with Russell having ended in disaster), enrolls in Frincke's Business College, prepared to spend the rest of her life in a menial job.

The Films

The first film adaptation was produced by King Vidor in 1923. It was directed by Rowland V. Lee and featured Vidor's wife, Florence, in the title role. Little is known about the project, since it is apparently a "lost" film. Surviving references indicate that the six-reel film follows the basic story line, including the famous dinner scene with Arthur Russell (Vernon Steele), the failure of the Adams glue factory, and Alice's determination to set aside her social pretensions and remain home to help her father (Claude Gillingwater).

The 1935 version marked the ascendance of director George Stevens from comedy vehicles for the team of Wheeler and Woolsey (*Bachelor Bait* and *Kentucky Kernels*, 1934) to "A" class pictures. It was also a return to public favor for Katharine Hepburn, whose popularity was then in limbo. Despite its upbeat ending and its sentimentalization of the character of Alice, the film stands out as one of the more darkly honest portrayals of family life to come from Hollywood in the 1930s.

The small town is identified as "South Renford, Indiana, The Town With a Future." Several sequences deftly convey the clash between Alice's (Katharine Hepburn) social aspirations and her poor economic state, including the opening scene when, after wistfully eyeing a corsage in a shop window, she picks violets in the park to make her own; the Palmer dance, when Alice persuades her brother to park their old car on the street so she can pretend to the butler that their car has broken down; and the ill-fated dinner with Arthur Russell (Fred MacMurray), during which Alice valiantly tries to disguise the shabbiness of her home. This last sequence is the highlight of the picture. Mrs. Adams has hired a black maid and cook (Hattie McDaniel) for the evening. Everything goes wrong—the maid's cap keeps coming askew as she clumsily serves the dinner, Mr. Adams' shirtfront keeps popping open, and everyone sweats profusely as the hot, humid evening wears on. Afterward, Alice takes Arthur outside to the porch and painfully admits she knows the relationship is over and they should not see each other again. "After all, when everything's spoiled, you can't do anything but run away," she declares.

The most significant alteration from the book is the tacked-on happy ending. Instead of leaving, as he does in the book, Arthur Russell confesses his love for her. "Gee whiz!" she exclaims, melting into his arms. It affirms that Alice's Cinderella fantasies—much more pointed in the movie than in the book—can come true, especially in Hollywood. Even before the publication of the book in 1921, Tarkington had predicted that such a happy ending might be inevitable on screen. In her study of the film, commen-

tator Nancy L. Schwartz writes, "It is a typical Depression conclusion, the shop girl's fantasy in which economics are forgotten and virtue triumphs."

The critics, while applauding Hepburn's performance, generally caviled at the "poor taste" of the delineation of Alice's social climbing, disapproving of her dissatisfactions in the face of the widespread depression gripping America. "What does remain consistent about *Alice Adams*, book and film," concluded Nancy L. Schwartz, "is the depiction of the powerlessness of the lower-middle-class woman in the first half of the twentieth century, powerless to change her social position except through marriage or art."

REFERENCES

Dowd, Nancy and David Shepard, *King Vidor* (Scarecrow Press, 1988); Downer, Alan S., ed., *On Plays, Playwrights and Playgoers: Selections from letters of Booth Tarkington to George C. Tyler and John Peter Toohey, 1918–1925* (Princeton University Press, 1959); Schwartz, Nancy L., "*Alice Adams*: From American Tragedy to Small-Town Dream-Come-True," in *The Classic American Novel & the Movies*, eds. Gerald Peary and Roger Shatzkin (Frederick Ungar, 1977).

—*J.C.T.*

ALICE IN WONDERLAND (1865)

LEWIS CARROLL

Alice in Wonderland (1903), Great Britain, directed and adapted by Cecil Hepworth; Hepworth.
Alice's Adventures in Wonderland (A Fairy Comedy) (1910), U.S.A., Edison.
Alice in Wonderland (1915), U.S.A, directed by W.W. Young, adapted by Dewitt C. Wheeler; Nonpareil Feature Film Company.
Alice in Wonderland (1930), U.S.A, directed by Bud Pollard, adapted by John E. Godson and Ashley Miller; Commonwealth Pictures Corporation.
Alice in Wonderland (1933), U.S.A, directed by Norman McLeod, adapted by Joseph L. Mankiewicz and William Cameron Menzies; Paramount.
Alice in Wonderland (1951), France, directed and adapted by Marc Mauarette and Dallas Bowers; Victorine Studios.
Alice in Wonderland (1951), U.S.A., production supervised by Ben Sharpsteen; Walt Disney.
Alice's Adventures in Wonderland (1972), Great Britain, directed and adapted by William Sterling; Twentieth Century-Fox.

The Novel

Dr. Charles Lutwidge Dodgson, better known to the inhabitants of Wonderland and adjacent territories as "Lewis Carroll," took three small girls on a rowboat ride down the Isis River on a storied "golden afternoon" on July 4, 1862. The improvised tale that became *Alice's*

Adventures in Wonderland especially intrigued little Alice Liddell, who urged the handsome Oxford don to write it down. He called the first draft *Alice's Hour in Elfland*, retitled it a year later *Alice's Adventures Underground* (providing his own illustrations), and finally published it in 1865 under its present title. But Carroll wasn't finished with Alice—or *she* wasn't finished with *him*—and *Through the Looking-Glass and What Alice Found There* appeared as a Christmas book for 1871. Both books seem to be so much of a unit that they are frequently confused. They are quite different, however: The first is a child's dream, a "free-fall adventure" based on a pack of playing cards and featuring memorable characters like the White Rabbit, the Mad Hatter, the March Hare, the Cheshire Cat, and the King and Queen of Hearts. Among the memorable poems is the classic "Father William." The second is based on a chess game, a kind of deterministic fable, and introduces the characters Tweedledum and Tweedledee, Humpty Dumpty, and the White Knight. The famous "Jabberwocky" is contained in this volume. The original illustrations by Sir John Tenniel are virtually inseparable from both texts. The Alice books have been translated into over 50 languages, imitated, condensed, parodied, and relentlessly analyzed.

The Films

Oddly, although motion pictures had appeared years before Dodgson's death in 1898, there are no references to them in his diaries and letters. Dodgson was an inveterate tinkerer and inventor, and surely he would have seen in the new medium the ultimate "looking-glass." Did not the character of Alice ask, "What is the use of a book . . . without pictures or conversation?" Certainly his stories are rife with all the trappings of a kind of proto-cinema—special effects, songs, conversations, visual spectacle, transformations, and scenic episodes. At any rate, the movies found *him* quickly enough, and since 1903 there have been more than 15 movie versions of the Alice books, not to mention the many more that allude either to Dodgson's life, like *Dreamchild* (Great Britain, directed by Gavin Millar and written by Dennis K. Potter), or to the Alice character, like the 1934 Betty Boop cartoon, "Betty in Blunderland," Walt Disney's "Alice in Cartoonland" series (a mixture of live action and animation, dating from the mid-1920s), and Woody Allen's *Alice*, a 1991 comedy-fantasy of neurosis and infidelity.

All of the Alice films have combined the characters and incidents of the two books into a single narrative unit. This is unfortunate, since by combining elements of both, the movie adapters have forgone the integrity of each for the more episodic nature of a hybrid. Cecil Hepworth produced the first adaptation, a 16-scene, 10-minute version called "Alice's Adventures in Wonderland." Utilizing the special-effects resources of the camera, it contains scenes of Alice shrinking, growing, and dissolving into nothingness. It concludes with a chase scene, as the children of the Hepworth studio employees pursue her

Charlotte Henry in Alice in Wonderland, *directed by Norman McLeod* (1933, U.S.A.; PARAMOUNT/THEATRE COLLECTION, FREE LIBRARY OF PHILADELPHIA)

about the woodland. This is significant in that in the books Alice herself is never the prey of a chase; that reversal would be left to the always chase-hungry movies! Although the pictorial elements are interesting, the film ignores Carroll's wordplay—not one line from the books appears in any of the title cards!

In 1910 the Edison studio entered the lists with *Alice's Adventures in Wonderland, a Fairy Comedy*, a 10-minute version that utilizes the plot elements involving the White Rabbit and the Knave of Hearts. A few lines from the poem, "Speak Roughly," are incorporated into the title cards. The first feature-length film version, *Alice in Wonderland*, appeared in 1915, and featured Viola Savoy as Alice. Giant lobsters, the Mock Turtle, and the Caterpillar are dressed up in elaborate costumes clearly derived from Tenniel, and there are extensive quotes from Carroll in the title cards.

Alice first spoke in 1930 in a "Wonderland" sequence in *Puttin' on the Ritz* (directed by Edward Sloman with music by Irving Berlin), in which Joan Bennett appeared as Alice with a line of chorus girls dressed like playing cards. A few months later a second talking picture, *Alice in Wonderland*, directed by Bud Pollard and starring Ruth Gilbert as Alice, turned the tables on the silent versions. Here, the talk was nonstop and the action was static and dull. In a scene that stretched even the bounds of Wonderland, the White Rabbit confesses he stole the tarts to give to his love, the Duchess! As David and Maxine Schaefer write in their study of the Alice films, "A plethora of Carroll's words on a soundtrack cannot put Humpty Dumpty together again."

Paramount's all-star *Alice in Wonderland* appeared in 1933, starring Charlotte Henry as Alice. Considered one of the best entries in the series, it liberally blended elements from both books. In the prologue, for example, Alice passes through a mirror where she finds the White Rabbit and a set of chess pieces. The splendid cinematic

effects included four size changes, a beautifully realized illusion of Alice passing through the mirror, conversations with a leg of mutton and a pudding, the use of live flamingos as croquet mallets, and an animated cartoon version of "The Walrus and the Carpenter." William Cameron Menzies's sets suggested the various modern art movements of the day—the expressionist angles of Tweedledee and Tweedledum's forest, the surrealist distortions of the banquet scene with the talking pudding and the walking leg of mutton, the Pre-Raphaelite delicacy of the pool of tears, and the American poster art stylizations of the Mock Turtle scene. "Hollywood here displays not only special effects," writes commentator Roderick McGillis, "but also its influences from the visual arts." Highlights among the cameo appearances were W.C. Fields as Humpty Dumpty, Edward Everett Horton as the Mad Hatter, Gary Cooper as the White Knight, and Cary Grant as the Mock Turtle.

In 1951 a French production, *Alice in Wonderland*, costarring actor Carol Marsh and the puppets of Lou Bunin, did poorly, purportedly because of the grotesqueness of the figures. Meanwhile, Walt Disney released an animated feature in 1951 with the voice of Kathryn Beaumont as Alice. The Tenniel visual conceptions were consulted by the artists, but not slavishly imitated. The five-year, $5 million production had some memorable songs, like Mack David's "A Very Merry Un-birthday" and Sammy Fain/Bob Hilliard's "I'm Late"; a wonderful Cheshire Cat (Sterling Holloway); and some fine set pieces, including the Tea Party (with Ed Wynn as the Mad Hatter and Jerry Colonna as the March Hare), and the march of the cards heralding the Queen's arrival. It remains the most episodic of Disney's full-length story features, beginning with Alice lapsing into a daydream and, at the end, waking up. Ironically, one of the most successful scenes—involving a talking door knob ("one good turn deserves another")—

Fiona Fullerton (right) in Alice's Adventures in Wonderland, *directed by William Sterling* (1972, U.K.; TCF/NATIONAL FILM ARCHIVE, LONDON)

doesn't belong to Carroll at all, but was devised by the screenwriters. The critics, however, attacked the film as a "dreadful mockery of the classic" (*The New Yorker*) and a "shock to oldsters brought up on the famous John Tenniel illustrations" (*Life*). In a more recent assessment, historian Leonard Maltin wrote: "[It is] a very flashy and generally entertaining film, but it lacks . . . warmth."

More recently, a 1972 English musical adaptation, *Alice's Adventures in Wonderland*, with songs and lyrics by John Barry and Don Black, featured Fiona Fullerton as Alice, Peter Sellers as the March Hare, Dame Flora Robson as the Queen of Hearts, and Sir Ralph Richardson as the Caterpillar. Adapter/director William Sterling pulled out all the stops, framing the action in 70mm format and relying on all manner of lens distortions and stop-motion effects. It was lavish and it was monumentally tedious. Designer Michael Stringer's slavish imitation of Tenniel's illustrations—the rock faces and seaweed mustaches that form a background to the Lobster Quadrille, the Duchess's unpleasantly dirty kitchen, the puce field of mushrooms—were heavy-handed and too literal. An overabundance of makeup on the players, as opposed to the wearing of masks, resulted not in the desired presentation of animals with human characteristics, but in merely bizarre humans. They moved, moreover, amidst a dull and slow-paced script. Despite its good intentions, complains commentator Roderick McGillis, the results were confused, occasionally repellent, and inconsistent: "Without an understanding of the book's coherence, even the most sincere effort at faithfulness must break down."

Inevitably, perhaps, the X-rated *Alice in Wonderland, an X-Rated Musical* appeared in 1976, starring Kristine DeBell and a number of other characters in various stages of undress. *Through the Looking Glass and What Alice Found There* (1980), an Anglo-Belgian-Polish production updated the White Rabbit into a jogger, the Queen into the Godmother of the Mafia, and the Lobster Quadrille into a disco dance.

Despite the seeming compatibility between the graphic wonderlands of cinema and the wild imagination of Carroll's texts, no truly satisfactory Alice film has yet emerged. It should be remembered that it was Carroll's dazzling prose, as much as his narrative invention, that distinguished the texts. It says a lot about the movies, perhaps, that the most successful Alice film to date, in this writer's opinion, strays the furthest from the literal text and the Tenniel illustrations and substitutes a mute, animated mouse for the character of Alice. Disney's classic, short Mickey Mouse cartoon, "Thru the Mirror" (1937) is a dazzling succession of wonderful sight gags involving contemporary technology and cultural referents, like a talking telephone, a Busby Berkeley–like formation of dancing playing cards, and a gallant Mickey who tap dances like Fred Astaire and swashbuckles like Doug Fairbanks. It is the spirit, if not the letter, of Carroll that emerges intact. Those who complain about this translation of Carroll's Victorian world into our own contemporary contexts should remember that when Carroll wrote his stories he was a thoroughly modern citizen writing during a time of burgeoning technology and social change (providing many of the targets for his satire). As Walter de la Mare said of him, "He was concerned with the joys of a new world, not with the follies and excesses of an old."

REFERENCES

Maltin, Leonard, *The Disney Films* (Bonanza Books, 1973); McGillis, Roderick, "Novelty and Roman Cement: Two Versions of *Alice*," in *Children's Novels and the Movies*, ed. Douglas Street (Frederick Ungar, 1983); Schaefer, D.H., *The Film Collectors' Alice: An Essay and Checklist*, in Edward Giuliano, ed., *Lewis Carroll Observed* (Clarkson and Potter, 1976); Schaefer, David and Maxine, "The Movie Adventures of Lewis Carroll's Alice," *American Classic Screen* 5:5 (1980): 9–12; Tibbetts, John C. (under the pseudonym of "Jack Ketch"), "Room Enough," *The World and I* 2:4 (April 1996): 278–84.

—*J.C.T.*

ALL THE KING'S MEN (1946)

ROBERT PENN WARREN

All the King's Men (1949), U.S.A., directed by Robert Rossen, adapted by Robert Rossen; Columbia.

The Novel

When the Pulitzer Prize Committee honored Robert Penn Warren's *All the King's Men* in 1947, they were paying tribute to what they regarded as a major political novel. Reviewers speculated that Warren had based his character Willie Stark on the controversial Louisiana governor and senator Huey P. Long, who had dominated his state's politics from 1928 until his assassination in 1935. Warren denied neither that Long's career was one among many sources of his inspiration nor that his novel examines the abuse of political power. But for Warren *All the King's Men* most encompassingly concerns his narrator Jack Burden, larger philosophical questions about the nature of self, and the challenge of being a morally responsible citizen in the 20th century.

In *All the King's Men* narrator and protagonist Jack Burden looks back at the key periods in his life and ponders his evolving relationships with a host of characters. Adding to the novel's complexity is the discursive, exploratory manner of Burden's narration. Jack prowls back and forth in time, as he puzzles over his attempts to evade commitment to persons, jobs, institutions, and ideas. It is clear that he tells his convoluted story in order to learn and accept his responsibility in the network of events and people that make up his life.

The narrative strategies and prose style of *All the King's Men* embody Jack's perception of himself as an investigator. His training as a prelaw student, as a doctoral candidate in history, as a newspaper reporter, and as a special researcher for Governor Willie Stark have refined his

All The King's Men, directed by Robert Rossen (1949, U.S.A.; COLUMBIA/PRINT AND PICTURE COLLECTION, FREE LIBRARY OF PHILADELPHIA)

skills in information gathering. Governor Stark knows this when he assigns Jack the job of researching information that can be used to blackmail political opponents. But Jack is more than an information gatherer: He is compelled to shape information into living stories in which truth is conveyed through metaphor and symbol. The method of this novel expresses a key realization that Jack finally senses what in the past he has evaded: Mere information must be interpreted and transformed into knowledge.

When Jack, posing as a cynical reporter, first encountered the young Willie Stark, he believed that he had found an idealistic, honest politician who cared for the welfare of the people. As Stark learns to specialize in power politics, Jack responds with both dismay and fascination over the governor's rationalizations that in a corrupt world good ends can be brought about only by evil means. Jack watches Stark strong-arm his way to an impressive record of public works achievements. He tries to forget that his research has provided a corrupt means by

which Stark achieves his ends—and that information uncovered by him produces the suicide of his childhood mentor, the death of his closest friend, and the assassination of Governor Stark. At the close of his story Jack accepts his pivotal role in the fatal chain of events and vows a return to the political arena convinced that good ends can be produced only by good means and that knowledge, not mere information, is the key to life.

The Film

When director Robert Rossen wrote the script for his Oscar-winning version of *All the King's Men* (1949), he shifted Willie Stark into the center of the story. While Jack Burden provides occasional voiceover transitions, Rossen's movie sensibly makes little attempt to establish him as a center of consciousness, much less capture his discursive and reflective point of view. Rather than simulate Jack's shifting time perspective by developing a complex system of

mental flashbacks, Rossen omits all of Jack's ruminations and much of Jack's personal story to concentrate on a chronological account of Stark's development into his state's political boss. Whereas in the novel Jack's meditating consciousness creates a leisurely pace, Rossen's adaptation maintains a relatively objective and fast-paced style, pushed along by generally brisk cutting and strategically placed montages as well as by a dynamic, Oscar-winning performance by Broderick Crawford.

Crawford effectively captures the commanding figure of Willie Stark that Jack creates in the novel. He skillfully conveys a man who is naive, earnest, committed, and idealistic, as well as self-absorbed, callous, brutal, and menacing. By the same token, able camera work and effective shot composition help to evoke the sense of Stark's dynamic presence. Yet, without Jack's interpretive imagination giving shape and mystery to character, Crawford and Rossen's Willie Stark falls short of the subtlety and ambiguity achieved by Warren in the novel.

Despite the preeminence of Stark, Jack Burden, played ably by John Ireland, by no means melts into a peripheral role in Rossen's story. Still well dramatized is Warren's intent to contrast the active Willie Stark who commits himself and seeks to shape history with the passive, reactive Jack who tries to remain uncommitted and believe that he is merely shaped by history. By the same token, Rossen economically conveys that, despite his posture of cynicism, Jack sees in Stark a fellow idealist who might well bring about positive social change. Compensating for the reflective, retrospective narration of the novel, Rossen uses dialogue and well placed reaction shots to convey Jack's slow, reluctant acknowledgment that Stark, in his increasing reliance on corrupt means, has betrayed the good and become corrupt himself.

It is true, though, that the shifting of Stark to the center of the story diminishes Jack's role in the story's conclusion. In the novel the entirety of the final chapter is devoted to Jack's attempt to pull the strands of his life together and explain that his experience with Willie Stark has taught him who he must become, that is, a morally alert, proactive citizen who will reenter the political arena. In the movie Jack, in the tumultuous scene after the shooting of the governor, hurriedly comments that what was good in Stark's vision must be carried on by the living. The significance of the lines is swept aside, however, by the final close-ups of the dying governor's face as he mutters, "It could have been the whole world—Willie Stark." The concluding optimism of the novel significantly fades in the movie.

Rossen's streamlining of *All the King's Men* makes filmmaking sense in that cinematic equivalents to the novel's complex narrative would be cumbersome. But Rossen had equally strong personal and political reasons for centralizing the political story in his adaptation. Since his past membership in the Communist Party had prompted a subpoena from the House Un-American Activities Committee, Rossen was sensitive to both political persecution and the specter of suppression and censorship. Into his version of *All the King's Men* Rossen added a scene in which Stark previews a March of Time–like newsreel. After it dramatically portrays both Stark's good works and his strong-arm tactics, the newsreel ends with the question: "Messiah or Dictator?" When Stark expresses concern over the ambiguity of the question, the director firmly responds, "Sorry, Governor, but that's our view. And that's how it stands." Stark shrugs and replies, "All right. That's how it stands—for now." The scene reinforces Stark's characterization and adds a clear note of menace. But its primary function is to declare Robert Rossen's position on freedom of expression in both politics and in the arts, and it sums up some of his own fears that he brought to the making of *All the King's Men*.

REFERENCES

Combs, James, *American Political Movies* (Garland Publishing, 1990); Rossen, Robert, *All the King's Men*, in *Three Screen-Plays*, Steven Rossen, ed. (Viking, 1972); Walling, William, "In Which Humpty Dumpty Becomes King," in *The American Novel and the Movies*, eds. Gerald Peary and Roger Shatzkin (Frederick Ungar, 1978).

—*C.T.P.*

ALL QUIET ON THE WESTERN FRONT
(Im Westen Nichts Neues) (1929)

ERICH MARIA REMARQUE

All Quiet on the Western Front (1930), U.S.A., directed by Lewis Milestone, adapted by Maxwell Anderson, George Abbott, and Dell Andrews; Universal Pictures.

The Novel

All Quiet on the Western Front (*Im Westen Nichts Neues*) was published approximately 10 years after the end of World War I and is a deeply felt portrait of the dehumanizing effects of military conflict. Remarque's partially autobiographical novel was praised by left-leaning and working-class Germans for its defense of the common soldier. *All Quiet* became a universal bestseller because it addressed issues of alienation, self-discovery, and pacifism; to this day it remains, for many readers, the ultimate antiwar novel.

There is no "plot" per se, only a cast of characters featuring a central protagonist, Paul Bäumer, and his comrades, most of whom are former schoolmates now bonded together as World War I recruits behind the front lines. Remarque's main business throughout the novel is the development of Bäumer's insight that they have been trapped by a false conception of war as a heroic and nationalist experience. *All Quiet* has very few scenes of actual warfare; impressions, feelings, and reactions are more important. In several key episodes, including an affecting encounter between Bäumer and a French enlisted man, Remarque shows how far Bäumer has drifted

from the jingoistic values of the German Empire. In the final chapter, Bäumer is the last surviving member of his unit. He dies from an enemy bullet, relieved that the end to his physical and spiritual suffering has come.

The Film

The scenario of *All Quiet* was rewritten chronologically— a painless task, it would seem—from the loosely composed scenes of the book. The viewer can sympathize with director Lewis Milestone's decision to film a logical narrative rather than the "disjointed" and impressionistic flow of thoughts and feelings that give Remarque's book its tone. Though Remarque seems not to have actually taken part in guiding the course of this, his first feature film adaptation, Milestone remained faithful to the pacifist thesis of the novel. *All Quiet* clearly shows Paul (Lew Ayres) as a victim of the war. There is a scene (not in the novel) of Bäumer's hand reaching out to touch a butterfly in no-man's-land and another of superimposed crosses, implying that the final triumph belongs to the lovers of peace rather than war. Considering the populist and commercial slant of most Hollywood productions, it is unusual that Milestone was able to avoid war film cliches and romanticized pictures of soldiering. *All Quiet* won the Academy Award for best picture in 1930 and is still featured in film retrospectives everywhere: though Milestone's name has faded, his classic antiwar film has not.

REFERENCES

Firda, Richard Arthur, *All Quiet on the Western Front: Literary Analysis and Cultural Context* (Twayne Publishers, 1993); Jones, Dorothy B., "War Without Glory," *Quarterly of Film, Radio, and Television*, Spring 1994.

AN AMERICAN TRAGEDY (1925)

THEODORE DREISER

An American Tragedy (1931), U.S.A., directed and adapted by Josef von Sternberg (with assistance from Samuel Hoffenstein); Paramount.

A Place in the Sun (1951), U.S.A., directed by George Stevens, adapted by Michael Wilson and Harry Brown; Paramount.

The Novel

Considered one of the most important American novels of the century, Dreiser's last major work pulls no punches in its story of a young man's desperate, failed grasp at the American dream. It was a pioneering psychological study of a murderer; and unlike literary precedents in Poe, Dostoyevsky, and Conrad, the crime is not motivated by passion or madness so much as by simple expedience. The novel grew out of several preoccupations of the 54-year-old author—an absorbing interest in real-life crime stories (the murder by Chester Gillette of Grace Brown in Moose Lake, New York, in 1906), his growing frustration with his own loveless marriage, and his readings in Sigmund Freud and Jacques Loeb of the biological, subconscious, and mechanistic forces that work upon our lives. Critic Joseph Wood Krutch called it "the greatest book of its generation," and criminal lawyer Clarence Darrow praised its "fanatical devotion to truth." Unimpressed, the city of Boston banned it and the Massachusetts Supreme Court declared certain passages were "indecent, obscene, and manifestly tending to corrupt the morals of youth."

Clyde Griffiths is a street preacher's son who helps his poor family financially by becoming a bellboy in a Kansas City hotel. His earnings enable him to savor the good life for the first time. But after killing a nine-year-old girl in an automobile accident, he flees to Chicago and finds work at the Union League Club. Later, assisted by a wealthy uncle, Samuel Griffiths, Clyde relocates to Lycurgus, New York, where he finds employment in a collar factory.

Clyde's eastern relatives consider him below them socially, and he is not accepted into their exclusive circle. His cousin Gilbert particularly resents his presence. Clyde starts out at the very bottom of the factory hierarchy (in the aptly named "shrinking department"). He is soon promoted to a slightly higher position as a supervisor, where he falls in love with an employee named Roberta Alden—although it is against company policy for him to socialize with her. After refusing his advances for a time, Roberta gives in to him, preferring to become his mistress rather than lose him.

Meanwhile, a beautiful young socialite, Sondra Finchley, invites Clyde to fancy parties. Her motive at first is merely to annoy Gilbert, but Clyde's increasing popularity elicits her genuine affection. For his part, Clyde is helplessly infatuated with her and the glamorous lifestyle she embodies. Standing in the way of his schemes to marry her is Roberta, who has become pregnant. After unsuccessfully trying to remedy the problem with drug store medicines and a shady abortionist, Clyde takes Roberta to an isolated lake resort in order to arrange a boating "accident." While in a rowboat, after a moment of irresolution, he accidentally hits her with his camera. They tumble into the water. Roberta drowns while he swims to safety. Significantly, she dies not by any action of Clyde, but by his *non*-action.

The murder is a botched affair. Incriminating letters to Roberta are discovered and her pregnancy is revealed. Moreover, the blow to her head is suspicious. Clyde is arrested, prosecuted, and sentenced to the electric chair. On Death Row his mother comes to him and encourages him to give his soul to Christ. Clyde finally signs a confession of his sins, although it is unclear if the document is sincere. In his meeting with the Reverend McMillan shortly before the execution, he seems likewise ambiguous. In some of the most absorbing pages in all of modern literature, Clyde grapples with "the puzzle of his own guilt": "He had a feeling in his heart that he was not as guilty as they all seemed to think . . . Even in the face of all the facts and as much as every one felt him to be guilty, there was

something so deep within him that seemed to cry out against it that, even now, at times, it startled him." At last Clyde enters the death chamber, whose door closes upon "all the earthly life he had ever known."

Despite the novel's fame as a "realistic" novel, Ellen Moers, in her classic study, *Two Dreisers*, insists that by now Dreiser thought the realistic novel had reached a "dead end" and that *An American Tragedy* was essentially a "dream" story rooted in the Arabian Nights tale of Aladdin, a tale compounded as much of fantasy and poetic imagery as of gritty, mundane surface details. "Fable, more than epic, describes the method by which the realism of *An American Tragedy* took on an inward cast."

The Films

In 1927 Dreiser sold the movie rights to Famous Players-Lasky for $90,000. That was for silent film rights only. When no such film was produced, and when the talkie revolution hit Hollywood, another contract was negotiated with Paramount for an additional $55,000. Russian filmmaker Sergei Eisenstein, then visiting the United States, was called in to produce a screenplay. Unlike Dreiser, who felt Clyde was guilty but was not to be blamed (certainly not to be executed), Eisenstein thought it was society that was guilty for executing Clyde. His scenario took the standard form of dialogue and generalized camera directions, plus rather elaborate descriptions of settings and camera moods. What attracted him to the project, according to commentator Keith Cohen, was not just the ideology behind the rise and fall of Clyde Griffiths, but what Eisenstein called the "cinematic" nature of the prose—"a highly visual, long, though rapidly paced novel, recounted at points with the rhythm of breathlessness." The breathless concentration of tense moments—particularly, the rowboat scene, the train ride during which Clyde ruminates on Roberta's fate, and the execution—was enhanced by fragmented images that could be translated into visual montage sequences ("zigzags of aimless shapes" and "racing visual images over complete silence"). The dual "voices" within Clyde that debate the feasibility of the murder could become elements of an audio montage, what Eisenstein claimed would be the first "inner monologue" in cinema. Unfortunately, Paramount refused Eisenstein's script for a number of reasons, including public outrage at their importing of that "accursed Red dog, Eisenstein" and because his treatment maintained, according to critic/director Ivor Montagu, that Dreiser's original was not merely "the story of a crime" but "an indictment of a whole society."

Josef von Sternberg, fresh from his triumphs with *The Blue Angel* (1929) and *Morocco* (1930), took over the project, eliminating, with the help of scenarist Samuel Hoffenstein, the story's sociological implications. His version was an individual study of a self-destructive young man (Phillips Holmes) impelled to murder by his social ambitions. Gone was the careful delineation of Clyde's evangel-

Theodore Dreiser

istic background; and gone was a sense of indecision concerning the murder of Roberta (Sylvia Sidney). In their places was an inordinate amount of screen time devoted to that staple situation of so many talkies of the period, the courtroom trial. "Distrusting motion pictures in general and me in particular," recalled Sternberg, "[Dreiser] flew to Hollywood, swooping down from the air like a corpulent eagle." After the picture was released, he took legal action against Paramount on the grounds that it altered an indictment of the whole social system to just an ordinary murder story—in short, that it "outraged his book." In what surely is one of the only instances of a legal commentary on the subject, Associate Justice Graham Witschief of the Supreme Court ruled that the film was a faithful transcription of the book. Ironically, writes Sternberg, Dreiser was right: "Literature cannot be transferred to the screen without a loss to its values; the visual elements completely revalue the written word."

George Stevens' remake for Paramount in 1951, *A Place in the Sun*, proved to be a lush, romantic picture that won six Oscars (including directing, screenplay, and cinematography) and acclaim for Montgomery Clift and Elizabeth Taylor as Griffiths and Sondra (here renamed George Eastman and Angela Vickers). In her study of the picture, Bernice Kliman notes that the script leaves behind

Dreiser's darkly ironic determinism and is now about "an individual's effort to earn his place in the sun, a place that is lost finally only because of chance circumstances."

There are many changes in the story. It is now set in the 1940s and Eastman works in a factory that manufactures bathing suits. In the courtroom scenes, George claims to the D.A. (Raymond Burr) that he had had a "change of heart" in his murderous plans. This underscores a philosophical and legal question not emphasized by Dreiser: Is plotting a murder as criminal an action as actually killing the victim?

A highlight of the movie—and a scene that hews closely to Dreiser's intended ambiguity regarding Clyde's culpability—is the boating "accident": George and Alice (Shelley Winters as the character of Roberta) sit in the rowboat and discuss their future. It is only when Alice stands up in the boat that it capsizes and the two fall into the water (the blow from Clyde's camera is not depicted). A protracted shot reveals George straggling out of the lake alone, begging the question of his culpability in her drowning.

The romantic episodes between George and Angela are the stuff of pure Hollywood romance. Not so much victims of circumstance, they are star-crossed lovers, and their encounters are staged in magnificent, overwhelming close-ups. Their affair is limned in high-key light, as contrasted with the low-key chiaroscuro of the relationship with the drab Alice. In the end, glowing romance wins out over tragic irony when a flashback image of George and Angela's famous screen kiss is superimposed over George's form as he walks the "last mile" to his execution.

REFERENCES

Cohen, Keith, "Eisenstein's Subversive Adaptation," in *The Classic American Novel & the Movies*, eds, Gerald Peary and Roger Shatzkin (Frederick Ungar, 1977); De Grazia, Edward, *Girls Lean Back Everywhere: The Law of Obscenity and the Assault on Genius* (Random House, 1992); Kliman, Bernice, "*An American Tragedy:* Novel, Scenario, and Films," *Literature/Film Quarterly* 5:3 (summer 1977): 258–67; Moers, Ellen, *Two Dreisers* (Viking Press, 1969); Slide, Anthony, *Selected Film Criticism, 1931–1940* (Scarecrow Press, 1982).

THE ANDROMEDA STRAIN (1969)

MICHAEL CRICHTON

The Andromeda Strain (1970), U.S.A., directed by Robert Wise, adapted by Nelson Gidding; Universal.

The Novel

The Andromeda Strain was the first novel Michael Crichton wrote under his own name, and its success influenced Crichton to make writing his career.

Crichton takes great pains to produce a novel that has the appearance of verisimilitude. He explains in his acknowledgments that the book "recounts the five-day history of a major American scientific crisis," and he thanks those who have assisted him in the investigation of the Wildfire project, concluding the novel with a list of unclassified documents used in the writing of the book. The novel is filled with authentic-looking warnings, machine language, and computer-generated diagrams.

The novel opens as a satellite sent into space by the U.S. government, ostensibly to collect extraterrestrial organisms for study but in reality to use in the development of biological weapons, has fallen to earth in the Arizona desert. The satellite is discovered in the town of Piedmont, population 48. Everyone appears to be dead, including the first two technicians sent to retrieve it. Project Wildfire is put into effect and the four scientists that comprise the Wildfire team are brought to an underground laboratory, built to investigate and analyze extraterrestrial life forms and equipped with a nuclear device to be detonated in the event that a biological hazard can not be contained.

The scientists discover that a hungry baby and an old man with bleeding ulcers and a habit of drinking sterno are the only survivors of the Piedmont disaster, and they set about to discover what the two have in common that allowed them to survive. By the time they realize the baby and old man initially survived because the organism could grow only within a very narrow pH range, the virus has mutated into a form that is harmless to living beings but dissolves plastic, which puts Wildfire in new danger. The gaskets that prevent contamination throughout the laboratory begin to dissolve, which triggers the lab's defense mechanism—the nuclear self-destruct sequence that is designed to detonate within three minutes in the event of contamination. Because the organism grows by changing matter to energy, rather than killing it, a nuclear explosion would allow it to multiply and likely infect, in multiple mutated forms, the whole planet. Mark Stone, whose presence on the team depended on his being single and theoretically better able to make-life-or-death decisions, must then disarm the nuclear device by making his way through the lab's defense mechanism.

In the course of their investigation and in spite of the brilliance of these hand-picked scientists, there are missed clues and wrong conclusions, which underscores Crichton's concern about the fallibility of scientists. And even with the millions of dollars spent on state-of-the-art equipment, disaster is averted purely by luck, when the Teletype machine fails to notify them that the president has chosen not to follow procedure and detonate an atomic bomb over Piedmont.

The Film

The Andromeda Strain was well received by critics and moviegoers alike, and was nominated for two Academy Awards, for editing and for art direction. With the popularity of the novel and film, "Andromeda strain" has come into the language as a term for any unexplained biological threat.

Wise and Gidding's film perfectly matches the dry, analytical feeling of the novel, from the diagrams, documents, and tables that appear behind the opening credits to the suggestion that the events are actually a compilation of Senate testimony.

The characters are lifted directly from the novel, though with somewhat different names and a change in gender—Drs. Jeremy Stone (Arthur Hill); Charles Dutton, Burton in the novel (David Wayne); Mark Hall (James Olson); and Ruth Leavitt (Kate Reid). The few changes Robert Wise and Nelson Gidding, whom Wise worked with on several films, including *I Want to Live* and *The Haunting*, make to the film serve to increase suspense. The events of the novel are presented chronologically in the film, which encourages suspense and emphasizes the scientists' race against time to identify and neutralize Andromeda. Wise shortens the five-day span of the novel to four and lengthens the amount of time available to disarm the self-destruct mechanism to five minutes. The additional time until self-destruct allows for a real-time race against the clock as Hall climbs through the laser defenses of the laboratory core to reach the substation that will allow him to disarm the device.

Wise also warns that the public should not place too much trust in either the government or in scientists. Like Crichton, Wise emphasizes that the failed Teletype machine, rather than the scientists, inadvertently forestalls nuclear disaster. And neither have the scientists done anything significant to control Andromeda. They have studied it and concluded that it has moved into the upper atmosphere where it can harmlessly dissipate, or be dispersed by rain into the sea where the salt will neutralize it. Both novel and film end with the suggestion that Andromeda is just the beginning of our encounter with organisms outside our comprehension and the ineffectuality of the scientists to conquer Andromeda is calculated to add to our anxiety.

REFERENCES

Thompson, Frank, *Robert Wise: A Bio-Bibliography* (Greenwood Press, 1995); Trembley, Elizabeth A., *Michael Crichton: A Critical Companion* (Greenwood Press, 1996).

AND THEN THERE WERE NONE (1939)

AGATHA CHRISTIE

And Then There Were None (1945), U.S.A., directed by René Clair, adapted by Dudley Nichols; Popkin/20th Century-Fox

Ten Little Indians (1965), U.K., directed by George Pollock, adapted by Peter Welbeck; Tenlit/Warner Bros.-Seven Arts.

And Then There Were None (1975), Spain-Italy-West Germany-France, directed by Peter Collinson, adapted by Enrique Llovet and Erich Krohnke; EMI.

Ten Little Indians (1989), U.S.A., directed by Alan Birkinshaw, adapted by Jackson Hunsicker and Gerry O'Hara; Cannon.

The Novel

Originally published in England as *Ten Little Niggers, And Then There Were None* (its first American title, subsequently reissued as *Ten Little Indians*) is an example of Agatha Christie's particular artistry as a writer of detective fiction. As Julian Symons has put it, Christie's skill in the construction of classic puzzle-type mysteries resembles that of a magician rather than a chess player: "She shows us the ace of spades face up. Then she turns it over, but we still know where it is, so how has it been transformed into the five of diamonds?" In *And Then There Were None*, 10 people are lured by written invitations to a weekend gathering on a remote Indian island. On the first evening, a recorded voice reads a list of indictments against them: Each guest has been guilty of a murder for which he or she cannot be brought to trial. The guests realize that they are cut off from help on the mainland, and a storm makes leaving the island impossible. Then, one by one, the guests are murdered. Each murder conforms to the means given in a nursery rhyme ("Ten little Indian boys went out to dine;/One choked his little self and then there were nine," etc.), and

The Andromeda Strain, *directed by Robert Wise* (1970, U.S.A.; UNIVERSAL/THEATRE COLLECTION, FREE LIBRARY OF PHILADELPHIA)

each is marked by the breaking of one of the 10 little Indian figurines used as a centerpiece on the dining-room table. As the number of the living shrinks, tensions and suspicions grow until finally all the guests have died. In an epilogue two Scotland Yard detectives are stumped by the problem, but a manuscript confession delivered to their office identifies the murderer and ties up the loose ends.

The Films

The first filmed version of the story, directed by René Clair in 1945, is by far the best. Aside from minor differences in the nature of the crimes committed and in the substitution of a Russian emigré prince for a young English playboy, the film's major deviation from the book comes at the end, in which the last two remaining guests, instead of dying as a result of murder and suicide, turn out to be innocent of the crimes they have been accused of and survive by tricking the real killer into revealing himself. Thus, in the film, being suspicious of others pays off, whereas in the book it is futile. Also, the film has a farcical quality that is far from the fatalistic and cynical tone of the book.

In each successive remake, the central conceit remains the same—people are gathered in a remote place where they are trapped and at the mercy of a hidden avenger who eliminates them one by one, and whose identity comes as a surprise to the viewer—but in the later versions the locations become increasingly outlandish: an Alpine *Schloss* in 1966, Iran in 1975, and a safari camp in Africa in 1989. The key to the Christie story in each of its versions is the sleight-of-hand with which the identity of the murderer is concealed, rather than the suspense of who will be the next victim.

REFERENCES

Symons, Julian, *Bloody Murder: From the Detective Story to the Crime Novel* (Penguin, 1972).

—S.C.

DIE ANGST DES TORMANNS BEIM ELFMETER (1970)

See THE GOALIE'S ANXIETY AT THE PENALTY KICK.

ANNA KARENINA (1877)

COUNT LEO TOLSTOY

Anna Karenina (1915), U.S.A., directed and adapted by J. Roy Edwards; Fox.

Love (1927), U.S.A., directed by Edmund Goulding, adapted by Frances Marion; MGM.

Anna Karenina (1935), U.S.A., directed by Clarence Brown, adapted by Clemance Dane/Salka Viertel/S.N. Behrman; MGM.

Anna Karenina (1948), U.K., directed and adapted by Julien Duvivier/Guy Morgan/Jean Anouilh; London/United Artists.

Leo Tolstoy's Anna Karenina (1996), U.S.A., directed and adapted by Bernard Rose; Icon/Warner Brothers.

The Novel

Leo Tolstoy worked on *Anna Karenina* for seven years, beginning in 1870. Although the opening chapters appeared in 1875—the novel was first published in installments—the last chapters didn't reach print until 1877. He described the writing process as a kind of slow agony, frustrated by what he described as a "block" that hindered his progress. Nonetheless, the finished product has been acclaimed as a masterpiece that is the equal of his *War and Peace*.

Tolstoy's express purpose was to write about the subject of adultery, of how human emotional needs are often in conflict with societal norms. Anna Karenina pays for her transgression, although the retribution is more divinely inspired than socially generated—hence, the novel's epigraph, "'Vengeance is mine: I will repay,' saith the Lord." Tolstoy insisted that he was not judging his characters, since that would usurp a godly privilege; rather, he wanted to describe events dispassionately and show that retribution for our sins came only from God.

There are two intertwined plots, that of the tragedy of Madame Karenina's affair with Count Vronsky; and the story of Kanstantin Levin's marriage to Kitty. In the first, the growing attraction between the married Anna and the dashing Vronsky arouses much gossip in St. Petersburg. Anna's husband, a cold and ambitious man, confronts her—not out of jealousy so much as out of fear of the social consequences of her behavior. Out of duty to her young son, Seryozha, Anna agrees to end the affair. But when Vronsky is injured in an accident, she resumes the relationship. When she learns she is pregnant with Vronsky's child, she petitions her husband for a divorce. He refuses, fearing scandal, and he threatens to take away Seryozha if she resists. However, after the birth of her child, Karenin finally agrees to allow Anna to run away to Italy with Vronsky and the baby. But life between the lovers grows difficult and, believing Vronsky no longer loves her, Anna goes to a railway station where she throws herself in front of an approaching train.

In the second plot, meanwhile, Levin pursues his love of Kitty, the sister-in-law of Anna. At first, Kitty refuses his advances, and he returns to his country estate, busying himself with problems of agriculture and peasant labor. But when Levin proposes to Kitty for a second time, she accepts. Together, they work the farm and learn the values of toil and happiness.

The Films

Little information is available concerning a version made by the Fox studios in 1915. The second version, also a

silent film, was MGM's *Love* (1927), which starred Greta Garbo and John Gilbert. It was updated to modern dress and abandoned the Levin/Kitty plot. While applauding the romantic sizzle between Garbo and Gilbert (who at the time were lovers in real life), *Photoplay* magazine deplored the cuts, complaining that without the Levin/Kitty plot, "the movie has separated the wheat of sex from the chaff of preachment." Two versions were released, one in which Anna commits suicide, and one in which the lovers are reunited. Exhibitors could take their choice; and most of them preferred the happy ending.

Audiences that saw the 1935 version, produced by David O. Selznick, had no such choice. This new Anna was thoroughly chastised and fatally punished for her transgressions. At this time the film industry in Hollywood labored under the censorial agencies of the Catholic Legion of Decency and the newly formed Production Code Administration, presided over by Joseph Breen. Censorship had existed in a milder, less institutionalized form at the time of the release of *Love* in 1927; but now it was more restrictive and more firmly entrenched. Subjects like those in *Anna Karenina*—adulterous love, illegitimate children, desertion, and suicide—were more problematic than ever.

Chief PCA censor Breen realized that overt attempts to censor Tolstoy would look foolish; yet a faithful adaptation would outrage civic and religious leaders. He agreed that adultery could remain in the story, but only if the entire film served as a rebuke to the lovers for their sin. Details of the relationship itself were to be kept to a minimum—no passionate kissing or undue physical contact; indeed, there was to be no hint that the couple was even living together! Meanwhile, all references to the illegitimate child were removed.

Evaluating the finished product, historian Greg Black, in his book, *Hollywood Censored*, says that it "reeks throughout with moral indignation." At every opportunity, characters step forward to either denounce Anna (Greta Garbo) and Vronsky (Fredric March), or to foretell dire results of the continued affair. The resistance by Karenin (Basil Rathbone) to his wife's affair has none of the duplicity suggested by Tolstoy; rather, he is portrayed as refusing a divorce solely because it would "legalize a sin." This makes him seem insufferably sanctimonious; but, as Black reminds us: "He was not, at least in Breen's eyes, a 'hypocrite' as Anna charged." An unhappy marriage—in Hollywood at least—was not a legitimate reason for divorce or sexual transgression.

All these changes notwithstanding, the Catholic Legion of Decency proclaimed the film "indecent," and it condemned it for "ethical reasons." Across the aisle, meanwhile, *The Nation* had a different opinion, dismissing it as "lifeless" and objecting to its "purity-sealed" rendition of Tolstoy. Graham Greene dryly summed up the situation when he predicted it would delight "millions of cinema-addicts who have never heard of Tolstoy."

Producer Alexander Korda's 1948 British version was an overlong, yet sumptuously produced effort starring Vivien Leigh as a rather stiff, aloof Anna; Kieron Moore as a bland Vronsky; and Ralph Richardson as a convincingly tortured Levin. By all reports it was not a happy experience for anyone, especially Leigh, who was undergoing personal and career problems.

The most recent version by Bernard Rose was the first to be shot in the actual locations of St. Petersburg and Moscow. Music director Sir Georg Solti performed and recorded Tchaikovsky's *Pathétique* symphony for the soundtrack in the Great Hall of St. Petersburg, in the very place where Tchaikovsky himself conducted its premiere over a century ago. The film is not only much more faithful to the book in general, but it is the first version to restore relatively intact the Levin/Kitty (Alfred Molina and Mia Kirshner) story. And that is precisely where the strength of Rose's script lies. If we care little about his pallid Anna (Sophie Marceau) and her insipid lover (Sean Bean), we at least grow ever more fascinated by the unpredictable Levin and his Kitty. Tolstoy had always intended Levin's spiritual quest to counterpoint Anna's rampant sensuality (thus reflecting his own duality). And to his everlasting credit, Rose has taken him at his word. He has even given the narrative voice to Levin, making it clear that he is a stand-in for Tolstoy himself (at the end, we see Levin signing his manuscript with Tolstoy's name).

While the sensual aspects of Anna and Vronsky's lovemaking are graphically depicted—not much censorship here!—other problems present themselves: Much of the almost three-hour length was cut for American distribution, resulting in gaping holes in the continuity (including key scenes depicting the development of the liaison between Anna and Vronsky). The performances of Marceau and Bean are frankly lackluster, dim, and *flattened*, somehow, as if their faces have been pressed against the other side of a pane of glass.

From the beginning it was Rose's stated intention to bring Tolstoy himself somehow to the fore. A wholly added scene at the beginning has a figure representing Tolstoy racing across the ice, ravenous wolves closing in behind him. He stumbles down into a well, breaking his fall by grabbing at tree roots. He hangs there, helplessly suspended between the certain death of the hungry wolves waiting above and those below. It is Rose's metaphor not just for Tolstoy himself (it is derived from a recurring nightmare he suffered) but for humankind in general, poised between the summit of aspirations and the pit of failures.

REFERENCES

Black, Gregory, *Hollywood Censored: Morality Codes, Catholics, and the Movies* (Cambridge University Press, 1994); Durgnat, Raymond, *Greta Garbo* (Dutton, 1965); Gardner, Gerald, *The Censorship Papers* (Dodd, Mead, 1987).

—*J.C.T.*

BABBITT (1922)

SINCLAIR LEWIS

Babbitt (1924), U.S.A., directed by Harry Beaumont, adapted by Dorothy Farnum; Warner Brothers.

Babbitt (1934), U.S.A., directed by William Keighley; adapted by Mary McCall, Tom Reed, Jr., Niven Busch, and Ben Markson; Warner Bros.

The Novel

Babbitt is one novel in Lewis's "Zenith trilogy," comprised additionally of *Main Street* (1920) and *Arrowsmith* (1925). Lewis dedicated *Babbitt* to fellow novelist Edith Wharton with whom he shared a professional friendship and whose social vision remained a lifelong influence.

Steeped in irony and sharply critical of the materialistic values of the Midwestern middle class of fictional Zenith, *Babbitt* is a portrait of a morally and intellectually sterile person, living a bland, empty life. George F. Babbitt is a complacently dull businessman, proud of his house, which looks like everyone else's; his unethical, but moderately successful business deals; and his vapid speeches, which are well received by other babbits who are looking for easy answers. Babbitt is a braggart and a hypocrite, who is a member of the Good Citizen League, yet bullies and belittles his wife and children; who extols business as the means to God's own country, yet engages in dishonest real estate deals; who praises Prohibition, yet drinks bootleg gin; and who publicly touts traditional morality, yet keeps a mistress. A series of crises force Babbitt to examine his life, and although it appears that he is on the threshold of a realization, in the end Babbit remains unchanged.

The Films

There are two film versions of *Babbitt*. Two years after the novel's publication, the first version (1924) appeared. A silent film directed by Harry Beaumont, the picture is dismissed as an unfortunate and dull effort, lacking subtlety, credibility, and energy. In 1934 the remake appeared, directed by William Keighley, largely known for gangster and adventure movies, and starring Guy Kibbee as Babbitt. Any film translation of *Babbitt* must confront the difficulty of the novel's structure, an essentially plotless stringing together of episodes illustrating various aspects of George Babbitt's life. The film does a laudable job in its sequencing of briefly rendered scenes. In large part a comedy of middle-American manners, the movie, like the novel, opens ironically with a tour of Babbitt's house: his pride and joy world of silly standardized gadgets and faux accoutrements. Guy Kibbee is convincing as the cluelessly self-satisfied George Babbitt, content in Zenith where success is measured in purely material terms and social progress is appraised by personal gain. If somewhat plodding, the film has a certain wit, as when Babbitt dictates an ungrammatical letter to his secretary who reads it back to him as he listens with swelling pride. Kibbee's performance, the engine of the movie, occasionally tends to caricature, but overall his Babbitt—dense, gullible, and absurdly smug—rings real. While the film lacks the unrelenting bite and satiric raillery of Lewis's novel, it is a convincing portrayal of babbittry.

REFERENCES

Peary, Gerald and Roger Shatzkin, eds., *The Classic American Novel and the Movies* (Ungar, 1977); Schorer, Mark, *Sinclair Lewis: An American Life* (McGraw-Hill, 1961).

—L.C.C.

BABETTE'S FEAST (1950)

ISAK DINESEN (KAREN BLIXEN)

Babette's Feast (Babettes Gaestebud) (1987), Denmark, directed and adapted by Gabriel Axel; A.S. Panorama Film International/Nordisk/Danish Film Institute.

The Novel

This novella was first published in *Ladies' Home Journal* (June 1950) and later included in *Anecdotes of Destiny* (1958). A Danish translation (Dinesen wrote in English) was published separately in 1955 in Denmark and became a bestseller. The story exhibits two characteristics of Dinesen's narrative style: the presence of a storytelling narrative voice that has been compared to Scheherezade, and an ingenious plot that reflects a cosmic design. And it also reflects Dinesen's recurrent concern with the role of the artist.

In a small Norwegian village live two elderly ladies, daughters of the founder of a pious sect. In their youth, each had an encounter with potential worldly success: Martine with a young officer named Loewenhielm, who would go on to become a general and move in court circles; and Philippa with a Parisian opera singer named Achille Papin, who sees in her a diva who would conquer the operatic stage. Loewenhielm feels inadequate to the ascetic life of the sect and leaves in pursuit of pleasure and fame; Philippa renounces the world of fame promised by Papin. Years later, in 1871, Papin writes to the sisters, asking if they can take in a woman named Babette Hersant, whose husband and son have been shot as Communards; she herself has escaped arrest as a Pétroleuse. "Babette can cook," he adds. Babette becomes the sisters' servant, cooking their spartan meals and managing the household thriftily. The 100th birthday of the sisters' father arrives, and the sisters are worried about its celebration, since the sect has become quarrelsome and divisive. At this time, Babette wins 10,000 francs in the French lottery and offers to cook a celebratory dinner, with ingredients ordered from France. The sisters and members of the sect are skeptical of such indulgence and vow not to mention the food at all during the meal. General Loewenhielm happens to be visiting his old aunt, a sect member, and comes to the dinner with her.

There are 12 seated around a lavishly decorated table. The menu is elaborate. Loewenhielm cannot at first grasp that he is eating a meal exactly like those served at the Café Anglais in Paris, whose cook was celebrated. A transformation takes place. The general becomes "but a mouthpiece for a message which meant to be brought forth." He realizes God's grace—that choice makes no difference, because "that which we have chosen is given us, and that which we have refused is, also and at the same time, granted us." During the meal, "Time itself had emerged into eternity" and the diners "had been given one hour of the millennium." The quarrelsome celebrants leave holding hands and singing. Babette reveals to the sisters that she was cook at the Café Anglais, where a dinner often cost 10,000 francs, the amount that she spent on this one. She is drained of all energy. When the sisters reproach her for having spent all her money, she replies, "I am a great artist, Mesdames . . . A great artist, Mesdames, is never poor." Philippa embraces her, telling her that in Paradise she will be the great artist that God meant her to be: "Ah, how you will enchant the angels!"—words that repeat exactly those of Achille Papin in his letter, where he says he hopes to hear Philippa's voice again in Paradise, where "you will be the great artist that God meant that you to be. Ah! how you will enchant the angels."

Elements of Dinesen's ingenious plot fall into place with an almost audible click. Her world is one of cosmic design, in which fate is all-controlling. The story is like an

Stéphane Audran in Babette's Feast, *directed by Gabriel Axel* (1987, DENMARK; PANORAMA-NORDISK-DANISH FILM INSTITUTE/NATIONAL FILM INSTITUTE, LONDON)

intricate web that structurally embodies the meaning of the sisters' father's recurrent observation: "God's paths run across the sea and the snowy mountains, where man's eye sees no track."

The Film

Because Dinesen's fiction is intricately plotted (emphasizing its thematic concern with cosmic plotting, or fate) and deemphasizes psychological characterization, it lends itself readily to adaptation. Axel has followed Dinesen's structure, beginning in the present, flashing back to the sisters' youth, and then continuing with the lottery win and the dinner. He has a female voice narrate off and on, capturing the Scheherezade-like orality of Dinesen's narrative voice. Much of the dialogue is unchanged from the story, including the story—and the film's—final words. Two episodes in particular are expanded for their full aural/visual potential: the duet between Papin and Philippa, which makes audible the sublime music of Mozart while simultaneously making us see the sensuality, which will scare Philippa off; and the dinner preparation, which seems indeed a work of art.

Stanley Kauffman feels that the very quality of Dinesen's storytelling—the immediacy of the narrating voice—is the problematic obstacle to adaptation. Sound track narration, he says, is no replacement. "The original is a tale couched in the 'orality' of one speaker, through whom all the characters are given life. These people were not designed to be dramatically autonomous and, given autonomy, are not full—or dramatic." As a result, we watch the story as though "through a figurative glass window that only the storyteller herself could shatter." Yet most other reviews were highly positive. Ansen called it a "bountiful movie," which like the feast itself "can turn your heart." Schickel wrote that "in all of film there is no happier ending than this one: an artist achieving transcendence." Canby found Axel treating the Dinesen story "with self-effacing but informed modesty," with images and language "that reflect the writer's style—swift, clean, witty and elegant." *Babette's Feast* won the Academy Award as best foreign film for 1987.

REFERENCES

Ansen, David, *Newsweek* (March 14, 1988); Canby, Vincent, *The New York Times* (October 1, 1987), III, 22:5; Johannesson, Eric O., *The World of Isak Dinesen* (University of Washington, 1961); Kauffmann, Stanley, *The New Republic*, March 21, 1988; Schickel, Richard, "Dining Well is the Best Revenge," *Time*, March 7, 1988.

—U.W.

BARRY LYNDON (1844)

WILLIAM MAKEPEACE THACKERAY

Barry Lyndon (1975), Great Britain, directed and adapted by Stanley Kubrick; Warner Brothers.

The Novel

First published in serial form as "The Luck of Barry Lyndon: A Romance of the Last Century," *Barry Lyndon* was Thackeray's first novel. It parodies the memoir genre by juxtaposing the self-serving autobiography of Barry Lyndon with a bevy of critical comment, in the form of footnotes ridiculing Barry, a scathing critique of the Romantic novel, and a reflection on the memoirs after Barry's death by the fictional G.S. Fitz-Boodle. Through these comments, Thackeray constructs a critique of the Romantic novel, a rejoinder to the Romantic proclivity for hero worship.

Barry Lyndon's memoirs begin in his teenage years. Forced to leave his home of Ireland because of his part in a duel (fought over his cousin Nora, with whom Barry was foolishly in love), he enlists in the English army to fight in the Seven Years War. Barry deserts but is quickly captured by one of Frederick the Great's men. At the end of the war, Barry is forced to remain in Berlin as a spy for Frederick's military. But when he is instructed to spy on his own uncle, Barry joins forces with him instead. They flee Prussia together, with Barry learning his uncle's trade—high-stakes gambling. Upon meeting a rich widow Barry decides to return to Britain and settle down, using his new wife's money to establish himself as a lord. But Barry runs the Lyndon estate into the ground, terrorizing Lady Lyndon in the process. Lord Bullingdon, Lady Lyndon's son from her first marriage, helps his mother maneuver Barry out of the family. Barry lives out the rest of his life in debtor's prison.

The Film

Stanley Kubrick's 1975 movie adaptation of *Barry Lyndon* is a 20th-century adaptation of a 19th-century novel that parodies the life and fiction of the 18th century. Kubrick's film is resolutely modern, presenting Barry (Ryan O'Neal) as an alienated, postmodern subject. Whereas Thackeray's novel casts an ironic eye on the social values that emphasize the appearance of propriety over actual conduct, Kubrick's film is more interested in the Oedipal relations among the characters.

This shift is best exemplified by the different endings. Thackeray's novel ends with Barry's death in the Fleet Prison and the subsequent critique of Barry's character by Fitz-Boodle. Kubrick's film ends with an exquisitely staged duel between Barry and Lord Bullingdon; as a result of Bullingdon's cowardice, Barry loses a leg. Our last glimpse is of Barry the cripple, stumbling into a horse-drawn coach that is to take him out of Britain forever. The shot ends in a freeze-frame with Barry eternally frozen in time. The film's final scene is of Lord Bullingdon sitting in the Lyndon estate, having Lady Lyndon sign her name to bills. Bullingdon pauses over their monthly payment to Barry to keep him out of the country. The bill is dated 1789.

This final scene emphasizes two major thematic concerns. *Barry Lyndon* ends with a reference to the birth of

the modern era as represented by the French Revolution. Unlike Thackeray, whose novel ends in 1811, Kubrick sees the end of Barry's life as the onset of a particular alienation that plagues us to the present day. Secondly, the scene with Lady Lyndon and Lord Bullingdon virtually replays an earlier bill-paying scene with Barry and Lady Lyndon. Jealous of Barry from the start, Lord Bullingdon has finally achieved his psychological aim—his rightful place, the seat next to his mother.

Besides the ending, the other major adaptational shift occurs in Kubrick's use of the narrator. In Thackeray, Barry's first-person memoirs are periodically interrupted by critical footnotes from the manuscript's skeptical editors. The novel is a bitterly ironic comedy: It parodies Barry's foolishly romantic vision of himself. However, Kubrick's narrator is a dour commentator on Barry's life. While he begins with a somewhat wry tone, by the film's end, his commentary is sympathetic to Barry, treating him as a victim of his social order. Kubrick's narrator sees the story as a tragedy in which the hypocrisy of 18th-century moral values leads to Barry's fall.

This shift from comedy to tragedy in the two versions is indicated by the different usage of this famous passage: "It was in the reign of George II that the above-named personages lived and quarreled; good or bad, handsome or ugly, rich or poor, they are all equal now." In the novel, Barry begins his memoirs with this passage, writing as a bitter old man in Fleet Prison. Thackeray uses the passage to ironically present Barry's belief that he will eventually be vindicated for the "injustice" committed to him by the Lyndon family. On the other hand, the film ends with this passage as an intertitle epilogue. Backed by Handel's baroque "Sarabande," the film uses the written quotation as a somber reflection on mortality. What the novel used to ridicule Barry, the film uses to seal his tragic fate.

REFERENCES

Lewis, George H., "Culture, Kubrick, and *Barry Lyndon*," *Film in Society*, ed. Arthur Asa Berger (Transaction, 1980), 109–14; Nelson, Thomas Allen, "*Barry Lyndon*: A Time Odyssey," *Kubrick: Inside a Film Artist's Maze* (Indiana University Press, 1982), 165–96; Sinyard, Neil, "Adaptation as Criticism: *Barry Lyndon*," *Filming Literature: The Art of Screen Adaptation* (Croom Helm, 1986), 130–35; Stephenson, William, "The Perception of 'History' in Kubrick's *Barry Lyndon*," *Literature/Film Quarterly* 9:4 (1981): 251–60.

—*W.M.*

BEAU GESTE (1924)

PERCIVAL CHRISTOPHER WREN

Beau Geste (1926), U.S.A., directed by Herbert Brenon, adapted by Brenon and John Russell; Paramount.

Beau Sabreur (1928), U.S.A., directed by John Waters, adapted by Tom Geraghty; Paramount.

Beau Ideal (1931), U.S.A., directed by Herbert Brenon, adapted by Elizabeth Meehan and Paul Schofield; RKO.

Beau Hunks (1931), U.S.A. (aka "Beau Chumps" in U.K.), directed by James W. Horne; Roach/MGM.

Beau Geste (1939), U.S.A., directed by William A. Wellman, adapted by Robert Carson; Paramount.

Beau Geste (1966), U.S.A., directed and adapted by Douglas Heyes; Universal.

The Last Remake of Beau Geste (1977), U.S.A., directed by Marty Feldman, screenplay by Feldman and Chris Allen, story by Feldman and Sam Bobrick; Universal.

Beau Geste (1982), U.K., directed by Douglas Camfield, adapted by Alistair Bell; BBC.

The Novel

Author Percival Christopher Wren (1885–1941) was peculiarly appropriate as a writer of thrilling action stories. After graduating from Oxford, Wren worked as a "sailor, navvy, tramp, schoolmaster, journalist, farm laborer, hunter, [and] costermonger." He served with the British army in India and later joined (and deserted) the French Foreign Legion. In Africa, he distinguished himself as a fencing champion and upon the outbreak of World War I, joined the Indian army. Chronic malaria led to his retirement in 1917 and he devoted himself to writing from then on.

Wren was a Legionnaire only briefly, but he was to continue celebrating the Legion and its ideals of honor, bravery, and lust for death in novel after novel. Indeed, although Wren presumably experienced the hardship and cruelty of the Legion, he is almost exclusively responsible for its mysterious and romantic popular image.

Wren published his first work of fiction, *Dew and Mildew*, in 1912 and produced, on average, one book per year from then until his death. None had the impact of *Beau Geste*; published in 1924, it was an enormous hit both critically and commercially and its author was compared with Dumas and Kipling. The structure of *Beau Geste* consists of flashback-within-flashback, laced with mystery, romance and more than a dollop of coincidence. The novel begins on a train where Major Henri de Beaujolais relates a mysterious event at Fort Zinderneuf, in the Sahara. Heading a relief column for the beleaguered fort, de Beaujolais finds every soldier in Zinderneuf standing at his post—dead. He sends a bugler inside to check on things, but the man never emerges. Finally, de Beaujolais himself enters the fort. There, he finds one soldier lying down, his hands folded peacefully over his chest, while the fort's commanding officer has been murdered with a French bayonet. As de Beaujolais ponders these circumstances, Fort Zinderneuf bursts into flames.

The story then flashes back again about 15 years, to a lavish estate in England. Here we are introduced to Lady Patricia Brandon and her family of foundlings: a nephew, Augustus, a vaguely defined "cousin" Claudia and her

companion Isobel, and the three Geste brothers, twins Michael (known as "Beau") and Digby and their younger sibling, John.

When Major de Beaujolais visits their Aunt Patricia, all three Gestes decide that they will join the Foreign Legion when they grow up. This boyish fancy is nearly forgotten until several years later when the family's precious sapphire, the Blue Water, is stolen. Only Lady Brandon or one of the six children could possibly have taken the jewel. To shield the others, Beau admits the theft and runs away to the Foreign Legion. Unwilling to let Beau take the blame, Digby and John follow him.

There they encounter a villainous officer, Sgt. Lejaune, who hears about the stolen jewel and determines to get it for himself. The brothers are separated and Beau and John find themselves among the small band of soldiers at Fort Zinderneuf. Lejaune's cruelty leads the men to mutiny, but the Arabs attack at that moment. A brilliant tactician, Lejaune decides to make the Arabs believe that the Fort is manned by a large force. Each time a Legionnaire is killed, the sergeant props his corpse back into his place on the wall.

Beau is killed and when Lejaune begins rifling through his clothing, in search of the sapphire, John stabs him. Digby arrives with the relief column. He is the bugler who enters the fort, hides until de Beaujolais has left, then sets it afire, giving Beau the "Viking's Funeral" they had promised each other as boys.

John and Digby run off with two American friends, Hank and Buddy, and after many adventures in the desert, John returns alone to England with the solution to the mystery of the Blue Water.

The Films

The popularity of *Beau Geste* made a movie sale inevitable. In 1926, director Herbert Brenon marched 2,000 men into the desert outside Yuma, Arizona, kept them there for

Robert Preston, Ray Milland, and Gary Cooper in Beau Geste, *directed by William Wellman* (1939, U.S.A.; PARAMOUNT/ THEATRE COLLECTION, FREE LIBRARY OF PHILADELPHIA)

three months in "a womanless paradise" and emerged with one of the greatest, most profitable epics of the 1920s. *Beau Geste* starred Ronald Colman as Beau, Ralph Forbes and Neil Hamilton as his brothers, Noah Beery as the sadistic Lejaune, and William Powell as the treacherous toady Boldini.

In 1929, a mammoth London stage production of *Beau Geste* failed miserably, even though it starred young Laurence Olivier as Beau and utilized a cast of 120, five huge sets, several battle scenes, and an onstage fire.

Wren, in an understandable desire to keep the bank accounts on an upward trend, wrote two sequels, *Beau Sabreur* and *Beau Ideal.* Other than sharing the bad pun aspect of the original's title and several overlapping characters, the latter two-thirds of the trilogy had neither the narrative propulsion nor the audience appeal of *Beau Geste.* Nevertheless, movies were made of both. Gary Cooper starred in *Beau Sabreur* as Henri de Beaujolais (1928; this film is now lost), and Herbert Brenon brought back the sole surviving Geste, John, played by Ralph Forbes, for *Beau Ideal,* a talkie, in 1931. Loretta Young portrayed Isobel in this version, taking over the role from Mary Brian, who played Isobel in 1926.

Beau Geste inspired a legion of imitations and spoofs, the best of which is Laurel and Hardy's hilarious *Beau Hunks* (1931). In 1939, Paramount decided to get back to the source and remake the original, so maverick director William A. Wellman was hired to breathe life into what was, by then, an old chestnut.

Instructed to base the new *Beau Geste* shot-for-shot on the old, Wellman's company returned to the same Yuma sand dunes. As the three British brothers, Wellman cast Gary Cooper, Robert Preston, and Ray Milland. (Since Cooper starred in *Beau Sabreur* in 1928 his appearance in *Beau Geste* gave him the odd distinction of having been in the sequel to a film over a decade before starring in the original.) Despite the incongruity of Cooper and Preston talking more like ranch hands than cultured English gents, the 1939 *Beau Geste* is a real rouser, one of the best action films of all time. Wellman's bravura direction is immeasurably aided by the powerful musical score of the great Alfred Newman—an advantage Brenon didn't have in 1926.

Beau Geste was Americanized in 1966 with Doug McClure as John, Guy Stockwell as Beau, and Telly Savalas as the sergeant, called Dagineau here. Marty Feldman spoofed the genre in *The Last Remake of Beau Geste* (1977) with Michael York as Beau, Ann-Margret as Lady Patricia, and Peter Ustinov as the sergeant, now named Markov. (Markov is peg-legged in this version; so is his horse.) The title of Feldman's film was clever but erroneous. The BBC produced a four-hour mini-series in 1982, which starred Benedict Taylor as Beau, Jonathon Morris as John, and Anthony Calf as Digby. The most faithful adaptation of Wren's book, the BBC version is nevertheless a lackluster affair that cries out for the zest and style of Wellman or Brenon.

Because of the novel's awkward structure and multitude of characters, filmmakers have always had to streamline it considerably. In the 1926 version, neither Augustus nor Claudia appear. In 1939, the priggish Augustus shows up, but still no Claudia. In 1966, there are only two (American) brothers, Beau and John; Isobel is only a poorly painted portrait in a locket. Marty Feldman's spoof also has only two brothers, but this time they are Beau (Michael York) and Digby (Feldman); the joke is that the handsome York and the pop-eyed grotesque Feldman play twins. (Interestingly, this it the only film version that actually depicts the brothers as twins, as in the novel.) Not until the BBC version do we have the full complement of characters.

As noted earlier, the names of the sergeant and his henchman change from film to film. In the novel and Brenon's 1926 film, their names are Lejaune and Boldini. But in the spring of 1939, the Soviet Union signed a pact with Nazi Germany, so the villains became Russian: Markoff and Rasinoff. In subsequent versions, the names were changed more capriciously: Markoff becomes Dagineau in 1966, Markov in 1977, and back to Lejaune for the BBC mini-series.

But the main elements remain constant through all the versions of *Beau Geste*—the love of brother for brother; the mystery of the Blue Water (except in the more prosaic 1966 version in which the theft simply involves money); the harsh life in a desert outpost under siege from Arabs without and an evil officer within; the rousing action of battle; and the chilling tactic of soldiers who continue to defend their fort even after death. Few stories include so many compelling elements: drama, emotion, humor, mystery, excitement. Perhaps this—and the timeless, romantic allure of the French Foreign Legion—accounts for the enduring popularity of *Beau Geste*, novel and film.

REFERENCES

Bocca, Geoffrey, *Best Sellers* (Wyndham Books, 1981); Gallagher, John Andrew, *William Wellman: A Bio-Bibliography* (unpublished mss.); Richard, Jeffrey, "Legion of Honor," *Radio Times* (October 30–November 5, 1982), 4–5; Thompson, Frank, "La Légion Sans Cesse," *Southline* 2, no. 19 (June 18, 1986): 18–19, 29; Thompson, Frank, *Lost Films: Important Movies That Disappeared* (Citadel Press, 1996); Thompson, Frank, *William A. Wellman* (Scarecrow Press, 1983).

—*F.T.*

BELOVED (1987)

TONI MORRISON

Beloved (1998), U.S.A., directed by Jonathan Demme, adapted by Richard LaGravenese; Harpo Productions/Walt Disney Company.

The Novel

Nobel laureate Toni Morrison's Pulitzer Prize–winning novel about the tragic and violent legacy of slavery

is based on a number of documented incidents concerning runaway slaves. One such is the case of Margaret Garner. During the winter of 1856 two slaves, Margaret and her husband, Robert, escaped from a Kentucky plantation and sought refuge in Ohio. When the slave masters pursued and overcame them, Margaret declared that rather than return to slavery, she would kill herself and her four children. Before she was restrained, she succeeded in slitting the throat of her infant daughter. She declared to the local newspapers that "she had killed one and would like to kill the three others, rather than see them again reduced to slavery."

The story of *Beloved* opens in the Ohio farmhouse of Sethe, a former slave—a woman of "iron eyes and backbone to match." The year is 1873, and Sethe lives there alone with her teenage daughter, Denver. Well, not quite alone. Some sort of "outrageous behavior" is haunting the place, an invisible force described cryptically as "lonely and rebuked" that overturns tables and scatters the crockery. It is the ghost of Sethe's baby daughter, who died at age two, and like many of the supernatural events in the story, this presence is accepted matter-of-factly. Indeed, Sethe is determined to remain in the house with her other daughter, regardless: "I got a tree [scars of the slavemaster's whip] on my back and a haint in my house, and nothing in between but the daughter I am holding in my arms," she declares. "I will never run from another thing on this earth." Arriving at the house is Paul D—a man "with something blessed in his manner"—also a former slave and friend of Sethe's. He remains, against Denver's wishes, and takes up housekeeping with Sethe. During another ghostly disruption, Paul D admonishes the ghost and banishes it from the house. Soon after, another visitor arrives, a beautiful but strange young woman whose eyes are so "big and black that there seems to be no expression there at all." Her voice is a raspy growl, her words are barely articulate, and she seems weak from fatigue and hunger. She whispers ominously her name: "In the dark my name is Beloved." Time passes, and Denver nurses her assiduously. Sethe and Paul D find work in nearby Cincinnati, and life looks sweet. But startling revelations intrude upon the narrative, nightmarish intrusions of the past—Sethe's rape and torture at the hands of the slaveowners of Sweet Home, back in Kentucky; her desperate escape to Ohio and the birth of her daughter Denver; and, most horrendously, her own slaughter of another baby daughter lest she fall into the hand of the slavemasters who have come for her. In the present, the world of Paul D and Sethe is falling apart. Paul D is seduced by Beloved, and he leaves the home (by now, we know Beloved to be the ghost of Sethe's dead child, physically grown to 19 years, but retaining the mind of a baby). Sethe loses her job in the city. Beloved, Sethe, and Denver close out the rest of the world and stay inside the house. Determined to make amends for murdering her baby, Sethe takes care of Beloved. She spends all her money on decorations and trimmings for the house. But eventually the house falls into ruin and Beloved's strange

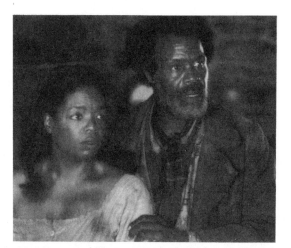

Danny Glover and Oprah Winfrey in Beloved, *directed by Jonathan Demme* (1998, U.S.A.; HARPO PRODUCTIONS; WALT DISNEY COMPANY)

behavior grows more violent as her belly swells up with Paul D's child. Sethe takes to her bed, broken and exhausted. Finally, Denver leaves the dying house and strikes out on her own to find work in Cincinnati. When her benefactors learn of Sethe's plight back at the farm, the women gather and go to visit her. They find Sethe on the porch with the naked body of a very pregnant Beloved. The spell is broken. Sethe runs from the house and Beloved disappears. At the end, Paul D returns to take care of Sethe. "Sethe," he says, "me and you, we got more yesterday than anybody. We need some kind of tomorrow."

Morrison tells the story as if it were Sethe's quilt, a product stitched together from memory and imagination, reality and myth, objective observation and subjective view. The survivors of slavery are like ghosts, frail and failing, while the spirits of the dead are very physical, robust, and threatening. As critic David Denby insightfully points out, Morrison teases us with the conflict between what is told and what is withheld. The story "must be worked over, worked through, and we, in turn, must struggle to put the overlapping fragments together in our heads." From its gradual accumulation of details emerges a ghost story that is a metaphor for a racist past that haunts the present.

The Film

Oprah Winfrey, whose portrayal of Sethe marked her return to the big screen after her Oscar-nominated role in *The Color Purple* (1985), was the presiding force who brought Morrison's novel to the screen. She optioned the movie rights immediately after its publication and, over a span of a decade, hired at least three writers to take on the challenges of adapting the densely textured story. First came Akosua Busia, a Ghana-born actress/author, then Richard LaGravenese (*The Bridges of Madison County*), and

finally Adam Brooks. Winfrey herself chose Jonathan Demme, whose last picture was the award-winning *Philadelphia* (1993), to helm the project over the protests of a few who felt a black director would be more suitable.

Demme called in a crack team of collaborators, including cinematographer Tak Fujimoto (*Philadelphia, Devil in a Blue Dress*), production designer Kristi Zea (*Silence of the Lambs, GoodFellas*), and composer Rachel Portman (*The Road to Wellville, The Joy Luck Club*). Exteriors of Sethe's Bluestone Road house were shot in Maryland locations 45 minutes south of Philadelphia. The results are both literal-minded and arty.

On the one hand, there is no doubting that it is an astonishingly faithful rendering of Morrison's text. Entire stretches of incident and dialogue in the book, particularly in the opening pages, were veritable blueprints for the screenplay. The shocking details of Sethe's victimization (including the suckling of her mother's milk by her captors), her crossing of the Ohio River with her newborn baby Denver, Paul D's exasperation at Beloved's spooky eccentricities, the secret of Denver's earrings, Denver's job-seeking in Cincinnati, and Baby Suggs' sermons ("Love your hands! Love them. Raise them up and kiss them. Touch others with them . . . This is flesh I'm talking about here. Flesh that needs to be loved. Feet that need to rest and to dance. . . .") are all here.

On the other hand, whereas Morrison was careful to plant enough clues to guide the attentive reader through the convoluted structure and the enigmatic, sometimes baffling prose ("What made [Beloved] think her fingernails could open locks the rain rained on?"), the filmmakers have unnecessarily complicated the story line with an overindulgent use of slow-motion effects, sudden flashbacks, a barrage of persistently recurring image motifs (a blaze of fire, slaves wearing crowns of iron, a body hanging from a tree), a succession of starkly contrasting mood changes, and numerous irritatingly contrived special effects. Superimposed images come and go, colors flow and change. The full-color palette in one scene changes to sepia in another and then to desaturated hues in still another. It's a dazzling visual display, but one that seems intent more on impressing viewers than moving them. Morrison's magical prose bound together all the disparate elements of her story; alas, there's no such consistency to the film's visual schema.

Another major problem is in the characterization of Beloved. Whereas Morrison created a feral, but relatively articulate person, into whose psyche the reader is occasionally permitted entry, the film presents a repulsive creature (portrayed in a bizarre performance by Thandie Newton) whose croaks and drools and screeches recall Linda Blair's demonic child in *The Exorcist*. Beloved first appears in the book as a slim form rising out of the river, but in the film she is first seen crookedly splayed against a tree trunk, her twisted body and face crawling with insects. What was unsettling in Morrison is simply monstrous here. Beloved seems more like an abstract oddity than a meaningful metaphor. A ghost story has been transformed into a horror show.

If ever a film was burdened under the strain of its own portentousness, it's *Beloved*. Even the music by composer Rachel Portman, dominated by an interminably moaning solo voice, is mired in its own sincerity. As for Winfrey, it was an unabashed labor of love, and she threw all the resources of her television programs and her international celebrity into its promotion. Yet, despite an intensive $30 million publicity campaign by the Disney Company, it played to small, mostly baffled audiences. Although some critics praised its ambition and craftsmanship, others demurred. Owen Gleiberman in *Entertainment Weekly* described the film as "an epic shackled by good intentions." David Denby cut deeper, noting its "excruciating sense of responsibility" made it something to be "endured," not enjoyed. As for Oprah's untiring promotion of the picture: "There's no gravy in attacking a woman who has done so much to promote reading, but one can ask—can't one?—whether some novels shouldn't be left in peace as mere books, unredeemed by the movies."

REFERENCES

Denby, David, "Haunted by the Past," *The New Yorker*, October 26 and November 2, 1998, 248–53; Gleiberman, Owen, "Ghost Bluster," *Entertainment Weekly*, October 23, 1998, 45–46; Lerner, Gerda, "The Case of Margaret Garner," in *Black Women in White America: A Documentary History*, ed. G. Lerner (Pantheon Books, 1972), 60–63; Morrison, Toni, "Unspeakable Things Unspoken: The Afro-American Presence in American Literature," *Michigan Quarterly Reviews*, 28, no. 1 (winter 1989), 1–34; Winfrey, Oprah, *Journey to Beloved* (Hyperion, 1998).

—*J.C.T. and J.M.W.*

BERLIN ALEXANDERPLATZ: THE STORY OF FRANZ BIBERKOPF (1929; English translation, 1961)

ALFRED DÖBLIN

Berlin Alexanderplatz (1930), Germany, directed by Phil Jutzi: adapted by Alfred Döblin and Hans Wilhelm; Südfilm.

Berlin Alexanderplatz (1980), West Germany, directed and adapted by Rainer Werner Fassbinder; 14-part film made for television and also theatrically released; Bavaria Atelier.

The Novel

Döblin's novel is set in the east Berlin working-class district around Alexanderplatz (where the author worked as a psychiatrist) and was written in 1929, during the tense last years of the inflation-ridden Weimar Republic. The protagonist, Franz Biberkopf, a former transport worker and pimp released from a four-year prison term for the fatal

beating of his girlfriend, doggedly tries to win a degree of financial security, naively trusting in the goodness of others and his own luck. His personal story is often overshadowed by a montage of documents and narratives depicting the heterogeneous life of the city, and the reader is further distanced by a variety of intrusive and ironic narrative techniques.

Biberkopf tries to support himself in a series of petty sales jobs. He shores up his wounded ego through affairs with a series of women, whom he often abuses. He is betrayed by several male friends in whom he has placed his trust. One of them, Reinhold, is a member of a gang of warehouse thieves who draw Franz unknowingly into their criminal activity. Reinhold pushes him from a getaway car into the path of a following automobile following a burglary, and Franz loses his right arm. Later Reinhold murders Franz's "one true love," Mieze. After that betrayal, Biberkopf is admitted to a psychiatric hospital, where he experiences terrifying nightmares. He eventually recovers and, severely chastened, takes a job as assistant doorman of a factory. He admits his error in thinking that he could survive completely on his own. However, he is skeptical of the mass movements that ominously threaten these latter days of the Weimar Republic.

The Films

Jutzi's 1930 adaptation maintains the novel's dual public-private emphases, interrupting the story of Franz Biberkopf several times with a "pictorial thicket" of documentary shots. The film simplifies the plot of the book, substantially reducing the number of women in Biberkopf's life and coming to a simple, optimistic conclusion, in which the one-armed Biberkopf returns to the Alexanderplatz to sell tumbler puppets. Beating on his chest, he tells onlookers that arms and legs don't matter so long as one has mettle in the right place.

The controversial and extraordinarily prolific postwar West German filmmaker Rainer Werner Fassbinder was fascinated by Döblin's novel long before he turned it into his magnum opus in 1980. Fassbinder claimed that the novel, particularly the relationship between Franz and Reinhold, had helped him as an adolescent to deal with his "tormenting fears" about his "homosexual longings." The influence of Döblin's novel can be seen in the male protagonists of many of Fassbinder's earlier films (often named Franz) whose trust in friends and intimates is painfully betrayed.

Fassbinder transformed Döblin's mostly ironic and stylistically experimental treatment of life in the modern metropolis into an emotionally charged melodrama, focusing intently on the subjective aspects of Franz's life, and drawing the viewer into a strong emotional involvement. This is accomplished through the compelling performance of Günter Lamprecht as Franz and through complex cinematic effects: expressionistic use of color and light, fluid camera work, and a subtle, multi-layered musical track.

Most of Döblin's characters are much more sympathetically developed in the film than in the novel. The outstanding female performance is Barbara Sukowa's interpretation of Mieze as an evanescent symbol of innocence and self-sacrificing loyalty.

Fassbinder's *Berlin Alexanderplatz* also makes use of Franz Biberkopf's private melodrama to explore substantial public themes. The novel's extensive documentation of life around the Alexanderplatz is briefly recapitulated through a fast-cut montage, which appears underneath the opening titles of each of the 14 parts of the film. The difficulties of surviving in depression-era Berlin are also documented in the accounts of Franz's frustrated efforts to find work and in his shoddy apartments. Several scenes—particularly one in which Franz attacks a former socialist comrade who objects to his Nazi armband—powerfully suggest how the despair and frustration of the lower bourgeoisie in the Weimar era fed the fires of the Third Reich.

Fassbinder's film concludes with a largely surrealistic epilogue, which the director titled "My Dream of Franz Biberkopf's Dream." In adapting the nightmares and hallucinations that Biberkopf experiences in novel's final chapter, the director let his imagination run riot, creating a lurid, surrealistic phantasmagoria, which, in the minds of many critics, detracts from an otherwise masterful work.

The initial screening on West German television caused a public outcry. Many viewers complained that the film was too dark to see on a television screen; but Fassbinder and cinematographer Xavier Schwarzenberger claimed that they were deliberately seeking to revive lighting effects of German expressionist films of the 1920s. There were also vicious attacks against the film's frank treatment of sex, and its irreverent use of Christian symbols in the epilogue. But Fassbinder's *Berlin Alexanderplatz* received international acclaim following its successful commercial release in American arthouses. In 1984 it was broadcast again on West German television and in 1992 was the centerpiece of a seven-week-long Fassbinder exhibition and retrospective in Berlin—on the Alexanderplatz.

REFERENCES

Dollenmayer, David, *The Berlin Novels of Alfred Döblin* (University of California Press, 1988); Kracauer, Siegfried, *From Caligari to Hitler: A Psychological History of the German Film* (Princeton University Press, 1947); Fassbinder, Rainer Werner, "The Cities of Humanity and the Human Soul: Some Unorganized Thoughts on Alfred Döblin's Novel, *Berlin Alexanderplatz*," *The Anarchy of the Imagination: Interviews, Essays, Notes*, ed. Michael Töteberg and Leo A. Lensing, tr. Krishna Winston (Johns Hopkins University Press, 1992), 160–67; Watson, Wallace S., *Understanding Rainer Werner Fassbinder: Film as Private and Public Art* (University of South Carolina Press, 1996).

—W.S.W.

EL BESO DE LA MUJER ARAÑA (1976)

See KISS OF THE SPIDER WOMAN.

LA BÊTE HUMAINE (1890)

EMILE ZOLA

La Bête humaine (1938), France, directed and adapted by
 Jean Renoir; Paris Films.
Human Desire (1954), U.S.A., directed by Fritz Lang,
 adapted by Alfred Hayes; Columbia.

The Novel

La Bête humaine (The Human Beast) is the 17th novel in
Zola's 20-volume series, *Les Rougon-Macquart*. A naturalist,
Zola subtitled the series "a natural and social history of a
family under the Second Empire." In this cycle of novels,
Zola tracks the relationships between one family and the
corrupt social system in which they live. *La Bête humaine*
concerns Jacques Lantier, a descendant of Gervaise Mac-
quart and August Lantier, characters in Zola's more
famous *L'Assommoir*. August Lantier was an alcoholic, and
his affliction, passed through the generations and surfacing
in various manifestations, is the impetus for the plots of
the Rougon-Macquart novels.

Train engineer Jacques Lantier inherits August
Lantier's moral corruption: Every time he is aroused sexu-
ally, he desires to kill the woman to whom he is attracted.
La Bête humaine brings Lantier into close proximity with
Severine, a young woman who was raped at an early age by
a corrupt aristocrat, President Grandmorin. Years later,
Severine's husband, Roubaud, finds out about his being
married to "an old man's leavings." Roubaud forces Sever-
ine to assist him in murdering Grandmorin on a train to
Paris. Also on the train, Lantier witnesses the murder, but
befriends Severine and refuses to betray her to the police.
Lantier and Severine fall in love and carry on a steamy
affair, while Roubaud wallows in guilt, gambling, and
drinking. Severine tries to convince Lantier to kill
Roubaud so that they will be free to marry, but Lantier
backs away at the last minute. In a fit of desire, Lantier
instead kills Severine due to his hereditary affliction.

The Films

Jean Renoir's 1938 film version of *La Bête humaine* is
deeply reverential to its source. The film begins with a
famous passage from the novel documenting Lantier's
atavistic moral corruption: "He knew of his hereditary fail-
ing, and though he was paying for the others . . . his
drunken forebears . . . the generations of drunkards . . . His
mind broke under the effort . . . of being compelled to act
against his wishes . . . and for no cause within himself."
Afterwards, a portrait of Zola emerges out of the cloudy
background and an invisible hand signs the name of Emile
Zola. Renoir's film operates under the sign of French High
Culture, seemingly sanctioned by Zola himself.

While Renoir's film retains the plot of the novel, and is
faithful to its spirit, it does make two major cuts. The novel
features long passages describing the corruption of the
Second Empire's legal system. The police cover up a scan-
dal against the government by arresting an innocent man
for the murder of President Grandmorin. Because Grand-
morin's murder was the result of his sexual assault on Sev-
erine, the police refuse to arrest Roubaud, even though
they possess evidence against him. Zola critiques the way
the self-preservation of the Second Empire's government
takes precedence over justice. Having made the film within
the (albeit last) days of the Popular Front government (a
once promising leftist coalition elected in 1936), Renoir
does not include this devastating political critique.

Zola's novel also includes a subplot featuring Aunt
Phasie who is married to a cruel man, Misard. Aunt
Phasie possesses a sum of money that she has hidden from
Misard. Misard is slowly poisoning her so that she will
reveal to him where she has hidden the money. Phasie dies
and Misard spends the rest of the novel in an absurd quest
to find the money, endlessly digging up his property. Zola
uses this subplot to reveal the intense effect on individu-
als of the systemic social corruption of the Second
Empire. Maintaining the last gasps of the Popular Front,
Renoir does not engage in such a critique.

Emile Zola

Human Desire, Fritz Lang's 1954 American film version of *La Bête humaine*, has been consistently denigrated since its release. However, like Lang's *The Big Heat* (1953), the film is an effective generic hybrid of the film noir and woman's film genres. But unlike Renoir, the film is not concerned with paying homage to Zola. Lang's film barely acknowledges Zola's existence, changing the title and all of the characters' names. Only one small credit tells us that *Human Desire* is "based on a novel by Emile Zola."

Despite playing fast and loose with both the Zola and Renoir versions of the story, *Human Desire* usefully recontextualizes the plot within cold war American culture. The contiguity between the three versions can best be seen by the sensibilities of their endings. Each narrative activates a reaction to the process that Zola critic Philip D. Walker labels "world destruction and renewal."

Zola's novel ends with the imminent downfall of the Second Empire. After killing Severine, Lantier begins an affair with the wife of his fireman, Pecqueux. While driving a train carrying soldiers to the front of the Franco-Prussian War of 1870, Lantier and Pecqueux fight. The two men drag each other off the speeding train and get mutilated under the wheels. The novel ends with the soldiers singing patriotic songs, unaware of their impending doom (on the train or in the war). Zola uses this absurdist ending to signal the death of the Second Empire.

Renoir's film alters this ending significantly. In the film, Lantier does not have an affair with Pecqueux's wife. In keeping with the sensibilities of the Popular Front, Lantier and Pecqueux are brothers to the end. Distraught at having killed Severine due to his illness, Lantier attempts to commit suicide by jumping off the train. Pecqueux desperately tries to save Lantier's life. When he cannot, Pecqueux stops the train, and holds the dying Lantier in his arms. Renoir provides an elegy to the demise of the Popular Front's promise to establish a kinder, more communitarian society.

Lang's film alters this ending even further, but still keeps the sensibility of "world destruction and renewal" in play. At the end of *Human Desire*, Jeff Warren realizes that Vicki (the Severine character) is nothing but trouble and breaks off his affair with her. In this version, Jeff is not affected by a hereditary disease; instead, his distress is created by the trauma of having served in the Korean War. After casting Vicki aside, Jeff is framed between the words "central" and "national" written on his train engine. In keeping with the sexist cold war American discourses vilifying women as dangerous to the national security, the film argues that only with a strong patriarchal morality can the nation survive. Having rid himself of the evil femme fatale, Jeff does not die; he instead drives his train through the now-secure American heartland.

REFERENCES

Andrew, Dudley, "Jean Renoir: Adaptation, Institution, Auteur," in *Mists of Regret: Culture and Sensibility in Classic French Film* (Princeton University Press, 1995), 275–317; Braudy, Leo, "Zola on Film: The Ambiguities of Naturalism," in *Native Informant: Essays on Film, Fiction, and Popular Culture* (Oxford University Press, 1991), 95–106; Eisner, Lotte, "Human Desire," in *Fritz Lang* (Oxford University Press, 1977) 338–43; Walker, Philip D., "Zola: Poet of an Age of World Destruction and Renewal," in *Critical Essays on Emile Zola*, ed. David Baguley (G.K. Hall, 1986), 172–85.

—*W.M.*

BIIOS KAI POLITEIA TOU ALEXI ZORBA (1946)

See ZORBA THE GREEK.

THE BIG SLEEP (1939)

RAYMOND CHANDLER

The Big Sleep (1946), U.S.A., directed by Howard Hawks, adapted by William Faulkner, Leigh Brackett, and Jules Furthman; Warner Bros.

The Big Sleep (1978), U.K., directed and adapted by Michael Winner; Winkast.

The Novel

Raymond Chandler wrote his first novel, *The Big Sleep*, in just three months in 1939. He claims he "cannibalized" two of his previously published stories in *Black Mask* magazine—for which he had been writing since 1933—the blackmail plot from "Killer in the Rain" and the disappearance plot from "The Curtain." (He would employ this same writing strategy for two later novels, *Farewell, My Lovely* and *The Lady in the Lake*.) The principal character, private detective Philip Marlowe, evolved from a number of stories in which he was referred to as, variously, Carmody, Dalmas, Malvern, and Mallory. Of the novel's notorious complexity, commentator Stephen Pendo notes that it is "a confused tangle that demonstrates Chandler's problem of producing a cohesive story line."

Admittedly, it is a loosely plotted and crowded narrative. But, contrary to received opinion, it can be comprehended. As Roger Shatzkin says in his valuable study of the subject, it is a text about confusion; impenetrability is at its core. The issue becomes, Shatzkin wittily observes, not who killed whom, but who cares who killed whom. It is a tale of process rather than of facile solutions to a puzzle. Philip Marlowe, the detective/narrator, is hired by the elderly, infirm General Sternwood to investigate some gambling debts incurred by his younger daughter, Carmen—debts that in turn may become the basis for blackmail. Meanwhile, the general's son-in-law, "Rusty" Regan, is missing, and his older daughter, Regan's wife Vivian, suspects that Marlowe has been engaged to find him. Carmen's ostensible blackmailer, Arthur Geiger, runs a pornographic lending library. He is murdered at his home in the presence of a stupefied Carmen, whom he has already

provided with drugs and photographed nude for future extortion schemes. Marlowe rescues Carmen, entering Geiger's place after hearing shots and observing two men leaving in quick succession. The first man turns out to be Carmen's ex-boyfriend Taylor, who drives off to his mysterious death. Attention now shifts to the second man out of the house, Joe Brody, who, like Taylor, is also an ex-boyfriend of Carmen's. After obtaining the negatives of Carmen, he blackmails her. Marlowe goes to Brody's apartment to recover the negatives and pictures, disarming Brody and then Carmen, who has come to retrieve the blackmail materials herself. After Carmen leaves, Carol Lundgren, Geiger's valet and lover, shoots Brody, mistakenly thinking that Brody has killed Geiger.

At the gambling hall of Eddie Mars, Marlowe sees Vivian win a considerable amount of money. He saves her from being robbed in the parking lot but, fearing a setup, refuses to sleep with her. When he gets back home, a naked Carmen is in his bed, and he orders her to leave. Some time later, to Marlowe's office comes one Harry Jones, who offers to tell him the whereabouts of Mars's

wife, Mona. But before Harry can divulge his information, he is poisoned. Marlowe learns through another source that Mona is at a farmhouse outside town. He tracks her down, but is knocked out. Later, at the Sternwood house, after Marlowe returns Carmen's gun, she tries to shoot him. He realizes that this must have been what happened to Regan. Vivian then reveals that Carmen killed Regan, and that Mars's wife was part of the plot to keep the murder from being uncovered. Carmen must be sent away.

Mind-boggling as it all is, Shatzkin urges that the reader not get derailed by the demonic details: "The novel functions as an entertainment, a sometimes self-satiric, self-contained world of double-cross, moral and political corruption in which our confusion as readers helps engender our involvement and our identification with the hero, Philip Marlowe."

The Films

Howard Hawks's 1946 film was made as a followup to his previously successful Bogart/Bacall vehicle, *To Have and*

Lauren Bacall and Humphrey Bogart in The Big Sleep, *directed by Howard Hawks* (1946, U.S.A.; WARNER/MUSEUM OF MODERN ART FILM STILLS ARCHIVE)

Have Not (1944). According to Hawks, the screenplay was completed in eight days, with Chandler acting only in an unofficial capacity, since he was already under contract to Paramount. After its pre-release to the Armed Services in the summer of 1945, Hawks acceded to a request from Warner Bros. and added more scenes featuring Bogart and Bacall (including the famous "horse race" dialogue). The initial script largely follows the plot with several important exceptions: The explicit allusions to drug use, Carmen's nymphomania, the homosexual relationship between Lundgren and Geiger, and Geiger's pornography racket are removed. These deletions seem to have been the result of Faulkner and Brackett's attempts to head off the Production Code censors. And whereas in the novel's conclusion Carmen was set free to be "cured," in the movie she is punished as per the requisites of the aforesaid Production Code. The final script, with more changes and deletions by another scenarist, Jules Furthman, emerges as a confusing affair. It has become the stuff of legend that not only Hawks and the scenarists, but also Chandler himself couldn't figure it out! As Leigh Brackett wryly observed: "Audiences came away feeling that they had seen the hell and all of a film even if they didn't rightly know what it was all about. Again, who cared? It was grand fun, with sex and danger and a lot of laughs."

While the film is often categorized as one of the great films noir of the 1940s, commentator Michael Walker notes that it is atypical in its lack of flashback, voiceover narrative, and expressionist visual style.

Because Michael Winner's 1978 version starring Robert Mitchum as Marlowe was freed of the censorship restrictions that dogged Hawks' film, the script was more faithful to the original, even though it was updated to the 1970s and set in London. Historian Gerald Mast describes it as the "original making of Chandler's [narrative]." But critic Richard Schickel says it is aesthetically unsatisfactory: "What matters is being faithful to Chandler's singular vision, and that requires acts of cinematic imagination that are beyond the reach of the crude craftsman whose biggest previous success was *Death Wish*."

REFERENCES

Pendo, Stephen, *Raymond Chandler on Screen: His Novels into Film* (Scarecrow Press, 1976); Mast, Gerald, *Howard Hawks: Storyteller* (Oxford, 1982); Shatzkin, Roger, "Who Cares Who Killed Owen Taylor?" in *The Modern American Novel and the Movies*, eds. Gerald Peary and Roger Shatzkin (Ungar, 1978).

—*K.R.H. and J.C.T.*

BILLY BUDD, FORETOPMAN (1891)

HERMAN MELVILLE

Billy Budd (1962), U.S.A./U.K., directed by Peter Ustinov, adapted by Ustinov and De Witt Bodeen from the play by Louis O. Coxe and Robert Chapman; Allied Artists.

The Novel

Herman Melville's last work was begun in 1886 and went through several revisions before the author's death five years later. It was not until 1924 that the manuscript was discovered in an attic trunk and published at the behest of the author's granddaughter. The final, "authoritative" version, the Hayford-Sealts text, appeared in 1962. Among the changes in the latter version was the alteration of the name of the ship aboard which the action occurs, from *Indomitable* to *Bellipotent*. The name change reinforces Melville's emphasis upon the novel's theme of the effects of war on the individual.

Set aboard the HMS *Bellipotent* during the Napoleonic Wars, the story begins with Billy's impressment from the merchant ship *Rights of Man*. He offers no resistance but determines to conduct himself as the ideal sailor. However, the ship's master-at-arms, John Claggart, takes an immediate dislike to him and wrongfully accuses him of plotting mutiny against Captain Vere. Coming face to face with his accuser, Billy can only stutter, striking out with a single blow that kills Claggart. Vere imprisons Billy and sees him hanged after a court-martial conviction. Soon afterward, during a battle with a French ship, *Athée*, Vere is mortally wounded. Although a subsequent Royal Navy chronicle paints Billy as a mutinous, knife-wielding killer, Billy's mates revere his memory, regarding chips of the spar from which he had hung as if they were fragments of the True Cross.

Beyond the obvious theme of the individual's sacrifice at the hands of an impersonal, authoritarian state, Melville's symbolism is clear: Claggart is the spirit of evil, the foe of innocence, a Judas-like betrayer. Vere is the intermediary between spiritual ideals and cruel pragmatism (a figure doubtless drawn from Melville himself). Billy is both a Christ figure and a representation of innocent, or Adamic, man. Hints of a divine paternity are many, including the moment when an officer asks, "Who is your father?" and Billy answers, "God knows, sir"; and is further reinforced when, during the confrontation with Claggart, Billy's face is described as having "an expression which was as a crucifixion to behold." Even in the verses which close the novel there is a reference to the Last Supper: "They'll give me a nibble—bit o' biscuit ere I go./ Sure a messmate will reach me the last parting cup."

The Film

A dramatization by Louis O. Coxe and Robert H. Chapman (*Uniform of Flesh*, 1949) served as the basis for Peter Ustinov's Allied Artists film. Screenwriter DeWitt Bodeen had already written several script versions for Robert Rosson before Ustinov took over the project and added

changes of his own. The film was made in England with exteriors filmed off the coast of Spain.

Ustinov himself portrays Vere, captain of the HMS *Avenger*, a paternal contrast to Robert Ryan's sinister cruelty. The basic story line is padded by several incidents, including a fight involving Billy (Terence Stamp) and the death of a sailor as the result of Claggart's (Robert Ryan) bullying. The battle with the *Athee*, instead of transpiring months after the hanging, breaks out immediately, providing a rousing finale to the film. The *Avenger* is destroyed and, in the concluding shot, floats away on the troubled sea.

A more significant alteration occurs as a result of the film's depiction of the personality conflicts driving the Claggart/Budd antagonism. This deemphasizes the novel's biblical allusions while it enhances the sense of a generation gap between age and youth, between authority and individuality—an element bound to appeal to youthful viewers on the threshold of the Vietnam era. Indeed, according to Robert Nadeau, the picture was enthusiastically received by college-age youths of the day: "Vere, willing . . . to sacrifice youth and innocence to preserve a corrupt world order, conjured up associations of . . . authority figures who spoke against civil disobedience and for American military intervention abroad."

Although Ustinov's performance failed to capture the tortured ambivalence of Melville's original, Stamp's performance as the blond, beautiful Billy earned him an Academy Award nomination.

REFERENCES

Crowther, Bosley, "The Screen: 'Billy Budd,'" *New York Times*, October 31, 1962, 32; Nadeau, Robert L., "Melville's Sailor in the Sixties," in *The Classic American Novel and the Movies*, eds. Gerald Peary and Roger Shatzkin (Ungar, 1977), 124–31.

—*J.A.A.*

THE BLUE ANGEL (*Professor Unrat*) (1905)

HEINRICH MANN

The Blue Angel (1930), Germany, directed and adapted by Josef von Sternberg; UFA/Paramount.
The Blue Angel (1959), U.S.A., directed by Edward Dmytryk, adapted by Nigel Balchin; 20th Century-Fox.

The Novel

The Blue Angel, a landmark novel whose title in German is actually *Professor Unrat* (Professor Trash), was written by the older brother of Thomas Mann. Heinrich's early criticism of German life under the Wilhelmine Empire (1871–1914) appears in novels like *In the Land of Cockaigne* (1900) and *The Goddesses* (1903). Heinrich Mann was also an early Nietzchean and had more than a passing interest in the then-fashionable vogue of literary decadence. His stunning portrait of Lola Fröhlich as a sexual trap for Professor Rath in *Angel* is thematically an inheritance of this "decadence," but Heinrich sets his novel within the wider, ultimately more enduring context of social and political criticism. Rath's late-blooming sexuality is portrayed as part and parcel of the Prussian school system that is base, dishonest, and abusive of its ideals.

Professor Rath, a teacher at the local *Gymnasium*, is a symbol of propriety and academic rectitude, and a tyrant in the eyes of his students. In the 17 chapters of Mann's book, six are devoted to setting up Rath as a victim of his false morality and the hypocrisy of the German teaching establishment. Under the pretext of following his charges into the nightlife of the Blue Angel cabaret where Lola performs, Rath meets and is seduced by her. The professor makes plans to free Lola from her sordid life at the cabaret.

The next six chapters detail Rath's comical and pathetic seduction by Lola and his subsequent failure to "elevate" his lover. Rath is fired from his position at the *Gymnasium* and turns from pedagogue to social anarchist. There is soon a conflict between Rath and the rest of the town, in which he and Lola open a gambling house. Ultimately, Rath is arrested and his relationship with Lola ends.

The Films

Sternberg decided to focus primarily on the effect of sexuality on the professor (Emil Jannings)—the influence of eros rather than politics. His choice of Marlene Dietrich to portray Lola is the stuff of movie legend, and their artistic bond would lead to seven feature films. Dietrich emerged as the essence of feminine glamour and exoticism, but the ambiguity of her screen persona began originally under Sternberg's canny manipulation of the character of Lola, a wily cabaret singer with the potential to ruin Rath who—in the changed ending of the film adaptation—not only loses his position as a teacher but also is effectively portrayed as a victim of masculine humiliation.

Sternberg's scenario follows the first half of the novel closely, revealing Rath's character as a result of background and social context. Gradually, through the use of stylized settings, mood, and lighting, the realism gives way, symbolizing the destructive influence of sexual passion. Rath dies, and Fröhlich is the survivor in the eternal struggle between the sexes.

The 1959 remake of *The Blue Angel* featured Curt Jurgens in Jannings's role and May Britt as Lola. This version of Sternberg's adaptation deserves the artistic oblivion that it shares with other remakes of classic films. The most notable change in the film scenario was the astounding decision on the part of Edward Dmytryk to give his film a "happy ending." Rath abandons Lola to her cheap devices, a conclusion that is contrary to both Mann's political study and Sternberg's portrait of sexual passion. Clearly Dmytryk and the Fox studio failed to understand the essence of their source material.

Marlene Dietrich (center) in The Blue Angel, *directed by Josef von Sternberg* (1930, GERMANY; UFA/NATIONAL FILM ARCHIVE, LONDON)

REFERENCES

Linn, Rolf N., *Heinrich Mann* (Twayne Publishers, 1967); Weinberg, Herman G., *Joseph von Sternberg* (Arno Press, 1978; reprint).

—R.A.F.

THE BODY SNATCHER (1884)

ROBERT LOUIS STEVENSON

The Body Snatcher (1945), U.S.A., directed by Robert Wise, adapted by Philip MacDonald and Carlos Keith (Val Lewton); RKO.

Flesh and the Fiends (1960), U.K., directed and adapted by John Gilling; Valiant/Hammer.

The Novel

Stevenson originally drafted the story in the summer of 1881 but he laid it aside "in a justifiable disgust, the tale being horrid." On its eventual publication as a Christmas story in an 1884 issue of the *Pall Mall Gazette*, police confiscated the lurid advertising posters carried by sandwich men. Stevenson had such a poor opinion of the story that he refused to accept the magazine's full payment. His work is based on real-life incidents in the Edinburgh of 1829. Two grave robbers, Burke and Hare, supplied a Dr. Knox with suspiciously fresh corpses. They murdered 18 people. On their arrest, Hare testified against Burke, leading to his partner's hanging. Although released, Hare suffered physical harassment from an Edinburgh mob while Dr. Knox moved to London to continue a prestigious anatomy career for another three decades.

The story begins on a dark night in Debenham, England. Four men sit in the parlor of an inn. Among them is Fettes, an old drunken Scotsman known for his disreputable habits. A doctor arrives to tend a patient suffering from a stroke. When Fettes hears the name Dr. McFarlane, he awakens from his stupor and confronts his former friend. The embarrassed McFarlane attempts to avoid

Fettes who clutches him and whispers "Have you seen it again?"

After McFarlane flees in terror, Fettes tells others his past history. He and McFarlane were once young medical students in Edinburgh who assisted a "Mr. K—" in anatomy experiments. Recognized for his abilities, Fettes purchases bodies delivered by two notorious unnamed men. Both he and McFarlane ask no questions despite the freshness of the bodies. One is Jane Galbraith whom Fettes encountered the previous day. Fettes is later invited to a tavern dominated by a coarse man named Gray who has power over McFarlane. After they all leave, Fettes is awakened the next morning by McFarlane who carries Gray's dead body. They make arrangements for the corpse's dissection and continue on their body-snatching career. One evening they travel out into the country to disinter the body of a 60-year-old countrywoman. Carrying the body to their carriage they begin their journey back to Edinburgh but feel something has happened. Holding the lamp to the body, they retreat in fright when they discover "the body of the dead and long-dissected Gray."

The Films

RKO producer Val Lewton reworked Philip MacDonald's script to expand Stevenson's story into a feature-length film. He created new characters such as Meg, Mrs. Marsh, Georgina, and Josef, and changed the relationship of Fettes and McFarlane into younger disciple and older mentor. Gray's character expanded to suit Boris Karloff's star status; he is now cabman by day and grave robber by night. Henry Daniell, known for villainous roles in *The Sea Hawk* and *Jane Eyre*, portrayed the older Dr. McFarlane. Edith Atwater became McFarlane's secret wife Meg, while Rita Corday and Sharyn Moffat were added to the script as Mrs. Marsh and her crippled daughter, Georgina.

The story is set in 1831, two years after the trial of Burke and Hare, referred to in the script along with Dr. Knox's successful career in London. McFarlane becomes an accomplice of Knox who escaped justice since he used Meg's savings to bribe Gray into silence during the trial. Gray uses his hold over McFarlane to exercise sadistic pleasure over an "upper class" master who formerly used and abused him. McFarlane lacked the courage to face judgment. He seeks refuge in alcohol and a lower-class wife he can never acknowledge publicly.

Stevenson's story becomes condensed into the climactic 20 minutes of the RKO film. The adaptation by MacDonald and Lewton enlarges the original story. McFarlane's initial cowardice during 1829 also appears in a lack of confidence in his own abilities. Dr. Knox's unseen figure dominates him since McFarlane knows he can never eclipse his master's reputation. He takes compensation by dominating pliable students rather than performing operations. Like Captain Stone in Lewton's *The Ghost Ship* he is reluctant to perform an operation, fearing the revelation of his insecurity. Ironically, when he later sells the deceased Gray's horse, a working-class horse trader gets the better of him and a serving wench (another parallel to Meg) suggests the deceived McFarlane deserves a drink by way of compensation.

Fettes is far more of an innocent in the film. Intending to leave the medical profession due to lack of money, he is persuaded to remain when McFarlane offers him a teaching assistantship. He is more of a reluctant participant in the events than Stevenson's original character. When he and McFarlane disinter the corpse in the concluding scenes and discover Gray in its place, McFarlane dies of a broken neck when the carriage later overturns. Fettes is left alive to discover the old woman's body next to McFarlane. He walks away up to the highway while a quote from Hippocrates fills the screen. "It is through error that man tries and rises. It is through tragedy he learns. All the roads of learning begin in darkness and go out into the light." Lewton uses this classical quotation to suggest a Hollywood happy ending, at least for Fettes, who will presumably join Mrs. Marsh and her daughter. Hammer Studios used the Burke and Hare story for *The Flesh and the Fiends* in 1959, but the best version of Stevenson's original appeared on independent British television on May 2, 1966, directed by Toby Robertson, with Ian Holm in the role of the forever haunted student "Toddy" McFarlane.

REFERENCES

Bansak, Edmund G., *Fearing the Dark: The Val Lewton Career* (McFarland, 1995).

—T.W.

THE BODY SNATCHERS (1955)

JACK FINNEY

Invasion of the Body Snatchers (1956), U.S.A., directed by Don Siegel, adapted by Daniel Mainwaring and Sam Peckinpah (uncredited); Allied Artists.

Invasion of the Body Snatchers (1978), U.S.A., directed by Philip Kaufman, adapted by W.D. Richter; United Artists.

The Body Snatchers (1993), U.S.A., directed by Abel Ferrara, adapted by Raymond Cistheri, Larry Cohen, Stuart Gordon; Warner Bros.

The Novel

It began humbly enough. First a short version in *Collier's* magazine in 1954; then, a year later, an expanded Dell paperback original. "I simply felt in the mood to write something about a strange event or a series of them in a small town," recalled Jack Finney. At the time Finney (whose real name was Walter Braden Finney) was an unknown 35-year-old advertising writer dabbling in fantasy fiction. Largely thanks to the popular adaptation made by filmmaker Don Siegel a year later, Finney's modest little

tale quickly came to be regarded as a modern classic. Only Ray Bradbury's *Fahrenheit 451* and Arthur Miller's play *The Crucible*, both written the year before, rival it as essential literary expressions of cold war paranoia.

In the tiny town of Santa Mira, California (a 1976 edition relocated the action to Mill Valley), Dr. Miles Bennell is letting out his last patient of the day when his friend, Becky Driscoll, casually tells him her cousin Wilma has somehow gotten the idea that her Uncle Ira isn't her uncle anymore. Indeed, there's something *strange* about Uncle Ira. A little later, Becky is unsure about her own father. Similar reports about other townspeople come in. Psychiatrist Mannie Kaufman rationalizes it all away as a case of low-key mass hysteria. But what about the oddly unformed body of a naked man that's found on the pool table of Miles' friend, Jack Belicec? And another podlike form found in a cupboard in Becky's basement? Eventually Miles learns these seed pods are alien life-forms that have drifted through space and accidentally landed on planet Earth. "[They] are now performing their simple and natural function," explains one of "them . . . which is to survive on this planet. And they do so by exercising their evolved ability to adapt and take over and duplicate cell for cell, the life this planet is suited for." From Santa Mira trucks will take more pods to surrounding areas, then to other cities, across the country, to other continents and beyond. Soon the earth will be populated by pod people, entities lacking emotion, beings bereft of the hungers of passion, hate, and love. And in a matter of a few years those life-forms will turn to dust, leaving the planet as bare and lifeless as those that have come before. And the spores will move on again, back out into space . . .

Miles and Becky escape their captors and flee out of the valley, destroying pods as they go. Suddenly, to their amazed relief, the sky is filled with pods detaching themselves from their stems and drifting back into the void from which they came. Resistance on the planet has apparently proven to be too much and the pods are, in effect, giving up and moving on: "And so now, to *survive*—their one purpose and function—the great pods lifted and rose," says Miles, "climbing up through the faint mist, on and out toward the space they had come from, leaving a fiercely implacable planet behind . . ." Soon, Santa Mira is back to normal. Or is it?

In his study of the horror tale, *Danse Macabre*, Stephen King declares *The Body Snatchers* set the mold for the modern horror novel. Its method was to strike first one "off-key note," quietly followed by another, then another: "Finally the jagged, discordant music of horror overwhelms the melody entirely. But Finney understands that there is no horror without beauty; no discord without a prior sense of melody; no nasty without nice."

The Films

Few movie adaptations of a novel have been more faithful to the original than Don Siegel's classic 1956 *Invasion of the Body Snatchers*. For three-fourths of its length, it's virtually an exact duplicate—dare I say, a "pod"?—of the characters, situations, and dialogue. Upon returning from a vacation, Dr. Bennell (Kevin McCarthy), hears reports about strange behavior throughout the little town of Santa Mira, California: People are complaining that their friends and relatives are behaving strangely, that they "are not themselves." But when Bennell stumbles upon direct evidence that alien seed pods are sprouting duplicate human forms to replace their originals, he and his girlfriend, Becky (Dana Wynter), flee toward Los Angeles to spread the alarm. It is at this point that the movie radically departs from the novel. The fugitives take heart when they hear the strains of a beautiful song coming from beyond the next hill. To their disappointment and horror they discover the source of the music is a truck radio, a truck being loaded with more pods. When Becky herself falls victim, Miles alone stumbles on, eventually reaching a busy highway. Wildly shouting for help, he is arrested as a drunk and taken to a police station. But when a report comes in about an accident involving a truck loaded down with strange seed pods, his story is confirmed and the police prepare to act. (Siegel's original conception was to end the film with Dr. Bennell pointing to the camera and yelling, "You're next!") Many viewers and commentators agree that this slam-bang finish is preferable to Finney's gentle, anticlimactic bit of deus ex machina.

The 1978 Philip Kaufman adaptation is a kind of sequel, taking up the story from the point where Kevin McCarthy lurches down a highway, warning of an invasion. The pod plague is now spreading to the big city, San Francisco. The decision to switch locations is interesting: On the one hand, in the Siegel version the terrible anonymity of the alien forms was effectively contrasted against the cozy intimacy of a small town; on the other hand, in the Kaufman version, the aliens are perfectly at home in the conformity of San Francisco's urban sprawl (a disturbing implication in its own right). Moreover, in a sly, satiric touch, the pods find ample places to hide in the chic houseplant-infested world of city dwellers! Sounding the alarm are a public health inspector, Matthew Bennell (Donald Sutherland), and his assistant, Becky (Brooke Adams). In a not-so-subtle allusion to the Siegel film, they attempt to escape on an outgoing ship after hearing voices from within singing "Amazing Grace." But they are foiled when they witness pods being loaded on board. In an ironic twist, they flee the city in a cab driven by Don Siegel, in a cameo role! While the shock effects—including flashy cutting, graphic transformations, and startling aural blasts emitted by the pod people—are far more elaborate than those in the Siegel film, and while the film had a far bigger budget, the pacing and the overall sense of mounting terror are more diffuse and therefore less effective.

Abel Ferrara's 1993 version, reclaiming the book's original title, *The Body Snatchers*, again changes the location, this time to a mysterious army base located somewhere in the South. Dr. Malone (Terry Kinney), an environmental

protection scientist, arrives to check ongoing toxic experiments. He discovers men clandestinely loading odd, seed-pod-like objects from the swamps onto trucks. Meanwhile, the base doctor (Forrest Whittaker) claims some of his patients have delusions that if they fall asleep, they'll change into monsters. And worst of all, the scientist's wife Marti (Meg Tilly) has herself changed into a soulless creature. As the base begins to crawl with these human substitutes, Dr. Malone flees with his daughter and son. After a terrific confrontation involving helicopters and ground vehicles, they escape to warn the world of what's coming. Although the monstrous transformations are pretty slimy affairs, with moist tendrils sprouting from the pods to envelope and invade the forms of sleeping humans, the real horror of the picture arises from its quiet buildup and its exceptional visual style, its skewed visions of half-seen, spidery forms sprawling across the edges of the frame.

Novelist and filmmakers alike have objected to overt readings of the story and the films—particularly the Siegel version, which remains the most tautly successful—as an anticommunist and/or anti-McCarthy parable. But there is too much supporting evidence to yield the point so easily. As Danny Peary has pointed out in his study of Siegel's film, the space aliens fit all too closely the stereotypes held by Americans in the mid-1950s of Russians—"ice cold,

outwardly peaceful but very authoritarian, emotionless." On the other hand, their campaign to seek out and destroy the "nonconformists" like Dr. Bennell are like HUAC's investigations and subsequent blacklisting of suspected communists.

There is even division on where the real terror of the thing lies. Horror film historian Carlos Clarens has pointed out that "the ultimate horror in science fiction is neither death nor destruction but dehumanization . . . That the most successful SF films . . . seem to be concerned with dehumanization simply underlines the fact that this type of fiction hits the most exposed nerve of contemporary society: collective anxieties about the loss of individual identity . . ." Countering this view is the rather more insidious suggestion by historian Vivian Sobchack that there is emotional appeal in being "taken over," as it were: "[The] emotional attraction is 'no more responsibility.' Being 'taken over' can be likened to being drafted, to having to follow orders. 'Taken over,' we cannot be held accountable for our crimes—passionate or passionless." Perhaps the latter view is the most terrifying implication of all.

REFERENCES

Clarens, Carlos, *An Illustrated History of the Horror Film* (G.P. Putnam's Sons, 1967); King, Stephen, *Danse Macabre* (Everest House,

Meg Tilly and Terry Kinney in The Body Snatchers, *directed by Abel Ferrara* (1993, U.S.A.; WARNER/MUSEUM OF MODERN ART FILMS STILLS ARCHIVE)

1981); Peary, Danny, *Cult Movies* (Dell, 1981); Sobchack, Vivian Carol, *The Limits of Infinity: The American Science Fiction Film* (A.S. Barnes, 1980); Tibbetts, John C. "Time Out of Joint: The Stories of Jack Finney," *The World and I* 10, no. 9 (September 1995): 281–85.

—*J.C.T.*

THE BONFIRE OF THE VANITIES (1987)

TOM WOLFE

The Bonfire of the Vanities (1990), U.S.A., directed by Brian De Palma, adapted by Michael Christofer; Warner Brothers.

The Novel

In his books of the late 1960s, Tom Wolfe, an exponent of New Journalism, used bitter sarcasm to skewer his political enemies: Jewish intellectuals, hippies, and other radicals. Wolfe's later books intermingled with the Reagan Revolution, forwarding America's conservative interests. For example, *The Right Stuff* (1979) celebrated the cold war American colonization of space, while *The Bonfire of the Vanities* presents a yuppie besieged by the rabble of "liberal" New York City.

One night, Sherman McCoy, a successful Wall Street bond salesman, drives Maria Ruskin, his mistress, home from the airport. On the way into Manhattan, they make a wrong turn and end up lost in the South Bronx. Immediately, the car is stopped by two young black men; to escape, Maria grabs the wheel and runs over one of them. Sherman and Maria return to Manhattan and decide not to tell the police, for fear of having their affair exposed to their spouses. Sherman's involvement in the hit-and-run accident is gradually exposed, and he is arrested. The novel ridicules the various characters who self-servingly prey on Sherman's "misfortune": Peter Fallow, a drunk tabloid reporter; Reverend Bacon, a black activist; and Abe Weiss, the Bronx district attorney running for reelection. At Sherman's trial, the judge dismisses the indictment due to tainted evidence, and a race riot ensues. The novel ends with the penniless Sherman about to be re-indicted. The other characters profit from Sherman's fall: Fallow has won the Pulitzer Prize; Weiss has been reelected; and Reverend Bacon has won a major monetary award in a civil suit against Sherman.

The Film

Brian De Palma's movie adaptation of Wolfe's bestselling novel quickly became a financial disaster for Warner Brothers. The novel had been well received among the general public for its insightful skewering of self-interested New York society. However, the novel's race politics, when transferred to the screen, are revealed as the caricatures they are. What seemed acceptable in print—a comedy about a rich white man running over a poor black man—could not be rendered on film without producing an offensive product.

In an unsuccessful attempt to refigure the novel's racism, the filmmakers changed the ending. In the novel, a race riot ensues after a Jewish judge sets Sherman free. In the film the judge is black and delivers a lengthy sermon about the need for justice to be color blind. He implores the crowd to go home and be "decent, like your grandmothers taught you." The film replaces the novel's outright racism with a kind of benign, "can't we all just get along" fantasy of racial harmony.

The standard take on the adaptation of *The Bonfire of the Vanities* is that De Palma's incompetent film ruins the witty satire of Wolfe's novel. But Wolfe's novel is more bitter than funny in its attack on the Left. The novel sees all activism against discrimination as self-serving; Wolfe argues that protest results from the quest for celebrity rather than genuine discontent with one's condition. Furthermore, in Wolfe's vision of the class war, it is rich Sherman McCoy who is abused by the system: quickly forgotten is the actual victim, Henry Lamb. Wolfe uses Lamb only to vilify Reverend Bacon as a greedy opportunist who seeks to profit via a civil suit against Sherman.

While certainly equally racist in the way it preserves Wolfe's assumptions, the film is also open to interpretation as a subversion of the novel. In the courtroom scene at the end, De Palma uses grotesque, wide-angle close-ups of the self-serving participants. These shots might serve to vilify Wolfe's depiction of these characters *as stereotypes*, just as much as they vilify the characters themselves. In its clearest attack on Wolfe, the film adds a framing device where we learn that Peter Fallow has won fame off of Sherman's story by writing a book about the events: the film thus positions Fallow as Wolfe. The film's framing narration reveals Wolfe as yet another character, albeit a metatextual one, who has profited immensely from the plight of the black underclass. In this way the film subtly reveals Wolfe to be the most grotesque of all the self-serving opportunists presented.

REFERENCES
Davis, Eugene H., "The Bonfire of the Vanities," *Magill's Cinema Annual*, ed. Frank N. Magill (Salem, 1991), 60–64; Salamon, Julie, *The Devil's Candy: The Bonfire of the Vanities Goes to Hollywood* (Houghton Mifflin, 1991); White, Armond, "Brian De Palma, Political Filmmaker," *Film Comment* 27, no. 3 (May–June 1991): 72–78.

—*W.M.*

THE BOURNE IDENTITY (1980)

ROBERT LUDLUM

The Bourne Identity (1988), U.S.A., directed by Robert Young, adapted by Carol Solieski; Warner TV.

The Bourne Identity (2002), U.S.A., directed by Doug Liman, adapted by Tony Gilroy, William Blake Herron and (uncredited) David Self; Universal.

The Novel

Robert Ludlum's espionage novel was published in 1980 and became a Doubleday Book Club selection that was also offered to members of the Literary Guild. Though some reviewers of the 2002 film adaptation dismissed the novel as a cold war "relic," the plot was more contemporary than they realized, with its focus on an international terrorist assassin named Carlos. The protagonist is a CIA operative who has been trained and conditioned to seek out Carlos, but because of an accident at sea that begins the story, he has a much larger quest. Shot and then dumped into the Mediterranean Sea, presumed dead, the man eventually known as Jason Bourne has lost his memory and is trying to discover who he is and what he has done. The "Bourne identity" turns out to be one of many, since he is also known as Cain and, going back to his service in Vietnam, as Delta.

Bourne is considered dangerous because he is believed to be a professional assassin by the world at large and by the terrorist Carlos, who wants him dead; but the man is also dangerous to the Treadstone 71 team that trained him because of what he presumably knows (though, ironically, he in fact remembers almost nothing); the CIA believes that their secret agent has "turned." They, also, want the alleged traitor dead. Bourne is nursed back to health by an alcoholic doctor, who sobers up long enough to give him medical attention and useful advice. In tending to his wounds, Dr. Washburn discovers a microchip implanted in Bourne's back. It contains the code for a numbered Swiss bank account, which Bourne goes to Zurich to investigate after he recovers. He finds there a stash of millions of dollars and francs; he also finds goons waiting to kill him. Resourceful and trained in ways he does not fully understand, Bourne manages to elude capture. He instinctively understands self-defense and has a skilled knowledge of weapons. He is a killing machine.

Bourne needs help in order to extract the money held in his Swiss bank account and finds it in the person of a Canadian economist, Marie St. Jacques, whom he takes hostage. Without her specialized knowledge of international banking, Bourne could not function. She falls in love with him, and they travel together to Paris, which Bourne senses is his home base. Throughout the novel he has flashes of memory that give him guidance. But he is being framed by the terrorist Carlos, who has vowed to destroy him, partly as an act of self-defense, partly because Bourne apparently intends to replace Carlos as Europe's top assassin. As Bourne infiltrates Carlos's Paris headquarters, the terrorist becomes concerned. When Bourne assumes responsibility for the death of Carlos's cousin and mistress, Angélique Villiers, vengeance also becomes a motive. In fact, the woman was murdered by her husband,

André Villiers, a respected French war hero and politician, whose son was assassinated by Carlos. Villiers befriends Bourne and Marie and helps Bourne get out of Paris (with diplomatic immunity) and to New York City, where Bourne sets the trap for Carlos. But the contest is left unresolved. Marie convinces Bourne's handlers to treat him decently after three years of life-threatening deep cover. In the final confrontation Carlos and Bourne injure each other, but Carlos escapes, living to see another sequel. Bourne finally discovers his true identity, introducing himself to Marie at the novel's end as David Webb.

The Films

As reviewer Gary Arnold pointed out in the *Washington Times*, Doug Liman's film is actually the second adaptation of the expertly plotted 1980 espionage novel. The first adaptation was a made-for-television film produced in 1988, starring Richard Chamberlain and Jaclyn Smith, supported by Denholm Elliott, Anthony Quayle, and Donald Moffat. The television adaptation was more faithful to the novel, partly because it was produced on a mini-series scale and was able to devote more time to the plot. For Arnold, Liman's film demonstrated "that a snappier adaptation was always feasible, provided the plot was streamlined." But in fact the plot was serviceable enough, though rather too complicated for a feature film. The film was based on the first of a trilogy of novels Ludlum wrote featuring Jason Bourne.

In Liman's *The Bourne Identity* Matt Damon plays the amnesiac who doesn't know his own strength. A trained secret operative who takes a bullet at sea in the film's prologue, Jason Bourne (Matt Damon) is reborn without a clue as to his identity, though he is multilingual and well trained in the martial arts. This is hardly an astonishingly inventive gimmick to drive the plot, which was freely adapted by Tony Gilroy and William Blake Herron from Robert Ludlum's novel, described by Todd McCarthy in *Variety* as "a first-rate thriller with grit and intrigue to spare."

As in the novel, Treadstone, the top-secret clandestine CIA operation that seeks to control, contain, and kill Jason Bourne, is what Alfred Hitchcock would have called the MacGuffin, a distracting gimmick that drives the plot. Having been shot in the back and then ditched at sea, Bourne is conveniently rescued by fishermen in the Mediterranean, some 30 miles south of Marseilles. His only clue as to his identity is an account number at a Swiss bank in Zurich, where he finds substantial amounts of currency, a gun, and several passports suggesting multiple identities, one of them being Jason Bourne, with a Paris address. In the film this motivates his journey to Paris, but in the novel he remembers Paris as being his base of operations. His well-developed sixth sense warns Jason when he is being followed.

Puzzled, he then goes to the American consulate (in a departure from the novel's plot), where he is soon targeted

by security. He is saved by his self-defensive instincts (he is a trained killer, though he does not understand his skills or his power yet) and hitches a ride to Paris with a German bohemian, Marie Kreutz (not the novel's Marie St. Germain and not Canadian, but played by German actress Franka Potente) by offering her $10,000. In the novel her motive is not merely mercenary. Jason's pursuit across Europe culminates in an effectively filmed car chase in Paris.

At this point the audience is let in on the secret of Bourne's identity, revealed through a backstory that will not be familiar to readers of the novel. He is described as "black op" for the CIA, so well trained that he is called a $30 million weapon, sent to assassinate an African dictator who threatens to blackmail the agency. Bourne has hidden himself on the dictator's yacht and is in position for the kill, as a flashback reveals later in the film, but it turns out that the mark's young children are with him on the yacht, which gives Jason pause. Consequently, he takes two bullets in the back and disappears into the sea. Therefore, Jason botched the assignment, which, if disclosed, could embarrass the CIA, so Bourne is considered expendable. His director at CIA headquarters, in Langley, Virginia (Ted Conklin, played by Chris Cooper), wants Bourne "in a body bag by sundown." Although handicapped by his amnesia and acting on instinct, Bourne is still resourceful and dangerous. The motives portrayed in the film are therefore drastically different from those in the novel, in which Bourne's backstory includes a family murdered in Vietnam.

After the chase through Paris, Jason and Marie escape into the French countryside, but after an encounter that endangers the lives of Marie, her British friend who owns a farmhouse, and the man's children, Jason sends Marie away for her safety, with all of the money, except $30,000. All of this was invented for the movie. Jason decides to end it by facing down his enemy. Jason walks into a trap but is able to control the situation. He wants out. After Conklin, his minder, is then assassinated on the street (Conklin is spared in the novel), on orders from the minder's superior, who is under congressional scrutiny, Jason limps off. Everyone is expendable, but, apparently, Jason is finally permitted to walk away. The film ends with Jason in Greece (on the island of Mykonos), where Marie is now running a business, renting scooters to tourists. How Jason managed to find her is not explained in this cozy false conclusion. In fact, director Doug Liman and his producers had trouble deciding on how the story should end. The compromise seems to have been the final showdown, followed by a Greek travelogue.

In his *New Yorker* review, David Denby unfairly protested that the film, based on a cold war novel published in 1980, "feels like a relic." According to Denby, the film operates on the premise that the CIA "operates with bottomless calculated villainy." Although Denby believed that Matt Damon was seriously miscast as Bourne, the contention is arguable, if one considers the vacuum and

Matt Damon in The Bourne Identity (2002, U.S.A.; UNIVERSAL)

hollowness that surrounds and defines the character, the emptiness at the core of his being. In these terms, Damon seems exactly right for the role, though at first glance he might seem an unlikely action hero cast as a professional assassin.

Damon told *Entertainment Weekly* he wanted to "try an action movie," working "with someone who was thinking outside the box." The project did not go smoothly, however. Damon was not happy with revisions written by (the uncredited) David Self, who stepped in after Tony Gilroy was called to work on another project, *Proof of Life*, a thriller starring Russell Crowe and Meg Ryan. "Every few pages, something blew up," Damon protested, adding "it was not the movie I agreed to do." After finishing *Proof of Life*, Gilroy returned to do last-minute rewrites for *The Bourne Identity*. The project had continuing problems with the "third act," and Gilroy apparently had to rewrite the conclusion several times, perhaps because the novel's "third act" was too elegant and complicated.

Baltimore Sun critic Michael Sragow approved of the way Liman played "the frantic action off of" the "budding rapport" between Jason and the flaky "Eurodrifter," Maria, perhaps not realizing that no such flake existed in the novel. Bourne's "underlying calmness works like a three-way charm," conveying the character's compassion, self-knowledge and command. This is crucial, because viewers

need to be convinced that Bourne "still possesses a human identity worth saving," and "his relationship with Marie convinces us," though not as much as in the novel. Over time, the character's initial hollowness seems to fill up. But, unfortunately, the novel's Marie was far more convincing in this regard and quicker to recognize Jason's essential decency. At least the novel avoided the sentimental contrivance of the film's Greek travelogue ending.

REFERENCES

Arnold, Gary, *The Washington Times*, June 14, 2002, B5; Ascher-Walsh, Rebecca, "The Hitman Cometh," *Entertainment Weekly*, June 21, 2002, 33–35; Custen, George F., "Debuting: One Spy, Unshaken," *The New York Times*, June 23, 2002, 5; Denby, David, "Keeping Secrets," *The New Yorker*, June 17 and 24, 2002, 176–177; Gleiberman, Owen, "Memory Blank," *Entertainment Weekly*, June 21, 2002, 47–48; McCarthy, Todd, "Spy Genre re-Bourne," *Variety*, June 10–16, 2002, 28, 32; Sragow, Michael, "Bourne to Thrill," *The Baltimore Sun*, June 14, 2002, E1, E4.

—*J.M. Welsh*

BREAKFAST AT TIFFANY'S (1958)

TRUMAN CAPOTE

Breakfast at Tiffany's (1961), U.S.A., directed by Blake Edwards, adapted by George Axelrod; Paramount.

The Novel

William Nance has called *Breakfast at Tiffany's* a work that marks a turning point in Capote's fiction—from inward-looking to topical, cool, and sophisticated. The narrator is a writer who has "begun to look around him at the world," as Capote himself was doing. Indeed, the narrator in *Breakfast at Tiffany's* is generally considered to represent Capote; they even share the same birthday (September 30).

The novel is constructed as a memory. When he receives a phone call from an old friend, a writer returns to the New York neighborhood where he lived during World

Audrey Hepburn as Holly Golightly in Breakfast at Tiffany's, *directed by Blake Edwards* (1961, U.S.A.; PARAMOUNT/PRINT AND PICTURE COLLECTION, FREE LIBRARY OF PHILADELPHIA)

War II, approximately 15 years earlier. His friend, a barman named Joe Bell, shows him a picture of a carved African head whose features resemble those of Holly Golightly, a woman who was the writer's neighbor during the war.

The photo prompts the narrator to recollect his acquaintance with Holly. "Her mouth was large, her nose upturned. A pair of dark glasses blotted out her eyes. It was a face beyond childhood, yet this side of belonging to a woman." She earned her income from the monetary favors bestowed upon her by the gentlemen who took her to dinner. She had a nameless cat and a brother named Fred, both of whom she loved dearly. The narrator was fascinated by her wild, sweet, distant air and eventually decided that he loved her in a platonic sense. Holly left the country before the end of the war, and the narrator has not seen her since.

The Film

Paramount's popular 1961 adaptation of *Breakfast at Tiffany's* stars Audrey Hepburn and George Peppard. For the screen, the story was updated to the 1960s and set in a fashionable New York neighborhood. The nameless narrator becomes Paul Varjak, a writer who is in a dry spell and is being "kept" by a rich, elegant woman (Patricia Neal). A romance soon develops between Paul Varjak and Holly Golightly; each is "morally tainted" and able to help and understand the other. Although a hatred of being "put in a cage" causes Holly to resist the love Paul offers, he eventually overcomes that resistance, and he and Holly end the film in a memorable Hollywood clinch.

Clearly, Hollywood felt that Capote's novel needed some major modifications. "It was not really a story for pictures," George Axelrod (who wrote the screenplay) has commented. "Nothing really happened in the book. All we had was this glorious girl—a perfect part for Audrey Hepburn. What we had to do was devise a story, get a central romantic relationship, and make the hero a red-blooded heterosexual." The nameless narrator's platonic love becomes George Peppard's "red-blooded" passion. Outrageous, Ultimately Unknowable, Mysterious Holly becomes Misguided Good Girl Holly Who Eventually Discovers the Error of Her Ways.

And yet, if the film is faithful to the novel at all, it is in its representation of Holly. Although such things as her pregnancy by a Brazilian lover and her comments about "bull dykes" being good roommates do not appear in the film, Holly's essential personality does. Like Capote's Holly, Blake Edwards gives us a character who is sexual yet innocent; bold yet timid; self-assured yet lost; loving yet distant; wild yet caged. Hepburn fit the "Holly" bill so well that there was considerable speculation as to whether Capote had had her in mind when he wrote the novella. Actually, Capote claimed that he had envisioned Marilyn Monroe in the part.

REFERENCES

Capote, Truman, "Breakfast at Tiffany's," *Esquire*, December 1961, 64+; Garson, Helen, *Truman Capote: A Study of the Short Fiction* (Twayne, 1992); Hofstede, David, *Audrey Hepburn: A Bio-Bibliography* (Greenwood Press, 1994); Lehman, Peter and William Luhr, *Blake Edwards* (Ohio University Press, 1981); Nance, William, *The Worlds of Truman Capote* (Stein and Day, 1970).

—*H.A.*

THE BRIDGE OVER THE RIVER KWAI
(Le pont sur la rivière Kwai) (1952)

PIERRE BOULLE

The Bridge on the River Kwai (1957), U.S.A., directed by David Lean, adapted by Michael Wilson and Carl Foreman; Columbia.

The Novel

A battalion of World War II British troops, commanded by Colonel Nicholson, are sent to a Japanese prison camp. Colonel Saito tells the British, including officers, that they will build the Kwai bridge. Nicholson disagrees because the men need to be under British command in order to feel like soldiers and not slaves. Saito changes Nicholson's mind, and the British take over the job of designing and constructing the bridge, unaware that there is a company of British soldiers (Force 316) coming to destroy the bridge. In the end, all members of 316, Nicholson, and Saito are killed. Author Pierre Boulle, better known for his science fiction, also wrote *Planet of the Apes* (1963).

The Film

This seven-time Academy Award–winning film stars Alec Guinness as Nicholson and Sessue Hayakawa as Saito. Boulle did not speak English, so Carl Foreman and Michael Wilson and producer Sam Spiegel supervised the adaptation of the novel into film. The writers made a great film, even though the novel was turned into a very Hollywood-type production.

Perhaps the biggest difference between the novel and film is the exaggerated character of Shears, an officer in the novel and an impostor in the film. Played by William Holden, Shears is an American who serves to cast a Hollywood feel to the film. Unlike the dedicated officer in the novel, Shears is jaded and even tells a beautiful blonde nurse (another addition to the text) that he is a "civilian at heart." David Lean was quoted as saying that Holden's Americanized character "softens the Yorkshire pudding effect of the whole." Indeed, similar to his role in the film *Picnic*, Holden spends much of his screen time shirtless. Interestingly, Lean cited *Picnic* as an American film that he thought was "unusually good."

Also added to the film is a dramatic ending in which Nicholson falls on the detonator, blowing up the bridge himself. Unlike the novel, the bridge is totally destroyed and the train falls into the river. Hitting one over the head with the irony of British pride resulting in ultimate failure, the sign Nicholson posted (to let the world know that this masterpiece was constructed by the British) floats among the rubble in the River Kwai.

Yet, even with the changes, *The Bridge on the River Kwai* is a powerful film with an incredible performance by Guinness. Even with the Hollywood tropes, there are scenes directly from the book, such as when each member of Force 316, one by one, notices that the river has fallen in the night and that the explosive wires are visible. With suspenseful scenes like that, the film proves to be a masterpiece of Hollywood adventure. It won Academy Awards for best picture, best director, best actor (Alec Guinness), and best adaptation.

REFERENCES

Maltin, Leonard, *Leonard Maltin's Movie and Video Guide* (Signet, 1995); Thompson, Howard, "Lean Views From a New 'Bridge'," *New York Times*, December 15, 1957.

—*S.H.*

THE BRIDGES OF MADISON COUNTY (1992)

ROBERT JAMES WALLER

The Bridges of Madison County (1995), U.S.A., directed by Clint Eastwood, adapted by Richard LaGravenese; Warner Brothers.

The Novel

Robert James Waller wrote *The Bridges of Madison County* in two weeks. Though widely criticized for its insipid prose, the book's phenomenal success is due in large part to the impact its moving love story has on its readers—Waller regularly receives fan mail thanking him for writing about love with such sensitivity and passion.

The novel concerns a lonely Italian immigrant housewife, Francesca Johnson. While the rest of her family is away at the Illinois State Fair, Francesca meets *National Geographic* photographer Robert Kincaid and they quickly fall in love. After a steamy four-day affair, Robert and Francesca decide to return to their previous responsibilities.

The Film

Producer Kathleen Kennedy secured Clint Eastwood to direct and star in the film, and Eastwood called on Meryl Streep to play Francesca. Streep expressed concern about the book's prose style and its politics, but after reading LaGravenese's adaptation, she agreed to take the part. Streep's decision probably stems from the fact that while the novel tells the story from Robert's point of view and glorifies his masculinity, the film tells the story from Francesca's point of view—even adding a framing device where her adult children discover evidence of the affair—and focuses on her torment at having to choose between family and happiness.

Waller's book offers an intriguing story but is narrated with what Frank Rich calls "Hallmark prose." One example will suffice (note that this comes from what the publishers consider a passage worthy to reproduce on the jacket): "Let it go, Kincaid, get back on the road. Shoot the bridges, go to India. Stop in Bangkok on the way and look up the silk merchant's daughter who knows every ecstatic secret the old ways can teach." This passage is characteristic of the novel in political as well as stylistic terms. Worshiping Robert's masculine power at every turn, the novel compounds its sexism (i.e., running from a woman he finds too powerful emotionally to one he can control sexually) with orientalist overtones (the woman who knows the exotic lovemaking techniques is of course from the Far East).

Whereas the novel is unintentionally funny, the film uses humor to complement its melodramatic plot. Francesca is endowed with a bitingly sarcastic wit, which she uses to express her disdain for romantic conventions: When Robert gives her flowers, she jokes that they are poisonous. The film also revises the novel's conservative politics. In the scene quoted above, the desire to go to India and make love to an exotic woman is replaced by Robert telling Francesca about a time he was bathing in an African jungle and a female gorilla took an interest in him: "We got engaged," he says wryly, "we still write." Such adaptations are typical of this film, which self-consciously delivers both a love story and a critique of one.

REFERENCES

Collins, Gail, "Recipe for a Best-Seller," *Working Woman*, February 1994, 76; Rich, Frank, "One-Week Stand." *New York Times Magazine*, July 25, 1993, 54.

—*W.M.*

THE CAINE MUTINY (1951)

HERMAN WOUK

The Caine Mutiny (1954), U.S.A., directed by Edward Dmytryk, adapted by Stanley Roberts; Columbia.

The Novel

In 1949 Wouk began work on *The Caine Mutiny*, which drew on his World War II experiences as a communications officer on a destroyer-minesweeper. The fictional story of a mutiny against an incompetent commander, *The Caine Mutiny* explores the conflict between freedom and order, ultimately endorsing a conservative philosophy of obedience. The novel was published in 1951 and topped the *New York Times* best-seller list from August 1951 to August 1952. It won the Pulitzer Prize, and Wouk's Broadway adaptation, *The Caine Mutiny Court-Martial*, ran for 415 performances.

Willie Keith, a spoiled bon vivant, enters the navy at the start of World War II and is assigned to the USS *Caine*, a dilapidated minesweeper. His first captain, the slovenly but skilled De Vriess, is replaced by Queeg, who torments the crew over superficial details but is an incompetent sailor and a coward. During a climactic tornado, he refuses to adjust his assigned course to save the ship, and Maryk, the skilled second-in-command, mutinies with Willie's support. Maryk undergoes a court-martial and is acquitted, but Willie comes to understand that the military system requires obedience and the mutiny was wrong. At the end of the novel, Keith, having learned the importance of authority and discipline, becomes captain of the

Caine. This military narrative is intertwined with a domestic one in which a matured Keith stands up to his domineering, snobbish mother and pursues a romance with a lower-class woman. While the novel condemns the mutiny against Queeg, which threatens military hierarchy, it applauds the mutiny against Mrs. Keith, which reestablishes patriarchal authority.

The Film

Stanley Kramer, a producer under contract at Columbia, bought rights to the novel and began extended negotiations with the navy for the use of ports and boats. Unhappy with the subject matter, the navy initially demanded major revisions, but Kramer finally won their cooperation in exchange for minor script changes and an opening disclaimer that there had never been a mutiny in the U.S. Navy.

Wouk wrote a screenplay but Kramer rejected it and hired Stanley Roberts, whose first draft would have taken over three hours of film time. Harry Cohn, the studio head, insisted that the movie be under two hours. When Roberts refused to make radical changes, Michael Blankfort was hired for a rewrite. The final script focuses on the mutiny, eliminating Willie's early training and his rise to captain.

The Caine Mutiny, Kramer's first big-budget film, was buoyed by Edward Dmytryk's taut direction and Humphrey Bogart's memorable performance as Queeg. It was nominated for seven Academy Awards, including picture, actor (Bogart), supporting actor (Tom Tully) and screenplay. It was the second highest grossing movie of 1954.

Despite the movie's popular success, Dmytryk considered it a disappointment, complaining it was too short. *The*

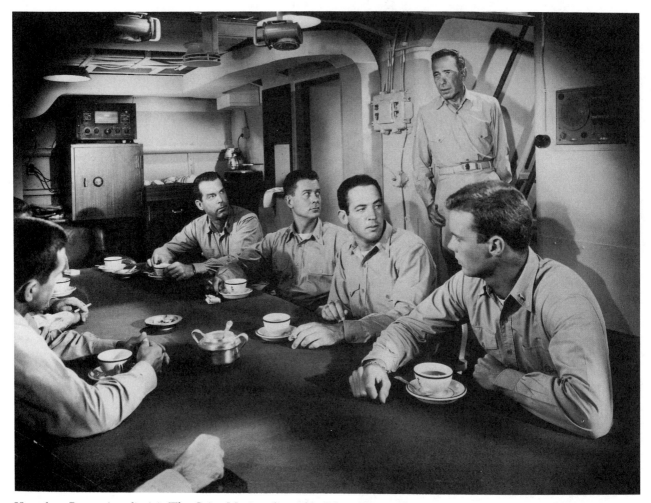

Humphrey Bogart (standing) in The Caine Mutiny, *directed by Edward Dmytryk* (1954, U.S.A.; COLUMBIA/PRINT AND PICTURE COLLECTION, FREE LIBRARY OF PHILADELPHIA)

Caine Mutiny reveals the difficulty of condensing a long novel into a feature-length film. The biggest structural problem is Willie. He is the center of the novel, which treats the mutiny as one moment in his moral maturation. Wouk's stage play, on the other hand, focuses on the ethical issues raised by the court-martial and makes Willie a minor character. The film occupies an uneasy middle ground, focusing on the mutiny yet retaining Tom's romance. This romance was integral to the novel, which fused Willie's acceptance of naval hierarchy and the patriarchal reclamation of a female-dominated family. But since the movie skips Willie's early callowness and his later rise to captaincy, the romance becomes an arbitrary subplot.

REFERENCES

Dmytryk, Edward, *It's a Hell of a Life, but Not a Bad Living* (New York Times Books, 1978); Mazzeno, Laurence W., *Herman Wouk* (Twayne, 1994); Spoto, Donald, *Stanley Kramer: Film Maker* (G.P. Putnam's Sons, 1978).

—*T.S.H.*

THE CALL OF THE WILD (1903)

JACK LONDON

The Call of the Wild (1923), U.S.A., directed and adapted by Fred Jackman; Hal Roach/Pathé.

The Call of the Wild (1935), U.S.A., directed by William Wellman, adapted by Gene Fowler and Leonard Praskins; Twentieth Century.

The Call of the Wild (1972), U.K./West/Germany/Spain/Italy/France, directed by Ken Annakin, adapted by Harry Alan Towers, Wyn Wells, Peter Yeldman; Massfilms/CCC/Izaro/Oceania/UPF.

The Novel

Jack London drew his inspiration from his own adventures in the Yukon during the gold rush, where he heard stories told by veteran gold miners and, perhaps more importantly, experienced the Yukon firsthand. His experience

allowed him to capture not only the look, but also the feel of the north country.

After being stolen from his California home, Buck is sold as a sled dog for the gold rush in Alaska. Violence rules both men and dogs in the wilderness, and Buck must tap the most primitive part of himself in order to survive. Buck takes the lead of his team, controlling the other dogs with strength and shrewdness.

After many owners the team is purchased by two men and a woman who know nothing about the trail. They pull into John Thornton's camp in early spring and decide to continue despite weak trail ice. Buck refuses to move. One of the men beats Buck until Thornton steps in. The team and its owners leave without him and fall through the ice while still in sight. Buck shifts his loyalty to Thornton.

Buck wins a bet for Thornton by breaking a heavy sled free of the ice and pulling it down the street. Thornton and his partners use the winnings to finance an expedition to east Alaska. They discover gold but are killed by Indians. With his friend gone, Buck is now free to return to his primordial past. He joins a pack of wolves, but returns every year to visit the place where John Thornton died.

The Films

Jack London's novel drew the attention of filmmakers from its publication. D.W. Griffith directed a one-reel silent in 1908. Fred Jackman's 1923 screenplay remains faithful to the plot of the novel, but critics complained about the lack of any love interest.

Wellman's popular and well known adaptation allows the relationship between his two stars, Clark Gable and Loretta Young, to overshadow Buck's story. This screenplay combines episodes from *The Call of the Wild* as well as another of London's novels, *White Fang*.

The more recent film, starring Charlton Heston, follows the novel and offers beautiful scenery, but fails to develop the bond between the man and his dog.

When initial reviews of *The Call of the Wild* applauded London's complex human allegory, he accepted the praise, but insisted that he had set out to write a dog story. Regardless of motive, London's novel remains one of the best examples of allegory in American fiction. In it he deals with primitivism, a move away from the corrupting influence of civilization. Unfortunately, filmmakers tend to focus on the superficial tale of adventure rather than the more complex thematic concerns.

REFERENCES

Labor, Earle, and Jeanne Campbell Reesman, *Jack London*, (Twayne, 1994); Tavernier-Courbin, Jacqueline, ed., *Critical Essays on Jack London* (Hall, 1983); Williams, Tony, *Jack London—The Movies: An Historical Survey* (Rejl, 1992).

—S.H.W.

CARMEN (1845)

PROSPER MÉRIMÉE

Carmen (1915), U.S.A., directed by Cecil B. DeMille; adapted by William DeMille; Jesse L. Lasky Feature Play Company/Paramount.

Carmen (1915), U.S.A., directed and adapted by Raoul Walsh; Fox.

Burlesque on Carmen (1916), U.S.A., directed by Charles Chaplin; Essanay.

Carmen (1918), Germany, directed by Ernst Lubitsch, adapted by Hans Kraly and Emil Rameau; Ufa-Union-Atelier.

Carmen (1926), France, directed by Jacques Feyder; Les Films Albatros.

The Loves of Carmen (1927), U.S.A., directed by Raoul Walsh, adapted by Gertrude Orr; Fox.

Carmen, la de triana (1938), Spain, directed and adapted by Florián Rey.

Carmen (1943), France/Italy, directed by Christian-Jacque, adapted by Charles Spaak and Jacques Viot; Scalera Films.

The Loves of Carmen (1948), U.S.A., directed by Charles Vidor, adapted by Helen Deutsch; Columbia.

Carmen proibita (1953), Italy/Spain, directed by Giuseppe Maria Scotese, adapted by V. Calvino, J. Cortes Cavanillas, G.M. Scotese; Italo-Iberica.

Carmen de Granade (1959), Spain, directed by Tulio Demicheli, adapted by J.-M. Arozamena, A. Mas-Guindal, T. Demicheli, J.-P. Feydeau.

Carmen di Trastevere (1962), Italy, directed by Carmine Gallone.

Carmen, Baby (1967), Yugoslavia/U.S.A., directed by Radley Metzger, adapted by Metzger and Jesse Vogel; Audubon Films.

Carmen (1983), Spain, directed by Carlos Saura, adapted by Carlos Saura and Antonio Gades; Emiliano Piedra; Orion Classics.

Prénom: Carmen (1983), France, directed by Jean-Luc Godard, adapted by Anne-Marie Mieville, Alain Sarde; Spectrafilm.

La Tragédie de Carmen (1983), France, directed by Peter Brook, adapted by Brook, Jean-Claude Carrière, and Marius Constant.

The Novel

Prosper Mérimée's novella *Carmen* was first published in *La Revue des Deux Mondes* in 1845. Mérimée denigrated his effort and even claimed that *Carmen* would have remained unpublished had he not needed the money. The novella was not well received in its time by a public that saw this story as rather harsh and even immoral.

Mérimée's *Carmen* is actually a story within a story where only the third of four chapters is the Carmen tale with which we are now so familiar. (The fourth chapter of

the novella, added in 1847, is simply a short treatise on bohemian customs and language.) The first two chapters detail how the narrator befriended the bandit Don José. This same bandit later rescues the narrator who had run into the dangerous gypsy Carmen. Several months later, José is arrested and sentenced to death. The narrator visits the jailed outlaw who, in gratitude, reveals the events in his life that led to his involvement with Carmen.

The long third chapter is then the story of José as told to the narrator. As a young, homesick soldier in Seville, José first encounters Carmen, whom he later must arrest for a violent crime. Carmen talks José into letting her escape, however, and the dishonored José eventually kills in jealousy—but also in self defense—a superior officer who is vying for Carmen's attention. José joins Carmen's smuggling band that also includes Carmen's husband, Garcia le Borgne. After José provokes and kills Garcia, he becomes increasingly possessive of Carmen who soon begins to tire of his attention and takes up temporarily with Lucas, a picador. José desperately tries to convince Carmen to follow him to America or at least to change her life. Rebuked by the gypsy, José leads her to an isolated gorge. Even though she has no attachment to Lucas, the defiant Carmen again refuses to submit. José kills her with his knife, buries the body, and turns himself in to the authorities.

Mérimée's Carmen accepts her fate at the hands of José—she does not attempt to flee—and her murder has no witnesses. The relationship between Carmen and José as well as the memorable conclusion is, however, often distorted when the novella is filmed. Such negligence can be traced to the success of the 1875 opéra comique version of *Carmen*, scored by Georges Bizet. This opera popularized a different development for the gypsy: Carmen does have a new lover—the toreador Escamillo—and she attempts to flee to him when José confronts her. Carmen unsuccessfully resists death in a public plaza in front of the arena where her new lover performs for her. Bizet's librettists thus transform Mérimée's dark tale into a love story of a woman trapped between two men.

The Films

Although more than 50 film versions of *Carmen* exist, many are simply based on the opera plot, and several are direct filmings of the opera whose growing popularity at the turn of the century coincided with the emergence of the cinema. Some seven opera-story-inspired *Carmen* films or excerpts preceded the rival efforts of Cecil B. DeMille and Raoul Walsh in 1915. DeMille's film was actually based more on the opera and starred Geraldine Farrar, the greatest prima donna of the American opera, already famous for her *Carmen* performances. DeMille claimed that his film was based on Mérimée's novella, however, after he learned that Bizet's heirs would demand huge fees. Even though DeMille borrowed few novella elements, the public generally believed his claim. At the same time, Raoul Walsh turned out a *Carmen* with Theda Bara, the famous vamp and guaranteed box-office draw, as the gypsy. Walsh's film was also scripted more according to the opera libretto but named Mérimée as source. At the premiere of both films (on the same day in 1915), orchestras played selections from Bizet's music before and during the feature. An indication of the *Carmen* popularity of this time is the indirect tribute that the emerging comedian Charlie Chaplin gave it when he immediately produced a short burlesque, taking liberties with the circumstances surrounding the death of Carmen, as had DeMille and Walsh.

When Ernst Lubitsch directed a *Carmen* in 1918 with Pola Negri in the title role, he purposely tried to return to the vitality of the novella. One of the rare attempts to retain a suggestion of Mérimée's original framework, his film is a story retold by a gypsy around a campfire. Nevertheless, Lubitsch also surrendered to the opera's appeal when he replaced Lucas with Escamillo and favored the opera's scripting of Carmen's death in front of the bullring. At Lubitsch's Berlin opening, the orchestra naturally played selections from Bizet before the film and greeted the arrival of Escamillo on the screen with the opera's stirring Toreador Song.

In 1926, French director Jacques Feyder created a *Carmen* with Raquel Meller that was faithful to Mérimée's more complicated novella. Feyder even took the time to develop the Lucas character that is so often replaced by the operatic Escamillo, although the development of this Lucas certainly goes beyond the brief mention that Lucas enjoys in the novella. But the following year saw another mixed novella-opera effort, a second attempt by Raoul Walsh. Walsh was able to use Dolores del Rio, a Mexican actress whose exotic on-screen temperament seemed well-suited to the task. Mérimée was, of course, listed as the source, but Escamillo again displaces Lucas in this film named *The Loves of Carmen*, a title possibly taken from a line of the libretto.

After the advent of sound, it was only a matter of time until the opera score could become part of the permanent soundtrack, no matter which influence prevailed for the story line. In 1938, the Spanish actress Imperio Argentina starred in a German version entitled *Andalusische Nächte*, which was soon after redone in Spanish as *Carmen, la de triana*, directed by Florián Rey. This film betrays both novella and opera, for José dies a dignified death defending his fellow soldiers while Carmen remains alive to grieve. In 1942, French director Christian-Jacque directed an Italian-sponsored production of *Carmen* starring Viviane Romance, and this film was popular when it reached the United States in 1946. Indeed, the roles are nearly the same as in the novella, and much was made of the film's obvious restraint. Nevertheless, the opera score served as background music even if the story remained faithful to Mérimée.

The success of this film makes it difficult to understand why the most serious Hollywood effort to this date would attempt to bypass the opera completely and return to the original story. But this was the intent in Charles Vidor's 1948 *The Loves of Carmen*, which starred Rita Hayworth as the fiery gypsy. Much to the film's credit, none of the opera roles or names were borrowed, and not one note of the opera was heard. But even if Lucas is not replaced by Escamillo, *The Loves of Carmen* returns to an operatic conclusion: José kills Carmen near the bullring as she tries to return to Lucas.

The next several decades witnessed attempts to adapt the story to different contexts. The 1953 Italian-Spanish production of *Carmen proibita*, directed by Giuseppe Maria Scotese, modernizes the story. Carmen, who now traffics in American cigarettes, finds her José in an Italian naval officer. Tulio Demicheli directed *Carmen de Granade* in 1959, but this film's action was set in the Napoleonic era, well before the adventures of the original novella. The 1962 Italian film *Carmen di Trastevere* of Carmine Gallone returns Carmen to the modern era, but this version's action takes place in Rome. Predictably, the growing popular myth of Carmen would also turn up in a modernized soft-porn film, the 1967 *Carmen, Baby*, directed by Radley Metzger.

There has never been an interruption in the production of *Carmen* films, but the early 1980s saw a surge in these efforts as the opera music entered the public domain. In 1981, Peter Brook filmed a stage version set to Bizet's music, but his *La Tragédie de Carmen* interweaves the novella and opera elements so well that it is nearly impossible to separate them. The 1983 *Carmen* of Carlos Saura also fails to choose between the two sources. Saura's film is the story of a dance troupe putting on a version of *Carmen*, but the relationship of the actors playing Carmen (Laura del Sol) and José (Antonio Gades) begins to resemble that of their namesakes. Saura makes use of Bizet's score, but he also seems determined to include Méerimée by quoting his novella and even showing Gades holding a copy of the work. Nevertheless, neither Brook nor Saura choose a direct operatic conclusion, although Bizet's score is nowhere more evident than at this moment in both films. Brook and Saura fuse the novella and opera into a single narrative, refusing to separate the two for the satisfaction of a public that certainly brings many expectations to any *Carmen* film. Jean-Luc Godard goes one step further in his modern day terrorist tale: In *Prénom: Carmen*, Godard appears deliberately to excite the viewers' expectations with brief references to both sources before failing to meet such expectations.

It is evident that filming the story of *Carmen*, unless it is a matter of a simple adaptation of the opera (such as the 1956 *Carmen Jones* of Otto Preminger), forces a choice between novella and opera. Many interpretations of *Carmen* claim to be Mérimée-based but simply mix elements of both as need be; serious attempts to film the novella often succumb to either the influence of the opera libretto or the popularity of Bizet's score. In addition, the popularity of the *Carmen* story through time and location further complicates the study of this work as filmed literature. Any effort to examine the film versions of *Carmen* must take into account the possible competing sources as well as the cultural myth that this gypsy has become.

REFERENCES

Siebenmann, Gustav, "Carmen—Von Mérimée über Bizet zu Saura und Gades. Ein Spanienbild im Spiel der Medien," in *Einheit und Vielfalt der Iberoromania* (Helmut Buske, 1987), 169–200; Tambling, Jeremy, "Ideology in the Cinema: Rewriting *Carmen*," in *Opera, Ideology and Film* (St. Martin's Press, 1987), 13–39.

—*W.P.H.*

CARRIE (1974)

STEPHEN KING

Carrie (1976), U.S.A., directed by Brian De Palma, adapted by Lawrence D. Cohen; United Artists.

The Novel

Stephen King's first published novel, *Carrie*'s original idea "came from a strange woman Stephen King saw while he worked in a laundromat, and fell to wondering what kind of children such a woman might have," according to John Baker. *Carrie* was begun as a short story, but King became frustrated, throwing away the first few pages; his wife encouraged him to continue. With too long a short story but too short a novel, Ben Indick reports that King added fake articles and sections of books for length.

Carrie White, 17, terrified by menstrual onset during a gym class shower, retaliates against her persecutors by using telekinetic powers. Her mother, Margaret, a religious zealot, punishes Carrie for her power and her sexual maturity. Popular Sue Snell convinces Tommy Ross to invite Carrie to the prom, while Chris Hargeson convinces Billy to punish Carrie. Although Margaret objects, Carrie accepts Tommy's invitation. After Carrie and Tommy are crowned prom king and queen, they are drenched with pig's blood rigged in the rafters. Carrie, using her telekinetic powers, burns the school down. At home, her mother wounds her with a butcher knife, but Carrie stops Margaret's heart. The dying Carrie is found by Sue. The last passage describes a baby with telekinetic powers.

The Film

Novel and film follow Carrie from discovered telekinetic powers in the shower scene through the climactic prom scene, but they are structured differently. King employs multiple, contradictory sources: first-person accounts,

Sissey Spacek in Carrie, *directed by Brian De Palma* (1976, U.S.A.; UA-RED BANK/THE MUSEUM OF MODERN ART FILMS STILLS ARCHIVE)

commission reports, and autobiographies. Director Brian De Palma also emphasizes the story's telling, but through self-conscious, expressionistic techniques: slow motion, overhead shots, split screen, and montage. The endings also differ. The novel's Carrie burns the town down; the film's Sue, placing flowers on Carrie's grave, is terrifyingly grasped by Carrie's bloody arm (a dream sequence). De Palma also heightens ironic religious iconography: the grotesque closet crucifix, closely resembling Margaret, and Margaret's "crucifixion" by knives.

Textual differences, Leigh Ehlers believes, result from differing antecedents: King is "indebted to gothic and science fiction literary tradition, which question or warn against the limitations of technology and rationality" while De Palma "pointedly draws upon its antecedents in the horror film, dealing in repression, guilt, and a self-destructive subconscious."

De Palma's films have been widely criticized for their misogynist tendencies, but as Kenneth MacKinnon acutely observes, in *Carrie* such a reading requires the reader to adopt Margaret's perverse interpretation of female sexuality. He suggests that the film satirizes fundamentalism because Margaret's beliefs perversely enable her sadomasochism.

REFERENCES

Baker, John F., *Publishers Weekly*, January 17, 1977, 12–13; Ehlers, Leigh A., "Carrie: Book and Film," *Literature/Film Quarterly*, 9, no. 1 (1981), 32–39; Indick, Ben F., "What Makes Him So Scary," in *Discovering Stephen King*, Darrell Schweitzer, ed. (Starmont Press, 1985); MacKinnon, Kenneth, *Misogyny in the Movies* (University of Delaware, 1990).

—*K.R.H.*

CATCH-22 (1961)

JOSEPH HELLER

Catch-22 (1970), U.S.A., directed by Mike Nichols, adapted by Buck Henry; Paramount.

The Novel

Although he would go on to write two plays and five more novels (including a *Catch-22* sequel), Joseph Heller is still known almost exclusively for this first novel, which earned high academic and critical praise as well as becoming a cult classic. It remains a defining work of the 1960s generation, encapsulating French existentialist descriptions of life's absurdity and a generation's protest against war and authority. Heller was working within the tradition of such American war novels as *The Red Badge of Courage* and *A Farewell to Arms*, but his black humor, his depiction of war as not mere hellishness but uproarious absurdity redefined those texts and went on to influence such later works as Kurt Vonnegut's *Slaughterhouse-Five*.

Set at the end of World War II, alternately at a U.S. Army Air Force base on the Italian Mediterranean island of Pianosa and in a series of brothels in Rome, *Catch-22* follows the crazy antics of rebel bombardier Captain Yossarian and a large cast of memorable fellow military men. The novel defies simple plot summary. The story is more patterns of repetition than linear narrative. Told in a complicated, circular narrative, the novel loops back and forth in time and setting, creating in effect a grand mural of military and human madness in which a single individual is struggling to define a sane policy of protest in a world where insanity rules, to embrace life in a world of death. Heller himself links the narrational strategies to Faulkner: "to tell a narrative largely in terms of fragments and slow feeding of interrupted episodes . . . to give a feeling of timelessness, that the same things will happen again unless something is done, and do happen again."

The surface narrative details Yossarian's efforts to resist Colonel Cathcart's maniacal demands for an increasing number of flight missions, told against background caricatures of crazy generals, a symbol of American corporate capitalism (Milo Minderbinder), and a spate of hilariously evoked fellow officers. Along the way Heller satirizes McCarthyism, loyalty oaths, General Motors, the Chambers-Hiss trial, and dozens of other 1950s cold war moments. At the same time, the vatic satire seems to predict the following decade: An Italian village the U.S. Army Air Force must destroy in order to save it, for instance,

came to define the Vietnam experience for many war protesters. In circular flashbacks, Yossarian's experiences with grotesquely comic and nightmarish events take on increasing horror, and his decision at the end of the novel to flee to Sweden seems a heroic action.

The expression "catch 22," which the novel placed into the American vocabulary, specifically describes the logical paradox that if you're sane enough to claim to be mad, then you can't be insane; it also symbolizes the absurdity of not only military bureaucracy, but also human existence itself.

The Film

Mike Nichols (who had made two earlier adaptations: *Who's Afraid of Virginia Woolf?* and *The Graduate*) used a Buck Henry script (Henry also played the role of Lieutenant Colonel Korn in the film). Given the length, complexity, and extremely literary wit of the novel, Nichols necessarily cut and restructured his adaptation, leaving out many readers' favorite characters or scenes (Heller himself regretted the absence of the novel's hilarious interrogations). Nichols also tapped into the late 1960s zeitgeist, updating Heller's satiric political commentary, for instance linking glory-mad Colonel Cathcart to a famous image of Lyndon Johnson.

Perhaps Nichols's most innovative change was to frame the entire film as what appears to be a possibly hal-

Alan Arkin as Yossarian in Catch-22, *directed by Mike Nichols* (1970, U.S.A.; PARAMOUNT-FILMWAYS/JOE YRANSKI COLLECTION, DONNELL MEDIA CENTER)

lucinatory flashback, opening the film with Nately's whore's stabbing of Yossarian (Alan Arkin), which takes place at the end of the novel. The rest of the film's narrative, up to the final scene that opens with Yossarian recovering from the knife wound, then follows a seemingly random pattern of fragmented memory, one thematically linked to Nichols's brilliant opening shot of silent predawn blackness disrupted by the screaming engines of bomb-carrying B-25s. Nichols uses five carefully orchestrated flashbacks, showing in increasingly horrific detail a traumatic event (the gory death of gunner Snowden) that defines Yossarian's epiphanic horror and man's unavoidable fear of death. The film thus suggests the simultaneity Heller creates in the prose, in which all the narrative's action has always happened and is always happening.

The film received primarily negative or mixed reviews. Critics felt the film didn't live up to the novel's reputation (a perhaps impossible touchstone) and deemed it heavy-handed where Heller was light and subtle; some also found the film's length burdensome (although the novel itself is long and complex). The film was praised at best in terms of being a flawed masterpiece or an interesting failure. Ironically, Robert Altman's adaptation of the Richard Hooker novel, *M*A*S*H*, came out the same year, and it (like Kubrick's earlier adaptation, *Dr. Strangelove*) seemed to do a much better job of capturing Heller's black humor sensibility than did Nichols.

This is one of those adaptations that initially disappoint critics (who want nothing less than the experience of reading the novel all over again), but that gain a lot with distance. Admittedly, Nichols's visual medium does not allow for the brilliant manipulation of language and logic that informs Heller's linguistic nightmare, and much of Heller's verbal wit is lost—an inevitable result in the transition from language to image. Similarly, language allows for a kind of narrative patterning difficult to recreate in the film. On the other hand, Nichols and Henry do manage to capture the text's black humor spirit: What they lose of Heller's satiric verbal machinations they compensate for in the visual evocation of war's horror. The film's Felliniesque Rome imagery, with the youthful Aryan Jon Voight as Milo Minderbinder riding Nazi-like through the desolate streets, perfectly captures Heller's description of Yossarian's final visions of horror.

REFERENCES

Kiley, Frederick and Walter McDonald, eds., *A Catch-22 Casebook* (Thomas Y. Crowell, 1973); McCaffrey, Donald W., *Assault on Society: Satirical Literature to Film* (Scarecrow Press, 1992); Merrill, Robert and John L. Simons, "The Waking Nightmare of Mike Nichols' *Catch-22*," in *Take Two: Adapting the Contemporary American Novel to Film*, ed. Barbara Tepa Lupack (Bowling Green State University Popular Press, 1994).

—D.G.B.

THE CHILDREN (1928)

EDITH WHARTON

The Marriage Playground (1929), U.S.A., directed by Lothar Mendes, adapted by J. Walter Ruben and Doris Anderson; Paramount Famous Lasky Corp.

The Children (1990), Great Britain, directed by Tony Palmer, adapted by Timberlake Wertenbaker; Isolde Films/Channel Four.

The Novel

Edith Wharton's *The Children* was published in 1928 and quickly became one of her most popular and successful novels. Selected by the Book-of-the-Month Club for its September 1928 offering, it brought her more money (in excess of $95,000) than any novel she had written. It belongs to a late series of novels, borne out of her long residence in Europe, which were preoccupied with the disorientation and loss felt by the generation that reached middle age in the years following World War I. Its seriocomic tone and graceful style betray little of the depression she felt at the time over the death of her longtime friend Walter Berry, with whom she had recently been living in Paris.

At the center of the novel is Martin Boyne, a bachelor in his mid-40s, whose life has been devoted to a career in engineering in the remote spots of the world. The opening scene places Boyne on a ship bound for Italy, where he is to meet an old flame, the recently widowed Rose Sellars. Despite his need for what he calls "sea-solitude," he yearns to consort aboard ship with people "worth bothering about." He meets the children of his boyhood friends, Cliffe and Joyce Wheater, who are escorted by their nurse on their way to meet their parents. Cliffe and Joyce have each been married three times and the seven children are a collection of siblings, half-siblings, and stepchildren.

Led by the eldest, 15-year old Judith, the curious brood displays a fierce determination to stay together despite the constant divorcing and remarrying of their respective parents as they wander from one European watering hole to another. As commentator Linda Costanzo Cahir notes, "They band together in a faithful and felicitous bond, which by contrast, makes their parents' faithlessness, which has grown quite acceptable in their roaring-twenties world, seem so very childish." This family, writes another commentator, Millicent Bell, seemed typical of what Wharton regarded as a "new race," "despicable and appalling, a race of *humans* without purpose or dignity neither knowing nor needing any traditional sanctions."

Boyne himself is an outsider, always working, never settled in any particular place. He enjoys what Wharton describes as "the feeling of being lost in the throng, alone and unnoticed, with no likelihood of being singled out." The one fixed element in his life is Rose Sellars, with whom he had fallen in love five years before. Now that Rose is a widow, Boyne is bent on marrying her. But he is distracted by the children, whose desire to remain together attracts Boyne's sympathies. He becomes a kind of godfather to the motley brood. In particular, it is the precocious Judith who attracts his attention, and finally his love. Judith sees in him the same qualities Boyne sees in Rose.

In the end, however, Boyne is unsuccessful in keeping the children together. Moreover, there can be no bond with Judith. Though she is mature in certain ways of the world, her education has been limited and, as Wharton biographer Blake Nevius points out, Judith is morally and emotionally still a child—not altogether unlike Boyne himself. His growing attentions to her disrupt his engagement to Rose; and his attempt to propose to Judith is a botched business of stutters and stammers that she misconstrues as a declaration to the absent Rose. As a result, writes Wharton, Boyne feels "like a man who has blundered along in the dark to the edge of a precipice." Sad and disillusioned, Boyne sails for New York and another engineering job.

Years later he returns to Europe, where he learns that the children have been separated. He catches a glimpse through a ballroom window of Judith, but he leaves without speaking to her. In its widest context, according to biographer R.W.B. Lewis, *The Children* is Wharton's "indictment of the nearly grotesque irresponsibility of the parental generation." On a more personal level, Martin is left with a glimpse of a joy he knows now he will never attain, in spite of his best efforts. "We cannot always see just how our actions will affect another person," comments Cahir. "Conversely, there will be times when we will want our actions to ripple into pools of change, to provoke and affect other people into responsible action, only to discover that these provocative acts provoke little more than a polite nod. This is the fate of Martin Boyne in Wharton's *The Children.*"

The Films

The book's success led Paramount studios to lose no time in adapting it to the screen. Considerable changes were wrought by screenwriter J. Walter Ruben and director Lothar Mendes. In this early talkie, retitled *The Marriage Playground*, Joyce and Cliffe Wheater (Huntley Gorden and Lilyan Tashman) are a much-divorced American couple who, during their European travels, carelessly leave their seven children in the charge of the eldest, 18-year-old Judy (Mary Brian). On holiday they meet a family friend, Martin Boyne (Fredric March), who is on his way to visit his fiancée, Rose Sellers [sic]. After helping them through a crisis, Boyne realizes he has fallen in love with Judy (who, in any event, has already declared her love for him). In the end, he declares to the family's father that he intends to marry Judith and take over the care of the children. The ending is, of course, a travesty of Wharton's intentions. The casting of Mary Brian, one of Paramount's brightest stars at the time (*A Kiss for Cinderella*, *The Virginian*),

insured that Wharton's ill-starred romance with Martin would now have a happy ending. Moreover, her advanced age allowed the romance a reassuring "legitimacy" in the eyes of the prevailing censorship restrictions in Hollywood.

The only other version of the novel was released in 1990 and directed by Tony Palmer. It cast Ben Kingsley as Martin, Kim Novak as Rose, and young Siri Neal as Judith. At first glance, Tony Palmer would seem to have been an unlikely choice to helm this version. After serving an apprenticeship with Ken Russell on the BBC "Monitor" series in the late 1960s, Palmer had made his name with a number of documentaries about pop and classical composers and musicians, including a series of pungent portraits of the pop and rock scene in Britain and America collectively entitled *All You Need Is Love* (1975–76); several well-received documentaries about composers Benjamin Britten and William Walton; and a number of theatrical features about Richard Wagner (*Wagner*, 1983), Puccini (*Puccini*, 1984), Handel (*God Rot Tunbridge Wells*, 1985), and Dmitri Shostakovich (*Testimony*, 1987). Although he had enjoyed a rather controversial reputation for his political editorializing and displays of graphic violence, Palmer displayed an unexpected reticence of technique and tone in this, his first foray into literary adaptation.

Timberlake Wertenbaker's script is faithful to the general outline of the novel. Like the book, the film opens with Martin Boyne on a steamer bound for Italy, where he anticipates a reunion with the recently widowed Rose Sellars. His mood is melancholy, he confesses in a letter to Rose; there is scarcely any worthwhile society on shipboard; and he is aware that his life holds no "adventures" for him. He goes on to note his encounter with a noisy brood of children in the dining salon. Later, docking in Venice, he discovers that the children belong to two old college friends of his, the boorish Cliffe Wheater and his neurotic wife, Joyce (Joe Don Baker and Geraldine Chaplin). Both Cliffe and Joyce have been married several times, and they display a distracted carelessness toward the care of the children and stepchildren. One day at the beach with the children, Boyne notices the eldest child, 16-year-old Judith, as she emerges from the breakers in her bathing suit—she seems to him a curious combination of innocence and experience.

In Switzerland, Boyne visits his former flame, Rose Sellars. Her husband died several months before, and now she seems disposed to continue a romance she had enjoyed with Boyne in their youth. Together during a walk, he knowingly ties a flower stem around her fourth finger, hinting he will soon replace it with something better. She demurs only slightly, indicating that they must take their time while details of her husband's will are settled. He greets her guardedness with some impatience. "Someone once said, a marriage is like two cannibals," he replies with more than a little cynicism, "each waiting for the other to go to sleep."

But Boyne's interest in Rose is soon distracted by his growing involvement with the Wheater children. They see in him the security they lack from their parents, and they come to him for his protection. Judith, in particular, seems inordinately attracted to him. She comes boldly to his bachelor rooms and playfully apologizes for detaining him from his plans with Rose. Her flirtatious behavior and offers of kisses, innocent though they may be, profoundly disturb and confuse him. Rose is quick to notice a change in his behavior. Significantly, when Boyne presents her with an engagement ring, he absentmindedly places it on the wrong finger of her hand. Dismayed at this turn of events, Rose returns Boyne's ring and leaves him. Free to direct his attentions towards Judith, he stammers and mumbles the beginnings of a proposal—but she misunderstands his words, interpreting them as a proposal to Rose.

Boyne is shattered. He goes back to Brazil. Years later, during a return visit to Paris, he runs into several of Judith's siblings. In a conversation he learns that the smallest of the children, Chip, has died of meningitis and that some of the other children have separated. That night, he attends a ball at the palace of Versailles. Outside the ballroom, he gazes through the window at the dancing figure of Judith. He stands there, silently, face inscrutable, unable—or unwilling—to enter the room.

His voice-over accompanies the image of a ship approaching from the distance in a golden light: "We go step by step into the darkness. The only truth is the movement; or so it seemed all those years ago when I, Martin Boyne, engineer of middle years, came across various children along the way of my adventure. So long ago."

Fade out.

Although Ben Kingsley is properly stiff and distant in his demeanor toward Judith and Rose, he displays little of the worldly airs with which Wharton endowed him. Kim Novak came out of retirement to take on the role of Rose, and her performance is a model of restraint. The real find here is Siri Neal, who made her film debut in the role of Judith.

True to his penchant for music, Palmer has liberally laced the scenes with excerpts from Benjamin Britten's *Gloriana*, Ralph Vaughan Williams's *Job: A Masque for Dancing*, and (during the ball scene), Khachaturian's "Waltz" from *Masquerade*. The *Job* music wells up during the final scene and under the credits. The pacing is stately, the location shooting in Switzerland, Bavaria, France, and Venice spectacular, and Nic Knowland's cinematography lends a wonderfully burnished light to the interior scenes. Although the *New York Times* critique praised the photography and the performances of Kingsley and Neal, it complained that the pacing was too leisurely and that what could have been "a beautiful, sad story" was instead "uninvolving and dated."

REFERENCES

Bell, Millicent, *Edith Wharton & Henry James: The Story of their Friendship* (George Braziller, 1965); Cahir, Linda Costanzo, *Solitude and Society in the Works of Herman Melville and Edith Wharton* (Greenwood Press, 1999); Fitzpatrick, Kathleen, "From *The Children* to *The Marriage Playground* and Back Again," *Literature Film/Quarterly* 27,

no. 1 (1999): 45; Lewis, R.W.B., *Edith Wharton: A Biography* (Harper & Row, 1975); Nevius, Blake, *Edith Wharton* (University of California Press, 1953); Stratton, D. "The Children," *New York Times*, May 30, 1990.

—*J.C.T.*

A CHRISTMAS CAROL (1843)

CHARLES DICKENS

Scrooge: or Marley's Ghost (1901), U.K., directed by W.R. Booth; R.W. Paul.

A Christmas Carol (1908), U.S.A., Essanay.

A Christmas Carol (1910), U.S.A., Edison.

Scrooge (1913), U.K., directed by Leedham Bantock; Zenith Film Co.

A Christmas Carol (1914), U.K., directed and adapted by Harold Shaw; London Film Co.

Scrooge (1922), U.K., directed by George Wynn, adapted by W.C. Rowden; Master Films.

Scrooge (1923), U.K., directed by Edwin Greenwood, adapted by Eliot Stannard.

Scrooge (1928), U.K., directed by Hugh Croise; British Sound Film Productions.

A Dickensian Fantasy (1933), U.K., directed by Aveling Ginever; Gee Films.

Scrooge (1935), U.K., directed by Henry Edwards, adapted by Seymour Hicks; Twickenham Films.

A Christmas Carol (1938), U.S.A., directed by Edward L. Marin, adapted by Hugo Butler; MGM.

Leyenda de Navidad (1947), Spain, directed by Manuel Tamayo; Panorama Films.

Scrooge (1951), U.K., directed by Brian Desmond Hurst, adapted by Noel Langley; Renown [released in the U.S. as *A Christmas Carol*].

A Christmas Carol (1960), U.K., directed by Robert Hartford-Davis; Alpha.

Scrooge (1970), U.K., directed by Ronald Neame, adapted by Leslie Bricusse; Waterbury.

The Passions of Carol (1975), U.S.A., directed and adapted by Amanda Barton; Ambar Films.

Mickey's Christmas Carol (1983), U.S.A., directed by Burny Mattinson; Walt Disney Productions.

A Christmas Carol (1984), U.K., directed by Clive Donner, adapted by Roger O. Hirson; Entertainment Partners [shown only on television in U.S.].

Scrooged (1988), U.S.A., directed by Richard Donner, adapted by Mitch Glazer and Michael O'Donoghue; Paramount/Mirage Productions.

The Muppet Christmas Carol (1992), U.S.A., directed by Brian Henson, adapted by Jerry Juhl; ITC.

The Novel

When Charles Dickens wrote *A Christmas Carol in Prose* in 1843, he did not necessarily intend to create a deathless and beloved work of literature. His aim was far more prosaic: to earn some much needed money. His current serial, *Martin Chuzzlewit*, was not successful, and the author—who supported not only a large family but also an impressive group of hangers-on—found himself neck-deep in bills.

There is no greater inspiration than poverty, but even at this low point in Dickens's life, his social concerns threatened to outweigh those of his personal life. While researching the subject for an article on the education of England's lower-class children—to be given the rather unwieldy title of "An Appeal to the People of England on Behalf of the Poor Man's Child"—Dickens was inspired to work some of his ideas about the poor into a seasonal story. In "odd moments of leisure" between installments of *Chuzzlewit*, Dickens wrote the story of miserly Ebenezer Scrooge's redemption in a frenzied period of only six weeks.

While writing *A Christmas Carol in Prose* its author was profoundly moved by it, writing that he "wept and laughed, and wept again, and excited [myself] in a most extraordinary manner in the composition." His was only the first of a countless number of such responses to his moral tale. Reading it today, or seeing the better motion picture versions, invariably inspires the same mixture of laughter and tears and good-hearted inspiration.

The story, in fact, has become so well known that it has transcended its origin as a work of fiction and has entered the public consciousness with the life-changing power of scripture. Even those who have never read Dickens's story, or seen any of the movie adaptations, know—as though by instinct—what a "scrooge" is and what "Bah! Humbug!" means.

In brief, *A Christmas Carol* concerns Ebenezer Scrooge, "a squeezing, wrenching, grasping, scraping, clutching, covetous old sinner," a miser who has gradually cut himself off from human warmth in his relentless pursuit of money. On Christmas Eve, he is visited by the ghost of his former partner, Jacob Marley, who warns him to expect three more ghosts over the next three days. The first takes Scrooge on a tour of his own bitter past, the second into the Christmas of the present, and the third into the darkness of an unpromising future. Scrooge is profoundly changed by what he sees and learns on these ghostly tours and vows thereafter to be a changed man, keeping the spirit of Christmas and generosity in his heart forever.

It barely needs stating that *A Christmas Carol in Prose* was, eventually, just as financially rewarding as Dickens hoped it would be. More important, it continues to be republished for, and reread by, new generations. Since its publication over 150 years ago, *A Christmas Carol* has never been out of print for so much as a single day.

The Films

As the 19th century wound to a close, a new medium—the moving picture—began to develop and grow. Filmmakers

wasted little time in turning to Dickens's classic stories; American Mutoscope presented *Death of Nancy Sykes*, an episode from *Oliver Twist*, as early as 1897.

In England, Robert W. Paul followed with several Dickens adaptations, including *Scrooge: or Marley's Ghost*, which was released in November 1901. Although we are not certain who played Scrooge in this first film version, Dickens scholar Michael Pointer finds a close similarity between its scenario and the then-current play written by J.C. Buckstone and starring Seymour Hicks; Pointer suggests that Hicks himself played Scrooge in this very brief (600 feet) movie. If this is the case, Hicks has the distinction of playing Scrooge on film more frequently than any other actor, for he also essayed the role in *Scrooge* (1913) and *Scrooge* (1935).

No matter how many times he played the part, Seymour Hicks was only the first of scores of actors who "Bah! Humbugged!" across the screen over the next nine decades—actors as distinguished as Albert Finney, Michael Caine, George C. Scott, and Alastair Sim. *A Christmas Carol* has been reincarnated countless times as spoof (*Scrooged* [1988]), musical (*Scrooge* [1970]), cartoon (*Mr. Magoo's Christmas Carol* [1962] and Disney's *Mickey's Christmas Carol* [1983])—even as pornography (*The Passions of Carol* [1975] with Mary Stewart as "Carol Screwge").

Television productions of *A Christmas Carol* are too numerous to mention, dating back to at least 1945. But if one counts the number of television series that refer to Dickens's story, or spoof it, the number of resulting Scrooges would block out the horizon.

But as plentiful as movie and television Scrooges have become, many actors have found something profound in the role; each must discover Old Ebenezer's essence and find a way to reinterpret and bring alive what is in danger of becoming a stock character.

Seymour Hicks's Ebenezer Scrooge is a crabby, cruel man whose reformation comes, we suspect, more because the script demands it than because he has understood the error of his ways. The great majority of actors play the role in a similar one-note fashion. In fact, although movie adaptations twist and fold the story, add and drop characters and events, and even change the time and place of the original story, the litmus test remains the ability of an actor to create a fully dimensional character who gradually reveals to us—as it is revealed to him—why Scrooge is the way he is, and why he is capable of change.

After Hicks's British sound version, Hollywood took on the story in 1938, casting Reginald Owen as Scrooge. This MGM version takes several unfortunate deviations from Dickens, each of which helps make Owen less sympathetic and renders his redemption unconvincing. Owen's Scrooge has no Belle to love and lose, nor any Christmas party at Fezziwig's to give him an example of a kind and benevolent employer. Worse, he has his change of heart while with the Ghost of Christmas Present, smiling widely and declaring, "I *love* Christmas!"—

an attitude that renders his bleak foray into the future a bit redundant.

George C. Scott's 1984 performance comes much closer to the heart of the character. He stubbornly holds on to his "principles" of being a stern businessman and an unsentimental, clear-eyed thinker, even as the three ghosts and their visions gouge deeper chinks in the armor of his spirit. Scott's Scrooge changes gradually, regresses, softens, hardens again. When at last he collapses in tears at his own graveside and, later, bounces exuberantly on his bed like an ecstatic child, it is easy to believe that he has survived a profound journey and undergone a terrific change.

The greatest of all Scrooges, the Once and Future Scrooge, remains Alastair Sim, who played the role in 1951, in what is also the finest, most thoughtful, most emotional screen adaptation of the story—*Scrooge*, directed by Brian Desmond Hurst. Sim's is a sardonic Scrooge, snarling out deliciously sarcastic dialogue straight from Dickens but unaccountably left out of most

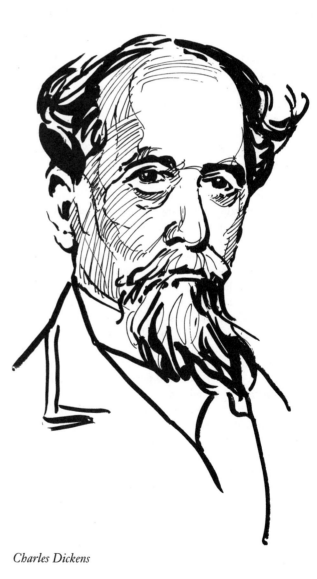

Charles Dickens

adaptations. Overhearing his nephew Fred and his employee Bob Cratchit exchanging fond Christmas greetings, Scrooge mutters to himself, "There's another fellow, my clerk, with fifteen shillings a week, and a wife and family, talking about a Merry Christmas. I'll retire to Bedlam!"

Christmas Past is given great emotional weight in this version, expanding upon Ebenezer's love for his frail sister Fan and using her death in childbirth as the source of his hatred for the nephew whom Scrooge blames for Fan's death. While Sim also dances joyously on his bright Christmas Morning After, there is also a keen sense of melancholy for "all of life's opportunities lost." When he approaches his nephew's house, he hears the folk tune "Barbara Allan" being sung within. It is music that we identify with Fan and it imbues the scene with a palpable sense of regret. Sim's *Scrooge* is the saddest of all movie adaptations of the Dickens classic.

Most of the supporting characters in *A Christmas Carol* change little from version to version. Bob Cratchit is always meek and sad, but optimistic and noble of heart. Nephew Fred is hearty and forgiving, Fezziwig fat and boisterous, Tiny Tim frail, ethereal, and pure.

On the other hand, Ebenezer's sister Fan—a rather minor character in the story—grows older and younger depending upon the film. In the 1938 film she is the child that Dickens describes although, for reasons of their own, the filmmakers changed her name to "Fran." Fan is a young woman in most other versions; and only in the 1951 *Scrooge* does she appear in any scene other than her schoolhouse meeting with young Ebenezer. To his dismay, Scrooge is brought by the Ghost of Christmas Past to her bedside as she is dying and watches his younger self storm angrily out of the room, flashing a look of hatred toward her newborn baby. Only now can he hear her last words, pleading with him to take care of her son.

Of the three ghosts, two are generally depicted on film as Dickens described them: the Ghost of Christmas Present is a large, bearded, bare-chested giant who wears a fur-trimmed robe and a wreath of holly and ice on his head. The Ghost of Christmas Yet to Come is always an ominous, faceless, speechless, black-robed figure.

However, Dickens's Ghost of Christmas Past is more problematic; it is described by the author as "like a child; yet not so like a child as like an old man." The ghost has long white hair, a wrinkle-free face and is physically small as though "having receded from view" and seen from a distance. The Ghost is a child in *The Muppet Christmas Carol*, an adult woman in the George C. Scott *A Christmas Carol*, an old man in *Scrooge* (1951), and a sexy young blonde in *A Christmas Carol* (1938).

All of the changes, however, are important only to the extent of their impact upon the spiritual and emotional message of the film. The endlessly repeated journey of Ebenezer Scrooge from bitterness, selfishness, greed, and loneliness to generosity, joy, thanksgiving, and love is satisfying on an almost primal level. We all believe that we are capable of change for the better and take comfort and

inspiration from the reformation of that "covetous old sinner." Though the details differ slightly from telling to telling, it is Charles Dickens's basic and eternal truth that keeps *A Christmas Carol* and its memorable people and ghosts always vital, ready to live again, and live forever.

REFERENCES

Farjeon, Eleanor, "Introduction," *Christmas Books by Charles Dickens* (Oxford University Press, 1994); Jacobson, Dan, "Charles Dickens," *Brief Lives* (Little, Brown, 1971); Pointer, Michael, *Charles Dickens on the Screen: The Film, Television and Video Adaptations* (Scarecrow Press, 1996); Tibbetts, John C. (under the pseudonym "Jack Ketch"), "The Man Who Invented Christmas," *The World & I* 8, no. 2 (December 1993).

—F.T.

THE CIDER HOUSE RULES (1985)

JOHN IRVING

The Cider House Rules (1999), U.S.A., directed by Lasse Hallström, adapted by John Irving; Miramax.

The Novel

In *The Cider House Rules* (1985) John Irving uses an orphanage to explore themes such as identity, self-discovery, and redemption, and to examine the controversial political issue of abortion. While he uses the omniscient point of view, Irving, for the most part, only allows his readers access to the thoughts of Dr. Wilbur Larch, the administrator of the orphanage at St. Cloud's, Maine, and Homer Wells, an orphan whom Larch unofficially adopts. Although the story is set primarily in Maine, readers also follow the Burmese and Ceylonese travels of Wally Worthington, who was shot down during World War II.

Larch, an obstetrician haunted by his refusal to perform an abortion on a woman who subsequently died from her efforts to abort her own fetus, now performs abortions for women who need them and also delivers babies whose mothers then put them up for adoption. Homer proves to be a difficult person to place and eventually remains at the orphanage. Larch loves him and teaches him medicine from *Gray's Anatomy*. Intent on being "of use," a recurrent theme in the novel, Homer reads from *Great Expectations* and *Jane Eyre* to the orphans, helps his mentor deliver babies, and also watches him do abortions, even though he vows never to perform one himself. His other mentor is Melony, who is his age and also proves impossible to place; she calls him "Sunshine," introduces him to sex, and gets him to promise not to leave her at the orphanage.

Homer does leave the orphanage, however, with Candy Kendall, who has Larch abort her fetus, and Wally Worthington, her rich boyfriend. They take him to Wally's home in Heart's Haven, where Wally's parents have an orchard and where Candy's father is a lobsterman. Wally's father drinks heavily and behaves eccentrically, and

everyone believes that the drinking causes his behavior. Homer describes the situation to Larch, who correctly diagnoses Alzheimer's disease. Because of his help and his skill in the orchard business, Homer stays on in Heart's Haven. Unfortunately, Homer loves Candy, his best friend's girlfriend; and she comes to love both Wally and Homer.

Meanwhile, Melony steals money and a coat from Mrs. Grogan, who is in charge of the girls' wing of the orphanage, and vows to find Sunshine. In her search for Homer she encounters two would-be rapists, whom she viciously beats. She then drives their truck to the orchard where they work, and she bullies the owner into giving her a job. At the onset of World War II she finds work at the shipbuilding plant in Bath, where she meets and falls in love with Lorna, who eventually betrays her, gets pregnant, and is sent by Melony to get an abortion from Larch.

Wally leaves the University of Maine to enlist, goes to flight school, and is shot down over Burma. He is the only one of his crew not found and is believed to be dead. In his absence Homer and Candy become lovers, and Candy gets pregnant. Since she is not sure about Wally's fate, Candy is unwilling to marry Homer, instead telling him that they have to wait and see, another recurrent motif. Claiming that they can be of more use at the orphanage, Homer and Candy go back to the orphanage, where Larch delivers her baby, which Homer says he has adopted and named Angel in honor of Nurse Angela at the orphanage. After planting some apple trees on the hillside at the orphanage in the spring, Homer, Candy, and Angel return to Heart's Haven. Before Candy and Homer can be married, Wally is found. Now paralyzed, he returns home and marries Candy.

Larch, who is having problems with two new board members at the orphanage, concocts a scheme to thwart his adversaries. Although Fuzzy Stone had died at the orphanage, Larch told the other orphans that Fuzzy had been adopted; he did not want to upset them. Using Fuzzy's name, Larch creates another person, a doctor, complete with transcripts, and manufactures a correspondence between himself and "Fuzzy," who opposes abortion. He intends to have Homer eventually assume "Fuzzy's" identity and replace him at the orphanage so that the dual roles of delivering and aborting can continue.

The narrative then switches to a time 15 years later. Wally's father and mother have died, and Wally, Candy, Angel, and Homer live together on the orchard farm. Angel does not know that Candy is his mother, and Wally may not know that Homer and Candy have discreetly slept together 270 times, with both of them keeping score. When the apple pickers, led by Mr. Rose and his daughter Rose, arrive, the plot takes an abrupt turn. Angel, now 16, falls in love with Rose Rose, who has a baby and is pregnant by her father. The long-absent Melony appears suddenly and tells Homer that he is no hero and has disappointed her by not telling everyone that Angel is his and Candy's son (Melony recognized Angel's parents at a glance). Larch, who had sent Homer his doctor's bag with

the initials FS, passes away while indulging in ether and is therefore unavailable to perform an abortion on Rose Rose. Homer now realizes that not only must the truth be told and his relationship with Candy ended, but also he must perform the abortion Rose Rose seeks. The abortion is performed, after which Rose Rose kills her father and flees. The truth is revealed, and Homer returns as Dr. Fuzzy Stone to administer the orphanage. The novel concludes with Melony's return to the orphanage as a corpse; she had wanted to be of use, like the corpses that she had earlier seen delivered to the orphanage for study by Larch and Homer. Fuzzy/Homer buries her among the apple trees on the hillside by the orphanage.

The last two pages of the novel provide updates to Larch's nightly words to the orphans. When he announces that a child has been adopted, Larch says, "Let us be happy for X. X has found a family." When he substitutes Melony's name, Homer means that her "family" is at the orphanage, just as his is. Larch also bids good night to the orphans by calling them "Princes of Maine, Kings of New England."

For Nurse Edna and Nurse Angela, Larch and Homer did indeed deserve those titles. In a sense, the novel focuses primarily on Homer's search for his identity. Like the Bedouin riding off into the desert before the credits in the swashbuckler film, Homer does not feel that he belongs; and that feeling is shared by Melony and by the minority migrant workers who are constantly on the move. Eventually he accepts the orphanage as his real home and becomes a real hero when he is of use and when he learns that some rules must be broken.

The novel's canvas is immense. There are hundreds of characters. There are several themes, including ecological and political ones. There is a wealth of information about subjects as diverse as apple growing, medical operations, torpedo making, raunchy limericks, and even a wrestling scene. *The Cider House Rules* runs a gamut of emotions from the black comedy of the station master's death to the tenderness Larch exhibits with Homer to the violence of Rose Rose knifing her father. Irving's ability to encompass such a mass of material has won him a National Book Award and has resulted in some of his books being adapted to film with varying degrees of success.

The Film

Because of its sprawling nature, the novel, like an apple tree, must be pruned; and Irving, who wrote the screenplay, lops off time, characters, and plots in order to produce a two-hour film. The film begins with baby Homer at the orphanage, shows two of his four unsuccessful adoptions, and then in 1943 he (Tobey Maguire) is a young man studying with Dr. Larch (Michael Caine), learning to deliver babies, and observing abortions. Irving includes Larch's goodnight words, the reading of Dickens, Hazel's adoption (with its "Let us be happy for Hazel. She has found a home"), and a woman's death because of a botched

abortion at the hands of a butcher. Her death provides Larch with the opportunity to show Homer, who does not want to perform abortions, the results of women not getting abortions from qualified people.

Candy (Charlize Theron) and Wally (Paul Rudd) appear at the orphanage, where she has her abortion, and they take Homer with them to Cape Kenneth, where Wally gives Homer a job. The rest of the film covers the next two years. During that time Homer and Candy fall in love. Also, Rose Rose (Erykah Badu) is impregnated by her father (Delroy Lindo), and Homer performs an abortion on Rose Rose (who later kills her father). Wally, now paralyzed from the waist down, returns home to Candy just as Homer leaves with the migrant crew and returns to the orphanage, where he becomes Dr. Homer Wells, thanks to Larch's forgery of diplomas.

Irving's script also omits Larch's background, which includes the gonorrhea he contracts from a prostitute. That sexually transmitted disease causes his addiction to ether, which eases his pain, and also leaves him with a scarred urethra and a "rocky" prostate. It is enough to convince him that "a life of sexual abstinence was both medically and philosophically sound." In the film Irving does not account for Larch's addiction, and he has him dallying and dancing with Nurse Angela (Kathy Baker).

Without details about Larch's past and the 16 years following Angel's birth, there are many missing characters, and Irving simply omits many characters who would be tangential in a film, but who add context to a novel. The most significant omission is Melony, who initiates Homer into sex, serves as a parallel to him, forces him to be honest with himself and others, and then comes "home," like him, to the orphanage to "be of use." To compensate for Melony's loss, Irving expands the role of Mary Agnes (Paz de la Huerta) to make her the orphanage love interest who is delighted at Homer's return and then seriously alters Mr. Rose's character. Unlike the sinister Mr. Rose of the novel, the film Mr. Rose loves his daughter, wants the fetus aborted, and then covers Rose Rose's murder by stabbing himself and getting people to say his death was a suicide. But Mr. Rose, ironically, becomes Homer's conscience. He repeatedly confronts Homer about his affair with Candy and asks him, "What is your business?" The crew's business is apples, Mr. Rose's is knives, and Homer finally accepts his as medicine. In effect, Mr. Rose forces Homer to see where he is of most use and where he belongs.

Other significant omissions include Debra Pettigrew, who is Homer's date when he goes to the drive-in with Wally and Candy. In the novel, it was Debra who taught Homer the "rules" of dating, a separate lesson from the sexual one taught him by Melony. Homer learned from Mr. Hood, his high school biology teacher, about the aftereffects of botched abortions by inept abortionists. From Wally's father, through Dr. Larch, Homer learned about Alzheimer's disease; and from the religious alcoholics who were Homer's fourth adoptive family Homer learned about buggery. The point is that the novel's Homer is sexually experienced (he "romantically" carries with him one of Candy's pubic hairs from her abortion), unlike the callow youth whom Candy seduces in the film. Candy is likewise changed. Her love for Homer is not the result of a slowly developing relationship that is deepened when they return to the orphanage to have her baby; it is because she is not good alone, a young woman who needs a sexual relationship and is ready to love the one she's with.

One result of having Wally on leave from the army is Homer's living with the migrants rather than in the Worthington home. His and Candy's betrayal of Wally is heightened in the novel since the affair is carried on while Homer sleeps in Wally's room and is treated like another son by Wally's mother. Homer is thus sanctified while Candy is cheapened in the film. By having Homer return in two years to the orphanage, Irving creates some problems with credibility. In the novel Larch had created a file of letters between himself and Dr. Fuzzy Stone, and when Homer assumes the doctor's identity, he is nearing middle age. In the film Homer has the credentials, but it is hard to imagine how any board of trustees could mistake him for a physician with years of training and missionary experience abroad. Moreover, all the orphans know Homer in the film; in the novel he can pass himself off as Fuzzy because all the orphans who knew him have left St. Cloud's.

The most significant problem with the adaptation is its lack of attention to the deepening relationship between Larch and Homer and its stress on Homer and Candy. Despite Caine's Larch receiving considerably less importance in the film than he has in the novel, Michael Caine's performance received an Oscar for Best Supporting Actor. If the novel had been made into a miniseries for television, Larch's role might have had its due but would have had to compete in the Best Actor category. The film's director, Lasse Hallström, who went on to direct quality films like *Chocolat* and *The Shipping News*, received an Oscar nomination for his direction of the film. In his memoir, *My Movie Business*, novelist-screenwriter Irving noted that Hallström was the fourth director on the project, on which Irving had worked for 13 years. The Swedish director inherited the project from Michael Winterbottom, whose treatment, Irving explained, "moved the screenplay back closer to the book," though it put too much emphasis on "a love affair that makes up less than a quarter of the story of the novel." Working with Hallström, Irving at least intended to make dominant the relationship between Dr. Larch and Homer Wells, "as it should be."

REFERENCES

Irving, John, *My Movie Business: A Memoir* (Random House, 1999); Irving, John, "There's Writing and There's Screenwriting," *New York Times*, November 14, 1999, 35, 37; Rooney, David, "The Cider House Rules," *Variety*, September 13–19, 1999, 48, 50.

—T.L.E.

THE CLANSMAN (1905)

REV. THOMAS DIXON JR.

The Birth of a Nation (1915), U.S.A., directed by David Wark Griffith, adaptation by Griffith and Frank E. Woods; Epoch.

The Novel

The second volume in a trilogy that included *The Leopard's Spots* and *The Traitor*, *The Clansman* is one of 20 novels by the former North Carolina Baptist minister Thomas Dixon, whose works are primarily ideological tracts attacking such early 20th-century movements as integration, feminism, pacifism, and socialism. Dixon promulgated vicious and ugly depictions of African Americans juxtaposed with romantic paeans to the glories of the pre-Reconstruction South. Deliberate in its extremist ideological message (as much as the famous Stowe novel *Uncle Tom's Cabin* to which Dixon's novels were responding), *The Clansman* conflates the genres of the Sir Walter Scott historical romance with Southern domestic melodrama to narrate a story of the evils of miscegenation and Reconstruction and the rise of the "glorious" Ku Klux Klan in response to "African enfranchisement." Dixon claimed his "romance" told the "true story" of American history "without taking a liberty with any essential historic fact"; this claim informs the repeated references to the historical accuracy of the film, which Griffith continued to defend for the rest of his life. Dixon later stated that one purpose of his play, *The Clansman*, "was to create a feeling of abhorrence in white people, especially white women against colored men . . . to prevent the mixing of white and Negro blood by intermarriage." Although now little studied, the novel and the play were quite popular, especially in the South, although nowhere nearly as successful as would be Griffith's adaptation.

The story has four major focuses: Abraham Lincoln, from the conclusion of the Civil War to his assassination; Austin Stoneman (loosely based on the Radical Republican House of Representatives leader Thaddeus Stevens, who, claimed Dixon, made a "bold attempt to Africanize the ten great states of the American union" after the war) and his struggle to control Congress during the Andrew Johnson presidency; Stoneman's move to South Carolina where he and his mulatto protégé Silas Lynch conspire to enfranchise the freed slaves; and the beginnings of the Ku Klux Klan to save the South from the rising power of freed blacks and Northern carpetbaggers.

The novel simultaneously relates the parallel stories of two families: the Camerons from South Carolina and the Stonemans from Pennsylvania. On opposing sides during the Civil War, they eventually join together in what Dixon envisions as a new, entirely Aryan, post–Civil War paradise, where "Civilization has been saved, and the South redeemed from Shame." Ben Cameron has fought gallantly in a battle where he is badly injured; he is nursed to health by the novel's heroine, Elsie, sister of Phil and daughter of Austin Stoneman. In the Reconstruction South, Ben's former sweetheart Marion is raped by the Camerons' former slave Gus; in mutual shame, Marion and her bereaved mother commit suicide. In rebellion against "Negro rulership," Ben and other disenfranchised Southern whites (joined by "Northerner" Phil Stoneman) form the Ku Klux Klan, which Dixon compares to a "picture such as the world had not seen since the Knights of the Middle Ages rode on their Holy Crusades"; they begin their "nights of terror" by capturing, trying, and killing Gus. Despite Austin Stoneman's best efforts, Northern troops are unable to quell the KKK; when his son Phil (in the guise of Ben) is almost mistakenly killed, Stoneman changes heart and realizes he has been wrong all along, subject to the wiles of his mulatto mistress. At the novel's end, Southern whites have regained power; the blacks have returned to servile obedience; and (Dixon's idea of) order is restored.

The Film

Griffith's film came primarily from three sources: Dixon's original novel, *The Clansman: An Historical Romance of the Ku Klux Klan*; the second novel in Dixon's original trilogy, *The Leopard's Spots: A Romance of the White Man's Burden, 1865–1900*; and the play *The Clansman: Four Acts*, which Dixon based on both novels and which was never printed. Famously, Griffith had no written script (although apparently co-scenarist Woods had previously written a planned adaptation of the original play a year before Griffith began filming, and Raymond Cook has claimed that Griffith and Dixon worked on a scenario before filming began), and critics have argued that Griffith "transformed rather than adapted" the original novel.

The scholarship surrounding the "textual" variants that comprise the film's history is as controversial as the ideology of the film. As Robert Lang summarized the problem: "not only was Griffith bent on improving his film after every subsequent screening he attended . . . but official censorship, Epoch's careless preservation of the negative and primitive methods of assembling release prints, and inexpert on-the-spot repairing done by projectionists after film breakage during projection in theaters make it impossible to identify something that could be called a 'true print' of *The Birth of a Nation*." What now remains is in any event significantly less racist than Dixon's original trilogy.

Griffith's major changes from the novel include a more sustained narration of Civil War battle scenes (which comprise most of part one); Silas Lynch's attempted forced marriage to Elsie; a more developed and dramatically effective depiction of two exciting rescues; the more "romantic" conclusion of the double marriages that represent the "birth of a new nation," a romantic subtext that Griffith expertly foreshadows in the film's opening scenes;

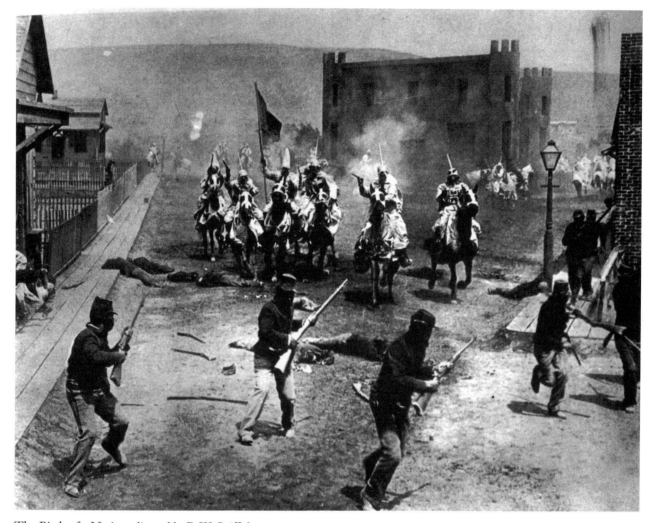

The Birth of a Nation, *directed by D.W. Griffith* (1915, U.S.A.; EPOCH/MUSEUM OF MODERN ART FILM STILLS ARCHIVE)

and an allegorical final shot of a peaceful and benevolent Jesus Christ ascending into heaven after seemingly vanquishing the God of War. In part, the film's success is due to Griffith's greater focus on the battle scenes, the domestic life of the Camerons, and the framing romance.

The film previewed under the title *The Clansman* in California in January 1915, but received its permanent title, *The Birth of a Nation*, at the world premiere in New York three months later. It was an instantly significant cultural and political event, changing the very nature of filmmaking and filmgoing, and immediately raising questions about the role of film in narrating history that would continue to inform criticism of history and filmmaking until the present day. Charging an unheard of $2 per ticket, the film went on to be the greatest moneymaking film until the release of another romantic vision of the South, *Gone With the Wind* (and some film historians claim it outsold even the Mitchell adaptation). Famously (although he later tried to deny it) President Wilson (one of Dixon's former classmates, and the author of a work that influenced

Dixon, *A History of the American People*) praised the film as "like writing history with lightning. And my only regret is that it is all so terribly true." At the same time, the film caused riots and massive national protest, especially from the NAACP. After the success of the film, Dixon went on to make five more films on his own, all adaptations of his own novels.

Griffith brought all the filmmaking techniques he had learned and developed while making more than 400 short films at Biograph to this elaborate, carefully constructed work. Even now it remains a riveting film experience, its expressionist power far exceeding many contemporary war films: the brilliant battle scenes; the emotional drama from the rhythmically edited sequence of Gus's attempted rape of Flora; the famous parallel editing detailing the KKK rescues of Elsie from Lynch and of Ben's sister Margaret. But it is absolutely impossible to talk about *The Birth of a Nation* without confronting the profound conflict between its grotesquely presented ideological message and its unquestioned genius; the film's conflation of accurate his-

torical detail with perversely misrepresentative "history" continues to inform controversies over contemporary American films. The film has been almost universally acclaimed the most important and most influential work in the early development of film. At the same time, it has been almost universally declaimed for its racist depiction of African Americans. Film historian Scott Simon terms it "one of the ugliest artifacts of American popular culture." For the 80 years since its release, it has continued to influence simultaneously both American culture and Hollywood filmmaking, and controversy along the "form versus content" line continues to dominate criticism.

Meanwhile, its status as an adaptation has long been obscured by the film's commercial success and the political dissent it engendered. Few people now even associate *The Birth of a Nation* with the little-known Dixon novel from which it came: The film has entirely eclipsed Dixon's novel. In a sense one can argue that the original text offers only the ideological message presented within a simplistically-imagined prose narrative, whereas the film has this same pernicious message, but now within a work of great art that helped define the very medium of filmmaking.

REFERENCES

Cook, Raymond A., *Thomas Dixon* (Twayne, 1974); Cuniberti, John, The Birth of a Nation: *A Formal Shot-by-Shot Analysis Together with Microfiche.* (Research Publications, 1979); Gunning, Tom, *D.W. Griffith and the Origins of American Narrative Film: The Early Years at Biograph* (University of Illinois Press, 1994); Lang, Robert, ed., *The Birth of a Nation*, Rutgers Films in Print series (Rutgers University Press, 1994); Rogin, Michael, "'The Sword Became a Flashing Vision': D.W. Griffith's *The Birth of a Nation*," *Representations* 9 (1985): 150–95; Schickel, Richard, *D.W. Griffith: An American Life* (Simon & Schuster, 1984); Silva, Fred, ed., *Focus on The Birth of a Nation* (Prentice-Hall, 1971); Simon, Scott, *The Films of D.W. Griffith* (Cambridge University Press, 1993); Stern, Seymour, "Griffith: I—*The Birth of a Nation*: Part I," *Film Culture* 36 (1965): 1–210.

—D.G.B.

CLEAN BREAK (1955)

LIONEL WHITE

The Killing (1956), U.S.A., directed by Stanley Kubrick, adapted by Kubrick and Jim Thompson; United Artists.

The Novel

Former police reporter and newspaper editor Lionel White began writing crime novels in 1953. After working as a true-crime writer, he specialized in the "caper" novel, stories dealing with the planning and execution of big-time heists.

The novel begins with vignettes depicting the various protagonists of the heist before they meet: Gambling addict and court stenographer Marvin Unger, racetrack barman Michael Henty, racetrack cashier George Peatty, and debt-ridden cop Randy Kennan gather at Johnny Clay's New York apartment to plan robbing the racetrack. The scheme is Johnny's brainchild. He has been released from prison after serving four years. Johnny has specially chosen these men, who have no criminal records but various money problems. Unger needs money for his gambling habit. Henty wishes to move his wife and wayward teenage daughter into a better neighborhood. Peatty wishes to buy the love of his flirtatious wife, Sherry, while Kennan has gambling debts.

Suspicious over George's secrecy, Sherry follows him to the meeting. When she listens outside, the men sense her presence and Johnny knocks her out. She convinces Johnny she heard nothing but in truth she has already informed her hoodlum boyfriend, Val Cannon, about her suspicions. The group decides to proceed with the robbery.

The heist goes according to plan on Saturday afternoon. But after beating information out of Sherry, Val and his gang arrive at Johnny's apartment to confront Unger, Henty, Peatty, and Kennan. A gun battle ensues leaving Peatty as sole survivor. Johnny arrives late to find the police present. He decides to leave for the airport. Believing Johnny seduced Sherry, Peatty goes in search of him. Johnny arrives at La Guardia Airport and meets his girlfriend, Fay. The mortally wounded Peatty mistakes Fay for Sherry and shoots Johnny. *Clean Break* concludes with a policeman pulling a blood-soaked newspaper from under Johnny's elbow. The headlines read, "Race Track Bandit makes Clean Break with Two Million."

The Film

Kubrick and Thompson use the basic structure of White's novel but change the ending and location as well as adding significant embellishments to the plot. The racetrack is now near San Francisco. Peatty kills his cheating wife after surviving the confrontation with Val, but he dies after shooting her. A random incident at San Francisco Airport involving a small poodle is instrumental in causing Johnny's rickety suitcase to fall from a baggage container and send the $2 million flying in the air at the conclusion of the film. Both novel and film utilize pseudo-documentary techniques popularized by *The March of Time* series and films such as *The House on 92nd Street* (1945), *13 Rue Madeleine* (1946), and *Boomerang* (1947). But the film has a very tight structure, beginning and ending on a Saturday. It introduces its characters as pieces in a chess game envisaged by Johnny's grandmaster scheme. But the sudden appearance of various unforeseen elements disrupts Johnny's carefully planned moves.

When Johnny recruits the philosophically natured Maurice, it is at a chess game. As he tells Johnny, "I often thought the gangster and the artist are the same in the eyes of the Master." The chess motif is a pattern appearing in

later Kubrick films. But it is never deterministic. Chance factors often destroy the most intricately conceived plans of either machine (*2001: A Space Odyssey, A Clockwork Orange*) or man (the gunnery sergeant's boot camp techniques in *Full Metal Jacket*). The overintrusive nature of the *March of Time* voice-overs in the film gives the commentaries a deliberate self-reflexive comedic satire.

Kubrick and Thompson add significant elements to the film, such as Unger's homoerotic feelings for Johnny. When Johnny diplomatically ignores his "offer" on the morning of the robbery, Unger disobeys him by turning up drunk at the racetrack. But his "unplanned" appearance helps Johnny escape from a cop. George is out of the room getting a drink when Val arrives. His random absence gives him an unforeseen advantage. Random and haphazard factors add various suspense elements in the latter part of the film.

REFERENCES

Polito, Robert, *Savage Art: A Biography of Jim Thompson* (Alfred A. Knopf, 1995); Nelson, Thomas Allen, *Kubrick: Through an Artist's Maze* (Indiana University Press, 1982).

—T.W.

A CLOCKWORK ORANGE (1962)

ANTHONY BURGESS (PSEUDONYM OF JOHN ANTHONY BURGESS WILSON)

A Clockwork Orange (1971), U.K., directed and adapted by Stanley Kubrick; MGM.

The Novel

Anthony Burgess's ninth novel has been called the most cogent and terrifying vision of things to come since George Orwell's *Nineteen Eighty-four*. Esteemed primarily for his work outside the science fiction field—he was a scholar, musician, and specialist in Joyce and Shakespeare studies—Burgess nonetheless wrote several dystopian futuristic visions, of which this is by far the best known. Set in the immediate future, *A Clockwork Orange* speaks to the social and political concerns of today—teen alienation, police state violence, dehumanized science, and soulless technology. The most ingenious feature of the book is its creation of "Nadsat," a private language shared by the antihero Alex and his hoodlum gang. What seems at first an unintelligible stream of gibberish, pop slang, onomatopoeic expressions, and puns (reflecting Burgess's Joycean predilections), Nadsat grows intelligible through repetition and context. Critic Alexander Walker explains that the equally enigmatic title implies that "it is far better for an individual to possess free will, even if it is exclusively the will to sin, than for him to be made over into a clockwork paradigm of virtue."

The novel is structured in three parts. The first section chronicles the activities of 15-year-old Alex and his droogs (friends) who, when they're not slugging down a hallucinogen called milk-plus at the local milkbar, are assaulting an old drunk, raping the wife of a left-leaning writer, and attacking a reclusive elderly woman who owns many cats. After Alex strikes the old lady with a bust of Beethoven, he is knocked unconscious by his companions and left to be arrested by the police.

In the second part the imprisoned Alex befriends the prison Charlie (chaplain) and learns about the government's enforced therapy for antisocial behavior, the "Ludovico treatment." Alex is injected with a powerful emetic and, eyelids clamped open, forced to watch films containing extreme graphic violence and pornographic images. He protests only when the music of Beethoven's Ninth Symphony accompanies a film of Nazi atrocities. Eventually, Alex is transformed into a "clockwork orange," a compliant and mindless citizen.

The concluding section begins when the "reformed" Alex is cast back into the streets, now helpless against his revenge-seeking former victims, the old drunk and the leftist writer. Alex is then turned over to the opponents of the government, who attempt through torture to reverse his conditioning. Driven beyond endurance, he dives out a window in a suicide attempt, but he survives the fall, and awakens in a hospital to find he is a local celebrity, hailed by the press as the victim of a criminal reform scheme. He returns home to his parents. The novel ends with Alex asking to hear Beethoven's "glorious Ninth." Referring to the violent fantasies he used to associate with it, he declares, "I was cured all right."

The Film

Kubrick's adaptation, his ninth feature film—sandwiched in between *2001* and *Barry Lyndon*—has aroused more controversy than any of his other works. Against charges by Pauline Kael that it is pornographic and appeals only to the prurient interests of its viewers, commentator Wallace Coyle claims it is a "savagely bitter satire of man and society that moves far beyond the preoccupation with sex and violence that has unduly concerned so many of its detractors."

While Kubrick faithfully captures the transformation of Alex (Malcolm McDowell) from juvenile monster to "clockwork orange"—Burgess's own voice is used for Alex's narrative voice-over, capturing at least a semblance of the Nadsat dialect—the critique of totalitarianism is not always as acute as Burgess's. The sheer inventiveness and flamboyance of John Barry's art direction and John Alcott's cinematography—the sleek, erotic statuary of the Korova Milkbar; the weird all-white combat suits of the droogs; the slapstick choreography of the rape of the writer's pregnant wife; the use of outsized phallus props (as in the scene where they harass the Cat Woman)—

Malcolm McDowell in A Clockwork Orange, *directed by Stanley Kubrick* (1971, U.K.; WARNER-POLARIS/ NATIONAL FILM INSTITUTE, LONDON)

tends to diminish the stark issues of the state's control over the individual.

When it comes to music, however, Kubrick goes Burgess one better. As with all of Kubrick's films, music is a vital counterpoint—and sometimes an outright contradiction—to the action. Walter Carlos's moog synthesizer realizations seem to envelope the droogs' violent acts in a sterile, dehumanized musical gauze. The gang rape of a young girl unfolds to the brisk sounds of Rossini's Overture to *La Gazza Ladra;* the rape attempt against two teenaged girls is accompanied by another Rossini work, the familiar overture to *William Tell.* Particularly memorable is Alex's mimicking of the Arthur Freed pop song "Singin' in the Rain" while attacking the pregnant wife of the leftist writer. At the end, after Alex's failed suicide attempt, gigantic speakers in his hospital room boom out the Beethoven "Ode to Joy" (the leitmotif of the entire film), the crowning moment in Kubrick's satiric attack on the hypocrisy of the state. Cut to Alex copulating with a blonde dressed only in stockings. "I was cured all right!" he notes sardonically. Over the end titles, Gene Kelly reprises "Singin' in the Rain."

Kubrick himself may be regarded as the very embodiment of the duality of Alex's world—the clash between those forces that manipulate and those that assert an uncompromising individuality. Rub those sticks together and you have a fierce combustion, indeed.

A Clockwork Orange won the New York Film Critics' Awards for best film and best direction, 1971. It was shot September 1970—March 1971 in MGM's British studios at Boreham Wood, England.

REFERENCES

Boytinck, Paul, *Anthony Burgess: An Annotated Bibliography and References Guide* (Garland, 1985); Coyle, Wallace, *Stanley Kubrick: A Guide to References and Resources* (G.K. Hall, 1989): Kael, Pauline, "Review of *A Clockwork Orange,*" *The New Yorker,* January 1, 1972, 52; Walker, Alexander, *Stanley Kubrick Directs* (Harcourt Brace Jovanovich, 1971).

—*V.P.H. and J.C.T.*

COLD MOUNTAIN (1997)

CHARLES FRAZIER

Cold Mountain (2003), U.S.A., directed and adapted by Anthony Minghella; Miramax

The Novel

Although Charles Frazier's National Book Award–winning *Cold Mountain* is ostensibly a Civil War novel, the war takes second place to the odyssey Inman, his protagonist, undertakes when he leaves the military hospital to find "his lost self" and to return to Cold Mountain, "another world, a better place," and Ada, the woman he left behind. Frazier even has Ada read passages from *The Odyssey* to her friend Ruby; and Balis, Inman's hospital roommate, continues his study of Greek, a study Inman later vows to continue. Like *The Odyssey, Cold Mountain* alternates between Inman's journey and Ada's patient waiting, like Penelope, at home.

The novel begins with Inman's view from his hospital bed, a view framed by the window through which he later escapes. In the opening chapter, Inman's talk with a blind man who sells chestnuts near the hospital leads to a discussion about whether it is worth it to possess something (sight, or a woman) for a short time and then lose it. Inman's willingness to have something, if only for a while, foreshadows the ending of the novel when Inman and Ada are reunited briefly, for about five days before he dies at the hands of the Home Guard.

In the next chapter, the focus is on Ada, and the novel then alternates between Ada and Inman. Ada, the spoiled and pampered daughter of a well-to-do minister who moves to Cold Mountain from Charleston, inherits Black Cove, a large farm, when he passes away. Unable to manage the farm, she relies on the generosity of her father's parishioners, particularly the neighboring Swangers, who

are concerned about her fate and well-being. They suggest that she will see her future if she bends over backwards and looks into their well, using a mirror. She sees a figure, but whether it is returning to her or is fading away is uncertain. This vision also foreshadows the end of the novel, when both interpretations prove to be true. By the end of the first chapter, Ruby, an illiterate but nature savvy young woman, arrives to assist Ada, but only if Ada treats her as an equal, not a servant.

Inman's odyssey resembles a picaresque novel, full of unrelated events and adventures. Since he is a deserter, Inman must avoid the Home Guard, which either returns deserters to the war, now a lost cause, or kills them. At times he looks back to the past and recalls the relatively short time that he and Ada had together before he left and the horrors of the battles, particularly Petersburg, he fought in. His first posthospital adventure involves being attacked by three men and then escaping on a ferryboat run by a young woman.

Inman then meets Veasey, a preacher who is about to throw his drugged and pregnant lover into a river. After returning the woman to her home, Inman ties Veasey to a tree and leaves a note explaining the situation. Inman is then taken in by a band of gypsies, who feed him; one of the young women reminds him of Ada. A few days later Veasey, who has been beaten by his congregation, rejoins Inman, who is understandably reluctant to travel with him. Veasey appropriates a crosscut saw, which he and Inman use to saw up a dead bull that is mired in a stream that is Junior's water supply. Junior then takes them to his house, where the lecherous Veasey has sex with one of Junior's sisters-in-law and then, after Junior has betrayed them to the Home Guard, helps Junior "marry" Inman to another sister-in-law. Veasey and Inman are chained to other deserters, and within a few days, all the deserters and Veasey are shot by the Home Guard (though in the film they are discovered by Union troops). The sole survivor, Inman, frees himself, returns to Junior's farm, and kills his betrayer.

After receiving a map from a slave who protects and hides him, a weakened Inman resumes his journey and is aided by an old woman who is a goat farmer, root woman, herbalist, philosopher, and illustrator of native plants. This is the novel's spiritual center. She heals Inman emotionally and physically. He later encounters a young woman whose husband has died in the war and who has a sick baby. She also helps Inman, then asks that he sleep with her, though without having sex. The next morning three Federal soldiers arrive and take the woman's hog; they almost capture Inman, who follows and kills all three, then butchers the woman's stolen hog for her so that she might survive the winter. Inman then resumes his journey, and, after hearing from Reid, a young deserter from Georgia hiding at Black Cove, eventually reaches Ada.

In the course of his journey, Inman thinks about the past—the battles he has witnessed, lacrosse games played with the Indians (including his native American friend Swimmer, seen but not named in the film), conversations under the stars—and hears many stories from the people he encounters. He travels with a donated copy of William Bartram's *Travels* as a companion, guide, and personal comfort, for much of the terrain Inman traversed had been described in the book, written some 90 years earlier (1773–78). Inman also becomes increasingly despondent about himself, wondering if what he has done and seen will make him unfit for Ada. Even his acts of kindness are tainted with violence.

With Ruby's help and urging, Ada begins to reclaim Black Cove. Working long days and learning about plants and farming transforms the Charleston debutante into a farm girl. Instead of cowering in a secluded haven near the farmhouse, Ada acquires skills her father had not considered proper for her. To get through the coming winter, she even sells her piano, the ultimate symbol of the Charleston life that she occasionally dreams about. Of course, as she reclaims the farm, she reclaims her selfhood and forges her own identity. Ada continues to write to Inman, although she does not get many letters from him. Their correspondence is formal, rather than romantic, since they had agreed not to speculate about what their relationship would be after his return.

Compared to Inman's adventures, Ada's seem tame, but they are nevertheless profound, since they make her a woman; Inman was a man, albeit a fairly innocent one, when he left. What little action that occurs in *Cold Mountain* involves a rogue named Teague and his Home Guard, a nefarious bunch who are using the war to take land from people who harbor deserters. Ada hears Esco Swanger describe how Teague and his men tortured a woman by pressing fence rails on her hand, and a captured deserter tells people how the Home Guard kill a man and his two sons who are deserters. When Ruby finds her father, Stobrod, also a deserter, caught in her trap by the corn crib, Ruby and Ada are aware that providing help to him and Pangle, his simple pal, may cause them to forfeit Black Cove (though this threat belongs more to the film, which emphasizes Teague's claim to all the farms on Cold Mountain).

Stobrod, an irresponsible degenerate, has been redeemed by music; and he and his suspicious daughter Ruby, whom he neglected as a child, are eventually reconciled. Before that can occur, however, Teague and his Home Guard find Stobrod and Pangle and shoot them, after the two have performed musically for their entertainment. Reid, another deserter, sees the shootings and runs off to tell Ada and Ruby. When they return to the murder scene, they find Pangle dead and Stobrod badly wounded. They take Stobrod to an abandoned Cherokee village, where he is healed and sheltered. Ada, who has never fired a gun, succeeds in killing two turkeys and then finds a stranger in her sights. That stranger, Inman, recognizes her, but she is slow to identify him.

Together they return to the Cherokee village and spend the next five days tending after Stobrod, planning their futures, and making love. Of the three options they

have, they choose to leave Cold Mountain and go to Georgia, where they will be free of the Home Guard. (The other choices were joining the Federal forces or going back into the Confederate Army.) As they begin their journey, however, they meet Teague and his Home Guard gang of four. Inman kills Teague and three of the others, but the youngest killer is too quick for Inman, who is mortally wounded. In the epilogue, which occurs eight years later, Ada and her daughter, Ruby and Reid and their three kids, and Stobrod gather together for a communal meal, and Ada reads them the appropriate tale of Baucis and Philemon, two classical lovers who are metamorphosed into an oak tree and a linden tree, apt symbols for Inman and Ada.

The Film

"Adaptation is an act of thievery," Anthony Minghella wrote in his introduction to the Newmarket Press book on the making of the film. "Beautiful stories are plundered, seemingly in the most perverse ways. The literature, a novel's flesh, the very thing that makes the novel memorable, is discarded. The screenwriter is more concerned with the gristle of situation, with the small bones of the story's architecture." The director guards against being "captivated by the prose, or its contours." He approaches the task "without the book at hand," a storyteller determined to tell a fresh story. "The novel's delicious peregrinations, its asides, its tricks with point of view, must remain unscathed, waiting to be discovered and appreciated. Viewers of *Cold Mountain* can become readers of Charles Frazier's book." But the film ultimately goes its own way.

Minghella's adaptation essentially captures the plot of the novel, while altering some of the characters (and omitting several others), and emphasizing both the love story and the battle spectacle. In an effort to provide more structure to the plot, the adaptation merges the material about the Home Guard's torturing a woman and killing the father and the sons and then has the Swangers become the victims of these atrocities. Sally Swanger (Kathy Baker) is seen later among the "family" that gathers for the communal meal at the end of the film. The film also alters Inman's ferry ride across the Cape Fear River; in the film Inman is joined by Veasey, and the girl is killed, whereas in the novel Inman and the wild girl are beyond the range of sharpshooters on the far bank. Similarly, the film expands the role of Teague (Ray Winstone), who appears at the welcoming celebration for Ada (Nicole Kidman) and Monroe, her father (Donald Sutherland), later tells Ada that Inman (Jude Law) will not return home, and then makes advances to Ada. The film shows Inman helping to build the church for Rev. Monroe and meeting Ada there. Moreover, Ada takes Inman a refreshing drink while he works—even though this would have been totally inappropriate behavior for a Southern belle. At the showdown, Ada plays an important role; in the novel, it is Inman's show.

Almost all of the stories in the novel are omitted: of the omissions, Odell's story is the most significant. Odell, the son of a wealthy plantation owner, falls in love with a slave. When she becomes pregnant and he wishes to marry her, his father sells her. The distraught Odell strikes his father, leaves home, and tries to find her. As he searches unsuccessfully, he is reduced to becoming an itinerant peddler. As in most odysseys, a subplot echoes the main plot: As a man searches for his lost love, he becomes reduced in circumstances but perseveres. The goat woman's story also involves lovers who are parted. Even Monroe's story about his marriage to Ada's mother involves a betrayed lover who later recaptures the woman he loves. Blount's story, which depicts the fear felt by some of the rebel soldiers, is also missing.

Other omissions stem from attempts to move the plot along, forsaking long tales and mythological stories for action, "moving" pictures. Ruby's comments about suiting farm activities to the seasons and digressing about learning from crows (the novel also stresses Inman's comments about crows and flight) are likewise omitted. Occasionally, as in the case of Swimmer (Jay Tavare), the omissions may cause viewers unfamiliar with the novel to become confused. In the novel Swimmer is a Cherokee who plays lacrosse with Inman and makes him a stick; in the film he is a valiant soldier who seems to be on close terms with Inman, but why he is remains a mystery.

Other changes involve softening Inman's character. There is no "marriage," for example; Inman does not shoot the bear cub that remains after its mother has fallen off the cliff; the gypsy girl does not remind him of Ada, and he does not shoot all three of the Federal soldiers who steal the young mother's hog. He cannot bring himself to shoot the third soldier, the one who had shown compassion for the child; but the child's mother has no hesitation about gunning him down.

The episode involving Veasey (Philip Seymour Hoffman), whose humorous hypocrisies and mock-heroic lines provide much needed comic relief in the novel, and his attempted murder of his mistress is also changed, perhaps to make his crime more serious in the film. In the novel, Veasey's mistress is white, and her pregnancy, considering his betrothal to another woman and his stature as a minister, understandably results in his beating. More than a century later an affair like this involving a "man of God" might seem almost trivial. As a result, in the film the mistress is black. In addition, the Home Guard's inexplicable shooting of Veasey, Inman, and the other prisoners is altered in the film. When the Home Guard sees Federal troops, Inman and some other prisoners rebel against their captors and, in the ensuing battle, all except Inman are killed. His change softens the Home Guard (one unit not under Teague's command in the film) and demonstrates Inman's courage.

Because the media differ, much of the "literary" material (Balis's translation, the tale of Baucis and Philemon) is gone, replaced by action. The film opens with the siege

and massacre at the Battle of Petersburg rather than beginning with Inman's perspective from his hospital bed. What is missing from the film is, in fact, a sense of Inman's perspective as he attempts to recover his "lost soul." In the film Inman acts, in the novel he acts and then ruminates about his actions. To compensate for these deletions, the script stresses the love affair between Ada and Inman by using voice-over excerpts from letters (the film begins with those letters).

The way the shootout is treated illustrates the difference between the two media. In the novel Inman "has the drop" on the last of the Home Guards, but the boy moves his hand "quicker than you could see." Inman's death at the boy's hands is inexplicable, unless Inman, who has had his brief time with Ada and knows that he has no real options, allows himself to be shot. At the very least, the manner of his death is ambiguous. In the film the final confrontation is pure Hollywood. Inman and the boy, who are both on horseback, draw simultaneously; and the boy falls dead to the ground. Inman seems at first to be unscathed, but then the audience, warmed by the apparent outcome, discovers that he, too, has been wounded. In its broader design, the film is faithful to the novel.

Inman is the anchor of the plot, rougher and more dangerous in the novel, and always armed with his distinctive double-barreled pistol. Inman is not a man to be trifled with. Jude Law falls short of Inman's quiet desperation, nor are his wounds as serious. In general, however, the acting in the film is excellent, although some reviewers found the older, blonde Kidman not exactly the dark-haired young Ada of the novel. Neither Kidman's coiffeur nor her baby fat seems to have suffered from the near starvation and demanding grind of farm work. Renée Zellweger, who seems to relish taking on a wide variety of roles, seems, in contrast, absolutely on target playing a Ruby in the rough. Golden Globe nominations went to both actresses, as well as to Jude Law, Minghella for his scripting and direction, and to the film itself, but that signifies mere popularity.

The art direction and historical reconstruction is difficult to fault in this adaptation, which was filmed in the Carolinas and Virginia then in Romania's Transylvanian Alps, in the mountains outside of the Saxon city of Braşov. As a civil war epic, the film holds up in its opening battle sequence; but the story has more to do with the journey home than with the Civil War proper, drawing towards its conclusion over the mountains to the east. The novel creates a sense of fatality yet stoic reflection and harmony, and a grasp of the past that goes beyond mere art direction and set design. That calm novelistic reflectiveness gets lost, and, to quote Charles Frazier, "What you have lost will not be returned to you. It will always be lost."

REFERENCES

Denby, David, "Star Season," *The New Yorker*, December 22 and 29, 2003, 166–168; Gleiberman, Owen, "Civil Rites," *Entertainment Weekly*, January 9, 2004, 56–57; Griffin, Nancy, "Making Love and War," *Premiere*, December 2003/January 2004, 102–108; Sunshine, Linda, ed. *Cold Mountain: The Journey from Book to Film* (Newmarket Press, 2003).

—T.L.E. and J.M. Welsh

THE COLLECTOR (1963)

JOHN FOWLES

The Collector (1965), U.K./U.S.A., directed by William Wyler, adapted by Stanley Mann, John Kohn, and John Fowles (uncredited); Columbia.

The Novel

The Collector, John Fowles's first published novel, appeared in 1963. Fowles developed an idea for a modern-day variant of the "Beauty and the Beast" tale. It achieved a limited success: He was published and critically noticed, but in some quarters his novel was regarded as little more than a well-crafted crime thriller. It took the publication of *The Magus*, *The French Lieutenant's Woman*, and *Daniel Martin* to solidly confirm his status as novelist and to compel critics to give his first novel another, more respectful look. Most of Fowles's mature themes and stylistic methods, such as power differentials between social classes and authorial use of multiple story lines, are also present in *The Collector*.

Part one of *The Collector* is told from the point of view of Frederick Clegg, a government employee whose only diversions have been the collecting of butterflies and his furtive observations of Miranda Grey, a student at a London art school occasionally home to visit her family. When Clegg wins a sizable fortune in the pools, his new wealth allows him to quit his job and move to London. In London, the virginal Clegg cultivates a heretofore restrained taste for photography and pornography. Soon dissatisfied with his pornographic collecting, Clegg finds Miranda's art school and begins to shadow her movements. He fantasizes about their future life together, but after his purchase of an isolated rural cottage with a large double cellar, his fantasies become decidedly sinister. He kidnaps Miranda in the hope that, given time as a "guest" in his cellar, she will come to love him. Toward this end, he provides her with everything she asks for in terms of material comforts: meals, baths, clothes, books, art supplies. In the first few days of her captivity, Miranda attempts to negotiate the terms of her "visit" and then to escape. This establishes the pattern of Clegg and Miranda's relationship for the duration of the narrative: She bargains for more privileges, Clegg compromises and then recants, she tries to break out. After each escape attempt, Clegg grows increasingly angry with Miranda. Part one concludes with Miranda's failed seduction of Clegg in the vain hope that sex might break the stalemate and force him to keep his promise to release her on a predesignated date. However, all her ploy does is enrage him to the point that he feels

free to bind Miranda, now weakened by neglect, starvation, and imminent pneumonia, and repeatedly photograph her nude body.

Part two recounts the same series of events from Miranda's point of view as written in a journal she hides beneath her bed. She is a much more self-aware and articulate narrator than Clegg. She despises her captor ("Caliban," as she calls him) not just because he holds her prisoner but because he lacks artistic ability and taste, conforms to middle-class prejudices, and possesses money without wisdom. Her conversations with Caliban, born out of her loneliness, do not satisfy her intellectual desires. To escape the monotony of her daily existence, she contemplates her past, particularly her complicated attraction toward an older artist named G.P. As she grows more desperate in a confinement she knows will end only with her death, she loses faith in a benevolent god and learns to "hate beyond hate." Her journal ends with her feverish protests that she does not want to die. Part three reverts to Clegg's point of view while he debates whether to take the plainly ill Miranda to a doctor. He delays any significant decisions until Miranda dies. In part four, Clegg buries her in his yard and contemplates another kidnapping, this time of a local shopgirl named Marian.

The Film

William Wyler's 1965 cinematic version of *The Collector* stars Terence Stamp as Clegg and Samantha Eggar as Miranda. Wyler's immediate challenge is to translate the novel's two interior monologues and extremely limited setting into the visual medium of film. He does so by reshaping Fowles's complex narrative into a traditional chronological plot line and substituting dynamic, visually expansive sequences for Fowles's quieter, more claustrophobic original scenes. For example, the film begins with a long tracking shot on Clegg, during an entomological field trip to the country, running into and then exploring the empty cottage in which he will imprison Miranda (as opposed to learning of its existence in a newspaper advertisement). Wyler takes every opportunity to move his camera out of the cellar prison, thus opening up the film frame but losing the sense of claustrophobia so crucial to Fowles's story.

Because of the overriding necessity to maintain suspense for a general cinematic audience, Wyler emphasizes the more melodramatic aspects of Fowles's narrative: Clegg's extended stalking of Miranda, the kidnapping itself, Miranda's escape attempts, her climactic and bloody fight with Clegg. Toward this end, Wyler inserts an entirely new scene wherein a local busybody interrupts Clegg as he allows Miranda to take a bath in the main house. Clegg must then attempt to shoo away the intruder, who keeps edging farther and farther into the house in a not-so-subtle attempt to check out Clegg's surroundings. Meanwhile, in the upstairs bathroom, a bound and gagged Miranda manages to open the tub faucets all the way, causing an overflow that eventually spills down into the hallway where Clegg and his visitor stand. Clegg must hurriedly improvise an excuse for his suspicious visitor: His girlfriend, embarrassed to be caught in such compromising circumstances by a stranger, didn't call out for help when she was unable to shut the faucets down. "You know how it is," Clegg finishes. The old man harrumphs and says, "I used to," providing one of the film's rare touches of humor. The joke also defuses the tension of a scene where the audience has identified both with Clegg's nervousness and Miranda's desire to escape.

The decision to favor plot contrivance over character study, however, is not without sacrifice. Miranda's psychological reactions to her plight become entirely subordinate to the screenplay's focus on Clegg's actions. The horror-film spectacle of her attempts to escape Clegg assumes narrative primacy, and therefore much of the depth of her characterization is lost. Similarly, Clegg as portrayed by Terence Stamp resembles nothing more than *Psycho*'s Norman Bates in an English setting. Fowles's unflinching examination of Clegg's sexual psychopathology has also been diluted, probably in the interests of not offending the ratings boards, through the deletion of the climactic bondage scenes. Fowles himself, who had an uncredited hand in drafting the screenplay, was unsatisfied with the film, in spite of its Academy Award nominations for best director, best screenplay, and best actress.

REFERENCES

Aubrey, James R., *John Fowles: A Reference Companion* (Greenwood Press 1991); Foster, Thomas C., *Understanding John Fowles* (University of South Carolina Press, 1994).

—P.S.

THE COLOR PURPLE (1982)

ALICE WALKER

The Color Purple (1985), U.S.A., directed by Steven Spielberg, adapted by Menno Meyjes; Amblin Entertainment/Warner Brothers.

The Novel

Alice Walker's Pulitzer Prize– and American Book Award–winning third novel, *The Color Purple* (1982), catapulted her into the national spotlight. Neither her first two novels—*The Third Life of Grange Copeland* (1970) and *Meridian* (1976)—nor her poetry—*Once: Poems* (1965) and *Revolutionary Petunias* (1973)—nor her short story collections—*In Love and Trouble* (1973) and *You Can't Keep a Good Woman Down* (1981)—had achieved significant popularity, although scholars had acclaimed them. Her fiction and poetry feature vulnerable African-American women surviving in a hostile, patriarchal world by discovering their inner strength.

In an essay, "Writing *The Color Purple*," Walker asserts that she knew immediately that she had discovered the germ of the story when her sister Ruth, talking about a lover's triangle, said, "And you know, one day The Wife asked The Other Woman for a pair of her drawers." Walker adds, "Instantly the missing piece of the story I was mentally writing—about two women who felt married to the same man—fell into place."

Written in an epistolary form of letters from (and to) the main character, Celie, to God and her sister Nettie, the story spans 30 years, from about 1910 to 1940. Repeatedly raped by her "Pa" (later revealed as her stepfather), Celie bears two children, Adam and Olivia, both of whom are taken away from her and adopted by Samuel and Corrine, who with Nettie serve as missionaries to the Olinka tribe in Africa. Celie's "Pa" gives her to Mr.__ (later identified as Albert Johnson), as wife and new mother to Mr.__'s unruly children.

Mr.__ also abuses Celie until the peripatetic blues singer, Shug Avery, Mr.__'s true love (and eventually Celie's lover), whom Celie has nursed back to good health, intervenes and convinces her to stand up to him. Celie eventually leaves Mr.__ to live with Shug in Memphis, where Celie's skill at designing pants for women begins to earn her money, which, in turn, strengthens her sense of self worth. Before Nettie returns from Africa with Celie's grown children, Celie learns that she has inherited her family home, and the novel ends happily with the family reunion and with the rehabilitation of Albert from spouse abuser to sensitive man.

The Film

Steven Spielberg's 1985 adaptation follows the general plot somewhat faithfully and, occasionally, literally. However, in pre–*Schindler's List* Spielberg style, the movie turns the male characters into caricatures, especially Harpo, Mr.__'s oldest child, whose slapstick leitmotif of falling through roofs provides comic indigestion instead of relief. Even the detestable Mr.__ falls into bumbling buffoonery anticipating the first arrival of Shug.

In typical Hollywood fashion, Spielberg and Meyjes turn dramatic silk into a melodramatic, schmaltzy sow's ear with an invented dueling voices scene: Shug's at Harpo's juke joint vs. an unnamed lead choir singer in the church. Predictably, Shug chimes in with her bluesy version of the gospel and leads a procession that bursts into the church and turns religious service into spectacle ending with a reconciliation between Shug and her estranged preacher-father. Another invented sequence crosscuts between Celie preparing to shave Mr.__ (and possibly to slit his throat), Shug running back to prevent that possibility, and "Nettie in Africa dashing to a ritual of initiation" involving scarification.

Some of the movie's stunning visual imagery helps explain the close relationship between Celie and Nettie as well as the title: a meadow of purple flowers serving as a backdrop for childhood scenes and for Shug's assertion to Celie: "I think it pisses God off if you walk by the color purple in a field somewhere and don't notice it." Not surprisingly, Spielberg mutes the novel's explicit sexual relationship between Celie and Shug by showing only one scene of them—fully clothed—flirting with, and finally kissing, each other in a passionate embrace and by omitting the entire Memphis episode (except for their departure on the train).

Pauline Kael admits Spielberg wanted to make a "serious" movie, but that he probably liked Celie's childlike character and "the book's lyrical presentation of the healing power of love" more than he did the seriousness of the story. She also asserts that "visually, the picture suggests *Song of the South* remade by Visconti."

Controversy about the novel's treatment of African-American males as mostly one-dimensional brutes surfaced in early reviews, but seemed overshadowed by the acclaim and likely by a felt need for the African-American community to present a unified front. Writing in *The New York Review of Books*, Robert Towers notes that "the women on the whole support each other warmly and band together against the common enemy: man." In the same breath, he reports the "current male-female antagonisms within the black community." African-American novelist Ishmael Reed also spoke out against Walker's general treatment of males. However, when the movie appeared, protesters picketed screenings, complaining about the further demonization of black males by whites and finding easy targets in Spielberg and Meyjes (and in white studio executives). Ironically, the movie allowed the protest to transfer from within to the outside of the black community.

REFERENCES

Kael, Pauline, *Hooked* (Abrahams-Dutton, 1989); Towers, Robert, *Emerging Voices: A Cross-Cultural Reader*, eds. Janet Madden-Simpson and Sara M. Blake (Holt, 1990), 358–59; Walker, Alice, *The Color Purple* (Washington-Simon, 1982); "Writing *The Color Purple*," in *In Search of Our Mother's Gardens: Womanist Prose by Alice Walker* (Harcourt, 1983); Winchell, Donna Haisty, *Alice Walker*, Twayne's United States Authors Ser. 596. (Twayne, 1992).

—*J.A.A.*

COMO AGUA PARA CHOCOLATE (1989)

See LIKE WATER FOR CHOCOLATE.

THE CONFORMIST (1951)

ALBERTO MORAVIA

The Conformist (1970), Italy, directed and adapted by Bernardo Bertolucci; Mars Film/Marianne Prods./Maran Film.

The Novel

Alberto Moravia, who died in 1990, was one of the most respected Italian novelists of the 20th century. Many of Moravia's novels have been adapted for cinema, for at least two reasons: They have a surface realism, so that translation into images is not highly problematic; and they emphasize psychosexual material, which provides dramatic and voyeuristic opportunities for the cinema. *The Conformist* is Moravia's meditation on why an ordinary man becomes a fascist, written at a time when this was a central question in the popular imagination.

Marcello Clerici, the only child of inattentive parents, lives in a comfortable villa in Rome. On the way home from school, Marcello meets a chauffeur named Lino, who promises him a revolver as a present. On his second visit to Lino's house, the older man makes sexual advances, and Marcello shoots him with the promised revolver.

After this prologue, Marcello, now an adult, goes to a library and finds a newspaper notice of Lino's death. Marcello, a minor official in the fascist government, is engaged to Giulia, a pretty but otherwise average young woman. Marcello is seeking "normality," in every way.

To prove himself to his superiors, Marcello volunteers to contact his former professor, Edmondo Quadri, in Paris—Quadri is now an antifascist leader. His bosses agree, so Marcello and Giulia spend their honeymoon in Paris, and visit Quadri and his wife Lina. The Quadris are welcoming, though they know Marcello is an Italian agent. As a further complication, Marcello is violently attracted to Lina Quadri, but Lina is sexually interested in Giulia.

Orders change, and Marcello is now required to give information that will aid in the murder of Quadri. He communicates to Manganiello, a fascist assassin, that Quadri plans to drive alone to his vacation home in Savoy. But at the last moment Lina decides to accompany her husband, and both are ambushed and murdered on the way to Savoy.

The novel's final episode takes place just after Mussolini's fall from power. Marcello, in his quest for normality, has identified himself with the disgraced regime. He has even been involved in murder for the regime. His career and perhaps his life in jeopardy, Marcello wanders with Giulia through a celebrating Rome. Amazingly, he meets an older but still recognizable Lino; the newspaper article had misreported Lino's death. So, Marcello's obsession to prove himself normal was based on an error. The next day, Marcello is killed by a strafing plane as he drives his family to the relative safety of the country.

The Film

Bertolucci made many changes to *The Conformist*. First of all, the film is told mainly in flashback. The flashbacks, not always chronological, are presented as Marcello sits huddled in Manganiello's car, en route to the assassination. Second, the film includes new characters (e.g., Marcello's friend Italo, a blind radio commentator) and new scenes (e.g., the assassination of the Quadris in the snow). Third, as T. Jefferson Kline points out, the film has a dreamlike quality, with many visual and narrative doublings.

The film of *The Conformist* is an extraordinary visual experience, with high-contrast lighting, expressionist settings, and gliding camerawork. The flashbacks are often disorienting, as are the compositions and camera angles. In its narrative and visual complexity, *The Conformist* is in many ways reminiscent of *Citizen Kane*. Vittorio Storaro, gifted cameraman for *The Conformist*, mentions in the documentary film *Visions of Light* that he was strongly influenced by Gregg Toland, and Bertolucci was influenced by Orson Welles.

Jean-Louis Trintignant, who plays Marcello, has been a positive character in so many films that it takes some effort to understand that he is unsympathetic here. But perhaps that is what Bertolucci wants—to encourage our identification with Trintignant, then to wean us from that identification. Marcello turns out to be a despicable character. In the assassination scene, he offers no help to Professor and Mrs. Quadri, even though he respects the one and loves the other. Further, because he does not actively take part in the murders he is despised on the fascist side, as well.

Near the end of Moravia's novel, Lino tells Marcello that we all lose our innocence, and that *this* is normality. The child molester speaks the novel's moral. Bertolucci's ending is even more troubling. In the film's final images of Rome at night, Marcello sits turned away from a child on a bed. The child, it is clear is *not* an innocent. But by turning away from this aspect of himself, Marcello becomes a conformist, a fascist, and a killer.

The Conformist is a fine novel and a better film.

REFERENCES

Cottrell, Jane E., *Alberto Moravia* (Ungar, 1974); Kolker, Robert Phillip, *Bernardo Bertolucci* (Oxford, 1985); Kline, T. Jefferson, "The Unconformist," in *Modern European Filmmakers and the Art of Adaptation*, eds. Andrew Horton and Joan Magretta (Ungar, 1981).

—P.A.L.

CONTACT (1985)

CARL SAGAN

Contact (1997), U.S.A., directed by Robert Zemeckis, adapted by James V. Hart and Michael Goldenberg; Warner Bros.

The Novel

In 1980 Carl Sagan, with his wife Ann Druyan and writer-producer Lynda Obst, wrote an original movie treatment about a young woman's voyage to the stars. Five years later

Sagan expanded it into novel form under the title *Contact*. Previously, the literature of science fiction had only a few books about first encounters with extraterrestrials to rival *Contact*'s philosophical depth and scientific rigor (Arthur C. Clarke's *Childhood's End* and Pournelle and Niven's *The Mote in God's Eye* come to mind). Clearly, it was not Sagan's intention to spin out just another swashbuckling space opera; rather, it was to write both a semiautobiographical account of his experiences as a radio astronomer and to furnish a polemic about the importance of searching the skies for extraterrestrial intelligence. Scarcely a novel at all, it was filled with lengthy disquisitions on mathematics and theoretical physics and peppered with extended debates between religion and science, emotion and intellect, poetry and prose idea and action. Unfortunately, these effusions sometimes retarded the narrative pace and flattened the characterizations.

Since childhood Ellie Arroway had displayed a precocious grasp of physics, mathematics, and astronomy. The death of her beloved father, a shopkeeper, and her mother's subsequent remarriage to a college professor of physics—whom she despised—enforced in her a lonely independence. The starry night sky became her only friend. In college under the tutelage of Professor David Drumlin, she studied radio astronomy. Later, while working in New Mexico as the director of Project Argus, a VLA (Very Large Array) field of 131 linked dish-shaped radio telescopes positioned to receive radio transmissions in space, she picked up mysterious signals that proved to be communications from the star Vega, many light years distant. After years of calibrating and translating the transmissions, it is discovered they are blueprints for a Machine to transport humans to Vega.

Now, on the eve of the New Millennium, while the process of selecting five multinational astronauts to make the trip is under way, politicians, theologians, philosophers, and scientists all argue the merits of the undertaking: Is it a fraud or a cold war intrigue; is it a plot to enslave or liberate mankind; is it nothing short of a trip to heaven or to hell?

In addition to Drumlin, Ellie's former teacher, other figures enter the project. There's Kenneth der Heer, the president's science adviser, with whom Ellie has an affair; Michael Kitz, assistant secretary of defense, whose political agendas complicate Ellie's mission; Vasily Lunacharsky, a brilliant Russian scientist; S.R. Hadden, who has reasons of his own for wanting to bankroll the building of the Machine; and Palmer Joss, a popular evangelist with whom Ellie sustains a long debate about the conflicts between religion and science. "The scientists want to take away our faith, our beliefs, and they offer us nothing of spiritual value in return," says Joss. Ellie replies: "I'm not any more skeptical about your religious beliefs than I am about every new scientific idea I hear. But in my line of work they're called hypotheses, not inspiration and not revelation."

After an aborted test of the Machine, in which Drumlin is killed, Ellie is selected to join the crew of astronauts. Here at last is the mission she has been preparing for all her life. "Her romanticism had been a driving force in her life and a fount of delights. Advocate and practitioner of romance, she was off to see the Wizard."

The trip to Vega is a wild plunge through a kind of "black hole transit system"—a series of time-space tunnels that deposits the breathless five astronauts onto a beautiful stretch of tropical beach. "So they had voyaged 30,000 light-years to talk on a beach," reflects Ellie sardonically. "Could be worse." To their astonishment, each of the five encounters an "alien" that is the fleshly embodiment of a departed loved one. Ellie reunites with the father who had died in her childhood. He admits he and the other aliens have scanned the minds of the Earthlings and re-created these living simulacra for greater ease of communication. He further reveals that his race has been observing Earthlings and, despite their self-destructive tendencies, has found them to be benign dreamers worth helping along their evolutionary path. He and his race are not the Creators of the universe, but merely Gate Keepers who have inherited a cosmic system and who are now determined to maintain it in good running order.

Upon returning to Earth, the five discover to their chagrin that their trip lasted only 20 minutes by Earth time; indeed, there seems to have been no trip at all. Any supporting evidence, like Ellie's microcameras, has vanished. The five are accused by Michael Fitz, assistant secretary of defense, of fomenting a conspiracy, a colossal hoax upon the world. He advises them to keep quiet and allow the world to think that the project has failed.

For Ellie, however, who remains convinced of the truth of her adventure, it is a transforming experience. Formerly an agnostic, she has found at last a sense and a meaning to the universe. Inspired by her conversation with her "father," she sets out to prove that within the mystery of "pi" lurks the central meaning—call it the "God"—of the cosmos. (And on a more personal level, the novel's epilogue has Ellie learning the truth of her parentage—that her biological father is not the man who died so long ago, but the man she had despised as her stepfather.) "She had spent her career attempting to make contact with the most remote and alien of strangers, while in her own life she had made contact with hardly anyone at all. She had studied the universe all her life, but had overlooked its clearest message: For small creatures such as we the vastness is bearable only through love."

The Film

The project was on the back burner at Warner Bros. for a dozen years before Robert Zemeckis (*Back to the Future*, *Forrest Gump*) brought it to the screen. It was an ambitious production, shooting over a period of 99 days at locations in Washington, D.C., the Kennedy Space Center, Florida,

Jodie Foster listens in Contact, *directed by Robert Zemeckis* (1997, U.S.A.; WARNER BROS.)

New Mexico, Puerto Rico, Newfoundland, and Fiji. The cast included Jodie Foster as Ellie Arroway, Matthew McConaughey as Palmer Joss, Tom Skerritt as David Drumlin, James Woods as Michael Kitz, David Morse as Ted Arroway, and John Hurt as S.R. Hadden. Carl Sagan took an active part in the initial casting (he personally approved of Jodie Foster's selection) and in the screenplay preparations. According to Zemeckis, Sagan worked with writers Michael Goldenberg and James V. Hart to retain the integrity of the science and the philosophical issues in the face of their wish to simplify the windy debates and to bring more action, romance, and vividness to the characters.

Nonetheless, the movie stubs its interstellar toe in a variety of ways. In its zeal to provide more of a profile and an edge to the rather bland Ellie, it concocts a woman who is a much more driven, neurotic character. The loss of her beloved father in her childhood (there is no mention of a mother) transforms her natural scientific bent into an obsession with finding a spiritual "father" somewhere out there in the cosmos. Instead, she finds Palmer Joss. She and Joss are no longer intellectual sparring partners, as they were in the book; here they are lovers who debate scraps of pseudoscience and religious clichés between romantic clinches. For example, on the eve of her voyage—in a scene not in the book and one that Sagan surely would have disowned—Joss challenges her about her

agnosticism, claiming the first emissary to an alien race should be required to believe in God. Scenes like this, while doubtless well intended (more than one critic, notably Roger Ebert, was conned into applauding them, claiming that "most Hollywood movies are too timid for theology"), are almost comic: Ellie gazes on Matthew McConaughey's Joss with trembling, erotic intensity, her pinched features and sharp little nose twitching in earnestness, while he gamely maintains the slightly stunned expression that in Hollywood always connotes the Spirit of Faith. Viewers who have not read Sagan's book will wonder just who is this vaguely ecclesiastical popinjay, this be-robed figure who carries a mysterious book and who keeps popping up with annoying regularity. Requiring viewers to believe that he and Foster could be bedmates is simply ridiculous.

Since this is a Jodie Foster film, there is no room on the Machine for anyone but her. When Drumlin is killed in a terrorist explosion of unknown origins (an incident in the film attributed to an albino religious fanatic), she is chosen to make the trip to Vega alone. The star system—not in the heavens, but in Hollywood—wins out. At journey's end her dialogue on the beach with her "father," a scene that in the book involved a lengthy and complex discussion of astrophysics, is here reduced to a handful of dewy-eyed homilies about the "human community" of the cosmos and the need to know we are not alone. It can be summed up in the

following dialogue, a nickel-candy piece of existentialist philosophy that is repeated several times throughout the film:

> Question: Do you think there are people on other planets?
> Answer: I don't know. But if it's just us, it would be an awful waste of space.

This message has all the pop-cult profundity of a Dead Sea Scroll by Erma Bombeck.

By the way, the choice by both Sagan and the movie to depict the alien in the climactic scene as a beloved parent is unfortunate. It is an oft-used and clichéd device, and it was employed much more effectively—and devastatingly—half a century ago in Ray Bradbury's short story "Mars Is Heaven" (and more recently in the closing scenes in the Iowa cornfield of the Kevin Costner film *Field of Dreams*).

Zemeckis, meanwhile, is up to his old tricks. With the same digital manipulations he used in *Forrest Gump*, he injects a "real-life" character into the action. In the former film it was President Kennedy. Here it is President Clinton. The line between fiction and reality is blurred. The results, however, are only gimmicky and distracting. After the picture's release, Clinton's lawyers considered suing the filmmakers for the unauthorized use of his image.

Speaking of *Forrest Gump*, the award-winning visual effects team from that film—production designer Ed Verreaux, cinematographer Don Burgess, editor Arthur Schmidt, effects supervisor Ken Ralston—reunites here for the admirable special effects. Burgess estimates that there are some 500 visual effects shots. The opening shot, particularly, is an amazing, prolonged zoom, opening on a star-spangled cosmos and retreating back to the circular orb of a human eye. Two of the most spectacular sequences take their cues from Sagan's book. The first depicts the visual decoding of the message from Vega; and the second, Ellie's trip across the cosmos. What Sagan had described as a series of plunges "down a long dark tunnel just broad enough to permit passage" is here elaborated into a dazzling series of kaleidoscopic light shows.

In sum, however, *Contact* hardly justifies Roger Ebert's opinion that it is "the smartest and most absorbing story about extraterrestrial intelligence since *Close Encounters of the Third Kind*." It's an apt comparison, but not, perhaps, in the way Ebert intended. Both films seem overwhelmed by a cloying sweetness. Their characters register spiritual ecstasy rather as if they were deer standing stunned in the path of oncoming headlights. Sagan's portentousness is replaced with simplistic slogans, fortune-cookie platitudes calculated to appeal to a mass audience. *Contact* ultimately conveys less about the wonder and absurdity of humanity's relationship to the great big cosmos than do the bizarre real-life doings in another, more terrestrial location—Roswell, New Mexico. And it generates less suspense and fun than its recent B-movie counterpart, *The Arrival*.

To paraphrase that dreaded line that recurs all too often in this movie: "If this movie is all we have to show for all the budget and hype, then it's a waste of time."

REFERENCES

Fisher, Bob, "Creating Contact," *International Photographer* 68, no. 7 (July 1997): 28–33, 45; Sagan, Carl, *Billions & Billions: Thoughts on Life and Death at the Brink of the Millennium* (Random House, 1997).

—*J.C.T.*

CORELLI'S MANDOLIN (1994)

LOUIS DE BERNIÈRES

Captain Corelli's Mandolin (2001). Directed by John Madden, adapted by Shawn Slovo; Working Title Productions/Free Range Films/Universal Pictures/Studio Canal/Miramax Film Corp.

The Novel

In *Corelli's Mandolin* (1994) Louis de Bernières blends history with romance, fantasy with brutal realism, love with betrayal, and politics with religion in a novel that spans almost 50 years. It is set on Cephallonia, a Greek island "filled with gods," most notably Apollo, whose bisexuality is tied to not only the romantic relationship between Corelli, a mandolin-playing Italian officer, and Pelagia, a young Greek woman, but also to the relationship between Corelli and Carlo, an Italian soldier who declares his love for Corelli only in letters that are read after his death.

The novel begins just before World War II. Led by the duplicitous Mussolini, who is given a chapter-long dramatic monologue in the novel, the Italians invade Greece. Antonio Corelli, who commands the occupation forces in Argostoli, is attracted to Pelagia, the educated, independent daughter of the town physician; but she is already betrothed to Mandras, an attractive but illiterate fisherman. When he enlists in the Greek army, the Pelagia/Corelli relationship deepens but never becomes sexual. Since Mandras does not answer her romantic letters, Pelagia slowly loses interest in him and the letters become more impersonal and shorter. (A metaphor for their relationship is the jacket she knits for Mandras but never finishes; she later gives it to Corelli.)

When the disillusioned and physically debilitated Mandras returns from battle, Pelagia doesn't even recognize him; and once her father heals him, he goes off to join the partisans, who teach him to read and to learn communism by rote. When he again returns, he knows that Pelagia loves Corelli and tries to rape her, but she wounds him with a derringer, and his mother, who sees what has happened, disowns him. Despondent, he drowns himself, but he becomes the stuff of myth when townspeople say they have seen him swimming with three dolphins.

The German allies of the Italians control the other half of the island, and Günther Weber, one of the officers,

becomes friendly with Corelli and the members of his opera club, who sing arias while seated in the latrine. The friendship, however, cannot survive Italy's surrender to the Allies. The Germans, who regard their former allies as traitors, dupe the Italians into surrendering and then kill them. When the shooting starts, Carlo, the burly homosexual, saves Corelli by standing in front of him, but the bullets pass through Carlo and severely wound Corelli. Weber sees that Corelli has survived but cannot shoot him. Velisarios, the village strongman, brings Corelli to Pelagia's father, who heals him and arranges for his escape from the island. Velisarios then brings Carlo's body to the doctor's home and buries him in the backyard.

After the war, Pelagia believes that Corelli, who had promised to return to her, is dead. She, her father, and Mandras's mother live together and adopt a baby who has been left on their doorstep. In 1946 she is holding Antonia, the baby she has named after Corelli, when she thinks she sees Corelli but can't find him. The "ghost," as the figure comes to be called, reappears several times; and she begins to receive unsigned postcards from all over the world. Antonia grows up, marries, and has a son named after Pelagia's father, Iannis, who died in the 1953 earthquake. After a bouzouki player tells Iannis that he should try the mandolin, Pelagia tells her 10-year-old "grandson"

that Corelli's mandolin is buried beneath the old house. Velisarios, who has been putting red roses on Carlo's grave, helps Iannis recover the mandolin, Weber's record player, and the doctor's history of Cephallonia.

Four years later (1993) Iannis meets Corelli, who had heard the boy play his mandolin. Learning that Pelagia was not married (his sight of the baby Antonia had led him to believe she was), Corelli is reunited with his beloved Pelagia, but not without a great deal of trouble. She is furious with the famous mandolin player who has composed "Pelagia's March" in her honor. To win her back, Corelli resorts to bringing her a goat to replace the one his troops had killed, and by getting her to ride with him on a motorcycle, bringing back memories of their time together during the occupation. The concluding image of the two elderly lovers roaring down the road is hardly a traditional romantic ending.

This bare-bones plot scarcely does justice to this Dickensian tale, which contains several subplots and many unforgettable ancillary characters. Carlo's heart-wrenching letters about his homosexuality, the doctor's hilarious attempts to write an "objective" history of the island, Pelagia's determination to become a physician, the gradual erosion of socialist tendencies in Antonia's rich husband, the political squabbles of the monarchist and the communist

Nicolas Cage in Captain Corelli's Mandolin (U.S.A., 2001; MIRAMAX)

who die in each other's arms after the Germans march them off to a concentration camp, the obese, drunken priest who becomes saintlike as he wanders over the island, the shepherd isolated and above the action, and the pet marten who sleeps in Corelli's helmet are the details that root the plot in a complex and comic world few authors can describe. This romantic novel begins with the doctor performing a "miracle," curing a case of deafness by extracting a pea from an old man's ear by "mollifying the supererogatory occlusion" and then describing the pea as "very papilionaceous." Later the old man, who can now hear his wife's nagging, asks if the miracle can be reversed. The verbal dexterity, which includes humorous "translation" problems for the Italians and for the Oxford-educated British operative who initially knows only classical Greek ("Sire, of youre gentillesse, by the leve of yow wol I speke in pryvetee of certyn thing" is de Bernières's Middle English rendering of what classical Greek would sound like in English).

Included in the novel are dramatic monologues, letters, sermons, and "history," with the appropriate tone and diction for each. As one critic put it, the novel "is more a symphony than a solo piece, a multi-voiced triumph over history."

The Film

Because the book was such a triumph, readers looked forward to seeing it transformed to the screen, but its verbal density and tonal shifts resisted the efforts of the filmmakers. Shawn Slovo, the screenwriter, truncated the novel and ended the film shortly after the war and the earthquake; and he also seriously altered the characters and, for the most part, omitted the political implications.

The film seems to have opted for a traditional love story with some cultural problems that are easily overcome. In the film, for example, Mandras's stint with the communist partisans is omitted, and since he has Pelagia's letters read to him while he is on the Albanian front, he is well aware that he has lost her love. He is quickly cured in the film instead of malingering as he does in the novel, and he actually joins forces with Corelli in the futile battle against the Germans. He, not Velasarios, finds Corelli alive and takes him to the doctor. Why? Because he wants Pelagia to love him. Most importantly, he does not attempt to rape Pelagia, and rather than dying with dolphins merely walks off into the night, never to be seen again.

Carlo's letters are missing from the film, so the homosexual subplot is omitted and film audiences can only guess why Carlo tells Pelagia, "I know what you feel," before the battle with the Germans. The extent of Carlo's bravery and love are entirely gone from the film, and since he is not buried in the doctor's backyard, Velasarios's annual red rose cannot serve as a visual reminder of Carlo's presence.

Weber's character is expanded (he becomes the German officer to whom the Italian officials surrender) and

made more human. He actually has a Greek girlfriend with whom he leaves his gramophone; she pays with her life for fraternizing with him (Mandras's hanging of the girl is his only unheroic act). In the film he seems incredibly naive, truly surprised and appalled by his German superiors' perfidy, and cannot kill Corelli. (In the novel Corelli actually looks up to Weber, who has become a clergyman.)

Although the film does include the massacre of some Italian soldiers, it does not reveal the extent of the Nazi butchery—at least 4,000 Italian soldiers were killed and burned. Nor does the film deal with the German occupation of Cephallonia. In the novel Pelagia's father is broken in a Nazi concentration camp before he returns home, and the two political adversaries/friends die while being marched to the camp. In the novel the Nazi brutality is described in great detail; in the film it is glossed over.

The whole historical context is ignored. Audiences miss Mussolini's posturing, Metaxas's incompetence and credulousness, the partisan splinter groups with the Communists fighting other Greek partisans instead of the Germans, Eisenhower's decision to abandon the Greeks despite Churchill's objections, the Greek civil war, the natural progression from socialism to capitalism as people age and have something to conserve, the sense that the Cephallonians are only pawns, and the antiwar message that permeates the novel. In addition, the doctor's history, which Pelagia resumes writing, is absent. Since the history also concerned the place of mythology in Cephallonia, the idea that myth is continually being made (Mandras's death with the dolphins) is similarly absent.

Slovo's script also sanitizes the novel. In the film the Opera Society sings while shaving, not while squatting on latrines; the explosion of the Turkish mine does not ironically sever the head of the munitions expert who warned Corelli about possible dangers; Pelagia's father does not urinate on the herbs in his garden; and the prostitutes' pubic hair is not described. Strangely enough, however, the film also omits what is truly romantic, the idyllic trysts between Pelagia and Corelli as he slowly recuperates from his wounds and both lovers refrain, despite normal urges, from sexual intercourse. Perhaps today's audiences would find such restraint unnatural and even laughable, but in the novel that restraint bespeaks care, consideration, and real love.

In the film, director John Madden relies on significant and extended close-ups to convey relationships, particularly the one between Corelli (Nicolas Cage) and Pelagia (Penélope Cruz), but without the information in the text, the nature and depth of the relationship is not clear. The romantic mood is enhanced by the music and the singing, which, of course, receive more emphasis in the film. However, without the notion that Iannis continues Corelli's mandolin playing, the film fails to capture the idea that it is about the mandolin. In fact, the novel is more about the mandolin and Pelagia than it is about Corelli, who makes only sporadic appearances in the later

40-year span. Perhaps because of the novel's focus on Pelagia, the film seems to end abruptly, while Cage, the real star, enjoys lots of film time.

By reuniting the lovers after the earthquake (in which Pelagia's father [John Hurt] does not die), the film has the requisite happy ending. It ends on a festival day with an embrace between the two lovers. Other closing images include a spat between the monarchist and the communist, the marital advice the doctor gives his ear patient (that advice is given in the first pages of the novel), the image of dancers, with Lemoni replacing Pelagia, and a sense that all's well that ends well. Readers of the novel know otherwise.

REFERENCES

Arroyo, José, "Paradise Lust," *Sight & Sound* 11, no. 5 (May 2001): 17–18, 44; Betzold, Michael, *"Captain Corelli's Mandolin," Magill's Cinema Annual 2002* (Gale/Thompson, 2002), 83–85; Macnab, Geoffrey, *"Captain Corelli's Mandolin," Sight & Sound* 11, no. 5 (May 2001): 44–45.

—*T.L. Erskine*

COUNT DRACULA

See DRACULA.

THE COUNT OF MONTE CRISTO (1845)

ALEXANDRE DUMAS

The Count of Monte Cristo (1912–13), U.S.A., directed by Edwin S. Porter, adapted by Joseph Golden; Famous Players.

Monte Cristo (1922), U.S.A., directed by Emmet J. Flynn, adapted by Bernard McConville; Fox.

The Count of Monte Cristo (1934), U.S.A., directed by Rowland V. Lee, adapted by Lee, Philip Dunne and Dan Totheroh; Reliance.

The Count of Monte Cristo (1975), U.S.A., directed by David Greene, adapted by Sidney Carroll; Norman Rosemont Productions/NBC.

The Count of Monte Cristo (2002), U.S.A., directed by Kevin Reynolds, adapted by Jay Wolpert; Touchstone/Spyglass/Buena Vista.

The Novel

First published in 1845, *The Count of Monte Cristo* is not a swashbuckler at all, as the many film versions imply, but a classic romantic melodrama, "the greatest 'revenger's tragedy' in the whole history of the novel," as proclaimed by Dumas's (1802–70) biographer F.W.J. Hemmings. The plot, which was prefigured in many respects by Dumas's earlier novel, *Georges*, was derived in part from a true story about the false imprisonment of a shoemaker called François Picaud. While in captivity he met an Italian priest who bequeathed to him a hidden treasure, which he subsequently used in his vengeful pursuit of those who wronged him. Dumas transformed the Picaud character into Edmond Dantes, a hero who wreaks his vengeance so cleverly and indirectly that he is never suspected of his actions. So successful was the novel that Dumas dramatized it three years later in a spectacular stage version with 20 acts, 37 tableaux, 221 scenes, and 59 characters. In that form it went on to an even greater success in a variety of stage incarnations.

The year is 1815. Young Dantes, a French sailor, is arrested on a trumped-up charge of treason and imprisoned in the Chateau d'If. After 17 years in a cell, he contrives to escape by impersonating an inmate he had come to know, the Abbé Faria, a man who had not only educated him in letters and sciences, but who had informed him of the location of the fabulous treasure of Monte Cristo. After escaping the prison by impersonating the corpse of the dead Abbé, Dantes is picked up by a gang of smugglers. A stroke of luck takes the smugglers' ship near the island of Monte Cristo, and Dantes contrives to remain behind while he locates the treasure in an underground grotto. Now wealthy, he returns to Paris in the guise of the mythical Count of Monte Cristo who, with the assistance of a slave girl, Haydee, exacts vengeance on his three accusers, the fisherman Fernand de Morcerf (who has married Edmond's sweetheart Mercedes and is now a distinguished soldier), the banker Danglars (who has amassed vast wealth as a result of his unscrupulous machinations, and the magistrate Villefort (whose prosecution of Dantes has advanced his career). "I wish to be Providence," Dantes proclaims, "for there can be nothing in the world more splendid, greater and more sublime than to mete out reward and punishment." Dantes' plots to ruin of his enemies are complex and subtle, resulting in the public disgrace and suicide of Fernand; the flight abroad of Danglars after his family is dispersed; and the insanity of Villefort upon being informed that his second wife and his natural son are murderers. Sickened by his quest, Dantes departs, having learned that that Mercedes's son, Albert, is his own. After doing a good deed by uniting the lovers Maximilien Morel and Valentine de Villefort, Dantes returns to the now-abandoned Chateau d'If, where he is reminded of the cruelty that had inspired his insatiable lust for revenge.

The Films

The novel has proven to be enormously popular with filmmakers. There have been at least seven screen translations in France between 1908 and 1960 and numerous others around the world. Hollywood has contributed nine silent and sound versions. According to historian Jeffrey Richards, in most of these pictures "the Faustian elements of the story are played down and the swashbuckling elements played up. The complexity and much of the intrigue

are removed, the tone lightened, and often a happy ending added, uniting Edmond and Mercedes."

Edwin S. Porter's screen adaptation is important historically because it was the first American-made release by the Famous Players studio. Following the success of Famous Players' release of the French-made *Queen Elizabeth* (which starred Sarah Bernhardt), it was filmed in October and November 1912 in four reels and featured members of the original New York stage cast, including James O'Neill in the role of Edmund Dantes. O'Neill had been associated with the play since 1883 and had appeared for many years in numerous touring road companies. Dantes is first seen as he takes leave of his invalided father, bids farewell to his betrothed Mercedes, and boards the ship *Pharaon*. After delivering the documents to Napoleon, he is arrested and incarcerated in the Chateau d'If. He escapes by impersonating the dead Abbé Faria, is rescued by a passing ship, finds the treasure at the island of Monte Cristo, and embarks on his missions of vengeance against Danglars and Fernand. At the end, after besting Fernand in a duel, he is reunited with Mercedes and Albert, whom he has learned is his son. The three famous scenes in the play version—wherein Dantes mutters "One!" "Two!" and "Three!" after dispatching his enemies—are retained. However, many of the novel's plot complications and incidental characters are eliminated—the scenes with Noitier, the brother of Villefort; the count's African exploits; and Dantes's catharsis upon realizing the tragedy of his vengeful ways.

Seldom seen today, the film is one of the most literal translations of a play ever committed to film. The use of painted backdrops (most egregious in the harbor scenes) predominates, excepting a few exteriors at the treasure island. The interior of the Chateau d'If, for example, is nothing more than a shallow playing space backed by a painted flat of a stone wall. When Dantes swings his pick at the floor, he is careful to avoid contact, broadly pantomiming instead the digging movement (an effect perhaps adequate for a theater stage, but hardly for the movie cameras!). Characters enter and exit by means of the sides of the frame, which approximate the wings of a stage proscenium. O'Neill is in almost every scene, and he stands stage center and employs the broad gestures and stiff attitudes all too typical of actors unaccustomed to the relative intimacy of the camera. Audiences already accustomed to the story and the stage play might have excused the lack of intertitles and dialogue titles, but viewers today would find it baffling.

Little information is available about the 1922 version from Fox, *Monte Cristo*, starring John Gilbert as Dantes, Estelle Taylor as Mercedes, Robert McKim as de Villefort, Spottiswoode Aitken as the Abbé, Ralph Cloninger as Fernand, and Albert Prisco as Danglars. As usual, the ending depicts the reunion of Dantes and Mercedes.

Edward Small's 1934 production cast Robert Donat in the title role (his only Hollywood appearance), Louis Calhern as de Villefort, Sidney Blackmer as Fernand, Raymond Walburn as Danglars, and Elissa Landi as Mercedes. Among the many alterations and simplifications made by screenwriters Philip Dunne, Rowland V. Lee, and Dan Totheroh include the following: Danglars goes mad instead of de Villefort; the strife among the de Villefort family members is eliminated; and Edmond and Mercedes are happily reunited at the end. Although actor Donat was not a man of action (a severe asthmatic condition restricted his activities in subsequent roles), his sword duel with Sidney Blackmer was expertly staged by fencing master Fred Cavens, and it set the standard for similar fight scenes in future adaptations.

The 1975 remake was adapted by Sidney Carroll and shot in Cinecitta Studios, Rome and on locations in the port of Marseilles and the nearby islands of If and Monte Cristo. In the cast were Richard Chamberlain as Dantes, Trevor Howard as the Abbé Faria, Louis Jourdan as de Villefort, Tony Curtis as Mondego, and Donald Pleasance as Danglars. The film was shown only on television in the United States and was released theatrically in Europe.

The most recent version, directed by Kevin Reynolds, is by far the most elaborate. Most of the screenplay's alterations of the novel quicken the pace and intensify dramatic tension. For example, a prologue has been added involving the meeting with Napoleon at Elba. The relationship between Dantes and Fernand has been expanded—now they are friends from childhood (which makes Fernand's treachery all the more vicious). The relationship with the prisoner, the Abbé (Richard Harris), has been developed so that the old man teaches him mastery of the sword (setting up the final confrontation with Fernand, who has already been established as a skilled fencer). Rather than dying of natural causes, the Abbé dies more dramatically during a cave-in. Instead of the servant girl that the novel provides Dantes as an assistant, we have the character of a pirate, Jacopo (Luis Guzman), who provides Dantes with more skills as a fighter. The revenge strategies, as usual, are more direct and blunt than the novel's more subtle vendettas: Dantes first targets Danglars, the ambitious shipmate who took over his ship. In a scuffle at Danglars' ship, he tosses him overboard and watches coldly as the man catches his neck in the ropes and hangs himself. Next is Villefort. Dantes contrives to extract a confession from him of murder and looks on as the man is bundled into a prison carriage and sent off to jail. Finally, there is Fernand. Fernand has married Dantes's girlfriend, Mercedes, sired a son named Albert, and become successful in business. Dantes uses his influence to call in all Fernand's debts and get him tossed out of the country. Before he can complete his plot, however, he learns that the son of Fernand and Mercedes is, in actuality, his own son. Mercedes had kept the truth of his parentage from both son and husband. In a climactic scene at a ruin in the country, Dantes, Fernand, Mercedes, and Albert all come together in several wild confrontations. Ultimately, Dantes bests Fernand in a duel and reunites with Mercedes. His son,

Albert, is left kneeling beside the body of the man he had presumed to be his father. The brief epilogue depicts Dantes and his new family returned to the steep cliffs of the Chateau d'If. His revenge is completed and his humanity restored.

Many of these changes, it must be admitted, are entirely satisfying dramatically. The character of Albert, the natural son of Mercedes and Fernand, becomes in the film the son of Dantes himself (which tightens up the conflicts with Fernand and provides Dantes with a reason to temper his vengeance). And by having Dantes reunite with Mercedes (which never happens in the novel), the movie provides satisfying closure to romantically-inclined viewers. And, finally, kudos to a nicely choreographed and photographed duel scene (not in the book), which transpires in a field of tall green grass, the camera whizzing at top speed, following and complementing the trajectories of the characters.

The cast is uniformly excellent. Harris carries off the part of the old man with suitable relish (giving us a wonderful scene when he hoists himself on Dantes's shoulders to gain a view of the blue sky, which he hasn't seen in years). James Frain's Villefort is appropriately oily, and Guy Pearce's Fernand is suitably sleazy as the corrupt aristocrat. Best of all is Jim Caviezel's Dantes, a frail and guileless young man at the beginning, a tortured wreck in the prison, and a magnificent figure in beard, top hat, and diamond-studded cloak as the Count. Here is a real arc for an actor to get his teeth into, and Caviezel carries it off. In a big film like this, it's a pleasure to note attention to detail, such as the slender piece of string that Mercedes keeps around her finger as a sign of loyalty to Dantes. It is that string, frail yet lasting, that convinces Dantes that she has been true to him (if only in her fashion). It turns out to be stronger than the brutal lash of his revenge. Filming locations include the island of Malta and Ireland. Costumes were designed by veteran designer Tom Rand, who worked on Ridley Scott's *The Duellists*. Cinematographer is Andrew Dunn, who also lensed Altman's *Gosford Park*.

For the record, Dumas's story has spawned a host of dubious sequels and variants, including Edward Small's *Monte Cristo's Revenge* (1946), in which Dantes's grand-nephew is framed and shipped to Devil's Island by a trio of villains clearly based on the original characters; *The Sword of the Avenger* (1948), a pirate story set in the Philippines; and numerous other films whose titles tell all—*Island of Monte Cristo* (1952), *Sword of Monte Cristo* (1951), *The Wife of Monte Cristo* (1946), and *The Son of Monte Cristo* (1940).

REFERENCES

Hemmings, F.W.J., *Alexandre Dumas: The King of Romance* (Charles Scribner's Sons, 1979); Richards, Jeffrey, *Swordsmen of the Screen* (Routledge, 1977); Thomas, Tony, *The Great Adventure Films* (Citadel Press, 1976); Tibbetts, John C., *The American Theatrical Film* (Popular Press, 1985).

—*J.C.T.*

COUSIN BETTE (1846)

HONORÉ DE BALZAC

Cousin Bette (1998), U.S.A., directed by Des McAnuff, adapted by Lynn Siefert and Susan Tarr; Fox Searchlight Pictures.

The Novel

Honoré de Balzac (1799–1850) has often been credited as one of the prime architects of the modern "realistic" novel. He was born into a peasant family and adopted the title "Balzac" from the noble family of Balzac d'Entragues. Perpetually in crushing debt—failing as a printer, a type-foundry owner, and a silver miner—he finally turned to writing. He drove himself relentlessly to create a gigantic body of work, subjecting himself to a rigid work schedule of 16 hours a day, fueled by large amounts of specially blended Parisian coffee. Balzac chronicled French life in its every aspect. Characters moved from novel to novel, interlocking in what he collectively called "The Human Comedy"—97 novels, novelettes, and short stories comprising 2,000 characters in all.

Among his last published works was *Cousin Bette* (1846), which contained, among other things, thinly veiled autobiographical elements of the many love affairs in his life. The story begins in Paris in 1838. Cousin Bette holds a marginal position in the family of the aristocratic Baron Hulot d'Evry. As a young girl, she had wanted to marry Hulot but was spurned when he married her cousin, Adeline. Now a spinster, Bette, a severe figure in black, has found a new love, Count Wenceslas Steinbock, an aspiring artist. But when he prefers the favors of Baron Hulot's daughter, Hortense, Bette decides enough is enough, and she plots revenge against her whole family. She enlists as an accomplice in her intricate schemes the beautiful courtesan Valerie Marneffe. Valerie not only seduces Steinbock, but also wins the favor of Hulot, who squanders his fortune on her. Bette, meanwhile, blackmails Hulot over the affair.

In order to pay off his debts, Hulot skims profits from his Algerian business ventures. When his scheme is exposed, he is dismissed in disgrace. Moreover, he discovers that Valerie has double-crossed him by promising to marry Crevel, his rich old friend. A desperate man, Hulot disappears into the slums of Paris. Hulot's son, Victorin, hires an underworld crony to kill Valerie. But she has other problems: Her Brazilian lover discovers her affair with Steinbock and vengefully infects her with an incurable, disfiguring disease. She in turn infects Crevel, and they both expire from the illness. As for the now-poverty-stricken Adeline—you will remember she is the hapless wife of Hulot—she takes a job as a social worker while searching for Hulot. Bette, however, obligingly warns Hulot, who flees farther into the slums.

Ironically, Bette's complex intrigues fail in the end. Adeline does eventually find Hulot and leads him back to

a life of respectability. Bette falls ill with pneumonia and dies. The irrepressible Hulot resumes his old ways, seduces the cook, and then, after the cook's death, marries the cook's apprentice.

The Film

Des McAnuff, who directed the stage version of *Cousin Bette*, made his screen debut with this picture. Along with screenwriters Lynn Siefert and Susan Tarr, he faced a daunting task in conflating the many subplots and characters into a coherent story. Together, they excised details of Hulot's various financial disasters, his attempts to extricate himself from debt, the public scandal over his Algerian misadventures, and the fates of other family members. Also missing are Hulot's dalliances with five mistresses and Valerie's juggling of four lovers and a husband. Hulot's son, Victorin, is assigned a relatively insignificant role. Adeline, Hulot's wife—who in the novel had provided virtually the only stable element in this misbegotten family—is disposed of in the film's first scene with her death. The character of Jenny Cadine is introduced as a composite of Valerie and other mistresses of Hulot.

The film opens with the death of Adeline (Geraldine Chaplin) and Bette's promise to her to take care of the family. Her expectations to marry Hulot are dashed when he requests she join the family in the role of housekeeper. Spurned, she returns to her spartan lodgings, where she works as a seamstress. Enter her Prince Charming (this is, after all, assuming the aspect of a fairy tale), the starving sculptor Wenceslas. Bette saves him from suicide and mothers him back to health. The grateful Wenceslas is unaware of her secret passion for him, nursing instead a passion for Hortense. To Bette's angry astonishment, Wenceslas marries Hortense and settles down to an indolent life, abandoning his serious ambitions as an artist. Now the rejected Bette has much to be vengeful about. She enlists a burlesque singer and dancer, Jenny Cadine (Elizabeth Shue), to toy with the Baron's emotions and

play him against another suitor, the wealthy Crevel, and to seduce Wenceslas. The jealous Baron learns of Jenny's other affairs and suffers an incapacitating stroke. Hortense, meanwhile, discovers Wenceslas's perfidy and shoots him dead. She is dragged off to jail. Financial panic sets in as Bette manages some disastrous loans from local bankers for the remaining Hulot family members.

In a striking departure from the book, Bette is left alone in the Hulot mansion to raise the baby born to Hortense and Wenceslas. Her revenge, thwarted in the original story, is here consummated. While the 1850 Revolution ravages the streets outside her window, Bette coos lovingly to the child, who she vows to raise as "a great artist." Meanwhile, back at the dance hall, Jenny has perfected a new way to show off her bare bottom—dressing as a nun in a chorus line.

Part melodrama, part slapstick satire, part musical, *Cousin Bette* suffers from an uneven tone. Yet it captures something of the greed, lust, and corruption pervading the 19th-century Parisian aristocracy. The costumes by Gabriella Pescucci and sets by Hugo Luczyc-Wyhowski are superb. The music score is an amalgam of works by Sarasate, Novacek, Palestrina, and others. Aden Young is a believably debauched Wenceslas. Elizabeth Shue's Jenny Cadine certainly can't sing, but her bawdy songs (by Danny Troob) are delicious, and she looks sensational in her derriere-baring costumes. Towering over it all is Jessica Lange, painfully vulnerable and grimly vengeful by turns.

REFERENCES

Holden, Stephen, "'Cousin Bette,' A Stunted Tale of Scheming," *The New York Times*, June 12, 1998, B16; Kanes, Martin, *Critical Essays on Honoré de Balzac* (G.K. Hall, 1990); Robb, Graham, *Balzac: A Life* (W.W. Norton, 1994).

—*J.C.T.*

CRASH (1973)

J.G. BALLARD

Crash (1996), Canada, directed and adapted by David Cronenberg; Movie Network/Telefilm Canada.

The Novel

J.G. Ballard's brilliant, controversial novel probes contemporary society's obsessions with sex, death, and the automobile. Flesh and metal, blood and gasoline, copulation and collision run like bright threads through the narrative—frequently intertwined, sometimes fused—forecasting an impending apocalypse of transcendence and disaster.

According to Ballard, the story grew out of a concatenation of circumstances, including a bad acid trip, a personal preoccupation with earth-shattering cataclysm

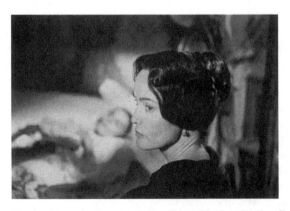

Jessica Lange in Cousin Bette, *directed by Des McAnuff* (1998, U.S.A.; FOX SEARCHLIGHT PICTURES)

(foregrounded in his 1960s science fiction novels), and a museum exhibit he organized himself in 1970 of three car wrecks introduced to the public by a topless female guide. The latter event, he says, was his "green light" to write *Crash*. Public response was one of immediate shock and indignation. "This author is beyond psychiatric help," moaned one commentator.

Author Ballard casts himself as the narrator, a filmmaker at London's Shepperton Studios (the suburb of Shepperton is Ballard's home in real life). After surviving a nearly fatal car crash, Ballard quickens to the erotic charge of a culture given over to traffic jams and automobile accidents, and to the subculture of sex-and-crash freaks huddled at its margins. "The motor car," he writes "was the sexual act's greatest and only true locus." Ballard indulges in every aspect of sex with a picaresque and mutilated band of visionaries—his friend Robert Vaughan, a former actor who now spends his time photographing accidents and plotting imaginary collisions for himself and others; Catherine, his nymphomaniac wife; Dr. Remington, a survivor of Ballard's crash; Gabrielle, an accident survivor whose body has been patched and shackled with metal braces; and Seagrave, a stunt driver who revels in his work.

What follows is not a plot so much as a series of violent (some would say pornographic) encounters, described in highly graphic detail. Ballard and his companions seem stunned by the glare of approaching headlights and damaged by concussions of metal and bone. Their bodies, like their automobiles, are broken and twisted into bizarre shapes that invite new experiments in erotic activity. "[Their] wounds," says narrator Ballard, "were the keys to a new sexuality born from a perverse technology." It's an arc of steadily intensifying behavior that culminates in Vaughan's obsession with stage-managing a crash that will kill actress Elizabeth Taylor.

In the end, it is Vaughan, not the actress, who lies dying in the crumpled metal. Left to mourn is Ballard, who realizes that now is the time to begin designing the elements of his own car crash. Indeed, it will be but a small part in an apotheosis of carnage: "In his mind Vaughan saw the whole world dying in a simultaneous automobile disaster, millions of vehicles hurled together in a terminal congress of spurting loins and engine coolant."

Although there may be strenuous objection to the novel's incessant catalog of horrors and perverse pleasures—whose ultimate effect, suggests critic Tom Shone, is "the world's first slow-motion novel . . . a book better contemplated than read"—there is no denying Ballard's virtuoso use of language. The LSD-induced vision of car-clogged trafficways near the book's conclusion, in particular, is a masterpiece of surreal vision. "The cars overtaking us were now being superheated by the sunlight, and I was sure that their metal bodies were only a fraction of a degree below their melting point, held together by the force of my own vision. . . ." There is even more than a hint of celebration hovering over the crumpled bodies and fenders of the story: "In our wounds we celebrated the re-birth of the traffic-slain dead, the deaths and injuries of those we had seen dying by the roadside and the imaginary wounds and postures of the millions yet to die."

The Film

One can scarcely imagine a more sympathetic filmmaker than David Cronenberg to adapt Ballard's novel. One of the few truly radical sensibilities operating in "mainstream" cinema, Cronenberg is equally preoccupied, as critic Gavin Smith notes, with "the communion of characters with technology, disease, narcotics, telepathy, and Otherness." One has only to recall the loners and malformed techno-creatures of *Videodrome*, *The Fly*, and *Naked Lunch* to get the point.

Crash, which received a mixture of boos and prizes (the Special Jury Prize) at Cannes in 1996, and a chilly reception in America from distributor Ted Turner, is a bravely faithful adaptation. Except for a minor change in location (from London to Toronto) and the excision of the Elizabeth Taylor motif, it retains intact the novel's major elements. James Ballard (James Spader) is a filmmaker who, after a near-fatal car crash, finds himself sexually aroused by the mangled bodies and crumbled fenders littering highways and parking lots. The widow (Holly Hunter) of the man killed in the crash introduces Ballard to a strange, dark man named Vaughan (Elias Koteas), the guru of car crashes. Carnage feeds his hunger, extends his vision, and arouses both his pain and his fulfillment. He hangs around hospitals taking pictures of accident victims. He and his friends sit at home watching videocassettes of crash-test dummies. They stage reenactments of famous auto disasters (a plot detail only hinted at in the novel). In front of a bleacher full of onlookers, Vaughan reprises the James Dean collision—and almost kills himself in the process. (He will indeed eventually kill himself in an attempt to restage the Jayne Mansfield tragedy.) After conducting business with prostitutes (in his car, of course), he kills them in hit-and-run "accidents."

Meanwhile, our hero, James, has been sampling on his own all kinds of automotive sex. His encounters are more like collisions, random and anonymous. James finally is left with no ambition but to wander the freeways looking for sex and disaster. In a departure from the novel, the climactic scene has him impulsively running Catherine's (Deborah Ungar) car off the road. He scrambles down the embankment and embraces her broken and bleeding body. Is he glad she's still alive; or is he disappointed she's not dead? "Maybe next time," he says enigmatically. The camera lifts up and away—leaving the scene of an accident, as it were—as they couple furiously in the midst of the wreckage.

Aside from this shocking ending, which is not an alteration so much as a visualization of the prophecy in the novel's penultimate paragraph, the film's most sensational moments stem directly from the book—the homosexual encounter between Ballard and Vaughan, the bizarre sex scene between Ballard and the metal-braced Gabrielle

(Rosanna Arquette), and the lyrically dazzling carwash sequence, which intercuts back-seat lovemaking with the orgasmic frenzy of the squirting sudsy water and flailing cloth pads.

Crash has the panoply of imagery and props typical of a Cronenberg film—the mating of flesh and metal, the dehumanization of the sex act, the invasive presence of broadcast media, etc. The sex scenes are frequent (there are three encounters within the first minute of screen time), blunt, and graphic. It earns its NC-17 rating. Significantly, however, the film version of *Crash*, like Ballard's novel, chronicles all this in a cold, remote fashion (the cinematographer is Peter Suschitzsky), regarding the flounderings and cruelties of the characters with a dispassionate gaze—as if they were but mere reflections spreading across the sleek surface of polished metal. Cronenberg eschews stylistic hype, the expected hard-rock soundtrack, the token frenzied hand-held camera, and the predictable frenetic cutting. Instead, the characters and the story seem to drift, a gasoline-inhaling machine moving at full throttle, but with the clutch all the way in. As Gavin Smith writes, "Cronenberg's film exemplifies cool, hieratic austerity. His setups and cutting have never been more inhumanely deliberate and exact. . . . In its subdued, subtractive minimalism and almost oppressive formal control, *Crash* toys with the possibilities of enervation and entropy." It is "the imagination of disaster" to which both author Ballard and filmmaker Cronenberg aspire, but it is a fantasy that burns with an intense, and cold, flame.

REFERENCES

Shone, Tom, "The Road to 'Crash,'" *The New Yorker*, March 17, 1997, 70–75; Smith, Gavin, "Cronenberg: Mind over Matter," *Film Comment* 33, no. 2 (March—April 1997): 14–29.

—*J.C.T.*

CRIME AND PUNISHMENT (*Prestuplenie i nakazaniye*) (1866)

FYODOR DOSTOYEVSKY

Crime and Punishment (1935), U.S.A., directed by Josef von Sternberg, adapted by S.K. Lauren and Joseph Anthony; Columbia.

Crime and Punishment (*Crime et Châtiment*) (1935), France, directed by Pierre Chenal, adapted by Marcel Ayme; General Production.

Crime and Punishment (*Prestuplenie i Nakazaniye*) (1970), USSR, directed by Lev Kulidjanov, adapted by Nikolai Figurowsky and Lev Kulidjanov; Gorky Studios.

The Novel

Dostoyevsky's most widely known novel was serialized in *The Russian Messenger* from January through December 1866, with a first separate edition appearing in 1867. In it

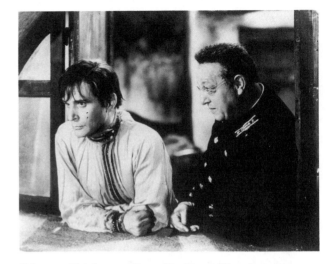

Crime et Châtiment, *directed by Pierre Chenal* (1935, FRANCE; GENERAL PROD/NATIONAL FILM ARCHIVE, LONDON)

Dostoyevsky probes deeply into the Underground Man's call for freedom at all costs in a society that increasingly seeks to snuff consciousness and turn human beings into piano keys (*Notes from Underground*, 1864): "What man wants is simply *independent* choice, whatever that independence may cost and wherever it may lead." In *Crime and Punishment* Dostoyevsky puts such a choice at the very heart of the action and explores in graphic psychological detail the consequences of that freedom.

Superficially considered, *Crime and Punishment* belongs to the genre of detective fiction, which flourished at the end of the 19th century and continued in the 20th and 21st, the basic conventions of which were established by Poe. But Dostoyevsky's point of view is with the criminal, not with the detective, and the suspense lies not in the detective's detection of the criminal, but in the criminal's self-detection.

Raskolnikov is a poor young student in St. Petersburg, where he lives in squalor and feels guilty about the sacrifices his mother and sister are making to send him to school, even though he has dropped out. His poverty, guilt, and failure make him psychologically receptive to a "superman" ideology. Raskolnikov comes to believe that each age gives birth to a few superior beings who, like Napoleon, are not constrained by ordinary morality. Taking himself for such a being, he rationalizes the murder of an old pawnbroker, dismissing her as a useless, even pernicious, member of society, who can be expended so that he can use her money to fulfill his "humanitarian duty toward mankind." Chance and coincidence govern events leading up to the deed and even shape the murder itself: When she unexpectedly intrudes, Raskolnikov is forced to kill the pawnbroker's younger crippled sister, a truly meek person who is one of the very downtrodden whom his theory is supposed to

benefit. He leaves the door open during both murders, neglects to take much of the money, and falls asleep in his unlocked room with his blood-soaked clothes and stolen articles plainly in sight.

The Russian word for *crime (prestuplenie)* translates literally as *transgression*, which means "crossing over" or "stepping beyond." Raskolnikov's punishment begins right after the crime, before the police could even suspect him, and it takes the form of a slow agonizing coming to terms with the arrogance that led him to intellectualize himself as an exceptional being, thereby breaking his spiritual bond with the rest of humankind. He becomes obsessed with Porfiry, the examining magistrate in charge of the case. Dostoyevsky had early on introduced a prostitute named Sonia, a compassionate woman who will come to reflect the good side of Raskolnikov. Eventually Raskolnikov turns to Sonia and confesses. She follows him to his imprisonment in Siberia where he finally experiences a conversion, kisses the ground in redemption,

reconciles himself with the earth that he had defiled, and recognizes that he had betrayed, not helped, his fellow human beings.

The Films

Eisenstein (as Nizhny records) once gave his students a challenging lesson: to film the entire murder scene with one camera position in a single shot, which would emphasize what he called "hidden editing." He suggested a wide-angle lens (to heighten the scale-contrast and to embrace greater space) and shooting from slightly above (to suit the nature of the passage and Dostoyevsky's theme of the humiliated and insulted), as well as moving the characters in such a way as to create the effect of close-ups and long-shots within one shot. This *mise-en-shot*, as Eisenstein coined it, was above all to convey both the "outer subject" of the scene (the murder) and the "inner subject" (the "fall" and dethroning of Raskolnikov).

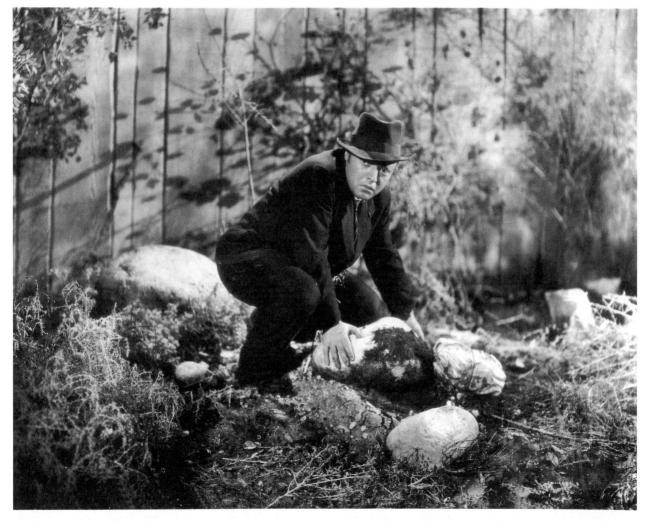

Peter Lorre in Crime and Punishment, *directed by Josef von Sternberg* (1935, U.S.A.; COLUMBIA/PRINT AND PICTURE COLLECTION, FREE LIBRARY OF PHILADELPHIA)

Eisenstein himself never adapted *Crime and Punishment*, but at least six others have since 1917. There is a 1948 Swedish version, directed by Hempe Faustman. A 1958 French version, directed by Georges Lampin, updated the action to modern-day Paris. And a 1959 U.S. version, *Crime and Punishment U.S.A.*, directed by Denis Sanders, moved the action to contemporary California. Of the two 1935 adaptations discussed here, von Sternberg's also updates the action, while Chenal's was praised for depicting the dark, brooding settings of 19th century St. Petersburg. Kulidjanov's 1970 version is the most ambitious of all, at three hours and 20 minutes. Shot in extremely wide screen, in brilliant black and white, it is also the most faithful to the details of Dostoyevsky's novel, preserving characters and incidents that Chenal and von Sternberg's abbreviated adaptations omit (such as Svidrigaylov) by keeping the focus on the relationship between Raskolnikov and Porfiry.

Von Sternberg's is the most pared down, conceiving the novel as primarily a detective story and thus emphasizing the cat-and-mouse game between detective and criminal. Peter Lorre's Raskolnikov—although a very interesting performance in itself—is more of a psychopath than he is the spiritually tormented sufferer of the novel. When he commits the murder, it seems an impulsive act, motivated on the spot, rather than the compulsive finalization of an *idée fixe*. The film then concentrates primarily on the battle of wits between Inspector Porfiry and Raskolnikov rather than on the internal struggle within the latter. The external battle is important to Dostoyevsky too, but only insofar as it lays bare the much more significant battle inside Raskolnikov's very soul. Chenal's version manages to convey some of this struggle, through Pierre Blanchar's portrayal and through the mise-en-scène, which visually suggests how the dark, cramped, stifling environment is partially responsible for driving Raskolnikov inward toward his fatal ideology.

Kulidjanov's version, with more than double the running time of the other two, is most successful in suggesting that Raskolnikov is undergoing punishment well before he actually commits the crime. Canby found his use of the Cinemascope image so effective that "it's the first time I can remember that doom has had a visible screen shape." Gilliat, pointing out that "Dostoevsky's people experience crises that are lived in their heads, not in their taverns or their hovels or their attic rooms," noted Kulidjanov's use of concrete detail to describe people's minds. "It is not for nothing that Raskolnikov's tall frame barely fits into his warped little lodgings when he is standing up. His head seems to be struggling to get through the ceiling." She found that "Dostoevsky's unique sense of the topography of his characters' soul is preserved intact, and so is the novel's diffuseness. The film does nothing to distort the meaning of the book."

Chenal's version received very favorable reviews, while von Sternberg's reception was decidedly mixed. Comparing the two, Sennwald said that the difference between them was "the difference between Dostoevsky and a competent wood pulp fictioneer." The weakness of the American version, he felt, was "a basic flaw" in von Sternberg himself: "A superb camera man, capable of strikingly lovely visual composition on the screen, he is almost totally lacking in dramatic imagination." This insight emphasizes the adapter's interpretation of the source material as the crucial stage of adaptation. But given the studio system that von Sternberg was constrained by, it may well be that he simply worked with the screenplay handed to him and gave no thought to the Dostoyevsky novel. He was not himself the adapter nor collaborator in the adaptation, as today's filmmakers often are. Still, there was praise for his film by the reviewer in *Time*, who lauded Lorre's skill in portraying a multiple-personality Raskolnikov—sensitive student, half-starved intellectual, contemptuous psychopath, and childish martyr. And Mark van Doren found the two films "extraordinarily pitiful and powerful—the French one much more so than the American one, but both of them miles high above the average."

REFERENCES

Canby, Vincent, *The New York Times*, May 15, 1975, 48; "'Crime and Punishment' in French, English and American," *Newsweek*, November 30, 1935, 27; Gilliat, Penelope, "Russian Minds," *The New Yorker*, May 26, 1975, 104-06; Nizhny, Vladimir, *Lessons with Eisenstein*, tr. and ed., Ivor Montagu and Jay Leyda (Hill and Wang, 1962); Van Doren, Mark, "When Acting Counts," *The Nation*, December 4, 1935, 659.

—*U.W.*

LOS CUATRO JINETES DEL APOCALIPSIS (1918)

See THE FOUR HORSEMEN OF THE APOCALYPSE.

THE CURSE OF CAPISTRANO (1919)

JOHNSTON MCCULLEY

The Mark of Zorro (1920), U.S.A., directed by Fred Niblo, adapted by Eugene Miller; United Artists.

The Bold Caballero (1936), U.S.A., directed and adapted by Wells Root; Republic Pictures.

The Mark of Zorro (1940), U.S.A., directed by Rouben Mamoulian, adapted by John Taintor Foote, Garrett Fort, and Bess Meredyth; Twentieth Century-Fox.

Zorro, the Gay Blade (1981), U.S.A., directed by Peter Medak, adapted by Hal Dresner; Twentieth Century-Fox.

The Mask of Zorro (1998), U.S.A., directed by Martin Campbell, adapted by Terry Rossio and Ted Elliott; TriStar.

The Novel

It says a lot about the swashbuckling Señor Zorro that the magnitude of his legend has far outstripped the puny reality of his literary origin. Forgotten are the many Zorro stories that delighted the readers of pulp magazines in the first half of the century; and vanished utterly is the name of their creator, a newspaper man-turned novelist, Johnston McCulley. McCulley may have been a hack, but his importance in American pop culture should not be underestimated. "He is the spiritual father of all . . . avengers who administered bushwhack justice from the night," writes Robert Sampson in *Yesterday's Faces*, a study of pulp magazines.

Zorro first appeared in the five-part *The Curse of Capistrano*, in *All-Story Weekly* from August 9 to September 6, 1919. Set during the Spanish occupation of California in the years 1775 to 1800, when the aristocracy contended for power against the governor's brutally oppressive military regime—and the peons suffered from abuses of power in the process—the story teemed with corrupt politicians, blooded caballeros, fainting ladies, and, of course, a mysterious vigilante on horseback named Señor Zorro, Swathed in a purple cloak, face black-masked to the chin, whip tied to the saddle, and sword at his side, he rode his mighty black horse along El Camino Real, a 650-mile trail linking 21 Spanish missions, from San Diego de Alcala to Sonoma, north of San Francisco de Aris.

At the beginning of the story, he materializes out of the night to rebuke the villainies of Sergeant Pedro Gonzales. "I am the friend of the oppressed, senor," he tells the fat soldier, "and I have come to punish you." Meanwhile, Don Diego Vega, scion of a noble family in Reina de Los Angeles, sighs languidly and touches a perfumed handkerchief to his nostrils. "Violence," he says. "Violence. It is something I cannot understand." Don Diego is more concerned with his courtship of the fair senorita Lolita Pulido. He has two rivals for her hand, however, the wicked Captain Ramon and the selfsame Zorro. Their respective wooing strategies are studies in contrast. Don Diego recites poetry, Zorro sweeps her off her feet, and Ramon impugns her father's good name and throws her family in jail. Zorro, who has persuaded the caballeros to unite in resisting the governor's troops, frees Lolita and bests Ramon in a duel. He and Lolita take flight from pursuing soldiers and barricade themselves into a tavern, where they are rescued by the caballeros. He emerges at the end to reveal that he is, in actuality, none other than Don Diego Vega! He confesses that for 10 years he has been practicing a double masquerade, assuming the languid pose of Don Diego while practicing in secret the deadly swordsmanship of Señor Zorro. Clothes indeed made the man, he confesses. "The moment I donned cloak and mask, the Don Diego part of me fell away. My body straightened, new blood seemed to course through my veins, my voice grew strong and firm, fire came to me! And the moment I removed cloak and mask I was the languid Don Diego again. Is it not a peculiar thing?" The story comes to an end as he proclaims: "And now Señor Zorro shall ride no more, for there will be no need."

The Films

Zorro's decision to retire was premature; it took less than a year for him to ride again. Douglas Fairbanks stepped—or rather vaulted—into the role as if born to it. He bought the rights to McCulley's tale and released it in 1920 under the title by which it has become best known, *The Mark of Zorro*. The basic story elements and characters are transferred intact. However, it needs to be said that the scenario, credited to Eugene Miller, was enhanced considerably by the contributions of one "Elton Thomas," Fairbanks's pseudonym; indeed, it was Fairbanks who really forged the Zorro image that is still with us today—a classic case of the interpreter of a literary character influencing the subsequent development of that character. For example, the book contained only a handful of brief references to Zorro's trademark "Z." Fairbanks seized on the device and elaborated on it with considerable ingenuity. He had done this sort of thing before, notably in the visual tag he utilized for his character in an earlier film, a western adventure called *The Good Bad Man* (1916). The visual effectiveness of the "Z" is beautifully demonstrated in a scene wherein Zorro carves it into Captain Ramon's (Robert McKim) cheek and then shows him its reflection along the surface of the blade. Furthermore, there is no mention in the story of a bit of business Fairbanks uses to emphasize Don Diego's foppishness—i.e., the query that accompanies his little feats of sleight-of-hand, "Have you seen this one?" McCulley was obviously impressed by these added details, because he adds them to his Zorro sequel, *The Further Adventures of Zorro* (1992), and to the reprint of *The Curse of Capistrano* in 1924, now called *The Mark of Zorro*. Suddenly, Zorro is carving "Zs" all over the place and Don Diego is asking, "Have you seen this one?" at every opportunity.

Fairbanks leavens the story with high-flying acrobatics. The confrontation between Zorro and Ramon, after Ramon's attempt to "compromise" Lolita Pulido (Marguerite de la Motte), has Zorro literally falling into the frame from a great height. The chase sequence near the end—not included in the book—is one of Fairbanks' best trajectories: With the governor's men in hot pursuit, his agile form leaps across stiles, vaults over walls, tumbles down rooftops, and flies in and out of windows. Pausing a moment on a window sill, he munches some bread, dispenses advice to a peasant woman ("Never do anything on an empty stomach"), and whirls away again.

The character stayed with Fairbanks. Not only did he make a sequel, *Don Q, Son of Zorro*, in 1925 (wherein father and son fight alongside each other in some cleverly double-exposed scenes), but in the late 1920s he purchased 3,000 acres of San Diego County real estate that he

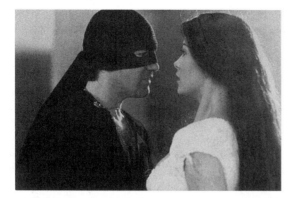

Antonio Banderas and Catherine Zeta-Jones in The Mask of Zorro, *directed by Martin Campbell* (1998, U.S.A.; COLUMBIA TRISTAR)

planned to turn into a hacienda called Rancho Zorro—a project not fully completed at his death in 1939.

Fairbanks was a tough act to follow, but Tyrone Power did a credible job in the Rouben Mamoulian remake for Fox in 1940. Of course, by now the secret of the Zorro/Diego dual identity was out, so this and all subsequent adaptations would reveal it at the outset. The bare bones of the McCulley original were considerably fleshed out. A backstory in Spain was added, establishing Don Diego's prowess as a swordsman. Called to America by his father, who needs help resisting the tyrannical Don Luis Quintero (J. Edward Bromberg) and Captain Esteban Pasquale (Basil Rathbone), he secretly assumes the "Zorro" identity and sets out to usurp the villains. Meanwhile, his foppish ways as Don Diego repel the beautiful Lolita Quintero, (Linda Darnell), niece of Don Luis. Diego's masquerade is exposed when he is forced to dispatch Pasquale in a duel. In a switch on the book's original ending, it is Diego who is thrown into jail, not his girlfriend. He breaks out and leads his caballeros and the peasants against the soldiers. Quintero is defeated, a new regime is established, and Lolita (having discovered Diego's true macho qualities) falls into his arms.

The stylish production is considerably enhanced by Arthur Miller's outstanding camerawork and Alfred Newman's superb musical score. Rathbone was a bona fide expert swordsman, and his duel with Power remains one of the finest scenes of its kind. Power's own acting abilities contribute nicely to the ironic subtleties of his wooing of Lolita, a woman he truly loves but before whom he dare not abandon his foppish guise.

Among the Zorro oddities of the 1930s were several entries from Republic Pictures. The little-known *The Bold Caballero* (1936), scripted by Wells Root, used only the McCulley character in an otherwise original story: Instead of Don Diego masquerading as Zorro, it is Zorro (Robert Livingston) who poses as Don Diego, a gentleman pauper from Mexico who overthrows the wicked Commandante Sebastian Golle (Sig Rumann). From 1937 to 1949 Repub-

lic also released several Zorro serials, including *Zorro Rides Again* (with John Carroll), *Zorro's Fighting Legion* (with Reed Hadley), and *Zorro's Black Whip*. In all but *Zorro's Fighting Legion* the original Zorro character was replaced by either a relative or, in the last instance, a woman (Linda Stirling).

By the early 1980s Zorro had long since ceased to be taken seriously. After the silly plot contrivances (contributed by an aging McCulley) and cheap studio look of the Walt Disney television series of the 1950s featuring Guy Williams in his pre–*Lost in Space* years, there seemed no place to go with the character. So it was no surprise that George Hamilton, fresh from his spoof of Dracula in *Love at First Bite* (1979), decided to up the ante and present a gay version of Zorro. Actually, this Zorro had a gay twin brother named Bunny, "a screamingly limp-wristed stereotype," in the words of critic Roger Ebert. The laughs were in bad taste and the story line mostly incomprehensible. For the record, Lauren Hutton came along for the ride as the love interest for Don Diego.

The most recent Zorro entry, *The Mask of Zorro*, starring Antonio Banderas, is a welcome return to the high heroics of the Fairbanks and Power versions. Inexplicably, the writing credits, which list Terry Rossio, Ted Elliott, and John Eskow, do not mention author Johnston McCulley, despite the fact that not only the eponymous character, but also many plot elements obviously derive from his novel.

The action is transferred forward in time to the middle decades of the 1800s, when Spain and Mexico are in contention for control over Old California. It is Anthony Hopkins, not the headlining Antonio Banderas, who actually portrays Zorro. This Zorro appears only once, in the film's gloriously exuberant prologue, when he sweeps into the city plaza to rescue several peasants from the firing squad of the wicked Spanish general Don Rafael Montero (Stuart Wilson). But upon returning to his home and his identity of Don Diego de la Vega, the loving husband and father of a baby girl, he is captured by Montero and thrown into prison.

The rest of the film transpires 20 years later. Diego escapes from his long imprisonment and, with the aid of a wandering bandit, Alejandro Murrieta (Banderas), concocts a vendetta against his old nemesis, Montero, who has returned from exile in Spain to hatch a plot to take control of Old California for himself. The sequences wherein the aging Diego teaches his young protégé Alejandro the art of the sword, or self-control, and of gentlemanly conduct, are particularly delicious. Hopkins's icy poise contrasts beautifully with Banderas's fumbling earnestness. Gradually, Diego and Alejandro reverse roles—it is the shambling Alejandro who becomes the sleek and deadly Zorro, and Diego who disguises himself as Zorro's meek and obsequious servant, Bernardo.

The action sequences are beautifully choreographed by director Martin Campbell (*GoldenEye*), swordmaster Bob Anderson, and stunt coordinator J. Mark Donaldson. At times a slapstick element takes over, especially during Ale-

jandro's initial attempts to assume the mantle of Zorro, when he suffers several clumsy falls from his horse (once while negotiating a leap from a high window). Otherwise, a superbly swashbuckling tone prevails. Prime examples include the glorious prologue in the city plaza, when Hopkins's Zorro engages in a gorgeously preposterous series of fights, falls, somersaults, and rope swings. Banderas's first appearance as Zorro in the soldiers' barracks is a happy, slapstick free-for-all, highlighted by his fencing with both hands. Next is the fight inside Don Rafael's hacienda, when most of the action is confined inside a narrow corridor (again, with two-handed dueling). Banderas's duel with the beautiful Elena (Catherine Zeta-Jones), Diego's grownup daughter, provides not only some delicious verbal sparring, but also an opportunity for her to hold her own with the sword. There's also a wonderful chase sequence where Zorro stands astride two horses pursuing a squad of soldiers. The climax, however, is too busy and too distracting. The script contrives to have *both* Diego and Alejandro fighting duels with their respective adversaries, the action busily cross-cutting from one to the other. The action is literally sliced up into too many competing elements. It might have been better if Diego had been allowed to die earlier, clearing the decks for Alejandro's final vengeance.

Banderas is likably energetic as Alejandro/Zorro. He flashes his boyish smile in quick, tight closeups and obviously is doing a fair measure of his own stunts. Hopkins is the stickum that holds the whole thing together. He looks unusually trim and moves well in the dueling sequences.

Heralding a bid by the filmmakers to turn this Zorro into a series of films is the opening and closing "signature" moment when Señor Zorro appears, draws his sword, and sweeps a red Z across the screen. Stay tuned.

REFERENCES

Sampson, Robert, *Yesterday's Faces: A Study of Series Characters in the Early Pulp Magazines* (Popular Press, 1993); Tibbetts, John C., and James M. Welsh, *His Majesty the American: The Films of Douglas Fairbanks, Sr.* (A.S. Barnes, 1977).

—*J.C.T.*

DAISY MILLER: A STUDY (1878)

HENRY JAMES

Daisy Miller (1974), U.S.A., directed by Peter Bog-
danovich, adapted by Frederic Raphael; Paramount.

The Novel

Daisy Miller is the closest Henry James ever got to having a
best-seller, and it made him famous in England and in the
United States. In it James "created the paradigm of a central
American myth, the myth of the American girl as free, spon-
taneous, independent, natural, and generous in spirit." But it
also created something of a furor on this side of the Atlantic
when some readers resented what they saw as a satirical por-
trait of American womanhood. W. D. Howells claimed that
such readers were misreading James's story, and he pointed
out that, so far as the average American girl was studied at all
here, her indestructible innocence and her invulnerable
new-worldliness had never been so delicately appreciated.

Within the text, the central problem is whether Win-
terbourne's reading of Daisy is on target or not, and outside
the text, the central problem is *our* reading of Winter-
bourne's reading. But James's narrative technique compli-
cates this even further, for the actual (technically,
first-person) narrator is a friend of Winterbourne and is
studying *him* studying Daisy. All of the other characters in
the story are "reading" Daisy as well, yielding interpreta-
tions that Winterbourne must reconcile with his own.

Frederick Winterbourne, an American expatriate
studying in Geneva, meets Daisy Miller, a young American
woman doing the grand tour of Europe with her mother

and younger brother Randolph. Winterbourne is immedi-
ately attracted to Daisy, though he realizes at the same
time that she violates all of the propriety and decorum that
the American community in Europe adheres to. "They're
horribly common," sniffs his aunt, Mrs. Costello.
"They're the sort of Americans that one does one's duty by
just ignoring." An unchaperoned excursion to the Castle of
Chillon leaves Winterbourne completely infatuated. "She
struck him afresh . . . as an extraordinary mixture of inno-
cence and crudity."

The second half of the story takes place in Rome, where
Daisy has begun going around with Giovanelli, a man
Winterbourne takes to be a fortune hunter. Daisy resists
Winterbourne's attempts to warn her away from Gio-
vanelli. One night he runs into Daisy and Giovanelli at the
Colosseum, in defiance of the danger of malarial mosqui-
toes. "I was bound to see the Colosseum by moonlight,"
Daisy insists. Daisy does catch the Roman fever and dies. In
a graveside conversation, Winterbourne learns that Gio-
vanelli had no illusions about ever marrying Daisy. When
Giovanelli tells him that Daisy was "the most innocent"
lady he ever knew, Winterbourne realizes his error in hav-
ing eventually read her as a flirt: "I was booked to make a
mistake," he tells his aunt later, "I've lived too long in for-
eign parts." But, the narrator tells us in a concluding para-
graph, Winterbourne went back to Geneva, where it's
reported "that he's 'studying' hard—an intimation that he's
much interested in a very clever foreign lady."

The Film

Bogdanovich said, "*Daisy Miller* is in fact a kind of
sketch . . . I don't think it's a great classic story. I don't treat

Henry James

tions are more valid than others. The challenge with *Daisy Miller* "is that of rendering the story's delicately modulated tone," which Bogdanovich fails to do because he misreads this tone and as a result plays out "the film as an extremely broad comedy of manners rather than as a subtle satire." Also controversial was the casting of Cybill Shepherd as Daisy; she had yet to outgrow her bad-girl persona from Bogdanovich's *The Last Picture Show* and was thus difficult for viewers to accept as a possibly innocent young woman.

REFERENCES

Birdsall, Eric, "Interpreting Henry James: Bogdanovich's *Daisy Miller*," *Literature/Film Quarterly*, 22 (1994), 272–77; Boyum, Joy Gould, *Double Exposure: Fiction into Film* (New American Library, 1985); Canby, Vincent, "*Daisy Miller* Is an Unexpected Triumph," *The New York Times*, June 16, 1974, II, 1:4; Dawson, Jan, "An Interview with Peter Bogdanovich," *The Classic American Novel and the Movies*, ed. Gerald Peary and Roger Shatzkin (Frederick Ungar, 1977), 83–89.

—*U.W.*

THE DANCER UPSTAIRS (1995)

NICHOLAS SHAKESPEARE

The Dancer Upstairs (2003), U.S.A., directed by John Malkovich, adapted by Nicholas Shakespeare, Fox Searchlight Productions

The Novel

Nicholas Shakespeare's *The Dancer Upstairs* (1995) concerns turbulent Peruvian politics during the Sendero years leading up to the capture of Abimael Guzmán in September 1992. As a political novel, *The Dancer Upstairs* resembles some of Graham Greene's fiction, but in its structure it seems quite Conradian. Johnny Dyer is an American journalist who has lived in South America for several years. Given the opportunity to write one last feature for his paper before he is relocated to Russia or the Middle East, he decides to cover Ezequiel, the revolutionary leader who was finally caught after a 12-year manhunt. When he tries to get his Aunt Vivien's help to secure an interview with Captain Calderón, who could provide important information, she does not want to become involved and flees. Dyer goes to Pará, Brazil, where she is supposedly staying, but he is unable to find her. Instead, at one of the restaurants he finds Colonel Rejas, the man responsible for Ezequiel's capture. In the course of three nights Rejas tells his story to Dyer, who thinks that he is getting his feature without Rejas knowing that he is a reporter likely to print what he hears.

Rejas, a former lawyer who quit to become a policeman in order to find real justice, describes his first meeting with Ezequiel at a border post; but at that time he did not realize that the man without papers was Edgardo Vilas, a former philosophy professor soon to become "President

it with that kind of reverence . . . The thing that interests me *least* is what James saw in it. Though on the surface I think we've been very faithful to the story." His adaptation makes no attempt to preserve James's narrative technique, though the movie is careful never to show us Daisy without Winterbourne's presence, so it approximates the point of view of the novella.

The major change is in the emphasis on Daisy herself. In the story, she is secondary; the narrator's interest is in Winterbourne. Daisy's death is narrated in an almost perfunctory way—"A week after this the poor girl died; it had been indeed a terrible case of the *perniciosa*." Bogdanovich keeps Daisy's illness and death offstage as well, but the scene when Winterbourne learns of her death is an effective use of film both to prevent melodramatizing it and yet, simultaneously, through indirection, to appeal to emotion as well. We see Winterbourne with a bouquet of flowers enter the hotel door and through its window we observe a silent exchange between him and the desk clerk, after which Winterbourne comes back outside and throws the flowers away; on the soundtrack is an organ-grinder version of "La donna e mobile," suggesting, among other things, Daisy's lack of discipline, the public's ostracizing of her, and Winterbourne's misreading of her as a flirt.

For Boyum "the only truly meaningful way to speak of any given film's 'fidelity' [is] in relation to the quality of its implicit interpretation of its source," and some interpreta-

Ezequiel," the infamous revolutionary leader. The Marxist revolt—Ezequiel described himself as the "fourth flame of Communism"—begins in the country with isolated incidents but soon spreads to the capital, where Rejas has become a detective. The first signs of the revolution are the dead dogs that are suspended from lampposts in the city; the first one has a sign referring to Deng Xiaoping, the Chinese Communist leader, and the others refer to President Ezequiel. Other animals carry explosives, and then the violence spreads to children who are willing to blow themselves up and then to children willing to assassinate leading politicians.

General Merino, "our most distinguished policeman," picks Rejas to lead a squad charged with finding Ezequiel. Both Merino and Rejas are determined to keep the Ezequiel matter out of the hands of Calderón, who would kill Ezequiel and who would like any excuse to have the army in charge instead of democratically elected people. During the course of the lengthy investigation, several other atrocities are committed, the first of which is the assassination of several prominent politicians at an "audience participation play." Since Rejas narrates, he tells the story as a reconstruction from an account by an eyewitness. At a later assassination, schoolgirls are the killers, and it is Rejas's knowledge of the lechery of Admiral Prado that allows him to guess at how the killing was orchestrated.

While Rejas is conducting his investigation, his marriage to Sylvina crumbles, partly because of his absences and his change of career, but also because his lighter-skinned wife is unhappy with her social status and finally resorts to a Sally Fay cosmetics racket (really a pyramid scheme) to improve the family's fortunes. Her preoccupation with status and makeup reveal her to be a social climber with intellectual pretensions: The novel she discusses with her book club friends is *The Bridges of Madison County*. She is in sharp contrast to Yolanda, the dance teacher who suggests that Rejas's daughter, Laura, abandon classical dance, which Sylvina had suggested, for modern dance. Yolanda has also given up ballet, but for political reasons. She is intent on choreographing a ballet based on Sophocles' *Antigone*, which has a political theme related to her own life. Not surprisingly, Rejas finds himself attracted to Yolanda, whom he does not want to suspect of criminal involvement.

During the lengthy investigation, there is a false rumor of Ezequiel's death, the arrest of revolutionaries who will not talk, and Rejas's return to his rural hometown to seek evidence. When he returns home, he is almost killed by villagers who associate him with the *pishtaco* myth, the story of a creature who gathers the grease from children. Because of Ezequiel's invisibility and his followers' brutality there are few clues to Ezequiel's whereabouts. Rejas only knows that his quarry has psoriasis that requires the use of Kennacort E and that he smokes Winston cigarettes. He does get some other leads, including a video that contains Ezequiel and part of a street sign. This information and a careful raking over of garbage from the possible

streets ultimately lead him to Yolanda's dance studio with the apartment upstairs. Concerned about the safety of his daughter and of Yolanda, Rejas postpones the raid until all Yolanda's dance pupils have left. Sylvina is the last mother to pick up her child, and her delay at leaving, prompted by her concern about her makeup, exasperates Rejas and reinforces Sylvina's shallowness. When Ezequiel is captured, Yolanda discovers that Rejas is a policeman and expresses her contempt for him.

Rejas takes custody of Ezequiel, announces his arrest, and interrogates him before Calderón's men take him away. Because of Rejas's public actions, Calderón cannot kill Ezequiel, but attempts to humiliate him by displaying him in a cage. Yolanda is sentenced to life imprisonment and is deprived of light, a terrible punishment since she has earlier demonstrated her fear of the dark. Such is her hatred of Rejas that Yolanda refuses to accept the blankets he receives permission to send her. The story, however, does not end with the capture of the revolutionaries. Dyer realizes that he has been manipulated by Rejas, who intuited his reluctance to tell the story and his willingness to negotiate a deal with Calderón. In a later conversation with his returned Aunt Vivien, Dyer asks her to arrange his meeting with Calderón, who subsequently agrees to arrange Yolanda's early release in exchange for Rejas's refusal to run for president. At the end of the novel, Sylvina has left Rejas, who has been named Minister of Native Affairs, and Rejas's daughter Laura, due to Vivien's intervention, has been accepted by the Metropolitan Ballet.

The Film

John Malkovich, the critically acclaimed actor who directed *The Dancer Upstairs*, first became interested in adapting Shakespeare's novel to film in 1995, but because of financing problems, the film was not released until May 2, 2003. Although Shakespeare, who wrote the screenplay for the film, retained much of the content, he did make one important deletion. The Dyer material that frames the novel and gives it a *Heart of Darkness* structure and theme is missing. As a result, we lose the Marlow/Dyer and Kurtz/Ezequiel parallels and the concept of a journalist/user being used by someone he sets out to exploit. Instead of Dyer negotiating Rejas's deal, Rejas (Javier Bardem) does his own negotiating, and Vivien's ballet connection to Laura (Marie-Anne Berganza) is lost. Without the exposition provided by Dyer, the plot simply begins with the outpost meeting between Rejas and Ezequiel (Abel Folk) and then shifts to a later date when Rejas has been reassigned to the capital city of an unspecified South American country. (The film was actually shot in Ecuador, Portugal, and Spain; but the ties to Peru and the Shining Path movement are discernible.) As a result, the film is more difficult to follow than the novel, a fact not lost on reviewers who criticized the structure of the film.

Although most of the significant events are included in the adaptation, there are some changes, made no doubt to make the film more appealing. Sylvina (Alexandra Lencastre) is as insipid, vain, and shallow as she is in the novel, but the part of Yolanda (Laura Morante) is not only expanded, but made more appealing, at least until her capture. In a kind of "dumbing down," she loses her intellectualism, and her ties to Antigone, perhaps beyond the average moviegoer, are dropped. Similarly, the political context is downplayed, and the striking resemblances between the methods of the army and the revolutionaries are ignored. Audiences do not learn the fate of the innocent drama group whose name was used in the audience participation execution. Without the Dyer/Vivien link, audiences do not understand the fate of critical journalists and their informants in "dictatorial democracies." (In the novel, Vivien was understandably reluctant to speak with Dyer, one of whose earlier stories had embarrassed her and jeopardized her position.)

Some tangential items in the novel were omitted while others were included. Unless the "fishing" that General Merino (Oliver Cotton) does can be metaphorically linked to investigating, it seems almost irrelevant, but it is stressed in the film, which seriously alters Rejas's trip home. The *pishtaco* material, which helped to heighten the ambivalent feelings of the rural folk toward Ezequiel and demonstrated how myth can influence people, is omitted, and the trip seems relatively uneventful. While the film does contain material about the young woman who is caught transporting arms to the revolutionaries, it does not identify her as the wife of a naive American who cannot believe that his wonderful wife is a follower of Ezequiel. The novel uses this incident to drive home the point that anyone can be a revolutionary and to foreshadow Rejas's own incredulous response to Yolanda's relationship to Ezequiel.

Most importantly, the ending of the film differs from that of the novel. Using Dyer, Shakespeare can supply his readers with information about the aftermath of Ezequiel's capture. The loose ends are tied up. Dyer has negotiated Yolanda's early release; Sylvina has gone to Miami; Laura will become a ballerina; and Rejas has adopted the position of minister of native affairs. Accepting a post in the government he has every reason to distrust would seem to be selling out to the enemy and contradicting his desire to find real justice, what he thought he would find by giving up a lucrative law practice for a career as a policeman. However, Shakespeare kept his readers aware of Rejas's color and his background, thereby stressing his agrarian roots and "native" status. Perhaps Shakespeare is suggesting that Rejas's new position will enable him to reach his expressed goals and that the countryside is where Rejas really belongs.

In the film Rejas meets with Calderón (Luis Miguel Cintra) and negotiates Yolanda's early release and decent treatment in exchange for promising not to run for president. Calderón is flabbergasted when Rejas forsakes political ambition because of an unconsummated and unrequited love. At the end of the film Rejas has nothing, except his futile love for Yolanda. This ending might be more convincing if film audiences were more aware of Rejas's obsession with Yolanda: in the novel Rejas seeks to find out everything he can about his love, even interviewing one of her first lovers. How film audiences respond to Rejas's choice is left to them, but in the novel Vivien tells Dyer all she knows, the positive and negative, about Yolanda and warns him about "folding" her into his life. Essentially, Vivien deconstructs Rejas's narrative, suggesting that Dyer may have been taken in by Rejas's portrait of Yolanda. Hers is a less idealistic and less naive view of Yolanda's political role: "You start with a humanitarian idea, and before you know it, you're cutting throats." There is nothing in the ending of the film to suggest that it is Rejas's story, one that needs careful scrutiny.

REFERENCES

Cohen, Joshua, *Library Journal* 122 (January 1997): p. 150; Atamian, Christopher, *New York Times Book Review*, March 16, 1997, 21; Gliatto, Tom, *People*, May 26, 2003, 36; Felperin, Leslie, *Sight & Sound* 12 (December 2002): 44.

—T.L.E.

DAVID COPPERFIELD (1850)

CHARLES DICKENS

David Copperfield (1935), U.S.A., directed by George Cukor, adapted by Hugh Walpole/Howard Estabrook; MGM.

The Novel

David Copperfield, Dickens's own favorite among his works, was to some extent autobiographical in nature. As English scholar Martin Day has observed in his *History of English Literature*, the orphaning of David reflects the "lost child" theme, which also surfaces in such other Dickens novels as *Oliver Twist*. This theme suggests the novelist's bitter feeling that his own parents never surrounded him with the security essential to childhood.

This lengthy—not to say sprawling—novel covers the youth and young manhood of its hero. David is content with his widowed mother, until she marries the tyrannical Mr. Murdstone. The drudgery of working in his stepfather's business is relieved by David's visits to the improvident but amiable Micawber family. When he grows up David subsequently marries Dora, a childish young woman who dies shortly after they are wed. David in due course marries Agnes, who proves to be a much more mature wife for him. David tries hard to develop himself into a respectable Victorian gentleman, while he pursues his career as a writer, first as a journalist and later as a novelist like his creator.

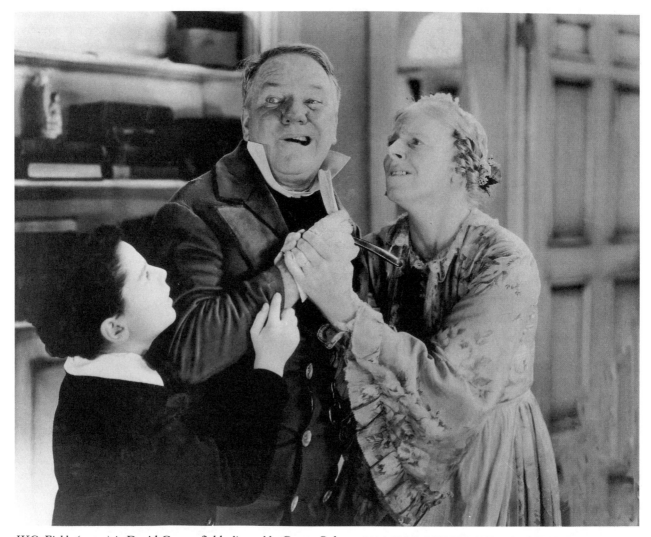

W.C. Fields (center) in David Copperfield, *directed by George Cukor* (1934, U.S.A.; MGM/PRINT AND PICTURE COLLECTION, FREE LIBRARY OF PHILADELPHIA)

The Film

George Cukor's screen version of *David Copperfield* (1935) followed his triumphant film adaptation of *Little Women* (1933). *Copperfield* was produced at MGM by David O. Selznick, who encountered a great deal of opposition there when he began planning to produce the Dickens film. In spite of the critical and popular success of films like *Little Women*, costume pictures based on literary classics were still looked upon as risky ventures by studio executives because they were so expensive to make. Eventually the front office at MGM reluctantly gave Selznick the go-ahead on *Copperfield*, but he later recalled that the opposition continued all the way through the production period.

It is not surprising, then, that Cukor and Selznick failed to convince the front office to let them shoot the entire movie in Britain, since the studio had not been enthusiastic about the project in the first place. Hence the producer and the director, along with screenwriter

Howard Estabrook, traveled to England before shooting commenced to visit several sites associated with Dickens's life and with his semi-autobiographical novel. They returned to Hollywood with location footage that would furnish background shots, which would establish the authentic English milieu of the novel, as well as hundreds of still photographs to guide the art department in designing the sets for the film.

During their stay in England, Cukor and his collaborators engaged the distinguished British novelist Hugh Walpole to contribute dialogue to the screenplay, since Walpole possessed the knack of devising dialogue passages that had a genuine Dickensian ring to them. (He also played a cameo role in the movie as a vicar.)

Estabrook was responsible for the overall layout of the screenplay, which retains the episodic structure of Dickens's rambling tale. The second half of the novel is not as exciting as the first, and the same can be said of the film.

The problem is that David is a much more appealing character as a youngster than he is after he grows up to be a typical Victorian prig. Asked about this point, Cukor responded with another question: "If a writer like Dickens couldn't straighten out that difficulty satisfactorily, how could we have been expected to do it for him?" Cukor was a firm believer in the notion that capturing the essence of a classic novel on film involves accepting the book's flaws as well as its virtues, and then trusting in the original author's genius to carry the story along. The somewhat crude, melodramatic plot contrivances and the craggy, awkward structure of this vast, rather unwieldy novel give the book what Cukor called "a kind of strength that one should not tamper with."

Cukor's "warts-and-all" approach to filming *Copperfield* resulted in a faithful rendition of Dickens's work that *New York Times* critic Andre Sennwald termed "the most profoundly satisfying screen manipulation of a great novel that the camera has ever given us." It is astonishing, Sennwald continued, how many of the myriad incidents of David's life found their way into the film. Some of the episodes have admittedly been telescoped for the sake of brevity; but the movie nevertheless "encompasses the rich and kindly humanity of the original so brilliantly that it becomes a screen masterpiece in its own right" (January 19, 1935). The *Times* critic also thought that the characters in the picture seemed to have stepped right out of Phiz's celebrated illustrations for the original edition of the novel.

Cukor cast the picture with great care. MGM tried to foist a popular American child star of the day named Jackie Cooper on him to play David as a boy; but Cukor insisted that the part should go to an English lad, Freddie Bartholomew.

Although W.C. Fields seems perfectly suited to the role of the eccentric Micawber, Cukor recalled that "he was diffident at first about playing a straight character part because he was essentially a comedian." Cukor convinced him that he was born to play Micawber, since Fields's screen image as a bumbling, impecunious, erratic type was totally in keeping with Micawber's character.

"In his films Fields was forever being frustrated by inanimate objects," Cukor explained; "so I let him integrate a bit of this kind of comedy into his portrayal of Micawber. In the scene in which Micawber gets flustered while working at his tall bookkeeper's desk, Fields dipped his pen into a cup of tea instead of into the inkwell and stepped into the wastebasket as he walked away from the desk."

Fields's superb interpretation of Micawber, one of his best-loved roles, is but one of the finely tuned characterizations contributed to the film by the outstanding group of character actors assembled for the movie, including Basil Rathbone as a coldly sneering Mr. Murdstone. Indeed, the entire cast added immeasurably to the overall artistic excellence of the film. The movie opened to rave reviews and gratifying box-office receipts. Thus Cukor proved once and for all his capability to mount handsome productions of classic novels like *David Copperfield.*

REFERENCES

Bernardoni, James, *George Cukor: A Critical Study* (McFarland, 1985); Klein, Michael, and Gillian Parker, eds., *The English Novel and the Movies* (Ungar, 1981); Phillips, Gene, *Major Film Directors of the American and British Cinema* (Associated University Presses, 1990).

—*G.D.P.*

THE DAY OF THE LOCUST (1939)

NATHANAEL WEST

The Day of the Locust (1975), U.S.A., directed by John Schlesinger, adapted by Waldo Salt; Paramount.

The Novel

Nathanael West, novelist and screenwriter, not well known during his short life, is now considered one of the foremost American modernists, despite a modest productivity that also included the short novels *The Dream Life of Balso Snell* (1931), *Miss Lonelyhearts* (1933), and *A Cool Million* (1934). All his acerbic, nihilistic fiction reveals the corrupt and despairing underside of the American consumer culture during the depression. Based on his experiences during the 1930s as a scenarist in Hollywood, *The Day of the Locust* was his last novel.

Located in a surreally evoked Hollywood peopled by depression-era émigrés who are futilely seeking the great American dream that seems to remain forever beyond their grasp, the novel focuses on recent Yale graduate, painter Tod Hackett, and the other lost souls he meets in Los Angeles: 17-year-old would-be starlet Faye Greener, who, like Nabokov's Lolita, has a personality formed entirely by the movies (all the characters appear as Hollywood clichés parodically incarnate); her out-of-luck father, former actor-comedian Harry, who is now a door-to-door salesman garrulously reciting a probably false past; and Homer Simpson, a simple, vaguely retarded 40-year-old former Midwestern hotel bookkeeper who briefly houses Faye and her various unpleasant acquaintances. Also on the scene among the other West grotesques is the pugnacious and salacious dwarf, Abe Kusich, and a Hollywood brat, Adore Loomis, whose mother expects him to be a major star. The novel's leitmotif is captured by West's line: "Few things are sadder than the truly monstrous."

With bitter humor, West details Faye's role as sexual cynosure; Tod's plans for an apocalyptic surreal painting, *The Burning of Los Angeles;* and Homer's despairing attempt to flee the madness of California back to his home of Iowa, foiled after he's caught up in the uncontrolled violence of a restless mob at a Hollywood premiere. The novel ends in an apocalyptic vision of the crowd's violence seemingly derived from the imagery of Tod's imagined painting.

The Film

Critically praised for his adaptation of *Midnight Cowboy* (1969) and for his direction of film critic Penelope Gilliat's *Sunday, Bloody Sunday* (1971), Schlesinger had already adapted *A Kind of Loving, Billy Liar,* and *Far From the Madding Crowd.* With a screenplay by Waldo Salt (who had written the *Midnight Cowboy* screenplay) and a large Paramount budget, he tried for a literal rendition of West's tale, capturing 1930s Los Angeles with a painterly eye to match Tod's point of view, jump-cutting from character to character in West's famous episodic (and, arguably, "cinematic") style, leading up to the final frightening crowd scene.

The film was a financial disaster. Critics tended to be at best mixed in their praise. Pauline Kael, for instance, found it "overblown," a "mosaic that never comes together." Jay Cocks wrote that the film "misses what is most crucial: West's tone of level rage and tilted compassion, his ability to make human even the most grotesque parody." However, even the film's detractors praised the acting, especially of those in minor roles (e.g., Billy Barty

as Abe, Jackie Haley as Adore, and Burgess Meredith, who won an Oscar for his role as Harry). More problematic was the choice of Karen Black to play Faye; as with complaints about Sue Lyon's too-old Lolita and Jennifer Jones's similarly wrong age as Faye Doyle in *Lonelyhearts,* critics were unhappy with the 33-year-old actress playing the very childlike girl of the novel.

Despite critics' initial disappointment, Schlesinger's adaptation still holds much fascination for Nathanael West fans. He has created an engrossing work (even if it is of the kind film critics love to term "failed masterpiece"). If at times the film seems to boast parts greater than the sum, those individual parts still amaze: Schlesinger's brilliant merging of the film-within-a-film concept that marks West's hilarious descriptions of Tod wandering lost through Hollywood sets; Faye and Homer's dismal quotidian life "together"; androgynous child Adore's brutal Shirley Temple parody of Harry while Homer (Donald Sutherland) just looks on silently.

Admittedly, the pithy descriptions that mark West's genius are lost, as is his subtle intersection of the surreal and the real (although Joy Gould Boyum tries to argue

Karen Black in The Day of the Locust, *directed by John Schlesinger* (1974, U.S.A., LONG ROAD-PARAMOUNT/PRINT AND PICTURE COLLECTION, FREE LIBRARY OF PHILADELPHIA)

that this is precisely where Schlesinger succeeded). As is often true when subtle and/or narratively complex novels are adapted, the film remains more accessible and aesthetically convincing for those familiar with the text. Joanna Rapf argues persuasively that "idea novels" such as *The Day of the Locust*, where there is no central dramatic character for audience empathy, have an intrinsic problem in the medium of film.

Certain changes either enhance or diminish West's intentions. For example, West's penchant for satirizing religious zealots is furthered by the addition of a scene wherein Faye and Harry attend a Christian faith-healing assembly led by a charismatic Geraldine Page. Unfortunately, the nightmarish frenzy of the concluding sequence is diminished by a tacked-on, sentimental ending wherein Faye returns to look for Tod. It is in such romanticized conclusions that Hollywood typically dilutes the sterner stuff of its source novels.

Schlesinger's film proves once again the paradox that modernist novels that display a "cinematic" style and sensibility often become flat and prosaic when transferred to the screen.

REFERENCES

Boyum, Joy Gould, *Double-Exposure: Fiction into Film* (New American Library, 1985); McCaffery, Donald W., *Assault on Society: Satirical Literature to Film* (Scarecrow Press, 1992); Murray, Edward, *The Cinematic Imagination: Writers and the Motion Pictures* (Ungar, 1972); Rapf, Joanna E., "'Human Need' in *The Day of the Locust:* Problems of Adaptation," *Literature/Film Quarterly* 9, no. 1 (1981): 22–31.

—D.G.B.

DEATH IN VENICE (*Der Tod in Venedig*) (1912)

THOMAS MANN

Death in Venice (*Morte a Venezia*) (1971), Italy, directed by Luchino Visconti, adapted by Visconti and Nicola Badalucco; Mario Gallo/Warner Bros.

The Novel

The period of German Romanticism in the early 19th century produced a number of novels with artist protagonists, most notably Goethe's two "Wilhelm Meister" works (1777–1829). As a lingering look back at that great era, Thomas Mann's *Death in Venice*—written in 1911 after the success of *Buddenbrooks* (1901) and *Tonio Kröger* (1903)—tells the story of the artistic and personal crisis of a writer, Gustave von Aschenbach. The middle-aged man is at a difficult point in his career, and he comes to Venice seeking solace and peace. He is disturbed, however, when he finds his affections for a beautiful young boy named Tadzio, a guest at the Hôtel des Bains, growing into infatuation, even love. Increasingly self-conscious about their age discrepancy, Aschenbach tries to rejuvenate himself with the aid of hair dye and makeup. Despite warnings about an outbreak of cholera in the city, Aschenbach refuses to leave; he dies on the beach, dreaming of a vision of a boy pointing to a faraway place on the horizon.

The Film

Luchino Visconti had long admired Thomas Mann. Although he never realized a lifelong ambition to film *The Magic Mountain*, his adaptation of *Death in Venice*, the second installment of his so-called German Trilogy, which began with *The Damned* in 1967 and concluded with *Ludwig* in 1973, continued his increasing preoccupation with decadence and ambiguity. The story's references to the sometimes fatal links between art and homosexuality—a constant theme in Germany's cultural past—frightened prospective financiers until the unlikely combination of Italian producer Mario Gallo and the American studio Warner Bros. enabled Visconti to proceed with relative freedom.

The screenplay makes two major changes. First, Aschenbach's profession is changed to that of a composer (a reference to Mann's devotion to Gustav Mahler, who had died during the writing of the story), which allows for the extensive use of quotations from the "Adagietto" of Mahler's Fifth Symphony. The second introduces flashbacks departing from the book's back history. They depict fleeting, sometimes ambiguous images of Aschenbach's home life, the loss of his little daughter, an encounter with a young prostitute, and fragments of arguments about life and art with a "friend" named Alfried. These latter moments, in which Aschenbach defends his belief in art as a rigorously intellectual pursuit, set the stage for his quickening vulnerability to the irrational emotions aroused by Tadzio. "Aschenbach's resistance is gone," suggests Claretta Tonetti in her study of Visconti; "and at the end of his life he finally sees that his religious worshipping of purity and rationality was only self-deception."

It has been charged that Visconti's images of lingering glances between the composer (Dirk Bogarde) and Tadzio (Bjorn Andresen)—their encounters are never physical and the boy never utters a word—suggest a mutual homosexual attraction more obviously than in the book. Yet there is no question that those implications are present in Mann's original. More importantly, both book and film remain true to Mann's idea that the search for artistic perfection exacts a terrible price. Like Aschenbach, the artist may die before (or as a result of) the culmination of that quest. This irony, so characteristic of Mann's work, reveals his lifelong skepticism regarding the artistic life. Certainly Venice, in many ways the cradle of artistic expression for countless artists in the past, proves fatal for Aschenbach. If his repressed Dionysian self is released by the symbolic and physical presence of Tadzio, he is destined to die of

cholera, a disease that seems almost banal in the face of the surrounding artistic context.

Certainly the reality of Venice itself allows Visconti's camera eye full range, and he effectively contrasts the fragile elegance of the Belle Epoque milieu with the deteriorating splendor of a city buried in fog and decaying from sickness. From the attention given to these details, concludes commentator Tonetti, "it is obvious that Visconti wanted not only to tell the story of Aschenbach, but also to portray an aristocratic society close to death, oblivious to the real world, and already shadowlike."

REFERENCES

Sterling, Monica, *A Screen of Time: A Study of Luchino Visconti* (New York, 1979); Tonetti, Claretta, *Luchino Visconti* (Twayne, 1983).

—*R.A.F. and J.C.T.*

DELIVERANCE (1970)

JAMES DICKEY

Deliverance (1972), U.S.A., directed by John Boorman, adapted by James Dickey; Warner Brothers.

The Novel

The poet James Dickey published his first novel, *Deliverance*, in 1970. The novel was an immediate bestseller. Critical response was mixed, with some academic critics objecting to what they regarded as an exaltation of violence. Later critics have been more positive, often stressing the mythic dimensions of the book.

Four big-city businessmen plan a canoe trip on the wild, but soon to be damned, Cahulawassee River. They are Lewis, an ardent bow-hunter and survivalist; Ed, the first-person narrator, an advertising man; Bobby, a cynical, somewhat overweight salesman; and Drew, a sales supervisor and amateur guitar player. They are most likely from Atlanta, though the city is never named.

The first day of the trip goes well, with the rapids challenging but not overwhelming. On the second day, Ed and Bobby are confronted on the bank by two local men, whom Ed takes for bootleggers, or escaped convicts, or possibly just hunters. At gunpoint, one of the men sodomizes Bobby. The other begins to force Ed into a sex act when he is killed by an arrow from Lewis's bow. His companion flees into the woods.

Descending another rapids, near twilight, Drew topples from the lead canoe and is lost. The three remaining men are thrown from their canoe, and Lewis is seriously injured with a broken thighbone. Ed decides he must climb out of the gorge that night and kill the man who shot Drew. He climbs the high, sheer cliff in darkness and kills the group's antagonist with an arrow. Ed and Bobby then throw this unknown killer, weighted with rocks, into the river. When they find Drew's body, they do the same with him.

Ed, Bobby, and Lewis descend the river through an incredible rapids and find help at the first town. They outwit the country lawmen asking questions about their trip, and in a few days return home.

The Film

Deliverance was very quickly made into a popular movie, with Burt Reynolds, an action star linked to the South, playing Lewis, and Jon Voight, a star thanks to *Midnight Cowboy* (1969), as Ed. In supporting roles, Ned Beatty plays Bobby and Bobby Cox plays Drew. Director John Boorman does a beautiful job of creating an ambiguous relation (joy? dread? excitement?) between the city men and the wilderness river. In later films, Boorman has presented this same kind of complexity between man and nature—see, for example, *Zardoz* and *The Emerald Forest*.

The primary difference between the book *Deliverance* and the film lies in the change from first person to third person narration. The novel tells us a great deal about Ed—his admiration for Lewis, his boredom, his love of wife and son, his resourcefulness when challenged. The novel is extraordinarily good at presenting the extremes of emotion when Ed climbs the cliff and kills the man who is waiting on top, preparing to shoot all the canoeists. These 30 pages of the novel present, in gripping prose, a peak experience for Ed. The film does not have the resources of subjective prose narration, and reaches no such transcendent peak. As an objective account, it is as much Lewis's film as Ed's. But the film does manage to work on several levels at once. It is about the separation of man and nature, the attraction of nature, the cultural conflict between country and city, the centrality of violence in human experience. It is also, in simple genre terms, a horror film—our heroes meet horrific Others in the forest.

All of the above themes are in Dickey's book, but the film plays up the centrality of violence. The slightly different emphasis between book and film can be seen by comparing endings. In the book, Ed has survived a rite of passage, and he can now relax and appreciate his everyday life. He relegates nature to a cabin by a peaceful lake, *not* the damned (also damned?) Cahulawassee. The film ends with Ed still wrestling with the experience of violence. In bed with his wife, he has a nightmarish dream of a dead man raising his hand out of a lake. In the visual and visceral medium of film, an experience of extreme violence cannot be easily sublimated.

Recent scholarship has critiqued the film *Deliverance* for stereotyping the rural men. Carol J. Clover suggests that the country antagonists are "demonized" to justify city guilt: The city and suburbs need electric power, which can be supplied only by damming the river and destroying the countryside. But if the country dwellers are degenerate and demonic, then the rape of their land is justified. Clover refers to this revenge scenario as "urbanoia." *Deliverance* (book or film) is very sophisticated in contrasting

Jon Voight in Deliverance, *directed by John Boorman* (1972, U.S.A.; WARNER-ELMER/THEATRE COLLECTION, FREE LIBRARY OF PHILADELPHIA)

man and nature, but book and film also present the crude, "urbanoid" horror pattern.

REFERENCES

Burns, Margie, "*Easy Rider* and *Deliverance*, or, the Death of the Sixties," *University of Hartford Studies in Literature* 22, no. 2/3 (1990): 44–58; Calhoun, Richard J. and Robert W. Hill, *James Dickey* (Twayne Publishers, 1983); Clover, Carol J., *Men, Women and Chainsaws: Gender in the Modern Horror Film* (Princeton University Press, 1992); Kirschten, Robert, *Critical Essays on James Dickey* (G.K. Hall, 1994).

—P.A.L.

D'ENTRE DES MORTS (1954)

See VERTIGO.

DER TOD IN VENEDIG (1912)

See DEATH IN VENICE.

DESPAIR (published in 1934, in Russian; in 1937, in English; in 1965, in a revised English version)

VLADIMIR NABOKOV

Despair—Eine Reise ins Licht (Despair) (1977), West Germany, directed by Rainer Werner Fassbinder, adapted by Tom Stoppard; Bavaria Atelier.

The Novel

It is Nabokov's literary conceit that this tale was written in 1931 by Hermann Karlovich, an upper-class Russian living in Berlin. He is distressed by the threatened failure of his chocolate factory, the stresses of late Weimar-era politics, his empty-headed wife Lydia's affair with her cousin Ardalian, and psychic "dissociations." Hermann seems to find a way out of all of this when he discovers a tramp, Felix, whom he mistakenly takes to be his exact double. He

insures his life, dresses Felix in his own clothes, and murders him. But the plan soon unravels, since Hermann has carelessly left Felix's walking stick, with his name engraved on it, at the murder scene—as he realizes while rereading his manuscript account of the perfect murder "as a work of art." In the process, the originally charming and witty Hermann is gradually revealed to be a madman or an absolute scoundrel, or both. At the story's end, he contemplates the crazy idea of escaping the police who are closing in on his hideout in a Swiss village by pretending to be the star of a film under production.

The Film

This was the second film made for the international art market by the prolific and controversial German director Rainer Werner Fassbinder. It was the first of his films for which he did not write the script himself, although he had tried to do so after seeing in the novel affinities with the personal crisis he was undergoing at the time. In securing the celebrated British playwright Tom Stoppard to write the screenplay, Fassbinder said he was looking for "something light and loose and funny," which he thought no German screenwriter could produce. Stoppard obliged, producing a free adaptation of the novel that is largely sympathetic to the protagonist (renamed Hermann Hermann, an apparent allusion to the Humbert Humbert of Nabokov's *Lolita*). The screenplay clarified the book's confusing timeshifts, replaced its literary self-consciousness with several instances of cinematic reflexivity, and incorporated many of its puns and other verbal witticisms.

Fassbinder's film transforms Stoppard's screenplay into a heavily mannered cinematic tour de force; striking visual effects include a memorable scene in a movie theater, many shots through the etched glass and into the mirrors of an art nouveau studio set, and evocative use of light and shadow. In eliminating many of the transitions provided in the script, the film impels the viewer to share in the psychic dislocations of Hermann, played by Dirk Bogarde in what some critics have seen as the most brilliant role of his distinguished career. Through Bogarde's subtle acting, and the film's intimate and sympathetic treatment of him, Hermann emerges as a heroic sufferer of modernist angst and sexual frustration, caught in the web of a Germany on the verge of the Nazi epoch.

REFERENCES

Elsaesser, Thomas, "Murder, Merger, Suicide," in *Fassbinder*, ed. Tony Rayns (British Film Institute, 1980), 37–53; Fassbinder, Rainer Werner, "'Of despair, and the courage to recognize a utopia and to open yourself up to it': Two Monologues and a Text on Despair," in *The Anarchy of the Imagination: Interviews, Essays, Notes*, ed. Michael Töteberg and Leo A. Lensing, tr. Krishna Winston (Johns Hopkins University Press, 1992); Watson, Wallace Steadman, "Rewriting Nabokov," in *Understanding Rainer Werner Fassbinder: Film as Private and Public Art* (University of South Carolina Press, 1996), 189–204.

—*W.S.W.*

DIARY OF A CHAMBERMAID (*Le Journal d'une femme de chambre*) (1900)

OCTAVE MIRBEAU

The Diary of a Chambermaid (Le Journal d'une femme de chambre) (1946), U.S.A., directed by Jean Renoir, adapted by Renoir and Burgess Meredith; Bogeaus-Meredith/United Artists.

Le Journal d'une femme de chambre (Diary of a Chambermaid) (1963), France/Italy, directed by Luis Buñuel, adapted by Buñuel and Jean-Claude Carrière; Cocinor, Speva Films-Ciné Alliance, Filmsonor (Paris) & Dear Film Produzione (Rome).

The Novel

Characterized by a vivid and violent style, Mirbeau's work expresses his protest for social justice. After a first writing experience as a journalist in several conservative Catholic and royalist newspapers, Mirbeau created his own paper, *Les Grimaces*, in which he vehemently attacked all social institutions. With an ambiguous, intense, and revolutionary style, *Le Journal d'une femme de chambre* brought a new, bitter turn into French literature. Mirbeau's purpose was to attack aristocrats, whom he depicted as ethically degenerate and obsessed by outlandish fantasies.

Mirbeau wrote *Le Journal d'une femme de chambre* in 1900 and set it a few years earlier, at a time when the *ancien regime* was under pressure from the new socialists. Célestine, a sophisticated city girl, takes a job as maid at the country house of the Monteil family because she seeks a rich husband. When a local game keeper, Joseph, is suspected of the rape and murder of a little girl, Célestine offers herself to him in hopes he'll confess. But she falls in love with him and marries him, confessing in her diary that she is satisfied to be in his "demonic possession."

Whereas Mirbeau's words captured sensual passion as violence, his abrupt style depicted in his characters, according to Blanchot, "some sort of intense life, emotion or thought." Woven throughout the novel, the political background inserts into the story patterns of silence to acknowledge past historical material. What is strikingly new in the narrative form is the extraordinary visual quality of Mirbeau's images, which stems from the text's poetic dimension.

The Films

In order to realize a long-cherished ambition to make a movie version of the Mirbeau novel, Renoir went into partnership with his friends, actors Burgess Meredith and Paulette Goddard, to form Camden Corporation. The resulting production, if not even within hailing distance of the bitter eroticism of the original story (the restrictive Hollywood Production Code was still in force), at least reveals the fascination Mirbeau and Renoir had in com-

mon regarding the disparity in class status between domestic servants and their middle-class masters. Beyond this, the story has changed drastically: Joseph (Francis Lederer) is a common thief and Célestine abhors him. He gets his just desserts when he is lynched by villagers. Célestine and her lover live happily ever after.

In the Buñuel version, scripted by Jean-Claude Carrière, Célestine (Jeanne Moreau) coaxes Joseph into confessing the murder, reports him to the police, and then leaves to marry someone else. But Joseph flees and goes to Cherbourg, where he opens a bar. Biographer John Baxter describes this final irony in his study of Buñuel—"the forces of bourgeois conformism always win in the end." Buñuel's visual palette is gruesome in the extreme: the monstrous Joseph butchers his poultry by thrusting a needle through the brain; and the brutalized child is found in the woods with her thighs crawling with snails.

Le Journal d'une femme de chambre does not accurately reflect Renoir's famous taste for social realism and sarcasm. Exiled abroad after the mixed reception in France of his 1939 movie *La Règle du jeu* (*Rules of the Game*), which left him dissatisfied, Jean Renoir's artistic vigor was diluted when he moved to Hollywood.

By contrast, social injustice surrounds Buñuel's characters, who are either blinded by fascist dogmas or mystified by religious and ethical hypocrisies. Depicting the sexual whims of the privileged class, Buñuel also creates models of vanquished individuals with decaying morals in a disintegrating society. Displaying fetishism, eroticism, and sadism, the director's main concern remains with the arbitrary nature of social justice in corrupt provincial life, where human justice is shown to be ambiguous enough to confound even the smartest police officer.

While the criminal Joseph uses fascist theories to mask his sadistic drives, the virile master of the house is busily pursuing every maid to gratify desires resulting from his wife's sexual inadequacies. Following his imagination, Buñuel orchestrates the film's depravity around the arrival of the new maid, Célestine, and her tragic attempt to uncover the murderer of the innocent little Claire. Buñuel's lucidity and pessimism paint an accurate portrait

Jeanne Moreau in Le Journal d'une femme de chambre, *directed by Luis Buñuel* (1964, FRANCE-ITALY; SPEVA-CINÉ ALLIANCE-FILMSONOR/NATIONAL FILM ARCHIVE, LONDON)

of postwar ambiguities, as he captures repressed hopes that conservative power will alleviate social pessimism.

As a fervent follower of the French Realism of the Thirties, Jean Renoir attempts to represent nature's infinite diversity through detailed observation, while avoiding abstraction and ideology. His careful portrayal of contrasted characters reveals the collective representation of a confused and disturbed French social reality. According to Pierre Maillot in his book *Le Cinéma français*, Renoir depicted "the death of our society or at least its decline, among the confusion of its values, the loss of meaning and the insanity of a disoriented society" long before Visconti, Fellini, Bergman, and Godard. His decision to show nothing more in actors than what he observed in real life guides him deliberately to address sensitive postwar French issues.

Buñuel draws images from his personal experience of social injustice, obscurantism, military dictatorship, and religious terrorism. He provides a lucid vision of a world dominated by political dogmas that coercively distort individual experience and imprison his characters in a system of social inequality and alienation. With his co-scenarist Jean-Claude Carrière, Buñuel chose to retain most of the characters of Mirbeau's novel, expanding the novel's suspense beyond the resolution of the murder. In addition to the concrete suspense of discovering the assassin, Buñuel prefers to emphasize the elements of mystery found in the novel to show us the demise of Christian faith and the enslaving pervasiveness of all dogmas. Buñuel also establishes an intense visual imagery so that one feels admiration for the individual.

Buñuel's metaphorical handling of social depravity best reflects his strategy of remaining ambiguous, without overt moralizing, while he systematically demolishes the façade of respectability. Buñuel's great film goes beyond the compromise of Renoir's more timid adaptation, and has established itself as an enduring masterpiece of modernist cinema.

REFERENCES

Bertin, Célia, *Jean Renoir: A Life in Pictures*, tr. Mireille Muellner and Leonard Muellner (Johns Hopkins University Press, 1991); Mellen, J., *The World of Luis Buñuel* (Seghers, 1967); Brady, L., *Jean Renoir* (Doubleday, 1972).

—*C-A.L. and J.C.T. and J.M. Welsh*

DIARY OF A COUNTRY PRIEST *(Le Journal d'un curé de campagne)* (1936)

GEORGES BERNANOS

Le Journal d'un curé de campagne (1950), France, directed and adapted by Robert Bresson; UGC.

The Novel

Le Journal d'un curé de campagne was written between October 1934 and January 1936, and published by Plon in March 1936, the first part having already appeared in serial form, in a journal called *La Revue hebdomadaire*. The book is an account, in the form of diary, of a young priest's experiences in his first parish, Ambricourt, which is characterized by lust, greed, and injustice, and by a loss of spiritual conviction. Through his diary entries, we learn about the curé's reflections and theories, his interpretations (which often do not agree with our own), of his actions and those of others, and his relationship with God. We witness his gradual discovery of the spiritual problems that beset his parishioners, and of his efforts to help them. We also share his own spiritual and physical anguish, as he struggles on, until his agonizing death from cancer.

Bernanos's decision to present the story as a personal diary, discovered after its "author's" death, is important for many reasons: Its intimacy creates a direct bond between us and the curé, while the episodic and fragmentary nature of the diary entries allows the action to move directly from one crucial issue to the next, without the need for explanation, commentary, or linking passages. Above all, the form enables Bernanos to deal directly with questions of faith, and with the struggle between good and evil, without proselytizing.

Despite the apparently random nature of the entries, the structure of the novel is both complex and tight, while the depiction of the characters, all of whom are seen through the curé's eyes, is coherent and convincing.

The Film

The French press followed the production and premiere of the film with close interest, and its reception was almost unanimously positive. While the film immediately captured the enthusiasm of traditional cinephiles, it also interested intellectuals and devout Catholics—people who had not shown much previous interest in the cinema. In this way, as has been widely commented, Bresson's work can be seen to have been innovative in the exploitation of the film medium, as well as in its conception and realization of the story itself.

The film follows the original closely. The plot, depicting the mental and physical anguish of a young priest dying of stomach cancer and assailed by self-doubt, is unchanged. But Bresson realized that it was essential to see beyond the plot in order to reach the spiritual drama that forms the core of the book: The atmosphere and images of Bernanos's novel are beautifully expressed in Bresson's stark, bleak film. Starting from a desire to remain faithful to the original at all its levels, Bresson challenged the dominant aesthetic concerns of French cinema, including the primacy of the image and the preoccupation with quality, by creating a fluid, musical, and intimate form of filmic expression.

Bresson's first concern in his adaptation was to find a way of expressing the intimacy of the diary form and its centrality as the locus of the curé's thoughts. However,

equally important was the need to recreate the strong sense of spirituality that fills Bernanos's novel. The diary is variously represented as written pages on the screen, as a voiceover that situates the actions we see, and as those actions themselves, when, through fades, ellipses, and the like, we realize that what is represented before us, on the screen, is a reflection upon an event, not the event itself.

The film's spirituality emerges in its repetitions and details (lamps, wine bottles, prayer books, feet, hands, eyes), as well as in the intensity of its language, music, and imagery. The relentlessly dark, barren landscape, the cold, unwelcoming houses, are transcended by the priest in his diary. Bresson uses lighting to make us aware of this, in scenes where the priest's face is filled with delicate luminosity.

The dialogue with Chantal in the confessional is one of the greatest scenes in which Bresson allows us to witness the spiritual luminosity of two faces and two hands, alone visible in the intense darkness of the shot, where only voice and intention matter. Light is both physical and metaphorical in the film, referred to in the curé's discourse during the long, dark nights; and physically present in his longing for the comforting glow of lamplight, or the first promise of dawn. At times, light becomes both the focus and substance of a shot whose wider context is total darkness.

Bresson himself saw this film as "revolutionary," creating an entirely new style of cinematic expression. Even today the film astounds us by its directness, and by its creation of a sense of spirituality that is hard to describe or to pinpoint, involving, but somehow surpassing, the film's rich spiritual imagery and Christian symbolism. It would be far too simplistic to describe the film as allegorical; Bresson cut 45 minutes without hesitation, recognizing that its true drama transcended its plot, and was actually present in the quality of each of its moments. Above all, *Le curé de campagne* offers an example of an adaptation that remains true to its original, but does so in terms that are entirely cinematic.

REFERENCES

Hayward, S., *French National Cinema* (Routledge, 1993); Hebblethwaite, P., *Bernanos* (Bowes and Bowes, 1965).

—*W.E.*

DO ANDROIDS DREAM OF ELECTRIC SHEEP? (1968)

PHILIP K. DICK

Blade Runner (1982), U.S.A., directed by Ridley Scott, adapted by Hampton Fancher and David Peoples; Ladd-Shaw/Warner Bros.
Blade Runner: The Director's Cut (1992), U.S.A., directed by Ridley Scott, adapted by Hampton Fancher and David Peoples; Warner Bros.

The Novel

Do Androids Dream of Electric Sheep? was Philip K. Dick's reworking of his at that time unpublished novel, *We Can Build You* (1972), about a schizophrenic woman who builds androids because they, like herself, cannot feel love or empathy. Dick's primary genre was the science fiction novel, and like much good science fiction, his work extrapolates forward from the present, envisioning the social and technological dystopias that may follow from our current malaise. He wrote *Do Androids Dream* at the height of the Vietnam War after having read the diaries of a Nazi officer who complained that he was kept awake by the cries of imprisoned children. Patricia Warrick observed that the novel "evolved from his insight that a man takes on the very qualities of the evil he fears and hates when he goes to war with his enemy to destroy the evil. When man fights and kills, he destroys himself spiritually."

Consisting of 22 chapters and two plot threads, the novel covers one "marathon" day in the life of Rick Deckard, a bounty hunter contracted by the police to "retire" wayward Nexus-6 androids. The second plot tells the story of John Isidore, a "special"—so named because his genes had been mutated by radioactive fallout and he had failed to pass a "minimum mental faculties test." The setting is 2021 San Francisco, several years after World War Terminus, a global nuclear war that altered the Earth's atmosphere and destroyed most of the world's animals. Deckard is hired to retire a group of six outlaw androids for $1,000 apiece, money that he wants to use to purchase a live animal (a rarity, as well as proof that one can have empathy for a living creature) and thereby gain social status (at present he owns only an electric sheep). Isidore, whom Deckard doesn't meet until near the end, seeks communion with Mercer, a messiah who helps people exercise their capacity for empathy via an electronic fusion box. Isidore ultimately falls in love with one of the androids that Deckard must kill.

At the start of the novel, Deckard and his wife, Iran, bicker over the settings on their Penfield Mood Organ, which they use to determine their emotional states. On this particular day, Deckard dials for a "creative and fresh attitude toward his job." But once Deckard begins to hunt down the androids, who had killed some human colonists on Mars, he begins to question whether he's just a "murderer hired by cops," as his wife says, or if he's justified in "killing the killers." Deckard eventually meets Rachael Rosen, a Nexus-6 android; she sleeps with him in the hope that he'll learn to empathize with androids and thus not kill any.

Meanwhile, Isidore falls in love with Pris Stratton, one of the outlaw androids hiding out in his rundown building. Isidore, unlike Deckard, makes no distinctions between human and android, electric and real animals. He feels for all of them. But after he watches Pris sadistically tear the legs off a live spider, sees the aggressiveness of Pris's leader, Roy Batty, and learns that Mercer is a fraud, Isidore is disillusioned.

Harrison Ford in Blade Runner, *directed by Ridley Scott* (1982, U.S.A.; WARNER-LADD-BLADE-RUNNER PARTNERSHIP)

The two plots converge when Deckard shows up to retire Pris and Batty. He succeeds but questions whether doing so makes him as inhuman as the androids. Suffering from nervous exhaustion, Deckard heads for the desolate wilderness near the Oregon border, where he has a spiritual fusion with Mercer and learns to love an electronic toad. Isidore also recovers after seeing the spider come to life during a vision of Mercer. Both men gain renewed faith in their capacity to love.

The Films

This novel's progression from print to screen is one of the better documented and most bitterly contested adaptations in film history. After producer Herb Jaffe's option to film Dick's novel ran out in 1978 (Dick thought the draft screenplay was "a bad joke"), the project was optioned to Hampton Fancher and Brian Kelly, then picked up by Universal. Fancher wrote increasingly variant screenplays of the novel, but when Ridley Scott, fresh off his success with *Alien*, was hired as the director, he began to convert the story into what Dick later called an "eat lead, robot!" screenplay, with Deckard as a "cliche-ridden Chandleresque figure." Further exacerbating Dick's annoyance

was a published interview with Scott in which he claimed not to have read the novel, fearing that doing so would corrupt his vision. Dick went public with his dissatisfaction, creating a nightmare for the film's publicist. David Peoples then joined Fancher and Scott and introduced changes that ultimately found their way into the finished project.

Each of the collaborators had a distinct conception of what *Blade Runner* should be: Dick wanted the androids to be the catalysts for Deckard and Isidore's moral and spiritual growth in facing evil; Fancher saw it as a love story about a man who discovers his conscience; Scott, a futuristic film noir set in a densely packed, garish cityscape (he wanted the title to be *Gotham City*); Peoples, an exploration of the distinguishing qualities of humans and their replicants. All four perspectives ultimately found their way into the film. Not that an adaptation needs the artistic approval of the story's creator, but in the end Dick believed that Peoples's revisions of the script made it a "beautiful, symmetrical reinforcement" of his novel's main theme. Ironically, Dick died suddenly of a stroke just a few months before the film's release and never saw more than a few minutes of footage.

The 1982 version of *Blade Runner* did not receive much critical acclaim nor did it do well at the box office. The

film completely abandoned the second plot involving John Isidore, the religious framework of Mercerism, and nearly all of the novel's attention to electric animals (which helped Dick balance the android/human dialectic). The most glaring weaknesses of the film were Deckard's (Harrison Ford) voiceover narratives, which rival the voiceover narratives in *Dances with Wolves* in redundancy and inanity. (Some of Deckard's first lines are "Sushi. That's what my ex-wife used to call me. Cold fish.") Even worse, the studio insisted on a happy ending, in which Rachael (whom Deckard learns has no preset termination date) and Deckard fly off into the wilderness together. The film succeeds, however, on an important level. Norman Spinrad argues that Roy Batty's rescue of Deckard near the end effectively conveys Dick's ontological message: "In a scene that was not in the book, it poignantly and forcefully manifests Dick's true meaning in entirely cinematic terms . . . That by achieving empathy, a manufactured creature can gain its humanity, just as by losing it, a natural man can become a human android."

Scott's 1992 "Director's Cut" improves the film immensely: The voiceover narrative is deleted entirely, the dialogue between Rachael and Deckard enriched, and the Hollywood ending completely scrapped. The result is a film that retains only the best of the original without sacrificing continuity. The film now ends when Deckard finds Gaff's origami unicorn in the apartment where Rachael has been sleeping, letting us know that even Gaff, the sinister policeman who hounded Deckard, has found some shred of empathy within himself. (In the 1982 version, the voiceover hits us over the head with that point.) Not surprisingly, the rerelease received highly positive reviews.

Blade Runner presents a complex problem for adaptation theorists. The film is more than a simple borrowing of idea or plot from the novel. Brooks Landon argues that the film is an adaptation concerned with fidelity to the form of the novel. However, *Blade Runner*, as Dick himself suggested, doesn't merely reproduce that form. The film provides an "experience equivalent to that of the written text" and might also serve as "a lens for understanding its source and as a mirror for better studying ourselves." Scott recontextualizes the question of what Spinrad calls *caritas* (the human capacity for charity and benevolence), shifting the focus from Deckard and Isidore's struggles to Roy Batty's discovery of his own humanity, which he achieves, ironically, at the very moment of his termination. The question thus shifts from "Have humans lost the capacity to empathize?" to "Can we endow our creations with the qualities we value most?"

REFERENCES

Kerman, Judith B., ed., *Retrofitting* Blade Runner: *Issues in Ridley Scott's* Blade Runner *and Philip K. Dick's* Do Androids Dream of Electric Sheep? (Bowling Green State University Press, 1991); Spinrad, Norman, *Science Fiction in the Real World* (Southern Illinois University Press, 1990); Warrick, Patricia S., *Mind in Motion: The Fiction of Philip K. Dick* (Southern Illinois University Press, 1987); Williams,

Paul, *Only Apparently Real: The World of Philip K. Dick* (Arbor House, 1986).

—D.B.

DOCTOR ZHIVAGO (1957)

BORIS PASTERNAK

Doctor Zhivago (1965), U.K., directed by David Lean, adapted by Robert Bolt; MGM

The Novel

The publishing history of *Doctor Zhivago* is quite intriguing. Since the early thirties, Pasternak had been nurturing the idea of composing a novel that would reflect the fate of his own generation. In the thirties and early forties Pasternak wrote a few pieces in prose form, prefiguring thematically and aesthetically his later seminal work. In 1945 Pasternak began his actual writing of *Doctor Zhivago*, which took him over 10 years to complete. Rejected for publication in the Soviet press for its controversial point of view on Russia's Bolshevik Revolution, *Doctor Zhivago* was translated into Italian and then first published in 1957 by the Italian publisher Feltrinelli. In 1958, a year after the novel's first publication abroad, the author of *Doctor Zhivago* was honored with the Nobel Prize, which he was forced to renounce by the Soviet authorities.

Through the eyes of the main character, Yuri Zhivago, readers are confronted with a series of tremendous sociopolitical transformations that characterized the first half of the 20th century in Russian life. The novel starts with the funeral of Yuri's mother a few years before the 1905 revolution and ends with a short episode, occurring "five or ten years" after World War II, in which Yuri's old friends—Yuri himself dies in 1929—contemplate the fate of their country. Whereas the dramatic events of the 1905 revolution are only passively observed by the young Zhivago, the cataclysms of the World War I, the two revolutions of 1917, and the Civil War, in which Zhivago becomes personally involved, affect his life immensely. Sent to the front during the World War I as a doctor, Zhivago falls in love with Lara, a nurse in an army hospital; throughout the novel Zhivago and Lara are repeatedly separated, but his love for Lara will carry on for Zhivago's whole life. Later, while living in a remote village in Siberia, to which he fled with his family after the 1917 Bolshevik Revolution to escape the famine, Zhivago accidentally meets Lara again. Torn between his passion for Lara and his feeling for his wife, whose love for him he cherishes and whose personality he greatly admires, Zhivago is determined to break up with Lara. On his way home to confess his guilt to his wife, Zhivago is kidnapped by Bolshevik partisans.

Having spent two years with Bolshevik partisans in their forest camps during the Civil War, Zhivago escapes and

returns home only to be told by Lara that his family, terrified by the atrocities of both the Whites and Reds, moved back to Moscow. Subsequently, he finds out that his wife and their two children were forcefully exiled. Persuaded to immigrate to the Far East by her "benefactor" Komarovsky, Lara also leaves the country. Zhivago comes back to 1922 Moscow, on foot, and attempts to start a new life. Incapable of adjusting to the requirements of a postrevolutionary time, he suffers a physical and psychological breakdown and soon dies of a heart attack. In his later period, he writes poetry, most of which he dedicates to Lara.

Although a central figure in Pasternak's work, Zhivago is surrounded by numerous characters with different philosophical and political beliefs, whose lives become unexpectedly connected in the novel. Having his characters constantly merge and overlap, Pasternak deliberately opposes the realist tradition of constructing rounded characters with clear motivations. The fact that the doctrine of causality is completely absent from the novel makes the process of adapting this work to the stage or film highly problematic.

The Film

The only movie version of Pasternak's *Doctor Zhivago* is David Lean's film made in 1965 together with the screenwriter Robert Bolt. Omar Sharif played Yuri; Julie Christie portrayed Lara; Geraldine Chaplin was chosen for Yuri's wife, Tonya. Having won public recognition with his famous film *Lawrence of Arabia*, Lean became attracted to Pasternak's novel, realizing its inherent possibilities for cinematic effects. The film's astounding imagery has indeed proved Lean's reputation of being one of the best "spectacle" directors.

Aside from a few insignificant changes, the film version of Pasternak's *Doctor Zhivago* closely follows the novel's plot. The romantic story, which becomes the film's primary narrative, is recounted in a flashback structure by Yuri's stepbrother, Yevgraf. With its emphasis on the love triangle—Zhivago, Tonya, and Lara—the film, however, doesn't overcome the simplicity of the plot and, as the critics Alain Silver and James Ursini point out, "suffers from an overdose of simplistic history and social drama."

The film starts with the meeting between Yevgraf and Tonya, Yuri and Lara's lost child. The following episode transports the audience to Yuri's childhood. Yevgraf's narration then moves subsequently through different stages of Yuri's life, focusing on Yuri and Lara's numerous encounters and farewells, which become interwoven with the significant historical events. In fact, while omitting a number of characters and scenes important for the novel's thematic development, Lean and Bolt add episodes such as Yuri and Lara's first encounter on the streetcar and Yuri's last sight of Lara in a Moscow street, to simply frame the romantic story.

By centering their film on the love triangle, full of excessive sentimentality, and by providing the characters with clear motivations, Lean and Bolt drastically simplify

Omar Sharif and Julie Christie in Doctor Zhivago, *directed by David Lean* (1965, U.K.; MGM/CARLO PONTI/ THEATRE COLLECTION, FREE LIBRARY OF PHILADELPHIA)

Pasternak's poetic narrative. Furthermore, the film's emphasis on the love story undermines the overriding philosophical theme of the novel—the creation of a new cosmic order—which constantly recurs in the philosophical thoughts of Pasternak's characters.

The critic Michael A. Anderegg mistakenly praises Bolt's script and Lean's film for "bringing form out of shapelessness [of the novel], creating vivid characters from vague shadows, and eliminating much pseudophilosophical nonsense . . ." The film's tendency to "clarify" Pasternak's poetic tapestry by simply reducing the novel to its plot leads to the entire disappearance of Pasternak's polyphonic structure, necessary in his *Doctor Zhivago* to convey the multiplicity of reality. Moreover, the flashback structure in the film—Yevgraf's narration—totally ignores Pasternak's desire to reflect the turbulent reality of pre- and postrevolutionary Russia mostly through the eyes of Zhivago, whose poetic imagination surpasses the linear and conventional.

What the film adaptation seems to have successfully achieved is the buildup of a sequence of poetic symbols throughout the narration. Besides a few overwhelming spectacle scenes, which in *Doctor Zhivago* become merely cinematic effects without revealing the texture of Pasternak's prose, Lean's imagery includes important symbolic

elements such as the candle or the ice castle, both of which poetically reflect the psychological state of Pasternak's characters. Still, as a whole, the film does not reach the poetic and philosophical complexity of Pasternak's novel.

REFERENCES

Anderegg, Michael A., *David Lean* (Twayne Publishers, 1984); Silver, Alain, and James Ursini, *David Lean and His Films* (Silman-James Press, 1991).

—*J.L.*

DODSWORTH (1929)

SINCLAIR LEWIS

Dodsworth (1936), U.S.A., directed by William Wyler, adapted by Sidney Howard; Goldwyn/United Artists.

The Novel

Written at the height of his career, *Dodsworth* was as popular as Lewis's earlier novels, *Main Street, Babbitt, Arrowsmith,* and *Elmer Gantry. Dodsworth* represents a departure, however, from works like *Main Street* and *Babbitt,* for it seems to valorize the same middle-class, Midwestern values Lewis's satiric novels hold up for critique.

In 1903, Sam Dodsworth, about to begin his career manufacturing automobiles, falls in love with socialite Fran Voelker. There is an ellipsis: The couple have been married 20 years and Sam is retiring, his firm bought by a larger manufacturer. Their two children grown, Sam and Fran embark on their first trip abroad. The journey is a painful one: Sam wants to sightsee and enjoy the company of fellow Americans, while Fran is determined to join the smart circles of Europe's leisure class. Fran becomes preoccupied with an Englishman, then begins an affair with an exotic-looking American Jew. Sam goes back to America alone, where he is lost without her—and the sense of purpose his career had provided. He returns to Europe; the couple reconcile, then travel together until Fran takes up with another suitor, a German baron. When Fran decides she wants a divorce, Sam begins wandering the Continent. He has a brief but liberating affair with an earthy bohemian, then a fulfilling affair with a divorced expatriate, Edith Cortwright. The German baron's mother puts an end to Fran's wedding plans, and Fran tells Sam she needs him again. The couple sail back to America, but, convinced he can't make a go of it, Sam returns to Europe and Edith, still sometimes melancholy about losing the woman who had been the center of his life.

The Film

The film tells essentially the same story, but rather than drawing directly on the novel, Wyler's film is based on Sidney Howard's successful Broadway play starring Walter Huston and Fay Bainter. Differences between play and screenplay are the result of Howard and Wyler's (uncredited) collaboration, and the addition of an introduction and conclusion penned by screenwriter Eddie Chodorov. While *Dodsworth* was not a box-office success, it was critically well-received: seven Academy Award nominations, an Oscar for art director Richard Day, and universal acclaim for Huston's screen portrayal of Dodsworth.

Most discussions of *Dodsworth* echo Albert LaValley's argument that the play and the film represent an improvement of the novel because Howard streamlined the narrative, softened Dodsworth, and at the same time, "intensified and centralized a theme that is subordinate in the novel: the process of aging." LaValley's analysis is persuasive; it considers, for example, the way play and film dramatize scenes that are simply recounted in the novel, and the fact that both adaptations do not wait until the end to introduce Edith Cortwright. It makes a good case as well for the position that Wyler's "carefully calculated mise-en-scène" gives the film a "richness of suggestion" that is absent even in the play.

Yet it may be that Wyler's film does not necessarily represent an "improvement" on the novel, but instead a shift in focus, for it makes the Americans' journey through Europe a secondary issue, while the novel places its narrative about a marriage gone awry within a larger meditation on never-resolved oppositions between America and Europe. And where the film suggests that Sam arrives at some final destination in returning to Edith, the novel closes with Dodsworth wiser, but still troubled by desires that had shaped his past.

REFERENCES

LaValley, Albert J., "The Virtues of Unfaithfulness," in *The Classic American Novel and the Movies*, eds. Gerald Peary and Roger Shatzkin (Ungar Publishing, 1977); Light, Martin, *The Quixotic Vision of Sinclair Lewis* (Purdue University Press, 1975).

—*C.A.B.*

DOUBLE INDEMNITY (1936)

JAMES M. CAIN

Double Indemnity (1944), U.S.A., directed by Billy Wilder, adapted by Wilder and Raymond Chandler; Paramount.

The Novel

Cain's second novel was suggested by a remark about a printer who had spent his life obsessed with the "angles" he had to study to protect his company and who decided to play the angles instead. Changing the subject from a printer to an insurance salesman, Cain borrowed some details of the 1927 Snyder-Gray murder case for his story, which appeared in abridged form as an eight-part serial in

Liberty (1936) and was first published at full-length in Cain's omnibus *Three of a Kind* (1943).

Walter Huff, a salesman with General Fidelity in Los Angeles, is seduced by Phyllis Nirdlinger into a plot to kill her husband for the proceeds of an accident policy. Having gotten the unwitting Nirdlinger's signature on the policy application, Walter and Phyllis bide their time until Nirdlinger plans to leave by train for his college reunion at Stanford. On the way to the train station, Walter kills Nirdlinger, takes his place on the train and jumps from the rear deck of the observation car, faking a suicide. (Deaths involving moving trains pay double.) Despite its cleverness, the scheme founders almost immediately, partly because Walter's boss Keyes suspects murder, partly because Walter finds himself falling in love with Nirdlinger's innocent daughter Lola and distrusting her pathological stepmother. On his way to a rendezvous where he plans to shoot Phyllis, Walter is ambushed by her instead. But the police blame the shooting on Lola and her boyfriend, Nino Zachette, who has become involved with Phyllis. In order to protect Lola, Walter confesses to Keyes, who secretly arranges for Walter and Phyllis to leave the country on a cruise they will cut short by killing themselves.

The Film

The major studios had shown a lively interest in Cain's serial even before its initial publication. But a 1935 memo from Joseph Breen, administrator of Hollywood's Production Code, to MGM (with copies to four other studios) pronounced the story categorically unfit for family audiences, and the project languished until Paramount producer Joseph Sistrom interested Billy Wilder in the story. Since Charles Brackett, Wilder's collaborator on his first two films, declined to work on this one, and Cain himself was under contract to Fox, Wilder signed Raymond Chandler, who had never worked in Hollywood before, to write the screenplay with him.

Despite Wilder's objections, Chandler argued that Cain's formulaic, repetitive dialogue needed to be sharpened for the ear (the author, when consulted, agreed), and throughout the film Cain's naturalistic cadences are replaced by Chandler's signature similes and metaphors: "Have I got my face on straight?" or "They can't get off until the end, and the last stop's the cemetery." And although the Hays Office was far more receptive to the project than it had been eight years before, further changes were required to satisfy the censors, who feared the film would provide the audience with "the blueprint for the perfect murder," and demanded that the screenplay mute the novel's sexual frankness and mitigate its bracing amorality.

By the time Wilder and Chandler finished the screenplay, Cain's story was dramatically altered. All the main characters except for Keyes (Edward G. Robinson) have new names, and Walter Neff (Fred MacMurray) now works for the ominously named Pacific All-Risk Insurance Company, where he begins the film by confessing his guilt into a dictaphone, turning the rest of the story into an extended flashback and heightening its fatalism. Making Phyllis Dietrichson (Barbara Stanwyck) chillingly sane rather than obsessed by death allowed Wilder and Chandler to discard most of the final quarter of Cain's story. Walter never falls in love with Lola (Jean Heather), nor does anyone suspect her of killing her father. Instead, Keyes, whose relationship with Walter is much more important in the film than in the novel, focuses on Nino Zachette (Byron Barr), whom Phyllis has indeed entangled in her schemes. The showdown between Phyllis and Walter is moved to the Dietrichson home, where Phyllis wounds Walter but cannot bring herself to deliver the coup de grace, whereupon Walter takes the gun from her and kills her, then leaves after warning Zachette, whom he had lured to the house and planned to implicate, away from the scene. Despite all these changes, Wilder and Chandler avoid sentimentality in their handling of Walter and Phyllis, both of whose final speeches stop well short of deathbed conversions.

Apart from the changes he and Chandler agreed on, Wilder introduced new material on his own. The car that will not start, threatening to strand a panicky Phyllis and Walter near the murder scene, was an impromptu inspiration of Wilder's. The director also wrote and shot an elaborate final sequence, absent from Chandler's published screenplay, in which Walter is executed in the gas chamber. But Paramount executives decided that this ending was repetitious and depressing and decided not to use it. Ironically, the final ending used, with Keyes lighting a match for the wounded Walter huddled on his office floor, not only suggests a prison by incorporating many visual motifs of entrapment—including wrought-iron bars and high-contrast shadows—but also reinforces one of Cain's slyest touches: the complete absence of the police throughout the story. Only the insurance company, which stands to lose financially from Dietrichson's murder, has any interest in solving it.

Following the film's first preview, Cain embraced Wilder and told him it was the first time anyone had done one of his stories justice, and his considered judgment was equally enthusiastic: "It has been put on the screen exactly as I wrote it, only more so."

REFERENCES

Allyn, John, "*Double Indemnity: A Policy That Paid Off*," *Literature/Film Quarterly* 6, no. 2 (1978): 116–24; Luhr, William, *Raymond Chandler and Film*, 2nd ed. (Florida State University Press, 1991); Moffatt, Ivan, "On the Fourth Floor of Paramount: Interview with Billy Wilder," in Gross, Miriam, ed., *The World of Raymond Chandler* (Weidenfeld and Nicolson, 1977); Prigozy, Ruth, "*Double Indemnity*: Billy Wilder's *Crime and Punishment*," *Literature/Film Quarterly* 12, no. 3 (1984): 160–70.

—*T.M.L.*

DOWN THERE (1956)

DAVID GOODIS

Shoot the Piano Player (1960), France, directed by François Truffaut, adapted by Truffaut and Marcel Moussy; Les Films de la Pléiade.

The Novel

David Goodis (1917–67) was an obscure American writer of crime fiction. He wrote one popular novel, *Dark Passage* (1946), which was made into a Warner Brothers film. With the success of *Dark Passage*, Goodis worked for a few years as a Hollywood screenwriter. After 1950, he returned to his native Philadelphia and wrote only paperback originals ("pulp fiction").

However, Goodis was better-known in France, where he was regarded as a proto-existentialist. His novels were translated and published in the "Série Noire" by Gallimard, a major French publisher; some have been in print for 40 years. *Tirez sur le pianiste* (*Shoot the Piano Player*) was the title of the French translation of *Down There*, and this title was used by François Truffaut for the film adaptation.

Eddie plays the piano in a working-class bar in Philadelphia. One day his brother Turley stumbles in. Turley is being chased by two gangsters, and Eddie helps him get away.

Eddie buys dinner for Lena, the waitress at the bar. The next day, the gangsters kidnap Eddie and Lena. They want Eddie to lead them to his two brothers, who are small-time hoods. Eddie and Lena escape, and walk back toward the bar in a snowstorm. On the way back, Lena reveals that she knows Eddie's identity. He is Edward Webster Lynn, a famous classical pianist.

This triggers a flashback in Eddie's mind. He relives a sad childhood on a farm in South Jersey, music training, struggling for success, and at last a big break. While having lunch at the coffee shop where his wife Teresa works, he meets Woodling, a musical agent. Woodling signs Edward, and gets him engagements at top concert halls. But Teresa becomes more and more withdrawn. Finally, Teresa admits she had an affair with Woodling to set up the meeting. Eddie rushes from the room; Teresa jumps out of a window and dies. Eddie then becomes a violent, alcoholic bum. He eventually gets a job sweeping up at the Philadelphia bar, and one day sits down at the piano to play.

Returning to the bar with Lena, Eddie confronts the bouncer, who sold his address to the gangsters. They fight, and Eddie kills the bouncer in self-defense. Lena takes him to his brothers at the family farm. But when Lena comes back the next day with news that witnesses have cleared Eddie, the gangsters follow her. In the ensuing shootout, Lena is killed. Eddie is once again devastated.

Down There is a surprisingly good novel. Its mixture of third-person "objective" narration and second-person interior monologue (Eddie talking to himself) presents a powerful view of a man who has been emotionally destroyed. The action scenes in the novel are not convincing, but the psychological portrait is admirable.

The Film

François Truffaut, one of the leaders of the then-controversial French New Wave, turned this minor gem into an amazing film. Goodis's portrait of a loser is nicely rendered, with singer Charles Aznavour giving a marvelous performance as Charlie (Truffaut's name for the bar pianist) and Éduard (the concert artist). The fatalism of Goodis's design, with Lena's murder repeating the death of Teresa, also remains. But Truffaut, a young filmmaker in love with his medium, has added a mixture of humor, tenderness, and emotion reminiscent of the best films of Jean Renoir. In Truffaut's film, a stranger talks about his marriage, Lena confesses her love in a series of dissolves, and even the kidnappers become human as they give their own, often bizarre, views of women. The camerawork is virtuosic, and the visual design gives a subtle view of life's complexity. *Shoot the Piano Player* is one of Truffaut's finest films.

Shoot the Piano Player is both a free adaptation of Goodis and a very faithful one. Truffaut changed the setting from Philadelphia to Paris, added characters and incidents, threw in a variety of jokes. But Truffaut also respected the uniqueness of the novel's main character, whose loss has plunged him into dissociation. *Shoot the Piano Player* showcases two artistic personalities: Truffaut and Goodis.

REFERENCES

Allen, Don, *Finally Truffaut* (Beaufort Books, 1985); Braudy, Leo, ed., *Focus on Shoot the Piano Player* (Prentice-Hall, 1972); Sallis, James, "David Goodis: Life in Black and White," *High Plains Literary Review* 7, no. 1 (1992): 27–53.

—*P.A.L.*

DRACULA (1897)

BRAM STOKER

Nosferatu, Eine Symphonie des Grauens (1922), Germany, directed by F.W. Murnau, adapted by Henrik Galeen; Prana-Films.

Dracula (1931), U.S.A., directed by Tod Browning, adapted by Garrett Fort; Universal.

Dracula (1931), U.S.A. Spanish language, directed by George Melford, adapted by Garrett Fort; Universal.

Horror of Dracula (1958), U.K., directed by Terence Fisher, adapted by Jimmy Sangster; Hammer Films.

Count Dracula (1970), Spain/Italy/West Germany, directed by Jesus Franco, adapted by Franco, Peter Welbeck, and Augusto Finochi; Fenix Films/Corona Filmpro-

duktion/Filmar Compagnia Cinematografica/Towers of London.

Nosferatu (1979), West Germany, directed and written by Werner Herzog; Filmproduktion/Beaumont.

Dracula (1979), U.S.A., directed by John Badham, adapted by W. Richter, Universal.

Bram Stoker's Dracula (1992), U.S.A., directed by Francis Ford Coppola, adapted by James Hart; Columbia Pictures.

The Novel

Twenty-nine-year-old Abraham "Bram" Stoker, Dublin drama critic and journalist, was already an accomplished writer of horror stories when he became manager of the flamboyant actor Henry Irving in 1878. Inflamed by Irving's saturnine charisma, his own growing fascination with vampire lore and fiction (especially J. Sheridan LeFanu's classic vampire story, "Carmilla"), and the historical record of the infamous 15th-century Wallachia ruler, Vlad Tepes, Stoker published *Dracula* in 1897. "What distinguishes *Dracula* from the vampire fictions that preceded it," writes Leonard Wolf in his *The Annotated Dracula*, "is the way in which folklore and authentic history merge to give Stoker's tale the texture of something long known or naturally remembered." *Dracula* may also be seen as a metaphor for the relationship between Irving and Stoker—i.e., between the ruthless, tyrannical Dracula (Irving) and the methodical vampire hunter Van Helsing (Stoker).

The novel is composed in epistolary format, a traditional narrative form popular in the first half of the 19th century (and since borrowed by Stephen King in *Carrie*). Letters, diary entries, and newspaper clippings piece together a dark tale of supernatural terror. The year is 1893. House agent Jonathan Harker comes to Castle Dracula in Transylvania to arrange for the count's purchase of a house near London. Although Dracula first appears to Harker as a cultured aristocrat—"a tall old man, clean shaven save for a long white moustache, and clad in black from head to foot"—Harker soon notices that he has peculiarly sharp teeth. Held prisoner in the castle, Harker realizes his host is a vampire bent on carrying the plague of vampirism to London. Harker escapes. The scene changes to the Yorkshire coast, where Dracula's ship, filled with coffins, arrives. Near London, Lucy Westenra and Mina Murray (Harker's fiancée), the two heroines of the story, are menaced by the newly arrived count. Lucy dies and becomes a full vampire. The Dutch vampire hunter Van Helsing arrives and puts a stake through her heart. The chase is on as Van Helsing, joined by Dr. John Seward, Harker, and Mina (who is already on the way to becoming Dracula's next victim), pursues Dracula to Transylvania. Beating back attacks by wolves and peasants, they attack the cart bearing Dracula's coffin. Prizing open the lid, Harker confronts a terrible sight: "I saw the Count lying within the box upon the earth, some of which the rude falling from the cart had scattered over him. He was

deathly pale, just like a waxen image, and the red eyes glared with the horrible vindictive look which I knew too well." Under the shadow of Castle Dracula, the fiend is killed by knife cuts to the heart and throat. The body crumbles to dust.

The Films

Few literary properties have spawned more motion pictures. In cinematic terms, at least, the count is immortal. While the genuine adaptations of the Bram Stoker novel number less than a dozen, the Dracula character and all his progeny have appeared in more than a hundred sequels, pastiches, and outright farces, renamed as Baron Latoes, Count Alucard, and Count Yorga, and attracting the talent of figures as diverse as Abbott and Costello, Mel Brooks, and Eddie Murphy. Prominent in the "blaxploitation" movies of the early 1970s were *Blacula* (1972) and *Scream Blacula Scream* (1974), in which Dracula (Charles Macauley) "vampirized" Prince Mamuwalde (William Marshall), a black 18th-century antislavery activist, as his African counterpart. Several creditable television adaptations include Dan Curtis's CBS teleplay featuring Jack Palance in 1974 and the BBC's Louis Jourdan vehicle in 1978. Cataloging these is too lengthy (and exhausting) for this essay, and the patient reader is advised to seek out Donald Glut's *The Dracula Book* (1975) or J. Gordon Melton's *The Vampire Book* (1994).

The earliest surviving adaptation—and by many accounts still the best of the lot—is F.W. Murnau's *Nosferatu*. The word, which appears in a speech by Van Helsing in the novel, is derived from the Old Slavonic word *nosufuratu*, which was associated with the spread of plague. Prana-Films neglected to gain permission from Stoker's widow, Florence, to adapt the novel. Attempting to sidestep the issue, director Murnau and scenarist Galeen changed the title; the time period, from the 1890s to 1838; the Transylvanian and English locations to Germany and Bremen, respectively; and the names of all the leading characters (Dracula was renamed "Graf Orlock"). Added scenes not in the novel include Nosferatu's deadly sea voyage and the subsequent great plague of Bremen. The vampire himself, frequently absent from the novel, here comes to center stage, as it were. As portrayed by Max Schreck, he is markedly different from Stoker's original: He displays a rodent-like appearance, exerts control over rats (accounting for plague-infested Bremen), and falls victim to sunlight (after being seduced by a virgin girl, played by Greta Schroeder-Matray).

The film received only limited screenings before legal proceedings stopped its exhibition altogether and forced the destruction of many of the prints (a restored copy was screened in 1984 at the Berlin Film Festival and has since become commonly available). The film benefits from designer Hermann Warm's gothic arched sets and Murnau's weird blend of camera trickery (several scenes are shot in negative and in accelerated motion) and naturalis-

Max Schreck in Nosferatu, *directed by F.W. Murnau* (1921, GERMANY; PRANA/MUSEUM OF MODERN ART FILM STILLS ARCHIVE)

tic settings. In the words of German film historian Lotte Eisner, "Murnau's *Nosferatu* is the most visionary of all German films. It prophesied the rise of Nazism by showing the invasion of Germany by Dracula and his plague-bearing rats."

Universal Pictures bought the rights to the novel in 1930 for $40,000 and simultaneously made two talking-picture versions, the English-language version directed by Tod Browning and featuring Hungarian actor Bela Lugosi (formerly Bela Blasko) in the role that made him famous; and the Spanish-language version by George Melford with Carlos Villarias Llano (shortened to "Carlos Villar") in the title role (and wearing Lugosi's wig). With the exception of the early scenes in Transylvania (where it is Renfield, not Harker, who visits the castle), Garrett Fort's script is primarily an adaptation of the stage play: The rest of the action transpires in London. Dracula appears in evening dress rather than the customary black cloak. He loses his bad breath, mustache, and hairy palms. His transforma-

tions into a bat occur in between the edits, and his incarnations as mist and wolf occur offstage and are reported only in the dialogue. Throughout, the static staging, tedious dialogue, and pedestrian camerawork reinforce the film's dubious qualities as a photographed drama.

Although the Spanish-language version was based on the same script and shot at the same time as the Lugosi, it is a markedly different achievement. Shot at night with a different cast and crew, it displays a more fluid camerawork and a greater emphasis on eroticism (particularly in the frankly lustful attitudes of the suggestively gowned Brides). It was released in Mexico City and received admiring reviews.

Hammer Films bought the film rights from Universal in the mid-1950s and cast Christopher Lee in *Dracula* (*Horror of Dracula*, in the United States) in 1958. Although budgetary restrictions forced the entire story to be confined to one location in central Europe (never explicitly identified as Transylvania), the abandonment of the count's special-

effect transformations, and the reduction of the number of characters (notably Renfield), scenarist Jimmy Sangster was determined to emphasize certain elements missing in the Lugosi version, namely sex, gore, and Dracula's canine teeth. He also added a spectacular climactic scene, not in the book, wherein Van Helsing (Peter Cushing) kills the vampire by leaping on some draperies and tearing them aside to permit the intrusion of the morning sun's fatal rays.

Jesus Franco's Italo-Spanish-German adaptation, *Count Dracula* (1970), while lesser known than its brethren, boasts a splendid cast, with Christopher Lee reprising the Dracula role and Klaus Kinski as a sympathetic, intelligent Renfield. Despite its claim that the story is told, for the first time, "exactly as [Stoker] wrote it," there are many alterations: Arthur Holmwood, Lucy's fiancée in the novel, does not appear at all; Dr. Seward, who in the book has his own sanitarium, is downgraded to an employee of Van Helsing (Herbert Lom); and the theatricality of Stoker's ending is muted and changed.

Werner Herzog's *Nosferatu* was released in 1979 and featured Klaus Kinski as, in the words of commentator Nigel Andrews, "a subversive, a prophet of anarchy in a smug and ossifying society . . . an incarnation of evil, but also a man who is suffering, suffering for love." Musical excerpts from Wagner's *Ring* cycle underscore a kind of overripe Romanticism, especially in its working out of the theme of the "love-death" and in the suggestion of Nosferatu's godlike power and isolation. While Herzog uses Stoker's original character names, the film is an unabashed homage to Murnau, especially in the vampire's ratlike appearance, his death from the sunlight, and his spreading of the plague. Among the many surreal effects sprinkled throughout are the horses that bolt at a casual gesture of Nosferatu's hand and the spectacular swarm of rats that overwhelms the Baltic town (most of the locations utilized are near the Dutch town of Delft). "When Dracula comes to the town," says Herzog, "it is almost like the coming of paradise. He is a prophet of change in

Kate Nelligan and Frank Langella in Dracula, *directed by John Badham* (1979, U.S.A.; UNIVERSAL/PRINT AND PICTURE COLLECTION, FREE LIBRARY OF PHILADELPHIA)

a bourgeois world that must change . . . Lucy [Isabelle Adjani] sees that there is good as well as evil in the vampire, but her perception comes too late. Too late to save her or the town."

In the John Badham *Dracula* (1979), Frank Langella created the most sympathetic Dracula since Lugosi. Here is a romantic hero far more attractive than Stoker's, an aristocrat who was gracious and intelligent in society and brutal and bestial when hunting his prey. In the light of the new Ratings Code, which had replaced the censorial Production Code of previous decades, the erotic undercurrent of the novel was realized at last. The moment when Dracula and Lucy (Kate Nelligan) exchange blood marked the first time this vital scene from the novel was shown on screen. In general, the film attempts a "progressive" interpretation of the character, a more positive view of the repressed forces the vampire represents. Unfortunately, it lacks one basic ingredient essential to any Dracula story—the capacity to terrify.

To date, the most faithful adaptation of the book is Francis Ford Coppola's *Bram Stoker's Dracula*. The departure of Jonathan Harker (Keanu Reeves) from his beloved Mina (Winona Ryder), Harker's first encounters with Dracula (Gary Oldman) in Transylvania, Harker's escape back to England, Dracula's arrival in London (where he walks the streets in broad daylight, as per the novel), and his subsequent attacks on Lucy (Sadie Frost), the arrival of Dr. Van Helsing (Anthony Hopkins), and the climactic battle back at Castle Dracula—all follow the basic story outline. Important deviations include an elaborate prologue depicting the story of Vlad the Impaler (doubtless influenced by the published histories of Raymond T. McNally and Radu Florescu) and his centuries-long quest for his lost love, Elizabeth (also played by Winona Ryder). Despite its occasionally overwrought tone and chaotic mise-en-scène, the movie was a smash hit, grossing more than $32 million.

Witnessed through a variety of viewpoints in the novel and fleshed out in diverse impersonations in the movies, the character of Dracula remains a half-seen but compelling figure bound up in the primordial mysteries of death, blood, and love. Both he and the frozen images on the filmstrip are born of darkness and light, creatures of illusion, ageless entities plucked out of the slipstream of mortality.

REFERENCES

Andrews, Nigel, "Dracula in Delft," *American Film* 4, no. 1 (October 1978): 32–38; McNally, Raymond T., and Radu Florescu, *In Search of Dracula* (Galahad Books, 1972); Melton, J. Gordon, *The Vampire Book* (Visible Ink Press, 1994); Roth, Lane, "Dracula Meets the Zeitgeist: *Nosferatu* (1922) as Film Adaptation" *Literature/Film Quarterly* 7, no. 4 (1979): 309–13; Skal, David J., *Hollywood Gothic: The Tangled Web of "Dracula" from Novel to Stage to Screen* (W.W. Norton, 1990); Wolf, Leonard, ed., *The Annotated Dracula* (Clarkson N. Potter, 1975).

—*J.C.T.*

DUNE (1965)

FRANK HERBERT

Dune (1984), U.S.A., directed and adapted by David Lynch; Universal.

The Novel

Dune is a recognized classic of science fiction, the first of six novels in the *Dune* series. The novel possesses not only an epic human scope but also a genuinely convincing treatment of an alien ecosystem. Though Herbert had been fascinated and disturbed for years by humanity's apparent need for messianic leaders, the novel's final shape originated in a 1958 newspaper assignment to study a government ecological project designed to halt the spread of sand dunes on the Oregon coastline. From this Herbert extrapolated the fictional world of Arrakis, the Desert Planet. Herbert combined religious and ecological considerations into one narrative that immediately appealed to the heightened environmental awareness of the 1960s. Herbert's novel was one of the first to give ecology the political dimension so familiar to us now.

The novel is divided into three parts: "Dune," "Muad'Dib," and "The Prophet." The first part begins on the planet Caladan, ancestral home of the House of Atreides. Fifteen-year-old Paul Atreides, son of Duke Leto and his concubine Jessica, undergoes a painful, potentially fatal initiation at the hands of the reverend mother, who is an adept of the all-female Bene Gesserit order and Truthsayer to the emperor. Paul survives the test. Meanwhile, the emperor, in covert alliance with the Harkonnens, sworn enemies of the House of Atreides, has directed that Duke Leto assume control of Arrakis from its former rulers, the Harkonnens. Arrakis is the only source of the universe's most valuable commodity: melange, an addictive spice that not only extends life but also confers visionary powers upon its consumers. For the duke, Arrakis is also a deadly trap, set by the emperor and Baron Vladimir Harkonnen. Shortly after shifting ducal power to Arrakis, the House of Atreides is betrayed by Dr. Yueh, a teacher of Paul's. While Leto manages to kill the baron's Mentat assassin as well as himself, Harkonnen escapes. However, Paul and Jessica escape from a Harkonnen transport when Jessica uses her Bene Gesserit–trained voice to control their captors' actions. Part one ends with Paul's full awakening to his prescient powers.

In part two, Paul and Jessica rendezvous with Duncan Idaho, a weapons trainer, at a remote desert station that is subsequently destroyed by the Harkonnens. Idaho is killed. Paul and Jessica fly an ornithopter into an immense sandstorm and are presumed dead. Forced down, they are confronted by a tribe of Fremen, the warrior inhabitants of Arrakis. One of the Fremen, a woman named Chani, has featured in Paul's visions. Impressed by Paul and Jessica's

fighting skills, the Fremen leader, Stilgar, accepts them into the group. Paul takes the Fremen name "Muad'Dib." Jessica becomes the tribe's new reverend mother after she successfully drinks the Water of Life, a poisonous but mind-altering drug produced by the drowning of a sandworm. However, as Jessica is pregnant with Leto's daughter, the unborn infant also incorporates the visionary properties of the drug. Part two concludes with Paul and Chani's prescient knowledge that they are to have a life and a son together.

Part three, set a few years later, describes Paul Muad'Dib's full ascension to ultimate power: a destiny foretold by the Bene Gesserit. After Paul rides a sandworm, one final test remains before he can become the male Bene Gesserit and messiah—he must drink the Water of Life and survive. The act places him in a deep coma for three weeks, but when he awakens, he is ready to battle the Harkonnens and the emperor, who has personally come to Arrakis to oversee the efforts to exterminate the Fremen. Paul and the Fremen, riding atop sandworms, blast through the emperor's defenses. Meanwhile, Paul's sister Alia, who as little more than an infant has already acquired speech and full adult awareness because of her *in utero* exposure to the Water of Life, seeks an audience with the emperor. During Paul's attack, she kills Baron Harkonnen. The emperor himself is captured and the baron's nephew, Feyd-Rautha, challenges Paul to a duel; but Paul dispatches him quickly. The emperor abdicates his throne to Paul, who places himself in the line of succession by marrying the emperor's daughter Irulan. The marriage is political only; Chani remains Paul's true wife. The novel ends with Paul as not only emperor but also messiah in a universe on the brink of jihad.

The Film

Latin American filmmaker Alejandro Jodorowski first attempted to bring *Dune* to the screen in 1975–78, but budgetary difficulties forced him to drop the project. Next, producer Dino De Laurentiis acquired the film rights to the novel. Director Ridley Scott worked on the project but later withdrew, so De Laurentiis hired David Lynch. Lynch's expensive 1984 adaptation of *Dune* is by most critical assessments, including the director's own, a disappointment at best and a resounding failure at worst. Perhaps the greatest difficulty Lynch faced was how to compress Herbert's complex geopolitical scenario into anything approaching coherence for a 135-minute commercial film. Though Lynch's screenplay gamely tries, there are distracting, frequent voiceovers from most of the many on-screen characters and intrusive exposition provided by diagrams and computer voices. Moreover, the cinematic story line is perhaps too faithful to its source for its own good, and it remains largely inaccessible and confusing to anyone not familiar with the novel. Yet there are also significant departures from Herbert's key concepts; for instance, the book's Bene Gesserit voice-control tech-

nique becomes in the film a practical application of sonic waves honed to lethal force by mechanical devices known as "weirding modules." A television version of the film, padded out with an additional hour of footage trimmed from the theatrical release, does nothing to clarify matters, and in fact fatally slows an already hobbled narrative pace. Lynch repudiates the television version, having removed his name from the credits, so the theatrical release is to be preferred in any candid evaluation of *Dune*'s considerable weaknesses but also overlooked strengths.

Whatever one's opinion of the finished film, large portions of it unmistakably bear the stamp of Lynch's uniquely powerful style. As several critics have noted, the movie begins with an image right out of Lynch's previous film, *The Elephant Man:* an ethereal female face against a background of stars. The face belongs to Princess Irulan, the emperor's daughter, now "promoted" to primary narrator in the film adaptation. She begins the unenviable task of explaining the political intrigues behind the Atreides/Harkonnen feud to a mass audience. Little mention is made of the Bene Gesserit sisterhood or the ecological concerns of Herbert's novel; the emphasis now, for the purposes of an audience accustomed to the space opera of the *Star Wars* films, is to be on the masculine struggle for power between the Houses of Atreides and Harkonnen. To underscore this theme, the next scene following the opening credits takes place in the emperor's palace, where a conspiratorial meeting between the emperor and a Third-Stage Guild navigator seals the doom of Duke Leto. The Guild navigator, mutated by the effects of spice addiction into something resembling a deformed fetus swimming in formaldehyde, is a classic Lynchian creation in the tradition of the misshapen lead characters in *Eraserhead* and *The Elephant Man.*

But even Lynch's trademark touches cannot fully compensate for perhaps the film's gravest weakness: the simplification of the key characterizations. Paul's (Kyle MacLachlan) seizure of the emperor's throne lacks the ambivalent tone present in the novel. Herbert's deep suspicion of messianic fervor makes Paul's victory far less of a triumph than Lynch would have his audience believe. Indeed, Paul is the messiah foretold by the Bene Gesserit, Herbert concludes, but he remains a human who must work under human limitations. By contrast, Lynch's messiah literally works miracles at the film's climax. The very sound of his name, Muad'Dib, shatters stone without the aid of the weirding modules; the sandworms attend the awakening, or "birth," of the planet's messiah; and Paul as Kwisatz Haderach summons life-giving rain to the barren surface of Arrakis. Herbert also envisioned water for the distant future of Arrakis—as a result of long-term terraforming rather than immediate divine intervention.

REFERENCES

Alexander, John, *The Films of David Lynch* (Charles Letts, 1993); Touponce, William F., *Frank Herbert* (Twayne, 1988).

—*P.S.*

EAST OF EDEN (1952)

JOHN STEINBECK

East of Eden (1955), U.S.A., directed by Elia Kazan, adapted by Paul Osborn; Warner Bros.

The Novel

John Steinbeck's *East of Eden* is a ponderous, violent, and poetic tome that ambitiously tackles three themes simultaneously: a panoramic history of the Salinas Valley at the turn of the century, a melodramatic chronicle of two families in the valley, and a symbolic re-creation of the Cain and Abel story. The novel is atypical of Steinbeck's work in that it does not emphasize social issues told from a realistic point of view. Rather, it is a historical romance spanning the period from the Civil War years to World War I, from the East Coast to the West Coast, over several generations.

The Trask family lives in Connecticut. It includes Adam, a kind and gentle boy; his half-brother Charles, who is wild and violent; and their strict father and his mousy second wife. The father chooses the military for Adam, and Charles, feeling neglected, flies into a rage and nearly beats Adam to death. Recovering, Adam becomes a cavalryman. When he finally returns home after his father's death, he discovers he and his brother have inherited a fortune. One day Adam and Charles take in a stranger, one Cathy Ames, a young woman who has been savagely beaten. She has quite a past: Born in Massachusetts, she grew up an amoral, ruthless opportunist who has killed her parents and been the mistress of a man who ran a string of brothels. While Adam thinks her pure and beautiful, Charles finds her evil.

Indeed, she sleeps with him on her wedding night with brother Adam! Unaware of her perfidy, Adam takes her with him to his new ranch in the fertile Salinas Valley in California. But after giving birth to twin boys, Cathy shoots and wounds her new husband. She leaves the house, changes her name to Kate, and begins working in a nearby brothel. When Adam learns of this, he keeps the knowledge from his sons, Caleb and Aron.

The two boys develop very different personalities as they grow up. Aron is fair-haired and loving and is favored by his father. Caleb is dark, brooding, and solitary. When Adam's lettuce venture fails, Caleb is determined to regain the family's lost fortune. Aron, meanwhile, has fallen in love with a girl named Abra, who tells him the truth about his mother.

At the outbreak of World War I, Caleb makes a sizable profit in the bean business, which he gives to his father. However, Adam rejects him and his money, refusing to gain financially from the war. Caleb takes out his rage on his favored brother. He takes him to Kate's brothel, whereupon Kate, after making out a will leaving everything to Aron, commits suicide. Now severely disturbed, Aron joins the army and leaves for France. Abra turns to Caleb and admits she has loved him, not Aron, all along. Upon hearing the news of Aron's death in the war, the heartbroken Adam suffers a stroke. On his deathbed, he hears Caleb's confession regarding his responsibility for Aron's enlistment. Adam forgives his son and dies.

The Film

Because Elia Kazan had been dissatisfied with his collaboration with Steinbeck on *Viva Zapata* (1952), Kazan

chose a different scenarist, Paul Osborn, for his next Steinbeck project. *East of Eden* was his first production in color and wide screen. It recounts only about a quarter of Steinbeck's sprawling narrative, the portion he described as a "small, tender, poetic story." Within those parameters, however—the second generation of the Trask family in the year 1917—the film is relatively faithful to the text. Raymond Massey is Adam Trask, James Dean (making his big-screen debut) and Richard Davalos are the two sons, Caleb and Aron, respectively, Jo Van Fleet is the wicked Kate, and Julie Harris is the flirtatious local girl, Abra. Caleb, or "Cal," is attracted to his brother's fiancée, Abra, and pursues his feelings at the great cost of family harmony. Meanwhile, after secretly borrowing $5,000 to take advantage of a coming wartime market for beans, he presents his father the profits. He is rejected, and in the subsequent angry exchange Adam is paralyzed with a stroke. The guilt-ridden Cal takes Aron to Kate's brothel, destroying his illusions and, apparently, his sanity as well. Aron smashes his face through the train window as he goes off to war. The film ends rather abruptly, making the eventual reconciliations seem forced and contrived.

Kazan said he was attracted to the story's attacks on puritanism and absolute values: "I was trying to show that right and wrong get mixed up . . ." Moreover, he saw in it strongly autobiographical elements: "It was more personal than anything I've ever done . . . I knew every feeling in that picture. That's why it is very pure. You like it or you don't, but what's being said there is heartfelt . . . This was the first film in which I opened up and allowed myself to experience the emotion of tenderness and lovingness towards other people."

Cinematographer Ted McCord lends stunning visuals to the production, and Leonard Rosenman's musical score is now regarded as a classic. For her performance as Kate, Jo Van Fleet won a supporting actress Oscar. Best remembered today is James Dean's tense, neurotic take on Cal, which at the time at least one critic denounced, calling it "a mass of histrionic gingerbread."

REFERENCES

Ciment, Michel, *Kazan on Kazan* (Viking Press, 1974); Ditsky, John, *Essays on "East of Eden"* (John Steinbeck Society of America, 1977); French, Warren G., *John Steinbeck's Fiction Revisited* (Twayne, 1994).

—S.C.M. and J.C.T.

EFFI BRIEST (1895)

THEODORE FONTANE

Fontane Effie Briest (1972–74), West Germany, directed and adapted by Rainer Werner Fassbinder; Tango Film.

The Novel

Effi Briest is a landmark novel from Germany's most famous 19th-century realist novelist. Fontane, a member of a long-settled German family of Huguenot origins, spent his early years in Berlin and the adjacent areas of Neuruppin and Swinemuende. His French and German origins would thus firmly stamp his sympathy and tolerance for the characters of his books who, though Prussian and Berliners to the core, travel and get exposure to a world beyond Brandenburg. *Effi Briest* deals with moral and ethical issues, perhaps unresolveable, arising from the tragic aftereffects of adultery.

Superficially at least, the novel's events resemble those of Flaubert's *Madame Bovary*. The 16-year-old Effi is married off by her parents to an older man, Baron von Instetten, who, it is hinted, was a former lover of her mother. Effi and the Baron relocate to Kessin, a German coastal town on the Baltic. As an "outsider" in the community, she suffers from the town's resentment of her youthful tendencies to test the limits of decorum and civility. She indulges in a brief affair with Major von Crampas, a local military commander. Years later, after she and her family have moved to Berlin, her husband discovers a cache of incriminating letters. True to his Prussian code of honor, he challenges von Crampas to a duel and kills him. He then casts Effi out, and she dies alone and abandoned. Fontane lets readers judge for themselves the justice of the actions of Effi and her husband. They alike move within rigid social structures and pay the price of either rejecting or embracing them.

The Film

Rainer Werner Fassbinder began thinking about adapting Fontane's novel as early as 1969. Numerous other projects, including *The Merchant of the Four Seasons* (1971), *The Bitter Tears of Petra von Kant* (1972), and *Fear Eats the Soul* (1973) interrupted his plans; and it wasn't until 1974 that his long-cherished project was completed. Meanwhile, over that period of time Fassbinder decided against merely adapting the text itself; rather, he decided to make a movie about Fontane's *attitude* toward his subject, hence the title, *Fontane Effi Briest*. "It is completely clear," explained Fassbinder, "that it is a film about the relationship between the author and the story he tells, and not a film based on that story."

Nonetheless, Fassbinder maintains a remarkably literal fidelity to the book, retaining much of its exact dialogue and narrative commentary (Fassbinder himself providing the voiceover). All the key scenes are here, including Effi's (Hanna Schygulla) meetings with von Crampas (Ulli Lommel), Innstetten's (Wolfgang Schenck) discovery of the incriminating letters, the duel, Effi's renunciation of the baron, and her final acceptance of her fate.

In order to maintain the kind of distance from the action achieved by Fontane, Fassbinder resorts to a cool

black-and-white palette ("colors," he said, that have a subtly archaic flavor), deep-focus compositions, long takes, sparing camera movements, intertitles in gothic script, the romantic yet bittersweet music of Saint-Saëns's *Havanaise* on the soundtrack, and slow, deliberate fadeouts into white (which critic Vincent Canby found suggestive of "the empty space on the page at the end of a chapter"). This distancing effect would, he argued, force the viewer out of the passivity he or she customarily falls into in the movie theater: "One is not creative as a member of a film audience," Fassbinder said, "and it was this passivity that I tried to counter in *Effi Briest*. I would prefer people to 'read' the film." In this way the viewer participates in Fontane's (and Fassbinder's) own ambivalence toward the story and social codes that protect and destroy the characters.

Effi Briest, as both an effective adaptation of the novel and a striking work of cinematic stylization is one of the masterpieces of the New German Cinema of the 1970s.

REFERENCES

Magretta, William R., "Reading the Writerly Film," in Horton, Andrew S. and Joan Magretta, eds., *Modern European Filmmakers and the Art of Adaptation* (Ungar, 1981); Thomsen, Christian Brand, "Five Interviews with Fassbinder," in *Fassbinder*, ed. Tony Rayns (British Film Institute, 1976).

—*R.A.F. and J.C.T.*

ELMER GANTRY (1927)

SINCLAIR LEWIS

Elmer Gantry (1960), U.S.A., directed and adapted by Richard Brooks; United Artists.

The Novel

When Sinclair Lewis published *Elmer Gantry* in 1927, its satire of a corrupt preacher who bilked his congregations was promptly banned in Boston, and public libraries across America and in Britain refused to stock the book. While some critics, secular and religious, charged that the novel's depiction of religion was irreverent or distorted—*Survey's* 1927 review attacked *Gantry* as anticlerical "propaganda"—others, like H.L. Mencken, wrote that *Gantry* confirmed Lewis's genius. In 1973 commentator James Lundquist noted that Gantry never experiences redemption or insight; he only goes from bad to worse. Thus, Lundquist writes, Lewis anticipated the antiheroes of later 20th-century literature.

The story begins in 1902 when the 22-year-old Elmer Gantry is the football captain at the Baptist-sponsored Terwilliger College in Kansas. An outspoken religious skeptic, he is "reborn" as a result of trying to impress a charismatic YMCA leader. Gantry enrolls at Mizpah Theological Seminary, where he is ordained. On a pastoral assignment, he seduces Lulu Bains, a congregant's daughter. Gantry covers up the affair by announcing his engagement to Lulu, but he then breaks it off when he "discovers" her in another man's arms.

After being expelled by the seminary for drinking, he spends the next two years as a traveling salesman. But when he meets tent revivalist Sister Sharon Falconer, he decides to stay awhile and return to the Good Book. Sister Sharon lets him preach with her organization. He becomes her right-hand man, and they eventually seduce each other. Falconer builds her own permanent church, but a fire kills her and many worshipers. Gantry escapes, clearing his path by shoving others into the flames; and once outside, he pretends to rescue those already safe.

After other revivalist and inspirational speaking stints, Gantry accepts the tutelage of a Methodist bishop, who guides his career eventually to a prestigious New York pulpit. Gantry's fire-and-damnation sermonizing swells his reputation. He marries Cleo Benham and fathers children, but—as has happened with all the women in his life—his interest in her wanes with familiarity. After a string of affairs, Gantry is blackmailed by new secretary Hettie Dowler. When the gossip reaches the papers and threatens Gantry's chance to head a national conservative organization, he manages to coax Dowler's retraction and emerges unscathed. At the close of the novel, Gantry basks in 2,500 congregants' admiration and prays "Dear Lord, thy work is but begun! We shall yet make these United States a moral nation." We know, however, that Gantry's thoughts are in reality focused on a lovely new choir member.

The Film

Filmmaker Richard Brooks, who would write the scripts for 19 of his 24 films, heeded reviewers' complaints about the novel's length and controversy. His adaptation cleverly sidesteps potential objections from the Hollywood censors by rendering Gantry and Falconer more sympathetically than Lewis had done. Concentrating on chapters 11 to 15, which detail Gantry's relationship with Falconer, Brooks constructed a number of additional scenes of his own, revised events, and created composite characters to interpret cinematically the novel's spirit.

As though stressing source fidelity, the film's beginning shows the actual book opening to page one: "Elmer Gantry was drunk . . ." In a Christmas Eve speakeasy, drunken salesman Gantry (Burt Lancaster) sermonizes for others to give money to Salvation Army-like collectors. He spends the night with a girl from the bar. Next morning, while she sleeps, he sneaks out to jump a train. Hobos steal Gantry's shoes and throw him off the train. Barefoot, he finds a black congregation singing "I'm on My Way up to Canaan Land." He gets beans and shoes in return for shoveling coal. He tries to swindle a store owner into buying unsalable items by distracting everybody with liquor and offcolor jokes. Then he sees Falconer's revival poster.

These opening scenes, mostly invented, economically convey Gantry's contradictions: his passions for sermonizing

Burt Lancaster (standing) as the title character in Elmer Gantry, *directed by Richard Brooks* (1960, U.S.A.; UA/THEATRE COLLECTION, FREE LIBRARY OF PHILADELPHIA)

and drinking, for charity and self-indulgence, for righteous talk and sinful conduct; and, most paradoxically, the apparent sincerity of his every wayward impulse. Book and movie versions differ also in that Brooks's Gantry is not merely an unhappy, unsuccessful salesman but an outright vagrant and huckster. Brooks further compresses the novel's conflicts through composites. Jim Lefferts (Arthur Kennedy), Gantry's seminary classmate, becomes an agnostic Mencken-like newspaperman. Brooks's version of Lefferts also incorporates much of another Lewis character, Frank Shallard: Both confess that they doubt the divinity of Jesus. While Lewis's Gantry reaches Falconer (Jean Simmons) through a contact with a man in her orchestra, Brooks's Gantry seduces her assistant, a choir leader named Sister Rachel (Patti Page). Following Lewis's taste for self-reference, Brooks imports George Babbitt (Edward Andrews) from another Lewis novel to play a business leader.

Brooks's version of Lulu Bains (Shirley Jones) is a prostitute who attempts to blackmail Gantry (like Hettie

Dowler does in the book). The motivation and plausibility of this threat are more convincing than in the book, because the film's Gantry causes Bains's social downfall when he leads a vice raid on a brothel where she worked. Bains sends compromising photos to the newspapers, and disillusioned worshipers pelt Gantry with rotten vegetables. However, when Gantry rescues Bains from a beating by her pimp/boyfriend, she then retracts her story, and worshipers fill the next revival in Falconer's new tabernacle.

When, as in the novel, a worker carelessly tosses a cigarette into oily rags, a fire destroys the tabernacle. The morning after the fire, Gantry apparently gives up revivalism, quoting St. Paul: "When I became a man, I put away childish things." He departs on foot, perhaps to jump the next whistling train.

Brooks's Falconer, unlike Lewis's, really believes in her mission, and it is clear she reluctantly succumbs to Gantry's seductions. Lewis's Gantry is an ordained Baptist minister; Brooks's Gantry is unordained. This tempers the

novel's anticlericalism. In the novel, most denominations support Falconer's revivals; but in the film Falconer is clearly outside the church's mainstream.

"Not so irreverent as it is irrelevant," groaned *Time*. Several other critics noted that Brooks, like Lewis, failed to sufficiently emphasize the redeeming qualities of the characters. Nonetheless, Brooks's adaptation and actors Lancaster and Jones all received Oscars. Although later critics often view *Gantry* as dated, recent televangelist scandals (e.g., Jim and Tammy Faye Bakker, Jimmy Swaggart) have breathed new life into the Gantry archetype. Despite the structural flaws of the book and the inevitable softening of the message in the movie, *Elmer Gantry* stands unparalleled among fictional and cinematic depictions of Protestant American clerical hypocrisy.

REFERENCES

Fleming, Robert E., with Fleming, Esther, *Sinclair Lewis: A Reference Guide* (G.K. Hall, 1980); Kantor, Bernard R., Irwin R. Blacker, and Anne Kramer, *Directors at Work: Interviews with American Film-Makers* (Funk and Wagnalls, 1970); Lundquist, James, *Sinclair Lewis* (Frederick Ungar, 1973); Richard Brooks Seminar, *American Film*, October 1977.

—B.F.

EMMA (1816)

JANE AUSTEN

Clueless (1996), U.S.A., directed and adapted by Amy Heckerling; Paramount.

Emma (1996), U.S.A., directed and adapted by Douglas McGrath; Miramax.

The Novel

Emma appeared in 1816, the year before Jane Austen's death. It is the fourth of her six novels and is generally regarded as the most accomplished. Like her other work, *Emma* is concerned with the plight of young women desperate to be appropriately married. Spinsterhood and bad connections—such as marrying beneath one's station—are to be avoided at all costs. Emma's preoccupation for matchmaking among marriageable members of her circle—Austen makes it clear this "handsome, clever, and rich" young lady has too much time on her hands—extends, for example, to choosing for her friends those male partners of just the right rank and sensibility. But her intentions exceed her maturity. After a series of disastrous attempts to pair off her friends with men who prove to be decidedly incompatible (if not unworthy), Emma is confronted with a dilemma of her own: She has fallen in love with her brother-in-law, the noble Mr. Knightley, but hardly knows how to recognize, much less deal with her emotions. Of course, it turns out that Knightley does indeed share her feelings, and the two marry happily.

The Films

Perhaps as a demonstration of the timelessness and universality of Jane Austen's art, *Emma* has been successfully adapted in two radically differing screen versions. *Clueless* (1996), adapted and directed by Amy Heckerling, translated some of the situations and characters into the slightly daft milieu of the malls and high schools of the San Fernando Valley. Douglas McGrath's version, by contrast, faithfully retains and realizes down to the smallest detail the original English Regency characters and settings.

The Heckerling version is the more marginally faithful of the two and need not detain us long. Emma is renamed "Cher" (Alicia Silverstone), the daughter of a widowed attorney, a 16-year-old girl lost in her world of teen-speak and clothes, flirtations, and matchmaking. But if she is perfectly meddlesome in the affairs of her friends, she is clueless about her own love life. Her infatuation with the new "hunk" in class dwindles quickly when she finds out he is gay. She contents herself with taking him shopping instead. It is only after many misadventures that she realizes at last her true love is Josh (Paul Rudd), an older man who is her father's law clerk. If one of Jane Austen's prime virtues is her mastery of language arts—the use of words as an indicator of social rank and position—the updated vernacular of this film is no less an important and significant element. The slang here is a "secret code," if you will, the cement that bonds together the members of Cher's insular circle. (Reference to a "Monet," for example, is not a teen allusion to the great Impressionist painter, but to a person who looks great at a distance but is disappointingly coarse up close.)

A more distinguished installment in the great Jane Austen movie revival of the 1990s is Douglas McGrath's adaptation of *Emma*. It is distinguished by its airy charm and outstanding performances, especially by Gwyneth Paltrow in the title role.

The trajectory of Austen's story, if not the acid satiric bite, is generally maintained. Having married off her former tutor, Emma's next goal is to find a proper husband for her friend Harriet Smith (Toni Collette), a sweet but rather dull and awkward girl. Although Harriet has fallen in love with a farmer, Mr. Martin (Edward Woodall), Emma deems him inferior; she sets her sights on Mr. Elton (Alan Cumming), an impossible snob who, unbeknownst to Emma, is infatuated with her and ends up proposing to her passionately. This proposal of marriage takes Emma quite by surprise, but does not really disturb her composure (though her rejection is devastating to Mr. Elton). Meanwhile, Emma becomes infatuated with Frank Churchill (Ewan McGregor), who to her dismay turns out to be something of a bounder and a cad. The Churchill plot, an important thread in Austen's tapestry, is much abbreviated and simplified in the film.

Meanwhile, Mr. Knightley (Jeremy Northam), Emma's brother-in-law, and her avowed friend and moral adviser, secretly loves her. But because he is 16 years her

senior, he is uncertain about expressing his feelings. It is he who, unlike Emma, sees through the pretensions of Frank Churchill. And it is he who does not hesitate to criticize Emma for her own occasionally immature and insensitive behavior. For example, he reproves her for insulting the foolishly loquacious Miss Bates (Sophie Thompson) at a garden party: "That was badly done, Emma, *badly* done!" This criticism marks the beginning of Emma's self-realization and forces her to realize that she has her own limitations.

The film's opening credit sequence is astonishing. An image of a spinning planet soaring through the star-spangled heavens turns out to be merely a small bauble that Emma presents to her former tutor at her wedding. The ball is decorated with Emma's tiny little paintings of the people and places of her narrowly circumscribed world. This is a brilliant visual pun: What seems at first to be a view of the cosmos is in reality a depiction of a microcosm. Indeed, Austen herself regarded her work as infinitely small in its scale and pretension: "the little bit (two inches wide) of ivory on which I work with so fine a brush as produces little effect after much labor." The movie's use of the metaphor of the decorated ornament beautifully reflects this comment, introducing the characters and settings with a series of cameo-like decorations inscribed on the surface of the tiny orb. But however brittle and circumscribed these images may be, they, like the novel and the film, suggest truths of a more universal scale.

REFERENCES

Lascelles, Mary, *Jane Austen and Her Art* (Clarendon Press, 1963); Menand, Louis "What Jane Austen Doesn't Tell Us," *The New York Times Book Review*, February 1, 1996, 13–15; Schwarzbaum, Lisa, "'Whatever' Works," *Entertainment Weekly*, August 16, 1996, 54–55.

—*J.C.T.*

EMPIRE OF THE SUN (1984)

J.G. BALLARD

Empire of the Sun (1987), U.S.A., directed by Steven Spielberg, adapted by Tom Stoppard; Warner Bros.

The Novel

J.G. Ballard's novel is based on his experiences growing up in Shanghai and Lunghua, where he was interned in a Japanese camp during most of World War II.

Ten-year-old Jim lives a privileged life with his parents in a wealthy section of Shanghai. His dreams are full of flying planes and brave fighter pilots. Harsh reality intrudes with the outbreak of Pearl Harbor, and Jim is separated from his parents. Adrift in Shanghai, he meets two Americans, Basie and Frank, who teach him how to survive. Together, they are sent to the Lunghua Civilian Assembly Centre, where they endure a lengthy internment by the Japanese. Despite the squalor and disease, Jim grows accustomed to the place, knowing that at least it is safer than the war outside.

After the war, he is released; but after Basie abandons him, he wanders around China, surviving encounters with Kuomintang guards, Chinese coolies, and Japanese soldiers. Finally, as a result of meeting a friend of his parents, he is returned to their home. Jim begins his old life again, yet often asks his chauffeur to drive him back to the Lunghua camp, where he remembers the important events of his lost childhood.

The Film

Plot and thematic elements such as the inscrutable workings of fate, the loss of innocence, and the seduction of flight appealed to Steven Spielberg. Initial plans had him working as producer and David Lean as director; but when Lean bowed out, Spielberg realized he wanted to direct it himself. "From the moment I read the novel, I secretly wanted to do it myself," he said. "A child saw things through a man's eyes as opposed to a man discovering things through the child in him. It was just the reverse of what I felt was my credo."

Working with playwright Tom Stoppard on the script proved to be a fruitful collaboration. While remaining faithful to the basic story line of the novel, Spielberg's whimsical, up-beat nature and Stoppard's contrasting darker, more intellectualized approach collaborated to conjure up unforgettable images. Examples of this collaborative dialectic—elements of the fairytale fused with nightmarish reality—abound: the image of Jim (Christian Bale) flying his toy plane while a real fighter aircraft roars overhead (later echoed by his cries of delight at the attack on the compound by P-51 Mustangs); the magical, silvery parachute from which spills forth vitally needed food supplies; the blooming flower of light that turns out to be the Hiroshima bomb; etc. Ultimately, it was Spielberg who insisted on tempering some of the horrific details of carnage depicted in Ballard's book (although the tone at times is grim enough, to be sure); and that the film conclude with Jim's emotional reunion with his parents on the street when they recognize him among a group of orphans.

From the beginning, Spielberg insisted on authenticity, and he was able, after overcoming many political obstacles, to shoot in Shanghai locations for three weeks in March 1987. Because the city had changed little since the war, he found he had to make few alterations for the street scenes and in the exteriors of Amherst Avenue, where the wealthy European community lived. The prison camp was constructed on the banks of the Guadaquiver River near Jerez. For the film's spectacular air-raid sequence, Spielberg used three U.S. P-51 Mustang fighter planes, each a collectors' item valued at $500,000.

Ultimately, of course, it's more a film by Spielberg than an adaptation of Ballard. "The film seems to speak a language all its own," said critic Janet Maslin in *The New York*

Times. "In fact it does, for it's clear Spielberg works in a purely cinematic idiom that is quite singular. Art and artifice play equal parts in the telling of this tale." Other critics found this transformation objectionable. Writing in *Commonweal,* Tom O'Brien attacked what he called the "arrested development" of the picture and Spielberg's "childish" take on mature themes. That Spielberg was hurt by such attacks, suggests Douglas Brode in his book on the director, is evident in his subsequent return to fairy tales for adults (*Always*) and for kids (*Hook*). It would be six more years before he would take on another "adult" picture, *Schindler's List.*

REFERENCES

Brode, Douglas, *The Films of Steven Spielberg* (Citadel Press, 1995).

—S.H.

THE END OF THE AFFAIR (1951)

GRAHAM GREENE

The End of the Affair (1955), U.S.A., directed by Edward Dmytryk, adapted by Lenore Coffee; Columbia Pictures.
The End of the Affair (1999), U.S.A., directed and adapted by Neil Jordan; Columbia Pictures.

The Novel

As Gene D. Phillips noted in his groundbreaking study *Graham Greene: The Films of His Fiction,* Britain's foremost Roman Catholic novelist employed for the first time in this novel "a narrator, from whose particular point of view we see the events of the story unfold," in other words, a "subjective first person narrator, through whose outlook the events of the story are filtered." This narrator, Maurice Bendrix, is a novelist who needs to research the life of a civil servant. His choice is Henry Miles, and in the course of his research, Bendrix becomes romantically involved with Henry's wife, Sarah. The two meet in a building that is bombed during an air raid. Bendrix is knocked unconscious during an air raid, and the next day Sarah decides to end their affair. Meanwhile, her husband remains oblivious about what had transpired.

Three years later Henry meets Bendrix by chance and invites him to visit his home in order to discuss a personal problem that involves Sarah. Henry now suspects that Sarah has taken a lover, and, ironically, Bendrix is more jealous than Henry, though Henry still knows nothing of the earlier affair. Bendrix hires a private detective to spy on Sarah, and the detective steals Sarah's personal diary. The narrative then shifts to the diary, and Sarah's voice becomes dominant. From the diary Bendrix discovers that Sarah feared for his life the night of the air raid and promised God that she would sacrifice her love for Bendrix if God would spare his life. When Bendrix then regained

consciousness, Sarah felt duty bound to end the affair because she thought her prayers had been answered. Sarah was transformed, as her love for Bendrix changed to divine love, which then threatened to displace her earthly love. She discusses this transformation with an atheist named Smyth, but, in the words of Phillips, she concludes that "Smyth's hatred of God stemmed less from rational statements than from the bitterness which he felt because his face was partially disfigured by a strawberry birth mark."

Sarah's spiritual journey, then, is from adultery to sanctity. As Sarah writes to Bendrix before her death, "I've caught belief like a disease. I've fallen into belief like I fell in love." During the final days before her death Sarah prays for those she loved, and her prayers result in a second "miracle" (the first miracle by her accounting was the salvation of Bendrix) as the strawberry birthmark disappears from Smyth's face. Greene told Phillips that he had "cheated" this detail: "The incident of the strawberry mark had no place in this book; every so-called miracle should have a natural explanation as well as supernatural ones; it would better appear that God is tempting Bendrix to believe and not forcing him." Greene could be demanding of himself as well as of his readers.

The Films

In the first film adaptation, directed by Edward Dmytryk in 1955, Deborah Kerr played Sarah, with a relatively unconvincing Van Johnson attempting to play Bendrix. The generally competent cast also included Peter Cushing's sympathetic portrayal of Henry Miles and John Mills as the eccentric detective Parkis.

Dmytryk told Phillips that although the film was originally shot in flashback, "Columbia was worried that a story that was told out of chronological sequence would confuse the mass audience. So they requested that we rearrange the scenes in strict chronological order." Greene apparently liked the prerelease flashback approach that Dmytryk had originally used, but "was disappointed when the film was re-edited."

Phillips praised Lenore Coffee's adaptation for using "the words of Sarah's diary as the novel does, to add a spiritual perspective to the events which we have already seen portrayed from Bendrix's uncomprehending point of view." The film balances Sarah's conversations with the atheist Smyth (Michael Goodliffe) with additional conversations with a priest (Stephen Murray), who advises: "If you've made a vow to someone you don't believe in, you don't have to keep it." The implication was that Sarah does believe in God.

The film follows the novel in having Bendrix meet Sarah's mother at the time of Sarah's death so the mother can tell him that Sarah had once been a Catholic, since she had had Sarah baptized as a child to spite Sarah's father, who was not a believer. But the film left out the "miracles" that follow Sarah's death. Dmytryk explained why: "It's one thing to write about miracles in a novel and quite

another to present them in a film. When you show them on the screen you seem to be insisting that the audience believe that they really happened. The miracle that we were interested in preserving in the film was the one that occurred in Sarah's mind. She believed that her prayer brought Bendrix back to life and that belief changed her whole life."

According to Sarah Lyall's production essay on the Jordan adaptation that appeared in the *New York Times*, this earlier adaptation was widely considered a dud and "quickly faded into merciful obscurity." This assessment is unduly harsh, however, and flatters Neil Jordan, whose adaptation dwells more on the passion of Greene's story and less on the metaphysics. Jordan and his producer Stephen Woolley believed that the original Hollywood treatment could not be fair to the novel. They presumed to make a "much more explicit" treatment, which they believed would be "a much truer version of his book." Jordan's filmed treatment departs from Greene towards the end, however, when Bendrix and Sarah are allowed a fling in sunny Brighton. The bad news is that Sarah only has three months to live.

Consequently, the new version changes the plot "so that the denouement—the death of the protagonist—occurs at the end of the film rather than in the middle." Jordan argued that the change "was necessary because of the difficulty of making a movie in which one of the main characters dies so early in the story," according to Sarah Lyall. Assuming that this was the "most autobiographical" of Greene's novels, Lyall contends that Greene, like Bendrix, fell hopelessly "and jealously in love with a married woman [Catherine Walston, to whom the novel is dedicated] whose Catholicism was a driving force in her life." But she would not "leave her husband, who [not only] knew [about but] tolerated the affair."

Neil Jordan's adaptation not only took a different approach to the "miracles," but made other significant departures to the latter end of the novel. A strawberry birthmark disappears from the face not of the atheist Smyth (in the film, which makes him a priest, Father Smyth is played by Jason Isaacs), for example, but of Lance Parkis (Samuel Bould), whose cheek had been kissed by Sarah Miles (Julianne Moore). Lance, who inherits the birthmark from the novel, is the 12-year-old son of detective Parkis (Ian Hart). Neil Jordan regular Stephen Rea plays Henry Miles with appropriate decency and sympathy.

"When I began to write our story down, I thought I was writing a record of hate, but somehow the hate has got mislaid," Bendrix muses in the novel. If his hatred of Sarah for ending the affair is gone, Bendrix wonders if he might also lose his hatred of God, an idea that he firmly rejects. "I hate you God," he proclaims, "I hate You as though You existed." This becomes the opening statement for Neil Jordan's film adaptation. Ralph Fiennes as Maurice Bendrix is hunched over his typewriter, banging out the opening words: "This is a story of hate." Jordan's film will not explain that opening statement until the end, however, as

Greene's character explains, "I'm too tired and old to learn to love." One critic in England, reviewing the novel, speculated that this might be the last Graham Greene story "that a non-specialist in moral theology would be able to review."

Neil Jordan was interested in " how little the characters in the book understand their own emotions." Jordan "wanted to explore the way that sex and the idea of love seem like such ultimate issues in people's lives. But in the novel, even people who say, 'I'll love you forever' can't escape the promises and pledges that they've made." So perhaps in Neil Jordan, Greene's novel found its best adaptor, even as he changed the latter part of the narrative.

REFERENCES

Adamson, Judith, *Graham Greene and Cinema* (Pilgrim Books, 1984); Lyall, Sarah, "Filming the Drama between the Novelist's Lines," *New York Times*, June 6, 1999, 13; Phillips, Gene D., *Graham Greene: The Films of His Fiction* (Teachers College Press, 1974); Tomassini, Christine, "The End of the Affair," *Magill's Cinema Annual 2000* (Gale Group/Videohound Reference, 2000), 174–177.

—*J.M. Welsh*

THE ENGLISH PATIENT (1992)

MICHAEL ONDAATJE

The English Patient (1996), U.S.A., directed and adapted by Anthony Minghella; Miramax Films.

The Novel

Author Michael Ondaatje was born in Sri Lanka (formerly Ceylon) in 1943, the son of a Dutch burgher colonial family, and now lives and works in Canada. The "English Patient" of the title of Ondaatje's Booker Prize–winning novel is in fact not English, but a Hungarian cartographer, Count Laszlo de Almásy, reduced when the story begins to a charred shadow of his former self, an amnesiac burn victim cared for in Italy just after World War II by a compassionate and sympathetic French-Canadian nurse. As revealed to *The Washington Post* by Elizabeth Salett (December 4, 1996), the fictional character was based on an actual Nazi spy who later became an aide-de-camp to Field Marshal Erwin Rommel of the German Afrika Korps. Anthony Minghella's film, more than Ondaatje's novel, romanticizes this committed Nazi collaborator by transforming him into a heroic lover who collaborates with the Germans only to save the woman he loves, Katharine Clifton, whom he met in North Africa.

In a bombed-out Tuscan villa, the dying "English" patient gradually remembers his past, his service for the Royal Geographical Society in North Africa, and his torrid romance with Mrs. Clifton that begins during a Christmas party in Cairo in 1938. The romance is complicated by World War II and leads to a tragic conclusion for

Katharine Clifton, her husband Geoffrey, and Almásy. Ondaatje's labyrinthine narrative spans seven years and two continents. Hana, the shellshocked Canadian nurse who chooses to care for the mysterious "English" patient during his final days, constructs the story of his wasted life through dim memories filtered through a morphine haze and the patient's copy of the histories of Herodotus and the memorabilia it contains. The nurse and her patient are joined by a mysterious thief named Caravaggio and a Sikh British army lieutenant named Kip who is an expert in defusing bombs.

"I fell burning into the desert," Almásy tells the nurse, Hana, but his memories in this interior narrative are fragmented and incomplete as he gradually remembers "picnics, a woman who kissed parts of his body that are now burned into the color of aubergine." Hana and her love affair with the Sikh demolition expert Kip is initially the focal point of the novel, as her patient struggles to remember his affair with Katharine, which does not begin to emerge until the novel is one-third consumed.

The Film

The strategy of the film is to reverse the novel's priorities and to bring Almásy's adulterous love story to the forefront, showcasing the talents of Ralph Fiennes as Almásy and Kristin Scott Thomas as Katharine. The framing story of Hana (Juliette Binoche), Kip (Naveen Andrews), and the mysterious Caravaggio (Willem Dafoe), who seems to suspect the identity of the "English" patient, is compressed and less complete than in the novel, which does more to explain Kip's departure at the end of the story, for example. It clearly becomes the film's framing story, set in 1945, that is a springboard for the patient's epic love story, told far more clearly and coherently for a mass audience in chronologically ordered flashbacks. This story of love and betrayal in a far more exotic setting easily becomes dominant, and the link between their ill-fated romance and flight and its disastrous consequences becomes much easier to follow.

Almásy is immediately romanticized in the film in a way that he is not in the novel, which explains why the film was so disturbing to Elizabeth Salett, whose father's life (he was Hungarian consul general in Alexandria) was put into jeopardy by the real Almásy. Michael Ondaatje's Almásy emerges differently and more obscurely from the narrative, which does not at first seem to be primarily his story. The novelist created an imaginary construct. So did the director, though not exactly the same one.

"I knew from the beginning there was no linear or conventional way to tell the story," writer-director Anthony Minghella remarked after having spent nearly four years laboring over the screenplay. Minghella apologizes for "my sins of omission and commission, my misjudgments and betrayals" that were made in a sincere attempt "to make transparent what was delicately oblique in the prose." The novelist was satisfied and sympathetic. "What

we have now are two stories," Ondaatje wrote in his introduction to the published screenplay, "one with the pace and detail of a 300-page novel and one that is the length of a vivid and subtle film. Each has its own organic structure. There are obvious differences and values, but somehow each version deepens the other."

As Caryn James pointed out in the New York Times, this is a brilliant adaptation because it manages to create an artistic equivalent rather than an exact version of the original. The approach is poetic in that it adapts the strategy of the best translators of poetry, as must be done when the language is intractable. Instead of asking "How can I be faithful to the book?" James asserted, screenwriters should rather ask "How can I make this novel my own?" By agreeing to be different, Ondaatje and Minghella created parallel but related stories, each romantic in its own way and each structured to take advantage of its own medium. Thus the film both is and is not the same as the novel, though some of the details, such as Hana's feeding a succulent plum to her disabled patient, are the same and rendered with vivid clarity. The film excavates the heart of the novel in a bold and inventive, heart-rendering way. The characters—particularly Almásy, Katharine, and Hana—are vividly and brilliantly portrayed in what turned out to be the most inventive film adaptation of 1996.

REFERENCES

James, Caryn, "Any Novel Can Be Shaped into a Movie," *The New York Times*, November 17, 1996, II, 17, 28; Minghella, Anthony, *The English Patient: A Screenplay* (Hyperion/Miramax Books, 1996); O'Steen, Kathleen, "Anthony Minghella's Triumph Over Hollywood," *The Washington Post*, November 22, 1996, D, 1, 7; Salett, Elizabeth; "The Dark Side of the English Patient," *The Washington Post*, December 4, 1996, C, 1, 17.

—*J.M. Welsh*

ETHAN FROME (1911)

EDITH WHARTON

Ethan Frome (1993), U.S.A., directed by John Madden, adapted by Richard Nelson; American Playhouse/Miramax.

The Novel

Edith Wharton had already established her reputation with *The House of Mirth* (1905) and *The Fruit of the Tree* (1907) before publishing this most compact of her novels. *Ethan Frome* was originally conceived as a longish short story, but it soon grew into what she described as a "large long-legged hobbledehoy of a young novel." By contrast to its dark and dreary tone, Wharton wrote it with what she described as her "greatest joy and fullest ease." She had wanted to write a book like this for years, she noted in her memoir, *A Backward Glance:* "I had wanted to draw life as

it really was in the derelict mountain villages of New England, a life even in my time, and a thousandfold more a generation, utterly unlike that seen through the rose-coloured spectacles of my predecessors, Mary Wilkins and Sarah Orne Jewett . . . [where] insanity, incest and slow mental and moral starvation were hidden away behind the paintless wooden house-fronts of the long village street, or in the isolate farm-houses on the neighbouring hills." The story's climactic tragedy, the sledding accident, was drawn from a real incident from her youth when several young people crashed their sled at he base of Courthouse Hill in Lenox, Massachusetts (Schoolhouse Hill in the book). *Ethan Frome* ran in *Scribner's* from August through October 1911 and was published concurrently in book form. Not surprisingly, this compact, chilling tale of gothic horror and its profoundly disturbing denouement met with less success than her previous books. Yet, as Lewis declares, "It is a classic of the realistic genre," her "most effectively American work."

The story begins as the narrator, a young engineer, hears from the lame figure of Ethan Frome—"a ruin of a man"—a sad tale of thwarted love. Piecing together Frome's story with accounts from other villagers, the narrator assembles, bit by bit, Frome's background. As a young farmer in the New England village of Starkfield, Ethan had married an older woman, Zenobia (Zeena), a humorless and hypochondriacal person, who had nursed his mother through her final illness. When her cousin, Mattie Silver, arrives at the farm to help with the household chores, Mattie falls in love with Ethan. Zeena announces that Mattie must be sent away and replaced by a more efficient housemaid; and the lovers determine to kill themselves by crashing their sled into the large tree at the foot of the hill. The attempt, however, is unsuccessful, and Ethan and Mattie are maimed for life. They live on now in the joyless ménage, the whining invalid Mattie and the lame wreck Ethan dominated by Zeena. "The inexorable facts closed in on him like prison-warders handcuffing a convict," writes Wharton about Ethan. "He was a prisoner for life."

The narrative strategy is complicated, observes Linda Costanzo Cahir in her study of Wharton. "The accounts regarding Frome often contradict each other. . . . In reading *Ethan Frome* we engage in the same process that occupied the narrator; we must sift through the account and decide how accurate the narrator's reconstructed 'vision' of Frome really is."

The Film

John Madden's film is a deliberate and quietly moody evocation of the novel. The Vermont woods are thin and stark under the lowering clouds, and the house interiors glow dimly in the burnished candlelight. Groping about the kitchen, stairs, and upper rooms are three ghosts, locked in a mutual death grip.

The prologue reveals the twisted figure of Ethan (Liam Neeson) clumping over the snow fields of Starkville.

"Who is this strange person?" inquires the new minister, and as the local landlady begins her tale, the film flashes back to the death of Ethan's mother, who has been cared for by his cousin Zeena (Joan Allen). More out of gratitude than out of genuine love, Ethan marries Zeena. Soon, after complaining of her health, Zeena decides to send for her cousin, Mattie (Patricia Arquette), to come to work and live with them.

It's only a matter of time before Ethan notes the contrast afforded by Mattie's full, fresh-cheeked charms over the gaunt, pinched querulousness of Zeena. When Zeena goes to see a doctor in the next valley, Ethan and Mattie begin an affair. In his lovemaking, he seems to devour her face in his mouth and hands. In the days that follow, the two are happy, although their good spirits raise more than a few eyebrows in the village. Zeena returns and announces that Mattie must leave and be replaced by another domestic. But before Ethan can get Mattie to the train station, they impulsively decide to take a sled-run down the hill. Down they go, once, and then again. On the third time, she tells him she "doesn't ever want to leave the hill." The two settle themselves on the sled and the ride begins. Children coming up the hill are startled to see fragments of the sled flying through the trees. The bodies of Ethan and Mattie are found, crumpled and bloody, at the base of a big tree.

Returning to the present, the story follows the minister to visit Ethan's little house. Inside, he meets the twisted and bedridden woman he presumes to be Mrs. Frome. But no, it's Mattie. Looking over her with the feverish intensity and hunger of a vampire is Zeena. As the minister turns to leave this bizarre scene, he encounters the broken figure of Ethan, stooped and silent, attending what has become of his family.

In its unrelieved dreariness and subdued tone, director Madden and screenwriter Richard Nelson have bravely wrought a faithful translation of Wharton's grim novel, even if it loses some of its subtlety by abandoning Wharton's wonderfully enigmatic multiple narration technique. Too grim for popular consumption, the film proved to be a failure at the box office.

REFERENCES

Cahir, Linda Costanzo, *Solitude and Society in the Works of Herman Melville and Edith Wharton* (Greenwood Press, 1999); Lewis, R.W.B., *Edith Wharton: A Biography* (Harper and Row, 1975); Wharton, Edith, *A Backward Glance* (Simon and Schuster, 1998).

—*J.C.T.*

THE EXORCIST (1971)

WILLIAM PETER BLATTY

The Exorcist (1973), U.S.A., directed by William Friedkin, adapted by William Peter Blatty; Warner Bros.

The Novel

By 1969 Blatty had amassed significant research on demonic possession, but in his autobiography *I'll Tell Them I Remember You*, he claims that only after his anxiety over his mother's death had been assuaged by inexplicable "signs" of her supernatural "presence" could he complete *The Exorcist*.

Blatty's goal in *The Exorcist* was to make demonic possession a realistic and thus reasonable explanation for the continuing presence of inexplicable evil in the world. And if the forces of supernatural evil could control our destinies, so could faith in the supernatural forces of good.

The novel has several plots that gradually converge. The prologue describes Father Merrin's discovery of an amulet of the Mesopotamian demon Pazuzu at an archaeological dig in Iraq. Merrin has "the icy conviction that soon he would face an ancient enemy." The novel then shifts to Georgetown and the home of Chris MacNeil (a divorced actress), Regan (her 12-year-old daughter), Karl and Willie (the housekeepers), and Sharon Spencer (Chris's secretary). After Chris hears odd noises in the attic, the precocious Regan acts strangely, including urinating on the floor at one of Chris's parties. Part one ("The Beginning") concludes with Regan's bed shaking violently as Chris looks on in horror. Also throughout part one, Father Damien Karras, a Jesuit priest and psychologist, fears losing his faith, a crisis magnified by his mother's death.

In part two ("The Edge"), Regan's condition worsens dramatically, doctors cannot find any physical causes, and a friend of Chris's (Burke Dennings) is found dead at the bottom of a stairwell outside Regan's bedroom window. Chris then seeks Karras's help, believing Regan needs an exorcism. Skeptical, Karras eventually asks the Church if he can perform the ritual. Meanwhile, a homicide detective (Alex Kinderman) investigates the Dennings murder, suspecting Karl. In part three ("The Abyss"), Father Merrin performs the exorcism, but in the act suffers a heart attack. Karras, infuriated by Merrin's death and Regan's suffering, struggles with the demon, finally leaping to his death from the bedroom window after the demon leaves Regan to possess him. Karras receives absolution from another priest, dying in peace. In the epilogue, the MacNeils leave for California, Regan having forgotten all.

The Film

Few films have generated as much controversy as *The Exorcist*. Hoping to make the film a "realistic view of inexplicable events," William Friedkin retained many of the novel's most hideous images, including the projectile vomiting, head rotations, and the demon's/Regan's masturbation with a crucifix. Although the film received 10 Academy Award nominations (winning for screenplay and sound), Vincent Canby called the film "a chunk of elegant occultist claptrap," and many others felt it was a film with visceral but no psychological impact. Despite unfavorable reviews, *The Exorcist* replaced *The Godfather* as the biggest money-maker of its time, earning over $250 million.

Whether the film preserves the novel's exploration of religious themes has been hotly contested. Most critics (such as Pauline Kael) believe the film follows the novel closely, but Stephen Bowles rightly argues that Friedkin sacrificed character development (of Karras, Merrin, and Karl) and moral depth in the interest of creating suspense and titillating the audience visually: "Blatty's novel [but not Friedkin's film] suggests a dialectic on the nature of good and evil combined with evident distrust of medical and psychiatric science." But while the novel does explore with some depth Karras's dilemma (as priest and psychologist) and Kinderman's investigation, ultimately the novel's religion/science opposition also lacks development. In the end, only Merrin clearly recognizes the presence of the demon, and he doesn't have to think much to do it. Importantly, in both novel and film, Regan and Chris apparently learn nothing from the experience, Regan having repressed it entirely.

Friedkin's film is, nevertheless, a remarkably vivid cinematic treatment of demonic possession, a visual carnival that would set the stage for future blockbuster horror films like *Jaws*. In Steven Farber's view, Friedkin goes further than anyone else had dared: "he found the perfect mixture of blood, excrement, perverse sexuality, and religious symbolism to drive audiences wild." At the same time, Friedkin doesn't sacrifice style (the shot of the exorcist standing outside the MacNeil home shrouded in mist is the most memorable instance). *The Exorcist*, as lurid and gaudy as it is, scared the wits out of many.

Many critics have noted the film's horrifying treatment of Regan, a teenage girl on the verge of her sexual awakening, brutalized by a demon known for its serpent-like phallus. Andrew Britton shrewdly argues that the film ultimately reaffirms dominant patriarchal authority, depicting female sexual assertiveness as aberrant and punishable (Regan's unconscious sexual desires are directed by the demon toward Christ, her mother, even Karras) and homosexuality as "naturally unnatural" (the demon assaults Karras and Merrin with a "torrent of homosexual abuse"). Barbara Creed notes that the film's primary opposition is between men and women, the "fathers" and the "mothers." The "fathers" in the film try to drive out the evil that "possesses" the young girl, a thinly disguised reenactment of the traditional stereotype of feminine evil: "beautiful on the outside/corrupt within." The film "exorcises" male anxiety toward the feminine other.

REFERENCES

Blatty, William Peter, *William Peter Blatty on* The Exorcist *from Novel to Film* (Bantam, 1974); Bowles, Stephen E., *"The Exorcist and Jaws,"* Literature/Film Quarterly 4, no. 3 (summer 1976): 196–214; Britton, Andrew, *"The Exorcist,"* Movie 25 (winter 1977/78): 16–20; Creed, Barbara, *The Monstrous-Feminine: Film, Feminism and Psychoanalysis* (Routledge, 1993); Travers, Peter, and Stephanie Reiff, *The Story Behind* The Exorcist (Crown, 1974).

—D.B.

FAHRENHEIT 451 (1953)

RAY BRADBURY

Fahrenheit 451 (1966), U.K., directed and adapted by François Truffaut; Rank/Anglo Enterprise/Vineyard.

The Novel

In 1950 Ray Bradbury wrote a short story called "The Fireman." Several revisions later (the titles changing to, variously, "Fire Burn!" "Burn Books," and "The Hearth and the Salamander"), a novel of 50,000 words emerged, the most ambitious project the 30-year-old writer had yet attempted. It may be regarded as a seismic reading, as it were, of cold war paranoia and the anticommunist feelings rife in postwar America. Its passionate, poetic vision of a near future where censorship and book burning herald global destruction places it alongside other modern dystopian novels, like Orwell's *1984*, Vonnegut's *Player Piano*, and Burgess's *A Clockwork Orange*.

Guy Montag is a fireman who starts, rather than extinguishes, fires. He works in the service of a totalitarian state bent on destroying the ideas and individual expressions contained in books. Unbeknownst to the other firemen, however, he has been stealing books and reading them in secret. His growing fascination with literature is fueled by his meeting two extraordinary people—the strange young girl named Clarisse, who reproaches him for his destructive occupation; and Dr. Faber, an ex-English professor who tells him about a band of outsiders who memorize books in order to preserve them for the future. At last, in some of the most moving pages in all of contemporary science fiction, Mon-

tag, now an outlaw himself, flees society and joins the rebel band, choosing the Book of Ecclesiastes as his mission. Behind him lies a world consumed by a different kind of flame, the holocaust of nuclear war. "We're the odd minority crying in the wilderness," says one of memorizers. "When the war's over, perhaps we can be of some use in the world."

The Film

Ironically, the very medium Bradbury worships, the motion picture, has served his work with only spotty success. "As far as moviemakers go, I've gotten accustomed to being carried into the forest so far," he has said. "Then the mysterious bridegroom disappears into the trees, and I'm left weeping, heading back to the city."

Part of the difficulty in adapting Bradbury stems from the utter inviolability of his metaphor-laden prose (what do you do, for example, with phrases like "flapping, pigeon-winged books"?). François Truffaut and his cinematographer, Nicolas Roeg, took their cues from the book's lyrical descriptions of book-burning ("It was a special pleasure to see things eaten, to see things blackened and *changed.*") and filled the screen with ecstatic images of conflagration, the tongues of orange flames consuming—first daintily, then ravenously—the pages of books. Nothing else in the film, not the impassivity of Oskar Werner as Montag or the mild sensuousness of Julie Christie in the dual role of Clarisse and Linda (Mildred), can rival these scenes of terrible, intoxicating beauty.

The basic plot outline and characters are retained in the screen adaptation. However, the character of Clarisse (who dies early in the book) is considerably expanded in the film version: Now it is she who first urges Montag to

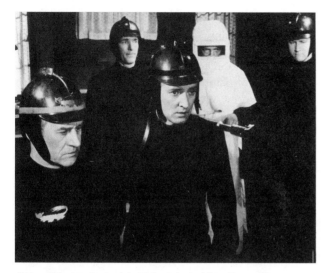

Oskar Werner (center) in Fahrenheit 451, *directed by François Truffaut* (1966, U.K.; UNIVERSAL/THEATRE COLLECTION, FREE LIBRARY OF PHILADELPHIA)

read books, and it is she who at the book's conclusion receives him into the company of "living books." Unfortunately, the final scenes, where the memorizers drift about the countryside in a trancelike state, reciting their assigned tomes, leaves an (unintended?) unsettling, almost ludicrous impression on the viewer. They seem more like robots than revolutionaries. Confirmed, nonetheless, is the fact that Bradbury's prophecy of the age of the "talking book" is surely already upon us.

Characteristically, Truffaut was more interested in the obsessions—destructive and nurturing, by turn—of the human heart than in the traditional trappings of futuristic science fiction. Spaceships, towering cities, and technological gizmos—like the Mechanical Hound, a targeting device used by the state to track down outlaws—are replaced by a world all too much like our own, where a sterile, suburban conformity, illuminated by the flickering images of television sets, stifles and paralyzes individual will. Truffaut has defended this approach against its detractors, declaring: "When you dream, you don't see an extraordinary world, you see our everyday world curiously deformed. It is that deformation I have tried to show in *Fahrenheit 451*." Moreover, like Bradbury, he has consciously avoided implying any particular political ideology behind the Firemen's actions—they burn *Mein Kampf* with the same detachment that they destroy Andersen's fairy tales.

Despite his frequent carpings about film adaptations of his works, Bradbury praises this one. "The results were very good indeed," he has said. "It has a terrific ending that makes me cry every time I see it."

REFERENCES

Greenberg, Martin Harry and Joseph D. Olander, eds., *Ray Bradbury* (Taplinger, 1980); Tibbetts, John C., "Pandemonium in Paradise:

Interview with Ray Bradbury," *The World and I* (May 1991): 222–33; Truffaut, François, *Truffaut by Truffaut* (Harry N. Abrams, Inc., 1987).

—*J.C.T.*

FAIL-SAFE (1962)

EUGENE BURDICK AND HARVEY WHEELER

Fail Safe (1964), U.S.A., directed by Sidney Lumet, adapted by Walter Bernstein; Columbia.

The Novel

This sprawling, polemical novel was catapulted to national attention and became a best-seller (over 2 million copies) because of the Cuban Missile Crisis, when, on August 29, 1962, U-2 aerial photographs revealed 75 to 90 medium-range missiles being prepared in Cuba, which prompted President John F. Kennedy to impose a naval blockage around the island, one of the central confrontations of the cold war. Maxwell Taylor, chairman of the Joint Chiefs, had a force of 250,000 men ready to invade when the Soviet Union threatened thermonuclear war as a consequence of the blockade. Nuclear warheads were already in place and the situation was tense and dangerous indeed, until the approaching Soviet ships decided not to challenge the blockade, causing a relieved Secretary of State Dean Rusk to remark: "We were eyeball to eyeball, and the other fellow just blinked."

The ideology of the novel is decidedly liberal and antimilitary, a bit muddled, perhaps, but obviously sincere. An irrational and unpredictable accident—a mechanical failure, a computer breakdown—threatens thermonuclear devastation. The president of the United States and Soviet premier Khrushchev are locked into a nuclear double-bind after bombers have been deployed. "If the bombs fall on Moscow," Khrushchev promises, "We will strike back." The story is told from the perspective of Sergeant Peter Buck, the American president's translator, who is privy to exchanges between these world leaders.

Cold war strategist Walter Groteschele claims that the "Positive Control Fail-Safe system is the ultimate protection against mechanical failure," and General Black and the Pentagon believe this to be true, but they are later told by Knapp, the manufacturer, that "there is no such thing as a perfect system" and that "we never told anyone that it was infallible." He concludes: "We knew that a perfect system was impossible. The mistake was that no one told the public and the Congress." Unable to recall his bombers from their mission to Moscow, the president offers to sacrifice New York City to equalize the balance of terror and avoid all-out nuclear war.

The Film

The logic of the novel supposes that such an accident is inevitable. This logic infuriated the right wing, and Sidney Hook wrote *The Fail-Safe Fallacy*, a polemical attack upon the novel. Interestingly enough, Sidney Lumet's film adaptation changed the characters and the story in an apparent attempt to answer Hook's criticisms. Hook objected, for example, to the character of Walter Groteschele, a brilliant career strategist but a philandering, inhuman, opportunistic, self-serving sadist, for Hook claimed Groteschele was a hideously misshapen caricature of Herman Kahn, whose book *On Thermonuclear War*, published by Princeton University Press, had helped to shape nuclear policy. The film removes all references to Groteschele's Jewish background and improves Groteschele's moral character, casting a likable actor, Walter Matthau, to portray him.

Lumet's film works other substantial changes upon its source, some political, others dramatic and historical. The president in the novel was patterned after President Kennedy, who was assassinated before the film was made. The film's president is played by Henry Fonda, and the Kennedy resemblance is gone. Thus the film avoids trivializing the memory of the slain president and his wife. The characters in the film are not so fully developed as in the novel, which carefully provides background information. The purpose is to emphasize the situation rather than character motivation, to emphasize how they feel rather than how they think. This decision is a matter of effective dramatic economy.

The novel begins with Peter Buck (Larry Hagman), who is presented as a major central character. In the film Buck translates only from Russian into English, whereas in the novel he translates both ways. In the film he is a more functional medium, a means to an end. The tensions and frustrations of the Soviet premier are reflected in his anguished face as Buck attempts to convey the feelings of the words he translates for the president. Buck becomes an icon of the psychological drama between world leaders, and that explains the flatness of his character in the film. The film is effectively structured to emphasize the dramatic present and immediately concerned with the crisis at hand, the drama of the War Room, and less with the motivation of the players in that drama. This structural shift serves to emphasize the message of the book rather than its novelistic development.

Lumet, a theatrical director, understandably still works theatrical solutions into his adaptation; machines are not dramatic, but men under pressure are. In the film the emphasis is not on a technical miscue, but on dark, human frailty. True enough, the film's nuclear accident is mechanical, as in the novel (although under slightly different circumstances), but the human element complicates the tense situation that follows. In the film, for example, Colonel Cascio is presented as being psychologically unstable from the outset and therefore unfit for high command. In the film Cascio breaks down completely. In the novel he is a

dedicated, loyal soldier, whose breakdown and mutiny is excused, to a point, since one can understand that his refusal to reveal requested classified information to the Soviets, which would assist in the destruction of the American Vindicator bombers, would run counter to his beliefs and military conditioning.

Despite changes made in the adaptation, the film preserves the intent and message of the book effectively, even if the film was soon eclipsed by that other apocalyptic film of 1964, Stanley Kubrick's *Dr. Strangelove, or How I Learned to Stop Worrying and Love the Bomb*. Kubrick's satire does not nullify, however, the effectiveness of the montage suggesting the destruction of New York that closes Lumet's film.

REFERENCES

Bowles, Stephen E., *Sidney Lumet: A Guide to References and Resources* (G.K. Hall, 1979); Cunningham, Frank R., *Sidney Lumet: Film and Literary Vision* (University Press of Kentucky, 1991); Hook, Sidney, *The Fail-Safe Fallacy* (Stein and Day, 1963); Lumet, Sidney, *Making Movies* (Alfred A. Knopf, 1995).

—*J.M. Welsh*

FALSCHE BEWEGUNG

See WILHELM MEISTER'S APPRENTICESHIP.

A FAREWELL TO ARMS (1929)

ERNEST HEMINGWAY

A Farewell to Arms (1932), U.S.A., directed by Frank Borzage, adapted by Benjamin Glazer and Oliver H.P. Garrett; Paramount Pictures.
A Farewell to Arms (1957), U.S.A., directed by Charles Vidor, adapted by Ben Hecht.

The Novel

Ernest Hemingway began his writing career as a reporter for *The Kansas City Star* but moved to Paris in 1921 and joined other American expatriates, including Gertrude Stein, F. Scott Fitzgerald, and Ezra Pound. By the time that *A Farewell to Arms*, his first commercial success, was published, he was already known as the voice of the Lost Generation as a result of *The Sun Also Rises* (1926). Over the years, some theorists have criticized his writing style as being too stripped down—to a form almost resembling a film script. Hemingway always believed that less is more, but some complain that his stoic characters are simplistic and lacking in depth. Instead, his stark language reflects the disillusionment of characters traumatized by war. As one critic articulates, "Hemingway confers on a seemingly routine experience affecting ordinary people a cosmic significance."

A Farewell to Arms is told from the point of view of Lieutenant Frederic Henry, an American ambulance driver on the Italian front during World War I. He meets Catherine Barkley, an English nurse who eventually becomes his lover. When Frederic is not with her, he is in the mountains collecting the wounded or he is drinking heavily with his friends, in part to forget why they are there in the first place. After Frederic is badly wounded, he is sent to the American hospital in Milan, where Catherine is assigned. Meanwhile, the Italians have lost hundreds of thousands of lives, and Frederic is to be sent back to the front. Before he leaves, Catherine reveals that she is three months pregnant.

Frederic departs for his assignment, only to learn that the Italians suffered a crushing defeat at Caporetto and will begin their retreat. Hemingway vividly describes soldiers and vehicles drifting in a slow processional through the rain, as if "the whole country was moving." Frederic decides to desert the war because "that life was over." He follows Catherine to Stresa, and they flee by boat to Switzerland. During a difficult labor, the doctor performs a cesarean, but the baby is stillborn. Catherine awakens from the operation and begins to hemorrhage, and after a final conversation with Frederic, she dies. Frederic returns to see her one last time, but "it wasn't any good. It was like saying good-bye to a statue."

The Films

Frank Borzage's 1932 *A Farewell to Arms* was the first Hemingway novel to be made into a film. In order to appeal to the many fans of the book, the marketing department at Paramount claimed the film was a duplication of the original, but in fact there were many changes, and Hemingway was very unhappy with the finished product. The script stressed the romance of the story and the promotional materials sold it as a vulgar melodrama: "Ernest Hemingway's world famous story of two who began in passion's reckless abandon with a love that grew until it heeded neither shame, nor danger, nor death."

Paramount even released two versions with different endings, expecting that "most likely the exhibitors will prefer the pollyanna ending." In the novel, Catherine dies alone in her stark hospital room. In one of the film endings, Gary Cooper carries Helen Hayes's lifeless body to the window as he murmurs "peace" and the bells toll ironically. However, in the second version, which opened only at smaller houses due to Hemingway's outrage, Catherine miraculously revives as an armistice is declared and cheers are heard rising from the streets. Many reviewers chided Hemingway for objecting so strenuously, and they praised the sentimentality as the film's greatest achievement. "And please, Mr. Hemingway," wrote *Variety*, "don't make yourself ridiculous by finding the slightest faults with Paramount's production of your tale, for in Frank Borzage's picturization there lies a thousand times more than you, or any of you, will ever put into the sterile, colorless black and white of type and paper."

Because Borzage chose to highlight the romance, key elements of the war are downplayed. The Caporetto retreat, which helped the film secure Oscars for best cinematography and best sound, is rushed and incoherent at times. Instead of exploring the implications of war, Borzage simply employs it as a plot device. Thus, while the book links Frank's desertion to the overall exhaustion and angst associated with warfare, Cooper deserts the army to be reunited with Hayes.

Censorship by the Hays office also led to a number of changes in the script. Paramount's primary concern centered on the premarital sex, so screenwriters Glazer and Garrett intended to wed them as soon as possible. Borzage agonized over audiences' reactions and whether they would view the marriage as legitimate. An additional concern was the timing of Catherine's pregnancy: Borzage inserted a "respectable" period for her to become pregnant, as well as an image of a hand wearing a ring. In the end, the film passed the test—the Catholic Legion of Decency rated it as "morally unobjectionable."

Another censorship issue was political. In October 1917, the Italians had suffered a tremendous defeat at Caporetto. The Germans and Austrians claimed 250,000 prisoners as the Italians retreated. In Hemingway's portrayal of the chaos, soldiers abandon their units, wish for defeat, and throw away their guns while crying for peace. Due to this defeatist, antipatriotic flavor, Mussolini banned the book in Italy and also threatened to ban the film. He even notified Paramount that if the movie insulted Italy, his country would outlaw *all* American films. The financial threat lead the studio to cut one scene of officers charting the course of the Italian army's retreat on a map. Furthermore, the characters never speak the word "Caporetto" and instead refer to a different battle—one at which the Italians were victorious.

More than two decades later, David O. Selznick purchased the screen rights from Warners and hired Ben Hecht (with whom he had worked on the adaptation of *Gone With the Wind*) to write the screenplay. It was to be his last film. John Huston was signed on to direct, but, after running afoul of the ever-meddling Selznick, was replaced by Charles Vidor. Although the film was designed to be a superproduction (it was shot in Italy with the usual "cast of thousands"), outstripping the scale, length, and spectacle of the Borzage film (not to mention the book), it adhered in many ways more closely to the Hemingway original.

Here, the shameful handling of the retreat by the Italian officers is not glossed over, as it was in the 1932 film. The chaplain (Albert Sordi) is a heroic figure, in keeping with Hemingway's portrayal, although his death in the Caporetto retreat is not to be found in the novel. Nor is the death of Catherine (Jennifer Jones) in childbirth romanticized; rather, it ranks among the most harrowing childbirth sequences ever put on film. However, ironically, the attempt to transfer portions of dialogue and interior monologues intact to the screen results in scenes that seem

mannered and overwrought, especially in the instance of Frederic's (Rock Hudson) ruminations about death and defeat in the final hospital scene.

Nonetheless, there are significant alterations from the book as concessions to public taste, such as a spurious wedding scene (at a race track, no less!) between Frederic and Catherine, and battle scenes that overwhelm the individual stories (commentator Gene Phillips writes that they "are really overblown set pieces which have been developed far beyond their function as plot devices in the story"). The miscasting of Rock Hudson and Jennifer Jones further marred Hemingway's intentions, as Hudson seemed too young for his character and Jones too old for hers.

Unconvinced the new film version had sufficiently "cleaned up" the Hemingway original, the Catholic Legion of Decency designated the movie "morally objectionable in part for all audiences; and the film's subsequent box-office take suffered.

When Selznick offered Hemingway $50,000 against the eventual profits, the author suggested he convert the amount into nickels and "shove them up his ass until they came out his ears." Later, after he walked out of a screening of the picture, Hemingway noted that when a novelist sees a movie like this made from a book he is fond of, "it's like pissing in your father's beer."

REFERENCES

Laurence, Frank M., *Hemingway and the Movies* (University Press of Mississippi, 1981); Phillips, Gene D., *Hemingway and Film* (Ungar, 1980); Weekes, Robert P., ed., *Hemingway: A Collection of Critical Essays*, introduction (Prentice-Hall, 1962), 1–16.

—R.L.N.

FAR FROM THE MADDING CROWD (1874)

THOMAS HARDY

Far From the Madding Crowd (1967), U.K., directed by John Schlesinger, adapted by Frederic Raphael; MGM.

The Novel

Far from the Madding Crowd was Hardy's fourth novel and his first real success, appearing in installments in the *Cornhill Magazine*, beginning in January 1874. As in much of Hardy's other fiction, there is a balance between the roles of chance and environment in shaping the action.

The major line of action in the novel follows the development of the relationship between Bathsheba Everdene and Gabriel Oak. From Oak's early proposal of marriage (initially refused by Bathsheba), through her encounters with and marriage to another suitor (Sergeant Frank Troy), and his subsequent murder by yet another suitor (William Boldwood), most of the action provides a series of experiences through which Bathsheba can finally realize how significant Gabriel Oak is to her success as a gentlewoman farmer and her happiness as a woman. Over a period of years, she learns that neither the flashy romance of Sergeant Troy nor the obsessive, possessive drive of Boldwood could have provided her with what she truly needs. Only Oak gives her the leeway to show what she is capable of accomplishing in a world still dominated by patriarchal attitudes, and loves her enough to look beyond the vanity her beauty produces within her.

The Film

Not much is known of a silent version of *Far From the Madding Crowd* made in England in 1915. In appraising his 1967 version, director John Schlesinger remarks, "We didn't adapt the novel with sufficient freedom" and "I was dealing with a considerable classic which perhaps, looking back on it, I regarded with too much awe," suggesting that his primary goal was to produce a film true to Hardy's original narrative. Having decided not to rewrite, truncate, or refocus the original story, a director must select essential elements of plot, make manifest those elements visually, and create equivalent visual substitutions where and when problems exist in transforming the written word to a visual image. Problems also exist in fitting an almost 500-page novel into the typical feature film running time of two hours and working with a cast of actors who may have their own conceptions of what Hardy meant his characters to be. Schlesinger worked under a number of difficult conditions.

The film's lack of success at the box office might have been due to original length (a 165-minute running time with a built-in intermission). It received mixed evaluations from movie reviewers and literary critics alike, praising one element and in the next paragraph damning another. (Schlesinger was blamed for a wide range of discrepancies from failing to cast actors with consistent West Country accents to lingering too long on "water [that] drips too precisely off a leaf.")

Yet Schlesinger, his crew and cast, did a remarkable job of transferring Hardy from the printed page to the cinematic screen. The color cinematography of Nicolas Roeg captures the beauty of Hardy's fictional Wessex. Schlesinger maintains a balance between incidents that provide the impetus to romantic relationships between the male and female characters and the everyday situations that made up existence in the England of that time, in essence, those creating Hardy's Wessex. Schlesinger effectively transforms word to image. For example, the scene in which Troy displays his swordsmanship to Bathsheba captures all of the potential sexual, phallic symbolism implicit in the action Hardy described in words. The substituted new scenes and dialogue, which capsulize an incident that took chapters to develop in print, remain remarkably true to Hardy's original narrative.

REFERENCES

Constabile, Rita, "*Far From the Madding Crowd:* Hardy in Soft Focus," in *The English Novel and the Movies*, ed. Michael Klein and Gillian Parker (Frederick Ungar, 1981), 155–64; Phillips, Gene, "*Far From the Madding Crowd*," in his *John Schlesinger* (Twayne, 1981), 80–92; Welsh, James M., "Hardy and the Pastoral, Schlesinger and the Shepherds," *Literature/Film Quarterly* 9 (1981): 79–84.

—N.S.

THE FAR SIDE OF THE WORLD (1984)

PATRICK O'BRIAN

Master and Commander: The Far Side of the World (2003), U.S.A., directed by Peter Weir, written by Peter Weir and John Collee, based on the novels by Patrick O'Brian; Twentieth Century Fox, Universal Pictures, and Miramax Films.

The Novel

Patrick O'Brian wrote 20 novels about the British navy during (and just after) the Napoleonic Wars; published between 1970 (*Master and Commander*) and 1999 (*Blue at the Mizzen*), the novels explore the lives and friendship of Captain Jack Aubrey and Dr. Stephen Maturin, who generally serves as surgeon aboard Jack's ships. O'Brian's books are based on rigorous research and reflect his extensive knowledge of the design and handling of men-of-war during the period. O'Brian was also recognized as a noted authority on life aboard these vessels; and his descriptions of the quarters and living habits of officers, midshipmen, and seamen are filled with details from this demanding occupation.

The Far Side of the World (the 10th novel in what has become known as the Aubrey-Maturin series) is a rich, complex novel that, from beginning to end, examines in minute detail the theme of fidelity and, of course, its opposite. The novel is set during the War of 1812 and begins with Captain Jack Aubrey's having to provide a dinner for Laura Fielding, a woman with whom he was falsely rumored to have had an affair, and her husband Lt. Fielding, also of the British navy, who has heard the rumor. Another guest is Stephen Maturin, who has also wrongly been identified (by Jack, among others) as a lover of Mrs. Fielding. The novel ends with Jack, Stephen, and a small part of the crew of *HMS Surprise* being stranded on an island that also shelters the captain and remaining crew of the *USS Norfolk*, the American frigate that Jack has been ordered to "take, burn, sink, or destroy." Making up a part of the crew of the American frigate are several former British sailors who had participated in the mutiny aboard the *HMS Hermione*, the most heinous mutiny in British naval history because the crew murdered every officer (including the young midshipmen) and then turned the ship over to the enemy.

Between these two framing episodes of personal and professional infidelity, O'Brian dissects the concept layer by layer, character by character. As the *Surprise* prepares to embark on its mission to intercept the *Norfolk*, which has been sent into the Pacific to disrupt the British whaling fleet, these secondary but essential characters begin to come aboard: Hollum, a man approaching 30 but still a midshipman because of his inability to pass the exam for lieutenant; Higgins, an assistant hired by Maturin primarily for his skill in pulling teeth; the ship's newly appointed gunner, Mr. Horner, a man who is impotent only with his wife; and the young, beautiful Mrs. Horner. (Here and in other novels, O'Brian correctly observes that it was not at all unusual for a ship to have women aboard; some captains sailed with their wives and most captains allowed warrant officers to bring wives along. In fact, the wife of the gunner or the bosun would often be assigned the responsibility of caring for the "squeakers," boys as young as five who had been sent to sea by their parents.) Also coming aboard at this time as the master of the *Surprise* is Michael Allen, a man who had sailed with the famous Captain Colnett during his voyages throughout the whaling fisheries; O'Brian then uses Allen to create an extended literary allusion to *Moby Dick* as Allen informs Aubrey and the others about whales: their types, behaviors by type, their travels, anatomies, breeding habits, and so on, and about whalers and their jobs.

Before the *Surprise* departs, Stephen receives a letter from his wife Diana informing him that someone has relayed the news that he has been having an affair with Mrs. Fielding; her response is one of the many attitudes toward infidelity that O'Brian examines; for Diana, physical infidelity is neither here nor there; what she objects to is that Stephen is apparently so indiscreet that he becomes the object of discussion. Stephen, who is himself an intelligence agent for the British Admiralty, sends his letter of explanation to Diana by way of an Admiralty colleague who happens to be the double agent that Stephen is trying to discover; thus the infidel is unwittingly entrusted with the profession of Stephen's fidelity. Later Stephen receives a series of anonymous letters telling him of Diana's betrayals, news that Stephen does not believe but that leads him into an extended analysis of *The Iliad* as a great outcry against adultery. These letters are just the beginning of the examination of all the variations of the theme that can be observed on the man-of-war.

Early in the voyage, Mr. Horner, the gunner, begins to seek Dr. Maturin's treatment for his impotence "where his wife is concerned." At the same time, Higgins, Stephen's assistant, begins to take advantage of his position to "practice" medicine on the more naive members of the crew. Captain Aubrey is aware of tension and division among the members of the crew but is unable to learn the cause. The crew has been divided as a result of the affair between Hollum, the older midshipman, and Mrs. Horner. These men in Hollum's division support him; those in the gunner's are angry; others condemn the affair out of religious principle;

and still others condemn it simply because it will create ill will. In other words, some are faithful to leaders; some to moral principle; others to social law and harmony. Eventually when Mrs. Horner solicits the care of Dr. Maturin and, after he confirms her pregnancy, asks him for an abortion, Stephen—a physician and a Catholic—must honor his Hippocratic oath and faith although he agrees with Mrs. Horner that her temperamental husband might kill her if he learns of her affair. Later, after Mrs. Horner becomes dangerously ill, Stephen suspects that Higgins has obliged her. She recovers, but she and Hollum are murdered by the husband some time afterward while they are on an island where the ship is being refitted. Horner later hangs himself in remorse; the crew reestablishes harmony on board the ship by giving Higgins a "Jonah's lift" late one night as he goes to use the head. This solution invokes that biblical story of faithfulness that has such strong appeal to the mariner.

The ship continues its search for the *Norfolk*, which takes it past the Galápagos Islands and into the vast Pacific. After Stephen and Jack become stranded on a small island, the novel ends with two episodes that focus on professional fidelity. Stephen unequivocally accepts Jack's half-hearted assertions that the officers and crew of the *Surprise* will be able to retrace the course to locate them. They do, and after sailing along the edge of a hurricane, the *Surprise* eventually finds the ship wrecked on yet another island after being in the worst of the same storm. While Jack, Stephen, and a part of the crew are ashore to negotiate the surrender of the American sailors, the *Surprise* is again blown out of sight by the weather. After weeks of diligent effort it returns, just as the survivors of the mutinous crew of the *Hermione* are attacking Jack and his crew. Fidelity triumphs over infidelity.

The Film

It is more accurate to say that the script for the film was written by Peter Weir and John Collee, based on O'Brian's novels, than to say that it was "adapted by" them because, although the film borrows the titles of two O'Brian books and includes brief episodes from several others in the 20-novel series, the film does not follow any one plot closely. The film takes the primary mission of HMS Surprise in *The Far Side of the World* (chase and take or destroy the *USS Norfolk*, which has been sent to the Pacific during the War of 1812 to destroy British whaling interests) and converts it into something different (chase and take or destroy the French privateer *Acheron*, which is in the Pacific to extend the war to that area of the world).

The film is set in 1805. Napoleon is threatening supremacy over the high seas. And the *Surprise* in the command of Captain Jack Aubrey (Russell Crowe) is on a mission to intercept the French frigate *Acheron*. A surprise attack at dawn from a fog bank disables the *Surprise* and leads the crew to assume they will have to turn back to Portsmouth. But "Lucky" Jack is determined to press on, despite the fact that the *Acheron* is faster than the *Surprise*, has twice its guns, and has an armored hull. Repairs are made, and the chase is on. At the Galápagos Islands, the crew goes ashore while Dr. Stephen Maturin (Paul Bettany), the ship's surgeon, undergoes self-administered surgery to remove a musket bullet. When the ship is becalmed, superstitious gossip runs rampant through the crew that one of the lieutenants is a jinx. In despair, the unfortunate man throws himself overboard, weighed down by a cannonball. The chase continues. At last, the *Acheron* is sighted. Inspired by a demonstration by the naturalist Maturin of the ability of an insect to disguise itself against its predators, Aubrey devises a stratagem to surprise the *Acheron*: He fits out the ship like a whaling vessel, hauls down the British flag, conceals the weapons, and hides his marines in the topsails. Sure enough the *Acheron* takes the bait, pulls alongside, and a furious battle ensues. Ultimately victorious, Aubrey takes command of the *Acheron*'s debris-filled decks. He finds the ship's surgeon, who assures him that the French captain is dead. Aubrey orders his first mate to take charge of the *Acheron* and take it to Portsmouth. A little later, Aubrey learns he's been tricked—the *Acheron*'s "doctor" was the ship's captain in disguise. Somewhat petulant and whimsically resigned to the task, Aubrey orders his ship to turn around. Another chase is on.

The chase of the *Acheron* is at the core of Weir's film, a distillation of O'Brian's complex plot. The film develops neither the complexity of the relationship between the two central characters nor the incredible depth of personality given by O'Brian to each of the men. The central theme of the first novel (*Master and Commander*) is honor; that of the 10th (*The Far Side of the World*), fidelity. In the film, Jack Aubrey is honorable because he does nothing dishonorable; and he is certainly faithful to his duty, perhaps even overzealous in his pursuit of it. But there is nothing in the depiction of Jack Aubrey by Russell Crowe that necessarily separates the character from other glorious naval captains of literature and film; and the character of Stephen Maturin as adapted by Weir and Collee is stripped of the biographical, political, and intellectual complexity created by O'Brian. For example, in the novels Stephen Maturin is the illegitimate son of an Irish father and a Catalonian mother (hence, passion and independence flows from both sides of his heritage), a physician, a natural philosopher, a Catholic, a man who participated in the Irish uprising and who was in Paris as a medical student during the French Revolution, a man committed to democratic principles of government, and an unpaid intelligence agent for the British Admiralty because of his hatred for Napoleon.

Jack Aubrey is the son of a British army general and a devoted mother who died when he was young, a naval officer who went to sea before he was 12 and who has lived his adult life in the rigorous hierarchy of the British navy, a Church of England Tory, and an unthinking antipapist.

O'Brian creates a basis for the friendship between these two men by revealing their flaws: Jack's setbacks and triumphs come from his breaking rules or stretching limits; Stephen's sorrows and joys come from his inability to break from formal convention. In finding this basis for their relationship, O'Brian gave the characters life. In the film these characters refer to one another as friend; but the reason is not apparent.

The loyalty of Aubrey and Maturin is at the core of the novel *The Far Side of the World*; but a different idea of fidelity is at the heart of the film—sensory fidelity. That is the strength of this undertaking, and it is a noteworthy accomplishment. Much has been made of the director's attempts to recreate as accurately as possible the many elements of life at sea during this period, from the entire ship with its complex sails and rigging to the buttons on the officers' uniforms. Most viewers are probably not capable of grasping the integrity of a complete man-of-war and are probably not concerned with the accuracy of a button; but virtually everything in between is also masterfully presented to place the viewer in the action, whether that action is a running broadside battle or the almost motionless drift of a ship in the doldrums. The sounds of the cannon firing and the balls flying overhead or crashing into the hull of the ship were recorded using antique weapons; and the manipulation of those sounds—combined with the amazing visual images of the splintering wood—recreate the chaos of such battles. And in more peaceful moments other sounds and images faithfully reproduced life aboard, as in one of the early scenes of men sleeping in crowded hammocks that sway as the sounds of the ship's timbers and planking work to the opposing forces of water and wind. In fact, Peter Weir and his associates have created a magnificent union of visual and auditory effects; there is almost always a perfect combination of sound and scene regardless of the moment: the sights and sounds of the pandemonium of hand-to-hand combat, the constant, soothing sound of running water in calm seas as objects sway below decks, the shrill sound of the wind mixed with the heavy seas off the Horn, or the occasional sessions when Aubrey and Maturin play the violin and cello. Indeed, music pervades the entire picture: the crew breaks out in a couple of impromptu sea chanteys; music from Vaughan Williams's *Thomas Tallis Fantasy* underpins the tragic fate of the castaway sailor in the storm; Boccherini's *Nights in Seville* provides a piquant counterpoint to the final scenes as the *Surprise* is turned around in another pursuit of the *Acheron*. Along the way there are a few reprises of the opening measures of a Bach cello suite and a few measures of Mozart's Third Violin Concerto. This film is a sensory delight.

REFERENCES

Buckley, William F., Jr., "Happily Seduced: Master and Commander Is Not to Be Missed," *National Review Online*. Available online. URL: www.nationalreview.com/buckley/buckley200311121006.asp.

Posted November 12, 2003; Day, Anthony, "Master Storyteller," *Smithsonian*, December 2003, 77–80; Hunter, Stephen, "Master and Commander: Heavy on the Ballast," *The Washington Post*, November 14, 2003, C1, C5; Morgenstern, Joe, "Something to Crowe About: In Master and Commander, the Naval Epic Returns," *The Wall Street Journal*, November 14, 2003, W1, W10; Ringle, Ken, "Hollywood's Approach Is Less Than Novel," *The Washington Post*, November 14, 2003, C4; Scott, A.O., "Master of the Angry Sea (And the Marauding French)," *The New York Times*, November 14, 2003, B1, B13.

—D.G. Hagar

THE FIRM (1991)

JOHN GRISHAM

The Firm, (1993), U.S.A., directed by Sidney Pollack, adapted by Robert Towne and David Rayfiel; Paramount.

The Novel

A former criminal defense attorney in Mississippi, John Grisham's first best-seller was *The Firm*. It was his second novel. Marketed as a thriller, but also advertised in law journals, the success of *The Firm* enabled Grisham to leave law for writing, and established what some have called the Grisham formula. It was enthusiastically welcomed by a popular readership, but panned by some critics for its poor writing and appeal to the "current American fashion for the paranoid."

The Firm tells the story of young, bright, driven Mitch McDeere, top in his class at Harvard Law who takes a dream job with a prestigious Memphis law firm: great pay and benefits, coupled with the beginning lawyer's traditionally very long hours. Then he discovers that the firm's primary client is the Chicago mafia, the Morolto family, currently the target of a major FBI investigation. Now Mitch is caught. He can be indicted with the rest of the firm, or become an FBI tool with sudden death the penalty for detection. Over several months, Mitch steals, copies, analyzes, then gives the firm's files to the FBI, but declines to support these papers with his personal testimony (he leaves a video tape instead). Now hunted by both the Mafia and FBI, he escapes to hide on a deserted island with wife Abby.

The Film

In midmovie the plot departs from Grisham's original with the addition of Mitch's awakening to the ethical demands of his professional position; he realizes that helping the FBI would mean violating attorney-client privilege. Suddenly it's no longer acceptable to break the law to help convict other lawbreakers. Mitch's solution is to trap the villains we've seen—the firm—for mail fraud (for inflated bills sent through the mail); this, and some other minor

accommodations to the law, earn at least the respect of the previously abusive FBI agent. The many boxes of the firm's files are not completely forgotten. Here they are copied in one frantic night and become Mitch's insurance against the mafia because lawyer-client confidentiality lasts only through his lifetime.

With a far more pretentious story line, the screenplay has changed an adventure story into a film with a heavy message, putting too much weight onto too light a vehicle. The film's Mitch (Tom Cruise) is simply not believable; sometimes he's too good to be real, his unarmed combat and hiding and escaping skills come from comic books, not Harvard Law School. Where the story gives Mitch some human characteristics, such as the perfectly reasonable fear of being killed for discovering the truth about his employers, Tom Cruise fails at making Mitch seem human, perhaps because he simply does not do fear well. The film goes even further than the book in focusing only on white upper-middle-class males; the book's Tammy was a tough, streetwise, clearly lower-class woman whose independence is so downplayed in the film that she is paired off, if not married off, in the end. Similarly, the film's ending eliminates the black boat captain's much more heroic role in saving Mitch's life, reducing him to a water taxi driver for Mitch's brother, Tammy, and a boatload of Morolto files. Finally there is heroism without much cost: Where the book forces Mitch and Abby onto a deserted island waiting for their killers to discover them, the film's couple also reunites, but now to return to Boston and the alternative law career they both know would have been the right choice all along. Nevertheless, lots of action, maybe a bit of melodrama, what passes for suspense when we know that the good guys must win, reaffirmation of family values that would have seemed conservative in the 50s, and Tom Cruise all helped this become the third-highest-grossing film of 1993.

REFERENCES

Jensen, Eric M., "The Heroic Nature of Tax Lawyers," *University of Pennsylvania Law Review* 140:285; Nichols, Peter M., "Home Video," *New York Times*, December 17, 1993, D, 22; Winks, Robin W., "Old Thriller Formulas Still Work," *The Boston Sunday Globe*, May 31, 1992, 96.

—C.B.D.

THE FIXER (1966)

BERNARD MALAMUD

The Fixer (1968), U.S.A., directed by John Frankenheimer, adapted by Dalton Trumbo; MGM.

The Novel

Malamud recalls that the novel grew out of his father telling him the (true) story of Mendel Beiliss, arrested by the czar's officers for a ritualistic murder. But Malamud emphasizes invention, as he wanted his story to be "mythological," an "endless story" that would echo the plight of Jews under the Nazis, of black Americans, of Dreyfuss, and of Vanzetti. Malamud received a Pulitzer Prize and a National Book Award for *The Fixer*.

In czarist Russia, circa 1910, Yakov Bok leaves his native shtetl to seek his fortune in Kiev. No longer a believer in God, the fixer (handyman) would, if he could, resign being Jewish. After rescuing a drunken businessman from a snowdrift, Bok is employed by him, under the anti-Semitic employer's presumption that Bok is a Gentile. Accused of the ritualistic, bloodletting murder of a young boy—and framed partly by workers whose thievery from his boss he has prevented—Bok is imprisoned indefinitely. His "triumph" at the end is in his being brought to trial and in his not having compromised his personal beliefs and values.

The Film

Less than a smash at the box office, John Frankenheimer's film also played to mixed critical reception. Many who reviewed it were in awe of its capturing of one man's suffering and, simultaneously, its attainment of a universal representation of human dignity. Just as many, however, found these to be its intentions but not its achievements. Over and again, one finds it spoken of as "worthy but dreary," "intense but dull," a tedious film that "crawls along on its intentions." Generally, the acting has been praised, especially that of Alan Bates, despite his being miscast as the Russian Jewish protagonist, and of Dirk Bogarde as Bibikov, the one man in the czar's legal system who is sympathetic and helpful to Bok. The script and the direction have generally been treated less kindly, a typical objection being to the film's "synthetic" quality.

One school of response to this adaptation is that it was needless. Malamud's novel, this theory goes, did everything the film does well and several things the film cannot duplicate. What remained then for Trumbo and Frankenheimer was pale imitation. In the words of Robert Kotlowitz: "The film has nothing to tell us beyond Mr. Malamud's novel; it simply reproduces it." Further, Kotlowitz argues, unlike Malamud's work, "the movie depresses rather than releases us."

One undeniable oddity of the film is in Frankenheimer's having taken it to Hungary to be photographed. Presumably this seemed the nearest one could come to the impenetrable Soviet Union. But almost the entire film is shot indoors, most of it in prison cells.

For all its oddities and all its detractors, the film is occasionally spoken of in positive superlatives, as that of Philip Hartung (in *Commonweal*): "As a hymn celebrating the survival of the human spirit, 'The Fixer' is in a class by itself."

REFERENCES

Kotlowitz, Robert, "Victims: Two Films and a Play," *Harper's*, January 1969, 107–08; Lasher, Lawrence, ed., *Conversations with Bernard Malamud* (University Press of Mississippi, 1991).

—*C.K.P.*

FORREST GUMP (1986)

WINSTON GROOM

Forrest Gump (1994), U.S.A., directed by Robert Zemeckis, adapted by Eric Roth; Paramount.

The Novel

Winston Groom's novel is an outlandish, picaresque comic odyssey that seems to suggest that anyone, even a moron, can find fame and success in America. Gump cheerfully admits that he is an idiot, but that doesn't keep him from being recruited to play football for Bear Bryant at the University of Alabama. Thanks to Forrest, the Crimson Tide beats the University of Nebraska and wins the Orange Bowl, the first of Forrest's many remarkable achievements. After being named Most Valuable College Back of the Southeastern Conference, Gump flunks out of Alabama after one semester, but mainly because he flunked his phys ed course. Being an idiot savant, Gump earned an A in physics, but that could not compensate for his failure in physical education.

Gump's career is intertwined with that of childhood sweetheart Jenny Curran, who becomes first a war protester and then the lead singer of a rock group called the Cracked Eggs. After Gump serves in the Vietnam War, where he becomes a decorated war hero and meets President Johnson, he finds Jenny in Boston and himself becomes a rock star, thanks to his skills in playing the harmonica. His talents are many. While in the service he becomes a Ping-Pong champion and is sent to Beijing to represent his country during the first round of Ping-Pong diplomacy. While there he saves the life of Chairman Mao and becomes a national hero in Red China.

Gump ends up at the National Institute of Mental Health (which he considers a "serious loony bin"), where the doctors are amazed by the fact that Gump appears to be a "human computer." They send him to NASA in Houston, where he trains to become an astronaut. Gump is then sent into space with "a crabby-lookin' lady called Major Janet Fritch, who is supposed to be America's first woman astronaut," and a male orangutan named Sue. Although they are successfully launched into space, the return to earth is off course and they find themselves captured by cannibals in "Borneo, or someplace." Their lives are spared, however, by Big Sam, the cannibal leader, who was educated at Yale and is seeking a chess partner. And so, in the novel's most surreal twist, Forrest Gump is taught to become a chess master before NASA rescues him from cannibals and headhunters.

Back home again, Gump finds his Vietnam War pal Lieutenant Dan, and the two of them go to Indianapolis, where Gump finds Jenny and becomes a television star and professional wrestler, calling himself "the Dunce." Gump's head is turned by his celebrity success, and Jenny leaves him. Gump goes to California and finds a role in a movie, opposite Raquel Welch, in a remake of *The Creature from the Black Lagoon*. In Hollywood, Gump is also happily reunited with Sue, the orangutan, but he is most successful in California under the guidance of Mister Tribble, a retired chess master who arranges a match between Gump and international grand master Ivan Petrkivitch, which Gump wins by breaking wind as a foul diversion.

Gump then returns to Alabama, where he becomes a successful entrepreneur, developing his shrimp business with the father of his friend Bubba, who was killed in Vietnam. Gump, being Gump, cannot escape from success and is encouraged to run for the U.S. Senate, until his past begins to catch up with him. He finds Jenny, married in Savannah and raising a son that Gump had fathered. Gump arranges to provide for little Forrest and for Bubba's daddy, who helps to run the shrimp business while Gump performs as a busker in New Orleans.

The Film

The motion picture adaptation directed by Robert Zemeckis popularized Groom's comic novel by sentimentalizing it and twisting Gump into a "lovable" character protected by his mama (Sally Field), played by lovable actor Tom Hanks. The novel's opening sentence, "bein' a idiot is no box of chocolates," was transformed into the movie's sentimental tagline: "Life is like a box of chocolates. You never know what you're gonna get." Protesting the Vietnam War was a primary concern in the novel, leading up to Gump's throwing his Congressional Medal of Honor at head of the Clerk of the U.S. Senate. What does Zemeckis make of this politically symbolic gesture? Conservative pundit Pat Buchanan described the film as a "testament to Republican values and virtues."

Critic David Lavery summarized (and protested) the many changes made by screenwriter Eric Roth by asking the following questions: "Why is Forrest made smarter? Why make Forrest crippled as a child? Why make Forrest squeaky clean, morally upright, and virginal? Why make Forrest a devoted and loving son? Why make Bubba an African-American? Why make Forrest into a college graduate? Why have Forrest enlist in the Army instead of being drafted? Why have Forrest save Lieutenant Dan's life? Why equivocate on Forrest's opposition to the Vietnam War? Why make Forrest and Dan close, influential, lifelong friends? Why have Lieutenant Dan lose his legs but not become badly scarred? Why have Lieutenant Dan become reborn? Why make Jenny the victim of sexual abuse at the hands of her father? Why have Forrest and Jenny marry? Why have Forrest raise his child by Jenny? Why have Jenny die?"

Other questions might well follow: Why, for example, is the Zemeckis film haunted by gimmicks borrowed from *Zelig* and *Being There?* Why does the film up the celebrity ante by having Gump encounter not only Elvis but John Lennon? Why is Gump standing behind Governor George Wallace as he attempts to hold the line against integration at the University of Alabama? Why is it not enough for Gump to meet LBJ and Richard Nixon (as in the novel)? Why does the film also bring JFK into the picture? Because it can be done?

The novel was thus stripped of its sense of satire and irony and made manipulative, gimmicky, and sentimental. David Lavery concluded, "Virtually every decision made in altering Winston Groom's novel for the screen—from Forrest's heroic (and very cinematic) overcoming of his childhood handicap, to his very un-nineties moral uprightness, to his too-good-to-be-true son persona, to his politically correct and Southern-stereotype-defying friendship with an African-American, to his inspirational influence on the courageously handicapped (but not deformed) Lieutenant Dan, to the *Love Story* death of the sympathetically child-abused Jenny, to Forrest's 'new male' single-fathering —can be seen in retrospect as a kind of self-censorship-

for-profit re-conceptualizing of a *Candide*-like novel, appropriate to the era of the death of irony."

The novel, then, was reconfigured, reimagined, and digested into nonoffensive sentimental pap that would offend no one, and put into alignment with what cultural critic Curtis White has called the "middle mind." According to Lavery, the novelist claimed on CNN that "he was not troubled by the changes screenwriter Eric Roth made in adapting his book for the screen." The film made him famous, if not exactly rich and famous, since, after the film had grossed $660 million worldwide, Groom had not by May 1995 collected anything from his contracted 3 percent net profit, Paramount claiming that it had not yet realized a profit. In 1985 Groom was paid $350,000 up front, however, when the film rights were negotiated. The financial success of the film most certainly boosted sales of the novel, however, and its sequels and spin-offs, *Gump & Co.* and *Gumpisms: The Wit and Wisdom of Forrest Gump*, which became a number-one *New York Times* best-seller.

It would be comforting to claim that the Zemeckis adaptation captured the essence of Gump, but that is to be found only in the original novel. Although J. Hoberman claimed in his *Village Voice* review that the film "freely adapts (and improves upon) Winston Groom's 1986 novel, an autobiographical monologue delivered by an American *Candide* with an IQ of 70," he later added that Zemeckis and screenwriter Eric Roth "lack the requisite misanthropy to make Forrest more than a figure of c&w bathos, just another good ol' boy out looking for love." After Forrest gets wounded in the buttocks in Vietnam, Hoberman thought the movie "turns mawkish and tiresome; its affect, like Forrest's, could be classified as 'dull normal.'" The film pushes as many buttons of sentimental populism— "simple goodness triumphing over retardation, amputation, assassination, exploitation, intolerance, child abuse, and AIDS"—as it can reach, mingling Oprah with Capra; as Hoberman suggested, "there's never a point where you can't see the Forrest for the trees."

REFERENCES

Hoberman, J., "Back to the Garden," *Village Voice*, July 12, 1994, 41; Lavery, David, "'No Box of Chocolates': The Adaptation of Forrest Gump," *Literature/Film Quarterly* 25, no. 1 (1997): 18–22; Masters, Kim, "Hollywood Is As Hollywood Does," *Washington Post*, May 27, 1995, C1, C7.

—*J.M. Welsh*

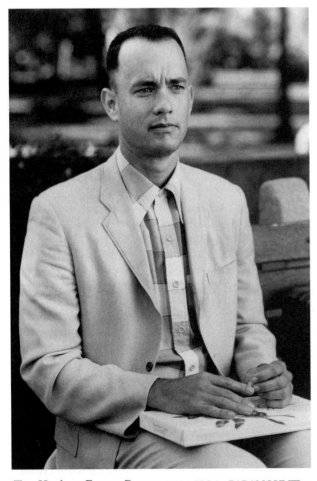

Tom Hanks as Forrest Gump (1994, U.S.A.; PARAMOUNT)

THE FORTUNES AND MISFORTUNES OF THE FAMOUS MOLL FLANDERS (1772)

DANIEL DEFOE

The Amorous Adventures of Moll Flanders (1965), U.K., directed by Terence Young, adapted by Denis Cannan and Roland Kibbee; Paramount.

Moll Flanders (1996), U.S.A., directed and adapted by Pen Densham; MGM.

The Novel

Defoe's *Moll Flanders* is perhaps best summarized by citing the novel's full title: "The Fortunes and Misfortunes of the Famous Moll Flanders, &c. Who Was Born in Newgate, and during a Life of continu'd Variety for Three-score Years, besides her Childhood, was Twelve Year a Whore, five times a Wife (whereof once to her own Brother), Twelve Year a Thief, Eight Year a Transported Felon in Virginia, at last grew Rich, liv'd Honest, and died a Penitent." Indeed, it's a wild saga of an abandoned girl in London who worked her way through seductions, dangerous liaisons, a ring of pickpockets, and several husbands on her way to a successful plantation business in Virginia and Maryland. The tale concludes as Moll, now aged 70, returns to England with her husband to do penance for her sin-filled life.

It remains to say that Moll is brought at a very young age to understand the value of a shilling; she is the original economic woman who, in the words of commentator Kenneth Rexroth, "moves through a narrower world than one of ordinary material objects; her life is led almost exclusively among commodities." Every action, every emotion in the novel is assessed through Moll's sensibilities, i.e., each according to its financial costs and benefits. The novel is indeed the story of "fortunes and misfortunes," and it is not an accident that Moll was able to live honest and die a penitent only after first acquiring riches. Indeed, a sternly moral current (not without irony) runs throughout. As Rexroth notes, "There is not a wicked action in any part of it but is first or last rendered unhappy and unfortunate; there is not a superlative villain brought upon the stage but either he is brought to an unhappy end or brought to be a penitent; there is not an ill thing mentioned but it is condemned, even in the relation, nor a virtuous, just thing but it carries its praise along with it."

The Films

One would think such a novel would be ideal material for the movies. Significantly, however, the 1965 adaptation, directed by Terence Young and starring Kim Novak, changed the title from "fortunes and misfortunes" to "amorous adventures." Thus, while this stylish and rollicking adventure adheres to many of the picaresque particulars of Defoe's plot, it entirely misses the ironic undercurrents. An 18th-century cautionary tale is turned into a "sexy romp." The "twelve year a whore" aspect of the story is eliminated entirely, and the "twelve year a thief" portion reduced to a couple of months of pickpocketing. As critic Brendan Gill writes, "Defoe's Moll was truly a moll, while Miss Novak's is a grown-up Brownie, much more likely to be found baking tollhouse cookies than picking pockets and bargaining over the price of her body."

Pen Densham's 1996 adaptation cannily hedges its bets by announcing immediately that it is "based on the character from the novel by Daniel Defoe." Indeed, the film bears only a superficial resemblance to the book. Moll (Robin Wright) has been converted into a politically correct feminist standard-bearer ("I take orders from no man") and advocate for the rights of the suffering poor. Orphaned as a child, she works as a maid in a wealthy home, falls into hands of a prostitution ring headed by Mrs. Allworthy (Stockard Channing), forms a friendship with a black servant named Hibble (Morgan Freeman), becomes the mistress of a wealthy but terminally ill portrait painter, bears his child, and is abducted by Allworthy to America. There, as a result of a shipwreck, she acquires Allworthy's fortune and now manages a successful plantation. At the final fadeout, Moll, with her daughter and companion Hibble, dances along the beach while happy black workers till the fields.

Of course, this is all nonsense. Neither Hibble, Allworthy, nor the portrait painter are to be found in Defoe's original. A framing story involving Moll's daughter has been added, which seems only to complicate the story structure with a series of flashbacks. Actress Robin Wright gives us a dour, insufferably virtuous Moll, lacking entirely in color and vitality. Ironically, only Stockard Channing's Mrs. Allworthy conveys anything like Defoe's energy. She deserved to have been the proper heroine of her own story.

REFERENCES

Gill, Brendan, review in *The New Yorker*, May 29, 1965, 68; Rexroth, Kenneth, afterword to *Moll Flanders* (Signet Classics, 1996).

—K.F.

FOR WHOM THE BELL TOLLS (1940)

ERNEST HEMINGWAY

For Whom the Bell Tolls (1943), U.S.A., directed by Sam Wood, adapted by Dudley Nichols; Paramount.

The Novel

Published after the author had already established himself as a major force in the literary world, *For Whom the Bell Tolls*, Hemingway's longest novel, used the conflict between Loyalists and Fascists in Spain in 1937 as an allegory for the human condition. It also reflected Hemingway's own experiences supporting the Loyalist cause in Spain, when he scripted the pro-Loyalist documentary, *The Spanish Earth*, and when he covered the civil war in 1937 as a correspondent for the North American Newspaper Alliance. The book became an immediate best-seller. Occurring over three days in the life of a young American Loyalist sympathizer, the novel spins out epic themes of love, war, and loss within a modern-day context. The work is more sentimental than much of Hemingway's earlier

Ernest Hemingway

the survivors now is to avoid the deadly gunfire that strafes the one and only path to safety. They make it safely, except Jordan, who goes last and who is badly injured. Maria begs to stay with him, but Jordan tells Pilar to take her away by force. As he waits for the Fascists to either kill him or take him prisoner, Jordan props himself against a tree, a submachine gun across his knees, and mulls over his role in the war. He is confident that he has fought on the side of democracy and justice. He smiles at the approaching Fascist officer and thinks to himself, "I have fought for what I believed in for a year now. If we win here, we will win everywhere."

The Film

The book's compact time frame and central incident of the bridge demolition seemed ideally suited to film adaptation. Moreover, the exposition was primarily accomplished through action and dialogue; and there was enough "love interest" to attract moviegoers not otherwise interested in war stories. Thus, within three days of the book's publication, Paramount bought the screen rights for $150,000. Actor Gary Cooper, who had become a friend of Hemingway's, had the author's approval to play Jordan (despite the fact that Cooper had starred in the earlier *A Farewell to Arms*, which Hemingway disliked). Exteriors were shot on location in the High Sierra in northern California.

Dudley Nichols' script was more faithful to the novel in incident than in ideology. Aside from a short speech late in the movie, in which Jordan explains that the Fascists are using the civil war as a dress rehearsal for a full-scale European war, the film is relatively neutral politically. The Civil War is seen more as a struggle between foreign powers than as an internal political struggle in Spain between Fascist and democratic factions. When Hemingway objected, producer/director Sam Wood responded, "It is a love story against a brutal background. It would be the same story if they were on the other side." Studio chief Adolph Zukor added, "It's a great picture, without political significance. We are not for or against anybody." In his study of the film, Gene D. Phillips adds that perhaps the *real* reason for the depoliticization of the film was that Wood and the studio bosses wanted to avoid the risk of box-office boycotts by pro-Franco Spanish groups either in America or abroad (just as the same studio's officials had worried about offending Italians with the 1932 version of *A Farewell to Arms*). Indeed, nowhere is Franco mentioned, although, of course, he leads the Fascist movement depicted in the story!

There were narrative alterations. Interior monologues by Jordan were deleted, robbing his final moments of their poignant power. Maria's (Ingrid Bergman) account of the abuse she received at the hands of the Fascists was verbalized, rather than seen in flashback (a bow to the prevailing censorship restrictions in Hollywood).

Despite its three-hour length and talky nature, the picture was one of the top grossers of 1943, and Academy

work, especially the stories of *In Our Time* and the novel, *The Sun Also Rises.*

Robert Jordan is a teacher from America who is in Spain assisting the Loyalist cause. His assigned mission is to blow up a strategically important bridge during a planned Loyalist guerrilla attack. While behind enemy lines, he meets up with the peasant guerrilla leader, Pablo, and his wife Pilar. Also a part of the band is a young refugee, Maria, whose boyish appearance is the result of having her head shaved while a prisoner of the Fascists. Her tales of abuse at their hands fans the flames of Jordan's hatred against the Fascists. At the same time, his immediate attraction to Maria gives him a new reason to live.

When the unpredictable Pablo, who is not entirely in sympathy with Jordan's mission, steals and loses Jordan's explosives and detonators, Jordan realizes that the bridge must be destroyed by the far more dangerous use of hand grenades. After the deed is done, Jordan learns that the treacherous Pablo has killed other members of the guerrilla band to get their horses. The problem confronting

Award nominations went to Cooper, Bergman, and Akim Tamiroff (as Pablo). Katina Paxinou won a supporting actress Oscar as Pilar. While critic James Agee was unimpressed, complaining of its "defective" narrative rhythm, Hemingway himself admired the acting (if not the politics), declaring to Cooper: "You played Robert Jordan just the way I saw him, tough and determined. Thank you."

REFERENCES

Bloom, Harold, *Ernest Hemingway* (Chelsea House, 1985); Canham, Kingsley, *The Hollywood Professionals* (A.S. Barnes, 1973); Phillips, Gene D., *Hemingway and Film* (Frederick Ungar, 1980).

—*S.C.M. and J.C.T.*

THE FOUNTAINHEAD (1943)

AYN RAND

The Fountainhead (1949), U.S.A., directed by King Vidor, adapted by Ayn Rand; Warner Bros.

The Novel

Ayn Rand's lengthy novel concerns Howard Roark, a heroic architect whose visionary career recalls that of Frank Lloyd Wright and Wright's mentor, Louis Sullivan. This novel of ideas sets the individual artist Roark at odds with the establishment representing his chosen field because Roark's designs are avant-garde. Roark labors to maintain his integrity while others pressure him to compromise. Rand reverses the first impressions formed about nearly all of her characters: Roark's nemesis, the manipulative and devious critic Ellsworth Toohey, for example, is first defined by an apparent avuncular kindness, whereas he is in fact a cruel, ruthless, and evil manipulator. In the novel Roark is curiously detached from ordinary human emotions, a man incapable of sentiment but dominated by passion. Dominique Francon, Roark's soulmate and catalyst, is equally abstract and unreal. She is a femme fatale, always in control of the men around her, except for the dominant Roark.

Roark is defined by his work, his genius, his dedication and integrity. His foil is the less talented Peter Keating, who succeeds because of ideas plagiarized from Roark. The conventional Keating succeeds while Roark does not; Keating becomes a partner in Guy Francon's firm and hires Roark as a mere draftsman. Toohey helps to build Keating's reputation while Keating courts Toohey's niece Catherine Halsey. Keating is a total opportunist and deserts Catherine in order to marry Dominique and rise in the firm. When Keating is awarded a contract to design the Cortlandt Homes project, he has to turn to Roark for inspiration and help. Roark agrees to design the project only if Keating will guarantee that it will be fabricated exactly as Roark designs it.

When Keating later compromises Roark's designs, Roark destroys the project. Roark is protected by newspaper tycoon Gail Wynand, who admires his work. Toohey, who writes for Wynand's newspaper chain, concocts a scheme to get Roark a contract to design a cathedral for the fabulously wealthy Hopton Stoddard, knowing full well that Roark is an atheist. Toohey misrepresents the concept to Roark, knowing that Stoddard will be outraged by Roark's "Temple of the Human Spirit." Stoddard rejects the design, takes Roark to court, and turns the cathedral into a "home for subnormal children" on Toohey's advice. Nothing of the Stoddard plot remains in the film.

In the novel Roark and Wynand, Roark's industrial counterpart, are defined by their selfishness, which, in Rand's philosophy, becomes a virtue so long as that selfishness is linked to personal integrity and is beyond compromise. Toohey's motives are to elevate mediocre talents he can control and to destroy individualism. Toohey wants power and influence, and he is nearly able to subdue Roark's talent and defeat Wynand.

The Film

The film adaptation focuses on the triangles formed first by Roark (Gary Cooper), Keating (Kent Smith), and Dominique (Patricia Neal), then between Roark, Dominique, and Wynand (Raymond Massey). Ellsworth Toohey (Robert Douglas) is central as a catalyst and cartoon villain, but his villainy is less ominous and he is reduced to a secondary character. Roark's superhuman individualism is scaled down to human (and sometimes wooden) dimensions.

One major challenge is to reduce and compress a novel that runs 700 pages into a two-hour film. The power struggles between Toohey and Wynand and between Toohey and Roark constitute the dynamic of this novel. Ellsworth Toohey cannot be reduced to a secondary character if the story is to retain its own integrity, and yet Rand herself made compromises with the studio, damaging the integrity of her own novel that was mainly *about* integrity. It is shameful that she would compromise her own work for the sake of a popular mass audience, diminishing Dominique's power and authority, turning her into a soulful, melodramatic twit, allowing Toohey to have the upper hand over Wynand, reduced to a broken man in the film who commits suicide, whereas in the novel Toohey is reduced to working for *The Clarion*, "a third-rate afternoon tabloid" but still a Wynand paper. The novel makes clear that the Wynand empire is "sound and doing as well as ever throughout the country, with the exception of New York City," where Wynand has been forced to close down his flagship paper, *The Banner*. Wynand has the most tragic potential of any character Rand created for this novel, but suicide is not his punishment, nor is it fitting. In the novel he lives on with an awareness of his failure. Rand's novel has been subverted, but not conquered.

REFERENCES

Baxter, John, *King Vidor* (Monarch Press, 1976); Durgnat, Raymond and Scott Simmon, *King Vidor, American* (University of California Press, 1988); McGann, Kevin, "Ayn Rand in the Stockyard of the Spirit," in *The Modern American Novel and the Movies*, ed. Gerald Peary and Roger Shatzkin (Frederick Ungar, 1978); Vidor, King, *King Vidor on Filmmaking* (David McKay, 1972).

—J.M. Welsh

THE FOUR FEATHERS (1902)

A.E.W. MASON

The Four Feathers (1915), U.S.A., directed and adapted by J. Searle Dawley; Dyreda Art Film Corp.

The Four Feathers (1929), U.S.A., directed by Lothar Mendes, Merian C. Cooper, and Ernest Schoedsack; adapted by Howard Estabrook; Paramount Famous Lasky Corp.

The Four Feathers (1939), U.K., directed by Zoltan Korda, adapted by R.C. Sheriff and Lajos Biro; London Films.

Storm over the Nile (1956), U.S.A., directed by Terence Young and Zoltan Korda, adapted by R.C. Sheriff; London Films.

The Four Feathers (2002), U.S.A., directed by Shekhar Kapur, adapted by Michael Schiffer and Hossein Amini; Paramount/Miramax.

The Novel

The Four Feathers was A.E.W. Mason's most successful novel of historical adventure and intrigue. Mason, one of England's most popular and respected storytellers (today, he is revered by mystery buffs for his seminal 1923 detective novel, *The House of the Arrow*, featuring the redoubtable Inspector Hanaud), first published the novel serially in the *Cornhill* from January to November 1901. It came out in a single volume a year later and quickly became his greatest success, selling more than a million copies during its first 40 years. The story grew largely out of a trip the 36-year old author made to Egypt in 1901. Among his stops were Khartoum and the ruined city of Omdurman, where Lord Kitchener had broken the Khalifa's power two years earlier. Nearby was the notorious prison called the House of Stone, where the Khalifa's captives had been imprisoned like sheep in a pen. There Mason heard legends of a man disguised as a dervish who had assisted in the escape of a number of British prisoners. "From all this grew [Mason's] idea of a boy growing to manhood in the belief that he is a coward," writes biographer Roger Lancelyn Green, "forced into the army by tradition and by a father without imagination, losing his honour and with it his fiancée—not by fear, but by the fear of fear—and finding, when it seems too late, that his is that finest bravery of all which can endure danger and pain in spite of the vivid imagination which urges him to run away."

The political and economic contexts behind the events chronicled in *The Four Feathers* are complicated, to say the least. In brief, when Egypt penetrated into the Sudan during the 1820s, it borrowed heavily from European banks; and in an attempt to finance this massive debt, the Circassian bureaucrats taxed excessively the Egyptian and Sudanese people. When engineers finished the Suez Canal in 1869, Egypt became a country of strategic importance, ensuring an alliance with the British, who owned a portion of the canal that linked it to India. Any threat to Egypt also jeopardized the canal. Meanwhile, mounting unrest led to Colonel Ahmed Bey Urabi's nationalist coup d'etat in September 1881. This in turn unleashed an Islamic revolt in the Sudan, a jihad against the British and their Egyptian allies, led by a Muslim religious leader, Muhammad Ahmed, the Mahdi ("Expected Guide"). When a company of Egyptian infantrymen was slaughtered by the Mahdi in 1881, Colonel William Hicks and a British army of 8,000 were dispatched to Obeid, the capital of Kordofan province, where they too were massacred almost to a man. An outraged Prime Minister Gladstone then sent General Charles Gordon to Khartoum to evacuate the European and Egyptian populations against the Mahdi's further incursions. Now it was the turn of Gordon and his troops to fall in bloody defeat. The year was 1885.

Against this historical backdrop, we are introduced to *The Four Feathers* hero, Harry Feversham, a man with a bright future ahead of him in the military. The story begins in 1869 when young Harry listens with growing alarm to stories by his father of wartime atrocities in the Crimea. His overactive imagination paralyzes him with fear, and he wonders if in times of crisis he might prove to be a coward: "I saw myself behaving as one," he later tells a friend, "in the crisis of a battle bringing ruin upon my country, certainly dishonouring my father. . . ." Thirteen years later he is a lieutenant in the East Surrey Regiment. While dining with his fellow officers one night he announces that his engagement to Ethne Eustace necessitates his resignation from the regiment. When a telegram arrives moments later alerting his regiment to impending active duty in the Sudan, he feigns ignorance of the news, afraid that his decision to resign will seem to have been inspired by it. But his fellow officers, Trench, Castleton, and Willoughby, reach their own conclusions and send him a box containing their calling cards and three white feathers, accusations of cowardice. A fourth feather is added by Harry's humiliated fiancée, Ethne. Harry now determines to go to Egypt and return the feathers to his accusers. "They stand in great peril and great need," he says to himself. "To be in readiness for that moment is from now my career." It is obvious that it is not patriotic duty so much as his loyalty to his comrades and his own moral imperative that motivates his decision.

Harry now all but disappears from the main narrative. For more than half the book—spanning five years—he flits

in and out of the action. He is briefly glimpsed in a variety of disguises and names, sometimes as an Arab beggar, an itinerant musician, a Greek, and frequently accompanied by a mysterious Arab named Abou Fatma. Eyewitness accounts, speculations, and hearsay by colleagues and friends Lieutenant Sutch, Durrance, and Captain Willoughby track Harry's movements as he penetrates marketplaces and bandit encampments, all the while contriving to return the feathers of cowardice. It is only in the last chapters that Feversham once again resumes center stage as he contrives his and Lieutenant Trench's escape from the Khalifa's notorious prison in Omdurman, the House of Stone, a desolate place if there ever was one—"a brown and stony plain burnt by the sun, and, built upon it, a straggling narrow city of hovels crawling with vermin and poisoned with disease."

Meanwhile, back in England, Durrance, Sutch, Willoughby, and Ethne have been incessantly examining and debating the circumstances and the meaning of Harry's withdrawal from his regiment and the nature of his "cowardice." Durrance argues that Harry's resignation from his regiment was not an act of cowardice so much as an act of fear engendered by an overactive imagination concerning the horrors of war. "Don't you see that? It's his opportunity to know himself at last. Up to the moment of disgrace his life has all been sham and illusion. The man he believed himself to be, he never was, and now at the last he knows it. Once he knows it, he can set about to retrieve his disgrace. Oh, there are compensations for such a man." Sutch offers a counter view, "that Harry fancied himself to be a brave man, and was suddenly brought up short by discovering that he was a coward."

When Harry reappears, near the end, to return the fourth feather to Ethne, his lined face and scarred body have aged him beyond his years and rendered him almost unrecognizable. He is Ulysses returned home. Only Ethne's collie dog issues a welcome. "The years of probation had left their marks," writes the author. "He had put himself to a long, hard test; and he knew that he had not failed." During his reunion with Ethne, he learns that she has already promised herself to Durrance. It is only Durrance's withdrawal from the engagement that allows Ethne and Harry to reunite.

The Films

Mason's novel has proven too complex in its historical context and too philosophical in its musings about the issues and contradictions of cowardice, fear, duty, and friendship to survive successfully its numerous translations to the screen. As historian David Levering Lewis observes, "Detailing the connections among finance capital, technology diffusion, and national self-determination was much too tall an order for the filmmakers." Moreover, author Mason's determination to limit the scope of the action and to keep Harry offstage for extended periods of time (effective as it was on the page in transforming him from an indi-vidual character to a more universal metaphor) left little room for the rousing spectacle and graphic heroic exploits a commercial cinema audience demanded. Changes obviously had to be made. As can be seen in the films, ethical debates were, for the most part, abandoned and historical contexts are reduced to a scant few references in favor of a handful of sweeping battle scenes. And Harry's near-mythic status in the book's central part is dropped in favor of keeping him in the foreground of the action.

The first film adaptation was directed by J. Searle Dawley in 1915 for the newly formed Dyreda Art Film Corp., which released through Metro Pictures. Howard Estabrook portrayed Captain Harry Faversham [sic], Arthur Evers was Durrance, and Irene Warfield was Ethne. Although the film is not extant, the plot outline in the *AFI Catalogue of Motion Pictures* suggests that its storyline remained relatively true to the novel, beginning with young Harry's fright at tales of military atrocities, his resignation from his regiment 10 years later, his reception of the four feathers, his trip to Africa, his rescue of Durrance from prison, and his subsequent homecoming and marriage to Ethne.

David Selznick's 1929 version was made for Paramount producer B.P. Shulberg. It had begun as a silent film a year before, but music and sound effects and some dialogue were quickly added as the talkie revolution gained momentum. Selznick reworked Howard Estabrook's script so that several big battle scenes were added to the film's climactic sequences. Richard Arlen was cast as Harry, Clive Brook as Durrance (who here is made to deliver one of the feathers), and Fay Wray as Ethne. The general plotline of the novel is retained until the final sequences, when, after Harry and Trench's escape from the House of Stone, they encounter numerous hazards, including a jungle fire and a herd of rampaging hippopotami. After their rescue by British soldiers, there is a native uprising, which is quelled when Harry kills the chieftain. Coproducer Merian C. Cooper disliked the results (much of the African location footage he had shot had been cut) and requested that Selznick take his name off the picture.

By far the most successful adaptation is the Korda Technicolor 1939 version, in which Mason himself assisted in the translation to screen. Mason had already seen his Elizabethan story, *Fire over England*, adapted for the screen by Korda in 1936. With the exception of fine performances by Flora Robson as Queen Elizabeth and Raymond Massey as King Philip, Mason ultimately had seen little of note in it. "If you make another film of a new story of mine," he wrote Korda, "I must have a say—and a big say—in the treatment of it." Indeed, he was encouraged to write an original story for Korda's next project, a story of India, which was eventually filmed in 1937 under the title *Drums*. Its success led immediately to Korda's adaptation of *The Four Feathers*. The cast included John Clements as Harry Faversham [sic], Ralph Richardson as Durrance, June Duprez as Ethne, C. Aubrey Smith as Ethne's father,

Donald Gray as Ethne's brother Peter, and Jack Allen as Tom Willoughby. The film capped a series of films Korda and his brothers, Zoltan and Vincent, made in the 1930s celebrating the imperial ideal of the British Empire, including *Sanders of the River* (1935) and the aforementioned *Drums*.

The noted playwright R.C. Sheriff worked closely with Mason in writing the scenario. Retained here is Mason's carefully detailed scene in which the young Harry is struck dumb by General Burroughs's blood-curdling tales of wartime atrocities (a crucial character-motivating incident left out of subsequent adaptations). Added to the script are several dramatically satisfying scenes: Durrance is one of the deliverers of a feather, and Harry is in a position later to effect the rescue of his blinded friend (although he conceals his identity from Durrance). Harry's success undercover as an Arab is made more believable by incorporating scenes wherein he enlists the aid of a doctor friend to learn Arab customs and languages. For sentimental reasons—and doubtless for the sake of the filmgoing public—Ethne is not allowed to deliver her feather; rather, Harry plucks it from her fan himself. The film's penultimate sequence depicts an attack on the city of Omdurman by Lord Kitchener, during which Harry and his companions capture the city's arsenal. And, finally, upon his return, he confronts General Burroughs and challenges the accuracy of his long-winded military stories. The film was shot in Technicolor and utilized many locations in the Sudan.

"What truly lingers in the memory about *The Four Feathers*," writes historian Tony Thomas, "are the stunning sequences filmed in the Sudan and the splendid staging of several battles, showing the then standard British tactics employed in holding off attackers—the forming of squares, with riflemen deployed in standing, kneeling, and lying positions. These exciting scenes of combat and carnage were made impressive by the Kordas' hiring of thousands of natives, many of whom were—with a touch of irony—the descendants of the Fuzzy Wuzzies, the only enemies ever to have smashed through the famous British squares." However, historian Roy Armes notes that, on balance, the film reflects British imperial sentiments of the 1890s rather than those of the late 1930s: "It was more an expression of an official rhetoric than a deep-seated popular mood, and [its] lofty sentiments were not shared by those who might have been expected to go out and serve the imperial cause." Needless to say, continues Armes, its positive attitudes toward empire-building "are totally out of touch with present-day sentiments."

Zoltan Korda tried to repeat its success with a remake in 1956, *Storm over the Nile*. A lot of action footage from the 1939 version was reprised. Anthony Steel portrayed Faversham [sic]. According to historian Tony Thomas, "It had little of the original flair" and "Anthony Steel . . . fell short of the intensity John Clements gave the part in 1939."

The 2002 screen version sports impressive location photography in Morocco, the tall mountains of Fint, and the 600-year-old town of Ait Ben Hobdou, which represents the fortress of Abou Clea; and in England, Blenheim Palace and Hyde Claire Castle. In the pressbook, screenwriter Hossein Amini and director Shekhar Kapur declared that the film was intended to be a revisionist view of British colonialism in Africa. "It's a fascinating story," says Amini. "Imperial England was confronting a world and society about which it knew very little. Those young men went from fantastic country mansions into the middle of the desert, and in the end their overconfidence and belief in their superiority led to mistakes and ultimately disaster."

Astute as Amini has been in his other screen adaptations of literary works—witness the admirable job he did on Henry James's *The Wings of the Dove*—and successful as Kapur has been in the pageantry of his earlier film, *Elizabeth*, they fail miserably here. In the first place, like previous adaptors, they are determined to sacrifice the complexities of historical contexts, the ethical and psychological issues, and the multiple-viewpoint narrative for the sake of linear storytelling and big battle scenes. Africans, Egyptians, English, and Muslim fanatics all blur into a confusing mass of indeterminate characterizations and ill-defined actions. Harry (Heath Ledger) is kept at the center of the action. The backstory establishing his long-standing fear of war is gone. All we know is that as a young soldier he prefers rugby to war, and that he resigns his commission more out of fear than out of deeply rooted psychological conflicts. Moreover, his decision to leave England for the Sudan is spurred by news of his comrade's entrapment by the Mahdi's Muslim fanatics—not, as in the book, by the larger imperatives of his own redemption. Here, he's bent on rescuing his mates, not himself.

Despite the insistence on a linear narrative, there are curious lapses in continuity. One gets the impression that huge chunks of footage have been left on the cutting-room floor. For example, one moment the disguised Harry and Abou (Djimon Hounsou) are members of a marauding force that overwhelms a British fort; the next, Abou shows up alone in the British camp with warnings of the dangers lying ahead (whatever happened during that split-second gap in continuity will never be known). Later, following the example of the Korda film, Harry rescues Jack (Wes Bentley) after he has been blinded in an attack. Here again, the jump cuts leave the viewer breathless: In one shot Harry is cradling Jack in his arms; in the next shot they are safely back in England. And when Jack and Trench escape from the House of Stone (with the assistance of the ever-present Abou), they move in the twinkling of yet another jump cut from the desert wastes of the Sudan to the green woods of Merrie Olde England. "How do our chaps, half of them badly wounded, make it back from the godforsaken middle of nowhere to rainy old England in a single cut?" asks critic Anthony Lane of

such lapses; "Hot-air balloon? Helicopter? E-mail? We may never know."

In any event, it should be noted that an inordinate amount of screen time is expended on detailing with graphic, almost sadomasochistic zeal Harry's sufferings in the House of Stone as he gets conked on the head with a rock, whipped by the slavemasters, beaten up every few minutes, and finally smashed head down into a sand dune. Ironically, when the film turns at last to the details of the book, the results are listless and boring. Witness the final two sequences, when Harry's reunion with Ethne (Kate Hudson) in a chapel and Durrance's withdrawal from his engagement to her serve as mere anticlimaxes.

Worse, there is little evidence to support the film's vaunted revisionist view of British empire-building. Aside from the fact that the Mahdi is made to seem like a precursor to Osama bin Laden, and apart from one line of dialogue in which an Arab declares to Harry, "You English walk too proudly on the Earth," the film clings to a standard pro-British agenda. For example, the film carefully avoids any reference to the later inglorious British defeat of the Mahdi at Omdurman in 1898. As critic Stephen Hunter points out, "Men on horseback charged men with automatic weapons, with predictable results. When the buzzguns stopped buzzing, the Dervishes stopped whirling. Final body count: 11,000 Dervishes, 28 British soldiers. Is that a battle or an industrialized execution?" No, as critic Roger Ebert concludes, "The film is not revisionist at all. . . . I do not require Kapur to be a revisionist anti-imperialist; it's just that I don't expect a director born in India to be quite so fond of the British Empire." In conclusion, says Ebert, "The less you know about the British Empire and human nature, the more you will like it; but then that can be said of so many movies."

REFERENCES

Armes, Roy, *A Critical History of British Cinema* (Oxford University Press, 1978); Ebert, Roger, "The Four Feathers," *Chicago Sun-Times*, September 20, 2002; Green, Roger Lancelyn, *A.E.W. Mason: The Adventure of a Story-Teller* (Max Parrish, 1952); Hunter, Stephen, "'Feathers': Lightweight Remake," *Washington Post*, September 20, 2002, C01; Lewis, David Levering, "Khartoum," in Mark C. Carnes, ed., *Past Imperfect: History According to the Movies* (Henry Holt and Company, 1995), 162–165; Thomas, Tony, *The Great Adventure Films* (Citadel, 1975); Thomson, David, *Showman: The Life of David O. Selznick* (Alfred A. Knopf, 1992).

—J.C.T.

THE FOUR HORSEMEN OF THE APOCALYPSE (*Los Cuatro Jinetes del Apocalipsis*) (1918)

VICENTE BLASCO IBÁÑEZ

The Four Horsemen of the Apocalypse (1921), U.S.A., directed by Rex Ingram, adapted by June Mathis; Metro.

The Four Horsemen of the Apocalypse (1961), U.S.A., directed by Vincente Minnelli, adapted by Robert Ardrey and John Gay; MGM.

The Novel

The precise inspiration of *The Four Horsemen*—beyond a desire to support the Allied cause in World War I and perhaps to capitalize on the rampant patriotism of the day—is difficult, if not impossible, to discover. Blasco Ibáñez was a well-known political activist, and no doubt he believed strongly in the ideas expressed through this novel. But his earlier work, leaning more toward realism than propaganda, is considered far superior.

In the novel, Don Marcelo Desnoyers flees his native France for Argentina in 1871 in order to escape military service. He hires on with a wealthy landowner, Madriaga, and eventually becomes caretaker for the entire estate. Desnoyers also marries one of Madriaga's daughters, has a son named Julio, and inherits most of his father-in-law's wealth. Madriaga also hires a German, Karl von Hartrot, who marries his other daughter and fathers three sons. After Madriaga's death, both families return to their native countries just as the Great War is starting.

Don Marcelo spends much of his early days in France acquiring expensive antiques and a castle to keep them in. Julio, having been spoiled by his grandfather, spends his time in a Paris art studio having an affair with Marguerite Laurier, wife of a French senator. As the Germans overrun France, they pillage Don Marcelo's estate and murder many nearby villagers. Eventually the French push them back, and Don Marcelo returns to Paris with a new sense of patriotism.

Julio, meanwhile, avoids military service until he discovers that Marguerite has become a nurse and dedicated herself to the care of her husband, who was blinded in the war. Having a sudden change of heart, Julio not only enlists but also becomes a much-beloved soldier, known for his bravery. He and Don Marcelo have one last meeting on the battlefield before Julio is killed. In the end, the family locates his grave within a massive cemetery and they shed their grief together.

The Films

The Four Horsemen is a good lesson in how art cannot be calculated. In 1920, Metro Pictures was struggling financially when head scenarist June Mathis proposed filming the Blasco Ibáñez novel. Though the general perception was that the public had tired of war movies, studio chief Richard Rowland gave her the go-ahead. Mathis wrote the script, chose Ingram to direct, and then made the stunning announcement that an unknown named Rudolph Valentino would play the key role of Julio Desnoyers. Blasco Ibáñez's novel was little more than war propaganda, June Mathis was talented but heavily steeped in a melodramatic tradition, and Rex Ingram had artistic notions drawn from his

talent as a sculptor. These factors combined would not seem to promise a very kinetic result on film.

Yet, Mathis and Ingram focused on the spiritual theme from the novel, and Valentino was truly magnetic. Ingram added new dimensions to conventional scenes—such as an army marching through a village—that helped audiences stay involved. Mathis also aimed for new levels of realism by keeping an extraordinary scene from the novel in which German soldiers revel in drag. By focusing on the book's spiritual side, the Mathis-Ingram-Valentino triumvirate was able to take a work of unabashed patriotism and produce a condemnation of violence and greed suitable for the transition to peacetime.

Metro put more money into *The Four Horsemen* than it had on all of its previous films combined. The gamble paid off with a major critical and box-office success. *Variety* claimed that Mathis had not merely adapted the novel, but "breathed life's animation into its people and themes." Valentino was regarded as having brought new depth and sensitivity to the figure of the romantic hero.

The 1961 version did not have the same good fortune. In his memoirs, Vincente Minnelli states that he did not want the story updated to World War II, nor did he want Glenn Ford as Julio. He got both. The result is a film praised mainly for its cinematography and special effects, which nevertheless mute its commentary on the horrors of war. Minnelli presents the conflict through the symbolic four horsemen, not actual battles or deaths. The film does not condemn war, since the resolution comes from Julio calling in an airstrike on a German command post. But the bombs kill Julio too, so there is no real sense of hope, either. The movie ends with a final shot of the four horsemen, still prancing in the sky. Overall, updating the story to World War II simply did not work, and the film survives mainly as another example of the Hollywood excess that seemed so prevalent during the period.

REFERENCES

Minnelli, Vincente, *I Remember It Well* (Doubleday, 1974); O'Dell, Scott, *Representative Photoplays Analyzed* (Palmer Institute of Author-

The Four Horsemen of the Apocalypse, *directed by Rex Ingram* (1921, U.S.A.; METRO/JOE YRANSKI COLLECTION, DONNELL MEDIA CENTER)

Glenn Ford in The Four Horsemen of the Apocalypse, *directed by Vincente Minnelli* (1961, U.S.A.; MGM/JOE YRANSKI COLLECTION, DONNELL MEDIA CENTER)

ship, 1924); O'Leary, Liam, *Rex Ingram: Master of the Silent Cinema* (Academy Press, 1980); Ramsaye, Terry, *A Million and One Nights* (Simon and Schuster, 1926).

—*T.J.S.*

FRANKENSTEIN; OR, THE MODERN PROMETHEUS (1818; revised edition, 1831)

MARY SHELLEY

Frankenstein (1910), U.S.A., directed by J. Searle Dawley; Edison Company.

Life Without a Soul (1915), U.S.A., directed by Joseph W. Smiley, adapted by Jessie J. Goldberg; Ocean Film Corporation.

Frankenstein (1931), U.S.A., directed by James Whale, adapted by John L. Balderston from a play by Peggy Webling; Universal.

The Curse of Frankenstein (1957), U.K., directed by Terence Fisher, adapted by Jimmy Sangster; Hammer.

The Horror of Frankenstein (1970), U.K., directed by Jimmy Sangster, adapted by Sangster and Jeremy Burnham; Associated British Picture Corp.

Roger Corman's Frankenstein Unbound (1990), U.S.A., directed by Roger Corman, adapted by F.X. Feeney, Ed Neumeier, Brian W. Aldiss, and Roger Corman; Twentieth Century Fox.

Frankenstein (1992), U.S.A., directed and adapted by David Wickes; Turner Pictures.

Mary Shelley's Frankenstein (1994), U.S.A., directed by Kenneth Branagh, adapted by Steph Lady and Frank Darabont; TriStar.

The Novel

In her introduction to the 1831 revised edition of *Frankenstein*, Mary Shelley reports that her publishers had wondered, "How I, then a young girl, came to think of, and to dilate upon, so very hideous an idea?" She says that during a stay with Lord Byron in Switzerland in 1816, she and her husband, Percy Bysshe Shelley, accepted Byron's

challenge to write a ghost story. One night soon after, she drifted into a dreamlike state, during which a vision appeared to her of a man who dared to "mock the stupendous mechanism of the Creator of the world' by endowing a corpse with life. The "horrid thing," once left to die, returns to haunt its creator. Shelley knew that she had the makings of a frightening story, and she says that with her husband's encouragement, she completed the novel within a year. (Byron's and her husband's attempts failed.) These incidents were dramatized in Ken Russell's film *Gothic* (1987).

The daughter of feminist Mary Wollstonecraft and radical philosopher William Godwin, Shelley learned much from the writings of her famous parents. From her mother (who died of an infection 10 days after giving birth to her), she learned of the political oppression of women and of the working class. Her father greatly influenced her understanding of revolutionary politics. And her husband Percy, himself a great admirer of Godwin, pushed her to prove herself "worthy of her parentage." These influences would be channeled by the 19-year-old Shelley into a novel in 1817 that—in addition to its Rousseauistic conception of the creature as a Noble Savage—would be a stinging indictment of the elitism and ethical irresponsibility of the novel's main character, Victor Frankenstein.

Frankenstein is an epistolary novel, consisting of a series of letters from Robert Walton (an English Arctic explorer) to his sister, as well as the journal that he keeps upon hearing Victor Frankenstein's strange tale. Walton and his crew are trapped in polar ice when they spot a strange creature being pulled across the ice on a dogsled. Later, Frankenstein arrives, severely weakened by his pursuit of the creature. As he recuperates, Frankenstein relates his story to Walton, who sees something of himself in the weary traveler.

Frankenstein was born to a wealthy Geneva family and raised with his adopted sister, Elizabeth, who becomes his close friend and, ultimately, his fiancée. When he is 17, his mother dies of scarlet fever—an omen of his "future misery"—shortly before he leaves for Ingolstadt to study natural science and medicine. At Ingolstadt, he draws on his knowledge of occult philosophy and the teachings of his mentor, Waldman, to discover the "cause of generation and life." Frankenstein assembles a creature from parts of bodies he steals from butcher shops, dissecting rooms, and charnel-houses. When he sees its hideous form come to life he is repulsed. Later that night, the monster appears at his bedside, causing Frankenstein to flee. The monster disappears.

Frankenstein falls ill and is nursed back to health by Clerval, a fellow medical student. Then he hears that his younger brother William has been strangled and one of his family's servants, Justine, charged with his murder. Frankenstein suspects that his demon has killed his brother, but when Justine confesses, she's hanged, while he sits idly by, knowing that these were the first two victims of his "unhallowed arts." Distraught, he wanders through the countryside and meets his creature, who describes how he learned "the ways of man" by secretly observing a peasant family and befriending an old blind man. When the family was horrified by his appearance, he pledged to wreak havoc on humanity, in particular on Frankenstein. He murdered William and framed Justine. He then tells Frankenstein that he wants him to make him a mate and that if he does, they will never bother anyone again. Frankenstein agrees but his conscience won't let him follow through on the promise. The creature sees Frankenstein destroy the mate before it's brought to life. The creature seeks revenge, first killing Clerval, then Elizabeth on her and Victor's wedding night. Frankenstein chases the creature to the Arctic but shortly after relating his tale dies of exposure. Walton decides to cut short his expedition, having realized the vanity of his own endeavors. But then the creature reappears and describes to Walton his efforts to seek out beauty, love, and fellowship. When Frankenstein failed to help his progeny and people were horrified by his appearance, he became a murderous wretch, one now content to take his own life. The creature leaps from the ship and is borne away by the waves.

The Films

Frankenstein's monster has become a cultural icon around the world, having now appeared in over 50 films, only a few of which can really be considered adaptations of Shelley's novel. (Those that cannot range from *Abbott and Costello Meet Frankenstein* [1948] to *Frankenhooker* [1990], from *Frankenstein Meets the Space Monster* [1964] to *Frankenstein of Sunnybrook Farm* [1971].) The Edison Company's 1910 adaptation consisted of one 975-foot reel and had long been considered lost until recently discovered in a collector's archives. The American Film Institute had listed this film as one of the 10 most important "lost" films in 1980. Not much is known about its content, but after adverse reviews, it was pulled from nickelodeons. Little is known about the now-lost *Life Without a Soul* except that its ending explained away the entire story as a "dream vision."

Frankenstein enjoyed great success on the English stage throughout the 19th century, and following its successful revival in Peggy Webling's 1927 dramatization, *Frankenstein: An Adventure in the Macabre*, Universal took note but did not move ahead with the project until *Dracula*'s screen success in early 1931. James Whale directed *Frankenstein* later that year and, with Boris Karloff replacing Bela Lugosi as the monster, the film was an enormous success. (In fact, most *Frankenstein* films that follow are takeoffs of Whale's film, not Shelley's novel.) It was not intended to be a literal adaptation of the novel, but it does retain some of its central themes, notably Frankenstein's obsessive desire to wield the power of life and death and the monster's ill treatment by both his maker and the society as a whole. Persecuted by Fritz (Frankenstein's assistant), the monster rebels. And after the famous scene with little Maria by the

lake (whom he throws in the water thinking she'll float like flowers), the monster is hunted down and killed, having never been taught by Frankenstein how to live.

There were many spinoff versions of *Frankenstein* after 1931, but it was not until the 1950s that Hammer Film launched another series, beginning with Terence Fisher's *The Curse of Frankenstein* in 1957. As with previous adaptations, this one devotes considerable screen time to the actual construction of the monster (an event that Shelley's novel glosses over). And most importantly, Fisher shifted the focus from the creation to the creator (the 1931 *Frankenstein* chose to develop the creature's character), which may reflect more accurately the novel's emphasis on Frankenstein's ethical dilemma. In this film, Frankenstein is an overzealous scientist with no conscience. Jimmy Sangster, who wrote the screenplay for this 1957 version, also directed and wrote 1970's *The Horror of Frankenstein*, which is essentially a parodic treatment of Whale's 1931 version. (By 1970 *Frankenstein* had appeared in so many guises that the natural progression was toward parody, Mel Brooks' *Young Frankenstein* [1974] is the best example.)

Roger Corman revived interest in *Frankenstein* in 1990 when he took the story in a new direction. *Frankenstein Unbound* tells the story of a weapons scientist of the future transported back to 19th-century Switzerland where he meets not only Frankenstein and the creature, but also Shelley, her husband, and Byron. The film explores the ethical consequences of unrestrained technological development and the necessary linkage between creator and creation. David Wickes's 1992 adaptation, a made-for-television movie, is an unremarkable adaptation focusing specifically on the symbiotic relationship between Frankenstein and his creature.

Kenneth Branagh's *Mary Shelley's Frankenstein* (1994) marks a significant development because it purports to be a literal adaptation of the novel. As early as 1972, Francis Ford Coppola had expressed interest in making such a film, but it was not until after he produced *Bram Stoker's Dracula* that he followed through with the project, selecting as his director Branagh, who had already distinguished himself with Shakespearean adaptations (e.g., *Henry V* and *Much Ado About Nothing*). Branagh does attempt to reproduce the form and thematic content of Shelley's novel. But in this case, one weakness of the film, in spite of its many strengths, is precisely its fidelity to the novel, at least in one key respect. As in the novel, the focus is split between the ambitious Frankenstein and the Noble Savage. Frankenstein (played by Branagh himself) in this adaptation is consumed by his desire to end human suffering, a noble cause corrupted by the means he chooses. In Shelley's novel, after Frankenstein creates his monster, he immediately perceives that he has, as Shelley herself said, "mocked the Creator." The same thing occurs in the film, but because Branagh devotes so much time to dramatizing Frankenstein's motivation and the creation of the monster, Frankenstein's sudden turnabout has no objective correlative (one minute he's saying, "It's alive!" the next, "What have I done?").

Given the rapid development of scientific knowledge and the deployment of technological innovation in the 20th century, it is not surprising that many adaptations of Shelley's novel emphasize the ethical consequences of unrestrained "progress" and, importantly, the secularization of knowledge once restricted to divine forces. What has been lost, however, is the sociopolitical dimension of her novel, particularly the dialectic we see operating between the bourgeois world of Frankenstein and the proletarian world of his monster. And like Branagh's adaptation, any future films must contend with not only Shelley's novel but also the many intervening adaptations, which tend to reify conceptions of the original story. Branagh clearly understood that his audience would want to see the monster created, as they had since Whale's version. But dramatizing that act at great length diverts attention away from the social themes that Shelley clearly had in mind. She spent only a page or two in the original novel on the creation of the monster because she was more concerned with elaborating the ethical indifference of her main character, who never acknowledges, like the society he represents, his responsibility for the plight of the oppressed.

REFERENCES

Forry, Steven Earl, *Hideous Progenies: Dramatizations of* Frankenstein *from Mary Shelley to the Present* (University of Pennsylvania Press, 1990); Glut, Donald, *The Frankenstein Legend: A Tribute to Mary Shelley and Boris Karloff* (Scarecrow Press, 1973); Levine, George, and U.C. Knoepflmacher, eds., *The Endurance of Frankenstein: Essays on Mary Shelley's Novel* (University of California Press, 1979); Shelley, Mary, *Frankenstein! or, The Modern Prometheus*, ed. Johanna M. Smith (St. Martin's Press, 1992).

—D.B.

THE FRENCH LIEUTENANT'S WOMAN (1969)

JOHN FOWLES

The French Lieutenant's Woman (1981), directed by Karel Reisz, adapted by Harold Pinter; United Artists.

The Novel

John Fowles's third published novel, *The French Lieutenant's Woman*, is one of his most successful, both popularly and critically. The novel's narrator is meta-historical—poised omnisciently above the 20th and 19th centuries, occasionally intruding upon his own narrative to draw attention to the fictitiousness of the story, comparing and commenting insightfully on both eras as the narrative's Victorian romance progresses in decidedly postmodern form.

The novel opens as Charles Smithson, a leisured-class Victorian who indulges himself in the hobby of paleontology, walks along a seaside quay at Lyme Regis with his fiancée, Ernestina Freeman. She is the daughter of a

wealthy tradesman in London, now staying with her Aunt Tranter in Lyme. At the far end of the quay, they notice a lone woman whom Ernestina identifies as "Tragedy," or as the local fishermen know her, "the French lieutenant's woman." Suffering from the aftereffects of a doomed love affair with a French naval officer, as Ernestina sketches out the story, the "mad" woman now spends hours searching the ocean horizon for signs of her lover. Nearing the isolated figure, Charles attempts to warm her away from the sea, but he is met only with silence and an inscrutable but piercing look. This enigmatic first meeting between Charles and Sarah Woodruff, "the French lieutenant's woman," heightens Charles's curiosity about her. Shortly thereafter, while hunting fossils in a locally notorious tract of wooded, sparsely inhabited land called Ware Commons, Charles sees Sarah asleep on a ledge overlooking the beach, and she in turn awakens to see him. Following this brief encounter, and in spite of the strong disapproval of Mrs. Poulteney, the tyrannical widow who employs Sarah as a governess, Sarah keeps returning to Ware Commons, where Charles contrives to meet her periodically. (The narrator interrupts to complain that his characters are making choices that he cannot authorially control.) Eventually, Sarah tells him about Varguennes, a shipwrecked and wounded French sailor whom she fell in love with as he recovered and eventually followed to Weymouth, where she gave herself to him. He then left on a ship for France, dishonestly promising to return. After hearing her story, Charles impresses upon her the need to leave Lyme, but they are interrupted by the approach of two lovers, one of them Charles's servant Sam and the other Aunt Tranter's servant Lucy, who have come to the Ware Commons for privacy. Jolted by the sight of the amorous couple, Charles begins to realize belatedly the depth of his attraction to Sarah.

The remainder of the novel, then, traces, the evolution of Charles's romantic feelings for Sarah, his corresponding rejection of Ernestina, and his gradual distancing from Victorian society.

Charles receives a note giving him the address of a hotel where Sarah is staying in Exeter. (The narrator mischievously interjects an alternate ending here, in which Charles ignores the summons, returns to Lyme, and marries Ernestina.) He stops at the hotel and gives in to his passion, taking Sarah to bed, where he is surprised to learn that she is a virgin. Sarah confesses that she lied about giving herself to the French lieutenant and that, while she does love Charles, he must now leave. More bewildered than ever, Charles meditates in a nearby church and decides to leave Ernestina and plead his love to Sarah in a letter that Sam, on the verge of leaving Charles's employ, fails to deliver. Charles does indeed break the engagement to Ernestina, ensuring his exile from the society of gentlemen, but when he returns to Exeter to find Sarah, she is gone. Charles searches for Sarah for two years, finally finding her living in the artist Dante Gabriel Rossetti's house in Chelsea. Sarah refuses to marry Charles, or indeed any man. The novel ends with two equally likely scenarios, their order of presentation decided by the narrator's flip of a coin. In one, Sarah introduces Charles to their daughter Lalage; in the other, Charles leaves without knowing he has a daughter. In either case, however, Charles has attained something of the independence of thought and action that Sarah possessed all along.

The Film

Karel Reisz's 1981 cinematic version of *The French Lieutenant's Woman* stars Meryl Streep as Sarah and Jeremy Irons as Charles. Fowles is on record as approving of the film—quite an accomplishment for Reisz and screenwriter Harold Pinter, since Fowles's metafictional novels have always proved supremely difficult to translate to the screen. The challenge posed by adapting *The French Lieutenant's Woman* is particularly daunting, primarily because its narrator defies literal transference to the film medium. Director John Frankenheimer, for one, reportedly called the novel unfilmable after struggling to find a way to adapt it. Reisz succeeds because, instead of attempting to literally portray Fowles's ironic narrator on-screen, a device more suitable to the written word, he creates a metacinematic effect by making a film about making a film of *The French Lieutenant's Woman*. To Fowles's Victorian romance, Reisz adds a parallel story line about an adulterous 20th-century affair between Mike and Anna (again, Irons and Streep), the two actors portraying Charles and Sarah in the film-within-the-film. The plot then cross-cuts between the evolving Charles/Sarah and Mike/Anna relationships at key moments, intermingling the dual story lines to an extent that is distracting and often confusing to some critics but quit pleasing to iconoclast Fowles.

From the first scene, the film violates mainstream Hollywood narrative conventions by showing the painstaking behind-the-scenes preparations that go into creating the illusion of spontaneous action for the camera: Anna, in her Sarah costuming, checks her makeup in a hand mirror; a clapboard identifies the scene as the opening shot of *The French Lieutenant's Woman*. Only then does the camera pull back for a long tracking shot of Anna as Sarah walking along the quay as the credits roll. Thus alerted to the artifice most films try very hard to make viewers forget, the audience for Fowles's Victorian romance accepts the intrusion of the contemporary Mike/Anna story line a few scenes later, when Mike answers a wakeup call meant for Anna in her hotel room. That their affair is illicit is suggested by Anna's concern that the film crew, now knowing that Mike was in her room early in the morning, will think she's a "whore," a label also suffered by her celluloid counterpart Sarah. Anna sympathizes with the fictional Sarah's plight in many scenes, particularly the one where she cites to Mike the statistics concerning the number of prostitutes and brothels in Victorian London as evidence of the grim fate awaiting Sarah should she be fired as a governess. In another similarity, Anna's obvious ambivalence concerning the ultimate wisdom of the affair with Mike continues to

keep pace with Sarah's reaction to Charles. Mike also resembles Charles in that both men become obsessed with their lovers to the exclusion of other considerations, obligations, and good sense. The fuzziness of the boundaries between plot levels manifests itself in many such ways: Anna and Mike rehearsing a scene juxtaposed with the scene itself, Sarah leaving the frame and Anna entering it from the same point, Charles playing indoor tennis followed by a shot of Mike playing table tennis at a garden party, and so forth.

The Charles/Sarah story line remains reasonably faithful to Fowles's original narrative arc, excising only the subplot concerning Charles's uncle. But the dual endings proposed by Fowles pose a substantial problem for any successful adaptation, a point made by Anna's husband David when he asks Mike which ending the film will choose: the "happy" or the "unhappy" ending. Mike, perplexed by the question, leaves the matter indeterminate for the audience: "We're going for the first ending—I mean the second ending." Reisz's film manages to have both a happy and an unhappy ending by reuniting Charles and Sarah in a far more definitive fashion than Fowles does in the novel—Charles forgives Sarah, they kiss, and the scene cuts to the couple rowing blissfully across a lake—but driving apart Mike and Anna. Anna leaves the film's wrap party without saying a word to Mike, implying that the affair has ended. "Sarah!" he futilely calls after her from an upstairs window as she swiftly drives away. Alone, he slumps down onto the floor of the same set that served as the locale of Charles and Sarah's reunion. And so both story lines conclude, one happily and one tragically, and Fowles's twin endings have made a successful transition to the movie screen.

REFERENCES

Aubrey, James R., *John Fowles: A Reference Companion* (Greenwood Press, 1991); Foster, Thomas C., *Understanding John Fowles* (University of South Carolina Press, 1994).

—P.S.

FROM HERE TO ETERNITY (1951)

JAMES JONES

From Here to Eternity (1953), U.S.A., directed by Fred Zinnemann, adapted by Daniel Taradash; Columbia.
From Here to Eternity (1979), U.S.A., directed by Buzz Kulik, adapted by Don McGuire.

The Novel

Considered the finest novel written about World War II, *From Here to Eternity* is set in 1941, just before the attack on Pearl Harbor, the port of Honolulu, Hawaii. It tells the story of a recruit from Kentucky, Private Robert E. Lee Prewitt, known as Prew to his friends. A champion welterweight boxer and a gifted bugler, Prew was drummed out of the Bugle Corps because he refused to join the company's boxing team. He has given up boxing because of the damage he did in the ring to another boxer, Dixie Wells. Captain Holmes offers to make Prewitt the company bugler if he will join the boxing squad, but, as much as Prew loves his horn, he refuses. Holmes warns him that "in the Army it's not the individual that counts," but Prew refuses out of personal integrity. Consequently, Prew gets "The Treatment," as Holmes attempts to break his spirit. First Sergeant Milton Anthony Warden respects Prewitt and knows him to be a good and honorable soldier, but he is not able to help him. Warden has his own problems when he becomes involved with Karen Holmes, the wife of his commanding officer. This affair constitutes a steamy romantic subplot and lust on the beach, but the story is mainly Prew's, not Warden's.

Holmes comes to realize that he cannot "break" Prewitt, but General Sam Slater orders him to use Prewitt as a test case to prove that the "system" of military intimidation can be used to control individualists. Prew gets romantically involved with a bar girl named Alma Schmidt. He also befriends an Italian named Angelo Maggio, who also has problems with army authority. Maggio is thrown into the Hickam Field Stockade and brutalized by a sadistic sergeant named Fatso Judson. Maggio's spirit is not broken in the stockade, but he is so badly beaten that he is hospitalized in a mental ward. Judson also brutalizes another of Prew's friends in the stockade, Blues Berry, whom he beats so badly that the man dies the next day at the stockade hospital. After serving time for insubordination at the Schofield Barracks Post Stockade, Prew goes after Judson for revenge. They fight with knives. Prew is wounded, but he kills Judson. The wounded Prew then goes AWOL and is taken in and sheltered by Alma. When the Japanese attack, Prew decides to go back to the post to serve, but he is shot and killed by the guards as he attempts to return.

The Films

James Jones wrote the first story treatment himself, taking out the brutality and making Karen Captain Holmes's sister, not his wife, to escape the taboo against adultery in Hollywood. The novel ran to 859 pages and had to be seriously condensed, since Columbia Studio head Harry Cohn had ordered that no film produced by Columbia should run more than two hours. Daniel Taradash was given the opportunity of writing and shaping the screenplay that would go on to win an Academy Award. The novel was a challenge because of its length, its complexity, its controversial context, and its large population of characters. According to Taradash, the challenge was to remain true to the novel and escape the scrutiny of the censors, though Taradash claims the Breen office was surprisingly sympathetic to his efforts. Taradash would

have expanded the picture if left to his own devices, but he had to work within Harry Cohn's time limitations. Cohn also wanted army cooperation, and neither he nor director Fred Zinnemann wanted to make a picture that was anti-army. Taradash compromised by taking out the whole stockade section, which eliminated 150 pages. The largest sacrifice here was the existential radical Jack Malloy, whom Prew respects and who manages to escape from the stockade, but that portion of the novel reflects badly on the army and its procedures. Thus the character of Blues Berry is not in the film, where Maggio (Frank Sinatra) is killed instead by Judson (Ernest Borgnine), which established a clear motive for Prew's revenge.

Taradash worked carefully on the conscious intercutting of the two romantic plots of the story—Prew (Montgomery Clift) and Alma (Donna Reed), and Warden (Burt Lancaster) and Karen Holmes (Deborah Kerr)—parallel romances in parallel montage, brought together, as in the novel, at the very end, when the two women meet on the ship that will take them back to the mainland. Taradash sent James Jones the first draft, then met with Jones early in 1953. Jones later wrote Taradash: "You couldn't be more pleased with my reaction than I was with your screenplay." The film won multiple Academy Awards, including best picture and best adapted screenplay.

There was also a made-for-television adaptation directed by Buzz Kulik in 1979, starring William Devane as Milt Warden, Natalie Wood as Karen Holmes, Steve Railsback as Prewitt, Joe Pantoliano as Maggio, Kim Basinger as Alma, and Peter Boyle as Fatso Judson. Despite some casting surprises—Andy Griffith as General Slater, for example, and Will Sampson as Chief Choate, who used to be the heavyweight champ of Panama—this television product lacked the stellar appeal of Zinnemann's film, especially in the roles of Prew and Maggio, and the tightness of Taradash's writing. These was absolutely no need to remake what had already been expertly made by Hollywood's best talents.

REFERENCES

Dick, Bernard F., *Columbia Pictures: Portrait of a Studio* (University Press of Kentucky, 1992); MacShane, Frank, *Into Eternity: The Life of James Jones* (Houghton Mifflin, 1985); Zinnemann, Fred, *Fred Zinnemann: An Autobiography* (Bloomsbury, 1992).

—*J.M. Welsh*

FROM RUSSIA WITH LOVE (1957)

IAN FLEMING

From Russia with Love (1963), U.K., directed by Terence Young, adapted by Johanna Harwood and Richard Maibaum; Eon/United Artists.

The Novel

Written the same year that the Soviet Union successfully orbited the first Sputnik satellite, *From Russia with Love* not only reflects cold war politics, but also indicates the decade's burgeoning fascination with technology and adumbrates the loosening of sexual mores that was to surge through Western culture for the next two decades. All of these elements were embodied in the persona of John F. Kennedy, and it is no surprise that in 1961 Kennedy listed *From Russia with Love* as one of his 10 favorite books. Whether Kennedy actually read Ian Fleming or not is open to question, but there is no doubt that his "endorsement" stimulated American acceptance of the Bond novels and films.

Tatiana Romanova, a 24-year-old Russian intelligence clerk, has apparently fallen in love with Bond while reading through his Soviet casefiles. She engineers a plot to steal a super-secret Russian cipher machine, intending it as bait for Bond, in hopes that he will rescue both her and the machine from Istanbul. At the same time, the Russian SMERSH agency is plotting to kill Bond, a man regarded, writes author Fleming, as the almost "mythological force upon whom the British Secret Service depends." Bond travels to Istanbul, where he is assisted by the local station chief, Darko Kerim, son of a Turkish father and British mother. With the cipher machine as her passport, Tatiana joins Bond and Kerim for an escape on the Orient Express, where they are pursued by Russian agents through the Balkans, to a classic cliffhanger ending in Dijon. Along the way, Bond encounters Donavan "Red" Grant, a "lunatic" executioner, and Rosa Klebb, a grotesque and venomous SMERSH operative with deadly boots.

The Film

Immediately following the spectacular success of *Dr. No* (1962), the production team of Albert (Cubby) Broccoli and Harry Saltzman prepared *From Russia with Love* for filming at London's Pinewood Studios and on locations in Turkey, Scotland, and Madrid. Although more sumptuously mounted than *Dr. No*, it seems somewhat quaint compared to the later, more lavish productions in the Bond series (there would be four more before the end of the decade). Screenwriter Dick Maibaum wisely chose to retain as much as possible of Fleming's original story, even though it was more complicated and slow-moving than the other Bond books, and even though much of its action was confined in spaces that didn't afford much opportunity for visual spectacle. He added exterior scenes and introduced a device that would become standard fare in later films, a short pretitle sequence. In this case, Bond is attacked and strangled by an assailant dressed in black, but the scene turns out to be a rehearsal by Bond's enemies for a forthcoming assassination. Complementing Connery's Bond

Daniela Bianchi and Sean Connery in From Russia with Love, *directed by Terence Young* (1963, U.K.; UNITED ARTISTS-EON/MUSEUM OF MODERN ART FILM STILLS ARCHIVE)

are Daniela Bianchi as Tatiana, Bernard Lee as "M," a beefed-up, blond Robert Shaw as the deadly Red Grant, and Lotte Lenya as the dour, sinister Rosa Klebb. This film also introduced the character of "Q" and his murderous devices (although now they seem somewhat archaic—as in the example of the explosive briefcase).

Most of the film takes place in a rather seedy Istanbul and a rather "low-tech" Orient Express. Highlights include an amusing scene set against the backdrop of a large wall poster originally of Marilyn Monroe in *Niagara* but changed prior to the film's release to Anita Ekberg in *Call Me Bwana*, an exciting sea chase that climaxes in the fiery explosion of several fuel tanks; and a superbly staged, bloody fight to the death between Bond and Grant in the train carriage. Less dependent on the fantastic element that would predominate in later Bond pictures, it resembles, in the opinion of Bond biographer John Brosnan, more of a Hitchcockian style of thriller like *North by Northwest*. In general, this is a grittier, more "realistic," relatively less tongue-in-cheek James Bond—before technology, scenery, and endless strings of "Bond Girls" became the foci of the productions. As Connery biographer Michael Feeney Callan observes, "Superb photography by Ted Moore, richly daring editing by Peter Hunt, Bianchi oozing sensuality with every timid arch of a brow and the martyrdom of President Kennedy six weeks after the London opening of the film hoisted *From Russia with Love* into the realms of stellar immortals." Fleming, who had initially expressed doubts about Connery, was now reported as saying Connery was much as he had imagined Bond. In sum, Bond mania was approaching its zenith, and it would be a long time before it would falter.

REFERENCES

Bennett, Tony, and Janet Woollacott, *Bond and Beyond: The Political Career of a Popular Hero* (Methuen, 1987); Brosnan, John, *James Bond in the Cinema* (A.S. Barnes, 1981); Callan, Michael Feeney, *Sean Connery* (Stein and Day, 1983); Del Buono, Oreste, and Umberto Eco, eds., *The Bond Affair* (Macdonald, 1965).

—M.W.G.

FUXI FUXI (1988)

See THE OBSESSED.

THE GARDEN OF THE FINZI-CONTINIS *(Il giardino dei Finzi-Contini)* (1962; English translation, 1965)

GIORGIO BASSANI

The Garden of the Finzi-Contins (1971), Italy, directed by Vittorio De Sica, adapted by Ugo Pirro and Vittorio Bonicelli; Lucari-Cohn/Titanus.

The Novel

The Garden of the Finzi-Contins achieved great popular and critical success in Italy, winning the Viareggio Prize in 1962. Giorgio Bassani based the novel on his personal experiences growing up as a Jew in the northern Italian city of Ferrara. According to H. Stuart Hughes, "[Bassani] alone among his contemporaries [Italo Svevo, Alberto Moravia] celebrated his Italian Jewish heritage as the underlying and pervasive theme of his work." In all of his stories and novels, Bassani focuses particularly on representing the tension in the Italian Jew's struggle to negotiate the "double world" of assimilation and respect for one's religious heritage.

The Garden of the Finzi-Contins focuses on the years 1938 to 1943, when the anti-Jewish Racial Laws were passed in Italy. The key figures in the novel are the protagonist (who is never named, but who, by critical convention, is called Giorgio, recognizing the autobiographical quality of the narrative) and his middle-class family, and the Finzi-Continis, an aristocratic and extraordinarily wealthy family. The Finzi-Continis live secluded from the other citizens of Ferrara on a vast, walled estate, the "gar-

den" of the novel's title. Giorgio's obsessive and finally unrequited love for Micòl Finzi-Contini dominates the narrative, but the painful and difficult progress of their romance is shaped as much by political and social factors as it is by their personal desires. Critics of both the novel and the film have complained that the love story is irrelevant to the Holocaust story, or that it trivializes the greatest persecution in history. But neither Bassani nor De Sica tells a purely political story: the major theme is the loss of innocence, and both Bassani and De Sica use the experiences of Giorgio, denied emotional fulfillment, and his father, denied political expression, to collapse the distinction between the public and the private, the patriotic and the romantic.

The Film

The film version of *The Garden of the Finzi-Contins* follows the narrative of the novel in its broad strokes: Both novel and film are told in flashback, both emphasize the protagonist's desire for the unattainable Micòl, both use the garden as the primary allegorical symbol, and both represent the Holocaust in Italy only in oblique ways. According to Millicent Marcus, however, Bassani was not pleased with De Sica's adaptation of his novel, despite the film's being awarded an Oscar for best foreign film. The flashback structure has different aesthetic effects in the novel than in the film. In Bassani's hands the use of flashbacks gives the novel a fatalistic, hopeless flavor, which Bassani formalizes with an epilogue in which he tells us, rather offhandedly, that Micòl and her family were deported to Germany. De Sica, on the other hand, creates a mood of nostalgia and poignancy by leaving the ending unclear and

by photographing the flashback scenes in beautiful golden tones, like the last perfect Indian summer day. Probably the major difference is De Sica's shift in focus from the novel's concentration on Giorgio's inner life and its resulting solipsism and self-pity to the mysterious character of Micòl. Audiences generally come to dislike Micòl, resenting her treatment of Giorgio. One key scene, in which the jealous Giorgio sees Micòl sleeping with his rival, which is only imagined in the book, is explicitly represented in the film in a way that breaks the audience's heart as well as Giorgio's. It is a testimony to De Sica's skill that, despite our dislike for her, the audience is still able to be profoundly saddened when the Finzi-Continis are arrested along with the rest of the Jews of Ferrara.

REFERENCES

Hughes, H. Stuart, *Prisoners of Hope: The Silver Age of the Italian Jews* (Harvard University Press, 1983); Marcus, Millicent, *Filmmaking by the Book: Italian Cinema and Literary Adaptation* (Johns Hopkins University Press, 1993).

—S.C.

GERMINAL (1885)

ÉMILE ZOLA

Germinal (1913), France, directed by Albert Capellani.

Germinal (1963), France, directed by Yves Allégret, adapted by Charles Spaak; Marceau-Cocinor/Metzger & Woog/Laetitia.

Germinal (1993), France, directed by Claude Berri, adapted by Berri and Arlette Langmann; Renn Productions.

The Novel

Germinal is the 13th of the famous Rougon-Macquart series of 20 novels to which Zola devoted much of his literary life. Offering a detailed study of the living conditions, struggles, and morals of the working class, his novels are of historical as well as literary value. True to his naturalist principles, and to ensure authenticity, Zola carried out extensive research before writing *Germinal*, visiting the Lille-Valenciennes-Anzin area of France in the winter of 1884, taking copious notes about a strike in the Anzin mine that still constitute the most accurate sociological and historical document in existence on France's 19th-century coal mines. This research inspired *Germinal*, although the strike that it depicts occurs in the late 1860s, toward the end of the Second Empire.

The book begins with the arrival of Étienne Lantier, a young machinist who has come to the northern French mining town of Montsou in search of work. He is befriended by the Maheu family, who find him work and somewhere to live. His first descent into the mine, where he encounters the violent and unscrupulous Chaval, with

whom he will become a rival for the affection of Maheu's daughter Catherine, reveals the appalling conditions in which the miners are forced to work. Wanting to improve their miserable lives, he turns to socialism and becomes involved in organizing a reserve fund, in anticipation of a strike. The mine owners hit back; wages are cut, and Étienne becomes one of the leaders of the prolonged, and largely unsuccessful, strike that results, and that eventually destroys many of his friends.

When the strike is suppressed by the army, Étienne sets off again, through the April sunshine, leaving devastation behind him, but anticipating a new and glorious dawn for the workers.

The novel is divided into seven main sections, each portraying a particular phase in the conflict, while each of the chapters within each section is devoted to specific secondary incidents. The book is tightly structured to create maximum dramatic impact.

Because of its breadth, the characters tend to be two-dimensional types rather than individuals; the contrasts between the miners and the middle classes are emphasized, and the book is rich in symbolism (the mine, for example, being presented as a wild beast, crouched menacingly, ready to devour its daily ration of human flesh).

The Films

Germinal is recognized as one of the greatest of all 19th-century novels, and occupies a central position in the cultural history of France. For that reason, and because of its highly dramatic plot and extremely visual descriptions, it has long fascinated film directors.

The earliest version was directed by Albert Capellani, one of the first directors to experiment with making longer films, lasting up to an hour. He was known for his adaptations of the classics, and had already filmed Zola's *L'Assommoir* (1909) before making *Germinal* in 1913. While he attempted a faithful recreation of the story, clearly he had to produce a much simplified and truncated version, as the novel itself is over 500 pages long.

Yves Allégret's version, filmed in Hungary in 1962, is a dull and rather colorless reflection of the novel, not helped by the boring and somewhat theatrical acting, although some of the strike scenes are dramatically successful. Lacking Zola's intensity, the film impresses as little more than period melodrama.

Claude Berri had long wanted to direct *Germinal*, which to him symbolizes the struggle of the oppressed and is important in providing today's generation with an essential sense of national and cultural history. Seeing the book in these somewhat grandiose terms encouraged him to make a big-budget film, and indeed, *Germinal* was the most expensive French film until then. The set, built on location near Valenciennes, took seven months to construct. Berri chose a star-filled cast, including Gérard Depardieu and Miou-Miou (themselves something of a national institution) as Maheu and his wife.

The film's spectacular opening in Lille was attended by all of France's dignitaries, including the then president, François Mitterrand, revealing the extent to which Zola's novel has become part of French national history. It received massive publicity, which, along with the universal recognition of the status of the book, helped the film to achieve widespread success in France, where more than five million people had seen it by the middle of 1994.

In many ways, *Germinal* could have been written for the cinema. Its fast-moving and dramatic plot, its epic vision and sweep of colorful characters, easily classified within strongly contrasting groups, lend themselves to the screen. Moreover, the book is filled with human drama and emotion: Love, fear, jealousy, sex, violence, and tenderness are all to be found in abundance. The novel's vivid visual descriptions provide a perfect basis for a film, right from the moment when the solitary figure of Étienne appears, walking toward us across a desolate plain, until he walks away from us, and out of sight, at the end.

Berri, it is true, is not known as an innovative director, and it is possible that he was particularly overawed by the status of Zola's *Germinal*, seeing his role as illustrator rather than as creative artist, for while the film offers a lavish vision of socialist realism, in a way the budget and spectacle overshadow the rest. Given the length of the novel, he was obliged to cut some of the subplots and secondary actions, but he tries to include as many events as possible, and the result is simultaneously bland and indigestible. The film moves rapidly from one important scene to the next with no coherent narrative link, giving an overall impression of shapelessness, and it therefore feels longer than its actual 160 minutes. Berri's photography is sometimes dramatic, and his sets and costumes are entirely authentic, yet there is a flatness about the film in comparison with the novel. The acting is generally good, but even the most responsive imagination will find it difficult to see Depardieu as a starving miner.

Perhaps Berri should have been a little less respectful and more daring in his film. *Germinal* presents myriad possibilities that are never fully exploited, and the film feels a bit like a history lesson.

REFERENCES

Hemmings, F., *Émile Zola* (Oxford Paperbacks, 1970); Mitterrand, H., *Zola: l'histoire et la fiction* (Presses Universitaires de France, 1990).

—*W.E.*

THE GETTING OF WISDOM (1910)

HENRY HANDEL RICHARDSON

The Getting of Wisdom (1977), Australia, directed by Bruce Beresford, adapted by Eleanor Witcombe; Southern Cross/AFC/Victorian Film Corporation.

The Novel

The second novel of Henry Handel Richardson (pseudonym of Ethel Florence Lindsay Richardson Robertson), *The Getting of Wisdom* was published in 1910, 13 years after Richardson left the Presbyterian Ladies' College in Melbourne, where much of the novel is set. Early in the story 12-year-old Laura Rambotham is sent from her outback home to be schooled at the college. It is an exile from an edenic childhood. Within a fatherless family, Laura has reigned as the intense and difficult oldest child, whose chief delight has been her pastime of spinning fantastic yarns for her younger siblings.

At the Ladies' College, however, Laura's penchant for blurring the line between fantasy and fact only creates conflicts with teachers and peers. For example, in one episode Richardson's heroine cheekily tries to raise her stock in the eyes of her schoolmates by fabricating a tale of passion with the new curate. She almost succeeds, until her deception is discovered; then she is humiliated.

Again and again, the college's penumbra of fake gentility threatens to smother Laura's strong-willed spirit. But Richardson never romanticizes the ensuing struggle. Rather, from beneath the pressures to conform to mediocrity, Laura emerges as a comically graceless figure. The college functions to prepare women for their conventional social role—a role that Laura instinctively rejects. Yet with no one to appreciate or nurture her individualism, Laura cannot see what the reader does: Her rebellion is rooted in her own unsuitedness for conventional womanhood. Instead, she longs for the social acceptance that goes along with playing the conventional role, and as a result, becomes a poor but willing hypocrite, ready to ostracize new arrivals or social inferiors just as she herself has been ostracized.

Even though Richardson herself dismissed *Getting* as a "merry little book," Germaine Greer has lauded its graceful profundity. By the end of the novel, despite repeated clashes between her expectations and reality, Laura has matured on her own terms, rather than those of the school. Ironically, she has gotten the wisdom of the title only by defining herself in opposition to the cultural values that the college represents (a point not lost on school officials, who struck Richardson's name from their records after *Getting* was published). Laura does preserve her integrity, but the contest is so touch-and-go all the way that the slenderness of her triumph—along with the sad ordinariness of her struggle—is what gives the novel its pathos.

Counterpointing that pathos is Richardson's relentlessly detached, microscopically detailed examination of her heroine's consciousness and surroundings. Known as one of the best practitioners of continental-style realism and naturalism in the English novel, Richardson imitates Flaubert, her literary mentor, in withholding all authorial comment from her characterization of Laura. Praise for naturalistic technique—including the admiration of H.G. Wells—greeted the novel upon its publication. But the

book was later dismissed as veiled autobiography. In fact, Richardson's reputation as one of Australia's foremost novelists was not established until the 1960s—when her control of structure, organization, and style in the book was rediscovered.

The Film

Along with Fred Schepisi's *The Chant of Jimmie Blacksmith* and Peter Weir's *Picnic at Hanging Rock, The Getting of Wisdom* was one of the internationally visible historical films that helped define the Australian New Wave of the 1970s. As the subject of a feature film, Richardson's novel was a bold choice for two reasons. One was its period setting, which director Bruce Beresford lovingly recreates through both sets and camerawork, in conjunction with Don McAlpine's photography. The other was its intimation of a lesbian relationship between Laura and an older student, Evelyn Soutar.

Beresford handles this intimation with sensitivity, with restraint, and with his signature mise-en-scène craftsmanship, creating a sympathetic treatment of lesbianism that was rare in the industry at the time. But he and screenwriter Witcombe also allow this intimation to upstage Richardson's more complex primary theme. In the novel, what most distinguishes—and alienates—Laura from her conventional-minded classmates is not her sexual orientation but her original and nonconformist way of looking at the world, which marks her as a developing writer. Laura is thus the incipient artist learning to define, accept, and manage an imagination that is at best unruly and at worst socially deviant.

Such an interior struggle is, however, as difficult to capture on film as are the irony and detachment of Richardson's tone. The resulting reductionism is apparent, to cite one example, in the film's climactic piano-recital graduation scene. In this departure from the novel, Laura defiantly substitutes a Schubert impromptu for the Beethoven sonata she is supposed to play. The scene is intended to be a visual analogue of Laura's developing-artist discovery, in the novel, of her own literary technique. But the viewer who knows classical music is more likely to register its cinematic link to an earlier scene in which Laura and Evelyn play the Schubert side by side. Thus is Laura's developing artist identity upstaged by her "closeted" one.

As the actress who plays Laura, Susannah Fowle works hard but cannot compensate for the film's reduction of the novel's tone and theme. Fowle, an unknown with minimal dramatic training, seems to have been chosen mainly for her physical resemblance to the author at that age. Her Laura is too arrogant and defiant to invite viewer identification or sympathy. Nor is she able to register Laura's ambivalence toward the college's hidden "program" or to realize Laura's comic dimension. The detachment that Richardson brings to the novel does not work—for either actor or director—in the film.

Despite these drawbacks, many sequences in *The Getting of Wisdom*—like the Strachey tea party or Laura's visit to the curate's home—work well within themselves. The problem is that the sequences do not cohere in either following the novel or departing from it. As a result, *The Getting of Wisdom* remains, in the final analysis, an uncentered film of "incidental pleasures."

REFERENCES

Greer, Germaine, "Introduction," in *The Getting of Wisdom*, Henry Handel Richardson (Virago Limited, 1981); McFarlane, Brian, *Words and Images: Australian Novels into Film.* (Heinemann Publishers, in association with Cinema Papers, 1983), 56–69.

—T.B.M.

GIANT (1952)

EDNA FERBER

Giant (1956), U.S.A., directed by George Stevens, adapted by Fred Guiol and Ivan Moffat; Warner Brothers.

The Novel

Edna Ferber's novel *Giant* (1952) portrays two generations of a Texas cattle-ranching family, from the 1920s to the 1950s. As film historian Jack Ellis notes, the personal drama of the characters' lives is set against the background of life in modern Texas, from "a cattle roundup to an exciting oil strike."

Giant is the story of Bick and Leslie Benedict, a married couple maturing into middle age on a huge Texas ranch, and their relationship with Jett Rink, a cowhand on the Benedict ranch who becomes a Texas oil magnate. Jett is an outsider from the start, and is as remote from the other cowhands on the Benedict ranch as he is from the Benedict clan, though he secretly loves Leslie from a distance—which is the only way he could really love anybody.

Jett is the kind of outsider who is ambitious and self-centered; he is bent on gaining the money and prestige that will win him acceptance by his social betters. By striking oil Jett does become rich, but he remains an outsider. Even after he becomes wealthy, Jett is not accepted by the Texas "aristocracy," who patronize him for his inability to adopt the pretensions of the nouveaux riches.

The Film

Director George Stevens stuck close to the literary source in creating his handsomely designed film adaptation of the book. Indeed, the scale of his monumental film is adequate to encompass the epic scope of the Ferber novel. Furthermore, Stevens inspired his cast to give first-rate performances: As Bick and Leslie Benedict, Rock Hudson and Elizabeth Taylor give effective performances; while James Dean looms large throughout the film as Jett Rink.

Although Jett has grown callous and selfish in his rise to power, he continues to win our sympathy; for we are able to perceive in Jett right to the end the same lonely and vulnerable cowboy that he always has been, despite all of his bravado. This is emphasized in his last scene in the picture, which was inspired by a similar scene in the novel: Jett appears blind drunk at a banquet in his honor and passes out at the speakers' table. By the time he awakens, the embarrassed guests have all departed. In a stupor he delivers his speech to an empty dining room. Stevens photographs Jett during his speech in looming long shot, which encompass the huge banquet hall and dwarf Jett in his isolation. The harmonica theme associated earlier in the film with Jett when he was a cowhand accompanies Jett's speech, adding another pathetic note to the scene because it reminds us that, underneath, Jett remains the man he has always been. Jett finally collapses, overturning the whole speakers' table, as his bid for status comes crashing down with him.

By reflecting on the tragedy of Jett's life, Bick seems to have finally realized the truth of a remark made earlier in the film by his son-in-law, a remark that serves as an ironic reference to the film's title. The acquisitive Texas millionaires have confused bigness with greatness, said the young man, and have become less human in the bargain. That same point is made in the novel—an indication that Stevens's film is faithful to the spirit and theme of its literary source.

That Bick is becoming more concerned for others is reflected in one of the film's last sequences. Bick fights with the proprietor of a highway luncheonette who refuses to serve Mexican Americans: To his credit, Bick goes down swinging, but for the first time in his life he loses a fight. Now that he has been roused to action, the implication is that he will be more concerned for the needs and welfare of the Mexican Americans who work on his ranch; previously, he had thought of them as a mere source of manpower for his work force.

The better world that Bick hopes to help build with his considerable resources is symbolized in embryo form in the last image of *Giant:* his daughter's white child playing contentedly in a playpen with his son's mixed-race baby. Bick is an insider who wants to help the outsider; in Bick's case, then, bigness may at last come to mean greatness.

REFERENCES

Brode, Douglas, *The Films of the Fifties* (Carol, 1990); Ellis, Jack, *A History of Film* (Prentice-Hall, 1990); Richie, Donald, *George Stevens: An American Romantic* (Museum of Modern Art, 1970).

—G.D.P.

IL GIARDINO DEL FINZI-CONTINI (1962)

See The Garden of the Finzi-Continis.

GLORY FOR ME (1945)

MACKINLAY KANTOR

The Best Years of Our Lives (1946), U.S.A., directed by William Wyler, adapted by Robert Sherwood; Goldwyn/RKO.

The Novel

Inspired by a 1944 *Time* article about returning World War II vets, Samuel Goldwyn commissioned the novelist MacKinlay Kantor, who had been a war correspondent in Europe, to develop a screen treatment on the subject. To Goldwyn's surprise, Kantor produced not a treatment but a novel and, to capture the epic nature of the soldiers' return, he wrote it in blank verse. Goldwyn shelved the film project and Kantor published the novel to generally negative reviews, which dismissed it as pretentious.

Glory for Me intertwines the stories of three veterans and their troubled returns to a crass and superficial America. Al Stephenson is a banker whose wartime experiences have alienated him from the conservative values of his profession. He authorizes a loan to a vet with no collateral and is severely reprimanded. Homer Werfels, a wounded vet, is spastic, with little control of one arm, severe facial tics, and almost constant drooling. He rejects both his family and his childhood sweetheart, Wilma, and retreats into alcoholism. Fred Derry, the final vet hero, returns to discover his wife in bed with another man. After his divorce, he falls in love with Peggy Stephenson, Al's daughter, but won't pursue the relationship because of their class difference. He also faces problems at work. A respected bombardier in the army, he finds his military skills have no value at home and takes a job at the drug store where he was a soda jerk before the war. All three stories spiral downward. Al fights with a bank customer and quits his job. Fred is fired after a fight with a waitress and prepares to rob Al's bank. Homer tries, unsuccessfully, to shoot himself with the gun Fred got for the robbery.

At this point, Kantor constructs a pastoral utopian resolution. Al joins the nursery business of the vet whose loan he earlier approved, and Fred gets Wilma and Homer together at Al's country house. There Wilma and Homer and Peggy and Fred are united. The romantic ending, the natural setting and the role of the nursery combine to create a vision of social rebirth.

The Film

Director William Wyler returned from making army propaganda movies with a strong commitment to telling the stories of soldiers. He owed Goldwyn a film from a prewar contract and chose *Glory for Me.* Goldwyn wanted the story to be less downbeat and less political, and he hired Robert Sherwood, an established playwright who had worked in the Office of War Information, to write the

script. One major change was in the character of Homer. Sherwood and Wyler felt his spasticity was too repulsive for film and they rewrote the character as an amputee, casting Harold Russell, a vet who'd lost both his hands and whom Wyler had seen in an army training film, in the part. Sherwood also felt that the story required a narrative center and found it in the romance of Fred and Peggy. Rather than having Fred divorce his wife immediately, Sherwood had him stuck in a loveless marriage while falling for Peggy. The conflict between marital duty and romantic desire became a central narrative tension and introduced a strain between Fred and Al.

Many of the novel's events remain in the screenplay but the most melodramatic ones are toned down or eliminated. Al strains at his job and is reprimanded for a vet loan but he does not quit. Fred loses his job but never descends to bank robbery. Homer is depressed but does not attempt suicide. Where the book presents epic conflicts between the vets and society, with a story of destruction and rebirth, the film is a more sober tale of constraint and accommodation.

The contrast between Kantor's stylized, portentous free verse and Wyler's naturalistic mise-en-scène captures the difference between the works. Inspired by his experience with wartime documentary, Wyler aimed for a clear, honest cinema. Rather than having costumes designed, he dressed his cast in clothing off the department-store rack. He instructed the set designer to make rooms slightly smaller than scale. Perhaps the most important stylistic element in the film is Gregg Toland's deep-focus photography, which allows multiple foci within the shot and eliminates the need for frequent cutting. André Bazin, in an appreciation of Wyler's unimposing style, noted that most Hollywood films of the time had 300 to 400 shots per hour, yet *Best Years of Our Lives* has fewer than 200 in almost three hours.

Goldwyn showed a 170-minute version of the film to a preview audience to help decide how to edit it down to 90 minutes, but the audience's response was so positive that he released it uncut. The film was immensely popular, becoming the highest-grossing film to that date since *Gone With the Wind*. It received a rapturous critical response and won seven Academy Awards, including picture, director, screenplay, actor (Fredric March), and supporting actor (Harold Russell).

The Best Years of Our Lives is a clear example of a film that is superior to its source material. Although Kantor's novel is an interesting experiment with some fine passages, it is preachy and overblown. Wyler's film is the opposite— understated, beautiful, and deeply moving. It is one of the great achievements of 1940s Hollywood.

The film and novel differ not only in tone but also in politics. Kantor's novel attacks the dominant society and invokes an alternative social order closer to the land. Sherwood thought this agrarian utopianism was irrelevant to the majority of vets who were not about to quit their banking jobs. The film hails accommodation rather than rebel-

lion. It also changes the novel's sexual politics. *Glory for Me* presents American social decay in terms of feminized bureaucratic work and the growing social power of women. Both Fred and Al leave their jobs after fights with status-conscious women who treat vets with contempt. Neither of these women appear in the film, where the focus is on women's nurturing private power. The film celebrates women who heal damaged men, and, as Kaja Silverman has argued, celebrates damaged men because they create a space for female power. This domestic ideology ties *The Best Years of Our Lives* to the woman's film, a genre utterly foreign to *Glory for Me*.

REFERENCES

Anderegg, Michael A., *William Wyler* (Twayne, 1979); Epstein, Lawrence J., *Samuel Goldwyn* (Twayne, 1981); Gerber, David A., "Heroes and Misfits: The Troubled Social Reintegration of Disabled Veterans in *The Best Years of Our Lives*," *American Quarterly* 46 (December 1994): 545–74; Madsen, Axel, *William Wyler: The Authorized Biography* (Thomas Y. Crowell, 1973).

—T.S-H.

THE GOALIE'S ANXIETY AT THE PENALTY KICK *(Die Angst des Tormanus beim Elfmeter)* (1970)

PETER HANDKE

The Goalie's Anxiety at the Penalty Kick (1972), West Germany, directed by Wim Wenders, adapted by Wenders and Peter Handke; Filmverlag der Autoren and Österreichischer Telefilm.

The Novel

Peter Handke, the Austrian postmodernist dramatist and prose writer, had a stormy but meritorious career in the early 1960s with his challenge to conventional theater in the shape of "language pieces" (*Sprechstücke*) in which Handke examined audience-actor relationships and language, especially the question of language as it relates to perception. Communication through "signs" as they convey shifting layers of meaning brought Handke's name to the forefront as a proponent of language theory in literature, especially the avoidance of "descriptive" literature, for Handke an impossibility. As critic Thomas F. Barry has noted, Handke's "concern with seemingly abstract issues of language and psychology" brought the author to the end of the road in his search for a wider audience. This was achieved (on a wide basis) with the publication of *Goalie*, a more accessible text and a novel that hit home, suggesting, as it did effectively, the alienated, isolated private world of a man who becomes a psychiatric case study for the reader but one who also effectively portrays Handke's continual interest in the collapsing, floating world of meaning and reality in language. Thus *Goalie* does not represent a

clear break or separation between Handke's past (or future) creative work. The novel represents the same intense study and examination of problems found elsewhere in the author's many novels, plays, and essays, for which he has achieved justifiable fame and recognition.

The setting of Handke's novel is 1960s Vienna and an Austrian border area near the former country of Yugoslavia. His protagonist, a German Everyman, Joseph Bloch, is a onetime soccer goalie, now a construction worker, who, at the beginning of the novel, interprets as a "fact" that he has been fired. This, it turns out, is a serious instance of noncommunication and, according to Handke's underlying thesis of the novel, an instance of the collapse of language and its referents. Bloch begins to drift from the familiar moorings of society, experiencing a self-generating "terror of words as self-generating concepts." He is mugged and then strangles Gerda, a theater cashier with whom he spends the night. Handke shows both episodes as instances of disconnection between one's inner self and the world's access to it. *Goalie* can thus be read (partially) as a novel of alienation and a murder mystery, especially in those events that show Bloch's protracted stay in a small inn in a south Austrian border town. But for Handke, physical estrangement and separation are often linguistic and language entrapment. Bloch's case is guided by Handke's skilled hand away from a down-and-out study of mental abnormality toward the psychopathology of language. The novel contains two stunning episodes of language alienation as "nausea," in which Handke rivals contemporary European masters of fictional existentialism. If the book never resolves or even portrays Bloch's arrest for Gerda's murder, Bloch is depicted as a tortured and suffering creature, pursued by the "furies" of language schizophrenia. The last several pages of *Goalie*, however, go far in explaining Bloch's mysterious state for the reader. At a soccer game in the village, Bloch points out to a listening companion that in a penalty shot the goalie, and not the kicker, suffers the greater anxiety in never being able to accurately (and correctly) anticipate the direction of the kicker's shot. The goalie, like Bloch himself, and by implication modern man, confronts the substance of Bloch's dilemma. There is no fixed interpretation of anything, especially the "connection" between words and meaning. Barry claims, however, that for Handke, Bloch's "behavior is only an exaggerated form of what is found in everyday perception, that his tendency to construct reality is essentially typical of all people."

The Film

It helps to have read Handke's novel before viewing Wenders's film adaptation, for while both novel and film enjoy the postmodernist practice of ruling out the traditional notion of narrative (story), critic Brunette points out that Wenders as a film director has to work around the real theme of Handke's *Goalie*, a "dramatization of the arbitrariness of all sign systems . . . Handke's hero, alienated from the concrete reality which surrounds him and lost in a sea of signs, experiences the breakdown of the 'natural' link between signifier and signified." Words and their validity in describing a specific object, to which they relate, can never be the stuff of film's visual aesthetics. So in Wenders's film, linguistic alienation shifts toward the general direction of misused communication, the innumerable scenes rendered in cinematic terms, of Bloch in seemingly irrelevant responses to words and stimuli of the surrounding environment, whether it be an urban or rural context. Passivity characterizes not only Bloch but also all the women with whom he has contact. Even the dreadful murder of Gerda, a movie cashier, is rendered by Wenders as a crime without motivation. Five days in the Austrian border village, aimless and preoccupied with the "triviality" and "absurdity," all serve to offer the viewer of Wenders's film a portrait par excellence of modish seventies alienation. As a director and central adaptor of Handke's novel, Wenders uses static, neutral shots of objects and characters. No one scene or episode carries more weight "emotionally" than any other. Only one unique change in narrative digression from Handke's novel should be noted. Handke, in contrast to Wenders, shows Bloch at the beginning as a *former* goalie, being "fired" from his job, while Wenders has Bloch still on the soccer field, watching the soccer ball drift by his eyes into winning points for the opposing team. The visual and thematic significance of this brief opening shot set the mood and context of the film itself.

Brunette's essay on Wenders's adaptation in *Modern European Filmmakers* insists that the director had no choice but to make a cinematic character study of alienation, "visually and aurally inventive in his search for [film] equivalencies." Wenders might successfully focus on Handke's objects, rendering the schizophrenic relationship between them and Bloch, but is only doomed to failure in a search for one-on-one parallels between the subtlety of thought and language in Handke's book and its adaptation on the screen.

Goalie was not the first instance of film collaboration between Wenders and Handke. They were friends before *Goalie* was completed in 1971. *3 American LPs* (1969); *Wrong Movement* (1975), and the popular *Wings of Desire* (1987) would occur in their joint filmography. That Wenders changed very little in his direction of Handke's novel not only shows his respect for the written source of his film; it also demonstrates a similarity of cultural temperament, a sympathy for the central character Bloch that transcends the surface episode of Gerda's murder. Wenders's film, however, abandons Handke's forays and excursions into the crisis of language (word/sign) alienation. Characterization is Wenders' chief focus but the "motions and tensions are much the same." Arthur Brauss, in the role of Bloch, is excellent as Wenders's protagonist, impassively but anxiously internalizing his apparent social and spiritual alienation. Wenders, in contrast to Handke, stresses Bloch as a creature caught in an overall pattern of flight.

REFERENCES

Brunette, Peter, "Filming Words," in *Modern European Filmmakers and the Art of Adaptation*, ed. Andrew Horton and Joan Magretta (Frederick Ungar, 1981); Firda, Richard Arthur, *Peter Handke* (Twayne, 1993); Geist, Kathe, *The Cinema of Wim Wenders* (UMI Research Press, 1988); Kauffmann, Stanley, "Wenders," in *The New Republic* (January 29, 1977); Wilson, A. Leslie, "Die Angst des Tormanns beim Elfmeter," review of Handke's novel in *Books Abroad* (Winter 1972).

—*R.A.F.*

THE GO-BETWEEN (1953)

L.P. HARTLEY

The Go-Between (1971), U.K., directed by Joseph Losey, adapted by Harold Pinter; Columbia.

The Novel

The Go-Between is L.P. Hartley's most popular and highly esteemed novel. It was given the Heinemann Award of the Royal Society of Literature in 1954, while *Time* magazine's assessment of it was widely echoed elsewhere: "No other novel of recent years is a better example of English writing at its contemporary peak." After a series of respected but relatively neglected novels of adult life, Hartley turned to a theme he would explore not only in *The Go-Between* but in a number of subsequent novels as well: the portrayal of innocence corrupted, together with a sensitive understanding of childhood and adolescence in an earlier historical era than the present. Beginning and ending in the then present with a prologue and epilogue, *The Go-Between* frames 50 years in the life of Leo Colston and his troubled century. While concentrating on personal relationships, Hartley reflects larger historical and political issues in the process.

The action is presented via a diary of events in the summer of 1900 and the responses provoked by them, whereby Leo Colston, the narrator-protagonist, recalls, after a prolonged lapse of memory, his visit to Brandham Hall in Norfolk, where he turned 13 and unluckily discovered the traumatic reality of adulthood (especially adult sexuality) before he was mature enough to cope with that discovery. In 23 chapters, which stand for the 23 days he was in residence at the hall, the aged Leo, now in his sixties, acknowledges that the child was lamentably father of the man. Hartley's greatest fame may rest on the novel's opening sentence, an epigram dutifully attributed to the author but often used in a variety of contexts: "The past is a foreign country: They do things differently there." The privileged, Victorian world of the country house appears insulated from catastrophe as long as certain restrictions, of class and otherwise, are observed. The marriageable daughter of the hall, Marian Maudsley, is torn between the gallant Lord Trimingham, scarred veteran of the Boer War and owner of the hall,

and the virile tenant of Black Farm on the estate, Ted Burgess, a character resembling someone out of D.H. Lawrence. As Marian breaks out of the tidy enclosure of her milieu for riskier emotional connection, Leo unwittingly becomes the prepubescent Pandarus between Marian and Ted in arranging their meetings—hence their go-between.

Tension mounts until Leo and Mrs. Maudsley discover the two young lovers coupling on a floor in an outbuilding. Leo with his addiction to mythic constructions of seeing the denizens of his world as members of the zodiac registers the sight as "the Virgin [Marian] and the Water-Carrier [Ted] two bodies moving like one." Ted commits suicide; Trimingham, who proclaims that nothing is ever a lady's fault, marries Marian who bears Ted's son. Leo is left permanently damaged emotionally, the aged bibliographer who since his 13th birthday has come to prefer the life of facts to the facts of life.

The Film

The acclaimed film version won the Grand Prize at the Cannes Film Festival in 1971. An attempt to shoot an adaptation of Hartley's novel about a decade earlier had proved abortive. Interestingly, in that effort, Marian Maudsley was to be played by Margaret Leighton who portrays Mrs. Maudsley in the Pinter-Losey version. While preserving the novel's evocative first sentence with narrator's voiceover, the film wisely eliminates the frame provided by Hartley's prologue and epilogue and handles the narration with a double articulation of time, beginning in the past with occasional flashes forward (confusing at first but gradually more comprehensible as the film progresses). The shadowy glimpses of the old man (played well by Michael Redgrave) give us Leo as an adult in search of his past, which is unfolding before us at the moment. This becomes a far more flexible way of establishing continuity than the narrative frame of the novel's diary. Losey's largely visual narrative style is complemented by Pinter's laconic dialogue. Gerry Fisher's photography captures the beauty and dread of Leo's experience amid the golden society through which he perilously moves. The haunting musical score by Michel Legrand may telegraph too much in advance occasionally, but, on balance, it effectively underscores the story's tension.

Often Losey and Pinter reverse Hartley's handling of Leo, usually with surprisingly happy results. With the zodiac and other symbolic projections, Hartley's Leo invests the hall and much of his existence with larger-than-life creatures. In contrast, the director and screenwriter emphasize the absolute smallness and detachment of Leo, well-played by Dominic Guard, often looking perplexed, whether in the midst of adults or amid the dizzying verticality of Norwich Cathedral.

These devices stress the sociological implications of *The Go-Between* somewhat more than Hartley does in the

novel. L.P. Hartley, himself, liked the movie version of his novel and felt it captured what he wanted the material to do.

The young lovers, played by Julie Christie and Alan Bates, are ably supported by the others in the cast such as Edward Fox as Lord Trimingham and Michael Gough as Mr. Maudsley. Losey and Pinter remain faithful to Hartley's original material, as much romance as novel, with their pastoral idyll of death, casual, tasteful cruelty, and the corruption of innocence. While the novel ends on a sentimental note carried by the aged Leo that there is no curse except an unloving heart, the movie version concludes with greater ambiguity. Although the movie garnered much praise and good box office at the time of its original release, *The Go-Between* remains under-appreciated today, perhaps because of its "look" and ambience, which have became somewhat clichéd through Masterpiece Theatre and the films of Merchant-Ivory. Losey's film is made of sterner stuff.

REFERENCES

Grossvogel, David I., "Under the Signs of Symbols: Losey and Hartley," *Diacritics* (1974): 51–56; Klein, Joanne, *Making Pictures: The Pinter Screenplays* (Ohio State University Press, 1985); McEwan, Neil, *The Survival of the Novel: British Fiction in the Later Twentieth Century* (Barnes and Noble, 1981); Tashiro, Charles Shiro, "'Reading' Design in *The Go-Between*," *Cinema Journal* 33 (1993): 17–34.

—*E.T.J.*

GOD'S LITTLE ACRE (1933)

ERSKINE CALDWELL

God's Little Acre (1958), U.S.A., directed by Anthony Mann, adapted by Philip Yordan; Security/UA.

The Novel

Erskine Caldwell's novel begins with Ty Ty Walden expressing frustration to his sons, Buck and Shaw, over failing to find grandfather's legendary buried gold on his homestead. Rather than growing cotton, he has dug up most of his land over the years. When Ty Ty hears from the campaigning candidate for sheriff, Pluto Swint, about the nearby presence of an albino who can reputedly divine the presence of gold, he drives off with his two sons to kidnap him. Ty Ty's sexually promiscuous daughter, Darling Jill, teases the fat and bald Pluto who desperately wishes to marry her. Buck's wife, Griselda, experiences marital difficulties. Griselda suggests Darling Jill and Pluto drive to Scottsville and bring Ty Ty's other daughter, Rosamund, and her husband Will to help with the digging.

Darling Jill and Pluto find Rosamund upset over Will's drinking due to the local mill's closure. He intends to open the mill by turning on the machinery. In the morning, Darling Jill seduces Will and Rosamund chases her naked husband out of their home. The four return home to find Ty Ty in proud possession of the swamp albino, Dave Dawson, whom Darling Jill later seduces. Dave later "divines" gold near Ty Ty's house. Ty Ty then removes the cross marking "God's Little Acre" (a plot of land whose wealth he promised to the church) to another part of his ranch. After a fight among Will, Buck, and Shaw, Ty Ty decides to take Will, Rosamund, Griselda, Jill, and Pluto to visit his older son Jim Leslie in Augusta to borrow money for sharecropping. Jim Leslie married an older woman who contracted gonorrhea. He is now a prosperous cotton broker ruthlessly dispossessing tenants in the Depression. Although embarrassed at his family's presence, he loans Ty Ty money and expresses desire for Griselda.

Will decides to return to the valley and take over the mill with the rest of the striking workers. Will, Rosamund, Jill, and Griselda return in Pluto's car. Back home, Will becomes sexually attracted to Griselda, tears off her clothes, and takes her to bed. Deciding to take over the mill, he leads the strikers inside and switches on the power before company guards kill him. After his funeral, they all return to Ty Ty's farm. Buck and Ty Ty quarrel over Griselda's involvement with Will. Jim Leslie arrives and attempts to take Griselda away. Buck murders him with a shotgun and walks away to commit suicide with the same weapon. Ty Ty is left surveying a desolate landscape and returns to his digging.

The Film

Although using much of the novel's plot and language, Anthony Mann's film version dilutes certain components due to censorship pressures from the Production Code office. Caldwell's ripe lyrical paeans to female body parts are absent. Will and Griselda had a previous relationship before she married Buck. Mann drops the clothes-tearing scene and expresses their mutual erotic desires by the use of dissolves in a night scene. Griselda attempts to dissuade Will from turning on the power by having sex with him in the mill. A doddering nightwatchman kills him accidentally rather than company men, a change dictated by post-McCarthy-era concerns. After preventing Buck from impaling the widowed Jim Leslie, Ty Ty orders him off the land. A Hollywood "happy ending" shows Buck and Griselda reunited, Darling Jill embracing Sheriff Pluto, and Ty Ty productively tilling the land until he accidentally finds grandfather's shovel and begins digging for gold for just one day.

REFERENCES

Watson, Jay, "The Rhetoric of Exhaustion and the Exhaustion of Rhetoric: Erskine Caldwell in the Thirties," *Mississippi Quarterly* 46, no. 2 (1993): 215–29; Howard, William L., "Caldwell on Stage and Screen," *The Southern Quarterly* 27, no. 3 (1989): 59–72.

—*T.W.*

THE GOLDEN BOWL (1904)

HENRY JAMES

The Golden Bowl (2001), U.S.A., directed by James Ivory, adapted by Ruth Prawer Jhabvala; Lion's Gate.

The Novel

The Golden Bowl was Henry James's last novel. He began it in early 1903 and finished it in 1904. Biographer Leon Edel describes it as "the richest of all his creations" and critic Philip M. Weinstein asserts it is "at once the most poetic and impenetrable novel of James's career." The title refers to a historical artifact, a bowl presented by King George I to the Lamb family. James saw it in the possession of the family that had built the house he now lived in. It reminded him of a quotation from Ecclesiastes 12:6–7: "Or ever the silver cord be loosed, or the golden bowl be broken, or the pitcher be broken at the fountain, or the wheel broken at the cistern. Then shall the dust return to the earth as it was: and the spirit shall return unto God who gave it."

As Edel quotes in his biography of James, in his notebooks James described the novel in deceptively terse fashion: "The Father and Daughter, with the husband of one and the wife of the other entangled in a mutual passion, an intrigue." American expatriates Adam and Maggie Verver, widowed father and daughter, live in London. They are devoted to each other. Into their lives come Prince Amerigo and Charlotte Stant, former lovers who have been unable to marry each other for financial reasons. They are as worldly as Maggie is innocent. Amerigo is bent on marrying Maggie, and Charlotte has designs on Adam. Maggie, who is unaware of Charlotte's and Amerigo's former relationship, encourages her father to marry Charlotte because she feels it will be a "consolation" for the loss of his daughter. But after Charlotte marries Adam, her old romance with the prince springs up afresh. When Maggie learns of the renewed affair, she experiences for the first time the worldly evil that can hide behind beauty—the crack in the bowl, as it were: ". . . the horror of finding evil seated, all at its ease, where she had only dreamed of good; the horror of the thing hideously *behind*, behind so much trusted, so much pretended nobleness, cleverness, tenderness." She maneuvers to oust Charlotte from her husband's affections without alerting her father to the affair. The story ends with Charlotte and Adam departing for America and Maggie triumphant in her management of the situation.

The first part of the story is told from the point of view of Prince Amerigo. The final two sections are told from Maggie's point of view. There are two joined triangles here, as Edel notes: "Father, daughter, and daughter's husband; and the husband's mistress, who then marries the father and so becomes the stepmother of the heroine, and mother-in-law of her lover." Maggie has learned that she cannot be a daughter and a wife both. She accepts her mature role as wife. She and the prince have children—the first and only time, says Edel, that a James novel ends with a family in which the offspring is allowed to live.

Ongoing debate over Maggie concerns her role either as a manipulator or as an agent of harmony. She seems to be an innocent who grows up through worldly contact. The golden bowl motif is introduced when Charlotte wants to offer it to the prince as a gift for the marriage between him and Maggie. He refuses it because he realizes that it is a flawed artifact; moreover, he knows it is not made of gold but of gilded crystal. When Maggie does ultimately come into possession of the bowl, it is dropped and shattered by her friend Fanny Assingham. Edel says it is "emblematic not only of the marriage of the Prince and Maggie . . . but of the entire civilization in which this marriage has been consummated." There is also another metaphor which, like the golden bowl, bespeaks an empty, or flawed existence. It is the pagoda artifact—merely an ornament of life, not a substitute for it. "Life without love wasn't life," says Edel.

In sum, writes Edel: "The prose is dense, yet fluid, and the surfeit of architectural and museum-world imagery, the gathering of social and artistic materials to suggest the fabric of civilization, combined the art of realism James had learned long ago from Balzac with the old art of the fable."

The Film

The team of James Ivory, Ismail Merchant, and Ruth Prawer Jhabvala already had adapted to the screen James's *The Europeans* (1979) and *The Bostonians* (1984). Attentive as always to the details of historical period and ensemble casting, they crafted a respectful reworking of *The Golden Bowl*. The time is 1903. Wealthy American art collector Adam Verger (Nick Nolte) and beloved daughter Maggie (Kate Beckinsale) have come to England, where they meet Europeans Charlotte (Uma Thurman) and Prince Amerigo (Jeremy Northam). Two years after Maggie marries the prince, she contrives to have her father marry Charlotte. She does not know that Charlotte and Amerigo already have had an affair; moreover, she is ignorant that that affair is still going on, right under the noses of her and her father. Her suspicions, and those of her friend Fanny Assingham (Anjelica Huston), are borne out when she discovers that a golden bowl she has bought for her father's birthday was in fact the very bowl that was once almost purchased by Charlotte and the prince years before as a wedding gift to Maggie. In other words, Maggie has proof that the two enjoyed some sort of intimacy just days before her marriage. She confronts the prince. Abashed, he seems to regain his moral footing, and he tries to reject the advances of the still-amorous Charlotte. By this time Maggie has determined to exercise some control over this mess: She contrives to have her father take Charlotte with him to America (where he wants to found an art museum

filled with the art treasures of Europe); and at the same time, she denies to Charlotte that she is aware of the adulterous affair (and by doing so allows Charlotte to lie to her that it is Charlotte's idea that she and Adam go to America). At the end, Maggie and the prince stay on in London with their son, and Adam and Charlotte depart for America.

Whereas the film opened with a stylized prologue depicting the jealous machinations of Prince Amerigo's 16th-century forebears, it ends with a simulation of a black-and-white newsreel reporting Adams's establishment of the new art museum in New York City. "*The Golden Bowl* thus encases its characters' fate within a double trajectory," writes critic Ginette Vincendeau, "that of the march of time and that of technologies of representation."

The central metaphor of the James novel, the golden bowl, is preserved. It even breaks into the requisite three pieces, as he directed. However, the other metaphor of the pagoda is alluded to only in a dream Maggie has.

Maggie's benign perfidies are also preserved. At one point, her father declares that although she is a pure and noble creature, she can "lie with the best of them" if it serves to protect those she loves. Some of the film's best scenes have her rebutting Charlotte's suspicions that she knows of the affair; and her accepting Charlotte's lies that it was she, Charlotte, who persuaded Adam to go back to America. Kate Beckinsale's performance preserves the essential innocence lurking behind her craftiness.

As in James's novel, the movie is swamped in the imagery of Old World objects d'art. Not only are statues, paintings, and objects everywhere in evidence, essential elements of the mise-en-scène, but entire walls are covered with murals. Characters come and go through doors cut out of the murals. They live in these painted houses—conveying the effect that the characters have become a part of the vaguely erotic narratives depicted in the paintings. They regard each other, moreover, as objects to be appropriated and exploited. "You're a rarity, an object of beauty," Maggie tells the prince at one point, "an object of price." And frequently characters pause to discourse on these objects and paintings, as when the antique dealer discusses the flaw in the golden bowl, or when Charlotte guides visitors through her husband's art collection (discoursing, for example, on Holbein's *Henry VIII* (the *real* painting, by the way). This reflects in part Adam's obsession with acquiring Old World artifacts (making him a sort of benign Charles Foster Kane), not to mention Henry James's particular obsessions and those of filmmakers Merchant and Ivory with the details of decor. In a reversal of type, here is a story, in other words, where not only do Americans bring their culture to Europe, but they carry European culture back with them to America.

In proper Jamesian fashion, we are left with questions—most particularly what, if anything, old Adam Verger knows about his wife's infidelity. Nolte's performance here is quite effective, balancing a gruff sentiment toward her with a rather dangerous implication of reprisals to come. "I admired this movie," writes critic Roger Ebert. "It kept me at arm's length, but that is where I am supposed to be; the characters are after all at arm's length from each other." And David Lodge applauded it as a worthy realization of James's "imaginative vision": "The Master would not be displeased by this thoughtful and carefully crafted film."

REFERENCES

Ebert, Roger, "The Golden Bowl," *Chicago Sun-Times*, May 18, 2002; Edel, Leon, *Henry James: The Master: 1901–1916* (J.P. Lippincott Company, 1972); Edel, Leon, and Lyall H. Powers, eds., *The Complete Notebooks of Henry James* (Oxford University Press, 1987); Lodge, David, "In the Home of Eternal Unrest," *Times Literary Supplement*, November 10, 2000, 20–21; Vincendeau, Ginette, "The Golden Bowl," *Sight and Sound*, November 2000; Weinstein, Philip M., *Henry James and the Requirements of the Imagination* (Harvard University Press, 1971).

—*J.C.T.*

GONE WITH THE WIND (1936)

MARGARET MITCHELL

Gone With the Wind (1939), U.S.A., directed by Victor Fleming, adapted by Sidney Howard; Selznick International/MGM.

The Novel

Drawing on childhood memories of the South, Margaret Mitchell completed her runaway best-seller over the course of three years, storing sections of the manuscript in manila envelopes. Mitchell wrote the last chapter first and apparently composed the rest at random. The manuscript's working title was *Tomorrow Is Another Day*, but among the list of possible alternates Mitchell submitted to publisher Harold Latman was a line from "Cynara," a nostalgic poem by Ernest Dowson: "I have forgotten much, Cynara! gone with the wind/Flung roses, roses riotously with the throng,/Dancing, to put thy pale, lost lilies out of mind . . .". An immediate sensation, *Gone With the Wind* sold one million copies by year's end. Mitchell received a record-setting $50,000 from producer David Selznick for the film rights, although she reportedly "argued that the book was unfilmable."

Stung by handsome Ashley Wilkes's engagement to Melanie Hamilton, Southern belle Scarlett O'Hara agrees to marry Melanie's brother Charles. The Civil War erupts and Charles soon dies in camp, leaving Scarlett a pregnant widow at age 16. In Atlanta with Melanie, Scarlett agrees to work at a benefit, where Rhett Butler, a man of bad reputation, buys a dance with her; this scandalizes the crowd but delights Scarlett. Rhett visits Scarlett frequently, bearing gifts paid for by his blockade running. Ashley is

wounded and captured on the front while Melanie struggles with a dangerous pregnancy at home. As the Yankees approach Atlanta, Rhett secures Scarlett and Melanie's escape.

Back at Tara, her family home, a now 19-year-old Scarlett finds her mother dead, her sisters ill, her father feeble-minded, and a large tax debt on the estate. Desperate, Scarlett seeks money from Rhett in Atlanta, but he refuses, so she convinces her sister's beau Frank to marry her instead. After the war, Scarlett buys and profitably operates a sawmill despite disapproval from Frank and the community at large.

Scarlett is subsequently raped by a black man, and the Ku Klux Klan rides in her defense: Frank is killed, Ashley wounded, and the rest of the men saved from arrest through Rhett's intervention. After Frank's funeral, Rhett proposes and Scarlett accepts. They are shunned socially, but after the birth of his daughter Bonnie Blue, Rhett begins actively courting Atlanta society.

The romance between Scarlett and Rhett dissipates. In the midst of a violent argument, Scarlett informs Rhett that she is pregnant again. She subsequently falls down the stairs, causing a miscarriage and long illness. Bonnie breaks her neck horseback riding, and Rhett is grief-stricken. The deaths of Bonnie and Melanie cause Scarlett to realize that her infatuation with Ashley was childish and that she truly loves Rhett. She tells him so, but he replies that his love is worn out, and he leaves her. The book ends with Scarlett resolving to win Rhett back, because "Tomorrow is another day."

The Film

Producer David O. Selznick already had considerable experience adapting literary classics for the screen, including *David Copperfield* and *A Tale of Two Cities*. But in adapting *Gone With the Wind*, he faced some extraordinary challenges: epic scope; censurable material, including rape, drunkenness, and moral dissipation; controversy over the book's racial politics; and ironically, popularity, since many readers had already cast Scarlett and Rhett in their minds. A battery of writers, including Sidney Howard and Ben Hecht, and directors, including George Cukor, King Vidor, and Victor Fleming (who received screen credit)

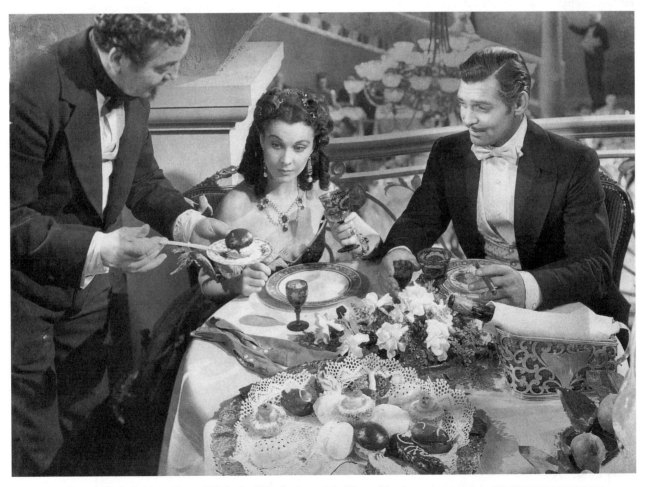

Vivien Leigh and Clark Gable in Gone With the Wind, *directed by Victor Fleming* (1939, U.S.A.; SELZNICK-MGM/JOE YRANSKI COLLECTION, DONNELL MEDIA CENTER)

hacked their way through the wilderness of the novel's sprawling incidents and the film's numerous production difficulties. The omission of Scarlett's first child, her family history, and the many gossipy neighbors at both Tara and in Atlanta helped trim the novel down to a more manageable length. Perhaps hoping to balance talk with action, Selznick "desperately wanted to show Rhett engaged in blockade-running and Ashley heroically battling the Yankees."

The Production Code Administration (or "Breen Office") voiced many concerns about the project, insisting that "any suggestion of rape or the struggles suggestive of rape" be eliminated and that Rhett "definitely be characterized as an immoral, or adulterous man." Meanwhile, a letter-writing campaign sprung up to protest the characterization of African Americans in the novel. An agreement was eventually reached to remove the word "nigger" and to avoid the depiction of both the Ku Klux Klan and black-on-white violence.

Some of the cuts produced important differences between book and film. For example, the portrayal in the book of Melanie's loyalty to Scarlett and her skilled efforts to prevent her friend's social ostracism had made her seem far less saccharine than in the film, and the novel's careful naming of Scarlett's age and description of her pregnancy soften somewhat Rhett's observation about her callous marriages to men she doesn't love. One of the most central differences in the two versions is in their depiction of Scarlett's essential character. As Gerald Wood noted, Mitchell's Scarlett is "so willfully self-involved that she is incapable of the mutuality out of which love grows," while Selznick's Scarlett learns to "demonstrate her resilience, her belief in the future." The novel also dramatizes the dynamic tension between the values of one's parents and community versus the need to adapt to changing circumstances; Mitchell's Scarlett agonizes over what her mother would think, as well as over the misfortunes of her neighbors and friends, who are still loyal to the old values but lack Scarlett's adaptability. This tension is largely lacking in the film where, as Wood observed, "rather than dramatize, as Mitchell does, an inconclusive conflict between aristocratic idealism and lumpish realism, the filmmaker makes a clear preference for days gone by."

Gone With the Wind is unusual among adaptations due to the legendary status of both the novel and the film. Although the novel was begun during the Jazz Age and based on stories Mitchell heard in childhood, both book and film spoke to a depression-shocked audience, and they continue to do so in our own economically uncertain age. According to Mitchell, "If the novel has a theme, it is that of survival. What makes some people able to come through catastrophes and others, apparently just as able, strong, and brave, go under?"

REFERENCES

Wood, Gerald, "From *The Clansman* and *Birth of a Nation* to *Gone with the Wind*," in *Recasting: Gone with the Wind in American Culture*, ed. Darden Asbury Pyron (University Presses of Florida, 1983); Taylor, Helen, *Scarlett's Women: Gone With the Wind and Its Female Fans* (Virago, 1989); Harwell, Richard, ed., *Gone with the Wind as Book and Film* (University of South Carolina Press, 1983).

—K.R.H.

GÖSTA BERLINGS SAGA (1891)

SELMA LAGERLÖF

Gösta Berlings Saga (1924), Sweden, directed by Mauritz Stiller, adapted by Stiller and Ragnar Hylten-Cavallius; Svensk Filmindustri.

The Novel

Despite a general trend toward realist literature at the end of the 19th century, Swedish novelist Selma Lagerlöf based the majority of her works on the folk legends of her homeland. Her first major work was *Gösta Berlings Saga*, published in 1891 when she was 33. Its great popularity, along with subsequent works like the trilogy, *Lowenskoldska ringen* (The Ring of the Lowenskolds, 1925), gained her a worldwide reputation as Sweden's greatest novelist. In 1909 she became the first woman to win the Nobel Prize for literature and in 1914 the first woman to become a member of the Swedish Academy.

The epic sweep, episodic structure, nationalist feeling, spectacular landscapes, and numerous characters qualify *Gösta Berlings saga* as the *Gone With the Wind* of Swedish literature. Berling is the minister of a poor parish in the Western Varmland. Accused of alcoholism, he leaves, determined to kill himself in the freezing snows. He is saved by Margareta Samzelius, the wealthy mistress of the estate of Ekeby. She takes him in and he promptly falls in love with Ebba Dohna, the sister of a count. After learning he is a defrocked minister, Ebba dies, an apparent suicide. Years pass and Berling, along with Margareta's other pensioners, takes control of the Ekeby estate. There is a succession of romantic episodes: He takes a sleigh ride with Anna Stjarnhok, a beautiful young woman engaged to be married, and they barely escape death when they are attacked by wolves; he wins the charms of the fair Marianne Sinclair in a card game; and he falls in love with Elizabeth, the wife of Count Dohna (the same count whose sister had died tragically years before). Abused by her cuckolded husband, Elizabeth is forced to leave the village. After her marriage is annulled, she has a child and entreats Berling (who is not the father) to marry her. But the fates are harsh and disasters follow, including the death of the child and the destruction by fire of Ekeby. The aging Margareta Samzelius, in the meantime, returns to reclaim the remnants of Ekeby. She offers it to Berling and Elizabeth. They refuse, declaring they would rather live simply and help others.

Presiding over these and many other episodes is the evil Sintram, master of the local iron works, who claims to

be the Devil himself. A master manipulator of the lives of the townspeople, he may also be responsible for the floods, plagues, and fires that bedevil the region.

The Film

Though Selma Lagerlöf frequently expressed her dissatisfaction with movie adaptations of her stories, they constituted the core of a film renaissance in Sweden from the late teens through the mid-twenties. "It is difficult to overestimate the importance of Selma Lagerlöf's contribution to the Swedish cinema," writes historian Forsyth Hardy. "Her novels had their roots deep in the country's culture . . . and in the breadth and sweep of their treatment, they gave the directors what they needed." For example, the two greatest directors for Charles Magnusson's Svensk-Bio, Victor Sjöstrom and Mauritz Stiller, frequently turned to Lagerlöf. Less satisfying than some earlier attempts, perhaps—if only due to the truncated versions currently available—is *Gösta Berling's Saga* (1924), Stiller's last film before his departure from Sweden to America. (Alternate English-language titles include *The Atonement of Gösta Berling, The Story of Gösta Berling, The Saga of Gösta Berling.*)

Stiller and collaborator Ragnar Hylten-Cavallius divided the action into two parts, and the finished work ran for four hours. A condensed version conflating both parts was prepared for showing outside Sweden. The cast of characters is reduced and the chronological order is altered somewhat, arousing Lagerlöf's accusation that Stiller had been seeing "too many poor serials."

The first half begins with the expulsion of Berling (Lars Hanson) and his romances with Ebba (Mona Martenson) and Elizabeth (Greta Garbo) and concludes with his carousing life at Ekeby Castle; the second depicts the destruction by fire of Ekeby Hall, the flight from wolves by sleigh across a frozen lake, and Berling's reunion and marriage to Elizabeth as he prepares to rebuild and assume charge of Ekeby (a considerable departure in itself from Lagerlöf's original). As a result of the condensation, the story line is occasionally disjointed and the characterizations flat. Yet, something of the scope of the original two-part film is suggested by the surviving scenes, like the celebrations at Ekeby Castle and Berling's spectacular flight across the snow. By contrast, the poignant moment when the Mistress of Ekeby seeks out her aged mother, who formerly had cursed her, is masterful in its understated power. "The film is not as uniform in style as *Sir Arne's Treasure*," writes historian Aleksander Kwiatkowski, "but it is still the work of a master and was acclaimed in Sweden and abroad."

The film marked the feature debut of the 17-year-old Greta Garbo (Greta Gustaffson), who previously had been seen only in some short publicity films and a Mack Sennett-like farce, *Luffar-Peter.* The precocious depth and sensitivity she imparted to the role of Elizabeth Dohna led to her next starring role a year later in G.W. Pabst's classic *The Joyless Street.* She came with Stiller to Hollywood in 1926 and the rest, as they say, is history.

REFERENCES

Hardy, Forsyth, *Scandinavian Film* (Falcon Press, 1952); Kwiatkowski, Aleksander, *Swedish Film Classics* (Svenska Filminstitutet, 1983).

—*J.C.T.*

THE GRADUATE (1963)

CHARLES WEBB

The Graduate (1967), U.S.A., directed by Mike Nichols, adapted by Calder Willingham and Buck Henry; Avco Embassy.

The Novel

Like his character Benjamin Braddock, author Charles Webb graduated from "a small Eastern college"—in Webb's case, Williams—but unlike his hero, who let the graduate fellowship he had won lapse without using it, Webb showed no such indecision, instead using his own fellowship to write his first novel, *The Graduate*, only two years after his graduation. The novel was generally well-reviewed, though it enjoyed nothing like the popular success of Mike Nichols's film.

Upon graduating, Benjamin returns to his hometown rudderless and enervated, determined only to avoid his parents' California lifestyle. When Mrs. Robinson, the wife of his father's law partner, comes on to him, he initially resists her advances, but after returning from a trip of three weeks away from home, he drifts into an aimless secret affair with her. Their loveless, inarticulate coupling leaves Benjamin increasingly unsatisfied–and ready to fall in love with Mrs. Robinson's daughter Elaine when he accedes to his family's pressure to take her out. Elaine, told of Benjamin's affair by her mother, flees from him back to Berkeley, but Benjamin follows her, doggedly pursues her, and eventually, in an unwonted burst of initiative, interrupts the wedding her parents have arranged for her, carrying her off to an ambiguous future on a providential city bus.

The Film

Though he postponed production of *The Graduate* to work on *Who's Afraid of Virginia Woolf?*, the Webb novel was the first film successful stage director Mike Nichols agreed to direct. Discarding an earlier screenplay by Calder Willingham, he asked Buck Henry to write a new one directly from the novel. Since whole scenes of the novel—the party to celebrate Benjamin's graduation, Mrs. Robinson's first attempt to seduce him, his forlorn attempt to enliven their lovemaking with a little conversation—consist almost entirely of hilariously minimalist dialogue (Benjamin's most common response to questions, appearing over a hundred

times, is "What?"), it is not surprising that much of Henry's screenplay follows the novel very closely indeed.

Despite a few changes in the film's opening scenes—the title sequence that establishes Benjamin's anomie, the omission of Benjamin's trip out of town to find himself (the film cuts directly from Benjamin's 21st birthday party, as the graduate cowers at the bottom of his parents' swimming pool in wet suit and scuba gear, to his first rendezvous with Mrs. Robinson), the addition of the film's most famous line, "Plastics!"—most of the film's most obvious departures from the novel occur in its final third, after Benjamin has followed Elaine back to Berkeley. Henry's screenplay prunes much of Webb's dialogue in these scenes, emphasizing the sharp upsurge in Benjamin's visual momentum as he moves to take charge of his life. The most notorious of all these changes, and the one of which Webb most strongly disapproved, was to present Benjamin as interrupting Elaine's wedding only after she and her bland, blond husband had exchanged wedding vows, raising questions about the legal status of her marriage that never arise in the novel, and failing, as Webb complained, to take a clearcut moral stance toward the hero's final situation.

More subtly, the film shifts the novel's satiric emphasis to exclude Benjamin, who, though quite as ridiculous as the adults in the novel, is presented sympathetically in the film, presumably in order to capture the emerging youth market by urging a closer identification with the young hero. Whether or not Nichols and Henry consciously adopted this strategy, the film—buoyed by the inspired casting of Anne Bancroft as Mrs. Robinson and Dustin Hoffman, only six years her junior, as the appealing hero—was phenomenally successful, joining *Bonnie and Clyde* as one of the first films to establish the college audience as a marketing niche, and rocketing by the end of 1967 to third place on *Variety*'s all-time top grossing list.

REFERENCES

Fairchild, Pete, "'Plastics': *The Graduate* as Film and Novel," *Studies in American Humor* 4, no. 3 (1985): 133–41; Gelmis, Joseph, *The Film Director as Superstar* (Doubleday, 1970); Macklin, F.A., "'Benjamin Will Survive . . .' An Interview with Charles Webb, Author of *The Graduate*," *Film Heritage* 4, no. 1 (fall 1968): 1–6.

—*T.M.L.*

THE GRAPES OF WRATH (1939)

JOHN STEINBECK

The Grapes of Wrath (1940), U.S.A., directed by John Ford, adapted by Nunnally Johnson; Twentieth Century-Fox.

The Novel

Still Steinbeck's most popular and critically respected work, *The Grapes of Wrath* was awarded the Pulitzer Prize in 1940, after wildly divergent reviews, depending on the politics of the critic. Oklahoma's State Representative Lyle Boren vilified the book in Congress as "a lie, a black, infernal creation of a twisted, distorted mind," while in its citation awarding the Nobel Prize to Steinbeck in 1962, the Swedish Academy called *The Grapes of Wrath* "an epic chronicle." Several critics have pointed out rough parallels to Exodus, depicting the movement of a people from oppression through homelessness to a new home. *The Grapes of Wrath* chronicles the mass migration of the Okies to the promised land of California. But Steinbeck recognized the need to focus on specific characters and situations. In his preface to *The Forgotten Village* (1941), he wrote: "It means very little to know that a million Chinese are starving unless you know one Chinese who is starving." His solution was to show the conditions of a whole social group by focusing on a representative family. Such chapters are narrated by an omniscient narrator who presents the family's story with minimal commentary. To preserve the chronicle voice, Steinbeck created the so-called intercalary chapters, in which the narrator "directs attention to himself as historian, social critic, and philosopher" and "points out that the family's situation is but one illustration of a larger, potentially catastrophic social reality."

Tom Joad, released from prison after serving time for homicide (he killed a man in self-defense during a drunken brawl), returns to the family farm in Oklahoma only to find it abandoned. The farmers, including the Joad family, are all being pushed off their land. Tom joins up with them, and the rest of the book details their journey west to California. Incidents accumulate; the grandparents die, a son leaves, Tom becomes a fugitive, and there are long episodes at a government camp and a workers' camp. The family's sheer will to survive is embodied in Ma Joad, who says, with her "eyes like the timeless eyes of a statue": "Why, Tom, we're the people that live. They ain't gonna wipe us out. Why, we're the people—we go on." The book ends with the Joads on the move again, this time from floodwaters encroaching on their boxcar home. (It has been suggested, in another biblical parallel, that "Joad" evokes "Job.") They take refuge in a barn on a hill, where Rose of Sharon, who has just delivered a stillborn child, suckles a starving man with her breast. Because of this ending, the book was denounced as obscene as well as being denounced for its politics.

The Film

Edmund Wilson wrote that "*The Grapes of Wrath* went on the screen as easily as if it had been written in the studios, and was probably the only serious story on record that seemed equally effective as a film and as a book." Bluestone's seminal *Novels into Film* (1957) concerns itself more with the consequences of *The Grapes of Wrath*'s "mutation from a linguistic to a visual medium." He is particularly interested in the transformation of the novel's major motifs: (1) biology (the turtle crossing the road), (2) the juxtaposi-

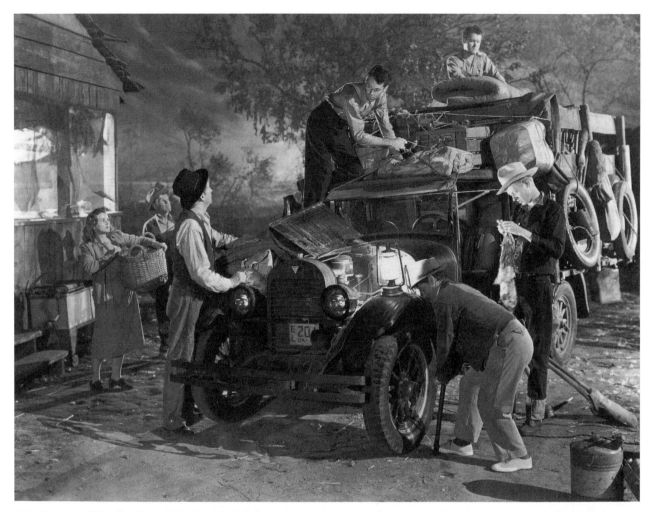

The Grapes of Wrath, *directed by John Ford* (1940, U.S.A.; TCF/THEATRE COLLECTION, FREE LIBRARY OF PHILADELPHIA)

tion of natural morality and religious hypocrisy, (3) the love of the regenerative land, (4) the primacy of the family, (5) the dignity of human beings, and (6) the sociopolitical implications inherent in the conflict between individual work and industrial oppression. He finds that the biological motif is dropped entirely; the religious satire, with one exception, is also abandoned; the political radicalism is muted and generalized. But the insistence on family cohesion, on affinity for the land, and on human dignity is carried over into the film version. Gregg Toland's photography effectively composes images that emphasize these, "so that some of the visuals—Tom moving like an ant against a sky bright with luminous clouds, the caravans of jalopies, the slow rise of the dust storm—combine physical reality with careful composition to create striking pictorial effects." Even the interchapters find occasional filmic equivalents in montage images such as the coming of the tractors and the highway signs along Route 66.

Two radical changes from novel to film, however, create a problem that has led to puzzling, even contradictory,

comments. The film switches the order of the Hooverville interlude and the strike-breaking episodes (in which Tom is clubbed and Casey killed), putting the latter earlier in the film. And the final episode (of the flooding) is deleted. Ma Joad's "we're the people" speech—spoken to Tom two-thirds of the way into the novel (chapter 20)—becomes the film's final word, now spoken to Pa. While the novel's dismal ending—a "blue shriveled little mummy" of a stillborn baby, a starving man, a remnant family escaping encroaching floodwaters—was widely criticized, the film not only gives us Ma's upbeat words but also a final image of the Joad jalopy leaving the government camp in bright sunlight. "The new order changes the parabolic structure to a straight line that continually ascends."

The Grapes of Wrath had obstacles that most adaptations don't have to overcome. Because of the flak generated by the novel, various groups opposed the project, while others worried that the studio would eviscerate it or abandon the production altogether. "Even as the film was being shot, [Producer Darryl] Zanuck received 15,000

letters, 99 per cent of which accused him of cowardice, saying he would never make the film because the industry was too closely associated with big business." But the studio's courage in tackling such a bold venture was diminished somewhat by the effects that the controversy had on the integrity of the adaptation. The film eliminates almost all of the book's specific accusations against unfair business practices, from the tactics of used-car salesmen to the rigged scales on the ranch.

The film received excellent reviews, was commercially successful, and was awarded an Academy Award for best director and best supporting actress (Jane Darwell as Ma Joad). It has subsequently achieved almost classic status as an adaptation that works. Siegfried Kracauer, for whom the film medium is "the redemption of reality," attributes this effectiveness to two qualities: "First, Steinbeck's novel deals in human groups rather than individuals . . . Are not crowds a cinematic subject par excellence? Through his very emphasis on collective misery, collective fears and hopes, Steinbeck meets the cinema more than halfway. Second, his novel exposes the predicament of migratory farm workers, thus revealing and stigmatizing abuses in our society. This too falls into line with the peculiar potentialities of film. In recording and exploring physical reality, the cinema virtually challenges us to confront that reality with the notions we commonly entertain about it—notions which keep us from perceiving it."

Yet there are more qualified views as well, exemplified by Pauline Kael's observation that it's "full of the 'They can't keep us down, we're the people' sort of thing, and a viewer's outrage at the terrible social injustices the film deals with is blurred by its gross sentimentality. This famous film, high on most lists of the great films of all time, seems all wrong—phony when it should ring true. Yet, because of the material, it is often moving, in spite of the acting, the directing, and the pseudo-Biblical talk."

REFERENCES

Bluestone, George, *Novels into Film: The Metamorphosis of Fiction into Cinema* (University of California Press, 1973; first published, 1957); French, Warren, *Film Guide to* The Grapes of Wrath (Indiana University Press, 1973); Johnson, Nunnally, "The Grapes of Wrath," in *Twenty Best Film Plays*, ed. Dudley Nichols and John Gassner (Crown, 1943), 333–77; Kael, Pauline, *5001 Nights at the Movies*, expanded ed. (Holt, 1991); Kracauer, Siegfried, *Theory of Film: The Redemption of Physical Reality* (Oxford University Press, 1960); Sobchak, Vivian C., "The Grapes of Wrath (1940): Thematic Emphasis through Visual Style," in *Hollywood as Historian: American Film in a Cultural Context*, ed. Peter C. Rollins (University Press of Kentucky, 1983), 68–87.

—U.W.

GREAT EXPECTATIONS (1861)

CHARLES DICKENS

Great Expectations (1917), U.S.A., directed by Robert G. Vignola, adapted by Doty Hobart; Paramount.

Great Expectations (1934), U.S.A., directed by Stuart Walker, adapted by Gladys Unger; Universal.
Great Expectations (1946), U.K., directed by David Lean, adapted by Lean, Ronald Neame, Kay Walsh, and Cecil McGivern; Rank.
Great Expectations (1998), U.S.A., directed by Alfonso Cuarón, adapted by Mitch Glazer; Twentieth Century Fox.

The Novel

Great Expectations began as a serialized publication in Dickens's periodical *All the Year Round* on December 1, 1860. It had "expectations" of its own, in that it was intended (successfully, as it turned out) to bolster the flagging circulation of the journal. In 1861 Chapman & Hall published it in three volumes. Variously categorized as a bildungsroman, a moral fable, and a fantasy, it has, according to G.K. Chesterton, "a quality of serene irony and even sadness, which puts it quite alone among his other works."

Philip Pirrip, nicknamed Pip, is an orphan living with his fierce-tempered older sister and her husband, the kindly blacksmith, Joe Gargery. One day, while wandering through the churchyard, Pip is collared by an escaped convict named Magwitch and forced to provide him food. After the convict is apprehended, Pip is brought to Satis House, the home of the wealthy but eccentric Miss Havisham as a playmate for her ward, Estella. Time passes and Pip, by now hopelessly in love with the heartless Estella, is informed by a lawyer, Mr. Jaggers, that he has "expectations": An anonymous benefactor has established a fund to educate Pip and enable him to live as a gentleman.

The newly wealthy Pip turns into a thoroughgoing snob and turns his back upon the friends of his youth. When the convict Magwitch returns to inform him that he is the boy's mysterious benefactor, he is appalled at being indebted to such a ruffian. But his heart softens: "In the hunted wounded shackled creature who held my hand in his, I only saw a man who had meant to be my benefactor." Pip's attempt to smuggle Magwitch out of the country fails, and the poor man is incarcerated and dies. His fortune now forfeit, Pip is penniless, his "great expectations" melted to nothing. Pip becomes a clerk in a trading firm, pays his debts, and marries Estella (the heiress to Miss Havisham's wealth). At least, that's the ending most editions print. In Dickens's original ending, Pip's "expectations" of love were also to be dashed: In the concluding moonlit scene, he reunites with Estella, only to realize his obsessive love for her is a thing of the past. She, in turn, mistakenly presumes he is married. They part, presumably forever.

The Films

All four feature-length adaptations ignore Dickens's original ending and follow instead the romanticized, albeit

unlikely reconciliation between Pip and Estella. Otherwise, the basic plot structure is retained. In the 1917 Paramount version, Jack Pickford and Louise Huff portray Pip and Estella; in the 1934 Universal adaptation, Phillips Holmes and Jane Wyatt; in the 1946 British production, John Mills and Valerie Hobson; and in the 1998 film, Ethan Hawke and Gwyneth Paltrow. Hampered by the restrictions of silence, the Paramount film drastically reduces the book's abundant roster of characters and incidents to a bare handful. The Universal film is in every respect an amplified production, and the convict scenes were shot on location off the south coast of England near Portsmouth and the Isle of Wight. David Lean's celebrated 1946 production, pronounced by film historian Anthony Slide as "the first adequate (and that is too small a word) screen adaptation of a Dickens work," remains the popular favorite of the group; and the 1998 version daringly transfers the story to modern times, its locations ranging from Florida's Gulf Coast to Manhattan's mean streets.

David Lean began shooting in September 1945 at Pinewood Studios, and the location work took place at Fort Darnet, on the Medway River in the Kent marshes. Cinematographer Guy Green won an Oscar for his superbly atmospheric photography. Scenarists Ronald Neame, Kay Walsh, and others trimmed the expansive novel into compact shape (reducing Uncle Pumblechook, Wemmick, and the Pocket family to minimal presences and eliminating altogether Trabb's boy and Mr. Wopsle). A host of secondary players brought vivid characterizations to Miss Havisham (Martita Hunt), Magwitch (Finlay Currie), Joe Gargery (Bernard Miles), and Jaggers (Francis L. Sullivan reprising his role from the 1934 film).

Acclaim was almost unanimous. "It does for Dickens about what *Henry V* did for Shakespeare," enthused James Agee; "that is, it indicates a sound method for translating him from print to film." Some recent commentators, however, offer a less positive evaluation, particularly concerning the film's upbeat ending, which allows the twice-blessed Pip not only to reconcile with the wealthy Estella, but also to keep Magwitch's fortune. This is a disastrous misstep, in the opinion of commentator Julian Moynahan: "[The script] wished to suggest that, as the song says, the best things in life are free. In this ending, Pip learns nothing or very little about the world and about himself. It was all, or nearly all, a matter of fool luck."

The success of this *Great Expectations* inspired a mini-revival of Dickens adaptations. Lean followed it up with *Oliver Twist* a year later; and Alberto Cavalcanti made a version of *Nicholas Nickleby* that same year. The newest version by director Alfonso Cuarón and writer Mitch Glazer makes, on the surface at least, a radical break from the Dickens original. The time period has been moved forward to the present day, and the locations have been moved to the Florida Gulf, where Pip (now "Finnegan," portrayed by Ethan Hawke) lives with his older sister and her husband (now "Joe Coleman"), and New York City,

Gwyneth Paltrow in Great Expectations, *directed by Alfonso Cuarón* (1998, U.S.A.; TWENTIETH CENTURY FOX)

where Finn will seek his fortune. Looking back upon the boy that was, Finn's narrative voice warns us: "This isn't the way things happened, it's the way I remember them happening."

One day on the beach the boy is surprised by an escaped convict (now "Walter Lustig," portrayed by Robert De Niro) who literally erupts from the surf. While trying to help Lustig escape by boat, Finn is overtaken by the Coast Guard. Lustig slips into the water, and Finn surreptitiously throws him a life preserver. A little later, a television broadcast reveals that Lustig has been recaptured and taken back to jail. Meanwhile, Finn is summoned by the mysterious Nora Dinsmoor (Anne Bancroft), who lives nearby in a moldering mansion alone with bitter memories of having been jilted 25 years before. Dinsmoor, in heavy makeup, spends her time prancing around the mansion to old phonograph renditions of dance music ("Chickiboom" she sings, periodically). She wants Finn to be a companion for her ward, Estella (Gwyneth Paltrow). "But don't fall in love with her," she warns not too subtly, "she'll break your heart."

Years pass and the two children grow up. Finn's trembling earnestness contrasts with Estella's detached and maddening ambivalence. An erstwhile painter, Finn finds in her a great subject and his first lover. The idyll is shattered when Estella suddenly departs for school. For the next several years, Finn abandons his painting and joins Joe in the fishing business.

Out of the blue one day a lawyer arrives with a fistful of money and an invitation for Finn to go to New York to work on a one-man art exhibition. Supposing his benefactor to be Miss Dinsmoor, Finn leaves for the Big City. He gradually gets his sea legs in the art world and, gifted with a luxurious, spacious studio, prepares his show. Into his life again comes Estella, rich, beautiful, and affianced to somebody else. They share a night of passion, but again she breaks his heart when she suddenly leaves to go off and marry her fiancée. The blow ruins his opening night success, and Finn returns home with a broken heart. Unexpectedly, Lustig reappears, almost unrecognizable in his fierce beard. Finn is startled, after a brief conversation, to realize that it was Lustig who had been his benefactor all along. But Lustig, obviously a con man or criminal of some sort, is again on the run. Before he and Finn can make their escape on the subway, Lustig is stabbed to death.

After spending some years in Paris, Finn returns to Joe Coleman's house on the Gulf. While visiting the abandoned Dinsmoor mansion (the old lady had died years before), he runs into Estella. She's divorced now and has a golden-haired little girl of her own. Estella wonders if Finn can ever forgive her. "Don't you know me by now?" he asks. Amidst the wheeling gulls, the reunited lovers clasp hands.

Despite the clever transformation to the modern settings and situations (aided by the superb photography of Emmanuel Lubezki and production design by Tony Burrough), Mitch Glazer's script is a hopeless morass of loathsome, self-indulgent, arty pretentiousness. None of the characters are in the least believable. Finn's perpetual whining inquiry, "Where's Estella?" grows exceedingly wearisome. (In the worst, most overwrought scenes in the film, we get images of a rainsoaked Finn desperately chasing a phantom Estella through the night streets, his pursuit accompanied on the music track by choral moanings and percussive combustions—the phoniest sort of contrived romanticism.) Estella's on-again, off-again moods are likewise annoying—now she rejects Finn, now she seduces him, now she runs away, now she strips off her clothes, now . . . well. And whatever happened to Dickens's scathing satiric view of Pip's conversion from a simple-hearted boy to a snob? Here, we're only told once that Finn is a snob (in the scene where he's embarrassed by Joe's unexpected appearance at his show opening), but it won't wash. The movie is too intent on showing him in a sympathetic light. This important, and ironic, aspect of his "coming of age" is lost in the process. Typical of the scathing reviews justly accorded the film is that of Owen Gleiberman of *Entertainment Weekly*, who called it "a fractured folly of extravagant art gestures, a Hollywood-cocktail-party version of literary updating."

In the face of this and so many other Dickens adaptations, it is perhaps churlish to remind ourselves that one of the great qualities of his work, indeed, the great thing, is the fierce vigor and metaphorical abundance of his prose. There are those, including Sergei Eisenstein, who rightly find "cinematic" elements and effects in his prose. Ironically, it is another thing to transfer those effects to the screen. Instead, what most scenarists seem to prefer are those elements less endemic to Dickens and a mere commonplace to a host of his contemporaries and imitators—the melodramatic, convoluted plots, the sentiment, and the picaresque characters. That may be saying a lot, but in Dickens' case it's not saying enough.

REFERENCES

Agee, James, *Agee on Film* (Grosset & Dunlap, 1969), 266–68; Chesterton, G.K., *Appreciations and Criticisms of the Works of Charles Dickens* (E.P. Dutton, 1911); Gleiberman, Owen, "What the Dickens?" *Entertainment Weekly*, January 30, 1998, 39–41; Moynahan, Julian, "Reading the Book, Seeing the Movie," in *The English Novel and the Movies*, ed. Michael Klein and Gillian Parker (Ungar, 1981), 143–54.

—J.C.T.

THE GREAT GATSBY (1924)

F. SCOTT FITZGERALD

The Great Gatsby (1926), U.S.A., directed by Herbert Brenon, adapted by Becky Gardiner and Elizabeth Meehan; Paramount.

The Great Gatsby (1949), U.S.A., directed by Elliott Nugent, adapted by Cyril Hare Hume and Richard Maibaum; Paramount.

The Great Gatsby (1974), U.S.A., directed by Jack Clayton, adapted by Francis Ford Coppola; Paramount.

The Novel

F. Scott Fitzgerald (1896–1940) had already established his reputation with two novels, *This Side of Paradise* (1920) and *The Beautiful and Damned* (1922), and a number of successful short stories when he began work on what would be his finest novel, *The Great Gatsby*, in 1922. It was drawn originally from Fitzgerald's boyhood memories of a friend whose social aspirations were impeded by his family's low economic status, and who tried to invent a more "suitable" background for his purposes. This character, one Rudolph Miller, eventually became the Jay Gatz of the novel, which was published in 1924.

The setting is New York City and Long Island during the 1920s, a time of jazz, popular fads, new wealth, and bootlegging. The eponymous hero, Jay Gatsby, is a rags-to-riches hero obsessed by his dream girl, Daisy, a woman with "a voice full of money." He settles in an estate in the relatively unfashionable West Egg, Long Island (patterned after Fitzgerald's home in Great Neck), where he meets the book's narrator, Nick Carraway. He entreats Nick to introduce him to Daisy Buchanan, a socialite who lives with her husband Tom in the more exclusive East Egg. Nick learns that Jay and Daisy had once been lovers and

that Jay is anxious to resume the romance. But Daisy's husband, stockbroker Tom Buchanan, learns of the affair and reveals to her that her former lover is nothing more than a shady bootlegger named Jay Gatz. Daisy is a snob if nothing else, and although she is willing to pursue the affair clandestinely, she will never leave her husband outright for a mere social-climbing gangster. Yet Gatsby remains loyal to the end when he shields Daisy from culpability in a hit-and-run killing. He pays with his life for his gallant gesture, and at the end Nick Carraway, about to return to the Midwest a disillusioned man, says that compared to the ruthlessly self-centered Buchanans, Jay is "worth the whole damn bunch put together."

The character of Gatsby is the embodiment of the failed American dream. He pursues his goal of romantic success—embodied in Daisy and the metaphoric image of the green light at the end of her pier—convinced that money and the display of wealth will bring it about. He never does understand that the real dream—his emotional fulfillment with Daisy—has already escaped him. As Fitzgerald once said, "America's great promise is that

something's going to happen, but it never does. America is the moon that never rose." Yet Gatsby alone among the characters in the novel—despite his disreputable past—is an innocent, a romantic hero who has dared to expect more from the American dream of opportunity than his more cynical friends.

The Films

Three movie adaptations have been made by Paramount. Each in its own way is remarkably faithful to the original novel. Warner Baxter played Gatsby and Lois Wilson was Daisy in the 1926 version. Although reviews at the time suggest the script hewed closely to the novel, Gatsby's shady past was omitted and much of the action was purportedly slowed down by wordy intertitles. Fitzgerald was in Europe at the time of the film's release, and its success may have influenced his decision the next year to go to Hollywood for the first time.

Fitzgerald had been dead for nine years when Alan Ladd portrayed Gatsby and Betty Field played Daisy in the

Alan Ladd (seated right) in The Great Gatsby, *directed by Elliott Nugent* (1949, U.S.A.; PARAMOUNT/PRINT AND PICTURE COLLECTION, FREE LIBRARY OF PHILADELPHIA)

Mia Farrow and Robert Redford in The Great Gatsby, *directed by Jack Clayton* (1974, U.S.A.; NEWDON-PARAMOUNT/PRINT AND PICTURE COLLECTION, FREE LIBRARY OF PHILADELPHIA)

1949 film version. It is typical of the noir-style films of the day in that the action is fast and flashbacks are employed—in this case to convey Gatsby's gangster past. Doubtless Alan Ladd's "tough guy" image contributed to a tougher Gatsby than is seen in the novel or in any of the other screen versions. (A scene is even added where Gatsby beats up an unruly guest at a garden party!) The action generally stays close to the novel, and the most important central symbols are retained—Daisy's green pier light, the oculist's billboard, and the location of the Valley of Ashes. Commentators such as film historian Lionel Godfrey claim this to be the best of the Gatsby adaptations and one of Ladd's most creditable performances.

The 1974 version, the first in color, seemed to have everything going for it. British director Jack Clayton had established himself as one of the most intelligent young directors of the day, and had recently made two masterpieces, *The Innocents* (1961), an adaptation of Henry James' *The Turn of the Screw*, and *Room at the Top* (1958), a trenchant satire on contemporary English life. Scenarist Francis Ford Coppola had impressive credentials of his own as the director of *The Conversation* (1971) and *The Godfather* (1971). And the stellar cast included Robert Redford as Gatsby, Mia Farrow as Daisy, Sam Waterston as Nick, and Bruce Dern as Tom Buchanan. Moreover, the movie was a sumptuous, even extravagant production. Budgeted at $6.5 million, the exteriors were shot in Newport, Rhode Island, and the rest was shot in England at Elstree Studios. The

musical score by Nelson Riddle received an Academy Award, and Theoni V. Aldredge's lavish costumes created something of a fashion fad at the time.

The movie emerged as one of the most faithful adaptations ever made of a novel. The changes were relatively few, including the omission of the figure of Dan Cody, Jay Gatz's original mentor, the alteration of the manner in which Nick first encounters Gatsby, and the introduction of several image motifs, like the ring Gatsby gives to Daisy and ends up wearing himself.

However, the tight structure and compact length of the novel is replaced with a sluggish, languorously paced story that is nearly an hour longer than the 1949 version. The sense of class distinctions between the inhabitants of West Egg and East Egg is blurred. Other problems can be traced to the casting. Mia Farrow was not convincing as a Southerner, Bruce Dern was not the rugged type necessary for Tom Buchanan, and Redford lacked the roughneck underside that Ladd had given the part. Howard da Silva, who played the character of Meyer Wolfsheim, summed up the general reaction when he declared, "As much as I admired Redford as an actor, I felt he could never play a man from the opposite side of the tracks."

The biggest problem with the film, however—and with the two versions that preceded it—is its lack of a clear and consistent point of view. Here is a case where mere fidelity between novel and film is not enough to guarantee a successful adaptation. The film medium inherently possesses an omniscient storytelling voice, while novels like this one relate the action and personalities through a single character's eyes and sensibilities—in this case, Nick Carraway. In the novel, Gatsby, as seen through Carraway, is a multifaceted, sometimes contradictory character—by turns an underworld gangster, social climber, vulgar liar, and selfless hero. He remains elusive, not because he is so complicated necessarily, but because Nick's view of him is constantly changing, just as Nick himself is changing. It is a crucial point because Nick's point of view enriches our sense of characters and events, at once interpreting them and distancing us from them. But in the film there is no such constant interpretive filter through which we perceive things. Even though there is an attempt to establish Nick as the storyteller—beginning and ending with him, and giving him more screen time than Gatsby—the movie nonetheless fails to *maintain* his perspective on events. Nick is absent for long periods of time so that crucial moments in the action—especially the romantic scenes between Gatsby and Daisy and the death of Gatsby in the swimming pool—are not witnessed and interpreted by him. We see Gatsby all too objectively and are forced to accept events as literal—and he seems dull and uninteresting as a result. As Joy Gould Boyum points out in her book, *Fiction into Film*, "deprived of his mystery and distance, Gatsby has a reality his sketchy character simply cannot hold, and under the film's scrutiny, his obsession is reduced from tragedy to mere sentimentality."

Considering the extent to which this novel and other stories by Fitzgerald continue to reach the movies, it is ironic that Fitzgerald himself had so much difficulty placing his own work on the screen. Indeed, despite his years in Hollywood and his work on many scripts, he garnered only one screen credit, an adaptation in 1938 of another author's work, Erich Remarque's *Three Comrades*. In a 1936 essay Fitzgerald expressed serious reservations about the adaptive process, declaring that because the movies subordinated words to images they could depict only the tritest thought and most obvious emotions of their literary sources. Eventually, he predicted, "the talkies would make even the best-selling novelist as archaic as silent pictures."

REFERENCES

Dardis, Tom, *Some Time in the Sun* (Charles Scribner's Sons, 1986); Boyum, Joy Gould, *Double Exposure: Fiction into Film* (New American Library, 1985); Godfrey, Lionel, "It Wasn't Like That in the Book," *Films and Filming*, April 1967; Phillips, Gene D., *Fiction, Film, and F. Scott Fitzgerald* (Loyola University Press, 1986).

—*J.C.T.*

THE GRIFTERS (1963)

JIM THOMPSON

The Grifters (1990), U.S.A., directed by Stephen Frears, adapted by Donald E. Westlake; Cineplex Odeon/Miramax Films.

The Novel

Like the other work of crime writer Jim Thompson, *The Grifters* is unrelenting in its bleak vision of human nature. It chronicles the last few months in the life of Roy Dillon, a short-con operator, who is beginning to feel the effects of his chosen lifestyle and is considering getting off the grift.

Roy is compelled to face his complex love-hate relationship with his mother Lilly when she makes an unwelcome visit after a seven-year absence and saves his life following a run-in with an unhappy mark. Lilly attempts to break up Roy and his tough-as-nails girlfriend Moira, without success, by encouraging his attraction to his nurse, Carol Roberg. Though Roy seduces Carol, her innocence takes him by surprise, bringing a painful and confusing ending to their relationship. Moira invites Roy to be her partner in the big con, and when he refuses, she flies into a rage, accusing him of an incestuous relationship with his mother.

Looking forward to having a stable life, Roy accepts the job of sales manager at the company he has been using as a front. Later, when he hears that his mother has committed suicide, he fears that Moira has murdered her, but when he goes to Tucson to claim the body, he discovers it is Moira who is dead. Lilly, very much alive and on the run, attempts to steal Roy's money to finance a new life. He tries to prevent her from taking it, but Lilly, aware of his attraction to her, starts to seduce him. When she hits him with her handbag as he takes a drink of water, the glass breaks and cuts his throat. After a brief moment of despair, Lilly takes the money and escapes from the apartment.

The Film

Stephen Frears's film garnered four Academy Award nominations, including best direction and best adapted screenplay for Donald Westlake, a mystery writer in his own right. While the plot of the film remains very close to that of the novel, the emphasis is less on Roy and more on Lilly Dillon's ability to survive.

The film immediately sets up a parallel between the three swindlers—Lilly Dillon (Anjelica Huston), Roy Dillon (John Cusack), and Moira Langtry (Annette Bening)—by crosscutting between them and putting them on a split screen. Thompson's focus is clearly on Roy as the only one of the three who stands any chance of redemption. In the film, however, none of them are redeemable. In the novel, for example, Roy's guilty seduction of Carol introduces a moral dimension to the story, marking him as a man who does distinguish between innocence and experience, a distinction not made in the film.

Though Lilly's flight and Moira's death follow the novel, the suspense suffers. In the novel, the reader knows only that Lilly has disappeared, discovering along with Roy that the murder victim has no burn on her hand. The only suspense in the film is waiting to find out who is killed when the gun goes off.

REFERENCES

Johnson, William, "The Grifters," *Film Quarterly* 45, no. 1 (1991): 33–37; McCauley, Michael J., *Sleep with the Devil* (Mysterious Press/Warner, 1991); McGilligan, Pat, "Donald Westlake and *The Grifters*," *Sight and Sound* 59, no. 4 (1990): 234–36.

—*J.S.H.*

EL GRINGO VIEJO (1985)

See THE OLD GRINGO.

THE HAMLET (1940)

WILLIAM FAULKNER

The Long Hot Summer (1958), U.S.A., directed by Martin Ritt, adapted by Irving Ravetch/Harriet Frank Jr.; Twentieth Century-Fox.

The Novel

Throughout the 1930s William Faulkner intermittently composed short stories about a crafty, ambitious young Southerner named Flem Snopes. He did so with a view to weaving these tales eventually into the fabric of a novel. Finally, in 1940 Faulkner published *The Hamlet*, which incorporated these earlier episodes with additional material, in order to round out the story.

The Hamlet traces Flem Snopes's efforts to rise above his status as poor white trash. He begins his climb up the ladder of success by working as a clerk in a general store in the village hamlet of Frenchman's Bend. The store is owned by Will Varner, a local businessman and landowner. Flem's position in Varner's store allows him to take his first steps toward becoming the old man's closest business associate. He has accomplished this feat by the conclusion of the novel, and has slyly maneuvered Will's daughter Eula into marrying him in the bargain.

Perhaps because *The Hamlet* began its creative life as a series of short stories, some literary critics felt that the novel lacked a strong sense of unity. Indeed, one reviewer termed the book a collection of episodes, strung together like beads on a string.

The Film

The film version of *The Hamlet* was entitled *The Long Hot Summer* (1958). Oddly enough, it was probably the novel's episodic narrative structure—which literary critics had decried when it came out—that made *The Hamlet* easily adaptable for film. Several incidents in the novel, some of which had been published separately as short stories before their inclusion in *The Hamlet*, constitute self-contained units. The screenwriters therefore were able simply to pick the episodes they judged screenworthy and drop the rest; in this manner they could develop to their fullest dramatic potential those incidents they did retain. The scriptwriters then adroitly placed the episodes lifted from the novel within an overall narrative framework of their own devising.

In *The Long Hot Summer* the central character is renamed Ben Quick (Paul Newman). Eula Varner is not the daughter of Will Varner (Orson Welles) in the film, but his daughter-in-law, the wife of his son Jody. Therefore, it is for Will's daughter Clara (Joanne Woodward) that Ben sets his cap. Will is impressed by the manner in which the aggressive, attractive young man manages his general store, and he urges Clara to marry him. Ben at first welcomes Will's active support of his campaign for Clara. But he finally tells her that she must be allowed to reach her own decision about whom she wants to marry. Clara, in turn, chooses Ben on her own initiative—and not because her father has sought to bully her into accepting him.

Obviously the movie's Ben Quick turns out to be a much better human being than the novel's Flem Snopes. Flem willingly conspires with Will to pressure Eula into

marrying him. Unlike Flem, Ben is capable of seeing the error of his ways and insists that Clara accept him on her own terms. Hence, he deserves to win Clara at the final fade-out of this highly entertaining film. Little wonder that the movie was a huge success, given the spirited direction of Martin Ritt and the appealing screenplay by Ravetch and Frank.

REFERENCES

Kael, Pauline, *I Lost It at the Movies* (Boyars, 1994); McGilligan, Pat, "Ritt Large: An Interview with Martin Ritt," *Film Comment* (January–February 1986); Quirk, Lawrence, *The Films of Paul Newman* (Citadel, 1976).

—G.D.P.

THE HANDMAID'S TALE (1985)

MARGARET ATWOOD

The Handmaid's Tale (1990), U.S.A., directed by Volker Schlöndorff, adapted by Harold Pinter; Cinecom.

The Novel

Published in 1985, the sixth novel by Canadian author Margaret Atwood became a quick best-seller. It drew mostly favorable reviews in which it was frequently compared to Orwell's *1984* or Burgess's *A Clockwork Orange*. The book's suggestive parallels with the contemporary growth of far-right political movements in the United States prompted many feminists to encourage the use of the novel as a tool for consciousness-raising. It has since become popular as a supplementary text in political science, sociology, and women's studies university courses.

The story is narrated in present tense by its main character, Offred. Offred (a patronymic describing ownership, "of Fred") is a "handmaid" in a near-future, post-revolutionary version of the United States, the Republic of Gilead. Gilead is an ultra-right martial state built primarily around the repression of women and nonwhites. Because of consistent ecological degradation, most of the populace has been rendered infertile. In this environment, those women still able to conceive, the handmaids, become the reproductive vessels of powerful families. Offred is a handmaid assigned to a high-ranking military commander. She tells her story from the point of her capture in a border-crossing attempt, through her stay at a handmaid indoctrination center, her assignment to "the Commander" (wherein the bulk of the narrative occurs), and her eventual flight via the resistance underground.

The Film

Harold Pinter, in his screenplay, takes a much more direct approach to the narrative than Atwood. Where the narra-

tor of the novel never states her real name, the film clearly labels her as "Kate." So too, the commander's wife, only hesitantly associated in the novel by Offred with a Gileadean propaganda singer, is made to be exactly *that* singer, Serena Joy, in the film. Pinter also collapses the chronology dramatically. While he leaves the passage of time uncertain, the endpoints seem about a year apart; they are at least three or four for Atwood.

Director Volker Schlöndorff follows Pinter's lead in whittling down the story to the concrete. Because of the novel's first-person narration, large sections of text are made up of Offred's thoughts. Curiously, Pinter and Schlöndorff opt not to use any narration (except, ironically, at the end, which is different, and far less open, than that of the novel). Perhaps as a result of the loss of subtlety forced by the screenplay, Schlöndorff shoots his film in a very conservative, almost pedestrian, style, a point and shoot representation of the novel's manifest story.

The overarching problem with the film is its inability to carry over the subtleties and uncertainties of the novel. This is a movie so adamant on underlining its feminism that it aspires to frighten rather than stimulate thought. As Stuart Klawans notes, "The result is a net loss of a few dozen layers of irony." Schlöndorff and Pinter fail to compensate for that loss or to bring out Atwood's more cinematic possibilities.

REFERENCES

Baughman, Cynthia, "The Handmaid's Tale," *The Pinter Review: Annual Essays* (1990), 92–96; Epstein, Grace, "Nothing to Fight For: Repression of the Romance Plot in Harold Pinter's Screenplay for *The Handmaid's Tale*," *Pinter Review: Annual Essays* (1992/93), 54–60; Klawans, Stuart, "The Handmaid's Tale," *The Nation*, April 2, 1990, 466–67.

—S.C.M.

HANNIBAL (2000)

THOMAS HARRIS

Hannibal (2001), U.S.A., directed by Ridley Scott, adapted by David Mamet and Steven Zallian; MGM.

The Novel

This sequel to *The Silence of the Lambs*, written a decade later, was promoted by the success of Jonathan Demme's film adaptation of that novel, brilliantly adapted by Ted Tally. The action is set seven years later. Having long since graduated from the FBI academy, Clarice gets notorious because of her involvement in a drug bust, since she shoots an AIDS-infected drug diva who has a babe in arms but is also armed and dangerous. It begins to look as though Clarice will be sacrificed to the press as a public relations ploy cooked up by an unfriendly Justice Department bureaucrat named Paul Krendler, who has it

in for Clarice. Reading about her problem, Hannibal Lecter sends her a sympathy card. This raises and later answers the question of what Hannibal "the cannibal" has been up to since his escape from prison.

Revenge drives the plot as surely as greed. One of Lecter's former patients, a very wealthy pedophile named Mason Verger, is Lecter's sole surviving (but hideously mutilated) victim, though he lives miserably under medical supervision. Lecter got Verger so whacked out on drugs that he cut off his face and fed it to the dogs. For revenge, Verger wants to feed Lecter to the pigs. Verger is using the family fortune to finance his revenge and to locate Lecter, who is now living in Italy as an art historian and supervising a library in Florence. (In the novel Lecter had plastic surgery to alter his face, but in the film, he obviously has to look like Anthony Hopkins, whose landmark performance in *The Silence of the Lambs* was the main motive for the sequel.)

Lecter's library predecessor disappeared under mysterious circumstances. Lecter is under investigation by Italian police inspector Pazzi, who is decidedly interested in the $3 million bounty Verger has placed on Lecter. (The problem with this Italian police procedural is that there is no place in it for Clarice.) When faced with the structural peculiarities of the story, reviewer Stephen Hunter wrote, "It feels at times like the first half of one story and the second half of another." But Pazzi is no match for Lecter, who captures and guts him. Thereafter Lecter escapes back to America from Italy, and the plot is jumpstarted, this time in nearer proximity to Clarice. Lecter then connects with Clarice but is captured by Verger's goons. He is rescued, however, by Clarice, who tracks the killer to Verger's estate. Verger is double-crossed by his twisted lesbian sister Margot, a character dropped from the film adaptation.

In the novel Clarice gets rather too close to Lecter, in a cannibal catharsis that involves the consumption of Krendler's brains. After this strange and grotesque feast, Clarice and Lecter elope to Buenos Aires. If the public wanted a cannibal celebration, then Harris was willing to oblige. As one reviewer wrote after reading the novel, "I feel like I've been mugged." Critic Stephen Hunter skewered the novel as follows: "Where *Silence* was rooted in reality and had a detail-rich documentary feel that pushed its creepiness content off the charts while giving it a moral center, *Hannibal* is Gothic opera with black-comic overtones, set in a world utterly disconnected from our own, a world without a center."

The Film

The film ran into trouble from the start, when Jodie Foster understandably refused to play Clarice Starling in the sequel. Of course, Anthony Hopkins, who once told television interviewer Charlie Rose that he had "touched the ceiling" in *The Silence of the Lambs*, came back to play Hannibal Lecter, but, arguably, Foster "owned" the Clarice role just as much as Hopkins "owned" the Lecter role. The

critical and financial success of *Silence of the Lambs* also was due to director Jonathan Demme and screenwriter Ted Talley, neither of whom was on board for the sequel, which starred Julianne Moore as Clarice. Giancarlo Giannini played Inspector Pazzi (who Hopkins's Lecter turns into a "Patsy"); Ray Liotta played Paul Krendler; Gary Oldman played Mason Verger (under lots of latex); Frankie Faison was standing by to reprise his *Silence of the Lambs* role as Barney, Lecter's jailer, who now makes money in the sequel by selling Lecter memorabilia. Despite the involvement of minimal talent from the original success, expectations were high, and in fact the sequel grossed more than $165 million, topping the earnings of *The Silence of the Lambs*. It was clearly a gross success, in every sense.

The screenplay was changed and the plot made less preposterous. As Mike Clark noted in his review, screenwriters Mamet and Zallian "wisely jettisoned the book's absurdly dreadful final pages." Verger was not fed to the pigs in the sequel, for example. Clarice does not elope to South America with Lecter. Instead, she contacts the FBI and works for Lecter's capture, but he escapes again, presumably waiting for the next sequel, although somewhat mutilated. Clark summarized the failures as follows: "Hopkins' Hannibal is no longer mysterious, Clarice is no longer vulnerable, and the overextended Florence scenes dash any hopes of early momentum." Those disappointed by this sequel would be made happier in 2003 when the Thomas Harris "prequel" to *The Silence of the Lambs, The Red Dragon*, was adapted more faithfully and successfully to film.

REFERENCES

Clark, Mike, "Tasteless 'Hannibal' Lacks Old Bite," *USA Today*, February 9, 2001, E6; Friend, Tad, "Acquired Tastes," *The New Yorker*, July 5, 1999, 81–84; Gottlieb, Annie, "Free-Range Rude," *The Nation*, July 19, 1999, 28–30; Hunter, Stephen, "'Lamb' Leftovers," *Washington Post*, February 9, 2001, C1, C5.

—*J.M. Welsh*

THE HARDER THEY FALL (1947)

BUDD SCHULBERG

The Harder They Fall (1956), U.S.A., directed by Mark Robson, adapted by Philip Yordan; Columbia.

The Novel

Based on the exploitation of thirties boxer Primo Carnera, Schulberg's novel is a devastating attack on the criminal practices contaminating a once-noble sport. But, as the opening line of Milton's *Samson Agonistes* states, audiences are equally as guilty as the racketeers who organize the fights: "I sorrow'd at his captive state, but minded not to be absent at that spectacle."

In the novel, mobster Nick Latka hires press agent Eddie Lewis to promote the newly acquired Argentinian

fighter, Toro Molina, in a series of fixed fights. Gradually becoming estranged from his girlfriend Beth, Eddie becomes deeply compromised within the corrupt fight game. Nick arranges a number of fights for Toro, building him up to championship status, until the fighter accidentally kills an opponent. After losing to another contender in New York, the hapless Argentinian finds that he has not acquired the money he had hoped to return home with, and so faces further exploitation in the ring.

The Film

Scenarist Philip Yordan often acted as a "front" for blacklisted writers during the period this film was made, so his actual authorship of this screenplay is a matter of debate. In any case, the movie sanitized the (now-married) character of Eddie (Humphrey Bogart) by transforming him into the noble hero who finally sees the light: He gives Toro $26,000 of his share of the profits and gets him onto a plane to Argentina, thus sparing Toro any further degradation. Eddie then resolves to write a series of articles exposing the boxing racket, vowing to get the sport outlawed "if it takes an Act of Congress to do it."

Superbly filmed in classic film noir style by Burnett Guffey, *The Harder They Fall* has affinities with other social-critique movies of the fifties, such as *Blackboard Jungle* and *Twelve Angry Men*. Apart from accommodation to Legion of Decency standards, it is a good adaptation of Schulberg's caustic vision, especially in its casting of real ex-fighters such as Max Baer and Jersey Joe Walcott in cameo roles. However, the movie really needed the novel's parallel between Eddie's moral fall and Toro's physical descent. While the novel's ending equates Eddie with the prostitute he sleeps with and reveals the contamination of

Humphrey Bogart and Mike Lane in The Harder They Fall, *directed by Mark Robson* (1956, U.S.A.; COLUMBIA/ THEATRE COLLECTION, FREE LIBRARY OF PHILADELPHIA)

the narrator (à la *All the King's Men*), the movie opts for the traditional Hollywood happy ending, as Eddie begins his crusade against the system that has dominated him throughout the movie.

REFERENCES

Fine, Richard, "Budd Schulberg," *Dictionary of Literary Biography*, vol. 6 (Gale Research Company, 1980).

—*T.W.*

HARRY POTTER AND THE SORCERER'S STONE (1997)

J.K. ROWLING

Harry Potter and the Sorcerer's Stone (U.S.A./U.K.), 2001, directed by Chris Columbus, adapted by Steve Kloves; Warner Bros.

The Novel

When J.K. Rowling's first novel, *Harry Potter and the Sorcerer's Stone*, was published in America in 1997, the author was an out-of-work single mother living in Edinburgh, Scotland. Seven years and four more Potter novels later, Rowling had gone from living on the dole to a personal worth of nearly $450 million (surpassing even the Queen, who is worth $400 million). Some have credited Rowling with inspiring a video-game-and-TV-addled generation to rediscover the joys of the written word. Others have attacked her as little more than an untalented rip-off artist. Still, the numbers speak for themselves. To date, Rowling's novels have been translated into 55 languages, published in 200 countries, and are the basis of a series of mega-budgeted Hollywood blockbusters. All of this from the adventures of an awkward young student wizard named Harry Potter who, Rowling claims, simply popped into her head one day, fully formed.

Sorcerer's Stone, the first of a projected series of seven novels (to date five have been published), begins in the grand tradition of children's literature, with the death of infant Harry's parents. Sent to live with uncaring relatives, the odious Dursley family, Harry's life is one of misery and servitude until deliverance comes on his 11th birthday in the form of Hagrid, a scruffy giant who informs Harry that not only were Harry's late parents rich, famous, and powerful wizards, but that Harry himself has been accepted to attend Hogwarts School of Witchcraft and Wizardry. Soon Harry is swept up into an enchanting new world of magic and mystery.

The Dursleys have deliberately raised Harry to be ignorant of this world, and thus Harry serves as the reader's surrogate in his confrontation with a world of wonders. Nonmagical folk such as the Dursleys, Harry learns, are referred to as *Muggles*, and the wizarding community takes great pains to keep its existence a secret from the wider

Muggle world. There are factions within the wizarding world as well. Hagrid informs Harry that there was once a very dark wizard named Lord Voldemort who led an army of evil witches and wizards in an attempt to rule the magical community and to eliminate the Muggles once and for all. It is at this point in his story that Hagrid informs Harry that Voldemort was the man who killed his parents. In fact Voldemort also tried to kill Harry himself, only to have his spell backfire. No one, Hagrid says, knows for sure what happened to Voldemort after that, if he is alive or dead. Harry, of course, has no memory of his encounter with the dark wizard, but he bears a reminder of it on his forehead in the form of a lightning-bolt-shaped scar.

When Harry arrives at Hogwarts he learns that his scar (and the story of how he got it) makes him something of a celebrity. Hogwarts is based upon the English public school system, with the student body divided into four houses: Gryffindor, known for the courage of its students; Hufflepuff, honest and hardworking; Ravenclaw, extremely clever; and Slytherin, ambitious, sly, and proud. Harry is chosen for Gryffindor, where he soon meets two fellow first-year students destined to become his best friends. The first is Ron Weasley, a red-headed boy from a wizarding family renowned for their poverty and carrot-tops. The second is Hermione Granger, daughter of Muggle parents and an extremely serious student who tries desperately to get Harry and Ron to do their homework and obey the rules and avoid the mischief to which they seem so prone.

At Hogwarts, Harry begins to know true happiness for the first time. His classes, such as Potions, Transfiguration, and Charms, are exciting and challenging. Harry, Ron, Hermione, and Hagrid (who works as the school's groundskeeper) soon forge a tight bond. Harry even begins to like some of his teachers, especially the kindly old Headmaster, Albus Dumbledore, who seems to take special interest in Harry. Best of all, though, is Quidditch, a wizarding game played on flying broomsticks at dangerous heights and speeds. Harry is a natural at the game and is soon made Seeker (the toughest and most important position) on the Gryffindor house team.

Still, life at Hogwarts is not perfect. His years of living as a Muggle have left Harry with a serious case of culture shock and he must constantly strive to keep up with his classes as well as with the ins and outs of life among magical folk. Also, there is one teacher, Potions Master Severus Snape, who delights in making Harry's life as miserable as possible. Aiding Snape in this endeavor is Draco Malfoy, a Slytherin first-year student from a wealthy family that was rumored to be among Voldemort's most loyal supporters. Malfoy is a snob who looks down his nose at anyone who is not, in fact, him.

Ostensibly, *Sorcerer's Stone* is designed as a mystery. Harry, Ron, and Hermione stumble upon a plot to steal the titular stone, a powerful magical artifact that endows its bearer with awesome powers. Among these is the power to restore any extremely ill or injured wizard to full power and potency. Harry and his friends learn that the stone has been secretly moved to Hogwarts, where it is protected by a series of powerful spells performed by each member of the faculty. Harry begins to fear that Lord Voldemort must be behind the plot, suspecting that he hopes to use the stone to recover from his encounter with Harry and renew his quest for power. Since Voldemort is likely near death, Harry, Ron, and Hermione surmise that he must be working with an accomplice. The three Gryffindors set out to foil the plot and uncover the traitor. This quest leads them on a lively adventure featuring unicorns and angry centaurs, and finally down into the dungeons beneath the school where they must use their wits and overcome their weaknesses to best the magical obstacles set up by their professors. It would be unfair to reveal all of the novel's secrets. Suffice it to say that Harry finally confronts Voldemort's accomplice, who is possessed by the spirit of the dark lord. Harry is able to win this battle through his own innate goodness and the lingering effects of his mother's love.

The story ends on a note of celebration. Based upon the heroism of Harry and his friends, Gryffindor wins the coveted house cup, crushing the hopes of Malfoy and his fellow Slytherins. Harry leaves for home in a bittersweet mood. He is unhappy about having to spend the summer with the Dursleys, but he has the memories of his friends and their adventure, as well as the prospect of seeing them in the fall, to help him over the rough spots.

As the first in a series, *Sorcerer's Stone*'s primary function is to set up the characters, situations, and themes that will see further development over the course of the following six volumes. As such, the main story is somewhat thin (perceptive readers should be able to figure out the identity of Voldemort's ally well ahead of Harry and company). The main strength of the book is in the imaginary world Rowling has devised for her continuing story. Rich in detail and color as well as abundant humor, Harry's world is enchanting and believable in a way that many novels for adults are not. The characters are well drawn, with complex emotions and motivations dictating their actions. In Dumbledore, Ron, Hermione, and Hagrid, Harry finds acceptance and love unlike any he has ever known. Yet Rowling is careful to sow the seeds of future strife and conflict. For example, Ron's envy of Harry's wealth, lightly hinted at here, becomes a major sticking point in the fourth volume (*Harry Potter and the Goblet of Fire*), nearly tearing the friends apart. As of 2004, Rowling's saga is still two volumes from completion. However, it is easy to believe that novelist/critic Stephen King may be correct when he declares that the series "will indeed stand time's test and wind up on the shelf where only the best are kept; I think Harry will take his place with Alice, Huck, Frodo, and Dorothy, and this is one series not just for the decade, but for the ages."

The Film

The phenomenal success of Rowling's novels made film adaptations inevitable. Rights to the series were picked up

by Warner Brothers Studios, whose executives must have felt like lottery winners as they watched Pottermania grow with each successive novel. The first major question was who would be chosen to direct the project. The Hollywood trades and the Internet were filled with speculation about such names as Tim Burton, Ridley Scott, and Terry Gilliam. For some time, however, the rumored front-runner was Steven Spielberg, the most powerful name in Hollywood. With its young protagonist and magical elements, the project had all the earmarks of a perfect project for the maker of *E.T.: The Extra-Terrestrial.* Yet Internet gossip sites and chat rooms were soon aflame with the rumor that Rowling, whose contract allows her an immense amount of creative control, had vetoed Spielberg herself. According to these rumors, Spielberg had wanted to combine elements of the first three volumes into one film, while Rowling insisted on one film for each novel. Also, Spielberg is said to have wanted to cast the young American actor Haley Joel Osment as Harry. Understandably, Rowling insisted that Harry, one of recent British literature's most famous characters, could be played only by a Briton. Whatever the actual facts of the case may be, when the dust settled it was announced that American filmmaker Chris Columbus (*Home Alone, Bicentennial Man*) would helm the project based on a screenplay adaptation by writer-director Steve Kloves (*The Fabulous Baker Boys, Wonder Boys*).

Columbus's first step was casting. The major adult roles were filled by a number of the biggest names in British cinema. Veteran actor Richard Harris took the role of Dumbledore on the advice of his granddaughter, who informed him that if he did not play the part she would never speak to him again. Robbie Coltrane was hired to play Hagrid, reportedly to Rowling's immense delight. Comedic actress Julie Walters agreed to play the minor role of Ron's mother in the film, because the character gains importance in the sequels, becoming a kind of surrogate mother to Harry. Alan Rickman played the nasty Professor Snape, while Dame Maggie Smith assumed the role of the stern but caring Minerva McGonagall, Professor of Transfiguration. This trend of casting big-name actors as Hogwarts faculty has continued in the subsequent films, with Kenneth Branagh, Emma Thompson, Gary Oldman, and Timothy Spall agreeing to join the saga. In this sense the series can be viewed as a British equivalent of America's *Batman* series, in which name stars often appear as villains. Everyone, it seems, wants to be part of the phenomenon.

For the major roles of Harry, Ron, and Hermione, the production launched a huge cattle call in England. Thousands of young hopefuls auditioned to play their heroes on screen. Eleven-year old Rupert Grint was selected to play Ron Weasley and young Emma Watson won the role of Hermione. Both were making their big-screen debuts. The big winner, however, was Daniel Radcliffe, who beat out all comers to play the coveted title role. Radcliffe's only major previous role had been as David Copperfield in a television adaptation of Dickens's novel. He had also appeared in the film *The Tailor of Panama.* All three young actors played their roles with energy and skill, bringing Rowling's famed trio alive for filmgoers.

Columbus also surrounded himself with a first-class production company. Acclaimed cinematographer John Seale lensed the adaptation, while Oscar-winning composer John Williams (a veteran of numerous Spielberg and Columbus films) composed the sweeping score. Stuart Craig handled the production design, creating vivid sets for such fan-favorite locations as Hogwarts and Diagon Alley (the wizards' shopping district). Together this team strove to visualize the numerous visual details that fill Rowling's novel. As critic Roger Ebert noted in the *Chicago Sun-Times*, the production design and cinematography in the Hogwarts sequences alone combine to give the film the "feeling of an atmospheric book illustration." Columbus and his staff created what may be one of the most faithful novel-to-film adaptations of all time. Every major scene and set piece from the book is here, and much of the dialogue is taken directly from Rowling's work.

The film begins as 11-year-old Harry Potter emerges from his humble room below the stairs to find that his aunt and uncle have been hiding a secret from him: His real parents were wizards defeated by the dreaded dark lord Voldemort. Harry, miraculously spared that fate, had escaped with a mysterious lightning-bolt scar on his forehead. Whisked away by the fiercely bearded Hagrid to the Hogwarts School of Witchcraft and Wizardry, Harry quickly learns that he is destined to do great things. But first, he must select the proper wand—or, rather, it must select *him*—and master his Nimbus 2000 broom and learn the game of Quidditch and pass his various courses in Potions and Spells and such. With his new friends, Ron and Hermione, he manages to encounter all manner of frights and mysteries—like the Sorcerer's Stone, which lies hidden in the bowels of the school, a gigantic troll, an encounter in the dark forest with Voldemort, a deadly game of chess, and a final grapple with Voldemort. Having survived all this—and having watched his house, Gryffindor, emerge first in the school competition—he departs for the summer, back to the humdrum world of his aunt and uncle and the rest of the Muggles.

Perhaps unsurprisingly, when the film was released in November 2001 it met with great box-office success. Children and fans of all ages lined up again and again to see their favorite story given the glossy Hollywood treatment. The critics, however, were more divided in their appraisal of the film. Ebert wrote, "During *Harry Potter and the Sorcerer's Stone*, I was pretty sure I was watching a classic, one that will be around for a long time, and make many generations of fans." Elvis Mitchell of the *New York Times*, on the other hand, denounced the film as "*Young Sherlock Holmes* as written by C.S. Lewis from a story by Roald Dahl." It is interesting to note that critical opinions on the film seem to mirror those on the book. As previously noted, Stephen King echoes Ebert in his belief that the book (and the series as a whole) will be remembered for

decades to come. Yet Yale literature professor and self-appointed protector of the canon Harold Bloom has decried Rowling and her work. "The writing," he feels, "was dreadful; the book was terrible . . . Rowling's mind is so governed by cliches and dead metaphors that she has no other style of writing."

Whatever one feels about the books and films, the phenomenon is real enough. In 2003 Rowling announced that she was finally going to publish the fifth volume in the series, *Harry Potter and the Order of the Phoenix*. This announcement immediately raised the stock price of her American publisher, Scholastic. Columbus stayed on to direct the second film adaptation, *Harry Potter and the Chamber of Secrets* (Warner Bros., 2002), before turning over the reins to Mexican director Alfonso Cuarón (*The Little Princess, Y Tu Mamá También*) for the third film, *Harry Potter and the Prisoner of Azkaban*, and British director Mike Newell (*Four Weddings and a Funeral, Donnie Brasco*) for *Harry Potter and the Goblet of Fire*. With two novels and five films yet to come, it is clear that Harry Potter will be with us for some time—perhaps, as King and Ebert believe, for the ages.

REFERENCES

Bloom, Harold, "Dumbing Down American Readers" in *The Boston Globe*, September 9, 2003; Ebert, Roger, *"Harry Potter and the Sorcerer's Stone,"* in *Roger Ebert's Movie Yearbook 2003* (Andrews McMeel Publishing, 2002), 258–259; Gibbs, Nancy, "The Real Magic of Harry Potter," *Time* June 23, 2003, 60–67; King, Stephen, "Potter Gold," *Entertainment Weekly*, July 11, 2003, 80–81.

—*F.A.H.*

THE HAUNTING OF HILL HOUSE (1959)

SHIRLEY JACKSON

The Haunting (1963), U.S.A./U.K., directed by Robert Wise, adapted by Nelson Gidding; MGM.
The Haunting (1999), U.S.A., directed by Jan De Bont, adapted by David Self; MGM.

The Novel

Shirley Jackson had already written two masterpieces of psychological horror, *The Bird's Nest* (1954) and *The Sundial* (1954), when she took on what would become generally regarded as her finest work, *The Haunting of Hill House* (1959). According to Jackson herself, the inspiration came from an article she read concerning a group of 19th-century psychic researchers who rented an alleged haunted house for study. Jackson set to work on a tale whose principal antagonist would be a house with a malevolent character and purpose all its own. Hill House serves not just as the focus of the action, but also as an influence on the characters and as a reflection of their psychological states. Into this setting comes the character of Eleanor Vance, a

quintessential Jackson protagonist, whose hold on reality is tenuous, to say the least, and who teeters on the brink of disorder and hysteria.

In the memorable opening passages, Hill House is peculiar at first encounter—an architectural nightmare of asymmetry: "Every angle is slightly wrong," and the walls are always "in one direction a fraction less than the barest possible tolerable length."

Leading the psychic investigation is Dr. John Montague, a professor of anthropology studying extra-sensory perception, who has rented Hill House during the summer months. Enlisted on his team are several persons who have demonstrated psychic gifts. Eleanor Vance, the protagonist from whose point of view the story is told, is a naive, lonely woman who in her youth encountered poltergeist phenomena. Until Montague's invitation, she had lived a sad and dull life caring for her invalid mother. Now, with the recent death of her mother, Eleanor sees in the Hill House venture a new beginning. Theodora, on the other hand, is bright and outgoing, as socially extroverted as Eleanor is withdrawn. Also joining the team is Luke Sanderson, a cynical ne'er-do-well whose aunt owns Hill House.

Two sets of relationships develop during the investigation—relationships among the characters and relationships between the characters and Hill House itself. On the one hand, the house—surely one of the great haunted houses in all literature—seems alive and bent on violating the personal space of Eleanor and Theodora, with incessant nocturnal bangings on the walls, invisible voices in the corridors, and faces emerging from the wallpaper patterns. As for the mortal relationships, Eleanor forms an ominous identification with the house, which will lead to her downfall. Meanwhile, Theodora, a lesbian, has designs on Eleanor, while Eleanor pursues Luke (who, of course, is more interested in Theodora).

Events culminate when Eleanor, obviously distraught and suicidal, is killed in an automobile accident while leaving the house. Her car collides head-on with a tree—the very spot where a former inhabitant of Hill House had died. Eleanor has gotten what she wants, the chance to remain at Hill House forever. Was she the victim of her own mental and emotional collapse, or were there indeed actual ghosts that destroyed her? Jackson implies both possibilities. The story ends, as it began, with Jackson's description of Hill House: "Hill House, not sane, stood by itself against its hills, holding darkness within. . . . Silence lay steadily against the wood and stone of Hill House; and whatever walked there, walked alone."

The Films

Director Robert Wise had already displayed a predilection toward the uncanny—as editor of Val Lewton's *Curse of the Cat People* (1944) and director of *The Body Snatcher* (1945) and *The Day the Earth Stood Still* (1952)—when he turned to Jackson's novel in 1963. Impressed with its quiet terrors, he signed on screenwriter Nelson Gidding (who had writ-

ten *I Want to Live!* for Wise five years earlier) to prepare the adaptation. Wise recalls: "I said, 'Oh boy, if this thing can do on the screen what it just did to me on the page, we'll have a fine classy horror picture there.'" Originally entitled *Night Cry*, it was filmed at a genuinely spooky house, Ettington Park, in Warwickshire in England (about 10 miles outside of Stratford-on-Avon). He insisted on shooting it in black and white in the wide-screen Panavision format; and with the aid of an unusually short focal-length lens, he was able to obtain striking deep-focus effects. Taking his cue from Jackson's subtle prose, Wise builds suspense and tweaks the horrors without ever resorting to the standard apparatus of ghosts, demons, and monsters. With his cinematographer Davis Boulton, sound designer A.W. Watkins, and composer Humphrey Searle, Wise masterfully exploits suggestive images and sounds to conjure up an atmosphere that is claustrophobic and threatening.

There are many memorable set pieces. Perhaps the finest of these is the wonderful prologue, narrated by Richard Johnson, which establishes in a series of eerie vignettes the wretched past history of Hill House. Other highlights, all of them derived directly from the novel, include the "hand-holding" episode between Eleanor and Theodora; the prolonged shots of the oddly decorated wallpaper—is that a demonic face emerging from the pattern?—accompanied by faintly heard cries and whimperings; and the anthropomorphic effects of a door bulging inward under the pressure of unseen ghostly forces.

Julie Harris seemed born to play the part of the neurotic Eleanor. Her interior monologues pepper the action with ominous foreshadowings of her impending tragic death. "I belong," she says to herself at one point, "I want to stay here. It's the only time anything's ever happened to me. They can't make me leave, not if Hill House means me to stay." Claire Bloom was likewise perfect as the brittle, caustic, sexually charged Theodora. Along for the ride are ex-dancer Russ Tamblyn (an odd choice for Luke) and Richard Johnson as Dr. Markway.

Alterations in Jackson's basic plot are minor. Eleanor's amorous yearnings are here transferred to Dr. Markway, rather than Luke. Ghostly incidents outside the house, like the memorable scene of an encounter with a picnic party, are deleted. At the end, it is Eleanor's voice who speaks Jackson's closing lines, but with a subtle alteration: "*We* [italics mine] who walk here—walk alone."

Despite its favorable reviews, *The Haunting* failed at the box office. Wise himself attributes this, in part, to his insistence that it be shot in black and white. One could also add that its relatively quiet surface, especially Julie Harris's understated voice-overs, went unheard by audiences too busy blubbering and shrieking to listen to the literate script. Today, however, its reputation is secure as one of a select company of screen horror masterpieces. "The undisputed jewel in the ghostly crown . . . of spectral cinema," wrote Bryan Senn in his study of the movie, "is Robert Wise's chilling masterpiece of understated terror, *The Haunting.*" Stephen King, in his *Danse Macabre*, sin-

gled out for particular praise the film's aural effects: "What we have in the Wise film is one of the world's few radio horror movies. Something is scratching at that ornately paneled door, something horrible. . . . But it is a door Wise elects never to open." *The Haunting* was released in France in 1964 under the title *La Maison du diable*.

Jan De Bont's update of Jackson's novel, from a screenplay by David Self, is a major disappointment. The investigator here is named Dr. Morrow (Liam Neeson), and instead of investigating the psychic phenomena of Hill House, he is researching the nature of human fear. Morrow figures the bad reputation of the place will trigger his team's nervousness and subsequent anxieties. He does not realize that the very real haunters of the house are just smacking their ghostly lips at the prospect of new victims. Thus, the professorial Morrow, the neurotic Eleanor (Lili Taylor), the flamboyant Theo (Catherine Zeta-Jones), and lanky Luke (Owen Wilson) all lock themselves in the house for a cozy weekend. For the first 40 minutes or so, the movie clicks along acceptably enough. We know that Eleanor has just come out of a traumatic time taking care of her ailing mother, and we realize that the house is concentrating on scaring her. What's missing, however, is the lesbian implications of her relationship with Theo (who is just along for the ride in this version) and her obsessive attachment to the good doctor. There is very little actual investigating or researching here—the folks are free to just wander around. In a departure from the novel, Eleanor learns that the former occupant, bad old Hugh Crain, had not only killed his wife (or forced her to commit suicide), but that he had exploited child labor from a local mill and then had killed the kids and buried them beneath the fireplace. Moreover, Eleanor, the granddaughter of Crain's deceased wife, has been summoned to "save the children," as she puts it. At this point, as the entire house begins to convulse and crumple into pieces (and the gargoyles and carved cherubs and other statues come to life), Eleanor faces the spectral Hugh Crain and declares repeatedly that she will save those children. "It's all about family, and you, Hugh Crain, can go to hell!" Eleanor's injunction must have been heard by a divine agency, because Hugh's spectral shape is duly engulfed by the carvings of the skeletal figures emerging from the walls. The spirit of Eleanor, who has expired in the meantime, flies away to a better place. Apparently the "forces of Good" had lain dormant in the house all this time, just waiting for Eleanor's commands.

Here is a ghost story for the 1990s—full of cheesy funhouse effects, a few token frights, and a politically correct—but patently phony—concern for family values. Surely the next "haunting" will be that of the ghost of Shirley Jackson, who has every right to pursue these filmmakers to their own bitter ends.

REFERENCES

Friedman, Lenemaja, *Shirley Jackson* (Twayne, 1975); King, Stephen, *Danse Macabre* (Everest House, 1981); Oppenheimer, Judy, *Private*

Demons: The Life of Shirley Jackson (G.P. Putnam, 1988); Senn, Bryan, "The Haunting," in *Cinematic Hauntings*, ed. Gary J. and Susan Svehla (Midnight Marquee Press, 1996), 71–99; Thompson, Frank, *Robert Wise: A Bio-Bibliography* (Greenwood Press, 1995); Wolff, Geoffrey, "Shirley Jackson's Magic Style," *The New Leader* 17 (September 1968), 18.

—*B.M. and J.C.T.*

THE HEART IS A LONELY HUNTER (1940)

CARSON MCCULLERS

The Heart Is a Lonely Hunter (1968), U.S.A., directed by Robert Ellis Miller, adapted by Thomas C. Ryan; Warner Bros.

The Novel

McCullers's first novel, originally titled *The Mute*, came about after several alterations of the main character. According to her biographer Virginia Spencer Carr, McCullers declined her husband's invitation to attend a deaf/mute conference in order to do research for the central character, preferring to write out of her imagination. The novel was critically acclaimed and allowed McCullers to leave the South of her novels for a life in New York. However, the South of her childhood continued to offer itself as the setting for future novels and it provided her a place among other Southern Gothic authors.

John Singer, a deaf mute, moves into a boarding house after his only friend, another deaf man, Antonapoulos, is sent to an asylum. He meets four people while living here, each alienated from a larger society: Mick, the daughter of Singer's landlord, who is a poor tomboy in proper Southern society; Dr. Copeland, a black activist doctor; Biff Brannon, a widower; and Jake Blount, a transient fighting against the capitalist system. Though Singer is unable to understand their stories, each of these characters finds in him the perfect person to talk to. Although they spend time with him, they never attempt to understand his life, nor do they know of his close friendship with Antonapoulos. Though none of these four ever find any solace, each searches for a way to fit in and to feel connected to the larger world. Eventually, on one of his visits to the asylum, Singer learns that Antonapoulos is dead; he returns home and kills himself. The novel ends with brief vignettes about the other four and their continuing loneliness and isolation.

The Film

The film, with its screenplay written by McCullers's friend Thomas C. Ryan, remains faithful to the major theme that love and communication can heal the loneliness of life, but that even love is ephemeral and destined to end. However, according to Robert Aldridge, the film "omits most of the 1930s topicality (except for the race issue)." In updating the events for a 1968 audience, much of the attention to anti-Semitism and to labor issues, both pronounced in the novel, is removed. Alan Arkin's performance as Singer won him the New York Film Critics award for best actor, and Sondra Locke's work as Mick in her first film role earned her an Academy Award nomination as best supporting actress.

While Singer remains largely a disconnected observer of the other characters in the novel, in the film he "has a more personal relationship to the major characters who revolve around him. He shares their loneliness," claims Aldridge. In addition, while Singer's relationships with Dr. Copeland and Mick form the center of the film, both Biff and Jake enter the film only as peripheral characters. Though the film leaves out some of the details of the novel's plot, it manages to clearly get across the central message of the film—only through understanding can people relieve their loneliness.

REFERENCES

Aldridge, Robert, "Two Planetary Systems," *The Modern American Novel and the Movies*, eds. Gerald Peary and Robert Shatzkin (Frederick Ungar, 1979), 119–30; Carr, Virginia Spencer, *The Lonely Hunter: A Biography* (Doubleday, 1975).

—*M.E.J.*

HEART OF DARKNESS (1902)

JOSEPH CONRAD

Apocalypse Now (1979), U.S.A., directed by Francis Ford Coppola, adapted by Coppola and John Milius; Omni-Zoetrope/United Artists.
Heart of Darkness (1993), U.S.A., directed by Nicolas Roeg, adapted by Benedict Fitzgerald; Turner Pictures.

The Novel

Joseph Conrad finished *Heart of Darkness* 12 years after attempting to get command of a steamer to travel up the Congo River. Since childhood, he had been fascinated with maps and, in particular, with the mysterious white blankness that marked contemporary maps of interior Africa. He wanted to explore that "white heart" of Africa, so when the opportunity to command a steamer arose, he endured an arduous 36-day overland journey (during which time he also worked on his first novel, *Almayer's Folly*) only to discover that the steamer had sunk. He abandoned his attempt, but his Congo experience had had an enormous impact on him. He had learned firsthand that Congo "explorers" committed atrocities at a whim if it improved their chances of financial gain. By the time he left the Congo, he would write, "Everything is repellent to me . . . Men and things, but above all men." Conrad's jour-

Dennis Hopper, Martin Sheen, and Frederic Forrest in Apocalypse Now, *directed by Francis Ford Coppola* (1979, U.S.A.;
OMNI-ZOETROPE/PRINT AND PICTURE COLLECTION, FREE LIBRARY OF PHILADELPHIA)

ney of discovery had ironically turned inward, away from the whiteness of unexplored territory and toward the darkness of the human soul.

The narrative frame of *Heart of Darkness* consists of three seamen, one of whom is the external narrator, and the "Director of Companies," all listening to Charlie Marlow tell the story of his journey up the Congo River as the captain of a steamer. Marlow's primary assignment was to discover what had become of Mr. Kurtz, who commanded a company station upriver, about whom there were disturbing but unsubstantiated rumors, and who was reportedly ill. Marlow learns that Kurtz was "an exceptional man," a "universal genius," an "emissary of pity, and science, and progress, and devil knows what else." Kurtz had also shipped back more ivory than all the stations combined. As Marlow makes his trek to the district station in the Belgian Congo to assume his command, Kurtz's character weighs on his mind, as do images of natives being starved, beaten, and worked to death. After waiting several months for repairs to be made on his steamer, Marlow sets off with the

district manager for the inner station to find Kurtz.

The journey up the river is perilous. As they near the inner station, they are attacked by savages and Marlow's faithful helmsman is killed (we later learn that Kurtz ordered the attack). Marlow also reveals more about Kurtz, including the fact that he had been commissioned to write a report on "The Suppression of Savage Customs," which concluded with Kurtz's postscript, "Exterminate the Brutes!" At the station, they meet a Russian traveler who idolizes Kurtz, saying rapturously, "Oh, he enlarged my mind!" As Marlow listens to this "harlequin's" stories of Kurtz's genius, he sees through binoculars that Kurtz's house is ringed with heads on stakes. Kurtz is indeed deathly ill, and after a confrontation with the district manager, Marlow brings him aboard the steamer for the return trip. Having looked inward to a soul that knew no restraint, fear, or faith and having been consumed by this darkness, Kurtz dies at the "supreme moment of complete knowledge," whispering the cry, "The horror! The horror!"

Marlow concludes his narrative by describing his return to the "sepulchral city" of London, as well as his fear and admiration of Kurtz's form of wisdom, which penetrated "all the hearts that beat in the darkness." When Marlow delivers Kurtz's papers to his "intended," he falsely tells her that Kurtz's last words were "your name" to appease her claim that she knew him better than anyone else.

The Films

Orson Welles's first film project for RKO Pictures was supposed to be an adaptation of *Heart of Darkness*, but because the plans never materialized, we have *Citizen Kane*, a film whose protagonist certainly has much in common with Conrad's Kurtz. In 1958, a live television performance of *Heart of Darkness* starred Boris Karloff as Kurtz and Roddy McDowall as Marlow. It was not until Coppola's 1979 Vietnam War epic, *Apocalypse Now*, that Conrad's novella was adapted for the big screen, and in this case, its theme influenced Coppola more than its story did. The 1993 adaptation by Nicolas Roeg, which follows the plot of the novella very closely, is an unremarkable made-for-television movie, even though it has a strong cast, with John Malkovich as Kurtz and Tim Roth as Marlow.

Apocalypse Now is a fascinating example of cinematic adaptation. *Heart of Darkness* is actually an uncredited source for the film. Conrad's name originally appeared in the credits, but it was removed after protest from the Screen Writer's Guild. Still, Coppola himself freely identifies three source texts: the novella, Michael Herr's *Dispatches*, and John Milius's 1969 script. Coppola ultimately wove all three together, excerpts from Herr's book serving as Willard's (Marlow's parallel) voiceover narrative, the Conrad and Milius texts informing the rest. The result is a *Heart of Darkness* transplanted to Vietnam with several different characters and, as many critics have pointed out, significantly different emphases.

The production itself was beset with numerous calamities, as has been chronicled in the companion documentary, *Hearts of Darkness: A Filmmaker's Apocalypse* (1992). This latter film, shot in part by Coppola's wife Eleanor during the production of *Apocalypse Now*, shows more than Coppola's intellectual struggle with the themes he hoped to represent on screen; it also chronicles his egomaniacal attachment to his vision of the horrors of the Vietnam War and his uncompromising devotion to artistic and technical precision in spite of many obstacles during production, including the heart attack of Martin Sheen (Willard), a monsoon, and huge cost overruns.

As Garrett Stewart has pointed out, *Apocalypse Now* is "an aesthetic repetition" of *Heart of Darkness*, a reenactment of the "returning nightmare of plunder, blunder, and malignity as old as the motives of empire." One central theme of Conrad's novella shows the gradual convergence of Marlow's imagination with Kurtz's insight into the impenetrable darkness of the soul. Marlow wrestles with

the realization that civilized life merely disguises our lack of a moral center. The focus is predominantly on the psychological consequences this discovery has on Marlow—how he manages to escape the lure of Kurtz's maniacal wisdom with an ethic of social responsibility. *Apocalypse Now* sacrifices this theme, choosing instead to show how the horrors of war are extensions of this individual psychology. Coppola himself has said that he wanted to "psychologize" Willard, but he did not want his personal revelation to interfere with "the audience's view of what was happening, of Vietnam." Willard has already seen in his own life the darkness that Marlow discovers in Kurtz and must learn to accept. Willard also kills Kurtz, unlike his counterpart in the novella, and this difference highlights the fundamental thematic difference between the source and the adaptation: In *Apocalypse Now*, the "horror" is symbolically repressed (killed), while in *Heart of Darkness* it is brought into the light, as horrible as it might be to do so. The film, then, accepts as a premise our capacity for evil, and goes ahead to show how the colonialist psychosis of Kurtz, and by extension Western culture, translates into a social nightmare. In such a world, the individual's confrontation with the evil within is less problematic than the spectacle of its worldly consequences.

REFERENCES

Cahir, Linda Costanzo, "Narratological Parallels in Joseph Conrad's *Heart of Darkness* and Francis Ford Coppola's *Apocalypse Now*," *Literature/Film Quarterly* 20, no. 3 (1992): 181–187; Chown, Jeffrey, *Hollywood Auteur: Francis Coppola* (Praeger, 1988); Greiff, Louis K., "Soldier, Sailor, Surfer, Chef: Conrad's Ethics and the Margins of *Apocalypse Now*," *Literature/Film Quarterly* 20, no. 3 (1992): 188–98; Stewart, Garrett, "Coppola's Conrad: The Repetitions of Complicity," *Critical Inquiry* 7, no. 3 (1981): 455–474.

—D.B.

HIROSHIMA MON AMOUR (1960)

MARGUERITE DURAS

Hiroshima mon amour (1959), France, directed by Alain Resnais, adapted by Marguerite Duras; Daiei/Pathé Overseas.

The Novel

After composing 11 novels, Marguerite Duras began, in 1959, to write her first film script for Alain Resnais—*Hiroshima mon amour*. She had already developed an ambiguous and paradoxical relationship between words and images in her novels. As a script writer, Duras felt that her task consisted in "writing what cannot be seen" on the screen. The political humiliations undergone by the Frenchwoman, the agony of her German lover, and the horrors witnessed by the Japanese man during the war parallel somewhat Duras's own story of her destroyed,

happy youth in Indochina. This novel is a psychological drama of love caught between multicultural identities and sociopolitical conflicts, stressing that memory is the only link to preserve life in the everyday struggle against forgetfulness.

During the making of a film on peace in Hiroshima, a young French actress meets a Japanese architect with whom she has a short affair. Both are happily married, and during their brief time together they speak about the absurdity of war, the pain of loss, and the capacity for suffering through time, mixing personal feelings and images of the past. After their first night together, she refuses to see him again, but they soon meet again when he finds her asleep on the film's production location.

In the course of their second meeting, the Frenchwoman tells him that she lost her German lover when she saw him getting killed during one of their rendezvous in Nevers. Because of her affair with a German, she was captured by militants from the Resistance and forced to hide in a cellar, mad from despair and ostracized by her own family. To protect her from people, her mother sends her later to Paris hoping that the scandal will not follow her there. The couple continue their discussion throughout the night in the streets, at a Japanese café, and on a public bench. The novel ends with both protagonists calling each other with the names of their respective cities. It is clear that the actress tries to forget her trauma even though she has come to relive it in Hiroshima with the Japanese man.

The Film

Produced in 1959 by Alain Resnais, *Hiroshima mon amour* starred Emmanuelle Riva and Eiji Okada. Instead of saturating the movie with images of the atomic blast, Duras deliberately weaves a sense of the destruction through two separate sets of intertwined stories. The first set evokes the present: It takes place between the actress and the architect. The second set refers back to the past: It links the actress at 18 with her 23-year-old German lover. She unconsciously replaces the German with the Japanese architect. With the force of repressed pain she's kept so long, the actress gives the film the great dramatic material it needs to accurately portray the atomic disaster. Through a series of refined shots, this film unveils the inner world of two opposite cultures, the consequences of a devastating war crime, and Riva's own psychological drama.

Eiji Okada and Emmanuelle Riva in Hiroshima mon amour, *directed by Alain Resnais* (1959, FRANCE-JAPAN; ARGOSCOMEI-PATHÉ-DAIEI/MUSEUM OF MODERN ART FILM ARCHIVE)

Duras contains her love scenes, her dramatic action, Riva's pain, and the Japanese architect's attempts to recover her hidden secret within a series of enclosed locations: a hotel room, a café, a train station, and the cellar of a house. In the movie, unlike the text, the cellar scene occurs only at the end so that the film can develop suspense.

In *Hiroshima mon amour*, Duras wants to touch upon a reality much too horrible to be assessed. Duras fights the notion of an absolute truth in history and time because multiple individual subjectivities do not amount to a final truth, especially in a film. History and love provide people with the illusion that they can momentarily escape time. Neither the Japanese man nor the Frenchwoman wants to forget the war, their horrid experiences, and their love, but time washes their feelings away.

If one can break down time's neutrality, one can capture feelings forever. The French actress tries to remember her love for the Japanese architect as the city where it happened, Hiroshima. She knows that time's most ephemeral aspect lies in expressed feelings. Her interest is never so much directed to him as it is to her German lover whom she entertains in her memories.

Duras's other preoccupation is to show us the pervasiveness of memory. Despite the strength of their affair, this Franco-Japanese couple's love is unused, like the Franco-German one. They exaggerate their feelings to each other and ignore facts and details so that ultimately time will preserve their story.

REFERENCES

Cohen, Keith, "Pleasures of Voicing: Oral Intermittences in Two Films by Alain Resnais," *L'Esprit Créateur* 30, no. 2 (1990); Kreidl, John, *Alain Resnais* (Twayne, 1978).

—C-A.L.

THE HISTORY OF TOM JONES, A FOUNDLING (1749)

HENRY FIELDING

Tom Jones (1962) U.K., directed by Tony Richardson, adapted by Richardson and John Osborne; Woodfall Films/United Artists.

The Novel

Henry Fielding's novel was published in six volumes. Fielding meant to portray as broad a slice of human nature as possible, to show life realistically, both in its rustic and courtly aspect. The story has almost 200 characters, moving all across England, from Bath to London, balancing high and low comedy. Fielding employs every rhetorical and dramatic device appropriate to irony and satire—parodies and burlesques, the intrusions of an omniscient narrator, and—not the least—occasional stylistic departures into the mock-heroic mode. (In the latter instance, note the announcement of the battle in the churchyard: "Recount, O Muse, the Names of those who fell on this fatal Day.") Underlying all this are Fielding's stated intentions "to laugh mankind out of their favourite follies and vices."

Squire Allworthy returns home from a three-month trip to find an abandoned baby in the home he, a childless widower, shares with his unwed sister, Bridget. A servant, Jenny Jones, is accused of being the mother, and a fellow named Partridge, her former schoolmaster, presumed to be the father. They are banished and Allworthy elects to bring up the foundling, now named "Tom," himself. Shortly thereafter, Bridget marries a Captain Blifil, who subsequently dies after Bridget bears him a son. At his sister's death, Allworthy takes in the baby to raise as a brother for young Tom. The two boys are a study in contrasts: Tom is wild, independent, and fun-loving; Master Blifil is dour, sulking, and resentful.

Tom spends much of his time rutting and poaching. He falls in love with Sophia Western and is admired by her father, who—like many people who come to know him—thinks Tom a misunderstood, loveable rogue. However, when it comes time for Sophia to choose a husband, she turns away from Tom and selects Blifil. Meanwhile, Squire Allworthy falls ill and, seemingly near death, summons Tom and Blifil to his side. He informs Blifil that he will inherit the estate and that Tom will be left a handsome provision. When the Squire unexpectedly recovers, Tom celebrates and Blifil mourns. Blifil contrives to turn the Squire against Tom, accusing Tom of impregnating Molly Seagrim. Reluctantly, Allworthy banishes Tom from his estate.

A picaresque succession of episodes follows. Tom has numerous misadventures, on the road and in London, involving amours and fighting. He believes himself guilty of incest as a result of a dalliance with Jenny Jones (now calling herself Mrs. Waters). He has become a gigolo to the wealthy, seductive Lady Bellaston. And as a result of a murder charge, he is thrown in jail. But when all seems hopeless, Tom's fortunes turn. Rallying to his support are those he has befriended, including his landlady, Mrs. Miller, and Partridge, whom he has met on the road. Eventually, Tom's name is cleared. Moreover, he learns that his mother really was Bridget Allworthy and that he is, in fact, Squire Allworthy's nephew. Blifil, it is also discovered, is guilty not only of destroying a letter disclosing the identity of Tom's mother but of hiring false witnesses to incriminate Tom. Tom is returned to the squire's good graces. He marries Sophia, and all ends well.

The Film

After making several film adaptations of plays for the Woodfall Films studio, like *Look Back in Anger* (1958) and *The Entertainer* (1959), director Tony Richardson and playwright/scenarist John Osborne now turned to the daunting task of transferring Fielding's sprawling novel to

the screen. "It had never really been filmed before," dryly notes Richardson in his autobiography, "because of its sexuality and irony, and probably because it's so long and movie people haven't got a great ability to read."

At the outset, Richardson and Osborne decided to find cinematic equivalents for Fielding's unique storytelling style. The movie adopted the novel's omniscient narrative voice (Michael MacLiammoir); conveyed Tom's self-conscious posturings by having him directly address the camera (at one point in mock modesty he covers the lens with his hat); and presented a dazzling array of New Wave–style cinematic effects, including freeze frames, jump cuts, stop-motion photography, slip frames (wipes), and irises. Indeed, as commentators Annette Insdorf and Sharon Goodman suggest, the use of these and numerous allusions to the techniques of silent film comedy—the title cards, keyboard accompaniment, and accelerated-motion episodes—constitute a grab-bag summary of the history of the film medium, just as Fielding's novel had summed up the evolution of narrative forms. Both novel and film treat the story as a plaything upon which to exercise considerable stylistic ingenuity. Fielding's remarks about his creative latitude as a storyteller could just as easily be Richardson's artistic credo:

> For as I am, in Reality, the Founder of a new Province of Writing, so I am at Liberty to make what Laws I please therein. And these Laws, my Readers, whom I consider as my Subjects, are bound to believe in and obey.

However, as a result, contend Insdorf and Goodman, an important distinction arises between novel and film: Fielding's novel unfolds in a leisurely manner that the reader follows at his own pace, whereas the film "acknowledges uniquely cinematic time—compressed, ceaselessly moving, imposing itself on the spectator as if he were riding a wild horse."

The trimming of episodes and the simplification of some of the characters was necessary, of course. As in dozens of other novel-to-film transformations, *Tom Jones*'s protagonist is both less good and less bad than in the novel. His "gigolo" status with Lady Bellaston is somewhat minimized, and at the same time, his benevolence toward young Nightingale is omitted. Other episodes were added by Osborne, including one of the film's most celebrated moments, the erotically charged scene when Tom shares a supper with a woman he's met on the road.

The filming, much of which transpired in the countryside of Dorset, occurred over a 10-week period in the summer and autumn of 1962. Ironically, despite the high spirits of the finished film, Richardson reports numerous problems and complications during the shoot. For one thing, although rising young star Albert Finney was the obvious choice to play Tom, he did so reluctantly, stating he hated the part because he thought Tom too "passive" a character. Budget problems plagued the project until

David V. Picker, the recently appointed production head of United Artists, rode to the financial rescue. The antagonism of the local fox-hunting fraternity forced Richardson to improvise a hunt of his own, with desperately comic consequences not apparent on the screen.

Despite Richardson's early predictions of box-office disaster, *Tom Jones* was an instant hit. It received numerous awards, including four Oscars (best picture, director, screenplay, and music (John Addison). The critic for *Newsweek* called it "the best comedy ever made"; and the more scholarly assessment of Martin Battestin declared it "one of the most successful adaptations of a novel ever made." For the Woodfall studio, it was a bonanza, pouring enough gold into the coffers to place it on a secure footing for years to come.

REFERENCES

Battestin, Martin C., *The Moral Basis of Fielding's Art* (Wesleyan University Press, 1959); Battestin, Martin C., "Osborne's *Tom Jones*; Adapting a Classic," in *Film and Literature: Contrasts in Media*, ed. Fred H. Marcus (Chandler, 1971), 164–77; Insdorf, Annette and Sharon Goodman, "A Whisper and a Wink," in *The English Novel and the Movies*, eds. Michael Klein and Gillian Parker (Ungar, 1981), 36–43; Richardson, Tony, *The Long-Distance Runner: A Memoir* (William Morrow, 1993).

—C.K.P. and J.C.T.

THE HOTEL NEW HAMPSHIRE (1981)

JOHN IRVING

The Hotel New Hampshire (1984), U.S.A., directed and adapted by Tony Richardson; Orion.

The Novel

The Hotel New Hampshire is John Irving's fifth novel and his most successful after the earlier *The World According to Garp*. Like its predecessor, *The Hotel New Hampshire* is a synopsis-defying novel about life and death, presented with numerous interpolations, bizarre characters like a woman who dresses and works as a bear, absurd violence coupled with dark humor. Irving's structural design, retained in the film, focuses on the four hotels that Win Berry and his family occupy. The hotels stand for the family itself; Berry dreams of his hotel as a New Eden despite many serpents along the way. The principal emotional events of the novel (and the film) are the gang rape of the adolescent Franny and the consummation—followed by the subsequent transcendence—of the incestuous relationship between Franny and her brother John. The latter, through his weight lifting, finally shoulders physically and spiritually the caretaking of his eccentric father and often oppressed siblings, an act that connects him to his deceased grandfather, Iowa Bob. Along the path are bomb-wielding anarchists who plan to blow up the Vienna State

Opera, the family dog named Sorrow—stuffed following his demise and finally seen floating in the Atlantic Ocean to provide a frequent tag in the novel that "sorrow floats"—and the undersized sister Lilly who writes a successful book about trying to grow yet cannot refrain at last from passing open windows without jumping to her death.

The Film

Obviously Irving's novel does not yield to easy adaptation on film. Tony Richardson attempted to be both free and faithful to the story; in part he succeeded, to a degree not achieved, in many viewers' judgment, in George Roy Hill's more popular adaptation of Irving's *The World According to Garp*. Richardson's large cast is extremely well-chosen, with Beau Bridges as the father, Lisa Banes as the mother, Wallace Shawn as the bear-trainer Freud, Nastassja Kinski as Suzie the bear, Jennifer Dundas as the diminutive Lilly, among numerous others. Jodie Foster's tough-talking Franny received considerable critical praise, but Rob Lowe's John was more often, and perhaps unfairly, criticized. Lowe's assignment seemed more difficult than Foster's, since he had to play a realist in a family of dreamers and would-be artists.

Richardson does indulge in a few signature cinematic devices for which he became famous (or infamous) in *Tom Jones* (1963), like speeded-up and stopped motion, some asides addressed to the camera, and a worthy attempt to present metaphor visually. If the viewer were not familiar with the novel, the parallel, for example, between the anarchists' bomb and the incestuous time bomb between Franny and John might not have the significance in the film that Irving assigns it. Still, the director expertly shows how that incestuous passion is defused or exploded by the marathon session of lovemaking with brother and sister.

Masculinity in John Irving's works is often the locus of tragedy, violence, and farce, but it frequently also has a nurturing, redemptive dimension as well. Richardson has captured this aspect of the novel better than might have been hoped. In the film's final sequence, Lilly grows beautifully, ever upward, and the dead are restored to exuberant life; yet the film has confronted the intractable realities that mar this idyll, as indeed the best fairy tales do. This ending is the director's embodiment of the F. Scott Fitzgerald–like ending Irving provides in the novel, derived from the close of *The Great Gatsby*, a work often alluded to in the narrative. Critics were not kind to Richardson's film, but the director rendered fairly well the axiom of the novel's King of Mice: Life is serious but art is fun.

REFERENCES

Corliss, Richard, review in *Time*, March 19, 1984, 91; Jones, Edward T., "Checking into While Others Run to Check Out of Tony Richardson's *The Hotel New Hampshire*," *Literature/Film Quarterly* 13 (1985): 66–69.

—E.T.J.

THE HOUND OF THE BASKERVILLES (1901)

ARTHUR CONAN DOYLE

The Hound of the Baskervilles (1914), Germany, directed by Rudolph Meinert, adapted by Richard Oswald; Vitascope Pictures.

The Hound of the Baskervilles (1921), U.K., directed by Maurice Elvey, adapted by William J. Elliott; Stoll Pictures.

The Hound of the Baskervilles (1929), Germany, directed by Richard Oswald, adapted by Herbert Jutke and George Klarens; Vitascope.

The Hound of the Baskervilles (1931), U.K., directed and adapted by V. Gareth Gundrey (dialogue by Edgar Wallace); Gainsborough Pictures.

The Hound of the Baskervilles (1939), U.S.A., directed by Sidney Lanfield, adapted by Ernest Pascal; Twentieth Century-Fox.

The Hound of the Baskervilles (1959), U.K., directed by Terence Fisher, adapted by Peter Bryan; Hammer Films/Warner Bros.

The Novel

Public outrage at the death of Sherlock Holmes in "The Final Problem," published in the December 1893 of *The Strand* magazine, was immediate. Women wept, men wore crepe mourning bands in their hats, and in a letter to Arthur Conan Doyle, a reader addressed him as "You Brute!" While Doyle's decision to kill off the world's first consulting detective was sincere and unregretted, motivated by a genuine desire to proceed with other writing endeavors, it seemed to readers an unforgivable act—nay, a heinous crime. Eight years passed before Doyle relented to public pressure (and financial enticements) and presented *The Hound of the Baskervilles* to grateful readers of *The Strand* from August 1901 to April 1902. Circulation leaped by 30,000 copies. When this most celebrated of Holmes's adventures appeared in hard covers a year later, Doyle received his knighthood. Eminent Holmesian Vincent Starrett flatly declares the honor had nothing to do with Doyle's services in South Africa; rather, it "was a mark of royal gratitude for the return of Sherlock Holmes, and nothing else."

It was a sinister affair that Dr. James Mortimer related to Holmes and Watson, of the legend of the dreadful death of Sir Hugo Baskerville on the Devonshire moors, his throat torn out by an enormous beast. That had been 200 years ago, and ever since, Sir Hugo's descendants had alike fallen victim to death "sudden, bloody, and mysterious." Now, Sir Charles Baskerville is dead of an apparent heart attack, his face constricted in terror, the ground around his body marked by *"the footprints of a gigantic hound!"* Small wonder that Sir Henry Baskerville, who inherits Sir Charles's estate, is nervous about assuming his responsibilities.

Due to pressing duties, Holmes remains behind while dispatching Watson to accompany Sir Henry to Baskerville Hall. There Watson meets the neighbors, the naturalist John Stapleton and his sister, Beryl, with whom Sir Henry is in love. He witnesses inexplicable events, including a woman's sobs in the night, the butler's nocturnal signalings to the moors with a lamp, and the savage death of an escaped convict out on the moors, another victim of the deadly hound.

Holmes, in the meantime, has secretly left London and hidden himself out on the moors where he pursues independently his own investigations. "The more *outré* and grotesque an incident is the more carefully it deserves to be examined," he declares. It is not until two-thirds of the way through the book that he reveals himself to a startled Watson (a scene acknowledged to be one of the great moments in the Holmes canon). Holmes has learned that Stapleton is actually an heir to the Baskerville estate. Together with his "sister" Beryl—in reality his wife—Stapleton is contriving to dispatch the Baskerville heirs standing in line before him. To that purpose he keeps an enormous hound in an abandoned tin mine out on the Mire. Provided with the scent of its victims, the hound pursues its deadly missions. Its latest victim, the escaped convict Seldon, had been accidentally wearing Sir Henry's clothing. (Seldon, it turns out, is the son of the butler, Barrymore. It was he who had received the mysterious nocturnal signals from Barrymore's lamp.)

But a greater mystery needs to be resolved. Using Sir Henry as "bait," Holmes and Watson confront the hound and shoot it dead. Far from a supernatural creature, it is a combination of bloodhound and mastiff, "gaunt, savage, and as large as a small lioness." The glow emanating from the beast is merely a phosphorous preparation applied to the muzzle. Further pursuit of Stapleton proves to be fruitless. He has disappeared utterly, presumably swallowed up by the Mire.

Having wrapped up the case—and having sent the shaken Sir Henry on a world cruise to recover himself—Holmes prepares for his next adventure, attending a performance of Meyerbeer's *Les Huguenots.*

The Films

The Hound first appeared on screen in Germany in 1914, only 13 years after its first serial publication and the very same year that Doyle published a brand new Holmes novel, *The Valley of Fear.* Rudolph Meinert's unauthorized four-reel *Hound of the Baskervilles*, starring Alwin Neuss as Holmes, played freely with the original. There were *two* Holmeses, one an impersonation by the dastardly Stapleton (an incident derived from the novel's allegations that Stapleton is skilled at disguises). Essentially a serial with the requisite trap doors, underground passages, and hairbreadth escapes, the film was so successful that it spawned a veritable "Hound" series of sequels using the same characters and basic situations.

Two more major *Hound* adaptations appeared during the silent era. In 1921 actor Eille Norwood, who had scored immense success as Holmes in a series of two-reel adaptations of the short stories for Stoll Films of London—Doyle himself described Norwood approvingly as possessing the "brooding eye which excites expectation and . . . a quite unrivalled power of disguise"—appeared in a feature-length adaptation of *Hound.* Paired with him was Hubert Willis as Watson. The Hound's appearances benefited from a special effects glow achieved by hand-painted frames of film. If anything, the adaptation was too literally faithful, since reviews complained of the tedious intrusions of dialogue and explanatory subtitles.

The last silent *Hound* came from Germany when Vitascope remade its 1914 adaptation. Carlyle Blackwell and Georges Seroff appeared as Holmes and Watson. The picture had only a brief run, as the talking-picture revolution was sweeping the world and audiences had grown tired of the suddenly passé silents. It has disappeared as utterly as Stapleton did in the Grimpen Mire.

Alas, Conan Doyle never heard the baying of the Hound on screen. Doyle died in 1930, just a year before a small British studio, Gainsborough Pictures, released the first talking-picture version. A tall, rotund Robert Rendel portrayed Holmes and Frederick Lloyd was Watson. The best-selling author Edgar Wallace provided some of the dialogue. The action, with the exception of the Hugo Baskerville prologue, was updated to the 1930s, and much of it was shot in authentic locations, including Dartmoor and the actual Lustleigh Hall (the presumed basis for Baskerville Hall). The Hound itself was a registered canine aristocrat, Champion Egmund of Send. *Variety* reported that the beast "bounded over rocks and walls like a big good natured mongrel rather than a ferocious maneater." Portions of the picture are lost and the entire soundtrack has disappeared. Thus, critical assessment today is mixed: Holmesians Steinbrunner and Michaels charge the film is marred by "routine melodramatics." Robert W. Pohle and Douglas C. Hart, on the other hand, applaud its "vigorous construction," moody atmospherics, and imaginative camerawork.

Although none of the films featuring the estimable British actor Arthur Wontner, reckoned by many as one of the finest Holmes impersonators, adapted *Hound*, his *Silver Blaze* (1937) cleverly conflated a few elements and characters of the novel into the eponymous short story. It was retitled for its United States release, *Murder at the Baskervilles.*

By far the best known, and perhaps the most distinguished, adaptation was Basil Rathbone's debut as Holmes in 1939 for Twentieth Century-Fox. Studio chief Darryl F. Zanuck determined that Rathbone would be the perfect Holmes; and indeed he was. The tall, lean, classically trained actor had already portrayed a detective on screen—Philo Vance in *The Bishop Murder Case* (1930)—but it was his Holmes that would eclipse his other roles and typecast him for the rest of his career. From 1939 to

1946 he would make a total of 14 Holmes films. Interestingly, this *Hound* was the first version to be deliberately set in period, i.e., in 1889. The Fox backlot featured winding, cobblestoned streets and gas-lit villages. A huge soundstage, 300 feet long by 200 feet across, beautifully served as a desolate expanse of rock and fen. Rounding out the cast was Richard Greene as the young Baskerville heir, Wendy Barrie as his love interest, Nigel Bruce as the amiably spluttering Watson, and, as the Hound, a 140-pound Great Dane named Chief. Ernest Pascal's script followed closely the book, making few changes other than altering the name of the Baskerville Hall butler from Barrymore to Barryman; altering the relationship between the Stapletons to brother and sister rather than secretly husband and wife; and introducing a séance to enhance the spooky atmosphere. The concluding dialogue exchange between Holmes and Watson is surely the most extraordinary in Sherlockian cinema: After being congratulated for his work on the case, Holmes prepares to retire. "I've had a rather strenuous day," he says. Then, as an afterthought, he finishes: "Oh, Watson, the needle!" Production Code censors blipped the line when the film went into release. When Specialty Films, Inc. rereleased the picture in 1975, however, the words were restored. (It would be 37 years before Holmes would indulge his habit again onscreen, in *The Seven-Per-Cent Solution*.) Critics were generally enthusiastic about the picture and especially about Rathbone. Basil himself admitted, "Of all the 'adventures' *The Hound* is my favorite story, and it was in this picture that I had the stimulating experience of creating, within my own limited framework, a character that has intrigued me as much as any I have ever played."

Hammer Films's 1959 version, starring Peter Cushing as Holmes, Andre Morell as Watson, and Christopher Lee as Sir Henry Baskerville, was the first Holmes movie in color. *"It's ten times the terror in Technicolor! The most horror-dripping tale ever written!"* blared the studio hype. The Baskerville legend was told as a prologue rather than a flashback. After the opening scenes in Baker Street, it veered wildly away from the book, altering the character of Stapleton, changing Beryl into Cecile, a hot-blooded, scheming Spanish beauty who is Stapleton's daughter and the real perpetrator of the horror of the hound, and incorporating a dash of Satanism into the villainies. There is even the implication that the Baskervilles had a reptilian ancestry (shades of H.P. Lovecraft!). Meanwhile, critics and viewers alike were disappointed that the Hound had so little screen time. "Outside of a little baying once in a while, we get no image whatsoever of this creature, until pretty near the end. Then we're given a glimpse of a Great Dane, looking somewhat like somebody's pet, except that he's wearing a false-face . . ."

Although television is outside the scope of this essay, it is worth noting that Hollywood's first color version was produced by Universal in 1972 for television, starring a silver-haired Stewart Granger. The abbreviated, 73-minute teleplay skimped on details, plot complications, and production values.

Doubtless more adaptations will follow, just as Holmes himself will continue to fascinate future generations. Filmmakers, like Sherlockians of all stripes, may pledge the toast that is uttered every Christmas season at the traditional Feast of the Blue Carbuncle: "Ave, Sherlock. We who will someday pass and be forgotten salute you, undying."

REFERENCES

Haydock, Ron, *Deerstalker! Holmes and Watson on Screen* (Scarecrow Press, 1978); Pohle, Robert W. and Douglas C. Hart, *Sherlock Holmes on the Screen* (A.S. Barnes, 1977); Starrett, Vincent, *The Private Life of Sherlock Holmes* (Pinnacle Books, 1975); Steinbrunner, Chris and Norman Michaels, *The Films of Sherlock Holmes* (Citadel Press, 1978); Tibbetts, John C., "The Game Is Afoot," *The World and I* 8, no. 2 (December 1993): 321–26.

—J.C.T.

THE HOURS (1998)

MICHAEL CUNNINGHAM

The Hours (2002), U.S.A., directed by Stephen Daldry, adapted by David Hare; Miramax Films/Scott Rudin Productions.

The Novel

The Hours (1998), Michael Cunningham's fourth novel, won both the 1999 Pulitzer and PEN/Faulkner awards for fiction. The inspiration for the book was Virginia Woolf's *Mrs. Dalloway* (1925), and initially the novel was to be about a gay man in a situation parallel to Mrs. Dalloway's, but Cunningham switched from his gay male protagonist to a lesbian one and then added a third woman, one modeled after his mother, and he wrote himself in as her child, Richard. The novel takes place essentially in one day, although the three stories occur in different times and places. Virginia Woolf is in a London suburb awakening from a dream that will eventually become the text of *Mrs. Dalloway*; Laura Brown is a Los Angeles housewife in 1949; and Clarissa Vaughan, a book editor, lives in Greenwich Village with her lover, Sally, at the end of the 20th century. Despite the obvious differences, the three women have much in common, and Cunningham effortlessly intertwines their stories.

In the novel's prologue, which takes place in 1941, Virginia Woolf composes suicide notes to her husband, Leonard Woolf, and for her sister Vanessa, walks to the river, fills her clothes with rocks, and drowns herself. In these five pages Cunningham introduces the water imagery that saturates the novel, and Woolf expresses her sense of having been a failure as a writer (she calls herself a "gifted eccentric"). Laura and Clarissa also feel that they

have failed, and the sense of failure is also shared by Richard, the gay writer who, like Woolf, commits suicide.

The prologue ends with a drowning, and a page later Clarissa (who shares her name with Woolf's protagonist) leaves her apartment to "enter the blue depths" of her neighborhood and experience the "plain shock of immersion." Later, Clarissa thinks of Richard, who actually falls to his death, "sliding from a rock into the water." Before his death Clarissa regarded his apartment as having "an underwater aspect" and Richard as seeming like "a drowned queen still sitting on her throne." Richard dies instead of Clarissa because he is a "deranged poet" and "visionary" like Woolf. As she reads about the fictional Mrs. Dalloway, Laura imagines herself to be a "sea creature" ready "to dive into cold water," but she does not commit suicide in the motel room and is the "thwarted' suicide" in the novel. Interestingly, in his autobiographical novel Richard has his mother commit suicide. There are other links between Laura and Woolf: Like Laura, Virginia had planned on fleeing from her husband, and Laura thinks of herself as not herself, but as Virginia Woolf. Both women sense that they are prisoners of their domestic situation.

Woolf battles depression and insanity in Hogarth House, where her husband Leonard, an editor and accomplished writer, acts as her companion and caretaker. Obsessed with a desire to create something perfect, she is both helped and hindered by the ministrations of her husband and by the difficulties of dealing with Nellie, the maid and cook. Clarissa also wants to create the perfect party for Louis, her first love, but her plans are destroyed when Louis cannot face "the hours" and commits suicide. Similarly, Laura is obsessed with making the perfect cake for her clueless husband's birthday, and she goes through her own "rough draft" before creating the perfect pastry. Fearing that she will go insane if she stays with her family, Laura flees, doing something that is decidedly eccentric and unnatural in the eyes of society. The child she leaves is the same Richard that Clarissa falls in love with, only to lose him to Louis.

Cunningham contrasts Laura with Kitty, the "May Queen," the perfect housewife, able to handle the domestic chores that challenge Laura but terrified of the results of the impending examination of her uterus. Yet the two women come together in a way that neither of them could with their husbands. They embrace, their lips touching, but they "do not quite kiss." This relationship is similar to the one between Virginia Woolf and her sister, Vanessa, who closely resembles Kitty. Virginia contrasts the chaste kiss she receives from her sister with the past when they were "two young sisters cleaving to each other, breast against breast, lips ready." These relationships and Clarissa's own relationship with Sally seem to be related to Virginia Woolf's own plan for her Clarissa Dalloway: "Clarissa Dalloway, in her first youth, will love another girl, Virginia thinks." In the novel men either become empathetic caretakers or are incapable of understanding women. It may be that women like Kitty and Vanessa can cope with their inadequate spouses, but the creative, independent women cannot or will not.

After Richard dies, Laura arrives at Clarissa's apartment, and she then realizes that this woman, the mother Richard castigated, had to survive and that her first real duty, is to herself. The "hours" of the title mean different things to the characters: for Richard and Virginia Woolf, they threaten and seem interminable; for Laura and Clarissa, they are those few times when "our lives seem, against all odds and expectations, to burst open and give us everything we've ever imagined," even though darker hours will follow. Such an hour happened between Richard and Clarissa, and it happens again with Clarissa and Sally. The novel ends with acceptance and reconciliation, including the strained relationship between Clarissa and her daughter.

The Film

The film adaptation is quite faithful to the novel. In fact, Cunningham claims that the "film is just bigger than the novel." There were few deletions, the most notable of which was Mary Crowell, the queer theorist who unsuccessfully pursues Clarissa's daughter in the novel. Cunningham actually had a few lines in the flower-shop scene, but these were later cut. It was judged one of the best films of 2001, winning the Best Picture Golden Globe and winning an Oscar nomination for Best Picture. The film also received the USC Scripter Award for Cunningham and screenwriter David Hare for the best adaptation among English-speaking films based on books or novellas. Nicole Kidman, who donned a prosthetic nose and was virtually unrecognizable as Virginia Woolf, won Best Actress awards from the Golden Globe and the Motion Picture Academy.

Director Stephen Daldry, whose earlier success was *Billy Elliot* (2000), captures the content of the prologue and provides more cuts between the action at the river and Leonard back at the house, but it is difficult to show the peace that Virginia Woolf finds after she dies. Perhaps voice-over narration could have supplied those feelings, but Daldry forsakes both voice-over and flashbacks. Nevertheless, the film flows seamlessly but cutting on parallel actions and images. After the film prologue, the three women—Virginia (Kidman), Clarissa Vaughan (Meryl Streep), and Laura Brown (Julianne Moore)—are shown in bed and then arising in consecutive scenes, and then flowers are bought, displayed, and discarded in another three scenes. When Clarissa visits Richard (Ed Harris), he tells her that he's only staying alive for her; obviously, the same thing is true of Virginia and Leonard (Stephen Dillane). This parallel is repeated at the end of the film when Richard tells Clarissa the same thing that Virginia tells Leonard: "I don't think two people could have been any happier than we have been." When Kitty (Toni Collette) asks Laura what *Mrs. Dalloway* is about, Laura answers,

"It's about a person who is giving a party. Everyone thinks she is fine, and she isn't." Laura is giving a birthday party for husband Dan (John C. Reilly), Clarissa is giving one for Richard; and Virginia has her sister Vanessa (Miranda Richardson) for tea. None of the affairs is a success.

The most effective scene is the one that intercuts action at the motel where Laura is contemplating suicide and the afternoon tea where Virginia is contemplating which of her characters will die. As Laura lies in bed, water fills her room until she is awash in troubled waters; at that point, Virginia comes out of her reverie and declares that instead of Mrs. Dalloway dying, the poet and visionary will die. Laura then wakes up and returns to her family.

The link between the young Richard and the AIDS-afflicted Richard is clearer in the film than in the novel. Hare's script portrays a young Richard who senses what his father cannot, that Laura is not fine, and that their domestic life is precarious. The Richard the audience sees is not fine either. The heart-wrenching scene where Richard cries out to "Mommy" as she speeds away is recalled by Richard shortly before his death; he seems to hear himself calling out to her. The scene of Laura's attempted escape is paralleled by Virginia's flight from Hogarth House and her attempt to return to London. Leonard finds her at the train station, where another effective scene occurs. Kidman gets the opportunity to deliver her best lines as she describes how she has endured "this custody, this imprisonment," words which portray Laura's situation. Leonard's insistence that it was "done for you, out of love," could have been spoken by Dan if he were more insightful and articulate. Both scenes are followed by another parallel scene in which both husbands entreat their wives to come to bed.

When Leonard inquires as to why someone must die, Virginia's response provides the key to Cunningham's novel. She says that when someone dies, "others value life more." That proves to be true in Clarissa's case when Richard's death allows her to go on, to take what she has (her embrace and kiss with Sally is life-affirming), and to accept what happens, even in those dark hours. She chooses life, just as Laura Brown had. As Laura talks with Clarissa, she says that she had no choice except life. Reconciliation in the film is further demonstrated by a scene that Hare added in which Julia (Claire Danes) brings some food to Laura and embraces her.

Unlike the novel, the film ends with a repeat of the prologue, which then serves as a kind of framing device, suggesting that all that has preceded, including the stories of Laura and Clarissa, is inextricably tied to Woolf's life and work, and that *The Hours* is also about many other women who have a great deal to bear and who make choices. As the film's Woolf puts it, the idea is "to look life in the face, to know it, love it for what it is, and to put it away." Of Cunningham's women characters, only Kitty seems unwilling to embrace Woolf's words. For the most part, the film captures both the content and the spirit of its source.

REFERENCES

Cunningham, Michael, "The Hours," *Interview*, April 2003; Giltz, Michael, "The Golden Hours," *The Advocate*, March 18, 2003; Lee, Hermione, *Virginia Woolf* (Vintage, 1999).

—*T.L.E.*

HOUSE OF MIRTH (1905)

EDITH WHARTON

House of Mirth (1918), U.S.A., directed by Albert Capellani, adapted by June Mathis; Metro Pictures Corporation.

House of Mirth (2000), U.K., directed and adapted by Terence Davies; Sony Pictures Classics.

The Novel

Wharton was 43 years old when *House of Mirth* first appeared in 11 installments in *Scribner's* magazine, beginning in January 1905. Within three months of its hardcover publication in October it had sold 140,000 copies; and a few months later a dramatized version by Clyde Fitch was playing onstage. *The House of Mirth* was Wharton's first fully expressed survey of American society from top to bottom, as it were. And, as commentator Ruth Barnard Yeazell suggests, it rivals as sociology and satire Thorstein Veblen's *The Theory of the Leisure Class*, published just six years before. The book's title is illuminating and, as Wharton expressed in a letter that year, "explains itself amply as the tale progresses." The title derives from Ecclesiastes 7:4: "The heart of the wise is in the house of mourning; but the heart of fools is in the house of mirth."

The book chronicles the accumulation of the little things, the missteps and the minor slip-ups, that propel Lily Bart from privilege to destitution to social ostracism, disgrace, poverty, and suicide. "We resist the big temptations," she says, "but it is the little ones that eventually pull us down." Headstrong and a bit of a nonconformist—verging on age 30, she always evades repeated advice from friends about the necessity of her getting married, and *soon*—Lily is protected at first by her independent means. But when, through a series of accidents, conspiracies, and willful pride she loses those means (her wealthy aunt is so outraged by her behavior that she all but leaves her out of her will), the society world turns its back on her. Forced to find work as a milliner, then as a private secretary, Lily lets opportunities to save herself—like a proposal of marriage from a man prepared to take on her debts—slip through her fingers. "It was bitter to acknowledge her inferiority even to herself," writes Wharton, "but the fact had been brought home to her that as a bread-winner she could never compete with professional ability. Since she had been brought up to be ornamental, she could hardly blame herself for failing to serve any practical purpose." Finally, alone, her friends gone, her options exhausted,

Lily swallows a fatal dose of chloral, a sleeping draught, and expires.

Lily pays the consequences for willful behavior in a world of highly codified social and behavioral conventions. The sham, greed, and artifice of that frivolous world were enough to destroy her. "In what aspect could a society of irresponsible pleasure-seekers be said to have . . . any deeper bearing than the people composing such a society?" asked Wharton rhetorically in a famous passage in her autobiography, *A Backward Glance* (1933). "The answer," Wharton continues, "was that a frivolous society can acquire dramatic significance only through what its frivolity destroys. Its tragic implication lies in its power of debasing people and ideals." As for Lily, her real fault lay in her inability to negotiate the contradictions between her individual impulses and her social priorities. As Linda Costanzo Cahir has pointed out in *Solitude and Society in the Works of Herman Melville and Edith Wharton* (2000), Lily is convinced that "the choice between society and solitude is an either/or decision, which, once made, translates into a lifestyle that continues throughout the stretch of one's life." What Lily lacks, continues Cahir, is "the insight, the self-knowledge, the faith, and the skill needed to move between modes of being." She may try to negotiate both, but she has not the compromising abilities of her friend Selden, who admits to her that he enjoys living in both worlds of individual freedom and social constraint. "I have tried to remain amphibious," he says; "It's all right as long as one's lungs can work in another air. . . . The people who take society as an escape from work are putting it to its proper use; but when it becomes the thing worked for it distorts all the relations of life."

The Films

Biographer R.W.B. Lewis reports that although several film adaptations of her works appeared in her lifetime, Wharton seems never to have entered a movie theater. The first film version appeared in 1918 from Metro Pictures, directed by Albert Capellani, and starred Katherine Harris Barrymore as Lily Bart, Henry Kolker as Lawrence Selden, Joseph Kilgour as Augustus Trenor-Dorset, and Christine Mayo as Bertha Trenor-Dorset. The main plotline concerns Lily's rejection of the advances of Augustus, her social ostracism at the instigation of Mrs. Trenor-Dorset, and her relocation to another town. When her aunt dies, leaving her penniless, Lily unsuccessfully seeks employment. Thwarted at every turn, she resolves to commit suicide. But the movie censors of the day, not to mention the demands of a popular audience, overturned

Eric Stoltz and Gillian Anderson in House of Mirth (2000, U.K.; THE LITERATURE/FILM ARCHIVE)

Wharton's original intentions; and Selden, who has never stopped loving her, dissuades her at the last moment. They live happily ever after.

Terence Davies's 2000 adaptation closely follows Wharton's storyline, even down to the close replication of several key dialogue scenes. The film opens as Lily's (Gillian Anderson) impulsive and unchaperoned visit to Lawrence Selden's (Eric Stoltz) bachelor quarters is witnessed by Simon Rosedale (Anthony LaPaglia), initiating a run of gossip that will follow Lily through the rest of the story. The money she thought she had received on her investments from Gus Trenor (Dan Aykroyd) in reality is *his* money, which she now owes him. Her friend Bertha Dorset (Laura Linney) invites her on a yachting trip to Monte Carlo; but Bertha in reality has reasons for throwing her into her husband's company: Bertha intends to initiate gossip about Lily in order to deflect talk about her own affair with a lover. When Bertha snubs Lily in public and dismisses her from her yacht, she forges another link in the chain of the deadly gossip and ostracism that increasingly threatens to ruin Lily. (The irony is that Lily possesses a packet of letters that incriminates Bertha of infidelities, but refuses to use them either for profit or her own exoneration.) The expected inheritance from her Aunt Peniston (Eleanor Bron) is mostly funneled away to her cousin Grace Stepney, who coldly refuses to help Lily because she blames her for her aunt's death. Lily loses her job at Mme. Regina's millinery. Her position as Mrs. Hatch's secretary is threatened when Hatch seeks out social connections with Bertha Dorset. And Mr. Rosedale refuses to renew his offer of marriage unless Lily blackmails Bertha Dorset into dropping the social ostracism that would threaten Rosedale's social position as Lily's husband.

Ultimately, Lily's vaunted independence has proven to be a mere commodity in a commercial exchange. In the end, she confesses her wretched condition to her only true friend, the lawyer Selden. Before leaving him, she surreptitiously drops Bertha's incriminating letters into his fireplace. Moments later, upon finding them Selden has a premonition of disaster. He races to Lily's shabby apartment, but he is too late. Assailed by thoughts of her "rootless and ephemeral" existence, Lily has swallowed the entire contents of the chloral bottle. Davies provides here an image not derived from Wharton's story: The camera lingers on Lily's last moments as the bottle falls from her fingers and spills out its contents in a slow, throbbing dark stain. It's a striking image, implying that Lily's own life has wasted away, inexorably, uselessly, leaving behind only an empty corpse, blue with the pallor of death. As Selden gazes down on her lifeless form, at the face that Wharton describes as the "delicate impalpable mask over the living lineaments he had known," he confesses too late his love.

As if to emphasize the exclusiveness of Lily's social set of Bertha Dorset, Gus Trenor, and Aunt Peniston—what R.W.B. Lewis refers to as "the species of idle rich that occupied only a corner of New York"—Davies places his characters in an environment hermetically sealed away from everything that is extraneous. Nothing of the outside world—the New York City of desperate streets and slums—is allowed to intrude. (Aptly enough, the city itself is literally absent from the film since most of the action was shot in locations in Glasgow.) Ladies and gentlemen defend their fortifications. Women are armored with bulging shoulder pads, their heads submerged under huge hats and parasols and their faces concealed by patterned veils; and the gentlemen peer out from behind their own barricades of starched shirts, vests, waistcoats, and heavy topcoats, cinched and buttressed with suspenders, watch chains, and walking sticks. No one speaks without a certain wary consideration; and everyone pauses at least one beat longer than expected at both ends of a dialogue. They move in a close-order drill, precisely and deliberately according to their prescribed circuits, inbred creatures unable to go anywhere without bumping into each other. Indeed, they all are so wrapped up in themselves—literally and figuratively—that when they attend the opera they display not the slightest interest in the stage action. They can only regard each other from behind their lorgnettes. They are at once the dramatis personae, spectators, and critics of their own performance. Davies trumps the scene when he likewise denies us a view of the stage, making us complicit in their self-inscribed spectacle.

Terence Davies surely ranks as the equal of Wharton as a master of the drama of interior mise-en-scène (Wharton's first book was entitled *The Decoration of Houses*). As *New Yorker* critic Anthony Lane observes, Davies "proves his credentials for the filming of Edith Wharton," since he is obviously "more at home with interiors, with accents of bronze and velvet and glass-fronted cabinets, than with rolling landscapes." Throughout the film, character and decor vie for attention. Figure and ground constantly shift. People arrange themselves like the drapes and furnishings, while the wallpaper and decor stir to life with a personality and demeanor of their own. When Lily awaits an assignation with Selden, her red hair and cream complexion play out against the scarlet cushions and rainbow-hued coverlets of her couch. Each complements and finally subsumes the other. Like the vivid room interiors described by Wharton—"I always saw the visible world as a series of pictures more or less harmoniously composed"—and by her American contemporaries John Singer Sargent and William Merritt Chase (images which Davies constantly invokes), the dramatic conflict and resolution reside in the arrangement, not in the action of the scene.

What Davies's film version cannot tell us is that *House of Mirth* reveals not only its nominal subject but something of its author. In Lily, suggests Wharton's biographer, R.W.B. Lewis, the novelist has delineated some of her own traits, "endearing, proud, sensitive, and exasperating by turns." Through Lily, moreover, "Edith Wharton conveyed her sense of herself as essentially unfitted for the only American society she knew, and as gravely misunderstood by that society." Trained like Lily to be a married

society woman, she, too, felt herself a failure and an out-sider. She noted in 1903 in a letter to a friend, "You see in my heart of hearts, a heart never unbosomed, I feel in America as you say you do in England—out of sympathy with everything." Indeed, Wharton, too, knew something about pain and entrapment and psychological turmoil. However, she also possessed something that Lily did not, what Lewis calls an "unshakeable belief in the possibilities of life." Ultimately, as Lewis quotes Wharton, life was "wonderful" and "astounding," even if one had to regard it "through the prison bars of illness and suffering!"

Wharton's own "house of mirth" at least had rooms with a view.

REFERENCES

Cahir, Linda Costanzo, *Solitude and Society in the Works of Herman Melville and Edith Wharton* (Greenwood Press, 1999); Dwight, Eleanor, *Edith Wharton: An Extraordinary Life* (Harry N. Abrams, 1994); Esch, Deborah, *New Essays on "The House of Mirth"* (Cambridge University Press, 2001); Lane, Anthony, "Gilding Lily," *The New Yorker*, December 25, 2000, and January 1, 2001, 156–157; Lewis, R.W.B., and Nancy Lewis, eds., *The Letters of Edith Wharton* (Charles Scribner's Sons, 1988); Lewis, R.W.B., *Edith Wharton: A Biography* (Harper & Row, 1985); Wharton, Edith, *A Backward Glance: An Autobiography* (Simon and Schuster, 1998).

—*J.C.T.*

THE HOUSE OF THE SEVEN GABLES (1851)

NATHANIEL HAWTHORNE

The House of the Seven Gables (1940), U.S.A., directed by Joe May, adapted by Lester Cole and Harold Greene; Universal Pictures.

Twice-Told Tales (1963), U.S.A., directed by Sidney Salkow, adapted by Robert E. Kent; Admiral Pictures/United Artists.

The Novel

Written in 1851, one year later than *The Scarlet Letter*, *The House of the Seven Gables* has suffered by comparison in popularity, critical acclaim, and scholarly attention. Hawthorne's preface claims it is a "romance" instead of a "novel"—i.e., he sought latitude to go beyond present, probable fact (the novel's proper subject) to approach a legendary, imaginative truth (the romance's proper realm). This distinction proved important in the development of the novel as we now recognize it, so that today's reader takes for granted the novel's proper claim to go beyond fact to explore imaginative truth.

Chapter one describes the eponymous house, located on Pyncheon Street in an unspecified New England town, as a deteriorating 160-year-old mansion with a curse hanging over it. Colonel Pyncheon, a wealthy Puritan, built it after obtaining its land by framing owner Matthew Maule

Nathaniel Hawthorne

for witchcraft. Maule, a poor man who long defied Pyncheon's claims to the property, prophesied before his execution that the colonel would drink blood. On the day the house opened, guests found the colonel dead in his chair, his beard blood-soaked.

One hundred and sixty years later, spinster Hepzibah Pyncheon lives alone in the gloomy house, except for a reclusive 21-year-old boarder, Holgrave. Hepzibah's 17-year-old niece Phoebe visits, and Hepzibah's brother Clifford moves in, broken in health and mind from imprisonment. Phoebe's caring fills a void in both her and her uncle's lives, and impoverished Hepzibah accepts Phoebe's help in the cent shop she has opened. A memorable customer is a child, Ned Higgins, who begs as many cookies as he buys.

Phoebe intrigues Holgrave. His shy advances toward her consist of telling stories about his past jobs, sharing his philosophical views, and reading to her from his manuscript, "Alice Pyncheon." His book is a chronicle about the Pyncheon family: Colonel Pyncheon's grandson pressures Matthew Maule's grandson to reveal the whereabouts of a

land deed lost since the colonel's death. Maule mesmerizes Pyncheon's young daughter Alice and interprets her vision to mean that Pyncheon cannot have the valuable deed. Alice never fully recovers from the effects of the trance and dies soon afterward.

Phoebe is fascinated by Holgrave's story. Deciding to make Seven Gables her permanent home, she returns to her parents to arrange her move. Meanwhile, Hepzibah finds Jaffrey Pyncheon, a wealthy cousin, at the door, demanding to see Clifford and threatening to commit him to an insane asylum if he does not cooperate. Jaffrey is convinced that Clifford knows the whereabouts of the lost land deed to a vast Maine estate. Hepzibah does not find Clifford in his chamber but, returning, she finds him with Jaffrey, who is struck dead from apoplexy, in the same chair where the colonel had died the same way. Fearing murder charges, Hepzibah and Clifford flee.

When Phoebe returns, Holgrave tells her of Jaffrey's death and her aunt and uncle's disappearance, and while sharing their trepidations, they confess their love for each other. Meanwhile, Clifford and Hepzibah return. The authorities establish their innocence. By their marriage, Phoebe (the youngest Pyncheon) and Holgrave (actually Matthew Maule's descendant) expiate the house's curse. As Jaffrey's heirs, the four leave Seven Gables to move into his country estate.

The Films

The two feature-film adaptations of *Seven Gables* both star Vincent Price. But they differ drastically in every other respect. Joe May's 1940 *The House of the Seven Gables* bypasses the novel's gothic features, infusing the adaptation instead with a social and political thrust. Made nearly 25 years later, Sidney Salkow's *Twice-Told Tales* is standard horror-genre fare. Billing itself as a "trilogy of terror," one-third is devoted to *Seven Gables*. It bypasses Hawthorne's reflective, philosophical qualities and emphasises the story's supernatural elements instead.

May (born Joseph Mandel), a prominent German director in the interwar expressionist movement, immigrated to Hollywood in the wake of Hitler's rise to power. Joining him as a screenwriter was Lester Cole (later jailed as one of the Hollywood Ten who refused to identify Hollywood communists). Cole, with coadaptor Harold Greene, altered certain relationships to sharpen conflicts between the main characters: Hepzibah became Clifford's fiancée instead of sister, while she remained Jaffrey's cousin. Clifford became Jaffrey's brother and the film's central character. Clifford and Hepzibah assumed younger ages than in the novel in order to heighten their love interest.

The film develops Clifford's conflict with his father, a conflict buttressed by making Clifford (Vincent Price) a musician (Price even performs a swing jazz song, Frank Skinner and Ralph Freed's "The Color of Your Eyes") while the father (Gilbert Emery) is a stodgy traditionalist. During a loud dispute between the two men, partially observed and overheard by extras from the street, the father dies from apoplexy. Jaffrey (George Sanders) accuses Clifford of murder.

Cole and Greene create two additional scenes: Clifford's trial and prison stay. He meets Holgrave (Dick Foran), a fellow prisoner and active abolitionist. Although the two men learn that they are descended from rival families, their shared, unjust imprisonment bonds them together.

In the meantime, Hepzibah (Margaret Lindsay) inherits Seven Gables, evicts Jaffrey, and packs away her now-useless wedding dress. When Clifford's 20-year confinement passes and he returns, the wedding dress is deteriorated, symbolizing the couple's loss of their youth. Holgrave joins Clifford and Hepzibah at Seven Gables, and his return to abolitionist work coincidentally pits him against Jaffrey—a proslavery investor. In a confrontation reminiscent of Clifford's with his father, Jaffrey too dies of apoplexy. The movie ends with a double wedding: Clifford to Hepzibah and Holgrave to the now-minor character Phoebe (Nan Grey).

While Hawthorne's Clifford was utterly devastated physically and psychologically by prison, the film's Clifford has a future with Hepzibah. The film drops the Pyncheon curse and its supernatural air, inserting the slavery issue and highlighting the political injustice (rather than the spiritual cost) of false imprisonment.

Twice-Told Tales' version of *Seven Gables* opens with a prologue showing the house's construction after witch executions "in the year of terror 1691." *Tales*, like the novel, resumes 160 years later, but the characters' names change and their number drops to four: Gerald Pyncheon (Vincent Price) corresponds to Jaffrey and to Gervayse Pyncheon, Alice's father in the novel, except that Gerald is married to Alice (Beverly Garland). Alice somewhat resembles Phoebe and the book's Alice but is not a born Pyncheon. Hannah (Jacqueline de Wit) corresponds to Hepzibah, and Jonathan Maule (Richard Denning) to Holgrave. Clifford and the other characters have been eliminated.

When Gerald returns bankrupt to Seven Gables after 17 years, sister Hannah is not happy. Hannah warns Alice to leave. Upstairs, Alice experiences paranormal phenomena, including déjà vu and an old locket's floating to her, opening on a portrait resembling her. Downstairs, Hannah warns Gerald to leave before the Pyncheon curse kills him, but he wants to find the vault containing a lost deed to a Maine estate. Alice enters, senses Jonathan Maule's approach, then plays music. Hannah thinks the music is from a ghost communicating with Alice. Jonathan appears and recognizes the music as a tune his grandmother played in his childhood. Gerald offers Jonathan Seven Gables in return for the vault's location. But Jonathan refuses, citing their families' feud. The colonel's portrait bleeds from the mouth. In bed later, Alice hears a voice saying "Nora" and wanders entranced to the garden, where she kisses a ghostly Matthew Maule, who transforms into Jonathan. He realizes Nora was Alice's ancestor who loved Matthew.

When Gerald sees the couple kiss, he moves to kill them, but Hannah says to use Alice and the ghost to find the vault first. In another trance, Alice walks to Matthew Maule's grave in the basement. Gerald and Hannah confront her. Guessing that Alice is near the vault, Gerald opens Matthew's grave. The skeleton is missing an arm but holds a note with directions to the colonel's portrait. When Hannah speaks of splitting the wealth, Gerald bludgeons her and throws Alice into the grave, shutting its stone cover on her hand. Jonathan from afar senses Alice's distress.

Behind the portrait, Gerald finds only the missing skeleton arm, which strangles him. The house begins to collapse, its cracking plaster oozing blood. Jonathan rescues Alice and they watch the house implode spectacularly. The last Pyncheon's death ends Seven Gables and its curse.

Robert E. Kent's script reduces the novel to hokum and horror. The character motivations are simplistic. Unlike reclusive Hepzibah, who scowls mainly from nearsightedness, Hannah is pure evil. Gerald lusts after fortune for no more complex reason than his own bankruptcy. Alice and Jonathan are mere reincarnated spirits playing out destinies from past lives. Furthermore, low-budget, limited sets, artificial-looking blood, and tepid acting give *Tales* a made-for-late-night-television feel.

REFERENCES

Asselineau, Roger, ed., *The Merrill Studies in The House of the Seven Gables* (Charles E. Merrill, 1970); Kaplan, E. Ann, "Hawthorne's 'Fancy Pictures' on Film," in *The Classic American Novel and the Movies*, Gerald Peary and Roger Shatzkin, eds. (Fredrick Ungar, 1977); Williams, Lucy Chase, *The Complete Films of Vincent Price* (Citadel Press, 1995).

—B.F.

HOWARDS END (1910)

E.M. FORSTER

Howards End (1992), U.K., directed by James Ivory, adapted by Ruth Prawer Jhabvala; Merchant-Ivory/Orion.

The Novel

Howards End is the most serious and symbolic of Forster's four Edwardian novels. Essentially, it is a novel of social criticism, Forster's response to the restlessness and seeming rootlessness of urban citizens of the period, which he called "a civilization of luggage." The novel's famous epigraph—"Only connect"—was, in a sense, an early version of T.S. Eliot's "heap of fragments" in *The Wasteland:* Modern men and women perceive experience only in fragmented form and fail to make connections between the fragments. The novel embodies this theme, opposing fragmentation with the vision of the house of the title, which represents permanence, order, and the best of the English yeoman tradition. The central character, Margaret Schlagel, eventually perceives life as a whole through a connection with Howards End: She loses her sense of flux, makes connections, and achieves a sense of English greatness.

The Schlagel sisters, Margaret and Helen, who are modeled in part on Virginia Woolf and her sister Vanessa Bell, belong to the British intellectual class. The sisters are chiefly concerned with culture and the redemptive potential of human relationships. Conversely, the Wilcoxes represent the world of business, property, and the acquisition of things. They include Henry, the father, Charles and Paul, his sons, his daughter Evie, and Charles's wife Dolly. The Schlagels meet the Wilcoxes at a German spa; subsequently, they live in opposite houses in London. Mrs. Wilcox, an intuitive and generous woman who was born in Howards End, becomes friendly with Margaret. On her deathbed, Mrs. Wilcox attempts to give the house to Margaret by writing a note to that effect in pencil, but the family sets it aside and never tells Margaret of her "legacy."

A second plot revolves around Leonard Bast, a member of the lower-middle class who aspires to culture: He reads Ruskin and attends lectures. Leonard meets the sisters when Helen inadvertently walks home with his umbrella after a concert. On the advice of Mr. Wilcox that a banking firm is unsound, the sisters induce Leonard, a clerk in the bank, to quit his post. After he does, the bank remains solvent, but having been hired by a new firm, he is the first to be let go in an economy measure and is unable to find work anywhere.

In the meantime, widower Wilcox proposes to Margaret and is accepted. When Helen finds Leonard and his wife Jacky starving, she blames Wilcox and brings the Basts to a country house that the Wilcoxes have rented to confront her future brother-in-law with the cause and effect of his acceptance of idle rumor. In an extravagant coincidence Jacky Bast reveals that she had once been Wilcox's mistress. Despite this, Margaret marries Wilcox. Helen begins a love affair with Bast, gets pregnant, and leaves for Germany. While she is away, the Schlagel possessions are stored at Howards End. On her return, Helen asks to spend a night at the house, but Henry refuses, appalled at her sexual indiscretion. Margaret demands that he make the connection between his previous behavior and his current moral stance.

The climax takes place at Howards End, as the characters converge. Bast arrives, as does Charles, who attacks Bast with the Schlagel sword hanging over the fireplace. In the scuffle, a bookcase topples, crushing Bast. Charles is imprisoned for manslaughter. Since none of the Wilcox children really wants Howards End, Wilcox deeds it to Margaret. Thus, Margaret finally inherits the house, as Ruth Wilcox wanted, but the ultimate inheritor will be the bastard son of Leonard Bast and Helen Schlagel.

The Film

Ruth Prawer Jhabvala's script, which won an Academy Award for best adapted screenplay, omits what E.K.

Browne called Forster's great expanding symbol of hay. Mrs. Wilcox is first seen in the novel walking on the lawn holding wisps of it. The Wilcoxes suffer from hay fever, and Helen's hopeful final words in the book are "It'll be such a crop of hay as never!" The hay has disappeared, probably because the adapter thought the symbol too literary. Nonetheless, the film ends with a shot of mowing, a kind of concession to readers of the book but one for which viewers have no context. Instead, the film offers images of nature, especially bluebells, associated with Mrs. Wilcox (Vanessa Redgrave) and Bast (Sam West) to convey Forster's theme of urbanites, displaced from their rural heritage. The idea of "only connect" has similarly vanished, although in a climactic scene Margaret does insist that Henry see "the connection" between his adultery and Helen's affair. What remains is a conflict of values between the Schlagels, representing culture, and the Wilcoxes, representing materialism. And, as many British films have done since the early sixties, the problem of class distinction is made plain through Helen's sense of social injustice done to the Basts and Mr. Wilcox's contempt for the poor. Overall, the adaptation follows Forster's plot line faithfully, making sharp juxtapositions of scenes without dissolves and establishing a great sense of period detail through mise-en-scène. The dialogue is either condensed from Forster's own words or designed to approximate his ideas.

As in their earlier and extremely successful *A Room With a View*, the Merchant-Ivory visualization of the period was outstanding, and Luciana Arrighi won an Academy Award for art decoration. Emma Thompson was voted best actress by the academy for her highly intelligent portrayal of Margaret. Indeed, the casting for the film was responsible for bringing Forster's characters to life, Anthony Hopkins making Wilcox seem at times a reasonably decent member of the British establishment. In spite of a somewhat reduced dimension from printed page to screen, the film is a superior example of adaptation and is likely to remain impressive for viewers in theatrical revivals or on video cassettes and laser discs.

REFERENCES

Brown, E.K., *Rhythm in the Novel* (University of Toronto, 1963); Furbank, P.N., *E.M. Forster: A Life* (Secker and Warburg, 1979); Long, Robert Emmet, *The Films of Merchant Ivory* (Abrams, 1991); Tindall, William York, *Forces in Modern British Literature* (Vintage, 1956).

—*J.V.D.C.*

HOW GREEN WAS MY VALLEY (1940)

RICHARD LLEWELLYN

How Green Was My Valley (1941), U.S.A., directed by John Ford, adapted by Philip Dunne; Twentieth Century-Fox.

The Novel

The vivid imagery and episodic nature of Richard David Vivian Llewellyn Lloyd's most famous novel derives in part from his training in London in the 1930s as a film producer and scenarist. The authentic locations and diction stem from his own boyhood experiences and education in St. David's, Cardiff. An inveterate traveler, Llewellyn worked and revised the novel in St. David's, India, and London. Immediately on its publication in 1940, it sold 150,000 copies in England and America and earned the National Book Award.

Huw Morgan's first-person narrative relates the 30-year history of his family in a late-19th-century south Wales mining community. The idyllic tone of the early scenes—the singing of the miners as they come up from the pits, the blooming meadows and rushing streams of the valley, the bustling hearth of the Morgan home—gradually darkens as the black slag overwhelms the mountain and a series of strikes divides the loyalties of the workers. Young Huw watches in dismay as three of his five brothers leave home to join the strikers. When his father is threatened for refusing to lead the men out of work, his mother marches out into a wintry night to denounce the agitators. She and Huw almost perish in the freezing cold. During the boy's prolonged recovery, he meets the Rev. Gruffydd, who becomes his best friend and teacher. When Huw attends the English National School, he is subjected to much abuse before he is accepted by the students and teachers. Meanwhile, there are tragic consequences to the marriages of four of his siblings: Gwilym's wife Marged goes mad and commits suicide, Ivor's wife Bronwen collapses in grief when he is killed in the mine, Ianto's wife dies, and Angharad grows bitter over her unhappy marriage to the mine owner's son (nursing all the while her secret passion for the Rev. Gruffydd). One by one, all of Huw's friends and siblings leave the valley. After the death of his father in a mining accident, Huw, now a mature adult, decides to follow their example and depart forever. "But you are gone now, all of you, that were so beautiful when you were quick with life," says Huw as he departs. "Yet not gone, for you are still a living truth inside my mind."

Llewellyn wrote two sequels, *Up, Into the Singing Mountain* in 1960 and *Down Where the Moon Is Small* (alternately titled *And I Shall Sleep Down Where the Moon Is Small*) in 1966.

The Film

The partnership of Twentieth Century-Fox studio chief Darryl F. Zanuck and director John Ford had already produced the literary adaptations *The Grapes of Wrath* (1940) and *Tobacco Road* (1941) when the decision was made to film Richard Llewellyn's popular novel. Zanuck purchased the movie rights for a record-breaking sum of $300,000, declaring it would be shot in color and stereophonic sound

in the Cwm Rhondda Valley, the coal-mining district of South Wales. He hired director William Wyler to work out a script with scenarist Philip Dunne. But when delays forced Wyler to depart, old friend John Ford was brought in. Meanwhile, the outbreak of war with Japan and Germany forced the production to move closer to home. A team of 150 carpenters and decorators converged in a remote glen of the Fox Ranch in the Malibu Hills and erected an 80-acre set of stone cottages, cobblestone streets, shops, a marketplace, a church, and a workable colliery. They created the slag heap by stripping a hill of vegetation and covering it with 50 carloads of slag rock and hundreds of gallons of black paint. A Los Angeles–based Welsh choir provided the many national songs and hymns heard on the soundtrack.

While preserving the episodic nature of the book and much of its dialogue, Dunne's script drops many characters and telescopes the 30-year saga into a single year in the life of Huw, its narrator (whose off-screen voiceover is not that of actor Rhys Williams, as is frequently reported, but of Irving Pichel). The novel's predominating conflict between labor and capital is reduced to its divisive impact on the Morgan family. Zanuck had impressed upon Dunne that he wanted to avoid another "sociological problem story" like *Grapes of Wrath*. "I felt that the emphasis should be on the family," writes Dunne in his invaluable account of the genesis of the screenplay. "The struggle of the miners to organize, the blackening of the green valley and the growing unemployment would serve only as catalysts for the gradual but irreversible disintegration of the once happy, prosperous and closely-knit family." And it was Zanuck who insisted that Huw's first-person voice be used throughout to bind together the disparate scenes and characters.

For the most part, the strategy works remarkably well. The narrative voice retains something of the peculiar, idiosyncratic quality of Llewellyn's poetic diction, and the lyric montage sequences discreetly simplify the lumpy complexes of subplots and digressions. The opening 15 minutes, particularly—beginning with the introduction of the Morgan family and concluding with the marriage of Ivor (Patric Knowles) and Bronwen (Anna Lee)—is a glorious blend of photographer Arthur Miller's crisply luminous imagery, Ford's lovingly sentimental tone, composer Alfred Newman's tender score, and the Welsh choir's sturdy songs (some of which were, in reality, Irish tunes). The ominous blast of the colliery whistle that interrupts the sequence is like a sad pedal point that, with a few exceptions, prevails for the rest of the film.

Unfortunately, there are times when the decision to telescope events into the span of just one year creates problems. It seems strange, for example, that in that brief span of time Huw (12-year-old Roddy McDowall in his American debut) could recover so quickly from his injuries in the snowstorm; that he could begin and complete his schooling; and that there could be so many strikes, marriages, family splits and reconciliations. Of the 20-year gap between the adult Huw who is leaving the valley and the small boy Huw in the flashback there is no account. On the other hand, the condensation of events occasionally works to the story's advantage, as in the episode of Huw's beating at school and his subsequent revenge on the teacher—a subplot that in the book is prolonged over hundreds of pages and several years of time.

Ford's unobtrusive camera is like a quiet and respectful guest in the Morgan home. Rarely does it move, and then with a profound effect: When Ivor's choir prepares to depart for a royal command performance, the camera pans away to reveal two of the other Morgan sons leaving home to go abroad. But it is the incomparable mise-en-scène of the static camera that is the most profoundly affecting, as when an uncut shot captures the departure of Angharad's (Maureen O'Hara) wedding carriage in the foreground, while the distant, isolated figure of the sorrowing Rev. Gruffydd (Walter Pidgeon) stands isolated in the distance.

How did the film fare in Wales? Dunne reports that although audiences enjoyed the Welsh songs, they deemed it too sentimental, as opposed to the harsher realities of the contemporaneous *The Stars Look Down*, directed by Carol Reed. One irony, moreover, still rankles—that Ford cast Irish actors in many of the Welsh roles.

How Green Was My Valley won six Oscars, including best picture (beating out *Citizen Kane*), best director, and best supporting actor (for Donald Crisp in the role of Huw's father). Despite Zanuck's ambitions to the contrary, declares historian Andrew Sarris, the picture can be regarded as a sequel to *The Grapes of Wrath*: "There were the same conflicts between capital and labour, the same spectacles of social injustice, the same strains on the fabric of the family and the same intimations of indomitability among the poeticized poor." Certainly it remained one of Ford's favorite projects: He selected it to be screened as part of the 1972 tribute to him organized by the Directors Guild.

REFERENCES

Dunne, Philip, "No Fence Around Time," in *How Green Was My Valley: The Screenplay for the John Ford Directed Film* (Santa Teresa Press, 1990); Mosley, Leonard, *Zanuck* (Little, Brown, 1984); Sarris, Andrew, *The John Ford Movie Mystery* (Indiana University Press, 1975); Zinman, David, *50 Classic Motion Pictures* (Chelsea House, 1983).

—*J.C.T.*

THE HUNCHBACK OF NOTRE DAME
(Notre Dame de Paris) (1831)

VICTOR HUGO

The Darling of Paris (1917), U.S.A., directed by J. Gordon Edwards, adapted by Adrian Johnson; Fox Film Corp.
The Hunchback of Notre Dame (1923), U.S.A., directed by Wallace Worsley, adapted by Edward T. Lowe, Jr.; University Pictures.

The Hunchback of Notre Dame (1939), U.S.A., directed by William Dieterle, adapted by Sonya Levien and Bruno Frank; RKO Radio Pictures.

The Hunchback of Notre Dame (1956), France-Italy, directed by Jean Dellanoy, adapted by Jacques Prevert; Paris Films/Panitalia.

The Hunchback of Notre Dame (1996), U.S.A., directed by Gary Trousdale and Kirk Wise, adapted by Tab Murphy and Jonathan Roberts; Walt Disney Pictures.

The Novel

An acknowledged leader in the French Romantic movement, the 28-year-old poet/novelist Victor Hugo had already achieved fame and notoriety with the plays *Cromwell* (1827) and *Hernani* (1830) before producing the celebrated novel *Notre Dame de Paris* (in later English translations, "The Hunchback of Notre Dame") in 1831. His inspiration purportedly came from his accidental dis-

covery of the Greek word for "fate" carved into the wall of one of the towers of Notre Dame Cathedral (he led efforts from 1845 to 1864 to restore the famous cathedral). Thus, against the colorful backdrop of the medieval age and the great cathedral itself, Hugo relentlessly tracked the fates of the doomed but devoted Quasimodo, the corrupt and lustful Frollo, and the virginal and pure Esmeralda.

The year is 1482 in the reign of Louis XI. All of Paris is awaiting the arrival of Flemish ambassadors to announce the forthcoming marriage of Louis's oldest son to Margaret of Flanders. Parisians, meanwhile, are also in the streets celebrating the Festival of Fools. As their Prince of Fools they elect the hideously disfigured Quasimodo, the deaf hunchback bellringer of Notre Dame Cathedral. Like the cathedral itself, Quasimodo possesses a beautiful, vulnerable sensibility behind his rough, gargoyle exterior.

Quasimodo's brief moment of public acclaim turns sour as the populace, suspecting him of an unholy association with Claude Frollo, archdeacon of Notre Dame and

William Park Sr. and Lon Chaney in The Hunchback of Notre Dame, *directed by Wallace Worsley* (1923, U.S.A.; UNIVERSAL/JOE YRANSKY COLLECTION, DONNELL MEDIA CENTER)

rumored alchemist, sentences him to be brutally flogged on the pillory. The only person to show pity to him is Esmeralda, a beautiful gypsy girl, who mounts the scaffold to give him a flask of water. Quasimodo is immediately smitten with her. So are his two rivals, the lustful Frollo and the dashing Captain Phoebus de Chateaupers. When Frollo stabs Phoebus, Esmeralda is implicated in the crime and thrown into prison. At her trial she is convicted of witchcraft and ordered to do penance before Frollo. She refuses his offer of freedom. Quasimodo suddenly appears, takes the girl in his arms, and carries her to sanctuary within Notre Dame Cathedral.

Now her ardent protector, Quasimodo guards her against the mob that has gathered to demand her release. He throws stones and pours melted lead upon their heads. Esmeralda, in the meantime, escapes in terror, only to confront Frollo again. Once more, she rejects his advances, and she is captured and sentenced to hang the next morning at the Place de la Greve. Witnessing her execution from the cathedral towers, a frenzied Quasimodo hurls Frollo to his death. He disappears, never to be seen again. Years later, during the reign of Charles VIII, two skeletons are found in the vault of Montfaucon. One is of a woman who had been clad in white; the other is of a man with a crooked spine. His bony arms are wrapped tightly around her body. The bodies crumble into dust when they are separated.

The Films

Hugo's story holds out great promise for filmmakers, with its pageantry, spectacle, occasional horror, sex, and Beauty-and-the-Beast theme. Unfortunately, little information is available about the first major film adaptation, Fox's *The Darling of Paris* (1917), a vehicle for the popular Theda Bara. According to the *AFI Catalogue of Feature Films, 1911–1920*, it is clear that its numerous story and character alterations presage the state of adaptations to come. Esmeralda (Bara) here assumes center stage; the character of Frollo is renamed "Frallo," whose status of priest is changed to that of scientist, lest the audience be offended; and Quasimodo (Glen White) is permitted to release the incarcerated gypsy girl for a happy ending.

The 1923 Universal picture was a spectacular production (budgeted by producer Irving Thalberg at more than a million dollars) that shifted the attention back to where it belonged, to Quasimodo. Lon Chaney, already famed for his physically taxing portrayals of legless men (*The Penalty*, 1919) and colorful fiends (Fagin in *Oliver Twist*, 1922), outdoes himself in his impersonation of the hunchback. Face disfigured by morticians' wax and fang-like teeth, body hampered by a 70-pound hump attached to a breastplate and shoulder pads, he dangles from bell ropes and scrambles about the facade of the gigantic cathedral set with the agility of a monkey. The villainies of the priest Frollo (Nigel de Brulier) are conveniently transferred to his brother, Jehan (Brandon Hurst)—another attempt to stave off public protest. The ending is also changed: After fighting off the attacking mob and saving Esmeralda, Quasimodo is fatally stabbed by Jehan. Things end happily for Esmeralda, who marries Phoebus. (Chaney's flogging scene was reconstructed by James Cagney in the 1957 Chaney biopic, *The Man of a Thousand Faces*.)

Generally acknowledged as the finest of the various screen adaptations is RKO's 1939 version, directed by William Dieterle at a purported cost of almost $3 million (the most expensive RKO production to date). Most of it was shot at the RKO ranch in the San Fernando Valley, where the studio constructed a 190-foot replica of the cathedral, complete with gargoyles, vaulted ceilings, and stained-glass windows. Charles Laughton came to the role only after Bela Lugosi, Claude Rains, and Orson Welles had first been considered. The plot outline, particularly in the first half, hews closely to the novel; and this time the lustful villainy of Frollo (Cedric Hardwicke) is restored. Things depart from the original story, however, when the mob that storms the cathedral proves to be sympathetic to Esmeralda (Maureen O'Hara in her American screen debut), rather than hostile about her presumed witchcraft. Misunderstanding their motives, Quasimodo repels the crowd with cauldrons of molten lead. But after rescuing Esmeralda from Frollo (and hurling him from the cathedral parapet to his death), he is rejected by the girl and left alone at the end. Forlornly he embraces one of the gargoyles and says, "If only I had been made of stone, like you."

Inasmuch as storm clouds were gathering over Europe at the time of the film's production, certain aspects of the script drew parallels between the persecution of the gypsies in the Middle Ages and Hitler's persecution of the Jews. Director William Dieterle has noted that Laughton's Quasimodo represented a plea for universal tolerance: "When Laughton acted the scene on the wheel, enduring the terrible torture, he was not the poor, crippled creature . . . but rather oppressed and enslaved mankind, suffering injustice . . ."

The 1957 French version, although beautifully shot in Technicolor, was marred by inept dubbing in its English-language release. However, it is the only adaptation to date that has retained at least a semblance of Hugo's original ending. After the death of Esmeralda (Gina Lollobrigida), Quasimodo (Anthony Quinn) brings her body back to the charnel house of Montfaucon. He embraces her, dying eventually of starvation.

Although the 1996 animated version from Walt Disney predictably strikes out in its own directions, it is nonetheless a striking achievement, the first film to be produced at Disney's new state-of-the-art animation studios in Burbank. Carried over from Disney's previous success, *Beauty and the Beast*, were producer Don Hahn, directors Gary Trousdale and Kirk Wise, and eight-time Academy Award song composer Alan Menken. The results are a vivid blockbuster with superb computerized animated effects, a vividly-realized cathedral, outstanding voice talents—

including Tom Hulce as Quasimodo, Demi Moore as Esmeralda, and Tony Jay as Frollo-and nine new songs (including Quasimodo's poignant soliloquy, "Out There"). Purists doubtless wince at the introduction of comic relief from "Quasi's" gargoyle friends, whimsically named "Victor" and "Hugo," the conversion of Captain Phoebus into a stalwart romantic interest for Esmeralda, and a happy ending (not without some poignant touches) wherein Quasimodo unselfishly stands aside while the lovers reunite. But there's no denying the wit of the story's framing device of the gypsy puppeteer, the erotic power of the crimson-hued dream sequence depicting Frollo's sexual frustrations over Esmeralda, the tour-de-force animation of Quasi's rescue of Esmeralda from a burning pyre, and the exciting, climactic fight on the cathedral towers between Quasi and Frollo.

REFERENCES

Franklin, Joe, *Classics of the Silent Screen* (Citadel Press, 1959); Magill, Frank N., *Cinema: The Novel into Film* (Salem Press, 1976); Walt Disney pressbook, *The Hunchback of Notre Dame* (1996).

—*J.C.T.*

THE HUNT FOR RED OCTOBER (1984)

TOM CLANCY

The Hunt for Red October (1990), U.S.A., directed by John McTiernan, adapted by Larry Ferguson and Donald Stewart; Paramount.

The Novel

Set near the end of the cold war, the novel opens with Soviet submarine captain Marko Ramius executing his plan to defect to the United States along with his senior officers and the newest nuclear missile submarine in the Soviet fleet, the *Red October.* The submarine, larger than a World War II aircraft carrier and so silent that it is almost impossible to detect, is designed for one reason: to give the Soviet Union first strike capability while allowing no time for a response.

The Soviets initially convince Washington that Ramius is a rogue bent on initiating World War III. It is up to Jack Ryan to convince the Joint Chiefs of Staff and the president's national security adviser that Ramius is actually trying to defect. Ryan works as an analyst, fitting together pieces of information and insights supplied by various experts to draw conclusions and offer possible courses of action for consideration by those in charge of the crisis.

The conclusion of the novel follows Jack Ryan and the other main characters, Bart Mancuso and his crew aboard the American attack submarine USS *Dallas.* After a complex deception, the Soviets are convinced the *Red October* has been lost at sea. Her enlisted crew returns home, but the officers, along with their boat, remain in the United States to enjoy the rewards of democracy.

The Film

John McTiernen's film adaptation closely follows the plot of the novel. The technology involved still threatens to overwhelm the characters, but with personalities as strong as Alec Baldwin, Tim Curry, and Sean Connery, the threat seems unlikely to develop into reality. The hero, Jack Ryan, becomes even more heroic, as the group effort that appears in the novel, with Jack acting as the catalyst, becomes in the film a one-man operation. The film also adds visual action to replace the mental activity described in the novel. High-speed submarine chases and near misses with numerous torpedoes satisfy the film audience.

Enlisting the aid of the military is of obvious concern in the production of a film that relies heavily on advanced military technology. For this film it was hardly a problem. When he first read the novel, Ronald Reagan, the last great cold warrior to sit in the White House, called it "the perfect yarn." The United States Navy, hoping the film would do for the submarine service what *Top Gun* did for naval aviation, cooperated in any way possible, including painting a red star on the conning tower of one of its submarines.

REFERENCES

Levine, Art, "The Pentagon's Unlikely Hero," *U.S. News and World Report,* September 15, 1986; Thomas, Evan, "The Art of the Techno Thriller," *Newsweek,* August 8, 1988; Ryan, William F., "The Genesis of the Techno-Thriller," *The Virginia Quarterly Review* 69, no. 1 (1993).

—*S.H.W.*

THE IDIOT (1868)

FYODOR DOSTOYEVSKY

The Idiot (1946), France, directed by Georges Lampin, adapted by Charles Spaak.
The Idiot (1951), Japan, directed by Akira Kurosawa, adapted by Eijiro Hisaita; Shochuku.
The Idiot (1958), USSR, directed and adapted by Ivan Pyriev; Mosfilm.

The Novel

When Dostoyevsky began writing *The Idiot* in 1867, he became fascinated with the idea of creating a "perfectly good," absolutely positive character. And thus one of the main characters in the novel became the Christ-like figure of Myshkin, whose saintliness borders on idiocy and who represents an unattainable ideal in a world filled with evil and moral corruption.

The action of the novel revolves around four characters: the epileptic Prince Myshkin, the "idiot"; the "fallen woman" Nastasya Filipovna; the merchant Rogozhin; and the general's daughter, young and uncompromising Aglaya. On his way to St. Petersburg from Switzerland, where he was treated for epilepsy, Myshkin meets Rogozhin. Rogozhin tells him about his wild passion for the beautiful Nastasya Filipovna, who was seduced—while still a girl—by her benefactor, who then mercilessly turned her into his mistress. Myshkin becomes accidentally acquainted with Nastasya and falls in love with her.

Torn between Myshkin's selflessness and Rogozhin's anarchism, the self-destructive Nastasya tortures herself and her suitors, alternating in her feelings between love and hatred toward these men. Although she is terrified that her marriage with the "holy" Myshkin will destroy him, she is simultaneously afraid of her alliance with Rogozhin, whose crazed passion both attracts and appalls her. Her relationship with Rogozhin and Myshkin is a sequence of Nastasya's escapes and subsequent returns: Having decided to marry Rogozhin, she flees to Myshkin on her wedding day; while marrying Myshkin, she escapes with Rogozhin.

The love triangle in the novel is complicated by Aglaya's passionate love for Myshkin, which can not be averted either by Myshkin's inadequacy due to his "morally perfect nature" or by his relationship with Nastasya. This complex, psychological tangle is undone by Rogozhin's murder of Nastasya, after which he goes insane. Rogozhin is brought to trial and then sent to Siberia for hard labor. Myshkin resumes his treatment in Switzerland where he is later found by his St. Petersburg acquaintance in a state of complete idiocy. Aglaya marries a Pole and leaves the country.

The Films

The oldest known film adaptation of Dostoyevsky's *The Idiot* is the silent, 25-minute Russian version made in 1910 by Petr Chardynin and based on mime and melodrama. The 1946 French film version of *The Idiot*, based on a script written by Charles Spaak, was made by the director Georges Lampin; the famous French actor Gerard Philipe played Myshkin. Neither of these film works are widely accessible. Better known film adaptations of Dostoyevsky's *The Idiot* are Akira Kurosawa's version released in 1951 and Ivan Pyriev's version released in 1958.

Kurosawa, known for his devotion to Dostoyevsky, was eager to produce a film not simply in the "Dostoyevsky manner" but based on Dostoyevsky's narrative itself. In his film *Hakuchi—The Idiot*—he transports the 19th-century Russian locale of the novel to a contemporary Japanese setting. The story begins after World War II and takes place in the snow-country of Hokkaido where Kameda—Myshkin in Dostoyevsky's novel—returns from Okinawa after having been kept in prison as a war criminal and then treated there in a mental institution. The plot of the novel is accurately preserved, focusing on the relationships among Dostoyevsky's four main characters: Myshkin (Kameda), Nastasya (Taeko), Rogozhin (Akama), and Aglaya (Ayako). The destructive power of love becomes the main theme of the film, divided into two parts that are subtitled *Love and Agony* and *Love and Hatred*.

Kurosawa's version of *The Idiot* has been regarded by the critics as a rare failure on the part of the director. Donald Richie has argued that "[Kurosawa's] desire to 'preserve' Dostoyevsky weakens the film at every turn . . ." Transported to post-World War II Japan, Dostoyevsky's characters, whose individual traits are left completely unchanged, indeed appear to be misplaced; the actors do not convey the intensity of their characters' internal life; the film as a whole does not reach the psychological and philosophical profundity of the novel, in which the numerous allusions to Christianity become interfused with the personal experience of Dostoyevsky's characters.

Despite all its weaknesses, however, the film is filled with the sense of dislocation and the pathological distortion that pervades Dostoyevsky's world. This effect is achieved in Kurosawa's *The Idiot* mostly through the director's visual style full of expressionistic metaphors—the desolate snowbound landscapes and the sinister fire-images—that are meant to reflect the characters' tortuous reality.

Pyriev's film version of *The Idiot* became the director's first work on his "Dostoyevski journey." After his 1958 *The Idiot*, Pyriev made film adaptations of Dostoyevsky's *White Nights* and *The Brothers Karamazov*. The script for a two-part film based on *The Idiot* was written by Pyriev himself in 1947. The first part of the script, which was subtitled *Nastasya Filipovna* and ended with Nastasya's disastrous flight with Rogozhin from her birthday party, was produced a decade later; the second part was never made. Pyriev's version of *The Idiot*—an adaptation of only one quarter of the novel—is a detailed portrait of 19th-century Russia and its hypocritical mores. The central figure in the film is Nastasya, who in Pyriev's adaptation is presented as a victim of her social environment—the capitalist society. In this film version, as the critic Lary has stated, "[t]here is little in [Nastasya] of the demonic quality arising from the fragmentation of her personality . . . The religious dimension underlying Myshkin's quest for brotherhood is ignored . . . The dilemmas of selflessness are barely suggested; the cultural ambiguities and allusions attached to self-sacrifice and martyrdom are dropped . . ."

In fact, Pyriev's adaptation of the first quarter of the novel (which can still be approached as a completed piece) totally ignores Dostoyevsky's fascination with pathological aspects of human nature and should instead be characterized as a perfect embodiment of socialist realism in Soviet film of the 1950s. Considered within the aesthetics of realism, the actors' work is very strong; the directing, on the contrary, reveals the oversimplification of the socialist realist approach. Lary has concluded that Pyriev's film "amounted to reducing the chosen novel to a series of set dramatic scenes, which would then individually receive 'cinematic treatment.'" It's possible that the difficulties of compressing the remaining part of the novel into the confining aesthetic of socialist realism may in part have affected Pyriev's decision to abandon his further work on *The Idiot*.

REFERENCES

Lary, N.M., *Dostoevsky and Soviet Film: Visions of Demonic Realism* (Cornell University Press, 1986); Richie, Donald, *The Films of Akira Kurosawa* (University of California Press, 1984).

—J.L.

IM WESTEN NICHTS NEUES (1929)

See ALL QUIET ON THE WESTERN FRONT.

IN COLD BLOOD (1966)

TRUMAN CAPOTE

In Cold Blood (1967), U.S.A., directed and adapted by Richard Brooks; Columbia.

The Novel

Truman Capote's *In Cold Blood: A True Account of a Multiple Murder and Its Consequences* was first serialized in *The New Yorker* in 1965; released the following year in book form, it became a major American best-seller and Capote's most famous work. With *In Cold Blood*, Capote (previously known for his 1948 novel about a homosexual boy, *Other Voices, Other Rooms*, and his 1958 New York City novella, *Breakfast at Tiffany's*) launched what would become known as American "new journalism," the artistic dramatization of highly publicized news events, what Capote at the time termed a "nonfiction novel." Although one might trace the conflation of history and fiction back at least as far as Defoe's 18th-century *Journal of the Plague Year*, the very specific blurring of fact and fiction in Capote's work is considered the beginning of a major new literary movement that would come to include such similar works as Tom Wolfe's *The Right Stuff*, Norman Mailer's *The Executioner's Song*, and Joe McGinniss's *Fatal Vision*, all three later adapted to the screen, the latter two tales of sensational murders as television miniseries.

In a precise and matter-of-fact style, Capote narrates in careful detail two ex-convicts' grisly 1959 shotgun murders of the wealthy Holcomb, Kansas, farmer Herbert Clutter, his wife, and his two teenage children. The novel opens with sharply intercut chapters moving back and forth between carefully evoked descriptions of Clutter's ideal middle-American home life and camera-like descriptions of smooth con man Dick Hickcock and psychopath Perry Smith as they prepare one day to drive 400 miles each way to commit what they think will be a major robbery (in fact, they find less than $50). The "novel" then follows the criminals as they flee to Mexico, return to the United States where they are caught by a massive Kansas police force, tried, convicted, and—after appeals to the Supreme Court—hanged in 1965. Although he based *In Cold Blood* on extensive research and interviews, Capote dramatized the story, retelling the events in taut, suspenseful narration, brilliantly juxtaposing descriptions of the innocent family with the psychopathic murderers.

The Film

If Capote's novel paved the way for similar new journalistic prose treatments of sensational crime cases, Brooks's searing adaptation (released the same year as Arthur Penn's *Bonnie and Clyde*) would inspire a spate of similar works, including films ranging from Terence Malick's "based on a true story" *Badlands* in 1974 to Oliver Stone's entirely fictional media satire *Natural Born Killers* in 1994 (in the novel, Dick even terms Perry a "natural born killer").

Richard Brooks had already successfully adapted major literary classics, including Lewis's *Elmer Gantry*, Conrad's *Lord Jim*, and Dostoyevsky's *The Brothers Karamazov*, as well as two Tennessee Williams plays. For this adaptation he adhered quite closely to the text (with a few minor, perhaps inevitable, changes); he especially captured the documentary tone while following Capote's artful and dramatic arrangement of detail and, in the opening scenes, the rapid intercutting between victims and criminals. As he has said, Brooks purposefully altered Capote's structure to accentuate the story's drama, specifically by delaying showing the actual murders, which Brooks justifiably felt would end any potential audience empathy for the killers too early in the film. His use of Quincy Jones's jazzy soundtrack (which even incorporates documentary sound recordings from a Greyhound bus station shown in the film) gives the film's 1959 setting the feel of the beat generation zeitgeist. Similarly, Brooks recreates Perry's earlier life with beautifully integrated flashbacks to offer at least a suggestion for a (mostly Freudian) psychological profile of his motivation (the flashbacks are perhaps most effectively used when intercut within the frame flashback to Perry's narration of the brutal murders). One brilliantly photographed scene captures the image of rain flowing down a window reflected on Perry's face as, just before his hanging, he recalls his father shooting an (unloaded) shotgun at him

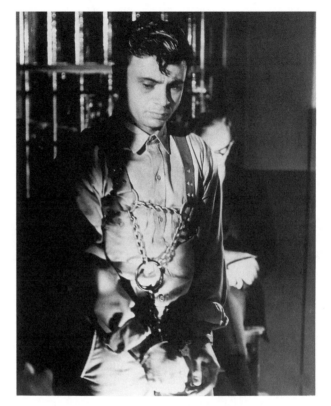

Robert Blake as Perry in In Cold Blood, *directed by Richard Brooks* (1967, U.S.A.; COLUMBIA/THEATRE COLLECTION, FREE LIBRARY OF PHILADELPHIA)

when he was a kid. (In the 1993 documentary, *Visions of Light: The Art of Cinematography*, photographer Conrad Hall explains that this was a fortuitous accident that they took advantage of after seeing the early rushes.)

In Cold Blood received four Academy Award nominations: Richard Brooks for direction and screenplay; Conrad Hall for cinematography; and Quincy Jones for the soundtrack.

Richard Brooks made a finely understated, faithful adaptation of Capote's depiction of an inexplicable act of viciousness. His underlit black and white Panavision images, shot on location in Kansas, recreates visually the tone of the "nonfiction novel": documentary footage arranged for maximum dramatic input. Brooks has said that "fear is best exemplified in black and white, not color." Robert Blake and Scott Wilson both offer stunning performances as the killers who are simultaneously compelling and repulsive. Where he misses Capote's power, perhaps, is in his depiction of the victims, the Clutter family, who in the film rarely rise above silhouetted subjects of the killers' frenzy—whereas in the original text Capote paints an almost hagiographic portraiture, one that works to further underscore the absolute horror their deaths held for their community of Holcomb, Kansas, and, ultimately, for the country at large. Brook's adaptation eschews the potential melodramatic tone a filmed version of such

domestic beatitudes might create, threatening to throw the film's dark tone out of balance. Brooks also suggests Capote's presence as observer of the trial and hanging, as if to offer a parallel sensibility to the distancing prose Capote affects in his dispassionate text. Three decades after its release, the film holds comparatively much more visceral power than the original prose, with the offscreen deaths more frightening in their absence than comparable contemporary bloodbaths that tend to merely attenuate criminals' inhumanity.

REFERENCES

Brion, Patrick, *Richard Brooks* (Chene, 1986); Brooks, Richard, "Richard Brooks," interview by Frank Spotnitz, *American Film* 16 (June 1991): 14–17, 48.

—D.G.B.

IN COUNTRY (1985)

BOBBIE ANN MASON

In Country (1989), U.S.A., directed by Norman Jewison, adapted by Frank Pierson and Cynthia Cidre; Roth/Warner Bros.

The Novel

Unlike most Vietnam War narratives, *In Country* is set exclusively in America and deals with the effects of the conflict a decade after the fall of Saigon. It concentrates on the younger generation whom the war never directly affected as well as those adults (veterans and nonveterans) coping in their own particular way.

Set in the summer of 1984, *In Country* deals with Sam Hughes, a lively 17-year-old girl whose father died in Vietnam before she was born. She wishes to know more about her father and reads his letters as well as the journal he kept during the war. Sam lives with her reclusive Uncle Emmett, who also fought in the conflict and who believes Agent Orange caused his skin condition. Emmett never speaks directly about the war, leaving Sam to draw analogies between past history and television programs such as *M*A*S*H*, in an era where shopping malls and contemporary popular culture dominate her.

She also becomes friendly with a number of veterans and falls in love with one of them. They are as evasive as Emmett and refuse to speak directly about the conflict. Sam's lover, Tom, tells her, "Some people want to protect you, Sam." Eventually Sam becomes frustrated by her failure to understand her father and decides to embark on her own version of being "in country" by spending the night at Cawood's Pond. Emmett goes to find her. They become reconciled but Emmett tells her, "You can't learn from the past. The main thing you learn from history is that you can't learn from history. That's what history is." Emmett next decides to visit the Washington Vietnam Veterans Memorial. While there, Sam discovers her father named her after one of his fellow soldiers. The novel ends with Emmett receiving an epiphanic vision before the wall—"and slowly his face bursts into flames."

The Film

In Country generally follows the main outlines of Mason's novel with the exception of a few additional scenes showing Emmett's post-traumatic stress disorder and the effect of memory on the present survivors of the conflict. The film begins with a crane shot of recruits waiting to board an airplane as the soundtrack plays a speech of L.B.J. praising the men for fighting "godless Communism." After the credits appear, the soldiers walk stealthily "in country" before a Viet Cong attack. The image then abruptly cuts to a close-up of Emmett, who is experiencing this flashback during Sam's high school graduation. This is one of several scenes in the film, which shifts the emphasis from Mason's exclusive concentration on Sam to emphasize the traumatic condition of veterans with "survivor guilt."

Bobbie Ann Mason's original novel suffers from a distinct problem. Although it focuses on a female character, it adopts the recuperative form of the bildungsroman, rejected by many radical works of Vietnam literature, to incorporate Sam into the male order. The novel is really a conservative "rite of passage" ending with Emmett's semi-religious conversion before the Vietnam Veterans Memorial. However, many scenes in the film contradict Mason's conservative premises. In the final scenes of the film, the main characters are filmed reflected on Maya Lin's memorial. The film succeeds here where the book fails. It does justice to the author's original intention of mediating feelings between past and present history rather than severing both periods from each other. For the film, the past remains a country always to be discovered anew, not exclusively separated from the present as in the novel.

REFERENCES

Kinney, Katherine, "'Humping the Boonies': Sex, Combat, and the Female in Bobbie Ann Mason's *In Country*," *Fourteen Landing Zones: Approaches to Vietnam War Literature*, ed. Philip K. Jason (University of Iowa Press, 1991), 38–48; Williams, Tony, "Rites of Incorporation in *Indian Country* and *In Country*," in *The Vietnam War and Postmodernism*, ed. Michael Bibby (Burning City Press, 1996).

—T.W.

THE INFORMER (1925)

LIAM O'FLAHERTY

The Informer (1935), U.S.A., directed by John Ford, adapted by Dudley Nichols; RKO.
Up Tight (1968), U.S.A., directed by Jules Dassin, adapted by Dassin, Ruby Dee, and Julian Mayfield; Paramount.

The Novel

The Informer was the third novel written by Liam O'Flaherty (1896–1984) and the first of four melodramas set in Dublin. Of the four, only *The Informer* brought (or merited) significant critical attention. O'Flaherty's Dublin is a dark and fetid place, a place of endings and despair rather than beginnings and promise. Even the revolutionary fervor of Dan Gallagher seems to draw its energy from nihilism rather than from any sincere belief in its stated communist objective, the worker's paradise of the future. The novel indirectly contrasts rural Ireland, which for O'Flaherty represented the primal and genuine, with the dark hypocrisy of Dublin, which he saw as bourgeois and spiritually truncated by Catholicism.

In *The Informer* Gypo Nolan, a powerful giant of a man, wanders the streets of Dublin penniless and down on his luck. A former policeman dismissed from the force and an Irish revolutionary exiled from the organization for an infraction of the rules, Gypo is an outcast. In Dunboy's lodging house, where the criminal element and the people of the streets congregate, Gypo meets his old friend Frankie McPhilip, former member of the organization on the run from the police for shooting a farmer. The Farmer's Union has offered a reward of 20 pounds for his capture. Frankie is dying of consumption and wants to make his way home to see his mother and father. Gypo assures him that the police are no longer guarding his house, so Frankie departs. Gypo leaves shortly thereafter and wanders the streets for a short time. He eventually makes his way to the police station where he informs the constable of Frankie's whereabouts and collects the 20 pounds reward. The police break into the McPhilip home and Frankie is killed in the ensuing gun battle.

Gypo's newfound wealth—particularly evident when later that evening he buys fish and chips for a crowd of street people—raises suspicions, as does his nervous and erratic behavior when he makes a bereavement call on the McPhilip family. Bartly Mulholland, an aide to Commandant Dan Gallagher, the communist leader of the organization from which both Gypo and Frankie had been expelled, begins to watch Gypo closely. After a brief encounter on the street—during which Gypo almost strangles Mulholland—Gypo is persuaded to meet with Gallagher. Gallagher asks Gypo's help in discovering the identity of the informer and in return promises to reinstate

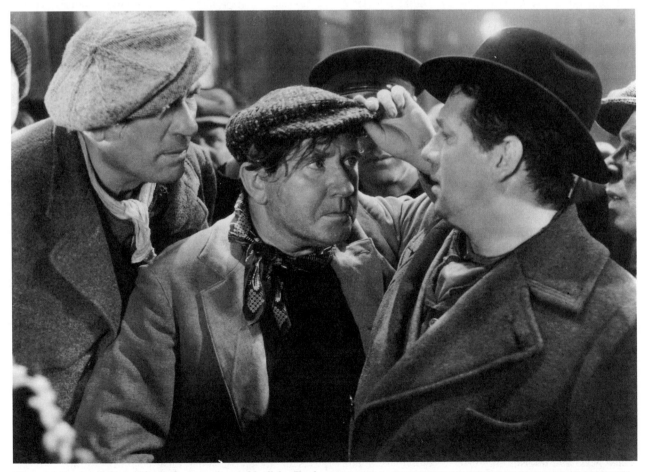

Victor McLaglen (left) in The Informer, *directed by John Ford* (1935, U.S.A.; RKO/THEATRE COLLECTION, FREE LIBRARY OF PHILADELPHIA)

Gypo in the organization. Gypo identifies Peter "Rat" Mulligan, an impoverished and consumptive tailor, as the informer.

At a court of inquiry lead by Gallagher, Mulligan is able to account for his time throughout the day in question, and Gypo, under relentless questioning, breaks down and confesses. The court condemns him to death but before the sentence can be carried out, Gypo escapes from his holding cell through a hole in the roof. Alone and friendless, Gypo makes his way to the room of his former girlfriend Katie Fox. Bitter about Gypo's past treatment of her, Katie waits until he is asleep and then leaves to tell Gallagher of his whereabouts. Gallagher's men come for Gypo, but although they shoot him twice, Gypo manages to escape. He heads for a Catholic church, where he finds Mrs. McPhilip praying for her dead son. Gypo confesses his betrayal and receives her forgiveness. He then turns to the altar and, with his arms stretched out as though to the cross, he collapses and dies.

The Films

John Ford's passion for all things Irish is no more profoundly expressed than in two of his most popular and enduring films: *The Informer* and *The Quiet Man* (1952). Both are particularly noteworthy for the acting of Victor McLagen, who won the Academy Award for his performance as Gypo Nolan. Screenwriter Dudley Nichols (who also won an Academy Award for *The Informer*) concentrates on Gypo as a character study, a man whose thoughtless behavior, generated by despair, has thrust him into Ford's concepts of a living purgatory: exile from the community. The bleak, foggy, lamplit streets of nocturnal Dublin offer neither solace nor retreat as Gypo is besieged by constant reminders of his treachery: a blind man who seems to pursue him, a wanted poster that seems to be in similar pursuit, the taunting poster of Frankie McPhilip. Perhaps the most telling scene depicting Gypo's self-inflicted damnation is the way in which Gypo receives his 20 pounds, pushed contemptuously across the table with the tip of a British officer's swagger stick.

The continuing reputation of O'Flaherty's novel seems to be largely dependent on Ford's screen production, which far exceeds it in general quality. Ford and Nichols wisely dispensed with O'Flaherty's simplistic and shallow Marxism, particularly Gallagher's dedication to communism, which in the novel is offered with more melodrama than political conviction. In the film Gallagher (Preston Foster) is a dedicated Irish nationalist, a patriot of high integrity, and as such is a far more consistent and effective foil to Gypo, the film's commanding presence.

Jules Dassin's *Up Tight* updates the story to urban Cleveland's African-American community in the turbulent days following the King assassination. Tank, played by Julian Mayfield, informs on a black revolutionary organization after an armored car robbery. His nemesis is B.G., played by a malevolent Raymond St. Jacques. Dassin finds high drama in close-ups of a panicked, sweating Mayfield, but the picture falls far short of the director's more impressive work, such as *The Naked City* (1948) and *Rififi* (1955).

REFERENCES

Baxter, John, *The Cinema of John Ford* (A.S. Barnes, 1971); Bluestone, George, "The Informer," in *Novels into Film* (University of California Press, 1956); Donoghue, Denis, preface to *The Informer*, by Liam O'Flaherty (Harvest/HBJ, 1980).

—R.C.K.

INTERVIEW WITH THE VAMPIRE (1976)

ANNE RICE

Interview with the Vampire (1994), U.S.A., directed by Neil Jordan, adapted by Anne Rice; Warner Bros.

The Novel

Opinions of Anne Rice's novel *Interview With The Vampire* are mixed. When the book was first released in 1976, Leo Braudy in the *New York Times Book Review* pronounced it "too superficial, too impersonal and too obviously made to touch the sources of real terror and feeling." At the same time, however, the novel became a best-seller and its film rights were sold to Paramount.

Recently, the issue of vampirism has been considered in relation to the epidemic of AIDS. For Rice, however, the practice of writing *Interview* was therapeutic in her coming to terms with the death of her daughter. Many view the character of Claudia as representative of Rice's daughter who died of leukemia at the age of five and the character of Louis as embodying Rice's own feelings of guilt and powerlessness. There is also a biographical connection to Rice's Catholic upbringing, seen in Louis's struggle of questioning God, and there are constant Catholic liturgical references and theological arguments throughout the novel.

The novel is Louis's recollection of his life as a 200-year-old vampire to a young journalist in present-day San Francisco. The narrative is intensely subjective as Louis examines his relationship as a vampire in a world of humans.

Upon the death of his brother, Louis—a young Louisiana plantation owner—grows despondent with life. Lestat, a Parisian vampire, seduces Louis into becoming a vampire and sharing his life, land, and money with him. With undertones of homosexuality, Lestat and Louis create a fractious but codependent life together.

When Louis gains the confidence to live on his own as a vampire, Lestat transforms a young girl, Claudia, into a vampire child for Louis and himself to raise. Over the years, although eternally she retains a child's body, Claudia matures intellectually and emotionally and begins to resent Lestat. Claudia unsuccessfully attempts to kill Lestat, but with Lestat much weakened, Claudia and Louis flee to Europe.

In Paris they discover the Théâtre des Vampires, a coven of vampires who engage in the decadent art of the late 1700s by performing acts of vampirism on stage before jaded audiences. Armand, the leader of the coven, and Louis become infatuated with each other, and Louis at last finds a vampire mentor. Claudia recognizes the attraction and persuades Louis to create a vampire mother/companion for her.

Soon after their arrival in Paris, Lestat reappears and accuses Claudia of attempted murder—a mortal sin for vampires. Claudia is murdered by the coven, and Louis avenges her death by destroying ‑he theater. He and Armand eventually return to New Orleans where Louis finds a greatly altered Lestat, fearful of and broken by the world. Armand leaves Louis, and Louis begins a life alone.

As Louis's narrative ends, the interviewer, impassioned by a romantic notion of vampirism, begs Louis to make him Louis's vampire companion. Enraged, Louis drinks the boy's blood and leaves him weakened but determined to seek out Lestat's house in New Orleans.

The Film

While the movie rights to *Interview* were sold in 1976, the adaptation had a long and involved history. Unsuccessful developments of the novel into a miniseries with Richard Chamberlain, an Elton John musical, and a transvestite saga had been untouched by studio executives in Hollywood. The rights to the film were eventually obtained by Warner Bros. to be produced by David Geffen. Neil Jordan, of *The Crying Game* fame, was selected, and the choice of casting remained.

Because of the immense popularity of the novel and the rise of a Lestat cult-like following, a general outcry among fans and Anne Rice herself ensued with the selection of Tom Cruise to play Lestat. The situation eventually dissipated upon Rice's viewing of the film and her public praise of it in a full-page ad in the *New York Times*.

Like Francis Ford Coppola's sensual, gothic adaptation of Bram Stoker's *Dracula*, *Interview* indulges in similar imagery and successfully reproduces the overblown, colorful language of Rice's novel. While the film does resort to the usual horror-film gruesomeness, seen in Lestat's feeding rituals and in Louis's attack on and burning of the Théâtre des Vampires, the rich cinematography and the elaborate costumes and sets ultimately capture Rice's language superbly.

The film also presents the characters of Louis and Claudia in a manner loyal to the novel. Kirsten Dunst, as Claudia, brings unusual maturity and understanding to her characterization of the intellectually mature child vampire. In addition, Tom Cruise presents an adequate portrayal of Lestat. He captures the mischievous playfulness and temperamental personality of Lestat. He will never, however, physically resemble the ethereal, lithe Lestat of the novel.

The end of the film deviates the most from the novel. There is no development of the relationship between Louis and Armand. While the novel reveals the constantly changing relationships between vampires, the film seeks to present a pat ending with a lasting relationship between Louis and Lestat. The final scene of the film is also unsuccessful as it presents a typical cliffhanger horror film ending, conveniently allowing for the possibility of a sequel.

REFERENCES

Abramovitz, Rachel, "Young Blood," *Premiere*, November 1994; Braudy, Leo, review of *Interview with the Vampire*, *New York Times Book Review*, May 2, 1976, 7+; James, Caryn, "In Search of the Man Within the Monster," *New York Times*, November 13, 1994, II, 22+; Koch, Jim, "Transforming a Ghoul Into a Leading Man," *New York Times*, November 6, 1994, I, 59+.

—A.D.B.

INTRUDER IN THE DUST (1948)

WILLIAM FAULKNER

Intruder in the Dust (1949), U.S.A., directed by Clarence Brown, adapted by Ben Maddow; MGM.

The Novel

As early as 1940 William Faulkner was thinking of writing a mystery story with racial implications, but he did not get around to composing the novel until 1948. He centered the story on an elderly black man named Lucas Beauchamp, who is falsely accused of shooting a white man named Vinson Gowrie in the back. Faulkner decided to make Chick Mallison, a white youngster, a key character in the story, by way of his efforts to prove Lucas's innocence. The novelist also introduced into the plot Chick's uncle, Gavin Stevens, a high-minded lawyer who figures in several of Faulkner's books. Chick convinces his uncle to defend Lucas.

Chick helps Stevens prove Lucas's innocence by digging up the corpse of Vinson Gowrie. Indeed, by intruding in the dust of Vinson's grave, Chick hopes to save Lucas from the mob that is preparing to lynch him. Once Chick has exhumed Vinson's body, he convinces Stevens to arrange for a belated autopsy to be performed on the corpse. The bullet that is extracted from the corpse is discovered to have come, not from Lucas's pistol, but from a gun belonging to Vinson's brother Crawford. It seems that Crawford had cheated Vinson out of a substantial sum of money. In order to avoid a showdown with the irascible Vinson, which Crawford feared might end with his own death, he murdered Vinson and framed Lucas Beauchamp.

The Film

Screenwriter Ben Maddow wrote the screenplay in consultation with director Clarence Brown. Maddow worked

William Faulkner

where the lynch mob, including some of these same townspeople, will soon gather. As film historian Alan Estrin notes, in the film's very first sequence "the director anticipates the contradictions that will run like a strong undercurrent throughout the film: How can people who profess to follow the teachings of Christ treat their fellow men . . . so barbarously?"

The film's racial concerns are also present in the scene in which Sheriff Hampton (Will Geer) escorts Crawford Gowrie to the jail after his arrest. When one of the crowd in front of the jail asks the sheriff if it is true that Crawford murdered Vinson, he replies, "That's right. He's the one. The man that killed his brother." The emphasis on the word *brother* implies that any man who kills another commits fratricide, because we are all members of the same human family; the mob's proposed lynching of Lucas Beauchamp (Juano Hernandez) would have been, symbolically speaking, another fratricide. The affirmation of human equality reverberates throughout the film.

This film is generally regarded as one of the best movies that Brown directed in his long career. Having begun directing pictures in the silent era, Brown placed a great deal of importance on telling a story visually; and there are many instances in the film that demonstrate his capacity to think in visual terms rather than to rely on dialogue to make a point.

Brown's sure visual sense is very much in evidence in the scene in which the townsfolk gather in the town square for the lynching, which they assume is shortly going to take place. The milling crowds, along with loudspeakers blasting frenetic swing music, create a gaudy carnival atmosphere. In the course of one uninterrupted shot, the camera glides unobtrusively from one group to another, pausing to capture a fleeting remark or gesture, such as a woman casually applying lipstick in the sideview mirror of a truck, then continuing on its way. At last the camera halts as a woman carrying a baby in her arms, as nonchalantly as if she had brought her child to see a circus parade, walks up to Crawford Gowrie and inquires when things are going to get started.

There follows immediately a dramatic sequence, which has been taken over virtually intact from the novel. Crawford approaches Miss Habersham, a venerable spinster (Elizabeth Patterson), who is resolutely sitting just inside the door of the jail with a sewing basket beside her, ostensibly concentrating on her mending. Actually she is silently, defiantly guarding the passage to Lucas's cell against Crawford and his surly henchmen, even though a flimsy screen door is the only barrier that stands between her and them. The old lady manages to hold out until Vinson's body is brought into town and the telltale bullet removed from it. In tribute to her courage, Stevens later remarks, "She's the only lady anywhere that ever held a jail with a twenty-gauge spool of thread."

By interpolating episodes like this one from the novel directly into film, Brown and Maddow succeeded in making the movie as faithful as possible to Faulkner's novel.

into the script portions of Faulkner's own dialogue whenever possible, in order to make the screenplay as faithful as possible to the film's literary source. Faulkner accepted Brown's invitation to touch up the final shooting script of the film.

One of the minor additions that Faulkner made to the screenplay was an interchange between Stevens (who is renamed John in the film) and Sheriff Hampton. In this additional dialogue Stevens (David Brian) generously acknowledges that it was the steadfast belief of Chick (Claude Jarman Jr.) in Lucas's innocence that eventually convinced him that the black man was being framed by a white man.

The movie's racial theme is expressed subtly and movingly right from the outset of the picture. In the film's opening shots, Brown's camera focuses on a church spire and then pans slowly downward to take in some Sunday worshipers about to enter the church. Hymns can be heard from inside as the group stands around the town square,

Hence Faulkner had every reason to be satisfied with Brown's film version of his book, as indeed he was.

REFERENCES

Estrin, Alan, *The Hollywood Professionals*, vol. 6 (Barnes, 1980); Fadiman, Regina, *Intruder in the Dust: Novel into Film* (University of Tennessee Press, 1978); Thomas, Tony, *The Films of the Forties* (Carol, 1990).

—G.D.P.

THE INVISIBLE MAN: A GROTESQUE ROMANCE (1897)

H. G. WELLS

The Invisible Man (1933), U.S.A., directed by James Whale, adapted by R.C. Sheriff and Philip Wylie; Universal.

The Novel

The Invisible Man is H. G. Wells's third "scientific romance," following *The Time Machine* and *The Island of Dr. Moreau*. It appeared in book form in September 1897 after its serialization in the June–August issues of *Pearson's Weekly*. Like Mary Shelley's *Frankenstein* and Stevenson's *Dr. Jekyll and Mr. Hyde*, it is a cautionary tale of the fate that awaits those who pursue forbidden knowledge. As Charles L.P. Silet has noted, it is a fable "in which Wells examines the myths of 19th-century culture, particularly the hubris of science, with its pretensions of infallibility and progress. It is a nervous book, full of fear concerning collapse of the sureties of the past and yet apprehensive about the possibilities for the future."

A mysterious stranger arrives at the Coach and Horses pub in the small village of Ipping during a wintry February day. His entire body and face is covered by mufflers; his eyes are hidden behind dark glasses; and his luggage consists of several crates of chemicals and books. Gossip attends his appearance and brusque manners. After a rash of petty thefts in the village, he is implicated as the culprit. The local constable arrives and discovers that the stranger is invisible. The stranger escapes. Naked and on the run, he enlists the aid of a tramp, Thomas Marvel, to help him retrieve the scientific notebooks he left in the village. But Marvel steals the papers and leaves. Desperate, the stranger contacts an old university mate, Dr. Kemp, for help. His true identity now revealed as Griffin, the man tells the doctor his story—how as an impoverished scientist dabbling in the mysteries of invisibility he had stolen money from his father (who had subsequently committed suicide); how he had then taken a room in a London slum to continue his researches; and how, after succeeding in his experiments, he had set his landlord's room on fire.

Clearly in the grip of megalomania, Griffin announces to Kemp that he intends to establish a "reign of terror" over humanity. Kemp alerts the police, but Griffin escapes.

Pursued by the police, he is finally caught and killed. After his death, Griffin's naked, battered body resumes visibility.

The book's strange epilogue has Marvel, now the landlord of an inn he has dubbed "The Invisible Man," telling the bizarre story to his guests. It is clear that Marvel, who remains in possession of Griffin's experiments, dreams of rediscovering the formula for invisibility.

The Film

On the heels of the success of his other Universal horror films, *Frankenstein* (1931) and *The Old Dark House* (1932), director James Whale, with scenarist R.C. Sheriff (with whom he had collaborated earlier on *Journey's End* [1929]), next turned to the Wells classic. Before Claude Rains made his screen debut as Griffin, other actors were considered, notably Chester Morris and Boris Karloff (whom Whale reportedly was dead set against). Filming took two months in the summer of 1933, with two more months devoted to the highly lauded special effects by John Fulton—making the invisible *visible*, as it were—which involved the use of composite matte work and the construction of special head and body casts for Rains. The extra effort paid off. The effects created sensational box office and resulted in a brilliant novelty: Rains's presence is only implied throughout; he is only actually *seen* in the final moments of the film.

The basic plot outline is maintained: "Jack" Griffin (Rains) arrives at a small inn in Ipping, England, swathed in bandages and dark glasses. Incriminated by a number local thefts, the police arrive and he eludes them by removing his clothing and taking to the open country. He goes for aid to the house of Dr. Kemp (William Harrigan), who alerts the authorities. Griffin kills Kemp and flees. But because there has been a recent snowfall, the police are able to track his footprints. They capture him, but he dies in the hospital after confessing that he should never have tampered with forbidden science.

Alterations include the deletion of the character of Marvel, the addition of a girlfriend for Griffin, Flora (Gloria Stuart), and the inclusion of numerous touches of "black" humor characteristic of Whale's work. Regarding the latter instance, one of Whale's principal objections to Wells's original novel had been the lack of sympathy for Griffin. By allowing him a mocking humor, Whale hoped to humanize him, as well as supply the excuse for a fair number of satiric potshots at society.

Another significant script change was to blame the use of a drug, "monocane," for Griffin's hopeless madness. Although Wells admitted he liked the adaptation in general, he objected to this, saying it changed Griffin from a brilliant scientist to a hopeless lunatic. Whale reportedly replied, "After all, in the minds of rational people, only a lunatic would want to make himself invisible in the first place!"

Wells's invisibility theme has "reappeared" in many subsequent films, all of which have little to do with the details of his original novel. *The Invisible Man Returns*

(1940) featured Vincent Price as a man condemned for murder who, after being rendered invisible by a secret serum, goes on the trail of the real killer. *The Invisible Woman* (1940) presents Virginia Bruce who "disappears" as a result of the experiments of mad scientist John Barrymore. This one was played more for laughs than for horror or social commentary. Most recently, Chevy Chase starred in Warner Bros.'s *Memoirs of an Invisible Man*, a seriocomic exploitation of superior special effects, if not much else.

REFERENCES

Bergonzi, Bernard, *The Early H.G. Wells* (Manchester University Press, 1961); Curtis, James, *James Whale* (Scarecrow Press, 1982); *Magill's Guide to Science Fiction and Fantasy Literature* (Salem Press, 1996), 481–82.

—*T.W. and J.C.T.*

THE IRON GIANT (1968)

TED HUGHES

The Iron Giant (1999), U.S.A., directed by Brad Bird, adapted by Bird and Tim McCanlies; Warner Bros.

The Novel

Five years after the suicide of his wife, the American poet, Sylvia Plath, in 1963, Ted Hughes wrote for his children a little book called *The Iron Man* (retitled in America *The Iron Giant*). It was neither the first nor the last of his fables targeted to young readers. A short story collection, *Meet My Folks!*, and a poetry collection, *The Earth-Owl and Other Moon-People*, preceded it in the early 1960s. What they shared with his works for adults were attempts, writes biographer Elaine Feinstein, to make sense of the emotional entanglements and confused upheavals in his life: "Hughes had been searching for a way to make sense of the damage that human beings inflict on one another in a cruelly indifferent universe."

The story begins as the 50-foot-tall Iron Giant stands at the top of a cliff, surveying the sea beneath him. Who is he? Where does he come from? Nobody knows. Stepping off the cliff into space, the gigantic metal man tumbles down the steep slope, his body breaking into pieces. At the foot of the slope, the pieces gradually come back together—a hand carries an eye to another hand, which reassembles both onto the trunk, the trunk rising on reassembled legs, striding in search of the other eye, and so on. At length, the Iron Giant goes in search of food. On a farm, his iron jaws tear apart tractors and gas stoves, his great teeth nibble at barbed wire. The farmer's son, Hogarth, spreads the alarm. The alerted farmers come up with a plan: They dig an enormous pit and entrap the creature. But he soon reemerges and continues snacking on the local machinery.

Inspired with an idea, Hogarth confronts the creature and leads him to a nearby scrap yard, where he feasts to his metal heart's content. But all is not well. A star approaches from out of the sky. Inside the star is an enormous bat-winged creature, as big as Australia. The creature warns that it intends to gobble up all the countries on earth, and earth's citizens too. Once again, Hogarth has an idea. He tells the Iron Giant that if the earth is gobbled up, his food supply will disappear. The mechanical man comes to the rescue. He issues a challenge to the space creature: Whoever proves the stronger will impress the other into slavery. The Iron Giant tells the townspeople to build a gigantic furnace. He lies down in the flames and is heated red-hot. Rising from the flames, he dares the space creature to survive a similar test—fly into the sun. The space creature returns, badly burned, but surviving. The test is repeated. This time the space creature confesses defeat. "What made you want to eat up the earth?" inquires the Iron Giant. "It just came over me," replies the monster, "listening to the battle shouts and the war cries of the earth." Thereupon, the Iron Giant issues his demands to the creature: He will sing the "music of the spheres" to the people of earth. "It's the music that space makes to itself," the monster had explained. All the spirits inside all the stars are singing. The music of the spheres is what makes space so "peaceful." And so it transpires that the creature ascends back into the heavens, from whence its strange music has a pacifying effect on the world.

Hogarth and the Iron Giant return in the sequel, *The Iron Woman*, written by Hughes in 1993. This Kafkaesque fable warns its readers of ecological disaster. The Iron Man teams up with an Iron Woman and reunites with Hogarth to teach humanity a lesson about the pollutants and toxic wastes that are polluting our streams and oceans. In a terrifying series of events, the townspeople of an English village are transformed into fish and insects. Before they die in the contaminated streams nearby, only a transformation of the human spirit from destructive impulses into life-preserving attitudes can save them.

The Film

Only the barest story outline of Hughes's *The Iron Giant* remains in the animated film adaptation by veteran animator writer and director Brad Bird (*The Simpsons* and *King of the Hill*), while some of the social commentary has been lifted from *The Iron Woman*. The story has been transplanted to America in 1957. With the cold war as the background context, new characters have been added, like Dean the beatnik, who runs the local scrap yard, and Kent Mansley, the sinister government agent. The metal giant is now a creature come to Earth from outer space. A Maine fisherman sees the object crash into the stormy sea and is astonished to confront a huge metal man. Later, a nine-year-old boy, Hogarth Hughes, encounters the creature in the woods and saves him from a tangle of deadly power

Hogarth (voiced by Eli Marienthal) and the Iron Giant (voiced by Vin Diesel) in Warner Bros.' animated adventure The Iron Giant (1999, U.S.A.; WARNER BROS./AUTHOR'S COLLECTION)

wires. The two become friends, and Hogarth becomes something of a "father" to the childlike creature (who is apparently suffering from some sort of amnesia). As a result of a collision with a train, the Giant's body parts are scattered over the countryside. As in the novel, they come back together and reassemble themselves. Also, as in the book, the boy leads the Giant to a scrap yard, where he can feed to his metal heart's content.

At this point, the film veers away from the novel. The menace of the space creature is replaced by the cold war fear of attack from outer space by Russia's newly launched Sputnik. When the news spreads of a giant creature prowling the woods, an inquisitive government agent, Mr. Manley, arrives with a contingent of tanks and heavy weaponry, intent on exposing a communist plot. Without waiting to determine if the Iron Giant is dangerous or peaceful, Manley attacks him with a nuclear missile. Quickly perceiving the danger to his new friends, the Giant launches himself into space on a collision course with the missile. The subsequent explosion occurs in deep space, safely out of reach of earth. There is no trace of the metal man, except a few body parts that have fallen back to earth. The townspeople build a statue in honor of their savior. The film ends as the scattered body parts begin to move and to reassemble themselves. In film, as in the novel, this fearsome "other," this enormous metal man, redeems earth from a deadly peril.

Although it is a radical departure from Hughes's novel, *The Iron Giant* is a charming surprise. The fable of a child finding a friend in the midst of cold war paranoia is wittily but gently and delicately told. The animation is outstanding—the humans are deftly caricatured, yet believable

(especially the boy); the primary tints of the color palette are perfect for 1950s decor; and the moments of dramatic lighting (especially the opening crash sequence and the scenes between the boy and the federal agent) are strikingly conceived. The animated movements of the Giant are a wonder to behold, seeming both mechanical and human at the same time.

And who, or what, is this Giant? We never really know. It just came from "out there." It can be a perfect weapon of destruction, yet it behaves in a peaceful manner. It is the emblem of every flying saucer, Martian invasion, and communist threat that was feared in the mid-1950s. Small wonder the movie is jam-packed with references to monster movies and television warnings about atomic blasts (certainly it is the first movie to animate black-and-white television shows!). Seen from the perspective of the late 1990s, it may be an allegory about our paranoia about guns—instruments of protection and aggression, depending upon who wields them and for what purpose. On a less pretentious level, we might just settle back and accept it as a lesson in friendship, how love and tolerance can transcend character differences. It is a gracious and intelligent film that, unlike most animated movies, does not have to resort to silly songs and cuddly bunny rabbits to entertain and enlighten its viewers. Commentator David B. Pankratz lamented the film's failure at the box office and applauded its "hand-drawn and computer animation imagery, its original musical score drawing on the styles of Brahms, Ravel, and 1950s be-bop, and its interweaving themes of Cold War paranoia, moral conflict and decision-making, existential choice, and Christian sacrifice and resurrection."

REFERENCES

Feinstein, Elaine, *Ted Hughes: The Life of a Poet* (W.W. Norton & Company, 2001); Pankratz, David B., "*The Iron Giant:* Commercial Culture and Arts Education," *Arts Education Policy Review*, 102, no. 3 (January–February 2001): 5; "Ted Hughes," in *Major Authors and Illustrators for Children and Young Adults* (Gale Publishing, 2002).

—*J.C.T.*

THE ISLAND OF DR. MOREAU (1896)

H.G. WELLS

Island of Lost Souls (1933), U.S.A., directed by Erle C. Kenton, adapted by Waldemar Young and Philip Wylie; Paramount.

The Island of Dr. Moreau (1977), U.S.A., directed by Don Taylor, adapted by John Herman Shaner and Al Ramrus; American-International.

The Island of Dr. Moreau (1996), U.S.A., directed by John Frankenheimer, adapted by Richard Stanley and Ron Hutchinson; New Line.

The Novel

In the January 19, 1895, issue of the English magazine *The Saturday Review*, an essay entitled "The Limits of Individual Plasticity" speculated that, through surgery, living tissues could be transplanted from one animal to another in order to change its intimate structure. The writer concluded that scientists would soon be capable "of taking living creatures and molding them into the most amazing forms . . . even reviving monsters of mythology." As if in response, H.G. Wells's "scientific romance," *The Island of Dr. Moreau*, appeared the following year. Unlike his previous novel, *The Time Machine*, which had been generally favorably received, this book was attacked for the author's "perverse quest after anything in any shape that is freshly sensational." Wells, a lifelong atheist and a confirmed Darwinist thinker, invested the horrific tale with attacks on religion, exposure of the horrors of vivisection, and ironic commentaries on the optimistic views of evolutionary theory held by colleagues like T.H. Huxley. Even today, writes Frank McConnell in his study of the book, it remains for many readers the most difficult and distasteful of Wells' five scientific romances. For his part, in an 1897 interview Wells defended it as "the best work I have done."

After the foundering of the ship *Lady Vain*, a passenger named Prendick (who tells the story in flashback) is picked up by a passing schooner. He is befriended by Montgomery, a biologist who is taking a strange menagerie of animals to a remote island destination. Accompanying him to the island, Prendick is astonished to find inhabitants of a half-human (or is it a semi-beastlike?) aspect existing under the lordly control of Dr. Moreau, a prominent physiologist whose ghastly vivisection experiments had led to his expulsion from London years before. "These creatures you have seen are animals carven and wrought into new shapes," explains Moreau. Through experiments in his locked laboratory—what the creatures call The House of Pain—their physiology and "chemical rhythm" are altered, and they are taught speech and elementary moral principles. With the sting of the lash, Moreau imposes precepts of the Law upon them ("Not to go down on all-Fours; that is the Law. Are we not men?"; etc.). However, confesses Moreau, despite his attempts to "burn out all the animal," bestial traits persistently creep back again. Prendick is struck by the plight of these hideous Beast People: "Now they stumbled in the shackles of humanity . . . fretted by a law they could not understand; their mock-human existence began in an agony, was one long internal struggle, one long dread of Moreau—and for what?"

When Moreau is killed by the Puma-Woman, Prendick, in a desperate attempt to restore order, assures the restless Beast People that Moreau is not dead after all but will soon return. Gradually, the creatures revert to their beastly ways. Prendick, with only the Dog-Man loyal to him, maintains a precarious peace. But when the creatures' reversion is complete, and his own destruction imminent, Prendick sets out to sea in an abandoned boat. In the epilogue, back in London, Prendick (like Jonathan Swift's Gulliver) is so changed that he is disposed to see only the beastly nature of Man, as if people were but "animals half-wrought into the outward image of human souls." He lives a recluse, concluding the tale on a sad, resigned note: "Even then it seemed that I, too, was not a reasonable creature, but only an animal tormented with some strange disorder in its brain, that sent it to wander alone, like a sheep stricken with the gid."

The Films

The first film version is one of the acknowledged classics of the horror film. Commentator Leonard Wolf astutely notes that the Waldemar Young/Philip Wylie script, while following the novel's general outlines (omitting the epilogue), brings out the theme of repressed or unacknowledged sexuality. Moreau (Charles Laughton) greets the arrival of Edward Parker (Richard Arlen in the Prendick role) as an opportunity for his most ambitious experiment, i.e., to mate a human being with one of his creations, Lota, the Panther-Woman (Kathleen Burke). Although Parker has a fiancée (through whose efforts he is eventually rescued), he is erotically attracted to this mysterious female. For his part, the saturnine-Moreau, whose own sexuality is ambiguous, to say the least, is the voyeur aroused by a romance with bestial overtones. Bela Lugosi, as the Sayer of the Law, is quite effective, both as the creature that articulates the Law and the rebel who breaks it. Made a year before the Production Code became more strictly enforced, *Island of Lost Souls* remains a truly nightmarish achievement quite beyond the tamer, more conventional horror films of its day.

Shot mostly in daylight and in color, the 1977 Don Taylor version is the least atmospheric of the three versions. Likewise, Burt Lancaster's Moreau is seemingly the sanest and most dignified (albeit humorless) of the three impersonations. In his first appearance, wearing a white suit and holding a book, he looks more like a priest than a scientist. Because of the controversial nature of his experiments, he has been forced to relocate his laboratory to a tropical island, where he experiments with his "humanimals." Only when Michael York as a castaway named Braddock comes snooping around, does Moreau take on a more overtly sinister character. He injects him with animal chromosomes (an update on the novel's vivisection experiments) to control what he calls "biological destiny," causing Braddock to revert to a primitive state. Keeping him in a cage and feeding him rats for food, Moreau expects Braddock to cooperate in the experiment by describing to him the precise physiological changes he is undergoing. At the end, after the death of Moreau, the tormented Braddock flees with a lovely female creation of Moreau's named Maria (Barbara Carrera). As they take to sea in a boat, Braddock's human aspect gradually reasserts itself. Although at this point Maria might be expected to undergo a reverse transformation to *her* true self, an animal, the expectation is disappointed. The film ends with the suggestion of a standard happy finale. "A more logical conclusion," declares commentator Thomas C. Renzi, "would have been the revelation that Braddock's figurative union with the Beast Man is paralleled by his literal union with a Beast Woman, a further erasing of the thin line that separates human aspirations from bestial tendencies."

The 1996 John Frankenheimer adaptation shares with Wells the conviction that at heart we are all animals, rending and tearing at each other, unable to repress our primal, destructive natures. A United Nations diplomat, Edward Douglas (David Thewlis), survivor of a plane crash, is rescued from shark-infested waters by a passing boat. Taken to a remote island, he meets Moreau (Marlon Brando) and his henchman Montgomery (Val Kilmer). In an update on Wells's science of vivisection, Moreau here is a geneticist whose DNA and gene-splicing experiments have induced human characteristics into dogs, rams, leopards, gorillas, and other creatures; moreover, his control over them is imposed not by whiplash and revolver, but by electronic implants. There is no House of Pain, only an operating room where a brief scene reveals a humanlike baby born to an animal. Taking a cue from the 1932 version, his most successful experiment is his beautiful "daughter," Aissa the Cat-Woman (Fairuza Balk). Unlike the earlier film, however, this plot element remains undeveloped. By contrast to Laughton's nasty madness and Lancaster's gentler benignity, Marlon Brando's Moreau is a fat, fey character who wears bizarre linen wrappings and white powder as protection from the sun. In his flowing robes and peculiar caps, he looks like a bloated potentate presiding over his flock. After Moreau's destruction by the creatures (who rebel after ridding themselves of the implants), Douglas

stays on, departing only after the creatures have reverted to their bestial state.

Frankenheimer characteristically endows the film with graphically violent images and a prevailing tone of nihilist bleakness. Images of Vietnam atrocities and various civil disturbances underscore a humanity bent on its own destruction. Searing white flashes of light mark scene transitions. Unfortunately, the continuity is wobbly, and there are long sequences where the characters seem to just drift about, stranded in the backwash of Richard Stanley and Ron Hutchinson's uneven script.

REFERENCES

McConnell, Frank, *The Science Fiction of H.G. Wells* (Oxford University Press, 1981); Renzi, Thomas C., *H.G. Wells: Six Scientific Romances Adapted for Film* (Scarecrow Press, 1992); Wolf, Leonard, *Horror: A Connoisseur's Guide to Literature and Film* (Facts On File, 1989).

—*J.C.T.*

IT HAD TO BE MURDER (1942)

CORNELL WOOLRICH

Rear Window (1954), U.S.A., directed by Alfred Hitchcock, adapted by John Michael Hayes; Paramount.

The Novel

Rear Window was first published as a story, "It Had to Be Murder," in the February 1942 issue of *Dime Detective*. It has since been frequently anthologized both during and after Woolrich's lifetime, receiving high praise from the Mystery Writers of America in a poll to determine the best crime stories of all time. In his brief autobiography, *Blues of a Lifetime*, Woolrich mentions that he was spied upon by two teenage girls as he was hard at work typing on a hot summer's day. Clad only in undershirt and trousers, he ignored these giggling voyeurs and returned to his writing. Some earlier short stories anticipated several motifs in "It Had to Be Murder." A binoculars-wielding blackmailer prominently figures in "Wake Up with Death" (1937). In "Silhouette" (1938), a middle-aged bourgeois couple think they have witnessed a murder by noticing two silhouettes on a window shade. Jeffries's speculation over problematic room dimensions in the apartment opposite to his also appears in the 1939 short story, "You'll Never See Me Again."

The narrative is from the first-person perspective of Hal Jeffries. Confined to the back bedroom of his stuffy New York apartment, he has nothing to occupy his mind except to stare out at the opposite tenement. Jeffries appears to have no interests, no job, no books, no friends, no radio, and nobody to talk to except a black houseman, Sam, who comes in every day to clean up. Jeffries is an unusual, passive, immobile figure, whose only active

Grace Kelly and James Stewart in Rear Window, *directed by Alfred Hitchcock* (1954, U.S.A.; PARAMOUNT/PRINT AND PICTURE COLLECTION, FREE LIBRARY OF PHILADELPHIA)

qualities emerge from looking out at the opposite world. Unable to sleep in the hot, humid pre–air conditioned New York of 1942, Jeffries focuses his attention on three particular neighbors: a widow with a young child, a frenzied young jitterbugging couple, and the Thorwald couple, inhabiting an apartment beneath one undergoing renovation. Mrs. Thorwald is sick. One night Mr. Thorwald gazes out of his window contemplating some enigmatic thought. The next day, Jeffries discovers Mrs. Thorwald is missing. Informing his homicide detective friend, Lieutenant Boyne, about his fears, Jeffries later learns from him that Mrs. Thorwald has gone on holiday and sent a postcard. Suspicious about the lack of a discernible date on the postcard, Jeff, as he's known by his friends, pursues Thorwald by a threatening note and phone call until his quarry realizes who his hidden tormenter is. Thorwald breaks into Jeff's apartment but is killed by Boyne, who has come to the rescue. Jeff tells

Boyne about his suspicion that Mrs. Thorwald's body is embedded in the concrete floor of the upstairs apartment. The story ends when the reader discovers the reason for Jeff's peculiar passivity and immobility. His leg has been in a cast for several weeks.

The Film

Both Alfred Hitchcock and John Michael Hayes developed Woolrich's short story into a feature film by inserting many new characters and themes while retaining the original plot structure. Hitchcock revealed Woolrich's original plot revelation in the very beginning, showing Jeff's (Jimmy Stewart) leg in a cast resulting from his risk-taking professional activities. *Rear Window* added other characters to the original story, making a suspense narrative into a treatise upon masculine fear of marital entrapment and a self-reflexive examination of the voyeuristic aspects of the

cinematic experience, shared by both director and viewer. Jeff now has a girlfriend, Lisa (Grace Kelly), who wishes him to give up his wandering male-adventurer ways and settle down with her. Hired nurse Stella (Thelma Ritter) replaces Sam, and Lieutenant Boyne becomes Wendell Corey's Lieutenant Doyle. As Jeff proceeds further in his voyeuristic journey, the lenses he uses in his search become both more penetrating and larger (in a phallic sense).

Hitchcock both changes and adds to Woolrich's original gallery of neighbors, all of whom represent different embodiments of aspects of Jeff's own world and fears. A young married couple may become future Thorwalds. Both the attractive dancer "Miss Torso" and spinster "Miss Lonelyhearts" represent aspects of Lisa. The middle-aged childless couple doting on their pet dog as substitute child embody Jeff's nightmare of a sterile marital future. And the middle-aged female sculptor and the composer both undergo the type of creative frustration familiar to any artist. The Thorwalds, of course, embody a dark version of the current "battle of the sexes" contest between Jeff and Lisa. If "Miss Torso" represents a rudimentary version of Lisa's sophisticated sexuality, however, her very name anticipates Mrs. Thorwald's fate in that dark Hitchcock association between sex, marriage, and murder.

Although Francis Nevins notes that the story contains "no emotional tie between the protagonist and the person he slowly and by fits and starts comes to suspect of murder," a connection does actually exist among the objects of Jeffries's gaze in the story. The first objects are the mother and child, as if Woolrich subtly and unconsciously hints not just at his long symbiotic relationship with his own mother but also at the masochistic aesthetic dominating his own fiction, one structured on pre-Oedipal links between the mother and male child. Furthermore, the mother is a solitary woman whose only means of economic survival is by prostituting her body at night as a "phantom lady" controlling her male customers.

Jeffries does draw some connections between his immobile situation and the condition affecting his neighbors. "The chains of little habits that were their lives *unreeled* themselves. They were all bound in them tighter than the tightest strait-jacket any jailer ever devised, though they all thought themselves free" (italics mine). Although Hitchcock developed Woolrich's original story, adding cinematic features, such elements were by no means absent from the original story. Jeffries muses over "synchronization" problems concerning his perceptions of a spatial distortion when he looks across at Thorwald's apartment. He agonizes over this like a movie editor dealing with synchronization problems until he gets it right. When Thorwald discovers Jeffries as his unseen tormenter, the latter comments, "There wasn't time enough now for one of those camera-finishes in this"—like a movie director deciding upon the climax of his suspense movie.

REFERENCES

Wood, Robin, *Hitchcock's Films Revisited* (Columbia University Press, 1988); Stam, Robert and Roberta Pearson, "Hitchcock's *Rear Window*: Reflexivity and the Critique of Voyeurism," *Enclitic* 7, no. 1 (1983): 136–45.

—*T.W*

J

JAMES AND THE GIANT PEACH (1961)

ROALD DAHL

James and the Giant Peach (1996), U.S.A., directed by
Henry Selick, adapted by Karey Kirkpatrick, Jonathan
Roberts, and Steve Bloom; Walt Disney Pictures.

The Novel

Roald Dahl wrote his first juvenile novel, *James and the
Giant Peach*, in 1961. It grew out of bedtime stories he told
to his daughters Olivia and Tessa (to whom the book is
dedicated). Formerly best known for his witty and macabre
adult fables (*Kiss Kiss, Someone Like You*), he devoted the
last 28 years of his life to following up the success of *James*
with more books for young readers, including *Charlie and
the Chocolate Factory, Danny the Champion of the World, The
Witches, The BFG,* and *Matilda* (all of which have been
adapted to film and television).

Like most of his juvenile stories, *James* is about a soli-
tary child coping with the frequently abusive world of
adults. Orphaned at an early age (his parents were eaten up
by an angry rhinoceros), James Henry Trotter goes to live
with a pair of repulsive and cruel aunts, Aunt Sponge and
Aunt Spiker. One day a strange old man gives him a bag of
"crocodile tongues," from which a gigantic peach tree
springs. James enters one of the peaches and finds it occu-
pied by a group of life-sized insects, a spider, a ladybug, a
grasshopper, an earthworm, and a centipede. The peach
rolls away, crushing the aunts, and carries its passengers
aloft. In their journey over the Atlantic Ocean, they
encounter bloodthirsty sharks and a race of "Cloud Peo-
ple." Eventually they arrive in New York City, where the
peach is safely impaled on the spire of the Empire State
Building. James and his friends decide to stay in America,
where "every one of them became rich and successful."

The Film

This wildly fanciful tale could come to the screen in only
two ways—either rendered simply, spare and clean as a
bone or delivered with all the extravagant special effects
the cinema is capable of. The Disney version, directed by
Henry Selick (*The Nightmare Before Christmas*), opted (in
the best Hollywood tradition) for having it both ways.

The opening 15 minutes is photographed in live
action, the action slowly paced, the color palette a neutral
gray. We are introduced to the orphaned James (Paul
Terry) and his dreary life at the seaside home of Aunt
Spiker and Aunt Sponge (Joanna Lumley and Miriam
Margolyes). The studio sets are starkly stylized—a
crooked house atop a craggy hill, a painted backdrop
looming behind. But upon James's entry into the peach
and throughout the ocean voyage, the film shifts to stop-
motion animation and computer-generated special effects
(supervised by Oscar-winning production designer
Harley Jessup, working from the conceptual designs of
illustrator Lane Smith). The pace quickens and the colors
explode into a rainbow of vivid hues. Songs by Randy
Newman ("Family," "That's the Life," "Eating the
Peach") delineate the insects' characters (whose voices
are provided by Demi Moore, Simon Callow, Richard
Dreyfuss, Jane Leeves, David Thewlis, and Susan Saran-
don) and underscore the underlying theme of the search
for family.

The most startling additions are dream sequences that take their cue from the psychological implications of Dahl's original. In one dream, for example, the rhinoceros that killed James's parents returns to threaten him; and in another dream James himself turns into a creature that is part human, part insect. These seem rather pointless, after all, considering they transpire in the already bizarre phantasmagoria of the animated world of the movie.

Surely the most spectacular achievement in special-effects animation to date, *James and the Giant Peach* nonetheless flattens the story under the wheels of its frenetic pacing and threatens to bury the story's whimsy under an avalanche of technology. More than once during the writing of the book, reports Dahl's biographer Jeremy Treglown, Dahl wondered, "What the hell am I writing this nonsense for?" Surely, it wasn't merely to provide fodder for the computer.

REFERENCES

Treglown, Jeremy, *Roald Dahl: A Biography* (Farrar, Straus & Giroux, 1994); Warren, Alan, "Roald Dahl: Nasty, Nasty," in Darrell Schweitzer, *Discovering Modern Horror Fiction*, vol. 1, (Starmont House, 1985); pressbook, *James and the Giant Peach*, Walt Disney Pictures, 1996.

—*J.C.T.*

JANE EYRE (1847)

CHARLOTTE BRONTË

Jane Eyre (1934), U.S.A., directed by Christy Cabanne; Monogram.

Jane Eyre (1944), U.S.A., directed by Robert Stevenson, adapted by Stevenson, Aldous Huxley, and John Houseman, Twentieth Century-Fox.

Jane Eyre (1983), U.S.A., directed by Julian Amyes, adapted by Alexander Baron; British Broadcasting Corporation.

Jane Eyre (1996) U.S.A., directed by Franco Zeffirelli, adapted by Hugh Whitemore; Miramax.

The Novel

Charlotte Brontë began writing *Jane Eyre* in 1846 during a distressing period in her life: Her father was going blind, her sisters battled against delicate states of health, an effort to publish an earlier piece had proven fruitless, and she had had unfulfilling ventures as a governess and teacher. In August 1847, however, it was enthusiastically received and published under a male pseudonym. By the end of the year, the publishers were encountering a rush for copies, and readers applauded the fresh voice that sounded out of northern England. Despite this success, *Jane Eyre* did not lack for critics. Many readers were disturbed by Brontë's challenge to the established role of women, particularly as seen in Jane's relationships with various male characters.

Roald Dahl

Deleted from the story is the long episode with the Cloud People. Instead, an underwater sequence has been invented in which James and his friends battle skeleton pirates. Another added sequence—perhaps the film's highlight—depicts the peach sailing through the spinning cosmos of clouds, planets, and stars while the cast sings the song, "Family." Several changes in story structure are intended to tighten up the book's otherwise loosely episodic narrative: The two aunts, instead of disappearing early in the story, pursue James and reappear in the concluding scenes. And James's arrival in New York, rather than being a happy accident, is forecast from the very beginning, when his parents tell him about its wonders. By the way, perhaps more than one viewer will wonder just why a frightened little boy would choose wicked old New York on which to fasten his dreams. But at least it does reinforce the ongoing "fruit motif" of the story—i.e., *it's ultimately about a peach that goes to the Big Apple.*

Probably the most famous critic, Elizabeth Rigby, best articulates this disapproval: "Almost every word she utters offends us . . . It is true Jane does right, and exerts great moral strength, but it is the strength of a mere heathen mind . . . She has inherited the worst sin of our fallen nature—the sin of pride . . . If we ascribed the book to a women [writer], we have no alternative but to ascribe it to one who has long forfeited the society of her sex." Nonetheless, the novel demonstrates Brontë's imaginative genius and has become an important source for feminist theorists.

Jane is a small, plain child who lives with her Aunt Reed and is treated with unkindness. Her aunt decides to send her to Lowood, a dismal charity school run by Mr. Brocklehurst, a sanctimonious despot who enforces Christian submission. Jane manages to find two friends at Lowood: Helen Burns, a fellow classmate who teaches Jane to appreciate spirituality, and Miss Temple, the kind headmistress. Jane remains at the school for eight years, but a restlessness prompts her to advertise for a governess position. Jane is hired to be in charge of Adèle Varens, the French ward of Mr. Rochester, the master of Thornfield Hall. They soon become intimate friends. He is aroused by her unearthliness and intellectual gifts, and she is intrigued by this enigmatic man, although she is also aware of an unsettling aura of mystery that surrounds Thornfield. One evening Mr. Rochester acknowledges Jane's declaration that their spirits are equal and proposes. However, the ceremony is stopped by a solicitor who reveals that he already has a wife. Mr. Rochester introduces them to Bertha, a savage creature, and he explains how his father arranged the marriage and he did not learn of her lunacy until afterwards. Although Jane pities him, she knows that it would be morally wrong to stay and leaves with 20 pounds to her name.

She looks in vain for employment, begs for food, and is finally taken in by a young clergyman, St. John Rivers, and his sisters. Jane adopts an alias and accepts a teaching position in the village. St. John eventually learns of her true identity from a solicitor who has been searching for their uncle's long-lost niece, Jane Eyre, and he has bequeathed her 20,000 pounds. St. John proposes that Jane marry him and go to a mission in India. Since she does not love him, she offers to go but not as his wife. He demands that they abide by social convention and marry, and when he proposes again, Jane is so moved by his sermon that she senses it may be God's will to succumb. At this moment, she hears Mr. Rochester's voice crying her name and knows she must go to him. Upon returning to Thornfield, Jane discovers that Mr. Rochester leads the life of a hermit, only venturing out at night to wander the grounds like a ghost. A few months ago, Bertha had started a fire that quickly engulfed the hall, and after he tried to stop her from leaping to her death, the staircase collapsed and fell on him, leaving him partially blind and without the use of a hand. They are finally reunited at his modest country estate.

The Films

Robert Stevenson's 1944 version of *Jane Eyre* captures the gothic texture of the novel with appropriately chiaroscuro photography and an ominous musical score. However, apart from mise en scène elements, the film strays from Brontë's concern with the development of an independent woman. Further, very little of the author's contempt for religious hypocrisy, revealed through such unsympathetic characters as Mr. Brocklehurst and St. John Rivers, is addressed. Indeed, the head of Lowood is a solicitor, and the St. John story line is eliminated altogether, most likely a result of the 1930 Production Code, which notes that "no film or episode may throw ridicule on any religious faith . . . and ministers of religion should not be used as comic characters or villains." Similarly, the code also forbade "repellant subjects (which include) brutality, gruesomeness . . . and apparent cruelty to children." Therefore, episodes of coarseness are altered or eliminated, such as Jane's cousin striking her with a book. Stevenson reduces Bertha's screen time to a scene where she quietly stands looking out of the tower, and to another shot of her hands gripping Rochester's (played by Orson Welles) neck; her low laughs and growls are reduced to high shrills. Some of these changes can be credited to censorship, but it was perhaps contemporary notions of appropriate behavior for women that accounted for the refashioning of Jane's character.

Peggy Ann Garner admirably portrays the young Jane. However, Miss Temple, who becomes a strong inspiration for Jane, is replaced by Dr. Rivers, who urges her to stay at the school because it is her duty. Unlike the novel, she does not grow to love learning but merely follows the rules laid down by male authority figures. For the rest of the movie, audiences see little of the perceptive and determined Brontë heroine. Instead, as the mature Jane, Joan Fontaine gives off an uncertain, subservient air. According to one critic, "one must strongly censure someone for the total and quite unnecessary suppression of Jane's intellect in the role played by Joan Fontaine." The screenwriters also omit Jane's internal monologues, which reveal her contempt for social injustice, as well as her struggle between the conflicting priorities of passion and duty. The section of the novel in which Jane leaves Thornfield to start a new life is eliminated, and she fails to inherit a fortune, thus robbing her of the financial power to lead an independent life. Ironically, Fontaine's Jane returns to Gateshead, her home village, out of desperation and begins a letter to Mr. Brocklehurst to apply for a teaching position—two unthinkable courses of action for Brontë's heroine. Thus, the Hollywood film loses the complex character development and becomes instead a simple melodrama in which the title character amounts to little more than "a governess governed."

Julian Amyes's 1983 version was made for television and lies outside the scope of this essay. Suffice to say, however, that scenarist Alexander Baron is admirably faithful

to Bronte's original conception of Jane. For example, Jane (Zelah Clarke) rejects Mr. Rochester's (Timothy Dalton) offer of jewels (a scene retained from the novel), thus demonstrating her preference for spiritual love over superficial affection. Screen time is also devoted Jane's sojourn away from Thornfield, allowing her to mature before her return to Mr. Rochester.

Franco Zeffirelli's production, scripted by Hugh Whitemore, is, as one might expect, a sumptuous and elaborately detailed film, photographed by Oscar-winning cinematographer David Watkin and designed by Roger Hall, who painstakingly recreated Lowood School at Twickenham Studios and selected Haddon Hall, an estate near Bakewell, Derbyshire, to serve as Rochester's Thornfield Hall.

The adaptation is respectful, almost to a fault, and viewers expecting high-style melodrama are bound to be disappointed. As if restrained by the classic text and the sober beauty of the English locations, Zeffirelli abandons his typical operatic flamboyance and works in a quiet, classically poised style (only in the chillingly effective "mad scene" with Bertha does he pull out all the melodramatic stops). His cast selections reveal the same low-key priorities: little Anna Paquin is no coy gamin but a sturdily defiant young Jane; Charlotte Gainsbourg is all too convincingly plain and ordinary as the older Jane; and William Hurt's Rochester, with his fair hair and hesitant, ambivalent manner is a far cry from the glowering, swashbuckling Welles and Dalton.

REFERENCES

Atkins, Elizabeth, "*Jane Eyre* Transformed," *Literature/Film Quarterly* 1, no. 21 (1993): 54–60; Gilbert, Sandra M., and Susan Gubar, *The Madwoman in the Attic: The Woman Writer and the Nineteenth-Century Imagination* (Yale University Press, 1984); Wagner, Geoffrey, *The Novel and the Cinema* (Associated University Press, 1975).

—*R.L.N. and J.C.T.*

JAWS (1974)

PETER BENCHLEY

Jaws (1975), U.S.A., directed by Steven Spielberg, adapted by Peter Benchley and Carl Gottlieb; Universal Pictures.

The Novel

In June 1971, Peter Benchley submitted an outline of his first novel, *A Stillness in the Water*, to editors at Doubleday. By the time the final draft was delivered in January 1973, producers with Universal Pictures had secured the film rights and Benchley was developing a script based on his novel, now titled *Jaws*. In his synopsis, Benchley revealed his purpose was "to explore the reaction of a community suddenly struck by a peculiar natural disaster." A contemporary retelling of the man versus monster myth, *Jaws* revisits territory familiar in the tradition of *Beowulf* and *Moby Dick*.

When a large great white shark claims a young woman off the shores of Amity, Long Island, the inhabitants of the small resort community become victims of an unseen menace that threatens both their physical and economic survival. Police chief Martin Brody, respecting his duty to serve and protect, attempts to close the beaches until the beast is gone. Lacking the authority to act alone Brody must yield to pressure applied by Amity's corrupt mayor, Larry Vaughan, and keep the beaches open. But not even Matt Hooper, the young and wealthy ichthyologist, can anticipate the unpredictable nature of the nomadic rogue.

The arrival of Hooper leads to a short-lived affair between Ellen Brody, the chief's wife, and Hooper, who reminds her of the privileged life she gave up to become the wife of a small town police chief. Although Brody's suspicions are never confirmed, his jealous dislike of Hooper complicates their mutual effort to confront the shark.

When the attacks continue Brody hires veteran shark fisherman, Captain Quint, and sets out with Hooper and Quint aboard the *Orca* to eliminate the beast. Before the shark is sapped of its strength it claims two more victims, Hooper and Quint, leaving Brody floating on pieces of the destroyed *Orca* as he watches the fish disappear in a slow death spiral toward the bottom of the sea.

The Film

The film was released by Universal in the summer of 1975, driving patrons away from the water and into theaters in record numbers. Deciding that the film's star would be the multimillion-dollar mechanical shark (nicknamed Bruce), Universal filled in the cast with relatively unknown live actors; Roy Scheider, Richard Dreyfuss, and Robert Shaw. Although the film failed to capture any of the major Academy Awards it did manage to place a well-deserved Oscar in the hands of John Williams for his unnerving, ominous musical score.

The corruption and adultery plots are eliminated and unsympathetic characters in the novel were literally given new life, as Hooper survives his encounter with the shark in the film. Relieved of these complicated plot considerations, the film was able to capitalize on the essential suspense and horror elements of the story.

Although seldom linked to controversial issues of the seventies, Robert Torry's reading of the film suggests *Jaws* was a conservative reaction to the failure of U.S. military involvement in Vietnam. For Torry, Brody, Hooper, and Quint represent trained professionals, stifled by public opinion, unable to engage the menace according to their professional instincts. The end unfolds as a revenge fantasy where the three are finally able to proceed unrestrained and destroy the enemy.

REFERENCES

Benchley, Peter, *Jaws* (Bantam Books, 1974); Bowles, Stephen E., "The Exorcist and Jaws," *Literature/Film Quarterly* 4 (1976): 196–214; Druce, Robert, "Jaws: A Case Study," *Dutch Quarterly Review of Anglo-American Letters* 13 (1983): 72–86; Gottlieb, Carl, *The Jaws Log* (Dell, 1975); Torry, Robert, "Therapeutic Narrative: The Wild Bunch, Jaws, and Vietnam," *The Velvet Light Trap* 31 (1993): 27–38.

—J.A.T.

LES JEUX INCONNUS (1947)

See UNKNOWN GAMES.

JOHNNY GOT HIS GUN (1939)

DALTON TRUMBO

Johnny Got His Gun (1971), U.S.A., directed and adapted by Dalton Trumbo; World Entertainment.

The Novel

The novel has an interesting critical history. In the time prior to the U.S. entrance into World War II, it was revered by the political right wing, particularly those inclined to be anticommunist and/or anti-Semitic. By the 1970s, however, politics had shifted and it became a favorite of the left. Winner of a National Book Award, it is perhaps the most powerful antiwar novel ever written in America.

In the last days of World War I, Joe Bonham is wounded. The reader is privy to his thoughts as he awakens in a hospital and realizes that he is a quadruple amputee, his face is nearly blown off, he is blind, deaf, and incapable of speech. Only some sense of touch remains, along with, unfortunately, his mind. Throughout, he struggles first to establish a sense of time, which he does, and to communicate. At last, by banging his head against his pillow, he sends a Morse code message that is detected and understood by an alert nurse. But when Bonham seeks to be released, he is told that would be "against regulations." He is left uncertain as to what will become of him, but pictures himself as "a new kind of Christ . . . saying to people as I am so shall you be."

The Film

Trumbo is an interesting story in his own right. One of the blacklisted "Hollywood Ten," he continued to write clandestinely for films. Under the pseudonym "Robert Rich," Trumbo won an Oscar for writing *The Brave One* in 1956, though he could not claim the award in person. Given full credit at last for *Spartacus* and *Exodus* in 1960, he went on to write scripts for *The Fixer* (1968) and *Papillon* (1973).

The transformation of *Johnny Got His Gun* from novel to film is a unique one, as the novelist both wrote and directed the film of his novel. It was Trumbo's first and

Timothy Bottoms in Johnny Got His Gun, *directed by Dalton Trumbo* (1971, U.S.A.; WORLD ENTERTAINMENT/THEATRE COLLECTION, FREE LIBRARY OF PHILADELPHIA)

only venture as a director. The 1971 movie is daring in its antiwar message and is mostly successful, despite relying (necessarily) on considerable voiceover. There are excellent performances, particularly by Jason Robards Jr. as Joe's father and Donald Sutherland as Jesus in two fantasy sequences. In fact, the movie errs primarily in underestimating its own power: a magnanimous nurse (the same one who understands Bonham's use of code) attempts euthanasia on Joe but is stopped by the doctor in charge. At the end, Joe's use of Morse code is a repetitive plea: "Kill me . . . kill me . . ." These additions are hardly necessary, since the film is a compelling and very disturbing antiwar vehicle without them.

REFERENCES

Trumbo, Dalton, *Johnny Got His Gun* (Lippincott, 1939);——, *Additional Dialogue* [Collection of correspondence] (M. Evans, 1970).

—C.K.P.

JOSEPH ANDREWS (1742)

HENRY FIELDING

Joseph Andrews (1977), U.K., directed by Tony Richardson; adapted by Richardson, Allan Scott, and Chris Bryant; Woodfall Films/Paramount.

The Novel

Henry Fielding called his first novel, *Joseph Andrews*, the first English "comic romance"; he modeled it on Cervantes' *Don Quixote*. In Fielding's picaresque narrative, young Joseph Andrews (presumed to be a serving-boy raised as a foundling by Gypsies) is loved by Fanny (presumed to be a serving-girl), instructed and mentored by Parson Adams (a moral and mild country parson) and seduced by many women along the way, most notably Lady Booby, his employer at the beginning of the story. *Joseph Andrews* allows Fielding to indulge his appetite for satire, especially of hypocrisy and what he calls "the Ridiculous," as well as to include much bawdry, a range of colorful characters from aristocrat to peasant, and a series of adventures centering on his handsome young hero Joseph (who is chaste, naive, but never entirely unresponsive to the many longing enticing looks he meets). By the end of the novel no one is quite who they seemed to be at the outset; finally, love conquers all.

Yet despite the many adventures and digressions in Fielding's novel, what Martin Battestin calls the "moral vision" of *Joseph Andrews* gives the narrative "meaning and cohesiveness." Fielding may well have had in mind not only *Don Quixote* but also Bunyan's *Pilgrim's Progress* as a model for *Joseph Andrews*. The memorable character of Parson Adams, in particular, embodies the learned wisdom, charity, and virtue Fielding most admired in his fellow human beings.

The Film

Tony Richardson's *Joseph Andrews* was his second try at adapting Fielding; the first, *Tom Jones*, was a critical and commercial smash in 1963. This time, however, Richardson misunderstood the work he was adapting (though he claimed that *Joseph Andrews* was a better film than *Tom Jones*). The film is fitfully interesting but mostly labored and shrill. It opens with a saccharine Queen-of-the-May episode designed, according to Richardson, to evoke an "England with its rituals, paganism, and lyricism intact." What follows is a series of episodes rushed together pell-mell, at times resembling a Monty Python sketch without the humor. One of the few interesting extended sequences is the "roasting squire" episode, which Richardson enlarges from Fielding's original into a lurid sequence somewhere between a Black Mass, a Gothic melodrama, and a day at the Playboy mansion. By the end, however, the film is mostly fart noises, bed tricks, and frenzied revelations. The last shot is a freeze-frame of a gratuitously topless Fanny and a disrobing Joseph getting ready for their nuptial love-making.

Richardson thought *Joseph Andrews* began as a parody of Samuel Richardson's 1740 novel *Pamela*, a notion Martin Battestin had disproved by 1959. Perhaps Tony Richardson's misapprehension led to the follies of his film adaptation; perhaps Richardson simply wanted to make a lusty, rambunctious, crowd-pleasing period movie. In any event, the film earned mixed reviews and lost money.

REFERENCES

Fielding, Henry, *Joseph Andrews*, ed. and intro. Martin C. Battestin (Houghton Mifflin, 1961); Radovich, Don, *Tony Richardson: A Bio-Bibliography* (Greenwood Press, 1995).

—*W.G.C.*

LE JOURNAL D'UN CURE DE CAMPAGNE (1936)

See DIARY OF A COUNTRY PRIEST.

LE JOURNAL D'UNE FEMME DE CHAMBRE (1900)

See DIARY OF A CHAMBERMAID.

JUDE THE OBSCURE (1896)

THOMAS HARDY

Jude (1996), U.K., directed by Michael Winterbottom, adapted by Hossein Amini; Revolution/Polygram.

The Novel

Jude's story starts in the village of Marygreen, when 11-year-old Jude watches Richard Phillotson, his schoolmaster, leave for Christminster (Hardy's name for Oxford) to study for a university degree. Jude is a devoted scholar who studies on his own and becomes an apprentice stonemason at the age of 19; but he is tricked into marriage by Arabella Donn, who is defined by her low-minded vulgarity. Jude is soon disappointed, becomes suicidal and turns to drink, whereupon Arabella leaves him.

Rededicated, then, to his scholarly ambition, Jude goes to Christminster to find work as a stonemason. There he meets Phillotson and Sue Bridehead, Jude's unconventional and "liberated" artistic cousin, who later becomes Phillotson's assistant. Independent-minded and contrary, Sue earns a scholarship to a teacher's college. Both Jude and Phillotson seem to be in love with her, and she enters into an unfortunate marriage with Phillotson, whom she later deserts in order to live with Jude in Aldbrickham, a large industrial city. After Sue divorces Phillotson, he loses his teaching position. Jude, in turn, divorces Arabella, which places him at liberty to marry Sue, but she refuses a church ceremony and the binding obligations of matrimony. Two children are born of this union, and then Arabella reappears to saddle the couple with a third, pathetic child Jude had fathered. This child, whom they call Little Father Time, is ultimately destined to ruin the couple's short-lived happiness.

Because Sue and Jude are not conventionally married, they become outcasts and Jude is refused employment. When the family has difficulty finding lodgings, Sue complains to Little Father Time that too many children are being brought into this world. This wretched boy solves their family problem by his own tragically simple expedient—by hanging the two younger children and then himself. At the sight of this, the again-pregnant Sue collapses, giving birth prematurely to a dead infant.

Sue attributed these misfortunes to God's punishment for her sinful ways and returns to Phillotson, whom she remarries, abandoning Jude, who turns back to drinking and is then tricked into marrying Arabella a second time. The dispirited Jude, in failing health, ventures forth in the pouring rain to see Sue a final time. He subsequently dies a miserable, lonely death.

Thomas Hardy (1840–1928) was ahead of his times, writing rather more honestly about the human condition than many readers in Victorian Britain could tolerate. He had earlier run afoul of censorship problems when his publisher found passages of *Tess of the D'Urbervilles* too sexually suggestive. Now, he was criticized for concentrating "on the sordid and painful side of life and nature," and for writing such a "gloomy, even grimy story," by Edmund Gosse, who was at least sympathetic to Hardy's goals, but who felt that in this case the novelist had simply gone too far. Hardy was so surprised and hurt by the reception of this novel that he spent the rest of his life writing poetry rather than fiction—and he was to live for another 33 years after *Jude* was first published in 1895 as a serial in *Harper's New Monthly Magazine*.

The Film

The screenplay, adapted by Hossein Amini, is reasonably faithful to the novel, though it truncates the opening and changes the focus of the conclusion. Director Michael Winterbottom unflinchingly conveys the general tone of blasted hopes and numbing failure. This is prefigured from the very beginning, in a prologue starkly photographed in faded colors, which depict Jude striding through a farmer's bleak wintry field. Although he is supposed to be frightening away marauding birds, he pauses occasionally to feed the poor creatures; but when his master witnesses this humane act, he angrily beats him. It is Jude's first lesson about the fate of compassionate people in a cold and uncaring world.

The casting is perfect: Christopher Eccleston's Jude is rough-hewn but vulnerable; Rachel Griffiths's Arabella is simple, robust, and appropriately vulgar; Liam Cunningham's Phillotson is admirably divided, at first a heroic example to Jude and, later, a sadly diminished failure; and Kate Winslet's Sue is self-possessed but remote, a magnetic figure in the mold of Jeanne Moreau (who played a similarly divided liberated woman in Truffaut's classic *Jules and Jim*).

Faithful to Hardy's design, the film's episodes correspond to the divisions of the novel: "At Marygreen," for example, "At Christminster," "At Shaston," and "At Aldbrickham & Elsewhere." However, there are some crucial departures from the book. There is no mention of Jude's alcohol problems, his enrollment in a theological college, or his subsequent bitter rejection of religion. At the end, after the death of the children, there is no indication that Jude remarries Arabella in the film, or that he dies unattended by her. Nor is there any mention of the child that is born dead to Jude and Sue. On the other hand, many crucial elements of the novel are retained: Sue's initial indifference to religion and physical love is traced in painful detail. Preserved is her speech to Jude that a man is essentially weak, that he can never pursue a woman unless invited to do so. It's also clear that she makes love to Jude only in the most perfunctory way (the nudity is handled in an intentionally clumsy and non-erotic manner) and only because of her jealousy of Arabella. The scene when Jude discovers his dead children is blunt and almost unbearable to watch. Later, Sue's sudden conversion to religion is almost terrifying in its fierce intensity.

This *Jude* is a courageous achievement, unflinching in its fidelity to the spirit of Hardy's vision, no matter how grotesque it occasionally becomes. It is that rare accomplishment in the checkered history of novel-to-film adaptations, a film that may stand beside its model without shame.

REFERENCES

Arnold, Gary, "Evocative Account of 'Jude,'" *Washington Times Metropolitan Times* (November 1, 1996), C-16; Faber, Stephen, "Hooked on Classics," *Movieline*, November 1996, 32–34; James, Caryn, "Any Novel Can Be Shaped into a Movie," *The New York Times*, November 17, 1996, II, 17, 28; Seymour-Smith, Martin, *Hardy* (St. Martin's Press, 1994).

—J.M. Welsh and J.C.T.

JULES ET JIM (1953)

HENRI-PIERRE ROCHÉ

Jules and Jim (1961), France, directed by François Truffaut, adapted by Truffaut and Jean Gruault; Films du Carrosse/SEDIF.

The Novel

Henri-Pierre Roché, who was entirely unknown during his lifetime, was made famous by Truffaut's version of his first novel, *Jules et Jim*, which he wrote in 1953 at the age of 74. Apart from *Jules et Jim*, Roché wrote one other novel, *Les Deux Anglaises et le continent* (also filmed by Truffaut), and a handful of short articles and reviews.

The largely autobiographical plot of *Jules et Jim* chronicles some 30 years in the lives of its three protagonists, extending from the heady Parisian life of the Belle Epoque to the grim era of the depression and the rise of Hitler.

The story begins in Paris when Jim, a Frenchman, and Jules, a German, meet and become close friends. Together, haunted by the image of a smile they see on a statue, they set off in search of the ideal woman, and their quest ends when they meet the fascinating Catherine. With the agreement of Jim, she becomes Jules's girlfriend and the three of them form an inseparable trio. When the First World War breaks out, Jules and Catherine, now married, settle in Germany, and Jules and Jim inevitably find themselves fighting in the trenches on opposite sides.

After the war, Jim visits Jules and Catherine and their young daughter Sabine, who seem to be idyllically happy, although Jules is in fact tortured by the certainty that Catherine will leave him. In order not to lose her completely, he encourages a *ménage à trois* involving Jim and Catherine, but it does not last long, and soon Jim returns to Paris and his faithful lover Gilberte. When Jules and Catherine return to France, some years later, nothing has changed in their complex triangular relationship. Catherine's final act is to drive her car into the river, with Jim in the passenger seat.

The Film

Jules and Jim is Truffaut's fifth film, made in 1961, and certainly one of the greatest documents of the French New Wave. He discovered the little-known novel on which it is based when he was a relatively unknown film critic, and claims to have fallen in love with it immediately, attracted by its breadth of vision, its essential dynamism, and its modern spirit, which he described as its "new morality incessantly reconsidered." He vowed, as early as 1953, that if ever he succeeded in becoming a director, he would film this work. He later made the acquaintance of Roché, and together they discussed the problems of adapting the book

Jeanne Moreau in Jules et Jim, *directed by François Truffaut* (1962, FRANCE; FILMS DU CARROUSSE/ SEDIF/MUSEUM OF MODERN ART FILM STILL ARCHIVE)

for the cinema. Because Truffaut recognized the ambitious nature of the project, he decided that he needed considerable directing experience before tackling it. Roché was very enthusiastic, particularly once he had seen photos of Jeanne Moreau, chosen by Truffaut to play Catherine. It is unfortunate that Roché died in 1959, and thus never saw the film.

Filmed on location in Paris and on the Côte d'Azur between April and June 1961, *Jules and Jim* was an immediate success, soon gaining cult status in Europe. Truffaut's film echoes Roché's plot closely, and he retains much of the original dialogue, while striving to reproduce the sense of breathless speed and freshness he discerned in the original. The film script, written jointly by Truffaut and Jean Gruault, was based on close textual analysis of the novel, guaranteeing detailed understanding and coherent adaptation. However, once the script was complete, it was used by Truffaut not as a rigid document, but as the basis for the shooting; working within its parameters, he allowed himself freedom to improvise, and to allow the actors to improvise, where necessary. This undoubtedly contributes a sense of spontaneity and immediacy to the film, which is cinematically exciting and innovative, rather than merely relying on reproducing visually the literary devices found in the novel. The film further captivates the audience through its excellent acting and sustained character development.

Truffaut saw his film as a way of paying homage to Roché's work, and he aimed to express in it the same poetic vision and sense of excitement he had found in the novel. He wanted to escape the traditional approach to adaptation, which he saw as a somewhat theatrical and predictable exploitation of plot, and to create instead a filmed novel that would express the vitality and beauty of the original. Therefore, despite remaining faithful to the original text, his film is a new expression of it, rather than an imitation.

Truffaut decided to use an offscreen narrator for those moments when it seemed impossible to transform the text into dialogue; he also alternates dialogue and reading aloud within the film, as a way of sustaining and acknowledging its close links with the original. For the sake of coherence and length he reduced the range of events and characters found in the novel, but at the same time he thought that it was essential to retain its vigor and its breathless pace. This he achieves through the visually stunning use of widescreen, Raoul Coutard's black-and-white cinematography, and Georges Delarue's lyric music score. When asked what the real theme of the film was, he claimed that it was explicitly stated in the film's theme song, "Tourbillon de la vie" (Whirlpool of life), and it is possible to read the whirling, circular camera movement in this light. As the film's action coincides with the period of silent film, Truffaut includes many silent-film devices in his text as an effective way of creating the atmosphere of the period; while, in order to capture the novel's sense of immediacy, he incorporates authentic newsreel footage

showing, for example, Paris in 1900, the First World War, and the Nazi book burnings. At the same time, the film can be seen as a fascinating catalogue of the arts, filled with references to film, photography, sculpture, paintings, and, of course, literature.

The shifting stresses that create the tensions composing the central triangular relationship, and the unpredictability and speed at which everything happens, help to capture a sense of an unorthodox concept of morality, and it is this, above all, that made the film so absolutely relevant to its time, and captured the imagination of young people everywhere.

REFERENCES

Nicholls, D., *François Truffaut* (Batsford, 1993); Truffaut, F., *Truffaut by Truffaut*, tr. Robert Erich Wolf (Harry N. Abrams, 1987).

—*W.E.*

JURASSIC PARK (1990)

MICHAEL CRICHTON

Jurassic Park (1993), U.S.A., directed by Steven Spielberg, adapted by David Koepp; Universal Pictures.

The Novel

Michael Crichton, called "the father of the technothriller," wrote this hugely popular science fiction novel as a cautionary tale about the insane scheme of John Hammond to bring prehistoric dinosaurs back to life through DNA experiments on an isolated island Hammond owns and wants to develop into a theme park. It is a thesis novel keyed to a nightmare vision of science run amok.

"Welcome to Jurassic Park!" is a good, ironic line, since Jurassic Park turns out to be inhabited by monsters that science has created and technicians, however gifted, cannot control or contain. Steven Spielberg's movie gives the line to kindly old John Hammond, a megalomaniacal billionaire whom the movie reinvents as merely a nice old man who is spared the horrible fate he suffers in Michael Crichton's novel as payment for his prideful, presumptive sins. In the novel, after all hell (and 15 dinosaur species) breaks loose, Hammond unwisely wanders off from the security of his central compound, breaks his ankle, and is eaten by scavenger dinosaurs—poisonous little fellows called "compys," about the size of a chicken. Serves him right in the novel, but there is not a single compy in the film.

The Film

The film's John Hammond, as played by Richard Attenborough, is a bit balmy and befuddled, but he means well. The screenplay gives him a little speech that allows him to explain how as a young lad he came down to London from Scotland to run a flea circus. There is no mention of this in the novel. In the film Hammond actually seems worried about the fate of his grandchildren, trapped in the park with deadly carnivorous dinosaurs on the loose. In the novel Hammond thinks only about himself and his mad dream.

The kids are also different in the movie. Lex, the girl, is older than she is in the novel, less given to whining, more aware of the danger, and able to put the computer system back on line after a total shutdown—a plucky, politically correct little heroine. Tim, her precocious brother, is the older sibling in the novel; it is he who fixed the computer system and is a take-charge little guy. Spielberg makes him younger and cuter. No surprise here.

An important character in the novel, who is reduced to almost nothing in the movie, is the chemical engineer Henry Wu (B. D. Wong), who unsuccessfully argues with Hammond—only in the novel—about designing more domesticated dinosaurs. Henry isn't even on the island when the storm comes in the movie and things go berserk, and his absence reduces the ethical subtext. Dennis Nedry (Wayne Knight), the turncoat computer wizard who attempts to steal dinosaur embryos for a rival genetic engineering firm, is an even more disagreeable slob in the movie and justly turned into dinosaur bait.

The paleontologist Alan Grant (Sam Neill) and his assistant Ellie (Laura Dern) are near the mark, but in the movie they seem to have thoughts of matrimony; in the novel, before thinking of marriage, Grant needs to develop a more positive and tolerant attitude toward children, which he does as a result of his adventures in Jurassic Park with Lex and Tim.

Ian Malcolm (Jeff Goldblum), whose reservations about Hammond's tampering with nature by experimenting with dinosaur DNA, give the novel its moral framework, is made more eccentric in the film and has a yen for Ellie. He is wounded in the movie, as he is in the novel, but his injury—like the whole film—is less serious. Spielberg attempts to save as many of the good guys as he can, and if the novel is distorted and dumbed-down (as it is), well, it's not quite the same as tampering with Tolstoy. Entertainment and profits are the bottom line here, and Spielberg certainly knows how to entertain.

The film begins in an amber mine in the Dominican Republic so as to explain up front how the dinosaur DNA is extracted from prehistoric mosquitoes trapped in amber. Spielberg even gives a visual demonstration of how amber is produced and how the insects got trapped. Spielberg also sends Hammond in person to coax Grant and Ellie away from their dinosaur dig in the Badlands. In the novel this is done by telephone. Gone is the novel's prologue about strange happenings in Costa Rica and the danger of migrating velociraptors, the deadly, cunning, and dangerous carnivores, 300-pound killers that stand only six feet tall. The movie wraps things up too neatly.

It's hardly surprising that Spielberg turns the novel merely into an action-adventure story calculated to generate a thrill or a surprise every five or six minutes. Instead of a car chase, he offers an open-topped Jeep filled with puny mortals being chased by a T-rex that can run up to 60 miles per hour, fast enough to keep the chase interesting.

The movie is a well-constructed scare machine that utilizes state-of-the-art special effects to make it the ultimate monster movie—big birds with teeth, and certainly with "legs," as they say in the industry. (The film grossed $48 million over its opening weekend.) It's unfortunate that the adaptation was not closer to its source, that so much of the dinosaur lore is abridged, and that the science lesson here is so rudimentary. Those who see the movie will not be bored, but those who have read the novel will expect more.

REFERENCES

Begley, Sharon, et al., "Here Come the DNAsyars," *Newsweek*, June 14, 1993, 58–65; Klawans, Stuart, "Films," *The Nation*, July 19, 1993, 115–16; Lemonick, Michael D., "Rewriting the Book on Dinosaurs," *Time*, April 26, 1993, 42–52.

—*J.M. Welsh*

KIDNAPPED (1886)

ROBERT LOUIS STEVENSON

Kidnapped (1917), U.S.A., directed by Alan Crosland, adapted by Summer Williams; Forum/Edison.

Kidnapped (1938), U.S.A., directed by Alfred Werker, adapted by Sonya Levien, Eleanor Harris, Ernest Pascal, and Edwin Blum; Twentieth Century-Fox.

Kidnapped (1948), U.S.A., directed by William Beaudine, adapted by W. Scott Darling; Monogram.

Kidnapped (1960), U.K., directed and adapted by Robert Stevenson; Walt Disney.

Kidnapped (1971), U.K., directed by Delbert Mann, adapted by Jack Pulman; Omnibus/American International.

The Novel

In the spring of 1885, Robert Louis Stevenson began work on a serial adventure story, set against the backdrop of the Scottish Jacobite rebellion; it ran in *Young Folks* magazine from May 1 through July 31, 1886. Cassell published *Kidnapped* as a full novel in July of that same year. The novel was quite successful for Stevenson, both critically and financially. Henry James, for one, championed the book, calling it Stevenson's best work, an assessment still shared by many literary critics today.

Kidnapped begins in June of 1751, when orphaned David Balfour, 17 years of age, is directed by the minister of Essendean to travel to the house of Shaws to receive his rightful inheritance from his uncle, Ebenezer Balfour. Ebenezer proposes that he and David go to Queensferry, where Ebenezer can conduct business with Captain Hoseason and David can settle his inheritance with the family solicitor. Lured onto Hoseason's ship, the *Covenant*, under false pretenses, David is knocked unconscious and taken to sea as part of an agreement between Ebenezer and Hoseason to sell the boy into servitude in America. After the cabin boy Ransome is killed by captain's mate Mr. Shuan, David becomes cabin boy.

A week later, the *Covenant* runs down a boat, killing all the smaller vessel's crew except one, who is brought safely aboard. The man, a former British soldier turned Jacobite rebel, is named Alan Breck Stewart; he pays Hoseason to set him ashore on the Scottish coast, but David overhears the captain's plans to overpower Alan and steal his money. Outraged, David alerts Alan to the plot and agrees to make a stand with him in the ship's roundhouse. The bloody battle between the two forces ends in David and Alan's victory. Hoseason and Alan come to terms, but the uneasy alliance is shattered when the *Covenant* founders on a reef during a storm. David comes ashore, alone. He chances across an old man who has a message for him from Alan: David is to find his way to Alan's home country in the Highlands.

Once upon the mainland, David unexpectedly encounters Colin Roy Campbell, the "Red Fox" of Glenure, and enemy of Alan Breck. An unseen assassin shoots Campbell, a crime in which Campbell's traveling companions think David is implicated. David escapes with the aid of Breck, whose proximity to the murder arouses suspicion in David. Breck, however, swears his innocence and leads David to the home of kinsman James Stewart. Stewart, fearful of redcoat reprisal, does not allow the two to stay for more than a night. Alan and David thus embark on a daylong

journey through the Scottish heather, pursued by British soldiers and seeking shelter in the cave of Jacobite exile Cluny MacPherson.

Alan and David leave the Highlands and reach the Bridge of Stirling, the last barrier between them and David's solicitor in Queensferry, Mr. Rankeillor. The presence of a guard prevents them from crossing. David charms a servant girl into stealing a boat and rowing Alan and David to the far shore. Once there, David contacts Mr. Rankeillor and relates to him all that has happened. Rankeillor conspires with Alan and David to secure David's rightful inheritance. David and Rankeillor also arrange for Alan's final escape to France, and Alan and David reluctantly say goodbye in Edinburgh.

The Films

Worldwide, many different film and television adaptations of *Kidnapped* exist; of these, five films are of note. The first cinematic adaptation of *Kidnapped* was a May 1917 release, four reels in length, directed by Alan Crosland and starring Raymond McKee as David Balfour and Robert Cain as Alan Breck. From contemporary reviews, it appears that the film, now unavailable, closely followed the highlights of Stevenson's original plot, giving particular emphasis to the roundhouse battle.

The major sound-era adaptations have varied in their fidelity to Stevenson's story line, with the widely excoriated 1938 Darryl F. Zanuck production, starring Warner Baxter as Alan Breck and Freddie Bartholomew as David Balfour, departing from it the most. The 1938 film resembles Stevenson's novel mainly in the title and the names of the main characters. Most of Stevenson's emphasis on the political conflict between the Whigs and Jacobites is discarded, apparently in the belief that American audiences would be uninterested in or unable to follow the complexities of another nation's history. Other narrative alterations, however, are less understandable. For example, David's kidnapping occurs after the death of the Red Fox and his meeting with Alan Breck; the sea voyage aboard the *Covenant* does not end in shipwreck and the subsequent flight across the heather, arguably the most important section of the novel. The film also shifts a great deal of narrative focus to the swashbuckling heroics of rebel Alan Breck, even going so far as to provide him with a completely superfluous love interest, Jeanie MacDonald (played by Arleen Whelan), and a climatic speech in which he does nothing less than unite a divided kingdom.

The 1948 Monogram adaptation, starring Roddy McDowall as David and Dan O'Herlihy as Alan, improves matters by restoring the Whig/Jacobite backdrop and placing David's journey to Uncle Ebenezer's house at the film's beginning, where it properly belongs. David's sea voyage is also rendered more or less faithfully, though the climactic shipwreck disappointingly occurs off-screen because of budgetary limitations. Some unnecessary additions to Stevenson's basic plot still occur; they include a love interest, Aileen Fairlie, for David; another brawl with Hoseason and his crew in a country inn; and a duel to the death between Ebenezer and Hoseason.

Filmmaker Robert Stevenson, when hired by Walt Disney to write and direct a 1960 version of *Kidnapped*, specifically rejected such extraneous material and stuck quite closely to the original scenario: a decision that ultimately hurt the film financially but endeared it to British critics, at least. Noted actor Peter Finch gives the best Alan Breck performance to date in a film that deviates only slightly from its source, and James MacArthur also plays a credible David.

Finally, the 1971 British release, directed by Delbert Mann and starring Michael Caine as Alan and Lawrence Douglas as David, combines the memorable highlights (David's trek to the House of Shaws, Ebenezer's betrayal, Alan's coming aboard the *Covenant*, the shipboard fight, Ebenezer's comeuppance, and so forth) of *Kidnapped* and key elements of Stevenson's sequel *Catriona* into one narrative. In the latter novel, David falls in love with a woman named Catriona; screenwriter Jack Pulman incorporates this development into *Kidnapped*'s plot with surprising effectiveness, largely because Catriona, seeking to effect the release of her father from prison, is pivotal in convincing Alan that the Jacobite rebellion, during which this adaptation is set, is doomed. Alan then turns himself in to the British so that Catriona's father can go free and David and Catriona can marry. Of the four major *Kidnapped* adaptations, Mann's version, even though not a literal rendering of the original, is generally regarded as the most intellectually and politically complex.

REFERENCES

Nollen, Scott Allen, *Robert Louis Stevenson: Life, Literature and the Silver Screen* (McFarland & Company, 1994); Swearingen, Roger G., *The Prose Writings of Robert Louis Stevenson* (Archon Books, 1980).

—P.S.

KING SOLOMON'S MINES (1885)

H. (HENRY) RIDER HAGGARD

King Solomon's Mines (1918), South Africa, directed by H. Lisle Lucoque.

King Solomon's Mines (1937), U.K., directed by Robert Stevenson, adapted by Ralph Spence, A. R. Rawlinson, and Charles Bennett; Gaumont-British Picture Corporation.

King Solomon's Mines (1950), U.S.A., directed by Compton Bennett and Andrew Marton, adapted by Helen Deutsch; MGM.

Watusi (1959), U.S.A., directed by Kurt Neumann, adapted by James Clavell; MGM.

King Solomon's Mines (1985), U.S.A., directed by J. Lee Thompson, adapted by Gene Quintano and James G. Silke; Cannon Productions.

The Novel

H. Rider Haggard, British author of *King Solomon's Mines*, was relatively unknown in the literary world prior to the publication of this African adventure. This novel was an outgrowth of Haggard's own experiences in Africa, where he had gone at the age of 19 on the staff of the lieutenant governor of Natal. Haggard wrote the novel, which became a financial but not a literary success, in six weeks after placing a bet with his brother. Critics derided Haggard as a careless writer who seldom revised his work. The novel's success, however, was attributed to Haggard's imaginative style of writing, a ready-made audience that eagerly awaited adventure stories, and an irresistible fascination that British readers held for the outside world.

Encompassing "all the ingredients of high-romantic adventure, with intrepid English heroes, sinister African villains—and a splendid African hero as well—a witch of incredible power and unimaginable age, and an epic exploration for fabulous treasure," Haggard's stories tantalized his readers' imaginations. *King Solomon's Mines* has never been out of print and has held an unparalleled attraction for screen audiences.

In the novel, the hunter Allan Quatermain meets Sir Henry Curtis, a fellow Englishman who is in search of his long-lost brother, believed to have disappeared en route to South Africa to excavate for diamonds. Curtis solicits the assistance of Quatermain in leading an expedition to find his brother. The two pair themselves with former naval officer Captain Good. They organize a caravan of supplies and men, one of them an African native, Umbopa, whose knowledge and skill will prove useful in their journey to King Solomon's mines.

Despite the intense heat, a sand storm, little water, no vegetation, and sparse wildlife, they successfully complete a desert crossing. The voyagers are again tested when they

Paul Robeson (center) as King Umbopa in King Solomon's Mines, *directed by Robert Stevenson* (1937, U.S.A.; GAINSBOROUGH/NATIONAL FILM ARCHIVE, LONDON)

encounter African natives who have never before seen whites and who believe them to be spirits, as affirmed by the white legs of the scantily clothed Good with a half-shaven face, glass eye, and chattering false teeth. Witnessing the tortuous rituals of the witch-doctor, Gagool, members of the caravan are startled to see death randomly inflicted upon the natives and soon realized that they will meet a similar fate unless they can prove their magical powers. Their white magic arrives just in time when an eclipse they had forewarned occurs.

Complicating their journey, Umbopa reveals that he is a descendant of these Kukuanas. Desiring to be restored to power, Umbopa involves them in a war with a rival faction. Following victory, the whites are ushered into King Solomon's mines by Gagool. However, the mine's chamber door closes, crushing Gagool to death and locking the Englishman inside until they manage to free themselves through a tunnel.

Venturing into an uninhabited area, they discover a hut occupied by a disabled white man, who is none other than Curtis's long-lost brother. The novel ends when Curtis is reunited with his brother and they return to England.

The Films

Five film versions of Haggard's novel have been produced. At least three of these films were made in the United States; one of the other two versions was produced in South Africa in 1918 (a seldom mentioned silent film) and the other in the United Kingdom in 1937 (one of the more well known). Of the U.S. productions, the 1950 version released by MGM was nominated for a best picture Oscar. The 1959 version was released under the title *Watusi*; the film was accused of being "cursed with a poor cast, unimaginative director, and . . . screenplay."

Among the more popular versions was the 1937 British production. It prominently featured African-American actor Paul Robeson, who had fled the United States in search of improved screen roles and more political freedom. This version, directed by Robert Stevenson, also featured Cedric Hardwicke, Roland Young, John Loder, Anna Lee, and Makabalo Hlubi and is regarded as outstanding because of its realistic African settings and because it captured Robeson's talent as both actor and singer. The plot is slightly altered from the novel: A young female is accompanied by male voyagers in her search for her father whose obsession with riches led him to King Solomon's mines. Robeson, as Umbopa, is developed more fully on the screen than in the novel. Whereas in the novel, Umbopa is described as a "cheerful savage . . . in a dignified sort of way," the film medium accentuates Robeson's stature and embellishes his characterization, leading one reviewer to refer to him as the "big, mighty Paul swaggering across the desert, his torso outlined against the sky . . . a photographic masterpiece."

Richard Carlson, Deborah Kerr, and Stewart Granger among the natives in King Solomon's Mines, *directed by Compton Bennett* (1950, U.S.A.; MGM/THEATRE COLLECTION, FREE LIBRARY OF PHILADELPHIA)

The film is an archetypal representation of the imposition of British colonialism on black Africa, evident in the characterization of Umbopa who is utilized for his knowledge of the terrain and skill in handling unruly natives, while white colonizers often remind Umbopa of his subordinate status. Robeson, however, manages to challenge such ideological constructions; when he resumes his position as king, he reminds the white men that they stood shoulder to shoulder in battle, a not-so-subtle implication that they should do so in real life and a reflection of Robeson's own deep-seated political views.

Reviews of the 1937 screen adaptation of *King Solomon's Mines* frequently refer to Robeson. *Variety* observed that he "is a fine, impressive figure as the native carrier . . . [who] puts on a proud dignity that his frequent lapses into rolling song cannot bring down." *Literary Digest* emphasized that "the real reason for going to the picture no matter how much 1937 has outgrown Mr. Haggard's naivete, is Paul Robeson." Less preoccupied with

Robeson and more concerned with African-American representations, the black press stated that the picture "is not exactly a sensational picture, nor for that matter does it idolize Robeson or Negroes to any great extent; the fact that it doesn't reek with the imperialistic theory of British superiority . . . is however, a big improvement."

In addition to Robeson's portrayal, the 1937 screen adaptation was applauded for its realism. The film was shot in Natal, South Africa. Many of the black actors were African natives, some of whom had to be coaxed into taking parts, since they feared they were being drafted for a new European war. Although the imaginative skill of Haggard as a writer was virtually impossible to duplicate on the screen, the movie was well received as a just adaptation in its transfer from novel to screen.

The 1950 version featured actors Stewart Granger and Deborah Kerr in the leading roles, and focused on a sister (Kerr) and brother (Richard Carlson) who engage in a search to locate her husband who has vanished in

search of the perilous King Solomon's mines. As they embark on their journey, a romance develops between Kerr and the white hunter, Allan Quatermain (Granger). This version is noted for its realistic depiction of animals who inhabit the African terrain; the stampede scene ranks as one of the most eye-bulging sights ever caught on film: accompanied by a ground-shaking roar, thousands of animals—zebras, gazelles, impalas, bushbucks, lions, giraffes —stampede into and around the camera. A second well-known scene in the film is the duel and dance between the Watusis and Buhutus who help Africa steal the show from Hollywood . . . they throw themselves into a long, exotically graceful dance that far outstrips any choreography ever put into one of MGM's musicals. The strengths of this film are that while African life and culture are recreated on the screen, they are developed in such a manner that Africans have not been patronized. And perhaps most of all, the film could not have achieved its level of realism without the acting talents provided by Granger and Kerr.

Less successful than its predecessors was the 1985 version of *King Solomon's Mines* with Richard Chamberlain as Quatermain, Sharon Stone, Herbert Lom, John Rhys-Davies, Ken Gampu, and June Buthelizi. While the romance between Stone and Chamberlain was designed to elevate the film, the film was unable to captivate audiences because of its cardboard characters and "tedious pace." Moreover, the film was compared unfavorably to *Indiana Jones and the Temple of Doom*. "Where Jones was deft and graceful in moving from crisis to crisis, *King Solomon's Mines* is often clumsy with logic, making the action hopelessly cartoonist." This version was also criticized for its script which was regarded as "like a child's maze with numerous deadends and detours on the way to the buried treasure."

That *King Solomon's Mines* has been endlessly reproduced on the screen attests to its lasting appeal and popular acclaim as an African adventure tale that never loses its fascination among moviegoing audiences.

REFERENCES

Benstock, Bernard and Thomas F. Staley, *British Mystery Writers, 1860–1919: Dictionary of Literary Biography*, vol. 70 (Gale Research Co., 1988); McManus, John T., "Tunesmiths and Zulu Chieftains," *New York Times*, June 27, 1937, X. p. 4; Nowlan, Robert A. and Gwendolyn Wright Nowlan, *Cinema Sequels and Remakes, 1903–1987* (McFarland & Co., 1989); Poupard, Dennis, ed., *Twentieth-Century Literary Criticism* (Gale Research Co., 1983).

—C.R.

KISS ME DEADLY (1952)

MICKEY SPILLANE

Kiss Me Deadly (1955), U.S.A., directed by Robert Aldrich, adapted by A.I. Bezzerides; Parkland/UA.

The Novel

Frank Morrison "Mickey" Spillane had already established himself as a comic book and pulp writer (he helped develop the characters of Captain Marvel and Captain America) when he created his most celebrated (and notorious) character, detective Mike Hammer in *I, the Jury* in 1947. Ten more Hammer adventures followed, the cycle ending in 1970 with *Survival . . . Zero!* Called by various commentators "a fascist," "a paranoid," even a "latent homosexual," Hammer is a "hard-boiled dick" who never backs away from violence, with men or with women. There is no doubt that Spillane identified with the character—he posed for the dust wrapper photographs of the Hammer books and starred in the motion picture version of *The Girl Hunters* (1963).

Kiss Me Deadly, seventh in the Hammer series, opens with a beautiful young woman, clad only in a trenchcoat, flagging down Hammer's sportscar on a lonely mountain road in New York State. Breathlessly, she explains her name is Berga Torn, and that she's just escaped from a sanitarium. Mike manages to get her through a police roadblock, but thugs waylay them, knock him out, torture Berga, and roll them and the car off a cliff. Mike survives, but his attempts to investigate the case are stalled when the police revoke his investigator's license. Working on his own, Mike locates Berga's roommate, Lily Carver, and learns a lot of things about Berga—that she was once the mistress of Mafia boss, Carl Evello; that she had known the location of a metal box containing $2 million in heroin smuggled into America before the war; and that she had swallowed a key before her death. Mike recovers the key during her autopsy and, with the help of Lily, locates Locker #529 at the City Athletic Club, which is filled with the missing narcotics. Meanwhile, his secretary, Velda, has been kidnapped by the Mob. In rescuing her, Mike beats one mobster to death and shoots through the eye one Dr. Soberin, who had referred Berga to the sanitarium. But a terrible surprise is in store for Hammer: The girl he had presumed to be Lily Carver is, in reality, Soberin's mistress; she has been using him as a patsy to get the narcotics. Allowing Mike a last cigarette, she gloats and torments him with one last kiss. Mike thumbs his cigarette lighter and ignites her rubbing alcohol-soaked body. He struggles away from the flames, his survival uncertain.

The Film

From the frenetically cut opening sequence with the trench coat–clad girl (Cloris Leachman) and the weirdly unsettling opening credits, which scroll *downward* on the screen, Robert Aldrich's *Kiss Me Deadly* veers crazily on its nightmarish way toward a climactic atomic holocaust. The narrative dislocations and interior tensions reflect, according to Aldrich, the rampant McCarthyism of the day. But historian Carlos Clarens adds that the film is "a case of genre running wild." Most of it is impossible to describe, he

admits, "but its sheer recklessness is liberating. It is all style—exacerbated, bizarre, as visually sophisticated as the early work of Orson Welles, to which it pays tribute more than once. . . ." Moreover, the movie ups Spillane's ante (which ain't easy to do!): The missing box of drugs becomes here "the great whatsit," a Pandora's Box that ultimately is revealed to conceal an atomic bomb. When Lily opens it, a pillar of fire engulfs her, the screen flares to white, and a mushroom cloud rises above Malibu (in the British print, the final image depicts Mike and Velda cowering together in the Malibu surf). It may be rightly said the movie spells an end both to the traditional detective genre and to the film noir, in general (not to mention the planet!).

The novel's first-person narrative is dropped and the story is transferred from New York to Los Angeles. Hammer (Ralph Meeker in his finest screen performance) is, if anything, less human than the character on the page (whose super patriotism, was, if nothing else, directed toward hunting down "un-American" types, especially communists). In the movie he's just a punk, motivated only by a narcissistic opportunism. When his assistance is sought by the police, he can only reply, "What's in it for me?" He assaults everyone, caring little for age, gender, and nationality; and it's significant that his abuse of the faithful Velda (Maxine Cooper), a caring, sensitive woman, parallels the abuse of Lily (Gaby Rogers) by Dr. Soberin (Albert Dekker).

An especially fascinating addition in the screenplay is a web of cultural allusions, including a Caruso vocal recording, a snippet of Tchaikovsky music on a radio, and a quotation of a Christina Rossetti sonnet, "Remember." While such elements all contribute to an ironic counterpoint to Hammers's dulled sensibilities, the Rossetti poem has a crucial role to play in the screenplay. As commentator Rodney Hill argues, the poem's words, uttered by the Berga/Christina character to Mike at the beginning of the picture, are misunderstood by Hammer (like everything else he encounters). Rather than correctly interpreting their message that he should give up the investigation and in so doing, avert global disaster—becoming a redemptive figure, as it were—he foolishly and selfishly presses on. "Instead of reading and understanding Christina's potentially world-saving message," says Hill, "Hammer simply seeks the key to personal gain. In the process, he hurries himself and his world toward an irreversible, fiery ruin."

Fortunately, *Kiss Me Deadly* represented the beginning flourish, not the fiery ruin, of Robert Aldrich's career. It turned the corner from a directorial career that had begun a few years before with the routine westerns *Vera Cruz* and *Apache* (both 1954); and pointed the way toward subsequent, tougher pictures like *The Big Knife* and *Attack!* (both 1956).

REFERENCES

Clarens, Carlos, *Crime Movies* (W.W. Norton & Company, 1980); Rogin, Michael, "*Kiss Me Deadly*: Communism, Motherhood, and Cold War Movies," *Representations* 6 (1984): 1–36; Hill, Rodney, "Remembrance, Communication, and *Kiss Me Deadly*," *Literature/Film Quarterly* 23, no. 2 (1995): 146–49.

—*T.W. and J.C.T.*

KISS OF THE SPIDER WOMAN (*El beso de la mujer araña*) (1976)

MANUEL PUIG

Kiss of the Spider Woman (1985), Brazil/U.S.A., directed by Hector Babenco, adapted by Babenco and Leonard Schrader; Filmes, Ltda./Island Alive.

The Novel

The publication in 1976 of *El beso de la mujer araña* established Manuel Puig's place in contemporary Latin American literature. By the time of its translation into English in 1979 as *Kiss of the Spider Woman*, the novel had already attracted considerable critical favor, and, because it clarified and elaborated many of the thematic interests in Puig's previous three novels, it marks a critical juncture in this Argentinean writer's career, having added scope, depth, and coherence to his artistic interests. Puig has reported in numerous interviews that his novels helped him look at his own problems, the central one being a long-held fantasy that "the reality of life was MGM films" and the "rest was 'B' picture stuff." He had to come to terms with his "fantastic belief in film action, which for [him] was not just film but the whole world of fantasy, of imagination, and, of course, of beauty." His writing helped him analyze the disparate esthetics of reality and beauty, and thus in *Kiss of the Spider Woman* he aimed to show how even in an ideal Marxist reality, physical and sexual beauty could not be shared but would have to be repressed or, worse, sublimated as a result of the desire for power and control. After the success of the novel, Puig adapted it himself for the theater, and since the film's release in 1985, the story has been adapted by John Kander and Fred Ebb into a Tony Award-winning Broadway musical.

Written entirely as dialogue, the extractable story of the novel dramatizes the evolving relationship between Molina (Luis Alberto) and Valentín (Arregui Paz), who share a prison cell in Buenos Aires for six months. Molina, a homosexual, has been imprisoned for "corruption of minors," while Valentín, an intellectual revolutionary, is a political prisoner. Initially cold and distant because of Molina's apparent disregard for both his own oppression as a homosexual and that of the proletariat, Valentín gradually befriends him as he sees Molina's genuine kindness, a kindness Valentín himself initially cannot muster. Molina helps them pass the time by narrating romantic and melodramatic films he has seen, embellishing them to stress his own desire for a world of beauty and sexuality free of political contexts. (The films include *Cat People* [1942], *I Walked with a Zombie* [1943], *The Enchanted Cottage* [1944], and an imaginary Nazi propaganda film.)

Raul Julia and William Hurt in Kiss of the Spider Woman, *directed by Hector Babenco* (1985, BRAZIL-U.S.A.; ISLAND ALIVE/PRINT AND PICTURE COLLECTION, FREE LIBRARY OF PHILADELPHIA)

Valentín, of course, initially detests Molina's sentimentalism, but after a humiliating bout with food poisoning during which Molina cares for him, he confesses that he too has desires inconsistent with his politics (his love for Marta, a bourgeois woman). Halfway through the novel, we learn that the warden has been using Molina—who knows he will never see his mother again unless he gets paroled early—to try to learn the names of Valentín's coconspirators. But Molina never divulges what he learns, seduces Valentín physically, and eventually is granted parole because the authorities think he might try to deliver a message for Valentín to his group. Indeed he does, and we learn from a surveillance report that Molina is killed by Valentín's people when the exchange is foiled by the police. Still in prison, Valentín, tortured and near death, drifts off into a morphine-induced dream of Marta and himself frolicking on a tropical island.

The subtext of the novel consists of a series of long footnotes that bring psychoanalytic theory to bear on Molina's homosexuality and on the evolving relationship between the two men. There are also passages that presumably represent Valentín's Marxist explanations of the films that Molina retells, particularly the Nazi propaganda film. These footnotes and explanations (as well as official police reports) constitute nearly 15 percent of the novel, and essentially provide another lens for interpreting the

dramatic dialogue. The result is a multi-voiced narrative whose focus is not merely the Valentín/Molina relationship, but also the way in which its dynamic can be explained through the filters of theoretical and "official" discourse. Ultimately, the narrative represented through these alternative discourses fails to account for the humanity of the two characters. The depersonalized scientific discourse can speculate about causes and perceivable realities, but it cannot contain or explain the desire for love or beauty.

The Film

Manuel Puig initially resisted efforts to adapt his novel to the screen because of previous disappointments with versions of his earlier works done by Latin American filmmakers. Although funding an international production proved difficult given the novel's controversial content, producer David Weisman persuaded Puig that a quality screenplay (written by Leonard Schrader) in English could attract two fine international actors and give the film based on Puig's "most cherished" creation a good chance of being the first Latin American film made in English to succeed internationally. Initially, Hector Babenco wanted Burt Lancaster (who had expressed great interest in the part) for the role of Molina, but Lancaster's health prob-

lems opened the door for William Hurt, who ultimately won an Oscar for his portrayal of Molina. Babenco's anxieties about preserving Latino integrity led to Raul Julia being cast in the role of Valentín. Released in the summer of 1985, the film met with immediate critical approval.

The film focuses exclusively on the evolving relationship of Molina and Valentín, leaving out the Freudian commentary on Molina's homosexuality and the Marxist analysis of the propaganda film that makes the novel a hybrid form. While dramatizing Valentín's written analyses could have been finagled, doing so would have corrupted the narrative flow of the central plot. Consequently, the film does capture the essence of Molina's character, but falls somewhat short of showing Valentín as a man who learns to recognize that his "theories" and politics cannot account fully for what he feels. That epiphany is central to his character in the novel, but while the film does show his transformation, its genesis and significance is muted by the necessity of preserving the form of the central narrative. Nevertheless, the film pleased the novelist as well as many viewers for its sensitive yet unsentimental treatment of homosexuality.

REFERENCES

Kerr, Lucille, *Suspended Fictions: Reading Novels by Manuel Puig* (University of Illinois Press, 1987); Bacarisse, Pamela, *The Necessary Dream: A Study of the Novels of Manuel Puig* (Barnes & Noble Books, 1988); Cheever, Leonard, "Puig's *Kiss of the Spider Woman:* What the Movie Version Couldn't Show," *Publications of the Arkansas Philological Association* 13, no. 2 (1987): 13–27.

—D.B.

LADY CHATTERLEY'S LOVER (1928)

D.H. LAWRENCE

Lady Chatterley's Lover (L'Amant de Lady Chatterley) (1959), France, directed and adapted by Marc Allegret; Regie du Film/Kingsley International Pictures.

Lady Chatterley's Lover (1981), France/U.K., directed by Just Jaeckin, adapted by Jaeckin, Christopher Pierce, and Marc Behm; Producteurs Associes-Cannon/Prodis.

The Novel

D.H. Lawrence began writing his last novel, *Lady Chatterley's Lover*, in Italy in October 1926. Focusing on the sexual relationship between an aristocratic woman and her husband's gamekeeper, the novel presents a portrait of class conflict and the potential for social and individual renewal through sexual passion. Because of its sexually explicit language and subject matter, no English or American publisher would handle the manuscript. Lawrence chose instead to publish the novel privately in Italy and distribute it by subscription. Word of the content of *Lady Chatterley's Lover* spread, and the authorities in England and America began to confiscate and suppress the novel. Almost immediately after the first copies of the first edition arrived in America, expensive pirated editions began to appear. Though Lawrence had resisted releasing an expurgated edition, he eventually agreed to publish an inexpensive pocket-sized version to combat the flood of unauthorized copies. Expurgated editions were published posthumously in the United States and Great Britain in 1930.

In 1960 *Lady Chatterley's Lover* was published in full by Penguin Books. Penguin was prosecuted in Great Britain under the Obscene Publications Act of 1959 and acquitted after a highly publicized trial in which many writers and critics testified to the book's validity. The novel was the subject of an obscenity trial in the United States as well. In this trial, too, it was determined that the novel was not obscene, thus making legal its publication and sale.

Lady Chatterley's Lover elicited dramatic responses from critics and readers alike. The critical reaction was divided between those who felt that the novel was a work of literature and those who condemned it as pornography unfit for circulation. One review in the London magazine *John Bull* declared that *Lady Chatterley's Lover* was an "abysm of filth" and "the most evil outpouring that has ever besmirched the literature" of England. Though all the reviews were not quite as vitriolic as this, many expressed shock and outrage. There were, however, many reviewers who treated the novel as a serious work. In a 1929 essay, J. Middleton Murray wrote that *Lady Chatterley* was "a book of the utmost value: for all its incompleteness and its still smoldering rage, a positive living and creative book." Despite the flurry of critical attention it received, it is not considered one of Lawrence's major novels. Many critics feel that its tone is too didactic, its plot too unoriginal to be considered in the same league with the likes of Lawrence's masterpieces *Sons and Lovers* and *Women in Love*; but because of the issues of censorship raised by its publication, its effect on the literature of the 20th century is immeasurable.

As many critics have noted, the plot of *Lady Chatterley's Lover* is not terribly complex. Constance Chatterley is married to Sir Clifford, writer, intellectual, and heir to

Wragby Hall, an estate in the Midlands. Having suffered injuries during World War I, Sir Clifford returns to Wragby Hall impotent and paraplegic. He throws himself first into his writing and then into increasing the productivity of his coal mines. Feeling increasingly alienated from her husband, Lady Chatterley has a brief affair with Michaelis, a successful young playwright. She then meets and begins a passionate affair with the gamekeeper Oliver Mellors. The two fall in love and she becomes pregnant by him. After a trip to Venice with her sister, Connie asks Clifford for a divorce, which he refuses to give her upon discovering the identity of her lover. The novel ends with the temporary separation of Connie and Mellors as she seeks a divorce from Clifford and he from his estranged wife Bertha.

The Films

The first film adaptation of Lawrence's controversial novel was produced in France in 1959. This French-language version directed by Marc Allegret was quite tame, but like the novel met with protest and questions of morality. The New York censors refused to license the film, charging that it was obscene because its dominant theme was the "presentation of adultery as a desirable, acceptable and proper pattern of behavior." The New York Court of Appeals upheld the ban. However, on June 29, 1959, the Supreme Court unanimously upset the ban, deeming it unconstitutional.

It is difficult to imagine what the censors found so objectionable in this film adaptation. Most likely, it was merely a knee-jerk reaction based on the controversy that surrounded the novel. The film is far from a celebration of adultery. Lady Chatterley is painstakingly presented as unbearably love-starved in her marriage to Clifford and is also shown to feel great conflict over her infidelity. Though the film remains true to Lawrence's basic plot, unlike the novel, the film shies away from any graphic depictions of sexual activity. The film prefers to cut away when any physical intimacy is about to occur, focusing instead on the burning embers in the fireplace as a stand in—a morally inoffensive, though heavy-handed bit of symbolic imagery. In answer to the question of how Lawrence's candid love scenes are handled, one critic wrote that "sex in this film is no more lusty than in a lecture about the birds and the bees."

The greatest departure from the novel in terms of the plot is the contrivance of a happy ending. Where the novel ends on a note of uncertainty with Mellors and Connie leaving Wragby Hall for separate destinations, the film has the two lovers running off together. The other differences are more a matter of tone than of content. For example, the Constance Chatterley of the film is a far more inhibited and tense woman than Lawrence's Lady Chatterley. Also, the French countryside is an inadequate substitute for the atmosphere of Englishness that is an integral part of the novel.

The Supreme Court case created expectations that the film would be rather racy. As soon as audiences realized that there wasn't anything to censor in the first place, the film began to bomb at the box office. The critical reception was equally unenthusiastic. While defending the film's morality and the importance of freedom of expression, most critics found the film to be "sterile and bland."

In 1981 Just Jaeckin, director of the soft-porn classic *Emmanuelle*, directed a remake of *Lady Chatterley's Lover*. This adaptation, like Allegret's, misses the mark, but the sex scenes are much more explicit. The acting is marginal and the dialogue is flat and lifeless, though the scenery is nice to look at and does a much better job capturing the atmosphere of the English estate than the previous version. Like its predecessor, this version also ends with Mellors and Connie together, departing from Lawrence's plot. Another deviation from the novel is that neither Michaelis, Connie's first lover, nor Bertha, Mellor's first wife, appear as characters in this film. This is a film of little consequence. When not ignored by critics, the film was deemed "vapid" and "banal."

REFERENCES

DiMauro, Lauri, ed., *Twentieth Century Literary Criticism*, vol. 48 (Gale Research, 1993); Draper, R.P., ed., *D.H. Lawrence: The Critical Heritage* (Barnes & Noble, 1970); Nash, Jay Robert and Stanley Ralph Ross, eds., *The Motion Picture Guide 1927–1983* (Cinebooks, 1987); *The New York Times Film Reviews 1959–1968* (The New York Times and Arno Press, 1970).

—L.M.

L'AMANT (1984)

See THE LOVER.

THE LAST HURRAH (1956)

EDWIN O'CONNOR

The Last Hurrah (1958), U.S.A., directed by John Ford, adapted by Frank Nugent; Columbia.

The Novel

Occupying an established place among the most enduring of American political novels, Edwin O'Connor's *The Last Hurrah* centers on the character of Mayor Frank Skeffington and the passing of an important institution, the so-called big-city boss. Based loosely on former Massachusetts governor and mayor of Boston James M. Curley, Skeffington possess charisma and a sense of expediency, which make him a compelling and perennial force in the city's politics. He has used a skillful oratory, expert one-on-one campaigning, and graft to battle the aristocratic political establishment and to promote his genuine concern for the city, particularly its laboring class and their

need for improved housing, health care, and recreational facilities. The novel chronicles the veteran Skeffington's final run for office and his surprising loss to a young political outsider who is less a personality than the outcome of a campaign strategy built around family values, a war record, and the slogan "Time for a Change." The story's anonymous narrator captures Skeffington's roguishness and highlights his illicit tactics but relies importantly on the perspective of the mayor's sympathetic nephew who sees his uncle as a complex and compassionate man of the people. Ultimately, *The Last Hurrah* does not discourage the impression that in the hands of some politicians the ends do justify the means.

In the four decades since its publication, readers of the novel have been even more likely to see the story as a nostalgic portrayal of an era when the political scene was more notably populated by dynamic men with strong but charming personalities. While there has been general praise for the vitality of Skeffington's portrayal, some critics have seen moral ambivalence toward "bossism" as a weakness in the novel's narration.

The Film

When the film of *The Last Hurrah* appeared in 1958, James M. Curley brought and then abandoned a suit to prevent its showing. Perhaps the former mayor of Boston was advised that whereas the O'Connor novel might have encouraged the public to recall some of the less savory details of his own political career, director John Ford's more sentimentalized version of the story would more likely evoke sympathy and nostalgia for the Curley brand of politics.

Furthermore, Curley must have been charmed by Spencer Tracy's lively and touching portrayal of Frank Skeffington. If the novel's narration allows the reader some room to sense the darker side of Skeffington's politics, Tracy's performance dramatically underscores Skeffington's fundamental kindness and goodwill and thus further reinforces a conviction that the wily mayor richly deserves his circle of loving, admiring associates and political supporters. As the sympathetic nephew, Jeffrey Hunter's image of solid good sense and wholesomeness further enhances Tracy's positive interpretation of Skeffington's character.

Some critics have observed that John Ford, in the twilight of his distinguished career, saw his own style and character in Skeffington and therefore in his adaptation laments the passing of both a political and a filmmaking institution. In any case, long known for an ability to infuse his films with the dimension of legend, Ford doubtlessly recognized a kindred spirit at work in O'Connor's tendency to magnify the figure of Skeffington.

REFERENCES

Blotner, Joseph, *The Modern American Political Novel* (University of Texas Press, 1966); Mellen, Joan, "Ford, John" in *The Political Companion to American Film*, Gary Crowdus, ed. (Lakeview Press, 1994).

—C.T.P.

THE LAST OF THE MOHICANS (1826)

JAMES FENIMORE COOPER

Leather Stocking (1909), U.S.A., directed and adapted by D.W. Griffith; Biograph.

The Last of the Mohicans (1911), U.S.A., directed and adapted by Theodore Marston; Thanhouser.

Last of the Mohicans (1911), U.S.A., directed and adapted by Pat Powers; Powers.

The Last of the Mohicans (1920), U.S.A., directed by Maurice Tourneur and Clarence Brown, adapted by Robert Dillon; Associated Producers.

Last of the Mohicans (1932), U.S.A., directed and adapted by B. Reeves Eason and Ford Beebe; Mascot (12-chapter serial).

Last of the Mohicans (1936), U.S.A., directed by George B. Seitz, adapted by Philip Dunne; Small/United Artists.

Last of the Redmen (1946), U.S.A., directed by George Sherman, adapted by Herbert Dalmas and George Plympton; Columbia.

The Last of the Mohicans (1992), U.S.A., directed by Michael Mann, adapted by Mann and Christopher Crowe; Twentieth Century-Fox.

The Novel

James Fenimore Cooper was the most significant American novelist before Nathaniel Hawthorne, achieving a wide international audience with his wilderness and sea stories. He was already the country's preeminent author when he published *The Last of the Mohicans* in 1826, his sixth novel and the second of his Leatherstocking Tales, an epic series of five books about the northeast woodland frontier that contained many of the conventions that would later constitute the Western genre in print and on film. Cooper's most famous creation is Natty Bumppo, the prototypical natural man, who is variously referred to as Hawkeye, Deerslayer, Pathfinder, and Leatherstocking (and after whom, of course, the tales are named).

The Last of the Mohicans has received a mixed critical response over the years. Mark Twain was one of its severest critics, citing stilted writing and pacing and, along with others, a fanciful rendering of history. In the 1920s, D. H. Lawrence underscored Cooper's affinity to the myths and symbols of the American consciousness, thus setting the agenda for most of the subsequent commentaries. Whatever the critical reactions, however, *The Last of the Mohicans* was instantaneously popular and influential on a worldwide basis, and has remained that way for nearly 175 years.

The Last of the Mohicans was published by Carey and Lea of Philadelphia in two volumes, a common production

method of the day, and the principal reason why the 33-chapter plot structure divides neatly into halves. In chapters 1 through 17, four British characters, Major Duncan Heyward, Cora and Alice Munro, and psalmodist David Gamut, are led astray in the forest by a Huron runner, Magua, who is supposedly guiding the sisters to their father, Colonel Munro, commander of Fort William Henry. The party stumbles upon Hawkeye, a white woodsman, and the Mohican father and son, Chingachgook and Uncas. When Magua spots the trio, he quickly retreats into the wilderness.

The protagonists are forced to spend the night in a cave at Glenn's Falls and are attacked the next morning by a group of warriors led by Magua. Out of ammunition, Hawkeye, Chingachgook, and Uncas escape downriver for help as the Hurons capture the others and take them on a long journey. Magua soon proposes to Cora and is rejected; and the three woodsmen eventually find the captives, killing all of the Indians except for Magua who flees again.

Hawkeye and his Mohican companions then escort Cora, Alice, Heyward, and Gamut to Colonel Munro who, without reinforcements, is forced to surrender the fort to the French general Montcalm who assures the English of safe passage. The first half concludes, however, with the bloody massacre of the withdrawing British troops by the Hurons and the recapture of Cora, Alice, and David Gamut by the ever treacherous antagonist, Magua.

Chapters 18 through 32 chart the elaborate pursuit of the captives by the three woodsmen, Heyward, and Munro, resulting in a variety of plot twists, including unfolding romances between Uncas and Cora as well as Heyward and Alice; the seizure and escape of Uncas; the revelation that Uncas is a chief to the patriarch Tamenund; and the final confrontation where a Huron rashly kills Cora with a knife, Magua fatally stabs Uncas, and Hawkeye shoots Magua with his "longue carabine." Chapter 33 concludes with the burial of Cora, the funeral of Uncas, the consoling of Chingachgook by Hawkeye, and an elegy by the sage Tamenund who laments the demise of the wise Mohican race and the worsening plight of Indians in general at the hands of the oncoming "pale-faces."

The Films

Hollywood has used *The Last of the Mohicans* for inspiration countless times. Besides the eight primary adaptations listed above, many other motion pictures and television programs have utilized plot elements from the novel or included Hawkeye as a character. Some of the more notable examples in this latter category are Republic's *In the Days of the Six Nations* (1911), a one-reeler involving the capture and rescue of two women by a trapper, and George B. Seitz's *The Leatherstocking* (1924), his first handling of the material and a compilation of *The Last of the Mohicans* and *The Deerslayer*.

In reviewing the main film adaptations, D.W. Griffith's *Leather Stocking* (1909) skillfully enacts a few episodes from the novel, such as the abduction of Cora (Linda Arvidson) by Magua (Mack Sennett); the pursuit by Leather Stocking (James Kirkwood), Uncas (Owen Moore), and Chingachgook; the killing of Uncas by Magua; and the deliverance of Cora by Leather Stocking and the Redcoats. The most noteworthy change is the undercutting of Chingachgook as a protagonist as he is captured and tortured by the Hurons, rendering him unimportant in the final rescue, and then having Hawkeye leave him alone at the end for the company of the other whites. The other two one-reelers by Marston (1911) and Powers (1911) follow Griffith's precedent of devoting 15 to 20 minutes to a few action sequences from the book and a portrayal of Native Americans that stresses either savagery or nobility, usually the former.

The first feature-length silent version in 1920 is visually stunning and also the most faithful of all the adaptations. Directors Maurice Tourneur and Clarence Brown focus on the love triangle between Uncas (Albert Rosco), Cora (Barbara Bedford), and Magua (Wallace Beery), as all the Anglos, including a much older Hawkeye (Harry Lorraine), are generally provided only minor consideration. The addition of a villainous British character, Captain Randolph, is one deviation from the original, however, and his treachery ultimately leads to a prolonged massacre sequence where the full gamut of violent, licentious, and drunken features now ascribed to the Hollywood Indian are presented in ample detail.

The most important point about Eason and Beebe's 1932 12-part serial is that it marks the first time that Hollywood fixes the dominant emphasis of the story onto Hawkeye (Harry Carey Sr.) in such 13-minute mini-narratives as "A Redskin's Honor" and "Paleface Magic." George Seitz's 1936 adaptation continues this pattern by replacing the Uncas–Cora–Magua love triangle with a new one involving Hawkeye, Alice, and Heyward. The introduction of a love affair between Hawkeye (Randolph Scott) and Alice (Binnie Barnes) suggests a radically different interpretation of the book where the singular beau ideal of the Leatherstocking Tales is transformed into the family man of a newly forming and soon to be independent nation.

Last of the Redmen is undoubtedly the most preposterous of all the adaptations. This 1946 Cinecolor version is campy and insipid, complete with Buster Crabbe as Magua; Michael O'Shea (Hawkeye) as a self-proclaimed "backwoods Irishman" with a lilting brogue and witty asides; and a new character, Davy (a strange mutation on David Gamut), who is the precocious 11-year-old brother of Cora and Alice Munro (and obviously designed as a surrogate for all the young adolescent boys in the audience). As the title implies, this B-movie Western is riddled with offensive stereotypes (e.g., tom-tom music whenever Indian characters appear); worn-out conventions (e.g., the British circle their wagons before an Indian attack); and plenty of inane inventions (e.g., Hawkeye scares the Indians horses with firecrackers; the cave where the

protagonists hide contains a picnic table with an Indian blanket as a tablecloth).

The most striking feature about Michael Mann's 1992 rendering of *The Last of the Mohicans* is that the foremost concern of the plot is now an alluring love affair between Hawkeye (Daniel Day-Lewis) and Cora (Madeline Stowe). Unlike in the book, however, Cora is no longer of mixed race, and the interracial relationship between Uncas and Alice is left undeveloped, thus keeping the threat of miscegenation well under control. Chingachgook (Russell Means) and Uncas (Eric Schweig) are both presented sympathetically and played for the first time by Native American actors, although they again are accorded only secondary emphasis throughout this particular adaptation. Finally, *The Last of the Mohicans* has always been recognized as one of the bloodiest novels in American literature, and the 1992 version merely extends these same violent tendencies to a level conducive to Hollywood's latest action-adventure standards.

North America is portrayed in both the novel and the subsequent film adaptations as a battleground of races and nationalities. As Cooper delineates in his introduction, the British and the French are "contend[ing] for the possession of the American continent." Each side has enlisted various Native American tribes as mercenaries in their struggle for empire. In the process, whites do clash with whites and Indians with Indians. The most heartfelt and vicious confrontation, however, is between Native Americans and Europeans, thus underscoring the story's most fundamental dramatic conflict—the confrontation between racial antagonists.

The French and Indian War of *The Last of the Mohicans* is, first and foremost, a race war; and the viability and appropriateness of a multiracial future for America inevitably emerges as the key concern of each and every version. Differences, of course, exist in the use and sequencing of events; in changes in the relative importance of various characters and their respective motivations; and, most importantly, in the ever-shifting ideological stresses and the resulting conclusions that invariably follow.

For example, the portrayals of the colonials have become progressively more negative and those of Native Americans more positive, with each successive update of the story. Despite occasional critiques, such as the appearance of the dastardly Captain Randolph in the 1920 film, British characters were generally reasonable, brave, and competent in the adaptations prior to World War II, even coming to the final rescue of the captives in the 1909 and 1936 versions. In the 1946 adaptation, however, a change begins as England is described as "so dull and civilized"; by the 1992 version, the English are blindly arrogant, totally out-of-step, and both brazenly imperialistic and ethnocentric (e.g., Heyward: "I thought British policy was to make the world English"). Whereas the latest Hawkeye does possess the chivalric qualities of honor and fair play, he symbolically ends this Old World legacy by shooting and killing Heyward who is tied to a Huron stake, ostensibly putting him out of his misery.

Not coincidentally, Chingachgook and Uncas, in particular, are presented far more sympathetically in comparison to British characters and culture in the 1992 film, although this revisionism of the Hollywood Indian goes only so far. The focus is more on the essential American virtues of Hawkeye, such as his courage, strength, honesty, and directness. The Mohicans share these features too, but through their inevitable passing, Hawkeye is left to personify these attributes all by himself.

Overall, the confrontation of racial adversaries is still resolved through violence instead of romantic coupling (i.e., Uncas and Cora; or Uncas and Alice; or Hawkeye and a mixed-race Cora), which keeps the centuries-old doctrine of racial purity intact. The next version of *The Last of the Mohicans* will undoubtedly rewrite the racial politics of the story in a way consistent with future needs and sensibilities. Whatever the results, the enduring value of the novel and its many film adaptations continues to be an evolving representation of America's complex multicultural landscape and heritage.

REFERENCES

Cawelti, J., *The Six-Gun Mystique*, 2d ed. (Bowling Green State University Popular Press, 1984); Edgerton, G., "'A Breed Apart': Hollywood, Racial Stereotyping, and the Promise of Revisionism in *The Last of the Mohicans*," *Journal of American Culture* 17, no. 2 (1994): 1–20; Fiedler, L., *Love and Death in the American Novel* (Criterion, 1960); Kelly, W., *Plotting America's Past: Fenimore Cooper and the Leatherstocking Tales* (Southern Illinois University Press, 1983); Marsden, M., and J. Nachbar, "The Indian in the Movies," in *Handbook of North American Indians* (Smithsonian Institution, 1988), 607–17; Slotkin, R., *Regeneration through Violence: The Mythology of the American Frontier, 1600–1860* (Wesleyan University Press, 1973); Walker, J., "Deconstructing an American Myth: Hollywood and *The Last of the Mohicans*," *Film & History* 23, no. 1–4 (1993): 103–15.

—G.R.E.

THE LAST TYCOON (1941)

F. SCOTT FITZGERALD

The Last Tycoon (1976), U.S.A., directed by Elia Kazan, adapted by Harold Pinter; Paramount.

The Novel

Left unfinished when Fitzgerald died of a heart attack, *The Last Tycoon*'s six completed chapters were published together with the author's outline, drafts of later scenes, and a synopsis of the outcome, put together from Fitzgerald's notes and conversations. Even in its imperfect state, Edmund Wilson wrote, this was "Fitzgerald's most mature piece of work." Moreover, Wilson added (writing in the foreword to the 1941 edition), it "is far and away the best novel we have had about Hollywood, and it is the only one which takes us inside."

The tycoon of the title is Monroe Stahr, "a marker in industry like Edison and Lumière and Griffith and Chaplin. He led pictures way up past the range and power of the theatre, reaching a sort of golden age, before the censorship." (Literary gossip has always had it that Stahr is based on Irving Thalberg, MGM's "boy genius" production chief from 1924, when he was 24, to his early death at 37 in 1936.) His story is narrated by Cecelia Brady, daughter of a chief executive at Stahr's studio. Cecelia takes an interest in Stahr because she is in love with him, though she realizes the futility of pursuing a relationship. Stahr is still infatuated with his dead wife; and he is in delicate health. When an earthquake strikes and Stahr views the damage on the studio lot, a miracle arises out of the improbable mix of reality and illusion that only Hollywood can provide: "On top of a huge head of the Goddess Siva, two women were floating down the current of an impromptu river. The idol had come unloosed from a set of Burma, and it meandered earnestly on its way, stopping sometimes to waddle and bump in the shallows with the other debris of the tide. The two refugees had found sanctuary along a

scroll of curls on its bald forehead and seemed at first glance to be sightseers on an interesting bus-ride through the scene of the flood . . . Smiling faintly at him from not four feet away was the face of his dead wife, identical even to the expression." The rest of the completed portion of the novel consists of Cecelia's observations of Stahr's pursuit of this woman, Kathleen. According to Fitzgerald's plan, Stahr, "the last of the princes" (*tycoon* means "prince"), was to be involved in a studio power struggle between the money men (represented by Cecelia's father) and the artists ("I'm the unity," Stahr says when asked how all the disparate talents come together in a movie). Cecelia's narrative voice is knowing and astute, as she observes as well the Hollywood that suffuses the sensibilities of all the characters. "A mining town in lotus land," one of them says; and as she wishes she looked more interesting at premieres, "when the fans look at you with scornful reproach because you're not a star."

The Film

In his screenplay, Pinter discarded the novel's opening episode—Cecelia flying home from Bennington and discovering Monroe Stahr on the plane—as well as Cecelia's voice, thus eliminating her sharp perceptions and reducing her to the role of unrequited love victim. The movie begins, instead, with studio tourists gushing over a portrait of dead star Minna Davis (Stahr's wife) and asking about earthquakes. Soon the film produces both an earthquake and a reincarnation of Davis. Thereafter the focus is exclusively on Stahr in his pursuit of the elusive and mysterious Kathleen. Still, Pinter manages to keep almost all of Fitzgerald's details, though now seen as Stahr's perceptions rather than Cecelia's observations. This is not the mindless fidelity for which he and Kazan were chastised as well as praised: "reverent noodling," Pauline Kael called Pinter's year and a half of work on the script, and "reverence piled upon reverence" Kazan's claim that he did not change any of Pinter's words; Richard Corliss admired this very reverence—"a 124-minute movie made from a 126-page book." In fact, the film demonstrates its filmic nature (as Fitzgerald's first-person narration is of necessity self-conscious and -reflexive) from its opening episode, a lesson in the nature and power of film, and a visualization of Cecelia's observation in the novel of "the dream made flesh." Kazan expands the episode in which Stahr demonstrates to the writer Boxley how to write for the movies—"just making pictures," Stahr shrugs to the mystified writer—into a motif that is repeated twice and then concludes the film as a voiceover while Stahr disappears into the darkness of a soundstage. This, together with inserted clips from films Stahr is overseeing, "affords us glimpses of [the film's] own nature as a work of cinematic art, its dialectical impulse for creation and entropy."

The positive reviews were very strong. Corliss found the movie "doggedly, even daringly, faithful," a film that "shows the work (and a meticulous reworking) of American

F. Scott Fitzgerald

literature's great romantic intelligence." The negative reviews were more numerous. Judith Crist said that Kazan had reduced the book to an insipid love story, and Stanley Kauffmann felt that Stahr's descent isn't made believable. Pauline Kael's criticism of the film's fidelity and of the inappropriateness of Pinter as adapter was no less severe than her disapproval of Kazan's whole project: "The movie world that Kazan shows us has no hustle. The characters are so enervated that *The Last Tycoon* is a vampire movie after the vampires have left." It may well be that the film will get its eventual reputation from more scholarly studies.

REFERENCES

Atkins, Irene Kahn, "Hollywood Revisited: A Sad Homecoming," *Literature/Film Quarterly* 5 (1977): 105–11; Callahan, John F., "The Unfinished Business of *The Last Tycoon*," *Literature/Film Quarterly* 6 (1978): 204–13; Corliss, Richard, "Tycoons and Tirades," *New Times*, November 26, 1976, 77–80; Kael, Pauline, "The Current Cinema," *The New Yorker*, November 29, 1976, 157–63; Marsh, Joss Lutz, "Fitzgerald, *Gatsby* and *The Last Tycoon:* The 'American Dream' and the Hollywood Dream Factory," *Literature/Film Quarterly* 20 (1992): 3–13, 102–08; Michaels, I. Lloyd, "Auteurism, Creativity, and Entropy in *The Last Tycoon*," *Literature/Film Quarterly* 10 (1982): 110–19.

—U.W.

LAUGHTER IN THE DARK (1938)

VLADIMIR NABOKOV

Laughter in the Dark (1969), U.K., directed by Tony Richardson, adapted by Edward Bond; Woodfall/United Artists.

The Novel

Although Nabokov considered his sixth novel (first translated as *Camera Obscura*, from the 1932 Russian title) one of his worst, its accessibility and tight cinematic plot made it one of his most popular pre-*Lolita* novels. Offered a Hollywood contract for the film rights, Nabokov retranslated it as *Laughter in the Dark*. The contrast between the titles suggests Nabokov's ambivalent response to the medium of film: Movies represented high drollery where one might "laugh in the dark" at Hollywood kitsch; however, the "camera" was also the locus of darkness. The novel shifts tone rapidly from Chaplinesque farce to bitter parody of Hollywood's romantic imagery of love. While not one of Nabokov's masterpieces, it remains one of his more accessible and entertaining works.

A rich and befuddled art-film critic, Albert Albinus, falls helplessly in love with Margot, a movie theater usher whose mind is filled with dreams of wealth and fame as a movie actress. A precursor of Lolita, Margot and her surface allure are creations of Hollywood culture, but Albinus is (metaphorically) blind to her faults; he leaves his wife and daughter, moves in with his mistress, and finances a movie project in which she acts horribly. Nabokov parodies the "love is blind" cliché when an auto accident leaves Albinus literally blind, living a nightmarish existence in the dark as Margot carries on with Albinus's nemesis, Axel Rex, a cruel caricature who takes great pleasure in wandering nude through Albinus's house, making love to Margot a room away from the foolish cuckold. The novel ends in bitter farce as Albinus, inadvertently discovering Margot and Rex's treachery, struggles in the darkness to shoot his mistress, but misses and shoots himself instead.

The Film

Although Nabokov's work has always interested Hollywood producers, his works have never done well on film. Kubrick's *Lolita*, Skolimowski's *King, Queen, Knave*, and Fassbinder's *Despair*—although occasionally provocative—never live up to the reputations of either Nabokov or the auteur directors. Nabokov sold two film options to his novel in the 1930s, but it wasn't until 30 years later that it came to the big screen, where it received universally negative reviews (it's not available in video). Despite his continued work with major literary texts, Richardson did not know how to deal with Nabokov's subtly mixed tones.

Alfred Appel has quoted Nabokov as saying that he wrote the "entire book as if it were a film." Brian Boyd notes that Nabokov "saw it as a motion picture" and rewrote the novel "to appeal more to . . . Hollywood." Despite the unmistakable "cinematic" quality of the prose—scenes rapidly developing in "jump-cut" fashion, simulated "tracking" and "aerial" perspectives, repeated references to film jargon, frequent references to verbal versus visual representation, and the importance of film and filmmaking in the plot—Tony Richardson's attempt to bring it to the screen was fraught with problems. Factors that had nothing whatsoever to do with the novel complicated the process: Weeks into the production frictions arose between Richardson and Richard Burton—originally intended to portray Albert Albinus—with whom he had worked in Woodfall's first film, *Look Back in Anger*. According to Richardson in his autobiography, Burton's ego and erratic behavior forced Richardson to replace him with Nicol Williamson. Moreover, Richardson's studio, Woodfall Films, was financially strapped and was forced to turn to United Artists for assistance—a move, according to Richardson, which incurred yet another ongoing set of money problems.

Moreover, contemporary accounts suggest that the bitterly humorous tone of Nabokov's story was lost in Edward Bond's script. Ponderous where Nabokov is light-footed, somber where he is droll, and heavyhanded where he is subtle, the film lumbers uncomfortably along, tentative and unsure of itself. Unfortunately, at this writing the film in unavailable in either film or video formats.

REFERENCES

Appel, Alfred Jr., *Nabokov's Dark Cinema* (Oxford University Press, 1974); Boyd, Brian, *Vladimir Nabokov: The Russian Years* (Princeton University Press, 1990); Radovich, Don, *Tony Richardson: A Bio-Bibliography* (Greenwood Press, 1995); Richardson, Tony, *The Long-Distance Runner: A Memoir* (William Morrow & Company, 1993).

—D.G.B.

LAURA (1942)

VERA CASPARY

Laura (1944), U.S.A., directed by Otto Preminger, adapted by Jay Dratler, Samuel Hoffenstein, Ring Lardner Jr., Jerome Cady, and Betty Reinhardt; Twentieth Century-Fox.

The Novel

Written in 1942, *Laura* was the first mystery novel by the 43-year-old Vera Caspary. The prolific writer had already written novels (including *The White Girl*, 1929, an examination of racist society), several plays (including *Blind Mice*, 1931), and the original story for the Mitchell Leisen/Preston Sturges screwball classic, *Easy Living* (1937).

Laura, her most celebrated work, contains three separate narratives by the story's main characters: the enigmatic Laura; Laura's Machiavellian mentor, the snobbish columnist Waldo Lydecker; and a detective, Mark McPherson. The narrative begins with the discovery of a bloodied, disfigured corpse who is identified as Laura Hunt. During his investigation of the case, McPherson learns that Laura was a young advertising woman who had ingratiated herself into the lives of two men: the snooty, ill-tempered Waldo Lydecker, who had taken her in as his protégée, promoted her career, and taken credit for her successes; and rich playboy Shelby Carpenter, who had incurred Lydecker's jealousy when he became Laura's fiancé. McPherson, too, as a result of his investigation, becomes fascinated, even obsessed, with the dead woman.

Gene Tierney and Dana Andrews (left) in Laura, *directed by Otto Preminger* (1944, U.S.A.; TCF/MUSEUM OF MODERN ART FILM STILLS ARCHIVE)

Much to everyone's astonishment, Laura shows up very much alive after her funeral. She claims she had been away on a vacation and was unaware of the crime. The dead woman is now correctly identified as Diane Redfern, a woman with whom Shelby Carpenter had been conducting a secret affair. According to Carpenter, he had taken Diane to Laura's apartment while she was away. He had hidden himself when Diane answered the doorbell and was shot by an unknown assailant. Shelby was afraid to go to the police lest he be considered a suspect in her murder. Convinced of Shelby's innocence, Mark hypothesizes that the jealous Waldo is the real killer. As a ploy to lure Waldo into the open, he arrests Laura. The narrative now shifts to Waldo's recounting of the events leading up to his final confrontation with Laura and his death at the hands of McPherson.

The Film

Originally intended as a B-class motion picture, producer Darryl E. Zanuck liked the script well enough to promote it to A-class status. Otto Preminger was brought in to replace the original director, Rouben Mamoulian, and the resulting picture emerged as an innovation in the genre of the noir detective thriller. The story begins with McPherson's (Dana Andrews) interrogation of Waldo Lydecker (Clifton Webb) concerning Laura's presumed murder. After a series of flashbacks narrated by Lydecker, establishing events leading up to the crime, Laura (Gene Tierney) appears and the story shifts back to a present-tense omniscient viewpoint. In the denouement, Laura listens to Lydecker's prerecorded radio broadcast, not realizing he has sneaked into her apartment. Vowing to murder her so no one else can have her, he is foiled by McPherson's last-minute intervention.

Among the film's virtues are the techniques by which Laura's enigmatic character is established. By eliminating her narrative voice at the outset, she is appropriately distanced from the viewer. Moreover, she remains unseen for a significant portion of the film, her presence cleverly suggested through the recurring strains of composer David Raksin's haunting title melody (heard both as source music and as a leitmotif of the background score) and by the magnificent portrait that seems to hover over the action. Not only are the obsessions of McPherson and Lydecker—flip sides of the same coin, as it were—established, but the viewer's voyeuristic fascination is also enlisted. She is more dream than reality. Thus, declares commentator Spencer Selby, "Laura's most alluring quality is her unattainability, and perhaps the viewer has a lot more in common [with Lydecker and McPherson] than he would like to admit."

Joseph La Shelle's Oscar-winning cinematography superbly complements these themes. The gliding, probing camera is an inquisitive presence in itself, prowling the decadent world of upper-class society, following McPherson as he pokes around Laura's apartment, peering into her closets, examining her possessions, scanning her letters and diary.

Critics were quick to praise the film. *Daily Variety*, for example, noted: "Rarely does a serious crime drama get such sound and brilliant professional treatment . . . The performances are top-notch, credible, fascinating . . . [and] the air of threatening reality which Preminger [imparts is] supported further by contributions from every technical department."

REFERENCES

McNamara, Eugene, *"Laura" As Novel, Film, Myth* (Edwin Mellen Press, 1992); Pratley, Gerald, *The Cinema of Otto Preminger* (A.S. Barnes, 1971); Selby, Spencer, *Dark City: The Film Noir* (McFarland, 1984); Silver, Alain and Elizabeth Ward, eds., *Film Noir: An Encyclopedic Reference to the American Style* (Overlook Press, 1979).

—S.C.M. and J.C.T.

THE LEARNING TREE (1963)

GORDON PARKS

The Learning Tree (1969), U.S.A., directed and adapted by Gordon Parks; Seven Arts of Winger Enterprises, Warner Brothers.

The Novel

The Learning Tree is a semiautobiographical novel by Gordon Parks about his boyhood in racially divided Ft. Scott, Kansas, in the 1920s. Newt Winger, the protagonist, is reared in Cherokee Flats, a town compared to a fruit tree as "some of the people are good and some of them are bad—just like fruit on a tree . . . let it be your learnin' tree." Enduring the pains and pleasures of adolescence, Winger confronts the harsh reality of racism, bigotry, poverty, violence, and murder—experiences often tempered with love and humility. Newt is inducted into manhood as he witnesses the senseless murder of a black crapshooter by the white town sheriff, Kirky. Newt's nightmares about death become an all too familiar occurrence as he endures the deaths of Big Mabel, who is killed in a car accident; Jake Kiner, who is murdered in Newt's presence; Booker Savage, who is forced to commit suicide; Marcus Savage, who is shot while fleeing Kirky; and Newt's ailing and aged mother, Sarah Winger.

The death of Newt's mother signals a turning point in his life as it forces him to overcome his fear regarding death and then forces him to accept the responsibilities associated with adulthood, as he vows to carry out his mother's desire to excel in life. Amidst these tragedies, Newt experiences the triumphs of first love—a relationship that ends abruptly when his girlfriend is impregnated by the son of the town's white judge—and triumphs in academic achievement, when Newt delivers the class graduation speech.

Gordon Parks

The Film

Two independent producers optioned to produce the picture but lacked adequate financing. Subsequently, Parks received an offer of $75,000 from London sources suggesting that the characters in the novel should be transformed as whites, an offer that Parks declined. Finally, negotiating a deal with Warner-Seven Arts, Parks was able to produce, direct, write the screenplay, and develop the musical score, becoming the first African-American to direct a picture produced by a major studio. Parks hired Burnett Guffey, the cinematographer for *Bonnie and Clyde* (1967), stipulating that he "wanted each camera move to begin and end with a beautiful still picture." Most of the film was shot on location in southeast Kansas. Following the completion of the film, which was alternately titled *Learn, Baby, Learn*, it received accolades for its photography, which was regarded as "sumptuous" and "excellent" and which served to compensate for the film's lack of narrative development. In fact, the film is remembered as much for its cinematography as for its plot, in view of the panoramic shots of sunsets and bird-filled skies that proliferate in the film. Impressed with the film's photography, one reviewer described the film as "incredibly beautiful as it captures this 1920 Kansas town and countryside."

In the novel's transformation to the screen what is most striking is that the film managed to effectively recreate the racial climate characteristic of the time period, while vividly conveying that despite racial differences, all humans endured similar forms of pain and suffering. The film was "not [about] black boyhood or white boyhood so much as human boyhood . . ." Both the novel and film were equally effective in conveying this sentiment, despite the fact that many scenes were omitted in the novel's transfer to the screen. For example, Mabel and Tuck's accidental death, Newt's visit to the funeral parlor following their death, the harassment that Newt's cousin Polly received because of her light complexion. Newt's graduation speech, and the protest staged by his parents who challenged white school administrators are among those scenes that were in the novel but were omitted from the film. The absence of these scenes, however, does not minimize the film's effectiveness.

Applauded for creating a black character who was not scarred and embittered by racism, *The Learning Tree* was also criticized for propagating "Uncle Tomism" during a period of heightened racial consciousness among African Americans. Charges were leveled that the film suffered from too many clichés, forcing one critic to defend Parks by stating that he "presented them with such feeling as to render them new . . . In the end he restored the clichés' original meanings, and his film remains a lyrical and eloquent statement on the black experience in America."

Parks's directing skill came under attack by critics who referred to the film as "an uneven piece of film craftsmanship . . . Parks's direction is sloppy or distracted." *The Learning Tree* is nonetheless considered a significant film in black film history; it represents one of the first attempts by the major film studios to render black life on the screen in a realistic manner and remains a film that will have lasting appeal as a re-creation of the African-American experience.

REFERENCES

Bogle, Donald, *Toms, Coons, Mulattoes, Mammies, & Bucks* (Continuum, 1989); Parks, Gordon, *Voices in the Mirror: An Autobiography* (Doubleday, 1990); Tibbetts, John, "Choice of Weapons," *The World and I* (September 1993), 184–93.

—C.R.

THE LEFT-HANDED WOMAN (*Die linkshändige Frau*) (1976)

PETER HANDKE

Die linkshändige Frau (1978), Germany, directed and adapted by Peter Handke; Road Movies/Wim Wenders.

The Novel

John Updike once wrote that Handke has been "widely regarded as the best young writer, and by many as the best writer altogether, in his language," but Handke has also directed films. Handke's first treatment of the story was a screenplay. When no funding was forthcoming for the film, Handke rewrote the story as a novel. After the novel's publication and translation, funding was found for the film, but the original screen treatment had by then been lost, so Handke had to write a new screenplay.

Marianne is 30 years old and married to Bruno, the sales manager of a porcelain company, who has just returned from an extended business trip to Finland, where he was very lonely. He is glad to return home to Marianne and Stefan, their son. Mysteriously, Marianne disappoints Bruno by having an "illumination." The idea comes to her that he is going away and leaving her: "Yes, that's it," she says. "Go away, Bruno. Leave me." So Bruno leaves Stefan and Marianne, who later finds work as a translator. At no point does Handke explain her motivation.

Marianne's friend and Stefan's teacher Franziska attempts to integrate Marianne into her own circle of liberated women, but Marianne is far more liberated than they are, though she suffers bouts of depression. Bruno later attempts to give her money, but she declines because she values her independence. "I don't care what you people think," she remarks. "The more you have to say about me, the freer I will be of you." Her father visits her for a while. Marianne has a passing affair with an actor. Marianne has a party and invites the actor, Bruno, Franziska, a salesgirl, Ernst (her publisher-employer), and his chauffeur. Bruno and the actor get into a scuffle, then later play Ping-Pong. Afterward the actor tells Marianne "I would like to be somewhere else with you now," but she answers: "Please don't put me in any of your plans." After the guests have departed, the woman remarks to herself: "You haven't given yourself away. And no one will ever humiliate you again."

Handke is a well disciplined postmodern minimalist writer. "I wanted to try a kind of prose in which thinking and feeling of the individual characters would never be described—in which, instead of 'she was afraid,' the reader would find: 'she left,' 'she walked over to the window,' 'she lay down next to the child's bed,' etc.—and I felt this form of limitation actually acted as a liberating force on my literary work." This sort of narrative approach is perfectly adaptable to the camera-eye point of view, which the film captures so brilliantly.

The Film

Thanks to the minimalist style of the novel, which has no interior development, the story translates almost exactly to the screen. The film is set in the Paris suburb of Clamont (though the characters are still German), in the same house where Handke once lived and wrote. "Die Frau"—the woman of the title—Marianne (Edith Clever) and Ste-fan (Markus Mühleisen) meet Bruno (Bruno Ganz) at the airport and the action follows the novel precisely, except this is a story of character relationships rather than "action." All of the characters, Franziska (Angela Winkler), the actor (Rüdiger Vogler), the publisher (Bernhard Wicki), Marianne's father (Bernhard Minetti), and the rest appear as expected in the film. The emphasis changes a bit, and some minor details are sacrificed. The concluding party sequence is compressed to less than five minutes of screen time, for example, and the dramatic fight does not take place between Bruno and the actor, nor do they make up and play Ping-Pong. In the novel Marianne translates the autobiography of a young Frenchwoman. In the film she translates Flaubert. The film ends with a line from a poem by Vlado Kristl: "*Ja, habt ihr nicht bemerkt/daß eigentlich nur Platz ist für den/der selbst den Platz mitbringt . . .*" ("Have you noticed: there's only room for those who make room for themselves . . ."). The film's "message" is distilled in this oblique way.

Reviewing for *The New Republic*, Stanley Kauffmann claimed the film was "more crystallized than the novel," as it no doubt was. In fact, it would be difficult to determine which is the substantive version of this story that began as a screenplay, was transformed into a novel, and then turned back into a screenplay for a film directed by the novelist himself. The film is not for everyone and would probably bore popular audiences, as Leonard Maltin's cynical two-star *TV Movies* description indicates: "The Woman demands that her husband Ganz leave her. He complies. Time passes . . . and the audience falls asleep." But for serious readers and viewers, this is about as interesting an adaptation as can be found, and one that achieves its goals brilliantly.

REFERENCES

Howard, Maureen, "The Left-Handed Woman," *The Yale Review* 68, no. 3 (March 1979): 439–41; Kauffmann, Stanley, "Notes on Handke's Film," *The New Republic*, March 8, 1980, 24–26; Klinkowitz, Jerome, and Janes Knowlton, *Peter Handke and the Postmodern Transformation* (University of Missouri Press, 1983); Linville, Susan, and Kent Casper, "Reclaiming the Self: Handke's *The Left-Handed Woman*," *Literature/Film Quarterly*, 12, no. 1 (1984): 13–21; Updike, John, "Northern Europeans: Discontent in Deutsch," *Hugging the Shore: Essays and Criticisms 1983* (Vintage Books, 1984).

—*J.M. Welsh*

LES LIAISONS DANGEREUSES (1782)

PIERRE AMBROISE CHODERLOS DE LACLOS

Les Liaisons Dangereuses (1959), France, directed by Roger Vadim, adapted by Claude Brule and Roger Vailland; Films Marceau.

Dangerous Liaisons (1988), U.S.A., directed by Stephen Frears, adapted by Christopher Hampton; Warner Bros.

Valmont (1989), France/U.K., directed by Milos Forman, adapted by Jean-Claude Carrière; Orion.

The Novel

Choderlos de Laclos began writing *Les Liaisons Dangereuses* while stationed in Rochefort as a lieutenant in the French Colonial Forces. This epistolary novel had an immediate success and earned him a great literary reputation; he was subsequently elected to the La Rochelle Academy of Letters. After the Revolution, he concluded his career as a general in Napoleon's armies. Subtitled "Assembled Letters from One Society Published for the Edification of Some Others," his novel was a witty, biting satire of amours among a closed society of aristocrats whose acquaintances and pawns include occasional military officers, the clergy, and servants.

Once lovers, the Vicomte de Valmont and Marquise de Merteuil now correspond regularly with accounts of their respective seductions. It is against her wishes that Valmont sets his sights on Madame de Tourvel, the pious wife of an absent lawyer. Merteuil, meanwhile, has enjoyed an affair with Danceny, a friend of Valmont. Stung by Danceny's new attraction to the innocent, convent-bred Cecile de Volanges, she plans to punish him by "giving" Cecile to Valmont. The seduction of *both* Cecile and Madame de Tourvel accomplished, Valmont and Merteuil agree to celebrate by spending one more night of love together. But when he returns to Paris, Valmont finds Merteuil with his friend, Danceny. In retaliation, in order to embarrass Merteuil, Valmont arranges a liaison between Danceny and Cecile. In turn, Merteuil discloses to Danceny that Valmont has already seduced Cecile. Danceny subsequently kills Valmont in a duel. When Merteuil's intrigues are publicized to a shocked public, and after she contracts disfiguring smallpox, she flees to Holland. "In a real sense," says John Fell in his study of the subject, "it is a story of two criminals [Valmont and Merteuil] falling out . . . Because the plot parallels seduction strategies as well as the contrived sentiments assumed by the vicomte and the marquise, the two emerge as a pair of complicated personalities whose relationship constitutes the book's core."

The Films

Following the success of his previous film, *And God Created Woman* (1956), Roger Vadim's *Les Liaisons Dangereuses* translated the novel's 18th-century setting into the modern-day world of Left Bank cocktail parties, skiing trips to Megeve, and locations at the U.N. and the Palace of Justice. Valmont (Gerard Philipe in his last role) is married to Juliette (Jeanne Moreau), and the two agree to operate with absolute sexual freedom, each recounting to the other his and her sexual exploits. The exposition is straightforward, the letters replaced by Valmont's occasional voiceover and the frequent use of telephone, telegraph, and tape-recorded messages. While much of the plot and the primary characters have been retained, the class relationships between aristocrats and servants have virtually disappeared. A succès de scandale upon its initial release, the film's overseas distribution was delayed by three years. "It now carries something of the charm of an old *Playboy*," drily observes commentator Fell, "with stylistic overtones of *Vogue*."

Both *Dangerous Liaisons*, directed by Stephen Frears and adapted by Christopher Hampton, and *Valmont*, directed by Milos Forman and adapted by Jean-Claude Carrière, return the story to its pre-Revolution setting. Both dispense with the epistolary apparatus. Handsome productions alike, meticulously detailed and sumptuously produced, they exemplify the studio period film at its best. Beyond that, however, they are wholly different in their general tone. By contrast to the static, hot-house claustrophobia of the Frears, Forman's *Valmont* is fresh and lively, the cameras taking to the streets, to the markets, the puppet shows, the Opéra Comique. Whole scenes are devoted to the intrigues and dances at country parties. Innocence is not so brittle here, nor is evil. Colin Firth's charming but reckless Valmont is not the snaky creature of John Malkovich; Annette Bening's beguiling Merteuil is not the evil harridan of Glenn Close; and Fairuza Balk's ingenuous Cecile is more disarming than the quickly corrupted Uma Thurman.

REFERENCES

Fell, John, "The Correspondent's Curse: Vadim's *Les Liaisons Dangereuses*," in Andrew Horton and Joan Magretta, eds., *Modern European Filmmakers and the Art of Adaptation* (Frederick Ungar, 1981); Singerman, Alan J., "Merteuil and Mirrors: Stephen Frears' Freudian Reading of *Les Liaisons Dangereuses*," *Eighteenth-Century Fiction* 5, no. 3 (April 1993).

—*C–A.L. and J.C.T.*

THE LIFE AND ADVENTURES OF NICHOLAS NICKLEBY (1838)

CHARLES DICKENS

Nicholas Nickleby (1903), U.K., directed and adapted by Alf Collins; Gaumont-British.
Nicholas Nickleby (1912), U.S.A., directed by George Nichols; Thanhouser.
Nicholas Nickleby (1947), U.K., directed by Alberto Cavalcanti, adapted by John Dighton; Ealing Studios.
Nicholas Nickleby (2002), U.S.A./U.K., directed and adapted by Douglas McGrath; Hart-Sharp Entertainment/Potboiler Productions Ltd.

The Novel

Having already garnered great success with his first three books, *Sketches by Boz*, *The Pickwick Papers*, and *Oliver*

Twist, the 26-year-old Dickens set out to shape into a novel his alarm and furious indignation at the negligence, cruelty, and pedagogical incompetence of schools in Yorkshire (based on his own observations from an investigative trip he had taken in January 1838). As biographer Edgar Johnson notes, "Dickens aimed to inform the ignorant and expose the vicious." Astonishingly, he began *Nicholas Nickleby* while completing the final chapter of *Oliver Twist* (the first of his books to be published under his own name), contemplating the writing of yet another new novel, *Barnaby Rudge*, and organizing the periodical that came to be called *Master Humphrey's Clock*. The first number of *Nicholas Nickleby* appeared in April 1838 and promptly sold 50,000 copies; and the entire work was finished by September. The full title was *The Life and Adventures of Nicholas Nickleby, Containing a Faithful Account of the Fortunes, Misfortunes, Uprisings, Downfallings and Complete Career of the Nickleby Family*. In the novel's preface, Dickens took pains to insist that the abuses of schoolchildren depicted in the novel were not mere figments of his imagination; rather, "the lasting agonies and disfigurements inflicted upon children by the treatment of the master in these places, involving such offensive and foul details of neglect, cruelty, and disease, as no writer of fiction would have the boldness to imagine."

Aside from its social criticism, *Nickleby* was distinguished from Dickens's previous books in that, in G.K. Chesterton's estimation, it "coincided with [Dickens's] resolution to be a great novelist and his final belief that he could be one." Moreover, as biographer Peter Ackroyd has written, it "has some title to being the funniest novel he ever wrote; it is perhaps the funniest novel in the English language." One need only compare it to an earlier "novel of education," Goethe's *Wilhelm Meister's Apprenticeship* (to which it bears more than a casual resemblance, particularly in its employment of theatrical settings and characters), to fully relish its color, vitality, and energy. "It is a book of hurry," writes Ackroyd, "of rapidity, of characters emerging then fading and, in those strange pulses of energy, clause following clause with the barest comma to mark their territorial bounds, we see something of the nature of Charles Dickens himself."

The story opens when Mrs. Nickleby, a widow, arrives in London with her children, Nicholas and Kate, seeking aid from her husband's wealthy brother, a usurer. The contrast between villainous Ralph and stalwart Nicholas tells the tale: "The old man's eye was keen with the twinklings of avarice and cunning; the young man's bright with the light of intelligence and spirit." The villainous Ralph Nickleby promptly contrives to get Nicholas out of the way while exploiting the charms of his pretty niece in his moneylending business. Nicholas—who is Dickens's first truly romantic young hero—endeavors to find security and happiness for his mother, his sister, and himself, while defeating the wicked designs of his uncle. In so doing, he finds himself in a variety of situations, including teaching at the notorious Dotheboys Hall under the cold eye of the brutish Wackford Squeers; acting in Portsmouth in the theatrical company of the redoubtable Vincent Crummles; and moving into business in London with the philanthropic merchants the Cheeryble Brothers. And he falls in love with young Madeline Bray, who also will be the target of more scheming designs of Ralph Nickleby. There are powerful moments aplenty, such as Nicholas's denunciation of the predatory Sir Mulberry Hawk, his extrication of the pathetic Smike from Squeers's clutches, his rescue of Madeline from the hideous miser Arthur Gride, and a flurry of last-minute revelations and plot resolutions, including the undoing of Squeers, the breakup of Dotheboys Hall, and the unraveling of Ralph Nickleby's treacheries. In the end, Ralph hangs himself, and a veritable plethora of betrothals closes the last chapter.

While one may wince at the melodramatics of Ralph, Hawk, and Arthur Gride, and delight in the inspired lunacy of the Crummles troupe—Nicholas's encounter with the Infant Phenomenon and his witnessing of a rehearsal of "The Indian Savage and the Maiden" is one of Dickens's greatest comic scenes—there is no denying the ferocious anger blazing through the Dotheboys episodes. Indeed, so powerful was Dickens's attack on the Yorkshire schools, for which Dotheboys was the model, that by 1864 a school commissioner reported that conditions had substantially improved. As Ackroyd notes, "*Nicholas Nickleby* did in fact have a permanent effect upon the world; single-handedly Dickens had been able, by exaggeration and grotesquerie, to extirpate a national abuse."

The Films

Little is known about the silent adaptations. The 1903 version was produced by Gaumont Studios in England with William Carrington in the title role. The 1912 version, produced in America, had Harry Benham as Nickleby, Justus D. Barnes as Uncle Ralph, N.Z. Wood as Smike, and Harry Marks as Vincent Crummles.

Fondly remembered is the Alberto Cavalcanti version, produced for Ealing Studios in 1947. "It is among the best of the Dickens adaptations," writes Christopher Mulrooney in a 2002 reassessment, "[Cavalcanti] creates a constant cinematic discourse running along with Dickens never out of its sight." The Brazilian-born Cavalcanti came to John Grierson's Crown Film Unit in 1934, where he worked on several distinguished documentaries, including *Song of Ceylon* (1934) and *Night Mail* (1936). In 1940 he turned to feature films at Ealing Studios, under the supervision of Michael Balcon, with the wartime allegory *Went the Day Well?* Today he is best remembered for two British mid-19th-century period pieces, *Champagne Charlie* (1944) and his adaptation of *Nicholas Nickleby* (1947).

Derek Bond appeared as Nicholas, Cedric Hardwicke as Uncle Ralph, Stanley Holloway as Vincent Crummles, and Sally Ann Howes as Kate Nickleby. Perhaps the film's release soon after David Lean's celebrated *Great Expectations*, which had a much more dramatic storyline, helps

account for its relative neglect. It boasts sumptuous production values and, in its best moments, a superbly choreographed camera style and chiaroscuro lighting design. Scenarist John Dighton's onerous task of smelting down the picaresque narrative, with its many digressions and incidental characters, resulted in a relatively linear storyline, highlighted by the depiction of the appalling conditions at Dotheboys Hall; Nicholas's stage debut with the Crummles theatrical troupe; Newman Noggs's hysterical denunciation of Ralph Nickleby; and Ralph's flight from the constabulary and subsequent suicide during a spectacular thunderstorm. As lively as the foregoing is, however, the scenes between Nicholas and Madeline Bray are drab and colorless. Director Cavalcanti is clearly attracted more to the picaresque than to the bathetic. Unfortunately, the thickly textured musical score by Lord Berners tends to overwhelm many of the scenes.

Since the Cavalcanti version, little was made of the novel, excepting its landmark, nine-hour Royal Shakespeare Company adaptation, seen on Broadway in 1981. That all changed with the newest screen incarnation, directed by Douglas McGrath, a young filmmaker already acclaimed for his adaptation of Jane Austen's *Emma*. McGrath does not hesitate in declaring, "Paradoxically, in being one of [Dickens's] lesser novels, *Nicholas Nickleby* is in some ways better suited to film than his superior novels. Because the structure is so loose and so many of the vignettes are not closely tied to the main adventure, deciding what to eliminate is not impossible." Rejecting the inclusive approach of the Cavalcanti film—"The movie feels like a trip through Nicholas Nickleby Land on a very fast monorail"—McGrath eliminated many characters and incidents not directly relevant to Nicholas's adventures.

McGrath has a knack for utilizing theatrical devices to open his films. *Emma* began with a series of views of miniature portraits of cast members painted on a bauble. And *Nicholas Nickleby*, appropriately enough, lists its credits against a succession of views of a toy theater, whose scenery and characters are shifted on and off with the appearance of each new name in the credits. The toy theater perfectly captures those aspects of Dickens that seem to me most obviously apparent, albeit superficially significant, that is, the pasteboard characters and contrived plot twists.

The casting, as critic Roger Ebert observed, is brilliant. "The actors assembled are not only well cast, but well typecast. Each one by physical appearance alone replaces a page or more of Dickens' descriptions, allowing McGrath to move smoothly and swiftly through the story without laborious introductions." It's a stroke of good fortune for viewers that Nathan Lane has been chosen to function as a sort of "chorus" to this Dickens tale. His voiceover at the beginning rapidly sorts through the tangled history of the Nicklebys and deposits 19-year-old Nicholas, his younger sister, and his widowed mother right on Ralph's doorstep in no time. Lane reappears midway through, as theatrical impresario Vincent Crummles, who takes Nicholas and his friend, the refugee Smike, into this theater troupe to give them—and us—a welcome respite from the film's otherwise melodramatic machinery. Finally, Lane as Crummles returns at the end to gather up all the characters, turn to the camera, and address us directly to enlighten us on all the plots and counterplots and their just and happy resolution.

Just as Lane was born to be in a Dickens film, so was Christopher Plummer, whose chillingly villainous Ralph Nickleby, the usurer who's been scheming against his niece and nephew throughout the film, dominates every frame he's in. His office has been appointed and decorated with stuffed animals and desiccated fossils, a mise-en-scène conveying all we need to know about him. And his scheming is delivered with such conviction that I was almost sorry to see the old boy hang himself at the end (surely, we think, he should have survived the awful revelations about his parentage of Smike [Jamie Bell] and the collapse of his business). And as wicked as Jim Broadbent is as the brutish head master of Dotheboys Hall, his wife (Juliet Stephenson) is even more evil.

A shining contrast to such dour characterizations is Charlie Hunnam as Nicholas, the stalwart blond champion of his sister, Kate, and of Smike. He's even prettier than his sister. And Timothy Spall and Gerald Horan as the Cheeryble brothers, those impossibly benevolent philanthropists, manage to make their roles more delightful than insufferable.

Many alterations were necessary to squeeze Dickens's 700-plus page sprawl of a novel into a two-hour film. Some of the most colorful characters have been scrapped as too incidental—the dotty Mrs. Nickleby, for example (who in the film is a nondescript presence in a mere handful of scenes), the exotic Mantolinis, that hothouse bloom, Miss Snevelicci, and the horrid old Arthur Gride. This last omission is understandable. His designs on Kate are replaced here by those of that reliably predatory rascal, Sir Mulberry Hawk (Edward Fox). Most of the intrigues surrounding Madeline Bray's (Romola Garai) inheritance are stripped away, as is Smike's second incarceration in Dotheboys Hall. And, most regrettably, so are many of Nicholas's adventures with the Crummles company.

But credit director McGrath with confronting Dickens's plot contrivances, improbable characters, and unbridled sentimentality head on. He takes Dickens at his word. And bless the ever-reliable screen composer Rachel Portman for providing a winning, sprightly theme that agreeably threads its way through the picture.

REFERENCES

Ackroyd, Peter, *Dickens* (Sinclair-Stevenson, Ltd., 1990); Barr, Charles, *Ealing Studios* (Overlook Press, 1997); Chesterton, G.K., *Appreciations and Criticisms of the Works of Charles Dickens* (J.M. Dent & Sons, 1911); Ebert, Roger, "Nicholas Nickleby," *Chicago Sun-Times*, January 3, 2003; Johnson, Edgar, *Charles Dickens: His Tragedy and Triumph*, vol. 1 (Simon and Schuster, 1952); McGrath, Douglas, "For a Movie, Lesser Dickens Is Sometimes More," *The New York*

Times, December 22, 2002, 13–19; Mulrooney, Christopher, "Nicholas Nickleby," *The Los Angeles Times*, May 7, 2002.

—*J.C.T.*

THE LIFE AND ADVENTURES OF ROBINSON CRUSOE (1719)

DANIEL DEFOE

Mr. Robinson Crusoe (1932), U.S.A., directed by Edward Sutherland, adapted by Tom Geraghty and Elton Thomas [Douglas Fairbanks, Sr.]; United Artists.

The Adventures of Robinson Crusoe (1952), Mexico/U.S.A., directed by Luis Buñuel, adapted by Buñuel and Hugo Butler; Tepeyac/United Artists.

Robinson Crusoe on Mars (1964), U.S.A., directed by Byron Haskin, adapted by Ib Melchior; Paramount/Devonshire.

Man Friday (1975), U.K., directed by Jack Gold, adapted by Adrian Mitchell; Avco Embassy.

Crusoe (1989), U.K./U.S.A./Yugoslavia, directed by Caleb Deschanel, adapted by Walon Green and Christopher Logue; Island Pictures/Virgin Vision.

Robinson Crusoe (1996), U.S.A., directed by Rod Hardy and George Miller, adapted by Christopher Canaan and Christopher Lofren; Miramax.

The Novel

Daniel Defoe's classic of high adventure and humble religiosity found its inspiration in an historical account about Alexander Selkirk, who had survived alone on the island of Juan Fernandez for seven years. Selkirk regarded the ordeal as a positive experience, claiming that he had become self-sufficient and "a better Christian while in his solitude than ever he was before, or than he was afraid he should ever be again."

So famous is Defoe's novel that a survey in 1979 found there had been 1,198 editions in English alone, plus translations into innumerable tongues (including an 1820 Latin version for schoolboys, *Robinson Crusoeus*). Thus, by now even those who have never read it think they know its basic outline—a man is shipwrecked without resources on a desert island; he survives by his wits; he suffers in his isolation; he discovers Friday's footprint in the sand; and he is finally rescued from his exile. That, in a nutshell, is the story. Right?

Wrong.

As Philip Zaleski wryly points out in his probing commentary on the subject, Crusoe's island is not a desert, he does have resources, he does not live solely by his wits, he does not suffer inordinately in his solitude, the footprint does not belong to Friday, and he is not rescued—he escapes. Moreover, before his tenure on the island, Crusoe is not a very sympathetic character; rather he is an arrogant slave trader.

A return to the book is in order. The story begins with Crusoe's birth in 1632. At the age of 19, he runs away to sea. During his third voyage, he is captured by pirates and sold into slavery. He escapes, only to suffer a shipwreck during his next voyage. Stranded on an island, with only a few supplies, including a Bible he has found in an old chest, he builds a hut and begins a journal. His island is a pristine land of surpassing beauty. "The Country appear'd so fresh," he writes, "so green, so flourishing, every thing being in a constant Verdure, or Flourish of Spring, that it looked like a planted Garden." Of other human habitation, however, there is no sign. Crusoe reconciles himself to his calamity. He puts aside his arrogance and bows before the will of God. He opens his Bible and repents, calling out, "Lord, be my help!" He learns how to handle tools, plant a field, and build a house. He declares himself "Lord of all this country . . . as compleatly as any Lord of a Manor in England."

After his sixth year, Crusoe discovers a human foot print in the sand. Savages arrive for a cannibal feast. Crusoe rescues one of the intended victims and dubs the grateful native "Man Friday." He also teaches him English and attempts to "civilize" him. Later, when an English ship in the hands of mutineers arrives, Crusoe rescues the captain and crew and helps them regain control of the vessel. With Friday he returns to England a wealthy man.

But the story doesn't end there. After years living as a farmer in England, Crusoe and Friday return to the island. They find the place rife with conflicts among several tribes of savages and groups of English and Spaniard colonists. Crusoe sets out to convert the natives to Christianity and subdue the tensions among the whites. He then sets out for Brazil. Friday dies during the voyage. After burying his faithful servant at sea, Crusoe reaches Brazil and journeys on to the East Indies, where he pursues his trading interests. Finally, he returns to London on January 10, 1708. The novel concludes with the 72-year-old Crusoe preparing to embark on a final voyage, this time with no plans to return.

No mere action story or fable of English colonialism, the book is a veritable manual of spiritual conversion and a guide to the good life. This was recognized as early as 1790 when Defoe's biographer, George Chalmers, wrote: "Few books have ever so naturally mingled amusement with instruction. The attention is fixed, either by the simplicity of the narration, or by the variety of the incidents; the heart is amended by a *vindication of the ways of God to man.*"

The Films

The epic scope and spiritual zeal of Defoe's novel has never received full screen translation. Adaptations usually concentrate only on the first part of the story. One of the earliest adaptations is also one of the most curious. Douglas Fairbanks, tired of Hollywood, the better part of his screen career behind him, updated the tale to 1932 and

transformed it into a labored satire on contemporary life, a kind of "Gilligan's Island" of its time. We are asked to believe that an American go-getter, on a bet, can bounce onto a South Sea island, transform it into a mechanical paradise with all the conveniences, and prove himself a superior White Father in the face of native savagery. For purposes of romantic interests, Man Friday is replaced by "Girl Saturday" (Maria Alba). The tree-house set is spectacular, and the rope-swinging acrobatics at the end are exciting, but the movie remains a strange valedictory to Fairbanks's career.

Next in line, and one of the most intriguing Crusoe adaptations, is Luis Buñuel's 1952 color version, a Mexican-American production. It was one of two English novel adaptations he made at this time, the other being *Cumbres Borrascosas (Wuthering Heights)*. On the face of it, the narrative line is simple enough: The film begins with Crusoe's (Dan O'Herlihy) landing on the island and proceeds for half its length detailing his efforts to cope with the hostile environment. Twenty years pass. He rescues Friday (Jaime Fernandez) from cannibals. When mutineers arrive on the island, he and Friday overpower them and return to England. But a closer look at the film reveals that Buñuel was more attracted to Crusoe himself, who narrates the film in a voiceover, than the book's spiritual affirmations. He sees Crusoe as a tortured soul, haunted by the ghost of his overbearing father (the hallucinatory sequences are pure Buñuel), anguished at the failure of his religion to console him (his despair is mocked when his recitation out loud of the 23rd Psalm returns in a hollow echo), and frustrated in his sexual repressions (cleverly conveyed by a scene where his drying garments are blown by the wind into a suggestively female form). Buñuel even suggests that the equality that is eventually established between Crusoe and Friday is only temporary when he depicts them arriving back in England, Crusoe clad in a captain's uniform and Friday in common seaman's clothes. In short, as commentator Gillian Parker suggests, "what is being achieved in the film is not Defoe's commendation, but Buñuel's critique of the middle-class ethos of Crusoe's day and, by implication, of our own."

The 1975 and 1989 versions, directed, respectively, by Jack Gold and Caleb Deschanel depart radically from Defoe's intentions by depicting Crusoe as an agent of a corrupt, industrial society who is redeemed by the noble savage. In the 1975 film Crusoe (Peter O'Toole) comes across as an insufferable fool in comparison to the noble Friday (Richard Roundtree). The fact that actor Roundtree is an African American is an obvious ploy to shift the novel's subtext of 18th-century race relations to a more contemporary context. Indeed, the spirit of Woodstock seems to hover over the scenes of life in Friday's village, which in its avowed free love and communal harmony resembles more a hippie commune instead of a preindustrial society.

Deschanel's film updates the story to the late 19th century. Crusoe (Aidan Quinn) is a slave trader shipwrecked on a remote island. He rescues an intended victim of human sacrifice and dubs him "Lucky" (there is no mention whatever of Friday). But the man dies and Crusoe is in turn captured by the tribe. He strikes up an antagonistic relationship with one of the warriors, who, it appears, is determined to kill him. But the mutual strife between the two softens, and a more complicated relationship develops. In a reversal of Defoe's story, it is not the savage who joins Crusoe's world, but Crusoe who grows so thoroughly ashamed of his former "civilized" life that he applies for membership among the cannibals.

Among the films peripheral to the basic elements in Defoe's novel is Byron Haskin's *Robinson Crusoe on Mars* (1964), a science fiction story about an astronaut Christopher Draper (Paul Mantee) who crash-lands on the seemingly abandoned planet of Mars, accompanied only by a monkey. In this version Friday (Vic Lundin) is an alien slave whom Draper rescues from a slave ship recently arrived on the planet. *Time* magazine applauded the film's intelligence, unusual in the genre, describing it as "a piece of science fiction based on valid speculation, a modest yet provocative attempt to imagine what might happen . . . in the next decade or so."

The most recent version, *Robinson Crusoe*, directed by Rod Hardy and George Miller, features Pierce Brosnan as Crusoe and William Takaku as Friday. Released in 1996, it received only limited distribution.

REFERENCES

Higginbotham, Virginia, *Luis Buñuel* (Twayne, 1979); Zaleski, Philip, "The Strange Shipwreck of Robinson Crusoe," *First Things* 53 (May 1995): 38–44.

—*J.C.T.*

LIKE WATER FOR CHOCOLATE (*Como agua para chocolate*) (1989)

LAURA ESQUIVEL

Like Water for Chocolate (Como agua para chocolate) (1992), Mexico, directed by Alfonso Arau, adapted by Laura Esquivel; Miramax Films.

The Novel

Laura Esquivel grew up in Mexico City, where she often spent time in her grandmother's old-fashioned kitchen. "She had a chapel in the home, right between the kitchen and dining room," says Esquivel. "The smell of nuts and chilies and garlic got all mixed up with the smells from the chapel, my grandmother's carnations, the liniments and healing herbs." After spending eight years as a teacher, Esquivel began to write and direct for children's theater, which prompted her to explore her childhood memories of food—and eventually to write *Like Water for Chocolate*. Her novel tries to capture the elemental, transformative nature

of food. For Esquivel, food is something that can change both those who prepare it and those who eat it.

The novel spans several generations as it follows the fates of several members of a Mexican family, but focuses primarily on the period of the Mexican Revolution after the turn of the century. The entire tale is related by the grandniece of Tita, the novel's main character, and is divided into 12 monthly installments, each of which foregrounds a traditional Mexican recipe such as "quail in rose petal sauce" or "cream fritters." The story opens with the grandniece peeling onions and speculating that she has inherited her intense sensitivity to them from her great-aunt Tita.

Tita grows up in the kitchen learning ancient recipes from Nacha, the elderly cook on the family's ranch. As the youngest of Mama Elena's three daughters, Tita is forbidden to marry and must care for her mother until she dies. When she is 15, however, Tita falls in love with a boy named Pedro. (The title of the novel, "like water for chocolate," refers to the way Pedro makes Tita feel; she boils like the water for hot chocolate.) Mama Elena refuses his request to marry Tita and offers him Rosaura, one of Tita's older sisters. Because he thinks it is the only way to be near Tita, Pedro accepts.

Tita's life is restricted and stunted by her mother, but Tita exerts her own power through her cooking. Tita's dishes affect others according to the mood she is in when she prepares them. Rosaura's wedding cake causes the guests to cry and vomit because Tita's tears fall into the batter. And although Mama Elena works furiously to keep Pedro and Tita apart, they communicate through the food that Tita prepares. When Pedro brings her flowers one day and Mama Elena orders Tita to destroy them, she hugs them to her breast and then uses the bloody petals in a recipe for "quail in rose petal sauce": "That was the way she entered Pedro's body, hot, voluptuous, perfumed, totally sensuous."

Tita's mental battle with her mother nearly drives her insane, but she is rescued by a local doctor, John Brown, who helps her recover. Meanwhile, Mama Elena is attacked by bandits and dies soon after. Tita refuses the widowed Dr. Brown's suit when she loses her virginity to Pedro, but 22 years later Dr. Brown's son marries Tita's niece Esperanza (Pedro and Rosaura's child). Rosaura is now dead, and Pedro and Tita make passionate love on the night of the wedding. It is so powerful it consumes them, and all Esperanza finds later is a cookbook, which she hands down to her own daughter. "Tita, my great-aunt, will go on living as long as there is someone who cooks her recipes," concludes the narrator.

The Film

One rarely encounters a film that so completely and accurately captures the mood and spirit of the novel upon which it is based. A yellow-orange glow, selective lighting, and slow, rhythmic music help make *Like Water for Chocolate* a stunning cinematic recreation of the novel's "magical realism." The structure of the novel is carefully followed,

even down to the "flashback" framing device of the grandniece's narration. A few events are compressed or rearranged chronologically, but the film is as close to the novel in form and content as it is possible for a film to be.

Faithfulness to a novel cannot always be applauded, but in this case it works magnificently. Celluloid seems even better able than prose to function as a window into the fantastic yet seemingly factual world that Esquivel has created. And a more appropriate creative team could not have been brought together: Esquivel herself adapted the screenplay, and Alfonso Arau, her husband, directed. His direction is simple and straightforward, like the descriptive passages in the novel. Esquivel and Arau opted to delete some of the more unbelievable occurrences in the novel. For instance, Tita's tears do not form "a stream running down the stairs" when she regains her sanity, and a renowned blanket that Tita knits is large but is not able to cover three hectares (the entire area of the ranch). Toning these events down prevents the film from being "overblown" and paradoxically makes it more faithful to the quiet sincerity of the novel, an effect that is rounded out by the restrained performances of Lumi Cavazos (as Tita) and Marco Leonardi (as Pedro).

The scenes involving nudity and/or sexual relations are brief and have a mythical, romantic quality. The primary theme of the book (and the film) is only incidentally sexual; it is about "the secrets of love and life as revealed by the kitchen." Food is one of the most basic aspects of life. It can link us to nature and to magic. "Technology and industry have distanced people from nature and magic and human values," Esquivel has commented. "You put a package in and cook it and it takes you back to the factory where it was all made. You don't go back to the earth; you don't get reminded of your nature." *Like Water for Chocolate*, in both its novelistic and cinematic forms, is there to do just that.

REFERENCES

Maslin, Janet, "Emotions So Strong You Can Taste Them," *New York Times*, February 17, 1993, C13+; Mora, Carl J., *Mexican Cinema*, University of California Press, 1989; O'Neill, Molly, "Sensing the Spirit in All Things, Seen and Unseen," *New York Times*, March 31, 1993, C1+.

—H.A.

DIE LINKSHANDIGE FRAU (1976)

See THE LEFT-HANDED WOMAN.

LITTLE BIG MAN (1964)

THOMAS BERGER

Little Big Man (1970), U.S.A., directed by Arthur Penn, adapted by Calder Willingham, Cinema Center Films.

The Novel

The third and best known of the novels by Thomas Berger is a lengthy picaresque journey through late 19th-century American history. The book criticizes American culture of the period, particularly the European Americans' destruction of the homeland, culture, and lives of the Plains Indians. The novel employs a narrative frame at the beginning and end, featuring an officious interviewer who records on tape the story of Jack Crabb, a man who claims to be 111 years old and the only white survivor of the battle of Little Big Horn (June 25, 1876).

Crabb's first-person narrative tells how he and his older sister Caroline were captured as children by drunken Cheyenne Indians, after they killed other family members. Jack is adopted by a Cheyenne chief, Old Lodge Skins, and learns the language and ways of the Human Beings (as the Cheyenne call themselves). He gets the name "Little Big Man" when he saves the life of an unsympathetic young Cheyenne brave, Younger Bear, during a raid on a Crow village. Later, Jack moves several times between the Indian and white worlds, employing his Indian or white identity as need arises, and never quite at home in either world. His adventures include a disappointed passion for the wife of a boorish Missouri preacher, marriage to a Swedish woman who is subsequently captured by Cheyenne Indians, and work on the Union Pacific Railroad as it divides the continental buffalo herd.

At an Indian encampment by the Washita River in the Oklahoma Territory, Jack becomes "100 percent Cheyenne" for a little while, as his Indian wife gives birth to their son and he makes love to his three widowed sisters-in-law, at his wife's urging. But this romantic idyll is interrupted when General George Armstrong Custer's cavalry stages a massacre. Jack's intentions of taking revenge by killing Custer soon dissipate in further adventures: He learns gunslinging from Wild Bill Hickock, masters the art of cheating at poker, and takes up with a con-artist. Eventually he joins Custer's Seventh Cavalry on the way to its annihilation at the Little Big Horn River. Observing the valiant death of the now-mad Custer, Jack is finally convinced that the general was a "great" man. But after Younger Bear saves his life, Little Big Man returns to the Human Beings. He is profoundly moved by a visit with Old Lodge Skins to the ghastly battlefield the day after the slaughter. Jack thinks he has gained the Indians' understanding of "the great universal circle."

The Film

Before making *Little Big Man*, director Arthur Penn had established his reputation as a thoughtful critic of the American scene in his imaginative treatment of home-grown violence in *Bonnie and Clyde* (1967) and his celebration of Arlo Guthrie's counterculture message in *Alice's Restaurant* (1969). His adaptation of Berger's novel is relatively faithful. The film retains the narrative frame, with

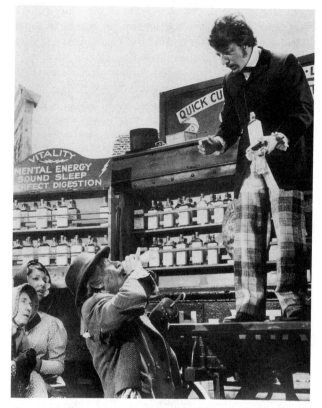

Dustin Hoffman (right) in Little Big Man, *directed by Arthur Penn* (1970, U.S.A., CINEMA CENTER FILMS/ THEATRE COLLECTION, FREE LIBRARY OF PHILADELPHIA)

Dustin Hoffman as a convincingly wizened and rasping Jack Crabb, whose comments on the visual action regularly remind the viewer of the old man's tall-tale vernacular and his unique point of view.

The on-location photography by Harry Stradling Jr. (in Technicolor and Panavision) is often impressive, particularly in the winter massacre by the Washita River. Hoffman plays the younger Crabb/Little Big Man with considerable subtlety, and Martin Balsam successfully expands the minor character of a frontier con-man into a snake-oil salesman who loses body parts as the movie goes along. Jack's sister Caroline (Carole Androsky) is given the additional assignment in the film of teaching her brother how to shoot, in a fine comic takeoff of the western gunslinger.

Among the alterations, Faye Dunaway's Mrs. Pendrake is too drippily duplicitous, even for farce. More problematically, the high point of Jack's Cheyenne experience, when he sleeps with his wife's three widowed sisters at the Washita, is handled in the film as a silly sex comedy. Furthermore, the movie's fast pace cannot do justice to the novel's specific historical rootedness or to Jack's ambivalent appreciation of Native American culture. Instead, the Indians are for the most part treated patronizingly as noble savages, like the blacks in *Uncle Tom's Cabin*. In general,

there is a serious discordance between the film's comic-picaresque components and its somber messages about Indian genocide and (implicitly) the Vietnam War.

REFERENCES

Bezanson, Mark, "Berger and Penn's West: Visions and Revisions," in *The Modern American Novel and the Movies*, ed. Gerald Peary and Roger Shatzkin (Ungar, 1978), 272–81; Kael, Pauline, "The Current Cinema: Epic and Crumbcrusher," *The New Yorker*, December 26, 1970, 50–52; Madden, David W., ed., *Critical Essays on Thomas Berger* (G.K. Hall, 1995).

—*W.S.W.*

LITTLE CAESAR (1929)

W.R. BURNETT

Little Caesar (1931), U.S.A., directed by Mervyn LeRoy, adapted by Francis E. Faragoh and Robert N. Lee; Warner Bros.

The Novel

Caesar Enrico Bandello, nicknamed "Little Caesar" but called "Rico" throughout Whit Burnett's novel, rises from his position as a lesser member of the Sam Vettori gang to become the gang's leader. He takes over an adjacent small-time boss's territory and is on the verge of taking over the position of the second highest mob boss, Pete Montana, when his empire comes to an end. Intensely self-centered, vain, and cold, Rico is nevertheless extremely competent, and he detests anything that makes a man "soft" or "yellow" even as he covets the soft life of the powerful top man, "The Big Boy."

Originally titled *The Furies*, the novel was intended to show the life of a Chicago gangster through his own eyes. Burnett was intrigued by the gangster as a man of the city. *Little Caesar*, which the author Burnett termed a "slang novel," is written in gangster vernacular. "I threw overboard what had until then been known as literature," Burnett said. Rico's associates are colorfully brought to life, as are the various mob leaders, women, and policemen. Rico kills a police captain, a fellow hood, and a rival small gang leader as he consolidates his power. He is compromised by fellow hood Joe Massara, who is arrested and squeals to the crime commissioner. Rico barely escapes Chicago police and arrives in Ohio, where he takes over a small gang. Pride contributes to his downfall, as he cannot resist bragging about his true identity to a gang member. He is ultimately shot in an alley in Toledo by an unidentified police officer.

The Film

Mervyn LeRoy's film differs from the novel in several ways. Jack Warner, who bought the property, instructed the screenwriters to make Rico more reminiscent of Al Capone, although the character in the novel is not based on him. When the film opens, Rico (E.G. Robinson) is knocking off gas stations with his partner and best friend, Joe Massara (Douglas Fairbanks, Jr.), whereas in the novel Rico is already a member of the Vettori gang, and he does not particularly like Joe.

Characters are dropped or combined in the film, in which women, who play prominent roles in the novel, are, with a few important exceptions, absent. In the movie it is important to build up the Rico-Joe friendship because part of the theme is carried by how Rico cannot shoot Joe, even when Joe is ready to turn state's evidence: The movie capitalizes on the image of the gangster hero who becomes "soft" when it comes to his friend. In the novel, Joe is in jail, talking, and as a result the police come after Rico. There is no dramatic scene in the novel in which Rico cannot shoot Joe. The film has a wonderful, black and white, Hollywood-underworld quality. Much of the action and dialogue are similar in novel and film; however, the surface resemblance can be misleading because the story is changed—the tragic theme is far more developed in the movie.

The crime commissioner, shot by Rico in a key scene in the film (shown in a montage of dissolves), is not shot in the novel. Rather, it is a police captain who is shot. Detective Flaherty (Thomas Jackson), the nemesis police officer, is pretty well developed in the movie. In the novel he is a lesser character; he does not bait Rico with news stories to smoke him out at the end. In fact, in the novel Rico does not deteriorate, drunk in a flophouse. He escapes to Toledo where, using an alias, he takes over a minor gang and runs alcohol across state lines. In both novel and film, however, it is pride that is Rico's undoing. In the film, because he cannot resist responding to Flaherty's inflammatory newspaper stories, he is located and killed. In the novel, he cannot resist divulging his identity to a two-bit hood, and he is brought down in a Toledo alley, where he shoots first. The officer who shoots him is not identified in the novel, and there is no ironic billboard advertising Joe and Olga's dance show as there is in the film. His dying words, the last words in the novel, are "Mother of God, is this the end of Rico?" In the film, the words are slightly altered to the well-known "Mother of Mercy, is this the end of Rico?"

Little Caesar is, in historian Eugene Rosow's estimation, "a landmark in the history of gangster movies." While not as stylistically interesting as its closest contemporary rivals, *Public Enemy* and *Scarface*, it consolidated all the essential scenes of the American gangster's rise and fall—the introduction to the gang, the takeover, the nightclub robbery, the meeting with the Big Boy, the success banquet, and a final, pathetic fall from power and grace. So indelibly was Edward G. Robinson's performance etched into the public consciousness that he spent the rest of his life resisting typecasting as a tough guy.

REFERENCES

Peary, Gerald, ed., *Little Caesar,* Wisconsin/Warner Bros. Screenplay Series (University of Wisconsin Press, 1981); Rosow, Eugene, *Born to Lose: The Gangster Film in America* (Oxford University Press, 1978); Warshow, Robert, *The Immediate Experience* (Doubleday, 1962).

—K.O.

A LITTLE PRINCESS (1903)

FRANCES HODGSON BURNETT

A Little Princess (1917), U.S.A., directed by Marshall Neilan, adapted by Frances Marion; Artcraft-Paramount.

The Little Princess (1939), U.S.A., directed by Walter Lang, adapted by Ethel Hill and Walter Ferris; 20th Century-Fox.

A Little Princess (1995), U.S.A., directed by Alfonso Cuarón, adapted by Richard LaGravenese and Elizabeth Chandler; Warner Bros.

The Novel

The genesis of Frances Hodgson Burnett's *A Little Princess* is complicated. In 1886 Burnett, basking in the acclaim of her just-published *Little Lord Fauntleroy,* wrote a rather somber short novel called *Sara Crewe, or What Happened at Miss Minchin's.* She dramatized it in 1901 under the title *A Little Princess.* The reviews were excellent, and two years later she rewrote it as the book we now know. Like her other books, it relied heavily upon melodrama, coincidence, the collision of class structures, and the enduring values of imagination and courage. For most of its length it's rather a grim tale about the misfortunes that threaten to break the spirit of an imaginative seven-year-old girl named Sara Crewe. Her father, Captain Crewe, brings her from India to London to enroll her in Miss Minchin's Seminary for Girls, a place so unrelievedly miserable that "the very armchairs seemed to have hard bones in them." The Minchin sisters take an instant dislike to little Sara's precociously fanciful ways—her tendency to be "always dreaming and thinking odd things . . . as if she had lived a long, long time"—but stifle their disapproval in the face of her father's wealth. Sara, meanwhile, ingratiates herself with most of the other children (excepting the vicious brat named Lavinia) and regales them with fanciful stories.

When news comes of the failure of her father's investment in some diamond mines and his subsequent death from "brain fever," Sara (now presumed to be penniless) is banished to the attic and condemned to work as a servant with the only friend to remain loyal to her, Becky the scullery maid. Abused, abandoned, forced to tramp through the wet streets on thankless errands (she's even given a coin one day, as if she were a beggar), Sara endures. "Soldiers don't complain," she mutters to herself. "I am not going to do it; I will pretend this is part of a war." Even her fantasy about being a little princess remains intact: "Whatever comes cannot alter one thing. If I am a princess in rags and tatters, I can be a princess inside."

One morning her fairy-tale fancies seem confirmed when she wakes up to a room full of new furnishings and servings of food. "The one thing I always wanted was to see a fairy story come true," she exclaims. "I am *living* in a fairy story. I feel as if I might be a fairy myself . . ." Day after day, new treasures mysteriously appear in the attic. "It was more romantic ad delightful than anything she had ever invented to comfort her starved young soul and save herself from despair." She doesn't know that the new neighbors next door, an elderly gentleman and his Indian servant, Ram Dass, are responsible for the acts of kindness. And they don't realize at first that the little girl in rags is in reality the very child they have spent years looking for: It seems that Captain Crewe didn't die penniless after all; the diamond mines are flourishing and Sara is the long-sought heir to a fortune. In the end the Minchin sisters are sternly rebuked and Sara is adopted by the gentleman to a new life of comfort and ease.

The Films

The first movie version was the result of a happy collaboration between Mary Pickford, director Marshall Neilan, and screenwriter Frances Marion. During Pickford's tenure at the Artcraft studios (1917–18), they adapted several well-known children's stories, including *Rebecca of Sunnybrook Farm, Amarilly of Clothes-Line Alley,* and *A Little Princess.* The latter proved to be among her most successful films. Ironically, it also confirmed to a generation of moviegoers that "little Mary" must always be cast in little-girl roles.

While simplifying the plot elements and reducing the number of characters, it's a creditable adaptation that adheres to the story's basic situations and themes. The most obvious alteration is the telescoping of climactic events concerning Sara's (Mary Pickford) discovery of the fairy-tale banquet and the subsequent revelations about her benefactors, Ram Dass and the mysterious elderly gentleman (George McDaniel and Gustav von Seyffertitz). Condensing all this into a few, hurried minutes spoils the dramatic buildup and prolonged suspense so carefully drawn in the novel.

Otherwise, the movie abounds in moments of charming whimsy. The close bond between Sara, newly arrived at the school, and her absent father (Norman Kerry) is effectively conveyed in a sustained montage of cross-cutting as each lingers in the other's thoughts during their daily activities. When Sara regales her little friends with the tale of Ali Baba (an elaborate sequence that constitutes fully one-third of the film), the dark schoolroom dissolves into the bright bazaars of the Orient. In another scene, when Sara tells Becky about the secret life their dolls enjoy when their owners are away (a scene lifted directly from the book), there's a stop-motion sequence of the toys

cavorting about. At the end, when Sara, her fortune restored, giggles with her friends, the ghostly figures of her dead parents hover protectively about her.

Fairly stealing the movie is ZaSu Pitts as Becky. Her wan, wry character (deliciously registering gently cynical reactions to Sara's fantasies) is a perfect foil for the sweet, bright Mary. When, in the face of near starvation, Sara declares that they both remain "little princesses," Becky shrugs: "That may be true, but it's hardly fillin'."

Two other film adaptations have followed. The Shirley Temple version, released in 1939 in the chocolate-box colors of the Technicolor process, was conceived as a perfect vehicle for Twentieth Century-Fox's most viable star. Events and characterizations were carefully tailored to her cloyingly plucky screen personality, sacrificing in the process most of the trenchant bite and gloom of the Burnett original. The recent Alfonso Cuarón film, by far the most detailed—if not always the most faithful—of the three versions, is more interested in story, mood, and atmosphere than in becoming just another vehicle for a child star (young Liesel Matthews was at the time a relatively unknown actress).

Both of these adaptations refuse to allow Captain Crewe (Ian Hunter and Liam Cunningham, respectively) to die. The tragedy of the diamond mine is discarded altogether, and Crewe is instead wounded in battle (the Boer War in the first and World War I in the second) and returned shell-shocked to London (where he is found in a hospital ward in the first and next door to the school in the second). The finale of the Temple version is especially interesting in that none other than Queen Victoria herself assists in the happy reunion!

Other alterations in these two versions deserve mention. The Temple version softens the harsh, abusive atmosphere of the Minchin school by introducing a secondary plot, a love story between Sara's riding instructor (Richard Greene) and her tutor (Anita Louise), and several musical sequences (including dances staged by Nicholas Castle and Ernest Belcher and a song, "The Fantasy," for little Shirley). The Cuarón film likewise lightens things up with a number of fantasy sequences that bring the stories in Sara's exotic Indian picture book to life. It also casts a young black girl (Vanessa Lee Chester) as the scullery maid, Becky—a change that adds a racial implication to her victimization at the hands of the abusive Minchins. As for the wicked Miss Minchin, her retribution is harsher, and as a consequence more satisfying than in the novel: She is reduced to the menial role of chimney sweep's assistant.

By contrast to the stark simplicity of the Pickford version and the hokum of the Temple, the Cuarón film is a brilliantly crafted, luxuriantly atmospheric, and dramatically satisfying fable. Above all, it is ravishing to look at, from the radiant, shadowless visions of her storybook to the shadow-haunted confines of the Minchin attic. Sharply drawn images come to mind: closeups of Sara's arching hands as she describes flights of angels to the other girls, the candle-lit procession of the students coming down a hallway, the sinister, gliding form of Miss Minchin as she descends the stairway, and the golden light suffusing Sara's room when she awakens to the miracle of the "phantom banquet."

REFERENCES

Carpenter, Angelica Shirley, and Jean Shirley, *Frances Hodgson Burnett: Beyond the Secret Garden* (Lerner Publications, 1990); Overton, Grant M., *The Women Who Make Our Novels* (Moffat, Yard & Company, 1922); Tibbetts, John C., "Mary Pickford: Remembering the Glad Girl," *American Classic Screen* (September–October 1976, 14–18, and November–December 1976), 18–21.

—*J.C.T.*

LITTLE WOMEN (1868)

LOUISA MAY ALCOTT

Little Women (1933), U.S.A., directed by George Cukor, adapted by Sarah Y. Mason and Victor Heerman; Metro-Goldwyn-Mayer.

Little Women (1949), U.S.A., directed by Mervyn LeRoy, adapted by Andrew Solt, Sarah Y. Mason, and Victor Heerman; Metro-Goldwyn Mayer.

Little Women (1994), U.S.A., directed by Gillian Armstrong, adapted by Robin Swicord; Columbia.

The Novel

Before Louisa May Alcott began writing *Little Women* in 1867, she had already written several stories and tackled a variety of literary genres, including sensational thrillers that appeared anonymously in weekly magazines. Then a publishing friend asked her to write a book for girls. Alcott agreed, although as she drafted the chapters she recorded in her journal, "I plod away, though I don't really enjoy this sort of thing. Never liked girls or knew many, except my sisters, but our queer plays and experiences may prove interesting, though I doubt it." Little did she know that she was composing one of the most well-received children's books to date. Her audience, which was not limited to young girls, grew in her lifetime. By the end of 1939, *Little Women* had been translated into over a dozen languages and had won various "best book" awards. While critics over the years have labeled the book as too preachy and sentimental, its appeal has not waned.

Little Women describes the journey from childhood to adulthood of the March sisters—Meg, Jo, Beth, and Amy. Their mother, affectionately known as Marmee, cares for them while their father serves as a Civil War preacher. They were once a well-to-do family before financial difficulties set in, but the girls entertain themselves by producing plays and a weekly newspaper. They soon befriend Laurie, the friendly, handsome, mischievous boy next door. The novel entertains readers with anecdotal tales such as Amy burning Jo's manuscript, Meg learning a difficult lesson at a ball, Beth's friendship with Laurie's grand-

father, and the sisters scolding Jo for her slang. Some years pass, and the sisters embark upon young adulthood. Meg becomes a wife and mother, Jo sells her stories and vows never to marry, Amy studies art in Europe, and Beth's health deteriorates. Meanwhile, Laurie falls in love with Jo. To quell her restless nature and to make Laurie forget her, Jo goes to New York City and continues to write, where she meets Professor Bhaer, an older, gentle, awkward scholar from Germany. Jo's rough edges and wild ways soften, and her respect and estimation for his intellect grows. He gives her German lessons and convinces her to stop writing sensational stories for magazines. After Jo rejects a proposal from Laurie, he flees with his grandfather to Europe where he and Amy grow closer. Jo focuses her attention on Beth, and she stays by her side until the end. Afterward, when Jo becomes melancholy and quiet, Marmee inspires her to write a novel for the family, and she records a collection of March memoirs. In the end, everyone is paired off: Amy and Laurie become engaged abroad, and Professor Bhaer marries Jo. Aunt March bequeaths Plumfield to Jo, and she opens a boys' school with the professor.

The Films

Not including two silent movie versions, there have been three adaptations of *Little Women*. In the 1933 film, which secured a best picture Oscar nomination, Katharine Hepburn leads a likable cast as the rambunctious and ambitious Jo. The screenwriters, who received an Academy Award for best adapted screenplay, incorporated many incidents from Alcott's book and added a few new but fitting scenes, like Jo sliding down the banister at Aunt March's (a memorable, comic portrayal by Edna May Oliver). In spite of the fact that thousands of readers have been disappointed with Professor Bhaer, Paul Lukas comes closest to portraying this plain, clumsy character of the three actors. All in all, Cukor's film is charming, albeit a bit dated and melodramatic for viewers of the present. For audiences in the 1930s, the film contrasted with the age of modernism and exuded a glow of nostalgia. According to a *New York Post* critic, *Little Women* was "a reminder that emotions and vitality and truth can be evoked from lavender and lace as well as from machine guns and precision dancing."

The screenwriters returned in 1949 and added Andrew Solt to the scripting team, but LeRoy's production is still a mediocre adaptation. The general tone of this Technicolor enterprise, where all of the successes are on the surface, is sugar-coated and misrepresents the struggles of the March family. The cutesy musical score, the immaculately made-up faces of the sisters, and the rainbow in the final shot all serve as precursors for the domestic bliss commonly associated with the upcoming decade. Furthermore, some of the casting is erroneous. With Margaret O'Brien playing a youthful, frail Beth, Elizabeth Taylor looks dreadfully out of place as a taller, more mature-looking Amy. While June Allyson's somewhat hoarse voice coincides nicely with the

boyish Jo, her perpetual smiles fail to reveal the character's tendency for a fiery temper and mood swings. Keeping in step with the gender politics of the post–World War II era when Rosie the Riveter was shooed back into the kitchen, Laurie (Peter Lawford) belittles Jo's stories on two separate occasions and cannot understand why she would choose to waste her time working for money. This contrasts sharply with Alcott's Laurie, who, upon learning that Jo is published, exclaims, "Hurrah for Miss March, the celebrated American authoress! . . . your stories are works of Shakespeare compared to half that rubbish that is published every day." Additionally, whenever Jo confronts Meg (Janet Leigh) about falling in love, she declares that her sister could not possibly love John because she lacks the stereotypical symptoms of the lovesick heroines in novels—fainting spells, loss of appetite and depression. This remark makes Jo look like a naive person and also detracts from the original who challenges gender relations with her steadfast belief against marriage in the quest for an autonomous life.

Anne Hollander criticizes Gillian Armstrong because she "seems determined to be true to Alcott the woman, and to see her book with a 1990's sensibility, rather than to respect the dated fictional efforts." The 1994 version does insert social concerns of Alcott into the dialogue, such as suffrage, segregated schools, child labor, transcendentalism, and feminist discussions between Marmee (Susan Sarandon) and her daughters. While none of these scenes

Louisa May Alcott

come directly from the book, they do not betray the spirit of the book, which does address women's place in society, the temperance movement, and stresses benevolent community service. In this fashion, the production seems more relevant for today's politically aware audiences. The result is a graceful film that lures us in with charm and its carefully unfolding story line.

The casting is superb. Claire Danes portrays the best Beth to date and delivers a powerhouse performance on her deathbed, and Kirsten Dunst explodes with personality as the younger Amy, who realistically transforms into the older Samantha Mathis to reflect a lapse of four years. Like the other two, it abandons the ubiquitous religious morality of the novel, which is a good thing since it has often received criticism for being too preachy. The saintly Marmee is an ironic, outspoken woman who is ready with sound advice for her daughters. In a scene that Swicord incorporates into the script, Jo and Meg, played by Winona Ryder and Trini Alvarado respectively, question the discrepancy in attitudes toward men and women drinking and flirting in public. Marmee explains that men can engage in such behavior with their reputations intact simply because of their gender. Ryder's voiceover may direct more of the audience's attention onto her character than the other sisters, but it is not surprising that Swicord chose this technique. After all, Jo is the sister with whom most readers identify—the awkward, sometimes unsatisfied, willful heroine—the one who wasn't pretty and popular. In writing the screenplay, Swicord views this story as a tale of strong women, and she ideally wants young girls to come away from the film with a sense of validation and feeling stronger in this male-dominated world. Finally, this production includes Aunt March's bequeathal of Plumfield to Jo, so that she could potentially have a project in her future other than marriage.

For generations, readers could not believe that Jo refuses Laurie and accepts the hand of Professor Bhaer. Alcott never intended to unite the pair, even after she received hundreds of letters following the appearance of the first installment: "Girls write to ask who the little women marry, as if that was the only end and aim of a woman's life. I *won't* marry Jo to Laurie to please anyone." What many readers may not know is that Alcott did not envision Professor Bhaer in the story and planned to model the heroine after herself—an unmarried artist. Consider what she wrote to a friend after the entire book was printed: "Jo should have remained a literary spinster but so many enthusiastic young ladies wrote to me clamorously demanding that she should marry Laurie, *or* somebody, that I didn't dare to refuse and out of perversity went and made a funny match for her." Like many authors, Alcott could not help but be influenced by the people for whom she created. But in spite of the fact that the conclusion of *Little Women* resembles an idyllic paradise, the reality is that Jo resigns to the traditional female role in the end. It is through her interaction with Professor Bhaer that her resignation becomes most evident and disturbing.

In the earlier chapters of *Little Women*, Jo's willful spirit, yearnings for adventure and her masculine mannerisms are apparent. She regrets not being a boy and struggles with her limits as a girl. After Laurie suggests that they travel to Washington, Jo replies, "If I was a boy, we'd run away together and have a capital time, but as I'm a miserable girl, I must be proper and stop at home. Don't tempt me, Teddy . . . prunes and prisms are my doom, and I may as well make up my mind to it." Yet in the end Jo does marry, not to her equal—her wild, dearest friend—but to a father figure who tames her and comes across more as a paternalistic mentor than a lover. What was once a story of a girl who shunned the acceptance of an oppressive feminine role becomes one of courtship and marriage. During a German lesson, Professor Bhaer grows impatient and stomps out of the room as if he were reprimanding a little child. Most notably, he discourages her writing—her one means of self-affirmation. Although she eventually writes a novel, she admits in the end that her dreams of her youth—to write and have wild adventures—seem in retrospect to be "lonely, selfish and cold."

The movie versions are not as horrific as the book itself. But one cannot ignore that Hepburn and Allyson sew on the professor's buttons and are called "my little friend." While Gabriel Byrne, who plays the most recent German scholar, is the furthest portrayal from the original, he is the one who seems to come the closest to a worthy partner for the heroine. As Hollander notes, "Armstrong's movie is the only one to reward Jo's forceful independence with a really sexy, intelligent lover who also won't interfere with her work."

REFERENCES

Estes, Angela M. and Kathleen Margaret Lant, "Dismembering the Text: The Horror of Louisa May Alcott's *Little Women*," *Children's Literature* 17 (1989): 98–123; Hollander, Anne, "Portraying *Little Women* through the Years," *New York Times*, January 15, 1995, H11, 21; MacFarquhar, Larissa, "Sweet 'N' Jo," *Premiere*, January 1995, 74–77; Myerson, Joel, Daniel Shealy, and Madeleine Stern, eds., *The Journals of Louisa May Alcott* (Little, Brown, 1989).

—R.L.N.

LOLITA (1955)

VLADIMIR NABOKOV

Lolita (1962), U.K., directed by Stanley Kubrick, adapted by Vladimir Nabokov; Seven Arts/Anya/Transworld.
Lolita (1997), U.K., directed by Adrian Lyne, adapted by Stephen Schiff; Guild/Pathé/Samuel Goldwyn Company.

The Novel

Although he had already published seven novels in Russian and two in English, Vladimir Nabokov was still a relatively

unknown expatriate teaching Russian literature at Cornell University when *Lolita* appeared in 1955. Its controversial depiction of an older man's obsession with a 12-year-old "nymphet" immediately became a cause célèbre. However, despite its scandalous reputation (it was banned in Paris from 1956 to 1958 and not published in full in America or the United Kingdom until 1958), *Lolita* in fact disappoints the merely prurient reader. Nabokov's elegant prose and ironic tone demands (but may baffle) closer attention.

Imprisoned in a psychiatric ward on a charge of murder, European expatriate Humbert Humbert pens a prison-diary account of his lifelong fascination with pubescent "nymphets." The seriocomic chronicle begins with his childish love for a little girl, Annabel Leigh, who dies of typhus. The adult Humbert, after periodic bouts of mental instability, emigrates to the United States and establishes himself as a French literary scholar. One summer in the New England town of Ramsdale, he meets and marries Charlotte Haze. The union is merely a pretext for Humbert to be near Charlotte's 12-year-old daughter, Lolita, who reminds him of the little girl he loved as a boy. When Charlotte dies in a freak car accident, Humbert takes his stepdaughter on a 12-month, 17,000-mile cross-country automobile trip. She "seduces" him before he can seduce her, and he discovers that she has long before lost her virginity. After an increasingly unhappy year of unpleasant domesticity at Beardsley College, Humbert takes Lolita on a second cross-country trip, only to lose her in Arizona. Years later, he finds her again, now 17, married, and pregnant. Lolita informs Humbert that she had left him to be with Clare Quilty (Humbert's nemesis and double), a popular playwright and pornographic filmmaker. Now she has left Quilty and needs money. Enraged with jealousy, Humbert kills Quilty. He is imprisoned and subsequently dies of a heart attack. One month later, Lolita dies in childbirth after delivering a stillborn daughter.

The Films

The novel has been adapted twice, by Stanley Kubrick and Nabokov and by Adrian Lyne and Stephen Schiff. The challenges lay in the subject matter—pedophilia remains a problematic subject, to say the least (the "Crimes and Criminal Procedure" section of the U.S. Code construes it as pornography)—and the novel's unreliable first-person narrative to adapt to the medium of the camera eye. As commentator Brandon French has noted, "A conventional notion of cinema as a recorder of what is preeminently *there* seems problematic for a novel which concerns itself with intangibles, uncertainties, and invisibilities, partial or total." The novel's introduction, penned by the hilariously pompous, fictitious Dr. John Ray, informs the reader immediately that Humbert is a "demented diarist" and a "panting maniac." And Humbert himself interrupts his narrative with asides that leave little doubt as to his mental state. For example, after noting that Lolita is the "light

of my life, fire of my loins," he notes that "you can always count on a murderer for a fancy prose style." The reader, simultaneously repelled, fascinated, and baffled, is complicit in Humbert/Nabokov's conspiracy of fact and fiction, observation and hallucination. As critic Michael Wood succinctly put it, "The difficulty with *Lolita* is not that it is an immoral book, but that it is soaked in Humbert's morality, that it leaves us scarcely anywhere else to go."

One year after filming *Spartacus* (1960), Stanley Kubrick turned to Vladimir Nabokov to collaborate on a screen version of *Lolita*. It was perhaps an odd move on the part of a filmmaker little disposed to adapting works of such worldwide acclaim. But, as Alexander Walker notes, "A forbidden devotion like that of Nabokov's hero, pursued under the surface of apparently orthodox society, put out ironic vibrations for him." Indeed, Kubrick described the book as "one of the few modern love stories" and, purportedly, at one point considered ending it with a marriage between Humbert and Lolita! Not surprisingly, Kubrick rewrote much of Nabokov's screenplay, although Nabokov ultimately received sole screen credit.

Perhaps because he felt the book's bizarre nature demanded directorial detachment, Kubrick employed a relatively unintrusive and pedestrian camera and cutting technique, choosing medium shots, neutral angles, and naturalistic lighting to avoid undue image distortion or exaggeration. The results effectively convey the banality of Humbert's life but little of the ecstatic lyricism of his fantasy and desire. As critic Andrew Sarris wrote, "We are never shown the inspired gestures and movements [that] transform even the most emotionally impoverished nymphet into a creature of fantasy and desire." Kubrick himself admitted that Nabokov's rhapsodic prose defied the camera: "If Nabokov had been a worse writer, my film might have been better." For his part, Nabokov later called the film a disappointment, claiming that very little of his screenplay survived in the finished film.

For all that, the film begins promisingly. Over the opening credits a man's hand tenderly applies toenail polish to the foot of a young girl. As the story proper begins, Humbert (James Mason) arrives in his white station wagon at the home of Clare Quilty (Peter Sellers). The subsequent confrontation and murder—a scene containing some invention by Kubrick and improvisations by Sellers—is packed with reflexive jokes (allusions to Kubrick's *Spartacus*) and sexual symbols (the use of hollow ping-pong balls to suggest Quilty's impotence). The remainder of the movie, with the aid of occasional narrative voice-overs by Humbert, flashes back to events leading up to this catastrophe. Kubrick's handling of Humbert's first glimpse of Lolita is memorable: Kubrick cuts abruptly from Humbert's voyeuristic gaze at Lolita in bikini and heart-shaped sunglasses to a scene from a horror movie. The next shot reveals Humbert, Lolita, and Charlotte sitting in the front seat of their car at a drive-in movie, watching *The Curse of Frankenstein*. Humbert, meanwhile, furtively lays his hand

on Lolita's, while Charlotte clasps his other hand. Sprinkled throughout the main narrative are dialogue exchanges to imply what the reader of Nabokov's novel knows—that Humbert is mad. At one point, for example, Lolita turns on Humbert and declares, "You're sick—you need help. You're imagining things."

Because of favorable financial conditions, Kubrick shot the film in England (his adopted home), sacrificing Nabokov's superlative evocation of the American western landscape of superhighways and cheap motels. James Mason's Humbert is no longer the tormented, dynamic game player of the novel—a "brilliant-but-mad literary raconteur" and a "monstrous child molester"—but a weak, befuddled professor. Shelley Winters's Charlotte is a perfect "haze" of kitschy confusion. The then 14-year-old Sue Lyon's Lolita, despite her seductive lollipop pose (a key MGM promotional image) was perhaps too old and self-aware to be convincing. She seems simply a "sex kitten" attracted to dirty old men. The novel's Lolita's "elusive, shifty, soul-shattering insidious charm" is lost here.

In America the film was restricted to audiences over the age of 18. Walker declares that this was interpreted "less as appeasement to morality groups like the Legion of Decency than as an additional allure for those who expected to see sex-play between a grown man and a virtual infant." According to Alexander Walker, Kubrick later admitted that his fear of the Hollywood Production Code kept him from depicting details of Humbert's erotic obsession. "Naturally I regret that the film could not be more erotic," Kubrick later said. "The eroticism of the story serves a very important purpose in the book, which was lacking in the film: it obscured any hint that Humbert Humbert loved Lolita. . . . It was very important [that Nabokov delayed] an awareness of his love until the end of the story, [but] I'm afraid that this was all too obvious in the film."

The 1998 Adrian Lyne/Stephen Schiff version has had a long and complicated script history. According to scholar Christopher C. Hudgins, there have been no less than four filmscripts commissioned by Lyne, by James Dearden in 1991, Harold Pinter in 1994, David Mamet in 1995, and Stephen Schiff (the one used by Lyne) in 1995. In brief, Hudgins concludes that the Pinter version is the best of the lot, the one that comes closest to the novel's complex irony. The Dearden and Mamet versions, on the other hand, are either too "pedestrian" (in the first instance), or too much at variance with the plot (in the second). The Schiff script, while displaying "critical intelligence," includes elements of the other three; it preserves the main plotline, "punches up" the humor and sex, and employs extensive voice-over narration by Humbert. In interviews on National Public Radio, for which he was formerly a film critic (he also worked as a staff writer for *The New Yorker*), Schiff declares that he felt he had to virtually "reinvent" Humbert and Lolita: They are an "odd couple" who, because each is seen imperfectly in the novel's subjective prose, have to be fleshed out for the more objective camera.

The movie begins with a blood-spattered Humbert (Jeremy Irons) driving his station wagon erratically down a country road. One hand clutches a revolver; the other, a child's hairpin. "Lolita, light of my life, fire in my loins," intones his voice-over; "my sin, my soul, Lolita. But there might have been no Lolita at all had I not first met Annabel." The story flashes back to a series of brief vignettes depicting the boy Humbert's meeting with the flirtatious Annabel and his abject grief at her untimely death from typhus. Years later the middle-aged Humbert arrives at the house of Charlotte Haze (Melanie Griffith) and, after seeing Lolita (Dominique Swain) lying on the lawn, the twin sprays of the sprinkler rising above her body, decides to stay on. It is clear his marriage to Charlotte is only a pretext to be near her daughter. When Charlotte discovers a diary by Humbert that reveals his revulsion toward her and his fascination with her daughter, she threatens to leave. Moments later, however, she is killed in an auto accident. Humbert immediately leaves to pick up Lolita from her summer camp, and soon the two are on the road. Her aggressive sexual teasing escalates beyond a few passionate kisses to an open invitation to make love. After a brief stay at Blakesley Prep School, where Humbert gets a teaching job, Lolita grows bored and demands that Humbert take her on another trip. Their relationship deteriorates, and she begins extorting money from him to continue dispensing her sexual favors. It is at this point that Humbert realizes he is being followed. The pursuer, he suspects, is one Clare Quilty (Frank Langella), a known pornographer and pedophile. Quilty eventually catches up to the couple and snatches Lolita away from right under Humbert's nose. Three years pass. Humbert has just about given up his frantic search for her when a letter arrives from Lolita. She is married (not to Quilty), pregnant, and in need of money. Humbert goes to her decrepit shack and, after giving her $4,000, invites her to run away with him. He realizes he is more in love with her than ever. But she rejects his offer and he leaves, distraught. Later, he confronts Clare Quilty and fires several rounds into his bloated body.

Humbert's narrative is almost over. Back in his car, careering crazily down the road, he is overtaken by state troopers. He staggers from his car and wanders into the trees. He pauses and gazes soulfully toward a distant valley from which emanate the sounds of children at play. A concluding title card states that he died in prison of a coronary and that a few months later Lolita died in childbirth.

Jeremy Irons's Humbert moves in a kind of protracted, soulful trance. He is presented as a pitiable, passive victim as much of the memory of his own childhood tragedy—"whatever happens to a boy during the summer he's fourteen can mark him for life"—as of Lolita's sexual enticements. His elegiac, humorless narrative tone is utterly serious and demands to be taken at face value. It is entirely bereft of Nabokov's ironic detachment and self-derision. And only in the concluding scenes, when he suffers from a nightmarish hallucination (the cause of which,

apparently is an illness, not the onset of madness) and goes berserk with Quilty, does his overwrought state of mind become apparent. Finally, in a major departure from the novel, Humbert, after declaring his love to the housewifely woman Lolita has become, ends up eulogizing the loss of the child, not the discovery of the woman. As he gazes at the pregnant Lolita standing in the doorway, her image dissolves back into the little girl she was when they first met. "And I knew that the hopelessly poignant thing was not Lolita's absence from my side," are his last words as he later gazes upon the children in the distant valley, "but the absence of her voice from that chorus."

One could argue that this Humbert is no pedophile at all. He is attracted only to Lolita, and it is made quite clear that that is due more to her resemblance to the lost Annabel than to anything pertaining to her age. At no time, for example, does he pay the slightest attention to the many other little girls that scamper about the edges of the story. It is the malevolent Clare Quilty who, by contrast, is the genuine pedophile. Director Adrian Lyne suggests Quilty's evil by literally keeping him in the shadows, veiling him in infernal smoke, pushing him to the edges of the frame (he even accompanies his presence at one point with the strains of Mussorgsky's "Night on Bald Mountain" on the soundtrack). Indeed, Quilty does not assume center stage until the final confrontation with Humbert, when he catalogues some dreadful details concerning his own pedophilic activities. Humbert, by this time, although clearly distraught, seems to be acting more like an avenging angel than a deranged maniac. He has ultimately fallen victim more to his misplaced passion than to anything else. This, again, is at considerable variance with Nabokov's intentions: The novel never pretends to moral uplift. It never excuses or diminishes what is clearly Humbert's wickedness. And it never elicits the viewer's approval of his actions.

Although Lyne did not have to knuckle under to the production code, as did Kubrick, he faced censorial constraints of his own. During the film's shooting, Congress passed the Child Pornography Prevention Act of 1996. Consequently, on a lawyer's advice, Lyne cut out most of the nudity, used a 19-year-old body double for Swain, and disallowed physical contact between Swain and Irons—a pad or a board separated their (mostly clothed) bodies. Lyne himself was quoted as protesting the film's moral high ground: "No one comes well out of it. They all die, for chrissake." The release of the "R"-rated film was held up in the United States for more than a year. It was first shown on the Showtime cable network in August 1998, then subsequently released to a limited number of theaters a month later.

The response was predictably mixed. In the United Kingdom, the *Daily Mail* moaned that "perverts will flock to this travesty"; and the *Times Literary Supplement* noted that Swain, like Sue Lyon before her, appeared as no nymphet but a "fetishized woman pretending to be a child in a consensual sex romp." Yet in America the mainstream

Entertainment Weekly sarcastically dismissed it as a "Lolita Lite," lamenting its "humorless" tone and "gauzy" piety: "It cowers before the morally self-righteous, sexually-spooked America of the late '90s." A more moderate view came from Anthony Lane in *The New Yorker*, who described it as a "slight, tender movie," full of "seedy regret," which displays a "careful, even loving, loyalty to the book [which] marks an advance upon the Kubrick version, which mangled the novelists's own screenplay."

REFERENCES

Appel, Alfred, Jr., *Nabokov's Dark Cinema* (Oxford University Press, 1974); French, Brandon, "The Celluloid Lolita: A Not-So-Crazy Quilt," in *Modern American Novel and the Movies*, eds. Gerald Peary and Roger Shatzkin (Frederick Ungar, 1978); James, Nick, "Humbert's Humbert," *Sight and Sound* 8, no. 5 (May 1998): 21–23; Lane, Anthony, "Lo and Behold: Why Can't America See the New *Lolita*?" *The New Yorker*, February 23–March 2, 1998; Tucker, Ken, "Little Girl Lust," *Entertainment Weekly*, July 31, 1998, 53–54; Walker, Alexander, *Stanley Kubrick Directs* (Harcourt, Brace, Jovanovich, 1971); Wood, Michael, "Revisiting Lolita," *The New York Review of Books*, March 26, 1998.

—*J.C.T.*

THE LONG GOODBYE (1953)

RAYMOND CHANDLER

The Long Goodbye (1973), U.S.A., directed by Robert Altman, adapted by Leigh Brackett; Lion's Gate/United Artists.

The Novel

The Long Goodbye is Chandler's last complete novel. It presents private detective Philip Marlowe as a loner and a loser, but still a man of integrity. He refuses money, influence, sex, and marriage, and shows tremendous loyalty to his friend Terry Lennox. Marlowe does, however, spend one night with Linda Loring, in a departure from the chaste chivalry of the earlier novels.

Marlowe gives his friend Terry Lennox a ride to the Tijuana Airport, no questions asked. When he returns to Los Angeles, Marlowe is in trouble with the police because Sylvia Lennox, Terry's rich wife, has been killed. Marlowe is released from jail when Lennox commits suicide in Mexico; the suicide note confesses to Sylvia's murder.

Marlowe is hired by the beautiful Eileen Wade to find her husband, alcoholic novelist Roger Wade. Marlowe discovers Wade at a shady clinic and brings him home. A few days later Marlowe helps again, carrying the drunken Mr. Wade to his studio. Mr. Wade is then killed by a pistol; it looks like suicide.

The very complicated plot continues as follows: Marlowe figures out that Eileen Wade killed both Sylvia Lennox and her husband; Mrs. Wade takes a fatal overdose of pills; Marlowe sleeps with Linda Loring, Sylvia

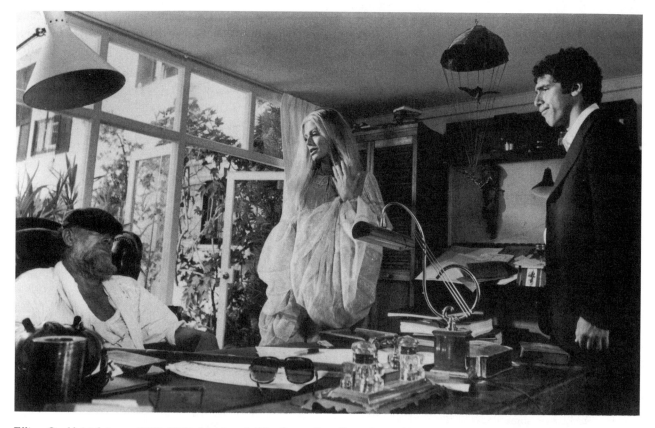

Elliott Gould (right) as a 1970s Philip Marlowe in The Long Goodbye, *directed by Robert Altman* (1973, U.S.A.; UA/ MUSEUM OF MODERN ART FILM STILLS ARCHIVE)

Lennox's sister, but refuses to marry her; Terry Lennox, alive, returns after plastic surgery to visit Marlowe. Marlowe refuses Terry's friendship and ends the novel alone.

The Film

Robert Altman's *The Long Goodbye* is very much an updated, Altmanized version of Chandler. Many of the director's signature traits are here: loose structure, overlapping dialogue, Elliot Gould as an antiheroic leading man. Altman not only simplifies a lengthy novel, he also changes several key plot points. In the film, Roger Wade really does commit suicide, Marlowe's cat is an important new character, and there is no Linda Loring. The most important change involves Marlowe's integrity and self-control. In the novel these are his heroic qualities. But the film ends with Marlowe losing all control and shooting Terry Lennox in anger. He is no longer Chandler's "knight" in a corrupt world; instead, Marlowe becomes a man no better than the rest of us.

William Luhr mentions in *Raymond Chandler and Film* that many admirers of Chandler hate Altman's film of *The Long Goodbye*. This antipathy is easy to understand: Not only is the adaptation a loose one, but also Marlowe loses his heroic virtues. There is one area, however, where Altman successfully emulates Chandler. Raymond Chandler

was a wonderfully acute observer of Los Angeles: the terrain, the subcultures, the psychology, the politics. Robert Altman is a similarly sharp observer of Los Angeles. In *The Long Goodbye* he shows us the all-night supermarket, the half-naked yoga faddists, the brutal cops, the unhappy enclaves of the rich, and—most of all—the loneliness of this demi-paradise. Altman may be debunking Chandler in some ways, but he follows the author's example by unsentimentally chronicling the Southern California of 1973.

REFERENCES

Durham, Philip, *Down These Mean Streets a Man Must Go: Raymond Chandler's Knight* (University of North Carolina Press, 1963); Keyssar, Helene, *Robert Altman's America* (Oxford University Press, 1991); Luhr, William, *Raymond Chandler and Film* (Ungar, 1982).

—P.A.L.

LORD JIM (1900)

JOSEPH CONRAD

Lord Jim (1925), U.S.A., directed by Victor Fleming, adapted by John Russell; Famous Players/Paramount.
Lord Jim (1964), U.K., directed and adapted by Richard Brooks; Columbia/Keep.

The Novel

Joseph Conrad's best-known novel began as a short story for periodical publication. Although contemporary critics generally faulted the novel-length version for its rambling construction, most modern critics agree that its narrative complexities do indeed establish a peculiar unity uniquely its own.

Jim's story, as told by his friend, the narrator named Marlow, begins when he goes to sea as a young man on a training ship for officers of the mercantile marine. After two years, he becomes chief mate of a fine ship. However, his hopes for an exemplary career are dashed when, as a result of an accident, his ship is disabled and he is charged with cowardice. Now an outcast, wandering from port to port, he takes a post as chief mate on the *Patna*, a battered old steamer carrying 800 Malayan pilgrims to Mecca. Once again, in a freak accident, the ship is disabled and Jim escapes. His action is branded as desertion.

At the subsequent investigation Jim meets the sympathetic Marlow and tells him his story. He explains that his escape from the *Patna* was the result of a instant decision that he now bitterly regrets. He considers suicide as the only way out. With Marlow's help, he wanders desultorily from temporary post to temporary post, always just ahead of incriminating rumors and gossip. Finally, a friend of Marlow's, Stein, appoints Jim manager of a trading post in remote Patusan. Jim finds the island divided into two camps, that of the cruel Rajah Allang and that of a native chief named Doramin. Allying himself with Doramin, Jim rids Patusan of the Rajah's forces and wins the devotion of the villagers, who dub him "Tuan Jim" (Lord Jim). His newfound success seems complete when he falls happily in love with a beautiful native girl he names Jewel.

Hearing rumors about the wealth of the great "Lord Jim," a roving pirate named Gentleman Brown attempts to plunder the Patusan stronghold. He is driven back and held under siege until Jim secures his promise to leave peacefully if released. But Brown betrays the agreement and ambushes the town. Jim is held to blame. No longer caring if he lives, Jim gives himself up to Doramin and is shot dead. Upon hearing the news Marlow wonders if at last Jim has found what he was looking for.

The Films

Victor Fleming's 1925 version is a lost film. According to the *AFI Catalogue of Feature Films, 1921–1930*, it dispenses altogether with the Marlow narrative apparatus. The structural complexities and digressions have been trimmed away for the sake of a quick, linear plot line. The story of Jim (Percy Marmont) now begins with the *Patna* incident. After several years of dissipation and vagabondage, he winds up in Patusan, where his past is unknown. He becomes a trusted friend of the local rajah (there's no trace of the native chief, Doramin) and a beloved adviser to the villagers. Peace is disrupted with the arrival of one Captain Brown and his men, former shipmates of Jim's now turned pirates. They betray Jim's peaceful overtures and kill the rajah's son. Under the law Jim's life is forfeit. The rajah executes him and he dies in the arms of Jewel (Shirley Mason).

Richard Brooks's 1964 adaptation casts Peter O'Toole as Jim, Jack Hawkins as Marlow, and James Mason as Gentleman Brown. The basic plot line of the first half of the book is retained, although, as a contrast to the earlier version, Marlow's character is present and the story is expanded to include incidents before the disaster on the *Patna*. Once Jim reaches Patusan, however, the story veers away slightly from the novel. Jim has come on an arms-delivering mission. When he discovers that the natives are enslaved by a warlord called the General, he conceals the weapons. He is captured by the warlord, but despite torture he refuses to disclose their whereabouts. A native girl (Daliah Lavi) helps him escape and he organizes a successful revolt. Disgruntled factions of the General call in Gentleman Brown, a pirate, to usurp Jim. In the climactic battle scene Jim dispatches Brown, but the son of the native chief is killed. Jim sacrifices his own life to appease the chief.

Brooks's script insists on Jim's innate heroism, blaming his guilty conscience more on his neurosis than on the reality of wrongful actions. Thus, the enigma of Jim and the subtle ironies of his story as Conrad filtered it through Marlow's narrative voice are lost. Moreover, as in many other attempts to adapt Conrad's works, the use of the film medium proves insufficient for Conrad's distancing techniques and philosophical ruminations.

REFERENCES

Kuehn, Robert E., ed., *Twentieth Century Interpretations of "Lord Jim"* (Prentice-Hall, 1969); Watts, Cedric, *A Preface to Conrad*, 2d ed. (Longman, 1993).

—S.H.W. and J.C.T.

THE LORD OF THE RINGS (1954–1955)

J.R.R. TOLKIEN

The Lord of the Rings (1978), U.S.A., directed and adapted by Ralph Bakshi; Saul Zaentz Productions/MGM.
The Lord of the Rings: The Fellowship of the Ring (2001); *The Two Towers* (2002); *The Return of the King* (2003). U.S.A. All three films directed by Peter Jackson, adapted by Jackson, Philippa Boyens and Fran Walsh; New Line Films.

The Novels

One day in 1930 John Ronald Reuel Tolkien (1892–1973), an Oxford professor of English language whose specialties included Old Norse languages and the West Midland dialect of Middle English, sat down in his study and wrote

this sentence: "In a hole in the ground there lived a hobbit." Thus began *The Hobbit*, published by Stanley Unwin in 1937, a tale of a diminutive, furry-footed fellow named Bilbo Baggins who, accompanied by a crotchety old wizard named Gandalf, journeys into the Wilderland of the East to rescue dwarf treasure from the lair of the dragon Smaug; and who returns to his native Shire with a curious golden ring. A sequel was in order. *The Lord of the Rings* didn't appear until almost 20 years later, 1954–55. Its epic 1,000-page heroic fantasy of a cosmic clash between good and evil was quite different from the light-hearted whimsy of its predecessor. Quaint old Gandalf was now an awesome figure of sorcery and moral order. Bilbo yielded the story to his nephew, Frodo Baggins, who was destined to lead the fight against encroaching evil. And that curious little ring was now the Ring of Power that held the key to the survival of humankind.

Tolkien had been thinking about these stories and their themes since his confrontation with the horrors of World War I at the Battle of the Somme with the Lancashire Fusiliers; and during World War II, when his son, Christopher, fought in the Royal Air Force. Although Tolkien always denied that the *Lord of the Rings* themes and conflicts were intended to symbolize both world wars, and that Mordor was supposed to represent Nazi Germany and/or Soviet Russia, he was nonetheless aware, declares Stratford Caldecott, "of its 'applicability' to the death camps and the gulags, to Fascism and Communism." Certainly his great theme was of a "paradise lost," a near-perfect beauty in the world that has been defeated and can never be regained.

Among the thousands of commentaries that have greeted these books, none are more sympathetic, yet tough-minded, than that of Tolkien's friend C.S. Lewis. He describes the trilogy as "like lightning from a clear sky," a myth as opposed to an allegory, a tale that appeals and relates to a generally ecumenical, apolitical readership: "What shows that we are reading myth, not allegory, is that there are no pointers to a specifically theological, or political, or psychological application. A myth points, for each reader, to the realm he lives in most. It is a master key; use it on what door you like." This last point might be construed as a caveat to those determined to read distinctly political and Christian implications in the work.

The trilogy's contrast between the peaceable, unpretentious mortal Hobbits of the western lands of Middle-earth and the destructive forces of immortal evil in the East is crucial. The Hobbits have been taking their humdrum happiness in the Shire for granted. They are forced to discover that their very existence has been hitherto protected by immortal powers of elves and wizards about which they have no concept. At any moment some, like Frodo Baggins, will find themselves expelled from that haven of harmony and thrust into the high conflict of good and evil. Yet *The Lord of the Rings* is not a simplistic saga of the Fellowship's defeat of Sauron, the victory of good over evil. Rather, as C.S. Lewis points out, it is only one of a thousand such battles against an eternal evil: "Every time we win we shall know that our victory is impermanent. If we insist on asking for the moral of the story, that is its moral: a recall from facile optimism and wailing pessimism alike, to that hard, yet not quite desperate, insight into Man's unchanging predicament by which heroic ages have lived." Thus, this is no escapist story: "What we chiefly escape is the illusions of our ordinary life," continues Lewis. "We certainly do not escape anguish. Despite many a snug fireside and many an hour of good cheer to gratify the Hobbit in each of us, anguish is, for me, almost the prevailing note. But not, as in the literature most typical of our age, the anguish of abnormal or contorted souls: rather that anguish of those who were happy before a certain darkness came up and will be happy if they live to see it gone."

As noted, in *The Hobbit*, a sort of elaborate prologue to the *Ring*, the hobbit Bilbo Baggins returns to the Shire after many adventures, wearing a ring wrested from a

J.R.R. Tolkien

strange being named Gollum or Smeagol who lived in darkness under a mountain. As the trilogy opens, Sauron, the Dark Lord, seeks out Bilbo's ring, which turns out to be one of several Rings of Power forged by the Elvensmiths of Eregion in the Second Age. Sauron of Mordor had assisted in the forging, but he infected the rings in the process with his malevolent designs. Bilbo's ring turns out to be the Master Ring, the ring that Sauron forged himself, which controlled all the others. But before Sauron could use it against his enemies, it was cut from his hand and ultimately was lost for thousands of years at the bottom of a riverbed. Gandalf knows the ring confers great powers, but it also inevitably destroys its wearer. It must be destroyed before Sauron retrieves it and wields its powers to destroy the world. However, he also knows that destruction of the ring has tragic consequences. When it is destroyed, the good works brought about by the other rings will also be undone. As Richard Mathews notes in his study of the trilogy, "*The Lord of the Rings* is a mythic embodiment of the paradox that one must lose one's life to save it. It is a narrative of loss—a loss that is echoed on many levels, from Bilbo's first giving up of the Ring and his life in the Shire, to Frodo's giving up the home and community he has found after the loss of his parents, to the final relinquishing and destruction of the Ring itself." It is a crucial point of the trilogy, and one that is often lost sight of by readers, fans, and filmmakers determined to make a happy romance out of the trilogy's conclusion.

At any rate, Gandalf persuades a reluctant Bilbo to give the ring over to his nephew, Frodo, and urgently demands that Frodo and his three Hobbit friends, Meriadoc "Merry" Brandybuck, Samwise Gamgee, and Peregrin "Pippin" Took set out to destroy it in the fires where it was forged, in Mount Doom, in the far eastern regions of Middle-earth, where Sauron dwells. Frodo is instinctively aware of the danger of this quest. "Bilbo went to find a treasure, there and back again," he says; "but I go to lose one, and not return, as far as I can see." The quest is immediately beset with dangers: Sauron's Black Riders invade the Shire. Only the intervention of a mysterious character named Strider, a Ranger of the wilderness, saves them. Together, they arrive at a center of art and learning called Rivendell, the home of Elrond, a king of the Elves. There, they are joined by Gimli the Dwarf, Legolas the Elf, and a man, Boromir of the kingdom of Gondor, to form the Fellowship of the Nine. They track their course through the vast underground city of Moria. There, in one of the great scenes in fantasy literature, Gandalf does battle with the fiery Balrog on the bridge of Khazad-dum. Locked in combat, Gandalf and the monster plunge to their deaths. Bereft of their leader, the remaining members of the fellowship find their way to the Elven realm of Lothlorien, where they gaze into the mirror of the Lady Galadriel and receive more historical and moral contexts to their mission.

The fellowship breaks up as Boromir succumbs to the ring's temptation and is killed while trying to seize it.

Merry and Pippin are abducted by a race of Sauron's henchmen called Orcs. Strider—now revealed to be Aragorn, returning from exile to claim the throne of Gondor—and Gimli and Legolas go in pursuit, and Frodo and Sam set off together toward Mordor. As Frodo and Sam continue their trek toward Mordor, they meet Gollum, who turns out to be the corrupt personality of the creature once called Smeagol. Although Frodo knows the history of this treacherous creature through Bilbo's stories, and suspects that he desires the ring for himself, he takes pity on him and accepts Gollum's offer to lead them to Mordor. Gollum betrays them by leading them into the lair of a demon spider, Shelob. Frodo is stung by the spider's poison, but Sam fights off the creature and makes off with the ring. Frodo, meanwhile, is captured by Orcs and taken to Mount Doom. Sam rescues him and returns the ring.

All this time the other members of the fellowship are undergoing their own adventures. Gandalf returns, having survived the tussle with the Balrog and newly empowered with greater magic. He is no longer Gandalf the Gray but Gandalf the White. He reunites with Aragorn and together they lead the forces of Rohan and Gondor against the evil wizard Saruman at the Battle of Helm's Deep. They then turn their attention to the besieged Gondor, where Sauron's forces are gathering. In a huge battle, Sauron's advance troops are routed. But the defenders of the West realize that one more battle lies ahead—they must advance toward Mordor in the hopes that they can distract Sauron from Frodo's mission.

While this final battle is brewing, Frodo and Sam reach the fires of Mount Doom at last. But just before releasing the ring, Frodo suddenly changes his mind and refuses to destroy it. He puts it on his finger instead. At this moment, Gollum reappears and, in a scuffle with Frodo, bites off Frodo's ring finger. But he loses his balance and plunges to his death, carrying the ring with him. The destruction of the ring turns the tide of the battle. The reinvigorated allied troops complete the rout as the Orcs and Trolls disperse in a panic. In some of Tolkien's finest writing, the aftermath of the scene is described: "For morning came, morning and a wind from the sea; and darkness was removed, and the hosts of Mordor wailed, and terror took them, and they fled, and died, and the hoofs of wrath rode over them. And then all the host of Rohan burst into song, and they sang as they slew, for the joy of battle was on them, and the sound of their singing that was fair and terrible came even to the City." Mordor falls into ruins. Gandalf arrives on the back of an eagle to rescue Frodo and Sam.

Back in Gondor, Aragorn is enthroned as king. All seems well, until the hobbits return to the Shire and find their village devastated and ruled by wicked ruffians, a gang of men, ruled by Saruman himself, fleeing from his defeat in the East. Sam, Merry, and Pippin organize a citizen's revolt, and soon they dispatch the villains. Years pass, and Hobbiton returns to normal—except that Frodo is plagued by bouts of illness. After chronicling his adventures in a

book, he tells Sam that he and the aging Bilbo must leave for the Grey Havens. "I tried to save the Shire," Frodo says, "and it has been saved, but not for me. It must often be so, Sam, when things are in danger: some one has to give them up, lose them, so that others may keep them." Sam objects, but Frodo continues, "You will . . . keep alive the memory of the age that is gone, so that people will remember the Great Danger and so love their beloved land all the more." Frodo and Bilbo join a company of Elves, including Galadriel and Elrond, who are passing out of Middle-earth forever. At a nearby quay they are greeted by Gandalf himself, who will take passage on the waiting ship with them. They disappear into the West, leaving the hobbits behind. Returning to his family, Sam regards his little daughter and, drawing a deep breath, says, "Well, I'm back."

It is the end of the Third Age. The Fourth Age begins. Good works as well as evil ones have been lost. The Golden Age is irretrievably gone; what remains is a fallen world, only partially redeemed. "The past can never be fully recovered," writes Richard Mathews, "but, consistent with his own Catholicism, Tolkien shows in his story that great faith and sacrifice in the fallen world can indeed limit the power of evil. Indeed, one *must* work constantly to prevent its triumph, and no price is too great to pay to prevent its victory."

Tolkien's 200,000-word trilogy involved not only six decades of thinking and work and revision—including his own publications and those supplementary editions published by his son, Christopher, of the extensive backstory, titled *The Silmarillion*, and a 12-volume series, *The History of Middle-earth*—but the invention of an entire language, stemming from his own academic study of languages. Indeed, as Stratford Caldecott reports, Tolkien was fond of saying that that he created Middle-earth partly in order to provide a fictional context for the speaking and writing of Elvish.

Few works in epic fantasy have elicited more comment and exerted more influence on subsequent works in the genre than *The Lord of the Rings*. Readers and scholars of varied backgrounds and interests have all appropriated it for their own devices. "Counterculture readers embraced its exaltation of nature and simple living above progress and the will to power," writes commentator Robert McClenaghan; "fans of adventure stories were captivated by its headlong pace; and scholars began to appreciate the extraordinary craft with which Tolkien, over a period of decades, had constructed his imagined world." By contrast, the trilogy has had its share of detractors. In a lengthy, thoughtful essay, commentator Jenny Turner responded to Tolkien champions like Professor Tom Shippey, a professor of philology and the author of several books about Tolkien, and reviewed the body of attacks against the trilogy's alleged misogyny and racism, its "adolescent" appeals, its occult systems, its derivative inventions, even its "dreadful" archaic prose style. She cites Edmund Wilson's charge that the trilogy is "hypertrophic . . . a children's book which has somehow got out

of hand . . . [displaying] a poverty of invention which is almost pathetic"; and poet John Heath-Stubbs's complaint that it is "a combination of Wagner and Winnie-the-Pooh." Such cavils notwithstanding, in 1997 voters in a BBC poll named *The Lord of the Rings* the greatest book of the 20th century. Two years later, Amazon.com customers chose it as the greatest book of the millennium.

The Films

Now overshadowed by New Zealand director Peter Jackson's monumental adaptation of the Tolkien trilogy, Ralph Bakshi's animated version of the *Lord of the Rings* appeared in 1978 and has been since reissued on DVD. It featured the voices of Christopher Guard as Frodo Baggins, William Squire as Gandalf, Michael Scholes as Samwise, John Hurt as Aragorn, Anthony Daniels as Legolas, and Peter Woodthorpe as Gollum. After British filmmaker John Boorman failed to bring his adaptation of the trilogy to the screen in the mid-1970s, American animator Bakshi (*Fritz the Cat*), a longtime admirer of Tolkien's work, decided that only animation techniques could fully realize a cinematic version of the novel. Extensive use of rotoscoping—an animation technique utilizing live-action films of actors as models—not only minimized budget costs and produced a "live-action" effect, but, less fortunately, clashed with scenes employing the more traditional use of the clumsier hand-drawn process. Such disparities incurred critical and popular outcries.

As for the adaptation itself, under instructions from producer Saul Zaentz, Bakshi reduced Tolkien's three books to a two-film project, the first part finishing after the battle at Helm's Deep (in *The Two Towers*). However, to the consternation of legions of Tolkien fans, the first half of the project was released in 1978 and advertised as the "complete" *The Lord of the Rings*. MGM had decided to drop Part Two and the project was mothballed. As a result, the compression of events dictated by the two-hour running time collapsed the storyline and the delineation of characters into a confusing succession of battles, each indistinguishable from the others, with little sense of closure to the narrative. Commentator Eamonn McCusker insists, however, that Bakshi's film does have its virtues, namely, scenes of Bilbo's birthday party in the Shire, Frodo's singing to Strider (Aragorn) in the tavern, the entry to the mines through the gates of Moria, and Peter Woodthorpe's voicing of the villainous Gollum. "This version of *The Lord of the Rings* is fascinating," concludes McCusker, "as it appears to be a textbook case of a director's ambition exceeding what was possible given the technical and financial conditions in which they found themselves operating."

Peter Jackson (*Heavenly Creatures*, 1994; *The Frighteners*, 1996) began his own *Lord of the Rings* project as a two-picture package backed by Miramax's Harvey and Bob Weinstein. "The technology has caught up with the incredible imagination that Tolkien injected into that story of his," declared Jackson, referring to the computer digital

Director Peter Jackson sets the stage for Orlando Bloom (Legolas) in The Lord of the Rings: The Two Towers (2002, U.S.A.; NEW LINE FILMS)

techniques he would employ in the films. "And so, this is the time." He was well aware of the expectations of the legions of Tolkien fans, many of whom had felt betrayed by the Bakshi project. "In the beginning," Jackson says, "it was a difficult tightrope to walk, but then we sort of abandoned thinking about it. If we make a good film, we'll be forgiven, whatever the crimes we commit to the book." But as expenses mounted, Jackson persuaded them to place it in "turnaround," allowing another studio to compensate Miramax for the time and money already expended (the Weinsteins' names are retained on the production credits). One by one, the other major studios backed away. But then New Line, a company not known for producing blockbusters, agreed to take it on as not a two-picture but a three-picture deal. Thus, the nine-hour trilogy was shot over a 14-month period, 1999–2000, in various locations in Jackson's native New Zealand.

In his lifetime, Tolkien himself advised that any film adaptation would be better served by an "abridgment" rather than a "compression" of the story. Cutting out subplots and travel sequences was preferable to imposing a breakneck pace onto the narrative. Jackson and his writers took him at his word. Of the trilogy's 22 chapters, three are not in the films at all (such as the whole Old Forest/Bar-

row Downs sequence) and another eight or nine are ancillary at most. The pacing, for the most part, is deliberate, and a proper emphasis has been placed on the elegiac tone and the core themes of corruption and loss that pervade most of Tolkien's original.

The first of Jackson's trilogy, *The Fellowship of the Ring*, was released only three months after the September 11, 2001, terrorist attacks. Commentator Jess Cagle claims that its "good-vs.-evil quest spoke to audiences looking for old-fashioned moral clarity . . . just as readers in the 1950s . . . found parallels to World War II, and hippies of the 1960s delighted in Tolkien's peace-loving hobbits." The film begins in biblical fashion with a voice intoning, "The Rings were forged." Note the passive voice. Who forged them? We don't know. (In Tolkien, the forging was by the Elvensmiths of Eregion.) The backstory—much of which has been cleverly visualized from the dialogue-heavy "Council of Elrond" section of *The Fellowship*—depicts in a series of swift images the distribution of the rings to gods and men—three rings to the Elven kings, seven rings to the Dwarf-Kings, nine rings to mortal men, and the lesser Rings of Power; and there is yet another ring, that forged by Sauron, the One Ring that controls the others; and the big battle between the Alliance of Free

People (elves, dwarves, ents, men, and hobbits), led by Elrond and Isildur against Sauron, from whose hand is cut the One Ring whose power would bind all the other rings. But the ring corrupts Isildur. (Omitted here are accounts of the Two Trees of Valar, the three jewels, called Silmarils, and the corruption of Morgoth in the First Age.)

Thus ends the Second Age. Isildur's ring is lost and it lies unknown at the bottom of a river for 2,000 years. Then, as the Third Age begins, the ring passes on to Smeagol (Gollum), who loses it. (It is recovered by Bilbo Baggins in *The Hobbit*, which precedes the trilogy). Years later it is passed on to Frodo (although not without great reluctance due to Bilbo's increasing possessiveness of it). At this point the defeated Sauron is stirring again and reaching out for the ring, which will enable him to bring darkness upon the land.

The time is now the Third Age, the location is Middle-earth. The action begins in Hobbiton on the occasion of Bilbo's "Eleventyeth Birthday" celebration. The wizard Gandalf the Gray (Ian McKellen) arrives to provide a fireworks display. But so also arrive Sauron's Night Riders, bent on recovering the ring. Sauron's dreaded "Eye" is active, even if his material form is not yet realized. At Gandalf's urging, his nephew Frodo (Elijah Wood) flees with the ring, accompanied by Meriadoc (Merry), Peregrin (Pippin), and Samwise (Sean Astin). Their quest is to travel eastward to Sauron's stronghold in the Land of Mordor and hurl the ring into the fires from which it came, in Mount Doom. On the road they meet the Ranger called Strider (Viggo Mortensen)—who will soon be revealed as Aragorn, the rightful king of Gondor—who helps them

Aragorn (Viggo Mortensen), Legolas (Orlando Bloom), and Gandalf (Sir Ian McKellan) (2002, U.S.A.; NEW LINE FILMS)

elude the Riders. (The previous adventure, with Tom Bombadil and his freeing of the hobbits from the Barrow-wights, is omitted.) Gandalf visits his fellow wizard, Saruman (Christopher Lee), at the Tower of Isengard and barely escapes with his life (he hooks a ride on an eagle) from his now-corrupted former friend. What follows is a swiftly-paced series of incidents—a chase where the immortal elf, Arwen (Liv Tyler), saves the wounded Frodo by calling upon the surf-steeds of the river to repel the pursuing Ringwraiths (in the book Frodo himself defies the villains); a healing respite at Rivendell, where the Lady of the Forest gives Frodo the magical *mithril* (chain mail); the forming of the Fellowship of Nine (Gandalf, Gimli the dwarf [John Rhys-Davies], Boromir of Gondor [Sean Bean], Legolas the Elf [Orlando Bloom], Frodo and the three hobbits); the fellowship's tunneling through the mines of Moria, where Gandalf is overthrown by the Balrog; a stay in Lothlorien and Frodo's glimpse of the future in the Mirror of Galadriel (at which time Galadriel successfully resists the temptation to take the ring from Frodo). At the end, several things happen all at once: Boromir's sudden attack on Frodo to acquire the ring, a battle with the Orcs wherein Boromir redeems himself but is killed, and the dispersal of the fellowship (Strider and Gimli and Legolas go to rescue the kidnapped Merry and Pippin, and Frodo and Sam venture alone toward Mordor).

By film's end, Gandalf is gone, the fellowship is dispersed, Saruman is breeding his own kind of monsters, Uruk-hai, cross-breeding Orcs with creatures that can exist in the daylight, and Frodo is already feeling the oppression of the ring. He realizes that its corrupting power is too strong for the immortals, and that only he is capable of bearing it to the destructive fires from which it was forged.

The viewer's first impression is the sheer size and texture of the film. It's big, with soaring mountains, plunging green valleys and rocky crevasses, wide blue skies, and ever-present lightning flickering on the reddened horizon of Mordor. Sauron's "Eye" is a flaming orb with a narrow, dark vertical slit in the middle. Gandalf's towering seven-foot height is contrasted with Bilbo's three-foot stature (an effect enhanced more by figure-ground distributions than by optical effects). The exterior locations in New Zealand lend a great deal of authenticity to the added special effects, matte paintings, and digitally generated images. Some of the scenes predictably sag under Tolkien's wispy female idealizations, like shots of the white-clad, aureole-crowned Galadriel. And there is a twinge of unease in the depiction of the good as white and the bad as dark. But so has it always been.

The most impressive sequences include Gandalf's escape borne aloft by an eagle from Saruman's Tower, Arwen's summoning of the surf-steeds, the Balrog's fiery whip that drags Gandalf down from the bridge, and Legolas's archery. Everywhere the camera swoops and dives, circling over the Balrog's bridge, plunging into the bowels of Saruman's fortress.

Tolkien's seriousness is merited—and honored—in the second film of Jackson's trilogy, *The Two Towers*. Although it teems with action—from the opening reprise of the battle between Gandalf and the Balrog to the climactic battle between the forces of men and elves and the armies of Saruman (with a particularly fine skirmish between Aragorn's men and the Wolves of Isengard in between)—there are some beautifully sensitive touches, such as the reflective moments when the immortal elf, Arwen, is warned by Elrond of the consequences of her marrying Aragorn, a mortal, and of her having to face a dreary gray life of mourning after his death. (The romance between Arwen and Aragorn doesn't appear in Tolkien's trilogy, but was based instead on an appendix that Tolkien later wrote.) Particularly outstanding are the many sequences with Gollum (a memorable performance by Andy Serkis, who supplies the voice and the modeling for the computer-generated images), a slippery, eel-like, slobbering gray figure clambering through the swamps and among the rocks. He is—and will be—the wild card in this deck of otherwise rigidly defined heroes and villains. His dialogues with himself—as the wicked, grasping Gollum, who thinks of nothing but recovering the ring; and the more pathetically human Smeagol, who responds to the compassion of Frodo—are beautifully captured through shifting camera angles and varying vocal intonations. The narrative strategy imitates Tolkien's method of construction—it cross-cuts among the various characters: Frodo and Sam's trek with Smeagol toward the reaches of Mordor; Aragorn and Legolas's pursuit of their friends; the capture of Meriadoc and Pippin by the gigantic Treebeard, Lord of the Ents; Gandalf's reappearance in snowy robes as Gandalf the White; Saruman's gathering of a vast army to march on the Rohan stronghold of Helm's Deep (a relatively brief episode in the book); the indecisive actions of the exiled army of Gondor; and the efforts of Gandalf to release King Theoden (Bernard Hill) of Edoras, in Rohan, and his army from Saruman's debilitating spell and defend themselves against the approaching dark armies.

More strongly articulated than before is the theme of machine against nature—or what cultural historian Leo Marx identifies as "The Machine in the Garden"—a fable of ecological disaster that lies at the core of Tolkien's epic. Saruman is identified by Treebeard as a man with "a metal mind." He despoils the forests and uses explosives and crossbows against the primitive swords and longbows of the men and elves. Indeed, it is only when Treebeard witnesses Saruman's devastation of his beloved forests that he and his fellow Ents swing into action. (Unfortunately, the design concept of the Ents comes dangerously close to resembling the animated trees of Disney's 1932 cartoon classic *Flowers and Trees*.)

While the aforementioned battle between Aragorn's army and the Wolves of Isengard is a beautifully mounted sequence limited mostly to close-order combat, the climactic battle of Helm's Deep, by contrast, is a far more grandiose affair, with spectacular roving aerial views of

Frodo (Elijah Wood) and Sam (Sean Astin) make the treacherous climb to Mount Doom. (2002, U.S.A.; NEW LINE FILMS)

the fight in progress as thousands of elves launch their arrows from the battlements against the rising ladders and swarming goblins of the enemy. It's a thrilling moment when Aragorn and King Theoden ride out from the besieged stronghold across a narrow bridge teeming with the murderous Uruk-hai to reunite with Gandalf's rescuing forces.

Jackson paces the two-and-a-half-hour film well, although the narrative rhythm comes rather too close at times to a hypnotically repetitive pattern of confrontation/near-defeat/last-minute rescue, so typical of late 19th-century and early 20th-century adventure stories by H. Rider Haggard, Talbot Mundy, and Edgar Rice Burroughs. Visually, the color palette and graphic design ranges from the pastel-hued clearings and dells of illustrator Arthur Rackham to the apocalyptic, flame-tinted horizons and steep cliffs of the British visionary John Martin.

The film ends with the men of Gondor releasing Frodo who, aided by Sam, is determined to continue their journey. Sam whimsically speculates that maybe Frodo's adventures might be mythologized in the future into story and song. Without a touch of irony, Frodo quietly predicts that "Sam the Brave" will surely become a part of it.

Purists will quibble at some of the changes and additions. Some are trivial. It seems unnecessary to depict Frodo as threatened by the authorities of Gondor, when, as in the book, he is merely detained by them. Another change concerns the Ents' behavior during the climactic scenes. In the film, it falls to Pippin and Meriadoc to show the Ents the forest devastation that Saruman has wrought. In the book, the Ents themselves assessed the damage and

sallied forth against Saruman (Treebeard hardly needed the hobbits to show him the way). Of greater importance, perhaps, is the deletion of Tolkien's key scene in which Gandalf breaks Saruman's staff after defeating his army. Some fans of the books consider this exciting scene the greatest face-off in the entire trilogy: "He raised his hand, and spoke slowly in a clear cold voice, 'Saruman, your staff is broken.' There was a crack, and the staff split asunder in Saruman's hand, and the head of it fell down at Gandalf's feet." At any rate, Saruman is defeated and will remain throughout the rest of the trilogy confined to his tower.

Due to its almost three-and-a-half hour length, *The Return of the King* is more leisurely paced than the preceding two films. Its prologue returns us to the moment when Smeagol first finds the ring at the bottom of a river. Immediately, the frenzy of possession overtakes him and he kills his brother, Deagol, in a fight over it. A swift montage shows the deleterious effects of his addiction to it, his retreat from society, the withering of his body, and his descent into madness.

The story proper begins as Frodo and Sam continue their journey to Mordor. Crosscut throughout are the adventures of the other characters—Merry and Pippin find themselves separated in the events surrounding the siege of Gondor; King Theoden rouses the Riders of Rohan (the Rohirrim) to ride to the rescue of the besieged city of Minas Tirith, chief city of the kingdom of Gondor (the lighting of the signal fires, alerting the scattered forces to arms, is one of the highlights of the entire trilogy); Gandalf discovers corruption in the court of the Gondor steward, Lord Denethor; and Aragorn, Gimli, and Legolas seek out

the Dead Men of the Mountain for assistance in the cause. The battle outside the walls is joined at last as the fierce Orcs, the flying Nazgul, and their enormous siege towers attack the fortress of Minas Tirith, only to find themselves overwhelmed by the onrushing Rohan cavalry. The Rohirrim victory, however, is fleeting, because moments later a horde of soldiers astride gigantic Mumakil (elephants) arrive on the scene to trample down the riders. But Aragorn returns in the nick of time with the shadowy company of the Dead, and the battle is won at last.

Frodo and Sam approach the slopes of Mount Doom. Gollum/Smeagol have done their best throughout this last leg of the journey to divide the two friends, arousing Frodo's suspicions about Sam. In anger, Frodo orders Sam to turn back without him. When Gollum at last reveals his true intentions to murder Frodo and steal back the ring, Sam returns just in time to drive Gollum back and resume the journey with the grateful but exhausted Frodo. Just when they arrive at the fiery pit, into which they are supposed to throw the ring, Frodo pauses. His features harden into the very face of greed. He declares his refusal to throw away the ring and slips it on his finger instead. At that moment, Gollum reappears. There's a tussle, during which Gollum bites off Frodo's ring finger and retrieves the ring. Frodo goes after him and the two plunge into the fiery pit. Frodo saves himself by grasping at the cliff edge. He is pulled to safety by the ever-helpful Sam.

During these events, another battle is waging. Aragorn and Gandalf, and the forces of men, elves, dwarves, and the armies of Rohan and Gondor have come to the Fields of Pelennor outside the Black Gate of Sauron. Encircled by the enemy, they refuse to give ground. Indeed, Aragorn cries out his summons to the Men of the West—"There may come a day when the courage of men will fall," he cries as he rides along the ranks of his men; "but that day *will not be today!*"—and he leads the charge forward. During the engagement, the earth begins to shake. The summit of Mount Doom in the distance begins to break up. The destruction of the ring is taking its toll. Sauron's Eye plunges from its tower. The ground opens up and swallows the evil armies. Frodo and Sam are left perched on a high, rocky hill to contemplate the ruins, until Gandalf, leading several eagles, swoops down and carries them off to safety.

Epilogue. Frodo awakens in the fresh light of spring. Watching over him are the survivors of the fellowship— Gimli, Legolas, Aragorn, and Sam. The scene changes to Minas Tirith, where Aragorn, joined by Arwen, is crowned as king. During the celebration, the four hobbits are paid tribute by Aragorn: "You shall bow to no one," he says, as he kneels before them. Back in the Shire, Frodo and Sam arrive back to rejoicing. Time passes. Frodo sits alone at his desk, finishing a book begun by Bilbo Baggins so long ago. The title page reads: "'The Hobbit: Or, There and Back Again,' by Bilbo Baggins." Underneath Bilbo's name, Frodo inscribes, "'The Lord of the Rings,' by Frodo Baggins." The tale is not yet finished, he tells Sam, who has looked in on him. "There is room for you." Another change of scene. Frodo and his friends escort the aging Bilbo to a waiting ship, where Elrond and Galadriel beckon him aboard to embark to the Gray Havens. Gandalf steps forward and invites Frodo to join them. Frodo's wounds have doomed him, and it is his time, too, to depart. After a series of hugs, he leaves his friends behind.

But there is yet one more scene. Back in Hobbiton, Sam turns in his gate to greet his wife and two children. There is so much joy ahead for him in the remaining years of his life. "I'm back," he sighs. They enter the little circular door. It closes. Fade out.

"Tolkien may be charting the victory, familiar from a hundred fairy tales, of good over evil," wrote *New Yorker* critic Anthony Lane after viewing *The Return of the King*. "But such mastery comes at a melancholy price, for it marks the end of one age—that of wizardry, elvishness, and free trips on the backs of giant eagles—and the dawning of another. From now on, men will rule Middle-earth, and one senses, both in Tolkien and in Peter Jackson's adaptation, a wistful belief that life, though fair and wisely governed, will be much less of a blast."

In the trilogy of films, Jackson and company astutely straightened out the convoluted story and made compromises in the selection of incidents and number of characters. Among the major changes are Aragorn's indecision about reclaiming his heritage as king of Gondor. It is only when he finally takes up his sword, Anduril ("The Flame of the West"), and only when Elrond warns him that Arwen is dying and will perish unless he claims his destiny (there is no such scene in the book, wherein he had prepared steadily and unreservedly for that role), that he relinquishes the title of Ranger and assumes that of the king of Gondor; Sam's momentary addiction to the allure of the ring, leading to Frodo's rejection of him (whereas in the book Sam had remained impervious to the allure of the ring); and the omission of Tolkien's rather lengthy epilogue, "The Scouring of the Shire," in which the hobbits return to the Shire and defeat Saruman's minions. Otherwise, the wealth of incident and event is closely followed.

"Director Peter Jackson has an epic on his hands," opined Lane. "The word 'epic' is tossed around, in movie circles, with regrettable abandon, being used as a critic's noun to describe any picture more than two and a half hours long. . . . But 'The Lord of the Rings' fits the bill, because of the unflagging momentum of Frodo's quest . . . and because Jackson has revived a grand and unembarrassable quality that sustained moviemakers from Griffith to the heyday of David Lean: he has nerve." Moreover, adds commentator T.A. Shippey, "It also shows the effects of decades of horror films in its use of special effects, for which the plot, of course, gives every opportunity. But what catches the eye, and the breath, is not so much the close-ups as the vistas deployed with staggering profusion, and swooped on from one strange camera angle after another." What deserves the most credit, continues Shippey, "is the severe concentration on and fidelity to the story's main theme of the corruption of power."

Moreover, the emphasis Jackson places on duty reluctantly shouldered, "comes very close to Tolkien's central theme. It is one which has not lost relevance for a contemporary audience."

Considered the riskiest endeavor in the history of cinema—not just because of the length of the original literary text and the extravagant budget, but because none of the cast members were first-rank movie stars at the time—the $310 million trilogy has earned, collectively, more than $3 billion at the box office (as of March 2004) and established Viggo Mortensen and Orlando Bloom (as Aragorn and Legolas, respectively) as marquee names. All of the films have been released on video and DVD in extended versions. Understandably, there are those who fear Tolkien's original books might become only advertisements for a multimedia franchise that could make *Star Wars* and *Star Trek* pale by comparison. "The footnotes, languages, scripts, maps and appendices that are so much a part of *The Lord of the Rings* experience," laments commentator Jenny Turner, "are about to be replaced with fast-food tie-ins . . . hit pop recordings, trading cards, furry backpacks." Indeed, that commodification and marketing is certainly well underway. It is to be hoped, however, that it might also have a reverse influence—steering rapturous viewers back to the books themselves, *The Hobbit* and the trilogy.

"It is evident that the grip of 'The Return of the King' on Mr. Jackson is not unlike the grasp the One Ring exerts over Frodo," wrote Elvis Mitchell in *The New York Times* after the release of the *The Return of the King*. "It's tough for him to let go, which is why the picture feels as if it has an excess of endings. But he can be forgiven. Why not allow him one last extra bow?"

Indeed, at this writing Jackson has already announced his interest in making a film version of the trilogy's prologue, *The Hobbit*.

REFERENCES

Cagle, Jess, "Lure of the Rings," *Time*, December 2, 2002, 83–90; Caldecott, Stratford, "The Horns of Hope: J.R.R. Tolkien and the Heroism of Hobbits," *The Chesterton Review* 1 and 2 (February/May 2002): 29–55; Lane, Anthony, "Full Circle," *The New Yorker*, January 5, 2004, 89–91; Lewis, C.S., "Tolkien's *The Lord of the Rings*," in Walter Hooper, ed., *C.S. Lewis: On Stories* (Harcourt Brace and Jovanovich, 1982), 83–90; Mathews, Richard, "Lord of the Rings," in Frank N. Magill, *Survey of Modern Fantasy Literature*, vol. 2 (Salem Press, 1983): 897–915; McCleneghan, Robert, "Lord of the Rings," in T.A. Shippey, and A.J. Sobczak, eds., *Magill's Guide to Science Fiction and Fantasy Literature*, vol. 3 (Salem Press, 1996), 562–564; McCusker, Eamonn, "The Lord of the Rings" (animated), DVD Times, www.imdb.com; McKinley, Jesse, "In the Seventh Year, 'Lord of the Rings' Rests," *The New York Times*, December 14, 2003, 15–24; Mitchell, Elvis, "Triumph Tinged with Regret in Middle Earth," *The New York Times*, December 16, 2003; Shippey, Tom, "Temptations for All Time," *Times Literary Supplement*, December 21, 2001, 16–17; Turner, Jenny, "Reasons for Liking Tolkien," *London Review of Books* 15 (November 2001): 15–24.

—*J.C.T.*

LOS CUATRO JINETES DEL APOCALIPSIS (1918)

See THE FOUR HORSEMEN OF THE APOCALYPSE.

THE LOST HONOR OF KATHARINA BLUM (*Die verlorene Ehre der Katharina Blum*) (1974)

HEINRICH BÖLL

The Lost Honor of Katharina Blum (1975), Germany, directed and adapted by Volker Schlöndorff and Margarethe von Trotta; Paramount-Orion/West Deutsche Rundfunk/Biskop-Film.

The Novel

Although he did not name it, Heinrich Böll chose the city in which he lived, Cologne, during the Carnaval season, for the setting of his novel *The Lost Honor of Katharina Blum*. Winner of the Nobel Prize for literature in 1972, Böll was a prolific postwar German writer who preferred to work through his war memories rather than just evoke them. Viewed as a satiric rendering of his horrendous experience during Nazi times, this novel realistically delineates the social pressures imposed upon a nonconformist individual.

From this setting emerges the importance of violence used for political reasons in a social environment driven to identify and eliminate its enemies. Western Germans reacted first with indifference, then with fear, to the fate of eastern Germans ruled by communism. These reactions revealed the witch-hunt mentality, promoted by a fear of terrorism, that led German policy for many years. Böll's full title for the novel clearly states the scope and purpose at work: *The Lost Honor of Katharina Blum or How Violence Develops and Where It Can Lead.* Katharina's humiliations by the press and the police lead to the total destruction of her life. Böll describes events in such detail to evoke the hard retribution with which society repays individuals who have transgressed rules. Böll's clear study of social types turns this novel into a clear psychological drama, stressing that life is a constant struggle directed by the individual against the coercive power of society.

After the disappearance of a wanted criminal, Ludwig Götten, with whom she happened to have spent the night, the romantic and supersensitive Katharina Blum finds herself persecuted by the police and harassed by a journalist, Werner Tötges, in need of sensational subjects for articles. In the course of the investigation, Katharina finds her private life scandalously published in the papers, her former husband Brettloh's lies used, her godmother Else Woltersheim interrogated, her friends and employers', Dr. and Mrs. Blorna, words distorted, her father posthumously accused of being a communist, and her ailing, cancerous mother traumatized by the press. After examining her

Angela Winkler in the title role in The Lost Honor of Katharina Blum, *directed by Volker Schlöndorff* (1975, WEST GERMANY; WEST DEUTSCHE RUNDFUNK-BISKOP-FILM/NATIONAL FILM ARCHIVE, LONDON)

finances, car mileage, and a ring worth 10,000 marks, police officer Beizmenne suspects that Katharina knows Götten's whereabouts. The police tap her phone and learn Götten's location when Katharina contacts Götten by phone. Götten had been hiding at the villa of one of Blorna's clients, Alois Sträubleder, a prominent political figure who had been Katharina's former lover. Revenge will come as a human lapse when, after her mother's death, Katharina invites Werner Tötges for an interview and murders him as the agent solely responsible for the destruction of her life.

The Film

The 1975 film produced by Volker Schlöndorff is considered a milestone in German cinema. Angela Winkler was cast as Blum. Through a series of refined shots, stressing enclosement and emphasized by Hans Werner Henze's eerie music, this film unveils Katharina's psychological drama. As the action is mostly mental and emotional, Schlöndorff contains the dramatic variables, Katharina's guilt, until the end so that suspense can develop. Repeated mention of time elapsed brings a false sense of objectivity

and a temporal continuum to the drama. Katharina and Beizmenne's portraits of the innocent victim and the tormentor are carefully drawn. Katharina and Ludwig's affair adds a romantic touch, as if the author wanted to point out the inappropriate moment of a long anticipated passion.

In *The Lost Honor of Katharina Blum*, Schlöndorff reflects upon the calculated exploitation of unrest and feelings of insecurity, which are characteristically used to describe life during Nazi times. This film raises feminist concerns because Katharina is a single woman whose only dream in life is the acquisition of her own apartment. This only escape from the dissatisfaction of her solitary life is destroyed when the privacy of this innocent woman is invaded by the police investigation and the press harassment. As a housekeeper-caterer or an accountant, Katharina is perfect to organize other people's lives. Unlike the press, which drags Katharina's reputation in the mud, Beizmenne knows that Katharina is innocent, but he coldly takes advantage of the situation. If he can break down Katharina's neutrality, under attack by the multiple aggressions of the press, he will be able to capture Götten. Beizmenne feels no sympathy with Katharina's difficult life

and her efforts to improve her social position. He knows that Katharina's most vulnerable aspect is her supersensitivity. The police's interest is not so much directed to Katharina's entertainment of her "gentlemen visitors" as to the destruction of her self-confidence with their crude remarks. Breaking down her defense by heavy questioning is a sure means to capturing Götten.

Schlöndorff's other preoccupation is to show us the pervasiveness of police proceedings and the helplessness of individuals in the face of social institutions. Even the cheering festivity of Carnaval leads to an ambiguous police search in which everyone's identity is questioned. The police exaggerated Götten's casual presence at Else Woltersheim's, ignoring the fact that the festivities did not allow the hosts to check their guests for identification. Götten's disappearance gives police the right to suspect everyone and penetrate the darkest corners of Katharina's life.

Finally, this film preshadows the fear that Germany experienced, in the seventies, facing a post–Baader-Meinhof generation of terrorism and kidnappings, which culminated in 1977 with the Lufthansa highjacking and the assassination of Hanns-Martin Schleyer, head of the largest association of corporation executives in Germany. In many ways, *The Lost Honor of Katharina Blum* captures the intense fears of a society under attack for its traditional moral and social values.

REFERENCES

Magretta, William and Joan, "Schlöndorff & von Trotta's The Lost Honor of Katharina Blum," in *Modern European Filmmakers and the Art of Adaptation*, ed. Andrew Horton and Joan Magretta (Frederick Ungar, 1981); Wallach, Martha, "Ideal and Idealized Victims: The Lost Honor of the Marquise von O., Effi Briest and Katharina Blum in Prose and Film," in *Women in Germany Yearbook 1, Feminist Studies and German Culture*, ed. Marianne Burkhard and Edith Waldstein (University Press of America, 1985).

—C-A.L.

THE LOVED ONE (1948)

EVELYN WAUGH

The Loved One (1965), U.S.A., directed by Tony Richardson, adapted by Terry Southern and Christopher Isherwood; Metro-Goldwyn-Mayer.

The Novel

The Loved One was the first novel by Evelyn Waugh to reach the screen. English antihero Dennis Barlow is a failed screenwriter and plagiarist poet who earns his keep working for a pet cemetery in Los Angeles. When his uncle, an elderly knight, loses his studio job and commits suicide, Dennis is thrust into the Hollywood funerary world. At "Whispering Glades" (an obvious parody of Forest Lawn) he falls in love with the mortuary cosmetologist, Aimée Thanatogenos. Baffled by the competing attentions of Dennis and Mr. Joyboy, a mortician, Aimée seeks counsel from a newspaper advice columnist. When, having become engaged to Dennis, Aimée learns that his love poems to her have been plagiarized from Poe, Aimée commits suicide in Mr. Joyboy's embalming rooms by injecting herself with embalming fluid. When Joyboy turns to Dennis for help, Dennis agrees to cremate Aimée at the pet cemetery, having first taken care to extort from Joyboy sufficient funds to return to England.

The Film

According to Pauline Kael, numerous authors (including Elaine May and Luis Buñuel) labored in vain to adapt *The Loved One* for the screen. Finally, Terry Southern (also screenwriter for Stanley Kubrick's *Dr. Strangelove* [1964]) adapted Christopher Isherwood's treatment of *The Loved One*. The resulting material was almost unfilmably vast (yielding, according to some accounts, a five-hour film before editing); it doubles (and sometimes triples and quadruples) the object of Evelyn Waugh's satire. In addition to the novel's original targets of cinema and the funeral industry, the film (advertised as featuring "something to offend everyone") takes on the military-industrial complex, the real estate business, advertising, and the space program. The film underscores the mirrored satires on Forest Lawn ("Whispering Glades") and pet funerals by casting Jonathan Winters in the twin (literally) roles of Wilbur Glenworthy ("The Dreamer" of Whispering Glades) and his brother Henry (proprietor of "The Happier Hunting Ground"), Dennis Barlow's employer. Robert Morse plays Dennis Barlow as a more jaded version of the opportunistic ingenue he would play in *How to Succeed in Business without Really Trying* on Broadway and the film (1967). The film also features Ayllene Gibbons in the role of Joyboy's mother, whose erotic obsession with food echoes the imagery Richardson had used in his adaptation of *Tom Jones* (1963).

Not for all tastes, this audacious film, directed by Tony Richardson, manages to take gallows humor further than Waugh dared—which may not always be a good thing. The final plot in which Dennis disposes of Aimée's remains by blasting them into space might seem a dated artifact of the excesses of the 1960s' "space age" consciousness—except that, in a bizarre twist, entrepreneurs of the 1990s began to implement this very scheme. The satire, while often effective and occasionally brilliant, threatens to topple under its own weight, and is not nearly as successful as Southern's *Dr. Strangelove*.

REFERENCES

Kael, Pauline, review, *Life*, October 22, 1965, 10; McCaffrey, Donald W., "*The Loved One:* An Irreverent, Invective, Dark Film Comedy," *Literature/Film Quarterly* 11 (1983): 83–87.

—M.O.

THE LOVER (*L'Amant*) (1984)

MARGUERITE DURAS

The Lover (1992), France, directed and adapted by Jean-Jacques Annaud; Renn Productions/Films A2/Burrill Productions (London), in collaboration with Giai Phong Film.

The Novel

Marguerite Duras, widely recognized as one of this century's most innovative and challenging figures, has been writing novels and plays and making films for over 50 years. However, it was not until her short autobiographical novel, *L'Amant* (The Lover), was awarded the prestigious French literary prize the Prix Goncourt soon after its publication in 1984 that she achieved the status of popular novelist. More than 1.5 million copies were sold, and the book has been translated into 43 languages.

The book recounts the story of Duras's first love affair, at the age of 15 1/2, with the heir to a Chinese business fortune. An impoverished white girl living in French colonial Saigon, she has left her mother's house to study at the lycée. She meets the elegant young Chinese man on a ferry boat crossing the Mekong River, and their passionate love affair lasts until they are forced to part, she to complete her studies in France, and he to marry the Chinese bride selected by his father.

The Film

The unprecedented success of the book rendered it highly attractive to the film industry; Claude Berri obtained the rights and chose Jean-Jacques Annaud as director. From the start, he envisaged a large-budget production, and his decision to make the film in English was an attempt to consolidate its anticipated success. Despite the original intention of allowing Duras to collaborate, she and Annaud were so radically different in their understanding of the text that she was soon banned from the set. While Annaud retained the narrative thread outlined above, he did little to compensate for the loss of the multi-layered complexity of the original, so that the story seems somewhat bare. Critical attention reflected this by tending to focus on the nude love-making scenes between the film's young stars (Tony Leung and Jane March).

L'Amant is an autobiographical work in which Duras is concerned not with historical fact but with the nature of memory. The central reference document is a photograph that was never taken, and this indicates something of the complexity of the work, much of whose fascination comes from its delicate and lyrical prose. The constantly shifting voices and viewpoints, and the destruction of syntax and narrative linearity suggest that remembering is both precarious and impossible to contain within the limits of a text.

Although Annaud professed a concern with Duras's writing, rather than with historical accuracy, little in his adaptation supports this. While his film follows strict chronological narrative development, it displays none of the complex self-consciousness of the original, but lays great emphasis on authenticity. Annaud restored buildings, rebuilt roads, and imported from Seattle the only Morris Léon Bollée 1929 (the car belonging to the Chinese man) still in existence. The film is visually beautiful and successfully captures the atmosphere of Saigon, but the delicacy and fascination of the original text is lost, and it had only limited success. Duras thought it a disaster, retaliating by publishing *L'Amant de la Chine du nord* as an indication of how she herself might have made the film.

REFERENCES

Ames, S.S., *Remains to Be Seen: Essays on Marguerite Duras* (Lang, 1988); Daney, S., "Falling out of love," *Sight and Sound*, July 1992, 14–16.

—*W.E.*

LUST FOR LIFE (1934)

IRVING STONE

Lust for Life (1956), U.S.A., directed by Vincente Minnelli, adapted by Norman Corwin; MGM.

The Novel

Lust for Life is a fictionalized account of the life of Vincent van Gogh, the first of many such biographies by the popular writer Irving Stone. The main source for the novel is van Gogh's letters to his brother Theo, published in English in three volumes in 1927–30. Stone also researched the novel in Europe, tracing the life of van Gogh in Holland, Belgium, and France, interviewing family and friends of van Gogh, including Paul Gachet, the last doctor who treated van Gogh. Although Stone claims that, aside from certain technical liberties, "the book is entirely true," the novel is an imagined and fictitious account of the thoughts, feelings, conversations, and actions of van Gogh from the early 1820s in London to his death in 1890.

The plot of *Lust for Life* follows the events of van Gogh's life, beginning with his employment in the London branch of the Paris art dealers Groupil & Cie, a job arranged through his Uncle Vincent who worked in The Hague. Giving up the art business and London, van Gogh turns to a religious vocation and goes to the Borinage, an impoverished coal-mining district in Belgium where he works as a lay preacher sharing the poverty and hopelessness of the miners. After losing the support of his religious superiors, van Gogh begins to draw the mining life in the Borinage. His brother Theo begins sending a share of his monthly salary to Vincent. Van Gogh decides to become an artist, working in Brussels and The Hague, where he

studies with Anton Mauve who encourages him to use color. Van Gogh alienates himself from Mauve and others because of his relations with Christine, a pregnant prostitute with whom van Gogh lives and plans to marry. Van Gogh's father and Theo advise him against the marriage, and his relations with Christine eventually collapse. Vincent also falls in love with his recently widowed cousin Kay Vos, who flees van Gogh's proclamations of love and refuses to allow Vincent to see her. He lives with his family in Nuenen for two years, painting and drawing every day, and is perceived as an eccentric by the local folk.

After his father's death, van Gogh moves to Paris for two years, living with his brother Theo who continues to support him. Theo introduces Vincent to many of the major painters, including Monet, Renoir, Degas, Pissarro, Toulouse-Lautrec, and Gauguin. Relations with Theo become strained due to his brother's difficult nature, and van Gogh moves to Arles in the south of France, where he finds the sun, colors, and light dazzling. Setting up residence at the "yellow house," Gauguin comes to live with him, and the two artists provide mutual inspiration and antagonism. Vincent cuts off his left ear after a serious quarrel with Gauguin, leaving it at a brothel, and Gauguin quickly leaves Arles the next day. Vincent is diagnosed as mentally ill, and after failing to reestablish himself in Arles, accepts Theo's advice to enter an asylum at nearby St. Remy, where he is diagnosed as epileptic. He slowly begins to paint again, undergoing periodic attacks that incapacitate him. Although discouraged by his doctor, van Gogh paints the surrounding landscapes relentlessly. Theo arranges for Vincent's move to Auvers-sur-Oise near Paris, where Dr. Gachet will supervise his health and recovery. Initially Vincent responds well to the new setting, but he becomes distressed with his own work and his reliance on Theo, who is undergoing new financial and family difficulties. One evening, Vincent shoots himself in the stomach while on a walk and returns to his room. He dies the next day with Theo at his bedside.

The Film

Lust for Life was Minnelli's favorite among his movies, and he spoke of it as "the only time I ever asked a studio to make a picture." Norman Corwin's script is largely faithful to the basic plot and development of Stone's novel, depicting van Gogh as the tortured and mentally unstable artist who craved the affection and love of others, and whose artistic production was driven by an insatiable need for self-fulfillment. While Kirk Douglas's portrayal of van Gogh may strike some viewers as exaggerated or theatrical, the choice of Douglas for the role seems appropriate and opportune. Douglas convincingly depicts van Gogh's sudden shifts from ecstatic exuberance about painting to his self-doubts and dejection over his failures in love and life, the rejection of his painting, and his mental instability.

Kirk Douglas is Vincent van Gogh in Lust for Life, *directed by Vincente Minnelli* (1956, U.S.A.; MGM/THEATRE COLLECTION, FREE LIBRARY OF PHILADELPHIA)

Unlike the novel, Minnelli's film begins with Vincent's obtaining an unpaid position in the Borinage to preach to the coal miners. After losing his position and being reunited with the brother (admirably played by James Donald), the film quickly progresses through van Gogh's "Dutch" period and his relations with Christine (Pamela Brown). While Stone's novel goes into detail narrating van Gogh' introduction to Paris life and artists, Minnelli, except for one of two unintentionally funny scenes, largely omits the aesthetic debates and artistic soirees of Paris. The character of Paul Gauguin (played by Anthony Quinn) dominates the Paris sequences, with Gauguin as a strong, confident, and larger-than-life personality.

The clash of Gauguin and van Gogh in Arles serves as the catalyst that drives van Gogh to cut off his ear in a scene that solicits the viewer's sympathy for Vincent and his mental collapse. Although historically inaccurate, van Gogh's final collapse and suicide is equally effective in presenting van Gogh in a heroic but futile struggle to maintain artistic and personal stability. Minnelli captures the viewer's sympathy for the alienated artist through the

voiceover of the compassionate Theo reading his brother's letters. Rather than continue the narrative, the letters help to establish Theo's claim to others that his brother is a great artist and human being tortured by his sensitive and vulnerable love for others and the world.

While James Naremore is correct in claiming that "this film can scarcely avoid the feeling of having been concocted in the salons of Beverly Hills," the film is an admirable and exceptional effort in retrieving the visual impact of van Gogh's painting, necessarily lost in Stone's novel. Most sequences were shot outdoors in the locations where van Gogh painted. Minnelli brings a number of paintings to life through his painstaking recreation of the natural scenes and people painted by van Gogh. The film allows the viewer to compare the paintings with the original subjects, implicitly arguing that van Gogh was a realist attuned to the subtleties in color and line already in nature.

Although Minnelli's film, following Stone's novel, risks clichés about the self-tortured and unappreciated artist (and both versions of *Lust for Life* helped to establish these clichés by turning van Gogh into the paradigmatic tortured artist), the film succeeds in developing an appreciation of van Gogh's art as well as his life. Using photographs of the original paintings, Minnelli inserts several montages into the film of the canvases, panning across a painting or zooming closer or away from the painting to focus the viewer's attention to details of color and brush stroke. While the visual impact of painting and film are typically contrasted on the basis of the lack of movement and static character of painting, Minnelli achieves a bridge between the two media by recreating the dynamic quality of van Gogh's art.

REFERENCES

Bleecker Street Cinema, *The Films of Vincente Minnelli* (Zoetrope, 1978); Harvey, Stephen, *Directed by Vincente Minnelli* (Museum of Modern Art and Harper & Row, 1989); Naremore, James, *The Films of Vincente Minnelli* (Cambridge University Press, 1993).

—*M.P.E.*

MADAME BOVARY (1857)

GUSTAVE FLAUBERT

Madame Bovary (1934), France, directed and adapted by Jean Renoir; Nouvelle Société de Film.

Madame Bovary (1937), Germany, directed and adapted by Gerhard Lamprecht; Terra Film.

Madame Bovary (1949), U.S.A., directed by Vincente Minnelli, adapted by Robert Ardrey; MGM.

Madame Bovary (1991), France, directed and adapted by Claude Chabrol, Marin-Karmitz–MK2–CED–FR3.

The Novel

At its publication in 1857, *Madame Bovary* became the subject of a court action attacking it as a dangerous and corrupting inducement to adultery. (To which accusation, Henry James replied that it could just as easily be used as a Sunday school text on the opposite.) Clearly, it shocked its contemporary readers by its refusal to provide explicit moral judgments; indeed, Flaubert wanted to make any such facile judgments impossible, seeking to inspire conflicting reactions, and requiring of the reader a creative and imaginative response.

Madame Bovary tells the tragic and apparently simple story of Emma, a passionate and romantic, but unfulfilled woman who can neither escape from, nor come to terms with, her humdrum existence. Emma is a farmer's daughter, whose convent education—creating an exaggerated sense of gentility and filling her mind with sentimental and romantic notions—does nothing to prepare her for reality. She marries Charles Bovary, a well-intentioned and

mediocre provincial doctor, and quickly discovers that despite his dogged devotion, marriage is not at all the romantic institution she had imagined. She therefore seeks to escape its monotony through a series of affairs; one lover, the local squire, uses her but abandons her when she becomes too demanding. The other is eventually frightened off by her romantic expectations, leaving Emma trapped and heavily in debt. An unscrupulous creditor threatens to expose her to her husband, and in despair, Emma poisons herself. Charles (with whose schooldays the book opens) ironically dies of a broken heart.

It is essential to recognize that the multilayered complexity of this tightly structured novel, along with Flaubert's constant preoccupation with style and language, means that the plot is probably the least important element. For Flaubert, what was important in a work of art was not the subject matter (Emma, for instance, cannot be considered a heroine) but its treatment; form and content, he maintained, are inseparable. Much of the fascination of *Madame Bovary* comes, therefore, from the constantly shifting viewpoints, the brilliant flashes of irony that serve to distance us from Emma, and the way tiny details create mood and atmosphere. It is easy, therefore, to appreciate both the fascination this novel exercises over filmmakers, and the stark problems it presents them with.

The Films

Madame Bovary's enormous influence on 20th-century culture extends to the cinema, the story having long fascinated filmmakers despite (or possibly because of) its inherent problems.

Renoir was the first director to accept the challenge, in 1934. His original version ran for over three hours; he was forced to make drastic cuts by his distributor, and some loss of coherence results. The quality of the surviving print is poor; nevertheless, Renoir's powerful camerawork—in particular, his stunning use of deep focus—is impressive, and he captures the conflicting beauty and boredom of the provincial world from which Emma longs to escape. Pierre Renoir's portrayal of Charles Bovary is excellent, although the acting of the rest of the cast, and particularly of Valentine Tessier in the title role, is theatrical and wooden. Nevertheless, the film provides a charming and unusual interpretation.

Gerhard Lamprecht's version, made in Germany in 1937, is competent, if rather more Germanic than French in tone. Its chief interest seems to have been that it starred the flamboyant Pola Negri, whose career in Hollywood had ended with the arrival of the talkies. It appears that the purpose of this film was to relaunch her career, with Hitler's blessing.

The 1949 version, directed by Vincente Minnelli, is also in black and white and has a strong cast, including Jennifer Jones in the role of Emma, whom she portrays as an incurable romantic, and Van Heflin as Charles, her husband. Minnelli actually includes Flaubert in the film, played by James Mason.

Claude Chabrol's 1991 version is lavish and beautifully crafted, with a convincing portrayal of Emma by Isabelle Huppert. The story is faithfully recreated, with only minor omissions or alterations (for example, the scenes from Charles's early life are left out, and his first wife is already dead when Emma meets him), but there is a flatness that perhaps indicates we are dealing with a novel of such multilayered complexity that a straight transfer into film is impossible. Flaubert was a great stylist, and his novel is much more than the simple story line suggests. For it is a novel that, while showing us the world through Emma's viewpoint, still allows us to recognize that this vision is flawed; and it demands an active and creative response from the reader. You must read between the lines if you are to understand the book.

Chabrol recognizes this problem and tries to make his film work at levels other than the straight narrative; however, he does not generally succeed. For instance, to reproduce the novel's distancing irony, he introduces a narrator whose comments overlap Emma's actions, or are interspersed with her own words. However, the ultimate effect is to authenticate Emma's viewpoint. Not coming from her but from an omniscient and unseen narrator, the words—which we should be learning to mistrust—acquire a serious and truthful aura. In the novel, for example, Emma's reflections upon why her life has been a failure reveal her inability to understand or to see things clearly. But when the narrator tells us why her life has been a failure, we tend to believe him.

Flaubert's irony, his carefully judged juxtapositioning of viewpoint and events, is not only effective, but also very funny. Again Chabrol attempts something similar, but too rarely and too clumsily. One brilliant example in the book is the local agricultural fair where, by cutting from the passionate dialogue between Emma and her lover Rodolphe to the prizes being awarded for livestock, Flaubert deflates the lovers' words and reveals their true nature. Chabrol attempts a similar cross-cutting, but it is labored and the humor is lost.

Given that many of the events in the novel are seen through Emma's eyes, Chabrol might have played more excitingly with this aspect. Two instances of his trying something similar are the blurred view of the bedroom when Emma is dying, and the low-angled, mobile camera shots when she is dancing at the ball. But generally the camera, which could have played an ironic and self-conscious role, remains transparent and neutral.

Emma's physical and mental breakdowns are convincingly portrayed, but the film merely recounts a banal story about a bored young housewife, while Flaubert's *Madame Bovary* is infinitely more complex, challenging, and enjoyable than that.

REFERENCES

Culler, J., *Flaubert: The Uses of Uncertainty* (Elek, 1974); *Revue d'histoire littéraire de la France* 4–5 (1981), special number devoted to Flaubert.

—*W.E.*

THE MAGNIFICENT AMBERSONS (1918)

BOOTH TARKINGTON

The Magnificent Ambersons (1942), U.S.A., directed and adapted by Orson Welles; Mercury/RKO.

The Novel

Booth Tarkington won his first Pulitzer Prize for this quintessentially American blend of nostalgic progressivism. Protagonist George Amberson Minafer comes of age in a rapidly and radically changing society, one in which his wealthy Midwestern family declines in power and prestige, overcome like many Gilded Age aristocrats by the twin forces of immigration and industrialization. Tarkington and his novel seem quite ambivalent about these two forces: Acclaim for Yankee ingenuity, American inclusiveness, and technological innovation is sometimes accompanied by bigotry and xenophobia.

Tarkington's novel also (and perhaps more successfully) explores Freudian notions of family romance. Georgie's mother, Isabel Amberson Minafer, dotes on Georgie; Tarkington implies that Isabel's sexuality is wholly sublimated into her devotion to her only child. He underscores the point by making George's father Wilbur into a milquetoast of no particular status or ability. Indeed, Isabel marries Wilbur only after she has been humiliated at a

misbegotten serenade by a drunken Eugene Morgan. Eugene is Tarkington's progressive hero, a free-spirited inventor who Isabel favors until his impulsiveness collides with her propriety. After this incident, Eugene leaves Midland in disgrace.

Many years later, a widowed Eugene returns to Midland and sets up an automobile factory. Wilbur conveniently dies soon after. Eugene begins secretly to court Isabel, while George begins a romance with Eugene's daughter Lucy. Now another character begins to shape the narrative: George's Aunt Fanny Minafer, Wilbur's sister, a spinster who has fallen in love with Eugene herself and vainly believes he welcomes her advances. Fanny's clumsy love intrigues succeed only in uncovering Eugene and Isabel's romance and provoking George into thwarting their plans to marry. Isabel dies of a broken heart, Eugene nurses a cold fury against George, Lucy shuns George though she still loves him, and Fanny loses her small inheritance in a failed investment—ironically, in automobile headlights. His own fortune gone, George does his duty by his aunt, and works in a dynamite factory to pay

for their apartment in a shabbily genteel boarding house. Later, in yet another irony, George is run over by an automobile and seriously injured. While he is hospitalized, George reconciles with Eugene and Lucy; Tarkington suggests they all live happily ever after.

The Film

Orson Welles's adaptation of *The Magnificent Ambersons* is arguably the greatest "lost" film of the sound era. In its original form, before RKO Studios cut 44 minutes and reshot much of the ending, it was perhaps a greater artistic achievement than *Citizen Kane*, Welles's first masterpiece. (Although the original footage is presumed lost forever, three "reconstructions" exist that rely on continuity scripts, storyboards, and production stills: the Voyager Company's laser disc [CC1109L], Robert L. Carringer's *The Magnificent Ambersons: A Reconstruction* [1993], and Jonathan Rosenbaum's lucid and cogent account in *This Is Orson Welles*.)

Although he did not by any means share Tarkington's bigotries, and although he readily admitted that Tarking-

Tim Holt in The Magnificent Ambersons, *directed by Orson Welles* (1942, U.S.A.; RKO/MUSEUM OF MODERN ART FILM STILLS ARCHIVE)

ton was not "a giant," Welles nevertheless insisted that Tarkington was an "extraordinary writer" who deserved serious attention. Welles also admired Tarkington's quixotic devotion to a certain chivalric gallantry, despite its being "hopelessly irrelevant." He said of his screenplay of *The Magnificent Ambersons* that whatever "doesn't come from the book is [nevertheless] a careful imitation of [Tarkington's] style."

Yet Welles's original cut of *The Magnificent Ambersons* enraged RKO precisely because of its striking *departures* from Tarkington's novel. RKO's version was actually much more faithful to Tarkington's happy ending than was Welles's version, which was long, frightening, and full of despair. Welles understated the matter when he called his changes to the novel "a third act which took the story into a darker, harder dimension." From all surviving evidence, Welles's original ending unflinchingly followed the Ambersons' decline to its blank and terrifying end—an existential finish in which Tarkington's bathetic reconciliation scene becomes an eerily formal report delivered by Eugene to a wasted and hollow Fanny Minafer as she sits alone and numb in a room full of mirrors, mocked by the cruel sound of a blackface vaudeville comedy record whispering on a scratchy gramophone. This scene, which Welles called the heart of the picture, comes after a spectacular series of tracking shots through the abandoned, graffiti-covered Amberson mansion, its still rooms and covered furnishings evoking a paradise not only lost but also defaced. This bleak sequence, cut by RKO, paralleled the first, festive look at the mansion during the opening Christmastime party given in Georgie's honor. Long takes and intricate tracking shots dominated both sequences; indeed, late in the film Welles directed an extraordinary 360-degree pan around the ruined ballroom.

From Welles's dark vision came two other important departures from Tarkington's novel. Throughout the narrative, victims of Georgie's snobbery long for him to get his "comeuppance." In the novel, George's comeuppance arrives when he cannot find "Amberson" in a list of Midland's 500 most prominent families. In Welles's film, however, George gets his comeuppance when he realizes he broke his mother's heart (and her will to live) by blocking her engagement to Eugene; this change underscores Welles's primary commitment to character over ideology. The other change is subtler but perhaps more important. In Welles's original cut, and to a large extent even in the RKO cut, the film of *The Magnificent Ambersons* gradually shifts its focus from George to Fanny, the maiden aunt whose ruined hopes end in exile and abandonment. Unlike George, when Fanny's derived, reflected magnificence disappears she is without even the memory of love or family splendor to console her. Welles's original film offered us a stark portrait of a lost soul and refused to sweeten our imaginations; like *King Lear*, Welles's *The Magnificent Ambersons* ended with a plangent repeated "never" tolling through the darkness. Is it any wonder that in 1942 RKO saw fit to replace this excruciating truthfulness with a con-trived and misleading finale, just as Nahum Tate did to *Lear* in 1680?

REFERENCES

Welles, Orson, and Peter Bogdanovich, *This Is Orson Welles*, ed. Jonathan Rosenbaum (HarperCollins, 1992); Naremore, James, *The Magic World of Orson Welles*, rev. ed. (Southern Methodist University Press, 1989).

—*W.G.C.*

THE MALTESE FALCON (1930)

DASHIELL HAMMETT

The Maltese Falcon (1931), U.S.A., directed by Roy Del Ruth, adapted by Maude Fulton, Lucien Hubbard, and Brown Holmes; Warner Bros.

Satan Met a Lady (1936), U.S.A., directed by William Dieterle, adapted by Brown Holmes; Warner Bros.

The Maltese Falcon (1941), U.S.A., directed and adapted by John Huston; Warner Bros.

The Novel

The Maltese Falcon, generally regarded as Dashiell Hammett's finest work, first appeared in 1929 as a serial in *Black Mask*, a popular pulp fiction magazine of the period. After gaining wider circulation via its publication in book form the next year, Hammett's taut and tense tale became crucial in establishing the hard-boiled detective story as a major and uniquely American genre. It also catapulted Hammett to the front rank of American novelists.

As exemplified by *The Maltese Falcon*, the hard-boiled style was tough and unsentimental. Its matter-of-fact tone was largely journalistic. Like a front-page crime story, the pell-mell pace was brisk. The narrator's voice was stoic and unemotional. Moral judgments, regardless of how sordid the crime, were left to the reader. The setting was the big city, most often late at night. The characters were edgy, their stories, spit out in rapid rat-a-tat bursts of dialogue, often ingenious yet suspect. Although operating within a generally amoral universe, the genre's archetypal protagonist, the private eye, found an ethical toehold in a loose yet vitally essential professional code.

The Maltese Falcon introduces private detective Sam Spade, a tough, cynical, and unassuming personality. In the novel, Spade can be seen as a forerunner of the antihero, a less than attractive and morally ambiguous character whose world, in this case, is the underbelly of San Francisco. In fact, Spade's chief source of income comes from chasing down wayward spouses. The plot is set in motion when Brigid O'Shaughnessy visits the office of Sam Spade and his partner Miles Archer to ask them to trail a Floyd Thursby. On the first day of the case, Archer is murdered. The police are inclined to suspect Spade since Archer's wife had been seeking a divorce in order to marry Spade. Spade persuades them otherwise.

Dashiell Hammett

Returning to his office, Spade meets the effete Joel Cairo who offers him a reward for the recovery of a statuette, the "Maltese Falcon" of the novel's title. Later he learns that Brigid, a duplicitous femme fatale, is also somehow involved in the quest for the falcon. He next encounters the unctuous Casper Gutman, a solicitous and sinister fat man. Gutman, too, seeks the falcon. Why? It's a medieval icon encrusted with precious jewels but covered with black enamel for protection. Tailing Spade as he pursues his investigation is Wilmer, an evil young man in Gutman's employ, determined to be as brutally nasty as possible.

After a suspenseful sequence of wild-goose chases and misadventures involving the comings and goings of all principals, a bundle containing the falcon finally arrives at Spade's apartment. With nervous anticipation, Gutman opens the package, scratching away some enamel to make sure that it's the genuine item. Surprise! Instead of the fabulously valuable 16th-century figurine, it's a lead imitation. In the novel's denouement, Spade calls for the police to pick up Gutman, Cairo, and Wilmer.

A final twist occurs when Brigid confesses to Spade that it was she who killed Archer. Although attracted to one another, Spade tells Brigid that he has to turn her in.

It is an act doubly motivated. While clearing him of suspicion in Archer's murder, it's also the fulfillment of the unstated yet fully understood professional code mandating that he avenge his partner's death.

The Films

Hot on the heels of the novel's publication in 1930, screen rights were purchased by Warner Bros. who immediately turned it into a tepid, low-budget romp directed by Roy Del Ruth. *Variety* called it a "placid program candidate which can't expect to do much more than give the theaters an even break." In 1936, Hammett's hard-boiled work turned up as the soft-boiled *Satan Met a Lady*, directed by William Dieterle. Played for laughs, with the falcon transformed into a gem-filled ram's horn, Bette Davis, who considered the film one of the low-points in her career, co-starred with Warren William. These two versions are happily forgotten.

In 1941, another script appeared. When studio boss Jack Warner read it, he liked it because it retained the dark overtones of Hammett's novel. The adapter was a young screenwriter named John Huston. Warner was so enthused that he granted Huston's wish to direct. When George Raft refused to play Sam Spade on grounds that he didn't want to work for a first-time director, the role fell to Humphrey Bogart.

Given the customary "gangster" budget of $300,000 and a tight shooting schedule of six weeks, Huston and his crew worked a miracle. Indeed, just as Hammett's novel ushered in the genre of hard-boiled fiction, Huston's precocious directorial debut opened the door for the film noir. With the film's critical and box-office success, Huston was suddenly cast into the front rank of Warners' directors. And in his nuanced portrayal of the cynical private eye caught in a den of jackals, Humphrey Bogart emerged a star.

Huston's script closely follows the contours of Hammett's plot. Indeed, the aspects that made the book unique, its malevolently paranoid and sharp-tongued characters, its unrelenting focus on the basest of human motives, are not only retained but also embellished. Then there is the first-rate cast. Bogart's Sam Spade is at once tough and vulnerable. Mary Astor gives nervous life to the mysterious Brigid O'Shaughnessy whose feigned fragility masks a greed so intense as to rationalize murder. For the effeminate Joel Cairo, Peter Lorre unleashes a disturbingly effective hiss. With his huge girth and faux sophistication, Sydney Greenstreet, in his screen debut at the age of 61, is the very embodiment of Kaspar Gutman (for the film, Hammett's "Casper" becomes the more exotically foreign "Kasp").

At the end, Spade's dilemma over what to do about Brigid comes to a deliciously disturbing close. As he debates the pros and cons of letting Brigid take the fall, he tries to balance her deceitful and murderous nature against the possibility of love. Refusing to believe that he's going to turn her in, she makes a final appeal. In response, he

says, "Listen. When a man's partner's killed, he's supposed to do something about it. It doesn't make any difference what you thought of him. He was your partner and you're supposed to do something about it." Here, the scales of justice are titled not by love or guilt, but they code of a professional.

With Huston's textbook perfect direction, every shot, every scene is distilled to its dramatic and ironic essence. The themes of greed and corruption play with waspish panache. Huston's visual treatment, though not as dark as the classic film noirs that would soon follow, nonetheless establishes the cramped, claustrophobic cosmos from which none of the characters escape unscathed. For a first-time director, Huston's ability to keep the tone unrelentingly arch and nasty is remarkable.

Although a few critics have taken exception to Huston's ironic treatment where we simultaneously laugh and shiver at such extravagances as Lorre's gardenia-scented threats or Greenstreet's seriocomic shortcomings as a mastermind, *The Maltese Falcon* remains a beloved and still highly entertaining classic.

REFERENCES

Cooper, Stephen, ed., *Perspectives on John Huston* (G.K. Hall, 1994); Hammen, Scott, *John Huston* (Twayne, 1985); Kaminsky, Stuart, *John Huston: Maker of Magic* (Houghton Mifflin, 1978); Silver, Alain and Elizabeth Ward, eds., *Film Noir: An Encyclopedic Reference to the American Style* (Overlook Press, 1979); Studlar, Gaylyn and David Desser, *Reflections in a Male Eye: John Huston and the American Experience* (Smithsonian Institution Press, 1993).

—C.M.B.

THE MAMBO KINGS PLAY SONGS OF LOVE (1989)

OSCAR HIJUELOS

The Mambo Kings (1992), U.S.A., directed by Arne Glimcher, adapted by Cynthia Cidre; Warner Bros.

The Novel

Cuban-American author Oscar Hijuelos won the Pulitzer Prize for this novel about two Cuban immigrant brothers coming to New York in 1949. Their early encounters in the United States are predictably tough. They find themselves trapped in the urban ghetto that offers little chance of escape from grueling jobs at low wages. However, their musical talents, showcased in Spanish Harlem nightclubs, eventually give them the "big break" into more financially rewarding show business. Their benefactor is none other than Desiderio Arnaz, the most famous Cuban entertainer in the United States.

Beyond the themes of immigrant experience, artistic success and decline, looms the larger theme of brotherly love between two men who are very different. The elder is strong, selfish, almost an antihero, while the younger is cor-respondingly angelic and vulnerable. After years of evading responsibility for his only daughter and eschewing female relationships with any emotional depth, the older brother is consumed by guilt at inadvertently causing his younger brother's death. Hijuelos leaves us with the character as a weakened, regretful, old man, who is now alone in life.

The Film

The film foregrounds the mambo music and is often categorized as a musical in video stores. It also emphasizes the meeting with Desi Arnaz and Lucille Ball in an artful montage of old clips. Although Desi Arnaz Jr. (in the role of his father) resembles the late Desi Arnaz, there is something disconcerting about his exaggerated laugh and accent, which threatens to become a parody. Nevertheless, the scenery is beautiful, and Armand Assante and Antonio Banderas adeptly evoke the dedicated musician's passion in some brilliant scenes that simultaneously show the deep bond between the two brothers. Specifically, the scene that depicts their musical debut in New York is expertly cut between the enthusiastic response of dancing club patrons, the energy of the band, and the brothers' mutual joy in their success. Through a vibrant soundtrack and fast-paced montage, the emotional aspect of performance and the bond between two musicians and brothers are directly communicated to the viewer.

The film emphasizes the atmosphere of the nightclubs. In terms of characterizations, the novel's elder brother is more extreme in his self-centeredness. The film keeps him as the rogue of the pair, but definitely plays down some of the uglier character flaws that presumably might have made a film audience unsympathetic. A car accident kills the younger brother, and essentially the vibrant spirit of the older, who declines in sorrow, guilt, and alcohol. The film deftly sidesteps the pathos of the novel by ending with a sadder, wiser—but still handsome—older brother, who has fulfilled his younger brother's dream of opening a nightclub. It's worth noting that this was a dream that failed in the novel.

REFERENCES

Barbato, Joseph, "Latino Writers in the American Market: in the Aftermath of Winning a Major Literary Prize a Minority Culture Faces a Welcome Threat: Mainstreaming," *Publishers Weekly*, February 1, 1991; Bergheim, Kim, "Remembering Dad," *Hispanic*, June 1991.

—K.E.K.

THE MANCHURIAN CANDIDATE (1959)

RICHARD CONDON

The Manchurian Candidate (1962), U.S.A., directed by John Frankenheimer, adapted by George Axelrod; MC/United Artists.

The Manchurian Candidate (2004), U.S.A., directed by Jonathan Demme, adapted by Daniel Pyne and Dean Georgaris; Paramount Pictures.

The Novel

Sergeant Raymond Shaw has recently returned from the Korean War. He is a hero, awarded the Congressional Medal of Honor. But in fact, his heroic deeds—single-handedly saving his patrol from an enemy attack while wiping out an entire company of Chinese infantry—have actually been planted in the minds of his fellow soldiers through a process of Pavlovian-inspired brainwashing. Raymond has been conditioned as an assassin (protected because he has no memory of his deeds, and thus no guilt or fear), who demonstrated his abilities by killing two of the most likable soldiers in his patrol before an audience of Russian and Chinese Communist Party officials. Two survivors of the "enemy attack" begin having nightmares, however, in which they see Raymond commit these murders. One of these survivors, Bennett Marco, begins an investigation, trying to determine how he could have such

vile dreams about a man he has been conditioned to believe is the bravest, kindest, best man he has ever known.

As a Medal of Honor winner, Raymond is being exploited by his politically ambitious mother, Eleanor Iselin, for the further advancement of the career of her husband, Senator John Iselin. As Eleanor's puppet, "Big John" Iselin begins making a series of McCarthy-like charges against the secretary of defense, claiming that there are a wildly varying number of card-carrying communists within the department. Raymond, under the control of his American operator, commits a number of murders. Marco, through his investigation, manages to learn the key to Raymond's control, a game of solitaire, played until the appearance of the queen of diamonds, which has been selected because of its connections to Raymond's domineering mother.

Raymond's American operator is finally revealed to be his mother, under whose direction he kills his father-in-law, a political enemy of Senator Iselin, and his own much-beloved wife. In agony over her loss, Raymond turns to Marco for help. Marco reconditions Raymond via a game of solitaire, getting him to reveal his ultimate purpose—to kill the presidential nominee at the party convention so

Frank Sinatra in The Manchurian Candidate, *directed by John Frankenheimer* (1962, U.S.A.; UA/THEATRE COLLECTION, FREE LIBRARY OF PHILADELPHIA)

that Senator Iselin, the vice presidential nominee, will be swept into office in the aftermath, thus giving the communists a profound foothold in the United States. Marco changes Raymond's orders, and so when the time comes, Raymond shoots and kills Iselin and his own mother rather than the nominee. After the shooting, Marco gives Raymond one last instruction: to kill himself.

The Films

The film adaptation created quite an uproar when it was originally released in 1962, by implication that the Far Right was nothing more than a tool of the Far Left. This was not, however, an implication that John Frankenheimer or George Axelrod dreamed up. It came from Condon's book, which Axelrod follows faithfully in his screenplay. In fact, the film is remarkably faithful to the novel. One of Frankenheimer's most remarkable inventions in the film is the parallel montage effect of the scenes in which Raymond's brainwashing is demonstrated to the party officials in Manchuria: A continuously moving camera reveals two different scenes, the meeting of a ladies' garden club, which the men believe they are observing, and the actual gathering of Chinese and Soviet communists. As the scenes continue, images of each trade places with their counterparts, producing a wonderfully disorienting sense of two realities colliding.

There are, however, a number of significant changes in the text, which take place in the translation from novel to film, most notably the removal of all traces of sex and drugs. In the novel, it is made clear that the Oedipal nightmare that is Raymond Shaw's mother was created by her sexual relationship with her own father; it is also clear that her relationship with Raymond is likewise incestuous. This incestuous relationship is implied in the film, but the implication is reduced to one "improper" kiss, which Angela Lansbury's Eleanor Iselin gives her son (Laurence Harvey). Moreover, one of the clues that proves that Raymond has been brainwashed is that his complete sexual repression before the war has lifted. This element of his transformation is never brought into the film. Finally, much is made throughout the novel of Eleanor Iselin's morphine and heroin use.

The most interesting change rests in the treatment of Raymond Shaw's fate. In the film, Marco does not figure out what Raymond is going to do until it is almost too late; he rushes toward the spotlight booth from which Raymond is to fire his rifle, but arrives just after he has pulled the trigger. The decision to shoot his mother and stepfather rather than the presidential nominee was thus Raymond's, as was the decision a split second later to take his own life. Frank Sinatra's Marco is thus kept clear of implication in any of the film's deaths.

The 2004 remake, directed by Jonathan Demme and scripted by Daniel Pyne and Dean Georgaris, moves farther away from the novel and the paranoid politics of the 1950s by updating the capture from Korea to Kuwait and the Gulf War. It changes the nature of the conspiracy, the

details of the brainwashing process (chemical implants replace post-hypnotic suggestion), and even the characters of the assassin and the investigating officer. Denzel Washington plays Marco, with Meryl Streep as evil Eleanor and Liev Schreiber as her son. As a result, so much is changed that the original story is hardly recognizable. Fans of the original will certainly miss the surreal garden parties, the Queen of Diamonds, and especially Angela Lansbury.

REFERENCES

Doherty, Thomas, "A Second Look," *Cineaste* 16, no. 4 (1988): 30–31; Pratley, Gerald, *The Cinema of John Frankenheimer* (A. Zwemmer, 1969).

—*K.F. and J.M. Welsh*

MANHUNTER

See RED DRAGON.

THE MAN IN THE IRON MASK (1848–1850)

ALEXANDRE DUMAS

The Iron Mask (1929), U.S.A., directed by Allan Dwan, adapted by Elton Thomas and Lotta Woods; United Artists.
The Man in the Iron Mask (1939), U.S.A., directed by James Whale, adapted by George Bruce; United Artists.
The Lady in the Iron Mask (1952), U.S.A., directed by Ralph Murphy, adapted by Aubrey Wisberg and Jack Pollexfen; Twentieth Century-Fox.
The Man in the Iron Mask (1976), U.K., directed by Mike Newell, adapted by William Bast; Sir Lew Grade/ITC Entertainment Group.
The Man in the Iron Mask (1998), U.S.A., directed and adapted by Randall Wallace; United Artists.

The Novel

During the 1840s Alexandre Dumas, in collaboration with Auguste Maquet, produced the series of "Musketeer" novels on which his fame rests. *The Man in the Iron Mask* is actually the last of a trilogy collectively titled *Vicomte de Bragelonne*, in itself a sequel to *The Three Musketeers* (1844) and *Twenty Years After* (1845). To understand *The Man in the Iron Mask's* complex plot structure and historical and dramatic contexts, one must be acquainted with the "back story" of *Vicomte de Bragelonne's* first two parts, *The Vicomte de Bragelonne* and *Louise de la Vallière*. The time is the 17th century during the reign of young Louis XIV of France. Louis' loyal supporters, the fabled "Four Musketeers" (d'Artagnan, Athos, Porthos, Aramis), have dispersed. D'Artagnan is now captain of the King's Musketeers; Athos is the Comte de la Fere and lives with his son Raoul; Porthos is now M. du Vallon and lives at the estate Pierrefonds; and Aramis

has assumed the title of bishop of Vannes (he also uses the name M. D'Herblay).

Several disparate, but related, plot threads lead in to the action of the novel. While d'Artagnan and Athos have been in England helping to restore Charles II to the throne of England, Louis XIV has become infatuated with Louise de la Vallière, the betrothed of Raoul de Bragelonne (son of Athos). In order to rid himself of his rival, Louis has dispatched Raoul to military service in England. Meanwhile, the king's ministers, Fouquet and Colbert, are engaged in a struggle for power, and Fouquet has enlisted the disaffected and ambitious Aramis in a plot to depose Louis. Hovering over everything, meanwhile, is an impending war between France and Holland.

Aramis, in his function as a priest-confessor, has found a way to depose the king. He visits a prisoner in the Bastille and informs him that he in actuality is the twin brother of the king. Many years ago he, Aramis, had been dispatched by King Louis XIII to spirit away the unwanted twin, named Philippe, to a rural exile and thence to the Bastille. Now Aramis offers Philippe his own plan: He will free Philippe and, after kidnapping the king from his bed chamber at the Chateau de Vauxle-Vicomte, substitute Philippe in his place.

The deed is done, and the king is bound and taken to the Bastille. But in an ill-advised moment, Aramis tells Fouquet of the scheme. Fouquet betrays Aramis, frees Louis, and helps Louis regain his throne.

The angry Louis orders the still-loyal d'Artagnan, who had nothing to do with Aramis' treachery, to take the impostor, Philippe, his face covered with an iron mask, and imprison him in the fortress at the Ile Sainte-Marguerite. The brief scene in which, for the first and only time, the Man in the Iron Mask is seen, is memorable:

> [He was] a man clothed in black and masked by a visor of polished steel soldered to a helmet of the same nature, which altogether enveloped the whole of his head. The fire of the heavens cast red reflections upon the polished surface, and these reflections, flying off capriciously, seemed to be angry looks launched by this unfortunate. . . .

The poor wretch tries to signal his fate by tossing out onto the sea a silver plate inscribed with a message for help. But the attempt fails when the plate is recovered by d'Artagnan and Athos. At this point, the wretched Philippe passes out of the narrative altogether.

Aramis and Porthos (who has never realized the full import of the conspiracy) flee the country and hole up at the island of Belle-Isle-en-Mer. Back in France, the vengeful Louis orders d'Artagnan to arrest Fouquet, leaving the minister Colbert in the unchallenged position as the king's first minister. Next, the busy d'Artagnan is dispatched to Belle-Isle-en-Mer to arrest for treason his former comrades, Aramis and Portos. Torn between loyalties, d'Artagnan contrives to capture the fortress but allows the two friends to escape. After d'Artagnan is ordered to return to France, the king's men close in and, after a fierce battle, kill Porthos. Aramis escapes to Bayonne.

For the first time in his life, d'Artagnan, shaken by the death of Porthos, denounces the king and declares his resignation from the Musketeers. But after a fierce argument, both men establish a mutual truce: The king agrees to pardon Aramis, who has settled in Spain; moreover, he promotes d'Artagnan to marshal and orders him to lead the war against Holland.

The epilogue is filled with sad farewells. Years pass. Saddened by the absence of his son, Raoul, who has gone to service in Africa, Athos retires to the country and rapidly declines in health. After suffering a vision of his son being killed in battle—which is soon confirmed by a dispatch from Africa—he dies. Soon after, Aramis, now an infirm old man, arrives back in Paris at the behest of King Louis to assist d'Artagnan in planning a military campaign against Holland. He and d'Artagnan know this meeting is to be their last. "When will it be my turn to depart?" wonders d'Artagnan. "What is there left for man after youth, after love, after glory, after friendship, after strength, after riches? That rock, under which sleeps Porthos, who possessed all I have named; this moss, under which reposes Athos. . . ." While in Holland d'Artagnan is killed by a stray bullet after a series of successful military campaigns. "Athos, Porthos, au revoir!" he exclaims with his dying breath, "Aramis, adieu forever!" At the end of it all, Aramis is the only one of the Four Musketeers still alive.

The Films

"More than any other single writer," says Richard Jeffrey in *Swordsmen on the Screen*, "it is Alexandre Dumas pere who has provided inspiration for the swashbuckling film." Indeed, filmmakers have always found the characters of the Four Musketeers irresistible. "Those four names," wrote Dumas, "—d'Artagnan, Athos, Porthos, and Aramis —were venerated among all who wore a sword, as in antiquity the names of Hercules, Theseus, Castor, and Pollux were venerated." And while some commentators, like Cynthia Grenier, might think that Dumas had a gift for creating dialogue and character that "would have made him ideally suited to working for motion pictures," the truth of the matter is quite a different affair. The narrative structure Dumas devised for *The man in the Iron Mask*, particularly, has always presented serious challenges to screenwriters.

Why? Because most of the complicated "back story" of the two "prequels," as already outlined, is far too complicated to survive the transformation to the screen. Moreover, Dumas commits the unpardonable sin of keeping the Four Musketeers separated throughout the book. He refuses to unite them even for the climactic scenes. With the exception of Porthos, who expires in a spectacular fight scene, each of their fates, as we have seen, in decidedly anticlimactic: Aramis survives into a doddering old age, Athos, dies in bed grieving for his lost son, and d'Artagnan perishes from a chance rifle shot during a lull in the battle

action. Moreover, Dumas blurs the boundary lines between heroes and villains. Among the candidates for "villain" are King Louis XIV, who, although guilty of some ruthless politics and reckless philandering, is nonetheless a sympathetic figure who is capable of compassion toward his Musketeers. "Oh, human heart, director of kings!" muses Louis in an introspective moment, "when shall I learn to read in your recesses, as in the leaves of a book? No, I am not a bad king, nor am I a poor king; but I am still a child." Aramis, who might at first be considered a villain for conspiring to depose his king, is guilty primarily of ill-conceived ambitions: "Soldier, priest, and diplomatist, gallant, avaricious, and cunning, Aramis had taken the good things of this life only as stepping-stones to rise to bad ones. Generous in spirit, if not high in heart, he never did ill but for the sake of shining a little more brilliantly."

As for heroes, the most obvious candidate is d'Artagnan. But so loyal is he to his king that he willingly carries out orders to arrest the "good" usurper Philippe and, without a blink, to cover him in an iron mask and incarcerate him for life in the fortress prison.

But, for modern readers, maybe Dumas' most unforgivable sin is to give the business about "The Man in the Iron Mask" such short shrift. In an otherwise lengthy narrative, this particular subplot occupies a mere handful of pages. Pity poor, wretched Philippe, who is released from the Bastille for but a few short weeks of freedom before he is summarily reinterred and subsequently dismissed from the tale at the midway point.

This will never do. However, Dumas does hold out one slim hope for future filmmakers: In a "vision" scene straight out of Hollywood, Athos has a vision of his son dying on the battlefield: "Raoul rose insensibly into the void, still smiling, still inviting with a gesture; he departed towards heaven." Here, at least, is one scene that Hollywood can effectively visualize, as Douglas Fairbanks Sr. would later demonstrate.

Independent producer Edward Small made a tightly budgeted version in 1939, directed by James Whale and adapted by George Bruce. In this version d'Artagnan (Warren William) is entrusted to guard the exiled twin, Philippe, while Louis XIV pursues his dastardly ways at court, including the imposition of crippling taxes on his people and the torture of prisoners in the Bastille. The circumstances of the "switch" of the twins are altered from the original story. Here, it is Louis who, upon discovering that he has a twin, proposes the substitution so that he can pursue an affair away from Court with his mistress, Mlle. de la Vallière (Marian Martin). However, the substitute king proves to be noble and good-hearted, and he wins the heart of Maria Theresa (Joan Bennett), the intended bride of Louis XIV! Outraged at this presumption, Louis returns to Court and imprisons Philippe in the iron mask. D'Artagnan, who by now has repudiated Louis, reunites with the Musketeers to rescue Philippe. It is Philippe, now, who forces the Iron Mask upon Louis and locks him away. But the king's minister, the wicked Fouquet, learns of this

Leonardo DiCaprio in The Man in the Iron Mask, *directed by Randall Wallace* (1998, U.S.A.; UNITED ARTISTS)

and sends his men to free Louis. While Louis is en route back to Court, he is intercepted by the Musketeers. The Musketeers are killed and Louis plunges to his death off a cliff. Philippe marries Maria Theresa and reigns now as "Louis XIV." Whereas his brother had declared, "In France I am the State," Philippe says he is "the servant of the state" and he sets out to improve conditions in France, including the abolishing of unfair taxes and the appointment of the upright Colbert to replace the wicked Fouquet.

In the 1976 Mike Newell version, adapted by Newell and William Bast, Richard Chamberlain portrays the twins, Louis Jourdan is d'Artagnan, Jenny Agutter is Louise, Patrick McGoohan is Fouquet, and Ralph Richardson is Colbert. Here, as in the Whale version, the exiled Philippe is the "good" twin who, with the help of d'Artagnan, usurps Louis and reigns in his stead. Once on the throne, Philippe remains there without further interference from Louis. An added touch is the news that Philippe was the first-born twin, which establishes him, not Louis, as the rightful heir to the throne. The duel of wits between Fouquet and Colbert is amplified, allowing for several memorable exchanges between those admirable actors Patrick McGoohan and Ralph Richardson. Louise's virtue remains intact in this version, as she succeeds in eluding the advances of both Fouquet and Louis in favor of Philippe (there is no mention of the Vicomte de Bragelonne). As for Louis, he is clapped into the Iron

Mask to spend the rest of his days in the cell he had formerly reserved for his brother. Oddly, this is the only version in which, apart from d'Artagnan, there is no mention of the Musketeers. It is d'Artagnan who, in collusion with Colbert, assumes the burden of the conspiracy to rescue Philippe from imprisonment, trains him in taking over Louis' role, and places him on the throne. The production values—exteriors were shot in France at the Chateau Vaux le-Vicomte and at Fontainebleau—and costume design are first rate. The casting, however, leaves one jarring note: Richard Chamberlain is far too old for the dual roles, which makes his position as a junior apprentice to the senior d'Artagnan quite unconvincing.

The 1998 Randall Wallace version casts Gabriel Byrne as d'Artagnan, John Malkovich as Athos, Jeremy Irons as Aramis, Gerard Depardieu as Porthos, Leonardo DiCaprio as Louis/Philippe, and Anne Parillaud as Anne of Austria (the Queen Mother). It takes a significant cue from Whale's 1939 adaptation in that Louis XIV is again a dastardly villain who is ultimately defeated—with the aid of the reunited Four Musketeers—by the "good" twin, Philippe, who thereafter reigns as king. Major differences, however, include the addition of elements of the Dumas subplot involving the romance between the Vicomte de Bragelonne and Louise de la Vallière (here rechristened "Christine") and the circumstances of d'Artagnan's death.

It is he alone who, during the Musketeers' rescue of the imprisoned Philippe, is slain by the wicked Louis. With his death, moreover, comes a bizarre revelation: D'Artagnan has not only had an affair in the past with Louis XIII's wife, Queen Anne, but he is also the biological father of the twins Louis and Philippe!

The movie ends with Philippe assuming the throne, vowing a son's love to his adopted "father," Athos. The Musketeers stand by d'Artagnan's grave while the Guard fires a rifle volley in tribute. The narrative voice intones the news that France is about to enjoy long years with its greatest king, Louis XIV.

The production values are sumptuous. Designers Anthony Pratt and James Acheson doubled the estate of Vaux le-Vicomte for the palace of Versailles and the well-preserved 15th-century streets of Le Mans for the Paris exteriors.

Inevitably, there have been adaptations that occupy a more marginal position. A curiosity from 1952 is *The Lady in the Iron Mask*, the first version in color, directed by Ralph Murphy, adapted by Aubrey Wisberg and Jack Pollexfen, and starring Louis Hayward (this time as d'Artagnan). The gimmick here is that the twins are sisters, Queen Anne and Princess Louise (both played by Patricia Medina). The evil Duc de Valdac (John Sutton) replaces Queen Anne with Louise. D'Artagnan, in love

Douglas Fairbanks in The Iron Mask, *directed by Allan Dwan* (1929, U.S.A.; UNITED ARTISTS/LIPPERT PICTURES INC.)

with the queen, rescues her and defeats Valdac. He marries Queen Anne and sails off with her to America, leaving Louise in place on the throne.

The finest of all the adaptations, Douglas Fairbanks's *The Iron Mask* (1929), has been saved for last—not only because it presents the best solution to the problems inherent in the Dumas original (indeed, it arguably tells a better story than Dumas did), but also because it does so, paradoxically enough, by departing furthest from the original tale. Some critics, then and now, even argue that it is Fairbanks' finest costume picture, benefiting especially from superb art direction by William Cameron Menzies, photography by Henry Sharp, and costume research by Maurice Leloir (a friend and associate of Dumas fils). Writing shortly after the film's release, *The Film Spectator*'s Welford Beaton praised it as "a superb example of screen art in its highest form. . . . The perfection reached in all the mechanical and physical arts that enter into the making of a picture, is matched in the story and the manner of telling it."

The screenplay by Elton Thomas (Fairbanks's oft-used pseudonym) reunites the Musketeers (Leon Barry as Athos, Gino Corrado as Aramis, Stanley J. Sandford as Porthos, and Fairbanks as d'Artagnan), simplifies the story line (while alluding to characters like Constance and Richelieu from the previous Musketeer books), provides satisfyingly fulsome heroes and villains, and expands upon Dumas's all-too-brief "Iron Mask" episode. It is the only movie version so far that casts De Rochefort, d'Artagnan's former antagonist, as the conspirator behind Philippe's presumption to the throne; and it is the only version—here, it comes within shouting distance of Dumas—that depicts Louis XIV as a relatively positive character (although the stark contrast of brother Philippe's villainy, while it served Hollywood's dramatic intentions, has no precedent in the book). It is Philippe's despicable actions at Court that spur the Musketeers into action. Thus, the Musketeers here are employed not in replacing the king with a presumptive, but in restoring the rightful king to the throne. Thus, in no way could audiences regard the Musketeers' actions as traitorous.

The film's dramatic conclusion is a worthy valedictory to Fairbanks' swashbuckling career. Before the grateful Louis can bestow the baton of a marshal of France on d'Artagnan, the dying Philippe stabs the Musketeer. Mortally wounded, d'Artagnan staggers out to the courtyard, crumples to the ground , and expires. In a moment perhaps inspired by the aforementioned "vision" scene in Dumas's novel, the ghostly figures of the Musketeers march forward out of the clouds and, laughing boisterously, reach down and pull up their fallen comrade. Swords upraised they stride away, pledging "All for one and one for all!" one last time. The words "THE BEGINNING" appear before the final credits.

REFERENCES

Grenier, Cynthia, "Dumas, the Prodigious," *The World and I* 13, no. 6. (June 1998): 284–89; Maurois, Andre, "What's Past Is Prologue,"

intro. *The Man in the Iron Mask* (Heritage Press, 1964), ix-xiv; Richards, Jeffrey, *Swordsmen of the Screen* (Routledge and Kegan Paul, 1977); Tibbetts, John C., and James M. Welsh, *His Majesty the American: The Films of Douglas Fairbanks, Sr.* (A S. Barnes, 1977).

—*J.C.T.*

MANSFIELD PARK (1814)

JANE AUSTEN

Mansfield Park (1999), U.K., directed and adapted by Patricia Rozema; BBC/Miramax.

The Novel

Mansfield Park was published in 1814. It was the first of Austen's published novels that was not a revision of a pre-1800 work. The most solemn and moralistic of her novels—and the least witty—it followed *Pride and Prejudice* and preceded *Emma*. As usual in Austen's work, it is about money and social status.

Ten-year-old Fanny Price is summoned from her poverty-stricken home in Portsmouth to be brought up in the estate of Mansfield Park by her rich uncle, Sir Thomas Bertram, and her aunt. Years pass. Despite the fact that she is treated badly, Fanny's honesty and modesty gradually make her an indispensable part of the household. She falls in love with her first cousin, Edmund, but he is interested in the more worldly Mary Crawford. Mary's rascally brother, Henry, falls in love with Fanny and proposes. Although the match is approved by Sir Thomas, Fanny rejects Henry's proposal, convinced he is an untrustworthy adventurer.

After a short stay back at her parents' home in Portsmouth, Fanny returns to Mansfield Park when she learns that one of her cousins is near death. It is at this point that Edmund finally realizes Mary's lack of principle. It seems there has been a scandal in the home—Henry was involved in an affair with one of the married Bertram daughters—and Edmund learns that Mary seems to care only about finessing the incident rather than acknowledging its immorality. Now aware of Fanny's superior moral values, Edmund turns away from Mary and offers to marry Fanny. Sir Thomas blesses the union and declares Fanny to be the daughter he has always wanted. Fanny and Edmund will establish their home at Mansfield Park.

The Film

Many critics and viewers were astonished, even shocked at Patricia Rozema's screen adaptation. While the film followed the story's basic outline quite closely, it reflected what Rozema presumed to be Austen's abolitionist and feminist sympathies.

For example, the character of Fanny (Hannah Taylor-Gordon) is made of sterner stuff than the anguished character in the book. No longer the novel's prudish, retiring,

unattractive young woman, she is self-reliant and assertive, a budding writer (obviously patterned after the young Austen) who reads to the camera portions of her melodramatic short stories and excerpts from her letters. Derived from such early Austen stories as the juvenile novels *Love and Friendship* and *Frederic and Elfrida*, these literary asides both comment on the action and provide bridging passages in the story's continuity. (At the end of the picture, the audience is assured that her writings will be soon be published.)

As commentator Claudia Johnson writes, "[The film] gives us what many of us love about Austen in the first place, what other movies never deliver: Austen's presence as a narrator." Admittedly, however, there are moments when one feels less sympathy toward her than for the suitor she rejects rather huffily, Henry Crawford (Alessandro Nivola).

The film also enhances the subtext of the Bertram family's dealings with the slave trade in Antigua (slavery is mentioned only once in the novel). On her way to Mansfield Park young Fanny views a slave trading ship in the harbor with curiosity. Later, as an adult, she finds a sketchbook of drawings by a family member depicting horrifying scenes of the slaveowners' brutality on the sugar plantations. Sir Thomas (Harold Pinter) has a scene where he talks freely to his family about his slaves and his plan to bring one home to England to work as a servant, at which point Fanny suggests that perhaps in that event he would have to free the slave. Cousin Edmund (Jonny Lee Miller) reminds her that the whole family lives off the profits from slavery. It is clear that Fanny's position at Mansfield Park as the poor country cousin is tantamount to slave status. Small wonder that when she rebukes Edmund's overtures, she declares, "I'll not be sold off like one of your father's slaves."

In her study of the screen adaptation of *Mansfield Park*, Sue Parrill makes much of this foregrounding of the slavery issue, asserting that the status of women at this time—including that of Austen herself—could be compared to the captivity of slaves: "Women moved from their parents' control to their husbands' control. Those who were not able to find a husband found themselves enslaved by poverty or by the whims of relatives."

Slyly, perhaps, Rozema seems to go out of her way to reverse the polarities of the characters of Henry, his conniving sister, Mary (Embeth Davidtz), and Edmund. Henry and Mary are portrayed more sympathetically than in Austen, as distinctly "modern" characters who view the world in relative terms rather than moral absolutes. By contrast, Edmund is a lost cause. Nothing can make him more sympathetic. He is devoid of the saving grace of irony and ambiguity. There are even some sly touches implying a sexuality not present in Austen that nonetheless imply a sensuality buried beneath the proprieties, such as Mary Crawford's knowing caresses of Fanny's bare, rain-drenched shoulders and father Thomas Bertram's prolonged embrace of Fanny.

The picture's visuals are splendid. It comes as no surprise that the cinematographer, Michael Coulter, also shot Ang Lee's *Sense and Sensibility* and Charles Sturridge's

Fairytale. The contrasts between the squalor of Portsmouth and the tidy gentility of Mansfield Park are superbly visualized, suggesting far more in a few images than in many pages of Austen's prose. In another scene the mise-en-scène says volumes about the conflicting agendas of love and duty—of marrying well as opposed to marrying for love. After Fanny has rejected Henry's suit, her mother reminds her, "There is nothing wrong with wealth." Fanny retorts, "Except on how you get it." The mother pauses a moment, then replies wistfully, looking around her dingy surroundings, "I married for love."

Finally, the film's finale is a joyous cinematic fantasy: As Fanny's voice relates the fates of each of the characters, and the music lyrically ebbs and flows (a fine score by composer Lesley Barber, who also did *A Price above Rubies*), the camera lifts up across the houses and treetops to check in on the actions of the characters, peering through windows, pausing now and then to dwell on a frozen moment (the characters momentarily freeze into *tableaux vivants*), moving on again when the characters come back to life. It is a thoroughly satisfying way of tying up all the loose plot strands. "Things could have turned out quite differently," Fanny keeps saying, "but they didn't."

In the final analysis, it is Fanny's wit, persistence, and moral example that wins the day and redeems the corruption that has hovered over Mansfield Park. "She has established herself as the true daughter of the house," writes author Sue Parrill. "This is indeed very much the point of the novel."

REFERENCES

Johnson, Claudia L., "The Authentic Audacity of Patricia Rozema's *Mansfield Park*: 'Run Mad, but Do Not Faint,'" *Times Literary Supplement*, December 31, 1999, 16–17; Parrill, Sue, *Jane Austen on Film and Television* (McFarland and Company, 2002).

—J.C.T.

THE MAN WHO FELL TO EARTH (1963)

WALTER TEVIS

The Man Who Fell to Earth (1976), Britain, directed by Nicolas Roeg, adapted by Paul Mayersberg; British Lion.

The Novel

The Man Who Fell to Earth was Walter Tevis's first science fiction novel, and is considered a rare success for a non–science fiction writer's first attempt in the genre. Tevis is best known for two other novels adapted for the cinema: *The Hustler* (1959) and *The Color of Money* (1984).

The Man Who Fell to Earth contains few of the trappings normally found in science fiction stories. Thomas Jerome Newton arrives on Earth from his dying planet,

Anthea. His mission is to build a ship capable of bringing the rest of his people to Earth and to prepare the way for their arrival. Newton begins his mission by selling goods, such as self-developing film, that are based on advanced Anthean technology, and quickly becomes a multimillionaire. He plans to use these riches to build the spacecraft he needs. However, the constant physical strain of Earth's stronger gravity and the terrible loneliness that Newton suffers causes him to become an alcoholic. Matters are further complicated when he is arrested and exposed by the CIA. After months of grueling physical and psychological tests, Newton is released because of his public celebrity and because no one will believe the true story. Before being released, however, Newton is subjected to one last physical examination, during which he is accidentally blinded. He gives up on his plans to rescue his fellow Antheans and becomes a reclusive alcoholic.

The Film

In making *The Man Who Fell to Earth*, Nicolas Roeg hoped to use the vehicle of science fiction to experiment with the fluidity of space and time in film. As screenwriter Paul Mayersberg commented, "*The Man Who Fell to Earth* is a movie where we hope to introduce another form, or an interesting variation of an existing one, into the cinema. I don't know if there is a true antecedent of this film." The result is a film that has little in common with the novel and very little narrative. As a result of Roeg's approach, the American distributor cut the film from 138 minutes to 116. Roeg's original version has been rereleased. The film is best known because the lead role of Thomas Newton is played by rock star David Bowie.

The lack of narrative and the extensive cuts make Roeg's experiments with character and perception of time and space largely unsuccessful because there is little framework in which to place them. As a result, it is barely clear that Newton is from another planet, and his plans concerning his fellow Antheans are even less clear. In addition, the notable differences between the film and novel are largely unmotivated, especially at the end of the film when, instead of being blinded during the physical, Newton simply finds that his contacts have become fused to his eyes. Fans of traditional science fiction are bound to be disappointed.

REFERENCES

Feineman, Neil, *Nicolas Roeg* (Twayne Publishers, 1978); Salwolke, Scott, *Nicolas Roeg, Film by Film* (McFarland & Company, 1993).

—B.D.H.

MARATHON MAN (1974)

WILLIAM GOLDMAN

Marathon Man (1976), U.S.A., directed by John Schlesinger, adapted by William Goldman; Paramount.

The Novel

Marathon Man is William Goldman's ninth novel and eighth screenplay, though it is the first time that he adapted one of his own novels to the screen. *Marathon Man* fits into the paranoid-conspiracy type of story that became popular in the mid-1970s, such as *The Parallax View* (Alan J. Pakula, 1974), *Three Days of the Condor* (Sydney Pollack, 1975), and *The Conversation* (Francis Ford Coppola, 1974). Like these films, *Marathon Man* features international intrigue and suggests that no one can be trusted.

The story focuses on Christian Szell, an ex-Nazi who escaped to Uruguay at the end of the war. Szell, who is modeled on Josef Mengele, although he is a dentist rather than a doctor, is wanted for atrocities committed at Auschwitz. He funds his "retirement" with diamonds that he has taken from his Jewish prisoners; when he needs money, his brother in New York will cash in a diamond or two. The story begins when Szell's brother is killed in a freak car accident with an old Jewish man. The death of his brother means that Szell must come out of hiding in order to personally get his diamonds out of the bank in New York. In order to feel safe, he decides to kill all the couriers who have worked with him in the past, including one called Scylla. We learn later that Scylla works for a U.S. government agency called the "Division"; he is also the older brother of a graduate student and amateur marathon runner named Thomas Babington Levy (called Babe). After murdering Scylla, Szell kidnaps Babe and tortures him by drilling into his healthy teeth, in case Scylla told him the secret of the diamonds. Peter Janeway (called Janey) rescues Babe but turns out to be working with Szell. Elsa Opel, a graduate student whom Babe meets and falls in love with, also turns out to be working with Szell. After eliminating all of Szell's henchmen, Babe captures Szell at his bank just after he has picked up his coffee can full of diamonds, walks him to the Central Park Reservoir, and shoots him.

The Film

Notorious for offscreen gossip about Dustin Hoffman's perfectionism in the central role of Babe Levy and his apparent cruelty to his costar, Laurence Olivier (Christian Szell), *Marathon Man* follows the outline of the book fairly faithfully. It is a good thriller, well acted and directed, and makes excellent use of its New York City location. The opening scene in upper Manhattan, in which one sees street after street full of German businesses behind Szell's brother's head, and the scene in the Diamond District as Szell walks past one Orthodox Jew after another, are particularly well done. The film's main differences relate to the character of Babe's brother, Doc (Roy Scheider), and to the ending. Scylla's identity as Babe's brother is withheld for much longer in the novel than in the film, and we learn much more about his feelings: "I'm dead, but I won't lie down," as he says in the book after a second unsuccessful attempt on his life. The violence in the book is much

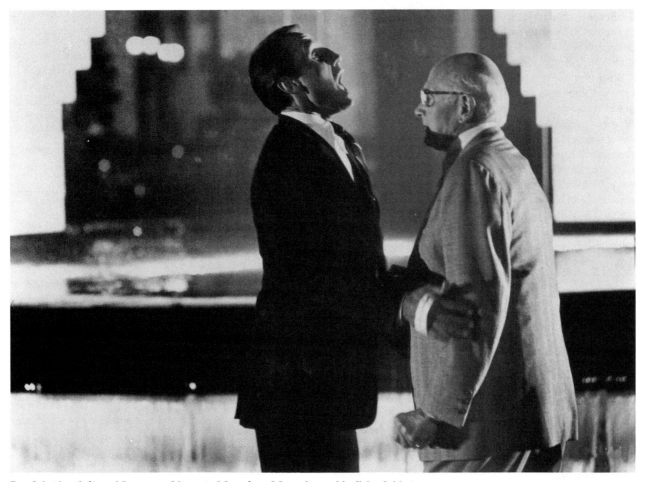

Roy Scheider (left) and Laurence Olivier in Marathon Man, *directed by John Schlesinger* (1976, U.S.A.; PARAMOUNT/ THEATRE COLLECTION, FREE LIBRARY OF PHILADELPHIA).

more graphic; the series of attacks on Scylla (his near-garrotting in Paris and his eventual murder by Szell in New York) are bloody, but pale in comparison to the central set piece in the book as well as in the film: Szell's dental torture of Babe. Could there be a more frightening villain than a Nazi dentist? In the book it is explicitly stated that Doc and Janey are longtime homosexual lovers; in the film this relationship is just hinted at. Thus, the book makes more of Janey's duplicity than the film: His cooperation with Szell is represented as cynical in the film, while in the book the character is sickeningly amoral. Finally, the ending is quite different. In the book, Babe shoots Szell; in the film, Szell stabs himself accidentally. Goldman says that someone else wrote the ending—he suspects it was Robert Towne—but does not explain the reasons for the change.

REFERENCES

Goldman, William, *Adventures in the Screen Trade: A Personal View of Hollywood and Screenwriting* (Warner Books, 1983).

—*S.C.*

THE MARQUISE OF O . . . (1808)

HEINRICH VON KLEIST

La Marquise d'O . . . (1975), France, directed and adapted by Eric Rohmer; Les Films du Losange/Gaumont and Janus/Artemis.

The Novel

Kleist's novella, written in 1807, was first published one year later in the journal *Phöbus* by his friend Adam Müller. While the subject, a woman who becomes pregnant during sleep or after having fainted, is quite common in literature, Kleist's story is most likely based on an episode from Montaigne's essay "De l'yvrongnerie" (1588). A number of other more obscure stories published at the end of the 18th century may have also been influential. Generally considered a master of the novella, Kleist brought the form to a new level by developing the psychological novella, of which *The Marquise of O . . .* is an example.

In a large town in northern Italy, Julietta, the widowed Marquise of O . . ., takes the unusual step of announcing publicly in the local newspaper that she has mysteriously become pregnant and asks the father of the child to confess his identity so that she may marry him. Having been expelled from her parental house and exposed to public scandal she finds this the only alternative. In a lengthy digression, it is revealed that a short time before, during the storming of her citadel, the marquise had been rescued from rape at the hand of a group of Russian soldiers by a young, courageous Graf F . . . who appeared to her like an angel. Shortly thereafter he asks quite impetuously to marry the marquise upon his imminent return from Naples. It is during his absence that the marquise realizes that she is pregnant and thus falls in disfavor with her father the Obrist von G. . . . A second notice appears in the newspaper saying that the father of her child will appear at a given day and time. To her surprise and shock, the Graf F . . . presents himself as the father. Reluctantly she agrees to marry him under the condition that he relinquish all claims as her husband. Over the years she comes to forgive him and abandon her idealistic views of perfection, and together they celebrate a second marriage of true love and happiness.

The Film

Rohmer's adaptation in 1975 came after the completion of a series of films he termed "Six Moral Tales." In many ways the historical setting of Kleist's story represent a departure for Rohmer, but thematically it is in line with his previous films. Rohmer retains the ambiguity of Kleist's story with regard to the marquise's innocence, and thus concentrates on the moral conflict and dilemma that she faces. Critics have noted that while the Moral Tales present female characters forced to choose between sexuality and womanhood, with this film Rohmer depicts the problem of a woman attempting to combine and come to terms with both passion and moral fortitude. Rohmer's adaptation follows Kleist's text word for word with the exception of the rape scene: Sensing that a modern audience would find it improbable that she was raped while fainted, Rohmer has the marquise fall into a deep sleep. In interviews, he has maintained that it was Kleist's language and imagery that intrigued him most. Thus he attempted to film the novella as word-true as possible. Moreover, the swan scene is given great symbolic importance and is thus moved to the end of the film so as to metaphorically summarize and close the story.

Critically the film was a great success and was universally praised for the quality of the acting and the staging. For the first time, Rohmer moved away from a realist style of filmmaking to an artistic and theatrical one. His primary approach in staging the film was to recreate the ambiance of 19th-century painting. In casting the film, he chose Germany's leading stage actors (among them, Edith Clever, Bruno Ganz, and Otto Sander), many of whom were gaining prominence in films by Germany's new wave of directors. The theatricality of the film, however, perplexed many critics unfamiliar with Kleist's work. Whereas reviewers in England and France read the film as a classic tragedy or historical drama, critics in the United States often viewed the film as a comedy of manners, emphasizing the absurdity of the story line. On both sides of the Atlantic, though, it confirmed Rohmer's position as a major European director.

Rohmer has always been on the margin of the French nouvelle vague. His early ideological split with Godard and Truffaut and his friendship with André Bazin, as well as the Catholic and metaphysical overtones of his films, have placed him in the role of a respected yet iconoclastic member of the New Wave. His decision to film a historical drama after a series of modern tales more typical of the nouvelle vague, is significant not only for his own development but also for the direction of French cinema. His determination to film literary period pieces and the ultimate failure of *Perceval* underscored the inability of the French cinema to produce viable historical features and how little the New Wave had affected the commercial mainstream. Furthermore Rohmer encountered for the first time financial difficulties with future projects and was forced to abandon his work on historical adaptations. Nevertheless the success of *The Marquise of O . . .* and Rohmer's break (albeit temporarily) from his realist origins make the film an important work within his oeuvre. Given the predilection for and the success of historical literary adaptations currently in the French cinema, it appears that Rohmer was simply too far ahead of his time.

REFERENCES

Crisp, C.G., *Eric Rohmer: Realist and Moralist* (Indiana University 1988); Kleist, Heinrich von, *Die Marquise von O . . .: Mit Materialien und Bildern zu dem Film von Eric Rohmers* (Insel, 1979); Monoco, James, *The New Wave: Truffaut, Godard, Chabrol, Rohmer, Rivette* (Oxford, 1976); Rhiel, Mary, *Re-Viewing Kleist: The Discursive Construction of Authorial Subjectivity in West German Kleist Films* (Peter Lang, 1991); Horton, Andrew and Joan Magretta, eds., *Modern European Filmmakers and the Art of Adaptation* (Ungar, 1981).

—D.N.C.

M*A*S*H (1968)

RICHARD HOOKER

*M*A*S*H* (1970), U.S.A, directed by Robert Altman, adapted by Ring Lardner Jr.; Aspen/Twentieth Century-Fox.

The Novel

*M*A*S*H* is an episodic novel written by Richard Hornberger, who served in Korea as a doctor. It was published under the pseudonym "Richard Hooker." Set during the Korean War at the 4077th Mobile Army Surgical Hospital

on the 38th parallel, the narrative begins with the arrival of Captains Benjamin Franklin "Hawkeye" Pierce and Augustus Bedford "Duke" Forrest. They quickly seize control of their commanding officer, Col. Henry Blake, and arrange to rid themselves of the religious Major Hobson, replacing him with a thoracic surgeon called "Trapper" John McIntyre. Their tent, "The Swamp," becomes a social center for the unit between crises, frequented by Father John Patrick "Dago Red" Mulcahy, Captain Walter Waldowski ("The Painless Pole"), Captain Ugly John Black, and other. In their chronic efforts to buck military routine, their nemeses include Major Margaret Houlihan (soon to be dubbed "Hot Lips") and Major Frank Burns, who is disposed of as rapidly as Major Hobson.

The plot meanders episodically as the Swamp residents thwart Waldowski's suicide attempt, arrange for a Korean boy to attend college in the States, expand an emergency surgery into a golf weekend in Japan, arrange a lucrative football game against another unit (each complete with college football ringers). The novel ends with Hawkeye's completing his tour and being shipped home to his wife and two sons in Maine.

The Film

While Hornberger's novel contains most of the characters and basic plot elements of the film, the movie version of *M*A*S*H* somehow moved the narrative to a cultural phenomenon of extraordinary scale, including a television series that lasted 11 seasons and produced two spinoff series(*After M*A*S*H* and *Trapper John, MD*). The film also moved Robert Altman's career into high gear; *M*A*S*H* remains his major commercial success.

A persistent incongruity between the novel and the film (and, more markedly, between the novel and the television series) derives from political context. By all accounts (including those of Larry Gelbart, who wrote for the television series, and W.E.B. Griffin, who ghostwrote several *M*A*S*H** sequels), Richard Hornberger is a political conservative who has little regard for the adaptations of his work. Indeed, an attentive reading of the novel reveals no fixed political agenda beyond the principal characters' natural disregard for authority. Moreover, the copious racial slurs throughout the novel, while understandable in a realistic novel about military life in the 1950s, reflect a different sensibility from that of the film.

The historical context of the film, however, was the Vietnam War, and in that context Altman's *M*A*S*H* took on an unanticipated political significance. It represents the kind of dark comedy and satire that would have been inconceivable in the Hollywood of the early 1950s, when the novel's events take place. Indeed, the principals' haircuts and demeanor are much more consistent with the late '60s than with the narrative's "historical" era.

The film fixed several enduring characters in the popular consciousness, although the later television series did much to sanitize (and, in the case of Alan Alda's "Hawk-

eye," virtually sanctify) the irreverent original. Donald Sutherland (Hawkeye) and Elliott Gould (Trapper John), like many of their fellow cast members, saw major boosts to their careers after the film. Other cast members included Sally Kellerman ("Hot Lips"), Robert Duvall (Frank Burns), and Tom Skerritt (Duke).

The direction is innovative. Altman's brand of cinematic realism is exemplified in the graphic surgical scenes, as will as in the signature use of multiple and overlapping dialogue tracks to convey a precise sense of chaos. Altman would use this technique again in films from *Nashville* through *Ready to Wear*, and the technique influenced television production techniques not only in the television *M*A*S*H** but also in such series as *Hill Street Blues* and *St. Elsewhere*.

Despite the political reverberations associated with the period of the film's release, *M*A*S*H* remains an important film for a host of reasons, including its establishment of Altman's auteur method with a broader audience and, for better or for worse, its inaugurating a virtual M*A*S*H industry. But more pertinently, the film holds up well after a quarter of a century. It has a sharp satiric edge that its television successor labored to lose, largely because of audience considerations in serial narratives. The tendencies of some of the film's most effective scenes (Hawkeye's driving Frank Burns literally berserk, the several pranks on "Hot Lips") would become unbearably cruel if sustained over several seasons. But Altman's *M*A*S*H* is Juvenalian satire where Gelbart's television *M*A*S*H** became Horatian—and, ultimately, borderline sanctimonious. The film stands on its own in ways that are less true of either the novel from which it came or the series to which it led.

REFERENCES

O'Brien, Daniel, *Robert Altman: Hollywood Survivor* (Batson, 1995); Self, Robert T. "The Sounds of MASH," in *Close Viewings: An Anthology of Film Criticism*, ed. Peter Lehman (Florida State University Press, 1990), 141–57.

—M.O.

MASTER AND COMMANDER

See The Far Side of the World.

MAURICE (1971)

E.M. (EDWARD MORGAN) FORSTER

Maurice (1987), U.K., directed by James Ivory, adapted by Ivory and Kit Hesketh-Harvey; Enterprise.

The Novel

Maurice is E.M. Forster's fifth novel, begun in 1913, completed in 1914, but not published until a year after the author's death in 1971, because of its homosexual content. Some have speculated that had Forster been willing to

publish this novel, which he circulated to friends in manuscript with numerous changes over the years, perhaps the repression of homosexuals would have been less severe from 1914 until the more liberated recent decades. In any case, without publication during Forster's long life, *Maurice* was unable to become the pioneering work it had the potential to be.

The plot of the novel is not complex. Maurice is a boy of the suburbs, much doted upon by his widowed mother who also has two younger daughters. From his public school Maurice goes to Cambridge where he meets Clive Durham of the landed gentry who, unlike the title character, understands better his own sexual proclivity. However, Maurice and Clive engage in a fairly chaste, Platonic conception of same-sex intimacy. Following two years of such friendship, Clive visits Greece and returns to England a committed heterosexual with a fiancée. Maurice, now a successful stockbroker, also seeks the more conventional straight path through hypnosis. Yet at Clive's country house he becomes involved with Alec, a gamekeeper who climbs in his bedroom window and makes love to him.

Forster provides some narrative interest by having his lovers cross class lines in their relationship, but his ending, which he revised after an earlier version wherein Alec sailed away from Maurice to Argentina, must be taken as largely wish-fulfillment. "Significantly Maurice and Alec are living in the woods," as Nicola Beauman explains, "in the 'greenwood' as Morgan calls it. For the novel is not merely a plea for homosexuals to be allowed to have the same happiness in personal relations as heterosexuals; it is also a heartfelt expression of Morgan's belief . . . that country life is pure, unselfish and full of integrity and that town life is the opposite."

The Film

James Ivory's film adaptation of *Maurice* won several awards at the Venice Film Festival in 1987, including the Silver Lion for the best director and shared best actor awards to James Wilby who played Maurice and Hugh Grant who portrayed Clive. Richard Robbins's score won an award also for the film's music. Faithful to Forster's novel in almost all ways, the film transcribes the source text into visual and dramatic terms with tact and taste. Indeed, more of Forster makes it to the screen out of whole cloth here than in virtually any other Merchant-Ivory adaptation of his work. This fidelity may not be an unmixed blessing, though it should be acknowledged.

For clarification Ivory has added one interpolated sequence not present in Forster's novel. The motivation for Clive's change to heterosexuality while in Greece remains in the novel as a mysterious "given"; in the film we see a preceding event when Maurice and Clive's fellow student, Risley, played by Mark Tandy, is entrapped by a guardsman and arrested for overt sexual advances and sentenced to prison—a fate risked by practicing homosexuals at the 1912 date of the narrative. This montage pro-

E.M. Forster

vides a further motive of fear to help explain Clive's about-face in his orientation. A high-angle shot of Risley being led down a flight of stairs to a cell stands in marked contrast to the vistas and wide views of courts seen earlier at Cambridge.

If, as Claire Tomalin has observed, the film makes Clive's change to desiring women rather than men somewhat more willed than Forster does in the novel, it serves to bring several characters into better focus. For example, Maurice himself appears less craven and more determined in his own sexual honesty because of his contrast with Clive.

Reviewers like Clive Tomalin found James Ivory's film "subtle, intelligent, moving, and absorbing; also extraordinary, in the way it mixes fear and pleasure, horror and love." Despite wanting to like the film, Quentin Crisp was

unable to suspend his disbelief for either Forster's novel or for Ivory's film: "If the minor masterpieces of literature are to be used as movie material, it does their authors no service to preserve on the screen all their slow, rambling, detailed quality." To varying degrees, one can agree with both assessments at least sporadically while viewing *Maurice*, although Tomalin's judgment finally persuades and prevails. Ivory's attention to layers of class, convention, and ambience becomes as functional as formal in this adaptation, which may not be so easily argued for all the many Merchant-Ivory collaborations. To be sure, *Maurice* is not so amusing as *A Room with a View* or as evocative of lost time as *Howards End*, yet it is perhaps the braver effort and the more artistic achievement against greater odds. That the film accords fundamental dignity and decency to the male lovers at the end, accepting, as Robert Emmet Long notes, "their homosexuality, which their society views with disapproval and condemnation, as being merely part of nature" constitutes a measure of triumph in equality. Ivory remains true to an element in E.M. Forster that is only beginning to be appreciated now in reevaluation of him—his political and sexual themes. While *Maurice* is not the Merchant-Ivory adaptation of Forster most moviegoers think of first, it merits the respect and praise that have endured and even increased since its original release.

REFERENCES

Beauman, Nicola, *E.M. Forster: A Biography* (Knopf, 1994); Crisp, Quentin, "Accepted Invitations: *Fatal Attraction* and *Maurice*," *Christopher Street* 116 (1987): 8–10; Long, Robert Emmet, *The Films of Merchant Ivory* (Harry N. Abrams, 1991); Tomalin, Claire, "Love Story: *Maurice*," *Sight and Sound* (autumn 1987): 290.

—E.T.J.

McTEAGUE (1899)

FRANK NORRIS

Life's Whirlpool (1916), U.S.A., directed and adapted by Barry O'Neil; World.
Greed (1924), U.S.A., directed by Erich von Stroheim, adapted by von Stroheim and June Mathis; MGM.

The Novel

Frank Norris was a 21-year-old student in Berkeley in 1893 when he read a newspaper account of a man who fatally stabbed his wife over a money dispute. Norris, already steeped in the naturalism of Emile Zola, was attracted to the story's lower-class contexts of brutality and poverty. "Terrible things must happen to the characters of the naturalistic tale," he wrote in 1896 while at work on his fictional version of the story, *McTeague*. "They must be twisted from the ordinary, wrenched out from the quiet, uneventful round of everyday life, and flung into the throes of a vast and terrible drama that works itself out in unleashed passions, in blood, and in sudden death."

Norris transformed the murderer, one Patrick Collins, into "McTeague," a brutish ex-miner turned dentist who practices on Polk Street. McTeague seduces a young woman, a toymaker named Trina Sieppe, in the dental chair and, lured by her newly won lottery riches, marries her. But when he loses his profession, the miserly Trina refuses to help. He murders her, takes the money, and returns to gold mining. In Death Valley he is confronted by a former friend and rival for Trina's attentions, Marcus Schouler, who claims a portion of the money. They struggle, and before Marcus dies he handcuffs himself to McTeague. In the end McTeague is alone in the desert, chained to Marcus's corpse, Trina's money useless to him now. "All about him," concludes the novel, "vast, interminable, stretched the measureless leagues of Death Valley."

With his customary zeal for authenticity, Norris drew carefully upon the San Francisco he knew. Excepting the location of McTeague's dental parlor, which never existed on Polk Street, Norris meticulously recreated San Francisco's street plans, shops, and local characters.

The Films

Little is known about the first film version, *Life's Whirlpool*, a five-reel feature released in 1916 and starring Holbrook Blinn as McTeague and Fania Marinoff as Trina. Von Stroheim's biographer, Richard Kozarski, reports that it was attacked by critics of the time for its "repellent" realism. He postulates that von Stroheim may very well have been influenced by its purportedly "stark visual quality."

As for von Stroheim's version, released late in 1924, it occupies a secure place in motion picture legend, surely the most famous (even notorious) example of a novel adapted for the film medium. Von Stroheim had been fired from Universal in 1922 during the making of *The Merry-Go-Round* when he came to Goldwyn Productions to adapt Norris's novel. He had wanted to film it for years. Doubtless he felt a special affinity with its fatalistic overtones and saw something of his own biography in its story of German-speaking immigrants in America, working-class struggles in prewar San Francisco, and the deleterious effect of financial problems on a young marriage.

Establishing the St. Francis Hotel in San Francisco as his base of operations, he quickly cast the lead roles with an unlikely collection of performers—British actor Gibson Gowland as McTeague, dizzy comedienne ZaSu Pitts as Trina, Danish actor Jean Hersholt as Marcus—and scouted the locations. Many of them, including the entire area around Polk Street and Sutter, had been destroyed in the 1906 earthquake, but suitable replacements were found.

Reports that von Stroheim's script was a literal transcription of the novel, "page by page, never missing a paragraph," are the stuff of Hollywood myth. Actually, he made many changes, some of which, in historian Herman G. Weinberg's opinion, further complicated an already dense novel. Von Stroheim's script proceeded in strictly linear development (no flashbacks). He took Norris's 10 sentences about McTeague's youth and expanded them

into a prologue explaining how McTeague came to be on Polk Street—his youth in the mining camp, the death of his alcoholic father, and his apprenticeship to a traveling dentist. The costumes, street traffic, and calendar dates were updated to the years from 1908 to 1922.

All manner of cinematic devices enhance, by turns, Norris's hard-edged realism and occasionally hallucinatory passages (always constituting a bizarre balance in his work). In the first instance, deep-focus photography captures a concreteness of detail, from foreground to background, that rivals even Norris's celebrated "camera eye" (the famous scene of the funeral cortege seen through a window during a wedding ceremony is a von Stroheim addition). His insistence on shooting in real locations imposed cruel hardships on his cast—choosing to go the Death Valley locations in midsummer, the hottest time of the year, and shooting the mining scenes 3,000 feet down in the shafts. In the third instance, golden color tints are used for scenes involving Trina's money obsession; and montages of weirdly elongated hands caressing coins add an expressionistic, dreamlike quality.

Sometimes Norris's prose defeats von Stroheim. It is one thing to describe on the page McTeague's brute strength in terms of a "hideous yelling of a hurt beast . . . an echo from the jungle," but it is quite another on screen to accept the mugging and grimacing of Gibson Gowland.

Early in 1924 a rough cut was assembled that was an estimated 45 reels long, over nine hours' duration. It was trimmed in half by March and bowdlerized yet again the following summer. By the time the final version was released by the newly formed Metro-Goldwyn-Mayer, Greed had been further shortened to 10 reels. Huge chunks of action and many subplots, including that of Zerkow the junkman and the back story of Trina's family, were gone; and ineptly written titles ("Such was McTeague.") replaced von Stroheim's originals. But some critics still thought the film too long. Robert E. Sherwood in Life called von Stroheim a genius "badly in need of a stop watch." Worse, a writer for Harrison's Reports labeled it "the filthiest, vilest, most putrid picture in the history of the motion picture business." A lone approving voice came from The New York Herald Tribune, calling it "the most important picture yet produced in America." Meanwhile, business was bad, even in Europe, where a supposedly more sophisticated audience could have redeemed its poor box office. Since then, Greed's fortunes have radically reversed, and it has regularly appeared on "Ten Best" lists of great motion pictures.

As significant an achievement as the truncated film is, it is the "uncut" Greed that continues to haunt film collectors and historians. It remains, in the words of Herman G. Weinberg, who published a reconstructed Greed in the form of a volume of photographs and production stills, "the Holy Grail" of cinema.

REFERENCES

Kozarski, Richard, The Man You Loved to Hate: Erich von Stroheim and Hollywood (Oxford University Press, 1983); Wead, George, "Frank Norris: His Share of Greed," in Gerald Peary and Roger Shatzkin, eds., The Classic American Novel & the Movies (Frederick Ungar, 1977); Weinberg, Herman G., The Complete "Greed" (Arno Press, 1972).

—J.C.T.

MEPHISTO (1936)

KLAUS MANN

Mephisto (1981), Hungary, directed by Istvan Szabo, adapted by Szabo and Peter Dobai; Mafilm/Manfred Durnick.

The Novel

Mephisto, written by Klaus Mann, son of the German writer Thomas Mann, was originally published serially in the Pariser Tageszeitung in 1936, but was not translated into English, by Robin Smyth, until 1977. The novel has been regarded primarily as a thinly-veiled biography of Mann's brother-in-law, the German actor Gustaf Gründgens, whose career flourished in Nazi Germany when he was appointed director of the State Theater by Reichmarshal Hermann Göring. Because of Gründgens's influential role in German theatrical circles, after the war Mephisto was successfully banned from publication in West Germany as late as 1966.

The novel follows the career of Hendrik Hofgen from his early days in the Hamburg Arts Theater, through his successes on the Berlin stage and in films, to his appointment as director of the State Theater. The events of his life are juxtaposed against the unfolding events of German politics from the early 1920s to the 1930s and before the outbreak of World War II.

Mann attempts (unsuccessfully) to introduce the Faust legend in his story as Hofgen flirts with the evils of the emerging Nazi regime in order to further his own career as an artist. At the end of the novel, Mann leaves Hofgen sobbing the line "All I am is an ordinary actor . . ." in his mother's lap. Confronted with the responsibilities and decisions he now recognizes in his life, he chooses to retreat from a sense of responsibility.

The Film

Adapted and directed by Hungarian filmmaker Istvan Szabo and performed by an international cast led by Austrian actor Klaus Maria Brandauer, the 1981 film adaptation successfully presents the ideas of Mann's novel.

Szabo lived during a time in Hungary when artists were required to make certain compromises with the existing communist regime. In his work, he joined other contemporary Hungarian filmmakers in challenging the existing government to release its hold on artists. Szabo brings this sense of artistic responsibility to his treatment of Mephisto. He presents the character Hofgen in a more sympathetic light than Mann, revealing the man's weaknesses but also revealing a quality of self-consciousness that causes the character to pull back occasionally and

question his role as an artist and the decisions he has made to further his career. This is accomplished by Brandauer's performance as well as Szabo's more extensive use of the Faust imagery that is only briefly suggested in the novel.

Szabo's use of the Faustian imagery begins earlier than in the novel, with Hofgen's performance as Mephistopheles in a production of *Faust*. His makeup consists of a ghostly white-makeup mask and a seemingly bald head. This face is illuminated on stage, creating a ghastly and evil appearance. It is at such a performance that Hofgen is first brought to the attention of the prime minister. Göring is enchanted with Hofgen's characterization and sees the figure of Mephistopheles as an essential part of the German character. A meeting of evil demon and statesman occurs during intermission as the theater audience's attention is focused on the prime minister's box in which Hofgen, in costume, and Göring first meet. This image comes up again in a different way: As Hofgen and his wife, Nicoletta, discuss the death of one of Hofgen's former communist comrades, Nicoletta's face is packed in a mud mask.

Szabo ultimately makes a different statement in his movie than Mann does in his novel, reflected in his choice of a different ending. In the film, Göring has taken Hofgen to the newly constructed Olympic stadium. As Hofgen stands alone in the arena, the spotlights are turned to him. His cry of "all I am is an ordinary actor" takes on a different meaning here as he is blinded and bewildered in the lights. He is seen to reach a sort of epiphany, questioning his role in the regime and his attempts to play a powerful artist in the midst of a powerful, commanding regime.

Both Mann in his novel and Szabo in his film attempt to address the question of artistic responsibility in relation to existing politics. Mann, however, fails at social satire, creating instead a tale embroiled with criticism and sarcasm directed at a particular individual. Szabo, on the other hand, successfully addresses the question of the responsibility and guilt of an artist to his political environment at large. Szabo, unlike Mann, leaves Hofgen in a state of questioning, allowing him the possibility of new choices and, ultimately, of change.

REFERENCES

Hoffer, Peter T., "Klaus Mann's *Mephisto*: A Secret Rivalry," *Studies In Twentieth-Century Literature* 13 (1989): 245–57; Margolis, Harriet, "'Nur Schauspieler': Spectacular Politics, *Mephisto*, and Good," in *Film and Literature: A Comparative Approach to Adaptation*, eds. Wendell Aycock and Michael Schoenecke (Texas Tech University Press, 1988); Paul, David W., "*Mephisto*," in *Magill's Survey of Cinema*, ed. Frank N. Magill (Salem Press, 1985).

—A.D.B.

MIDNIGHT COWBOY (1965)

JAMES LEO HERLIHY

Midnight Cowboy (1969), U.S.A., directed by John Schlesinger, adapted by Waldo Salt; United Artists.

The Novel

Midnight Cowboy was hardly a best-seller before its adaptation. Herlihy's reputation may well rest on the films made from his works (*Blue Denim*, *All Fall Down*, *Midnight Cowboy*) rather than on the plays and novels themselves. Yet this well-crafted novel tells an engaging story because it pulls off the considerable narrative feat of generating credibility—and even reader sympathy—for a protagonist who is almost inconceivably stupid and implausibly naive.

Joe Buck is a kind of orphan, raised by prostitutes. As a teenager, Joe "developed an acute sense of his own worthlessness." He does army service, then works at a lunch counter, and finally decides to market his one asset—his good looks—by becoming a stud in New York: "The men back there," said Joe, "is just faggots, mostly, and so the women got to buy what they want." In New York, Joe ends up being hustled every time he tries to hustle. He meets Rico "Ratso" Rizzo, a crippled low-life con man who has adapted to homelessness. Despite Ratso's initial trick on Joe, a kind of love grows between them, motivating Joe to earn the money to make the fatally sick Ratso's dream of moving to Florida come true. On the bus down there, Ratso dies, leaving Joe Buck hugging the dead body, "scared now, scared to death."

The Film

Schlesinger's film makes several significant changes. It begins with Herlihy's second part (the bus ride to New York) and intercuts details from Joe's earlier life (which occupy all of the first third of the novel) into this sequence by way of quick flashbacks. Second, it builds Ratso (Dustin Hoffman) into a major character who almost dominates the movie. Finally, it makes no attempt to find a filmic equivalent for the novel's third-person restricted narration, which is exclusively from the point of view of Joe Buck (Jon Voight). Instead, the movie fashions a satirically omniscient narration that at times hits with a sledgehammer, as in the juxtaposition of sound and image (views from the bus and of the other passengers as Joe listens to his precious radio).

There was considerable praise for the acting, especially the portrayal of affection between two men, physical and mental opposites in every way, yet both orphans of an uncaring, often overtly cruel, world. This oversimplified satire occasioned severe criticism, such as John Simon's finding the film "just a little too knowing, pert and pat," and taking offense at its "contrived manipulative technique, adroit through it may be." The film also never resolves its own attitude toward sexuality, celebrating on one level a kind of platonic homoeroticism and yet depicting every homosexual and heterosexual encounter as sordid, ugly, and pathetic.

REFERENCES

Birdsall, Eric R., and Fred H. Marcus, "Schlesinger's *Midnight Cowboy*: Creating a Classic," in *Film and Literature: Contrasts in Media*, ed.

Fred H. Marcus (Chandler, 1971), 178–89; Fiore, Robert L., "The Picaresque Tradition in *Midnight Cowboy*," *Literature/Film Quarterly* 3 (1975): 270–76; Simon, John, "Rape Upon Rape," *Film 1969–70*, ed. Joseph Morgenstern and Stefan Kanfer (Simon and Schuster, 1970); Wicks, Ulrich, *"Midnight Cowboy," Picaresque Narrative, Picaresque Fictions: A Theory and a Guide* (Greenwood, 1989).

—U.W.

MILDRED PIERCE (1941)

JAMES M. CAIN

Mildred Pierce (1945), U.S.A., directed by Michael Curtiz, adapted by Ranald MacDougall et al.; Warner Brothers.

The Novel

Mildred Pierce is atypical of the crime novels of James M. Cain in that it does not involve a murder as its central plot device. It is a satire spoofing middle-class pretentiousness and ambition, symbolized by the plucky heroine whose husband Bert deserts her for a neighbor woman who makes her living by renting hovels to Mexicans. Mildred is left with the challenge of paying the rent and raising two daughters, the elder of whom, Veda, Mildred desperately wants to believe is talented. Having no experience in the workplace, Mildred uses her household skills and becomes famous for baking pies. She takes a job as a waitress, which her high-minded daughter thinks is demeaning. All of her efforts are intended to please this thankless daughter. She opens her own restaurant by entering into an agreement with Monty Beragon, whose family once had money, though Monty, a spendthrift playboy, has all but depleted the family fortune. Mildred divorces Bert and weds Monty to please Veda, after her younger daughter, Ray, dies as a consequence of an infected pimple, apparently God's punishment to Mildred for spending a romantic weekend with Monty.

Veda is given piano lessons but displays no real talent. She does have a talent for singing, however, and becomes a gifted coloratura soprano, ultimately capable of earning a splendid income. Monty, meanwhile, begins to fool around with his stepdaughter while Mildred is busy making money to pay for the extravagances of her daughter and husband. Monty ultimately double-crosses Mildred and takes over her business. Mildred discovers Monty and Veda in bed together and attacks Veda, choking her. Veda pretends that her vocal cords are damaged and uses this excuse to break one singing contract in order to capture a more lucrative one that will take her to New York, away from her mother in California. Mildred ages over a decade into a "dumpy little thing," and, at the end, deserted by her ungrateful daughter, is reunited with her first husband, Bert.

The Film

The film adaptation was produced by Jerry Wald for Warner Brothers and shaped, according to Wald's wishes, as a film noir comeback vehicle for Joan Crawford, who makes Mildred appear to be smarter and more in control than she ever seemed to be in the novel, though she still dotes absurdly over her thankless daughter, who, in the film, has no talent at all and can do no better than to sing in honky-tonk bars. In the novel Mildred had to struggle to find a job in Depression America. In the film she is a more confident and classy woman who effortlessly makes her way to the top. The most astonishing change in this adaptation, however, is that the story is reimagined as a murder mystery. It begins at Monte's beach house at night. Monte (Zachary Scott plays the renamed "Monty") is seen being shot in the stomach, and, as he collapses and dies, he utters the name "Mildred," presumably naming his killer. Mildred is then seen walking the streets, desolately, and is stopped by a policeman from jumping off a bridge. She spends the night at the police station confessing to the murder of Monte and telling her sordid story in flashback. But it turns out that Mildred did not kill her husband and is only confessing to protect her daughter Veda (Ann Blyth), who shot Monte in a fit of rage after he had rejected her. The film ends with Veda being arrested, and, as day breaks, Mildred being reunited with her husband Bert (Bruce Bennett).

The film's narration is framed in such a way that it consciously imitates *Citizen Kane* (1941), as Cain's satire is transformed into a melodrama far removed from the original story. In the film Mildred is treated sympathetically for her noble attempt to better herself and her family. Her only flaw is her maternal dedication to her daughter, which is overstated, to be sure, but not so foolish as it had been in the original. Although Ranald MacDougall got the screenwriting credit, the picture involved many other writers. Thames Williamson wrote the first of eight treatments in 1944 and introduced the flashback approach. The screenplay was subsequently rewritten by Catherine Turney, Margaret Gruen, Albert Maltz, Louise Randall Pierson, and William Faulkner. All of these writers worked to reshape the novel according to Wald's melodramatic theme: "A mother sacrifices a great deal for the child she loves. The child turns out to be empty of real talent and a bitch who betrays her mother."

Mildred Pierce became a touchstone for feminist film critics during the 1980s who were not especially interested in the film's fidelity to its source so much as what it had to say about women's issues and the difficulty of a woman succeeding in the workplace. A secondary interest was established in the film as a vintage noir classic because of its convoluted plot, its flashback voiceover narration, its lighting, and its femme fatale, Veda, the spiteful little murderess who is brought to justice. The film did not deserve an Academy Award for best adapted screenplay because of the way it betrays its source, but as a reimagined noir feature it is well constructed and well acted, especially by Joan Crawford, who won a best actress Academy Award for reinventing the character. It is a perfect case study to show how a major studio could high-handedly reshape a well-

crafted novel in order to turn it into a star vehicle. For what it is, the film is well made and entertaining.

REFERENCES

Cook, Pam, "Duplicity in *Mildred Pierce*," in *Women in Film Noir*, ed. E. Ann Kaplan (BFI Publishing, 1980); La Valley, Albert J., ed., *Mildred Pierce* (University of Wisconsin Press, 1980); Madden, David, *James M. Cain* (Twayne Publishers, 1970).

—*J.M. Welsh*

LES MISERABLES (1862)

VICTOR HUGO

Les Miserables (1912), France, directed and adapted by Albert Capellani [studio and releasing organization unknown].

Les Miserables (1918), U.S.A., directed by Frank Lloyd, adapted by Lloyd and Marc Robbins; Fox Film Corp.

Les Miserables (1925), France, directed and adapted by Henri Fescourt; Films de France.

Les Miserables (1933), France, directed by Raymond Bernard, adapted by Andre Lang; Pathé-Natan.

Les Miserables (1935), U.S.A., directed by Richard Boleslawski, adapted by W.P. Lipscomb; Twentieth Century.

Les Miserables (1952), U.S.A., directed by Lewis Milestone, adapted by Richard Murphy; 20th Century-Fox.

Les Miserables (1957), France, directed by Jean-Paul Le Chanois, adapted by Le Chanois, Rene Barjavel and Michel Audiard; Pathé.

Les Miserables (Les Miserables du vingtieme siècle) (1982), France, directed by Robert Hossein, adapted by Hossein and Alain Decaux; Dominique Harispuru/SFPC.

Les Miserables (1995), France, directed and adapted by Claude Lelouch; Les Films 13/BAC Films.

Les Miserables (1997), U.S.A., directed by Bille August, adapted by Rafael Yglesias; TriStar/Mandalay Entertainment.

The Novel

Even before the last volumes of Victor Hugo's 1862 masterpiece *Les Miserables* (which, literally translated, means "the miserable ones") appeared in print, an enthusiastic French reading public was already breathlessly following the adventures of Jean Valjean, the exconvict turned philanthropic factory owner; Inspector Javert, that rigid paragon of rules and police procedure; Fantine, the abandoned grisette; and her orphaned daughter, Cosette, captive of the evil innkeepers, the Thenardiers. Thus, when the doors opened to Pagnerre's bookshop on the morning of May 15, 1862, the streets were already jammed with would-be purchasers. The thousands of newly published books vanished within a few hours. Factory workers set up subscriptions to buy what would otherwise have cost them several weeks' wages.

Written during Napoleon III's Second Empire, the novel looked back to a 20-year span between Waterloo and the 1832 insurrection in the Paris streets. Famous as a poet and generally known as a defender of the oppressed, Victor Hugo's prestige worked effectively to expose the misfortunes suffered by social and political outcasts. According to Hugo's biographer, Graham Robb, *Les Miserables* had a significant impact on affairs of state. "The Emperor and Empress performed some public acts of charity and brought philanthropy back into fashion. There was a sudden surge of official interest in penal legislation, the industrial exploitation of women, the care of orphans, and the education of the poor. From his rock in the English Channel, Victor Hugo, who can more fairly be called 'the French Dickens' than Balzac, had set the parliamentary agenda for 1862." While the novel was accessible to the masses, it placed itself in the cause of the individual. "Hugo had produced the most lucid, humane and entertaining moral diagnosis of modern society ever written."

The novel is arranged in sections, successively, "Fantine," "Cosette," "Marius," "Saint Denis," and "Jean Valjean." Interpolated into the main action are the famous "digressions" that constitute a significant portion of the book, like the mini-treatises on Waterloo, convents, and sewers. Indeed at its very beginning is a digression, the life story of Bishop Bienvenu, whose act of Christian charity will set ex-convict Jean Valjean on the path of righteous action.

The action proper begins when Jean Valjean, convicted for the theft of a loaf of bread to feed his sister's starving children, is released after 19 years of penal servitude. His first encounter is with Bishop Bienvenu, who, out of pity, exonerates Valjean with the police on a charge of stealing his silverware. The bishop adds a pair of silver candlesticks to his benefaction and sends Valjean on his way, charging him to henceforth lead a life of compassionate and charitable acts. In the ensuing years, Valjean changes his name to M. Madeleine and establishes himself as a successful merchant in a glassworks factory. So respected is he that he is soon elected mayor of the village.

The newly arrived police inspector Javert suspects that Madeleine is the ex-convict Valjean. He attempts to expose him to the prefect in Paris. But when he learns that another man has been arrested as Valjean, he confesses his deed to Valjean, exhorting him to fire him as police inspector. Stunned by the news that an innocent man may suffer from the mistaken identity, Valjean forgives Javert and hurries off to Arras where he clears the accused—even though he realizes it means losing his freedom.

Meanwhile, Valjean has taken under his protection the prostitute Fantine, an ex-worker in his factory who has taken to the streets to support her child, Cosette. Valjean rescues her from Javert's brutalizing, beats Javert senseless, and pledges the dying woman to take Cosette away from the evil innkeepers who are raising her for extortionate prices. But before Valjean can rescue Cosette, he's captured and sent back to jail. He quickly escapes, but he is

caught again. In a subsequent accident, he is mistakenly pronounced dead. Actually he survives and returns to rescue Cosette. For the next nine years, Valjean eludes the police as he works as a gardener in a convent and raises Cosette to be a beautiful young woman. When she declares her distaste for convent life, they move to a modest house in a side street of Paris.

Cosette falls in love with Marius, a young revolutionary in a group called the "Friends of the ABC." Their intent is to reestablish the French Republic. At first Valjean tries to block his daughter's growing romance, but soon he is distracted by the events that lead to the street insurrection of June 5, 1832. After numerous intrigues involving Marius, the scheming Thenardiers, and near-exposures of Valjean, Javert falls into the hands of the rebels and Valjean is entrusted with killing him. Instead, he releases him and, with the injured Marius, takes to the sewers to elude the police. But Javert reappears to capture him. Valjean bargains that he will surrender if Javert will allow Marius to escape. Javert acquiesces, but then unexpectedly runs away from Valjean and commits suicide by drowning himself in the Seine.

In a lengthy epilogue, Marius marries Cosette but upon learning of Valjean's past, banishes him from his house. Valjean dies at last, but not before he is reconciled with Marius and Cosette.

The Films

Hugo's sprawling novel has tempted many filmmakers since the early days of the feature film. It has had the unusually good fortune, moreover, of receiving relatively respectful treatment. Of course, in all of the adaptations, the epilogue is cut, as well as Hugo's digressions on such matters as Waterloo and the Paris sewers; the secondary plot of the adventures of the scheming Thenardiers is also simplified or abandoned outright. The first of the foreign film versions is a French production directed by Albert Capellani in 1912; contemporary accounts report it to be a faithful and internationally successful effort. Of subsequent French versions, Henri Fescourt's in 1925 and Raymond Bernard's in 1933, little information is available. Of particular interest in the latter film, however, is the casting of Harry Bauer as Valjean.

The first American adaptation was made by the Fox Film Corporation in 1918, directed by Frank Lloyd and starring William Farnum as Valjean and Hardee Kirkland as Javert. The film is no longer extant, but according to the *AFI Catalogue of Feature Films, 1911–1920*, it stays true to the letter, if not the details of the plot. The most significant departure occurs at the end when Javert, in a burst of sudden kindness, decides to give Valjean his freedom. And everyone lives happily ever after.

Next in chronology, and still the most popular of the talking-picture adaptations is the Twentieth Century film released in 1935, directed by Richard Boleslawski, adapted by W.P. Lipscomb, and starring Fredric March as Valjean,

Charles Laughton as Javert, Rochelle Hudson as the older Cosette, John Beal as Marius, and Florence Eldridge as Fantine. According to George F. Custen's study of producer Darryl F. Zanuck, it was a pet project for Zanuck. In taking on an ambitious project like this, Zanuck was "confronting an organized American cultural hierarchy opposed to placing the power to interpret high art in the hands of the vulgarians who ran the movie studios." Relating the book to contemporary audiences, Zanuck regarded it as an "I Am a Fugitive from a Chain Gang" in costume. Stripping it down to its bare essentials, he proclaimed it the depression America story of a normal, family-loving man who was persecuted for stealing to feed his children—"It's the theme of today." Setting and spectacle—the historical aspects of which might bewilder 1930s audiences—were subordinated to character. Valjean himself was carefully tailored to appeal to contemporary audiences. His nurturing relationship with Cosette was built up. To ensure that actor Fredric March preserved his appeal with audiences, makeup reminiscent of some of his prior film roles was prescribed. The script pared away the novel's subtleties and historical contexts and simplified the central story line. It concludes with Javert's death, omitting the epilogue. If Fredric March seems a trifle too puny for the hulking Valjean, Laughton's relentless Javert is repellently and convincingly sadistic. The real star of the picture is Gregg Toland's darkly cloaked imagery, a chiaroscuro that plunges its characters into the murk of their own obsessions. The film was nominated for four Academy Awards, including best picture and cinematography.

Rafael Yglesias's script for Bille August's 1998 film also preserves the main line of Hugo's narrative. The results, however, are not particularly compelling. It was perhaps judicious to trim away the complicated links between Marius and the Thenardiers, and the rather anti-climactic epilogue. But an important motivation behind the obsession of Javert (Geoffrey Rush), namely, the death of his father in the galleys, is also missing. The scenes leading up to and including the barricade insurrections—among the most vivid and exciting of the novel—seem perfunctory. Indeed, with the gathering storm of the 1832 insurrection, the story suddenly sags. The rebels, including Marius (an insipid Hans Mathesson), are sketched in too thinly. They never emerge as anything more than comic-book cutouts strutting attitudes and declaiming patriotic slogans. The same may be said for the romantic declarations between Marius and Cosette. A significant alteration in the ending has Javert taking Valjean (Liam Neeson) to the banks of the Seine, where he admits that he's trapped between an unwillingness to arrest the man who has saved his life and an inability to betray his profession. He puts on handcuffs and, before the startled Valjean, throws himself into the water. The movie ends at the point when amnesty for the rebels is imminent, when romance can blossom between Marius and Cosette, and when Valjean can resume a free life.

Finally, without question the most interesting of all adaptations of *Les Miserables*—virtually a commentary on

the adaptation process itself—is Claude Lelouch's award-winning 1995 version. The movie, which sets the main action in World War II, is a complex, sprawling, three-hour epic that contains scenes drawn from Hugo's novel, modern scenes that parallel the novel, scenes that have nothing to do with the novel, and excerpts from past movie versions of the novel. Jean-Paul Belmondo stars in the Jean Valjean role, which here is translated into a dual role as Henri and Roger Fortin, father and son. The action begins in 1900 as Henri, a chauffeur wrongly accused of the death of his aristocratic employer, escapes imprisonment after much persecution. Years later, his son, Roger, grows up to be a boxer in the shadow of the German occupation of France. He aids the Jewish Ziman family's flight from the Nazis and drives them to the Swiss border. Along the way Ziman promises to read *Les Miserables* to Roger, who has already seen scenes from the 1933 movie with Harry Bauer (which Lelouch intercuts into the action). Gradually, Roger begins to identify with the heroic Jean Valjean (he even has a Javert-like persecutor on his trail, a nameless policeman collaborating with the Nazis), and he eventually becomes a hero himself. In a post-war epilogue we are reminded that justice was not always properly dispensed among those French citizens who did and did not collaborate with the Nazis. The wealth of incidents, secondary characters, and subplots in this film is vast. As critic Roger Ebert has noted, "What I liked most about it was the expansive freedom and energy of its storytelling. Lelouch, like Hugo, Dickens, Balzac and the other great 19th century novelists, is not riveted to a central story line, but proceeds in the general direction of his conclusion while freely allowing himself side excursions to characters and incidents that catch his eye along the way."

Among the currently unavailable versions are Lewis Milestone's 1952 film, starring Michael Rennie as Valjean, Robert Newton as Javert, and Debra Paget as Cosette; Jean-Paul Le Chanois's 1957 film, which stars Jean Gabin as Valjean (capitalizing on his international reputation portraying "anti-heroes" in films by Jean Renoir and Marcel Carne), Bernard Blier as Javert and Daniele Delorme as Fantine; and Robert Hossein's 1982 adaptation (*Les Miserables du vingtieme siècle*) a five-hour television film (later cut to three hours for theatrical release), which stars Lino Ventura as Valjean, Philippe Khorsand as Javert, and Evelyne Bouix as Fantine.

REFERENCES

Custen, George F., *Twentieth Century's Fox: Darryl F. Zanuck and the Culture of Hollywood* (Basic Books, 1997); France, Peter, "His Own Biggest Hero," *The New York Times Book Review*, February 15, 1998, 7); Robb, Graham, *Victor Hugo: A Biography* (W.W. Norton, 1997).

—C-A.L. and J.C.T.

MISERY (1987)

STEPHEN KING

Misery (1990), U.S.A., directed by Rob Reiner, adapted by William Goldman; Castle Rock/Columbia.

The Novel

For Stephen King, the best-selling American horror author of all time, *Misery* was atypical of his usual approach, inasmuch as he relied more upon the power of the imagination and the dysfunctions of mental illness than supernatural elements (*Salem's Lot*, *The Shining*) to conjure up terror. Moreover, its tale of the gruesome fate of a popular writer at the hands of his manically adoring public may be regarded as a not-so-subtle piece of autobiography.

Paul Sheldon is the author of a series of popular romance novels featuring a heroine named Misery Chastain. Upon completion of the series, after killing off Misery, Paul travels to a remote lodge in Colorado determined to gain more respect as a writer by creating a "serious" novel. After finishing the book, Paul, anxious to bring the work to his publisher, is seriously injured while driving through a blizzard. To the rescue comes Annie Wilkes, a nurse who calls herself Paul's "number one fan." She takes him to her isolated house, claiming that because telephone lines are down and the roads are impassable, she will care for him herself.

Paul has a broken arm and fractures in both legs. Annie fusses over him, feeding him heavy doses of addictive medications until Paul is drug dependent. Meanwhile, Paul lets her read his new manuscript. She is disappointed in it because it does not feature her favorite character, Misery Chastain. She is further upset by its profanity. Paul grows fearful about her irrational mood swings and suspects she is a psychopath. Annie makes Paul burn his new manuscript and then, threatening him with a blowtorch and an ax, she forces him to write another manuscript and bring Misery back to life. She means business—when Paul tries to escape, she chops off his foot with an ax. Thus, like another doomed teller of tales, Scheherezade, Paul must spin out his stories to survive.

Meanwhile, the local sheriff has discovered Paul's car but cannot locate his body. The sheriff begins reading the eight Misery novels in hopes of finding clues to Paul's whereabouts. Coincidentally, he remembers that Annie, whom he suspects in a number of mysterious deaths in hospitals where she worked as a nurse, quoted Paul's novels at her trial. He visits Annie's house and hears cries for help from Paul, who is trapped in the basement. She kills the sheriff and plans a double suicide for herself and Paul. Paul, however, manages miraculously to overcome her and escape. Annie is ironically killed by the very typewriter Paul has used for his writing.

In the aftermath, Paul is obsessed by fears that he has made up the entire story out of his vivid literary imagination. Ironically, he regards the new Misery novel, *Misery's Return*, as one of his best works and plans to publish it.

The Film

Although King himself has tried his hand at filmmaking, directing the ill-fated *Maximum Overdrive*, for example, critics generally fell that other directors, such as Rob Reiner (who also directed the Academy Award-winning

Stephen King

King on his own career). It's also the kind of horror that King's biographer, Douglas E. Winter, says is typical of King: "Horror fiction has a cognitive value, helping us to understand ourselves and our existential situation."

Despite the film's shortcomings as a King adaptation, it has established itself as an important entry in the contemporary horror genre. In her seminal book, *Men, Women, and Chain Saws*, Carol J. Clover identifies the film as a prototype in a current trend in which the archetypes of the rapacious male and the passive female victim are reversed: "Here the 'feminine' or masochistic position is occupied by a man (one indeed with broken legs) and the position of sadistic, gender-disturbed, serial murderer (who 'adores' the object of her attentions in much the way slasher killers sometimes 'adore' their female victims) is played by a woman. It is an arrangement that allows for a particularly prolonged and brutal sadistic reversal."

REFERENCES

Clover, Carol J., *Men, Women, and Chain Saws* (Princeton University Press, 1992); Conner, Jeff, *Stephen King Goes to Hollywood* (New American Library, 1987); Winter, Douglas E., *Stephen King: The Art of Darkness* (New American Library, 1984).

—*S.C.M. and J.C.T.*

THE MISFITS (1960)

ARTHUR MILLER

The Misfits (1961), U.S.A., directed by John Huston, adapted by Arthur Miller; United Artists.

The Novel

Arthur Miller had already established himself as a major 20th-century American dramatist (*All My Sons, Death of a Salesman, The Crucible, A View from the Bridge*) when he penned a short story entitled "The Misfits" for *Esquire* in 1957. Basing it on his experiences during a visit to Reno, Nevada, to get a divorce from his first wife, Miller wrote the story a year after he had married Marilyn Monroe, his second wife. Three years later he would dedicate to Monroe a screenplay-novel that he developed from the *Esquire* piece, restructuring it to focus on the female character whose presence had only been hinted at in the short story. Monroe and Miller would be divorced one week before the film's release.

Written in Miller's words as "neither novel, play, nor screenplay . . . [but as] a story conceived as a film, and every word is there for the purpose of telling the camera what to see and the actors what they are to say," *The Misfits* may be considered a *ciné-roman*, or "cinema-novel," the only major nondrama that Miller wrote after the success of his plays beginning in the late 1940s. The novel, published after the film, reflects changes made in Miller's script as Huston shot the film, with Miller on location rewriting scenes, but even this version is not a precise shooting script. Robert Corrigan makes the argument that *The Misfits* is Miller's "pivotal

Stand by Me) have handled his adaptations to screen more effectively. *Misery* was a bit of a surprise to Reiner enthusiasts, marking a radical departure from the man who had recently made *Princess Bride* and *When Harry Met Sally*. Screenwriter William Goldman removed much of the gore and violence, concentrating more on the character of Annie, played by Kathy Bates, whose Oscar-winning performance mixed the terrors with black humor, keeping audiences off balance. It was also a "comeback" performance for the sagging career of James Caan, as Paul Sheldon. Cinematographer Barry Sonnenfeld's visuals, with their odd angles, dramatic close-ups, and frantic tracking shots, contribute to the tone of mounting anxiety.

Largely absent, however, is the book's ironic subtext about Paul's voyage of self-discovery. In accepting Annie's surprisingly insightful criticism of his "serious" new novel, and in returning to the "Misery" formula, he realizes that his literary pretensions have been misplaced. His true metier lies precisely in the "bodice-ripper" melodramas that had made him so popular in the first place. Thus, the writing of the new Misery book turns out to be a happy experience, even though each page brings Paul closer to his death. It's a potent image of the artist running to meet his own mortality—and loving it (surely a commentary by

work" in its lack of focus on identity as a theme and its increased foregrounding of women and sexuality.

The novel follows several weeks in the lives of three cowboys. These are Miller's "misfits," men who no longer belong—like the wild Nevada mustangs they hunt down to be sold as pet food—but try vainly to hold on to their fading sense of male machismo and independence in a changing world. As Miller phrases it, "It's just ropin' a dream now." Gay, the oldest of them, falls in love with the lonely and childlike Roslyn, who like so many others has come to Reno for a divorce. Like Hemingway's Brett in *The Sun Also Rises*, Roslyn is the sexually alluring woman who enters and disrupts a world of male comradeship, her romantic innocence and femininity forcing them to rethink their solitude and cynicism. She wants to curb the wild cowboy in Gay, but of course that's the very element that attracts her, and his effort to hold on to his masculine identity while also embracing her feminine point of view becomes a central motif, for example in the climax where she tries to stop him from capturing a half-dozen mustangs. Drinking, riding, and mustang-hunting with ex-cowboy Gay are the war-hero pilot Guido and the young,

mother-obsessed rodeo-rider Perce, each of whom is briefly obsessed with the innocent-seeming divorcée.

The Film

From the beginning expectations ran high for this movie. Huston and Miller's reputations and a cast with Marilyn Monroe (Roslyn), Clark Gable (Gay), and Montgomery Clift (Perce) seemed to assure a great Hollywood blockbuster in the making. However, production problems with the Nevada location shooting caused major delays, while Monroe suffered from physical and psychological illnesses. (Hospitalized during the filming for an overdose of sleeping pills, Monroe killed herself 18 months after the film's opening.) Gable was pushed beyond his physical limits as Huston had him performing his own stunts: He died of a heart attack shortly after the film was finished and never saw the final print. Clift himself suffered from ill health. Costs ballooned to $4 million (astounding for a black and white movie at that time).

Critics praised the acting over the story. Huston—despite some significant streamlining in the climax—never

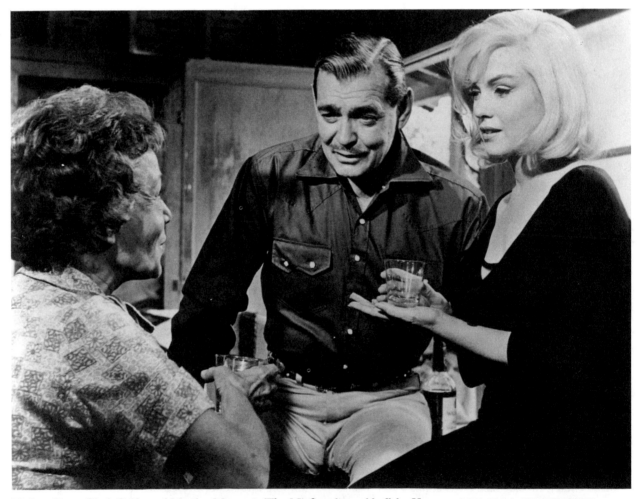

Thelma Ritter, Clark Gable, and Marilyn Monroe in The Misfits, *directed by John Huston* (1961, U.S.A.; UA/THEATRE COLLECTION, FREE LIBRARY OF PHILADELPHIA)

found in the heavy symbolism of Miller's script the kind of narrative drive that would lift his adaptation beyond the merely melodramatic—although, the film still generates the occasional poignant moment, perhaps due to our knowledge of the costars' fates.

Perhaps obsessed with the twin pulls of sex goddess Monroe and Hollywood imagination, Miller seems out of his genre in this melodramatic soap-and-horse opera; his prose ranges from eager and earnest "filmic" descriptions to heavy-handed and belabored philosophizing, as if the potential weaknesses of his major theatrical dramas rose to the surface when he dealt with this unaccustomed format. It's almost as if we were to get only the lengthy stage directions but not the drama of *The Crucible*; at times Miller seems incapable of dramatizing the themes and psychological portraits his long commentaries describe. *The Misfits* seems to prove that film was not a medium for Miller.

Huston, meanwhile, had made and would continue to make some of the finer adaptations of literary classics in Hollywood, but he also seems in awe of his stars and his scenarist, and neither "novel" nor film ever reaches the level one would expect. The most exciting scenes—the final mustang hunt that ends the film—feature remarkable filming, but even Huston's direction of the action sequences can not seem to spark the film, and instead the film slows right where it should be most dramatic. As Edward Murray points out, Huston also avoids following Miller's own specific directions concerning point of view, and thus loses some of the "rhythm and complexity" of the text. The film's primary interest now is for the acting and as a curiosity—Miller's one attempt to write a film and the final work of both Monroe and Gable, whose roles as lonely and misplaced "misfits" seem now to match their professional biographies. Their magnetism on the screen can still sway, and Clift's quiet demeanor as a family, as well as social, "misfit" is beautifully juxtaposed to their love.

REFERENCES

Conway, Michael, *The Films of Marilyn Monroe* (Cadillac Publishing, 1964); Corrigan, Robert W., *Arthur Miller: A Collection of Critical Essays* (Prentice-Hall, 1969); Garrett, George, O.B. Hardison Jr., and Jane R. Gelfman, eds., *Film Scripts Three: Charade, The Apartment, The Misfits* (Irvington Publishers, 1989); Goode, James, *The Story of the Misfits* (Bobbs-Merrill, 1963); Murray, Edward, *The Cinematic Imagination: Writers and the Motion Pictures* (Frederick Ungar, 1972); Walker, Alexander, *Sex in the Movies: The Celluloid Sacrifice* (Penguin, 1968).

—D.G.B.

MISS LONELYHEARTS (1933)

NATHANAEL WEST

Advice to the Lovelorn (1933), U.S.A., directed by Alfred Werker, adapted by Leonard Praskins; Twentieth Century-Fox.
Lonelyhearts (1958), U.S.A., directed by Vincent J. Donahue, adapted by Dore Schary; Schary/United Artists.

The Novel

Nathanael West, not well known during his short life, is now considered one of the foremost American modernists, despite a small productivity that includes *The Dream Life of Balso Snell* (1931), *A Cool Million* (1934), and *The Day of the Locust* (1939), his most famous novel, which focuses on the lost souls of Hollywood where West worked briefly as a scenarist. West's short fiction features bitter and satiric depictions of the corrupt and depressing underside of American culture, all told in a perversely nihilistic tone.

An embittered New York City newspaperman—known only as "Miss Lonelyhearts"—is a Baptist minister's son who has been assigned a column answering poignant letters from depression-era readers who write agonizing pleas for help and advice in their grotesquely depressing circumstances. Driven to despair by his cynical newspaper editor Shrike, who provides a non-stop mocking commentary, and by the epistles from the forlorn and the lovelorn, Miss Lonelyhearts seeks refuge alternately in alcohol, adultery, seduction, nature, psychosomatic illness, and, finally, a religious universal love of mankind he discovers in a fever-induced vision of a benevolent God. After this final epiphany, he embraces Peter, a "little cripple," the angered and armed husband of Fay Doyle, a woman with whom Miss Lonelyhearts had briefly had an affair. In a moment of brutal irony, the cripple's gun accidentally goes off and Miss Lonelyhearts is killed.

The Films

Alfred Werker first adapted *Miss Lonelyhearts* the same year as the novel's publication. The film, not available, is known mostly as a vehicle for Lee Tracy that emphasized the "farce melodrama" in the story while ignoring West's bitterness.

In 1958, using Howard Teichmann's two-act dramatization, Vincent Donahue absurdly tried to reform West's despairing vision, shifting the story from the Depression era to the postwar 1950s. Donahue softened West's bitterness, dramatically reversed the ending, and generally sought a sentimental Hollywood product in a novel whose very existence demarcated a disgust for all that Hollywood represented.

Maureen Stapleton, in her movie debut, was nominated for an Oscar for her role as the sex-starved adulterer Fay Doyle.

Miss Lonelyhearts has the episodic narrative of a comic strip; the narrative is composed of 15 snapshot vignettes from Miss Lonelyhearts's life that the reader must retroactively link into a single picture of horrific despair. Trying to create a more dramatically cohesive movie defied Schary's scripting abilities (he also produced the film) and Donahue's direction. The film now seems dated, overlong, and ponderous where West's writing remains contemporary and elegant. For all his work in Hollywood and the cinematic narrative he developed in his fiction, West's work did not survive the Hollywood system.

Most perverse to West's sensibility is the happy ending, a glaring reversal matched perhaps only by Barry Levinson's film of Malamud's *The Natural:* Instead of dying accidentally at the hands of his nemesis-companion, Miss Lonelyhearts and the cuckolded Doyle are miraculously reconciled as Miss Lonelyhearts finds love and marriage and Shrike returns lovingly to his wife. In Donald McCaffery's reading, "Consequently, the end of the movie becomes the pure, soft-hearted liberalism of Dore Schary with not a shadow of the dark, ironic satire of Nathanael West."

REFERENCES

Bloom, Harold, ed., *Modern Critical Interpretations: Nathanael West's* Miss Lonelyhearts (Chelsea House, 1987); McCaffery, Donald W., *Assault on Society: Satirical Literature to Film* (Scarecrow Press, 1992); Martin, Jay, *Nathanael West: The Art of His Life* (Farrar, Straus and Giroux, 1970); Murray, Edward, *The Cinematic Imagination: Writers and the Motion Pictures* (Frederick Ungar, 1972).

—D.G.B.

MOBY-DICK (1851)

HERMAN MELVILLE

The Sea Beast (1926), U.S.A., directed by Millard Webb, adapted by Bess Meredyth; Warner Bros.
Moby Dick (1930), U.S.A., directed by Lloyd Bacon, adapted by J. Grubb Alexander; Warner Bros.
Moby Dick (1956), U.S.A., directed by John Huston, adapted by Huston and Ray Bradbury; Warner Bros.

The Novel

"I have written a wicked book," wrote Herman Melville to his friend Nathaniel Hawthorne, "and feel spotless as the lamb." Wicked or not, *Moby-Dick*, which was published in America by Harper & Brothers on November 14, 1851, was dedicated to Hawthorne, who subsequently pronounced it the best of Melville's works. An early review in *Harper's* a month later agreed, praising its "pregnant allegory, intended to illustrate the mystery of human life." However, the general reader, who had embraced Melville's previous sensations *Typee* (1846) and *Omoo* (1847), found little fascination in the massive novel. The book's failure did much to hasten the decline of Melville's literary and popular reputation. Only a handful of extended prose works, including *The Confidence Man* (1857) and *Billy Budd* (not published until 1924), remained to be written. His death in 1891 went virtually unnoticed. "Even his own generation has long thought him dead," noted one of his obituaries, "so quiet have been the later years of his life."

Few commentators have resisted venturing their own interpretations on Melville's baffling book and the Beast that lurks at its core. Lewis Mumford said the White Whale represents man's collective Unconscious, which torments man and is yet the source of all his boldest

John Barrymore as Ahab in The Sea Beast, *directed by Millard Webb* (1926, U.S.A.; WARNER BROS./JOE YRANSKI COLLECTION, DONNELL MEDIA CENTER)

efforts. For Leslie A. Fiedler, it is Leviathan, "the immortal symbol of the inscrutability of the created world, a mystery not to be resolved until the end of days." Melville, at any rate, knew whaling at first hand—in 1842 he had served on two whaling ships, the *Acushnet* and the *Lucy Ann*—and the book's meticulous details about the sea, whales, and whaling are solidly grounded (if that be the word) in his experiences. The story itself opens in a kind of limbo. "Call me Ishmael," says the narrator, but neither do we know if that is his real name nor when the story is taking place ("Some years ago—never mind how long precisely . . ."). Referring to the fascination held out by the sea as "the ungraspable phantom of life," Ishmael decides to ship aboard a whaling vessel, the *Pequod*, as a harpooner. He recounts events as they sail toward the Cape of Good Hope, making particular note of his fellowship with the noble savage Queequeg (whom he had met in New Bedford before the beginning of the voyage) and his observations of the enigmatic Captain Ahab. The core of the story details Ahab's dark obsession with the unrelenting pursuit of Moby-Dick, the great white whale that in an earlier voyage had destroyed his leg. Ahab nails a goldpiece to the mast and offers it as a reward to the first man who sights the creature. Convinced that Ahab is mad, and unsettled by a prophecy by Ahab's Parsee servant, Fedallah, that Ahab would have neither hearse nor coffin for his burial,

Starbuck, the first mate, tries to dissuade him from the quest. But, unrelenting in his pursuit, Ahab spots Moby-Dick and orders his men into the boats. The chase lasts three days. Finally, the whale turns on the *Pequod* and rams it. Ahab hurls his harpoon, but the rope wraps around his neck and carries him into the sea. All perish, save Ishmael, who is rescued by a passing ship.

The Films

It's been rough sailing for the extant screen adaptations. Hollywood, of course, has had to change everything. In the first two adaptations from Warner Bros., *The Sea Beast* (1926) and its talking-picture remake *Moby Dick* (1930), John Barrymore is "Ahab Ceeley," a dashing swain whose desperate love for a minister's daughter (named "Esther Harper" in the first version and played by Dolores Costello; and "Faith" in the second version and played by Joan Bennett) is thwarted by his villainous half brother, Derek. When the jealous Derek pushes Ahab overboard on a whaling trip, Ahab's leg is chewed off by Moby Dick.

Ahab, now embittered because he believes that since his injuries his fiancée no longer loves him, sets out to kill Moby Dick. After accomplishing the deed, Ahab returns to port and kills Derek. Now at peace, he settles down in New Bedford with his bride. As outrageous as the screen adaptations by, respectively, Bess Meredyth and J. Grubb Alexander, might seem, Barrymore's histrionics, not to mention his passionate love scenes (particularly those with Dolores Costello), won the films considerable box office success. About his maniacal take on Ahab, Barrymore commented, "Give them torture. . . . The public loves torture."

A third Warner Bros. venture was released in 1956, and it brought together the formidable, but altogether dissimilar talents of swashbuckling veteran director John Huston and the sensitive young fantasy writer Ray Bradbury. The relationship was stormy, and the inexperienced Bradbury frequently found himself the target of Huston's sadistic, unpredictable humor. In his memoir, *Green Shadows, White Whale* (1992), Bradbury declares that he wrote the script alone. Huston's biographer, Lawrence Grobel, refutes this, claiming that Huston, who had already attempted a script

Moby Dick, *directed by Lloyd Bacon* (1930, U.S.A.; WARNER BROS.)

as early as 1942, contributed to the screenplay during the entire shoot. In any event, after arbitration by the Screenwriters Guild, the film was released with Huston and Bradbury credited as co-writers.

Actual production began in Ireland in 1953. The film took three years to complete and cost just under $5 million. A small Irish port served as New Bedford in the 1840s. An 110-foot squarerigger was equipped like the *Pequod*. The White Whale was created at Elstree Studios near London, while life-size sections and small scale-models were filmed in a specially constructed water tank. Cinematographer Oswald Morris gave the images the steely look of engravings with a special Technicolor process that muted the color palette. In the cast were Gregory Peck as Ahab, Richard Basehart as Ishmael, Frederick Ledebur as Queequeg, Leo Genn as Starbuck, and Orson Welles in a brief appearance as Father Mapple.

Inasmuch as this was the first film to take seriously the process of adapting the Melville novel, an outline of some of the daunting challenges is in order. Throughout the text, Ishmael's narrative voice accommodates the contradictions and identifies the paradoxes of Melville's richly metaphoric prose. (It is only Ishmael, after all, who can tell us that Ahab stood before his crew "with a crucifixion in his face . . . chasing with curses a Job's whale round the world.") Indeed, at least half the novel's 724 pages and 135 chapters is concerned with what Melville called "invisible spheres," an aggregation of richly metaphoric prose, myth, legend, folklore, philosophical speculations, and biblical allusions. Not only are such elements incompatible with the photographic medium, but they impede the progress of the main story line. Likewise, the documentary portions of the novel depicting the workings of the whaling industry—what Melville's Ishmael calls "the real living experience of living men"—interrupt the dramatic continuity. Meanwhile, there is that baffling ambiguity regarding Ahab and Moby Dick to contend with. Consider, for example, their final confrontation when their roles as, respectively hero and villain, seem to reverse—when it is the White Whale who is described as possessing "gentle joyousness" and a "mighty mildness of repose," and it is Ahab who is screaming a mad defiance. Which one, after all, is the real Monster?

Bradbury and Huston set to work. "Our biggest problem," Huston remarked, "was to turn Melville's expositional passages into characteristic dialogue. . . . While *Moby-Dick* has some tremendous action sequences it has little actual plot." Accordingly, dramatic tension was enhanced with the addition of scenes of a storm and a near mutiny. The character of the mystic seer, Fedallah, was judged to be extraneous and dropped. So were the book's extended passages describing whales and whaling. Ishmael's narrative voice was employed only sparingly. Most strikingly, the ending was changed to allow Starbuck to kill Moby Dick, leaving Ahab to die lashed to the White Whale. "My God," recalled Bradbury, "these two should be together forever through eternity, shouldn't they— Ahab and the White Whale? It's not in the book, but I do believe that Melville would have approved." (It could be argued that this ending was suggested by a scene earlier in the book when Fedallah's lifeless body is discovered bound to the whale.)

Critics have long been divided on the merits of the adaptation. In his essay "Lost at Sea," Brandon French attacks the screenplay. Without the richness of Ishmael's voice, he laments, "whatever contradiction and complexity Bradbury tries to retain in his script seems forced, heavy-handed, out of place." The decision to kill the White Whale is particularly singled out for criticism: "One can't kill the phantom of life in the novel, but evidently in Bradbury's estimation, Moby Dick was, after all, just a whale." On the other hand, commentators Willis E. McNelly and A. James Stupple, applaud the effort: "Moby-Dick may forever remain uncapturable in another medium, but Bradbury's screenplay was generally accepted as being the best thing about an otherwise ordinary motion picture."

There is little argument, however, that many scenes succeed admirably: the recreation of the Spouter Inn, the scene when the pious Bildad assigns Ishmael his portion of the voyage's profits, the *Pequod*'s meeting with the *Rachel*, Ahab's "annointing" of the harpoons, the death reverie of Queequeg, and Orson Welles' inspired delivery (in an uncut six-minute take) of Father Mapple's sermon.

Moby Dick earned John Huston the New York Film Critics Award for best director in 1956.

REFERENCES

Bradbury, Ray, *Green Shadows, White Whale* (Alfred A. Knopf, 1992); Delbanco, Andrew, "The Leviathan," *The New York Review*, May 15, 1997, 18–23; French, Brandon, "Lost at Sea," in *The Classic American Novel and the Movies*, eds. Gerald Peary and Roger Shatzkin (Frederick Ungar, 1977); Grobel, Lawrence, *The Hustons* (Charles Scribner's Sons, 1989); McNelly, Willis E., and A. James Stupple, "Two Views," in *Ray Bradbury*, eds. Martin Harry Greenberg and Joseph D. Olander (Taplinger, 1980).

—L.C.C. and J.C.T.

THE MOSQUITO COAST (1982)

PAUL THEROUX

The Mosquito Coast (1986), U.S.A., directed by Peter Weir, adapted by Paul Schrader; Warner Bros.

The Novel

One of the more significant aspects of his life, and one that informs *The Mosquito Coast*, was Theroux's involvement in the Peace Corps. Stationed in Malawi in 1963, Theroux was involved in the attempted coup of Dr. H. Kamuzu Banda. The coup failed and Theroux was deported from Malawi and expelled by the Peace Corps. When *The Mosquito Coast* was published in 1982, Theroux had been writing for 14 years. Theroux has had two other novels adapted for film: *Saint Jack* (1973) was directed by Peter Bogdanovich in

1979 (Theroux wrote the screenplay), and *Half Moon Street* (1984) was directed by Bob Swaim in 1986.

Narrated by Charlie Fox, *The Mosquito Coast* is the story of Charlie's brilliant, eccentric father, Allie Fox, who takes his family from what he sees as the decaying United States to the virgin forests of La Mosquita in Honduras. Allie is a true individualist; he would believe that God helps those who help themselves, if only he believed in God. He has a strong work ethic and is both feared and loved by his family. Shoddy work, Japanese exports, traditional schooling, and television are all, to Allie's way of thinking, symptoms of the downfall of the United States. With this in mind Allie packs up his wife, two sons, and two daughters and brings them to the Mosquito Coast.

Upon arrival, Allie buys a town called Jeronimo, deep in the jungle. The town is nothing, so Allie sets his family and the natives to work, building a village powered by Allie's inventions. Among these inventions is Fat Boy, a huge firebox that makes ice without electricity. Allie becomes convinced that ice can save the wretched lives of the natives and starts out like a missionary to bring ice to the innocent. During a trip, Allie meets three soldiers who soon arrive at Jeronimo with their rifles. It is soon obvious that they will not leave and in essence are holding the village hostage. Allie, who does not want to see the life he has built destroyed, tricks the rebels into sleeping the night in Fat Boy. Once they fall asleep, he turns on Fat Boy, with plans to freeze them to death. They awake, begin firing their guns, and rupture the ammonia filled pipes; Fat Boy explodes, destroying the village and poisoning the water supply.

It is at this point that Allie crosses the line from eccentricity to madness. He tells the family that America has been destroyed, and in their fear they believe him. Allie soon begins a struggle upriver to the heart of the country. In an encounter with a reverend met earlier, Allie is shot, and eventually dies back on the coast, prey to ravenous vultures. Free of Allie's tyranny, the family starts the long voyage home.

The Film

The film version, directed by Peter Weir in 1986, was most noted for its leading actor in the starring role, Harrison Ford, known best for his roles as Han Solo in the *Star Wars* trilogy and Indiana Jones in *Raiders of the Lost Ark*. Ford's work in the film was highly acclaimed, but the film was not and did poorly at the box office. This is not surprising, as the story and characters hardly fit the mold for Hollywood success.

Besides some condensing and combining of events, the film differs from the novel in two significant ways. The first is the somewhat reduced role of Charlie, Allie's teenage son. Though Charlie's voiceover narration parallels his narration of the novel, it is much less revealing, and the viewer does not gain nearly as much access into the thoughts and viewpoint of Charlie. His role is reduced plotwise as well. In the novel, Charlie leads the family to safety after the explosion of Fat Boy. Also missing from the film is a series of acts that

Allie dares Charlie to perform, including the climbing of a ship's rigging during a terrible storm.

The exclusion of these acts leads to the second difference between novel and film. Although in both novel and film, Allie is seen as an eccentric, driven, and sometimes crazy man, in the novel, he is also a dangerous and, at times, an almost evil man. The risking of his son's life through the three dares and Allie's subsequent enjoyment of those situations are the most obvious aspects of this part of his character.

Though the film does not capture the depth of the novel, it does a remarkable job of telling the story of the Foxes and capturing the spirit of Theroux's Allie Fox. Rarely does a viewer feel a near hatred for a film's protagonist, as here. Furthermore, this hatred is very complex because, despite his lies and the atrocious behavior, Allie's desire for a new world and the destruction of his sanity with the destruction of that world are very understandable. The film is especially remarkable because it presents the beautiful jungles and mountains of Central America in a grand and sweeping fashion without losing sight of the complex character study at its core.

REFERENCES

Coale, Samuel, *Paul Theroux* (Twayne Publishers, 1987); McGilligan, Pat, "Under Weir . . . and Theroux," *Film Comment* 22 (December 1986): 23–32.

—B.D.H.

MR. ARKADIN (1955)

ORSON WELLES

Mr. Arkadin (aka *Confidential Report*) (1955), Spain/U.K., directed and adapted by Orson Welles; Mercury Productions/Filmorsa (Paris)/Cervantes Films/Sevilla Film Studios (Madrid).

The Novel

It is ironically appropriate to this flawed but often fascinating film that Welles's "novel" *Mr. Arkadin* (translated from the French in 1956) is neither its source nor really by Welles. According to Jonathan Rosenbaum (with corroboration from Welles), in 1955 Maurice Bessy ghosted a French serial novelization of Welles's film as a promotional device. This "novel" was then translated (anonymously) into English and republished in 1956. Both versions are copyrighted under Welles's name alone.

Both novel and film revolve around three characters: Guy Van Stratten, a rootless young America con-man and entrepreneur; Gregory Arkadin, a rootless older European con-man and entrepreneur whose gangster origins have blossomed into middle-aged wealth; and Raina Arkadin, Gregory Arkadin's young and beautiful daughter. As the novel begins, Van Stratten witnesses a homicide and hears the victim's last word: "Arkadin." Van Stratten goes to find Arkadin; as he nears the mysterious man, he meets Raina

and they fall in love. To get Van Stratten away from Raina, Arkadin feigns amnesia about his past and hires Van Stratten to prepare a confidential report that will uncover his biography. In fact Arkadin is using Van Stratten to locate his early gang so he can kill them one by one, thus protecting Raina from learning of his unsavory beginnings. He intends to kill Van Stratten last, but Van Stratten rejoins Raina and has her radio Arkadin, as he comes for her in his private plane, that she knows everything (though she really knows nothing). In despair, Arkadin jumps from the plane to his death, and Raina leaves Van Stratten.

The Film

Although novel and film share many episodes and much dialogue, the novel's Van Stratten narrates his experience in the first person and is much more articulate and sympathetic than the film's Van Stratten (Michael Redgrave), who is too boozy, obnoxious, and dimwitted to be an effective narrator. The novel also includes a few scenes with Van Stratten's mother that do not appear in the film.

The novel's chronology is linear. By contrast, Welles's film in its original conception used a complex flashback structure that recalls or perhaps parodies *Citizen Kane*. (As in *Kane*, Welles plays the title character.) Unfortunately, Welles missed the deadline for his final cut, and the producer seized *Mr. Arkadin* and reedited it. The result, given its tangled production and distribution, was no fewer than four versions of this film. One is currently available through Corinth Films (as *Mr. Arkadin*) that retains some of the flashbacks and is closest to Welles's intent; the London version (entitled *Confidential Report*) retains only the initial flashback (following Van Stratten's visit to Jacob Zouk, Arkadin's next victim); a Spanish version was probably shot during the principal production; and a mutilated public domain version also exists.

No version of this film is completely satisfying, though Welles's compelling cinematic vision often achieves a kind of sublimity—a cluttered junk shop, a penitential procession, masks taken from Goya etchings, the camera's backing into a dark, irislike hallway.

REFERENCES

Rosenbaum, Jonathan, "The Seven *Arkadins*," *Film Comment*, January–February 1992, 50–59; Naremore, James, *The Magic World of Orson Welles* (Southern Methodist University Press, 1989).

—W.G.C.

MRS. BRIDGE AND MR. BRIDGE (1959, 1969)

EVAN S. CONNELL

Mr. and Mrs. Bridge (1990), U.S.A., directed by James Ivory, adapted by Ruth Prawer Jhabvala; Merchant-Ivory/Miramax.

The Novels

Told episodically and sometimes nonchronologically by a third-person restricted narrator in 117 short scenes (some as brief as half a page), *Mrs. Bridge* received considerable attention for its technique when it appeared in 1959. Although a few took exception, most reviewers praised it: "as skillful a piece of literary brick-building as we are likely to get this year"; "Mr. Connell is a skilled pointillist"; "a startling performance . . . superb technique." *Mr. Bridge* 10 years later employed the same technique in 141 chapters and received similar reviews.

The two novels tell the story of India and Walter Bridge and their three children, an upper-middle-class family in Kansas City. Amidst their comfortable existence, the Bridges are emotionally reticent. India is unable to communicate her unhappiness: "An evil, a malignancy, was at work. Its nature she could not discern, though she had known of its carbuncular presence for many years." Walter is unable to communicate his love: "Often he thought: My life did not begin until I knew her. She would like to hear this, he was sure, but he did not know how to tell her." At the end of *Mrs. Bridge*, India, now a widow, traps herself in a car by pulling out of the garage too close to the side. In the slowly cumulating portraits that emerge vignette by vignette, Connell's incisive but empathetic attitude results in an ultimately desolate view of middle-American, middle-class life.

The Film

Because of their episodic scenes and their overlapping chronologies, the two novels lent themselves easily to being combined into one film, which was produced by the Merchant-Ivory team and starred Joanne Woodward and Paul Newman. As Terrence Rafferty points out, the team of Ivory and Jhabvala shares Connell's qualities: "the meticulous, sometimes fussy, attention to physical detail; the flat, clean, neutral style; the air of cultured noncomformity; the dry, ironic tone that verges on haughtiness." Jhabvala's screenplay picks and chooses from among the episodes but is scrupulously faithful to detail in those it adapts. Home movies are added at the beginning and end. One major change is to leave out Walter's death and another to temporally shift India's entrapment in the car so that all she has to do is wait for her husband to come home.

Critic Stanley Kauffmann disliked the gimmick of the home movies: "These seem especially vulgar, a foot-scraping plea for 'identification.'" Rafferty observed that the very things Connell and the filmmakers have in common and that account for the success of the first 15 minutes of the movie also undermine it later on. "The filmmakers are, finally, too dogged in their fidelity to their source: too reverent toward material that needed to be re-imagined for the screen, and not alert enough to how their

actors will alter our responses to the characters. When the picture is over, we feel as baffled and empty as the Bridges: as if we, too, had been suspended over a void; as if, like them, we had begun with a sense of purpose and promise and then discovered we'd gone nowhere."

REFERENCES

Hughes, Riley, review in *Catholic World*, March 1959, 509; Kauffmann, Stanley, "Life with Father," *The New Republic*, December 24, 1990; Rafferty, Terrence, "Middle of the Road," *The New Yorker*, December 3, 1990, 170–73; Sommers, Hollis, review in *Saturday Review*, January 31, 1959, 18; Waterhouse, Keith, review in *New Statesman*, February 13, 1960, 229.

—U.W.

MUTINY ON THE BOUNTY (1932)

CHARLES NORDHOFF AND JAMES NORMAN HALL

Mutiny on the Bounty (1935), U.S.A., directed by Frank Lloyd, adapted by Talbot Jennings, Jules Furthman, and Carey Wilson; MGM.

Mutiny on the Bounty (1962), U.S.A., directed by Lewis Milestone, adapted by Charles Lederer; MGM.

The Novel

Nordhoff and Hall began planning work on an historical novel dealing with the April 27, 1789, mutiny on H.M.S. *Bounty*. Nordhoff got the idea after reading Sir Barrow's (1931) account of the incident. On the advice of their publisher, the authors did not travel to England but relied on researchers who investigated the British Museum archives and sent them rare prints, engravings, and historical information about the contemporary Royal Navy. Nordhoff and Hall then began a stirring adventure novel, envisaged as the first part of a trilogy dealing with the *Bounty* mutiny and its aftermath. They waited for public reaction to *Mutiny on the Bounty* before beginning the other parts, *Men Against the Sea* and *Pitcairn's Island*.

The authors tell the story from the perspective of a fictional character, Roger Byam, based upon an actual person, Midshipman Peter Heyward. They mostly follow Heyward's true story, mixing fact with literary invention. The novel begins with a 73-year-old conservative West Country gentleman, Roger Byam, reflecting on his 40 years at sea. He decides to occupy his remaining years by writing an account of the *Bounty* incident.

Following the death of his father in 1787, Roger and his mother have dinner with an old family friend, Sir Joseph Banks, who introduces him to Lieutenant Bligh who had sailed with Captain Cook. Bligh is sailing to Tahiti on the *Bounty* to collect breadfruit plants. He invites Roger to join him on the voyage in the capacity of midshipman, suggesting the voyage as an ideal opportunity for the young man to compile an accurate Tahitian dictionary. Roger agrees. Before the *Bounty* leaves port, he witnesses a brutal act of naval discipline when a sailor is flogged to death. After meeting the crew and striking up a friendship with Master's Mate Fletcher Christian, Roger witnesses Bligh's tyrannical behavior. The captain humiliates both officers and seamen and provides meager food for the crew, who believe he is lining his pockets at their own expense. After witnessing further evidence of Bligh's arrogant attitude, including harassment of Fletcher Christian, Roger is relieved when the *Bounty* arrives in Tahiti. He becomes attracted to the South Sea society as well as the beautiful Tehani.

The *Bounty* leaves the island after stocking up with breadfruit plants. Bligh again humiliates Christian on the voyage home. The incensed officer decides to leave the ship and asks Byam to visit his parents in Cumberland if he never returns to England. Byam agrees. Bligh overhears the last part of their conversation. The next morning Byam awakes to find Christian leading a mutiny against Bligh. Although he wishes to join Bligh and the other men who have been put out to sea on a launch, Byam is too late. He sails with the *Bounty* to Tahiti. Christian and the rest of the mutineers decide to take the *Bounty* to an unknown island and destroy it. Byam remains on Tahiti with the others and marries Tehani. They have a daughter.

Nearly two years later, Byam decides to surrender to the *Pandora*. He is arrested as a mutineer, taken to England, placed on trial with six others, and sentenced to death. However, he is pardoned when corroborating evidence supports his story against Bligh's written testimony. Three mutineers are hanged. In 1793 Byam returns to naval service. In 1809, he returns to Tahiti, finding his wife and native companions (save one) dead, the environment changed for the worse, and his daughter now married with a young child of her own. Deciding not to reveal his identity, Byam returns to his ship haunted by the ghosts of the past—"my own among them."

The Films

Both the Australian *In the Wake of the Bounty* (1933) and *The Bounty* (1984) have little connection with Nordhoff and Hall's novel; *The Bounty*, starring Mel Gibson as Fletcher Christian and Anthony Hopkins as Bligh, was filmed from a Robert Bolt screenplay adapted from Richard Hough's historical novel *Captain Bligh and Mister Christian* (1973), not the Nordhoff and Hall work. Frank Lloyd's 1935 MGM version retains Byam but makes him a background character (played by Franchot Tone), witnessing the conflict between Charles Laughton's Bligh and Clark Gable's Christian. The first film version basically follows the plot of the novel but contains some significant additions. It opens with Christian leading a press gang inducting future mutineer Ellison. Instead of his adolescent original, Byam is a young married man whose wife

has recently borne a child. Byam does not meet Bligh until the actual voyage. The film depicts Christian's desire to mutiny as the result of several major causes. It is not merely due to the personal humiliations Bligh inflicts on him during the voyage. A close-up reveals his anger when he discovers Bligh has stolen some cheeses. The death of the *Bounty's* friendly drunken doctor and the miserable conditions suffered by two sailors Bligh imprisons for temporarily leaving the ship stir him into action. Christian becomes less the novel's dangerously impulsive radical and more a figure who will indirectly bring better conditions into the Royal Navy, following the pattern of the film's post-credit message.

The film also incorporates other aspects of the *Bounty* trilogy into its narrative. Several sequences show Bligh's heroic status in navigating his small launch to safety, as in *Men Against The Sea.* When Christian flees Bligh, a brief moment of sexual tension and violence erupts on board the *Bounty*, prefiguring the violence to come in *Pitcairn's Island.* Another script departure involves Bligh's reappearance as captain of the *Pandora*, who arrests the "mutineers" and sets out in pursuit of Christian. He is also present at Byam's trial. Byam receives the death sentence, but the Hollywood happy ending ensures his pardon by King George III and the survival of his mother who does not die after receiving Bligh's cruel letter.

The 1962 film version represents a work of lost opportunities. As original screenwriter, Eric Ambler discovered valuable historical evidence about the real Captain Bligh's abilities as well as the fact that most mutineers suffered from syphilis during the *Bounty* incident. However, Marlon Brando's control over the screenplay eventually led to the departure of Ambler and original director Carol Reed, who was replaced by Lewis Milestone. Despite several rewritings of the screenplay, Trevor Howard sustains a brilliant performance as a captain who has risen from the ranks who resents the gentlemanly Fletcher Christian. The film ends with Bligh's acquittal and criticism at his actual court-martial and Christian's death on Pitcairn Island. Fearing Christian's desire to return to England, the mutineers set the *Bounty* on fire, resulting in Brando's masochistic, fiery martyrdom—replaying the fate of his Val Xavier in *The Fugitive Kind* (1960).

REFERENCES

Roulston, Robert, *James Norman Hall* (Twayne, 1978); Millichamp, Joseph R., *Lewis Milestone* (Twayne, 1981).

—*T.W.*

MY BRILLIANT CAREER (1901)

MILES FRANKLIN

My Brilliant Career (1980), Australia, directed by Gillian Armstrong, adapted by Eleanor Witcombe; Analysis Films.

The Novel

In 1898 at the age of 18, Stella Maria Sarah Miles Franklin began writing her first novel, *My Brilliant Career.* From her home in the Australian bush, she circulated the manuscript to publishing firms and magazines under the pseudonym Miles Franklin. After a few discouraging replies, the novel eventually made an impression on Henry Lawson, who compared it to Charlotte Brontë's *Jane Eyre* and Olive Schreiner's *Story of an African Farm* and sent it to a London publisher. Franklin agreed to the royalty offer but requested that her gender remain concealed, that the title appear as *My Brilliant Career* and that the content not be altered. Unfortunately, due to the lack of a swift enough mail service, authors were unable to review proofs of works published in England. Franklin was unhappy with the finished product, and despite commendable reviews, the monetary returns were minimal. In 1910, Franklin removed *My Brilliant Career* from the shelves and forbade a reprinting during her lifetime.

My Brilliant Career is an autobiography of Sybylla Melvyn, a headstrong girl from rural New South Wales who resists the narrow lot offered to women and opts to pursue literary ambitions. The eldest child of a father from a humble background and a mother born into bourgeois privilege, Sybylla's hoydenish nature and grit parallel their harsh, isolated bush life. As Sybylla grows older, she dreams of a better life and longs for music, art, and literature. Fortunately, a change of scene presents itself with an invitation from her grandmother to live at Cattagat. Sybylla welcomes the comforts of the bourgeois way of life and wins the hearts of her relatives, but she constantly frets over her plain appearance: "Why was I ugly and nasty and miserable and useless—without a place in the world?" Sybylla receives two proposals of marriage, which she rejects, and she wishes that society allowed women and men simply to be chums. But Sybylla strikes up a kinship with Harold Beecham, a young, amiable landowner. They fall in love, and their close comradery suggests to the families that an engagement will be announced. In response, Sybylla vehemently upholds her refusal ever to marry and scorns those who theorize that she would accept an offer for financial security. But when he discovers that he has lost his fortune, she concedes to marry him at the age of 21 in order to help him.

While Harry leaves for a few years to rebuild his wealth, Sybylla is forced to return to Possum Gully to serve as a governess for the McSwat family in order to repay the interest on a loan from her father. She is miserable in this uneducated and stagnant household, and her longing to write returns. After a near nervous breakdown, she returns home and attempts to resign herself to her domestic duty, but it is "all to no purpose . . . the spirit which has been dozing within [her] awakened and fiercely beat at its bars, demanding some nobler thought, some higher aspiration, some wilder action." Harry soon recovers his fortune and returns, but Sybylla concludes that love

is only for the beautiful and that she wants to be a writer. She admits that marriage is a chance to escape her dreary existence but concludes that Harry does not offer her control; she eventually writes her book.

The Film

When the film version of *My Brilliant Career* was released in 1980, much publicity centered on the fact that the key production players, with the exception of the cinematographer, were women, a fact that augments its feminist drive. Their post-second-wave feminism perspective resulted in the creation of a more resolute heroine, admirably portrayed by Judy Davis. But unlike Franklin's protagonist who "fights valiantly and instinctively against what she sees as the degradation of marriage and the heterosexual relationship; yet at the same time succumbs to the stereotype against which she is fighting," Davis is determined to adhere to her ideals. Audiences know from the beginning that Sybylla never intends to marry and only concedes to Harry Beecham's (Sam Neill) proposal after concluding that she may be of some help to him. But after spending some time apart, she recognizes that being a wife and a mother is not for her: "Maybe I'm ambitious and selfish, but I can't lose myself in someone else's life if I haven't lived my own yet. I want to be a writer, and I've got to do it now and I've got to do it alone."

One critic observes how an audience responded to the film: "The audience gasped when Sybylla refused the second time to marry Harry, and it applauded her, in the last scene, when she dropped her wrapped manuscript into the country post box and stood alone. Unlike the novel, the Sybylla of the film does not have a near nervous breakdown at the McSwats' nor pale in her petite stature next to Franklin's towering Harry Beecham. She is the one who anxiously strums her fingers on the fence post at the end after sending off her manuscript with eager anticipation, and she is the one who disagrees with Harry's aunt who warns, "loneliness is a terrible price to pay for being independent—don't throw away reality for some impossible dream." In contrast, Franklin's Sybylla is lonely and frets over her monotonous, purposeless existence and even questions why she writes. In terms of emphasizing the historical significance concerning Sybylla, consider how Uncle Julius treats her so differently within the two mediums. While in the film he encourages Sybylla to pursue her theatrical talents, the original gives her a doll for her birthday to lure her mind away from politics and jokingly dismisses her intention to write.

Franklin's Sybylla vacillates between her spirit of independence and her gravitation toward self-doubt and surrendering to the spousal role. On the one hand, Sybylla associates marriage with shame and subordination. Her mother sacrificed a life of privilege only to be strapped to a drunken husband, and her Aunt Helen suffered the humiliation of being abandoned by her spouse for his lover. Yet although Sybylla wants to escape a fate of matri-

Judy Davis in My Brilliant Career, *directed by Gillian Armstrong* (1979, AUSTRALIA; NSW FILM CORPORATION/NATIONAL FILM ARCHIVE, LONDON)

mony and carve out a self-sufficient life, she constantly feels guilt for her "unwomanly" behavior and wishes she could be pretty. Furthermore, even though she mocks the idea of romance and arduous suitors, this is the type of man Sybylla wishes Harry was like. These tensions continue throughout the text. Her ambivalence and anxieties indicate the difficulties encountered by a 19th-century woman in rebelling against conformity to social norms, whereas women today have a more confident perspective on gender roles.

Aside from addressing gender issues, *My Brilliant Career* is also acutely class-conscious. Sybylla's mother was abandoned by her family for marrying beneath her, and her relatives encourage her to marry someone with money and status in mind. The cinematic text does not delve into these nuances as deeply, probably due to length limitations. Yet this Sybylla, like the original, is also concerned for the beggars who drift through Cattagat and remembers her roots, conveyed most vividly with her pub songs and a common dialect that she sometimes assumes. One scene that Armstrong alters, which really accentuates the issue of class divisions, is at the Five Bob Downs' ball. Sybylla leaves to join a spirited get-together outside with the servants. As she dances and sings, some of the refined guests come to sit down to watch, and they seem uncomfortably out of place. When Harry drags Sybylla away, she yells, "You don't like me dancing with the servants—I've disgraced you." In terms of visual impact, the set designs of Possum Gully and the McSwat farm capture the scanty,

dusty, solitary existence of the working-class Australian outback, which contrasts so well with the privileged households of Cattagat and Five Bob Downs.

REFERENCES

Clancy, Jack, "Bringing Franklin Up to Date: The Film of *My Brilliant Career*," *Australian Literary Studies* (1980): 363–67; Franklin, Miles, *My Brilliant Career* (Angus & Robertson, 1990); McInherny, Frances, "Miles Franklin, *My Brilliant Career* and the Female Tradition," *Australian Literary Studies* 3, no. 9 (1980): 275–85; Wallace, Melanie, review in *Cineaste* 2, no. 10 (spring 1980): 63.

—R.L.N.

MYSTIC RIVER (2001)

DENNIS LEHANE

Mystic River (2003), U.S.A., directed by Clint Eastwood, adapted by Brian Helgeland, Warner Brothers.

The Novel

In his *Mystic River*, the Shamus Award–winning author Dennis Lehane turns from his successful crime novels involving Patrick Kenzie and Angela Gennaro, a team of private detectives, to focus on the deadly aftereffects of child molestation. *Mystic River* concerns the fates of Dave Boyle, Jimmy Marcus, and Sean Devine, friends who grow up in Boston, grow apart, and then find their adult lives inextricably related. The novel begins in 1975, when Dave is molested by Big Wolf (Henry) and Greasy Wolf (George), and concludes in 2000, when Katie, Jimmy's daughter, is murdered and Sean Devine's police investigation implicates Dave in her death.

The background information in Part One distinguishes between the three childhood friends, who are linked to their neighborhoods. Cautious Sean, from the Point, a white-collar area, refuses to take part in car theft. Both delinquent Jimmy, who risks his life and proposes the car theft, and Dave, a hanger-on who wants to be included, are from the Flats, an adjacent tougher and predominantly blue-collar part of Boston. The three are playing in the Point when two men posing as police interrupt them and ask where they are from. Sean admits to living across the street; Jimmy wisely lies about living in the Point; but Dave, who tells the truth, is taken into the car, ostensibly to his home in the Flats. After suffering four days of abuse, Dave escapes from the Wolves, only to discover that he will again be victimized, this time by schoolmates who regard him as "damaged goods" and taunt him about being a homosexual. Even though Jimmy and Sean did not get into the car, they are haunted by thoughts about the event. Sean has nightmares that end only when he learns that both Wolves have died, and Jimmy is plagued with similar nightmares. Sean comes to realize that in fact all three of them had gotten into the car and were trapped in the same cellar.

Part Two begins by recapping some of the events that have occurred since the molestation and prior to Katie's murder. Jimmy pursued a life of crime, served a two-year jail term, murdered Silent Ray Harris (who had informed on him), married Marita, who died after giving birth to Katie. He then married Annabeth, had more children, and owned a corner grocery store. Dave became a star baseball player, married Celeste, and had a son, but never could rid himself of the nightmares about his molestation. Celeste comes to believe that Dave "needed to rewrite his history and fashion it in such a way that it become something he could live with." Sean went to college, became a detective with the state police, married Lauren, who subsequently left him and had a child, and then was put on probation after he persecuted an enemy. Whitey, his partner, supervised him during his probation.

Katie had had a relationship with a small-time hoodlum named Bobby O'Donnell, but at the time of her murder was planning on going to Las Vegas and marrying Brendan Harris, whom Jimmy despised for no apparent reason. The night she was murdered, Katie and some of her friends were on a "girls' night out" that culminated with them dancing on a neighborhood bar, where Dave was drinking. Later that night Dave returned home covered with blood and an injured hand. He offers a pathetic explanation. As a result of a phone call, the police find Katie's abandoned car and then her body, in a small, enclosed area near a drive-in screen. At the scene, Sean has to deal with a distraught Jimmy and the Savages, his aptly named hoodlum brothers-in-law. He has three suspects: the jilted Bobby O'Donnell, who is quickly cleared, Brendan Harris, and Dave, of whom Whitey is particularly suspicious since he fits a murderer's profile. Sean then visits his father, who tells him Dave could not be the murderer. Dave comes up with another explanation for his injured hand (Celeste had already burned Dave's blood-soaked clothes), but the case becomes even more muddled when Sean and Whitey discover that another body was found near the Last Drop bar. (This proves to be the pervert Dave killed when he found him molesting a young boy.) Unfortunately, when she returns home, Celeste finds Dave watching a vampire film and behaving threateningly.

After going through files, Sean and Whitey find a link to Just Ray, who had held up a liquor store. Lowell Looney, the manager, states that Just Ray had a gun that was never found. When Sean and Whitey question Brendan about the gun, he unconvincingly denies its existence, leading the detectives to again suspect him. Brendan also believes that his father is still alive since his mother regularly receives $500 each month from an anonymous source, subsequently revealed to be Jimmy, his father's executioner. When Brendan finds the gun missing, he knows that Ray, his mute brother, and Johnny, his brother's crony, are responsible for Katie's death. He attacks Ray, but John is holding the gun on Brendan when Whitey and Sean enter and disarm Johnny.

Unfortunately, Celeste, whom Annabeth suspected had a crush on Jimmy, tells Jimmy that she suspects that Dave killed Katie. Jimmy and two Savage relatives take Dave to the Mystic River, where Jimmy had earlier killed Just Ray, and after questioning and getting "wrong" answers, Jimmy executes the man he thinks killed his daughter. When Sean later finds Jimmy and tells him that he and Whitey have found the real killers, Jimmy denies his guilt but says, "Maybe if you'd been a little faster, though?"

Jimmy is shaken by the experience, but Annabeth, in Lady Macbeth fashion, restores her husband's faith in himself. Earlier Jimmy had regarded her as his "wife, mother, best friend, sister, lover, and priest," and Sean had told her she was a "hard woman." Annabeth sees Jimmy as a king, not a prince (or a thane), who is strong and must do what needs to be done. The next morning Jimmy starts thinking like a king as he plots to run, with the help of the Savages, the entire city of Boston. It is in this state that Sean, whose Lauren has returned, and his wife see Jimmy, whom Sean vows to convict of the two murders. When he sees Sean, Jimmy smiles at him; but Sean responds by mimicking the firing of a gun at him. The indeterminate ending of the novel almost suggests that a sequel will follow.

The Film

Clint Eastwood's adaptation of *Mystic River* (2003) suggests that his Oscar for directing *The Unforgiven* (1992) was no fluke. The film is a masterful effort at capturing the fullness of Lehane's novel. The script, written by Brian Helgeland, contains almost all of the original plot, theme, setting, and characters. Only two characters are altered—Sean (Kevin Bacon) and Whitey—and those changes are minor. Whitey, in an ironic twist, is played by Laurence Fishburne, the acclaimed African-American actor; and his Whitey is not Sean's superior but his colleague. Since he still remains unduly suspicious of Dave (Tim Robbins), the overall change is minor. (In the novel Whitey has a son named Terry, who is absent from the film.) Sean's character is considerably cleaned up—he is separated from his wife, but his life is hardly the "mess" it is in the novel. He is not on probation, but is instead a kind of model cop. Besides Terry, there are other missing characters—Bobby O'Donnell, Brendan's lawyer, and Sean's parents—but only Sean's father is significant. Sean's visit to him indicates a kind of weakness since he seeks help from his father, but his father's remarks about the dead Wolves also reveal the extent to which Sean has been shaken by Dave's experience.

Dave's identity, a persistent theme in the novel, is visually elaborated on in the film. When the young trio are approached by the "police officers" in the film, they are writing their names in newly poured cement. Jimmy and Sean have written their names, but Dave only succeeds in scratching out the first two letters of his name before he gets

in the car—the suggestion is that his is a case of arrested development. The film also emphasizes that Dave is "dead," and that the demonic Wolves have captured his life. Young Dave is not older Dave. Not even killing the pervert will free Dave of the Wolves. In fact, the Wolves are associated with the vampires that Dave is watching on TV when Celeste comes home. While the novel suggests the blending of past and present, the film visually reinforces this by juxtaposing images from the distant past (the four days imprisoned in the cellar) with those from the immediate past (the scenes involving the pedophile). As Dave, a man possessed by demons, Tim Robbins conveys vulnerability and ferocity.

As Jimmy, Sean Penn runs the gamut of emotions from his intense love/worship of Katie, whom he unconsciously associates with Marita, to disgust/guilt over killing Just Ray, to pure hatred of his daughter's killer. Penn and Robbins both succeed in conveying visually what the novel so painstakingly spells out for readers. Perhaps that is the greatest success in this adaptation: to express through acting what is verbalized in the novel, which probes the thoughts, motives, and emotions of its characters. This information could, of course, be rendered through voice-over narration, but the resulting film would be more literary than cinematic.

Even though the novel is set in Boston, there are some changes in setting, the most significant of which is the site of Katie's murder. In the film she dies in a spot called the Bear Cave, a term that reflects the bestial nature of the crime and also ties in with the Wolves who molest Dave. In the film, the Flats and the Point are not distinguished from each other, and the friction between Jimmy and Sean is not developed. In the novel Jimmy is clearly jealous of Sean and even steals his baseball glove, though he never uses it, and both Dave and Jimmy envy the kind of unconscious authority and command that Sean exudes. Similarly, in the film the audience is not as aware of Celeste's unspoken feelings for Jimmy.

In addition to the outstanding acting, the film benefits from screenwriter Helgeland's and director Eastwood's contributions. In fact, Eastwood won the Golden Palm at Cannes for his direction, and the film received several Golden Globe nominations; Eastwood for directing, the film for best picture, Penn for best actor, Robbins for best supporting actor, and Helgeland for best screenplay. Both Robbins and Penn won their respective awards at the 2004 ceremony.

REFERENCES

Denby, David, "Dead Reckoning," *New Yorker*, October 13, 2003, 112–113; Ross, Lillian, "Nothing Fancy," *New Yorker*, March 24, 2003, 40–47; Klawans, Stuart, "Love Streams," *The Nation*, October 27, 2003, 42–44.

—*T.L.E.*

THE NAKED AND THE DEAD (1948)

NORMAN MAILER

The Naked and the Dead (1958), U.S.A., directed by Raoul Walsh, adapted by Denis and Terry Sanders; RKO/Warner Bros.

The Novel

In 1944 Norman Mailer enlisted in the U.S. Army, determined to write an important novel about World War II. Drawing on his experiences he was able by 1948 to shape his first published novel, *The Naked and the Dead.* Reviewers quickly compared the work to some of the great war novels and correctly hailed Mailer as a new, important voice in American fiction.

The Naked and the Dead portrays the invasion of a fictional South Pacific island named Anopopei and particularly the role of a reconnaissance platoon that is sent on a scouting mission behind Japanese lines. Mailer's story develops a spectrum of characters that cuts across socioeconomic, regional, national, and ethnic categories. In so-called Time Machine sections the narration flashes back to the earlier frustrations of 10 characters, all of whom have failed in personal relationships and have been thwarted in their careers. While the novel comments pessimistically on the status of the American dream, it also raises the ironic possibility that the fascist mentality might emerge from World War II with subtler, renewed vigor. Without question, Mailer's wide-ranging, discursive story makes provocative social and political statements as well as providing memorable depictions of combat and its aftermath.

But finally its epic strength resides in its portrayal of the futility of strategy and technology against the obliterating energies of Anopopei's natural landscape. The "sullen" ocean, the relentlessly growing vegetation, and the brooding mountains form a powerful and anarchistic nature, which mocks human effort whether carried out by solitary individuals or organized aggregates. Ultimately, both the defeated Japanese and victorious American forces on Anopopei succumb to nature.

The Film

When Raoul Walsh directed *The Naked and the Dead,* he was soundly established as one of Hollywood's most accomplished tellers of the adventure story. His fondness for rugged, expansive landscapes was well served by the prominence of terrain in Mailer's novel. Beyond its appropriate portrayal of the brooding landscape, however, Walsh's adaptation is uneven. Without the psychological portraits offered by the narration in the novel, the spectrum of characters tends to become an assemblage of stereotypes for whom viewers are unlikely to develop sympathy. Walsh made a decided effort to preserve some of the novel's explicit treatment of political philosophy, but erratic editing and simplified characterization often leave the impression that the philosophical dialogue is unmotivated and intrusive. The movie flashbacks are true to the novel in their attention to sexuality, but crucially are not as successful in suggesting that sexual frustrations and perversions reflect a larger futility associated with the American social system and, even more fundamentally, with the attempt by humans to achieve stable emotional bonds. Walsh's adaptation does convey some of the absurdity of

the Anopopei campaign and achieves some measure of what historian David Thomson associates with Walsh's best films, a sense of "the aimlessness, hopelessness, and tragedy of adventure." Nonetheless, Walsh could not accept the full force of the bleak vision projected by Mailer's novel. As part of a major change in plot and thematic emphasis, Walsh uses a key piece of dialogue late in the movie to raise the hope that in times of extraordinary duress humans are motivated by love and not merely by some selfish will to survive.

Aside from its photography, reviewers found little to praise about the movie of *The Naked and the Dead*. Norman Mailer himself described Walsh's adaptation as "one of the worst movies ever made" and went on to caution that "as a working rule of thumb, a novelist . . . cannot hope for his work to survive in Hollywood." Mailer's disappointment as the author is justified, although he and reviewers overstate the film's defects. In truth, if Walsh's movie had been based on an original screenplay, and thus had not been judged as an adaptation, he still would have been criticized for the ponderousness and unevenness of his production—but perhaps commended for his attempt to explicitly address serious ideas, to deglamorize war, to foreground the role of nature in warfare, and to develop a more complex point of view than that of his well-regarded World War II movie *Objective Burma!* Finally, though, it is scope of theme, diversity of characters, and discursiveness of style that make Mailer's novel a high-risk candidate for screen adaptation.

REFERENCES

Dick, Bernard F., *The Star Spangled Screen* (University of Kentucky Press, 1985); Mailer, Norman, "Naked Before the Camera," in *The American Novel and the Movies*, Gerald Peary and Roger Shatzkin, eds., (Frederick Ungar, 1978); Thomson, David, *A Biographical Dictionary of Film* (Morrow, 1976).

—C.T.P.

THE NAKED LUNCH (1959)

WILLIAM S. BURROUGHS

Naked Lunch (1991), Canada-U.K., directed and adapted by David Cronenberg; Twentieth Century-Fox.

The Novel

Homosexual heroin addict William Burroughs spent two years in Tangier editing what would be published in Paris in 1959 as *The Naked Lunch* (part of a 1,000-page diary detailing his surrealistic, drug-induced visions), the last major novel subjected to a trial in the United States on charges of obscenity. The novel became a cause célèbre among intellectuals in America, where it generated extraordinary praise and has had a profound impact on American postmodernism.

Burroughs's prose challenged the very form of the modern novel, and this work defies plot summary; it's a collage of sexually explicit, nightmarish visions loosely linked as the thoughts of its "narrator," "William Lee," an ex-junkie whose apomorphine treatment provides a cure and a series of hallucinations, primarily focusing on the twinned motifs of homosexuality and hanging, orgasm and death. The Swiftian, verbally kaleidoscopic satire of government, politics, drugs, pornographic films, racism, religion, household consumerism, capital punishment, and American society presents addiction as a metaphor of the human condition.

The Film

This plotless, fragmentary, and perversely pornographic mosaic defied adaptation for three decades. Any literal adaptation would be both prohibitively expensive and X-rated. Canadian cult director David Cronenberg (whose own early horror films had a Burroughsian imagery of insects, viruses, sexuality, and corporate media cabals), like Burroughs, had pushed his medium toward new standards of the acceptable. His script circumvents the obvious plot problems by conflating details from Burroughs's actual biography with scenes from the novel (and other Burroughs works). We see Lee (Peter Weller) as an exterminator in a film noir-like 1953 New York; accidentally shooting his wife Joan; living in an imaginary Tangier; receiving literary advice from two friends who represent Kerouac and Ginsberg (the self-reflexive plot involves Lee's writing of the novel *Naked Lunch*); and meeting an American expatriate couple who are meant to recall Burrough's actual acquaintances, Paul and Jane Bowles. Cronenberg creates grotesquely humorous special effects that depict the truly hallucinatory "Mugwumps," Lee's "talking asshole," mutating insect-like typewriters, the transsexual Fadela/Dr. Benway, the "sex blob" that participates in Lee and Joan Frost's brief coitus, and the black centipede drug market of the Tangier/Interzone world.

The film received relatively positive reviews, although Cronenberg's general effacing of Burroughs's focus on homosexuality generated complaints among the gay community, and some critics bemoaned his circumvention of the novel's most aesthetically and ideologically outrageous scenes.

Given an impossibly difficult text to film, Cronenberg made an excellent decision to avoid the kind of ponderous, literal (mis)reading of a classic American novel that marks, for instance, Joseph Strick's *Ulysses*. Instead, he used the entire Burroughs opus and the legendary biography as the inspiration for his film that became a brilliant *response* to the novel, rather than an adaptation per se. In translating the deadpan tone and rebellious spirit of the famous Burroughsian imagery into a film that can stand on its own, Cronenberg captured the essence of Burroughs's motifs without getting mired in the fragmentary and ultimately unfilmable original text.

Julian Sands and Peter Weller in Naked Lunch, *directed by David Cronenberg* (1991, CANADA-U.K.; TCF)

REFERENCES

Rodley, Chris, ed., *Cronenberg on Cronenberg* (Faber and Faber, 1993); Silverberg, Ira, ed., *Everything Is Permitted: The Making of Naked Lunch* (Grove Weidenfeld, 1992); Skerl, Jennie, *William S. Burroughs* (Twayne, 1985); Skerl, Jennie and Robin Lydenberg, eds., *William S. Burroughs At the Front: Critical Reception, 1959–1989* (Southern Illinois University Press, 1991).

—D.G.B.

THE NAME OF THE ROSE *(Il nome della rosa)* (1980)

UMBERTO ECO

The Name of the Rose (1986), U.S.A/Italy/France, directed by Jean-Jacques Annaud; adapted by Andrew Birkin, Gerard Brach, Howard Franklin, and Alain Godard; Twentieth Century-Fox.

The Novel

Long renowned for his intellectual achievements in critical scholarship, Umberto Eco published this, his first novel, in 1980. Given the book's density and its arcane topics, the original Italian publisher expected modest sales at best. However, after excellent sales in Italy and critical accolades worldwide, it was swiftly published in almost 30 other languages. The English translation became a surprise best-seller, topping the *New York Times* best-seller list for many weeks.

Eco's story concerns the visit of the English Franciscan monk William of Baskerville to an unnamed Benedictine monastery in northern Italy in 1327. Accompanied by a Benedictine novice, Adso of Melk, William's original purpose in his journey is to engage in a debate on the poverty of Christ. His preparations for the council, however, are stalled by the abbot, who wishes to employ William's famous investigative skills to solve the mystery of the recent death of a young monk. As William and his novice search for an explanation of the death, more deaths occur, each carried out in such a way that the murders are thought to be trumpets of the Apocalypse. Eventually, it is discovered that the deaths were not carried out by any Antichrist, but by the elderly Benedictine Jorge of Burgos. All the while he had been attempting to conceal the existence of a copy of Aristotle's mythic *Comedia* from those who would use it to justify laughter. In the end, William is unable to prevent Jorge from setting fire to the library,

destroying not only the Aristotle but also all the other books in what is described as the richest library in Christendom.

The Film

In the only adaptation of the novel, director Jean-Jacques Annaud eschews attention to its various subplots in favor of attention to the main murder mystery. This is not surprising considering the size and complexity of the novel. Where adaptations frequently suffer complaints from audiences that the film plots differ too much from those of the novels, Annaud in fact wavers only a little from the manifest main plot. Instead, the film simply bypasses huge segments of intimately related subplot.

Much of what has been left out relieves the viewer of the novel's notorious intellectual rigor. None of the Latin or Greek, for example, goes untranslated. The complexities of the heretical movements and the philosophical and theological upheavals in the religion and politics of the time are whittled down to a bare minimum.

Ironically, the reduction of the novel's subtleties renders the title practically unintelligible. Disparate as the subplots of the novel can at times seem, each is intimately related by the theme they share with the main story line: Each concerns the fragile distinction between right and wrong and the means by which this boundary may become blurred to those too adamant for a single cause, no matter how just. The rose and its guarded beauty remain an unfulfilling metaphor for a simple murder mystery.

By subtitling his film "A Palimpsest of Umberto Eco's Novel," Annaud suggests an understanding that any adaptation of the novel presents significant obstacles. But the fact that Annaud is aware of the potential pitfalls does not make those problems disappear. The overarching motif of the novel—the precarious distinction between the depraved and the divine—is almost completely lost. The interconnections among Aristotle, the library, Adso's sexuality, and church politics are left unexplored, with each component becoming a mere incidental subplot of the murder mystery. In many ways, it is Adso's indiscretion that twists the distinctions between "ecstatic vision and sinful frenzy," that serves as the novel's fulcrum for its struggles. However, Annaud and cinematographer Tonino Delli Colli so eroticize the event that it cannot present Adso's situation as much more than a naive rite of passage. Without the underlying importance of the indiscretion, it loses its connection with the discussion of heresies and poverty, William's own intellectual arrogance, and Jorge's unfaltering devotion to the Rule. Lacking this web, the film strips the texture away and leaves nothing but plot, a murder mystery set apart from pulp only by its historical name-dropping. If taken as a genre film with historical appeal (and without comparison to Eco's book), The Name of the Rose is an enjoyable, if average, mystery film; but as an adaptation, it stumbles painfully.

REFERENCES

Inge, Thomas, ed., *Naming the Rose: Essays on Eco's The Name of the Rose* (University of Mississippi Press, 1988); Moliterno, Gino, "Novel Into Film: *The Name of the Rose*," in *Fields of Vision: Essays in Film Studies, Visual Anthropology, and Photography*, Leslie Devereaux and Roger Hillman, eds. (University of California Press, 1995), 196–214; Sullivan, Scott, "*The Name of the Rose*," *Newsweek*, September 29, 1986, 62.

—S.C.M.

NATIVE SON (1940)

RICHARD WRIGHT

Native Son (1951), U.S.A., directed by Pierre Chenal, adapted by Chenal and Richard Wright; Argentina Sono/Classic.

Native Son (1986), U.S.A., directed by Jerrold Freedman, adapted by Richard Wesley; Cinecom/American Playhouse/Cinetudes.

The Novel

The first novel by an African-American writer to gain a large multiracial readership (it was a Book-of-the-Month Club selection), *Native Son* sold 200,000 copies within three weeks of publication in 1940. By keeping his focus unerringly on his inarticulate criminal hero, a Chicago black man named Bigger Thomas, Wright forces the reader to see the world through Bigger's eyes. Moreover, while Wright wants the reader to identify to an extent with Bigger's place in a racist society, he refuses to make his hero pleasing and acceptable. As Peter Brunette notes in his study of the book and film, "It is precisely this ultimate ambiguity, the creative tension of attraction/repulsion we feel toward the protagonist, which makes *Native Son* such a powerful novel."

Bigger Thomas is a black boy born and raised in a one-room apartment in a Chicago slum. Already in trouble with the law for petty crime, Bigger is given a chance at gainful employment as a chauffeur by a wealthy Chicago family named Dalton, whom he has seen in newsreels at the movies (ironically, the Daltons own the rat-infested building in which Bigger lives with his mother and two siblings). Bigger's first task is to drive Mary Dalton to the university, but he soon learns that she has lied to her parents and is actually going to meet her boyfriend, Jan Erlone, who is a member of the Communist Party. Jan and Mary patronizingly treat Bigger as an equal, sitting with him in the front seat of the car and not allowing him to drive. They pressure Bigger into taking them to a restaurant in the ghetto. After a drinking bout, Bigger carries the unconscious Mary up to her room, where he kisses and fondles her. When her blind mother enters the room, Bigger silences Mary by suffocating her with a pillow. In a panic, he carries the body to the basement. In order to fit it into the furnace, he cuts off the head. Bigger returns

home and sleeps soundly, oddly proud of his newfound power.

Later, Bigger attempts to place the blame on Jan. He sends a ransom note to the Daltons, signed by members of the Communist Party. But when Mary's bones are discovered in the furnace, Bigger flees to an abandoned building in the slums with his mistress, Bessie. After she wrings a confession out of him, he kills her and throws her body down an air shaft. Bigger is eventually captured on the rooftop and jailed while the public jeers and mocks him, demanding a conviction for raping and murdering a white girl (ironically, Bessie's rape and murder is hardly an issue).

While in jail, Bigger signs a confession. His defense attorney, Boris A. Max, pits his defense on the idea that society is to blame for Bigger's actions rather than Bigger himself. The prosecution, meanwhile, paints a picture of Bigger as an evil monstrosity. The debate becomes a symbolic exchange between those who believe in nature (Bigger is by nature a bad person) and those who believe in nurture (Bigger's upbringing forced him into bad behavior). Thus, Bigger does indeed become "bigger" than himself—larger than life—and his conviction and subsequent execution signal Wright's pessimism about the ability of Americans to balance these two belief systems. In the end, it is Bigger's declaration that remains indelibly etched in the reader's mind: "What I killed for must've been good! . . . I didn't know I was really alive in this world until I felt things hard enough to kill for 'em."

The Films

Wright, himself an avid filmgoer, conceived the work largely in cinematic terms. In an essay in *The Saturday Review* in 1941, he noted: "For the most part the novel is rendered in the present; I wanted the reader to feel that Bigger's story was happening *now*, like play upon a stage or a movie . . . Whenever possible, I told of Bigger's life in close-up, slow-motion, giving the feel of the grain of the passing of time." However, for 10 years Wright spurned Hollywood's offers, fearful of the alterations that would inevitably be made. He cited one such proposal by producer Harold Hecht, who suggested that Bigger might be changed into "an oppressed minority white man."

Finally, in 1949, he agreed to an offer by Pierre Chenal to shoot the film in France, Wright's adopted home after the war. Fearful of offending the United States, however, the Centre National de la Cinématographie Française scuttled the project. The shoot was relocated to locations in Buenos Aires, Argentina (with only a handful of Chicago exteriors included in the final print). Though 50 years of age, and inexperienced as an actor, Wright cast himself as the 19-year-old Bigger. Several Hollywood character actors were imported, including Jean Wallace as Mary Dalton and Gloria Madison as Bessie.

By the time it was distributed in America by the Walter Gould Agency, Wright's worst fears were confirmed. It was tamed and emasculated almost beyond recognition. The novel's forthright anti-Christianity and primitive existentialism were softened. Jan Erlone's communist activities were scrapped. The entire courtroom scene was reduced to a handful of shots. As for Bigger, his sexual appetites were barely suggested, his hatred of whites muted, the brutality of his actions downplayed, and his black dialect sanitized. But commentator Peter Brunette notes that the movie is by no means all concession to popular tastes: Wright was apparently proud of the addition of several sequences, including a surrealistic dream in which Bigger confronts his dead father, the Gestapo-like tactics of a police roundup, and a night chase actually filmed on the rooftops of Chicago.

The more recent adaptation of *Native Son* unfortunately looks and moves like a TV movie, which isn't helped by the casting of Oprah Winfrey in the role of Bigger's mother. Rounding out the cast are Matt Dillon as Jan, Geraldine Page as Mrs. Dalton, and newcomer Victor Love as Bigger. This adaptation is as disappointing as the first one—perhaps even more so because it obviously had such substantial resources behind it. Not only are the fine shades of emotion and aggression never conveyed in Bigger, but also the seriousness of his status as a social problem is never touched upon. The film operates on the assumption that Bigger is an innocent victim of his environment, which is of course his defense attorney's position during his trial, and which is partially true. But the brilliance of Wright's novel is that he portrays Bigger also as an unsympathetic, mean-spirited individual, apart from nurture (his siblings, for example, do not share his ill temper and sadistic tendencies). This makes Bigger truly a social problem in a powerful way that neither film conveys. The second adaptation even goes so far as to eliminate Bigger's murder of Bessie, in order to reinforce the idea that Bigger is a mild-mannered victim, thus robbing the story of any controversy, any dialectic, and any philosophical significance. It also robs the story of the complexities of gender relations between black men and black women that are touched upon by Wright.

REFERENCES

Bloom, Harold, ed., *Richard Wright* (Chelsea House, 1987); Brunette, Peter, "Two Wrights, One Wrong," in *The Modern American Novel and the Movies*, eds. Gerald Peary and Roger Shatzkin (Frederick Ungar, 1978).

—*S.C.M. and J.C.T.*

THE NATURAL (1952)

BERNARD MALAMUD

The Natural (1984), U.S.A., directed by Barry Levinson, adapted by Roger Towne and Phil Dusenberry; TriStar Pictures.

The Novel

This baseball novel by Bernard Malamud (1915–86) begins with Roy Hobbs, a gifted young pitcher, on a train going to Chicago, "where the Cubs are." On that train he meets celebrity sportswriter Max Mercy and star slugger Walter (the Whammer) Wambold. When the train is stalled in the countryside for half an hour, Roy matches his pitching skills against the Whammer and manages to strike him out. Harriet Bird, who witnesses this contest, is impressed and later invites Roy to visit her hotel room after they arrive in Chicago. Unbeknownst to Roy, she is a psychopath who murders star athletes. In her hotel room she shoots Roy in the stomach with a silver bullet, cutting short his promising career as a baseball star.

Roy recovers eventually, and the novel rejoins him at the age of 34, working his way through the semipro leagues. An agent signs him as left fielder for the New York Knights, managed by Pop Fisher. Roy's pitching days may be over, but he is a natural athlete and proves himself as a champion batter. His competition is Bump Baily, the league's leading hitter, but a blowhard and a bully. Coach Red Blow tells Roy that the team has good talent but that they have been demoralized by Bump's antics and his laziness. Another problem is Judge Banner, the team's majority stockholder, who, Red explains, "is trying to push Pop out of his job although he has a contract to manage for life." As a young man Pop lost the World Series when he tripped while running bases after an in-the-park home run. Like Roy, Pop has been given a second chance to redeem himself as a manager. To win the Series, this time, he needs Roy's help.

The novel is about second chances, hope, and aspirations, but it does not have a happy ending. The game is corrupt, Bump is corrupt, Max is corrupt, and the Judge is corrupt. It takes more than sheer talent to win against such odds. Roy's talent and Pop's leadership take the team to the pinnacle of success, but with one game remaining, Judge Goodwill Banner bribes Roy to throw it. Roy refuses, of course, but at the end of the game, faced by a gifted young pitcher, he strikes out. Roy refuses the payoff but is smeared by Max Mercy's cover story, "Suspicion of Hobbs's Sellout." At the end of the novel a boy confronts him with the newspaper, echoing the "Say it ain't so, Joe" question put to Shoeless Joe Jackson after the Black Sox scandal of 1919: "Say it ain't true, Roy." As the novel concludes, Roy "wanted to say it wasn't but couldn't." He is a broken man and a failure.

The Film

The film adaptation reshapes Malamud's story and puts Roy on the *Rocky* road to success. Barry Levinson's film will not disappoint its viewers in telling the story of a brave athlete who works hard against overwhelming odds to prove himself. It begins with young Roy playing baseball with his father and ends with old Roy playing baseball with his son, passing on the tradition. The film, which was TriStar Pictures' very first release, was not about to strike out at the end. The screenplay was adapted by Roger Towne and Phil Dusenberry. Towne, who was also the film's executive producer, intended to retain as much of the novel as possible, but, he explained in a pressbook statement, "by virtue of my own optimistic nature, I was soured on the grimness and darkness of the Malamud book." Therefore, he framed the story with a theme borrowed from Roger Kahn's *The Boys of Summer*, the suggestion that baseball has to do with male bonding between fathers and sons. That, then, became the framework for what he called his "version" of the novel. Thus Roy Hobbs was refashioned in Robert Redford's All-American image and the novel's conclusion infused with Hollywood happiness.

Reviewing the film for the *New York Times* (May 11, 1984), Vincent Canby complained that Towne and director Barry Levinson had turned Malamud's "brooding moral fable" into a fairy tale. Aside from the spoiled new ending, however, the film retained the essential design of the book, and the casting was splendid: Wilford Brimley as Pop Fisher, the irascible team manager; Richard Farnsworth as Red, the team coach; Robert Duvall as Max Mercy, the sleazy sportswriter who has never played baseball but uses his influence to manipulate those who have the talent to play; Robert Prosky as team owner Judge Banner; and an uncredited Darren McGavin as the bookie with an evil eye who is in cahoots with the Judge. Barbara Hershey played Harriet, the angel of death, and Glenn Close played Iris Gaines, her opposite, an angel of light and redemption who inspires the baseball star. Kim Basinger played Memo Paris, the floozie seductress who temporarily saps Roy of his strength. Finally, Joe Don Baker provided a wonderful Babe Ruth imitation in his portrayal of the Whammer. Redford's Roy is like a Western hero, a man with a past, strong, silent, enigmatic, a loner whose weapon is a bat carved by lightning and shaped by his own hands. Though sentimental (in contrast to the novel), the treatment is effectively mythic.

Despite its violations of the source, the film was designed to be a crowd-pleaser and was immensely popular. Over a decade after the film was released, *USA Today* polled 10,500 readers to pick their all-time favorite sports film. *The Natural* placed in their top three choices, after *Hoosiers* (1986) and *Field of Dreams* (1989). Though not a faithful adaptation, the film became a benchmark of American popular culture.

REFERENCES

Ansen, David, and Katrine Ames, "Robert Redford: An American All-Star," *Newsweek*, May 28, 1984 74–80; Arnold, Gary, "'Natural' Classic," *The Washington Post*, May 11, 1984, B1–2; Canby, Vincent, "Redford and Duvall in Malamud's 'The Natural,'" *New York Times*, May 11, 1984, B13–15; Griffith, James, "Say It Ain't So: *The Natural*," *Literature/Film Quarterly* 19, no. 3 (1991): 157–63; Sylvester, Harry, "With the Greatest of Ease," *The New York Times*, August 24, 1952,

B5; Turchi, Peter, "Roy Hobbs's Corrected Stance: An Adaptation of *The Natural*," *Literature/Film Quarterly* 19, no. 3 (1991): 150–56.

—*J.M.Welsh*

NESNESITELNA LEBKOST BYTI (1984)

See THE UNBEARABLE LIGHTNESS OF BEING.

NIGHT OF THE HUNTER (1953)

DAVIS GRUBB

The Night of the Hunter (1955), U.S.A., directed by Charles Laughton, adapted by Laughton and James Agee; Paul Gregory/United Artists.

The Novel

Night of the Hunter was the most commercially and critically successful of the eight novels written by the now-forgotten Davis Grubb (1919–80), a professional journalist born in Moundsville, West Virginia. Although marred by a pseudo-poetic, folksy literary style and overindebtedness to the work of Thomas Wolfe and Sherwood Anderson, and novel's powerfully thematic morality tale still stands the test of time.

The novel opens during the final days of condemned murderer and bank robber, Ben Harper. Despite the efforts of his wife Willa and a psychotic fellow prisoner, Preacher Harry Collins, to make him reveal the location of the stolen $10,000, Harper goes silently to the gallows. The preacher, a sexually repressed serial killer, travels to Harper's hometown at Cresap's Landing, insinuates himself into the good graces of the towns-people, marries Willa, and works on her two children, John and Pearl, to find where Ben hid the money. (Before he was captured Ben used Pearl's doll as a hiding place and swore his two children to secrecy.) Willa discovers her new husband's aversion to sex on their wedding night. Repenting of her "unclean" desires, she joins him in his evangelical activities, before he murders her and dumps her body in a nearby river.

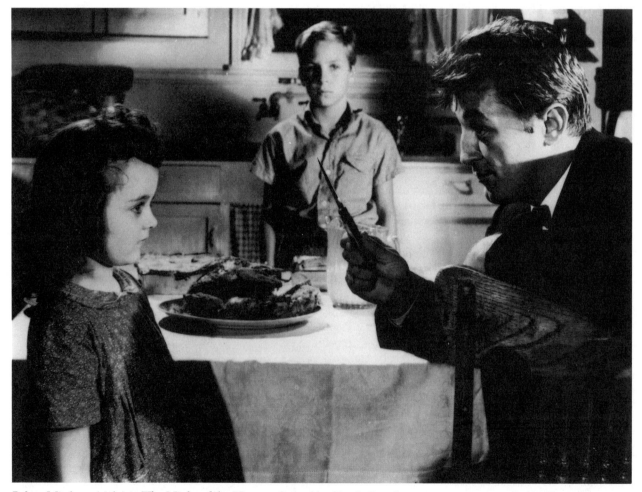

Robert Mitchum (right) in The Night of the Hunter, *directed by Charles Laughton* (1955, U.S.A.; UA/MUSEUM OF MODERN ART FILM STILLS ARCHIVE)

318

Before he can force the children to reveal the money's location, they escape in a skiff and travel through an Ohio Valley region suffering from the Great Depression. The preacher sets out in pursuit of them after telling neighbors that Willa ran away, followed by her children. He murders a farmer and travels on his horse in search of them.

Eventually, kindly sixtyish widow Rachel Cooper takes Pearl and John into her home to join her other adopted children, orphaned by the depression. The preacher finds them and demands Rachel return them to him. Sensing the preacher's real nature, Rachel refuses and begins a vigil, which ends when she uses her shotgun on the preacher who breaks into her house. The next morning the police arrest the preacher for Willa's murder. Upset by the incident (which resembles his own father's arrest), John reveals where the money is hidden. He also finds himself unable to testify at the preacher's trial in Moundsville. Later that evening, a lynch mob attacks the jail. The story ends with an epilogue set during Christmas showing the children enjoying newfound peace and security with Rachel Cooper.

The Film

Both Laughton and Grubb originally worked on the screenplay before James Agee's contribution. Suffering from alcoholism and ill health, Agee emphasized the depression aspects of the original novel, underplayed the drama, and eliminated the few good poetic passages in the book. However, after further collaboration with Grubb, Laughton wrote the definitive shooting script of the actual film. He emphasized the moral dimensions within the novel, and cinematically recreated it by using visual strategies of German expressionism and the artistic legacy of D.W. Griffith. Although condensing the novel, the final film closely follows the plot and creates its own distinctive interpretation by the cinematic contributions of Laughton and cinematographer Stanley Cortez.

The Night of the Hunter is a tale of the battle between good and evil, symbolically expressed by the "Love" and "Hate" tattoos on the preacher's right and left fingers. Unlike the book, the film begins with stylized images of the heads of Rachel and her children like stars in the heavens as she begins to tell a story related to the following film. The opening image immediately suggests the reassurance of a positive ending despite nightmarish images dominating the film. Laughton compares and contrasts two major influences within the early years of cinema: German expressionism (with all its overtones of the "dark night of the soul") and D.W. Griffith's 19th-century morality plays. Despite their happy endings, Griffith films always depicted overpowering battles between the forces of good and evil. Further, the casting of Lillian Gish as Rachel Cooper and Robert Mitchum as the preacher deliberately contrast two opposing cinematic traditions, personified by Griffith's most famous star and an actor associated with a film noir movement indebted to German expressionism.

Laughton also brought his interests in theater, painting, and music into the film. Laughton based the picnic scene on Seurat's *La Grande Jatte* and shot Willa's murder to synchronize with the movements of Sibelius's *Valse Triste*. The latter scene is a masterpiece of mise-en-scène, the murder bedroom shot at an impossibly unrealistic expressionistic angle. As the preacher moves the knife toward Willa's throat, a wipe follows the direction of his arm, forming a stunning transition to the next scene.

REFERENCES

Wood, Robin, "Charles Laughton in Grubb Street," in *The Modern American Novel and the Movies*, eds. Gerald Peary and Roger Shatzkin (Ungar, 1978), 204–14; Mills, Moylan C., "Charles Laughton's Adaptation of *The Night of the Hunter,*" *Literature/Film Quarterly* 16, no. 1 (1988): 49–57.

—T.W.

1984 (1949)

GEORGE ORWELL

1984 (1955), U.K., directed by Michael Anderson, adapted by William P. Templeton; Holiday Films.
1984 (1984), U.K., directed and adapted by Michael Radford; Virgin Films.

The Novel

1984 is the most famous work of British writer Eric Blair, who wrote under the pen name of George Orwell. Essentially a political writer, Orwell described and satirized the totalitarian aspects of modern times in his depiction of the future state of Oceania, where all aspects of personal, economic, and political life are strictly controlled by Big Brother and the Party. Orwell's story of the failure of one man to escape Big Brother has served as a grim reminder of the present and future of modern industrial society.

The central character, Winston Smith, seems well adjusted to the realities of Oceania—the pervasive picture of Big Brother, the Two Minutes Hate directed at Goldstein (who is supposedly plotting against Oceania), the mass hysteria over the wars against Eurasia and Eastasia, the linguistics of Newspeak, and his own job at the Ministry of Truth rewriting the past according to the Party's instructions. But Winston's discontent is indicated by his physical discomforts, his recollection of past events both political and personal, and his keeping a diary away from the gaze of Big Brother. As if coming to consciousness, Winston realizes that he has committed "thoughtcrime" in writing slogans against Big Brother and in his growing desire to reject thought control, the Anti-Sex League, was propaganda, constant surveillance, and the loss of individual personality.

A young woman named Julia slips a note into Winston's hand telling him "I love you." Accepting the risk of arrest, torture, and death, they agree to meet in a wood in

the country, where they make love. They continue to meet in a rented room at Mr. Charrington's antique shop in the proletarian district where Winston had first bought his diary, and gradually Winston retrieves more of his past and a sense of meaningful existence through his relations with Julia. Winston believes that O'Brien, a member of the Inner Party, is not sympathetic to Big Brother and is working with Goldstein. After expressing their hatred of Big Brother, O'Brien enrolls Winston and Julia in the conspiracy and lends them Goldstein's treatise.

One day in their rented room, Winston and Julia suddenly realize that they have been under surveillance by Big Brother. They are arrested, separated, and tortured. In excruciating detail, Orwell describes how Winston is tortured for weeks, forced to confess to real and fictitious crimes. In the later stages of his torture, O'Brien directs Winston's torture and rehabilitation, keeping him on a rack while lecturing Winston that Goldstein and his book are the inventions of the Party, and that Winston must will himself to accept that Two Plus Two Equals Five if the Party dictates that it is true. While Winston struggles to argue with O'Brien for the integrity of humanity, O'Brien succeeds in erasing all traces of Winston's rebellious and independent intelligence. After admitting that he still loves Julia and hates Big Brother, O'Brien arranges in Room 101 for a cage of rats to be fastened to Winston's face. In his mindless terror, Winston begs that the rats be allowed to eat Julia instead. In the end, Winston has been rehabilitated and released, working at a minor job and sitting in taverns drinking gin. One day, Winston and Julia, both shadows of their former selves, accidentally meet and inform each other that they betrayed each other. They have nothing else to say to each other. An announcement of a major military victory allows Winston to feel cleansed in his newfound love for Big Brother.

The Films

There are two film versions of Orwell's *1984*, the first being Michael Anderson's 1956 adaptation starring Edmund O'Brien, which is no longer available. The more recent and better known version is by British director Michael Radford, who both wrote and directed the film. Radford's *1984* was filmed in and around London from April to June 1984, the exact time and setting of the novel, and is remarkably faithful to Orwell in its script, visual effect, and mood. Surprisingly, the cinematography by Robert Deakins successfully presents Orwell's story in an apocalyptic past rather than future. London has the look of the 1940s during the Second World War and the period immediately after, when Orwell wrote *1984*. The shots of the victory rallies and propaganda films echo Soviet and Nazi films of the 1930s and 1940s, and the somber, washed-out colors of London dwellings and people recall earlier black-and-white films.

With John Hurt and Suzanna Hamilton starring as the doomed couple, Radford's *1984* emphasizes the importance of their relationship, which is often obscured in strictly political readings of the novel. The personal drama of Winston and Julia begins immediately in their exchanged glances at the Hate periods, military rallies, and the commissary. In contrast to the grim depiction of London, their rendezvous in the country is vivid and colorful—a "green world" away from the city. While their sexuality and love is not romanticized, both characters become more humanlike in their facial expressions and dialogue as their relationship develops. The film draws the viewer into their frightening, secretive world of living in constant fear of discovery by the thought police.

In his final screen role, Richard Burton plays the attractive and forbidding O'Brien. His gaze early in the film is both ominous and inviting, and Burton remarkably continues both qualities when he becomes Winston's torturer and educator, becoming the imposing force and voice as Winston is erased before the viewer's eyes. The use of voiceover to relate the contents of Winston's diary and mind is replaced with O'Brien's anticipation and articulation of Winston's thoughts until Winston no longer has thoughts of his own. The dreamlike states of consciousness under torture establish O'Brien and his "instruction" as the beautiful green world of the future.

The striking and squalid realism of the Radford film is effectively combined with moods, sounds, and scenes of a world of memories and dreams. The movie is positively influenced by the music video genre, both in the music of Dominic Muldowney and the Eurythmics as well as the use of rapid editing and slow motion to convey a range of human emotions and experiences rather than a series of events. While the movie eliminates much of Winston's reflective life and discussions from Goldstein's treatise, and does not capture the incredible sensuousness of Winston's experience of sights, smells, textures, tastes, and noises in the novel, the film still succeeds in expressing the alternating moods of hope and fear, freedom and terror. The film becomes as depressingly relentless as the book in its despairing depiction of a doomed love in a society that we uncomfortably recognize as our own. Radford's accomplishment is to create a film as utterly grim and hopeless as Orwell's novel.

REFERENCES

Bloom, Harold, ed., *George Orwell's "1984"* (Chelsea House, 1987); Bruitenhuis, Peter and Ira B. Nadel, eds., *George Orwell: A Reassessment* (St. Martin's Press, 1988); Gardner, Averil, *George Orwell* (Macmillan, 1987).

—M.P.E.

IL NOME DELLA ROSA (1980)

See THE NAME OF THE ROSE.

NOTRE DAME DE PARIS (1831)

See THE HUNCHBACK OF NOTRE DAME.

THE OBSESSED *(Fuxi Fuxi)* (1988)

LIU HENG

Judou (1990), China-Japan, directed by Zhang Yimou and Yang Fengliang, adapted by Liu Heng; China Film/Tokuma Shoten Publishing/Tokuma Comm./ China Film Export & Import/Xian.

The Novel

Liu Heng (pen name of Liu Guanjun) was born in Beijing in 1954 and began writing fiction in 1979. According to Li Ziyun's preface to David Kwan's 1991 translation of *The Obsessed*, Liu Heng is one of the most prominent of China's "new realists." This late 1980s movement—influenced by Western realism and modernism—features scenes from the daily lives of ordinary men caught in society's rules, juxtaposed to protagonists' inner thoughts, revealing the struggle between the passionate inner person and the stoic mask society forces him to maintain.

Set over several decades in rural China beginning in the politically turbulent 1940s, the story focuses on the plight of lovers in a traditional patriarchal society in which women are bought and love is irrelevant to marriage. Widower Yang Jinshan, unable to father a child with his first wife, buys bride Wang Judou in his obsession to produce a male heir. Old and impotent, Jinshan beats and sexually tortures the young Judou, much to the anger of his nephew Tianqing, who has fallen in love with her. Judou eventually seduces the naive Tianqing, beginning decades of passionate but illicit love that can never be revealed. Judou produces a son, Tianbai, who grows up to hate his

natural father (Tianqing); Jinshan is paralyzed in an accident, forcing Judou to try painful and ineffectual methods of birth control; Jinshan dies a peaceful death, while Tianqing, finding life intolerable, drowns himself. Judou escapes to give birth to a second son by Tianqing, which oddly the villagers (in the postrevolutionary times) simply accept as another Jinshan heir, raising the question of how such intense psychological drama and pain could be simply swept away as an artifact of feudal times.

The Film

Zhang Yimou's second film was banned in China. Western critics have theorized that the film's negative depiction of China's (sexually impotent but politically powerful) gerontocracy, the overt sensuality of Gong Li in the role of Judou, and/or the film's patricides offended the Chinese, who are still obsessed with filial piety. China tried (unsuccessfully) to pull the film from the best foreign film Academy Award nomination (the first Chinese film to be so honored).

Zhang has fleshed out Liu Heng's spare tale with his trademark Panavision imagery. Lengthy shots of Jinshan constrained as an impotent cripple are contrasted with lusty, vibrant images of his wife and nephew coupling. Zhang's major change was locating the story in a dye factory, an addition that provided shots of bolts of cloth dipping and rising out of red dye pools as feminine symbols of sexual passion, falling into clotted patterns as bloody symbols of reproduction, birth, and death. Setting the film in the more politically stable 1920s, Zhang has also given the tense struggle between passion and repression an allegorical atemporality, hinting that the violence might have

contemporary implications. In scenes not in the novel, Tianbai, the wooden and mute son, (accidentally) kills his legal father Jinshan and (purposefully) kills his natural father Tianqing, and Judou, in grief and frustration, sets the dye factory on fire in the final scene.

REFERENCES

Chow, Rey, *Primitive Passions: Vitality, Sexuality, Ethnography, and Contemporary Chinese Cinema* (Columbia University Press, 1995); Huot, Marie-Claire, "Liu Heng's *Fuxi Fuxi:* What about Nüwa?" *Gender and Sexuality in Twentieth-Century Chinese Literature and Society*, ed. Tonglin Lu (SUNY Press, 1993), 85–105; Lau, Jenny Kwok Wah, "*Judou*—A Hermeneutical Reading of Cross-cultural Cinema," *Film Quarterly* 45 (winter 1992): 2–10.

—*D.G.B. and C.C.*

OF HUMAN BONDAGE (1915)

W. SOMERSET MAUGHAM

Of Human Bondage (1934), U.S.A., directed by John Cromwell, adapted by Lester Cohen; RKO.

Of Human Bondage (1946), U.S.A., directed by Edmund Goulding, adapted by Catherine Turney; Warner Brothers.

Of Human Bondage (1964), U.K., directed by Ken Hughes and Henry Hathaway, adapted by Bryan Forbes; Seven Arts/MGM.

The Novel

Published in 1915, *Of Human Bondage* is the best known and most highly regarded work by British novelist and playwright W. Somerset Maugham. He would write in his 1938 memoir, *The Summing Up*, that *Bondage* "is not an autobiography, but an autobiographical novel. . . . The emotions are my own, but not all the incidents are related as they happened." Reviewers complained about the book's "morbid" central characters and "unwholesome" qualities. But two key enthusiasts helped the book find an audience: Sinclair Lewis, manuscript reader for George H. Doran, the book's American publisher, and Theodore Dreiser, whose *New Republic* review dubbed it a masterpiece.

Protagonist Philip Caren is orphaned at eight, when his mother dies of tuberculosis. Philip then loses his nurse and moves to Kent to live with his clergyman uncle and his wife, who are middle-aged and childless. The uncle enrolls Philip at King's School to prepare him for Oxford and a career in the church. Philip, who has a clubfoot, chafes under the school's stifling intellectual climate and ostracism from his peers. A solitary, bookish soul, he grows increasingly preoccupied with finding the meaning in life, and he begins to doubt his religious faith. At 16, he presses his uncle to allow him to study for a year in Heidelberg, Germany. He has his first affair, with an older woman, Emily Wilkinson. His uncle, eager to secure a respectable career for Philip—who now spurns Oxford and the pulpit—apprentices him to an accounting firm. Philip lacks all ambition and aptitude for this occupation and prevails upon his uncle to allow him to study at a Paris art school. After two years, he concludes he has no talent and returns to England where, as a last resort, he studies medicine. He falls into a disastrous affair with the manipulative Mildred, a waitress. So obsessed does he become with her that he willingly drains his savings to subsidize her romantic vacation with his best friend. Just as Philip finds happiness with another woman, Norah, a writer who genuinely cares for him, Mildred shows up pregnant, unmarried, and destitute. Philip allows her to move in with him on a platonic basis; and she performs housekeeping duties in lieu of rent. Eventually, she grows to hate him, vandalizes his quarters, and leaves. Philip finds he cannot go back to Norah, who is now engaged to another man.

Now penniless and denied help from his uncle, Philip must drop out of medical school. A free-spirited former patient, Mr. Athelny, takes him off the street and helps to find him a working-class job in the garment industry. Meanwhile, he waits for his uncle to die so he can use his inheritance to finish medical school. When this happens, Philip completes his studies and practices obstetrics in impoverished London neighborhoods. Then Philip falls in love with Sally, Athelny's daughter. Sally briefly suspects she is pregnant, but even after she realizes she is not, Philip asks her to marry him, realizing that what he really wants is love and family. At last, Philip has found his emotional and professional calling.

The Films

John Cromwell's 1934 adaptation of *Bondage* is the prototype for the 1946 and 1964 versions. In all three films, Philip's relationship with Mildred is the central element, whereas Mildred does not even appear in the novel until the midpoint, in chapter 55. Philip's childhood and schooling, the year in Heidelberg, his brief accounting job, and his relationship to his aunt and uncle are all dropped. Lester Cohen's decision to reframe the story in this way overcame the logistical problems of how to compress the novel's vast contents into an 86-minute feature film.

All three versions follow the same general pattern: After a brief Paris scene where he is told he will never succeed as an artist, Philip resolves to try medicine. While pursuing his medical training in London, Philip meets Mildred at the restaurant where she works as a waitress. Philip becomes obsessed with her and returns to sketch her. Despite Mildred's crude manner, aggressive indifference toward him, and open contempt for his clubfoot, Philip willfully allows her to take advantage of him as he neglects his studies and fails a major exam. Mildred even leaves him at one point to marry another, at which time Philip meets the second of his three love interests, writer Norah Nesbit. Despite Norah's selfless love for him, accentuated by her insistence that he study to pass his

examinations, Philip drops her when Mildred returns to him, pregnant and without a husband. Rather than remain faithful to him, however, Mildred has a fling with Philip's best friend. Eventually, Philip and Mildred separate, and she becomes a streetwalker. Philip tries to rescue her from selling herself by allowing her to live with him, but one day she destroys his belongings and leaves. Following her daughter's death, Mildred dies of disease. Her death takes place at the very hospital where Philip pursues his medical training. Philip meets the daughter of one of his patients, Athelny. She becomes his third love interest, and they vow to marry at the conclusion of each film.

Maugham's Mildred does not steal Philip's bonds (as in the 1934 version) or steal his savings to buy herself a negligée (as in 1946 version). Rather, in the novel Philip loses his last money to speculation. But one of the films' key departures from the novel is the episode of Mildred's death. Maugham's Philip last sees Mildred when he examines her at the hospital. She presumably has syphilis (the 1934 and 1946 versions speak of tuberculosis or pneumonia). The novel does not depict her actual death, as do the films, nor is Philip with her when she does die (as in the 1964 version) or almost so (the 1934 version).

Other variations among the films are relatively minor. One exception is Kim Novak's 1964 portrayal of Mildred, who is much more flirtatious, even seductive than her earlier counterparts. She is the one who initiates their first two kisses. She seems more guilty than devious when she lies about canceling a date so she can see another man, and when Philip (Laurence Harvey) discovers them, Novak ditches the other man for Harvey on the spot. Novak even suggests that Harvey take her to his place after a date. And when Harvey asks Novak to marry him, she initiates sex between them before telling him she is already engaged.

The 1934 version of *Bondage* firmly established the reputations of Bette Davis, who emerged from the film a major star, and John Cromwell, who cast her. Katharine Hepburn and Irene Dunne were among the actresses who turned down the role of the unsavory Mildred; Davis, in contrast, threw herself into the part, for which she received a large Oscar write-in vote and universal praise from reviewers. She would later cite *Bondage* as the turning point in her career, allowing her to move out of standard ingenue roles. Leslie Howard's Philip superbly captures the Maugham character's agonizing blend of cultivation, vulnerability, and naïveté.

Edmund Goulding's 1946 version is now largely forgotten or dismissed as a box-office disappointment. Eleanor Parker's Mildred and Paul Henreid's Philip, though credible, failed to ignite the kind of critical enthusiasm that Davis and Howard had.

Ken Hughes was the 1964 version's third director, taking over from Henry Hathaway after production was underway. Reviewers had mixed reactions to the casting of Kim Novak as Mildred and Laurence Harvey as Philip. Novak, at least, tackled her ambitious role enthusiastically;

Harvey's interpretation of Philip, on the other hand, seems bland.

REFERENCES

Burt, Forrest D., *W. Somerset Maugham* (Twayne, 1985); Curran, Trisha, "Variations on a Theme," in *The English Novel and the Movies*, eds. Michael Klein and Gillian Parker (Frederick Ungar, 1981), 228–34; Morgan, Ted, *Maugham* (Simon & Schuster, 1980).

—B.F.

OF MICE AND MEN (1937)

JOHN STEINBECK

Of Mice and Men (1939), U.S.A., directed by Lewis Milestone, adapted by Eugene Solow; Hal Roach/United Artists.
Of Mice and Men (1992), U.S.A., directed by Gary Sinise, adapted by Horton Foote; MGM.

The Novel

Of Mice and Men was published in 1937, two years after Steinbeck's first best-seller, *Tortilla Flat*. In 1938, his short story collection, *The Long Valley*, increased Steinbeck's critical reputation, as did the publication of *The Grapes of Wrath* in 1939.

Set in the depression, *Of Mice and Men* gives us a glimpse into the lives of George Milton, an itinerant ranch hand, and Lennie Small, a giant simpleton and George's devoted friend. Barely escaping a lynch mob when Lennie's childish/brutish advances frighten a young woman, George and Lennie find work at a barley ranch farther south in the Salinas Valley. Lennie gets in trouble again: Alone in the barn with the wife of the boss's son, Curley, Lennie becomes confused and excited by her attention, then accidentally breaks her neck as he tries to muffle her screams for help. Curley and the other ranch hands set out to hunt Lennie down, but before the men can find Lennie, George mercifully shoots him in the back of the head, as he tells Lennie his favorite story, how it's going to be when they have their own place and are living off the fat of the land.

The Films

Steinbeck wrote *Of Mice and Men* as a "play-novelette" designed to be adapted to the stage. In 1937, an adaptation by Steinbeck, with assistance from George S. Kaufman, led to a commercial success on Broadway, starring Wallace Ford and Broderick Crawford, and a Drama Critics award for best play of the year. Milestone's film draws on the novel as well as the play, for like the play, Curley's wife becomes a sympathetic character, as lost as all the others. Starring comparative unknowns, Burgess Meredith and Lon Chaney Jr., and produced in a year that offered

John Steinbeck

audiences some of the most memorable films in Hollywood cinema, Milestone's film received a nomination for best picture but was not a box-office success.

Because of its hard-edged realism, critics predicted that Hollywood would not be able to produce a film that satisfied the Production Code and the demands of the novel. Yet Milestone's film accomplished the task, and may even have improved on the novel, for it is truly an ensemble piece that makes us feel the isolation that plagues all the characters. The film effectively conveys the defining features of the novel in cinematic terms. It shows us the vulnerability of characters like Lennie, Candy, and Crooks through the plaintive score by Aaron Copland, and the black and white cinematography that captures the bareness of their lives and the simple beauty of the ranch's natural setting. Its quietly compelling performances (Roman Bohnen's portrayal of Candy when he becomes the third partner in George and Lennie's dream to get a place of their own; the work of Lon Chaney and Betty Field in the scene where he talks about the farm he will have and she

tells of her dreams of going to Hollywood) deftly reveal that the dreams of all the characters in the novel are doomed—but that their unfulfilled dreaming is their claim to greatness.

Gary Sinise's 1992 film originated with a 1980 Steppenwolf Theater production starring himself as George and John Malkovich as Lennie. In contrast to Milestone's adaptation that makes us see connections between its characters and the natural world, Sinise's film is essentially a buddy film: It ends with an image of George and Lennie peacefully walking through a sunlit field. The film's lush color cinematography fails to represent the bleakness of the depression, and with scenes added to underscore George's handsome youthfulness (e.g., alone with Curley's wife in the barn), it draws our attention away from the tragic, ennobling, pervasive sense of fate that Steinbeck's novel and Milestone's film evoke so effectively.

REFERENCES

Millichap, Joseph R., *Steinbeck and Film* (Ungar Publishing, 1983); Morsberger, Robert E., "Tell Again, George," in *John Steinbeck: The Years of Greatness, 1936–1939*, ed. Tetsumaro Hayashi (University of Alabama Press, 1993).

—*C.A.B.*

THE OLD GRINGO *(El gringo viejo)* (1985)

CARLOS FUENTES

The Old Gringo (1989), U.S.A., directed by Luis Puenzo, adapted by Puenzo and Aida Bortnik; Columbia.

The Novel

El gringo viejo was written by Mexican novelist Carlos Fuentes as a tribute to the American journalist and writer Ambrose Bierce, who disappeared mysteriously in Mexico in 1913 during the continuing civil unrest. Bierce wrote on December 26, 1913 that he intended to find Pancho Villa and fight for the revolution. Legend has it that he found Villa and became a staff adviser but was later shot as a deserter after he objected to Villa's cruelties. The novel works a variant on that legend. In the novel Bierce is referred to only as the "Old Gringo," and his motives are ambiguous. He is disenchanted with the United States and seems to be seeking a new frontier to the south, but as Fuentes states repeatedly, "the old gringo came to Mexico to die," presumably heroically, and with dignity in a man's world.

However, the novel really belongs to Harriet Winslow, a naive American spinster who goes to Mexico to work as a governess for the wealthy Miranda family and arrives in the midst of a revolution she does not understand. She is manipulated by General Tomás Arroyo, who uses her as a decoy to get past the Federales who are guarding the Miranda estate, which Arroyo and his troops capture. Arroyo exploits her both politically and sexually. The

Mexicans consider her a fool. The gringo knows that he was also exploited and manipulated by William Randolph Hearst, who employed him as a muckraking journalist—and he also blames himself for the death of his sons—so he treats Harriet with understanding and respect.

The gringo is an idealist who carries *Don Quixote* in his saddlebags as he goes tilting after windmills of his own in revolutionary Mexico. But instead of Pancho Villa, he finds General Arroyo, whom he antagonizes with his brutal honesty. Arroyo, the bastard son of the Mirandas, is conflicted after he captures the hacienda and is derelict in his duty to return his army to Villa. He discovers Spanish documents that he thinks will give him possession of the Miranda lands. The gringo tells him the documents are worthless, and when Arroyo refuses to believe him, the gringo burns the documents. In a rage, Arroyo shoots the gringo in the back.

Harriet is also conflicted, torn between Arroyo and the 71-year-old gringo. She allows herself to be seduced by Arroyo, claiming that she does so in order to save the gringo's life, but the gringo refuses to believe that. She comes to hate Arroyo and reports his murder of the gringo to the United States consulate, claiming that the gringo was her father and demanding that he be returned to Arlington National Cemetery for a military burial. Pancho Villa is therefore held responsible for the death of a U.S. Army captain, and since Villa needs the support of the U.S. government, he exhumes the body of the gringo and puts Arroyo before a firing squad. Harriet takes the gringo's body home, where she continues to live with her memories.

The Film

The adaptation has a curious history. Reviewing the film for *Mexico Journal*, John Ross suggested that the book was "originally cooked up" during a barbecue given by Jane Fonda and Tom Hayden at their Southern California ranch for Fuentes in 1980, though Fuentes claims in the cover notes for the first English edition that the book was first "conceived about forty years ago in Mexico, when I first read the stories of Ambrose Bierce. It lay dormant until 1964 when I wrote the first ten pages during a train trip through Chihuahua." At any rate, Fuentes apparently told Fonda in 1980 that the book was in progress and there might be a role in it for her. The film then became her project, but it was not to match the success of *On Golden Pond* (1981), a far more personal film involving a father figure.

The main interest of the novel is in the way the story is told, framed by Harriet's memory. If the story is retold from a merely objective, "cinematic" point of view, that interest will be destroyed. The film makes the novel more easily comprehensible—the identification of the gringo with Bierce, for example, is made clear to the viewer from the very beginning—but it cannot be understood as well, since the narrative shift reduces the psychological complexity, which cannot conveniently be brought to the surface and visualized. There is no effective visual equivalent for "she sits and remembers."

The question of identity, personal and cultural, is fundamentally important here. Harriet (Jane Fonda) is seeking her identity, linked to the memory of her father and her relationship with the gringo (Gregory Peck), who is also seeking his identity in a foreign land while seeking a frontier to the south, since the western frontier has long since moved to California and disappeared. Arroyo (Jimmy Smits) is seeking his identity and seems unable to decide where he belongs, at the Miranda estate or with Villa. The gringo is a father figure to both Arroyo and Harriet, while appearing at the same time to be a creaky, old consumptive lover in the film who is more verbal than physical.

The dynamic of the story, then, is triangular, involving two men and a woman, each exerting pressure on the other. The gringo is an anachronism whose time has passed. He goes south to Mexico to find adventure, to reinvent himself on a new frontier, to work for change and revolution, and to die heroically in pursuit of this goal; but he is also moving into a foreign culture he does not completely understand. He is quite verbal, of course, but as he declaims forcefully in English in the film, his audience is hispanic, and one wonders how these uneducated, illiterate peasant revolutionaries could possibly understand him. His age and sophistication suggest wisdom, but he is culturally naive and peculiarly innocent.

The gringa is less sophisticated and even more culturally naive. Being from the East, she understands neither the West nor the frontier, and one wonders how well she even understands Spanish. A repressed spinster, she does not understand men, especially hispanic men. After she gives herself to Arroyo, she is made to understand that she can never be a part of his world. She betrays Arroyo finally in the novel not to avenge the gringo "but to repay Arroyo for the wrong he did her." For this she cannot forgive him, but she cannot forget him, either. That is why "she sits and remembers." The motive is far more simple in the film, as scripted by Aida Bortnik and director Luis Puenzo.

The film has its moments, as when the gringo arrives at the Miranda estate to find, literally, a Mexican stand-off between the revolutionaries and the Federales. His first question is explosive: "Can anyone tell me where I might find Pancho Villa?" The revolutionaries then burst into action, each one claiming "I am Villa!" as they fire their weapons. In a film that is notably lacking in action sequences (though it seems to resemble a western), the storming of the Miranda estate is remarkable. No less remarkable is the presentation of the two duped, innocent Americans, young and old, male and female, representing both Eastern and Western perspectives.

By the end of the story, two sides of the triangle have collapsed. The film is interesting in the way it reflects the concerns of the 1980s as to Latinos and women. Cultural conflicts are nicely demonstrated between North Americans and Mexicans: our history vs. their history, our myths

vs. their myths, our ideology vs. their ideology. The novel reflects Fuentes's own sense of being split between cultures (he grew up in Washington, D.C.), but the film is not a very good or a very coherent adaptation. Given its strong casting and genre framework the film should have worked better with popular audiences. Peck is impeccable as the gringo and Smits is an energetic Arroyo, but Fonda, who is at least 10 years too old for the part, seems to be sleepwalking through her role. The film is an interesting failure.

REFERENCES

Brown, Georgia, "Culture Clash," *The Village Voice* (October 17, 1980), 90; Rohter, Larry, "Why the Road Turned Rocky for 'Old Gringo'," *New York Times* (Oct. 22, 1989), II, 15, 29; Ross, John, "Back from the Dead," *Mexico Journal* (October 20, 1989), 22+.

—J.M. Welsh

THE OLD MAID (1924)

EDITH WHARTON

The Old Maid (1939), U.S.A., directed by Edmund Goulding, based on the play by Zöe Atkins adapted from Edith Wharton's novel; Warner Bros.

The Novel

The Old Maid was published in spring 1924 as the second of a four-volume boxed set that comprised Edith Wharton's *Old New York*. The volumes were handsomely illustrated and the boxing together of the four works was considered innovative. Each book chronicles a decade in the social history of 19th-century New York: *False Dawn: The Forties; The Old Maid: The Fifties; The Spark: The Sixties;* and *New Year's Day: The Seventies.* The four volumes function as separate, independent narratives and as parts of an integrated whole, which explores the effects of the old social values on each volume's principal character, all of whom rebel against the confining conventions of the day.

Edith Wharton was 62 when she wrote *The Old Maid,* a novella about a young, unwed mother who belongs to the ultraconservative ruling families of old New York. In the beginning of the story, Charlotte (Chatty) Lovell is an unmarried young woman, innocent, energetic and curious about life. She wants more than the mundane lifestyle sanctioned by her "compact society, built of solidly welded blocks." Drawn to Clement Spender, a romantic and dreamy sort of fellow who is incapable of commitment, Charlotte spends a single night with him and becomes pregnant. She secretly has her baby and starts a home for foundlings, where her daughter Clementina (Tina) is raised as her special orphan. Conditions cause the two to move in with Charlotte's cousin, Delia Ralston, who also loved Clem and is jealous of Charlotte. Tina, unaware of

her parentage, quickly begins calling her aunt Delia "Mamma" and her mother "Aunt Chatty." The closer Tina grows to Delia, the farther she grows from Charlotte, until, in order to make Tina's marriage to the socially prominent Lanning Halsey possible, Charlotte, in a painful decision, allows Delia to adopt Tina and give her all the benefits that the Ralston name confers. Tina learns nothing of her mother's lifelong sacrifice; and, on the eve of Tina's wedding, Delia, much to Charlotte's sorrow, clearly emerges as the woman Clementina thinks of and loves as her mother.

The Old Maid relentlessly follows Charlotte Lovell's journey into despair. By the end of the story, Charlotte has grown "enigmatic and inaccessible." She is a stranger to Tina, the one person with whom she wants to make meaningful contact. Uncommunicative (except to Delia), solitary, and acutely private, the once charmingly vibrant Charlotte metamorphoses into a bitter and misanthropic old maid, whom her own daughter thinks of as an inconvenient fixture in the otherwise merry Ralston household. In the course of this deceptively simple story, Wharton helps us understand wounds that are so deep that a character must, in dignity, withdraw to nurse them in privacy rather than complain aloud to the world. Charlotte Lovell withdraws farther than most characters do, to a private world too remote for casual access.

In *The Old Maid,* Wharton uses the conventions of the sentimental narrative to construct a relentlessly unsentimental work. The sentimental ethos sends dangerous codes to women, Wharton warns us. It lauds a woman's patient and mute renunciation of life carried out in high service to love and virtue. This sentimental ideal, for Wharton, exists as a destructive mythology that reduces life to a joyless task and ultimately smothers the animus. The archetypal protagonist of sentimental fiction is the suffering and defenseless woman of fervent female virtue, who is either happily rewarded by marriage and children or ennobled by a redemptive death. However, far afield of the happy-ending reversals common to sentimental novels, *The Old Maid* illustrates society's crushing imposition of conformity and sacrifice of the worst sort on its members who are beset by a vision of something more.

Charlotte stands as an exemplar of spirited but constrained femininity who instigates an unconventional liaison but does so tastefully, behind the scenes, whose dark and curiously masculine appearance emerges as far more provocative than Delia's conventional feminine beauty, whose restrained surface hints at deep yearnings, and who always has to maneuver within the corseted restrictions of society. As such, she expresses a part of the American zeitgeist that found articulation in the genre known as "women's films" of the late 1930s and early 1940s.

The Film

The Edmund Goulding film version for MGM, like the Wharton novella upon which it is based, employs the spe-

cific conventions of the sentimental tradition, arguably, to debunk it. In handsome and judicious translations of the book's literary amplifying devices (its exclamation points, dashes, capital letters, ellipses, and italics), the movie employs cinematic devices to achieve the same heightening results. To an immoderate degree, dramatic fadeouts, hard cuts, atmospheric lighting, stylized acting, overwrought gesturing, and heightened music are used.

Because the plot involves an illicit affair and the illegitimate child who resulted, Edith Wharton battled censorship in trying to publish *The Old Maid*. In a similar situation, Warner Brothers, from 1935 to 1939, had to battle the Production Code Administration (PCA), headed by Joseph Breen, for clearance for the film's production. Before final PCA approval was awarded, however, many specific details had to be negotiated.

One such detail is that the film changes the novel's setting from 1850s New York to Philadelphia during the Civil War. Clem Spender (George Brent), rebuffed by Delia Lovell (Miriam Hopkins) on her wedding day to Jim Ralston, enlists in the Union Army and spends his final day and evening with her cousin, Charlotte Lovell (Bette Davis). The next afternoon, he heroically departs for the battlefield (none of the Ralston men enlists). He dies serving a virtuous cause, with the film's PCA-pleasing implication that, had he lived, he would have returned and done right by his new family. The film includes two key scenes between Clem and Charlotte: their return to Charlotte's home after having passed the infamous evening together and their farewell on the train platform, as Clem is about to embark for war. While both scenes are constrained, the more notable one is the farewell scene. In compliance with PCA demands, in this particular exchange Clem and Charlotte's passion and fears are held in abeyance. Their conversation hints of momentous things unsaid, and their parting kiss is kept polite. The scene is simply beautiful. To the actors' and director's credit, the sequence is more fully charged with emotion because of the manner in which the emotions lay unexpressed. The audience presumes the couple's restraint is a necessary response to the rigid rules of conduct imposed by their rigidly decorous world. Ironically, the off-camera constraints imposed by the PCA, invisible to the audience, heighten the sexual tension and lingering pathos of this sequence.

Wharton's *The Old Maid* is suffused with the language of double meanings, words unsaid, and coded conversations; and while these are literary nuances that do not translate easily into the medium of film and are often omitted in this production, the beauty of this movie is that we see, writ elegantly in the details of long full-screen close-ups and meticulously framed, dynamic two-shots, Delia's jealous furor, Charlotte's ongoing pain, the great and slow toll that her sacrifice takes upon Charlotte's spirit and her body, and the subterranean hell beneath the outwardly merry Ralston household. While the ending of the movie shows us Charlotte and Delia cordially embracing one another in what appears to be a rewriting of Whar-

ton's ending in order to serve Hollywood's preference for happy closure, the framing of the closing shots belies the apparent gladness. To its credit, the film is a bit more complex than that. The closing shot reveals Charlotte and Delia poised before the front door of the Ralston house. Both characters will walk back into their dolorous lives in which simply nothing has changed, despite our lingering wish that it had.

REFERENCES

Cahir, Linda Costanzo, *Solitude and Society in the Works of Herman Melville and Edith Wharton* (Greenwood Press, 1999); Lewis, R.W.B., *Edith Wharton: A Biography* (Harper & Row, 1975); Rae, Charlotte, *Edith Wharton's New York Quartet* (University Press of America, 1984); Wolff, Cynthia Griffin, *A Feast of Words: The Triumph of Edith Wharton* (Oxford University Press, 1978).

—*L.C.C.*

THE OLD MAN AND THE SEA (1952)

ERNEST HEMINGWAY

The Old Man and the Sea (1958), U.S.A., directed by John Sturges, adapted by Peter Viertel; Warner Brothers.

The Novel

Ernest Hemingway discovered the sport of marlin fishing in 1932 when he met a commercial fisherman, Carlos Gutierrez, a Cuban who became his friend and fishing guide. According to Hemingway's letters, Gutierrez told him a tale of an old fisherman and a marlin in 1935, and the seed of this story began with Gutierrez as a possible prototype for Santiago. Hemingway intended the tale to be published in a book of short fiction due out in the fall of 1939, but he didn't write the story of Santiago on his summer trip to Cuba as planned. It wasn't until after Christmas 1950 that Hemingway began to write the story, which he said unfolded easily after a 16-year dormancy. *Life* magazine published the story in 1952, which sold out the morning it hit the newsstands. It was then printed by Scribner's and also made a selection by the Book-of-the-Month Club. The book was a resounding critical and popular success. For three weeks after *Life's* publication, Hemingway received an average of 80 to 90 letters a week from readers who were moved by the story. He won the Pulitzer Prize for fiction in 1952, the only Pulitzer Hemingway ever won.

The plot revolves around Santiago, an aging Cuban fisherman who has not caught a fish in 84 days. His only friend, a young boy, continues to have faith in the old man who taught him how to fish. The old man sets out to sea, and after a life-threatening struggle with a huge fish, succeeds in landing the fish, but only after the fish has dragged him far out to sea. Santiago lashes the fish to his boat and struggles to return to shore as sharks devour his

prize fish, leaving him nothing more than a skeleton at the end of this grueling ordeal.

The Film

The producer of the film version of *The Old Man and the Sea*, Leland Hayward, was a friend of Ernest Hemingway. In the spring of 1952, Hayward took the manuscript of *The Old Man and the Sea* to New York and submitted it for publication after reading it on a visit to Hemingway's home outside Havana. Hayward was instrumental in having the story published, and also arranged for Warner Brothers to finance the movie. Hemingway suggested that Peter Viertel write the screenplay. Fred Zinnemann was originally engaged to direct Spencer Tracy as the star. Filming began in the spring of 1955 with James Wong Howe as cinematographer and Hemingway acting as guide. Background shots were made off the Cuban and Peruvian coasts, but little was ever used because the crew could not get action shots of any giant marlins. Although production began in Cuba in 1956, Hayward was vexed by Zinnemann's slow schedule, and Tracy was restless. Differences among the three continued, until Zinnemann bowed out and John Sturges agreed to take over as director.

Viertel's screenplay adheres faithfully to the story line of the novel. The internal conflict of the solitary hero is narrated by Spencer Tracy on the sound track. Except for a few dream sequences and one flashback of the old man's memory of his strong youth, the majority of the film revolves around the old man's quest in the boat.

The primary aesthetic challenge to adapting Hemingway's novel was its inherently one-character plot. Tracy's performance received mixed reviews; Hemingway thought Tracy too fat and rich to play an impoverished fisherman. But producers knew they needed a strong leading man to carry the one-character story, which some deemed boring

on film. Additionally, without good location shots of the marlin, the director relied on mixing in shots done in a studio tank. Music became an important element in capturing the allegorical and mythical qualities of this epic, and Dimitri Tiomkin won an Academy Award for his musical score.

REFERENCES

Baker, Carlos, *Ernest Hemingway: A Life Story* (Charles Scribner's Sons, 1969); Baker, Carlos, ed., *Ernest Hemingway: Selected Letters 1917–1961* (Charles Scribner's Sons, 1981); Deschner, Donald, *The Films of Spencer Tracy* (Citadel Press, 1968).

—D.P.H.

OLIVER TWIST (1837–39)

CHARLES DICKENS

Oliver Twist (1916), U.S.A., directed by James Young, adapted by Young and Winthrop Ames; Jesse L. Lasky Feature Play Co.

Oliver Twist, Jr. (1921), U.S.A., directed by Millard Webb, adapted by F. McGrew Willis; Fox.

Oliver Twist (1922), U.S.A., directed and adapted by Frank Lloyd; Jackie Coogan Prod.

Oliver Twist (1933), U.S.A., directed by William J. Cowen, adapted by Elizabeth Meehan; Monogram.

Oliver Twist (1948), U.K., directed and adapted by David Lean (with screenplay assistance by Stanley Haynes); Rank/Cineguild.

Oliver! (1968), U.K., directed by Carol Reed, adapted by Vernon Harris from Lionel Bart' stage version; Romulus/Columbia.

Oliver and Company (1988), U.S.A., directed by George Scribner, adapted by James Mangold and Jim Cox; Walt Disney.

The Novel

Charles Dickens was in his late twenties when he turned to a popular form of fiction known as the "Newgate Novel," i.e., a narrative that dealt with the prison life of rogues and highwaymen. He exploited this tradition for *Oliver Twist*, his first social tract, a decided contrast to the books that had come before, like the amiably picaresque *The Pickwick Papers*. Indeed, readers of the serialized installments in *Bentley's Miscellany* (February 1837–April 1839) must have been startled to read the account of old Fagin's teaching the innocent Oliver how to pick pockets, or of children swigging gin like drunkards, or of the horrible death of the unrepentant Sikes. "It is by far the most depressing of his books," writes G.K. Chesterton; "and it is in some ways the most irritating; yet its ugliness gives the last touch of honesty to all that spontaneous and splendid output. Without this one discordant note all his merriment might have seemed like levity."

Spencer Tracy in The Old Man and the Sea, *directed by John Sturgers* (1958, U.S.A.; WARNER/PRINT AND PICTURE COLLECTION, FREE LIBRARY OF PHILADELPHIA)

Dickens's compelling narrative style draws the reader into the story of the young waif, Oliver. He is very mild, "an item of mortality," a device around which the plot revolves. The villains and scoundrels at whose hands Oliver suffers throughout his youth are far more interesting than the good people, who turn up just as Oliver really needs them.

The story follows Oliver from birth, where the items that could have identified him are stolen from his mother's deathbed, and through the poorfarm and workhouse, where Dickens exposes the terrible conditions of the English poor. In a pivotal episode Oliver requests a second bowl of porridge and is put in solitary confinement in the workhouse until someone will take him off the parish's hands. He is apprenticed to a casket maker where he serves as an attendant at children's funerals, runs into trouble with another employee, and finally sets out for London alone.

Once in London, Oliver falls in with the Artful Dodger and becomes a member of Fagin's gang of young thieves. Also in the gang are the frightening Bill Sikes, Nancy, and many other characters. After being falsely accused of picking the pocket of Mr. Brownlow, Oliver is taken in by the kindly gentleman. But he is soon found by the Fagin gang and pressed back into service. Mr. Bumble, a workhouse official visiting London, tells Mr. Brownlow of Oliver's past. Oliver is wounded in a house break-in, and in a twist of fate is taken in by the owner, Mrs. Maylie, and her adopted daughter Rose. A ne'er-do-well from Oliver's past, Monks, who knows who Oliver is—and also knows who Rose is—finds the evidence of Oliver's parentage in the possession of Mrs. Bumble and throws the items into the river. Nancy overhears information about Oliver and she tells Rose, who later tells Mr. Brownlow. Nancy, followed by Fagin, tells Mr. Brownlow about the hideout of Fagin and his gang, but not of Bill Sikes, her lover. Later Sikes kills Nancy, thinking she has turned on him. In the end, Monks tells the forces of good that Oliver is actually his half-brother, whom he wanted to disinherit, and that Oliver's father was a friend of Mr. Brownlow's, and Rose is Oliver's aunt. The gang of thieves are captured after Sikes's dog leads the law to a house where they are hiding. Sikes accidentally hangs himself. Fagin is hanged at Newgate. Mr. Bumble ends up working in the workhouse he once ruled. Mr. Brownlow adopts Oliver Twist.

The Films

Filmmakers like D.W. Griffith and Sergei Eisenstein often applauded Dickens for his highly "cinematic" mode of writing, the accumulation of specific details, the parallel structuring of narrative strands, the vivid "staging" of key events, or the employment of a "camera eye" that ranged freely over the action. In addition, the serialization of his novels encouraged his use of "cliff-hanger" endings, where scenes were abruptly terminated at moments of dramatic tension. Filmmakers lost no time turning to Dickens for

material; and it was not unusual before 1915 to find one- and two-reel compressions of his works.

The year 1916 saw the first of three feature-length versions dating from the silent era. The Jesse L. Lasky Feature Play Corp.'s *Oliver Twist* featured a young stage actress, Marie Doro, in the title role (she had played the role on the boards in 1912). In the interests of screen propriety, Nancy (Elsie Jane Wilson) is here married to Bill Sikes (Hobart Bosworth). Otherwise, the bare bones of the plot, if not the artistry of the prose, are retained.

The second, *Oliver Twist, Jr.*, appeared in 1921 from Fox Film Corp. and was directed by Millard Webb. Although the film is lost, contemporary accounts attest that it is a modernized version, in which Oliver's (Harold Goodwin) mother, cast off by her family for marrying against their wishes, dies in childbirth, leaving only a locket as a clue to his identity. The child is brought up in a New York orphanage. Years later he runs away and joins a gang of thieves headed by Fagin (William Hummell). They discover the whereabouts of the boy's wealthy grandfather, James Harrison, but during a robbery attempt Oliver is shot and found on the grounds by one Ruth Norris (Lillian Hall), who befriends him. After learning his identity, he finds happiness with Ruth.

The third version, a vehicle for the phenomenally successful child star Jackie Coogan, was released in 1922. Because it would just not do to allow Coogan to grow up, the story is compressed and reshaped to fit a time span of less than a year. Moreover, according to a 1922 review, the grim tone of the story is softened for the sake of the censors: Details of Nancy's death, Fagin's imprisonment, and the end of Sikes (spelled "Sykes" in the credits) are skimped. Most lamentably, even the formidable Lon Chaney has been restrained in his portrayal of Fagin. "In going easy on 'the rough stuff' the producer has done a service to Jackie Coogan and to the long beards with the shears, but he has done a mischief to the work of Charles Dickens."

The only talking version preceding the classic 1948 David Lean version is a 1933 adaptation from Monogram, directed by William Cowen and written by Elizabeth Meehan. Prints are unavailable for viewing, but the *AFI Catalogue of Feature Films, 1931–1940* contains a detailed synopsis, which confirms that the film, a vehicle for child star Dickie Moore, maintains a close connection with the basic story line of the novel.

Best remembered is David Lean's *Oliver Twist*, which came hard on the heels of his first Dickens adaptation, *Great Expectations* (1946). While generally regarded as inferior to *Great Expectations*, it nonetheless is bravura visual storytelling, from the stormy prologue to its climactic rooftop chase, Lean surrounds his Oliver (a nine-year-old John Howard Davies) with a vivid gallery of rogues, including Robert Newton as Bill Sikes, a young Anthony Newley as the Artful Dodger, and, of course, Alec Guinness as Fagin. So repulsive was Fagin, that the film's release in America was held up for three years by the Anti-Defamation League on the grounds that it was

anti-Semitic. After the Production Code Administration excised 11 minutes (mostly close-ups of Guinness in some of his most revolting expressions), it was finally released in July 1952, by which time American interest in the picture had flagged.

The script by Lean and Stanley Haynes retains the story's basic structure and incidents. Guy Green's photography superbly captures the melodramatic chiaroscuro of the London slums and the poorhouse. By contrast, Oliver's life with the Maylies and Mr. Brownlow possesses a dreamy, high-key quality to the textures and light. The film is excellent Dickens and an excellent example of Dickens's impact on the function of narrative in cinema.

Oliver! was directed by Carol Reed in 1968. Nominally based on the Dickens novel, it is actually an adaptation of a stage musical by Lionel Bart. It became one of England's most successful musicals, a true extravaganza with a two-and-half-hour running time, an anamorphic widescreen format, and some of the biggest sets ever built in a British studio. However, it is hardly an accurate version of the original story. The social melodrama, the indictment of child labor and child crime, is replaced by a cozy portrait of an angelic child (Mark Lester) in a tidily picturesque environment. Similarly, Shani Wallis's Nancy is scarcely credible as a prostitute, and Ron Moody's Fagin is reduced to the status of a kindly old rogue. The catchy tunes play their part in banishing the shadows, like "I'd Do Anything," "Consider Yourself," and "You've Got to Pick a Pocket or Two." Only Sikes's (Oliver Reed) murder of Nancy, which takes place offstage, and the climactic rooftop chase challenge the boundaries of family entertainment. Fagin and the Dodger (Jack Wild), meanwhile, slip away to pursue "their happy lives of petty villainy." The film went on to win six Oscars and two Golden Globes. By mid-1970 its worldwide box-office gross had soared to $50 million.

Of marginal interest to Dickens purists is Walt Disney's animated feature *Oliver and Company* (1988), directed by George Scribner and adapted by James Mangold and Jim Cox. Oliver is a kitten cast adrift in modern New York City, where he is adopted by a scruffy gang of animals that scrounge the streets under the evil eye of Sikes. From here on, the story is so removed from Dickens that the viewer is best advised to approach it strictly as a Disney film. Animation highlights include the Dodger's boastful tour of the big town, a virtuoso sequence with him leaping on and off moving buses, trains, and balconies; and the rich chiaroscuro of the dockside scenes with Fagin.

REFERENCES

Chesterton, G.K., *Appreciations and Criticisms of the Works of Charles Dickens* (J.M. Dent, 1911); Eisenstein, Sergei, "Dickens, Griffith, and the Film Today," in *Film Theory and Criticism*, eds. Gerald Mast and M. Cohen (Oxford University Press, 1979); Magill, Frank N., *Cinema: The Novel Into Film* (Salem Press, 1980); Slide, Anthony, *Selected Film Criticism, 1921–1930* (Scarecrow Press, 1982).

—*K.O. and J.C.T.*

ON THE BEACH (1957)

NEVIL SHUTE

On the Beach (1959), U.S.A., directed by Stanley Kramer, adapted by John Paxton and James Lee Barrett; Lomitas/United Artists.

The Novel

Appearing at the height of the cold war in 1957, Nevil Shute's *On the Beach* generated heated controversy. Supporters of the best-selling novel hoped that its grim portrayal of a post-nuclear holocaust world would move the public to clamor for peace and nuclear disarmament. Opponents argued that such a public response would distract attention from the nuclear threat posed by the Soviet Union and thus play into the hands of the communist bloc nations. Both sides agreed, though, that Shute's story projected a terrifying vision of human annihilation.

On the Beach is set in southern Australia in 1964, two years after a brief but fierce nuclear war has raged in the Northern Hemisphere. At the story's open, there appear to be no survivors north of the equator. Moreover, generated by the detonation of over 4,700 nuclear bombs, a lethal shroud of radiation has begun to creep into the Southern Hemisphere. Scientific forecasts project that within one year no one will be left alive on Earth.

Attached to the novel's title page is T.S. Eliot's line "This is the way the world ends/Not with a bang but a whimper." In his portrait of a shrinking world of survivors that irrevocably winds down, Shute avoids shocking images of the cataclysm itself and of the wild, lawless behavior of the survivors. Rather, events unfold in and around the southern Australian city of Melbourne and center on a set of local citizens and the crew of an American nuclear submarine, which had escaped destruction. Along with the central story of an ill-fated romance between Australian Moira Davidson and Dwight Tower, commander of the American submarine, there are several subplots that illustrate the various ways in which the characters cope with their approaching demise. Also pivotal to the story is the American submarine's exploratory cruise into the Northern Hemisphere, which confirms that radiation levels there are lethally high. At the novel's close, as the plague of radiation sickness sets in, the Americans take their submarine to open seas where they intend to scuttle it, and the Australians, one by one, take government-issued suicide pills.

The Film

Members of the political and scientific communities who deplored the novel's grim, fatalistic message were not heartened by director Stanley Kramer's 1959 adaptation. In a no-nonsense style and black-and-white photography,

it captures the story's stark vision with its implied call for an end to the nuclear arms race. Kramer was already building his reputation as a director involved with packaging controversial social issues (service-related physical disabilities in *The Men* [1950]; anti-McCarthy messages in *High Noon* [1952]; race relations in *The Defiant Ones* [1958]) in accepted Hollywood terms, but he did little to undercut the novel's bleak message and mood. The film's last shot of a discarded Salvation Army placard reading, "There is still time, brother," might be interpreted as a concession to hope stronger than that of Shute's story. However, the sign lies in the gutter of a now-dead Melbourne and is nearly obscured by blowing trash, a superbly dark irony. Taking its cue from the book, the movie depicts none of the massive destruction in the Northern Hemisphere. Rather, the aftermath is suggested during the American submarine crew's exploration northward (led by Gregory Peck as Commander Dwight Towers) with eerie, understated shots of an abandoned Golden Gate Bridge and an empty San Diego power plant.

Also in the cast are a wistful, sensuous Ava Gardner as Moira Davidson, Tower's love interest, and Fred Astaire as the self-destructive scientist Julian Osborne (an odd choice, but ultimately an effective one). A pre-*Psycho* Anthony Perkins sensitively limns a portrait of Lieutenant Peter Holmes, a young Australian who must prepare for the time when he and his wife will feed their infant daughter a suicide pill. According to Stanley Kramer's biographer, Donald Spoto, *On the Beach* acquires much of its power through Kramer's insistence that that we see only attractive, healthy people facing their fate: "It's easier to identify with them, after all. Kramer everywhere insists on the proximity of the tragedy . . . and the obvious identification is made more plausible and poignant because the people's concerns are our concerns." Effectively holding together the visuals is Ernest Gold's haunting music score, which utilizes the song, "Waltzing Matilda," as an ongoing motif.

The picture opened successfully, grossing $5 million in domestic rentals alone. It was also screened to an appreciative Soviet audience in Moscow. The *New York Times* declared, "The great merit of this picture, aside from its entertainment qualities, is the fact that it carries a passionate conviction that man is worth saving, after all." By contrast, Arthur Knight in the *Saturday Review* complained that the film's avoidance of the horrors of war was just too antiseptic. "It all seems a bit too perfect," he wrote, "but these are minor details in a film that aims at something big and emerges as something tremendous."

REFERENCES

Parish, James Robert, and Michael R. Pitts, *The Great Science Fiction Pictures* (Scarecrow Press, 1977); Spoto, Donald, *Stanley Kramer: Filmmaker* (G.P. Putnam's Sons, 1978).

—*C.T.P. and J.C.T.*

ONE FLEW OVER THE CUCKOO'S NEST (1962)

KEN KESEY

One Flew over the Cuckoo's Nest (1975), U.S.A., directed by Milos Forman, adapted by Lawrence Hauben and Bo Goldman; Fantasy/United Artists.

The Novel

Following his graduation from the University of Oregon in the late 1950s, Ken Kesey began working at a mental hospital in Northern California. His outrage and morbid fascination over the treatment of the patients there led him to write his first novel, *One Flew over the Cuckoo's Nest.* At the same time, Kesey ingested several potent hallucinogenic drugs as a volunteer for scientific experiments at the hospital, an experience that prompted him to take peyote while writing parts of the novel. In the novel, the narrator's paranoid observations of the mental ward in which the action is set most clearly manifest the influence of hallucinogens on Kesey's writing.

The narrator, Chief Bromden, is a paranoid schizophrenic, and the events of the novel are seen through his altered consciousness. Bromden, who is six feet, eight inches tall, is half American Indian; he has been committed to the hospital for many years, during which time he has pretended to be deaf and dumb. His ward houses a mixed group of mentally ill patients: Acutes, who are presumed to be curable, and Chronics, who are incurable and mostly uncommunicative. The ward is strictly administered by Nurse Ratched, also known as Big Nurse, with the assistance of Doctor Spivey (a meek psychiatrist), a junior nurse, and three black attendants. A new patient is admitted to the ward—Randle Patrick McMurphy, also known as R.P. McMurphy or simply "Mac." McMurphy, a con man who has been transferred from a work farm where he was serving a sentence for statutory rape, believes he will receive better treatment in the mental hospital than on the work farm.

Bromden sees the ward through the filter of his mental illness, which drops and lifts like a fog; through his eyes, McMurphy and the rest of the characters seem bigger than life, and all their conflicts appear in clearcut terms of good and evil. As McMurphy attempts to wrestle control of the ward from Nurse Ratched, he gradually penetrates the fog that has enveloped Bromden, inspiring him and the rest of the Acutes to take charge of their lives and learn to laugh again. McMurphy challenges Nurse Ratched's authority whenever he can: by disrupting therapy sessions, inspiring the Acutes to change the ward schedule so they can watch the World Series, and organizing a group fishing trip. Only later does he learn that Nurse Ratched will determine when and if he will be released. He plans his escape and organizes a party, replete with alcohol and prostitutes, for his mentally ill friends before his departure. As a final

Jack Nicholson in One Flew over the Cuckoo's Nest, *directed by Milos Forman* (1975, U.S.A.; UA-FANTASY FILMS/MUSEUM OF MODERN ART FILM STILLS ARCHIVE)

gift to Billy Bibbit, a shy, stuttering young man, he offers to let him sleep with Candy, his girlfriend/prostitute. The next morning, when Nurse Ratched discovers Billy and Candy together and threatens to tell his mother, Billy slits his own throat. McMurphy attempts to strangle Nurse Ratched and is removed from the ward and given a frontal lobotomy. When he is returned to the ward, Bromden smothers him with a pillow—a mercy killing. But in the aftermath of his death, most of the Acutes find the strength and confidence to leave the ward. The last to leave is Bromden, who lifts a huge chrome and glass control panel, heaves it through a window grate, and escapes, hitchhiking toward Canada in the moonlight.

The Film

The novel was adapted into a play by Dale Wasserman and ran for 82 performances on Broadway in 1963, starring Kirk Douglas as McMurphy and Gene Wilder as Billy Bibbit. Douglas retained an option on the film rights, which he transferred to his son, Michael Douglas, who coproduced the film version and hired Milos Forman to direct. Kesey wrote the first version of the screenplay, but was replaced by Lawrence Hauben and Bo Goldman.

The most prominent change that the story underwent in the adaptation process was a shift in point of view: while the novel is narrated by Chief Bromden, the film is shot more objectively. Consequently, the entire style of the work changes. The film replaces the sometimes psychotic impressions of Bromden with a firmly realistic style. While the novel depicts the changes in Bromden's perceptions of the ward and the world about him, the film focuses more closely on McMurphy as the central character. In the film, the battle between McMurphy and Nurse Ratched overwhelms the relationship between Bromden and McMurphy. Consequently, because Bromden is somewhat marginalized as a character in the film, his escape from the mental hospital at the end of the film has less impact than it does in the novel.

Moreover, the end of the film differs from the novel in one other important aspect. Following McMurphy's

lobotomy and death in the novel, the remaining Acutes find the courage to leave the hospital and recommence their lives in the outside world. Bromden is the last of McMurphy's followers to escape and his dramatic exit evinces how powerful McMurphy's effect has been on the men. In the film Bromden is the only patient we see escape, thus McMurphy's effect appears diminished. This is consistent with the film's approach to making the narrative more realistic, but it greatly alters Kesey's story, which portrays McMurphy's influence on all of the men as rejuvenating and life-giving.

Forman's film version succeeds due to his casting, more than to any other element. The supporting ensemble of actors who play the patients are more fully realized than in the novel and thus become the spiritual center of the film. Nurse Ratched is markedly toned down; the absolute evil villain of the novel emerges as a systematic but cold administrator who attempts to keep order in her ward with little malice. Steven Farber misses the point when he suggests this is a flaw in the film. "It seems depressing," writes Farber, "that in a film setting out to attack dehumanization, the character of the Nurse is so completely dehumanized." Yet by portraying the nurse with little passion or feeling for her actions, Forman sets up a dichotomy between the dehumanized administrators of the hospital and the all-too-human and vulnerable patients.

Some critics have charged that both the novel and the film are misogynistic: "The slippery thing about *Cuckoo's Nest* is that the profound and admirable values that it champions are inseparable from the insidious sexual prejudices that it perpetuates." But Forman does his best to minimize Kesey's misogynist undertones. By making all of the characters more fully rounded, he reduces the polarization of good and evil that leaves the novel open to these charges, avoiding the novel's tendency to turn McMurphy into a hero or Christ figure. Nicholson's award-winning performance gives equal weight to McMurphy's sly, trickster side and his developing compassion for his fellow patients. What emerges is a much more realistic film, one that sacrifices the mythic characterizations and battles of the novel for a more human tragicomedy.

REFERENCES

Farber, Stephen, "American, Sweet and Sour," *The Hudson Review* (spring 1976): 95–98; Palumbo, Donald, "Kesey's and Forman's 'One Flew over the Cuckoo's Nest': The Metamorphosis of Metamorphoses as Novel Becomes Film," *The CEA Critic* 45, no. 2 (1983): 25–32.

—R.K.

THE ORCHID THIEF (1998)

SUSAN ORLEAN

Adaptation (2002), U.S.A., Directed by Spike Jonze, adapted by Charlie Kaufman; Columbia.

The Novel

Journalist Susan Orlean always made a habit of reading small-town newspapers, looking for interesting combinations of words that might expand into fascinating stories, and thanks to this pastime she discovered the story of John Laroche, orchid lover, orchid expert, and orchid thief. Employed by Florida's Seminole Indian Tribe (Incorporated), among whom he was generally referred to as "Crazy White Man" or simply "Troublemaker," Laroche had attempted to use an obscure contradiction in Florida state law to enter the feral Fakahatchee Strand Nature preserve and, using Native Americans, legally harvest wild, endangered varieties of swamp flora for the Seminoles' new nursery. When Laroche and three Seminoles were stopped by rangers on their way out of the Fakahatchee, they had in their possession several garbage bags and pillowcases full of rare wild plants, including dozens of orchids, and the greatest prize among them all, the *Polyrrhiza lindenii*, the ghost orchid. The law was not amused.

Susan Orlean finally caught up with John Laroche on the steps of the Collier County Courthouse in Naples, Florida, on the day of his trial. In court he had given testimony that he was a professional horticulturist, a former nursery owner, an author, and an expert in "the asexual micropropagation of orchids under aseptic cultures." He might have added turtle breeding, Ice Age fossils, lapidary, resilvering antique mirrors, and tropical fish. Laroche turns out to be a man of serial passions that, in the words of Orlean, "boil up quickly and end abruptly, like tornadoes." When Laroche finished his tropical fish stage, he vowed never to set foot in the Atlantic Ocean again and, 15 years later, despite living only miles from the coast, he still hadn't.

Orlean was fascinated by Laroche, and she made him the subject for her 1995 *New Yorker* article entitled "Orchid Fever." Yet, when Orlean expanded her article into the book-length *The Orchid Thief*, Laroche begins to disappear. As *New York Times* book reviewer Ted Conover observed, "though Orlean is marvelous at describing her wing nut and his esthetic and moral world, there is not nearly enough of him to fill a book." Instead, Orlean reveals Laroche's entire universe: the orchid and the history of orchid collecting, the steaming tropical world of the Fakahatchee Strand, the Seminole Indian tribe who still proudly consider themselves unconquered by the white man, and the unbuilt subdivisions of real estate con men whose empty grids of roads slowly sink back into Florida's primeval swamps. These stories almost couldn't make sense anywhere else, for in Florida Orlean finds a blank world, a world at once infinitely feral and utterly humanmade, where alligators lie on golf greens and nearly extinct orchids can be found beside freeway off-ramps. Florida is a microcosmos of a universe where life, in the words of a park ranger who leads Orlean into the Fakahatchee, has no meaning and "everybody's always looking

for something a little unusual that can preoccupy them and help them pass the time."

Yet John Laroche's life seems to have meaning, as do the lives of generations of orchid collectors and hunters who stop at nothing to acquire the rare beauties. In this passion, Orlean finds the possibility of meaning in this existential Florida, a force that "whittles the world down to a more manageable size" and "makes the world seem not huge and empty but full of possibility." Orlean wishes to share in this passion. She even muses that perhaps this is her own passion: the desire to be passionate. In the novel, Orlean's pursuit of the ghost orchid, which she desperately wants to see in bloom, comes to symbolize that pursuit of something, anything, that might spark a fire like Laroche's in her. Yet, in the end, after trudging through the Faka-hatchee with Laroche as her guide, she never finds her orchid.

The Film

Director Spike Jonze and screenwriter Charlie Kaufman had already collaborated on *Being John Malkovich* when they turned to bringing Susan Orlean's book to the screen. What resulted was not only an exercise in self-reflexive cinema, but a meditation on the process of adaptation itself. Kaufman and Orlean are cast as characters in their own story. Nicolas Cage portrays Kaufman, a bloated, balding, self-loathing, chronically masturbating screen-writer who has written *Being John Malkovich* and now is faced with adapting Orlean's (Meryl Streep) book into a movie. He's a talented man, a man dedicated to capture the expansive, *"New Yorker"* style of the book without sensa-tionalizing it into a rank melodrama with sex, a few car chases, and maybe an orchid heist. But how do you write a screenplay from a book that has no single, definite plot, traditional character arcs, and action scenes? *The Orchid Thief* was a story of exploration, not action, whose scope expands to the entire history of life on Earth and con-denses it into the inscrutable perfection of the ghost orchid. The book fascinates Kaufman, but can it be a movie?

To make matters worse, Kaufman has to deal with his happily vapid twin brother, Donald (also Cage), who has decided that he, too, wants to be a screenwriter and urges Charlie to follow the structural teachings of script-writing guru Robert McKee (another real-life character, por-trayed here by actor Brian Cox) and write an opus like his own: an utterly imitative crime thriller called *The Three* that, of course, will sell for far too much money. Then there's Amelia (Cara Seymour), a pretty violinist with whom Charlie is pitifully and awkwardly in love, and who clearly loves him. Yet Charlie's crushing self-doubt and introversion always seem to sabotage his romantic inten-tions. After all, Charlie can barely decide whether he should have a muffin before or after writing a page of script; it seems the only thing he is certain of is a bad case of writer's block.

Critic A.O. Scott observes that "one of [*Adaptation*]'s reigning conceits is that the boundary—between life and art, if you want—is highly porous, maybe even altogether imaginary." It's the story of the struggle to adapt a movie from a book called *The Orchid Thief.* As for Kaufman's real-life twin brother, Donald, he's credited as cowriter, and the film is dedicated to his memory. Nicolas Cage plays both the Kaufman brothers with such finesse that one begins to wonder if the Cage brothers don't deserve a double Oscar. As A.O. Scott said, this is a film that trades gleefully on our uncertainties.

The narrative of Kaufman trying to adapt the script, and adapt himself to the demands of romancing Amelia, unfolds in counterpoint to Susan Orlean and John Laroche's (the Oscar-winning Chris Cooper) meetings in the book. The real-life Kaufman remains more or less loyal to his original through this early section of the film, adding only a few bits of dialogue that solidify some of the later non–*Orchid Thief* action. Meanwhile, the film's character of Kaufman seems on the point of collapse, com-pletely unable to find an angle on the book and too shy to meet with Orlean and seek her help. Then inspiration strikes. He starts writing the story of "Charlie Kaufman," a bloated, balding, self-loathing, chronically masturbating screenwriter futilely trying to adapt Susan Orlean's *The Orchid Thief.* And this way lies madness.

To complicate matters even further, Charlie finally yields to his brother's suggestions and goes to one of Robert McKee's screenwriting seminars. McKee con-demns Kaufman's art and his worldview, a world where nothing much happens and no one changes or learns deep life truths, by playing the role of deus ex machina—a device he also condemns—and sending the story hurtling into the farther reaches of self-reference. Inspired by McKee, Charlie calls upon the aid of his brother and dis-covers that Orlean is having an affair with Laroche and that the two are creating a drug extracted from the ghost orchid. Unfortunately, Orlean and Laroche catch Charlie in his spying, and only the timely intervention of his brother allows the two to flee into the Fakahatchee Strand, where they have a perfectly structured moment of truth and Charlie learns to love himself and others through Donald's advice. The next morning brings a flurry of plot resolutions: Charlie and Donald attempt to flee, Laroche shoots Donald who then dies in a car acci-dent, an alligator eats Laroche, and Charlie stands up for himself against Orlean. The story ends with Charlie finally kissing Amelia, who confesses her love, and then driving home, thinking that the perfect end for the screen-play will be Charlie finally kissing Amelia and driving home. In the end, Kaufman's script, and his life, end up in perfect McKee style: interesting, well structured, and completely Hollywood.

One might wonder, after all is said and done, if direc-tor Jonze and scenarist Kaufman haven't violated McKee's first principle of screenwriting: Respect your audience. It's all too easy to believe that the real-life Kaufman, whoever

he is, couldn't find a way to adapt Orlean's book (and in interviews, he admits that he found it a great challenge), so he covered up the whole mess with a layer of amusing postmodern spackle in the hopes the world wouldn't notice. Many critics have violently attacked the post-McKee portion—what McKee himself might call the third act—as tacked-on, a deliberate copout, or a desperate retreat into the void of self-reference. Yet in a sense, Kaufman has followed Orlean's own technique. In an interview with the author, Tim McHenry observed, "John Laroche may be the title character of the book, but he is only its object; Susan Orlean is its subject."

Essentially, this film is about narrative and storytelling, but it never abandons the themes of its inspiration, the original book, *The Orchid Thief.* In the words of McKee, "story is not only our most prolific art form but rivals all activities—work, play, eating, exercise." Like passion in Susan Orlean's book, narrative is a way of comprehending the world, a way to condense, understand, and make sense of the universe. Whether or not Kaufman agrees with McKee's theories, either in the film or in reality, is irrelevant. Storytelling is a basic fact of human life, as essential as breathing or eating, and narrative is our most important way to understand change, evolution, and adaptation. This is the truth of A.O. Scott's statement, and of *Adaptation* itself: The line between fact and fiction will always be blurred because we understand fact through fiction. Thus the real-life Kaufman cuts through the Gordian knot. He translates Orlean's themes and techniques to a medium not friendly to them. He not only reveals that antipathy, he revels in it.

REFERENCES

Conover, Ted, "Flower Power," *New York Times Book Review*, January 3, 1999, 9–10; McKee, Robert, *Story* (HarperCollins, 1997); Scott, A.O., "Forever Obsessing about Orchids," *New York Times*, December 6, 2002.

—W.B.M.

OUR MAN IN HAVANA (1958)

GRAHAM GREENE

Our Man in Havana (1960), U.K., directed by Carol Reed, adapted by Graham Greene; Kingsmead/Columbia.

The Novel

Greene's novel was published shortly before Castro overthrew the Batista dictatorship in Cuba. Greene visited Havana while preparing the novel, so that he could present in an authentic manner his story of international intrigue against the backdrop of the dying days of the Batista regime.

Jim Wormold, a diffident British vacuum-cleaner salesman living in Havana, becomes an undercover agent for British Intelligence in order to augment his slender income as a salesman. But Wormold has no information to offer Hawthorne, the chief spy who employs him. He accordingly mollifies Hawthorne by manufacturing fictitious reports to pass along to him. He is dismayed to learn later on that Hawthorne has taken his reports seriously—with dire consequences for British espionage operations in Cuba.

The Film

Carol Reed commissioned Graham Greene to compose the script for the film from his own novel. Not surprisingly, the film stays very close to the novel, for Greene managed to get most of his original story into the script. Often he employs a kind of cinematic shorthand to get impressions over to the viewer quickly and neatly. For example, the oppressive atmosphere of the Batista dictatorship is established in the very beginning of the film by showing a man spitting on the car of the chief of Batista's secret police, as it passes by. The hapless individual is then dragged away by two policemen to be beaten.

Some of the scenes in the novel work even better on the screen than they did in the book. Hawthorne (Noel Coward) meets Wormold (Alec Guinness) in a bar and slyly tells him to retire to the men's room where they can discuss the possibility of Wormold's working for British Intelligence. In the midst of their discussion, someone enters the rest room, and Wormold is forced to hide in a stall until the third party leaves. In the novel the party is no one in particular; in the film it is a police officer. The latter's presence brings an additional element of comedy to the scene, since Wormold fears that the policeman will suspect that a homosexual assignation is in progress and will arrest them both. Moreover, Wormold's scrambling in and out of the stall also helps to set the absurd tone that will characterize his career as a spy.

The film is fairly farcical at the outset, when Wormold consistently muddles his duties as a secret agent. These early scenes are brightly lit to fit the comic atmosphere. But later on the mood becomes more serious, as enemy agents stalk Wormold and try to murder him. Hence these later scenes are lit in darker hues. There is, for example, the scene in which Wormold traps and kills a counteragent who has been assigned to liquidate him. Reed shot this sequence in a murky, shadowy fashion quite suitable for the dark, melodramatic action.

Nevertheless, although the film has its share of melodrama, the overall effect of the movie—as of the novel from which it is derived—is that of an entertaining spy spoof. That the film turned out to be a fine piece of cinema can be attributed to the work of its first-rate director. That the film is also a superior adaptation of a novel for the screen can be attributed to the fact that both novelist and scriptwriter happen to be the same person.

REFERENCES

Parkinson, David, ed., *The Graham Greene Film Reader: Reviews, Essays, Interviews* (Applause Theater Books, 1995); Thomson, David, "Reeds and Trees: the Career of Carol Reed," *Film Comment* (July–August 1994); Wapshott, Nicholas, *Carol Reed: A Biography* (Knopf, 1994).

—G.D.P.

AN OUTCAST OF THE ISLANDS (1896)

JOSEPH CONRAD

Outcast of the Islands (1950), U.K., directed by Carol Reed, adapted by William Fairchild; London Films/British Lion.

The Novel

Joseph Teodor Korzenowski, born in 1857 in Poland, went to sea at age 16. In 1883 he made his first voyage to the East, and in 1886 he became a British citizen. In 1888 he was given his first command of a sailing ship, and in 1894 he retired, devoting the rest of his life to a career as a novelist. Although for him English was a second language, he became a master of English prose. Set in the Dutch East Indies, *An Outcast of the Islands*, his second novel, is a sequel to *Almayer's Folly*.

On the docks in Malaysia, Tom Lingard found Peter Willems, a homeless cabin boy, took him into his service, taught him skills as a trader, and later released him to work as a confidential clerk for Hudig. As the novel begins, Willems has "borrowed" money from Hudig's accounts to pay debts and has almost replaced it when the theft is discovered and he is fired. Once again, Lingard comes to his aid, hiding him in Sambir, his secret trading place and source of his supply of india rubber and rattan, which lies upriver on a remote coast. Lingard reveals to Willems the secret of navigating the river, which rival Arab traders have failed to discover. Waiting for the scandal of his theft to blow over, Willems encounters the animosity of Almayer, Lingard's son-in-law who is in charge of the trading post, and is slowly attracted to Aissa, a native girl. Eventually besotted with passion for Aissa and furious with Almayer who goads his daughter Nina to repeatedly call him "Pig!" Willems, at the instigation of the intriguer Babalatchi, agrees to bring the Arab trader Abdulla upriver in order to assure Aissa's constant presence. He attacks Almayer's compound, humiliating Almayer by sewing him in a hammock. Lingard returns and denounces Willems for the betrayal. Aissa shoots Willems, and Lingard buries him with a headstone reading "Delivered By the Mercy of God From His Enemy."

The Film

Arguably, the film is the most successful adaptation of any Conrad work. The characters are introduced swiftly and succinctly, and part five of the novel, about one-fifth of its length, is excised without great loss. The narrative ends with Lingard's denunciation of Willems ("You are my shame!"), extracted directly from Conrad. Instead of death, Willems is condemned to live with Aissa in misery and mutual loathing. This bleak conclusion admits Conrad's essential pessimism, summed up in Lingard's line (also directly from the novel): "Life is foul, like a forebrace on a dirty night."

According to Raymond Durgnat, the film is Carol Reed's "stylistic *tour de force*. Through visual continuities whose deft intricacy rivals Pabst's, he traces the hectic succession of gloatings and grovelings through which a mean and desperate trader lurches to his doom." The film embodies the Conradian theme of moral choices: "In life—as in seamanship—there were only two ways of doing a thing—the right way and the wrong way." Nonetheless, the situation of white man "going native" or "to rot" in the jungle had unfortunately become a cliché (cf., *White Cargo*), and the "slave of passion" plot was already predictable in 1930 in *The Blue Angel*. The film is distinguished by its superior acting, particularly by Ralph Richardson (Lingard), Trevor Howard (Willems), and Robert Morley (Almayer). George Coulouris is an oily, insidious Babalatchi. The chiaroscuro of the cinematography by Ted Scaife and John Wilcox is worthy of comparison with Robert Krasker's work in Reed's *The Third Man*.

REFERENCES

Durgnat, Raymond, *A Mirror For England* (Praeger, 1971); Kulik, Karol, *Alexander Korda*, (Arlington House, 1975); Najder, Zdzislaw, *Joseph Conrad* (Rutgers University Press, 1983).

—J.V.D.C.

THE OX-BOW INCIDENT (1940)

WALTER VAN TILBURG CLARK

The Ox-Bow Incident (1943), U.S.A., directed by William Wellman, adapted by Lamar Trotti; Twentieth Century-Fox.

The Novel

Clark became a recognized author with the publication of *The Ox-Bow Incident* in 1940. His other works include *The City of Trembling Leaves* (1945), *The Track of the Cat* (1949), and *The Watchful Gods and Other Stories* (1950).

The story is set in Nevada in 1885. Art Croft, a thoughtful, leather-faced cowboy, and his hot-tempered partner, Gil Carter, arrive in Bridger's Wells after a long winter of range-riding. The two men take their usual places in the saloon, only to discover that the locals' talk about cattle rustling makes it plain they're outsiders. The simmering tension finally breaks into action when a young rider races into town with an (erroneous) report that Kin-

caid, a local cowhand, has been killed by rustlers. Sheriff Risley is not in town; Kincaid's riding partner, Farnley, wants revenge; ignoring calls to disband from the town preacher, the district judge, and storekeeper Art Davies, a lynch mob forms with local rancher Major Tetley in charge.

Art and Gil ride with the group out of town into the night, afraid the locals will suspect them if they don't join the "posse." Having heard that cattle were seen being taken out of the valley through Bridger's Pass, the group presses on to the Ox-Bow, a little valley that is the only place before the next town where cattle can be rested for the night. They find the cattle and three men, Donald Martin—who truthfully claims to have purchased the cattle from Drew, a local rancher, without getting a bill of sale to prove it—and two hired hands. Convinced of the men's guilt, or concealing their sympathy for them, the majority vote to hang the men at dawn. The lynching complete, the "posse" leaves the Ox-Bow, only to meet Sheriff Risley, Drew, and Kincaid. Drew confirms the truth of Martin's story, and agrees to deliver the letter Martin had written to his wife. Art, Gil, and the others return to Bridger's Wells, ashamed but assured they will face no reprisal from the sheriff or the townspeople. Tetley and his son commit suicide; Davies goes almost mad with self-loathing, admitting to Art that he could have stopped the lynching but had been afraid to take the decisive action of shooting Tetley. The novel ends with Art and Gil riding out of town, with Gil speaking for both of them in saying, "'I'll be glad to get out of here,' as if he'd let it all go."

The Film

The Ox-Bow Incident was a critical but not a box-office success when it was released in America in 1943. The film (released as *Strange Incident* in Britain) was more commercially successful in Europe, and later in the United States when it was rereleased in 1946 to continuing good reviews. Director William Wellman was the driving force behind the adaptation of Clark's *The Ox-Bow Incident;* in 1954 he also directed the other cinematic rendition of a Clark novel, *The Track of the Cat.*

Clark found only two minor differences between his novel and the film, opining that Wellman's film is a faithful rendition of the novel. Mary Beth Crain argues, however, that the film is "not a faithful representation of the actual spirit of Clark's book, not merely because of a few technical changes but because of a basic shift in center focus." She suggests that the novel leaves us in despair about the existential condition of mankind, while the film leaves us with hope for justice because it asks us to consider only the horror of mob violence. The novel does seem to be addressing certain broad concerns: Davies's appeal to one of the men set on revenge recalls Plato's *Republic,* as Davies begins with the question, "What would

you say real justice was, Bill?"; and traveling through the cold night two by two, Tetley's son pours out his disgust at man's mockery of justice, conscience, and responsibility so compellingly that Art finds himself admitting that "there had been something to the kid's ravings which made the canyon seem to swell out and become immaterial until [he] could think the whole world . . . into the half-darkness around [him]." These two sequences are left out of the film.

There are a collection of differences between the novel and the film, differences that suggest in the film that a few characters have a sense of morality. In Wellman's film, Art becomes a minor figure, while Gil (played by Henry Fonda) comes to embody both Art's thoughtfulness and Gil's fiery ability for decisive action, the combination results in a character who has the ability to act on his moral convictions. In the adaptation, Gil and Art decide to stand up and vote against the lynching. And at the end of the film, Gil reads the letter Martin had written to his wife to the men collected in the saloon after the hangings; then, upon Gil's urging, Gil and Art leave town to deliver the letter to Martin's wife. Similarly, Sheriff Risley condemns rather than pretends not to see the men's actions, Davies ends up confident he had done the right thing by trying to stop the lynching, and in the film's conclusion, the cowboys are deeply remorseful, rather than quite able to put the whole thing out of their minds. Most critics cite the Production Code and the film's wartime release as reasons for the film's seemingly more hopeful representation.

For those who see Wellman's film as a faithful adaptation, the changes are not significant because they do not obscure the novel's concern with depicting, as Clark put it, the "ever-present element in any society which can always be led to act the same way, to use authoritarian methods to oppose authoritarian methods." For those who see an essential difference between novel and film, the changes are crucial, for they allow the actions of characters like Art, Gil, and Davies to seem as if they arise out of a clear understanding of moral responsibility—while the novel suggests that even people with conscience are afraid to act in ways that would have a positive effect on the course of events. *The Ox-Bow Incident* so completely confounds the expectation that a "Western hero" like Gil/Henry Fonda will bring about law and order, that the film might for some be a faithful rendering of the novel in the sense that it complicates our collective nostalgia about America's past and, as a consequence, our sense of moral certitude.

REFERENCES

Bluestone, George, *Novels into Film* (Johns Hopkins University Press, 1957); Crain, Mary Beth, "The Ox-Bow Incident Revisited," *Literature/Film Quarterly* 4, no. 3 (summer 1976).

—C.A.B.

A PASSAGE TO INDIA (1924)

E. M. FORSTER

A Passage to India (1984), U.K., directed and adapted by David Lean; Thorn-EMI/Columbia.

The Novel

In 1921 Forster acted as private secretary to the maharajah of the state of Dewas Senior in Central India for six months. It was during this trip that Forster wrote *A Passage to India*. His visit coincided with the Indian non-cooperation movement against British rule. Forster was greatly influenced by this movement, favoring for India the creation of what he termed a "democratic Empire," as opposed to the oppressive social apartheid and repression of British imperialism.

A Passage to India is divided into three sections: "Mosque," "Caves," and "Temple." "Mosque" begins with the issue of race relations in India between the Anglo-Indians and the Indians. A young Indian doctor, Dr. Aziz, is called out to his superior's home. He arrives late to discover that his superior has already left. He is then further humiliated by two Anglo-Indian women who ignore him and take his tonga (a two-wheeled horse-drawn vehicle). This scene is contrasted with a pleasant meeting between him and Mrs. Moore. This meeting begins his brief relations with Mrs. Moore and Adela Quested, two recent arrivals from England, and temporarily disturbs the established system of race relations. This relationship culminates in an elaborate trip to the Marabar Caves, hosted by Dr. Aziz, and results in

Adela accusing Dr. Aziz of raping her in one of the caves.

The second part of the novel, "Caves," deals with the trial and Adela's eventual retraction of her accusation. However, the damage has been done and chaos ensues. Cyril Fielding, an Englishman running a school in Chandrapore, becomes involved in the life of Dr. Aziz and supports him after the accusation is made, despite being ostracized by his Anglo-Indian peers.

In "Temple," some years have passed, and Dr. Aziz has chosen to live away from the Anglo-Indians in an independent Indian state. He meets Fielding and, although they attempt to rekindle their former friendship, their different racial orientations leave them unable to "connect."

The Film

Before the 1985 film, *A Passage to India* had been a 1958 London stage play adapted by Santha Rama Rau. David Lean had read both the novel and seen the stage play and had attempted to purchase the rights to the novel. He was refused by Forster who decided that the rights to his work should be granted, upon his death, to Kings College Cambridge. In 1982 John Brabourne purchased the rights to the novel for David Lean to direct, and Lean both wrote the screenplay and directed the film.

Much has been written about the changes made in the film adaptation. Some criticize Lean for backing away from Forster's harsh critique of Anglo-Indian and Indian relations. Lean states that he did this to "even it up a bit more because I wanted to be fair to both sides." Ulti-

Judy Davis and Victor Banerjee in A Passage to India, *directed by David Lean* (1984, U.K.; COLUMBIA/PRINT AND PICTURE COLLECTION, FREE LIBRARY OF PHILADELPHIA)

mately, he presents a more sympathetic portrayal of the British.

Arthur Lindley notes that Lean also attempts to transform the successful social parody of the novel into an unsuccessful sympathetic romance. This is seen in Lean's choice of casting Nigel Havers as Ronny Heaslop and Judy Davis as his fiancée, Adela Quested. Lindley also complains about Lean's romanticized view of India; for example Lean rejected the real Marabar Caves as uninspiring and blasted out a hillside in order to create his own.

In addition, Lean rejects Forster's ending. As opposed to the novel's ending with the dissolution of Dr. Aziz and Fielding's friendship, Lean allows for reconciliation between the two, undermining Forster's ultimate view of Anglo-Indian and Indian relations.

A final significant change in the film adaptation is the handling of whether or not Adela was raped. Forster chose to leave this unanswered. Lean's version, however, develops the notion that the rape was, in fact, a figment of a sexually repressed woman's imagination.

There is no question that Lean's *A Passage To India* is an intelligently made film. However, there remain discrepancies between the message of the novel and the message of the film. Whereas Forster chose to portray a more realistic and complicated image of Anglo-India, Lean tends to present the "official British" image of India—the very thing Forster parodies in the novel. *New York's* David Denby states that Lean's film is "large-scale and spectacular . . . a rather startling revival of the large-scale Anglo-American 'prestige' epic that many of us had taken for dead." Somewhere in the midst of the grandeur of Lean's film, Forster's careful examination of race relations in India is ultimately lost.

REFERENCES

Beer, John, ed., *A Passage to India: Essays in Interpretation* (Macmillan, 1985); Lindley, Arthur, "Ray as Romance/Raj as Parody: Lean's and Forster's *Passage to India,*" *Literature/Film Quarterly* 20 (1992): 61–67; Sharpe, Jenny, "The Unspeakable Limits of Rape: Counter Violence and Counter-Insurgency," *Genders* 10 (spring 1991): 25–46; Silverman, Stephen M., *David Lean* (Abrams, 1989).

—*A.D.B.*

PASSION IN THE DESERT *(Une passion dans le désert)* (1830)

HONORÉ DE BALZAC

Passion in the Desert (1998), U.S.A., directed by Lavinia Currier, adapted by Currier and Martin Edmunds; Fine Line Features.

The Novel

Honoré de Balzac (1799–1850) penned a remarkable series of short novels and occasional pieces that attracted immediate public attention. As biographer Stefan Zweig has noted, "It is astonishing that in this brilliant pyrotechnic display there should be found perfect masterpieces [that] revealed the hitherto unknown young writer at one stroke as an unexcelled master. . . ." Among them, *Une passion dans le désert*, particularly, retains its place as one of his most unusual works.

It was inspired by events that had begun in 1798, when Napoleon attempted to strike at the British in Egypt but later failed. In the campaign's aftermath, wild animals had been sent back from Africa to Paris (where they eventually formed the core of the zoo at the Jardin des Plantes). Attracted to this spectacle, Balzac wrote a story that begins with a man and a woman friend attending the zoo. When the woman expresses her astonishment at the animals, her companion argues that it is quite possible to tame wild animals—in fact, he once knew a soldier, Augustin, who, after being captured by Arabs in Egypt, had escaped into the trackless desert, where he encountered a mysterious female leopard, and with whom he learned to coexist in mutual harmony.

The Film

American filmmaker Lavinia Currier had only the experience of directing a 50-minute film for television, "Heart of

the Garden," when she determined to film the Balzac story. It was a 10-year project that began with the simple conception of a "30-minute dreamlike film of this encounter between a man and a leopard—I saw it as a dance or a completely silent film." Eventually expanding this idea into a feature-length project, she discarded Balzac's framing narrative and concentrated solely on Augustin's adventures in the desert. Against advice from animal trainers, Currier insisted on using a leopard, instead of a more trainable tiger or lion. "They told me a leopard is the most dangerous, idiosyncratic and unmanageable of the great cats," she recalled, "But I thought only a leopard, so individualistic an animal, would be weird enough to take up with a human being." During the filming, the director and camera crew hid inside a covered cage, allowing the leopard wrangler and the animal to work undistracted. Actor Ben Daniels, who was drawn to the challenges in portraying the animal's friend, Augustin, admits that the unpredictable leopard terrified him and inflicted him with numerous bites and scratches. "I knew [the leopard] wasn't concentrating on the role," Daniels says. "She was thinking, 'So, how can I eat this person I'm playing with?'" Although much of the shooting transpired in Jordan, weather problems forced the crew to shoot some desert scenes in Utah.

The film begins in 1798, near the end of Napoleon's Egyptian campaign. A French officer, Augustin, has been ordered into the desert to locate and retrieve a French painter named Venture (Michel Piccoli) and bring him back to Paris. Accompanied by a small detachment of soldiers, Augustin locates the eccentric, corpulent painter, but despite his boast that it's impossible to get lost in a country "where there's the Nile and the Sea," they get hopelessly lost during a sandstorm. Water supplies dwin-

dle. To Augustin's dismay, Venture uses his last few drops of water to mix his paints. Later, when Augustin leaves the poor fellow to scout farther ahead, Venture drinks down the paints and shoots himself dead.

The second half of the film deals with Augustin's struggle to stay alive in the face of starvation and thirst. He finds a cave opening that leads into an underground ruin of a palace of some kind. There he encounters a huge leopard, whose slitted eyes glow ominously in the darkness. But, after some mutually wary maneuvering, each grows accustomed to the other. Leopard and man drink water together and feed off the freshly slain carcasses of goats and antelope. Soon, the man curls up next to the beast and caresses her (he calls her Simoom) in either friendship or outright love (take your pick). But when Simoom runs off briefly with a male leopard, Augustin goes a little crazy and strips himself, plunges into the waterhole, and smears his body with yellow-mud dye and brown spots. It's a startling sequence as, wordlessly, this man transforms himself into the simulacrum of a wild beast.

When Augustin espies the remainder of his troops come to find him, he ties Simoom to a rock, declaring he mustn't desert his fellows, dons his military uniform and departs. Simoom wrestles herself free and attacks him. Augustin kills her with his knife. Wrenched with grief, he disappears, alone, back into the trackless wastes.

This is a most remarkable film, redolent of Delacroix's Moroccan and Egyptian paintings, with its electric blue skies, salmon deserts, and exotic costumes (superbly lensed by cinematographer Alexei Rodionov). Its protracted silences and enigmatic actions are a meditation on the thin boundaries that ultimately separate human and beast, society and wilderness. Special credit must go to actor Ben Daniels, who survived the dangers of "acting" with such a wild beast, cavorting with an unpredictable animal that, no matter how tamed, would have been capable of ripping him to shreds at any moment.

REFERENCES

Zweig, Stefan, *Balzac* (Viking Press, 1946); pressbook for *Passion in the Desert*, Fine Line Features, 1998.

—*J.C.T.*

Ben Daniels in Passion in the Desert, *directed by Lavinia Currier* (1998, U.S.A.; FINE LINE FEATURES)

PATHER PANCHALI (1929)

BIBHUTI BHUSAN BANERJEE

Pather Panchali (1955), India, directed and adapted by Satyajit Ray; Government of West Bengal.

The Novel

Bengali author Bibhuti Bhusan Bandyopadhyay—more widely known in the West as Bibhuti Bhusan Banerjee—was born in 1894 in a small Indian village, Muratipur, north of Calcutta. *Pather Panchali*, his most famous novel,

which was published serially in 1928–29, reflected many of the circumstances of his youth and career: His father, Mahananda, earned a living as a village priest and singer of traditional songs. Though talented, he was apparently an impractical man, so Banerjee's mother, Mrinalani, struggled to feed the household, which included an old, widowed relative. Banerjee excelled in school and eventually went to college in Calcutta, where he earned a bachelor's degree and became a teacher for the rest of his life. English translations of portions of *Pather Panchali* were not published until 1970.

The bulk of the novel depicts the lifestyle of a poverty-stricken family in the little village of Nishchindipur. There is Horihor Ray, his wife Shorbojoya, their daughter Durga, their little boy Apu, and an old widowed relative of Horihor's named Indir Thakrun (whom everyone calls Auntie). The first part of the novel, "The Old Aunt," which is only 35 pages long, introduces the stormy relationship between Auntie and Shorbojoya, the birth of Apu, and Auntie's death. The second part, "Children Make Their Own Toys," is much longer and describes the details of village life. Apu grows into a young boy aflame with an insatiable curiosity for learning. Shorbojoya struggles to feed her brood, but she fights a losing battle as the money runs out. Horihor struggles to find work, but he does not seem overly concerned about their situation; when he is offered work, he is often slow to accept it. Durga, who has fallen into wicked ways and petty thievery, falls ill with a fever. Horihor leaves the village to seek work in Benares. Though he promises to be gone only a short time, he is absent for many months. Meanwhile, a monsoon pounds the village and, during a night of storms, Durga dies. Shortly thereafter, Horihor returns. Upon learning of the death of his daughter, he determines to leave Nishchindipur for Benares.

The remaining third of the novel follows the family to Benares. In the sequel, *Aparajita*, Apu grows up and becomes a father.

The Film

"The raw material of the cinema is life itself," said Satyajit Ray. "It is incredible that a country which has inspired so much painting and music and poetry should fail to move the filmmaker. He has only to keep his eyes open, and his ears. Let him do so." He uttered those words in 1948, when he was an aspiring but untrained Bengali filmmaker. A few years later, after viewing the Italian neo-realist classic *The Bicycle Thief* during a trip to London, he was moved to put his vision into practice. He approached Banerjee's widow for the literary rights to *Pather Panchali*. He would finance it himself, shooting it in a naturalistic manner quite apart from the stylized melodrama then common to Hindi cinema. From 1952 to 1954 he divided his time between weekend shoots and his regular job with a Calcutta advertising agency. Then, upon seeing some of the edited footage, Dr. B.C. Roy, the chief minister of West Bengal, decided to finance the rest of the film. It was completed in April 1955 and had its world premiere in New York at the invitation of the Museum of Modern Art. It subsequently won prizes at festivals in Cannes, Berlin, and Tokyo.

Ray turned to Banerjee's works more often than those of any other Indian author. Ray's so-called Apu Trilogy—*Pather Panchali* (1955), *Aparajito* (1957), and *The World of Apu (Apur Sansar*, 1959)—was adapted from Banerjee's *Pather Panchali* and its sequel, *Aparajita*. However, the lack of English translations of Banerjee's works makes sorting out the precise literary origins a complex affair. For example, the first film is based on the first two-thirds of *Pather Panchali*, which has been translated; *Aparajito* is based upon the last third of the novel and the first third of *Aparajita*, both of which have not. *The World of Apu*, likewise, is based upon the untranslated remainder of *Aparajita*.

My emphasis will be on the first film of the trilogy, *Pather Panchali*. A reading of the translated portions of the novel confirms Ray's need to condense, combine, and omit materials. Like the novel, however, he retained a basically episodic structure. Auntie's role (Chunibali Devi), which is minimal in the book, is enlarged. Here, she is a friend to Durga (Uma Das Gupta), who delights in her songs and stories, and a nuisance to Shorbojoya (Karuna Banerji), who kicks her out of the house on numerous occasions. Her death scene, a minor incident in the book, acquires more dramatic impact: Instead of returning to the home to die, she wanders, rejected, into the jungle alone, where Apu and Durga find her body. Other characters are simplified: Horihor and Shorbojoya are seen more sympathetically. Horihor appears to be more industrious and motivated than in the book; and Shorbojoya is depicted as a more sympathetic caregiver for the family. Durga, on the other hand, bears a closer resemblance to the book's depiction. She is seen as a mischievous child and loving sister. Her mature years, however, and an unsuccessful attempt to marry a rich cousin, are omitted.

Ray's treatment of the central character, Apu (Subir Banerji), also leaves out many episodes, including many details of his relationships with Durga and with his friends, his run-ins with the villagers, and his obsessive quest for book learning. Otherwise, the boy's essential sweetness, intelligence, and imaginative nature are intact. Memorable scenes abound: Apu's flight across a meadow to witness the passage of a steam train, the father's grief over the death of Durga, and the fury of the monsoon.

Pather Panchali, along with the two sequels, has secured an honored place in the history of classic cinema. Not only did it revolutionize Hindi cinema's so-called parallel cinema movement in the sixties and seventies with its naturalism, unobtrusive styles of lighting, and subtle acting, but it also aroused interest abroad in Ray's work and Indian cinema in general. When the Apu trilogy was rereleased in the early nineties, critic Richard Schickel was struck anew by its "cumulative power." "In

everything but physical scale [the three films] constitute an epic, as they range over two or three decades and embrace both village and city life in modern India and all the most basic human emotions in the most tender and patient way."

Although he had been frequently invited to work in other countries, Ray continued until his death to work exclusively in India. This is ironic in that his films remain relatively little known and little appreciated in his own country. "I feel very deeply rooted there," he nonetheless has said. "I know my people better than any other."

REFERENCES

Buruma, Ian, "The Last Bengali Renaissance Man," *The New York Review of Books*, November 19, 1987, 12–15; Ray, Satyajit, "Dialogue on Film," *American Film* (July–August 1978): 39–50; Robinson, Andrew, *Satyajit Ray: The Inner Eye* (Andre Deutsch, 1989); Schickel, Richard, "Days and Nights in the Arthouse," *Film Comment* (May–June 1992): 32–34.

—B.D.H.

PATHS OF GLORY (1935)

HUMPHREY COBB

Paths of Glory (1957), U.S.A., directed by Stanley Kubrick, adapted by Kubrick, Calder Willingham, and Jim Thompson; Bayna/United Artists.

The Novel

Humphrey Cobb published his stark antiwar novel about World War I in 1935. The title of the story is a reference to Thomas Gray's poem, "Elegy in a Country Church-yard," in which the poet remarks that the "paths of glory lead but to the grave." It becomes increasingly clear as the plot progresses that the paths of glory that irresponsible French generals are pursuing lead not to *their* deaths, but to the graves of men who are decreed to die in battles that are fought according to a strategy that the commanding officers manipulate for their own self-advancement.

The ghastly irresponsibility of the French officers toward their men is epitomized by the behavior of a general who hopes to gain a promotion by ordering his men to carry out a suicidal charge in the course of an attack. When they falter, he orders other troops to fire into the trenches on their own comrades. Colonel Dax must then stand by while three soldiers are picked almost at random from the ranks of his men to be court-martialed and executed for dereliction of duty as an "example" to the rest of troops.

The novel is divided into three parts: before the attack; the attack itself and its aftermath; the court-martial and execution. Stanley Kubrick followed this tripartite division of the story in his film adaptation of the novel.

The Film

"The film's anti-war message clearly has its source in Cobb's novel," as Mario Falsetto points out in his book on Kubrick. He further notes that Kubrick amplified the role of Colonel Dax (Kirk Douglas) from the marginal character portrayed in the book to the central character of the film. Colonel Dax thus becomes the character who most clearly articulates the film's antiwar theme. When Dax, who is the attorney for the defendants, delivers his emotional speech to the court, Falsetto concludes, "it is a direct plea to the audience."

"Sometimes I am ashamed to call myself a human being, and this is one of them," he begins. "This trial is a stain on the flag of France." The camera is slightly below Dax, shooting up at him in a way that makes his figure more imposing, as he finishes his statement: "Gentlemen, to find these men guilty will be a crime to haunt each of you to the day you die. I can't believe the noblest impulse in man, his compassion for another, can be completely dead here. Therefore I humbly beg you to show mercy to these men."

Peter Cowie has written in *Seventy Years of Cinema* that Kubrick employs his camera in the film "unflinchingly, like a weapon": darting into close-up to capture the indignation on Dax's face, sweeping across the slopes to record the wholesale slaughter of a division, or advancing relentlessly at eye level toward the stakes against which the condemned men will be shot.

Kubrick's mastery of the camera is exemplified in his deft handling of the breathtaking battle scene that is at the center of the film. When Dax leads his men into battle, Kubrick shows them pouring onto the battlefield in a high overhead shot of an entire line of soldiers, which reaches from one end of the screen to the other. Then he shifts to a side view of the troops sweeping across the slopes toward the enemy lines. The impact of this carefully crafted sequence is stunning.

As bombs explode overhead and shrapnel cascades down on the troops, they crouch, run, and crawl forward, falling in and out of shell holes, stumbling over corpses of comrades already dead. The director intercuts close-ups of Dax, a whistle clamped between his teeth, as he sees his men dying on all sides of him and observes the attack turn into a rout and a retreat.

The film is filled with both visual and verbal ironies, which reinforce its theme. Toward the end of the key battle scene, Dax must lead yet another hopeless charge on the impregnable German lines. As he climbs the ladder out of the trench, exhorting his men all the while to renew their courage, he is thrown backwards into the trench by the body of a French soldier rolling in on top of him. In the scene in which the condemned await execution, one of them complains that the cockroach he sees on the wall of their cell will be alive after he is dead. One of his comrades smashes the cockroach with his fist, saying, "Now you've got the edge on him."

The epilogue to the film ends on a note of hope for humanity. Dax watches his men join in the singing of a song about love in wartime, led by a timid German girl prisoner. Dax walks away convinced by the good-natured singing that his men have not lost their basic humanity, despite the inhuman conditions in which they live and die.

Paths of Glory has lost none of its power since its original release. Its examination of the moral dilemmas that are triggered by war, and sidestepped in both novel and film by the very men who should be most concerned about them, has becomes more relevant than ever in the wake of the Vietnam War. Indeed, the film's reputation has steadily grown over the years, not only as a superb example of the adaptation of a novel for film, but also as a searing commentary on the hypocrisies of war.

REFERENCES

Cowie, Peter, *Seventy Years of Cinema* (Barnes, 1969); Falsetto, Mario, *Stanley Kubrick: A Narrative and Stylistic Analysis* (Praeger, 1994); Nelson, Thomas, *Kubrick: Inside a Film Artist's Maze* (Indiana University Press, 1982).

—G.D.P.

PATRIOT GAMES (1987)

TOM CLANCY

Patriot Games (1992), U.S.A., directed by Phillip Noyce, adapted by Donald Stewart, W. Peter Iliff, Steven Zaillian; Paramount.

The Novel

In an attempt to dispel the criticism that his characters lack depth, Clancy decided to write a novel in which action and technology provide only a backdrop to a character-driven plot. Critical response and public reception indicated that he should have retained his original formula.

Patriot Games revolves around Jack Ryan, a history teacher turned CIA analyst. While vacationing in London with his wife and daughter, Ryan rescues the Prince and Princess of Wales from a terrorist attack. He testifies against one of the attackers, Sean Miller, who is a member of an ultra-left-wing faction of the IRA. After conviction and sentencing, the ULA, a maverick Irish terrorist group, assaults the transport van and rescues Miller. Miller formulates a plan to assassinate the entire Ryan family in a personal vendetta against Ryan, who killed Miller's younger brother in the initial attack. Marine guards at the Naval Academy, where Ryan teaches, foil the attack on Ryan. A second team succeeds only partially in their bold freeway onslaught directed at Ryan's wife and daughter.

After the failed assault on the Ryan family, Miller develops a second plan to kidnap the prince and princess, who will be visiting Ryan's home. During a barbecue with the royal family, the ULA attacks. Ryan and his guests escape in a speed boat. Pursued by Miller, they make for the Naval Academy where a detachment of Marines awaits. They trick Miller into revealing the location of the cargo ship on which he plans to escape. He and his accomplices are captured by the State Police and Coast Guard.

The Film

The film, starring Harrison Ford as Jack Ryan, follows the story line of the book closely with the exception of changes to reduce possible political concerns. The screenplay substitutes the fictional Lord Holmes for the Prince and Princess of Wales, perhaps to avoid political controversy. The film is also very careful about its portrayal of the IRA. The novel leaves no doubt as to the terroristic propensities of the IRA. The film leaves the issue unaddressed, relying on ambiguous representations of the organization to evade questions of political alliance. While Clancy's novel implicates the IRA, the film makes it clear that the IRA is not directly implicated or involved, but is the intended scapegoat of the maverick terrorists.

In the novel Ryan is a typical Clancy good guy and a patriotic family man. The film Ryan retains these qualities but transcends the good-guy image to become a superhero. After overlooking the fact that Ryan has been placed on an almost superhuman level, one can enjoy the thrilling action sequences throughout, particularly the climactic sea chase.

REFERENCES

Thomas, Evan, "The Art of the Techno Thriller," *Newsweek*, August 8, 1988; Ryan, William F., "The Genesis of the Techno-Thriller," *The Virginia Quarterly Review* 69, no. 1 (1993).

—J.M. Welsh

THE PAWNBROKER (1961)

EDWARD LEWIS WALLANT

The Pawnbroker (1965), U.S.A., directed by Sidney Lumet, adapted by David Friedkin and Morton Fine; Allied Artists.

The Novel

The Pawnbroker presents two weeks in the life of concentration camp survivor Sol Nazerman, who has been so battered by his experiences that he has withdrawn from any kind of emotional contact with other human beings. Approaching the 15th anniversary of his family's death in a concentration camp, Nazerman's memories overwhelm him, making even the simplest human transactions almost intolerable.

Nazerman runs a pawnshop for a hoodlum named Murillio as a place to launder money. He cares little that he is breaking the law, and the income allows him to

support his sister Bertha and her family, whom he tolerates in return for privacy and a comfortable place to live. Nazerman also supports Tessie Rubin, his occasional mistress, and her sick father, also Holocaust survivors.

Nazerman is assisted in the shop by Jesus Ortiz, who has adopted Nazerman as a father figure and mentor and longs for a business of his own. Though Ortiz has been a petty criminal in the past, he is endowed with a "cleanness of spirit" that Nazerman recognizes but cannot nurture.

Among the parade of unfortunates streaming through the pawnshop is Marilyn Birchfield, a social worker for a neighborhood youth center soliciting donations. In spite of himself, Nazerman is drawn to her freshness, "a medley of sunlight and tawny pink skin." He tries to reject her, but she convinces him to have lunch with her in the park and to take a boat ride down the Hudson, suggesting the possibility of peace for Nazerman.

Throughout the novel italicized segments represent Nazerman's memories and nightmares. One of these memories, a family picnic, would be pleasant but for the terrifying associations of subsequent events. More often they illustrate the horrors that Nazerman has endured—the oral rape of his wife by a Nazi officer while he is forced to watch, his daughter hanging on a meat hook, his son drowning in the human excrement on the floor of a cattle car packed with Jewish prisoners. The memory of his wife's abuse triggers a confrontation with Murillio because he refuses to accept the money from Murillio's brothel.

Because Nazerman has continually rejected his assistant and dismissed his dreams, Ortiz decides to join the hoodlum Tangee and his friends to rob the pawnbroker's safe. The robbery occurs on the day of Nazerman's anniversary, and when the pawnbroker refuses to hand over his money, one of the men turns a gun on him and fires, but Ortiz throws himself in front of Nazerman and takes the bullet. With Ortiz's sacrifice, Nazerman is reborn and all the grief and love of 15 years rushes over him. The novel ends as Nazerman staggers down to the river where he forgives himself, invites his dead to rest in peace, and allows himself to mourn.

The Film

Adapting the novel created special challenges because of Nazerman's many flashbacks and dream sequences, visions whose impact on the man create the "sensation of being clubbed." Lumet's use of flash cuts effectively replicates that sensation, the flash frames working to intrude abruptly on present action.

Though the film compresses the two weeks of the novel into one, and the "anniversary" becomes the pawnbroker's 25th wedding anniversary, for the most part, the film is faithful in its use of most of the key scenes of the novel, though often the sequence is not the same. While the novel begins as Nazerman (Rod Steiger) arrives at work, the film begins with the flashback to a family picnic, then cuts to a long shot of suburbia where Nazerman's sis-

Rod Steiger in The Pawnbroker, *directed by Sidney Lumet* (1965, U.S.A.; LANDAU-UNGER/THEATRE COLLECTION, FREE LIBRARY OF PHILADELPHIA)

ter-in-law and her family have created a generic American home. The flashback of Nazerman's son dying in the cattle car occurs very early in the novel and without logical antecedent; in the film it occurs late and is provoked by Nazerman's ride on the subway. Nazerman's confrontation with his employer, called Rodriguez (Brock Peters) in the film, is equally devastating, but Rodriguez does not use a gun to intimidate the pawnbroker, thus emphasizing Nazerman's powerlessness.

The Nazerman of the novel retains slightly more humanity than the pawnbroker of the film; the former is willing to engage in conversation, at least briefly, with George Smith (Juano Hernandez), a man desperate for intellectual discourse, and he shows glimpses of affection for his nephew Morton. Though Lumet includes Nazerman's lunch with Marilyn Birchfield (Geraldine Fitzgerald) and adds a visit to her apartment following his exchange with Rodriguez, their relationship is less hopeful. He does not include the boat excursion, and there is little sense that Nazerman is attracted to her; so little sense, in fact, that his arrival at her apartment seems imposed rather than a natural plot development.

The pawnbroker also does more to provoke his own death in the film than in the novel. In an original scene, Nazerman is beaten up because he repeatedly refuses to take care of the business the mobster demands. Shortly after, the robbery takes place. Nazerman's death wish is further emphasized in his confrontation with Tangee (Raymond St. Jacques) and his friends when he closes the door to the safe in front of them. Ortiz (Jaime Sanchez) is shot, and the pawnbroker seems to realize his own responsibility for Ortiz's death and the goodness of humankind in his sacrifice. Grief-stricken and needing to feel the pain that he has repressed for so long, the pawnbroker impales his hand on a receipt spindle, then wanders out into the neighborhood and is lost in the crowd, suggesting that he has rejoined the human race.

The most celebrated scene in the film is the visit paid to Nazerman by a black prostitute. The moment she bares her breasts to him provokes memories of his wife's rape in the camp. Officials of the Production Code Review Board and the Catholic Legion of Decency protested the nudity. By a narrow vote, however, the code permitted the scene to remain, establishing a precedent that soon would contribute to the demise of the code and the creation of a new ratings administration. The legion, on the other hand, allowed its "Condemned" rating to stand.

REFERENCES

Boyer, Jay, *Sidney Lumet* (Twayne, 1993); Cunningham, Frank R., *Sidney Lumet: Film and Literary Vision* (University Press of Kentucky, 1991); Galloway, David, *Edward Lewis Wallant* (Twayne, 1979); Leff, Leonard J. and Jerold L. Simmons, *The Dame in the Kimono* (Doubleday, 1990).

—*J.S.H.*

PETER PAN (1904)

JAMES M. BARRIE

Peter Pan (1924), U.S.A., directed by Herbert Brenon, adapted by Willis Goldbeck; Famous Players-Lasky/Paramount.

Peter Pan (1953), U.S.A., supervised and adapted by Ben Sharpsteen, Hamilton Luske, and Wilfrid Jackson; Walt Disney.

Hook (1991), U.S.A., directed by Steven Spielberg, adapted by Jim V. Hart and Malia Scotch Marmo; Amblin/Columbia TriStar.

Return to Never Land (2002), U.S.A., directed by Robin Budd, adapted by Temple Matthews; Walt Disney.

Peter Pan (2003), U.S.A., directed by P.J. Hogan, adapted by Hogan and Michael Goldenberg; Universal Pictures.

The Novel

The character of Peter Pan has been called the most famous person who never lived. The genesis of the play and subsequent novel by James M. Barrie (1860–1937) is long and complex, drawing characters and incidents from Barrie's boyhood in Kirriemuir, Scotland; his relationships with the four children of Arthur and Sylvia Davies (whom he had met in 1898 in Kensington Gardens and with whom he remained closely associated for the rest of his life); and two of his adult novels, *Tommy and Grizel* (1900) and *The Little White Bird* (1901). The story of a boy who refused to grow up and ran away to a life of adventure in the Never Land premiered in London on December 27, 1904, with Nina Boucicault in the title role and in America on November 6, 1905, with Maude Adams. It has been estimated that in its first half-century in England alone it was presented more than 10,000 times. In 1911 Barrie rewrote the play in novel form with a new title, *Peter and Wendy*. That Barrie himself felt close to the character can be seen from a quotation from his early novel *Margaret Ogilvey* (1896), in which his describes his own youth: "The horror of my boyhood was that I knew a time would come when I also must give up the games, and how it was to be done I saw not. . . . I felt I must continue playing in secret."

In the original play's first act, the sprightly Peter Pan arrives at the nursery of the Darling children—Wendy, John, and Michael—and flies away with them to Never Land. In the second, the Lost Boys accept Wendy as their mother and build her a house. In the third, the villainous Captain Hook and his pirate gang abduct the children. Peter comes to the rescue in Act Four and feeds Hook to a crocodile. And in Act Five, all the children return to the nursery while Peter remains in Never Land, occasionally visiting the nursery as the years pass. Barrie's novelized version follows this main outline, supplementing it with many incidents, characters, and atmospheric details.

The Films

Director Herbert Brenon made the first and only silent film version, with scenarist Willis Goldbeck, and took pains to retain the flavor of a stage production. Apart from a magical special-effects shot of Peter tipping out a pillowcase full of fairies (a suggestion from Barrie himself) and a few shots of a real pirate ship and a real sea (including a lovely image of seagulls gently circling around the ship's mast and shots of mermaids disporting about a beach), most of the action has a stagebound quality (the parts of Nana the dog and the crocodile were obviously played by humans in animal costumes). A few of Barrie's lines were utilized in the intertitles, and he personally endorsed the casting of young Betty Bronson as Peter (continuing the English stage tradition that a girl play the title role). Equally appealing was Ernest Torrence's Captain Hook who, according to Joe Franklin in *Classics of the Silent Screen*, delightfully indulged himself in "grimaces, eyeball-rollings, and other attention-getting gestures that have to be seen to be believed." Barrie, however, was disappointed at the results. "It is only repeating what is done on the stage," he declared, "and the only reason for a film should be that it does the things the stage can't do." His own scenario, amounting to 15,000 words, which he sold to Paramount, was never used. It is reprinted in Roger Lancelyn Green's *Fifty Years of Peter Pan* (1954).

Walt Disney had wanted to make an animated version of Barrie's play as early as 1939, when he arranged with the Great Ormond Street Hospital in London (to whom Barrie had bequeathed rights to the play) to produce a film. But it wasn't until late 1949 that actual production began. Including the costs for a live-action version, which was used as a model for the animators (in which dancer Roland Dupree portrayed Pan), it was to be one of his most expensive films to date, coming in at $4 million. The film owes more to the novel version than the original play, with the

In the 1924 silent version of Peter Pan, *Ernest Torrence and Edward Kipling portrayed Captain Hook and Smee* (1924, U.S.A.; AUTHOR'S COLLECTION)

action beginning in the nursery of the Darling family; continuing with Pan's arrival; his teaching of the children—Wendy, Michael, and John—to fly; their departure to Never-Never Land; their encounters with mermaids, Indians, and the villainous Captain Hook; Hook's abduction of the children; and Pan's exciting last-minute rescue of the children and Hook's fate in the jaws of the crocodile. In a striking departure from the play—which brings the children back to the nursery, to be visited sporadically over the years by Pan—Hook's ship is sprinkled with Tinkerbell's pixie dust and, now captained by Peter, it flies across the moon over London to the wondering eyes of the Darling household. As he gazes on the apparition, Mr. Darling gently murmurs that he seems to remember having seen it himself, long, long ago.

Film historian Leonard Maltin points out that Disney's film was the first enactment of the story in which Pan was *not* played by a girl, in which Nana was depicted as a real dog as opposed to the theatrical tradition of a person in an animal suit, and in which Tinkerbell was pictured as a tiny girlish sprite rather than a point of light reflected by a mirror. Moreover, one of the play's most famous moments was discarded—when Pan requests viewers to clap their hands

to revive the dying Tinkerbell. The film did not do well at the box office, and Walt himself was displeased at its performance. Commentator Richard Schickel complained, perhaps with justification, that *Peter Pan* was another example of the "Disneyfication" process: Disney's name, not Barrie's, appears over the title. Here, noted Schickel, was another example wherein Walt appropriated another person's work in order to sentimentalize it: "The egotism that insists on making another man's work your own through wanton tampering and by advertising claim is not an attractive form of egotism, however it is rationalized." But to less jaundiced eyes, the film wears well and there are many delightful moments, including the gags built around the relationship between Hook and Smee; the musical score by Oliver Wallace and songs by Sammy Cahn and Sammy Fain (especially "You Can Fly, You Can Fly," "Never Smile at a Crocodile," and "A Pirate's Life"); and the spectacular renderings of the London scenes, particularly when Pan and the children fly across night-shrouded London, the cityscape appearing through a break in the clouds below them.

As a filmmaker and artist who, in the opinion of some of his more acerbic critics, has never grown up, director

Steven Spielberg might have seemed the ideal choice to make a full-scale screen adaptation of Barrie's story. Thus, the Spielberg/Jim V. Hart/Malia Scotch Marmo adaptation was eagerly anticipated. Barrie's original plot outline was retained in only a tiny flashback section of the film, and the rest of the picture revealed that Pan had grown up to become Peter Banning (Robin Williams), a cutthroat corporate lawyer who is too busy with his career to pay attention to his own children, Jack and Maggie. "Granny Wendy" (Maggie Smith), an old London lady who had adopted him as a baby, lives in a picturesque old Victorian mansion with a servant and a strange old man named Toodles. One night, when Peter and his wife join Wendy for dinner, the kids are kidnapped and a note signed "Jas. Hook" is left behind. Sizing up the situation, Wendy informs the startled Peter that once upon a time he was Peter Pan and she was his Wendy; that Peter had married her granddaughter, grown up, and forgotten his boyish legend; and that this "Jas. Hook" is none other than the legendary villain, Captain Hook (Dustin Hoffman), returned to steal Peter's children. Later that night, Tinkerbell arrives and conducts the reluctant Peter to Never Land. Confronted by bloodthirsty pirates and their leader, Hook, Peter is humiliated at his inability to rescue his children. He has grown too old and forgotten how to be Peter Pan. Back with the Lost Boys, he remembers his past youth and gradually regains his ability to fly. His boyish vigor and strength renewed, he emerges as the Pan of old and returns to the pirate ship to defeat Hook, who is killed when an enormous statue of a crocodile topples over and crushes him. Tinkerbell takes them home. Peter stays behind to say goodbye to the Lost Boys and to appoint their next leader. At the end, he wakes up in Kensington Gardens from what he thinks is a dream. On his way home he fails to vault the garden wall. "I'm out of pixie dust," he muses sardonically. Adopting the more mundane method of climbing the drainpipe, he clambers through the window and rejoins his waiting family.

There is no denying that Spielberg's film is a rich concatenation of many things—an autobiographical allusion to Spielberg's own experiences as a father, an allegorical warning against false father figures, and a complex and challenging postmodern meditation on the whole Peter Pan myth (today referred to rather cynically as a "syndrome"). Despite the fact that all of it was shot on soundstages, the film is packed with delicious moments and effects, including aerial shots of the island lagoon with two large moons swimming in the hazy sky, Peter's first flying scene, Hook's embarrassment when his wig is knocked askew (didn't we always wonder if he was bald?), and, especially, the wonderful flashback sequence chronicling the story of the real Peter Pan (one of the finest things in all the Spielberg oeuvre). And yet, like the statue of the crocodile, the whole thing collapses under its own pretentious weight. This Pan has feet of clay. He has been allowed to grow up, which Barrie surely would have found unconscionable. Worse, after the adult Peter regains his lost boy-

hood and survives his adventures in Never Land, we are to believe that he can now resume his adult responsibilities and function as both father and child to his family. The original Pan's tragedy was that he could not—or, more precisely, would not—grow up. Here, Spielberg implies that both boy and man can commingle in some happy, fuzzy balance—doubtless an appealing notion to Spielberg but an appalling one to the tougher, more insightful, yet more sensitive Barrie. Other postmodernist attempts to inject modern elements and politically correct agendas into the story—and to erase the boundaries between imagination and reality—include a baseball game (with one team called "The Pirates"), references to pop culture icons like the Beatles, a troupe of skateboarding Lost Boys (who indulge in an *Animal House*–like food fight), the silly business with the crocodile statue, and a full-sized Julia Roberts as Tinkerbell. There are no Indians in sight (perhaps dispensed with out of fear of racial caricaturing), and Hook is no villain but merely a frustrated father figure who wants to make Peter's children love him. Similarly, Peter is another frustrated father who must cavort about in tights to regain his kids' love. This is errant nonsense: Those kids know something he doesn't—that parents are no longer children and can never be so again; any attempts to try would provoke only ridicule. In the end, this Pan declares that "to live must be an awfully big adventure," a reversal of the original play's most famous line. So be it. This Pan will live on as an adult-child even if it means that the play must die in the process.

The film's box-office performance was disappointing, and critics were generally unkind. David Ansen of *Newsweek* complained that "*Hook* is a huge party cake of a movie with too much frosting. After the first delicious bite, sugar shock sets in."

In Disney's *Return to Never Land*, an animated sequel to the 1953 film, little boys don't need mothers so much as they need sisters. Indeed, the character of Jane, daughter of the now-mature Wendy, becomes the first Lost Girl of Never Land. Tinkerbell, once Wendy's flirtatious rival for Pan's affections, is transformed into a supportive member of Jane's new Sisterhood. Thus, this adaptation owes more to the Spielberg's New Age and postmodernist-inflected *Hook* than anything in Barrie's original. The action is postdated to the violence-plagued London of the wartime Blitz. Wendy, the mother of two, tearfully watches her husband join the war effort. With no time for the Peter Pan fantasies her mother has been telling her, daughter Jane dons crash helmet and boots to lend her own efforts to the bomb-ravaged street defenses. But suddenly, one night, a gigantic pirate ship appears over the rooftops. Ropes are lowered, ferocious dark men clamber down, a hook unlatches Jane's window, and the terrified child is whisked away to Never Land. It is all part of Captain Hook's plan: He intends to hold Jane hostage until Pan reveals the whereabouts of his fantastic buried treasure. Peter comes to the rescue and installs Jane in his woodland home. Hook fumes and frets at his frustrated scheme. He

even has a new nemesis, a gigantic octopus, to worry about. Jane, meanwhile, Modern Woman that she is, can't fly because she refuses to believe in Tinkerbell; and she insists that Peter return her to London. But when pirates abduct Peter, she has a change of heart, gets sprinkled with pixie dust, and flies to the rescue. In her triumph, she is elected the first Lost Girl of Never Land. In the end, still determined to return to London, she persuades Peter to escort her home. She arrives just in time for the return of her father from the war. For an instant, hovering outside the window, Pan confronts the adult Wendy. Oddly, nothing is made of the moment, and after a brief pause, he flies away back to Never Land.

Except for the wonderful opening sequences and a few fine moments near the end, the film is rather pallid. When Wendy tells her children about Pan, the film cuts away to a marvelous montage of the agile boy, flashing his lantern grin in the darkness as he skirts the rooftops and flies over the town. Jane's abduction scene is a real standout, as Hook's great ship lowers from the stormy clouds and hovers over Blitz-ravaged London. The images linger long in the memory. Otherwise, the long middle section is unrelieved dullness and tedious pratfalls. Worst of all, the poignancy of Peter's refusal to grow up is lost in the insistently politically correct agenda. Surely, Barrie would have been appalled at the evisceration of his themes.

"All children grow up," proclaims the opening title of the 2003 adaptation, Peter Pan; "—except one." All the right elements are in place for the newest live-action adaptation of the Barrie story: the great cinematographer Donald McAlpine, composer James Newton Howard, fine actors for Peter and Wendy (Jeremy Sumpter and Rachel Hurd-Wood), and a particularly dashing Jason Isaacs for a muddled Mr. Darling and a flamboyant Captain Hook. And the sumptuous production values, a deft mix of animation, computer graphics, and live action, are charming without overloading the frame. Barrie's story is strictly respected—none of the irritating postmodern tricks that so marred the Spielberg version or the politically correct manipulations of the 2002 Disney Return to Never Land. Pan arrives at the Darling mansion one night while the parents are out, teaches Wendy and Michael and John how to fly, entices them out the window to Never Land, and subsequently plunges them into the requisite adventures with Tiger Lily (who here takes a shine to John), the Lost Boys, and Hook and his villainous pirate crew. Before Peter returns them all to London, he has to refuse Wendy's romantic overtures—she is ready to grow up and make a husband of him—and insist on remaining a boy. He departs at the end, after restoring the children to the nursery, uttering somewhat wistfully, "It would be an awfully big adventure to live." There the story ends, with no references to future visits to Wendy as she grows old.

The special effects are dazzling. Tinkerbell whizzes about in a shower of glittering sparks; Peter and the children loop, spin, and cavort about the rooftops of London; and, in the end, the pirate ship rises out of the waters in a cascade of shimmering fireworks. The sequence in the nursery where Peter chases his shadow is a virtuoso piece of clever editing and dazzling flying effects. A particularly memorable moment captures in slow motion a whirling aerial dance between Peter and Wendy in the misty depths of a forest glade. Although everything is handled, for the most part, with an appropriately light touch, there are, for the older viewers, a few moments between Peter and Wendy with distinctly erotic overtones (including Wendy's administering a full-on-the-lips kiss to a swooning Peter on the pirate ship's quarterdeck). Hook's rough treatment of Wendy and the boys in the penultimate scenes, and his fate in the snapping jaws of the enormous crocodile, might prove to be a bit too much for younger viewers. "Peter Pan is a bright, whirling pinwheel of a movie that tosses around special effects like confetti," writes critic Owen Gleiberman, "but the techno magic is graced with a touch of sensuality."

Producer Mohammed Al Fayed dedicated the picture to his late son, Dodi Al Fayed.

For the record, Mike Newell's film, An Awfully Big Adventure (1995), based on the novel by Beryl Bainbridge, is dark melodrama of incest and corruption surrounding the rehearsal and production of the play version of Peter Pan in Liverpool in 1947. Although the play itself is only depicted in a few brief scenes, its themes of the incursions of experience and disillusionment upon the precious dream of innocence are central to the film.

REFERENCES

Birkin, Andrew, J.M. Barrie and the Lost Boys (Clarkson Potter, 1979); Brode, Douglas, The Films of Steven Spielberg (Citadel Press, 1995); Franklin, Joe, Classics of the Silent Screen (Citadel Press, 1959); Gleiberman, Owen, "Peter Pan," Entertainment Weekly, January 9, 2004, 58; Green, Roger Lancelyn, Fifty Years of Peter Pan (Peter Davies, 1954); Maltin, Leonard, The Disney Films (Bonanza Books, 1973); Schickel, Richard, The Disney Version (Simon and Schuster, 1968).

—J.C.T.

THE PICKWICK PAPERS (1837)

CHARLES DICKENS

Pickwick Papers (1952), U.K., directed and adapted by Noel Langley; Renown Pictures.

The Novel

Charles Dickens, better known to the readers of his sketches as "Boz," launched his career as a novelist with this episodic, comic adventure tale. The fame it brought him was hitherto unprecedented among popular novelists. Beyond its impact on Dickens's career, Pickwick charted a new direction for the modern novel and its popularization. It was the first English novel to focus primarily on middle- and lower-class characters, and it found an audience even

among the illiterate, who attended groups to hear it read aloud.

The novel's narrator is putatively editing the Pickwick Club's documents. The club, named after its founder/president Samuel Pickwick, forms a four-man corresponding society to travel across England and forward its findings back to the club in London.

Same readers complain *Pickwick* lacks a cohesive plot, but narrative threads do link its episodes, even though the book is famous for including many apparently digressive stories that Pickwick and company hear on the road and record in their findings (e.g., "The Stroller's Tale," "The Bagman's Story," and "The True Legend of Prince Bladud"). In reality, *Pickwick* is a picaresque collection of tales, a veritable *Don Quixote* of English literature, although its traveling adventurers are not knights but self-important gentlemen.

Pickwick, along with Tracy Tupman, Nathaniel Winkle, and Augustus Snodgrass, all of whom had "volunteered to share the perils of his travels, and who were destined to participate in the glories of his discoveries," set off as the novel begins. Each Pickwickian has an exaggerated sense of his own special gifts and virtues: Tupman sees himself as a romantic adventurer, Winkle as a sportsman, and Snodgrass as an accomplished poet; each endures comic misadventures resulting from the discrepancy between his ideal and actual abilities; and each marries happily by the book's end. As for the rotund Pickwick, although he suffers disillusionments of his own, he at least succeeds in his avowed attempts to benefit others.

The villain is Alfred Jingle, an actor who reappears throughout the novel, wreaking havoc while masquerading as various gentlemen. His machinations are various: He implicates Winkle in a duel, he almost elopes with Rachel Wardle prior to her marriage to Tupman, and his servant, Job Trotter, even fools Pickwick into trespassing at a female seminary. Another recurring character is the redoubtable Sam Weller, whom Pickwick employs as a manservant. His colorful cockney speech and ingenuity in looking after Pickwick's interests mark him as one of literature's most memorable sidekicks. Weller, at the book's close, weds Mary, maid to Winkle's bride Arabella Allen.

A major plot element concerns Pickwick's troublesome relationship with a widowed landlady, Mrs. Bardell. When he tries to tell her he has hired a servant, she misconstrues this as a marriage proposal. The rapacious lawyers Dodson and Fogg eventually inspire her to file a breach-of-promise suit against him. Pickwick's subsequent conviction lands him in Fleet Street Debtors' Prison for refusal to pay what he considers unjust damages. Most of his friends and enemies follow him there: Sam Weller has his father throw him into the Fleet for debt so he can continue to serve Pickwick. Jingle's bad debts result in his incarceration. And Mrs. Bardell also suffers eventual imprisonment. In a burst of generosity, Pickwick is moved to forgive Jingle and pay Mrs. Bardell's debts (for which gift she agrees to absolve him of the charges). Meanwhile, Pickwick is horrified by the Fleet's conditions (which Dickens knew all too well from his childhood, when his family was jailed there for his father's debts).

The novel's epilogue-like close finds Pickwick retired from his adventures, attended by Sam and Mary, serving as godfather to the offspring of Winkle, Tupman, and Snodgrass.

"Pickwick will always be remembered as the great example of everything that made Dickens great," wrote G.K. Chesterton; "of the solemn conviviality of great friendships, of the erratic adventures of old English roads, of the hospitality of old English inns, of the great fundamental kindliness and honour of old English manners."

The Film

Prior to Noel Langley's 1952 film, *Pickwick Papers* had inspired many short silent films, but none had attempted to render more than a few scenes from the novel. Among these early fragmentary depictions were R.W. Paul's *Mr. Pickwick's Christmas at Wardle's* (U.K., 1901); *Gabriel Grub, The Surly Sexton* (U.S.A., Williamson, 1904); *A Knight for a Night* (U.S.A., Edison, 1909); Thomas Edison's four-scene *Mr. Pickwick's Predicament* (U.S.A., 1912); Larry Trimble's *Pickwick Papers* (U.S.A., Vitagraph, 1913), which depicts three incidents involving Jingle, "The Honourable Event," "The Adventures at Westgate Seminary," and "The Adventure of the Shooting Party"; another three-scene *Pickwick Papers* that included "Pickwick Versus Bardell," "Mr Pickwick in a Double-bedded Room," and "Mrs Corney Makes the Tea" (U.K., Clarendon, 1913); and Thomas Bentley's *The Adventures of Mr. Pickwick* (U.K., Ideal, 1921).

Langley's 109-minute film reflects the sprawling novel's characters and chronology with remarkable fullness and faithfulness. His screenplay a year earlier for *A Christmas Carol* had already honed his knowledge of Dickens. Despite his skill in realizing Dickens' vision combined with his impeccable casting to make this a prestige picture, it received a mixed response. "Langley's expert film aroused no passions in my breast one way or another," yawned *The Spectator*. On the other hand, the *Saturday Review* noted, "Mr. Langley has . . . had every consideration for the famous Dickens characters, and for our own feeling about them. He has even, wherever possible, made his scenes match the . . . illustrations."

Langley's adaptation strategy was to follow the book wherever possible, and to make changes by cuts rather than revision. He reduces the number of characters by about half. Notable deletions include the stories (e.g., "The Stroller's Tale") that the Pickwickians hear along the way; the scenes involving medical students Bob Sawyer and Jack Hopkins; Sam Weller's stepmother and the self-righteous Rev. Mr. Stiggins; the episode of the rival Eatonswill editors Slurk and Pott; and, most lamentably, the novel's glorious Christmas chapter at Dingley Dell.

After a brief prologue mentioning Dickens, the film opens with Pickwick (James Hayter), Tupman (Alexander

Gauge), Snodgrass (Lionel Murton), and Winkle (James Donald) planning their journey. Mrs. Bardell (Hermione Baddeley) and Mrs. Leo Hunter (Joyce Grenfell) see them off. Langley compresses the weddings of Tupman, Winkle, and Snodgrass into a group ceremony at the film's end, cutting the novel's closing chapters.

No performance is weak; even smaller roles such as Miss Tomkins and Mrs. Wardle are played to perfection by the likes of Hermione Gingold and Kathleen Harrison. The film reaches a height of absurd comedy during the courtroom scene, in which Sergeant Buzfuz (Donald Wolfit) masterfully indicts the innocent Pickwick before the jury. One of Langley's greatest strengths is his ability to capture the novel's spirit and detail, rushing the pace just a bit in order to fit all the action into 109 minutes. While the film was not a landmark event to cinema in the way that the novel was to fiction, Langley skillfully showcases Dickens, the novel, and the cast's performances.

REFERENCES

Johnson, Edgar, *Charles Dickens: His Tragedy and Triumph* (Little, Brown, 1952); Kaplan, Fred, *Dickens: A Biography* (Morrow, 1988); Smith, Grahame, "Dickens and Adaptation: Imagery in Words and Pictures," in *Novel Images: Literature in Performance*, ed. Peter Reynolds (Routledge, 1993); Zambrano, Ana L., *Dickens and Film* (Gordon Press, 1977).

—B.F.

PICNIC AT HANGING ROCK (1967)

JOAN LINDSAY

Picnic at Hanging Rock (1976), Australia, directed by Peter Weir, adapted by Cliff Green; B.E.F.-South Australian Film Corporation and Australian Film Commission.

The Novel

When it appeared in 1967, Joan Lindsay's best-selling novel aroused considerable controversy about the purported veracity of its events. Although she claimed to cite actual police transcripts and newspaper reports about the mysterious disappearance at the turn of the century of a party of students in Victoria, Australia, her brief preface hinted otherwise: "Whether *Picnic at Hanging Rock* is fact or fiction, my readers must decide for themselves. As the fateful picnic took place in the year 1900, and all the characters who appear in this book are long since dead, it hardly seems important." Yvonne Rousseau researched the issue in her book *The Murders at Hanging Rock*, and she revealed that Appleyard College never existed and that no such incident was reported to have taken place at the time. As for Ms. Lindsay, she has wisely removed herself from the debate, commenting only that in Australia "anything can happen."

Picnic Rock, a 500-foot-high volcanic formation, is the site of a picnic for two instructors and 18 young ladies of the Appleyard College on Saint Valentine's Day in 1900. At the end of the day it is discovered that four members of the party have disappeared—instructor Greta McGraw and three students, Miranda, Irma, and Marion. After a week's search, Irma is found, but she is unable to recall what had transpired on the Rock. The rest are never found, and the subsequent scandal brought about the ruin of the school, the mysterious death of another student, Sara, and the suicide of the stern headmistress, Mrs. Appleyard.

The Film

Peter Weir's film version was one of the seminal events in the so-called Australian Renaissance that began in the mid-1970s. Its worldwide popularity encouraged the popular reception of other directors of his generation, like Bruce Beresford, Fred Schepisi, and Gillian Armstrong. Like Dickens's *The Mystery of Edwin Drood*, it is one of the greatest mystery stories in the world precisely because it has an "unfinished" quality, ensuring that we will never know the solution to the problem.

The film is quite faithful to the book, excepting a few relatively minor details: The character of Sara (Margaret Nelson), for example, is not as "mousy"; nor is the revelation that she is the sister of Albert (John Jarrett) as subtly implied. And the circumstances of Mrs. Appleyard's (Rachel Roberts) death are briefly described by a narrative voice rather than in the detailed scene offered at the end of the book. All of that aside, Weir uses the resources of the cinema to powerful effect in evoking the sense of awe, mystery, and eroticism implicit in the text. The opening image—a rack-focus of a wall of mist dissolving into the phallic prominences of Hanging Rock—perfectly prefigures the theme of an irrational force breaking through the barriers of reason and order. The succeeding montage contrasting the grave monumentality of the school with the hot-house atmosphere of the rose-water-and-valentine-suffused toilette of the giggling schoolgirls adds a soupçon of erotic energy and the hint of sexual repression. The otherworldliness of the character of the beautiful, doomed Miranda (described as appearing "like a Botticelli angel") is beautifully conveyed in the superb handling of actress Anne Lambert. The picnic itself, the set piece of the film, is a marvel of soft-focus imagery, long-lens distortion, and slow-motion photography, all enhancing the sense of stopped time as the girls prepare to climb the Rock. On the soundtrack, the insistent buzzing of insects blends with the fluttering of Gheorghe Zamfir's pan pipes and the breathless suspensions of the slow movement of Beethoven's "Emperor" Piano Concerto.

Some critics, like Danny Peary, fuss at the anticlimactic nature of the second half of the film, which details the fruitless search for the girls and the steadily declining fortunes of the Appleyard School and its headmistress. The general effect, unlike that of the book, is that the story

Picnic at Hanging Rock, directed by Peter Weir (1976, AUSTRALIA; PICNIC PROD.-AUSTRALIA FILM CORP./NATIONAL FILM ARCHIVE, LONDON)

ends not with the proverbial bang, but with a whimper. However, a counter-argument notes that the film's formal structure forms a perfect arch, peaking at events on the rock, and decelerating into an ambiguous silence and stasis at the end, as if veils had been drawn away, revealing finally nothing but a blank slate. What really happened at Hanging Rock? There is a certain deliciousness with which the viewer is encouraged to entertain all manner of wild surmises, ranging from brutal murder by an aboriginal tribe to abduction by UFOs. Or, as the soundtrack voice reminds us periodically, has it all been nothing more than a dream?

Weir's favorite themes emerge here: the persistence of primitive forces beneath the surface of a repressively rationalized modern existence; and that Australia itself presents a history of Europeans who intruded into a timeless environment and have been rejected by the confounding mystery of the outback and aboriginal history. The fate

of these genteel, superbly self-conscious young ladies may reflect something of both. *Picnic's* refusal to explain its enigmas leaves viewers to their own conjectures. "Most of my films have been left incomplete," he has said, "with the viewer as the final participant."

REFERENCES

Hentzi, Gary, "Peter Weir and the Cinema of New Age Humanism," *Film Quarterly* 44, no. 2 (winter 1990–91), 3–12; Peary, Danny, *Cult Movies 2* (Dell, 1983); Rousseau, Yvonne, *The Murders at Hanging Rock* (Scribe, 1980); Tibbetts, John C., "Peter Weir, a View from the Apocalypse," *The World and I* 9, no. 4 (April 1994): 122–27.

—*J.C.T.*

LE PONT SUR LA RIVIÈRE KWAI (1952)

See The Bridge over the River Kwai.

A PORTRAIT OF THE ARTIST AS A YOUNG MAN (1916)

JAMES JOYCE

A Portrait of the Artist as a Young Man (1977), U.S.A., directed by Joseph Strick, adapted by Judith Rascoe; Ulysses Film Productions.

The Novel

A Portrait of the Artist as a Young Man apparently began as a quasi-biographical memoir entitled *Stephen Hero*, written by James Joyce (1882–1941) between 1904 and 1906 but later dismissed by the novelist as a "schoolboy's production." Joyce left Ireland in 1904 to become a professional writer abroad, but he could not find a publisher for *Stephen Hero*. An early biographer claimed that Joyce had burned the manuscript in a moment of despair and frustration. Only a fragment of the original manuscript survives, but enough to suggest that Joyce needed to distance himself from his alter ego, Stephen Dedalus.

The revised *Portrait of the Artist* was much more than just a personal history. The revised version told Stephen's story, but not in the naturalistic style of *The Dubliners*, Joyce's collection of short stories dealing with everyday life in Dublin. Rather, it began with a surrealistic rendering of the character's earliest family memories, involving his boozy father and his protective Irish mother, then traced his story through parochial school to Stephen's years at Trinity College. In the course of the novel Stephen takes his religion seriously to the point that he considers entering a seminary and studying to become a priest; he subsequently advances to a position of intellectual liberation, rejects Roman Catholicism, Irish nationalism, and, finally, his own family. He decides to leave Ireland and establish himself abroad as a writer.

Whereas in his first attempt to tell the story, which rather closely resembled his own development, Joyce was inclined to regard Stephen's rebellion as heroic, in his final rendering, Stephen was treated ironically instead of heroically. It became, therefore, a "portrait" of the would-be artist as a young man, self-righteous and smug, self-assured and selfish—to a degree, a young man willing to break his mother's heart in order to advance his own career. Many set pieces remain vividly in the memory: the family argument over Irish politics during a Christmas dinner, the fire-and-brimstone sermon delivered by a Jesuit priest (played in the film by John Gielgud), and Stephen's "initiation" by a prostitute. Throughout the book, Joyce's prose displays a richly symbolic density and assured, mature style—widening the ironic distance between himself as artist and subject—far surpassing his earlier efforts in *Stephen Hero*.

The Film

This novel presents many problems for anyone presuming to adapt it to cinema: The protagonist becomes increasingly vain and is often unlikable; the development is psychological and much of the action is internal; and the language is complicated and "literary" with a vengeance. In short, it's a far more complex operation than adapting something like the relatively "realistic" style of Joyce's short-story collection *The Dubliners*, which would lend itself far more readily to film adaptation, as director John Huston demonstrated in his later treatment of Joyce's "The Dead" (the last and longest story in that collection).

For example, when Stephen (Bosco Hogan) explains his aesthetic theories to his friend Lynch (Brian Murray), the words resist being translated into images. Stephen's theory of the literary "epiphany" might be visualized with an image of a woman on a beach (as in the film), or heard like "a shout in the street," but the sounds or images would have to be contextualized by a great deal of verbal exposition. The Irish actor Bosco Hogan was first approached by director John Huston to play Stephen, but Huston wisely decided to forego *Portrait* in favor of "The Dead," which proved to be far more filmable in terms of atmosphere, irony, and drama. The drama of *Portrait*, by contrast, is internal and existential, and the development of the character more psychological and spiritual. There is no central, unifying epiphany here that can be captured by the singing of a sentimental Irish air.

Director Joseph Strick had attempted to adapt Joyce's *Ulysses* to the screen in 1966, so he had already encountered the challenges of Joyce's prose and stream-of-consciousness style. *Portrait of the Artist* at least was more linear in its plot development than Joyce's later masterpiece. In fact, one could argue that a few scenes in Strick's *Portrait* succeed in translating the prose into effective imagery, as in the montage sequence that depicts the Dedalus family's several moves to ever-shabbier dwellings, and perhaps in the final scenes deriving from Stephen's diary entries, which attempt to provide evocative examples of "counter-discourse," as when Stephen's friend Davin (Niall Buggy) describes an ancient man representing Ireland's mythic past. Images of bleary-eyed drunks who embody Ireland's decline from that mythic past into a dismal present are juxtaposed to the discourse. In this way the film is able to suggest Stephen's (and Joyce's own) mixed feelings and ambivalent vision of Ireland.

In general, however, the problem with this novel is that its allusive (and elusive) prose style is essentially unfilmable. It demonstrates the notion that true classics cannot be transformed from the verbal to the visual without incurring risky consequences and that it may be relatively pointless to attempt to replicate literary perfection in another medium.

REFERENCES

Armour, Robert A., "The 'Whatness' of Joseph Strick's Portraits," in *The English Novel and the Movies*, eds. Michael Klein and Gillian Parker (Ungar, 1981), 279–90; Klein, Michael, "Strick's Adaptation of Joyce's Portrait of the Artist: Discourse and Containing Discourse," in *Narrative Strategies: Original Essays in Film and Prose Fiction*, eds.

Syndy M. Conger and Janice R. Welsch (Western Illinois University Press, 1980), 37–46; Pearce, Richard, *The Novel in Motion: An Approach to Modern Fiction* (Ohio State University Press, 1983), 16–23.

—*M.W.O and J.M.W.*

PORTRAIT OF JENNIE (1940)

ROBERT NATHAN

Portrait of Jennie (1948), U.S.A., directed by William Dieterle, adapted by Leonardo Bercovici, Paul Osborn, Peter Berneis, and David O. Selznick; Selznick International Pictures.

The Novel

Robert Nathan (1894–1985) was a prolific and bestselling American author whose métier was fantasy—sometimes satirical, as in *The Bishop's Wife* (1928), and sometimes lyrical and contemplative, as in *Portrait of Jennie*. In this novel, a young Manhattan artist named Eben Adams struggles to find the inspiration that will thaw "the life of his genius, the living sap of his work." One day in Central Park he meets a little girl named Jennie Appleton. As they converse, Eben realizes that Jennie is from another time; her enigmatic song confirms his sense of her uncanniness. For the rest of the novel, Jennie visits Eben continually and mysteriously, each time growing older and more mature. Finally Jennie becomes Eben's beloved. But time and Jennie's ambiguous position within it intervene, and the lovers are again separated. At the end of a long and weary summer in New England, Eben sees Jennie once more, only to lose her when a hurricane tears her from his arms. Eben eventually learns that in fact Jennie was washed overboard from an ocean liner that day and lost at sea; once again, Jennie seems to have eluded the limits of time and space,

Joseph Cotten paints a Portrait of Jennie, *directed by William Dieterle* (1948, U.S.A.; SELZNICK/THEATRE COLLECTION, FREE LIBRARY OF PHILADELPHIA)

if only for a last visit with Eben. Eben is left with a profound conviction that he and Jennie will be together forever. He is also left with his masterpiece, the "Portrait of Jennie" that will hang in the Metropolitan Museum of Art.

The Film

David O. Selznick thought Nathan's novel an exquisitely appropriate vehicle for his protégée and soon-to-be-wife Jennifer Jones. Instead, location and production problems as well as personal tragedies resulting from the stress (cinematographer Joseph August suffered a fatal heart attack while preparing an intricate tracking shot) meant that *Portrait of Jennie* would lose over $4 million and force Selznick to auction off his studio.

The film is uneven but full of lovely, haunting moments. August and director William Dieterle achieve many unusual cinematic effects, including one in which the texture of an artist's canvas is superimposed over the shot, suggesting that the entire film is a kind of portrait. This conceit is reinforced by the black-and-white film's final shot, inside a museum, of the "Portrait of Jennie" in glorious Technicolor.

Selznick's adaptation turns Nathan's speculative novel into a romantic Hollywood fantasy of heroic love and heroic yearning. The film omits Arne (Eben's artist friend and foil), downplays Eben's predatory landlady, gives the tough yet wistful spinster Mrs. Spinney much more prominence, and transforms Eben's obedient waiting into a chase. At the end of the novel, for example, Eben awaits Jennie's next appearance with a fatalistic detachment. In the film, by contrast, Eben learns that Jennie was drowned years ago during a hurricane. Eben then races the hurricane (through time and space) to the lighthouse where Jennie was last seen. In an incongruous cliffhanger Selznick added as a result of lukewarm previews, the film depicts, on green, sepia-print stock that gives the storm a weird, *Wizard of Oz* look, Eben's doomed attempt to rescue Jennie. (In a few major markets, "Cyclophonics" surrounded the audience with storm sounds, and a zoom lens enlarged the projected image by 50%.) These special effects won an Academy Award but could not raise the film's popularity. Years later, Robert Nathan expressed his dismay over the film and heaped particular scorn upon this bloated ending.

Today, however, many viewers love *Portrait of Jennie* for its cinematic beauty, its superb cast (including Jones, Joseph Cotten, Ethel Barrymore, and Lillian Gish), and its Debussy score (adapted by Dimitri Tiomkin). The film inspired the popular song "Portrait of Jennie"; in his book on Selznick, David Thomson argues that the film also helped inspire Hitchcock's *Vertigo*.

REFERENCES

Haver, Ronald, *David O. Selznick's Hollywood* (Knopf, 1980); Sandelin, Clarence K., *Robert Nathan* (Twayne, 1968).

—*W.G.C.*

THE PORTRAIT OF A LADY (1881)

HENRY JAMES

The Portrait of a Lady (1996), U.S.A., directed by Jane Campion, adapted by Laura Jones; Gramercy Pictures.

The Novel

With the successful *The American* and *Washington Square* behind him, Henry James resolved in the late 1870s to write something more ambitious, a "portrait of the character and recital of the adventures of a woman—a great swell, psychologically a *grande nature*—accompanied with many 'developments.'" *The Portrait of a Lady* was begun in Italy in the spring of 1880, and its serialized parts started appearing in magazines in both England and America later that fall. Like his earlier work, it was about Americans abroad and the collisions of New World innocence and Old World corruption. Isabel Archer leaves America a thorough provincial, a young romantic possessed of "meagre knowledge, inflated ideals, [and] a confidence at once innocent and dogmatic." She emerges at the end disillusioned and damaged, but prepared to take her destiny into her own hands. James's biographer, Leon Edel, pronounces *Portrait* "one of the best-written novels of its age," possessing "a prose of high style, with a narrative unsurpassed for its rhythmic development, with a mastery of character . . . that could be placed among the supreme works of the century."

After the death of her father, Isabel Archer leaves America to visit her relatives in England, the Touchetts. No sooner has she arrived than she is approached by two would-be suitors, a thoroughly masculine American, Caspar Goodwood, and a refined English nobleman, Lord Warburton. She refuses them both and leaves London with her cousin, Ralph Touchett. Upon learning of the imminent death of Ralph's father, she returns to England. To her surprise, she inherits one-half of his fortune, which enables her to live independently. Meanwhile, she meets Madame Merle, an old friend of Mrs. Touchett. Isabel is fascinated by her worldly ways and social ease. It is Merle who, during Isabel's subsequent travels to Florence, introduces her to the aesthete Gilbert Osmond and his convent-bred daughter, Pansy. Against the advice of her friends (including the devoted Ralph Touchett), who suspect Osmond is interested only in her money, she accepts his proposal of marriage. The newlyweds settle in Rome, where Isabel quickly realizes she has made a grave mistake: Osmond proves to be a manipulative and dominating husband. Not only is he intent on bending the high-spirited Isabel to his own will, but he plots to marry his daughter to the wealthy Lord Warburton. He ultimately fails in both regards. Isabel, meanwhile, learns from Osmond's sister that she has been the victim of a wicked deception: Madame Merle had been Osmond's mistress; Pansy was

their child; and Merle and Osmond had conspired to endow Pansy with Isabel's fortune. The rebellious Isabel leaves Osmond and returns to England where her cousin, Ralph Touchett, lies dying. After his funeral, she again is approached by her former suitor, Caspar Goodwood, who has learned of Osmond's ill treatment. Isabel rejects him and resolves to return to Italy to put her house in order.

The Film

Just as, in the opinion of Leon Edel, James had created in Isabel Archer certain aspects of his own egotism and power, so too has filmmaker Jane Campion seen in her the sensitive, yet sturdy characteristics that have dominated her other studies of women, notably *An Angel at My Table* (1990) and *The Piano* (1993)—what critic Kathleen Murphy calls a "self-destructive or even killing innocence." Moreover, Campion's generously budgeted production ranks among the most spectacularly sumptuous and carefully detailed literary adaptations in film history. Janet Patterson's period costumes and sets are impressively executed. A stellar cast, including Nicole Kidman, John Malkovich, John Gielgud, and Barbara Hershey, breathes life into the convoluted Jamesian rhetoric. And cinematographer Stuart Dryburgh limns the action in a generally chilly, low-key blue palette. Following James's many scene changes, it was shot over a year's time in 10 locations in England and Italy, such as the Colosseum in Rome, magnificent *palazzi* in Lucca, and areas in Salisbury and Florence.

With the exception of the film's prologue, a curious depiction of beautiful young women in modern dress lying languidly about on the grass, and a strangely ambivalent conclusion, the film hews closely to the basic plotline, i.e., the arrival in England of Isabel (Nicole Kidman), her rejection of the advances of Warburton and Goodwood, her reception of her uncle's legacy (John Gielgud), the unfortunate marriage to the malignant Osmond (John Malkovich), and the revelations about the byzantine manipulations of Osmond and his former mistress Madame Merle (Barbara Hershey). However, the overtly erotic implication of the story (including a fantasy sequence involving Isabel in bed with all three of her suitors and a moment smacking of necrophilia when Isabel passionately kisses the dying Ralph Touchett) is entirely the product of Campion and screenwriter Laura Jones. So, too, is an episode marked "My Journey," a dream sequence shot in a herky-jerky parody of a silent film, in which a feverish Isabel, clad in Bedouin garb, encounters a host of exotic Arabian scenes and Daliesque imagery. A more profoundly significant diversion from the novel is the suggestion that Isabel succumbs to Osmond in what commentator Laura Miller describes as "a kind of masochistic sexual swoon," and that she allows herself to be "bullied by his outright physical abuse." Indeed, in one of the film's ugliest scenes Osmond slaps her and wrestles her to the ground. Rather, James made it clear that she chose Osmond precisely because of his *weakness*, his self-pro-

fessed passivity and financial need. He controls her, concludes Miller, "not with violence, but by insinuating that every time she defies him she is doing something small and ignoble, going back on a vow—degrading, essentially, her fine idea of herself."

The problem underlying any attempt to adapt James lies, of course, in his penchant to sacrifice physical incident to the psychological probings of the fine sensibilities that inhabit his pages. If the film medium depends upon the correlations of outer surface and inner life, James does precisely the opposite: He writes about those things excluded from that equation—the imagined, the undone, the unseen. Campion's film gamely tries to compensate for all these invisibilities by adding incidents and underscoring the imagery.

Critical reception has been mixed. While Kathleen Murphy admires its "densely telling hues and uncompromising forms," Anthony Lane complains that it is "so stuffed and embroidered with visual significance that you find yourself fighting for air . . . The picture suffers, in fact, from all the faults that anti-Jamesians traditionally, and wrongly, ascribe to the Master: it is drawn out, overworked, packed with artsy energies that send it nowhere but keep it running furiously in place."

REFERENCES

Edel, Leon, *Henry James: The Conquest of London, 1870–1881* (J.B. Lippincott, 1962); Lane, Anthony, "Immaterial Girls," *The New Yorker*, January 6, 1997, 74–75; Miller, Laura, "Henry James: Losing It at the Movies," *New York Times Book Review*, January 19, 1997, 31; Murphy, Kathleen, "Jane Campion's Shining Portrait of a Director," *Film Comment* (November– December 1996): 28–33.

—J.C.T.

POSSESSION (1990)

A.S. BYATT

Possession (2002), U.S.A., directed by Neil LaBute, adapted by LaBute, Laura Jones, and David Henry Hwang; Warner Brothers.

The Novel

A.S. Byatt's award-winning novel at first appears to be a work that would defy adaptation. *Possession* is a bookish book—long, complex, brimming with literary in-jokes and allusions. But it is also a book that wants to delight the everyday reader. Antonia Byatt deliberately wrote it as a crowd pleaser, after writing serious fiction in England for nearly 30 years. *Possession* crosses over into many genres, including academic comedy, romance, and detective fiction. While the postmodern qualities of the book seized the attention of academics, the love stories, humor, and eventful plot appealed to the large readership that made it a best-seller.

Byatt was influenced by John Fowles's *The French Lieu-
tenant's Woman* and Umberto Eco's *The Name of the Rose* to
write a historical novel informed, with a wink, by contem-
porary qualities. The narrative functions on two levels. In
the present day, two British scholars, Roland Michell and
Maud Bailey, piece together the mysterious love story of
two Victorian poets after Roland discovers drafts of tanta-
lizing letters while doing research in the London Library.
The two poets are Randolph Henry Ash (who resembles
Robert Browning, among others) and Christabel LaMotte
(Byatt's fictionalized amalgam of Emily Dickinson and
Christina Rossetti). By creating love letters, poems, sto-
ries, and journals written by Ash, LaMotte, and other
19th-century characters, Byatt allows the reader gradual
access to their story, encouraging us to be critics and
detectives along with Roland and Maud. The novel only
occasionally gives the reader direct access to the 19th cen-
tury, but even so, it becomes obvious that the Victorians
live a more vigorous and multidimensional life than the
repressed 20th-century characters.

Byatt's romantic plot centers on the age-old motif of
the attraction between apparent opposites. Maud is a suc-
cessful young feminist, firmly ensconced in the world of
women's studies. Roland is scruffy and less successful, an
underemployed Ash specialist who lives with his unhappy
girlfriend Val in a basement flat that smells of the upstairs
cats. Maud refuses at first to believe Roland's theory that
LaMotte, a supposed lesbian and cult favorite among
feminists, could possibly have been the lover of Ash, a
prominent poet whom she considers patriarchal and tra-
ditional. Despite their antagonistic start, Maud and
Roland become gripped by the story they are unraveling,
find they have a mutual passion for poetry, and learn to
respect the knowledge of the other. Naturally, they also
experience the electricity of an unwanted sexual attrac-
tion, and Byatt gleefully keeps them from fulfilling their
uneasy desire until the final pages. Ash and LaMotte also
are unlikely lovers. Ash is, on the surface, a happily mar-
ried pillar of London intellectual life, while LaMotte is
reclusive, given to writing enigmatic verse on eccentric
themes.

The cast is augmented with a number of supporting
players in mostly comic roles: the flamboyant bisexual
American professor, Leonora Stern; the repressed and
anxious British researcher, Beatrice Nest; Roland's dour
supervisor, James Blackadder; the crusty owner of the cas-
tle where the love letters are hidden, Sir George Bailey.
Especially entertaining are two villains: Mortimer Crop-
per, who specializes in acquiring cultural artifacts and
whisking them to his American museum; and Fergus
Wolff, a handsome sexual predator who is a specialist in
postmodern literature, and through whom Byatt gets in
many digs at contemporary academic trends. All of these
characters become involved in the quest for the truth
about LaMotte and Ash, and the action moves briskly from
London to Lincoln to Yorkshire and finally to Brittany,
with the minor characters chasing Roland and Maud,

and the ownership of the important cache of love letters
threatening to cause a major cultural commotion.

Several mysteries are gradually untangled. The passion-
ate and tragic affair between LaMotte and Ash is es-
tablished, as is the existence of a child. The scholars learn
about the tragic end of Blanche Glover, LaMotte's com-
panion. Maud discovers her own surprising relation to both
poets. Finally, there is insight into the marriage of Ran-
dolph and Ellen Ash. In a moving section provided by the
narrator only to the reader (not to the scholar-detectives),
we learn that Ellen and Randolph never consummate their
marriage. Thus, in Byatt's intricate detective story, docu-
ments available to the scholars are also available to the
reader, but the reader is additionally able to enjoy privi-
leged information, a brief direct window into the past. We
alone know, for another example, that Ash does meet his
daughter Maia. Byatt affirms her faith in the reader and in
the primary importance of story, whereas other postmod-
ern novelists, with various narrative tricks, relish pulling
the rug out from under the reader.

Byatt's earlier fiction bears some resemblance to the
novels of Iris Murdoch, with their philosophical themes
and psychological investigations. In *Possession*, however,
Byatt was able to handle intellectual material with a light
touch, using warm-hearted comic characters and a pas-
sionate romantic plot.

The Film

American playwright and director Neil LaBute was an unex-
pected choice to make the adaptation of *Possession*. LaBute's
dark comedies about conflict between the sexes (*In the Com-
pany of Men, Your Friends and Neighbors*) are notorious for
their pitiless dissection of relationships and, in particular,
male anger. LaBute does have an appropriately sharp verbal
wit and apparent feminist sympathies, although this is much
debated. Andrew Sarris in the *New York Observer* has called
LaBute "witheringly misanthropic and misogynous" but
John Lahr in *The New Yorker* has championed LaBute as a
moralist who is provocative "not for the sake of shock but to
make an audience think against its own received opinions."
Those who worried about the Americanization of a British
novel were somewhat justified, as Roland was transformed
into an American researcher played by Aaron Eckhart, and
Gwyneth Paltrow starred as Maud. However, Eckhart is
appealing, and Paltrow manages a decent British accent, as
she did in *Emma* and *Shakespeare in Love*.

Although the tension in the novel between the tattered
but admirable British academics and their slick and mon-
eyed American rivals is largely absent from the screen ver-
sion, LaBute's *Possession* strives for accuracy in some
respects. The look of the Victorian scenes is lush and sen-
suous; LaBute wisely picked up on references to the Pre-
Raphaelites in the text. Luciana Arrighi, the production
designer, has worked on Merchant Ivory films, and the
quality is apparent. The director is obviously indebted to
Karel Reisz's film of *The French Lieutenant's Woman*, to the

point where Michael Wilmington has written that *Possession* "almost suggests visual plagiarism." The present-day sections lack excitement, and generally the cautious, prosaic atmosphere is surprising and disappointing, given LaBute's reputation.

In deciding what to leave out of their adaptation of such a voluminous novel, the adapters chose to emphasize conventional romance at the expense of comedy, quest tale, and academic hijinks. It is understandable that much of the literary discussion should be abandoned, but as a result the film is rather flat, since the two romances under scrutiny thrive precisely on intellectual conversations. Jennifer Ehle and Jeremy Northam are excellently cast as LaMotte and Ash, but are not given much to do but look soulfully at each other and adjust various elements in their prodigious wardrobes. The erotic heart of the story should be found in the pages of the profuse Ash-LaMotte correspondence, and while the film features some recitation of the letters, there is not enough.

The adapters also misjudge the film audience's ability to perform detective work, so instead of working along with Maud and Roland to unravel the mysteries of the baby and the wound festering within the Ash marriage, the solutions are granted to us effortlessly and too quickly. For example, less than a minute of screen time elapses during the scenes in Brittany, where LaMotte flees in order to have her baby in secret; in the novel, this involves 50 pages. Byatt provides a clever red herring within the LaMotte poem "My Subject Is Spilt Milk," which leads us to wonder whether the baby died (actually, she gives the child to her sister to raise). Thinking, of course, that poetry can't translate to the screen, LaBute and his fellow screenwriters pass up the chance to use this electrifying poem and substitute rather lame dialogue that hints at foul deeds and woman's misery.

The most grievous omission is comedy. The colorful characters of Leonora Stern and Beatrice Nest are excised, as is the comic squalor of Roland's dying relationship with Val. Neglecting these female characters also creates an imbalance in the feminist debate that recurs throughout the novel and jettisons Byatt's celebration of a wide range of sympathetic character types (lesbian, heterosexual, celibate, bisexual). One of the novel's best comic scenes features Leonora Stern and James Blackadder on a TV talk show discussing the cultural importance of the Ash-LaMotte love letters. Blackadder, a stereotypical dry academic, is galvanized by the presence of the outrageous Leonora to say "one *sexy* thing" to get the attention of the public. LaBute's overly hurried screen version (the film runs about an hour and a half) omits many such scenes, missing opportunities to allow us to warm to these characters. He also rushes through the novel's funny and melodramatic concluding cemetery scene, where the cast assembles at Ash's grave to dig up buried papers during a tremendous storm.

Generally, magic and mystery are lacking in the film, although the cast is good. Paltrow is perhaps too icy as Maud. This is in character, but the chill spreads to other elements of the film. LaBute depends on predictable piercing looks and kisses for his romance, and it never catches fire. The romance should be based on thought, conversation, and writing; a pleasantly "papery" book becomes strangely watery with sentimental glances and tears.

The Victorian sections of the film have preserved some of the original dialogue, but the screenwriters have tinkered unnecessarily with the contemporary scenes. By tampering with the relation that Byatt sets up between the two centuries, the film damages one of her major themes. In the novel, even though we have few moments of direct access to the 19th century and primarily glimpse it through documents, we nevertheless realize that the Victorians are much more vital and courageous than the neurotic present-day academics, who are living a half-existence, frightened of emotion. In the movie, the emphasis accidentally gets reversed. We spend too much time on Roland and Maud's incipient romance. The Victorians remain distant, still and quiet as if sitting for their portraits.

Whenever the film uses a selection from the poetry or letters that Byatt painstakingly created, it briefly flares into life. This novel appealed to people nostalgic for an era of detailed and heartfelt written communication. Who would not want to receive a letter that runs, "I have dreamed nightly of your face and walked the streets of my daily life with the rhythms of your writing singing in my silent brain"? Happily, this line does make it into the film, and although he is too straightforward and brisk, Neil LaBute does an adequate job of a difficult adaptation.

REFERENCES

Lahr, John, "A Touch of Bad," *New Yorker*, July 5, 1999, 42–49; Sarris, Andrew, film review of *Possession*, *New York Observer*, August 19, 2002, 21; Wilmington, Michael, film review of *Possession*, *Chicago Tribune*, August 16, 2002, 9.

—*S. Sorensen*

THE POSTMAN ALWAYS RINGS TWICE (1934)

JAMES M. CAIN

Le Dernier Tournant (1939), France, directed by Pierre Chenal; Gladiator Productions.

Ossessione (1942), Italy, directed and adapted by Luchino Visconti (assisted by Antonio Pietrangeli and Mario Alicata); Industrie Cinematografiche Italiane S.A.

The Postman Always Rings Twice (1946), U.S.A., directed by Tay Garnett, adapted by Harry Ruskin and Niven Busch; MGM.

The Postman Always Rings Twice (1981), U.S.A., directed by Bob Rafelson, adapted by David Mamet; MGM.

The Novel

American depression-era writers like Dashiell Hammett, Raymond Chandler, and James M. Cain crafted a type of

hard-boiled, violent melodrama that represented a new fusion of the traditional detective genre, European naturalism, and the "tough guy" thriller. Appearing in 1934, Cain's *The Postman Always Rings Twice*, his first novel, was a classic dissection of the dark side of the American dream. The characters Frank and Cora craved not only sex and freedom but also respectability and property—even if they must commit murder in the process. Cain's use of ironies, spare exposition, and swift dialogue rhythms was a model of taut, modern storytelling.

Writing on the eve of his execution, Frank Chambers reflects back on the chain of lust, murder, and betrayal that led him to the Death House. Frank is a 24-year-old vagrant who stopped at a roadside tavern and service station outside Los Angeles, stayed on to work for the owner, Nick Papadakis, had an affair with Nick's voluptuous wife Cora, and then conspired with her to kill him. All of that in the first 23 pages! Their first murder attempt failed, and the lovers ran away together. But Cora was afraid of losing Nick's money and the two lovers returned to make another attempt. Frank got Nick drunk while driving along the dangerous coastline of Santa Barbara, hit him on the head with a bottle, and drove the car off a cliff to finish the job. But Frank was injured in the process and soon fell under the suspicion of Sackett, the local D.A. Although neither Frank nor Cora (who is now pregnant) was convicted of murder, they suffered a different kind of punishment: Their relationship turned sour, fraught with bickering and recriminations. But after an apparent reconciliation during a beach outing on the Santa Monica coastline, Frank collides with a truck while driving home and Cora is killed. The police found a note she had written earlier in which she acknowledged their complicity in the murder of Nick. Frank was now suspected of having engineered the wreck to get Nick's insurance money. Because he could not be tried twice for Nick's death, he was convicted and now awaits execution for murdering Cora.

The Films

Four motion picture adaptations have appeared. *Le Dernier Tournant* (1939), directed by Pierre Chenal, is a little-known French version. In 1942 the 30-year-old Luchino Visconti produced his first film, *Ossessione*, as an attempt to appease Fascist critics of his previous, unfinished projects. Perhaps in adapting an American thriller about a destructive love triangle Visconti thought he might escape attacks from the political left. Nonetheless, Italian censors protested it as a critique of working-class life under Mussolini. For this and other reasons, including its violation of MGM's ownership of the screen rights, the film was withdrawn from circulation and remained unseen in the United States until the late 1970s. *Ossessione* was a landmark in Italian neorealism and a prototype of the film noir style. Visconti transferred the American setting to the Delta Ferrarese, a marshy region in northern Italy, where

a trio of characters—the dissatisfied wife, Giovanna (Clara Calamai), the vulgar husband, Bragana (J. de Landa), and the charming stranger, Gino (Massimo Girotti)—became embroiled in a destructive triangle. An added subplot is Gino's relationship with a secondary character, Spagnolo, a homoerotic element present in many subsequent Visconti films. After Gino and Giovanna murder Bragana in a simulated automobile accident, they are hounded by suspicious police. Their relationship, which has grown sour, is strengthened when Giovanna realizes she is pregnant. Here Visconti reveals his sympathy with the characters (he thought Gino "a symbol of revolution and freedom of thought"), lending them a poetic, almost heroic stature. But their short-lived reconciliation is shattered by a real automobile accident in which Giovanna is killed. The film ends with Gino's arrest. This squalid view of lower-class life was a turning point in Italian cinema, writes Visconti biographer Claretta Tonetti: "The idealization of reality is over in Italian films; the new trend, initiated by Visconti, will not suppress the dark side of life."

If Gino's fate is unclear, there is no doubt of the divine justice that awaits the murderers in the first American version, directed by Tay Garnett for MGM. In a voiceover, Frank narrates the story from Death Row (a device used in an earlier Cain adaptation, Billy Wilder's *Double Indemnity*, 1943) in an attempt to replicate the novel's first-person point of view: "You know," he tells a detective, "there's something about this which is like expecting a letter you're just crazy to get, and you hang around the front door for fear you might not hear 'em ring. You never realize that he always rings twice . . ." The "postman" is obviously a metaphor for the grim reaper. The introduction to Lana Turner's Cora is a classic moment in noir cinema, a slow camera pan from a dropped lipstick up along her slim, white-clad body to her face, a visual seduction somewhat different from the book's description—"Her eyes were shining up at me like two blue stars. It was like being in church." (Cain congratulated Turner on her characterization, remarking, "Thank you for giving a performance that was even finer than I expected," even though Lana Turner is no "Mexican Spitfire.") Although the basic story line is intact, Frank and Cora's relationship is portrayed more sympathetically than in the book. This is significant, because since 1934, when first RKO and then Columbia and MGM expressed interest in the novel, the Production Code Administration protested the elements of adultery, sordid violence, lust, pregnancy, and unpunished crime, and did its best to keep the story off the screen altogether. "Its picturization would be fraught with the gravest dangers to the industry as a whole," wrote chief censor Will Hays. "In all sincerity, it is difficult to conceive a more unwholesome narrative . . ." However, in 1946 MGM did an end-run around the objections by tailoring the script to Code dictates. "It was a real chore to do *Postman* under the [Code]," said Garnett, "but I think I managed to get the sex across. I think I like it better that way." The resulting film proved to be a sternly moral cautionary fable with

implied rather than explicit sex and violence; due punishment was explicitly meted out.

No such restrictions hampered the 1981 remake, directed by Bob Rafelson and scripted by David Mamet. The story is returned to its Depression-era setting, and elements from the novel not in the Garnett version are restored, notably Cora's pregnancy and the $10,000 insurance policy that comes to Cora after her husband's death. Oddly, some of the details of the murder plot hatched by Frank (Jack Nicholson) and Cora (Jessica Lange) are omitted. For the first time, the sexual savagery between Cora and Frank is brutally depicted, notably the notorious near-rape on a kitchen table top covered with flour. Indeed, the brutal intensity of such scenes approaches self-parody. While critic Roger Ebert admired the movie's period atmosphere ("every last weathered Coke sign, every old auto and old overcoat and old cliche have been put in with loving care") and the driven performances of Nicholson and Lange, he complained of the lack of tragic stature to the story: "[The characters] are kept rigidly imprisoned within a tradition of absolute naturalism: They exist, they eat, they sleep, they act." And of course they fornicate passionately. Yet in that detachment one could argue that Rafelson and Mamet have come closer to the Cain original than any of the films that preceded them. The postman fails to ring twice in this adaptation, however, which ends with Frank grieving over Cora's body. He is left uncaptured at the end.

REFERENCES

Gardner, Gerald, *The Censorship Papers* (Dodd, Mead, 1987); Silver, Alain and Elizabeth Ward, eds., *Film Noir* (Overlook Press, 1979); Tonetti, Claretta, *Luchino Visconti* (Twayne, 1983).

—S.C.M., J.C.T., and J.M. Welsh

PRESTUPLENIE I NAKAZANIYE (1866)

See CRIME AND PUNISHMENT.

PRIDE AND PREJUDICE (1813)

JANE AUSTEN

Pride and Prejudice (1940), U.S.A., directed by Robert Z. Leonard, adapted by Aldous Huxley and Jane Murfin; Metro-Goldwyn-Mayer.

The Novel

Even in her early writing, Jane Austen possessed an ironic humor and keenness for social observation that she refined in her later novels. One piece of juvenilia entitled "First Impressions" that she completed in 1797 would appear 16 years later as one of her most adored works, *Pride and Prejudice*. For some reason, Austen did not write very much for almost a decade, but her father submitted *Pride and Prejudice* for publication and it appeared anonymously on January 29, 1813. It turned out to be one of her contemporaries' favorites, which accounts for the fact that it was the only novel to go to three printings during Austen's lifetime.

Situated at the turn of the 19th century, *Pride and Prejudice* is an astute tale of class distinctions and identifying truth from appearances. The mother of the Bennet family, whose "business of her life was to get her daughters married," is a silly woman who uses every social trick in the book, while her sarcastic husband amusedly watches from the sidelines. Her anxiety is particularly high because an entail will transfer the property to Mr. Collins, their foolish, officious cousin. Considering that this was a time when marriages were economic contracts, it is no surprise that the town turns upside down at the arrival of Mr. Bingley and Mr. Darcy, two affluent bachelors. The former becomes interested in gentle Jane Bennet, but class is a barrier to their union—his sister Caroline is more concerned with Bingley acquiring an estate and an accomplished, wealthy wife. This snobbery manifests itself through the proud Darcy who slights Elizabeth Bennet, an intelligent young woman who abhors judgments based on social background. His insult mortifies her, and she concludes that he is nothing more than a pompous, ill-mannered man. But the class gulf between them does not prevent Darcy from becoming intrigued by her mind and spirit. Yet her prejudice against him increases with the help of the dashing Mr. Wickham, a military officer who slanders Darcy.

While visiting Charlotte and Mr. Collins, Elizabeth spends several evenings at the estate of Lady Catherine de Bourgh, Mr. Collins's patron, who is coincidentally Darcy's aunt. Elizabeth is the only guest who remains composed next to the haughty grandeur of Pemberley and stands her ground when the opinionated matron questions her about the lack of social privileges and practices in the Bennet household. Darcy eventually confess his love, albeit it is a confession laced with recognition of her inferiority. These references to her family stir up her prejudice, which peaks when she discovers that he dissuaded Bingley from marrying Jane, and she refuses him. However, Elizabeth eventually learns that Wickham had attempted to elope with Darcy's sister to get access to the family fortune. At this moment of recognition of misjudgment, she regrets the injustices she bestowed upon Darcy. Unfortunately, her younger sister Lydia has eloped with Wickham, and to everyone's horror they are not married. This event erupts into a scandal for the Bennet clan because, as their sister Mary observes, "the loss of virtue in a female is irretrievable—that one false step involves her endless ruin." Ironically it is Darcy who settles Wickham with an annuity so that he will agree to marry Lydia. Elizabeth apologizes to Darcy for her impertinence, and he credits her for breaking down his wall of tribal pride. The narrative ends with domestic closure—Elizabeth and Darcy are united in spite of his aunt's disapproval, as are Jane and Bingley.

The Film

Fifteen stage productions and a 1985 British Broadcasting Corporation adaptation notwithstanding, Robert Z. Leonard's 1940 production of *Pride and Prejudice* is the sole motion picture version, and a successful one at that. The main vehicle that illuminates this satirical novel of manners is the sound characterizations portrayed by the cast. As one critic notes, "Laurence Olivier is Mr. Darcy, that's all there is to it." Other actors, particularly Mary Boland (Mrs. Bennet), Edmund Gwenn (Mr. Bennet), Greer Garson (Elizabeth Bennet), and Edna May Oliver (Lady Catherine de Bourgh) bring much personality to their roles. The screenplay remains faithful to the book, although, at times, Leonard gives "farce free rein." While Austen sustains a heightened level of clever dialogue, the screenwriters insert various slapstick scenes such as the squawking parrot, Lady Catherine sitting on a music box, Mr. Collins scurrying on his knees as he proposes to Elizabeth, and the tipsy tendencies of Lydia and Kitty. For some viewers, these absurdities may seen incongruous with the sophisticated wit of the original text. On the other hand, some script additions brilliantly capture the flavor of Austen's *Pride and Prejudice*. In the opening sequence, after the Bennets and Lucases accumulate the gossip on the new bachelors, they race their carriages home in a comical mad dash. This action crystallizes the competition between the mothers to ensure weddings for their daughters, for in the marriage game every second counts.

The cinematic medium proves to be a fitting representation of *Pride and Prejudice*. Austen wrote during a time when mannerisms provided clearly understood signs of social meaning. Thus, Darcy's stiff carriage, Caroline's condescending tone of voice, Mr. Collins's bows and compliments aplenty, Anne de Bourgh's sneers, as well as the

flirtatious gestures of Lydia all typify the roles that each character assumes in the social landscape. While these are all illustrations of how Leonard captures the novel's tone, one article argues that it is difficult for a film to "present Elizabeth's intellectualism, idealism, morality, spiritualism—in short her inner life" because it is her internal point of view and transformation of consciousness that results in the recognition of her prejudice. It is true that the movie lacks some phases in her moral development. For example, Garson fails to detect her family's lack of propriety as the main cause of the Jane and Bingley breakup. Furthermore, the movie omits some insightful conversations between Elizabeth and Darcy. But to claim that Garson falls short in terms of intelligence, idealism, and morality is unwarranted.

There is one narrative slice of *Pride and Prejudice* that Leonard fulfills even better than Austen herself—the dramatic resolution of the emerging and evolving romance between Elizabeth and Darcy. Readers follow their development throughout the text and finally arrive at the reconciliation scene where, instead of encountering absorbing dialogue as they reveal their feelings, they are rewarded with a detached third-person voice. As John Halperin notes,

> It is an anticlimax of awful proportions, and it is a mistake Jane Austen makes in all of her books. If she has one overriding fault as a writer, it is her obvious and overhasty desire, near the ends of her novels, to wrap up loose ends and get the thing over with, once the dénouement has been reached, as quickly as possible. It is as if she has had enough of her people by the end of the book and cannot wait to get rid of them once they have reached their happy ending.

But Leonard does not disappoint us. To begin with, the glances, facial expressions, and verbal flirtations help to suggest a growing attraction. The scene at Pemberley opens with a dramatic surprise encounter between Elizabeth and Darcy that evolves into an evening of repartee. The tension mounts as Lady Catherine interrupts their piano work and calls each of them over for separate interviews. Ironically, the matron takes this opportunity to tell her nephew that the family always intended for him to marry her daughter Anne, but all the while he wants to marry the woman sitting across the room. Finally, instead of an anticlimactic union and an additional 20 pages that the book offers, the next to the last scene includes Elizabeth and Darcy in the garden where they achieve a romantic resolution. Whereas the original characters agree to marry and then give a history of their mistakes, Garson and Olivier resolve past misunderstandings before they seal their intent to marry with a kiss, which deepens the audience's anticipation.

Laurence Olivier and Greer Garson in Pride and Prejudice, *directed by Robert Z. Leonard* (1940, U.S.A.; MGM/ THEATRE COLLECTION, FREE LIBRARY OF PHILADELPHIA)

REFERENCES

Ames, Richard Sheridan, review in *Selected Film Criticism* 4 (August 17, 1940): 202–03; Crowther, Bosley, review in *New York Times*,

August 9, 1940; Halperin, John, *The Life of Jane Austen* (Johns Hopkins University Press, 1984); Lellis, George and H. Philip Bolton, "Pride but No Prejudice," in *English Novel and the Movies*, eds. Michael Klein and Gillian Parker (Frederick Ungar, 1981), 45–51.

—*R.L.N.*

PROFESSOR UNRAT (1905)

See THE BLUE ANGEL.

DER PROZESS (1925)

See THE TRIAL.

PSYCHO (1959)

ROBERT BLOCH

Psycho (1960), U.S.A., directed by Alfred Hitchcock, adapted by Joseph Stefano; Universal.

Psycho (1998), U.S.A., directed by Gus Van Sant, adapted by Joseph Stefano; Universal.

The Novel

The real-life activities of Wisconsin murderer Ed Gein provided the inspiration for Robert Bloch's novel of Grand Guignol horror. Gein, who kept the body of his long-dead mother in his isolated family home, killed females, ate parts of their bodies, and often fashioned clothing out of their skins. It was Bloch's genius to couple these horrific events with his own lifelong preoccupation with multiple personalities.

The novel opens with a plump, balding, 40-year-old Norman Bates, proprietor of the Bates Motel somewhere in the Southwest, reading a passage from Victor W. Von Hagen's *The Revolt of the Incas*, which describes a victory dance wherein drumbeats are struck upon flayed skin. In a "conversation" with his abusive mother, he is berated for his "filthy" interest in psychology and fascination with the dangers of Oedipal attachments. Arriving for the night at the Bates Motel is 27-year-old Mary Crane. She has taken the wrong turn from the main highway. Unbeknownst to Norman, she has also stolen $40,000 from a business associate of her boss in Fort Worth; soon she intends to join her lover, Sam Loomis, in Fairvale, where they will marry and use the money to pay off his father's business debt. Signing in under the false name of Jane Wilson, she joins Norman at his home on the hill for a snack in the parlor. She enters the big house on the hillside and is surprised that it lacks modern appurtenances like television and appliances.

After their conversation in the kitchen, in which Norman complains about his problems with his mother, Mary returns to her motel room. Thinking that "perhaps all of us go a little crazy at times," she has a change of heart and decides to return the stolen money to her employer's bank.

Relieved of her guilt, she lightheartedly enters the shower to clean up. At that instant a crazy old woman wielding a butcher's knife bursts in and decapitates her. Norman, meanwhile, after reviving from an alcoholic blackout, discovers Mary's body, and, believing his mother is to blame, puts it in a hamper inside her automobile, and pushes it into a nearby swamp.

A few days later Mary's sister Lila arrives at Sam's hardware store looking for Mary. They are joined by insurance investigator Milton Arbogast, who is on the trail of the stolen money. Arbogast goes to question Norman. Norman's mother intervenes and kills Arbogast with her son's razor. Concerned about Arbogast's disappearance, Sam and Lila contact Sheriff Chambers. He informs them that Mrs. Bates died 20 years before.

Alarmed at recent events, Norman carries his mother into the basement fruit cellar. Sam and Lila arrive at the motel, masquerading as a married couple. But Norman recognizes Lila as Mary's sister and overhears them talking in their room about their discovery of incriminating evidence, Mary's earring. Lila plans to alert Sheriff Chambers while Sam detains Norman. But Lila changes her mind and goes back to the Bates mansion, where she finds books of black magic and pornography. Believing that Norman might have incinerated Mary's body, she goes down to the cellar. There she discovers the preserved corpse of Mrs. Bates. At that moment Norman, who has escaped Sam, appears dressed in his mother's clothes at the top of the cellar stairs and screams "I am Norma Bates!" Before he/she can murder Lila, Sam arrives, overpowers Norman, and rescues Lila.

Later, Sam tells Lila about an examination of Norman conducted by Dr. Nicholas Steiner. Norman had poisoned his mother years ago and, in his deranged state, had apparently taken on her personality. Steiner speculates that it was at "Mother's" directive that he had committed the murders. Now, in the mental hospital, Norman is hopelessly psychotic; his two personalities have fused, leaving only Mother in charge, who condemns her son for the crimes and wishes now only to show the world that "she wouldn't even hurt a fly."

Although Bloch's achievement has been eclipsed in the popular consciousness by the celebrated Hitchcock adaptation, the novel itself has profoundly influenced the whole direction of modern horror writing. As writer Hugh B. Cave has noted, "Back onto dusty shelves went most of the vampires, the werewolves, and other such beasties of the Victorian novelists. To front and centre came a probing of people's minds and an awareness of the frightening things to be found lurking there. . . . With this novel Robert Bloch took us from then to now in one big, scary leap. . . . Almost every present-day writer of horror has in one way or another been influenced by *Psycho*."

The Films

It might truly be said that Alfred Hitchcock directed this film twice, once while living and a second time when

dead. The circumstances of both versions constitute a unique chapter in the history of literary-film adaptations. In her classic study of the modern horror film, *Men, Women, and Chainsaws*, Carol J. Clover describes the 1960 Alfred Hitchcock/Joseph Stefano adaptation (Hitch's 47th picture) as "the appointed ancestor of the slasher film," with the now-familiar elements of a psychotic killer who is the product of a sick family, a victim who is a beautiful, sexually active woman, and a slaying that is particularly brutal and is registered from the victim's point of view. Among the numerous progeny spawned by this most influential of modern horror films are *Homicidal* (1961), *The Texas Chainsaw Massacre* (1974), *Halloween* (1978), *Motel Hell* (1980), and *Dressed to Kill* (1980). What is often forgotten, however, is that it was Hitch's first true horror film; ever after, he would be regarded primarily (if erroneously) as a horror director. Moreover, it was in many ways the direct product of his television anthology series, *Alfred Hitchcock Presents*. It was not made by his usual motion picture unit but by a crew from the series (including cinematographer John L. Russell). It was shot quickly and on a limited budget (Anthony Perkins, Janet Leigh, and Vera Miles were paid considerably less than Hitch's usual set of reliables, like James Stewart and Cary Grant); and it was promoted in a manner recalling Hitch's famous television monologues. Moreover, its black-and-white photography looked very much like an extended episode of the series.

Hitchcock told François Truffaut that the "suddenness of the murder in the shower, coming, as it were, out of the blue—only one-third of the way through the Bloch novel—did not hold him back from making the film in the first place. Hitchcock and screenwriter Joseph Stefano approached the book as a cinematic challenge, with its brutal shower scene as its tour de force (it and the scene of Arbogast's murder were eventually storyboarded by graphic designer Saul Bass). While many details of the book were retained, like Mother's closing monologue about not harming a fly (capped by the addition of an image superimposing a skull over Norman's features), major changes were made in the adaptation. It was Stefano's idea to transform the pudgy, middle-aged Norman into a more appealing, "tender, vulnerable young man you could feel incredibly sorry for." Stefano also opted to begin the screenplay with Marion's story rather than with Norman's. And nothing could have prepared the reader of the Bloch novel for Bernard Herrmann's celebrated music score, which undoubtedly ratcheted up by several notches the impact of the violence. (Herrmann's determination to provide an elaborate, even obtrusive score of what he called "black-and-white" strings eventually won the day over Hitch's initial reluctance to feature music prominently.)

Because this was a Grand Guignol rather than a psychological study, the subtleties of Norman's voyeurism and Oedipal complex took a back seat to Hitch's predilection for sensational melodrama. Commentator Mark Jankovich argues that the film fails to touch on the complexities of Norman's misogyny and the conditions of his psychotic state. The book's extended "dialogues" between Norman and Mother, so revelatory of his unstable position between the need to be dominated by Mother and the counter-need to dominate other women (the fear of growing up versus the desire for omnipotence), are deleted. And Bloch's final warning that Norman's psychological condition may never be fully explained—the psychiatrist's "educated guess" is that "we'll never know just how much [Mother] was responsible for what he became"—is also ignored in favor of the film's rather glib, rational explanation. The fault may be Hitchcock's, according to Stephen Rebello, whose book on the making of *Psycho* is definitive: "The unease Hitchcock appeared to feel toward letting *Psycho* be anything more than a straight-out shocker hit Stefano hard. According to [him], at the first sign that the characters or situation might carry emotional weight, Hitchcock ridiculed or cut it."

Forgotten today are the film's problems with the censors. Scenes like the opening moments with Marion and Sam together in bed (the first such scene in a mainstream Hollywood film), shots of the toilet in Marion's room, and the shower murder, all aroused the wrath of the Production Code censors. However, as Rebello reports, Hitchcock duly received orders to make cuts, then ignored them. No one seems to have noticed when he sent the scenes back to the censors unaltered.

Despite initially lukewarm reviews, the picture opened to sensational box office. "No amount of optimism or carefully orchestrated hucksterism could have prepared anyone—least of all Alfred Hitchcock—for the firestorm the film was creating," writes Rebello. "Certainly no one could have predicted how powerfully *Psycho* tapped into the American subconscious. Faintings. Walkouts. Repeat visits. Boycotts. Angry phone calls and letters. Talk of banning the film rang from church pulpits and psychiatrists' offices. Never before had any director so worked the emotions of the audience like stops on an organ console. Only the American public first knew what a monster Hitchcock had spawned."

The 1998 *Psycho*, directed by Gus Van Sant from the original Joseph Stefano screenplay, proves definitively that you can't go home again. Van Sant had been pitching a new *Psycho* to the Universal studio executives for years before the success of his *Good Will Hunting* gave him the clout to make it happen. Perhaps few executives at Universal knew at the time the extent to which Van Sant planned to replicate the original, down to the shooting schedule, the script, the shot lists, the dialogue, Bernard Herrmann's music, most of the sets, even the timing of the actors' deliveries. The question is, as so many critics and Hitchcock devotees have subsequently asked, "Why?" Among Van Sant's more interesting responses: "I've always had a great appreciation for Hitchcock, but I never really

Anne Heche in Psycho, *directed by Gus Van Sant* (1998, U.S.A.; UNIVERSAL CITY STUDIOS PRODUCTIONS, INC.)

knew how he made his films. So the challenge was to follow his footsteps, to go back and figure out how he set up his shots." Besides, Van Sant adds, "It's never been done before."

Despite the slavishness of this imitation, the results are still more Van Sant than Hitchcock—proving once again that a film script, no matter how detailed and how slavishly followed, can never be anything more than a sketch waiting to be fleshed out in the hands of a given filmmaker. In the first place, the story has been updated. Marion Crane has now stolen $400,000 rather than a paltry $40,000. She is more feminist activist than passive doormat, and she sasses back the state trooper who accosts her on the highway ("Why?" she asks irritably when requested to turn over her license). Room rent at the Bates Motel has risen to $36.50. Marion's sister, Lila, wears a Walkman. And Norman keeps porno magazines and toy soldiers in his room (oddly, an addition that marks a return to a detail in Robert Bloch's original novel).

Other differences become apparent. The Bates mansion has a new facade, its Victorian gingerbread replaced by a blunt, brick face. The famous shower-scene montage now inexplicably contains a couple of flash cuts of a stormy sky and the pupil of an eye (and why, oh why, is there a pause of two full beats between the ripping aside of the shower curtain and the strident blast of Herrmann's music?); and one shot of Marion's nude backside reveals two or three nasty knife wounds (a sly reference to scenes that had to be cut in Hitchcock's original). Norman masturbates while spying on Marion through a peephole in the wall. And the montage of Arbogast's death also has

added—again, inexplicably—flash cuts of a woman and a view of a roadside.

But there are other, more serious alterations to consider, which create ruptures in this misbegotten game of copycat. The formerly black-and-white movie has acquired a pallid, desert-pastel color scheme (which suffuses the gothic atmosphere with an unwelcome, warm pallor); the rerecorded music track (supervised by Danny Elfman) is curiously lackluster and lacks the biting edge of the original; and the casting is wildly inconsistent. As good as William H. Macy is in the Martin Balsam role of the insurance investigator, Vince Vaughn's Norman Bates seems only mildly loony, more nervous than sinister, with his annoying chuckle carried over from his previous film, *Clay Pigeons.*

It might be argued that the foregoing examples are not failures in Van Sant's agenda, but cunning ways in which he has slipped under our unsuspecting eyes his own interpretive spin on the story. Maybe. "It's almost like we're doing a forgery," he has said, "like we're making a copy of the Mona Lisa or the statue of David." These words could be a feint, a misdirection worthy of that sly old dog, Hitchcock himself, leaving Van Sant free to pursue his own vision relatively undetected. Looking at it another way, Van Sant could be subverting that typically American presumption that anything and everything can be copied. Maybe he's saying that individuality and uniqueness can never be quite eliminated in the Age of Xerox.

Again, maybe. But it is also clear that if we accept this film as ultimately as much Van Sant as Hitchcock, then Van Sant must bear the blame for a movie that is curiously languid and dull. In scene after scene, the pacing is a beat or two out of whack, the tensions among the characters diffuse and weak, and the requisite suspense slack. Van Sant would have better served his audience (and perhaps Hitchcock) by departing from the story by a mile rather than coming within inches.

REFERENCES

Cave, Hugh B., "Psycho," in *Horror: 100 Best Books*, eds. Stephen Jones and Kim Newman (Carroll and Graf, 1988), 126–27; Clover, Carol J., *Men, Women, and Chain Saws* (Princeton University Press, 1992): Jancovich, Mark, *Rational Fears: American Horror in the 1950s* (Manchester University Press, 1996); Rebello, Stephen, *Alfred Hitchcock and the Making of "Psycho"* (Dembner Books, 1990); Svetkey, Benjamin, "Shower Power," *Entertainment Weekly*, December 4, 1998, 36–42.

—T.W. and J.C.T.

THE QUIET AMERICAN (1955)

GRAHAM GREENE

The Quiet American (1957), U.S.A., directed and adapted by Joseph L. Mankiewicz; Figaro/United Artists.

The Quiet American (2002), U.S.A., directed by Philip Noyce, adapted by Christopher Hampton and Robert Schenkkan; Mirage Enterprises, Saga Films, IMF/Miramax.

The Novel

The Quiet American tells the story of a love triangle complicated by politics, as a cynical and burnt-out British journalist named Fowler attempts to maintain the status quo of his own comfortable existence, both politically and romantically, while serving in Saigon during the early 1950s. The action is set in French colonial Indochina in 1952, two years before the French defeat at Dien Bien Phu, and three years before the novel was published, by which time the French were moving out and the Americans moving in to replace them. *London Times* correspondent Thomas Fowler is asked to identify a body found in the harbor. He recognizes Alden Pyle, "a quiet American," he tells French inspector Vigot. From there the story proceeds in flashback.

Fowler lives in opium-induced comfort, his every need attended to by a young, attractive Vietnamese woman named Phuong, whom he loves but cannot marry because he has left a wife in England who will not divorce him. Fowler's comfortable existence is challenged when he meets the "quiet American," a young idealist named Alden

Pyle. Pyle immediately falls in love in Phuong and offers to marry her and take her back home with him to Boston, but Pyle is not what he seems. He turns out to be an undercover troublemaker, sent by the Office of Strategic Services (the 2002 film makes it the CIA, to simplify matters) in order to foment political turmoil. His main goal is to discredit the Communist insurgents after Ho Chi Minh's defeat of the French colonial government. Pyle is the very soul of involvement; Fowler's creed, by contrast, is "I am not involved." As he tells Pyle, "I don't take sides; I just report what I see."

As Fowler learns more about Pyle, however, he changes his mind about his neutrality. After a particularly catastrophic bombing, Fowler discovers that Pyle was involved and that a plastic substance produced by an American company called Diolacton, with which Pyle works in the economic legation, is in reality an explosive substance. Pyle, secretly working in conjunction with a rogue general named Thé, who stands midway between the Communist insurgents and the French colonials—therefore representing a "third force"—has masterminded the disaster. When confronted, Pyle reveals a core of steel beneath his dapper white suit and mild-mannered ways. He admits that he is an undercover agent and that American interests are stepping up in Vietnam. The French will never win here, Pyle explains, and America will have to intervene. The bombing will help to trigger an American response: "Those lost lives are the necessary price to pay to produce a situation that ultimately will save lives," Pyle argues.

Therefore, Fowler decides to betray Pyle to the Vietnamese nationalists. "You must choose sides," Fowler is told by a French soldier, Captain Trouin, "in order to

remain human." So Fowler invites Pyle to dinner at the Vieux Moulin, knowing he is also setting him up to be attacked by armed enemies. Pyle is knifed to death, his body left in the street. And there the flashback ends. Fowler shows little emotion over the betrayal of his friend. In the novel, after Pyle's body is found under the bridge to Dakow, Inspector Vigot remarks to Fowler, "I am not altogether sorry. He was doing a lot of harm." Fowler confronts Phuong and tells her he intends to remain in Vietnam for the rest of his life. Will she come back to him? She agrees, and in the conclusion Fowler receives a telegram from his wife. She has finally consented to divorce him, freeing him to marry Phuong.

The Films

Written and directed by Joseph L. Mankiewicz, the 1957 version of *The Quiet American* was shot in Vietnam by Robert Krasker. It is wrapped in ideological billboards. The first title establishes the locale—"Saigon: 1952, Chinese New Year"—then goes on to state "there was an emperor who ruled by permission of the French, to whom [Vietnam] belonged," a dubious conclusion. At the end of the film thanks are given to the "chosen president of Vietnam." The film attempts to reverse the meaning of the novel and utterly distorts Greene's message by turning Pyle into a hero rather than a well-meaning bungler. In keeping with this propagandistic reversal, Pyle is played by Audie Murphy, who killed 241 Germans in World War II and became the most decorated soldier in American history. His iconic opposite, the communist Heng, was played by Richard Loo, a Hawaiian actor of Chinese parentage who hit his stride during World War II playing Japanese tormentors and villains. The film turns Fowler (Michael Redgrave) into a villain instead of a conflicted protagonist.

Greene considered the film an attack upon his novel. It makes Pyle entirely sympathetic while discrediting Fowler as a cowardly cynic. In the film the French police inspector Vigot's criticism of Fowler seems to be Mankiewicz's criticism of Greene. Vigot (Claude Dauphin) makes Fowler out to be a liar, an anti-American, and a communist sympathizer. Toward the end Vigot even criticizes Fowler for not being able to distinguish between reality and fictions or entertainments. Mankiewicz suggests through Vigot that Greene, like Fowler, is a misguided Englishman who is too vain and stupid to understand the political situation and is therefore duped by the communists, who, in the film, are responsible for the bombings in Saigon. Pyle, on the other hand, comes to Vietnam not as a covert agent for a phantom "Third Force" (Pyle's political dogma is not even mentioned in the film, because he has none), but as a dashing all-American boy who martyrs himself for the advancement of the American toy industry. (Vigot explains in the film that plastique is a French explosive invented by the British and has nothing to do with Pyle's interest in plastic materials.) For Mankiewicz, Pyle has no moral ambiguity and is an absolute political inno-

cent. The film is a reprehensible corruption of Greene's cautionary novel and a dismal failure as an adaptation.

The adaptation directed by Philip Noyce and released in 2002, on the other hand, was true to the novel's intent and did not distort the story or the characters in the interest of politics or propaganda. Despite the fact that the film is faithful to its source and given further authenticity because it was filmed in Vietnam, Miramax was nervous about releasing this film, which was shot in 2001. As Sharon Waxman explained, the film was quickly shelved after the terrorist attacks of September 11, 2001, because it was considered "too politically touchy." Todd McCarthy in *Variety* predicted that this "highly faithful" adaptation of Greene's "prescient" novel could "still rankle conservatives and knee-jerk patriots." Pyle is too enthusiastic about his mission; he believes in a "Third Force" that might save the day for American interests and he provides explosives to aid a campaign of political terrorism. In other words, Alden Pyle is an American terrorist who recalls the alleged exploits of Major General Edward Lansdale, who died in

Graham Greene

1987, described as the architect of what would become the Vietnam War.

Fowler understands that Pyle is dangerous and finally betrays him to put an end to Pyle's murderous antics by setting him up for a nighttime assassination. Vigot, the French police inspector investigating Pyle's death in the novel, suggests to Fowler that the motive for Pyle's murder might have been "a simple case of jealousy," since Pyle had stolen Phuong away from Fowler. But it is possible that Fowler did the right thing for the wrong reasons. As for the not-so-innocent Pyle, the ends justify the means.

This novel was driven by a moral purpose, to warn the American people against allowing their government to get involved politically in the quagmire of Vietnam. The message was ignored, of course, and Greene, perhaps the foremost Roman Catholic novelist of his era in Britain, was simply dismissed as a Communist pest in the United States. But listen to Greene, speaking through a French captain: "We are professionals; we have to go on fighting till the politicians tell us to stop. Probably they will get together and agree to the same peace that we could have had at the beginning, making nonsense of all these years."

As noted above, the 1957 adaptation was not only an outrageous violation of Greene's source novel but an absurd allegory concerning American innocence in contrast to Communist-inspired cynicism. Therefore, it was entirely appropriate that Australian director Phillip Noyce remade the film more than 40 years later, scripted this time by Christopher Hampton and Robert Schenkkan for Miramax International. Brendan Fraser was cast as Alden Pyle, and Thomas Fowler was played most impressively by Michael Caine in one of the very best performances of his career. The film premiered at the Toronto Film Festival on September 6, 2002, but was shelved for months before going into wide release. In his *Variety* review, Todd McCarthy speculated that the picture "could play into the growing public debate about the advisability of future American military intervention in distant lands."

Graham Greene is about guilt and conscience in that icy realm of moral ambiguity that critics have called "Greeneland." *New Yorker* critic Anthony Lane was especially impressed by the way Noyce filmed a key sequence at night on the road to Saigon, when Fowler's Citroën runs out of gas near a watchtower. When they come under attack while stranded in the countryside, Pyle saves Fowler's life, which ups the ante for Fowler's later betrayal. No one constructs a moral quagmire better than Graham Greene. Finding a movie equivalent for this dark night of the soul can't have been easy.

The Quiet American was certainly a critical success. Several influential reviewers named it as one of the year's best films, including Richard Corliss of *Time* magazine, David Sterritt of the *Christian Science Monitor*, Roger Ebert of the *Chicago Sun-Times*, and Kenneth Turan of the *Los Angeles Times*. Michael Caine was nominated for the Golden Globe Best Actor award and for an Academy Award as well, and Phillip Noyce was named Best Director by the National Board of Review. Stephen Holden opined in the *New York Times* that Fowler "may be the richest character of Mr. Caine's screen career."

REFERENCES

Greene, Graham, "Last Act in Indo-China," *The New Republic*, May 9, 1955, 9–11, and May 16, 1955, 10–12;———, *Ways of Escape* (Simon & Schuster, 1980); Phillips, Gene D., *Graham Greene: The Films of His Fiction* (Teacher's College Press, 1974); Sharrock, Roger, *Saints, Sinners and Comedians: The Novels of Graham Greene* (University of Notre Dame Press, 1984); Arnold, Gary, "'Quiet American' Warns about War in Vietnam Model," *The Washington Times*, February 7, 2003, B6; Lane, Anthony, "Love and War," *The New Yorker*, December 2, 2002, 117–119; Lawrenson, Edward, *Sight & Sound* 12, no. 12 (December 2002): 57–58; McCarthy, Todd, "Topical 'Quiet' Could Make Noise at B.O.," *Variety*, September 16–22, 2002, 28, 38; Schwarzbaum, Lisa, "Expert Witnesses," *Entertainment Weekly*, November 29, 2002, 76; Waxman, Sharon, "Caine, Still Able," *The Washington Post*, February 2, 2003, G1, G15.

—*J.M. Welsh*

RABBIT, RUN (1960)

JOHN UPDIKE

Rabbit, Run (1969), U.S.A., directed by Jack Smight, adapted by Howard Kreitsek; Warner Bros.

The Novel

When the 28-year-old John Updike published *Rabbit, Run* in 1960, he could scarcely have imagined that he was introducing one of the best known characters in modern American fiction, Harold "Rabbit" Angstrom. By 1990 four novels would unfold Rabbit's faltering quest for personal identity. Over the four decades covered by the novels, Rabbit gradually acquires material security and, with much pain to himself and others, advances modestly in moral stature and achieves a small measure of peace with himself.

Early in *Rabbit, Run* a gas station attendant advises Rabbit: "The only way to get somewhere you know, is to figure out where you're going before you go there." Rabbit is dubious; he trusts his instincts to guide him through life just as they had when he was a star basketball player in high school. And his instincts tell him that he is destined for something better than life as a kitchen-gadget salesman, as husband to a pregnant and demoralized wife, and as father to a puzzled two-year-old son. The plot follows the impulsive Rabbit as he bolts from his family three times and returns to them twice, once after the birth of his daughter and once after his distraught wife accidentally drowns the infant while giving her a bath. As a literary character Rabbit has been variously interpreted as an "absurdist" hero seeking to fulfill his true self or as a thoroughly irresponsible, self-absorbed scoundrel. In any case, the circular odyssey of Rabbit's life features encounters with his former coach who muddledly advises him about the "game of life"; a minister who ineffectively argues that Rabbit is a spiritual vagrant rather than a genuine quester; and a prostitute who in vain offers him love. At the close of the novel, Rabbit is seen running down a darkened street, destination unknown.

The Film

The film version of *Rabbit, Run*, directed by Jack Smight, offers an instructive example of what can happen when production problems and a filmmaker's miscalculations combine to sabotage an adaptation. Screenwriter Howard Kreitsek's adaptation follows the bare bones of the novel's story line and manages to incorporate some scattered key lines of dialogue; notably retained are a few statements by the minister who mentors Rabbit and whose function it is in the novel to express philosophical and religious themes. Unfortunately, the editing, which was so deplored by Smight that he denounced the final cut, pares down critical scenes in the novel so as to remove dialogue from its context and thus obscures both meaning and motivation. What is left is a talky movie in which the talk too often seems to have no point. Numerous disconnected attempts are made to retain the sense that Rabbit, however irresponsible and muddled, does believe that he is inspired by promptings of divine grace. Hazily the movie tries to show but can only hint that in Rabbit's impulsive running Updike intended to generalize the frantic, misguided spiritual pursuits of the modern world.

The casting of James Caan as Rabbit appeared to promise an effective performance that would capture the mixture of impulsiveness, insecurity, masculine self-centeredness, and wrong-headed ingenuousness that make up Rabbit's character. But either Caan never grasped the role or the final cutting destroyed the coherence of what might have been a credible performance. On the technical side of production, the cinematography sporadically captures a sense of Rabbit's confinement and limited horizons as he roams among the closely packed buildings of narrow city streets.

Smight miscalculated the filmic potential of the novel in two ways. He apparently underestimated the centrality of the narrator's role in doing what Rabbit cannot—namely, articulate the nature of his dissatisfaction, anxiety, and aspirations. Closeups of James Caan looking perplexed do not substitute for the narrator's portrayal of Rabbit's inner life, a vital component for establishing character depth and for reader/viewer empathy. Secondly, while he may have appreciated Updike's statements to the effect that images more than plot drive his novel, Smight underestimated the extent to which the rich texture of imagery woven by the narrator depends on metaphor and symbol to evoke emotional response and thematic depth.

Whatever filmic potential Updike and Smight may have imagined for the novel, *Rabbit, Run* the movie was given only limited release by Warners and was dismissed by most reviewers as a forgettable example of poor movie making.

REFERENCES

Siegel, Gary, "Rabbit Runs Down," in *The Modern American Novel and the Movies*, Gerald Peary and Roger Shatzkin, eds. (Ungar Publishing, 1978).

—*C.T.P.*

RAGTIME (1975)

E.L. DOCTOROW

Ragtime (1981), U.S.A., directed by Milos Forman, adapted by Michael Weller, Paramount Pictures.

The Novel

Ragtime is a vivid, panoramic novel of American life during the first two decades of the 20th century by contemporary American novelist E.L. Doctorow. It is centered on three fictional families: an upper middle-class family of a flag and fireworks manufacturer called "Father," a Jewish immigrant silhouette artist called "Tateh" (Yiddish for Dad), and a young black pianist from Harlem named Coalhouse Walker Jr. Interwoven in the lives of these characters and their families is an array of real historical figures, such as Sigmund Freud, Henry Ford, Admiral Peary, Evelyn Nesbit, Booker T. Washington, Harry Houdini,

Emma Goldman, and J.P. Morgan, whose real-life experiences Doctorow uses to contextualize and support the narrative of the fictional characters. The historical figures interact with the fictional characters so that Doctorow blurs the distinction between historical fact and artistic creation.

The central family is made up of Father, Mother, Little Boy, and Mother's Younger Brother. Father joins Admiral Peary in his quest for the North Pole, while Younger Brother is in love with Evelyn Nesbit, the turn-of-the-century femme fatale who motivated Harry Thaw to murder Stanford White. In her rides around New York City to escape the publicity of Thaw's trial, Evelyn briefly discovers Tateh and his daughter in a ghetto. After fleeing New York to Lawrence, Massachusetts, Tateh realizes the American Dream, first by selling a "flipbook" of silhouettes to a novelty store and later as the successful filmmaker "Baron Askanazy" who marries Mother after Father dies on the *Lusitania*.

Father's New Rochelle household is first disturbed with the discovery of a newborn black infant in their garden. After taking Sarah, the mother of the infant, into their home, Coalhouse Walker Jr., a Harlem jazz pianist and father of the child, comes to visit Sarah and propose marriage. Coalhouse's new Model T Ford is damaged by racist volunteer firemen and Coalhouse demands that his car be restored and the culprits punished. After legal channels fail, Sarah attempts to appeal his case to the vice president, but is mistaken as a political assassin and is shot. Her death provokes Coalhouse to recruit a group of Harlem youths and they mount attacks against the fire station, killing and burning as they go. The rebels, along with Mother's Younger Brother, seize and occupy J.P. Morgan's library full of priceless artworks, and demand that the car be restored and returned, and that the fire chief be handed over to them. After Booker T. Washington fails to change Coalhouse's mind, Father leaves his family in Atlantic City and serves as intermediary between Coalhouse and the police. After Younger Brother and the other youths are allowed to escape the library, Coalhouse offers himself to the law and is mercilessly executed by the police as he leaves the library.

The Film

Prior to *Ragtime*, Czech film director Milos Forman had demonstrated his abilities in adapting literary works to film with his version of *One Flew over the Cuckoo's Nest* (1975). While Forman's *Ragtime* necessarily omits characters and events in the epic novel, the film stays faithful to the complex fabric of the book. As with Doctorow's novel, the movie depicts an historical epoch rather than the hidden lives of its characters. When Coalhouse (played by Howard Rollins) first appears early in the film, he is accompanying on piano "newsreels" in a theater, informing the viewer of the conquest of the North Pole, Houdini's escapes, and the scandalous statue modeled from

Evelyn Nesbit. Michael Weller's screenplay drops the Polar expedition and Houdini's life in the novel, focusing on Evelyn Nesbit (played by Elizabeth McGovern) as the beautiful and whimsical chorus girl whose prior involvement with the architect Stanford White drives her manic husband to murder White in public. While Evelyn helps Thaw by attesting to his alleged insanity, she becomes involved with Mother's Younger Brother who has followed and admired her for months.

Father's household is a well-regimented and conventional setting, and Father, Mother, and Younger Brother personify the types of the stiff and dominating father, the intelligent and compassionate mother, and the wild-eyed, emotional younger man who is "having difficulty finding himself." The casting of Father, Mother, and Younger Brother with James Olson, Mary Steenburgen, and Brad Dourif rather than major stars helps to convey the cultural types and moods of a milieu. The idyllic, soft shots of New Rochelle are in contrast to the squalid ghetto scenes where Evelyn meets Tateh (played by Mandy Patinkin), his daughter, and Younger Brother. After the discovery of Sarah's infant and Mother's insistence at accepting them into her home, Coalhouse's appearance as a confident pianist from a jazz club in Harlem unsettles Father and inspires Younger Brother. Coalhouse's indignant reaction to the treatment of his car is dismissed by almost everyone as inappropriate for a black man. As in the novel, the movie neither condones nor condemns Coalhouse's resolve to settle the matter with violence. The abuse of his automobile and the death of Sarah are treated by Forman as a comic-tragedy, and Coalhouse's eloquent defense of his actions to Booker T. Washington indicates that he is fulfilling an inevitable and inexplicable destiny. None of the white characters are credited with the "integrity" that Father attributes to Coalhouse, except maybe Younger Brother, who has turned into a blackfaced revolutionary. As if signifying the enchantment that moving pictures will have in the coming decades, Mother leaves Father and New Rochelle (rather than being widowed, as in the novel) to marry Tateh/Baron Askanazy and follow him to the new film industry in California.

In *Ragtime*, Forman and cinematographer Miroslav Ondricek (who worked on Forman's earlier films) achieve a lush, theatrical quality characteristic of the period. Some critics, such as Boyum, have considered the movie a failure as an adaptation, claiming that "where *Ragtime* the novel is crisp and ironic, innovative and sharply critical, *Ragtime* the movie is soft, sentimental, and utterly conventional." While the movie does not often convey the ironic humor of the novel, scenes such as Evelyn's discussions with Thaw's attorneys are a delightful mockery of the period's corrupt materialism. An unfortunate omission is the absence of Emma Goldman in the film, who was dropped in the final cut to reduce the three-hour film to a more typical commercial length. An additional bonus of the movie is the final screen performance of James Cagney who plays the irascible police commissioner Waldo. But

the success of the film is not a consequence of any individual's performance, but of the luxuriant and fabulous tapestry of an exuberant age that Forman's *Ragtime* unfolds for the viewer.

REFERENCES

Boyum, Joy Gould, *Double Exposure: Fiction into Film* (Universe Books, 1985); Dawson, Anthony B., "*Ragtime* and the Movies: The Aura of the Dublicable," *Mosaic* 16, no. 1–2 (winter-spring 1983), 205–14; Forman, Milos, *Turnaround: A Memoir* (Villard Books, 1993); Hague, Angela, "Ragtime and the Movies," *North Dakota Quarterly* 50 (summer 1982): 101–12.

—*M.P.E.*

THE RAINBOW (1915)

D.H. LAWRENCE

The Rainbow, (1989), U.K., directed by Ken Russell; adapted by Vivian and Ken Russell; Vestron.

The Novel

The Rainbow was published on September 30, 1915, and the English court ordered it suppressed the following November on the grounds of obscenity. While the strong emotional and sexual feelings depicted between Ursula Brangwen and her female teacher may have proved shocking to Edwardian sensibilities, modern critics speculate that the court's decision, made during World War I, had as much to do with Lawrence's marriage to his aristocratic German wife Frieda von Richthofen (cousin to the infamous Baron von Richthofen) as to any actual obscenity present in the novel.

The Rainbow recounts three interrelated stories concerning three successive generations of one Nottinghamshire family, the Brangwens. The first story centers on Tom Brangwen's marriage to the Polish widow Lydia Lensky and his close relationship with and nurturing love for Lydia's daughter Anna. The second focuses on 18-year-old Anna's marriage to Tom's nephew, Will Brangwen. Young and passionately in love with one another, Anna and Will seem ripe for experiencing the Lawrentian "blood-intimacy." However, five children are born, Anna grows absorbed in the needs of her family, and Will, feeling underloved and alienated, transfers his affection to his oldest child Ursula, much as Tom had done earlier with little Anna. The third story, Ursula's, centers on her growing feminist awareness and her sexual and spiritual awakening. As her father's favorite, Ursula is given the privilege of an education. At school she meets Anton Skrebensky. Eventually they fall in love and consummate their relationship. Skrebensky wants to marry Ursula, but she refuses his offer several times, explaining that she wants more than the inevitable sterility of marriage. However, when Ursula becomes pregnant, she writes to him, recanting her prior

views and asking him to marry her. Unknown to Ursula, Skrebensky has already married, and before his response can arrive, she contracts pneumonia and loses her baby. Broken, confused, and despondent, Ursula sees a rainbow, a transfiguring vision of transcendent hope and exultation.

The Film

There are two film versions of *The Rainbow*. Under the direction of Stuart Burge, the British Broadcasting Corporation produced its modest adaptation in 1989. Also in 1989 Ken Russell's version, the more prominent and ambitious of the two was released.

Ken Russell is generally described as an unconventional and controversial filmmaker who, to one extreme, is highly lauded for his cinematic boldness, his feral images and soundtracks, and his absorbing psychosexuality and, to the other extreme, is easily dismissed as a maker of ludicrously lurid, visually and aurally noisy, lurching movies. In 1969 Russell made his film version of *Women in Love*, Lawrence's sequel to *The Rainbow*. Unorthodox in its stylistic excesses, boldly erotic, and wildly evocative, Russell's *Women in Love* drew strong, but somewhat mixed reactions from the critics. Twenty years later, a calmer Russell made a calmer film based on *The Rainbow*. This film is universally judged to be a restrained, ordinary, and polite version of Lawrence's ardent and daring novel. Lawrence's *The Rainbow* took chances and explored aesthetic, moral, and social boundaries, much as Russell's *Women in Love* had attempted to do. However, throughout *The Rainbow* Russell extinguishes the fire that blazes in Lawrence's prose.

In *The Rainbow* Russell intentionally uses many of the same people who collaborated with him on *Women in Love*: Billy Williams, the cinematographer; Luciana Arrighi, the designer; Glenda Jackson, as Gudrun in *Women in Love* playing Gudrun's mother Anna; and Christopher Gable, the drowned newlywed in *Women in Love* playing Will Brangwen. Despite these connections, *The Rainbow* lacks the unfettered spirit and the bold sensuality that made Russell's work in that earlier film so appropriately Lawrentian.

As a major departure from Lawrence's work, Russell's *The Rainbow* focuses on Ursula's story only. Rebelling against the mores and customs of her world, Ursula (Sammi Davis) early in the film announces that the singular most valued character trait a person can boast is the "courage" to follow one's own beliefs and impulses. She clearly wants more than the insularity and repression of her mother's domestic world. However, without the early stories of Lydia Lensky and Anna Brangwen, Ursula's announcement seems simply a facile response to the times instead of Lawrence's deeper understanding of character motivation. Lawrence showed us that Ursula's reaction has root in three generations of unresolved frustration, wretchedly suffocated passions, and buried dreams. Ursula resonates the sorrows and ambitions of the per-

sonal histories that preceded her own. She lives filled with yearning for sexual and spiritual fusion with another person. However, the film's Ursula, lacking both the family history that would give texture to her response and an actress capable of communicating Ursula's inner complexity, gives us instead merely an Ursula, sweetly plucky, given to temperish tirades, and rather blank—an *Ursula lite*.

The movie is Ursula's story and its incipient image is that of the child Ursula running to catch a rainbow, an image so big, bright, and robust as to be sky-consuming. Russell's rainbow appears as it would to the child who runs toward it with a single-focused determination. Fearing she will fall into the river, her father grabs her up. "I want it," Ursula tells him, to which he replies, "You can't have it." This scene, added by the movie, should establish the source of Ursula's confused rebellion: the formidable constraints and repression imposed by her family, who, acting out of genuine love and fear for her welfare, nonetheless quell her spirit. Ironically, often those who love us most attempt to kill the fire that burns within, Lawrence warns. This vision, which dominates the novel, is dark and sorrow-saturated. However, Russell lights this scene, and most of his film, with butterscotch hues and merry lusters; and while the look of the movie is quite lovely, Russell seems to miss the point. So uncharacteristic of Ken Russell's work, *The Rainbow* sweetens and subdues Lawrence. It plays it safe.

REFERENCES

Baxter, John, *An Appalling Talent: Ken Russell* (Joseph Pres, 1973); Hanke, Ken, *Ken Russell's Films* (Scarecrow Press, 1984); Moynahan, Julian, *The Deed of Life* (Princeton University Press, 1972); Phillips, Gene, *Ken Russell* (Twayne, 1979).

—*L.C.C.*

RAISE THE RED LANTERN *(Quiqie Chenggun ["Wives and Concubines"])* (1990)

SU TONG

Raise the Red Lantern (Da hong denglong gaogao gua) (1991), China-Taiwan-Hong Kong, directed by Zhang Yimou, adapted by Ni Zhen; China Film Co-Production Corporation.

The Novel

Su Tong has been labeled one of China's post-1980s "avant-garde, experimental, or New Wave" writers, a movement that some link to the postmodernists and magic realists in the West. These writers, critic Zhang Yingjin argues, retell local folklore, customs, and traditional mythology in a style combining fantasy, irony, and absurdity (often with a misogynistic tone). Originally titled *Wives and Concubines*, Su Tong's novella was changed

to *Raise the Red Lantern* following Zhang Yimou's popular adaptation (in fact, no "red lanterns" even appear in the original novella), and it appears under that title in Michael S. Duke's 1993 translation (along with two other novellas *Nineteen Thirty-four Escapes* and *Opium Family*). Each tale focuses on the dire consequences of unrepressed sexual desires: in *Red Lantern*, within the decadent confines of a rich man's mansion; and in the two tales of Maple Village, in a rustic village overpowered with the aroma of opium.

Set in the 1940s, the story follows Lotus, the young "Fourth Mistress" of Chen Zuoqian, an aging but wealthy man with an insatiable lust for sex and sons. When Lotus's own father kills himself after his business fails, Lotus is forced to quit college and consider her only option, marriage. Bitterly, she "chooses" a wealthy marriage, which, given her low status, means life as just one of several concubines. The story details Lotus's life as one of four women confined to the inner courtyards of a large house. Each woman must outmaneuver the others for the patriarch's sexual favors. Temptation to greater sexual fulfillment through adultery is thwarted by the image (and voices) of a "Well of Death," the only escape. Adulterous wives from previous generations of the family have been cast into it, and their voices call to Lotus, eventually providing her a different form of escape, insanity. The unnatural concentration of female power in the household causes an imbalance in the cosmic Yin and Yang forces. Chen Zuoqian becomes impotent, a disaster for the four "wives" who are competing to produce sons; his oldest son Feipu flirts with Lotus but, the narrative hints, he is homosexual; "Mistress Two" catches "Mistress Three" in an adulterous relationship, resulting in the latter being tossed into the "Well of Death"; and Lotus goes insane. Chen then buys himself a fifth mistress.

The Film

Zhang Yimou is one of the most famous of the "Chinese Fifth Generation" directors (named for the fifth class to graduate—after the hiatus during the Cultural Revolution—from the reopened, famous Beijing Film Academy). He originally worked as a cinematographer on Chen Kaige's *Yellow Earth* (1984) and *The Big Parade* (1985), as well as on Wu Tianming's *Old Well* (1987), in which he also acted, as he did in *Terra-Cotta Warrior* (1990). *Raise the Red Lantern* is his third film (after *Red Sorghum* in 1988 and *Judou* in 1990). Like those films, *Raise the Red Lantern* continued Zhang's reputation as a critical star in the West (the film, like *Judou*, was nominated for an Academy Award as best foreign film) and a controversial director in his homeland (where the China Film Bureau has banned his films and has tried to have them pulled from international competition). As with his other adaptations, the film *Raise the Red Lantern* has assured the novel a Western readership even as it exceeded, in many respects, the power of the original work.

As critics have noted, Zhang Yimou's work has shown a steady artistic growth as he continues to investigate his themes of human sexuality (love, marriage, impotence, homosexuality, and power and domination in relationships) in stories depicting the role of women in a patriarchal order. (Zhang himself has described *Raise the Red Lantern* as thematically linked to his previous two films as a kind of stylistic trilogy.) As he has gained confidence in his expressive cinematography, he has increasingly used his masterful composition to express more convincingly his characters' psyches. At the same time, Gong Li has also continued to develop as she stars in each of Zhang's films, and her performances show increasing range and power.

In this adaptation, Zhang has developed from Su Tong's stripped-down folklore prose an operatic film that borders on the melodramatic. As in *Judou*, where scenes of the film are framed by the house itself, confinement and intrigue are expressed through an endless maze of scenes framed through windows, doorways, and courtyards. While the character of the patriarch Chen is left purposefully faceless and remote, the women—everyone from wives to servants—are fully developed in close-ups that reveal both the pain and the craftiness behind each face. While Zhang's architectural frames are gray and lifeless (even to the point of being muted by snow) paralleling the patriarchy itself, the women's lives within struggle for color, sound, and passion. Red lanterns festoon the courtyard of the woman favored by Chen on any given day; the wives dress in bright silks; the favored wife is given a foot massage with tiny bell-filled hammers, the sound of which pervades the film; Coral, the irrepressible (but eventually murdered) third mistress, dresses in Beijing opera costumes and sings plaintive songs that echo (like the tiny bells) from courtyard to courtyard; music increasingly dominates as Lotus learns of one intrigue against her after another, until finally she is driven crazy and lights up the bedroom of the murdered Coral with lanterns and recorded opera music.

Lotus's fate is paralleled by Zhao Fei's photography. From the opening Bergmanesque full frontal face shot of an independent and educated woman whose father's misfortunes have now reduced her to the status of a commodity, to the final scene showing her walking in endless mad circles within the tiny limits of her courtyard, the camera defines the character's world. Zhang, like Kubrick, has learned to take simple novels and turn them into grand films.

REFERENCES

Berry, Chris, *Perspectives on Chinese Cinema* (British Film Institute Publishing, 1991); Chow, Rey, *Primitive Passions: Vitality, Sexuality, Ethnography, and Contemporary Chinese Cinema* (Columbia University Press, 1995); Zhang, Yingjin, "Book Review: *Raise the Red Lantern: Three Novellas*," *Chinese Literature Essays Articles Reviews* 16 (December 1994): 185–87.

—D.G.B. and C.C.

THE RAZOR'S EDGE (1944)

W. SOMERSET MAUGHAM

The Razor's Edge (1946), U.S.A., directed by Edmund Goulding, adapted by Lamar Trotti; Twentieth Century-Fox.

The Razor's Edge (1984), U.S.A., directed by John Byrum, adapted by Byrum and Bill Murray; Columbia.

The Novel

In Somerset Maugham's novel "Maugham" appears as a character/narrator in the story of a young Chicago man's search for self just after World War I. The story is presented as the narrator's recollection of various conversations and experiences with the main characters over the years.

Larry Darrell at 20 is a World War I veteran airman. Expected to marry Isabel Bradley and work in business, he postpones those fates, indefinitely leaving Chicago for Paris to find answers to philosophical questions nagging him since the war. Isabel's mother and her uncle, Elliott Templeton (a snobbish socialite), along with the narrator Somerset Maugham, discuss Larry's decision and Isabel's options. Visiting Larry in Paris, Isabel unsuccessfully attempts to convince him to return and they part again. She marries Gray Maturin and Larry goes to work in a coal mine, on a farm, at a monastery, and eventually to India where he studies Hinduism. When the 1929 market crash wipes out Gray and Isabel, they move to Elliott's Paris apartment. Larry, also in Paris, has greatly changed over the years. The three encounter an old friend from Chicago, Sophie McDonald, now a tragically alcoholic prostitute.

Larry plans to marry the reformed Sophie, but Isabel, still in love with Larry, tempts Sophie to drink again and Sophie flees to an opium den and, soon, death. Elliott dies, leaving his fortune to Isabel and Gray. Larry goes to America to work and live a simple life. The narrator concludes that each character got what he or she was looking for: Isabel, a life of wealth and prominence; Elliott, social eminence; and Larry, happiness.

The Films

There are two filmed versions of *The Razor's Edge*. The first was the expensive 1946 production by Darryl Zanuck who had Maugham write a script but rejected it, using Lamar Trotti's instead. Generally, the film is a very faithful rendition of the novel. However, one significant change is that the film distills Maugham's reflective, episodic novel into a basic, chronologically developed story. "Maugham" (Herbert Marshall) is the film's narrator, but his brief appearances function largely as transitions between scenes.

The film's focus is the love story involving Isabel, Larry, and Sophie. Isabel (Gene Tierney) is underdeveloped and not as likable, while Larry (Tyrone Power) is more directly involved in the film's plot (for example, he, not Maugham, confronts Isabel regarding Sophie's death). Sophie (Anne Baxter), absent from much of the book is a major character in the film. The novel's focus, Larry's search for meaning, is greatly abbreviated. In the novel, Larry works in the coal mines with Kosti (a former political activist), goes to a German farm, a Benedictine monastery, a cruise ship, and India. These travels are compressed in the film; and unaccountably Kosti is made a defrocked priest who suggests Larry's India excursion.

The film simplifies the philosophical-religious aspect of the story. The movie's swami, hardly mystical, appears

W. Somerset Maugham

as American as Larry; no reference is made to Hinduism. The novel's dialogues about God and the meaning of life are replaced by trite conversations between Larry and the swami. Larry's enlightenment occurs in an off-screen instant and the supposedly grueling experience leaves Tyrone Power's Larry staring wide-eyed but looking downright dapper. The limited sexuality of the novel is completely omitted from the film, understandably a concession to 1946 censors. Sophie's sexual experiences are only implied, Larry's are not mentioned, and Suzanne Rouvier, the would-be artist with many lovers, does not appear at all.

Released in 1984 the second version of *The Razor's Edge* starred comedian Bill Murray who secured Columbia's guarantee that he would play Larry by tying it to his agreement to costar in *Ghostbusters* the same year. Differing from the novel, "Maugham" is absent from the film, and from the onset Larry, Isabel, Sophie, and Gray are all interconnected. Sophie is already married and pregnant, and Larry and Gray experience the war together as ambulance corps members. The war changes Larry; and Gray, basically unchanged, serves as a point of contrast to Larry.

Isabel's (Catherine Hicks) first trip to Paris is handled differently also. In the novel and in the 1946 film, Isabel contemplates seducing Larry in order to trap him into marriage. However, such standards of "gentlemanly honor" might not be understood by a 1984 audience, so in the later film Isabel sleeps with Larry in Paris but, unweighted by 1940s morality, leaves him when his squalid lodgings are more than she can take. Like the 1946 film, the 1984 version compresses Larry's journeys and expands the character of Sophie (Theresa Russell). In addition, Elliott's death and Larry's confrontation with Isabel are made to occur simultaneously.

Unlike the earlier film, which reduced *The Razor's Edge* to a love story, this film focuses on Larry's spiritual development. The catalyst to Larry's search, the war (only alluded to in the 1946 version), is given full-screen treatment. Larry's time in India is extensive, the filming is appropriately picturesque and the Indian music and sounds are fit. In a reversal from the novel and 1946 versions, Larry's enlightenment is shown but not discussed. Also, we see the development of a loving relationship between Larry and Sophie, making her tragic end something of a tearjerker.

The film's sexuality is more overt and the 1984 Elliott gets to keep his dying words from the novel, calling a high society snob "the old bitch." In keeping with censorship codes, the 1946 Elliott was allowed only a reference to her as an "old witch."

Bill Murray, sometimes unrealistically silly just as Power was unrealistically stiff, can't help but be comedic throughout, occasionally making Larry an embarrassing cartoon (in India he clowns with a large vegetable). But more often he makes Larry real and likable, albeit in a 1980s way.

REFERENCES

Sarris, Andrew, *The American Cinema* (Dutton, 1968); Winnington, Richard, *Drawn and Quartered* (Saturn Press, 1949).

—S.C.C.

REBECCA (1938)

DAPHNE DU MAURIER

Rebecca (1940), U.S.A., directed by Alfred Hitchcock, adapted by Joan Harrison and Robert E. Sherwood; Selznick/United Artists.

The Novel

The strongest influence on Daphne Du Maurier through young adulthood was her father, Gerald, a charismatic British actor; she wrote in memoirs (1980) that she grew up feeling related to Gerald not only as daughter, but also as sister and mother. Critics consider this intense bond a source of Du Maurier's general fascination with relationships between her heroines and father figures (*The Progress of Julius; The King's General*) and also, in turn, of the complex feelings the narrator of *Rebecca* has for the much older aristocrat she marries. Du Maurier's 20 novels were almost all best-sellers, and she enjoyed a long, lucrative relationship with filmmakers, who fancied her macabre short stories as much as her novels. Interest in *Rebecca* remains so high that Susan Hill's "sequel" *Mrs. de Winter*, stylistically true to the original but far less suspenseful, was published by Avon in 1993.

The shy narrator whose reminiscences constitute the story has neither a first nor a maiden name, the better to convey her domination by her dead yet all-controlling predecessor, the beautiful and spirited Rebecca. In two opening chapters the narrator, now middle-aged, savors memories of life at Manderley, her husband's ancestral mansion on the English coast, but hints mysteriously that Manderley is "no more": The rest of the novel is flashback.

As a sensitive and pretty but awkward orphan of 21, the narrator ("I") is serving as a paid companion to crass American socialite Mrs. Van Hopper in Monte Carlo when they encounter the broodingly handsome Maxim de Winter, owner of Manderley. De Winter's behavior with "I" is so fatherly—by turns brusque and indulgent—and their time together so tainted for "I" by jealous curiosity about his first wife Rebecca that it is a shock to her, Mrs. Van Hopper, and the reader when Maxim proposes. They wed, then settle at Manderley, whose size and formality, local prominence, and grim housekeeper, Mrs. Danvers, intimidate the narrator; she constantly feels inferior to Rebecca, about whose death by drowning a year earlier she knows little and is afraid to ask. Maxim's moody detachment deepens the desperation of "I," as do two humiliating events: an eerie encounter with Mrs. Danvers in Rebecca's bedroom, maintained by the housekeeper as a

shrine, and a costume ball where "I," tricked by Danvers, angers Maxim by wearing the same costume Rebecca wore the year before. "I" confronts Danvers, whose efforts to induce the narrator's suicide are suddenly interrupted by a shipwreck in the bay, rescue work on which reveals still another surprise. The sailboat Rebecca supposedly drowned in is intact at the bottom of the bay; and though Maxim had identified a body washed up miles away as hers, there is a decomposed body in the craft.

Confiding in "I" for the first time, Maxim reveals he shot Rebecca, put her corpse in the boat, and sank it. Just as shockingly, he reveals he never loved Rebecca: "She was vicious, damnable, rotten . . . she was not even normal." A brilliantly deceptive nymphomaniac whose seamy London escapades Maxim tolerated only to avoid scandal, Rebecca had enraged Maxim by gloating about her pregnancy and the prospect of another man's son inheriting Manderley. Unrepulsed by Maxim's admission—ecstatic rather to learn that he never loved Rebecca—"I" now comes into her own as a mature, loving woman, helping Maxim weather a blackmail attempt by Rebecca's lover-cousin, the sleazy Favell. When Rebecca's doctor reveals she had not been pregnant but dying of cancer, Maxim and "I" understand why she baited Maxim into killing her; the "drowning" is officially decreed suicide; and a happy ending seems possible, briefly, until Danvers, plotting with Favell, burns Manderley to ashes rather than let "I" replace Rebecca as its mistress.

The Film

The Motion Picture Production Code as administered by the Hays Office demanded removal of the novel's heart— the fact that Maxim (Laurence Olivier) has murdered Rebecca—so that he would not go unpunished for a crime (evidently loss of Manderley was insufficient punishment). Selznick hired Robert Sherwood to doctor the conclusion, including the scene in which Maxim reveals the murder to his second wife (Joan Fontaine). In the film, Maxim explains that after Rebecca taunted him with her pregnancy, he "must have struck her"; she tripped, fell, hit her head, and died. It is an odd scene because instead of using a flashback for Maxim's story of the fatal night or having Maxim reenact Rebecca's movements, Hitchcock, in Tania Modleski's words "dynamizes [Rebecca's] absence" by making the camera "follow" Rebecca's movements across an unpeopled set as Maxim gives the step-by-step details ("She came towards me," and so on). This treatment deliberately creates anxiety in the viewer and makes Rebecca's "absence vividly present."

Another revision Sherwood made for the censors was to kill off Mrs. Danvers (Judith Anderson) in the fire. The novel lets Danvers and Favell escape the destruction they wreak on Manderley; in the framing chapters, the narrator worries about their whereabouts. But in the film Fontaine, watching flames lick the mansion, tells Olivier that Danvers has "gone mad"; Danvers then appears, gloating, at the window in Rebecca's bedroom from which she had tried to induce Fontaine's suicide. Her dress takes fire, the roof collapses, and the final shot is of Rebecca's bed, where flames consume the initial "R" Danvers embroidered for Rebecca on a lingerie case. The film's ending is as dramatic as the novel's but, as critic Richard Kelly observes, "morally tidier: the hero commits no crime, and the villain is destroyed by her own hatred and mad possessiveness."

Tension between Selznick and Hitchcock ran high, Selznick insisting on faithfulness to the novel, Hitchcock attempting to stray. (Hitchcock tried adding a madwoman to Manderley's attic á la *Jane Eyre;* Selznick's veto prevailed.) Perhaps as a result, the film, like the novel, is wonderfully tense. Enhancing its pervasive edginess was the way Hitchcock deliberately, as Fontaine later reported, divided the cast (he told her nobody liked her performance but himself, which "helped my performance, since I was supposed to be terrified of everyone"), as well as the coincidence of Germany's invasion of Poland and England's declaration of war on Germany with the start of filming. Olivier, Anderson, and the other British actors, including Nigel Bruce as Maxim's brother-in-law, feared the imminent bombing of London. Perhaps because it provided escape from world problems, *Rebecca* won best picture at the 1940 Academy Awards over films like *The Great Dictator, The Grapes of Wrath,* and *Our Town.*

Despite interference by the Hays Office, and despite what Hitchcock perceived as unwelcomed micro-management by Selznick, *Rebecca* is a highly successful film, faithful to the novel on which it is based. Selznick announced, "We bought *Rebecca,* and we intend to make *Rebecca,* not a distorted and vulgarized version of a provenly successful work"; he achieved his goal. Outside of the forced transformation of Rebecca's murder into an accident, deviations from the novel amount either to trivialities or actual improvements. For instance, since the film has no need of a first-person narrator, "I" does not accompany her husband to London to confer with Rebecca's doctor as she does in the novel; this suspenseful episode is scarcely less so for her staying home. And the first fearful glimpse "I" gets of de Winter in the film—he stands perilously close to the edge of a cliff, brooding Byronically—is quite in keeping with both characters, yet far more arresting an introduction than in the novel, in which their first contact is a hotel dinner.

Joan Fontaine, just 22, gives a superb performance: Until sure of Maxim's exclusive love, she makes her very posture and every movement express insecurity. The novel concerns the narrator's struggle for identity against the strong identities of her husband and his first wife, and Fontaine convincingly conveys this struggle. Olivier's acting is more problematic, perhaps because the secret his character harbors was changed so significantly by the Hollywood censors. George Sanders makes a suitably annoying Favell, and Judith Anderson is riveting as the evil Mrs. Danvers. Several critics have observed that Hitchcock seldom shoots Anderson in motion; he conveys her charac-

ter's eerie power by sudden appearances and disappearances.

A far more faithful adaptation of the novel was made by the BBC as a mini-series, broadcast in 1997 on *Masterpiece Theater* on PBS. This adaptation carefully preserves the first-person narrative voice, as well as many of the sordid plot details. Diana Rigg played a wonderfully sinister Mrs. Danvers.

REFERENCES

Bromley, Roger, "The Gentry, Bourgeois Hegemony, and Popular Fiction," *Literature and History* (autumn 1981); Kelly, Richard, *Daphne du Maurier* (Twayne, 1987); Modleski, Tania, "'Never to be Thirty-six Years Old': *Rebecca* as Oedipal Drama," *Wide Angle* (1982); Spoto, Donald, *The Dark Side of Genius: The Life of Alfred Hitchcock* (Ballantine, 1983).

—F.F.K.

RED ALERT (1958)

PETER GEORGE (PETER BRYANT)

Dr. Strangelove, or How I Learned to Stop Worrying and Love the Bomb (1964), U.S.A., directed by Stanley Kubrick, adapted by Kubrick, Terry Southern, and Peter George; Columbia Pictures.

The Novel

Peter George wrote *Red Alert* (U.K. title, *Two Hours to Doom*) during the escalation of Cold War paranoia in the late fifties. His own experiences in the RAF clearly influenced the writing of this novel, as *Red Alert* often becomes bogged down in technical descriptions and procedural maneuvers. Although his primary concern was with accidental nuclear war, the novel is implicitly nationalistic and glorifies military rationality, obscuring the antiwar sentiment in the novel. The ambiguity of George's message evidently confused his American publishers, causing them to advertise the novel as a war-action adventure, hoping to cash in on the "war buff" audience.

Although the film version hardly resembles George's original work, he not only received coauthor credit for the screenplay, but is also credited as the sole author of the novelization of the film, also titled *Dr. Strangelove*, published in paperback by Bantam Books in 1964. The incongruity of the two plots, the use of humor, the radical differences in literary style, and the ultimate differences in overall theme, has led Richard Powers, in the introduction to the 1979 Gregg Press hardcover edition of the novelization, to suspect that George had very little to do with either the screenplay or the novelization. The syrupy optimism that dominates *Red Alert* and *Commander 1*, George's 1965 sequel to *Dr. Strangelove*, directly opposes the biting misanthropy that drives the novelization and the film. *Red Alert* seems hopelessly blind to the absurdity of the "big

stick" rationality it places so much faith in, making it hard to believe that George could ever stop worrying and truly love the bomb.

Warning the reader that the action takes place "the day after tomorrow," the novel describes a race against the clock to save the world from nuclear destruction. With only months to live Senora Air Force Base commander, General Quinten, assessing the likelihood of a Russian nuclear attack, decides peace on Earth depends on an American first strike. By implementing a retaliatory safeguard (Plan R), he sends an attack wing to bomb primary targets inside Russia, believing that once the Pentagon realizes the futility of calling the planes back (since only Quinten knows the return code), they will commit to a full-scale attack. Seeing no other alternative the Joint Chiefs at the Pentagon advise the president to do just that. The president rejects this approach, revealing that political instability within Russia has led to a policy where if attacked and unable to retaliate, the Russian premier politically would be forced to detonate stockpiles of nuclear bombs hidden in the Ural Mountains, effectively rendering the world uninhabitable within six months. After alerting the Russian premier to the situation, the president decides to send troops into Senora and capture Quinten. Having foreseen this course of action Quinten effectively seals his base from attack.

After a bloody battle, troops manage to penetrate the Senora base, but not before Quinten, who believes that he can answer for his action to a higher power, kills himself, ensuring the secrecy of the return code. All hope is not lost as Major Howard, having spent the last two hours with Quinten, is able to deduce the return code. The hope provided by Major Howard is only temporary, after the successful recall of the attack wing reveals that one plane is unaccounted for.

The lone B-52 bomber, the *Alabama Angel*, although severely damaged, manages to elude Russian defenses and continue on course toward its target, unable to receive the return code. The president meanwhile concedes to the Russian premier that if the plane bombs its target he will sacrifice a comparable American city in order to preserve world peace. The *Alabama Angel* succeeds in unloading its warhead before it crashes, but the bomb, disabled in a dogfight with Russian fighter planes, fails to do any damage. After tense negotiations the Russian premier backs down from his threat to proceed with an attack on Atlantic City and for the moment the world is safe once again.

The Film

Interestingly enough, the most memorable moments in the Stanley Kubrick/Terry Southern screenplay are not present in the novel. Although Kubrick's first intention was to approach the adaptation seriously, he found the story so absurdly appalling that he shifted his emphasis to broadbrushed satire. His penchant for the ironic counterposing of music and images is seen in two particular effective

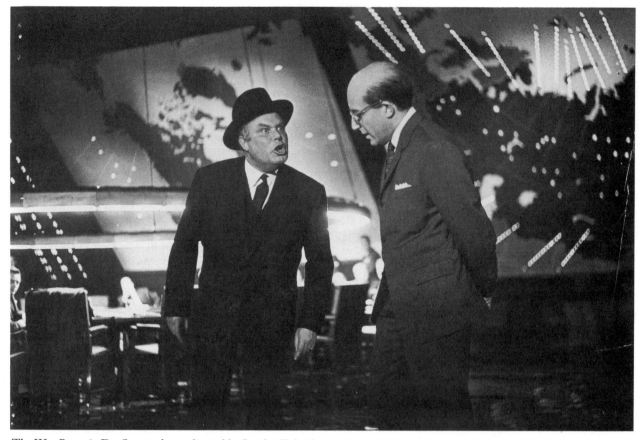

The War Room in Dr. Strangelove, *directed by Stanley Kubrick* (1964; U.S.A.; COLUMBIA/THEATRE COLLECTION, FREE LIBRARY OF PHILADELPHIA)

examples at the beginning and ending of the film: Near the beginning the refueling of the B-52 bomber in midair becomes a visual metaphor for a sexual coupling, accompanied on the soundtrack by the popular song "Try a Little Tenderness"; and at the end, the atomic holocaust becomes a sweetly sardonic commentary on global destruction, accompanied by the World War II song "We'll Meet Again." Departing from the novel's generally sympathetic treatment of characters, Kubrick has created a gallery of grotesque caricatures: Major T.J. "King" Kong (Slim Pickens), rides the bomb like a whooping cowboy astride a bucking bronco; George C. Scott's General Buck Turgidson is a right-wing cartoon, a Pentagon "hawk" in search of yet another paranoid conspiracy; Sterling Hayden's General Jack D. Ripper is a paranoid survivalist primarily concerned with preserving his "precious bodily fluids"; Keenan Wynn's Colonel Bat Guano blasts away at offending vending machines. The tour de force of this gallery of eccentrics, however, is Peter Sellers's multiple impersonations of President Muffley, Captain Lionel Mandrake, and Dr. Strangelove himself. So effectively does Sellers switch gears (and makeup and costumes) that the uninitiated viewer might not recognize him.

Whereas the novel concludes with the thwarted bombing run and the subsequent hopes for global peace, the movie will have none of that. Instead, the Doomsday Machine (another added plot element) retaliates, and the planet is engulfed in a gigantic mushroom cloud.

It might be assumed that author Peter George complied with these alterations, inasmuch as he receives coscreenwriter credit with Kubrick and Southern (and is listed as the sole author of the film's subsequent novelization). However, it should also be noted that in his introduction to the 1979 Gregg Press hardcover edition of the novelization, commentator Richard Powers claims that George had very little to do with either the screenplay or the novelization. In any event, critic Pauline Kael suggests that the finished film is a total confirmation of this century's nuclear anxieties and paranoia. And critic Alexander Walker says that Kubrick achieves "much more than a cautionary tale on a cosmic scale"; indeed, the film's many parts, skilled construction, and web of ironies transcends any simplistic label.

REFERENCES

Coyle, Wallace, *Stanley Kubrick: A Guide to References and Resources* (G.K. Hall, 1980); Nelson, Thomas A., *Kubrick: Inside a Film Artist's Maze* (Indiana University Press, 1982); Powers, Richard G., introduction to *Dr. Strangelove* (Gregg Press, 1979); Walker, Alexander, *Stanley Kubrick Directs* (Harcourt Brace Jovanovich, 1971).

—*J.A.T., J.C.T., and J.M. Welsh*

THE RED BADGE OF COURAGE: AN EPISODE OF THE AMERICAN CIVIL WAR (1895)

STEPHEN CRANE

The Red Badge of Courage (1951), U.S.A., directed and adapted by John Huston; Metro-Goldwyn-Mayer.

The Novel

Stephen Crane was 24 years old when *The Red Badge of Courage* was published. Although its author had never experienced battle (he drew on accounts of the battle of Chancellorsville and the works of Tolstoy), *Red Badge* became one of the classics of war literature. In his eagerness to see the book published, Crane accepted extensive deletions from his manuscript; a complete edition with those passages restored was published in 1979.

Red Badge relates the first battle experiences of Henry Fleming, a young Union soldier. Although the novel never mentions Chancellorsville by name, circumstantial references (such as those to the Rappahannock River) make clear that the narrative centers on the battle of Chancellorsville (May 2–4, 1863). On the one hand, this ambiguous battle represented Lee's last victory over the Union Army. On the other, Stonewall Jackson fell to "friendly fire" at Chancellorsville. His death proved disastrous for the Confederacy.

After weeks of tedious drilling, Fleming and his comrades lose their romantic illusions in the face of real war. Fleming soon runs from combat in terror. He must then cope with his shame and fear as a deserter, but events permit him to return to his unit without revealing that he had run. Eventually, Fleming comes to terms with his initial cowardice and conducts himself with some courage.

The Film

Huston's black-and-white cinematography in *Red Badge* has been compared, in its effect, to the famous Mathew Brady photographs of the Civil War. The film begins, unfortunately, with a ponderously condescending explanation of the film's origin in Crane's novel: The narration claims (erroneously) that the book was published when Crane was 22 and that its publication "made him a man" (we are not told how). The voiceover continues, "The narration you will hear spoken consists of quotes from the book itself."

The film succeeds largely on the strength of the casting, which entailed some risk. With the exception of character actor Andy Devine ("The Cheerful Soldier"), Huston largely cast unknowns, including Audie Murphy in the role of Henry Fleming. MGM objected, preferring Montgomery Clift, but Huston prevailed. Murphy, the most decorated GI of World War II, who would go on to play himself in *To Hell and Back* (1955), had appeared only

in low-budget westerns before *Red Badge*. More established character actors play supporting roles (John Dierkes as "The Tall Soldier," Royal Dano as "The Tattered Soldier"). Famed war cartoonist Bill Mauldin is quite effective as "The Loud Soldier."

The film's editors reduced what Huston intended as two separate battle scenes to one. The sequences alternating among tracking shots, point-of-view shots, and close-ups (soldiers' faces, their boots as they march, the regimental flag) convey the terrifying immediacy of battle—indeed, so well that they accentuate the intrusiveness of the narration.

The director's cut of *The Red Badge of Courage* might be another Holy Grail of modern cinema. Although the film as released has earned some critical praise, it is clearly

Stephen Crane

not the film Huston intended. Huston described *Red Badge* as his favorite film but refused to see the final edited version. Huston has sometimes been faulted for abandoning the film during its editing (he had moved on to *The African Queen*), but clearly the studios would have done considerable violence to it whatever his involvement at that stage might have been. *Red Badge*'s focus on an unromantic, naturalistic view of war was incompatible with studio politics during the Korean War, and the bizarre opening of the film seems calculated, in part, to distance the studio from Crane's implicit politics. In his autobiography, Huston noted that the film no longer exists in its original, uncut form, a fact that prompted him to demand a complete 16 mm print of his subsequent films as part of any contract.

As Ross and Huston's accounts demonstrate, the unresolved conflicts between Huston and MGM constitute a Civil War unto themselves. Nevertheless, the film's performances and cinematography retain the essential honesty of Crane's remarkable novel. Indeed, it should be noted that in 1894 Crane's publisher, D. Appleton and Co., demanded that he make the same types of cuts that L.B. Mayer demanded of Huston in 1951. In each case, however, the narrative survived its editors.

REFERENCES

Grobel, Lawrence, *The Hustons* (Scribner's, 1989), 352–65; Huston, John, *An Open Book* (Knopf, 1980), 177–80; Ross, Lilian, *Picture* (Rinehart, 1952); Stevenson, James A., "Beyond Stephen Crane; *Full Metal Jacket*," *Literature/Film Quarterly* 16 (1988): 238–43.

—*M.O.*

RED DRAGON (1981)

THOMAS HARRIS

Manhunter (1986), U.S.A., directed and adapted by Michael Mann; DeLaurentiis Entertainment Group.

Red Dragon (2002), U.S.A., directed by Brett Ratner, adapted by Ted Tally; DeLaurentiis/MGM/Universal Pictures.

The Novel

Novelist Thomas Harris became famous after Jonathan Demme's 1991 film adaptation of his 1988 novel *The Silence of the Lambs*, with Anthony Hopkins playing Harris's flamboyant psychotic villain, Hannibal "the Cannibal" Lecter. Lecter was making a second appearance in that novel. His first appearance, with FBI investigator Will Graham, was in the novel *Red Dragon*, published in 1981. Graham has to track down a serial killer, but can do so only by consulting with another serial killer he captured, Dr. Hannibal Lecter, knowing full well that Lecter, who is dangerously cunning, will probably betray him.

The formula behind both novels is essentially the same, since the procedure is to first study the monster, then consult with another monster (Dr. Lecter), find the monster, and then kill the monster. Harris writes scary adult fairy tales dominated by repulsive characters. In each story, an FBI investigator (Clarice Starling in *The Silence of the Lambs* and Will Graham in *Red Dragon*) has to seek help from Dr. Lecter (Anthony Hopkins in the remake, Brian Cox in *Manhunter*, the first film version), evil personified, who is able to enter the minds of the agents in subtle, seductive, and dangerous ways. In the case of *Red Dragon*, Lecter has a payback agenda with Graham, who was responsible for putting him in prison. So traumatic was Graham's initial encounter with Lecter that the investigator had to be hospitalized. He has since retired to the Florida Keys with his wife Molly, who does not want him to go back to work for Jack Crawford with the FBI (played by Harvey Keitel in the remake).

But, as Dr. Lecter tells him, Graham has a taste for such work and is lured into the investigation of the serial killer who has wiped out two middle-class families, in Atlanta, Georgia, and Birmingham, Alabama. The killer, Francis Dolarhyde (Tom Noonan, followed by Ralph Fiennes in the remake), is known as the "Tooth Fairy," because he bites his victims, but he prefers to be known as the "Red Dragon," an identity he has lifted from the artwork of the visionary poet and artist William Blake. He believes that he is in the process of becoming the Red Dragon. Since the character, who suffered from an abusive childhood and a cleft palate, is utterly crazy, his problems need to be contextualized, as was not the case in the earlier film *Manhunter*. The character has worked hard at bodybuilding and is therefore exceptionally strong. He has unexpectedly had a romantic affair with a blind woman named Reba McClane that has threatened to "normalize" Dolarhyde, but the alter ego of his split personality, the Dragon, finally proves to be dominant. His very name suggests the Jekyll-and-Hyde nature of his sickness. So, like a mad dog, Dolarhyde needs to be destroyed.

Dolarhyde works at a film processing plant in St. Louis, and it is by scrutinizing and copying home movies that he has managed to find his victims. Graham eventually discovers this clue, helping to lead him to St. Louis and Dolarhyde's home in the country, where Reba is being held captive. In the process of detection, Graham has fed misinformation to a sleazy yellow journalist named Freddy Lounds (Philip Seymour Hoffman is especially effective in the remake), suggesting homosexual tendencies calculated to infuriate the Tooth Fairy, and marking sleazy Freddy as the Dragon's next victim. Dolarhyde has also become a pen pal with Lecter, who communicates in coded language through the personals in Freddy's tabloid, disclosing the Florida address of Graham and his family. Since things become so personal, Graham has to resolve the problem with the Dragon, but the Dragon almost outsmarts him in a surprise conclusion that comes from the book but is not represented in the earlier film, *Manhunter*.

The Films

Brett Ratner's *Red Dragon* was not only an adaptation of the novel Thomas Harris used to introduce his psychotic character with a taste for murder and mayhem but also a remake, since Michael Mann had already adapted *Red Dragon* in his film *Manhunter* (1986). The earlier film did not do so well at the box office but still went on to become a cult classic, believed by some to be better than *The Silence of the Lambs* (1991), which introduced Anthony Hopkins as Hannibal Lecter in an effectively chilling Oscar-winning performance. In point of fact, just as *The Silence of the Lambs* is superior to *Red Dragon* as a novel, so, certainly, is Jonathan Demme's film superior to *Manhunter*. It is better acted and, thanks to screenwriter Ted Tally, better scripted. The rationale for remaking the film was that *Manhunter* was not widely seen at the time of its release and that as an adaptation of the novel, it was not as faithful as it might have been. (Considering Mann's film a flop, Sheila Benson of the *Los Angeles Times* concluded that "style [had] overrun content, leaving behind a vast, chic, well-cast wasteland.") The novel concluded with a double twist that was not taken into consideration by *Manhunter*, when the Tooth Fairy (Tom Noonan) is shot down by investigator Will Graham (William Petersen, who went on to became the star of the CBS television police procedural series *CSI*). There was no ambiguous ending here at all, since not all of the story was told.

Perhaps having had enough of Hannibal the Cannibal, reviewers lined up to trash *Red Dragon*, because, after all, it is in the nature of critics to be critical. But they were not at all fair to this film. An anonymous reviewer for the *The Washington Post* (probably Desson Howe, since the review appeared in the "Weekend" section of the paper), dismissed the film as "Reheated 'Lamb.'" But if *Red Dragon* could not quite compete with *Silence of the Lambs*, the reason is that Edward Norton simply could not be as vulnerable playing Will Graham as Jodie Foster had been as Clarice Starling. Her vulnerability transformed *The Silence of the Lambs* into a modern-day variant of the Beauty and the Beast legend, besides making her a superstar.

Lawrence Toppman, the critic for the *Charlotte Observer*, confessed that he could not tell if *Red Dragon* was more faithful to Harris's book than *Manhunter*, which he had not seen in 16 years. Of course, simple ignorance did not keep this critic from claiming that the film was "less artful and atmospheric" than *Manhunter*, a "straight-ahead thriller that never rises above superficiality." But it most certainly does. The film follows the production design of *Silence of the Lambs* exactly, whereas the hospital setting for Brian Cox's Hannibal in *Manhunter* cannot measure up to the far more atmospheric design of Jonathan Demme's Gothic cannibal cage for *Silence of the Lambs*, which is carried forward into Brett Ratner's *Red Dragon*. Demme knew how to build a proper cannibal cage, incarcerating the monster and constructing a transparent barrier between the beast and his "little Starling."

The Hopkins monster, then, is the beast in the dungeon. What could be more atmospheric than that? The difference between Brian Cox and Anthony Hopkins, moreover, as Hannibal Lecter, is the difference between a competent actor and a genius, who made the role his own years ago. Hopkins tends to ham up his third attempt at playing Lecter (the second attempt was for the film *Hannibal*, so nasty that Jodie Foster wouldn't agree to play Clarice, a role she owned as surely as Hopkins owned Lecter), but watching Hopkins perform is in itself a guilty pleasure. Two points need to be scored and underscored here. No one tops Hopkins in the personification of evil, and no one tops Demme in the conceptualization and contextualization of evil.

Writing for *USA Today*, Scott Bowles argued the merits and demerits in contrasting *Manhunter* and *Red Dragon*. In *Manhunter* the first glimpse of Lecktor (the name was changed) is in the antiseptic and not-so-scary, well-lighted cell. *Red Dragon* introduces Lecter in an establishing flashback, rehearsing the story of an unfortunate musician who hits a wrong note on his flute while performing with the Baltimore Symphony Orchestra and ends up at the cannibal's table at the wrong end of the fork. The scene also establishes Graham's history with Lecter as the scary doctor attacks Graham with a knife in a scene not exactly true to the novel, but effective enough. *Sight & Sound*'s Mark Kermode, who admired *Manhunter*, noted that "while Graham had to *ascend* to Lecktor's ironically radiant lair in *Manhunter*, he now *descends* to what looks for all the world like a shop window in hell to meet Lecter in *Silence* and *Red Dragon*." The more famous Lecter, Hopkins, gets far more screen time; the less famous Lecktor, Cox, is an almost forgettable minor character.

In *Manhunter* Tom Noonan was a tall Tooth Fairy (6-foot-6), whereas *Red Dragon* uses the shorter (5-foot-11) but far more flamboyant and more "normal"-appearing Ralph Fiennes as Francis Dolarhyde. The earlier film does not bother to explain the Tooth Fairy's motives, taking for granted that he is simply crazy. The remake attempts to confront his inner demons and abusive childhood. Fiennes can transform himself into the Creep Fairy simply by taking his shirt off to display the massive dragon tattoo that covers every inch of his back. The remake also covers his obsession with William Blake and his mission to the Brooklyn Museum of Art to steal and "consume" the Blake's original *Red Dragon* print.

To track Dolarhyde, Graham puts his wife (Mary-Louise Parker) in jeopardy in the novel, and this complication is restored to the film. Graham teaches his wife how to use a pistol, for good reason. *Variety* reviewer Todd McCarthy predicted, rightly, that Ratner's "faithful, immaculately appointed new retelling of the inescapably creepy tale will be an intensely unnerving restraint." Ratner was also particularly praised for his "intelligent restraint," in comparison to Ridley Scott's *Hannibal* (2001), the second Lecter film. Initial expectations were not high for Ratner, who had previously directed Jackie

Chan in *Rush Hour 2*, a film that was more busy than thoughtful.

It should be clear even to Michael Mann fans that *Red Dragon* is the better adaptation of the Robert Harris novel. It is also arguable that Brett Ratner's adaptation is the better film, despite the protests of reviewers who regard *Manhunter* as a cult favorite. Ralph Fiennes is a better dragon than Tom Noonan is a Tooth Fairy. Edward Norton is arguably more convincing than William Peterson as the world-weary Graham. Emily Watson was up against stiffer competition in duplicating the role of Reba, originally introduced by Joan Allen. But Ratner serves up sleazier characters in Harris's Freddy (Philip Seymour Hoffman) and Anthony Heald's Dr. Chilton, who eventually will be served up to Dr. Lecter. In his two scenes in *Manhunter* Brian Cox was all right as Lecter, but, after all, Anthony Hopkins now "owns" the Lecter franchise, and seems to enjoy taking the bad doctor over the top. On its opening weekend in 2002, *Red Dragon* set an October box-office record by grossing more than $37 million, demonstrating that the Lecter franchise is as potent as ever.

REFERENCES

Bowles, Scott, "'Red Dragon' vs. 'Manhunter': The Gloves Come Off," *USA Today*, October 7, 2002, D4; Flynn, Gillian, "First Blood," *Entertainment Weekly*, October 11, 2002, 30–35; Kermode, Mark, *Sight & Sound* 12, no. 12 (December 2002): 58–59; McCarthy, Todd, *Variety*, September 30–October 6, 2002, 24, 71; Schwarzbaum, Lisa, "Lecter Circuit," *Entertainment Weekly*, October 11, 2002, 51–52; Toppman, Lawrence, "'Red Dragon' a Pallid Rehash," *Charlotte Observer*, October 4, 2002, 3; "'Red Dragon': Reheated 'Lamb,'" *Washington Post Weekend*, October 4, 2002, p. 39.

—*J.M. Welsh*

THE RED PONY (1938)

JOHN STEINBECK

The Red Pony (1949), U.S.A., directed by Lewis Milestone, adapted by John Steinbeck; Republic.

The Novel

In his letters John Steinbeck writes of working on "a pony story" as early in his career as 1933. Two sections, "The Gift" and "The Great Mountains," were published in *North American Review* in late 1933. It wasn't until 1937 that "The Promise" appeared in *Harper's*, while "The Leader of the People" first appeared in the author's 1938 collection of stories, *The Long Valley*. The four tales, which have a common setting and characters, were later unified under the title *The Red Pony*.

The four stories are set in California's Salinas Valley, where a 10-year-old boy, Jody Tiflin, lives with his mom, Ruth, his dad, Carl, and a hired hand, Billy Buck. In the first sequence, "The Gift," Jody receives a red pony from his father, but it is Billy Buck who teaches Jody how to train and take care of the pony. When Jody accidentally leaves the pony out in the rain, it becomes ill and dies despite Buck's efforts to save it.

In "The Great Mountains" an aging Mexican laborer who was born and raised on the ranchland before the Tiflins owned it comes back to die there. Carl is cruel and tells the old man to leave in the morning. Before daybreak Gitano takes the Tiflin's broken-down old horse, Easter, and sets off to die in the mountains.

In the third story, "The Promise," Carl has the mare Nellie put to stud so Jody can have another pony. Jody, remembering the red pony, worries about the outcome, but Billy Buck promises Jody all will be well. When complications arise at birth, Billy kills the mare to save the colt, fulfilling his promise to Jody.

Jody's grandfather comes to visit in the final sequence, "The Leader of the People." Carl cruelly tells the old man that his repetitive tales of adventures are old and boring.

The Film

Steinbeck and Lewis Milestone became friends when Milestone brought to the screen another Steinbeck novel set in the Salinas Valley, *Of Mice and Men*. As early as 1940 they discussed filming *The Red Pony*. Other projects intervened until 1946 when they went into partnership with Republic Studios to do the film. The author was the screenwriter, his only adaptation of one of his own works. The movie, produced and directed by Milestone, was moderately successful.

In adapting the four episodes, Steinbeck completely cut out "The Great Mountains" and severely reduced "The Promise" from the script. Steinbeck, for unknown reasons, changed the names of the three Tiflins: Tom, the boy, Alice and Fred, the parents.

Unlike the episodic narrative of the original work, the screenplay stories were intertwined in order to conform to the traditional Hollywood narrative structure, thus compressing time so that Tom receives word that he will get Nellie's colt immediately after his red pony's death. In the film the grandfather owns the ranch and lives with the Tiflin family, changing the relationships that existed in the story "The Leader of the People."

The screenplay added two animated fantasy sequences, one in which Tom imagines he and Billy are knights and another in which the chickens he is feeding turn into circus horses. The brief portraits of schoolchildren in the original stories have, in the screenplay, become prominent characters whose antics were compared unfavorably to the Little Rascals. But the biggest deviation from the original story was concluding the film with a happy ending, whereby both the mare Nellie and her newborn colt miraculously survive a difficult birth.

At the time of the film's release the graphic segment of the red pony's death was criticized as being too violent for a children's film. Yet the maudlin happy ending which changed the harsh reality of Steinbeck's original, was also

seen as unsatisfactory, albeit for different reasons. The stark realities of nature, which made Steinbeck's story a classic coming of age tale, when visualized on the big screen were too harsh to be acceptable to the family audience of the day.

The addition of the "cute" schoolmates and Disney-like fantasy sequences was certainly out of character with the naturalistic settings and style of Steinbeck's original. These, too, may have been added in an attempt to make the story more acceptable as a children's film, but like the "happy ending" these changes detracted from the poignancy and overall mood of the story. Aaron Copland's music score has deservedly achieved concert hall status.

REFERENCES

Millichap, Joseph R., *Lewis Milestone* (Twayne Publishers, 1981): Raine, Elaine, "The Red Pony," *Magill's Survey of Cinema, Series II*, vol. 5 (Salem Press, 1980); Crowther, Bosley, *New York Times*, March 9, 1949; Steinbeck, Elaine and Robert Wallstein, eds., *Steinbeck: A Life in Letters* (Viking Press, 1975).

—D.P.H.

RED SORGHUM FAMILY (1987)

MO YAN

Red Sorghum (*Hong gaoling*) (1988), China, directed by Zhang Yimou, adapted by Chen Jianyu, Zhu Wei, and Mo Yan; Palace/Xian Film Studio.

The Novel

Mo Yan is a popular and critically acclaimed contemporary Chinese writer noted for his regionalist tales that depict powerful and passionate family dramas against a clearly delineated Chinese rural background undergoing radical and turbulent changes in the 20th century. His work (including the 1991 *Explosions and Other Stories*) details the conflicts between modern and traditional Chinese cultures, conflicts rife with ideological tension arising from political and social reforms super-imposed on peasant villages with deeply rooted rituals, customs, and beliefs. His language and narrative strategies have been compared to Faulkner's modernism, Heller's black humor, and Garcia Marquez's "magic realism." Due to the success of Zhang Yimou's film, Mo Yan is now best known in the West for *The Red Sorghum Family* (translated by Howard Goldblatt in 1993).

The novel describes three generations of one family's domestic history against an historical background that moves from the post-Chinese Republic 1920s and the pre-revolution 1930s and 1940s, up (briefly) until 1985. The "narrator" (born, like Mo Yan, in 1956 in Shandong Province) focuses on the lives of his father and his paternal grandparents in an almost medieval feudal village of Northeast China. These grandparents—the major characters in the novel—become lovers in a field of red sorghum, after which the narrator's grandfather (a lower-class "sedan carrier") murders a rich winery owner and his leper son (whom the narrator's grandmother had just previously been forced to marry) and eventually moves in with the "widow." After an idyllic period running the village's most successful winery, the narrator's grandparents and their fellow villagers confront the modern world in the form of a brutal Japanese invasion in the late 1930s.

Scenes from the resulting warfare are the longest and certainly most powerful sections of the novel: The prose captures perversely detailed images of carnage, rape, and starvation, which the narrator contrasts to the bland present day. Among these battle scenes against the foreigners, Mo Yan describes internecine Chinese warlord gang fights and a bizarre battle with a huge army of organized corpse-eating dogs gone wild, an army that ironically parallels the warring factions, including the competing Communists and Nationalists.

The novel's explicit violence renarrativized as family folklore is told in the kind of looping narrative that one associates with Western postmodernism: Stories are embedded within stories, and the narrative jumps almost incoherently back and forth in time. These flashbacks, flashforwards, and repetitions of individual events (with increasingly horrifying details added to each reference to the same event) create a sense of simultaneity that resembles a large mural, a mural replete with details of horrific violence, sexuality, war, humor, folklore, and sweeping natural landscapes. Humorous descriptions of the grandparents' red sorghum winery, for instance, are sharply juxtaposed in almost cinematic jumpcuts with descriptions of the Japanese invaders' atrocities.

The Film

Zhang Yimou, born in 1950, is the most famous of the "Chinese Fifth Generation" directors (named for the fifth class to graduate—after the hiatus during the Cultural Revolution—from the reopened Beijing Film Academy). He originally worked as a cinematographer on Chen Kaige's *Yellow Earth* (1984) and *The Big Parade* (1985), as well as Wu Tianming's *Old Well* (1987), in which he also acted, as he did in *Terra-Cotta Warrior* (1990). *Red Sorghum* was his first film, and it immediately marked Zhang as both a critical star in the West and a controversial director in China. (He went on to film *Judou, Raise the Red Lantern, The Story of Qui Ju,* and *To Live.*) This became the first Mainland Chinese film to win major Western recognition (including the Golden Bear Award at the 1988 Berlin Film Festival), but its vivid eroticism (although mild by Western standards) was also the cause of the so-called *Red Sorghum* phenomenon—the near riots it engendered in many Chinese cities where police were called in to patrol outside theaters where it was shown.

In its use of only the first two chapters, the movie adaptation avoids the even more potent political controversy of the novel (itself partially censored by Chinese authorities) in which Mo Yan offers mildly parodic commentary on Communist Party reforms and on the Cultural Revolution. The adaptation similarly eliminates the aesthetic problems posed by the novel's temporally complex narrative: The film uses the narrator's voiceover to maintain narrative coherence, but it completely avoids the novel's complicated and disturbing jumps in time, superimposing a strict linear narrative onto the story. Although an understandable decision, the result is much less compelling: Where Mo Yan's narrative cuts tended to emphasize the temporal permanence of the horror, Zhang Yimou's film contains it within a safe dramatic structure.

Most prominent in former cinematographer Zhang Yimou's first film is the photography (by Gu Chang-wei), which beautifully captures such flowery descriptions as Mo Yan's: "vast stretches of red sorghum shimmered like a sea of blood. Tall and dense, it reeked of glory; cold and graceful, it promised enchantment; passionate and loving, it was tumultuous . . . The sun, stained by human blood, set behind the mountain as the full moon of mid-autumn rose above the sorghum." The red sorghum in both novel and film provides a backdrop for love, sex, and death, symbol of the force of nature existent in the past but now gone.

Red Sorghum's evocation of a Chinese rural lifestyle has been attacked as merely appealing to a Western taste for a kind of "oriental exoticism," a *National Geographic* sensibility in which gorgeous imagery effaces ideology and simplifies characters' psychological complexity. While it is true that to an extent Zhang Yimou's sensuous, almost passionate, use of color and composition tends to reduce the story and, especially, the history to mere imagery, nevertheless the film on its own terms remains a powerful and provocative reading of Mo Yan's admittedly much more ambiguous and challenging epic imagination.

REFERENCES

Berry, Chris, *Perspectives on Chinese Cinema* (British Film Institute, 1991); Chow, Rey, *Primitive Passions: Vitality, Sexuality, Ethnography, and Contemporary Chinese Cinema* (Columbia University Press, 1995); Zhu, Ling, "A Brave New World? On the Constructions of 'Masculinity' and 'Femininity' in *The Red Sorghum Family*," in *Gender and Sexuality in Twentieth-Century Chinese Literature and Society*, ed. Tonglin Lu (SUNY Press, 1993), 121–34.

—D.G.B. and C.C.

THE REIVERS (1962)

WILLIAM FAULKNER

The Reivers (1969), U.S.A., directed by Mark Rydell, adapted by Irving Ravetch and Harriet Frank Jr.; National General.

The Novel

William Faulkner wrote his publishers in 1940 that he had a novel in mind about a young lad developing toward maturity while visiting a big city. But Faulkner did not get around to developing this idea into a full-scale novel until 1962. Nevertheless, the original story, as he conceived it in 1940, was not appreciably different from the plot of the novel as it was published two decades later.

At the center of the story, which is set in the early 1900s, is a youngster named Lucius, who takes a trip to Memphis with Boon Hogganbeck, a white handyman employed by his father, and Ned McCaslin, a black domestic servant in Lucius's home. The trio of reivers (an archaic word for rogues) commandeer the automobile belonging to Lucius's grandfather, who is nicknamed Boss, for their unauthorized excursion to Memphis. They are able to do so while Boss and Lucius's parents are themselves away from home. In the course of their stay in Memphis, the trio, along with Boon's girlfriend, a harlot named Corrie, get into trouble over a racehorse.

Ned swaps Boss's auto for a racehorse called Lightning, with a view to having the horse run in a race, with Boss's car going to the owner of the winning horse. At the novel's climax, Lucius, who is Lightning's jockey, duly wins the race and regains Boss's car.

The Film

Since the novel was narrated by Lucius as an old man, the screenplay by Irving Ravetch and Harriet Frank Jr. attempts to approximate the book's narrative point of view by having the elderly Lucius (voice by Burgess Meredith) give a voiceover commentary on the action as the plot unfolds on the screen. Most of the aging narrator's remarks are taken verbatim from the novel. Thus Lucius's older self comments, through voiceover, that the guilt he felt for taking the auto and for making the trip without the sanction of his elders undercut to a great extent the joy that attended his winning of the race. He returned home from the journey a sadder but wiser young man.

Lucius (Mitch Vogel) does not have an audience with his grandfather (Will Geer) about what he has done until he gets home. The old man takes Lucius into his lap; and the boy, deeply ashamed of his behavior, begins to sob. In an interchange that closely follows the novel's dialogue, Boss advises his grandson that he can redeem himself in the eyes of his family for his recent delinquency if he is willing to profit by the mistakes he has made. "Now go wash your face," Boss concludes. "A gentleman cries too, but he always washes his face." On this note of symbolic cleansing, an emblem of his grandfather's forgiveness, the sequence ends.

The movie version of *The Reivers*, like the novel itself, portrays Lucius's odyssey to Memphis as a genuine parable of the journey of a youngster toward maturity. In addition,

director Mark Rydell evoked uniformly splendid performances from Steve McQueen as Boon and from the other principal players. For his part, the director attributes the high quality of the film primarily to the Ravetch-Frank screenplay, which reflected Faulkner's humor and earthy characterizations in a most satisfying fashion. All in all, *The Reivers* remains one of the better films adapted from Faulkner's work.

REFERENCES

Crist, Judith, *Take 22: Moviemakers on Moviemaking* (Viking, 1981); Kael, Pauline, *5001 Nights at the Movies* (Holt, 1991); "Southern Reconstruction," *Time* (January 5, 1970).

—G.D.P.

THE REMAINS OF THE DAY (1989)

KAZUO ISHIGURO

The Remains of the Day (1993), U.K., directed by James Ivory, adapted by Ruth Prawer Jhabvala; Nichols/Calley/Merchant-Ivory/Columbia.

The Novel

Winner of the prestigious Booker Prize in England, Ishiguro's third novel is a tour de force of ironic narration. As Stevens—the conscientious, painstaking, meticulous British butler—tells his story, we realize, at first with a shock and then with increasing dread, that what he tells us and what he knows don't coincide, and that the latter is considerably less than the former. Says critic Phoebe-Lou Adams, "The author maintains this double-vision pattern without ever deviating from the overall careful style that he has created for Stevens, and the effect is funny and sad and ultimately disturbing, for questions of moral responsibility lurk behind the novel's highly polished surface."

In the narrative present Stevens is on his way to visit Miss Kenton, whom he hopes to persuade to return to Darlington Hall as housekeeper, a job she had left some years before. We learn that she had been in love with Stevens, but that he had either not realized it or had shrunk from doing so. We also learn, as Stevens reminisces, that his now deceased master, Lord Darlington, whom he idealizes as the perfection of aristocracy in his noble efforts to restore friendly relations with Germany between the wars, was really an unwitting collaborator in the Nazis' rise to power. This means that Stevens too, as a loyal servant, was a participant in that collaboration. What begins as a comedy of manners about a fussy butler lamenting the breakdown of the social order evolves, according to Lawrence Graver, "into a profound and heart-rending study of personality, class and culture." Miss Kenton is now Mrs. Benn, though separated.

Stevens does not pick up on this second chance; he notices that she's crying when they part. He sets out for home alone, intent on practicing bantering, because he's observed from people around him that in it may lie "the key to human warmth." He seems to have learned nothing, either from his missed chance at love or his blind devotion to Lord Darlington. In fact, ever the obedient servant, he hopes his new skill at bantering will please the current owner of Darlington Hall: "by the time of my employer's return, I shall be in a position to pleasantly surprise him."

The Film

The novel's skillfully inhibited yet simultaneously revelatory narration can have no real equivalent in film, yet the adaptation does manage to convey the butler's unwittingness while letting the audience know what he misperceives. This is not accomplished without a loss, however. As Kauffmann points out, Jhabvala "italicizes much of the subtlety." To make sure the audience does not miss the political point, she adds a scene in which a doctor criticizes Stevens for his collaboration in the treasonous goings-on at Darlington Hall. To defend himself, Stevens has to evade and lie, which changes him from a loyal servant to a "shifty time-server . . . just to make sure the audience understands that the film's political heart is in the right place." As Kauffmann also points out, the screenplay sentimentalizes the relationship with Miss Kenton, and at the end, by moving with her onto the bus, it disrupts the first-person perspective of Stevens, "not merely a literary device . . . but a comment on England."

Reviews were highly respectful, especially in praise of Anthony Hopkins's portrayal of Stevens. Even Kauffmann's reservations about the screenplay dissolved into praise for the film's elegiac and "melancholy beauty." Corliss thought the film "even more discreet, more Stevens-like, than the book." Lane, on the other hand, was grumpy, almost quirky, in dismissing the novel for not being by P.G. Wodehouse, calling the film version "even more anal and starchy than [its] hero," and dumping on all Merchant-Ivory adaptations for suggesting "that any movie full of well-behaved people is by definition a delicate work of art" and thus refines and betters the people watching it. Films like *The Remains of the Day*, he concludes, "play a low trick with high culture, and reverse its purpose: they turn us into snobs."

REFERENCES

Adams, Phoebe-Lou, review of novel in *Atlantic Monthly*, November 1989, 135; Corliss, Richard, "Still Life of Anthony Hopkins," *Time*, November 8, 1993; Graver, Lawrence, review of novel in *New York Times Book Review* (October 8, 1989); Kauffmann, Stanley, "An Elegy," *The New Republic*, December 6, 1993; Lane, Anthony, "In Which They Serve," *The New Yorker*, November 15, 1993.

—U.W.

RISING SUN (1992)

MICHAEL CRICHTON

Rising Sun (1993), U.S.A., directed by Philip Kaufman, adapted by Kaufman, Michael Crichton, and Michael Backes; Twentieth Century Fox.

The Novel

Michael Crichton is a skilled writer of techno-fiction tied to action-adventure, but his best work is also thesis directed, involving warnings about scientific presumption, as in *Jurassic Park* (1990), and the danger of a Japanese corporate takeover of America, in the case of *Rising Sun*. Crichton's polemic about Japanese influence is disguised as a murder mystery, investigated by two detectives, master sleuth John Connor and his apprentice sidekick Peter Smith. A young woman from Texas is murdered in an executive boardroom on the 46th floor of the newly-constructed Los Angeles headquarters of Nakamoto Industries. The Japanese attempt to control the police investigation of the murder to prevent embarrassment, since the call girl was murdered while a gala celebrating the building's opening was in progress.

The larger issue of the novel, however, concerns the Japanese takeover of an American company, Micro-Con, a sale that cannot take place without congressional action; this plot has to do with influence peddling, blackmail, and a cover-up intended to put the squeeze on a powerful senator, John Morton, who chairs the Senate Finance Committee and whose support the Japanese need. Senator Morton has been involved in a kinky romance with the murdered call girl and is made to believe he murdered her by strangulation while having intercourse. The Nakamoto security system captured this encounter on videotapes, which are being used to blackmail the senator; the Japanese have doctored the tapes to take Morton out of the picture, putting him in their debt. Connor and Smith need to find the missing tapes and to determine how the evidence was doctored. In the process they discover, at extreme risk to their lives and careers, that the woman was not killed until after Senator Morton had left the boardroom and that the murderer was Masao Ishiguro, the Los Angeles head of Nakamoto Industries, who is apprehended and so embarrassed in front of his peers that he commits suicide.

The "message" of *Rising Sun* is summarized at the end of the novel: "The Japanese are not our saviors. They are our competitors. We should not forget it." Crichton even provided a bibliography in the hope that "readers will be provoked to read further from more knowledgeable authors," listing books that further explored the issues raised by his novel. Because of the polemical nature of his novel, Crichton was accused of "Japan-bashing," a response that surprised him but was taken seriously by Hollywood producers when the novel was reshaped as a film adaptation.

Michael Crichton

The Film

The film was directed by Philip Kaufman, who wrote the screenplay in collaboration with Michael Crichton and Michael Backes, but Kaufman changed the novelist's first-draft screenplay and modified it in keeping with notions of "political correctness" that were dominant in America when the film was produced. Crichton and Kaufman were at odds about how the treatment should be handled, to the extent that Kaufman turned his screenplay over to Twentieth Century Fox bearing only his name, even though others were involved (even playwright David Mamet, who doctored the dialogue); but the Screen Writers Guild arbitrated shared credit, giving Kaufman permission to use his name first.

The changes were not subtle. Sean Connery was cast as John Connor, an American who had lived in Japan and whose understanding of the Japanese is far superior to anyone else in the LAPD; Crichton had originally designed the character with Connery in mind. Peter Smith, however, is turned into an African-American sidekick (Wesley Snipes) whose name is Web Smith. The video technician who helps the detectives sort out the mystery of the doctored tapes, Theresa Asakuma, is renamed Jingo Asakuma, and she is made the mistress of John Connor in the film. Web courts her at the end of the film, though why the two of them would want to betray Connor is not at all clear. In

the novel there was no such romantic involvement between Connor and Asakuma; in fact, Connor plays matchmaker for Smith, who had recently been divorced from his career-oriented lawyer wife, Lauren, who is not portrayed as a good mother for their young daughter.

Web Smith in the film is more perceptive than Pete Smith in the novel and far more assertive—not exactly co-equal with Connor, but only a few steps behind. The film turns "Fast Eddie" Sakamura into "Crazy Eddie" and indicates that he is involved with *yakuza* gangsters; it also gives Eddie a more heroic death, with guns blazing, adding film noir touches, and making the *yakuza* Eddie's avengers at the end. In the novel the detectives merely find Eddie's body face down in a swimming pool and he has no *yakuza* connections.

More important, the corporate plot is considerably changed. The villain is no longer the Nakamoto executive, who in the film is Connor's friend and golf partner, but a shifty, crooked Caucasian lawyer, Bob Richmond (Kevin Anderson). In the novel the point is made by the Japanese that their colleague had been contaminated and corrupted by American ways, that he had lived in the United States too long. There is an Ishihara in the film, but no Ishiguro. The deceptive murder plot of course drives the story, and the process of detection is similar, even if the detectives are not exactly the same, but the message is diluted.

If part of the challenge here is to represent cultural differences and "otherness," the film gets off to a brilliant start, but then overly emphasizes action and labors to mollify charges of Japan-bashing that had been leveled at the novel. The film underplays the novel's warning that American businessmen are shortsighted and too willing to sell off their technology for short-term profits while the Japanese invest more wisely in the future. Though the plot is fairly close to the original, the characters are foolishly reinvented and the message ignored in this entertaining but distorted adaptation.

REFERENCES

Canby, Vincent, "A Tale of Xenophobia and Zen in Los Angeles," *New York Times*, July 30, 1993, C, 8; Mitchell, Sean, "Strangers in a Strange Land," *Premiere*, August 1993, 58–63; Rafferty, Terrence, "City of Dreams," *The New Yorker*, July 26, 1993, 79–81; Rayns, Tony, "*Rising Sun*," *Sight and Sound*, October 1993, 51–52; Shapiro, Michael, "Is 'Rising Sun' a Detective Story or Jeremiad?" *New York times*, July 25, 1993, 9, 14; Smith, Gavin; "Heroic Acts and Subversive Urges: Philip Kaufman Interviewed," *Film Comment*, July–August 1993, 36–43.

—*J.M. Welsh*

THE ROAD TO WELLVILLE (1993)

T. CORAGHESSAN BOYLE

The Road to Wellville (1994), U.S.A., directed and adapted by Alan Parker; Dirty Hands/Beacon/Columbia.

The Novel

The Road to Wellville is T. Coraghessan Boyle's fifth novel and in terms of readership something of a "breakout" book, with more popularity, if rather less enthusiastic critical reception, than earlier novels like *East Is East* and *Water Music*. Mixing fact with fantasy, this novel recounts the career of Dr. John Harvey Kellogg of Battle Creek, Michigan, the inventor of the corn flake, peanut butter, and coffee substitutes. His dietary regimen of bran and yogurt coupled with five enemas a day won a loyal following to his sanitarium during the early years of the 20th century. With a Dickensian cast of characters and a somewhat problematic objective, Boyle illuminates the health craze of our 1907 ancestors to score a sometimes elusive satire upon our pursuits of health and longevity at the end of our century.

The hapless Will Lightbody and his wife, Eleanor, come to Dr. Kellogg's "Temple of Health" for the cure. Eleanor has already been a resident there following a miscarriage, and now she brings her husband, who is suffering from an undiagnosed stomach ailment. The Lightbodys are wealthy Easterners who meet Charles Ossining on the train to Michigan; Ossining's desire is to get rich from the manufacture of his own breakfast cereal, Per-Fo—"The Perfect Food" (Predigested, Petonized and Celery Impregnated. Perks Up Tired Blood and Exonerates the Bowels.) The novel is told from the three perspectives of Kellogg, Lightbody, and Ossining.

Dr. Kellogg's adopted son, George, becomes involved with the Per-Fo scheme to give the Kellogg name to this fugitive venture. Meanwhile Lightbody attempts to reestablish marital connection with his distant wife who has succumbed completely to the celibate rules of the sanitarium (even as she is receiving sexual release from the "therapeutic massage" of a Dr. Spitzvogel). In an heroic effort, Lightbody rescues his wife from the German doctor's ministrations and finally gets them both out of Battle Creek. Meanwhile, Dr. Kellogg confronts son George in a now-burning sanitarium—the result of arson. The final face-off occurs over the thousand-pound nut-butter vat where Dr. Kellogg drowns his son, his "failed experiment."

The Film

Alan Parker continues his penchant for filming seemingly intractable material with *The Road to Wellville*, described by David Denby as "one of the most intricately tiresome movies ever made," even though he concedes the elaborate, handsome production almost obliges one to try to see some merit. The excremental vision praised in Swift and Rabelais and sporadically appreciated in Boyle, fares less well in the visual medium. Anthony Hopkins, with protruding Bugs Bunny front teeth, delivers a manic and sometimes amusing portrayal of Dr. Kellogg, but the unabashed foolishness of the original source material becomes intensified in Parker's version. Despite the attrac-

tive presence of Matthew Broderick and Bridget Fonda as Mr. and Mrs. Lightbody, there is little to make us care about their characters. John Cusack as con man Ossining proves moderately convincing. Parker puts a brighter spin on the novel's events, especially with Dr. Kellogg's rescue of George from the vat. The darker comic elements of the novel are often reinterpreted as buffoonery.

Parker's film looks wonderful with Peter Biziou's skill as director of photography and a production design by Georgina Greenhill, suggesting *Last Year at Marienbad* on a high-fiber diet. Details have always been a touchstone of Parker's cinema, and the array of therapeutic instruments in the sanitarium engages the eye and the imagination. The most provocative sequences offer flashbacks of the young George, played by Jacob Reynolds, in the midst of bizarre and compulsive behavior. The controlling power of the adoptive father over his assembly of children is Dickensian in its resonance and reminds one of Parker's gifts in earlier films like *Angel Heart* and *Mississippi Burning.* Parker's presentation of the death of the doctor at an advanced age in the middle of a somersault dive surely generates a more memorable terminus than the flat vital statistic Boyle provides.

Unfortunately, quick cuts fail to be the equivalent of Boyle's prose, despite some amusing juxtapositions such as a colonic infusion and the sudden filling of a glass with draft beer. Without the novel's narrative voice(s), *The Road to Wellville* lacks focus. The weakness of the novel, which might lead a reader to ask "So what?" unfortunately seems more inevitable in the film version. Parker's movie was a disaster at the box office; it might have a slight chance of rebirth as a cult film, but then presumably for viewers with rather special tastes.

REFERENCES

Denby, David, *New York Magazine*, November 14, 1994, 76; Yates, Robert, "The Road to Wellville," *Sight and Sound*, February 1995, 50–51.

—*E.T.J.*

ROOM AT THE TOP (1957)

JOHN BRAINE

Room at the Top (1959), U.K., directed by Jack Clayton, adapted by Neil Paterson; Romulus.

The Novel

Room at the Top is the first novel by John Braine, one of a group of English writers known as the Angry Young Men who flourished in the 1950s. They expressed the discontent of a generation educated at redbrick universities but unable to enter the power circles of British politics, education, or literature because of entrenched upper-class privilege. The book, well-received by the critics and very

popular with readers, is considered a key work of this somewhat short-lived "movement." Braine (1922–86) wrote a sequel, *Life at the Top* (1962), and nine other novels, but he never duplicated the success of his initial effort.

The story is narrated by its protagonist, Joe Lampton, the events having taken place a decade before. With hindsight, Joe understands that he has achieved success but not happiness. For readers of the present day, the novel is less about the British class system than it is about Joe's shifting affections for Alice Aisgill, an unhappily married older woman, and for Susan Brown, the daughter of a wealthy industrialist. In discussing the film, Stanley Kauffmann noted that "the script makes its drama out of the development and counterpoint of character. The plot is secondary." In this respect, novel and film are alike. Joe, a former RAF sergeant with a college degree—his tuition paid by veterans benefits—works in civil service. As the novel begins, Joe is transferred from his hometown of Dufton, a drab industrial city, to the cleaner, more enterprising city of Warley. (The two places are contrasted frequently.) Joe joins the Warley Thespians, where he meets both Alice and Susan and gains entrance into Warley society. At first, Joe pursues Susan, always aware that his rival is the wealthy Jack Wales who personifies British privilege. Joe drifts into a love affair with Alice and for a time avoids Susan, but eventually they resume their courtship. When Joe and Alice spend an idyllic week at a seaside cottage, he realizes that he truly loves Alice. However, he has gotten Susan pregnant, and Mr. Brown forces him to marry his daughter and renounce Alice who by this time deeply loves him. He rejects Alice who gets drunk immediately afterward and dies agonizingly in a car accident. In the end, Joe has achieved his heart's desire, marriage to "a girl with a Riviera tan," but he has missed his "chance to be a real person."

The Film

The film deviates from its source in significant ways in its treatment of character and situation. First, the viewer understands that events are contemporary, not a decade in the past. Next, Joe's angry speeches about class distinctions sound harsher on the soundtrack than they appear on the printed page. In addition, Joe's antagonists are nastier than they are in the book: Jack Wales sneers loudly; Mrs. Brown is overtly snobbish; Aisgill is cold and unfeeling. Mrs. Thompson, Joe's generous-hearted landlady in Warley, which inexplicably has been changed to Warnley, disappears from the story; instead, Joe shares a dreary boarding house with Charles Soames (Donald Sinden). Furthermore, Charles and his fiancée June (Mary Peach) become foil characters to Joe and Susan, representing conventional aspirations of people in their class: The audience knows at the conclusion that Charles and June, unlike Joe and Susan, will have a happy marriage.

Joe's alternating affections for his women is neatly accounted for in the film when Susan's family sends her to

Simone Signoret in Room at the Top, *directed by Jack Clayton* (1959, U.K.; REMUS/THEATRE COLLECTION, THE FREE LIBRARY OF PHILADELPHIA)

the Riviera to separate her from Joe, allowing him to expand his affair with Alice. Mr. Brown also tries to separate the couple by anonymously offering Joe a job in Dufton, a device of the screenwriter that permits Joe to return there to visit his aunt and the bombed ruin of the home where his parents were killed. That Alice has become a Frenchwoman (Simone Signoret) is easily accounted for when she states that she was an exchange teacher before the war.

Neil Paterson's script maintains a shapely narrative. Narrative threads are, in fact, tightened; thoughts of the characters in the novel are verbalized and spoken words are sometimes rearranged for cinematic directness, although complexities of tone are reduced. The idyll at the beach cottage is better realized than it is in the book and creates a sense of doomed love. Joe's perception in print of his changed character is understood by the audience in the film since Joe is viewed objectively by the camera (there is no voiceover narration). Distinctions of class are conveyed by images and by the accents of the characters: Mrs. Brown and Susan speak Oxbridge English whereas the others, including the self-made Mr. Brown, speak a Yorkshire version. Toward the end of the film, as in the novel, after Alice's death Joe goes on a drinking binge, but on film he suffers an obligatory beating, obviously as punishment

for his treatment of Alice. At the wedding, a final scene that is not in the novel, characters seen earlier—Joe's aunt, Alice's friend Elspeth—are present to effect a neat closure, allowing Susan to repeat her earlier comment, as Joe weeps (for Alice or for himself or both) that he is really sentimental after all.

For England *Room at the Top* in 1959 was a breakthrough film. Jerry Vermilye states that "in both language and sexual attitude it was the most adult movie ever to come from a British studio," and it paved the way for other films about working class life, such as *Look Back in Anger, Saturday Night and Sunday Morning, A Taste of Honey, The Loneliness of the Long Distance Runner,* and *A Kind of Loving.* Working people in several countries identified with Joe's assertion "I'm as good as the next man." Film critics, unlike book reviewers, recognized that Joe had his literary forebears in Julien Sorel in Stendahl's *The Red and the Black* and in Clyde Griffiths in Dreiser's *An American Tragedy.* In Stanley Kauffmann's view, the film is better than the book and "an achievement" for director Jack Clayton in his first full-length film. But the real reason, then and now, to see the film is Simone Signoret, who gives one of the best performances by a woman in cinematic history.

REFERENCES

Hibbin, Nina, "British 'new wave'" in *Movies of the Fifties*, ed. Ann Lloyd (Orbis, 1982); Kael, Pauline, *5001 Nights at the Movies* (Henry Holt, 1991); Kauffmann, Stanley, *A World on Film* (Harper and Row, 1966); Simmons, Judy, "John Braine," in *Dictionary of Literary Biography*, vol. 15 (Gale, 1983); Vermilye, Jerry, *The Great British Films* (Citadel Press, 1978).

—*J.V.D.C.*

A ROOM WITH A VIEW (1908)

E.M. FORSTER

A Room with a View (1986), U.K., directed by James Ivory, adapted by Ruth Prawer Jhabvala; Merchant-Ivory Productions.

The Novel

There were a number of aspects of Forster's life that specifically influenced *A Room with a View* and had an effect on Forster's other writings. His experience at Tonbridge School as a teenager was very difficult for him because of the cruelty he suffered from classmates. This experience left him with deep sympathy for the individual against society, and this can be seen in Forster's portrayal of the Emersons. Forster's homosexuality directly influenced the writing of his last novel *Maurice* (1971), but also influenced his perception of social convention, which comes under fire in *A Room with a View.* Finally, his trip to Italy with his mother in 1901–02 directly influenced his Italian novels, including *A Room with a View.*

The novel is divided into two distinct sections. The first takes place in Florence, where young Lucy Honeychurch and her older cousin Charlotte Bartlett (acting as her chaperone) are starting their visit to Italy. They meet a host of interesting characters at the Pension Bertolini where they are staying. These characters include the bohemian novelist Eleanor Lavish, the spinsters Miss Teresa and Miss Catherine Alan, the clergyman Mr. Beebe who has been transferred to Lucy's home parish, and Mr. Emerson and his son George. Florence provides two especially exciting adventures for Lucy. First, she witnesses a murder and faints into the arms of the young Emerson. The experience of the murder has a profound effect upon the both of them, though Lucy is terribly embarrassed by her fainting spell. The second adventure occurs during a picnic in the country, during which George takes the liberty of embracing and kissing Lucy.

The second half of the novel takes place at Windy Corner, Lucy's home on Summer Street (where she lives with her mother and Freddie, her brother). It begins with Lucy's acceptance of a marriage proposal from Cecil Vyse, a seemingly snobbish bore whom Lucy met in Rome. When a nearby house is available for lease, Lucy and Mr. Beebe attempt to attract the Miss Alans, but Cecil, as a joke, recommends the villa to the Emersons. The Emersons become friends of the Honeychurches after George, Freddie, and Mr. Beebe are discovered bathing nude in the woods by Mrs. Honeychurch, Lucy, and Mr. Vyse. George seizes an opportunity to secretly kiss Lucy again. This prompts Lucy to rebuke George, who replies with a passionate speech about why Lucy should not marry Cecil. Though denying the impetus for it, Lucy breaks off her engagement with Cecil and plans a trip to Greece so that George will not believe her broken engagement is due to him. A meeting with Mr. Emerson, aided by Charlotte, convinces Lucy of her love for George, and the novel ends with the two of them honeymooning in Florence.

The Film

A Room with a View was the first Forster novel to be adapted by the team of Merchant and Ivory. It was followed by *Maurice* (1987), *Where Angels Fear to Tread* (1991), and *Howards End* (1992).

The adaptation of *A Room with a View* is very loyal to the novel. The main changes are designed to streamline the novel for film by combining events. For instance, in the novel, Lucy (Helena Bonham Carter) is deserted by Miss Lavish (Judi Dench) in the streets of Florence and finds company with the Emersons. The next day, while Miss Lavish and Charlotte (Maggie Smith) explore, Lucy wanders unaccompanied into town and witnesses the murder. In the film, the two trips are combined into one, and Lucy wanders into town alone and finds company with the Emersons. After being upset by Mr. Emerson (Denholm Elliott), Lucy leaves them and then witnesses the murder and is caught by young George (Julian Sands). Though the

details have changed, the essence of Lucy's experiences remains the same, and dialogue is expertly rearranged, switched between characters, and added by screenwriter Ruth Prawer Jhabvala.

The other notable changes are small additions of detail that visually communicate ideas expressed in words by Forster. For example, after switching rooms with the Emersons, Charlotte finds "an enormous note of interrogation" left by George. In the novel, it is scrawled on a parchment, which Charlotte rolls up with plans to return to it. In the film, it is written on the back of a painting, and just as it is discovered by Charlotte and Lucy, George walks in, flips the painting back to its original state, and leaves. Though the incidents are similar, the cinematic version goes further in communicating George's unusual personality.

A Room with a View is one of those rare films that is equal to its literary counterpart and in some places exceeds it. The film and its director were both nominated for Academy Awards, and screenwriter Ruth Prawer Jhabvala won for best adapted screenplay. Incidentally, the bathing scene involving George, Freddie (Rupert Graves), and Mr. Beebe (Simon Callow) is one of the funniest in motion pictures and would have been reason enough to give Jhabvala the award.

REFERENCES

Gardner, Philip, ed., *E.M. Forster, The Critical Heritage* (Routledge & Kegan Paul, 1973); Summers, Claude J., *E.M. Forster* (Frederick Ungar, 1983).

—B.D.H.

RUM PUNCH (1992)

ELMORE LEONARD

Jackie Brown (1997), U.S.A., directed and adapted by Quentin Tarantino; Miramax Films.

The Novel

Best-selling novelist Elmore Leonard has written 32 novels and won the Mystery Writers of America's Grand Master Award in 1991. *Rum Punch* is characteristic of Elmore Leonard's books in that it has a highly complicated plot, which requires detailed exposition here. The original source for the film *Jackie Brown* is set in Miami and tells the story of Ordell Robbie, an African-American criminal originally from Detroit, who is smart enough to stay out of prison after his first conviction. He buys and sells illegal arms and has a fortune stashed offshore. "Rum Punch" is Ordell's code word for his operation to sell arms to Colombians. His middleman and link to his fortune is a Bahamian named Cedric Walker, who lives in Freeport. Jackie Burke, a white, middle-aged flight attendant, has been bringing Ordell's cash in $10,000 packets on her

island flights without being searched or apprehended by customs, but when she exceeds the $10,000 limit and brings $50,000 on one trip, she is apprehended by special agents Faron Tyler and Ray Nicolet of the Treasury Department's Bureau of Alcohol, Tobacco and Firearms. Also in her possession is a packet of cocaine Walker has sent for Ordell's mistress Melanie, which means Jackie also faces penalties for drug smuggling. Agent Nicolet offers to help her in exchange for her cooperation in nailing Ordell.

Ordell gets bail bondsman Max Cherry to get Jackie released. Ordell, basically a brute with a history of killing those who can testify against him, considers killing Jackie, but she is smart enough to steal a pistol from Max to protect herself when Ordell comes calling. Moreover, Ordell still needs her help to smuggle his money in from the islands.

Jackie and Max have a great deal in common. She has been married to losers whom she had sense enough to divorce. He is separated from his wife Renee, who runs an art gallery and is having an affair with a younger man, David, a Cuban busboy and former punk turned artist. Both Jackie and Max are burned out on their jobs. Ray Nicolet wants to use Jackie to set up a sting operation to catch Ordell. Jackie agrees to transport a large stash of Ordell's cash to help Nicolet, but she also begins scheming to work a double sting and keep the cash for herself. She romances Max partly as a means of achieving her goal.

Ordell is both cagey and dangerous. He keeps three mistresses, two black and one white, and manipulates them as needed. He also befriends Louis Gara, a white ex-convict who has worked for Max but knows Ordell from earlier times. Louis has a fleeting affair with Ordell's white mistress, Melanie, who thinks Ordell is stupid and is also scheming to doublecross him. Ordell wants Louis to murder a racist gun dealer named Big Guy, a set-up that Melanie manages to disrupt, turning herself into a gun moll and killer. Ordell has already doublecrossed and murdered a punk named Beaumont Livingston after Max got the punk released on bail, and he plans to murder a "jackboy" named Cujo. Until the final sting, everybody is scheming to exploit or doublecross everybody else in Leonard's underworld. As Carlos Fuentes has rightly observed, "In the 20th century we don't have tragedy; we only have crime." Leonard's approach wonderfully satirizes flawed criminal types. Rather than just tragic heroes, he gives us satiric anti-heroes and -heroines.

Leonard is a master of noir plotting and has a distinctive talent for drawing vivid characters. He also has a wonderful ear for dialogue. No one is better at writing crime fiction and spinning character-driven adventure yarns. *Rum Punch* is first and foremost a caper-sting story, but it is also about growing older, evaluating one's life and livelihood, and dreaming about changing careers and starting over. Most of the characters in *Rum Punch* are not especially happy about who they are or what has become of

Robert De Niro and Samuel L. Jackson in Jackie Brown, *directed by Quentin Tarantino* (1997, U.S.A.; MIRAMAX FILMS)

their lives. The thoughtful ones, Max and Jackie, plan to change their lives, at the expense of the stupid and the greedy characters around them.

The Film

This convoluted plot transfers nearly intact to the screen. Quentin Tarantino's film makes a few changes to compensate for his casting of the film but since the director no doubt realized that Leonard had constructed a nearly perfect plot, he resisted tampering with the structure other than switching the locale from Miami to Los Angeles. In the film Jackie Burke becomes Jackie Brown, a reasonable alteration, since Pam Grier, who played the role, was better known to audiences under the name of her character in the film *Foxy Brown* (1974). Grier's Jackie is also foxy by nature, after all.

Samuel L. Jackson, who earned an Academy Award nomination for his role in Tarantino's *Pulp Fiction* (1994), was the perfect choice to play Ordell Robbie. Tarantino rescued Robert Forster from obscurity by casting him as Max Cherry. Bridget Fonda played Melanie Ralston, and Robert De Niro played second fiddle to Forster and Jackson by taking the role of Louis Gara. Michael Keaton stepped down from two *Batman* leading roles and a Shakespearean turn in Kenneth Branagh's *Much Ado About Nothing* (1993) to play Special Agent Ray Nicolet.

Jackie Brown was the first script that writer-director Tarantino adapted from a novel. He first became interested in Leonard's work when he read *The Switch* (1978), which, coincidentally, marked the first appearance of Ordell Robbie and Louis Gara as partners in crime. Tarantino shifted the locale of *Rum Punch* to California—El Segundo, Torrance, and Hawthorne in the South Bay area of Los Angeles—because he knew the region well and grew up there. By casting Pam Grier, he was able to capture the mood of the blaxploitation movies of the 1960s, and 1970s, as well as extending box-office appeal to a crossover African-American audience. One significant

alteration from novel to film should be noted: The novel's conclusion is ambiguous, but Max seems receptive to Jackie when she says, "Come on, Max. I'll take you away from all this." The reader is left entertaining the possibility that Max might take her up on the invitation. However, at the end of the film, Jackie simply leaves Max behind.

This film is a triumph of inventive casting, rediscovering Grier and Forster, while bumping De Niro, Keaton, and Fonda to secondary roles that were sure to strengthen the picture. Tarantino saw Forster, an actor demoted to B-roles, as a man very like Max Cherry, "who's basically been plugging away for years, trying to stay honest in a job that has a lot of seedy elements to it. And now he's middle aged and is facing the possibility that it's all over and that this is as much as he is ever going to accomplish." Just as Jackie gives Max a second chance in the novel, Tarantino gave Forster a second chance for his acting career, a gamble that paid off brilliantly with an Oscar nomination.

In addition to his many novels, Leonard also has written several screenplays and knows Hollywood, as his novel *Get Shorty* (filmed in 1995) gave evidence. He served as executive producer for Tarantino's film, which was not only an homage to his talent and reputation, but also indicated why Tarantino wanted the novelist's involvement and approval. The adaptation is faithful to the tone, spirit, and structure of the novel. Oddly enough, the novel was reissued in paperback under the film's title, *Jackie Brown*, even though the heroine's name, Jackie Burke, remains unchanged. This is arguably the best film adaptation of Leonard's work, better than the later *Out of Sight* (1998) and certainly better than *Get Shorty* (1995).

REFERENCES

Gleiberman, Owen, "Hooked on a Felon," *Entertainment Weekly*, January 9, 1998, 40–41; Grobel, Lawrence, "Elmore Leonard in Hollywood," *Movieline*, July 1998, 52–56, 87; Wood, Michael, "Down These Meaner Streets," *TLS*, December 5, 1986, 1370.

—*J.M.Welsh*

SALAIRE DE LA PEUR (1950)

See WAGES OF FEAR.

SANCTUARY (1929)

WILLIAM FAULKNER

The Story of Temple Drake (1933), U.S.A., directed by Stephen Roberts, adapted by Oliver H.P. Garrett; Paramount.

Sanctuary (1960), U.S.A., directed by Tony Richardson, adapted by James Poe; Twentieth Century-Fox.

The Novel

In 1929 William Faulkner, broke as usual, decided to write "the most horrific tale" he could imagine to make some money. In three weeks he cranked out *Sanctuary*, a morbid tale of rape, murder, sexual impotence, and perversion, which ends with two men found guilty of murders they did not commit.

Set in Mississippi in the 1920s, the novel traces the moral collapse of Temple Drake, the beautiful daughter of a local judge. The novel begins with Temple and her boyfriend, Gowan Stevens, on their way to a college football game. They stop at an isolated farmhouse to get some moonshine from Lee Goodwin, who lives with his common-law wife Ruby and their infant son. Goodwin is distrustful but not dangerous. A local Memphis hoodlum, Popeye, is also at the farmhouse.

After he sobers up, Gowan deserts Temple who is now stranded for the night. Ruby, fearing that one of the men might try to rape Temple, hides her in the barn for the evening and arranges for Tommy, a feebleminded helper, to guard her. But Popeye discovers where Temple is hiding, kills Tommy when he tries to interfere, and then rapes Temple with a corncob because he is impotent.

Temple is fascinated by this evil character and willingly accompanies him to Memphis, where they take residence in a local brothel. The perversion continues when Temple agrees to make love to "Red," another local hood, while Popeye watches. This ménage-à-trois falls apart when Popeye discovers that Red and Temple are seeing each other privately. He is so enraged by this act of disloyalty that he murders Red.

While all this is going on in Memphis, the police arrest Lee Goodwin for the murder of Tommy. Goodwin's lawyer, Horace Benbow, tracks Temple down and tries to convince her to tell the truth and free Goodwin. Temple refuses and testifies instead that it was Goodwin who murdered Tommy and raped her. In stereotypical Southern fashion, an enraged mob, determined to protect the honor of women, storms the jail and kills the innocent Goodwin. Temple's father sends her off to Europe so she can forget all this. Meanwhile Popeye, who has gotten away with murder, decides to drive to Florida. On his way he is mistakenly arrested, convicted, and executed for a crime he did not commit.

The Films

This was not the normal fare for a Hollywood film in 1933. But Paramount bought the screen rights from Faulkner despite protests that the novel was too sordid for

the screen. The project immediately ran into difficulty with the Motion Picture Producers and Distributors of America. Will Hays, president of the organization, ordered his chief censor, Dr. James Wingate, not to "allow the production of a picture which will offend every right-thinking person who sees it."

Wingate told Paramount to "make a Sunday school story" for the screen. Oliver H.P. Garrett's script fell short of that demand but did redirect the action on Temple (Miriam Hopkins) and the lawyer Benbow (William Gargan). When Benbow, handsome but rather dull, asks the young, beautiful Temple to marry him, she goes on a little "wild streak." She is still raped in the corncrib by Popeye (Jack LaRue), renamed Trigger in the movie, who needs no external ornaments to consummate his evil deed. After the rape, Temple happily follows Trigger and they set up a love nest in the Memphis whorehouse, but impotence, Red, and the ménage-à-trois themes are written out. Instead, the movie develops the regeneration of Temple, avoiding the more sordid aspects of her continual fall into degradation that Faulkner had developed. In the film, Benbow, a man of integrity who loves Temple, finds her living with Trigger in the whorehouse. When he asks Temple to testify to free an innocent man, she refuses because testifying will ruin her reputation and because she really does love Benbow and fears that Trigger will kill him if she takes the stand. After the lawyer leaves, Temple and Trigger quarrel and she kills him.

The scene is now set for the trial. On the stand Temple's dramatic and emotional testimony establishes the innocence of Goodwin (and clearly establishes her compliance with Trigger and her murder of him). After this emotional outpouring, she faints, and her fiancé swoops her up in his arms while telling everyone how proud he is of her courage. This was one understanding guy who was willing to take back a woman who had run away with a criminal, set up residence with him, witnessed one murder, and committed one of her own.

Despite a general softening of the more lurid scenes, censors in New York and Ohio banned the film until Paramount sliced additional scenes. Critics both blasted the film as "immoral" and praised Hollywood for bringing adult drama to the screen. Miriam Hopkins gave "a brilliant performance as Temple," according to *Time*, which judged the film as "dingy and violent" and "more explicit about the macabre aspect of sex than any previous" Hollywood product. The *Washington Times* called it "trash." Yet, like so many other films, opinion was divided. William Troy, reviewing the film for *The Nation*, called it "truly extraordinary" in capturing the "essential quality" of Faulkner's novel, and Richard Watts Jr. of the *New York Herald-Tribune* found the film "fascinating."

In 1951 Faulkner wrote a sequel, *Requiem for a Nun*, which continued the tragic story of Temple Drake. Set eight years after the events of the original novel, Temple is now married to Gowan Stevens and is the mother of a four-year-old boy and an infant. But domestic tranquillity has no attraction for Temple. When she learns that her old lover, whom she has believed dead, has returned, she is determined to run off with him. Her housekeeper, a black woman Temple has rescued from a life of drugs and prostitution, murders the infant to bring Temple back to her senses. The murder of her baby jolts Temple back to reality and she pleads for the life of her housekeeper—to no avail.

In 1960 director Tony Richardson and screenwriter James Poe attempted to meld the two books into a single film, *Sanctuary*. A Cinemascope production, the film starred Lee Remick as Temple and Yves Montand as the evil rapist (Candy Man in this version). The result was a mishmash that few liked. Richardson branded Poe's script "atrocious," and critics panned the film, which flopped at the box office.

REFERENCES

Degenfelder, E. Pauline, "The Four Faces of Temple Drake: Faulkner's *Sanctuary, Requiem for a Nun*, and the Two Film Adaptations." *American Quarterly* 28 (1976): 544–60; Phillips, Gene, "Faulkner and the Film: Two Versions of *Sanctuary*," *Literature/Film Quarterly* 1 (1973): 263–73; Black, Gregory D., *Hollywood Censored: Morality Codes, Catholics and the Movies* (Cambridge University Press, 1994).

—*G.B.*

SAYONARA (1954)

JAMES A. MICHENER

Sayonara (1957), U.S.A., directed by Joshua Logan, adapted by Paul Osborn; Warner Bros.

The Novel

Sayonara tells the story of the 28-year-old son of a four-star general, Major Lloyd "Ace" Gruver, who begins a vacation in Japan after shooting down his seventh MIG in the Korean War. His father's friend General Webster arranges for Ace to be near his daughter, Eileen, to facilitate a formal engagement. The career-minded, anti-Japanese Ace becomes involved in enlisted man Joe Kelly's plans to marry Katsumi, a Japanese woman, at a time when such liaisons were forbidden. Despite his racism, Ace falls deeply in love with Hana-ogi, a famous actress in the Takaruzaka theater. They set up home together near Joe and Katsumi.

The authorities soon intervene and break up the liaisons. Despite Joe's legal marriage to Katsumi, they decide to send him back to America. Although Ace wishes to marry Hana-ogi, she refuses. Joe and Katsumi die in a traditional Japanese double suicide, and the novel ends with Ace returning to the States, his promising career, and eventual marriage to Eileen. Ace is "forced to acknowledge that I lived in an age when the only honorable attitude

toward strange lands and people of another color must be not love but fear."

The Film

The film adaptation generally follows Michener's plot, with the exception of a happy ending added at Marlon Brando's insistence. Brando demanded the film version overcome the racial and cultural prejudices dividing the lovers at the novel's climax. *Sayonara* concludes with Ace breaking into the dancing school to find Hana-ogi has departed for Tokyo. He follows her there, dogged by the publicity machines of both cultures—the military *Stars and Stripes* reporters and Japanese newspapermen. Michener's "young lovers" then announce their separate breaches of cultural codes preventing their liaison and drive to the American Embassy to begin filling in the numerous forms leading to their marriage.

Patricia Owens's Eileen Webster occupies a more prominent role in the film than in the novel. The scenarist adds a new character to the film, Kabuki actor Nakamura (played by Ricardo Montalban in a manner resembling J. Carrol Naish's 1957 television version of Charlie Chan). Nakamura is a male parallel to Hana-ogi. In the novel Hana-ogi specializes in cross-dressing performances. Little trace remains of this in the film since "unacceptable" fifties transgender codes are now displaced onto Nakamura's Kabuki performances. The film indirectly hints at a developing love relationship between Eileen and Nakamura, and after Ace tells her of his love for Hana-ogi, Eileen disappears from the narrative entirely, announcing that Nakamura is the only person she can relate to. Although Brando's pressure for a Hollywood "happy ending" is laudable, contemporary racial and gender censorship codes resulted in the film's inability to explicitly depict a love relationship between a Japanese male and American female.

REFERENCE

Day, A. Grove, *James Michener*, 2nd ed. (Twayne, 1977); Logan, Joshua, *Movie Stars, Real People, and Me* (Delacorte Press, 1978).

—*T.W.*

THE SCARLET LETTER (1850)

NATHANIEL HAWTHORNE

The Scarlet Letter (1905), U.S.A. [no production credits available].

The Scarlet Letter (1926), U.S.A., directed by Victor Seastrom, adapted by Frances Marion; MGM.

The Scarlet Letter (1934), U.S.A., directed by Robert G. Vignola; adapted by Leonard Fields and David Silverstein; Majestic Pictures.

Der scharlachrote Buchstabe (1972), West Germany, directed by Wim Wenders, adapted by Wenders and Bernardo Fernandez (from a story treatment by Tankerd Dorst and Ursula Enler); Filmverlag der Autoren.

The Scarlet Letter (1995), U.S.A., Roland Joffé, adapted by Douglas Day Stewart; Cinergi Pictures Entertainment.

The Novel

Nathaniel Hawthorne's best-known novel is less about adultery and sin than about the debilitating nature of guilt. It was immediately recognized by critic Evert A. Duyckinck as an effective evocation of the consequences of Puritan repressions. However, another contemporary critic, Arthur Cleveland Coxe, charged that the novel was prurient, smelling of "incipient putrefaction."

The novel is set in 1642 in the Puritan town of Salem, Massachusetts. It begins with "The Custom-House" chapter, a device used to introduce the narrator, a Custom House surveyor who happens upon a worn scarlet letter A and a manuscript, which tells the story of Hester Prynne and Arthur Dimmesdale. The narrator says he is more or less objective, following the facts of the manuscript, but that he will interject some imagination into the tale. The story of Hester begins after her adulterous act has occurred with Dimmesdale and she stands with her illegitimate baby, Pearl, at the scaffold for public condemnation of her sin. Because she will not reveal the name of the baby's father, she is sentenced to wear a scarlet letter A, embroidered with gold thread, upon her attire to remind her of her sin. At this point, Hester recognizes her estranged husband who calls himself Roger Chillingworth in order to ferret out the identity of Hester's lover and to avenge himself.

In the novel, the Reverend Arthur Dimmesdale is not made highly sympathetic. His refusal to acknowledge his sin and thus his daughter Pearl, render him rather pitiful. His guilt, fueled by his position in the church and by Chillingworth's needling, prompt Dimmesdale to mortification of the flesh, including branding himself on the chest with the letter A. His spiritual guilt becomes a physical manifestation as Dimmesdale's health quickly declines until he dies, only after he has confessed his sin publicly on the scaffold with Hester and Pearl.

Unlike Dimmesdale, Hester's portrait is most sympathetic. She, more than any of the men, has a will of iron and survival skills that she evidently passes along to her daughter, Pearl. Hester is the rose from the wild bush, amid a crowd of weeds. She is exquisite, intelligent, and gifted with her needle. Ironically, Hester's embroidered A becomes the vehicle by which the town recognizes her embroidery skill and thus employs her. She learns to accept her ostracism and channels her vivacious nature into the attire of her child Pearl, often described as wearing fanciful red velvet dresses in a time when slate gray and black are the predominant colors.

If there is evil in the novel it comes in the form of Roger Chillingworth, Hester's estranged husband.

Described as physically deformed, Chillingworth is spiritually depraved as well. Posing as a physician, Chillingworth calculates the destruction of Dimmesdale by preying upon Dimmesdale's guilt. The only kind act Chillingworth undertakes is his bequeathal of land and money upon Pearl, Hester's daughter.

After the deaths of both Dimmesdale and Chillingworth, Hester disappears with Pearl to territories unknown. Years later when Hester reappears, she is without Pearl, who seems to have married happily and lives elsewhere. At the conclusion of the story, the narrator tells the reader that "the scarlet letter ceased to be a stigma which attracted the world's scorn and bitterness . . ." and ends with a view of Hester's tombstone, inscribed with the motto, "On a field, sable, the letter A, gules."

The Films

The earliest film version of *The Scarlet Letter* is recorded in 1905, a silent film. The most noted, prior to the Demi Moore version in 1995, was the 1926 film directed by Victor Seastrom and starring Lillian Gish. In a *New York Times* review by Mordaunt Hall, the critic praises the film as being "as faithful a transcription of the narrative as one could well imagine," noting that the unhappy ending of the novel is delivered as well. Gish's performance is extolled. There is also a 1934 version, starring Colleen Moore, that, like the 1926 film, follows the novel closely except for the interjection of comic relief by a Mutt and Jeff–type duo. In 1972 Wim Wenders directed Senta Berger as Hester in a German version for West Deutsche Rundfunk (Köln). In 1979, a television version of the film was produced for teachers by the education network WGBH of Boston.

Notable in light of the recent film adaptation, directed by Roland Joffé and starring Demi Moore, Gary Oldman (Dimmesdale), and Robert Duvall (Chillingworth), is a scene in the 1926 film involving a canary. Apparently written into the screenplay by Frances Marion, Hall notes an ingenuous scene in which Hester's canary escapes from its cage and Hester chases after it, causing her to be late for church services, which prompts gossip from the community. This scene is borrowed and incorporated into the 1995 version. In the latest version, Hester (Demi Moore) has already created scandal by moving alone into a house by the sea. A wild, red canary catches Hester's eye and leads her into the forest and into Dimmesdale's favorite spot for bathing in the buff. Hester, her head encircled with wild berries and vines like a sprite from *A Midsummer Night's Dream*, watches the naked Dimmesdale until she is startled by the calling of her name. Back at her house, she is accosted by the Wilsons who admonish her to remember the Sabbath. Perhaps that is where the similarities end between the 1926 and the 1995 versions. For instance, Hester is not late for church in this version, because her tardiness and a mishap with her carriage set her into the path of Arthur Dimmesdale, Hester's rescuer and coincidentally the minister of the church.

Even the best attempts to adapt this novel have taken liberties with the source. Wim Wenders jumps over "The Custom-House" apparatus, for example, and invents a new character, giving Governor Bellingham a daughter who serves as an alter ego for Hester and performs a choric function, suggesting that Hester's guilt is in fact the guilt of the community. This invention springs from Hawthorne's Mistress Hibbins, who, according to one period document, was the sister (rather than the daughter) of Richard Bellingham. Wenders makes her a younger parallel to Hester than Mistress Hibbins, but the character (played by Russian actress Yelena Samarina) is consistent with Hawthorne's general design. Hans Christian Blech's Chillingworth is neither satanic nor sadistic, but a world-weary man of science. Lou Castel's Dimmesdale, like Senta Berger's Hester, is a victim of the theocratic state and the theocratic mentality that sustains it in this adaptation. Wenders personalizes the source by presenting an existential updating of Hawthorne. His film makes the theocratic state more sinister than even Hawthorne presented it—utterly unforgiving, spiritually repressive, and inhumanely corrupt.

While the 1926 version remains close to the novel as does the 1972 German version, the 1995 version does not deserve to bear the title, *The Scarlet Letter*. This version opens with Arthur Dimmesdale (Gary Oldman) surrounded by Native Americans. Dimmesdale speaks in a Native American tongue to the chief, Metacomet, about the state of relations between the settlers and the Native Americans. All is not well, but the audience is told that of all the English, Dimmesdale comes with an open heart. This begins the incredibly sympathetic portrait of Dimmesdale. The next scene begins with a voice-over from our narrator, Pearl, not the Custom House surveyor of the novel, and features Hester and others in a rowboat coming ashore to the New World in 1666 (not the date of the novel, but symbolic in demonology). Unlike the narrator of the novel, who chooses to begin the story after the adultery, the narrator of the film chooses to focus on the love story between Hester and Dimmesdale. Thus, the film's focus is not so much on guilt and shame but on forbidden love and its power to conquer all, even the bigotry and severity of Puritan law. Intermingled with this are some Native Americans and one mute African enslaved girl, Mituba (Lisa Jalliff-Andoh).

As with most modern film adaptations, there must be a gratuitous sex scene. This one delivers. In fact, there are several shots of naked bodies including Gary Oldman, gliding through the water with his buttocks peeking out, a scene to rival any of Mel Gibson's many cheeky scenes. Also famous now for nude scenes is Demi Moore. In a lascivious bathing scene (Puritans do not use bathing tubs, but Hester does), Hester delights in her naked body. The audience is made voyeur through Mituba, Hester's slave girl, who peeps at Hester through a small hole. The actual sex scene takes place between Hester and Dimmesdale in

Hester's barn amid grains of wheat (symbolic of fertility) and is intercut with scenes of Mituba bathing with the now symbolic red canary perched near the bathing tub. Was the director trying to correlate Mituba's washing scene with the sex scene? If that is the case, then the audience interprets Hester and Arthur's love-making as a cleansing rather than a sinful act. In fact, that is the entire theme of the film.

Although the sex-is-never-sinful-if-it-is-love theme is not in the book per se, perhaps the screenplay writer is hinting at antinomianism, a spiritual movement that "stressed the true believer's responsibility to the Holy Spirit within the individual, even to the point of disobeying biblical, clerical or juridical laws" and for which Mrs. Ann Hutchinson (an historical figure of whom Hawthorne was aware and on whom he partially based Hester) was banished from Massachusetts in 1638. Repeated again and again is the idea that Hester and Dimmesdale have committed no sin by God. Of course, this free-love theory nullifies or at least eases Dimmesdale's guilt, which so racks him in the book that he dies. In the film, there is a scene in which Dimmesdale is shown scraping his hands on a pole until they bleed profusely but there is no brand on his chest. Perhaps this is because Chillingworth does not torment Dimmesdale in the novel nearly so much as he tortures Hester. Moreover, Dimmesdale knows Chillingworth's true identity, a fact that the novel does not reveal to Dimmesdale. Add to this the fact that Chillingworth is a demented, possessed pseudo-medicine man who dons Indian garb and scalps the head of a man he mistakes as Dimmesdale. It takes the plot and the theme in a whole new direction. Chillingworth is depicted as psychotic rather than maliciously evil. He dies by hanging himself after he discovers he has killed the wrong man, not after Dimmesdale dies in the novel.

At the conclusion of the film, Dimmesdale has his cathartic confession but just in time to save the day are the Native Americans (a new plot twist). The entire town becomes embroiled in chaos. Hester and Dimmesdale, ever the loving father in this version, search for Pearl. The town is devastated by the Indian raid. The last scene features Hester, Pearl, and Dimmesdale (in perfect health) driving away in a carriage to a new town. This nuclear family runs away. Pearl tells us that her father only lived until she was a teenager, many more years than the novel allotted Dimmesdale. It is an ahistorical happy ending for a time so bent on guilt and punishment, but speaks to the modern notion that there really is no evil in the world, nor guilt, just dysfunctional childhoods and happy endings with a good therapist.

REFERENCES

Amberg, George, ed., *The New York Times Film Reviews: 1913–1970* (Quadrangle Books, 1971); Dunne, Michael, *"The Scarlet Letter on Film," Literature/Film Quarterly* 25 (1997): 30–39; Gross, Seymore, et. al., eds., *Nathaniel Hawthorne's* The Scarlet Letter, *Critical Edition* (Norton, 1988); Kael, Pauline, *5001 Nights at the Movies: A Guide from A to Z* (Holt, Rinehart and Winston, 1982); Welsh, J.M., *Magill's Survey of Cinema: Foreign Language Films* (Salem Press, 1985): 2568–71.

—*J.D.N. and J.M. Welsh*

SCHINDLER'S LIST (1982)

THOMAS KENEALLY

Schindler's List (1993), U.S.A., directed by Steven Spielberg, adapted by Steven Zaillian; Amblin Entertainment/Universal.

The Novel

Thomas Keneally chose to tell Oskar Schindler's story as a novel, both because of his own background and because he felt it suited the ambiguity of the character. Yet he wrote in the author's notes to the novel that he scrupulously attempted to avoid inserting into his work any fiction, and based his construction of events on interviews with 50 Schindler survivors from seven nations and other wartime associates of Schindler. He also used the written testimonies from Yad Vashem, the Martyrs' and Heroes' Remembrance Authority, and Schindler's papers and letters, supplied by a variety of sources. *Schindler's List* won the Booker Prize and the *L.A. Times* Book Award for fiction.

Keneally traces Oskar Schindler's life, dealing summarily with his childhood and dwelling primarily on his life after 1939, when he moved from Zwittau to Krakow, where he became a successful businessman, trading upon his charisma to ply Nazi officials with food, drink, and money in order to obtain government contracts. Although Schindler is compassionate to the Jewish workers who people his enamelware factory, he is a war profiteer and a womanizer. In 1942, when a new SS commandant, Amon Goeth, arrives to destroy the Jewish ghetto and herd the survivors into a forced labor camp (Plaszow), Schindler ingratiates himself with Goeth and persuades the commandant to let Schindler build his own camp on the grounds of the enamelware factory.

On numerous occasions Schindler attempts to shelter his workers from Nazi brutalities, often resorting to some sort of bribe to grease the way. Though he claims that he needs Jewish workers to aid his factory and, therefore, the war effort, clearly Schindler's factory is full of some who are too old, too young, or too unskilled to really be useful. Clearly, his only motivation in feeding and housing them under the factory roof was to spare them from the Nazis. In 1944 as the German war machine crumbles, the Plaszow Jews are to be transferred to Auschwitz. Schindler sets up a new factory on the Czechoslovakian border, and literally buys the lives of 1,100 Jewish workers from Goeth. By war's end Schindler is broke, and flees to the West when his workers are liberated. Keneally gives a brief account of Schindler's troubled life after the war, which

clearly shows a role reversal, with the "Schindlerjuden" helping their benefactor in hard times as he had once helped them.

The Film

Steven Spielberg was already a financially successful and internationally known director when he came across the story of Oskar Schindler. His adaptation, an important personal and artistic statement, would earn the director of some of the top-grossing films of all time his first Academy Award. Steven Zaillian's screenplay closely follows the Keneally novel, in so far as it gives an account of Oskar Schindler's life from his 1939 move to Krakow to the war's end and the liberation of his Jewish workers.

Although the filmmaker weaves the same basic tale—the transformation of Oskar Schindler (Liam Neeson) from flamboyant war profiteer to the bankrupt, compassionate savior of more than 1,000 Jews—the movie contains some departures from the novel. Because of the sheer impossibility of depicting all the events in the novel, many individual incidents are left out. However, changes were made to the novel that went beyond omissions. The screenplay does not always observe the same time sequence as Keneally's narrative. More importantly, although the basic ideas remain intact, events are added for dramatic purposes that are a departure from Keneally's account. For example, Spielberg leaves out any dramatization of Schindler's life prior to Krakow, and introduces Schindler with an event that never took place in the novel: Schindler is a mysterious unknown who bribes his way into a club and quickly becomes the life of the party, spending lavishly and calculatingly on a variety of Nazi officers and an assortment of women. This scene captures much of Schindler's style and serves to sketch his charming and persuasive personality, allowing Spielberg to leave out many details of Schindler's individual dealings with Nazi officials that enabled him to start his factory.

According to Keneally, Oskar met Leopold Pfefferberg when he came to Leopold's mother's apartment to obtain an interior designer. However, in Zaillian's screenplay he meets Pfefferberg in a church that is represented as a safe meeting place for black marketeers. In another instance, Schindler's wife Emilie (Caroline Goodall), upon visiting Oskar in Krakow, discovers his infidelity when Pfefferberg asks her where Frau Schindler is, since this is the title he uses for Schindler's secretary and mistress. Zaillian gives the audience a less subtle version when Emilie, upon coming to Krakow, finds the mistress opening the apartment door and stands by while the humiliated woman packs to leave.

Little criticism was lobbed at the changes that Zaillian made to the real events that Keneally reconstructed, perhaps because the basic story line and characters remained unchanged. Ironically, while many adaptations of literature are criticized for deviations from the original, Spielberg was criticized for doing exactly the opposite.

The basic difficulty was an aesthetic one: how to represent so great an evil? For some any filming was unacceptable because it could not capture the magnitude of the event. For others, any emphasis on individual survivors was seen as diminishing those who didn't survive. Spielberg tried to evoke the solemnity of the subject in black and white cinematography. (He used color to film the end of the movie where the real survivors, together with the actors who played them, walk by Schindler's grave in Israel.) According to Spielberg the choice of black and white was a conscious attempt to evoke the memories of the black and white photographs of concentration camps.

Some critics felt the movie left out much of the history of what happened to other Jewish victims, yet Spielberg's film was true to Keneally's novel, which was clearly a story about one man and those people whose lives he touched, not a history of the Holocaust.

REFERENCES

Loshitzky, Yosefa, ed. *Spielberg's Holocaust* (Indiana University Press, 1991); Nagorski, Andrew "'Schindler's List' and the Polish Question," *Foreign Affairs* (July/August 1994); Simon, John, "From the Jaws of Death," *National Review*, January 24, 1994; Strick, "Schindler's List," *Sight and Sound*, September 1994; Wieseltier, Leon, "Close Encounters of the Nazi Kind," *The New Republic*, January 24, 1994.

—D.P.H.

THE SEARCHERS (1954)

ALAN LEMAY

The Searchers (1956), U.S.A., directed by John Ford, adapted by Frank S. Nugent; Warner Bros.

The Novel

Between 1927 and 1963 Alan LeMay wrote 17 novels and 67 short stories, most of them Westerns. LeMay also wrote 17 screenplays, the majority of them also Westerns, although he was responsible for some historical romances such as *Reap the Wild Wind* (1941) and *Tap Roots* (1948). In William T. Pilkington's judgment, "LeMay, a writer of formula westerns, created one excellent book—*The Searchers*—that artistically and literarily soars far beyond anything else he ever published."

The Searchers is a quest story. In the Texas panhandle in the late 1860s live two neighboring families: the Edwards and the Mathisons. A third family, the Pauleys, had been massacred by Indians 18 years previously, and their surviving son, Martin, the central conscience of the novel, was adopted by the Edwards. At the opening of the narrative, a party that includes Martin and his uncle, Amos Edwards, is lured away from the homesteads to search for stolen cattle. Actually, stealing cattle was a ruse of the Comanches whose intent was a raid on the Edwards ranch. Aaron

Edwards, his wife Martha, and his two sons are killed. His two daughters are abducted and the older, Lucy, is subsequently raped and killed, but the younger, Debbie, is held captive to be raised as an Indian.

Three men set out on the quest for Debbie: Martin, Amos, and Brad Mathison who was in love with Lucy. Brad is soon killed, but Martin and Amos continue the search for more than five years. After returning home once, they ride through northern territory, and after enduring 60 hours in a gully during a blizzard, the two men track Debbie to the camp of the Comanche chief Bluebonnet, but they lose the trail. Later, in New Mexico territory, the searchers track down Bluebonnet, who has a white wife but she is not Debbie. After a third homecoming, Lige Powers, an old buffalo hunter, appears to inform them that he has found Debbie at Seven Fingers. The men travel there and meet Yellow Buckle, or Scar, whose captive Debbie is. After the men leave Scar's camp, Debbie follows them to warn of Scar's imminent attack; then she runs away. Amos is wounded in the subsequent attack. In the final battle with Scar, Amos is killed, and Debbie flees into the wilderness, followed by Martin. When he finds the exhausted woman, Martin understands that Debbie will be his final reward—his sister by adoption will become his wife.

The Film

Screenwriter Frank S. Nugent has made several alterations. The number of characters has been reduced and some names have been changed. The Mathisons have become the Jorgensons (Olive Carey and John Qualen), and they now have only one son (Harry Carey Jr.) instead of three. Henry Edwards is renamed Aaron (Walter Coy), and he has one son instead of two. Amos Edwards becomes Ethan (John Wayne). On the whole, the roles have been adapted to suit the "John Ford Stock Company."

Most importantly, the point of view has shifted from Martin to Ethan so that, although the novel is a young man's book, the movie is not a young man's film. Martin on the printed page is 18 but already skilled in the ways of the frontier; on film Jeffrey Hunter's Martin is inexperienced and sometimes comically naive. The central character is obviously Ethan. The theme of family, important in other Ford films, is emphasized here, and even though the two families have been reduced in numbers so that Brad and Lucy, Martin and Laurie become identifiable pairs, the idea of "kin" in the film becomes complex, since after Brad's death Martin inherits his boots and clothes and Mrs. Jorgenson says that she feels as if the two Edwards girls are like her own. In fact, as Richard Corliss has pointed out, she becomes a surrogate character for Martha Edwards.

The theme of racial hatred has been intertwined with the theme of family. Martin, for instance, described in the novel as "dark as an Indian," has become one-quarter Cherokee, a fact that rankles his "Uncle" Ethan, who had secretly loved his brother's wife, Martin's "Aunt Martha." Moreover, the motives of Amos in the novel and of Ethan in the film have been recast: Amos hates Indians so much that Martin fears he may, in a black fit of rage, endanger the efforts of Debbie's rescuers, but Martin, in a significant alteration, fears that Ethan may try to kill Debbie since she has been living with a "buck" and therefore is contaminated by miscegenation. Indeed, not only has Debbie's appearance to warn the searchers of Scar's attack been moved from the end of the novel to the middle of the film, but also there is no equivalent in the book for Ethan's attempt at that time to kill the girl—perhaps the film's most dramatic scene—which fails when Martin shields her with his body.

In the final attack on Scar's camp, Ethan, unlike Amos, does not die, and when Martin this time is powerless to protect Debbie and when the audience is certain that Ethan will finally kill her, instead he lifts her up, as he had done when she was a girl in the first scene of the film, a gesture indicating that kinship has overcome racial hatred. For Douglas Brode, Ethan, a rugged American individualist, frees himself of racism, but Ethan denies himself a union in the final homecoming with his new family—Martin, Laurie, Debbie, and the Jorgensons—in what can be seen as a replacement for the Edwards house. As Martha Edwards opened a door to greet Ethan at the beginning of the film, a door closes upon him outside at the end of it.

In its initial release *The Searchers* was dismissed by critics as "late John Ford," and Winton C. Hoch's magnificent color photography was never considered for an Academy Award. However, the film's reputation grew. In 1973, in *The Great Films* William Bayer could write, "It is unfortunate that John Ford's *The Searchers* is not widely known, for it is among the few pictures of the genre [i.e., the Western] that one can safely label a work of art," and in the same year Roger Greenspun stated in *The New York Times* that the film is "arguably the greatest American movie." The film has influenced a younger generation of filmmakers as diverse as Martin Scorsese, Steven Spielberg, Paul Schrader, John Milius, and several others. In *Cinema: The First Hundred Years* David Shipman claims that "not until *The Unforgiven* [directed by John Huston in 1960 and based on LeMay's novel] did any film show the vastness of the territories, the loneliness, the distances," but surely *The Searchers*, ranging across Monument Valley, the snow country of the buffalo, and the sands of the Southwest brought this sense of America's expansiveness to audiences four years earlier in VistaVision. For Andrew Sarris, *The Searchers* is John Ford's "greatest tone poem."

REFERENCES

Bayer, William, *The Great Films* (Grosset & Dunlap, 1973); Brode, Douglas, *The Films of the Fifties* (Citadel, 1976); Byron, Stuart, "'The Searchers': Cult Movie of the New Hollywood," *New York*, March 5, 1979; Card, James Van Dyck, "*The Searchers* by Alan LeMay and John Ford," *Literature/Film Quarterly* 16, no. 1 (1988); Corliss, Richard, *Talking Pictures* (Penguin, 1975); Sarris, Andrew, *The John Ford*

Mystery (Indiana University Press, 1975); Shipman, David, *Cinema: The First Hundred Years* (St. Martin's, 1994).

—*J.V.D.C.*

THE SEA-WOLF (1904)

JACK LONDON

The Sea Wolf (1913), U.S.A., directed by Hobart Bosworth, adapted by Hetty Gray Baker; Bosworth Inc.

The Sea Wolf (1920), U.S.A., directed by George Melford, adapted by Will M. Ritchey; Paramount.

The Sea Wolf (1926), U.S.A., directed by Ralph W. Ince, adapted by J. Grubb Alexander; Ince.

The Sea Wolf (1930), U.S.A., directed by Alfred Santell, adapted by Ralph Block; Fox.

The Sea Wolf (1941), U.S.A., directed by Michael Curtiz, adapted by Robert Rossen; Warner Bros.

Wolf Larsen (1958), U.S.A., directed by Harmon Jones, adapted by Jack DeWitt; Allied Artists.

Der Seewolf (1971), Germany/Austria/France/Rumania, directed by Wolfgang Staudte [production details unknown].

Legend of the Sea Wolf (1975), Italy, directed by Giuseppe Vari [production details unknown].

The Novel

Jack London wrote *The Sea-Wolf* during a dramatic crisis in his life. For a predominantly middle-class audience, he conveyed the conflict within his personality between Socialist radical and writer via the conflict between the brutal Wolf Larsen and the affluent, effeminate Humphrey Van Weyden. London also had marital difficulties and became attracted to Charmian Kittredge who later became his second wife. He used many features of Charmian in the character of Maud Brewster.

After a shipping accident in San Francisco Bay, affluent milquetoast Humphrey Van Weyden ends up on the sealing schooner, *The Ghost*. Its brutal captain, Wolf Larsen, refuses to put Humphrey ashore and chooses instead to enlist him in the crew. Contemptuous of Humphrey's privileged existence, Larsen intends to make a man of Humphrey and reveal to him the real foundations of capitalist exploitation that allow his rich status. Van Weyden discovers Larsen to be a self-educated man, fluent in works of literature and philosophy, who has risen up the ranks of maritime society to his present position of captain. During their discussions, Van Weyden discovers Larsen to be affected by physical and mental ailments, which increase as the voyage progresses. Van Weyden also changes and becomes more masculine and self-assured: His rise counterpoints Larsen's decline.

When the shipwrecked Maud Brewster arrives on *The Ghost*, both men become attracted to her. After a seizure prevents Larsen from raping her, Humphrey and Maud

Jack London

decide to leave *The Ghost*. They eventually land on Endeavor Island and set up dominion over the seal colony, until they discover the abandoned *Ghost* with its now-blind captain left to die by the crew. Humphrey and Maud work together to make *The Ghost* seaworthy. After attempting to destroy *The Ghost*, the defiantly Miltonic and unrepentant Larsen dies, leaving Maud and Humphrey free to return to civilization renewed by their experience.

The Films

Jack London wrote *The Sea-Wolf* as a protest against the Nietzschean ideal of the superman, a protest also relevant to the brutal individualism of the Reagan and Thatcher eras of modern times. London also launched a scathing attack on industrial exploitation and its dehumanizing tendencies. Most movie adaptations neglect these ideas and

emphasize the adventure aspects of the original novel. *The Sea-Wolf* has seen many film versions—including a 1913 rendering starring Hobart Bosworth as Wolf (and cameo appearance by Jack London himself)—but the most cinematically effective is still Michael Curtiz's 1941 Warner Brothers version scripted by radical writer Robert Rossen and starring E.G. Robinson as Wolf. Eliminating the sentimental Endeavor Island sequences and genteel heroine, Maud Brewster, Rossen set the film a decade later and emphasized proletarian elements within the studio's familiar generic social realism. By emphasizing the minor role of working-class George Leach (played by John Garfield) and downplaying the original hero, Rossen made the film into a film noir allegory against European fascism in an era prior to America's involvement in World War II.

REFERENCES

Williams, Tony, "History and Interpretation in the 1941 Version of Jack London's *The Sea Wolf*," *The Jack London Newsletter* 19, no. 2 (1986), 78–88; Williams, Tony, *Jack London: The Movies* (David Rejl, 1992).

—*T.W.*

THE SECRET AGENT (1907)

JOSEPH CONRAD

Sabotage (1936), U.K., directed by Alfred Hitchcock, adapted by Charles Bennett, Alma Reville, Ian Hay, Helen Simpson, and E.V.H. Emmett; Gaumont-British.

Joseph Conrad's The Secret Agent (1996), U.S.A., directed and adapted by Christopher Hampton; Twentieth Century Fox/Fox Searchlight.

The Novel

This was the only novel written by Joseph Conrad to be set in London. The plot was inspired by a botched anarchist bombing in Greenwich Park on February 15, 1894, when Martial Bourdin was found on a hill near the Royal Observatory "in a kneeling position, terribly mutilated." Bourdin was accompanied to the park by his brother-in-law, H.B. Samuels, a secret police agent who was also editor of an anarchist newspaper. Conrad described the bombing attempt as "a blood-stained inanity of so fatuous a kind that it was impossible to fathom its origin by any reasonable or even unreasonable process of thought." A friend remarked that Bourdin was "half an idiot" and that "his sister committed suicide afterwards." These facts provided Conrad with the plot of his novel.

The novel was set eight years before the "Greenwich Bomb Outrage," in 1886. Mr. Verloc, the "secret agent" of the title, runs a Soho shop that deals in stationery and pornography. He works for the Metropolitan Police and for an unnamed foreign embassy and keeps company with

known anarchists. Pressed into service as an agent provocateur, Verloc is ordered to bomb the Royal Observatory. Verloc unwisely sends his mentally handicapped brother-in-law Stevie up the hill with the bomb, which accidentally explodes. Panic sets in and Verloc withdraws his savings to flee the country, but his wife Winnie is so distraught about her brother's death that she murders Verloc. Ossipon, one of the anarchists, stops by the shop, discovers Verloc is dead, and offers to help Winnie escape, but also steals her money. She then commits suicide.

The Films

The first adaptation, directed by Alfred Hitchcock in 1936, was entitled *Sabotage* (not to be confused with Hitchcock's *Secret Agent*, a film also made in 1936, which was based on Maugham's *Ashenden* and not on Conrad's novel). Hitchcock takes many liberties: He updates the story to the 1930s and makes Verloc (Oscar Homolka) a German spy who operates a seedy cinema in East London. The boy Stevie (Desmond Tester) is sent with the bomb not to Greenwich, but to Piccadilly Circus. Winnie (Sylvia Sidney) kills Verloc with a steak knife, as in the novel, but her life is spared in the Hitchcock version. A romance develops between Winnie and the police detective (John Loder) who kept Verloc under surveillance, and he prevents her from confessing her crime. The conclusion bears more resemblance to Hitchcock's earlier film *Blackmail* (1929), in which Detective Frank Webber protected a young woman who had killed an artist who had attempted to rape her, than to Conrad.

The Christopher Hampton adaptation moves the story back to the 1890s and the time of the actual "Greenwich Bomb Outrage." Hampton's Verloc (Bob Hoskins), like Conrad's, lives above his "book" shop devoted to "improper wares and pornographic publications," with his wife (Patricia Arquette), her mother (Elizabeth Spriggs), who moves out early in the story, and his wife's retarded younger brother Stevie (Christian Bale). Verloc's shop is a meeting place for East European anarchists, all of them warped, pathetic people.

In Hampton's adaptation Verloc is ordered by Vladimir (Eddie Izzard), the first secretary of the Russian Embassy, to create an incident that will make the British authorities reconsider their policy of tolerance toward political malcontents and foreign dissidents. Verloc sends Stevie up the hill in Greenwich Park, but the boy trips over a root and falls on the bomb, which then explodes. Verloc is closely watched by Chief Inspector Heat (Jim Broadbent), who puts on the pressure after the bombing. Verloc, a compulsive eater too stupid to be a double agent, gnaws on roast beef as he tells Winnie what has transpired. She snaps and stabs him through the heart with a steak knife. Ossipon (Gerard Depardieu) discovers what has happened and finds out that Winnie has a considerable amount of money Verloc has withdrawn from the bank. He escorts her to Waterloo Station, buys her a ticket to France, puts her on

the train, then jumps from the compartment, with the rest of her money, as the train departs. Arriving at the coast, Winnie boards the Channel steamer and drowns herself, as Ossipon discovers by reading a newspaper the next day.

The film is brilliantly cast. Robin Williams, cast against type as the mad bomber known as "The Professor" (in an uncredited role attributed to "George Spelvin"), leads a larger cast of comedians such as Eddie Izzard and Jim Broadbent playing sinister roles, all of them, and Bob Hoskins as well, cast against type. The casting gives the film a satirical bent that works very well indeed. As critic J.I.M. Stewart wrote, "the end of Mr. Verloc, although one of the greatest scenes in English fiction, belongs—as does the end of Stevie, if not Stevie's sister—to a world of savage comedy." Hampton's film is far better in its fidelity to its source and in its treatment of corrupt and amoral politics than the earlier Hitchcock version. It is exactly what its title proclaims: *Joseph Conrad's The Secret Agent.*

REFERENCES

Phillips, Gene D., *Alfred Hitchcock* (Twayne Publishers, 1984), Stewart, J.I.M., *Eight Modern Writers* (Clarendon Press, 1963); Yacowar, Maurice, *Hitchcock's British Films* (Archon Books, 1977).

—*J.M. Welsh*

SENSE AND SENSIBILITY (1811)

JANE AUSTEN

Sense and Sensibility (1996), U.K., directed by Ang Lee, adapted by Emma Thompson; Columbia.

The Novel

Sense and Sensibility is neither the best nor the brightest of Jane Austen's novels—it falls short of *Pride and Prejudice*, *Emma*, and *Mansfield Park*, for example—but it represents the first blossoming of her mature fiction and is in its own way adroit and charming in its satiric treatment of the Romantic sensibility. The novel concerns two sisters temperamentally at odds with each other. Elinor Dashwood is the older and more mature sister who represents common sense, composure, decorum, discretion, and reason. The younger and more impulsive Marianne represents "sensibility," intuition, spontaneity, and passion. The girls are the daughters of Henry Dashwood. The father also had a son, John, by a former marriage, who inherited a fortune from his mother and another from his wife, Fanny. The succession of the Norland estate in Sussex, where they live, is most important to the daughters, and John had promised his father that he would provide for them in event of the father's death. But his wife Fanny insists on moving into Norland and talks her weak-willed husband out of the promised inheritance to assist his father's widow and daughters. Thus, the impoverished widow and her daughters move to Barton Cottage in Devonshire, offered through the kindness and generosity of Sir John Middleton.

Once the main characters are settled at Barton, the plot in mainly influenced by the actions of Willoughby, whose charm allows him initially to overwhelm Marianne, though she is warned about him by Colonel Brandon, an older gentleman of means and an excellent judge of character, who is, nonetheless, enamored of Marianne himself. Willoughby is a devious heartbreaker who serves as a foil to both Colonel Brandon and Edward Ferrars, in whom Elinor is interested. Like Willoughby, Ferrars is more a structural necessity than a well-delineated character. Marianne, who considers herself a matchmaker, initially regards Brandon as an uninteresting, aging non-entity, the kind of man, as Willoughby says, "whom every body speaks well of, and nobody cares about; whom all are delighted to see, and nobody remembers to talk to."

Austen mocks the extravagances and foolishness of her characters by providing standards for common sense and good judgment against which that extravagance can be measured. Brandon is one such character, Elinor another. Both Elinor and Marianne have their faults. Elinor is perhaps too constrained by her long-suffering discretion, but Marianne is the main target of Austen's satire. At the end of the novel she is ashamed of the manner in which she has conducted herself when she is forced to compare her own disappointments and her reaction to them with the disappointments of her sister, whose extraordinary composure serves as a standard against which Marianne's frenzied sentimentality can be judged.

Austen derides the selfish, egocentric, base, inhumane, and inconsiderate qualities many of her characters exhibit. The opening chapter mocks the greediness of Fanny and John Dashwood, who surrenders to the rationalizations of his wife and succumbs to his own latent greed and self-interest. He is too easily convinced of the extravagance of his original intention to follow his father's wishes. The false, deceitful, and mean characters are naturally drawn to one another. Thus, for example, Mrs. Middleton and Fanny Dashwood prefer the parasitical Steele sisters to Elinor and Marianne and prove easy prey to Lucy Steele's deceit, her feigned politeness, and her willingness to flatter. The extreme distress that Fanny suffers upon learning that her guest, Lucy Steele, who is even more indigent than Elinor, is in fact engaged to her brother, the self-effacing Edward Ferrars, is fittingly comic.

Marianne's intellectual snobbery, her intolerance of the insensitive, her propensity to misjudge other characters such as Willoughby and Colonel Brandon, her hastiness to jump to conclusions are all laid open to ridicule as her character is gradually changed and as she learns from her experience and matures. Thus Marianne is forced to suffer the consequences of her folly, but even the anguish she suffers upon being rejected by Willoughby does not escape Austen's mocking treatment. Austen's satire is brilliant.

The Film

Emma Thompson, herself a gifted comedienne who starred opposite Robert Lindsay in the London stage revival of *Me and My Girl*, had never written a screenplay before and labored over this one for four years. She wanted to stress the universality of the novel, as she states in the "Diaries" appended to the published screenplay: "We start with Fanny. Everyone we see captures perfectly the balance of wifely concern and vicious self-interest." At the end of the day, director Ang Lee says: "This is a nation of Fannys," and for Thompson "it rings horribly true," an indictment of Thatcherite greed. Their casting choice, Harriet Walter, is perfectly mean-spirited and parsimonious as Fanny Dashwood. As she wrote the screenplay, Thompson had Hugh Grant in mind as Fanny's shy brother, Edward Ferrars. Alan Rickman, who played the devious Vicomte de Valmont in the Royal Shakespeare production of *Les Liaisons Dangereuses* and has since played some over-the-top movie villains, plays Colonel Brandon with admirable restraint as a socially awkward and rather stuffy aristocrat whose heart is in the right place and who helps reverse the fortunes of the Dashwood girls. Thompson herself plays Elinor, and Kate Winslet was good enough as Marianne to earn an Academy Award nomination for best supporting actress at the age of 19. The supporting cast is filled with gifted stage actors, such as Robert Hardy (Sir John Middleton), Gemma Jones (Mrs. Dashwood), Imogen Stubbs (Lucy Steele), Elizabeth Spriggs (Mrs. Jennings), and Greg Wise (Willoughby), Emile François is sprightly as the youngest Dashwood sister, Margaret. The casting of the film is perfect.

The genius of this well-adapted film directed by Ang Lee is the way it perfectly creates atmosphere but also captures a sense of the proprieties that governed Jane Austen's world. For many readers of Jane Austen, the atmosphere is all, but for others it is the discerning sense of irony that opens *Pride and Prejudice* and informs all of her novels. Verbally, the film is nicely nuanced and catches the spirit of the text. The female characters tend to be ironists or dimwits, though many of the latter are good, amusing people who generally mean well. For decades readers have been drawn to the civilized world Jane Austen created in her novels. This film brilliantly transforms that world to the screen and is sure to revive Hollywood's interest in Jane Austen, to the delight of literate viewers.

REFERENCES

Lascelles, Mary, *Jane Austen and Her Art* (Clarendon Press, 1939); Litz, A. Walton, *Jane Austen: A Study of Her Artistic Development* (Oxford, 1968); Thompson, Emma, *The Sense and Sensibility Screenplay and Diaries: Bringing Jane Austen's Novel to Film* (Newmarket Press, 1995); Watt, Ian, ed., *Jane Austen: A Collection of Critical Essays* (Prentice-Hall, 1963).

—*J.M. Welsh*

SHANE (1949)

JACK SCHAEFER

Shane (1953), U.S.A., directed by George Stevens, adapted by A.B. Guthrie Jr.; Paramount.

The Novel

When he wrote *Shane*, Jack Schaefer had never been west of Cleveland, Ohio, his hometown, yet he understood the myth of the West so well that his novel was honored in 1985 by the Western Writers of America as the best Western novel ever written. Set in 1889, the novel tells the story of a gunfighter who has outlived his time and who befriends the homesteading family of Joe Starrett, his wife Marian, and their son Bob. Shane agrees to work as Joe's farm hand, as though he is trying to adjust to a new way of life. But a powerful rancher, Luke Fletcher, is determined to run Starrett and the other homesteaders off the range. Fletcher brings in a gunfighter, Stark Wilson, to intimidate the homesteaders. Wilson picks a fight with one of the homesteaders, Ernie Wright, insults him by calling him a half-breed, then shoots him when Wright goes for his gun. This altercation is staged so that Wright's friend, Frank Torrey, will return to the peaceful farmers to tell them what has happened. Joe Starrett becomes their leader and advises them to stand and fight, but Joe is no match for Wilson. Shane, who has to that point avoided fighting with Feltcher's men, knocks Joe unconscious, then rides into town in Joe's place for a showdown with Wilson at Grafton's saloon. At the showdown, Shane kills both Wilson and Fletcher. Bob, who followed Shane into town, witnesses the gunfight. Having now reverted to what he was, Shane rides away, after explaining to Bob: "A man is what he is, Bob, and there's no breaking the mold." He concludes, "There's no going back from a killing." The story ends, as it must, with the mythic gunfighter riding off to the horizon, leaving the valley at peace.

The Film

A.B. Guthrie Jr., whose novel *The Way West* had won a Pulitzer Prize in 1949, wrote the screenplay adaptation, which was generally true to Schaefer's design but worked in minor changes in details and characters. Bob Starrett becomes a younger boy, renamed Joey (Brandon de Wilde) in the film, for example. Luke Fletcher becomes Ruf Ryker (Edgar Buchanan) and is given a brother, who attempts to bushwhack Shane at the end, after his fight with Wilson (unforgettably played by Jack Palance). Homesteader Frank Torrey (Elisha Cook Jr.) is reinvented as a reckless rebel from Alabama. In the film it is the hothead Torrey whom Wilson first kills, not Ernie Wright. The film expands the homesteaders into a community of immigrants and adds a Fourth of July celebration that would be

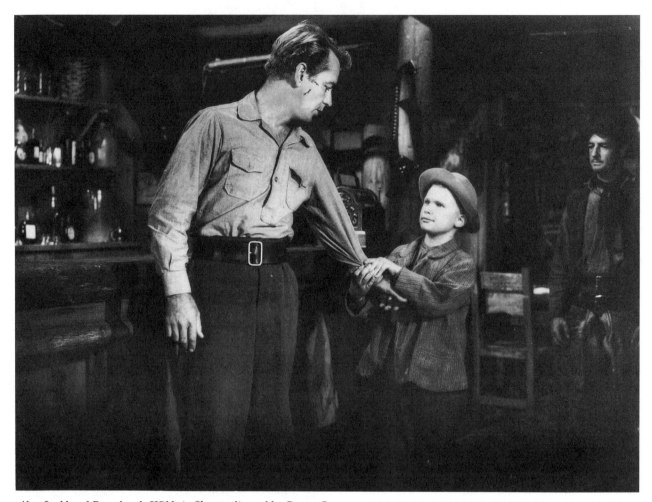

Alan Ladd and Brandon de Wilde in Shane, *directed by George Stevens* (1953, U.S.A.; PARAMOUNT/PRINT AND PICTURE COLLECTION, FREE LIBRARY OF PHILADELPHIA)

typical of a John Ford Western, the day that Torrey is shot. The bonding between Shane (Alan Ladd) and Joe Starrett (Van Heflin) is extended in the film, and the attraction between Shane and Marian (Jean Arthur) is made quite obvious. There is an extended fight between Starrett and Shane over who will go into town to face Wilson, a fight that Shane is able to win only by coldcocking Starrett with his revolver. The film loses the boy's point of view. Little Joey is merely one of many characters, and Alan Ladd is too much a gentleman, far more civilized than the edgy character in the novel seems to be. Whereas the novel focuses on character, the film focuses more on action. What the film misses is the mediation of character and events that the novel presents from Bob's perspective, but the older Bob has a better (though incomplete) understanding of the events than his less mature counterpart Joey in the film.

The film was shot in the Jackson Hole Valley, flanked by the Grand Teton Mountains, which Shane descends from. In his structural study of Westerns entitled *Sixguns*

and Society, Will Wright called *Shane* "the classic of the classic Westerns." Very popular at the time it was made, *Shane* was nominated for five Academy Awards: best picture, best director, best adapted screenplay, and best supporting actor (Brandon de Wilde) and won an Oscar for best cinematography (lensed by Loyal Griggs). In 1985 Clint Eastwood paid tribute to *Shane* by lifting its central conflict and characters into a different setting in *Pale Rider*, which took the good-badman archetype one step beyond *Shane* by making the unnamed Shane figure, played by Eastwood, both a gunfighter and a preacher, but Eastwood's hyper-Western on overdrive is little more than a pale imitation.

REFERENCES

Folsom, James K., "*Shane* (1953) and *Hud* (1963)," in *Western Movies*, ed. William T. Pilkington and Don Graham (University of New Mexico Press, 1979); Wright, Will, *Sixguns and Society: A Structural Study of the Western* (University of California Press, 1975).

—*J.M. Welsh*

THE SHAPE OF THINGS TO COME (1933)

H.G. WELLS

Things to Come (1936), U.K., directed by William Cameron Menzies, adapted by H.G. Wells; London Films/United Artists.

The Novel

Written in 1933 when H.G. Wells was 67 years old, the novel was subtitled "The Ultimate Revolution." It is a history of the world from 1913 to 2116. The framing device for the novel is that the narrator inherited the "dream book" of Dr. Philip Raven, a secret history of the future of the world. Despite certain disclaimers in the introduction, it appears that Wells thought he was on to something about the future, and he attributed his prescience to the manuscript left him by Raven. The novel is not a novel in the normal sense; it is a lecture, a discourse rather than a plotted story with real characters. Throughout the work are scattered treatises on all manner of subjects from politics, industry, communications, and housing to commentaries on language and people, such as the Jews, who "get over it" in this novel: "[B]etween 1940 to 2059 . . . this antiquated obdurate culture disappeared. It and its Zionist state, its kosher food, the law and all the rest of its paraphernalia, were completely merged in the human community . . . there was no extermination . . . yet they were educated out of their oddity and racial egotism."

Evidently it was startling to readers at the time that the book predicted the bombing of London (Everytown). But, contrary to the legend this book has become, many of the predictions are way off base, and the further into the future it ventures, of course, the further off track it gets. Wells does predict a war in the Pacific, but the circumstances are completely different and the sea battle lasts for two days. The future is envisioned as a place of massive crowds, plague, abandoned cities, and upheavals as the populace is subjected to various phases of world state movements.

Because the twenties and early thirties were Wells's points of reference, the book constantly returns to discussion of prominent people and issues tied to those days. This is understandable, but hardly pertinent in the light of all that has actually happened since the "dream book" was written. Thus, despite the many ideas that surface, the novel remains old fashioned. While the text provides a lengthy commentary on war, anarchy, reconstruction, and the emergence of a new society, it is hopelessly tied to its own time. How could it be otherwise? The novel ends with the reflection that survival depends on the sublimation of the individual into the group for common good. "The body of mankind is now one single organism" in which individual differences, like tentacles, serve only to bring new information to the one body. The book, unlike the film, does not end on a note of risk taking and space exploration; it is more interested in establishing the importance of the confluence of wills over the importance of individuals.

The Film

Admired by many, including major science fiction writers, as a seminal and influential science fiction film, *Things to Come* is nevertheless dated today. An impressive production at the time of its release, it was the most costly British film to date. William Cameron Menzies designed the sets with Vincent Korda. The end of the film features grand, futuristic sets of the new city of 2036, with circular architecture, outside elevators, and monorails, dominated by a large pseudoarchaic Greek statue and a large analog clock. Menzies, who directed the film, is better known for set design: Three years after this film, he won an Oscar for the production design of *Gone With the Wind*.

The film follows the text to the extent that it is about war, decline, the failure of the old governments, and the rise of the future. But the novel is expository with little attention to characters, while the movie must fill out the few characters, while still having them embody political stances. The film lacks the discourse of the book, which in some cases is a blessing, but it is difficult to contain this sort of book in acted out scenes.

Beginning with talk of war in England in 1940, the film is domestic, showing the Cabal children, their parents, friends, and grandfather at Christmas. The scene quickly changes from war talk to war, general crowd scenes, and expressionist-influenced scenes of destruction. The action moves through the years to the sixties, as a rather ridiculous "wandering sickness" begins to lose its grip on a world where people are ruled by warlords and dressed in rags. Into this situation comes Cabal (Raymond Massey), who arrives in a new, small "1970 model" plane from "Wings Over the World," headquartered in Basra. It is a strange machine, indeed, for the seventies. He represents the "government of common sense, which doesn't believe in independent sovereign states." Grand ideas are placed in the mouths of cardboard characters who, despite the fact that the year is somewhere in the seventies at this point, still speak in the cadences of the thirties. The old power structure falls to the new, pro-science air power command. The ragtag look of the movie becomes Flash Gordonesque (the first Flash Gordon was also released in 1936). Huge sets of production sites dissolve into one another as time moves on into the 2000s, the future seen as one of massive industry—Wells did not anticipate the rise of a service economy, just as he didn't anticipate the computer. It is odd to see our times and future times represented with no computers (Eniac was 10 years away) and with radio the primary communication technology. However, there is a sort of combination TV-hologram device used by the leadership. Crowd scenes reminiscent of Hollywood's ancient Rome extravaganzas alternate with smaller scenes between

important characters including Raymond Massey as the newest Cabal. The Cabals, in leadership positions, are the common thread running through the years. As in many subsequent science fiction movies, authority is completely top down.

Controversy at the end of the picture surrounds the sending off of two young people, one a Cabal, in a "space gun." A capsule is shot out of a huge gun, which resembles a cannon mounted on a launch pad. The movie becomes very futuristic, but with something very thirties around the edges. The acting is stagey and dated, the planes and tanks are incredible anachronisms, the political arguments are simplistic; nevertheless, the film is interesting to watch. Perhaps it is the hokey, antiquated quality of the film, with the appearance of a resplendent modern city at the end, that makes it even more interesting now than it would have been in the thirties, when the movie was seen as a bagful of futuristic curiosities. The theme is one of regression vs. progress. Finally, the film, if not the book, ends with the idea that man's destiny is in his own hands. He can have "all the universe or nothing, which shall it be . . .?"

REFERENCES

Johnson, William, ed., *Focus on Science Fiction* (Prentice-Hall, 1972); *International Dictionary of Films and Filmmakers*, 2nd ed., vol. 1 (St. James Press, 1990); Stover, Leon, *The Prophetic Soul: A Reading of H.G. Wells's Things to Come* (McFarland, 1987).

—K.O.

SHE (1887)

H. RIDER HAGGARD

La Danse du Feu (1899), France, directed by Georges Méliès.
She (1908), U.S.A., directed by Edwin S. Porter; Edison Production Company.
She (1911), U.S.A., directed by George O. Nichols; Thanhouser Production Company.
She (1916), U.K., directed by Will Barker, adapted by Nellie E. Lucoque; Barker Motion Photography.
She (1917), U.S.A., directed by Kenean Buel, adapted by Mary Murillo; Fox Films.
She (1925), Germany, directed by Leander De Cordova, adapted by Walter Summers; Reciprocity Films.
She (1935), U.S.A., directed by Lansing C. Holden and Irving Pichel, adapted by Ruth Rose; RKO.
Malika Salome (1953), India, directed by Mohammed Hussein; Comedy Pictures.
She (1965), U.S.A., directed by Robert Day, adapted by David Chantler; MGM.
Vengeance of She (1967), U.K., directed by Cliff Owen, adapted by Peter O'Donnell; Hammer Film Productions.

The Novel

She (1887) rivals *King Solomon's Mines* as H. Rider Haggard's most popular novel. It is on these two early novels, plus a handful of others mostly written before 1900, that Haggard's literary reputation rests. He was associated with Rudyard Kipling and Thomas Hardy, and *She* influenced the writings of Sigmund Freud and Carl G. Jung.

She opens with the narrator's introduction of Leo Vincey and his mentor L. Horace Holly crossing the Cambridge campus; a month later the narrator receives a letter and two packages from Holly. After a brief note about his reaction to the materials he has received, this narrator disappears. In the opening chapter (narrated by Holly), we meet Leo's father, John Vincey, who announces that he is dying and asks Holly to assume guardianship of his infant son until the boy is 25, when his legacy will be revealed to him and Holly. Despite Holly's protests, Vincey père is adamant, so he leaves a letter and keys with Holly; Holly resolves to sleep on the matter, awakening to the news that his manservant has found Vincey's corpse.

After a brief account of Leo Vincey's childhood and adolescence, he comes of age: Holly opens the chest he has drawn from a London bank on the eve of Leo's 25th birthday. It contains an ancient potsherd, a parchment, and a letter from Vincey senior. The letter details a story of Vincey's eternal love from whom he is separated, and recounts the existence of a white woman dwelling on the banks of the Zambesi River in Africa. The potsherd has a long inscription in demotic Greek, which is also translated into cursive Greek (the parchment), Old English, Middle English, Elizabethan English, and Latin, and details the story of Amenartas and her husband Kallikrates, who fled Egypt to escape the wrath of Ayesha, who also loved Kallikrates. Eventually, Ayesha slew Kallikrates, hoping to resurrect him at a later time; we learn that Leo and his father are both of the lineage of Kallikrates (and discover later that Leo himself is an exact physical double of Kallikrates).

Leo, Holly, and Job (Holly's manservant) travel to Africa, nearly drowning both on their ocean and river voyages. They meet Billali, Ayesha's general, at the village of the Amahagger. Learning that women in this world are socially above men, they also learn that, every generation or so, the older men kill the older women in order to prevent them from becoming arrogant and overbearing. Ustane, one of Ayesha's female subjects, falls in love with Leo, but Job is beaten and nearly killed by the Amahagger for rejecting a woman who wanted him. After travelling through a perilous mountain pass to the Plain of Kôr, they meet Ayesha, who immediately discerns Ustane's love for Leo, and later strikes her dead by pointing a finger at her. After pronouncing judgment on Ustane and on the Amahagger who attacked Job, Ayesha takes Leo and Holly on a tour through her catacombs, finally showing them the body of Kallikrates, her long-dead lover, who is an exact image of Leo.

Ayesha educates the men about her longevity, and about her ability to rule the Amahagger with such a small

army. After revealing to Leo and Holly her intention to make Leo immortal by taking him through the same cold flame that gave her eternal life, Ayesha reveals her desire to return to England with them in order to seize the British Empire from Queen Victoria. She leads them into the Temple of Truth, waits for the moonrise to illuminate the volcanic crater above the Flame of Eternal Life, and steps into the flame, requesting that Leo wait until she has completed her baptism. But her second pass through the flame makes her a shriveled, simian hag, then dissolves her completely.

The Films

There are at least 10 documented film versions of Haggard's *She*. Of these, only two are generally available: the 1935 RKO production and the 1965 MGM production. One feature shared by both is deviation from the novel in geographical setting; in Merian Cooper's 1935 production, Holly (Nigel Bruce) and Leo (Randolph Scott) travel to Siberia, near the Arctic Circle, in search of the Amahagger and Ayesha; in the 1965 production Leo, Holly, and Job set out from Israel. In the 1935 production, neither Job nor Ustane is present (Ustane is replaced by Tania, whose father runs a trading post for Arctic fur trappers), while the Amahagger of the book are replaced by northern cave dwellers, presumably Siberian tribal stock (but resembling Inuit). Cooper's production also invents a valley accessible only through a cave in a giant glacier.

Both Helen Gahagan (1935) and Ursula Andress (1965) are miscast; Andress is especially unconvincing as Ayesha by virtue of her far-from-imperious voice. And the character of Ustane, present only in the 1965 production (Rosenda Monteros), is much more sensitive than the semi-feral Amahagger woman Haggard created. The 1965 production's Leo Vincey (John Richardson) is more believable than Randolph Scott in the 1935 film.

A few other departures from the novel are notable in the case of the 1935 production, including Busby Berkeley–style choreography for the intermittent tribal dance movements that punctuate the action of the film (indeed, a musical stage production of *She* was mounted in 1887), and the epilogue in Holly's study, where Tania and Leo listen to Holly reading his account of their adventures. Also worth noting are the cubist sets, reminiscent especially of Picasso and Braque.

She, directed by Lansing C. Holden and Irving Pichel (1935, U.S.A.; RKO/PRINT AND PICTURE COLLECTION, FREE LIBRARY OF PHILADELPHIA)

There are fewer departures from the plot in the 1965 film, although some of these are glaring. For instance, the three Englishmen's meeting with Ustane in an Israeli belly dancing club seems gratuitous, as does the subsequent plot thread involving Ustane, Billali, and the desert bandits. Leo's hallucinations of Ayesha's face during the desert journey seem contrived, transforming the journey into psychedelic science fiction. There are problems with anachronism, like the classical Roman armor on Billali's soldiers, and the *Soul Train*-type dance sequences that serve no purpose but to remind viewers that they are watching an MGM production. A distracting departure from the novel occurs when Ayesha offers Leo the dagger she used to kill Kallikrates after he protests her decision to execute Ustane (Ayesha killed Ustane merely with a look in the novel). Finally, Billali's entrance into the chamber of the Flame of Eternal Life is out of character for the obedient Billali of the novel.

Unlike the novel, both films reach their climax when Leo, Holly, and Job escape from Ayesha's kingdom amid a battle royal, barely making it to the outside with Ayesha's army behind them: These are deus ex machina deliverances more characteristic of cinematic than novelistic grammar. The most consistent parallel with the book in both films is the horrific death of Ayesha; both filmmakers treat this faithfully, if too graphically in the lurid color of the 1965 production.

Despite its greater departure from elements of the novel's plot and setting, the 1935 production has preserved the spirit of the original more faithfully and with less affront to viewers' taste. The 1965 production is gaudy, splashy, and sexy, and it oversimplifies the politics of the story in ways that empty it of meaning. However, the 1935 production cannot be called the definitive *She* without debate, because the transposition of the setting to a tropical region (reached through a glacial cave in Siberia) strains the viewer's credibility.

REFERENCES

Etherington, Norman, *Rider Haggard*. (Twayne Publishers, 1984); Whatmore, D.E., *H. Rider Haggard: A Bibliography*. (Meckler, 1987).

—*V.P.H.*

THE SHELTERING SKY (1949)

PAUL BOWLES

The Sheltering Sky (1990), U.S.A., directed by Bernardo Bertolucci, adapted by Bertolucci and Mark Peploe; Warner Bros.

The Novel

The novel concerns three Americans adrift in North Africa, Kit and Port Moresby and their travelling companion, a friendly but trivial socialite named Tunner. Tunner is the typical American tourist, passing superficially through a foreign culture but believing he will soon return to the security and comforts of home. The more thoughtful Port considers himself a traveller rather than a tourist: "Whereas the tourist generally hurries back home at the end of a few weeks or months, the traveler, belonging no more to one place than to the next, moves slowly, over periods of years." By this definition in chapter two, the tourist "accepts his own civilization without question; not so the traveler, who compares it with the others, and rejects those elements he finds not to his liking." Port is the consummate "traveler."

The novel is partly a roman à clef since Port and Kit have a great deal in common with author Bowles and his wife Jane, herself a poet and novelist. The novel seems to be a fictive dramatization of psychological and sexual tensions Bowles and his wife experienced. They were living together in Tangier when the novel was written. The title was influenced by a trivial popular song, "Down Among the Sheltering Palms." Bowles, an established composer as well as a writer, wondered what the palms might "shelter" one *from*. The first two books of the novel belong to Port; book three belongs to Kit and her ability (or inability) to survive alone.

In the story Kit is completely dependent upon Port and follows him dutifully into the desert, visiting remote outposts. Port soon gets bored with Tunner and through deception manages a separation. Utterly alone in an alien wilderness, Port takes sick and dies at the end of the second book of the novel. Left to her own devices, Kit is picked up by a Tuareg merchant caravan and becomes the love slave of Belqassim, the caravan leader, and another Arab, both of whom rape her repeatedly. The novel is about identity, and Kit willingly relinquishes hers to become subordinate to any man willing to look after her. Eventually Belqassim's jealous wives so abuse her that she escapes, only to be raped and brutalized by others. Finally, she is hospitalized and seems to be quite mad. In real life Jane Bowles stopped writing after the publication of her husband's novel and eventually died at a psychiatric hospital in Spain.

Bowles had little patience with readers who wanted to know what the novel was *about*: "Americans are like Kit and Port. They want a lesson, a meaning, a moral. They want an answer," but "An answer to what?" Concerning the question of Kit's motive, Bowles told an interviewer in 1995: "People who want an answer are the ones that believe in progress—onward and upward! But there is no progress and there is no answer, of course." This ambiguous existential novel with its interior development would be a particular challenge for screen adaptation.

The Film

Bertolucci's film faithfully captures much of the meaning and texture of the novel's first two books, though he makes the relationship between Kit (Debra Winger) and Port (John Malkovich) seem more normal. In the film they

indulge in sexual intercourse at one point, for example, though this is never suggested in the novel. Changes in locale, time (Kit loses her watch), identity (Port and Tunner have their passports stolen; the conventional tourist Tunner makes an effort to recover his, but both Port and Kit give theirs up willingly), and culture. The cultural distance traveled is much greater in the novel, which develops a central conceit of life as a journey toward self-realization and discovery. In book three Kit continues the journey Port has started. But she cannot be the same person without him: She is a vessel without a Port. She has no will of her own in the novel. In the film the ordeal she suffers after Port's death is less brutal and not severe enough to drive her out of her wits. She is not raped while with the caravan in the film and Belqassim is idealized and made to seem innocent and caring rather than threatening. If the ordeal is less severe, Kit is more likely to come through it unscathed, as she does. When she escapes from the hospital at the end of the film, she seems to know where she is going. She emerges as a different character than one would recognize from the novel.

No doubt Bertolucci was respectful of his source. In fact, he cast Paul Bowles himself as the film's "narrator," though Bowles is not given much to narrate, nor does he give away any secrets of the omniscient point of view employed in the novel. The film clearly goes wrong in the way it romanticizes Kit's adventures in book three, as Bowles seems to suggest when he meets Kit, newly escaped from the hospital at the end, and asks her "Are you lost?" The suggestion here is that Kit is not where she is supposed to be according to the novelist's earlier design. As the film gives the character back to the writer who created her, Bowles seems to be asking "What has this flamboyant Italian done to you?" The newly invented Kit is not "lost" but seems to know where she is going. The ending of the film is far less ambiguous than the novel, but overall Bertolucci captures a sense of the novel's mystery, perhaps better and more sensitively than any other director might have done.

REFERENCES

Kael, Pauline, "New Age Day Dreams," *The New Yorker* (December 17, 1990), 118–21; Negri, Livio, ed., *The Sheltering Sky* (Scribners, 1990); Patteson, Richard F., *A World Outside: The Fiction of Paul Bowles* (University of Texas Press, 1987); Stewart, Lawrence D., *Paul Bowles: The Illumination of North Africa* (Feffer & Simons, 1974); Streitfeld, David, "Writer Paul Bowles Is 84," *The Washington Post* (February 9, 1995), C1, C2.

—*J.M. Welsh*

THE SHINING (1977)

STEPHEN KING

The Shining (1980), U.S.A., directed by Stanley Kubrick, adapted by Kubrick and Diane Johnson; Warner Bros.

The Novel

After completing his second novel *Salem's Lot*, Stephen King decided to move his family to Colorado for an extended holiday in the late summer of 1974. When they visited the Stanley Hotel in Estes Park in late September, King thought it would be a perfect location for a ghost story. The hotel led his three-year-old son to have a nightmare in which a fire hose chased him down the corridor. King then remembered his 1972 novel plot, *Darkshine*, which contained the idea of a location inspiring dreams. He also added his personal feelings of insecurity into the character of Jack Torrance despite the fact that King was at the height of his career.

Former alcoholic and ex-schoolteacher from Vermont, Jack Torrance applies for the job of caretaker of the Overlook Hotel, Colorado, following his dismissal for assaulting a pupil. The obsequious manager, Ulman, reluctantly hires him due to the influence of Jack's former drinking partner, Al Shockley, whose syndicate controls the hotel. Jack and his family will move into the hotel during the winter season months of October to May. Jack intends to write a play during that time and hopefully return to his old job in Vermont, since Al is also on the school board. However, Jack's five-year-old son Danny experiences nightmares about them. Overlook while he waits for his father to return. While Jack learns about the Overlook's violent history (including the former caretaker's murder of his family and final suicide), Danny's imaginary playmate Tony warns him about the hotel.

However, Jack returns and takes his family to the Overlook on its closing day. The black cook, Halloran, recognizes that Danny shares the power of the "Shining," a hypersensitive mechanism enabling him to experience things nobody else sees and foretell the future. He warns Danny to stay away from Room 217 and reassures him about what he might see. However, the Torrance family begins to experience past manifestations from the Overlook's history, such as a masked ball on August 29, 1945, the spirit of a woman who committed suicide in Room 217, and moving hedgerow animals. Jack discovers a scrapbook about the Overlook's history near the basement boiler whose pressure he has to control. Both Jack and Wendy suffer from past memories of parental abuse. Eventually, Jack becomes affected by the Overlook Hotel, which wishes to use him to obtain Danny's "Shining" powers. Jack attempts to murder Wendy in the hotel bar, but she knocks him out with a bottle and confines him to the large hotel pantry. Jack escapes with the aid of the former caretaker, Grady, who is now a spirit in the hotel.

Earlier, Danny sent a telepathic message to Halloran in Florida who has flown to Boulder and now makes his way to the Overlook in a snowcat. Halloran reaches the Overlook but has to fight his way past a hedge lion. Inside, Jack severely batters Wendy and seeks to kill Danny with a roque mallet to gain favor with the Overlook Hotel. He overpowers Halloran and eventually confronts Danny.

However, a vestige of the old Jack Torrance returns, and the loving father disfigures his own face with the mallet before the Overlook gains final control over him. Jack then realizes he has let the Overlook boiler gain a dangerous high pressure. But he is too late to prevent it exploding. Before this happens, Wendy, Danny, and Halloran manage to escape and see the spirit of the Overlook "assume the shape of a huge, obscene mantra" like a nest of hornets Jack had disturbed while repairing the Overlook's roof before the winter storms set in.

An epilogue depicts the survivors living in western Maine. Halloran looks after Wendy and Danny before they move to Maryland. The novel ends with the three experiencing a peaceful moment in the afternoon sun.

The Film

Apart from some exterior shots in Oregon and Colorado, *The Shining* was shot in Elstree Studios, England. Stanley Kubrick both directed and worked on the screenplay with Diane Johnson, an American academic. He originally intended to follow King's novel closely, but after experimenting with an ending in which Halloran completed Jack's task of killing his family and then committing suicide, Kubrick followed the present script outline.

Instead of reproducing the naturalistic and supernatural components within the original source material, Kubrick decided to fashion the screenplay along the lines of his creative interests. He disposes of cumbersome details difficult to reproduce cinematically, such as the hedge animals and other overtly supernatural elements. Instead, he creates an Overlook Hotel where the boundaries between reality and fantasy merge: Mirror imagery dominates the film, from the various shots of Jack (Jack Nicholson) seen through a mirror to the verbal enigma of Danny's (Danny Lloyd) repeated "Redrum" whose associations Wendy (Shelley Duvall) finally sees through the mirror. While the novel depicts Jack and Wendy as victims of a dysfunctional family situation, Kubrick satirically views them as part of a culture of grotesque comic-strip banality. Far from achieving his dream of becoming the Great American Writer of his era (rather than the playwright of the original novel), Jack becomes a dehumanized "Big Bad Wolf" or Roadrunner (with axe rather than roque mallet), pursuing Danny as Wile E. Coyote and attempting to break down the family bathroom door while voicing banalities from American television—"Here's Johnny!"

Instead of seeing the Overlook Hotel as a microcosm of post–World War II corruption, Kubrick juxtaposes the twenties "culture of consumption" era with its emerging Reaganite counterpart, soon to knock on the door of American history. At the climax, Jack becomes lost in the frozen maze outside and finally reappears in a 1921 photograph of the Overlook Hotel's July 4th celebrations. Unlike the original novel, Halloran becomes the victim of Jack's assault while Danny and Wendy escape to an unknown future. The Overlook does not explode but survives to claim its next his-

torical victim. Unsatisfied with Kubrick's alterations, King himself turned his novel into a television miniseries in 1997.

REFERENCES

Magistrale, Anthony, ed., *The Shining Reader* (Starmont House, 1990); Nelson, Thomas Allen, *Kubrick: Inside A Film Artist's Maze* (Indiana University Press, 1982).

—*T.W.*

SHIP OF FOOLS (1962)

KATHERINE ANNE PORTER

Ship of Fools (1965), U.S.A., directed by Stanley Kramer, adapted by Abby Mann; Columbia.

The Novel

Katherine Anne Porter first began writing drafts of this novel as far back as 1932 in Basel, after her first voyage to Europe the previous year. Porter described her work as "the story of the criminal collision of good people—people who are harmless—with evil. It happens through inertia, lack of seeing what is going on before their eyes." The novel is also an allegorical depiction of the tensions leading to World War II.

The passengers on board a North German ship, the *Vera*, sailing from Veracruz to Bremerhaven, August 22 to September 17, 1931, include many nationalities. As well as a prominent German contingent (including Captain Thiele and ship's doctor Schumann), Spaniards, Swiss, Cubans, Mexicans, Swedes, and Americans are on board. Also, some 876 Spanish men, women, and children occupy the steerage: After the failure of the Cuban sugar market, the government has decided to deport them back to the Canary Islands and various parts of Spain. The book has three main parts: embarkation, the high seas, and the harbors.

Porter uses the technique of shifting points of view throughout her novel to reveal different character perspectives. She presents the various passengers as a microcosm of the class, racial, national, and sexual tensions that will lead to the Second World War. Among the most notable passengers are sarcastic Jewish manufacturer Lowenthal, anti-Semitic Rieber, hunchback Glocken returning to Germany after selling his Mexican tobacco and newspaper business, Freytag returning to Germany to bring his Jewish wife and mother to live in Mexico, former political agitator La Condessa facing deportation from Cuba to Teneriffe, redneck Texan engineer William Denny, divorced middle-aged Mrs. Treadwell, and young painters David Scott and Jenny Brown on their first voyage to Europe. The most prominent tensions are those existing between Rieber and Freytag. Despising Lowenthal, Rieber initially believes Freytag to be Jewish. Freytag faces ostracism by most of the German passengers, a con-

dition heightened when they discover he is not Jewish but has married into an "inferior race." Captain Thiele despises most races while the widowed Frau Schmitt believes Americans are contaminated by the Negro. Diarist Frau Rittersdorf believes in eugenic disposal of unfit races. Dr. Schumann has a brief love affair with La Condessa. William Denny attempts a drunken assault on Mrs. Treadwell, which she rebuffs by a violent attack. Although David and Jenny become alienated from each other, they reunite at the end of the voyage.

The Film

Although David O. Selznick attempted to buy the movie rights before he finished reading the novel, United Artists outbid him paying $400,000 only a month after the novel appeared. Abby Mann began working on the adaptation as early as 1963 and cooperated closely with Porter. She defended Mrs. Treadwell from Mann's impression of her as "she-wolfish," resulting in Vivien Leigh's strong portrayal of the character as torn apart by conflicting sides of her personality. Alert to critical charges of anti-Semitism in the original novel, the unpleasant Dr. Lowenthal became a benign old gentleman with understanding and goodwill for all and was played by pre-Hitler German actor Heinz Ruehmann. Texan chemical engineer Denny became Lee Marvin's middle-aged, failed baseball player.

Donald Spoto's critique of *Ship of Fools* dubs it "Grand Hotel Afloat, or a Steamboat Named Desire." Despite strong performances by Vivien Leigh (recalling her earlier role as Blanche DuBois), Simone Signoret, and Oskar Werner, the film is too overtly melodramatic. Although Mann changes the time to Hitler's gains in the 1933 German election and hints at the ensuing holocaust in unwitting comments by the passengers, *Ship of Fools* suffers too much from Kramer's didactic liberalism and Hollywood-style "good intentions," which never depart from the realm of soap opera.

The film begins after the ship leaves Veracruz, with Michael Dunn's Glocken acting as introductory and concluding chorus and explicitly stating the message for the dumbest audience member. After the prominent cast members disembark at Bremerhaven, taking their exits from the camera in a theatrical manner, Glocken briefly addresses the audience with an ironic smile. "What has all this to do with us today? Why, nothing at all!" Unlike the book, Mann's omniscient Glocken is sent on cruises by his rich parents who want to keep him out of sight. Thus, he becomes the film's astute commentator on human nature. Mann's Freytag (Alf Kjellin) has separated from his wife as a result of Aryan peer pressure and returns home to ask her forgiveness. The film judiciously selects the main incidents from the novel for its two-and-one-half-hour running time, inserting its message about the Nazi menace ad nauseam. However, its redeeming feature is the finely acted, doomed love affair between La Condessa and the doctor who dies of a heart attack after she leaves the ship (another

change from the novel). The performances of Signoret and Werner are among their finest achievements and briefly transcend the limitations of this film.

REFERENCES

Unrue, Darlene Harbour, *Truth and Vision in Katherine Anne Porter's Fiction* (University of Georgia Press, 1985); Spoto, Donald, *Stanley Kramer: Film Maker* (G.P. Putnam's Sons, 1978).

—T.W.

THE SHIPPING NEWS (1994)

E. ANNIE PROULX

The Shipping News (2001), U.S.A., directed by Lasse Hallström, adapted by Robert Nelson Jacobs; Miramax.

The Novel

Annie Proulx's second novel, *The Shipping News*, begins in New York, where Quoyle, the second of two sons, quickly learns that he is a failure, at least in the eyes of his father, his abusive brother, and Petal, his promiscuous first wife, who leaves him, sells their two children to a pedophile, and then dies in a car accident. Shortly afterward he learns that his parents have both committed suicide. His aunt Agnis Hamm arrives to pick up her brother's ashes and persuades Quoyle to take his two daughters and go with her to Newfoundland, where their ancestors lived. Quoyle's friend Partridge, who worked with him on *The Mockingburg Record*, succeeds in getting him a job on the *Gammy Bird*, a weekly newspaper in the fishing village of Killick-Claw.

Agnis, who runs an upholstery business specializing in boats, directs Quoyle to the ancestral home that has been vacant for 40 years. The imposing green building, said to have been towed across the ice to its current isolated location, is moored by cables on its barren promontory. Intent on living in it despite its dilapidated state, Agnis arranges for repairs to be made; but with the coming of winter, the family moves to town, where she rents space for her business and where Quoyle reports on the shipping news and, ironically, on automobile accidents. When he writes a story about a yacht built for Hitler and now owned by Bayonet and Silver Melville, he wins praise from Jack Buggit, the owner of the newspaper: "This was the first time anybody ever said he'd done it right." He flourishes at the newspaper, and later, when the paper's managing editor leaves, Quoyle is promoted to the position.

Quoyle also has his share of problems, including Bunny, his daughter, who has something akin to ESP; she sees a frightening white dog that no one else sees (until Quoyle finally sees it) and sees in a nightmare the destruction of the green house. She also is suspended from school for striking a teacher, but Quoyle finds out that she did it to retaliate when the teacher humiliated her friend Herry, who has Down's syndrome. He also learns that his ancestors were a

lawless bunch who lured ships into rocks and then looted them, but his discovery that Agnis was raped and impregnated by his father when she was 12 years old is most shocking. Agnis obtains some measure of revenge when she dumps his father's ashes into the outhouse and then urinates on them. (He will, of course, continue to be "dumped on" by the whole family.)

One of the problems Quoyle has is his fear of the water; his father, in an effort to get him to swim, several times threw him into deep water. In the course of the novel Quoyle buys a wretchedly built boat and almost drowns. Eventually Alvin Yark builds Quoyle a proper boat, and Proulx demonstrates her knowledge of shipbuilding when she has Yark explain it in interminable talks with Quoyle. Another problem is his inability to get over Petal, whose only "gift" to him was two eggs that he had himself purchased. His situation is similar to that of Wavey Prowse, Herry's mother, who also had an unfaithful spouse, Herold, whom she could not forget. When she and Quoyle finally sleep together, it is ironically at "the hotel where Herold and I came on our honeymoon." At the end of the novel it seems that for Quoyle and Wavey "love sometimes occurs without pain or misery."

Much of the humor, which can be very black at times, derives from the newspaper. "Junior Suggs's Scruncheons," which Quoyle describes as "a jet of near-libelous gossip," is hilarious; and Nutbeem's countless stories about sexual abuse are both horrifying and, somehow, amusing. Judging from court cases, the two recurrent Newfoundland themes are "inventive violence and this tearing-off-of-clothes-in-court business." Quoyle himself tends to describe his foibles in terms of headlines: for example, "Stupid Man Does Wrong Thing Once More."

Agnis is stiffed by the Melvilles, who leave before paying her for the upholstery work, but things have a way of coming around for Newfoundlanders. Quoyle finds a suitcase with Mr. Melville's head in it, and later he discovers the rest of the corpse, which is floating in a yellow survival suit. Agnis gets paid anonymously, but she knows the money is from Silver Melville, who is later apprehended in Mexico with her young boyfriend.

Other corpses figure in the story. Jack Buggit, Quoyle's boss and Dennis's father, drowns while tending his lobster traps, and many people attend the funeral. Jack, however, wakes from the dead at his wake—embalming is not apparently a common practice in Newfoundland. The episode attests to the idea of redemption, which involves not only Jack, Wavey, and Quoyle, but also Warren, Agnis's dog, who dies but is "reborn" in Warren 2, the dog given to Bunny and Sunshine, her sister. When the green house is torn from its moorings and disappears, Quoyle has come to terms with his ancestry, including his crazy Uncle Nolan, whose knot tying was designed to hex Quoyle and his family.

Proulx begins almost every one of her chapters with an illustrated knot and an excerpt from *The Ashley Book of Knots*, and knots figure prominently in the novel.

("Quoyle," for example, is an archaic word meaning "a coil of rope.") The trip to Newfoundland enables Quoyle and his family, in addition to Wavey and the Bobbits, to untie or cut knots that were standing in the way of fruitful relationships.

The Film

After Proulx's second novel won both the Pulitzer Prize and the National Book Award, Hollywood came knocking for the movie rights. (Her first novel, *Postcards*, set in New England, was published in 1992.) Proulx told the *Baltimore Sun* that she "never read one version of the screenplay, never visited the set, and never met the actors." The film, directed by Lasse Hallström, featured an all-star cast that included Kevin Spacey (Quoyle), Dame Judi Dench (Aunt Agnis), Cate Blanchett (Petal), and Julianne Moore (Wavey). Although Proulx kept her distance from the film production, she was pleased by the result. "I was fearful of a romantic, watered-down thing," Proulx remarked. "I was braced to be disappointed, and I was enormously pleased. I found it highly intelligent and a witty, strong thing unto itself." She also told the *New York Times*, "Lasse comes from a cold, snowy place like Newfoundland, which made him unafraid to deal with the landscape."

Screenwriter Robert Nelson Jacobs was just as happy that Proulx chose to separate herself from the film project, because, as he told the *New York Times*, "In order to serve the book, you have to change the book." The project was in development for eight years, during which time other writers (Laura Jones and, later, playwright Beth Henley) and other potential directors (Fred Schepisi and Billy Bob Thornton) were variously involved. The challenge for the intrepid screenwriter was the novel's "strong, idiosyncratic voice," its "hapless protagonist," and its episodic plot. The novel could be compressed to "a middle-aged man's coming of age story," but could the screenplay capture the novelist's compressed style? In consultation with Hallström, whose films had featured outcast figures as early as *My Life as a Dog* (1986), Jacobs invented "a recurring image that would convey the essence of Quoyle's journey" and his attempt "to break free of a ruinous past." Hence the recurring image of "a drowning Quoyle, struggling to come to the surface." In the attempt to emphasize the relationship between Quoyle and the widow Wavey Prowse, characters such as Quoyle's youngest daughter were taken out of the story. In the novel Wavey is only one agent of Quoyle's transformation as he reclaims his life, since the community, his job, "and his other friendships all play a part, as well as his discovery of a grisly family history."

The film visually suggests Quoyle's ties to the past by juxtaposing Quoyle's imagined images of his piratical ancestors with the real scenes portraying the crazed destructiveness of the Newfoundlanders who sink Nutbeem's boat. The "drowning Quoyle" image begins the film and the audience shares Quoyle's view of the authority figure responsible for his passivity. Later, while Quoyle

Kevin Spacey and Dame Judi Dench in The Shipping News *(2001, U.S.A.; COURTESY LFQ ARCHIVES)*

rests on a bed, water rises up to engulf him. When his boat capsizes and he almost drowns, he is saved by the sensitive Jack Buggit. His rescue from a "watery grave" (the cooler contains Bayonet Melville's head and so is a coffin) foreshadows his emergence as a real person. Wavey, whose role is expanded in the film to make it more of a romance, also must be saved from her past. In the novel, her husband dies at sea, but in the film she must confront the story that she has created and confess that he actually ran off with a teenager. To get sympathy and to keep would-be suitors, including Quoyle, at bay, she pretends to be unable to get over the loss. When she confesses the truth, she is free of the past.

Washington Post reviewer Rita Kempley praised Hallström's talent for "adapting smalltown dramas" and his ability to "bring communities to life," though she preferred his earlier *The Cider House Rules* (1999) to the Proulx adaptation. "It's worth seeing," she concluded, however, "at the very least because it is so different from standard Hollywood fare." Annie Proulx was more impressed and found the film "Very tightly compressed. There's no empty space at all. Every bit of it is jammed with words or images, so I think the flavor of condensation is there." Jacobs remarked that the novelist did not want a "boot-licking adaptation" of her novel. "If you stay faithful to the book's every detail and approach it with too much rever-

ence," he warned, "you end up with a dry recapitulation." He chose, instead, to let the book inspire him, leading to "surprising new directions," while attempting to stay true to its spirit.

REFERENCES

Abeel, Erica, "Warily Adapting a Scary Book," *New York Times*, December 30, 2001, 22, 39; Dicker, Ron, "Annie Proulx Keeps Her Distance," *Baltimore Sun*, January 4, 2002, E1, E5; Kempley, Rita, "'Shipping News': In a Bleak World, the Promise of a Sea Change," *Washington Post*, December 25, 2001, C1, C13.

—*T.L.E. and J.M. Welsh*

THE SILENCE OF THE LAMBS (1988)

THOMAS HARRIS

The Silence of the Lambs (1991), U.S.A., directed by Jonathan Demme, adapted by Ted Tally; Orion.

The Novel

A serial killer known only as Buffalo Bill is on the loose, and the FBI has an all-points effort underway to capture him, but the randomness of his crimes establishes no clear

pattern, other than the repulsive fact that he kills and skins women. Rookie agent Clarice Starling is sent by Jack Crawford, head of the bureau's behavioral science division, to interview Dr. Hannibal "The Cannibal" Lecter, a brilliant psychiatrist turned serial killer, now serving multiple life sentences for his lethal appetites. Dr. Lecter takes an interest in Starling and gives her enough clues to make sure that she will be interested in him. Lecter toys with Starling and tricks her into letting him psychoanalyze her for his own amusement. It is clear that he knows something about the elusive Buffalo Bill. It is also clear that Clarice is fascinated by Lecter.

The immediate problem is that the daughter of Senator Ruth Martin has been kidnapped and appears to be Buffalo Bill's next victim. Dr. Frederick Chilton, who runs the facility where Lecter is imprisoned, informs Senator Martin of Lecter's knowledge about the case and Senator Martin has Lecter transferred to a prison facility in Memphis. Lecter is smart enough to outwit his guards, who do not fully appreciate his cunning, and escapes.

The focus then shifts to Starling's pursuit of Buffalo Bill, and her working relationship with Jack Crawford, whose wife is dying of cancer and who takes an apparently paternal interest in Starling. The novel is a well-crafted police procedural made tense by what one reviewer described as a race-against-the-clock manhunt. But it is also a meditation on the nature of evil, as stupidly represented by Buffalo Bill and as brilliantly represented by Lecter, who changes both his identity and appearance and is still on the loose at the end of the novel.

Each chapter of the book shifts perspective from one character to another, Clarice, Jame Gumb (the "Buffalo Bill" killer she is pursuing), Lecter, Chilton, and bureau chief Jack Crawford. The novel is certainly readable, but it creates its own edginess by constantly shifting perspective. Many readers would prefer not to be inside the perverted minds of Jame Gumb or Hannibal Lecter, but must journey there in order to pursue the novel to its conclusion.

The Film

The novel was wonderfully adapted to the screen by Ted Tally, who had been told by a producer that the novel would never be filmed because so much of the impact of Lecter in the book is in his mental processes and in his thoughts and reflections, which, of course, cannot really be dramatized. Tally thought the novel could be adapted by streamlining the narrative and eliminating the multiple points of view. His solution was to focus on the character of Clarice. Tally believed that the heart of the story was between Clarice and Lecter, that strange sexual power struggle, that chess game between this young woman and this man—this monster.

Even so, the film managed to preserve many of the procedural details from the novel. The character of Jack Crawford (Scott Glenn) is less complicated in the film, which reveals nothing of his personal problems. Gumb is

Anthony Hopkins as Dr. Hannibal Lecter in The Silence of the Lambs, *directed by Jonathan Demme* (1991, U.S.A.; ORION)

seen as a mad, murderous transvestite with an odd taste in dressmaking, but the film wisely avoids his warped psychology. The exchanges between Lecter (Anthony Hopkins) and Clarice (Jodie Foster) are not so numerous, but are so chillingly acted that they leave a very strong impression. The story is still repulsive, but less so than the novel. But the brilliance of this adaptation was Anthony Hopkins and his ability to portray the absolute insanity of his character with touches of macabre wit. Lecter is evil personified, but Hopkins makes him as fascinating to the viewer as he is to Starling. Even so, Ted Tally felt guilty because the film was so disturbing and concluded, "This movie is too scary for its own good."

REFERENCES

Broeske, Pat H., "Serial Killers Claim Movies As Their Prey," *The New York Times*, December 13, 1992, 18; Plagens, Peter, et al., "Violence in Our Culture," *Newsweek*, April 1, 1991, 46–52; Rafferty, Terrence, "Moth and Flame," *The New Yorker*, February 25, 1991, 87–88; Russakoff, Dale, "Writer Ted Tally and the Sacrifices of Lambs," *The Washington Post*, March 29, 1992, G1, G6.

—*J.M. Welsh*

SISTER CARRIE (1900)

THEODORE DREISER

Carrie (1952), U.S.A., directed by William Wyler, adapted by Ruth and Augustus Goetz; Paramount.

The Novel

Sister Carrie is a central text of the American naturalist movement, which sought to explore the reactions of the individual to larger-than-life forces, such as evolution, materialism, and the like, forces frequently aligned with a sense of social Darwinism. *Sister Carrie*, as can be said generally of the naturalist novel, carries with it some debate over the extent of free will in the face of such overpowering forces. The individual almost invariably succumbs to the pressures surrounding her; the naturalist novel thus frequently takes on a reformist, progressivist tone.

The novel begins in the 1890s, as Carrie Meeber boards the train that will take her from her small Wisconsin town to Chicago. On board, Carrie meets Charles Drouet, a traveling salesman who attempts to strike up a flirtation with her. Her life in Chicago does not allow for such frivolity, however; Carrie's sister and brother-in-law expect her to follow their austere example of work without reward. Carrie's wages in the shoe factory where she works barely cover the room and board she must pay them. Unable to buy a winter coat, she takes ill and loses her job. As she searches for a new one, she stumbles across Drouet, who gives her money and buys her clothes. Because she cannot bring these clothes into her sister's flat, however, Carrie acquiesces when Drouet offers to rent a room for her. She ends up living with Drouet, uncomfortable with her unmarried position but without other options.

A wealthy, successful acquaintance of Drouet's, George Hurstwood, falls in love with Carrie and encourages her to run away with him. Under the mistaken impression that Hurstwood will marry her, she agrees. When she discovers that he is already married, however, she refuses to see him again. Hurstwood, desperate to keep Carrie in his life, and under pressure from his wife, who has taken complete control of all of the family's money, one night notices that his employer's safe has not been properly closed. He opens it, takes the money out, puts it back in, takes it out again—and, while the money is out of the safe, accidentally knocks the safe door closed. Knowing that, from that moment on, he will be branded a thief regardless of his intent or what he does, he takes the money, gets Carrie to board a train to New York under false pretenses, and runs away. His employer's investigators catch up with him, however, and take what remains of the money in exchange for his freedom. Broke, unable to find work because of the reputation that has followed him from Chicago, Hurstwood begins a long, slow decline into poverty and degradation. Carrie, on the other hand, begins working in the theater in order to support them, and thus begins a rise to wealth and fame.

She deserts Hurstwood in order to save herself, and finally, after her success, when she sees him begging on the street, gives him the contents of her purse but forgets his predicament once she moves on. Hurstwood commits suicide in a Bowery flophouse and is buried in an anonymous grave.

The Film

Sharon Kern has said about William Wyler's decision to film *Sister Carrie* that it was "a courageous, some would say injudicious, choice, for 1950 was a precarious time to tackle a writer who so clearly preached the leftist message of social determinism." Indeed, the film met with significant resistance at the studio level; once the production was completed, the film was shelved for two years and was finally recut by the studio without Wyler's supervision. These cuts removed much of Hurstwood's decline into desperate poverty, as well as completely excising the scene of his suicide. Wyler explained this last excision by saying that the "superpatriots" found it un-American to suggest that a successful, hardworking American man could sink to such depths of degradation.

However, the studio is not responsible for all of the alterations in the adaptation. The film shifts responsibility for many of the novel's events from one character to another, and frequently changes accidents into choices. For example, in the film, rather than stumbling across Drouet while looking for work, Carrie seeks him out. Her sister finds out about the money Drouet has given Carrie and tells her that she will have to go back home, so that Carrie's decision to stay in the apartment with Drouet seems her only choice, rather than being driven by a desire to keep the clothes he has bought her. When Carrie leaves Hurstwood in the latter part of the film, she has an altruistic motive, feeling that she has been bad for him, and that he will find help and happiness with his family, rather than the pragmatic, self-interested reasons for the departure of the novel's Carrie. Finally, when Carrie finds Hurstwood begging on the street at film's end, she brings him into her dressing room and asks him to let her help him, to let her share her success with him; thus, Hurstwood's departure (and excised death) are most precipitously caused by his own pride and stubbornness rather than any final abandonment. These changes exert a subtle force over the film, as perhaps overstated by Kenneth Geist: "The Goetzes have pruned the work down to a neat, highly contrived drama of duplicity, with the fates of characters determined more by the exigencies of plot than by social circumstance." In fact, the film spends a great deal of effort on conventionalizing Carrie, showing her parents in the first scene (who never appear in the novel), pointedly referring to her education, and repeatedly confining her to safe, domestic spaces.

REFERENCES

Geduld, Carolyn, "Wyler's Suburban Sister: Carrie 1952," in *The Classic American Novel and the Movies*, eds. Gerald Peary and Roger

Shatzkin (Frederick Ungar, 1977); Kern, Sharon, *William Wyler: A Guide to References and Resources* (G.K. Hall, 1984).

—K.F.

SLAUGHTERHOUSE-FIVE (1969)

KURT VONNEGUT

Slaughterhouse-Five (1972), U.S.A., directed by George Roy Hill, adapted by Stephen Geller; Universal.

The Novel

The most well-known novel from the prolific contemporary American novelist Kurt Vonnegut, *Slaughterhouse-Five* became one of several defining texts of the 1960s zeitgeist, blending war protest with a general rebellion against authority and authoritative thinking. His partially autobiographical protagonist, Billy Pilgrim, joined the long list of rebellious American road heroes that includes Twain's Finn, Salinger's Caulfield, Heller's Yossarian, and Kesey's McMurphy, although Vonnegut's Everyman is a nobody, a schlemiel whom fate more than individual spirit launches into a world apart from his surrounding society. Along with such other Vonnegut works as *Player Piano*, *Sirens of Titan*, *Cat's Cradle*, and *Breakfast of Champions*, this novel plays with the genre of science fiction (a category Vonnegut simultaneously denied and embraced) while casting an acerbic glance at contemporary American society. All of Vonnegut's writing is comprised of pithy philosophical musings (here it's the classic "So it goes," which appears 100 times in the novel, following any mention of death, from mass slaughter to old champagne), verbal incongruities, social satire, bleak irony and black humor echoing French existentialism, and fragmented narrative.

The full title page gives an idea of Vonnegut's style and themes:

> *Slaughterhouse-Five, or The Children's Crusade: A Duty-Dance With Death*, by Kurt Vonnegut, "A fourth-generation German-American now living in easy circumstances on Cape Cod (and smoking too much), who, as an American infantry scout *hors de combat*, as a prisoner of war, witnessed the fire-bombing of Dresden, Germany, 'The Florence of the Elbe,' a long time ago, and survived to tell this tale. This is a novel somewhat in the telegraphic schizophrenic manner of tales of the planet Tralfamadore, where the flying saucers come from. Peace."

In this "telegraphic schizophrenic style," Vonnegut follows the allegorically named Billy Pilgrim, a 20th-century American heir to Bunyan's "Everyman." The story's chronology jumps around wildly as Billy "pilgrims" through history and space—Billy has become "unstuck in time." Recurrent scenes include: infantryman Billy in World War II when he is captured and imprisoned in the underground Dresden "Slaughterhouse-Five" during the infamous American and British fire-bombing that incinerated over 135,000 civilians; vignettes from his small-town life where he ends up as a Lions Club optometrist in New York State, vaguely happily married and father of two kids; a 1967 moment when he and Hollywood starlet Montana Wildhack are captured and taken to a distant galaxy as zoo attractions on the planet Tralfamadore; and his brief public life "of the future" (1976) when he is assassinated while lecturing on Tralfamadorian philosophy. As a convert to the Tralfamadore world view, Billy sees these events from past, present, and future as existing simultaneously. Vonnegut's prose equates the foolish, mock science fiction scenes on a distant planet with the historical slaughter of hundreds of thousands, thus creating a disturbing disfamiliarity for the reader trying to keep distinct the fabricated fantastic from the historical fantastic.

The Film

George Roy Hill had three years earlier succeeded with *Butch Cassidy and the Sundance Kid*, and that helped generate finances for this mainstream production of the Vonnegut cult novel. (Hill had already adapted Tennessee Williams's *Period of Adjustment*, Lillian Hellman's *Toys in the Attic*, and Nora Johnson's *The World of Henry Orient*, and he would go on to film John Irving's *The World According to Garp* and John Le Carré's *The Little Drummer Girl*.) *Slaughterhouse-Five* received mostly mixed and negative reviews. As with such other 1960s novels into film as *Catch-22* and *One Flew over the Cuckoo's Nest*, the reputation of the Vonnegut text almost guaranteed that any adaptation would disappoint true aficionados of the original prose. However, Hill's film is one that improves with age (and repeated viewings: the film is difficult for those not fully familiar with the novel); on its own terms it successfully integrates the impressionistic style, if not the cynicism and wordplay. Vonnegut himself declared that the film was superior to the book, an argument Andrew Horton supports in his chapter on the adaptation.

Science fiction novels have their own special problems for adaptations. Vonnegut can easily describe the Tralfamadorians in witty weird images that are both entertaining and—within the tale's context—"believable": When filmed literally, one bogs down in ludicrous special effects. Hill wisely leaves the Tralfamadorians and their spaceship invisible. Vonnegut's brand of science fiction relies more on philosophical asides than on linear narrative to convey his ideas, which naturally does not translate into a visual medium. Given the difficulty of capturing the novel's linguistic games, Hill and Geller have done well to focus on the impressionistic Vonnegut prose style, emphasizing rapid jump cuts (often via linking visual and aural overlapping motifs). They thus recreate Vonnegut's highly cinematic prose. To a small degree, Hill maintains more narrative linearity than Vonnegut in order to increase dramatic suspense, something Vonnegut purposefully undermines in his

Michael Sacks as Billy Pilgrim and Valerie Perrine as Montana Wildhack in Slaughterhouse-Five, *directed by George Roy Hill* (1972, U.S.A.; UNIVERSAL-VANADAS/THEATRE COLLECTION, FREE LIBRARY OF PHILADELPHIA)

anti-novel structure. Hill also effectively uses long shots to represent Vonnegut's emotionless prose narratives of death.

Perhaps least successful was their refusal to try to capture the framing point of view that gives the novel its self-reflexive, postmodernist flair. In the book, we experience Vonnegut's own process as author, his role as both "creator" of the fiction we are reading and the autobiographical source for Billy's war peregrinations; Vonnegut then makes recurrent appearances to remind us of his role outside the story. Had Hill tried to film a cameraman making the film, or otherwise integrated the "film within a film" motif (think of Harold Pinter's script from Fowles's *The French Lieutenant's Woman*), he might have made a more aesthetically challenging (if less commercially viable) production. However, Joy Gould Boyum argues that the absence of that framing voice ironically further accentuates the despairing tone of the work by forcing a participatory immediacy onto the viewer.

Finally, mainstream Hollywood (even during the political unrest of the late 1960s and early 1970s) was not ready to finance a big-budget production displaying the kind of entirely bitter and cynical antiwar and antilife subtext Vonnegut famously depicted in all his work. Instead, Hill focuses on the psychological nature of Billy's temporal-spatial travel, letting character development replace Vonnegut's historical and political commentary.

REFERENCES

Boyum, Joy Gould, *Fiction into Film* (New American Library, 1985); Horton, Andrew, *The Films of George Roy Hill* (Columbia University Press, 1984); Klinkowitz, Jerome, "*Slaughterhouse-Five*: Fiction into Film," in *Take Two: Adapting the Contemporary American Novel to Film*, ed. Barbara Tepa Lupack (Bowling Green State University Popular Press, 1994); McCaffery, Donald W., *Assault on Society: Satirical Literature to Film* (Scarecrow Press, 1992).

—D.G.B.

SO BIG (1924)

EDNA FERBER

So Big (1925), U.S.A., directed by Charles Brabin, adapted by Adelaide Heilbron; First National.
So Big (1932), U.S.A., directed by William A. Wellman, adapted by J. Grubb Alexander; Warner Bros.
So Big (1953), U.S.A., directed by Robert Wise, adapted by John Twist; Warner Bros.

The Novel

Edna Ferber's inspiration for the 1924 novel came after spotting the face of a farm woman in a crowd as she was taking her goods to market. Ferber also had an eye cocked to the "reckless youth" of the early 1920s, whom she described as "playing hide and seek with life." Undaunted by the fact that she knew little about farm life or the workings of farmers' markets, she worked on the novel for a year in her Central Park apartment. The book was first serialized in 1923 in the *Women's Home Companion* under the title *Selina*. With its book publication a year later under its new title, *So Big* became one of her most popular novels and won the Pulitzer Prize in 1925.

Selina Peake is a gambler's daughter whose father showed her good times and bad—but at the very least taught her an appreciation for the "grand adventure" of life. When he is killed, Selina uses her money to get an education and a teaching job among the rough Dutch farmers of Illinois. There, she finds few companions who share her interests, except Roelf Pool, the son of the family with whom she is boarding. Inspired by Selina, Roelf becomes a famous sculptor. Meanwhile, a farmer named Pervus DeJong falls in love with her and they are married. She develops a love for the beauty of the land and the crops; and after Pervus dies, her skills make the farm a success.

Selina's son Dirk (nicknamed "So Big") disappoints his mother by giving up an architectural career. Instead, he marries unwisely and enters into business. Although he is successful, Dirk comes to realize how empty his life has become. By contrast, Selina has found serenity and fulfillment when she reunites with Roelf, now a successful sculptor.

The Films

The major problem with the movie adaptations of *So Big* has been the difficulty of fitting the multitude of details of her life and the many strands of plot into the limitations of a standard feature-length movie. Moreover, the role of Selina posed great challenges to the actresses who portrayed her—Colleen Moore in 1924, who fought for the role and long prided herself on it; Barbara Stanwyck in 1932, who reunited with one of her best directors, William A. Wellman; and Jane Wyman, who had already had great

success with overtly melodramatic roles. Ferber was particularly upset with the way all three of the movies altered her original ending. Instead of Selina's son Dirk entering into a disastrous marriage, in the 1925 version he leaves his mistress and becomes a successful architect; in the 1932 version he stays in business and wins the hand of the artist Dallas O'Mara (Bette Davis); and in the 1953 version he likewise is successful with both his architectural career and O'Mara. Obviously, in Hollywood, an unhappily married Dirk was unacceptable; rather, true love, art, and a business career *do* mix.

Relatively little has been written about the three film versions of *So Big*. Wellman's biographer, Frank Thompson, says the 1932 version was "generally ignored" by the critics, except those who applauded Stanwyck's "fine and stirring" performance as Selina. Stanwyck's biographer, Ella Smith, confirms this, contending that her good notices saved her career from a temporary slump. Regarding the 1953 version, François Truffaut praised the work of director Robert Wise: "Using his own particular strength, Wise has made a kind of masterpiece from this long melodrama. His power as a director leads us to overlook the rather simplistic psychology of his characters . . . *So Big* raises the classic, traditional Hollywood style to its highest degree of effectiveness."

REFERENCES

Smith, Ella, *Starring Miss Barbara Stanwyck* (Crown Publishers, 1974); Thompson, Frank, *William A. Wellman* (Scarecrow Press, 1983); Truffaut, François, *The Films in My Life* (Simon and Schuster, 1975).

—*T.J.S. and J.C.T.*

SOMETHING WICKED THIS WAY COMES (1962)

RAY BRADBURY

Something Wicked This Way Comes (1983), U.S.A., directed by Jack Clayton, adapted by Ray Bradbury; Walt Disney.

The Novel

In 1948 the 28-year-old Ray Bradbury was barely eking out a living in Los Angeles when he published "The Black Ferris" in the May issue of *Weird Tales*. It contained key elements later expanded in 1956 into a screenplay entitled *Dark Carnival* (a title borrowed from his first collection of short stories, published by Arkham House in 1947): Two boys in a small Illinois town encounter a strange carnival featuring a supernatural carousel that can age or regress its passengers, according to the direction of its spin. Expanded by additional episodes and richer characterizations—many of them drawn from the many short stories he had been writing all along (which in turn stemmed from his child-

hood in Waukegan, Illinois)—the screenplay was turned back into a novel in 1962, the title now altered to a quotation from *Macbeth*—"something wicked this way comes."

Bradbury has divided the youth he was in Waukegan, Illinois, into two 13-year-old boys, Will Halloway (a thoroughly normal, good-hearted soul) and Jim Nightshade (a more daring, self-destructive sort)—born just minutes apart and separated by midnight of Halloween. Aided by Will's father, Charles, the town's library janitor (based on Bradbury's father), they confront the terrors of Cooger and Dark's Pandemonium Shadow Show, an ancient carnival arrived in Green Town late in the year. Presided over by the fiercely tattooed Mr. Dark, the carnival symbolizes everything that is abnormal, mutated, monstrous. As Stephen King has noted in his study of horror stories, *Danse Macabre*, "[Bradbury's] carnival is chaos, it is the taboo land made magically portable, traveling from place to place and even from time to time with its freight of freaks and its glamorous attractions." Its sideshow inhabitants have taken on the outward form of their inner vices: the Human Skeleton his miserliness, the Fat Lady her physical and emotional gluttony, the Dust Witch her vicious meddling, Mr. Electrico his impossibly degenerate nature. The exhibits likewise prey upon our innermost yearnings: The Mirror Maze swallows people up in their narcissistic reflections; and the carousel propels its passengers forward and backward in time, either to a lost childhood or to a wished-for future.

After claiming as victims several of the town's citizens, including the schoolteacher Miss Foley and the barber Mr. Crosetti, Mr. Dark sets his sights on Jim Nightshade. Only after a terrific confrontation in the midway late at night, when laughter and mirth become tools in the destruction of Mr. Dark and his carnival (a scene whose shameless symbolism and sumptuously exotic metaphors have drawn, by turns, howls of protest and delight from Bradbury's detractors and admirers), are the boys, now matured somewhat, able to resume the business of growing up. But Mr. Halloway warns them that the forces of Evil will always be there, ahead, waiting: "God knows what shape they'll come in next. But sunrise, noon, or at the latest, sunset tomorrow they'll show. They're on the road."

The Film

Bradbury has always insisted the story grew out of movies, rather than the other way around. "It sums up my entire life of loving Lon Chaney and the magicians and grotesques he played in his early films. I was a raving film maniac long before I hit my eighth year . . . in my home town of Waukegan, Illinois."

Nonetheless few novels as acclaimed as this one have had a tougher time making the transition to the screen. Before it landed with Jack Clayton and the Disney studios, the erstwhile adapters included Gene Kelly, Sam Peckinpah, Mark Rydell, and Steven Spielberg. Finally, a deal was struck with Disney in 1980, to Bradbury's delight (he has

always been a devout Disney fan). Chosen to helm the project was Jack Clayton, a director esteemed for his 1962 horror classic, *The Innocents* (adapted from Henry James's *The Turn of the Screw*), and more recently criticized for the disastrous *The Great Gatsby* (1974).

Bradbury's ripe prose and exotic metaphors necessarily must elude the more concrete medium of film (what do you do with passages like, "The carnival was a great dark hearth lit with gathered coals"?), but production designer Richard MacDonald gave the project his best shot, building Green Town from the ground up on the Disney Burbank lot and erecting the carnival sets at Disney's Golden Oak Range in Newhall, California. And a 70-year-old brass and wood carousel was located and rehabilitated. Bradbury's screenplay toned down the rhetorical effusions of the dialogue and streamlined the episodic story line. Clayton, for his part, decided to keep optical effects to a minimum explaining, "For this kind of film, I think makeup tricks, flashy lighting and exploding lasers would be totally wrong. I wanted to let the characters and the relationships carry the audience into the fantasy, *not* have the machinery do it for you."

But over a span of almost two years the production was plagued with dissension among the crew and squabbles

Ray Bradbury

over scenic conceptions and effects. Preview notices complaining the film was stiff, bland, and claustrophobic forced Disney to delay the release and add another $7 million to the already-inflated $12 million budget for a complete overhaul, including major reediting; more than 200 post-production optical effects; additional scenes not in the book (including an invasion of Will's house by hundreds of tarantulas and a climactic storm that destroys the carnival); replacing Georges Delerue's wistful musical score with a more dynamic work by James Horner; some location shooting in Vermont at the peak of the fall foliage season; and an added narration track spoken by Arthur Hill. But problems remained. An arid, static staginess persisted, which flattens the life and substance out of key scenes in Green Town and at the carnival. The deletion at the last moment of certain crucial scenes was particularly lamentable, including the spectacular scene where Will and Jim witness the carnival's tents being stitched from storm clouds; and the poignant moment when Will and his father have a heart-to-heart talk as they climb up the ivied trellis to the boy's second-floor room (and excision that particularly outraged both Bradbury and Clayton, who regarded it as the heart of the film).

The finished product opened to mixed critical reception. It was agreed that Jason Robards and newcomer Jonathan Pryce were wonderful as, respectively, Mr. Halloway and Mr. Dark. If Shawn Carson were not wholly convincing as the darkly troubled Jim Nightshade, Vidal Peterson was ideal as Will Halloway (closely resembling the bespectacled Bradbury as a boy). Horner's score remains one of his best, highlighted by the eerily effective four-note motif heralding the carnival train. But audiences, perhaps confused by the awkward mixture of intimate poetry and flamboyant situations, stayed home, and the film stalled at the box office, earning only $4 million nationwide during its first 12 days. Officially judged a flop at the time, the film has persisted in its video incarnation, becoming something of a minor cult classic for a new generation of viewers.

REFERENCES

Rebello, Stephen, "Something Wicked This Way Comes: Bringing Ray Bradbury's Fantasy Classic to Life," *Cinefantastique*, June–July 1983, 28–49; Tibbetts, John C., "The Martian Chronicler Reflects: An Interview with Ray Bradbury," *The Christian Science Monitor*, March 20, 1991, 16; Greenberg, Martin Harry and Joseph D. Olander, eds., *Ray Bradbury* (Taplinger, 1980).

—J.C.T.

SONS AND LOVERS (1913)

D.H. LAWRENCE

Sons and Lovers (1960), U.K., directed by Jack Cardiff, adapted by Gavin Lambert and T.E. Clarke; Twentieth Century-Fox.

The Novel

Lawrence began *Sons and Lovers* in 1910 and in its early drafts the novel was titled *Paul Morel*. In early 1912 two freeing, formative events occurred in Lawrence's life: when his mother died, Lawrence was not only filled with intense grief, but also liberated from her suffocating love; and then, fired by the faith that he was serving love's higher morality, he fled to Germany with his lover, the then-married German aristocrat Frieda von Richthofen Weekly (later to become Lawrence's only wife). By November, the novel as we know it was completed and its title, understandably, was changed to the more autobiographical name of *Sons and Lovers*.

The novel centers on Paul Morel and his relationship with his devoted but consuming mother and with two women, Miriam Leivers and Clara Dawes, his lovers. The opening of the book recounts the early married years of Paul's parents, Gertrude Coppard, schooled and refined, and Walter Morel, an unpolished, uneducated coal miner. Opposites in nearly every way, Gertrude is to her husband "that object of mystery and fascination, a lady"; and Walter is to Gertrude a man compellingly unique in his abundance of strength, joyousness, and life-spirit. Soon after they are married, however, Walter becomes a drunkard and an irresponsible provider; and Gertrude, disappointed and mortified, transfers all her love to her children. Her favorite child is clearly her first born son William, but when he dies, Mrs. Morel transfers her exclusive and consuming affection to Paul. Sensitive, artistic, and introspective, Paul wants to be a painter, and he is encouraged in this dream by his close friend Miriam Leivers. While the two love each other, Paul can not bring himself to have a physical relationship with Miriam. Ironically, it is through her that he meets an unhappily married woman, Clara Dawes, with whom Paul begins an affair. He wants to go to London to study art; however, he feels obligated to his mother and will not leave her. When he meets Miriam again, the two consummate their love; Paul is angry and rough, taking out all his complex familial hostility on her. Soon Paul returns to Clara, who Miriam believes Paul will outgrow and leave. Paul learns that his mother has inoperable cancer, and for several months he watches her great suffering deepen. When no amount of morphine will dull the pain, Paul "releases" his mother by giving her an overdose of the drug. Utterly desolate and empty, Paul realizes that Miriam is not what he wants, that Clara has returned to her husband, and that his beloved mother is dead. However, in the end Paul realizes that Gertrude Morel's life pulses within him, and he walks forward to forge his own future.

The Film

Released in 1960, the movie was directed by Jack Cardiff, who began his film career as a child actor in silent movies. Best known as a director of photography, Cardiff is often cited as England's first and most notable color cinematog-

rapher. While Cardiff's directorial accomplishments are less praised, his work on *Sons and Lovers* earned strong critical commendations.

Cardiff shot *Sons and Lovers* in black and white and with CinemaScope cameras that work as handsomely in the sitting room of the Morel cottage as they do in the landscapes of industrial "Bestwood." Cinematographer Freddie Francis creates a visual beauty, an ebbtide movement of winsome and lovely images that make the most lingering feature of this film the camerawork.

The script is principally by Gavin Lambert, a past editor of *Sight and Sound* and a film critic of considerable standing. Much of the actual dialogue is taken directly from Lawrence's novel, a sizable book (over 500 pages) compressed, rather successfully, into a 103-minute-long film.

The film, like the book, centers on Paul Morel, and in that principal role, Dean Stockwell, with his brooding eyes and yearning intonations, succeeds as a credible and suitable Paul. Caught in the psychological and emotional grip of his mother's (Wendy Hiller) domineering love, Paul feels responsible for her happiness and her safety. He believes that his mother is powerless before the drunken abuses of his father, and he stays in Bestwood because he feels obliged to protect her against her husband. Paul fails to see that his father's behavior largely is the result of Mrs. Morel's unrelenting castigation and demoralization of her husband. When Paul wins a contest for his drawing, a patron offers him the opportunity to study art in London. However, when Paul decides to remain at home, his mother promptly accepts his decision, making us see what Paul can not: She wants him to remain in Bestwood, hitched to her. Ironically, the winning art work is Paul's portrait of his father.

Trevor Howard as Paul's father gives the film its most compelling and memorable performance. We see why Gertrude Coppard first loved him and how he, working the mines since he was 12, has been devitalized by the coal pits and forsaken by his wife. There is an ungainly, yet tender, humanity to Howard's Morel, which makes his alienation from his son all the more poignant.

The film departs from Lawrence's novel in only two significant ways. First, it glosses over several of the novel's pages to Paul Morel's life as a young man, trying to make his way through complex relationships of the heart and body; and second, Paul's mother, convenient to censorship concerns, dies of a heart attack instead of Paul's act of euthanasia.

While the film *Sons and Lovers* may lack Lawrence's unrestrained passion, there is certainly a trenchant loveliness to it, due in large part to Trevor Howard's performance and to Freddie Francis's cinematography.

REFERENCES

Klein, Michael, and Gillian Parker, *The English Novel and the Movies* (Ungar, 1981); Moynahan, Julian, *The Deed of Life* (Princeton University Press, 1972).

—*L.C.C.*

SOPHIE'S CHOICE (1976)

WILLIAM STYRON

Sophie's Choice (1982), U.S.A., directed and adapted by Alan J. Pakula; ITC Entertainment.

The Novel

"Call me Stingo," says the narrator early in this novel by a much-honored, if at times controversial, American writer. William Styron's book is not as complex as Melville's *Moby-Dick*, whose opening words it so self-consciously echoes in this phrase. But Stingo's narrative is complicated enough. There are three major strands: his coming-of-age as a young ex-Marine from Virginia who has moved to New York shortly after World War II intent on writing his first novel; a destructive love affair between his two neighbors, Sophie Zawistowska, a Polish Catholic survivor of a Nazi extermination camp, and Nathan Landau, a charming, brilliant, but emotionally unstable American Jew; and Sophie's memories of her earlier life, in Krakow and Warsaw and at Auschwitz.

Stingo tells of his short-lived career as a manuscript reader in a New York publishing company, and then of his life in an apartment house in the Flatbush section of Brooklyn, where he works on his novel (living off $500 derived from the sale generations earlier of a black slave who had belonged to his grandmother). There he is drawn into the troubled relationship of Sophie and Nathan. Their idyllic ménage à trois—with parties, picnics, and intimate conversations—is periodically threatened by Nathan's black moods, which are later revealed to be manifestations of a paranoid-schizophrenic condition and an addiction to amphetamines and cocaine. Nathan accuses Sophie of infidelity with the chiropractors with whom she works, Stingo with racial bigotry and incompetence as a writer, both with sexual dalliance behind his back, and Sophie for sleeping her way to safety at Auschwitz. When Nathan threatens to kill the two of them, Stingo persuades Sophie to flee south with him by train, hoping he can convince her to marry him and share his life on a farm in southern Virginia. But Sophie returns to Nathan and shortly thereafter they commit suicide by ingesting cyanide in their Flatbush apartment.

Sophie's reasons for continuing her destructive relationship with Nathan become progressively clearer during a number of conversations with Stingo. She haltingly reveals several shattering truths about her past life—for example, that her law professor father, whom she has earlier characterized as a heroic protector of Jews, was actually a rabid anti-Semite. Later she tells how, after being deported with her two young children to Auschwitz, she tried to seduce the camp commandant, for whom she worked as a stenographer, and sought to convince him that she, an "Aryan"-looking Polish Catholic, was a Nazi sympathizer—in order to save her life or at least that of her

son. Near the end of the novel, Sophie finally brings herself to speak of her role in the death of her daughter, telling of the terrible choice she had to make upon her arrival at Auschwitz when forced by a German officer to choose which of her two children would be allowed to live. The self-condemnation arising from this devastating confession leads Sophie to make her final choice, rejecting Stingo's offer of a happy life in the rural south and returning to Nathan and almost certain disaster in that Brooklyn apartment.

Sophie's Choice has been praised both for its formal complexity and for its elegant style, reflecting a "baroque sensibility" unusual among contemporary American writers. Moreover, the originality and seriousness with which the book approaches its major themes—the Holocaust, American racism, postwar existential despair, and the art of fiction—are impressive. *Sophie's Choice* received the first American Book Award for fiction in the year of its publication. But a number of critics have disparaged the book as an "old-fashioned novel in an era of accelerating experimentation with language, form, and the idea of history." Many have found the autobiographical components (including many thinly veiled references to Styron's writing career), as well as Styron's choice of a Catholic protagonist, inappropriate in a Holocaust novel, and others have objected to Stingo's obsessive talk about his sexual frustrations and fantasies—including his lengthy treatment of a frustrating encounter with a stereotypical "Jewish princess."

The Film

Some writers have complained that Pakula's adaptation of *Sophie's Choice* perpetuates flaws in the novel—for example, the lack of a dramatic center, or racist and sexist presuppositions and blindness to the historical causes of evil. But most critics see the film as a major cinematic achievement, and a substantial improvement upon the book. Pakula effectively dramatizes the essence of the novel—a moving story of doomed love played against the background of the century's most horrific crimes. The film follows the novel's general plot but eliminates the book's verbosity, its most pointed autobiographical components, and many of the narrator's sexual fantasies. Stingo (Peter MacNicol) is appropriately reduced to an ineffectual observer of Sophie and Nathan's tragic love affair, and a sympathetic audience for Sophie's story and self-condemnation. His voiceover narration and commentary (performed by Josef Sommer) are restrained, for the most part flowing naturally from dramatized action.

Kevin Kline, Meryl Streep, and Peter MacNicol in Sophie's Choice, *directed by Alan J. Pakula* (1982, U.S.A.; UNIVERSAL)

Meryl Streep won widespread acclaim and an Academy Award for her portrayal of Sophie. The mercurial Nathan is convincingly acted by Kevin Kline in his first film role. Beyond its fine acting, the film is a showcase of Hollywood technical artistry—in set design, costuming, and makeup (which renders Sophie's suffering in poignantly realistic terms). Nestor Almendros here lives up to his reputation as an outstanding cinematographer—through such memorable sequences as the montage of the happy ménage-à-trois on Coney Island and in their Flatbush apartment house (recalling François Truffaut's *Jules and Jim*); Nathan's joyous preparation of dinner for the sickly Sophie on their first evening together; side-lit close-ups of Streep's evocative face as she tells Stingo about her past; and the moving dramatization of her terrible choice on the selection platform at Auschwitz. Music director Marvin Hamlisch creates a subtle soundtrack based on the music of Beethoven, Bach, Handel, and other classical composers.

REFERENCES

Cologne-Brookes, Gavin, *The Novels of William Styron: From Harmony to History* (Louisiana State University Press, 1995); Deutsch, Phyllis, "Sophie's Choice," *Jump Cut* 29 (February 1984): 9–11; Kauffmann, Stanley, "Pakula's Choice," *The New Republic*, January 10–17, 1983, 40–41; Ratner, Marc L., *William Styron* (Twayne, 1972); Tutt, Ralph, "Stingo's Complaint: Styron and the Politics of Self-Parody," *Modern Fiction Studies* 34, no. 4 (winter 1988): 575–86.

—*W.S.W.*

SOUNDER (1969)

WILLIAM H. ARMSTRONG

Sounder (1972), U.S.A., directed by Martin Ritt, adapted by Lonne Elder III; Radnitz/Mattel Productions–Twentieth Century-Fox.

The Novel

William Armstrong wrote *Sounder* based on a dog story that an elderly black teacher had shared with him. In the novel's foreword, Armstrong declared, "It is the black man's story, not mine. It was not from Aesop, the Old Testament, or Homer. It was history—his history." The novel was widely acclaimed by literary critics, although some accused Armstrong of imposing his own stereotypical views by developing black characters who remained virtually unnamed, while naming the dog Sounder. Armstrong responded that he was not denying black characters their individuality but instead was creating characters that had universal appeal.

The novel's plot focuses on a black sharecropping family in Louisiana in the 1930s, trying to survive hunger and economic degradation. Armstrong subtly accuses the criminal justice system itself of maintaining the black sharecropper's impoverishment and debasement. This system sanctioned the arrest for robbery of a man who had taken a ham to keep his family from starving—and sanctioned the father's incarceration for trespassing as he tried to overcome the frustrations of providing for his family by resorting to acts branded as "illegal." Following the father's arrest, the dog, Sounder, is injured. Enduring the father's absence and Sounder's disappearance, the family remains undeterred in their struggle to survive and maintain a sense of dignity. The novel ends when both Sounder and the father return home and the family is reunited, but the reunion is short-lived as the father and Sounder face death because of declining health and age.

The Film

The film, shot on location in Louisiana, was directed by Martin Ritt, referred to as a "white [director] working in a black medium." Ritt was assisted by black screenwriter Lonne Elder III, who became the first African American to serve in this capacity. Their efforts, combined with the acting of Paul Winfield (who played Nathan Morgan in the film), were described as "beautiful and believable." Cicely Tyson (Rebecca Morgan) was cited as "the first great black heroine on the screen." The film received widespread favorable criticism and Academy Award nominations for best actor, actress, screenplay, and picture.

The novel when transformed on the screen became an emotionally wrenching experience of human suffering and resilience. The film's ending was substantially altered when David Lee returns to school at his father's insistence.

In 1976, five years after *Sounder* was produced, a sequel was made. Rarely mentioned *Sounder, Part II* was directed by William Graham, written by Lonne Elder, and produced by Robert Radnitz. The sequel omitted actors Winfield and Tyson and rendered Sounder barely visible, thus leading one reviewer to assert that "Every dog has his day, and apparently the hound-type dog that gave his name to the movie *Sounder* five years ago had had his . . . The dog is hardly to be seen: He's just part of the barnyard background." *Sounder, Part II*, described as less successful than its predecessor, was characterized as "a depressed kind of film, with a lot of gloominess and teeth-gritting." Even though the sequel retained the same screenwriter and producer, while providing a new director, it was unable to create the same kind of appeal the original film generated.

The original version of *Sounder* was welcomed during the explosive 1960s. One of the few films to depict African Americans with compassion and understanding, *Sounder* was a significant achievement not only for African Americans generally, but also for black women specifically. Never before had black women been shown on the screen in this manner. Critics referred to *Sounder* as "a triumph of character and action: moving, lyrical, taut, intelligent, and perceptive." Others characterized the film as "always human, never descending to preachment or self-pity."

However, the film's stereotypical depiction of the South, sharecroppers, and law enforcement officials made it a target for negative criticisms. But while *Sounder's* "portrait of black Americans harked back to the past," the film continues to be regarded as a tribute to the black American family and a testament of the universality of human dignity and strength in the face of adversity.

REFERENCES

Evory, Ann and Linda Metzger, eds., *Contemporary Authors: New Revision Series*, vol. 9 (Gale Research, 1983); Bogle, Donald, *Blacks in American Films and Television: An Illustrated Encyclopedia* (Fireside, 1988).

—C.R.

THE SOUND AND THE FURY (1929)

WILLIAM FAULKNER

The Sound and the Fury (1959), U.S.A., directed by Martin Ritt, adapted by Irving Ravetch and Harriet Frank Jr.; Twentieth Century-Fox.

The Novel

In 1929 William Faulkner created this story of the Compson family, a once-proud Southern clan that has fallen on bad times. In essence, the novel portrays the different relationships of the Compson brothers with their sister Caddy, who left home to lead a wayward life, and shows how each of them copes with the loss of their sister.

One segment of the novel is devoted to Benjy, the youngest brother, who is mentally retarded. Hence he doesn't understand why his sister has gone away or what has happened to her. Another section of the novel centers on Quentin and is told primarily in flashback. Quentin's recollections of his sister Caddy indicate that his abiding attachment to her is tinged with decidedly incestuous yearnings; and the morose and despairing young man finally drowns himself. Jason, the third brother, is a mean-spirited, self-centered bachelor. He despises Caddy for leaving her illegitimate daughter, whom she named Quentin after her dead brother, in the care of the Compsons and taking off for parts unknown. (Caddy's daughter is hereafter referred to as Miss Quentin, to distinguish her from her deceased uncle.)

The Film

Producer Jerry Wald commissioned Irving Ravetch and Harriet Frank Jr. to compose the screenplay for *The Sound and the Fury* (1959), in consultation with the director, Martin Ritt. The film version is updated to the 1950s and all but eliminates the novel's use of flashbacks. Consequently the film script deals almost exclusively with events in the book that take place in the present. In this way, Wald

explained, the film could concentrate on the present plight of the Compson family, "and gradually reveal the weight of the past through this." For example, Wald continued, "instead of killing himself in his youth, Quentin lives on—but as a man self-destroyed, making his painful way as an alcoholic."

As a consequence, the Quentin character (who is renamed Howard in the film) is still very much alive when Caddy comes home for a visit. And this "precipitates a situation that dredges up the conflicts that existed between them in the past." Thus Howard's jealous recriminations of Caddy (Margaret Leighton) about her lovers obviously have their roots in the incestuous feelings that Quentin nurtures for his sister in the book.

A second major departure from the novel was opting to have Jason (Yul Brynner) and Miss Quentin (Joanne Woodward) fall in love by the end of the movie. This outcome of the film's action required that Jason could not be a blood relative of Miss Quentin in the film. So, in the movie's scenario he becomes a Compson by adoption. At the fade-out Miss Quentin is quite prepared to renounce her plans to elope with a carnival roustabout, as she does in the novel, in favor of settling down as Jason's wife.

The film negates the tragic denouement of the novel, whereby the Compson clan is irrevocably doomed to die out in the wake of Miss Quentin's flight with the carnival man. By contrast, the import of the ending of the movie is that she and Jason will marry and continue to perpetuate the Compson family. Though some film reviewers found the outcome of the film touching, it is clearly no match for the powerful ending of the Faulkner original.

REFERENCES

Halliwell, Leslie, *Film Guide* (Harper, 1995); McGilligan, Pat, "Ritt Large: An Interview with Martin Ritt," *Film Comment* (January–February 1986); Wald, Jerry, "From Faulkner to Film," *Saturday Review*, March 7, 1959.

—G.D.P.

STARSHIP TROOPERS (1960)

ROBERT A. HEINLEIN

Starship Troopers (1997), U.S.A., directed by Paul Verhoeven, adapted by Ed Neumeier; TriStar Pictures.

The Novel

Robert Heinlein's classic adventure, *Starship Troopers*, winner of the prestigious Hugo Award in 1960, marked a transition between his series of 12 juvenile adventures (including *Rocket Ship Galileo*, 1947; *Space Cadet*, 1948; and *Starman Jones*, 1953) and his more adult novels, such as *Stranger in a Strange Land* (1961). It first appeared in serial form, somewhat abridged, under the title "Starship Sol-

dier," in *The Magazine of Fantasy and Science Fiction* in 1959. The story, set in the 23rd century, follows the adventures of Juan "Johnnie" Rico, a raw military recruit who develops into a tough, full-fledged officer in the interstellar Mobile Infantry (M.I.).

The time is A.D. 2200. Earth's democracies have collapsed, both socially and morally, under the weight of self-indulgence and corruption. As a result, a new global governmental order, the Terran Federation, comprised of an elite military machine, now conducts earthly imperialism on a galactic scale against alien forces. Only those willing to sacrifice their lives for the state may govern and vote: "Under our system every voter and officeholder is a man who has demonstrated through voluntary and difficult service that he places the welfare of the group ahead of personal advantage."

The story opens as Johnnie, a veteran commando in the Mobile Infantry, a sort of interstellar Special Forces, has just participated in a successful raid on a hostile planet. The deed occasions a backward glance at his life and career. As the son of a wealthy merchant, he and his buddy, Carl, had enlisted in the military primarily to impress the beautiful Carmen, a classmate who was planning to become a starship pilot. At M.I. bootcamp, Johnnie endures rigorous training at the hands of Zim, his tough drill sergeant. His first assignment places him in Rasczack's Roughnecks, the toughest unit in the M.I., currently waging a battle against the "Bugs," intelligent arthropods bent on conquest of the galaxy. Upon learning his mother has been killed in a Bug bombing of Buenos Aires, Johnnie decides to become a career officer. He reunites with Carmen, now a successful starship pilot, and learns that their mutual comrade, Carl, has been killed in an enemy attack on Pluto. Johnnie's unit, now renamed "Rico's Roughnecks," continues the battle against the Bugs for "the everlasting glory of the Infantry."

Considered an extremely violent and fanatically pro-militaristic novel for its time, Heinlein's regular publisher, Scribner's, refused to publish it; it appeared eventually under the Putnam imprint. Whereas some of it may be considered progressive—the hero is Hispanic, women have at least equal standing in the military, and Earth's nations have melded into a United Nations homogeneity—in the main it is a promilitary polemic on behalf of a semi-fascist state, where only those in the military may vote, public corporal punishment is the norm, and the human race stalks across the galaxy in imperialist glory. Among its many fascinations is a superbly realized vision of tomorrow's mechanized combat arms, where infantry soldiers are equipped with rocket-propelled assault suits, talking terror grenades, and "pee-wee" atomic bombs.

The Film

The screen version, noteworthy as it is for the computerized "Bug" effects by Sony Pictures Imageworks and Industrial Light and Magic, nonetheless fails by reducing Heinlein's book to a simplistic story line filled with vapid characters and pop-culture philosophizing. It celebrates the style of 1940s combat movies (and here at least direc-

Starship Troopers, *directed by Paul Verhoeven* (1997, U.S.A.; COURTESY TIPPETT STUDIOS/TRISTAR PICTURES)

tor Verhoeven and screenwriter Ed Neumeier are in synch with Heinlein) by portraying a group of plucky, smooth-faced high school chums—Casper Van Dien as Johnnie Rico, Denise Richards as Carmen Ibanez, Dina Meyer as Dizzy Flores, Jake Busey as Ace Levy, Neil Patrick Harris as Carl Jenkins—who work out their own petty jealousies and bickerings against the larger canvas of interstellar war. They laugh, love, and fight as they separate and reunite again while working their way upward through the ranks of the federal armed forces—divided between the elite fly-ers of the Fleet rocket jockeys and the tough soldiers of the Mobile Infantry. Unfortunately, the actors here possess among them hardly a jot of personality of idiosyncratic texture. They all seem to have drifted in from episodes of *Melrose Place* and *Beverly Hills 90210*. Particularly insuffer-able is Denise Richards as Carmen Ibanez, the hotshot rocket pilot who chooses career over romance. Her kew-pie-doll face and bland personality stamp her instantly as the Character You'd Most Like to See Squashed by a Bug.

Oh, about those Bugs. Heinlein envisioned their society as a ruthless "total communism," its members "communal entities" functioning under "the ultimate dic-tatorship of the hive." This collective, assisted by a race of humanoids called "Skinnies," stood in stark contrast to Earth's society of cooperating individuals. In the movie, however, all traces of this relatively complex social and military organization shared by Bugs and Skinnies has van-ished. This leaves us with no explanation whatever as to how these nasty arthropods from the distant star system Klendathu have developed a technology capable of launch-ing fiery asteroid-projectiles at Earth. Worse, it reduces the battles between humans and Bugs to a series of silly comic-book collisions where the troopers are no longer fighting wars necessary to fulfill Earth's manifest destiny in the galaxy (as in Heinlein), but merely struggling to save their own skins.

As impressive as are the depictions of the battles between the human and insect forces, there's something else terribly wrong here. Heinlein had carefully envisioned in his book the fantastic armaments of tomorrow's foot soldiers. The movie—and doubtless it was a budgetary consideration—abandons all the hardware and presents just a bunch of grunts carrying standard-issue weapons. Of battle strategies they have none. They just land on the Bug's planet, wander around, and fire away willy-nilly at anything with more than two legs. You'd think after a few devastating defeats at the hands—rather, the mandibles—of the Bugs, they'd rethink their plan. But no, these troop-ers just mill around, convenient snacks for the Bugs.

Whereas Heinlein's novel was punctuated by quota-tions from apocryphal books about warfare and social order, the movie has chosen to interpolate into the action a wearisome series of newscasts, media bulletins, and com-mercial advertisements. These interruptions serve no dra-matic or satiric purpose whatsoever; they are merely annoying and, at best, sophomoric in their obvious humor. Worse, the action is punctuated by moments of incredibly

inane dialogue. When Johnnie Rico's girlfriend, Dizzy (Dina Meyer), is fatally wounded during a Bug attack, she expires in his arms, moaning: "It's all right if I die, as long as I'm with you." And there's the climactic scene when the Bugs' Central Brain is captured and dragged out of its lair, looking for all the world like a gas bag that's escaped from a Macy's Thanksgiving Day Parade. Neil Patrick Harris tunes in telepathically to the brain and, after a breathless pause, announces, "It's afraid!"

Starship Troopers is never consistent enough in its mix of comic-book pop, social satire, and gross-out carnage to be satisfying. Unlike Heinlein, it just can't bring itself to take its subject seriously enough, or explore it with suffi-cient complexity, to satisfy hard-core science fiction buffs or the equally earnest readers of adventure juvenilia. And both camps can be pretty hard to please.

REFERENCES

Aldiss, Brian W., *Billion Year Spree The True History of Science Fiction* (Doubleday & Company, 1973); Franklin, H. Bruce, *Robert A. Hein-lein: America as Science Fiction* (Oxford University Press, 1980); Schickel, Richard, "All Bugged Out, Again," *Time*, November 10, 1997.

—*J.C.T.*

THE STRANGE CASE OF DR. JEKYLL AND MR. HYDE (1886)

ROBERT LOUIS STEVENSON

Der Januskopf (The Head of Janus) (1920), Germany, directed by F.W. Murnau, adapted by Hans Janowitz.

Dr. Jekyll and Mr. Hyde (1920), U.S.A., directed by John S. Robertson, adapted by Clara S. Beranger; Famous Players/Lasky.

Dr. Jekyll and Mr. Hyde (1932), U.S.A., directed by Rouben Mamoulian, adapted by Samuel Hoffenstein and Percy Heath; Paramount.

Dr. Jekyll and Mr. Hyde (1941), U.S.A., directed by Victor Fleming, adapted by John Lee Mahin; MGM.

El hombre y la bestia (The Man and the Beast) (1951), Spain, directed and adapted by Mario Soffici; Sono Films.

Le Testament du Docteur Cordelier (The Testament of Dr. Cordelier) (1959), France, directed and adapted by Jean Renoir; Consortium Pathé.

Dr. Jekyll and Sister Hyde (1971), U.K., directed by Roy Ward Baker, adapted by Brian Clemens; Hammer Films.

Mary Reilly (1996), U.S.A., directed by Stephen Frears, adapted by Joan Didion from Valerie Martin's novel; Tannen-Heyman/TriStar/Sony.

The Novel

The appearance of *The Strange Case of Dr. Jekyll and Mr. Hyde* in 1886 was the culmination of four years of grow-

ing fame for Robert Louis Stevenson. Formerly a generally unread author of travel sketches and essays, he produced in this period the books that made him a celebrity, including *New Arabian Nights* (1882), *Treasure Island* (1883), and *Kidnapped* (1886). For a long time Stevenson had been wanting to write a tale about man's dual nature when, during a nightmare, the idea of *Dr. Jekyll and Mr. Hyde* came to him. He dashed off a first draft of 30,000 words in three days. At his wife's behest, due to the "sensationalism" of the story, he burned the manuscript. He promptly set about another version, tossing off another 30,000 words. *Longman's* magazine published it as a shilling paperbound book in January 1886, and it quickly became a best-seller in England and America. Instantly, the names "Jekyll" and "Hyde" became popular synonyms for the split personality of good and evil.

It is virtually impossible to read Stevenson's original with the same breathless suspense as did its Victorian readers. The "secret" of Hyde's real identity, all too familiar to us nowadays, was withheld for a substantial portion of the novel. To paraphrase Mr. Utterson, Jekyll's lawyer, if the mystery be "Hyde" the reader will be "Seek." Bit by bit the evidence accumulates through a series of testimonies. The story begins as Utterson learns from a distant cousin named Richard Enfield of the appearance in the neighborhood of a singularly nasty personage named Hyde. Utterson discovers to his amazement that Hyde is the heir of Dr. Jekyll's fortune. Later a maidservant identifies Hyde as the murderer of Sir Danvers Carew. Jekyll produces a letter from Hyde declaring his intentions to disappear forever. Meanwhile, Mr. Poole, Jekyll's manservant, relates strange activities in his master's laboratory: He fears that Hyde has slain Jekyll and is in hiding. Poole and Utterson break into the laboratory and discover the lifeless form of Hyde. Jekyll is missing. Subsequently, two documents are found that explain the mystery: The first is by the late Dr. Lanyon, Jekyll's old friend, which reveals that Jekyll and Hyde are one and the same person. The second is Jekyll's own account of the horrible affair. For a long time he had led a "double life" as a public servant and private scoundrel. Eventually, he had concocted a drug that would transform his body into the physical representation of its evil nature. As Hyde, he could indulge in nefarious pleasures without fear of recognition. But no sooner had Jekyll thought to reform and never again use the potion, than the transformation came upon him unbidden. He was now Hyde's prisoner, as it were. When the supply of drugs ran out, Jekyll/Hyde shut himself up in the laboratory and committed suicide. The last words of Jekyll's confessions are now obviously those of Hyde: "Here then, as I lay down the pen and proceed to seal up my confession, I bring the life of that unhappy Dr. Jekyll to an end."

The clergy hailed the novel since they believed it was a parable of the grim results of allowing free rein to man's baser nature. Modern readers may prefer to see in Jekyll a man desperately seeking an escape from the restrictions of Victorian prudery and morality.

The Films

In 1887 Thomas Russell Sullivan adapted *The Strange Case of Dr. Jekyll and Mr. Hyde* to the stage as a vehicle for the popular actor Richard Mansfield. It became the blueprint for most of the subsequent motion picture adaptations, rearranging the convoluted plot structure into a linear continuity, introducing the transformation scene early in the story, and adding a love interest for Jekyll.

It is doubtful if any horror story has inspired more movies. Among the early and lost silent versions is a one-reel film produced in 1908 by the Selig Polyscope Company, a 1909 version from Denmark, called *Den Skaebnesvangre Opfindelse*, and the British-made *The Duality of Man* (1910). The earliest extant adaptation is *Dr. Jekyll and Mr. Hyde* (1912), directed by Lucius Henderson for the American Thanhouser studio. One departure from the Mansfield play is that two actors played the dual roles, James Cruze as Jekyll and Harry Benham as Hyde in some of the scenes. More than a dozen more adaptations were made before 1920, when the first truly representative movies appeared.

It would seem the story would be a perfect vehicle for the sensibilities of German master F. W. Murnau and the expressionist style of the day. Alas, his 1920 *Der Januskopf* is a lost film. According to German film historian Lotte Eisner, who has examined the script, the story bears only superficial resemblance to the Stevenson original. In order to circumvent the story's copyright, the plot is altered and the names of Jekyll and Hyde are changed to Dr. Warren and Mr. O'Connor. The linear narrative of the Mansfield play, which replaces and simplifies Stevenson's convoluted structure, is adopted. Dr. Warren (Conrad Veidt) purchases an antique bust that has two faces, one godlike, the other diabolical. Haunted by this symbol of the duality of human nature, Warren is himself transformed into the grotesque O'Connor. Running amok, O'Connor kidnaps Warren's fiancée, who realizes the truth when she sees Warren's statue in O'Connor's chambers. Now unable to control the transformations, the Jekyll-Hyde figure takes a fatal dose of poison. The film's expressionist visual characteristics are apparent from the script's indicated camera angles and set descriptions. There is even a nightmare sequence in which the two personae confront each other.

John S. Robertson's 1920 version for Paramount/Famous Players, starring John Barrymore, brings us closer to the formula followed by most subsequent adaptations. Again, the Mansfield play is followed, except that the chaste companion of the stuffy Jekyll, here named Millicent (Martha Mansfield), is matched against another woman, Gina (Nita Naldi), a prostitute functioning as an appropriate sex object for the lascivious Hyde. Ironically, it is Millicent's upright father, Sir George Carew, who

introduces Jekyll to the seamier side of London nightlife ("The only way to get rid of temptation is to yield to it.") Delighted by his experiences, Jekyll creates a drug that will enable him as "Hyde" to indulge his pleasures unrecognized. Long thought a "lost" film, it has been recently located and restored. Barrymore's transformations into an

John Barrymore (right) in Dr. Jekyll and Mr. Hyde, *directed by John S. Robertson* (1920, U.S.A.; ARTCRAFT-PARAMOUNT/ JOE YRANSKI COLLECTION, DONNELL MEDIA CENTER)

ugly, misshapen Hyde are effective, if a bit too frenetic for today's audiences, relying more on a wig and greasepaint than special effects. A highlight, invented for the film, is a dream sequence when the sleeping Jekyll is visited by the nightmarish form of a gigantic tarantula (Barrymore himself in a spectacular costume). Two effects copied by the later Mamoulian and Fleming versions are Hyde's increasingly grotesque appearance with each change and Hyde's transformation back into Jekyll at the moment of death.

Rouben Mamoulian's much-acclaimed 1932 version featured Fredric March in an Academy Award-winning performance. The Mansfield formula is intact. Two female characters are introduced to match the Jekyll/Hyde dichotomy, the prostitute Ivy (Miriam Hopkins) and the prim society girl, Muriel Carew (Rose Hobart). Jekyll's erotic interests in Ivy are more pointed and graphic than in any previous adaptation. As was the case with Barrymore, March's Hyde is a grotesque monstrosity, an agile but misshapen creature (here resembling more a Neanderthal than Barrymore's spidery conception). So grotesque does each transformation become that one wonders how Hyde can walk the streets unnoticed. The film is justly famous for its innovative use of camera (Karl Struss), editing, and sound techniques—like the opening sequence of Jekyll's arrival at the medical theater, which is seen entirely from his point of view in a prolonged, uncut take; the special effects of the first transformation sequence (including the experimental use of synthetic sounds and the utilization of special camera filters); and interior monologues to reveal a character's thoughts. Unfortunately, scenes of Jekyll (here pronounced JEE-kill) playing the organ are rather too suggestive of Lon Chaney at the console in *The Phantom of the Opera* of a few years before.

In this writer's opinion, Victor Fleming's 1941 adaptation is the best of the lot. MGM bought up the Mamoulian picture, shelved it, and poured all its lavish resources into an extremely slick and well-produced picture. Joseph Ruttenberg's camera superbly visualizes a London lost in the fog, a gas-lit world of furtive figures and distantly clopping coaches. The inevitable two women this time are Lana Turner and Ingrid Bergman, both cast effectively against type as, respectively, Ivy and Muriel. Spencer Tracy is magnificent as the determined, if troubled Jekyll and the unrelentingly vicious and sadistic Hyde (even though his makeup is decidedly more subtle than Fredric March's). Each personification has its delicious touches, whether it's Jekyll assuring Ivy that she'll "see Hyde no more," Tracy's gaze so intense it's almost frightening; or Hyde's sadistic taunts, punctuated by Tracy's popping grapes into his mouth and spitting out the seeds like bullets. Indeed, the scenes of Hyde's abuse of Ivy are among the most frank and painful scenes of a dysfunctional relationship seen in any Hollywood film of that day. Other highlights include the Freudian dream sequence wherein Jekyll/Hyde frenziedly lashes a team of horses, which metamorphose into the nude figures of Ivy and Muriel;

and composer Franz Waxman's clever attachment of a polka tune to Hyde's misadventures, an aural cue heralding each transformation.

With the story laying dormant for awhile in America, several international productions stepped into the breach. In Argentina in 1951 appeared *El hombre y la bestia* (The Man and the Beast), directed by and starring Mario Soffici. Those who have seen it, including historian Donald Glut, pronounce it a creditable adaptation that is updated to the present day.

Although avowedly based on Stevenson's novel, Jean Renoir's French production, *The Testament of Dr. Cordelier*, bears only a passing resemblance. Dr. Cordelier asks his notary that a certain "Mr. Opale," a sadistic criminal notorious in the area, be named his sole heir (both parts are played by Jean-Louis Barrault). Unbeknownst to his colleagues, Cordelier and Opale are one and the same, the result of drug-induced transformations (accomplished by Barrault with only a wig and false teeth). Although he is aware that his researches will surely bring about his demise, Cordelier, a virtuous and devoted man of science, persists and suffers a horrible, agonizing death. Renoir's project was the first television/movie co-production in France.

Among the many curiosities spawned by Stevenson's story are, in chronological order, a Stan Laurel satire, *Dr. Pyckle and Mr. Pride* (1925), *Abbott and Costello Meet Dr. Jekyll and Mr. Hyde* (1953), Hammer Films's *Dr. Jekyll and Sister Hyde* (1971), Jerry Lewis's *The Nutty Professor* (1963), Eddie Murphy's remake of the latter, *The Nutty Professor* (1996), and Stephen Frears's *Mary Reilly* (1996). The Hammer Films production is a by-product of the "Love Generation," giving Stevenson's story a bisexual twist: Jekyll's elixir has the unexpected side effect of transforming him into a sexually voracious woman (Martine Beswick). The sight gags involving the confusion of the

Fredric March in Dr. Jekyll and Mr. Hyde, *directed by Rouben Mamoulian* (1931, U.S.A.; PARAMOUNT/MUSEUM OF MODERN ART FILM STILLS ARCHIVE)

sexes provide more interest than the tepid terrors. The Jerry Lewis and Eddie Murphy versions transform the Jekyll character into a nerdy chemistry professor whose alter ego is a boorish, loud-mouthed lounge lizard. (The Lewis is overrated and the Murphy fitfully sparked by impressive transformation effects.) *Mary Reilly* is by far the most interesting of the recent J&H spinoffs. Adapted from Valerie Martin's novel, which tells the familiar story through the eyes of a chambermaid working in Jekyll's house, it is a virtuoso exercise in point-of-view story-telling. Joan Didion's screenplay retains Martin's basic story outline and director Frears swaths the scene in a thick, gray sfumato of fog and chimney smoke. John Malkovich reverses the Jekyll/Hyde physiognomies, investing Jekyll with a seedy, unkempt look and Hyde with a glossy sleekness (for the first time in his history of the movies, Jekyll actually loses hair in the transformations!). *Mary Reilly*'s most valuable contribution to the body of J&H literature and films is its insight into the rigid stratification of Victorian society and its harrowing depiction of the sordid realities faced by lower-class working women.

For the most part, excepting portions of *Mary Reilly*, the movie adaptations have portrayed Jekyll as a virtuous idealist who creates a monstrosity (usually a large, grotesque, misshapen creature with a fright wig and buck teeth, rather than the small, lithe, "pale and dwarfish" character Stevenson describes) in the cause of science and/or humanitarian purposes. This misses an important point in Stevenson's original. The Hyde persona is not a separate entity that has somehow been created but an inner presence in Jekyll that has been liberated, or released. In other words, the truth of the Jekyll/Hyde duality is not that one man is two men, but, in G.K. Chesterton's words, "*the discovery that the two men are one man.*" Indeed, Stevenson takes great care to demonstrate that Jekyll, far from being the purely good man, has long felt evil and antisocial desires and impulses. He seeks only to create a surrogate to bear the blame for the shameful pleasures he cannot renounce. He wishes free passage, in Chesterton's words, between the alternatives of "that prim and proper pavement and that black and reeking gutter." Jekyll writes: "Men have before hired bravos to transact their crimes, while their own person and reputation sat under shelter. I was the first that ever did so for his pleasures."

REFERENCES

Chesterton, G.K., *Stevenson* (Dodd, Mead, 1928); Eisner, Lotte, *Murnau* (University of California Press, 1973); Glut, Donald, *Classic Movie Monsters* (Scarecrow Press, 1978); Welsch, Janice R., "The Horrific and the Tragic: Dr. Jekyll and Mr. Hyde," in *The English Novel and the Movies*, Michael Klein and Gillian Parker, eds. (Frederick Ungar, 1981); Perez, Michel, "Jekyll and Hyde and the Cruel Cinema," in Roy Huss and T.J. Ross, eds., *Focus on the Horror Film* (Prentice-Hall, 1972).

—*J.C.T.*

THE STRANGER *(L'Etranger)* (1942)

ALBERT CAMUS

The Stranger (Lo Straniero) (1967), Italy/France, directed by Luchino Visconti, adapted by Visconti, Suso Cecchi D'Amico, Georges Conchon; Dino De Laurentiis Cinematografica, Master Film (Rome), and Marianne Film Productions (Paris), in collaboration with Casbah Film (Algiers).

The Novel

Like Kafka's *The Trial*, with which it shares more than its startling opening, Camus's *The Stranger* is a seminal 20th-century work. Widely read and more accessible than most great works of literature, it has become the paradigmatic existential text. It is often read as the fictionalization of *l'absurde*—the condition of meaninglessness, of cosmic incoherence—which Camus expounded on in the essays collected as *The Myth of Sisyphus*.

"Mother died today. Or, maybe, yesterday; I can't be sure" (tr. Stuart Gilbert). Thus Merseault as he opens his story. *The Stranger* is framed by death (his mother's at the beginning, his own at the end) and has death at its very center (when he shoots the Arab at the end of part one). The first death-encounter extracts little emotion from him, which will be held against him later; the second—an apparently self-defensive gesture against a man who had threatened him and his friend Raymond with a knife on the beach—seems to rouse him out of the routine of a life so mechanical that he hates Sundays because they are not structured for him by mindless work. The third—facing his own execution for murder—awakens consciousness. After passionate arguments with the priest sent to console him in his cell, Merseault concludes: "It was as if that great rush of anger had washed me clean, emptied me of hope, and gazing up at the dark sky spangled with its signs and stars, for the first time, the first, I laid my heart open to the benign indifference of the universe."

The Film

Camus turned away all offers to film his novels, but his widow sold the rights to *The Stranger* to De Laurentiis with the condition that Visconti be the director. Also in charge of the adaptation, Visconti set out to make a scrupulously faithful film; as the reviewer in *Time* pointed out, the film "follows the action of the novel with hardly a comma missing—and therein lies both its strength and its weakness." Visconti was also meticulous in reconstructing an Algiers street so that it looked exactly as it had during 1938–39, when the story takes place. This adaptation thus raises yet again the thorny issue of fidelity, which seems to thrust itself to the forefront with any great and/or widely known work, but which recedes with lesser or relatively unknown texts. Visconti's film also brings to the forefront the prob-

Marcello Mastroianni in The Stranger, *directed by Dino De Laurentiis* (1967, ITALY-FRANCE; DINO DE LAURENTIIS CINEMATOGRAFICA S.P.A./THEATRE COLLECTION, FREE LIBRARY OF PHILADELPHIA)

lem of casting: Marcello Mastroianni's persona and age did not predispose viewers to believe in him as Merseault.

Predictably, the reviews were mixed, but more generous than serious readers of Camus might have predicted. Brendan Gill titled his *New Yorker* review "Honorable Failure": "In placing so much emphasis on the novel, I take my lead from Visconti; the novel is, word for word, his screenplay, and yet to be sedulously faithful is sometimes—there must be an ancient Italian play on words for this as well [as there is in *traduttore traditore* (translator betrayer)]—the supreme infidelity. The closer Visconti comes to Camus, the greater the discrepancy between what the author wrote and what we see." Gill gives two reasons: the film's voiceover for the book's first-person narration, and the larger-than-life and 43-year-old Mastroianni playing a 30-year-old nonentity of a shipping clerk. Stanley Kauffmann praised Mastroianni's portrayal, though he too had reservations about this film being the equivalent of the book. "But this is the expression, through their art, by some fine film artists of their sympathy and love for Camus's great book." Richard Schickel gave the film full praise as "a muted, careful, even slow film that achieves its victory through an austere honesty that matches that of its hero . . . It is . . . a film that any serious person must regard as inescapable."

REFERENCES

Gill, Brendan, "Honorable Failure," *The New Yorker*, December 30, 1967, 48; Kauffmann, Stanley, "The Colors of Camus," in *Film 67/68*, ed. Richard Schickel and John Simon (Simon and Schuster, 1968), 200–03; Schickel, Richard, *Second Sight: Notes on Some Movies 1965–1970* (Simon and Schuster, 1972), 163–67; "The Stranger," *Time*, December 29, 1967.

—U.W.

STRANGERS ON A TRAIN (1950)

PATRICIA HIGHSMITH

Strangers on a Train (1951), U.S.A., directed by Alfred Hitchcock, adapted by Raymond Chandler and Czenzi Ormonde, Warner Bros.

Once You Kiss a Stranger (1969), U.S.A., directed by Robert Sparr, adapted by Frank Tarloff and Norman Katkov; Warner Bros.

The Novel

The first of her 20 novels, Highsmith's *Strangers on a Train* was rejected by six publishers before it found its way to print. Shortly thereafter, Hitchcock purchased the film rights for a meager $2,000. Highsmith later claimed that her primary interest as a writer of crime novels was "the effect of guilt on my heroes." She also once said, "I rather like criminals and find them extremely interesting unless they are monotonously and stupidly brutal." *Strangers on a Train* certainly set the tone for much of her later work, exploring primarily the psychological complexities of guilt and creating in the novel's anti-hero (Charley Bruno) a character whom Hitchcock would mold into one of his most memorable "gentleman-murderers."

The action is set in the present, spanning approximately one tortuous year in the life of Guy Haines, an architect on the verge of great success. The novel begins with Haines traveling by train from New York to Metcalf, Texas, to see his estranged wife Miriam about arranging their divorce so that he can marry Anne Faulkner, the daughter of wealthy parents. On the way, he meets Charley Bruno, an alcoholic college dropout, angry at his rich father for not letting him loot the family till to pay for his flamboyant lifestyle and gambling debts. Bruno's guiding philosophy is that "a person ought to do everything it's possible to do before he dies." So once he discovers the reason for Haines's trip to Metcalf, Bruno proposes a plan for the perfect murder, one without a discernible motive: "I kill your wife and you kill my father! We meet on the train, see, and nobody knows we know each other! Perfect alibis!" Naturally, Haines finds the idea outrageous.

After they part ways Miriam thwarts Haines's plans for a divorce and threatens to sabotage his career plans. Bruno finds and strangles Miriam undetected at an amusement park, deriving sinister pleasure from "the mystery of stopping life." Even though Haines had wanted no part in the plot, Bruno hounds him with letters and phone calls that make Haines feel guilty and strangely attracted to Bruno, feelings that haunt him for the rest of the novel. He struggles to advance his career and to keep his complicity in Miriam's murder from Anne (whom he has married) and her family, but eventually he murders Bruno's father to put an end to the torment. Taking great pride in the clever plot and now free to dote upon his sexually provocative mother, Bruno continues to pester Haines until one day on

a sailing outing with him and some friends, Bruno falls overboard and drowns, despite Haines's attempts to rescue him. Still racked by guilt, Haines later finds Miriam's lover, confesses all to him, and is overheard by the Bruno family's private eye. Haines surrenders, knowing "there was no sophistry by which he could free himself" from the legal and psychological consequences of his crimes.

The Films

Hitchcock commissioned Raymond Chandler to write the screenplay for *Strangers on a Train*, having seen great potential in Highsmith's taut and brooding psychological tale and having a high regard for Chandler's own detective fiction. Their collaboration ended once Hitchcock decided Chandler's work was "no good," so Ormonde was hired to help complete the project, an important one for Hitchcock because his two previous films—*Under Capricorn* and *Stage Fright*—had not been received well. *Strangers on a Train* became the first of his great fifties films.

Hitchcock made two slightly different versions of the film, the U.K. version adding important dialogue between Haines and Bruno during their initial meeting, the U.S. version having the "minister tag" epilogue in which Anne and Guy, still unmarried, run into a minister on a train then quickly scurry away (U.K. censors may have seen the tag as slighting the Anglican Church or denigrating marriage). And *Strangers on a Train* marks the beginning of Hitchcock's collaboration with cinematographer Robert Burks, who helped Hitchcock define throughout the fifties the visual style that remains his most enduring legacy.

As with most of Hitchcock's adaptations, only the rudiments of the source plot remain intact. Highsmith's novel was more a psychological study than a suspense thriller, spending considerable time elaborating Haines's complicity, Bruno's oedipal urges, and their mutual homoerotic desires. Hitchcock retained the homoeroticism, shifting it primarily to Bruno, but minimized Haines's expression of guilt, added numerous images and metaphors of doubling, changed Haines's career to tennis, used the recurring image of a cigarette lighter to heighten the urgency of catching him, set the story in Washington, D.C., and restructured the family situations of Anne and Bruno.

The effect is vastly different from but just as provocative as the novel. In the film, Haines and Bruno are not so much driven by similar urges as they are opposite sides of a split personality, Bruno articulating Haines's repressed desires to get rid of Miriam, to avoid marrying Anne or at least eliminate her father so he can have her for himself, and to live his life free from all attachments to civilized morality. Hitchcock also minimizes Haines's feelings of culpability to comment ironically on Bruno's idea that anyone is capable of murder. As J. Yellowlees Douglas points out, Haines does share culpability with Bruno, yet he hopes to ascend through Washington's ranks aided by a senator/father-in-law only too willing to call off the police

and silence potential scandal, suggesting that even the highest levels of American society are implicated in Miriam's murder. Hitchcock also makes Bruno's evil more inscrutable than Highsmith had in the novel, muting her rather obvious treatment of his oedipal urges (in the novel, Bruno is sexually attracted by his mother and jealous not only of his father but also of all her male friends). In the film, Bruno functions as Haines's doppelganger, drawing out the less obvious but nonetheless sinister side of Haines's overtly guiltless facade of normalcy. In the novel, Haines is ultimately so consumed by his guilt that he confesses. At the end of the film, he runs from the minister who would stand in judgment.

Hitchcock always took great liberties with his source novels, and those liberties were justified not simply by his skillful translation of words into their cinematic equivalents, but also by his success in revealing the psychologically complex, seamy side of his ideologically-centered characters. As he does with young Charlie in *Shadow of a Doubt* and Marion Crane in *Psycho*, Hitchcock shows through Guy Haines that behind the mask of respectability and civility lurk not only the potential for but also the instruments of evil.

Sparr's 1969 adaptation, *Once You Kiss a Stranger*, retains only the murder plot from Highsmith's novel, but interestingly makes Bruno's character a woman with a fatal attraction for her coconspirator.

REFERENCES

Desowitz, Bill, "Strangers on Which Train?" *Film Comment* 28, no. 3 (May–June 1992): 4–5; Douglas, J. Yellowlees, "American Friends and Strangers on Trains," *Literature/Film Quarterly* 16, no. 3 (1988): 181–90; Spoto, Donald, *Hitchcock: Fifty Years of His Motion Pictures*, 2nd ed. (Doubleday, 1992).

—D.B.

STUART LITTLE (1945)

E.B. WHITE

Stuart Little (1999), U.S.A., directed and adapted by Rob Minkoff; Columbia.
Stuart Little 2 (2002), U.S.A., directed and adapted by Rob Minkoff; Columbia.

The Novel

Essayist, poet, novelist E.B. White did not spend his entire career writing for children, but *Stuart Little*, *Charlotte's Web*, and *The Trumpet of the Swan* may have gained him more affection and success—with readers young and old—than his 50-year association with *The New Yorker*. As commentator Beverly Gherman notes, "He likes a little touch of magic and fantasy in his life and in his stories, no matter who might read them." *Stuart Little* came late in his career. White had been telling stories about a tiny mouse

for years to his nieces and nephews before setting them down to paper in 1939. But it was another six years before the project was finished and an illustrator, Garth Williams, was found. *Stuart Little* was published in October 1945.

Stuart Little is the second son born to Mr. and Mrs. Frederick C. Little of New York City. Only two inches tall, he is not much bigger than a mouse; indeed, "the truth of the matter was, the baby looked very much like a mouse in every way." Stuart grows up happy in the Little household. Although his diminutive size helps the housekeeping—he can retrieve lost objects from drains, for example—he is in constant danger, as when he gets locked inside the refrigerator, stuck inside the window shade, and hauled out to the East River in a garbage scow. On outings to Central Park the little guy proves to be quite an adventurer. He takes over the tiller of a sailboat on a pond and wins a terrific boat race. One day, when Stuart is seven years old, a little bird named Margalo arrives and joins the family. "I come from fields once tall with wheat," she says poetically; "from pastures deep in fern and thistle; I come from vales of meadowsweet, and I love to whistle." Stuart can't resist such eloquence, and the two become fast friends. But

when Margalo learns she is in imminent danger from the neighborhood cats, she flies away. The lovelorn Stuart determines to find her. He packs up his little car and bravely drives out of the city. During his quest he has many more adventures, including a brief stint as a schoolteacher (abjuring the usual lessons in arithmetic and spelling for a disquisition on social ethics) and a bittersweet tryst with Harriet Ames, a little girl just his size. At last, following the advice of a telephone lineman, Stuart starts up the road leading north. "As he peered ahead into the great land that stretched before him," the book concludes, "the way seemed long. But the sky was bright, and he somehow felt he was headed in the right direction."

Despite some initial quibbles from school librarians that children might be confused about a mouse being born into a human family—White riposted, "Children can sail easily over the fence that separates reality from make-believe"—the book's popularity was phenomenal, selling into the millions. During his lifetime, White insisted on referring to Stuart not as a mouse but as a "second son." In our turn, we may be forgiven for seeing in Stuart the persona of White himself, who, like Stuart, loved to be up early in the morning to enjoy the "fresh smell of day" and who enjoyed being out on the water "with the breeze in his face and the cry of the gulls overhead."

The Films

The two film adaptations effect many wholesale changes in the book's slim plotline. Stuart (voiced by Michael J. Fox) is not born to Mr. and Mrs. Little (Hugh Laurie and Geena Davis), but is adopted from a local orphanage. Perhaps the filmmakers, like the librarians who first objected to the book, balked at the logic of a mouselike creature born to human parents. However, they did not cringe at the prospect of a live-action (digitally created) talking mouse living in an orphanage. Such is the logic of Hollywood. The relatively minor role of Snowbell the cat in the book is amplified. Margalo now plays a key role in a melodramatic plot development. And Stuart's departure from the Little home in search of Margalo—a quest that occupies almost one-half of the book—is entirely abandoned.

In the first film, Stuart is brought from the orphanage into the Little home. At first, Stuart's older brother, George (Jonathan Lipnicki), is dubious about having a mouse for a brother. And Snowbell (voiced by Nathan Lane), is miffed at his privileged position in the family being upstaged. Imagine, he complains, not being able to eat a mouse because he's one of the family! But no sooner has Stuart won George over (he wins the big boat race in Central Park by taking over the tiller of George's model boat) and become part of the family than disaster strikes. In a wholly fabricated subplot, two mice purporting to be Stuart's parents show up and claim him as their own. Stuart is a *mouse*, they argue; shouldn't he be with his own kind? Reluctantly, Stuart agrees to go with the mice to a little castle in a nearby miniature golf course. It seems

E.B. White

Stuart Little (2002, U.S.A.; THE LITERATURE/FILM ARCHIVE)

that the whole thing is a setup. Stuart's real parents had died years before; and the jealous Snowbell had conspired with his feline friends to get Stuart out of the house where he could become their next snack. But the plucky Stuart breaks free and, after barely escaping a horde of pursuing cats, rejoins the repentant Snowbell for the return home.

Margalo does not show up until the second film, *Stuart Little 2*. (Director Minkoff and the cast members reunite for this sequel.) The film opens with quick vignettes depicting Stuart's happy home life with the Littles. He drives his little red car through the busy New York streets, plays on the soccer team, and careers around Central Park in his miniature airplane. One day, Margalo (voiced by Melanie Griffith) literally drops out of the sky. Unlike Margalo's role in the book, which was brief and bittersweet, in this film she participates in a major plot development. She claims to have escaped from the predatory Falcon (James Woods). But it develops that she is not the sweet innocent Stuart presumes her to be; rather, she is the accomplice of Falcon, and, together, they pull scams on their unsuspecting victims. Margalo steals Mrs. Little's diamond ring and takes it to Falcon's lair atop a high-rise building. Stuart enlists Snowbell's aid and scales the high-rise building in a makeshift hot-air balloon. In a fierce aerial dogfight, Stuart defeats the villainous Falcon. Margalo is now ashamed of her villainy. She apologizes to the Littles and is taken back into the family. But one day she obeys the call of a flock of migrating birds and, after a tearful farewell, follows them south.

Both films benefit from the ingenious special effects of John Dykstra and the production design that transforms the gritty New York cityscape into a delicious confection of primary colors and fairy-tale features. Two vocal performances stand out, Nathan Lane's hilarious cynicism of Snowbell and James Woods's terrifying villainy as Falcon. When Stuart queries Snowbell, "Am I a man or a mouse?", Snowbell pauses a beat before declaring, "Is this a trick question?"

Casually conveyed throughout the series is White's conceit that a talking mouse and bird are a natural circumstance in the otherwise real world. Within the household of the Littles, talking animals are as natural as a baby learning to talk. Indeed, when the Littles' new baby girl utters her first words in the final scene of *Stuart Little 2*, the event is received with great joy: Consider the paradox: It's *her* speech, not Stuart's, that's considered to be the real miracle.

Underlying everything is the message that "family" is a concept, not necessarily a biological construct. It is a union of loving, caring, and sharing people. No matter if you are "different," like Stuart; there are many ties that bind beyond mere bloodlines. Indeed, love has no hard-edged definition nor biological basis. Few motion pictures have delivered that message in a more quaintly simplistic yet endearing way.

REFERENCES

Gherman, Beverly, *E.B. White: Some Writer!* (Atheneum, 1992); Russell, Isabel, *Katharine and E.B. White: An Affectionate Memoir* (W.W. Norton & Company, 1988).

—*J.C.T.*

THE SUN ALSO RISES (1926)

ERNEST HEMINGWAY

The Sun Also Rises (1957), U.S.A., directed by Henry King, adapted by Peter Viertel; Twentieth Century-Fox.

The Novel

Hemingway's first novel is narrated, in radically understated style, by Jake Barnes, an American newspaper reporter in Paris in the early 1920s. A wound in World War I has left him sexually incapacitated and frustrated in his love for Brett Ashley, who is in the process of getting divorced from an English lord and seeking to escape the pain of her impossible love for Jake in a series of affairs. Jake finds some relief in a fishing trip high in the Pyrenees with his friend Bill Gorton, an American writer. But tensions heat up in Pamplona, Spain, where Jake and Bill meet Brett, her fiancé Mike Campbell (an improvident Scottish aristocrat), and Jake's former Princeton classmate, Robert Cohn (a Jewish American, former boxer, writer, and unrelenting romantic, who is also in love with Brett). All of them join in the city's festival of San Fermin, with its famous running of the bulls and bullfights. Brett falls for the most celebrated (and one of the youngest) of the matadors, Pedro Romero, and runs away with him after Robert has beaten him up. Jake retreats for a few days to the Spanish coastal resort city, San Sebastian. But at Brett's call he joins her in Madrid, where she informs him she has given up Pedro, not wanting to be "one of those bitches that ruin children." In the book's melancholy final scene, they con-

firm the futility of their relationship. Brett: "We could have had such a damned good time together." Jake: "Isn't it pretty to think so?"

The Film

The Zanuck/King adaptation of *The Sun Also Rises* is superficially faithful to Hemingway's famous text, following its basic structure and reproducing much of the characterization and dialogue. But the film seems padded, in contrast to the spare, understated novel. Nevertheless, it slights several of the more thematically significant parts of the novel, all of which have considerable cinematic potential. Jake's two important interludes—the fishing vacation in the mountains with Bill, and his few days alone by the sea at San Sebastian—are radically shortened. And the bullfighting sequences at Pamplona give little indication of their significance to Jake, who as a true aficionado can see in the sport a metaphor for living with grace on the edge of the abyss. The film turns the novel's bleak ending into a sentimental suggestion that things really might turn out all right for Jake and Brett.

The action takes place in luxuriously decorated sets and on location in Pamplona, with additional shooting in Morelia, Mexico. The cinematography by Leo Tover (Cinemascope and DeLuxe Color) is competent but unimaginative. Fairly skillful editing incorporates the story of the principals into documentary-style photography of the San Fermin fiesta, although Romero's main bullfight is amateurishly cut. The cast includes many famous Hollywood stars. Errol Flynn gives the strongest performance, as the drunken Mike Campbell. Mel Ferrer is a credible Robert Cohn. But Tyrone Power (at 43, a rather old Jake Barnes) sulks in self-pity through much of the film. Glamorous Ava Gardner mainly models stylish clothes.

REFERENCES

Aldridge, John W., "*The Sun Also Rises*—Sixty Years Later," *Sewanee Review* 94, no. 2 (Spring 1986): 337–45; Hatch, Robert, "Films," *The Nation* (October 12, 1957), 251–52; O'Connor, John J., "'The Sun Also Rises,' Expatriates in Europe," *New York Times*, December 7, 1984, C 30; Wagner-Martin, Linda, ed., *New Essays on* The Sun Also Rises (Cambridge University Press, 1987).

—*W.S.W*

THE TAILOR OF PANAMA (1996)

JOHN LE CARRÉ (DAVID CORNWELL)

The Tailor of Panama (2001). Directed by John Boorman, adapted by John Boorman, Andrew Davies, and John Le Carré; Merlin Films/Columbia Pictures.

The Novel

The master of intelligent espionage after the passing of Graham Greene, John Le Carré (the pen name of former British intelligence officer David Cornwell) became the primary architect of cold war spy novels after the publication of *The Spy Who Came in from the Cold*, which was adapted to the screen by Martin Ritt in 1965. At his best Le Carré could match Greene in his ability to create wonderfully conflicted characters to populate his wonderfully elegant Byzantine plots. After the collapse of communism during the later 1980s, Le Carré had to reinvent himself. *The Tailor of Panama* was an excellent solution for his postcommunist dilemma. And it so happens that in the case of this novel, John Le Carré was, admittedly, imitating Graham Greene.

The "tailor" of the title, Harry Pendel (Geoffrey Rush in the film), is an imposter who claims to be carrying on the Savile Row tradition brought to Panama by his conveniently deceased partner, Arthur Braithwaite. Both the tradition and the partnership are bogus, however, a complete fabrication made up by Harry when he immigrated to Panama after serving time for arson in a British prison, where he learned his trade. Harry has been very successful at reinventing himself in Central America. Louisa (Jamie Lee Curtis in the film adaptation), Harry's wife, is an American

raised in the Panama Canal Zone who works for Ernesto Delgado, one of the few honest bureaucrats in Panama. She knows nothing about Harry's true background.

Harry is, then, a likable con man, who has working relationships with the wealthy members of the Panamanian ruling class. But Harry has financial problems. He has invested unwisely in a rice farm that failed, and his bank is threatening to call in a loan that Harry cannot possibly cover. His prospects look very bleak indeed, until one day dapper Andrew Osnard (Pierce Brosnan), a secret service operative assigned to the British Embassy, walks into Harry's shop, wanting to be measured for a suit, or so he tells Harry. In fact Andrew knows about Harry's background and intends to recruit him because of Harry's connections with the ruling class; he is therefore willing to reward Harry for any information Harry might be able to gather from his well-placed clients. Harry certainly needs the money and willingly becomes an informant, but Andrew does not quite understand Harry's tendency to stretch the truth. Harry is not really the insider that Andrew believes him to be, but Harry still wants to make a good impression and becomes very inventive in order to make Andrew believe that he can be helpful.

Andrew himself is a cad and a bounder who has been sent by MI6 to Panama as a punishment for having botched a previous assignment. When he recruits Harry, he knows all the embarrassing details about Harry's past. In order to blackmail Harry into cooperation, Andrew threatens to expose Harry to his wife. What Andrew does not realize is that Harry is an incorrigible liar who really enjoys tailoring fabrications that are sure to cause problems for his friends and family. Thus Harry cannot help himself as he "giddily" ascends "to hitherto unscaled heights of fantasy" while he

concocts a completely untrue conspiracy theory involving Panama's "Silent Opposition" to the thoroughly corrupt ruling class. "Panama's not a country," as Harry says in the novel, "it's a casino. And we know the boys who run it."

The action is set in the 1990s, and there are hawks in the U.S. military who would like nothing better than to have an excuse for recapturing the Panama Canal. Harry's misinformation about political unrest in Panama goes to London and it is then passed on to Washington. Harry identified his friend, Mickie Abraxas, as the leader of the "Silent Opposition." Mickie is an alcoholic who had served time as a political prisoner under Panama's dictator, General Manuel Noriega. In prison the once radical Mickie's spirit was broken by torture and abuse. He is so afraid of being sent back to prison that he commits suicide when Harry's lies begin to complicate his life. Harry also manages to complicate the life of his faithful assistant, Marta (Leonor Varela), whose face had been scarred by Noriega's thugs.

Harry certainly understands that he was responsible for Mickie's suicide, and Harry has a conscience, unlike Andrew, who is utterly ruthless. Harry therefore becomes a perfect patsy for Andrew's schemes. Andrew clearly intends to take the money and run. Harry's flaw is that he is essentially a muddler, but, to quote the novel, "Somewhere in his overworked mind was an idea that he could make a gift of love to Mickie, build him into something he could never be, a Mickie redux, dried out, shining bright, militant and courageous." There is a disconnect, however, between the film's comic irony and its parody of a silly spy genre and the awful past reality that has disfigured Marta's face and turned Mickie into a pathetic, terrified drunk.

Harry's muddling has disastrous consequences for himself and others. He stupidly betrays his wife by copying documents she brings home to work on. Louisa knows, however, that Harry is a good man at heart, a kind husband and father. Even after he tells her the truth, Louise is still willing to forgive him. "Whatever you've done wrong, I've done worse," Louisa tells Harry in the novel, adding "I do not mind what you are or who you are or what you've done or who to." But by that point in the novel, Harry is walking away from his wife and family and into the burning city. There is no calm and no easy reconciliation in the novel, which has rather more magnitude than the film.

The influence of Graham Greene hovers over the novel, as several reviewers noted that Le Carré owed a considerable debt to Greene's *Our Man in Havana*. This was not a hidden influence, however. Le Carré himself wrote that "without Graham Greene, this book would never have come about." He confessed that "After Greene's *Our Man in Havana*, the notion of an intelligence fabricator would not leave me alone."

The Film

The best joke going for this film is to have Pierce Brosnan, who had played James Bond in previous movie roles, spoof the Bond persona by playing Andrew Osnard as James Bond's evil twin, with feet of clay. The problem, of course, with doing an espionage spoof built around a James Bond lookalike is that viewers may expect the real thing instead of a comic spinoff, and therefore be disappointed. Brosnan plays the villainous and manipulative Andrew to perfection as a parody of an unworthy and conniving Agent 007. Stephen Farber of *Movieline* thought that Brosnan gave "the loosest, most compelling performance of his career" in this picture. Brosnan was matched, however, by the performing brilliance of Geoffrey Rush as Harry, for it was Rush who made the film what *Variety* called "a stylish, sardonic addition to the spy genre." Also not to be missed in the cast is the Irish actor Brendan Gleeson, who starred as the maverick Dublin gangland boss Martin Cahill in Boorman's film *The General* in 1998 and who plays Mickie Abraxas in *The Tailor of Panama*.

The ghost of Harry's Uncle Benny (nicely played by Harold Pinter, Britain's foremost playwright) appears with some frequency to help Harry get his moral bearings, once he has "lost his innocence." In general, the film was true to the letter and the spirit of the novel, though, as David Stratton noted in his *Variety* review, the ending of the novel "has been modified and is now far more upbeat," probably a forgivable concession to a mass audience, since the novelist himself was part of the scriptwriting team and must have approved the change in emphasis. The script was both witty and polished, nicely ornamented with inside jokes, as when Harry tells Andrew about another client named "Mr. Connery," or when Harry describes Panama as "Casablanca without heroes." Though the film earned only about $14 million, the reviewers were impressed by this "lively and provocative" adaptation.

REFERENCES

Kauffmann, Stanley, "Stages of Mastery," *The New Republic*, April 30, 2001, 30–31; Lane, Anthony, "Going to the Dogs," *The New Yorker*, April 2, 2001, 98–99; Rafferty, Terrence, "A Very English Risk Taker in a Play-It-Safe World," *New York Times*, February 25, 2001, 23, 32; Schwarzbaum, Lisa, "Suitable Intrigue," *Entertainment Weekly*, April 6, 2001, 85–86; Stratton, David, "'Tailor' Made for Spy Genre," *Variety*, February 19–25, 2001, 41.

—*J.M. Welsh*

A TALE OF TWO CITIES (1859)

CHARLES DICKENS

A Tale of Two Cities (1917), U.S.A., directed by Frank Lloyd, adapted by Clara Beranger; Fox.

A Tale of Two Cities (1935), U.S.A., directed by Jack Conway, adapted by S.N. Behrman and W.P. Lipscomb; MGM.

A Tale of Two Cities (1958), U.K., directed by Ralph Thomas, adapted by T.E.B. Clarke; Rank.

The Novel

Published roughly 70 years after the storming of the Bastille and barely a decade before Dickens's death at age 58, the novel began as a serial in the periodical *All the Year Round*.

Like many Victorian novels, *A Tale of Two Cities* is heavily dependent upon duality, confusion, and coincidence. The look-alikes Carton and Darnay, the missing peasant child who returns "with a vengeance," the revolutionary who once worked for the good doctor, and the wastrel brother (with a dual identity) who reappears at a critical juncture—are all examples of Dickens's use of basic Victorian plot devices.

The central connecting character in the novel is the representative of Tellson's Bank in both London and Paris, Jarvis Lorry. The novel opens on Mr. Lorry's mission to bring a former client, Dr. Manette, from the danger of revolutionary Paris to the relative security of London. Manette was unjustly imprisoned for 18 years in the Bastille by the Marquis de St. Evremonde, and has just been released to the Defarges, wine shop owners and secret revolutionaries. Also in Paris to ease Manette's transition is the daughter he no longer remembers, Lucy.

Returning to London on the same channel packet with Lorry and the Manettes is Charles Darnay, nephew of the marquis, who has renounced his uncle and, in effect, his position as a French aristocrat, in shame and guilt over his family's excesses. Also on the boat is Barsad, an agent of the marquis and whoever else will pay him. Over time, Darnay and Lucy fall in love, and her father is slowly "recalled to life" by the care of those around him.

Darnay is denounced as a traitor by Barsad and brought to trial at the Old Bailey, where he is saved by a clever but seemingly jaded lawyer, Sydney Carton, who bears a striking resemblance to Darnay. Carton becomes a habitué of the Manette household and falls in love with Lucy. However, it is clear to Carton that she loves Darnay, and that whatever passion he may feel is doomed to be unrequited.

In Paris, the marquis' coach runs over a peasant boy in front of the Defarges' shop. This is the catalytic event that triggers the storming of the Bastille, and the frenzied excesses of the Paris Commune. Darnay, who is now husband and father, returns to Paris in order to save a former teacher, but is himself arrested and imprisoned by the sans-culottes. Mr. Lorry comes to Paris, as do Lucy and Dr. Manette, whose reputation temporarily saves Darnay. But in a shocking chain of events, Darnay is reimprisoned and sentenced to the guillotine.

Carton, who once promised Lucy any sacrifice "to keep a life you love beside you," travels to Paris and engineers a scheme to substitute himself for Darnay in the execution cell. As the English group races for the coast, pandemonium builds in Paris, where Carton ascends the scaffold to a new sense of dignity and idealism. "It is a far, far better thing that I do, than I have ever done; it is a far, far better rest that I go to than I have ever known."

The Films

Although there have been at least a half-dozen film adaptations under various titles, there seems to be a consensus that four stand out—for reasons either of history, quality, or access—the 1917 silent film, the 1935 MGM classic, the 1958 British remake, and the 1980 made-for-television version.

The 1917 film was directed by Frank Lloyd and was generally well regarded in reviews of the time. Particular credit was given for the massive set design and the direction of the mob/riot scenes. It is also noteworthy that William Farnum played both the Carton and Darnay roles.

The most lavish and memorable production is the 1935 version, directed by Jack Conway. Conway no doubt should receive some credit, but the influence of producer David O. Selznick is unmistakable. Although not totally unique for the time, Selznick's gesture of listing himself after the director in the opening credits gives some idea of their relative influence. Selznick had recently produced both *Anna Karenina* and *David Copperfield*, and was experienced in the adaptation and development of literature for the screen. Within five years, he would also produce *Gone With the Wind* and *Rebecca*. A stickler for period detail in terms of sets and costumes, Selznick demanded visual interest, often at the expense of literary authenticity. It should also be noted that one of the most stirring and logistically difficult montages, the storming of the Bastille, was filmed by second unit directors Val Lewton and Jacques Tourneur. Lewton would later go on to produce, and Tourneur to direct, the moody, psychological thriller *Cat People*.

Of course, it is impossible to maintain complete cohesion between the novel and the film, with the narrative demand to bring a film in at, or around, two hours. Many of Dickens's supporting characters and his deliberately paced thematic development are truncated in order to keep the story "moving." This results in initially stagy, overly melodramatic dialogue and stock characterizations of such important secondary figures as Mr. Lorry, Miss Pross, and Jerry Cruncher. However, as the story line takes hold, many of the more memorable and thematically important scenes and passages of dialogue are presented with more subtlety and depth.

The artistic design of Cedric Gibbons, the costume design of Dolly Tree, and the lush cinematography of Oliver Marsh provide a textured sense of access to the period and the opposing cultures. The performances of Ronald Colman as Carton and Basil Rathbone as the marquis are now in the pantheon of great cinematic roles, but there are also wonderful supporting performances. Edna May Oliver as Miss Pross and Claude Gillingwater as Lorry are sometimes quirky, but finally winning, just as in the novel. Isabel Jewell is indeed a jewel in a very brief turn as the frightened seamstress who takes the final journey with Carton. The interesting casting includes Fritz

Ronald Colman (center) and Isabel Jewell in A Tale of Two Cities, *directed by Jack Conway* (1935, U.S.A.; MGM/JOE YRANSKI COLLECTION, DONNELL MEDIA CENTER)

Leiber as Gaspard, the peasant whose son is killed and who later kills the marquis, and H.B. Warner as Gabelle, Darnay's former tutor. The film was originally shot in black and white, but is now available in a colorized format.

In 1958, Ralph Thomas directed an adaptation for the J. Arthur Rank studios. Starring Dirk Bogarde as Carton, this film is notable primarily for the supporting cast, several of whom went on to distinguished careers as character actors in both Britain and America. Christopher Lee played the marquis, Ian Bannen was Gabelle, Donald Pleasence played Barsad, and Leo Mckern was cast as the attorney general—good preparation for later roles as the prosecuting Cromwell in *A Man for All Seasons,* and the ongoing BBC character "Rumpole of the Bailey."

A Tale of Two Cities is one of Dickens's most resounding and enduring successes. Still in print after almost a century and a half, it is also one of the most frequently filmed Dickens novels. Arguably one of his most "action filled" stories, *A Tale of Two Cities* is also replete with historical details of England and France during a most dramatically transformational period. The well-developed secondary characters, the biting wit and social commentary, and one of the great love stories of the Victorian or any other age, make *A Tale of Two Cities* a classic tale of both literature and cinema.

REFERENCES

Klein, Michael and Gillian Parker, eds., *The English Novel and the Movies* (Ungar, 1981); Mayne, Judith, *Private Novels, Public Films* (University of Georgia Press, 1988); Poole, Mike, "Dickens and Film: 101 Uses of a Dead Author," in *The Changing World of Charles Dickens,* ed. Robert Giddings (Barnes and Noble, 1983); Smith, Grahame, "Dickens and Adaptation: Imagery in Words and Pictures," in *Novel Images: Literature in Performance,* ed. Peter Reynolds (Routledge, 1993).

—*M.W.G.*

TARZAN OF THE APES (1914)

EDGAR RICE BURROUGHS

Tarzan of the Apes (1918), U.S.A., directed by Scott Sidney, adapted by Fred Miller and Lois Weber; National Film Corporation.

Tarzan the Ape Man (1932), U.S.A., directed by W.S. Van Dyke, adapted by Cyril Hume and Ivor Novello; MGM.

Tarzan the Apeman (1959), U.S.A., directed by Joseph Newman, adapted by Robert F. Hill; MGM.

Tarzan the Apeman (1981), U.S.A., directed by John Derek, adapted by Tom Rowe and Gary Goddard.

Greystoke, the Legend of Tarzan, Lord of the Apes (1984), U.K., directed by Hugh Hudson, adapted by P.H. Vazak and Michael Austin; Warner Bros.

Tarzan (U.S.A.), 1999, directed by Chris Buck and Ken Lima; Walt Disney Pictures.

The Novel

The 20th century's best-known personification of the "noble savage" myth, the character of Tarzan of the Apes may be rivaled only by Sherlock Holmes and Peter Pan as modern literature's most popular and recognizable figure. At the time of his death in 1950, Edgar Rice Burroughs had written 67 novels, 26 of which dealt with the Ape Man. The character, known variously in the first four books of the series as "Tar-Zan" ("white-skin" in the ape tongue), "John Clayton" and "Lord Bloomstoke" (later changed to "Lord Greystoke" by the English and simply to "M. Jean C. Tarzan" by the French), first appeared in October 1912 in the pages of *All-Story Magazine*. The story's immediate success, not to mention Burroughs' receipt of $700, prompted the failed salesman and entrepreneur to launch a fulltime writing career. Through two world wars Burroughs guided Tarzan in battles against Germans, Japanese, and Communists. He discovered many lost races, hunted bizarre animals, and even penetrated to the Earth's core. Once, he auditioned—and was turned down!—for the role of Tarzan in a Hollywood movie (see *Tarzan and the Lion Man*, 1933).

Tarzan of the Apes begins when young John Clayton and his wife, Lady Alice, en route to a colonial post and an assignment to stop the exploitation of natives, are marooned on the west coast of Africa by mutinous sailors. A son, born to the Claytons a year later, is orphaned when his mother dies insane and his father is killed by a great ape named Kerchak. The baby is carried away by Kala, a female ape whose own infant has just died. Raised as an ape, the boy quickly develops into a superior fighter among the apes, his quick brain compensating for his relatively lesser physique. When he kills Kerchak, he becomes leader of the tribe. Meanwhile, he discovers the truth of his parentage and teaches himself to read and write fluent English. Gradually, he detaches himself from the apes, convinced of his separateness and superiority: "As he had grown older, he found that he had grown away from his people. Their interests and his were far removed. They had not kept pace with him, nor could they understand aught of the many strange and wonderful dreams that passed through the active brain of their human king."

By a wild coincidence, another party of whites is marooned at the same spot as his parents. They consist of the Porters from Baltimore and William Clayton, the present Lord Greystoke. After saving them from various perils, Tarzan falls in love with Jane Porter. But before he can declare himself, Jane returns to America. Meanwhile, Tarzan is befriended by a French naval officer, d'Arnot, and taken to Paris, where he becomes a polished gentleman. When at last he goes to America in search of Jane, he arrives just in time to rescue her from a forest fire. Not realizing her savior is indeed the legitimate heir to the House of Greystoke, she rejects his offer of marriage and accepts the proposal of William Clayton. Rejected, disillusioned, yet unprepared to usurp William Clayton's claim, Tarzan prepares to return to Africa.

The Films

To date an estimated 20 actors have portrayed Tarzan on screen and on television, from Elmo Lincoln in the first film adaptation, *Tarzan of the Apes* (1918), to Christopher Lambert in *Greystoke* (1984) and Casper Van Dien in *Tarzan and the Lost City*. The movies alone have grossed $500 million. Otto Elmo Linkenhelt was a bit player in the movies when he was spotted by D.W. Griffith and, under his new name of Elmo Lincoln, cast as a blacksmith in *The Birth of a Nation* (1915). The barrel-chested physique of the 28-year-old newcomer attracted the attention of William Parsons, founder of the National Film Corporation. Parsons had already brought a Burroughs story to the screen, *The Lad and the Lion* (1917), and he was anxious to cast Lincoln as the first bona-fide movie Tarzan. The results, which included several alterations from the original novel, displeased Burroughs. His disappointment would escalate over the years, prompting him to remark, "As far as I know, no one connected with the making of a single Tarzan picture has had the remotest conception of either the story or the character as I conceived it."

Two more Lincoln sequels followed, as well as five additional silent features starring, in succession, Gene Pollar, P. Dempsey Tabler, James H. Pierce (Burroughs's son-in-law), and Frank Merrill. The era of the sound film brought a host of new Tarzans, including serials with former Olympians Buster Crabbe (1933) and Herman Brix (1934 and 1938). Johnny Weissmuller began his long reign in 1932 with MGM's *Tarzan the Ape Man* and ended his series 11 films later in 1948. From Weissmuller's retirement from the role until the present, successive actors have included Lex Barker, Gordon Scott, Denny Miller, Jock Mahoney, Mike Henry, Ron Ely, Miles O'Keefe, Joe Lara, Wolf Larson, Christopher Lambert, and Casper Van Dien.

Few of these films have come within shouting distance of the original novel. This was due primarily to the fact that Burroughs had sold the book's rights to William Parsons in 1916. Thus, the Elmo Lincoln version is the only one among the many that has been relatively faithful to the story line (excepting that in the film Tarzan does not pursue Jane to America—they depart Africa together for England). Subsequent films by other studios were able to acquire rights to the Tarzan character, but not to the first Tarzan novel. For example, the best of the pre-1948 films, Weissmuller's *Tarzan the Ape Man* (1932) and *Tarzan and His Mate* (1934), are typical in that they avoid any reference to Tarzan's aristocratic heritage, his childhood among the apes, and his pursuit of Jane Parker (renamed from "Porter") to America. They are concerned entirely with jungle confrontations between greedy white hunters and various tribes of bloodthirsty savages. Along the way, the dreaded Cheetah, initially a fierce companion for Tarzan (and named Nkima in the books), is reduced to the dubious role of comic relief. Moreover, despite his primal appeal and lithe grace, Weissmuller's Tarzan was illiterate and barely articulate. Gone entirely was the figure of fine, almost Jamesian sensibilities, a man who mastered civilized life—generally preferring it to the jungle—and eagerly

sought out the best in society while angrily rejecting the worst. Burroughs's original characterization had combined a simple, pure sense of justice with civilized man's moral and intellectual awareness of that justice.

In later films Lex Barker, Gordon Scott, and Jock Mahoney at least seemed more civilized—and their films had the benefit of color and some location shooting in Africa and other locales—but they had a woefully too few number of lines in which to express anything worth listening to. Jane was frequently absent and, mercifully in the Mahoney films, so was Cheetah. Of Tarzan's aristocratic heritage, there was nary a hint.

Arguably, the low point came in 1959 with *Tarzan the Ape Man*, starring Denny Miller. A tepid remake of MGM's 1932 Weissmuller vehicle, it borrowed large chunks from the original, including tree-swinging stunts and animal fights (like Weissmuller's classic tussle with a crocodile). Inexplicably, incredibly, not once was the Ape Man ever called Tarzan. Following this mess was John Derek's 1981 *Tarzan the Ape Man*, which cast Miles O'Keeffe as a Tarzan who was literally speechless at the sight of the spectacular Bo Derek (the nude scenes garnered the picture an R rating). The action begins with Tarzan as a mature adult, and there are no references

Johnny Weissmuller and Maureen O'Sullivan in Tarzan and His Mate, *directed by Cedric Gibbons* (1934, U.S.A.; MGM/JOE YRANSKI COLLECTION, DONNELL MEDIA CENTER)

whatever to his past life and heritage. There are no signs of intelligence, either.

The most despicable of the novel's adaptations, however, is the one that purported to be the screen's first faithful translation. Warner Bros.' *Greystoke: The Legend of Tarzan, Lord of the Apes* (1985) was "filmed as Burroughs originally conceived it," crowed the Warner publicity machine. And, indeed, for a while, it seemed all was well: Lord and Lady Greystoke are shipwrecked on their way to Africa, and their baby is orphaned when they are killed in an attack by giant apes. The child is reared as an ape and eventually assumes status as "lord" of the tribe. From here on, however, it's every ape for himself. The young lord grows up, unaccountably convinced, beyond all evidence to the contrary, that he's an ape. Imagine his astonishment when he learns from a Belgian scientist that he is in reality John Clayton, heir to the House of Greystoke in Scotland. Transplanted to his ancestral home, John (he is never referred to as Tarzan, strangely enough) meets the lovely Jane Porter (Andie MacDowell). But because his uncouth, apelike mannerisms and atavistic urges ill suit him for this new society, he returns to his beloved jungle. Jane can only look wistfully on as he sheds his clothes and disappears into the undergrowth.

Despite the evocative use of the Cameroon rain forests in the early scenes, some skilled work with apes (primate specialist Roger Fouts choreographed stunt persons in ape suits), and some poignant scenes with the lithe Christopher Lambert, the departures from the basic plot line are obvious. More problematic, however is Tarzan's aforementioned inability to distinguish himself from the apes who have reared him. What kind of dimwit is he? Moreover, back in Scotland, he continually reverts to ape chatter and, in his seduction scene with Jane, assumes suggestive simian postures over her recumbent form. This Tarzan, contrary to Burroughs's original, evidently is incapable of coping with civilization and incapable of transcending his jungle nature. It was bad enough to see the Tarzan of Weissmuller, Barker, and others shorn of his heritage, education, and moral sensibilities; it is quite another to see this particular Tarzan revealed as unworthy of them.

The newest screen Tarzan is played by Casper Van Dien, who played Rico in *Starship Troopers*. In Carl Schenkel's *Tarzan and the Lost City* the eponymous hero is first seen as a thoroughly civilized young man in a pub in England celebrating his upcoming wedding to Jane (Jane March). Suddenly, obeying an apparently telepathic injunction, he announces to his startled fiancée that he's needed in Africa. It seems a white European plunderer, Nigel (Steven Waddington), has trapped a large number of animals and is leading an army of brigands in a search for the lost, mystical city of Opar. Accompanied by Jane, who has come to his aid (and cleaned up their jungle tree house in the meantime), Tarzan faces many adventures in freeing the animals and pursuing the villains, including battles with a cobra, a runaway elephant, ghostly warriors, and a morphing snake priest. Van Dien's Tarzan speaks (more or less) correct English, smiles agreeably (defying Burroughs's own admonitions that Tarzan should never smile or grin), sports a new jungle yell (which sounds as if it were vocalized in an echo chamber), and disports himself well in the treetops. In all, in the opinion of Tarzan authority Robert R. Barrett, it's an agreeable return to the Tarzan films of the 1930s—even if it has little to do with Burroughs' original novels.

The first feature-length animated Tarzan came to the screen in 1999, courtesy of Walt Disney Pictures. Voicing the roles were Tony Goldwyn as Tarzan, Minnie Driver as Jane Porter, Glenn Close as Kala, and Lance Henriksen as Kerchak. This 48th movie adaptation—one of Disney's last successful hand-drawn animation features—offers perhaps the weirdest-looking Tarzan the movies have yet given us. His posture is stooped and his muscles and joints are deformed. He moves in a simian way, supported mostly by knuckles and toes. He has beady eyes, no lower lip, and an oddly pointed chin. There is a particularly nice touch when, upon first confronting Jane, Tarzan places his bent-knuckled hand on hers; and slowly his fingers straighten up to conform to hers—the simian nature yielding to his human state. Some of the poses and aerial choreography recall the great Tarzan illustrators Burne Hogarth and Frank Frazetta. The jungle tree-swinging sequences are superbly conceived and executed, including Kala's rescue of the baby Tarzan from the rampaging leopard, Tarzan's rescue of Jane from the baboons, and Tarzan's aerial combat with the leopard.

As far as the story goes, there is no mention of Tarzan's aristocratic ancestry and title. Unlike the book, where the infant Tarzan is born in the jungle, here he is already several months old when his family arrives. Whereas Burroughs had the mother die insane and father perish at the hands of Kerchak, the parents are killed offscreen by a marauding leopard. And whereas Tarzan had to kill Kerchak to assume leadership in the tribe, here his status is conferred on him after Kerchak is fatally wounded by a white hunter. The story's ending is entirely altered. It will be recalled that in the book Tarzan grows disaffected with his jungle ways and, after teaching himself to read and write fluent English, goes to Paris and eventually follows Jane to America, where his proposal of marriage is rejected. Here, Tarzan remains in the jungle and invites Jane and her father to remain with him there.

REFERENCES

Barrett, Robert R., "Tarzan and the Lost City," *The Gridley Wave* 188 (May 1998); Essoe, Gabe, *Tarzan of the Movies* (Citadel Press, 1968); Griffin, Scott Tracy, "Tarzan, Jungle Warrior," *Cinefantastique*, 30:1 (May 1998), 34–35; Porges, Irwin, *Edgar Rice Burroughs* (Brigham Young University Press, 1975); Tibbetts, John C., "A New Screen Tarzan," *Films in Review*, June–July 1984, 360–64.

—*J.C.T.*

TENDER IS THE NIGHT (1934)

F. SCOTT FITZGERALD

Tender Is the Night (1962), U.S.A., directed by Henry King, adapted by Ivan Moffat; Twentieth Century-Fox.

The Novel

The 1934 published version of *Tender Is the Night* includes revisions of the novel from its serialization in *Scribner's* magazine earlier that year. Malcolm Cowley edited and published a third version (1951), which represents some of Fitzgerald's planned changes in the novel's tone and structure—most significant, Fitzgerald had decided to reorganize the plot chronologically, rather than starting it in medias res. Despite three separately published editions, no definitive Fitzgerald text exists, since up until his death he was still in the process of reforming it. The novel, for all its potential, never became the "masterpiece" Fitzgerald had wanted.

Dick Diver is an American psychiatrist in Europe at the end of World War I; his beautiful patient Nicole Warren falls in love with him (her schizophrenia resulted from an incestuous relationship with her millionaire Chicago father). Although Dick loves her, their relationship is precariously founded on a patient-psychiatrist relationship that her family, specifically her sister Baby, encourages him to continue. Dick and Nicole live an expensive party life on the Riviera. Their friends include alcoholic composer Abe North, later killed in a Paris bar brawl, and Frenchman Tommy Barban, who becomes Nicole's lover. Dick and the young American starlet Rosemary Hoyt fall in love (the 1934 version opens with these scenes, told from Rosemary's point of view). In the end, Dick loses Nicole, his reputation, his livelihood, and Rosemary; he returns to an empty life as a general practitioner in upstate New York.

The Film

Fitzgerald in 1934 wrote a 10,000-word treatment, but his coscenarist Charles Warren was unable to market the property; the Goldwyn organization also prepared a film treatment, but nothing ever came of it. British modernist novelist Malcolm Lowry (with his wife) wrote an extensive film treatment. David O. Selznick bought the film rights but completely ignored the Lowry script, instead commissioning Moffat, whose screenplay formed the basis for King's adaptation at Twentieth Century-Fox where Selznick sold the film rights (and lost control of the project). Among his 100 previous films, dating back to 1916, King's work had included such literary adaptations as *The Sun Also Rises*, *The Snows of Kilimanjaro*, *A Bell for Adano*, *Twelve O'Clock High*, *The Gunfighter*, and *Love Is a Many Splendored Thing*. This would be his last film (and Selznick's also). Given three extant versions, Moffat had great latitude in how he could "justifiably" structure the

film, but his changes outraged critics. Edward Murray, for instance, points out the absurdity of having Selznick's 42-year-old wife Jennifer Jones play Nicole, who, like Rosemary, is in her late teens in the novel.

Despite the novel's having been thematically and stylistically influenced by cinema, King's adaptation fails to capture Fitzgerald's filmic sensibility, much less the novel's complex psychological portrait of the Divers. Critics have found the film "overlong and superficial," "sluggish and unflavorable." Murray summarizes: "[Moffat] leaves out everything that makes *Tender Is the Night* different from everything else ever written. If, in adapting a great novel, you alter its structure, change its point of view, omit its style, strip away its levels of meaning, distort its characters, cast the film all wrong—what becomes of the film's 'idea'?" Roy Pickard, however, defends the film as a "faithful and literate" adaptation, an argument that historian Gene D. Phillips supports, especially when comparing Moffat's screenplay to either Fitzgerald's or Lowry's.

REFERENCES

Latham, Aaron, *Crazy Sundays: F. Scott Fitzgerald in Hollywood* (Pocket Books, 1972); Lowry, Malcolm and Margerie Bonner Lowry, *Notes on a Screenplay for F. Scott Fitzgerald's Tender Is the Night*, Matthew J. Bruccoli, ed. (Bruccoli-Clark, 1976); Murray, Edward, *The Cinematic Imagination: Writers and the Motion Pictures* (Frederick Ungar, 1972); Phillips, Gene D., *Fiction, Film, and F. Scott Fitzgerald* (Loyola University Press, 1986); Pickard, Roy, "The Tough Race: The Films of Henry King," *Films and Filming* (September 1971): 38–44.

—D.G.B.

TESS OF THE D'URBERVILLES (1891)

THOMAS HARDY

Tess of the d'Urbervilles (1913), U.S.A., directed by J. Searle Dawley; Famous Players Film Company.

Tess of the d'Urbervilles (1924), U.S.A., directed by Marshal Neilan, adapted by Dorothy Farnum; Metro-Goldwyn Pictures.

Tess (1980), France, directed by Roman Polanski, adapted by Polanski, Gerard Brach, John Brownjohn; Renn/Burrill/Columbia.

The Novel

Tess of the d'Urbervilles, one of the last novels Thomas Hardy wrote before giving up fiction entirely, has a complicated publishing history. Hardy first offered his manuscript, in serial form, in October 1889 to *Murray's* magazine and later to *Macmillan* magazine, but it was rejected by each because of its "improper explicitness." With two previous rejections, Hardy cut the baptism scene and the seduction chapter and submitted the remainder to *The Graphic* where it was accepted for serial publication beginning in July 1891; the American version appeared in

Thomas Hardy

ence on people's lives. The novel begins with Jack Durbeyfield, a simple tenant farmer who learns that he is descended from the famous d'Urberville family. Never a hard worker, Durbeyfield declares himself too good to work. Durbeyfield's wife hatches a plan to send her daughter, Tess, to meet with their rich relations, the Stoke-d'Urbervilles, in the hope that Tess's beauty can bewitch a wealthy male cousin into marriage. Only after Tess accidentally kills Prince, the family horse, does she agree to meet with Alec Stoke-d'Urberville, the son of the family who has assumed the d'Urberville name. After tricking Tess into service as his mother's poultry maid, Alec later rapes her. Pregnant, Tess returns home to work in the fields, constantly stalked by Alec. Tess manages to escape Alec long enough to give birth to her daughter, Sorrow, who dies shortly thereafter. Several months later, Tess finds work on a dairy farm where she meets Angel Clare, a minister's son and apprentice farmer, with whom she falls in love and, despite feeling unworthy, agrees to marry him without successfully disclosing her past. On their wedding night, Angel confesses his past, which prompts Tess to do the same. While Tess forgives Angel, he cannot do the same and rejects her to live in Brazil. Alone again, Tess and her family become destitute and Alec reappears. Although Tess tries to contact Angel in a letter in the hope that he will rescue her from Alec, the letter does not reach Angel in time. In the interim, a desperate Tess succumbs to Alec's desires. When Angel returns, Tess is already unhappily living with Alec as his wife. When Tess learns Angel has come for her, she stabs Alec and flees with Angel, who forgives her even for the murder, and together they spend a few happy days before Tess is hanged publicly for Alec's murder.

The Films

The 1913 film of *Tess of the d'Urbervilles* was directed by J. Searle Dawley and was among the first productions of the Famous Players Film Company. Dawley stayed fairly close to the events as they transpired in the novel except that Tess was imprisoned for Alec's murder rather than hanged. The 1924 film adaptation was a silent version set in modern times with telephones, cars, and contemporary 1920s fashions and starred Blanche Sweet (wife of director Marshall Neilan) as Tess, Conrad Nagel as Angel Clare, and Stuart Holmes as Alec Stoke-d'Urberville. Later David Selznick bought the screen rights to the movie along with *Gone With the Wind*, but never made the Tess film.

Roman Polanski obtained the rights for the movie from the Selznick estate and began working on the film in 1978. Shot in France and highly touted for its cinematography, Polanski's 1980 film, *Tess*, has had largely favorable reviews. Polanski strives to be painstakingly faithful to Hardy's novel, even to the point of incorporating dialogue verbatim. Although the complexity through metaphor and symbolism is not wholly captured in the film, the film does

Harper's Bazaar. Hardy had no artistic quarrel about censoring his own work, partly because he considered fiction an inferior art form to poetry. Perhaps more importantly, Hardy planned to reintegrate the missing sections and chapter into the *Tess* manuscript for book form. He cared little how it got published, just that it did.

Hardy's *Tess* received a flurry of critical attention, most of it sensational and missing the point. Sought after by famous actresses to play the part of Tess on the stage Hardy wrote a stage adaptation for actress Minnie Maddern Fiske, but she found it too bookish and hired Lorimar Stoddard to write another version of the play, which opened in New York on March 2, 1897. There were several other stage versions including an opera adapted by Baron Frederic d'Erlanger and performed in Naples on April 10, 1906.

After the publication of *Jude the Obscure*, which received more negative attention than even *Tess*, Hardy decided to give up writing fiction entirely and devoted the remainder of his life to writing poetry.

Tess of the d'Urbervilles has all the elements of Greek tragedy and relies heavily on the idea of fate and its influ-

succeed in depicting the essential tragic quality of Tess and her victimization at the hands of fate and of men.

Much of the criticism of Polanski's movie concerns the characterization of Tess. Many critics complain that Polanski's Tess, Nastassja Kinski, while beautiful and captivating in her own right, is too childlike, submissive, and withdrawn to be the strong, intelligent, and resilient Tess of Hardy's novel. There are some differences between Polanski's version and Hardy. The film reverses the first two scenes of Hardy's novel so that the May dance is first and the scene in which her father learns of his heritage from the parson is second. Polanski also leaves out Alec's stalking of Tess so that her anxiety and distress cannot be fully understood by the audience. Moreover, in the novel Tess is asleep when Alec rapes her but is awake in the film version, so the rape is less clear. Some of the gothic aspects of the novel are omitted in the film version, such as Angel's dream of carrying a death-shrouded Tess into an empty coffin or portraits that resemble Tess in the ancestral mansion. Despite these incidental omissions, Polanski captures the desperate tragedy of Hardy's novel in a cinematic triumph.

REFERENCES

American Film Institute, *The American Film Institute Catalog of Motion Pictures Produced in the U.S.* (University of California Press, 1988); Orel, Harold, *The Unknown Thomas Hardy: Lesser-Known Aspects of Hardy's Life and Career* (St. Martin's Press, 1987); Veidemanis, Gladys V., "Tess of the D'Urbervilles: What the Film Left Out," *English Journal* 77, no. 7 (November 1988): 53–57; Waldman, Nell Kozak, "'All that she is': Hardy's Tess and Polanski's," *Queens Quarterly* 88, no. 3 (autumn 1981): 429–36.

—*J.L.D.*

THÉRÈSE RAQUIN (1867)

EMILE ZOLA

Thérèse Raquin (1915), Italy, directed by Nino Martoglio.

Thérèse Raquin (Du sollst nicht ehebrechen) (1928), France-Germany, directed by Jacques Feyder, adapted by Feyder, Fanny Carlsen, Willy Haas; Defa, Selznick (Berlin).

Thérèse Raquin (1953), France, directed by Marcel Carné, adapted by Carné and Charles Spaak; Paris-Films Production/Lux Films.

The Novel

Written in 1867, *Thérèse Raquin* is Zola's first naturalist novel. Convinced that the influence of the environment was paramount, Zola held the laws of heredity (recently proclaimed in 1847 by Dr. Prosper Lucas) to be the sole constituting forces of an inescapable fate for individuals. With *Thérèse Raquin*, Zola proceeded to write the first installment of a fictitious family saga in the 19th century: the Rougon-Macquart family. As a first novel *Thérèse Raquin* would both show his place as a practical sociologist and lead to his conception of a new "experimental novel," based on social and scientific beliefs relating to the crucial influence of the environment.

Unhappily married to the provincial Camille Raquin, Thérèse falls in love with the handsome Laurent. Enthralled with this new love, Thérèse discovers a short and instantaneous passion, which later turns to horror when the two lovers in desperation decide to drown Camille. They will later marry but their happiness will not last. Remorse overcomes them both and insanity is the result of the silent reproach of Thérèse's invalid mother-in-law, Mme. Raquin, who knows the whole truth. Unable to tolerate the memory of the murder, Laurent and Thérèse finally poison themselves in a dual suicide.

The Films

Set in a series of mostly aquatic places, Martoglio's *Thérèse Raquin* deeply influenced the Italian neorealism film school. With *Sperduti Nel Buio*, Martoglio was to become one of the forefathers of the neorealists. Boasting Second Empire costumes, this version disappeared in 1944 during the Nazi retreat.

By contrast, it is generally assumed by critics that Jacques Feyder's lost version was the most successful of the silent film versions. With an efficient and carefully planned script, the Belgian-born Feyder was able to recreate the pettiness of Thérèse's environment, turning his audience against the sterile and enslaving milieu that led to the crime. In the first part, Feyder framed the dramatic plot by foregrounding Thérèse's bourgeois surroundings, and in the second part he constructed dramatic suspense around the invalid mother-in-law's silent accusation. Consequently, Feyder prepared his audience for the ambiguous yet fatal obsession of a sensual love that emerges in revolt against a disintegrating environment. Shot in Berlin in 1928, Feyder's movie captured Zola's characters, not just by a naive portrait of their irregularities of blood and nerves, but also by means of the provincial atmosphere that created them. Few movies of the twenties were as efficient in transcribing Zola's setting of humanity's fate and determinism. This prewar remake of Zola's most famous novel operated most ideally in revealing Zola's naturalist medium. The most important merit of Feyder's *Thérèse Raquin* was apparently the force of its decor, which provided an adequate frame of reference for a world containing powerful elements of criminality.

Even more impressive is Marcel Carné's *Thérèse Raquin*, which is considered his best postwar movie. The dramatic plot of this 1953 version was freely adapted by Charles Spaak from Zola's novel. The action takes place in Lyon around 1950. Laurent is an Italian truck driver who kills Camille by throwing him out of a train. Thérèse is later blackmailed by a legionnaire recently returned from Indochina. Though the blackmailer will die accidentally, a maid will denounce the lover's conspiracy. A mean suburban

mood afflicts characters with what is perhaps the strongest dramatic aura, so that the lovers' gruesome murder of Camille seems to be a logical response to the degradations of the decor. Simone Signoret and Jacques Duby both provide a poignant rendering of a hopeless love, desperately trying to find a better reality.

More daringly, Carné's version exemplifies an expressionist form of realism, a "social fantasy" that had almost been exhausted by French directors in the thirties. In 1953, Carné's *Thérèse Raquin* received a prize (the Silver Lion) at the Venice Film Festival. Mostly shot in Lyon and in studios in suburban Paris (Neuilly), this movie's greatest merit was the emotional intensity of Simone Signoret and Jacques Duby. Both actors brought an intricate plot to high dramatic pitch, enabling the audience to anticipate the tragic outcome. But Carné's strength is also what earned him the ironic contempt of François Truffaut, who somehow identified him with the technician type of directors, the self-effacing minds who let their films be dominated by powerful scripts. As an ardent believer of proletarian values, Carné taunted conservatives with his humane themes. His films aimed at expressing popular feelings, such as love, children's innocence, and the simple joys of soldiers' and workers' lives.

Like René Clair, whom he assisted at the beginning of his career, Carné aims at visually representing popular reality. Historically, he follows the cinematographic movement of poetic realism, of which Renoir's early films gave excellent examples. Carné shoots with an engaged heart, and his cinematic style best captures Zola's social dedication to individuals fighting against an overwhelming fate.

REFERENCES

Bachy, V., *J. Feyder, artisan du cinéma* (Louvain, 1968); Carné, Marcel, *La Vie à belles dents* (Belfond, 1989).

—C-A.L.

THEY SHOOT HORSES, DON'T THEY? (1935)

HORACE MCCOY

They Shoot Horses, Don't They? (1969), U.S.A., directed by Sydney Pollack, adapted by Robert E. Thompson and James Poe; ABC-Palomar/Cinerama.

The Novel

Horace McCoy originally wrote *They Shoot Horses, Don't They?* as a screenplay, but it took 38 years and several transformations for his story to reach the screen. In 1932, having failed to place the script with a studio, McCoy turned it into a short story; by 1933, he had a draft of the novel. *They Shoot Horses, Don't They?* is set at a marathon dance in Hollywood in the early 1930s, during the Great Depression. In the transition from short story to novel, McCoy cut the most specific references to the depression, focusing on the more universal qualities of human suffering and exploitation. The novel begins with the courtroom sentencing of Robert, who has shot Gloria, his dance partner. As the judge pronounces sentence, Robert recalls the events that led to his mercy killing of Gloria, with the judge's sentence interspersed a few words at a time between each chapter. As the marathon dance unfolds, Gloria's despair grows, yet their friendship deepens through their shared ordeal. After almost 900 hours, the promoters shut down the contest when Robert and Gloria's sponsor for the marathon is killed by a stray bullet during a fight. Having lost all hope for the future, Robert acquiesces to Gloria's plea to shoot her. In the back of a patrol car headed to the police station, a policeman asks Robert why he killed Gloria, to which he responds, "They shoot horses, don't they?" The novel ends with the final words of the judge's death sentence, ". . . may God have mercy on your soul."

The Film

The publication of *They Shoot Horses, Don't They?* propelled McCoy to a screenwriting career that lasted over 20 years and encompassed about 100 screenplays. Despite McCoy's success in the film industry, he did not live to see his novel made into a film. Producers continually retreated from the project, deeming it too depressing for American audiences. Screenwriter James Poe bought the film rights to the novel—which had passed through many hands in the previous years, including those of Charlie Chaplin—with the intention of making it his directorial debut. But as the project gained support from ABC Pictures and picked up bigger name actors such as Jane Fonda, the studio replaced Poe with Sydney Pollack as director. Although Poe received shared credit for the screenplay, Robert E. Thompson substantially rewrote it.

The film stays fairly close in spirit to the intention of the original. In order to increase the sense of immediacy, Pollack depicts the marathon dance in the present and the trial is shown as a flash-forward. He spatially limits the scenes at the marathon dance to the dance hall to intensify the feeling of claustrophobia. The role of the emcee, Rocky, is expanded to further develop his cynical attempts to exploit the contestants. Unlike the novel, in which the sponsors shut down the marathon dance because of pressures from a lobbying group and a murder on the premises, when the film concludes the contest continues on, a neverending survival-of-the-fittest.

Although Pollack was nominated for an Academy Award for best director for *They Shoot Horses, Don't They?* critics were ambivalent about the film. Some felt that the film encouraged audiences to find pleasure in the pain of the contestants, a pleasure as sadistic as that of the original marathon dance spectators. Pollack claims that this was

precisely his intention: "Everyone who sees *Horses* is right there at the marathon cheering on the dancers. That's why the audience is so uncomfortable. They came to watch people suffer in the movie just like the audience came in the 'thirties' to see people suffer in the marathon." The film is completely successful in capturing the atmosphere of the marathon dances and in suggesting that such contests were emblematic of the societal desperation of the depression.

REFERENCES

Erens, Patricia, "Sydney Pollack: The Way We Are," *Film Comment* 11, no. 5 (1975): 24–29; Tuska, Jon, *The Contemporary Director* (Scarecrow Press, 1981), 26–30.

—R.K.

THINGS TO COME

See THE SHAPE OF THINGS TO COME.

THE THIN MAN (1934)

DASHIELL HAMMETT

The Thin Man (1934), U.S.A., directed by W.S. Van Dyke, adapted by Frances Goodrich and Albert Hackett; MGM.

The Novel

The length of Dashiell Hammett's artistic flowering is inversely proportional to his subsequent fame as one of the founders of hard-boiled detective fiction; all of his five novels were published between 1929 and 1934. *The Thin Man* is Hammett's fifth and final novel, written after *The Maltese Falcon* and *The Glass Key* had brought him to the attention of Hollywood and allowed him to begin a lucrative, if erratic, screenwriting career. Hammett began *The Thin Man* in May 1931 while living in New York and finished it a few months later in Los Angeles at a time when, according to Lillian Hellman, his primary motivation was making some money.

The novel is set in December 1932 and early 1933. The two main characters are Nick and Nora Charles—a fun-loving, sophisticated, upper-middle-class married couple who like to spend their time drinking and engaging in clever conversation. Nick narrates the novel. His and Nora's gay lifestyle is interrupted when they visit New York for the holidays (having resided in California for the last several years after Nick's retirement from the detecting business) and become entangled in crimes perpetrated both upon and by some former acquaintances.

These former acquaintances include the Wynant family, who are self-centered, scheming, and prone to lying. The father, Clyde Wynant (the "thin man" of the title), has vanished. His secretary Julia Wolf (for whom he left his wife) is found murdered, and Wynant is number one on the list of suspects. His ex-wife Mimi hovers around, hoping to get his money. His daughter likes to drink, date, and worry about becoming "insane" like her father. His son reads lots of books and has a morbid, detached curiosity about the evils of life.

Nick is adamantly disinterested in the case, but a number of circumstances (such as his being shot at) prompt his participation in it. Eventually a body is discovered buried in Wynant's shop. Nick develops a theory that the body is Clyde Wynant. Apparently, Herbert Macauley, Wynant's lawyer, had killed him several months earlier when Wynant discovered that Macauley and his secretary, Julia Wolf, had been cheating him. Macauley then had to kill both Wolf, because he was afraid she might spill the beans, and a man named Arthur Nunheim, because he saw Macauley kill Wolf.

The Film

The Thin Man was a very financially successful film and spawned five sequels. The initial film follows the novel fairly closely, with a few notable changes. While Clyde Wynant never appears in the novel, the film begins with him having meetings with his daughter and her fiancé (the Dorothy in the novel has no fiancé), his lawyer, and Julia Wolf, whom he confronts about some bonds that are missing. And in another change from the novel, the mystery is solved when Nick and Nora hold a "suspect dinner party." The police round up all the suspects and then Nick spearheads a talk-fest until he is able to determine that Macauley is indeed the guilty party.

The most striking difference between the film and novel is one of tone. Literary critics have referred to the novel as a "dark vision." George Thompson describes Nick's persistent attempts to remain aloof from Julia Wolf's murder case as resoundingly nihilistic, especially in comparison with Hammett's earlier novels: "Nick Charles has given up. The fact that Hammett's characters become mutilated in their struggle to *become* (like Beaumont [in *The Glass Key*]) or to preserve what they are (like Spade [in *The Maltese Falcon*]) is in itself a kind of existential exaltation. But with Nick Charles the struggle has ceased, and with its cessation, Hammett implies, the dignity that was once man's."

The rapport and repartee between Nick and Nora helps to suppress the generally nihilistic tone of the novel. It is this rapport upon which W.S. Van Dyke decided to build the film. According to Van Dyke's biographer, "It wasn't the detective angle he was thinking of at all—the characters in the story were the important thing. He told L.B. Mayer that all he wanted was a series of six or seven cute homey scenes between husband and wife . . . and the interruptions of their matrimonial bliss as a result of the Mr.'s being a private sleuth."

The year *The Thin Man* was produced—1934—was the first year that the now-notorious Production Code was enforced. This helped transform Hammett's "dark vision" into one of the first screwball comedies. Even the novel's villains were toned down; Hammett's manipulative, angst-ridden Dorothy Wynant became director W.S. Van Dyke's sweet, redeemable Dorothy Wynant, and Mimi no longer beat her daughter Dorothy black and blue when it suited her. The ironic despair of the novel is replaced by the upbeat escapism of depression-era Hollywood.

What does make the transfer from paper to celluloid, however, is the essence of the Charleses' relationship. Although the cinematic Nick and Nora may be nicer and a little more concerned about helping the world than their novelistic counterparts, William Powell and Myrna Loy *are* the Nick and Nora of Hammett's novel. They are quick-witted and affectionate toward one another. Though Nick is physically protective of Nora, he keeps her informed about the case and values her input. Both the film and the novel, then, can be appreciated from a feminist standpoint. Nora can be regarded as Hammett's only intelligent and sympathetic female character, and she is also notable as one of the first screen heroines to have her own identity as well as a happy marriage based on both mutual respect and intellectual equality.

REFERENCES

Cannom, Robert C., *Van Dyke and the Mythical City, Hollywood* (Murray & Gee, 1948); Marling, William, *Dashiell Hammett* (Twayne Publishers, 1983); Metress, Christopher, ed., *The Critical Response to Dashiell Hammett* (Greenwood Press, 1994); Sikov, Ed, *Screwball: America's Madcap Romantic Comedies* (Crown Publishers, 1989).

—*H.A.*

THE THIRTY-NINE STEPS (1915)

JOHN BUCHAN

The 39 Steps (1935), U.K., directed by Alfred Hitchcock, adapted by Charles Bennett; Gaumont-British.
The 39 Steps (1959), U.K., directed by Ralph Thomas, adapted by Frank Havey; Rank.
The Thirty-Nine Steps (1978), U.K., directed by Don Sharp, adapted by Michael Robson; Rank.

The Novel

John Buchan wrote *The Thirty-Nine Steps* in 1914 while ill in bed during the first few months of World War I. A novelist, biographer, historian, essayist, and politician, Buchan wrote this novel—the first of five with Richard Hannay as protagonist—at a time when British fears of foreign invasion were widespread. As in *The Thirty-Nine Steps*, his "shockers" (as he called them) describe intrusions into a complacent world (usually upper-middle-class England) of unexpected events that threaten its security.

Divided into 10 episodic chapters, Buchan's novel describes the adventures of Richard Hannay, a 37-year-old, wealthy Scot "bored with life" until he finds himself a "hunted man." Returning to London from abroad, Hannay befriends an American journalist named Scudder who tells of a plot by a group of educated anarchists to assassinate the Greek prime minister on an upcoming visit to England. After he finds Scudder murdered in his flat, Hannay flees to Scotland, fearing both that he will be the prime suspect and that the real murderers may hunt him down next. The plot thickens when he discovers in Scudder's notes that the anarchists also plan to steal government secrets about the Royal Navy, which could lead to an invasion from abroad. Hannay eludes both the police and the foreign spies by cleverly disguising himself and hiding out with innkeepers, politicians, archaeologists, and sheepherders. Finally, Hannay figures out that Scudder's cryptic note ("Thirty-nine steps—I counted them—High tide 10:17 p.m.") refers to the location of the anarchists' beach house. Armed with his information, the police arrest the conspirators, and Hannay declares proudly that even before the outbreak of the war, "I had done my best service."

The Films

Buchan's novel no doubt appealed to Hitchcock's sense of drama, which he called "life, with the dull bits cut out." Like so many Hitchcock films—e.g., *The Man Who Knew Too Much* (1934, 1956), *Young and Innocent* (1937), *Saboteur* (1942), *North by Northwest* (1959), and others—*The 39 Steps* follows the travails of a man who stumbles into a situation that threatens not only his own life but possibly the security of an entire nation. Charles Bennett's screenplay captures that element of Buchan's novel, but little else remains untouched by Hitchcock's influence in the film that Donald Spoto says may be his first "indisputable masterpiece." The scenario is vastly different from Buchan's novel, although some basic elements remain nearly the same: Hannay learns from a female agent of a ring of spies called "the 39 steps." She's murdered with Hannay being suspected, then he sets out to prove his innocence and expose the evildoers. The most prominent additions to the story include Hannay's encounter with Pamela, the prototypical Hitchcock blonde who helps Hannay (reluctantly at first) through his madcap adventures, and the plot device of the missing finger of Mr. Jordan, one of the spies.

The 39 Steps marks an important turn in Hitchcock's work for several reasons. First, as William Rothman notes, in Richard Hannay (Robert Donat) we have a hero with whom the audience identifies willingly. Hannay has no dark secrets, nor are we led to suspect any. The film opens with the camera following a man into a music hall/theater; he takes a center seat, then we see him framed frontally, centered both in the theater and in the frame, thus taking center-stage in the narrative. This sequence, which includes the stage "turn" of "Mr. Memory," will recur at

the end of the film. Second, the film emphasizes theatricality; Hannay assumes various disguises throughout the film, including a milkman, an auto mechanic, a politician, and a newlywed. These shifting identities suggest the ease with which people mask clear distinctions between appearance and reality, between the self and "other." In this regard, *The 39 Steps* anticipates later films like *Vertigo* and *Psycho* in its complication of psychological unity and, of course, follows in the tradition of disguise and deception that marked Shakespearean drama. The film presents a classic Hitchcockian theme, that beneath the surface of impressions available to perception there lies a hidden but not inaccessible psychological world marked by suspicion, dread, and desire.

Third, the structure of *The 39 Steps* anticipates the "double" plots of his later films, notably *Vertigo* and *Psycho*. In those films, major characters with whom we identify die untimely but predestined deaths ("Madeline" and Marian Crane) barely halfway into the film; in the second half of these films, Hitchcock resurrects doubles (Judy and Lila Crane) who fill the narrative void, allowing for new identifications to form. Halfway through *The 39 Steps*, Hannay is shot by Professor Jordan, and the screen fades to black, symbolizing his death. But by chance Hannay survives; the bullet was stopped by the hymnal in his coat pocket. From this point forward, we construct a new Hannay; this time he's not a wayfaring bachelor but a man handcuffed to a beautiful woman he doesn't trust, a character now in a romantic comedy, not a suspense thriller.

The latter half of the film picks up the familiar Hitchcockian glance on male-female relationships. A precursor of Lisa Fremont in *Rear Window*, Pamela (Madeleine Carroll) plays the seemingly innocent blonde who has been introduced to dark and secret plots by a male who would rescue or subdue her. Hitchcock contrasts their developing relationship with the situations of the three other married couples in the film: Margaret and her abusive husband, John; the servile Mrs. Jordan and Professor Jordan; and the romantic-minded innkeepers. (Such a dialectic of competing perspectives also animates *Rear Window*.) At the end of the film, after the climactic "confession" scene with Mr. Memory, Pamela's elegantly gloved hand gently grasps Hannay's still-cuffed wrist. This final shot is, in the opinion of historian Maurice Yacowar, a consummate Hitchcockian metaphor for the imminent rapprochement of Hannay's outsider status and Pamela's more elegant, conventional world. Indeed, "the last shot is a tidy summary of the disparate themes of the film and something of a romantic conclusion . . . [but] which stops short of total assurance."

Two subsequent British versions have been made. The first, a contemporary, color update directed by Ralph Thomas and adapted by Frank Harvey, has fallen into obscurity and is difficult to locate. According to James R. Parish and Michael R. Pitts in *The Great Spy Pictures*, the "suspense" and "wit" of Hitchcock is missing; and "only a good cast [Kenneth More and Taina Elg] kept this British

remake from sinking into oblivion." Bowing to both Buchan and Hitchcock, it "followed the original storyline closely and even tried to duplicate Hitchcock's thematic and scene shot breakdowns, but all to little avail."

The second, directed by Don Sharp and adapted by Michael Robson, is set in pre–World War I England. Due to its dismal box-office performance, it lapsed into obscurity for several years, but has recently surfaced on laser disc. The character of Mr. Memory is absent, as are the handcuffs with which Hitchcock had such erotic fun. Moreover, the "39 Steps" tag has been replaced by a literal reference to the location of a flight of steps.

REFERENCES

Parish, James Robert, and Michael R. Pitts, *The Great Spy Pictures* (Scarecrow Press, 1974); McDougall, Stuart Y., "Mirth, Sexuality and Suspense: Alfred Hitchcock's adaptation of the *Thirty-Nine Steps*," *Literature/Film Quarterly* (summer 1975): 232–39; Yacowar, Maurice, *Hitchcock's British Films* (Archon Books, 1977).

—D.B.

A THOUSAND ACRES (1991)

JANE SMILEY

A Thousand Acres (1997), U.S.A., directed by Jocelyn Moorhouse, adapted by Laura Jones; Beacon Communications Corp/PolyGram Filmed Entertainment.

The Novel

The plot of Jane Smiley's novel, borrowed from Shakespeare's *King Lear*, is set in motion when Larry gives away the farm, dividing it between his two daughters, Ginny Cook Smith (Jessica Lange) and Rose Cook Lewis (Michelle Pfeiffer). Both are made far more sympathetic when they later turn against their father than Goneril or Regan could ever be. In Shakespeare's play the daughters are evil and uncaring, defined by their greed and ambition and by their lust not only for power but also for Edmund, the bastard son of the earl of Gloucester. In Smiley's modern-day version, they are daughters, not tigers, and abused daughters at that. Both were sexually molested by their father while growing up. Rose, moreover, is a cancer victim. Since they have been clearly wronged by their father, they have motives for treating him as they do, unlike their Shakespearean counterparts.

Larry proposes, quite unexpectedly, to turn the family farm—the largest in the area, encompassing 1,000 acres—into a corporation that will be split three ways among his daughters, Ginny and Rose and their husbands Ty Smith (Keith Carradine) and Peter Lewis (Kevin Anderson), and Caroline Cook (Jennifer Jason Leigh), the youngest, and Cordelia's counterpart. Caroline has left the farm to become a lawyer, and, unlike her sisters who think Larry's scheme is a great idea, she ever so quietly expresses

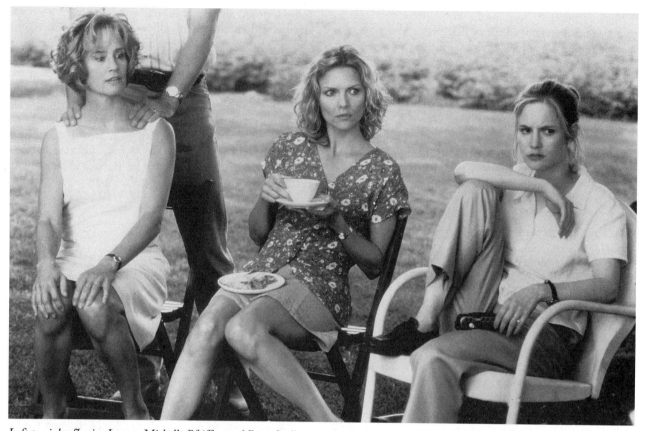

Left to right: Jessica Lange, Michelle Pfeiffer, and Jennifer Jason Leigh star as sisters whose unspoken rivalries and long-guarded secrets surface when the family farm is divided among them, in A Thousand Acres. (1997, U.S.A.; THE LITERATURE/ FILM ARCHIVE)

reservations about her father's intentions. That's Cordelia's fatal flaw, but in Smiley's story it's not fatal at all, merely bothersome.

All Caroline says is "I don't know." The father, who has had too much to drink at a pig roast given by his neighbor Harold Clark (Pat Hingle) in honor of the return of his prodigal son Jess (Colin Firth), responds in anger, "You don't want it, my girl, you're out! It's as simple as that." And she is disinherited on the spot. "My father's pride, always touchy, had been injured to the quick," Ginny explains in the novel, but in neither the novel nor the film does Larry's anger approximate the tragic rage of Shakespeare's Lear. Caroline spends the night with Rose after her run-in with her father. When she goes to see Larry the next day, he closes the door in her face, so she returns to Des Moines.

After he has given up the farm, Larry becomes moody and despondent and drinks himself into dementia. Ginny and Rose worry about him, and Ginny threatens to take away the keys to his pick-up truck after a drunken outing. A storm is brewing that night and Larry walks away from his house into the storm, vowing to live with Harold Clark. Before long, Jess Clark, the prodigal hippie, moves into Larry's house and has affairs, first with Ginny, then with Rose. Jess turns out to be a "bastard," but he is not

illegitimate. He doesn't betray his father as Edmund does Gloucester in the Shakespeare play. He doesn't have Edmund's motives. He is simply a self-indulgent, manipulative jerk and homewrecker. Aware that he has been cuckolded, Rose's husband gets drunk, wrecks his truck, and dies. It is no great loss, since he had been abusive (and was made a very shadowy character in the film).

Ginny's husband Ty goes to Des Moines and tells Caroline that her sisters have treated their father badly. Caroline takes her father to court to sue Ginny and Rose—litigation replacing the warfare of Shakespeare's play. The judge rules that Larry's case is not justified after Larry reveals himself to be insane and incoherent when giving his testimony. The litigation bankrupts Ty, and after Ginny's infidelity is revealed, Ginny goes to the city to work as a waitress, while Rose stays on to look after the failing farm. Ultimately the farm fails and Rose dies, falling victim to cancer. Families are destroyed, and the kingdom is in ruins.

The Film

Despite the promotional chatter surrounding the film's release, viewers should not expect to find a modernized

King Lear in this movie, since, after all, there are no kings in Iowa these days. Though Jane Smiley's 1991 novel lifts its plot design from Shakespeare's greatest play, the weight placed on the characters in the film is far different. The millionaire farmer, Larry Cook (Jason Robards), who makes a bad decision and later becomes a crazed and pathetic image of his former self, is not really the central character. Something is seriously amiss here if this story is merely a reworking of the Lear plot, which works better in the novel than in the dramatized and flattened-out version the film provides.

The film attempts a faithful adaptation of the novel as Jessica Lange's voice-over narration leads the viewer through the story. According to *USA Today*, "Smiley's book was the bible on the set," but Lange expected criticism from readers "because key scenes are deleted and the male roles are downplayed." Both Lange and Pfeiffer "committed to the film before deciding which sister each would play." Lange knew and respected the novel and understood that "certain things have to go" when a novel is reduced to a two-hour movie, but she hoped the picture would not "be dismissed as a woman's film in which all the men are 'crummy' and the women 'heroic'" Those hopes would soon be dashed after the film's release.

Despite the filmmakers' good intentions to be true to the book, reviewers were not impressed. Rita Kempley of *The Washington Post* objected to the "skeletal litany of miscarriages, mastectomies, sexual abuse, public humiliations and private betrayals." Although New Zealand screenwriter Laura Jones preserves much of the novel's dialogue and some of Smiley's prose through the narration, the film, directed by Australian Jocelyn Moorhouse, flattens the narrative into what Kempley called "a feminist screed" and turned Larry Cook into what *Washington Times* critic Gary Arnold called a "demented patriarch." Sister Caroline is hardly made endearing by being transformed into a big-city lawyer.

Comparisons were made to *The English Patient* (1996), which took a different approach to the problem of translating an award-winning novel to the screen by transforming the story into an equally powerful work of art, as Ann Hornaday protested in the *Baltimore Sun*: "Rather than make Smiley's story their own, Moorehouse and screenwriter Laura Jones settle for a tepid, visually static rehash, wherein the social issues the author wove into her book are pressed with hot-button force." Janet Maslin of *The New York Times* believed that once the characters of Ginny and Rose became dramatically central, the "talk-show subtext" gives the story "an all-too-modern aspect." Owen Gleiberman of *Entertainment Weekly* objected to the "tangle of 'issues' that includes miscarriage, breast cancer, and spousal abuse (as if incest weren't enough!)." He also objected to the film's manipulation and its "emotional structure, which asks us to see Lange and Pfeiffer caught in a complex storm of sympathy and rage" that is "undercut at every turn by Robards' odious, one-dimensional" performance.

David Ansen of *Newsweek* was not so hostile. He conceded that the film does not do justice to the book, but "anyone in search of a powerful emotional experience, and anyone who wants to see two of the juiciest performances of the year shouldn't miss it," he advised. Moreover, the film does carry a disclaimer pointing out that "dialogue and certain credits and characters contained in the film were created for the purposes of dramatization." Finally, it should be noted that the producers hired an outside editor to rework the film after rejecting the director's cut, which upset Moorhouse to the extent that she threatened to take her name off the film. In other words, the faults of the film might not be the faults of the director.

Although, as one reviewer noted, the filmmakers are occasionally able to make "a family in pain come into vivid focus," in general the film takes the material of high tragedy and reduces it to a cornfield soap opera. The novel does a better job of establishing Larry's dignity and his honored standing in the community, and that is utterly necessary if one is to appreciate the man's decline and fall. The film moves the Lear figure too quickly to the background, while it slathers pity, sympathy, and understanding on Ginny and Rose, who are excellently portrayed by Pfeiffer and Lange. Reviewing the film for *Variety*, Godfrey Cheshire singled out Keith Carradine as Ginny's husband Ty for the film's "standout performance." *Variety* saw Shakespeare as being left "stranded in the high corn" since the film owes more to "the spirit of Oprah than to the Bard." There is a twinned transformation at work here as Shakespeare's play becomes Smiley's Pulitzer Prize–winning novel, which is then, in turn, dramatized on film. But the resonance is lost in this pale imitation of art imitating life. The film is well worth seeing for the performances of Lange and Pfeiffer, but viewers should also read the novel, which will make more sense than this film ever could.

REFERENCES

Ansen, David, *Newsweek*, September 22, 1997, 82; Arnold, Gary, "Bitterness, Incest Make Life on 'Acres' Nasty," *Washington Times*, September 19, 1997, C15; Cheshire, Godfrey, *Variety*, September 15–21, 1997, 69; Gleiberman, Owen, "Sister Sludge," *Entertainment Weekly*, September 26, 1997, 51; Hornaday, Ann, "'A Thousand Acres' Suffers in Screen Adaptation," *Baltimore Sun*, September 19, 1997, E1, E7; Kempley, Rita, "3 Agri Women," *Washington Post*, September 19, 1997, C7; Maslin, Janet, "King Lear (Just Call Him Larry) in Iowa," *New York Times*, September 19, 1997, B12; Snead, Elizabeth, "'A Thousand Acres' Offers a Role Worth Cultivating," *USA Today*, September 18, 1997, D1–2.

—*J.M. Welsh*

THE THREE MUSKETEERS (1844)

ALEXANDRE DUMAS

The Three Musketeers (1914), U.S.A., directed and adapted by Charles V. Henkel; Film Attractions Co.

D'Artagnan (1916), U.S.A., directed by Charles Swickard, adapted by J.G. Hawks; Triangle Film Corp.

The Three Musketeers (1921), U.S.A., directed by Fred Niblo, adapted by Lotta Woods and Edward Knoblock; United Artists.

Les Trois Mousquetaires (1921–22), France, directed and adapted by Henri Diamant-Berger; Pathé.

The Three Must-Get-Theres (1922), U.S.A., directed and adapted by Max Linder; Max Linder Productions.

The Three Musketeers (1935), U.S.A., directed by Rowland V. Lee, adapted by Lee and Dudley Nichols; RKO Radio Pictures.

The Three Musketeers (1939), U.S.A., directed by Allan Dwan, adapted by M.M. Musselman, William A. Drake, and Sam Hellman; Twentieth Century-Fox.

The Three Musketeers (1948), U.S.A., directed by George Sidney, adapted by Robert Ardrey; MGM.

The Three Musketeers and *The Four Musketeers* (1974–75), U.S.A./U.K., directed by Richard Lester, adapted by George MacDonald Fraser; Twentieth Century-Fox.

The Three Musketeers (1993), U.S.A., directed by Stephen Herek, adapted by David Loughery; Walt Disney Pictures.

The Novel

The Three Musketeers is a magnificent tale of 17th-century France written for a 19th-century public by one of the most prolific and remarkable authors in history. Alexandre Dumas *pere*, son of a mulatto French general under Bonaparte and father of Alexandre Dumas *fils* (future author of *The Lady of the Camelias*), sifted through French history for events, figures, and mysterious, not fully explained episodes around which he could weave fictitious plots and characters. In the age of Louis XIII, for example, he surrounded the real-life D'Artagnan—captain of the King's Musketeers, a Gascon gentleman born in 1611 and killed at the siege of Maestricht—with a web of imaginary treachery and intrigue. "What is the use of raping history if you do not produce a child?" he asked.

The Three Musketeers first appeared serially in a Parisian newspaper. Its phenomenal success increased apace when it broke into book form in 1844.

The year is 1625, and young D'Artagnan leaves Gascony for Paris to pursue his great ambition to join the Musketeers of King Louis XIII. His father has given D'Artagnan his old sword, an aging, ridiculous-looking horse, and a letter of introduction to his friend, Monsieur de Treville, captain of the Musketeers. He has enjoined his son to endure nothing from any man, save the king or Cardinal Richelieu (the power behind the throne), and to fight duels often, especially since they are forbidden. En route, D'Artagnan encounters two of Richelieu's agents, the Count de Rochefort and Milady de Winter. Because Rochefort mocks his horse, D'Artagnan challenges him to a duel. But Rochefort's lackeys intervene, knocking the Gascon unconscious.

Later in Paris, Captain de Treville disappoints D'Artagnan when he tells him no one enters the Musketeers without either serving two years in a lesser branch of the military, or by distinguishing himself in feats of valor. After glimpsing Rochefort from Treville's window, D'Artagnan abruptly dashes off to have his duel. Before he can reach his target, however, he finds himself involved with challenges to Musketeers Athos, Porthos, and Aramis. When the three stalwarts learn their foe is this same D'Artagnan, they join ranks and turn their blades against five of the cardinal's guards, who have come to arrest them.

Eventually, D'Artagnan is drawn into courtly intrigues when his landlord, Bonacieux, approaches him for help. His wife, Constance, the seamstress (and faithful confidante) of Her Majesty Anne of Austria, Queen of France, has been abducted. Bonacieux fears her disappearance is linked to a rumored romance between the queen and the English Duke of Buckingham. D'Artagnan has his own theory: He believes the abductor to be none other than his nemesis, Rochefort. He also realizes that restoring Constance may gain him and his fellow Musketeers the gratitude of the queen. D'Artagnan comes to the rescue and, after learning Constance is young, beautiful, and doesn't love her older, cowardly husband, falls helplessly in love with her.

D'Artagnan assists Constance in arranging a secret meeting between the Duke of Buckingham and the queen, wherein she gives the duke a necklace with 12 identical diamond studs. When the cardinal learns of the tryst, he contrives to expose her infidelity by advising the jealous king to host a ball to which Her Majesty would be requested to wear that same diamond necklace. Meanwhile, the cardinal dispatches the predatory Milady de Winter to England to steal two of the diamonds from the duke. The Musketeers also set out for England to retrieve the incriminating necklace. Each man in turn is waylaid by separate ambushes, leaving the others to pursue the mission. At last, only D'Artagnan reaches the duke, who gives him duplicates of the missing diamonds. D'Artagnan returns to France with the necklace intact in time to spare the queen scandal. He is further gratified to find his fellow Musketeers have all survived the ordeal.

Events move forward. Rochefort kidnaps Constance again. A distraught D'Artagnan is advised by Athos to forget her. Athos confesses that once he too had married a beautiful woman, but when she turned out to be a branded criminal he had killed her and renounced his rank and lands. Undeterred by the warning, D'Artagnan pursues his amours and soon falls under the enchantments of Milady de Winter. To his horror, however, he sees a brand on her shoulder and realizes she is Athos's wife, still alive. She swears vengeance on D'Artagnan and sends assassins after him. Richelieu, in the meantime, plots to send de Winter to England to prevent—by murder if necessary—Buckingham's sending ships against France. The eavesdropping Athos learns of the plan and a warning is sent to Buckingham. At the same time, Aramis learns from his highly

placed mistress that the queen has moved Constance to a convent for safety. She is the next target of de Winter, who has already successfully arranged the assassination of Buckingham. By the time the Musketeers reach Constance, she is dying from de Winter's poison. De Winter is captured by the Musketeers and executed.

Rochefort arrests D'Artagnan, but when the cardinal learns of Milady's execution, he releases him and grants him a lieutenant's commission. The Young Gascon has achieved his life's ambition at last. He is saddened, however, when his three friends leave the service and depart Paris. He is alone in his triumph.

The Films

Dumas's intricate plotting, richly detailed characterizations, and warmly ironic narrative voice have attracted and confounded filmmakers for generations. Moreover, before the mid-1960s and the collapse of Hollywood's censorious Production Code, many versions were unable to follow faithfully the fortunes of a Gascon adventurer who is not only in love with a married woman but who also has sexual relations with his best friend's wife and with her maid! Thus, the inconvenient presence of her husband, the landlord Bonacieux, is either abandoned altogether or altered to the status of uncle/protector/godparent of Constance.

Little is known of the first American feature film version, which was released in 1914 in six reels by the Film Attractions Co. According to the *AFI Catalogue of Feature Films, 1911–1920*, it pares away the subplots and focuses on the episode of the diamond necklace. No information about the cast is available. *D'Artagnan*, released by the Triangle Film Corp. in 1916, was a "prestige" picture produced by the redoubtable Thomas Ince. As a vehicle for stage star Orrin Johnson, it enhanced the role of D'Artagnan at the expense of the other Musketeers (a tactic repeated in most subsequent adaptations). Again, the central business about the diamond necklace dominates the action. Dorothy Dalton portrays Queen Anne, Louise Glaum is Milady de Winter, Walt Whitman is Cardinal Richelieu, and George Fisher is the king.

Douglas Fairbanks's version was released by United Artists in 1921 on the heels of his successful proto-swashbuckler, *The Mark of Zorro* (1920). He had essayed the role of D'Artagnan once before in *A Modern Musketeer* (1918), a magnificently flamboyant actioner, of which only the first half now survives. Based on F.R. Lyle's story, "D'Artagnan of Kansas," Fairbanks plays a frustrated small-town yokel who imagines himself as the famed swordsman. The superbly acrobatic dream duels take their place among Fairbanks's best work. His *The Three Musketeers*, however, is more serious business; and if the action is not as irrepressibly exciting as in *A Modern Musketeer*, it at least is a careful adaptation of the Dumas original. Appearing as the other Musketeers were Leon Barry as Athos, George Siegmann as Porthos, and Eugene Pallette as Aramis. Although, like most adaptations, it drops the last half of the book, Edward Knoblock's scenario carefully delineates the court intrigues by means of the visual metaphor of a chess game that tracks the moves and countermoves of Richelieu and the Musketeers. One significant plot alteration "cleans up" the character of Constance, who is not only unmarried but is also the decidedly chaste recipient of D'Artagnan's ardent wooing. Otherwise, to a surprising extent, dialogue titles come straight from the novel and newly devised comic relief is delightfully consistent with the original material. It is worth noting that Fairbanks's swordplay is occasionally rather awkward in comparison with his later, more sophisticated work in the sequel, *The Iron Mask* (1928). Ironically, moviegoers in France had to wait almost a decade to see it, since its release was held up by the circulation of a French serial version from Pathe, directed by Henri Diamant-Berger.

Director/actor Max Linder satirized Fairbanks's film with *The Three Must-Get-Theres* (1922). Despite anachronistic gags involving telephones and motorcycles and the punning of names such as "Dart-In-Again," it is highly regarded among Linder's work. The film's fight director, Fred Cavens, was hired immediately by Fairbanks, whose swordplay ever after was more finely executed.

In 1935 RKO released Hollywood's first talking version, starring Walter Abel as D'Artagnan, Paul Lukas as Athos, Moroni Olsen as Porthos, Onslow Stevens as Aramis, Heather Angel as Constance, and Nigel de Brulier as Richelieu (reprising his role from the two Fairbanks films). The plodding script by Dudley Nichols and Rowland V. Lee is fitfully faithful to the original—for example, for the first time on screen the marriage between Athos and Milady is revealed—although Constance is again sanitized, appearing now as the ward of Bonacieux. It is possibly the dullest extant version of the story—stiff, talky, and stagebound, weighed down by Max Steiner's irritatingly jaunty, overused theme.

Four years later Don Ameche's D'Artagnan teamed up with the Ritz Brothers in a Twentieth Century-Fox musical version. (U.K.: *The Singing Musketeer*). It is quite the unlikeliest of the Musketeer adaptations, despite reported attempts of at least a token fidelity to the story. But that's a lot of story to squeeze into 73 minutes, including songs (by Samuel Pokrass and Walter Bullock) and Ritz Brothers comedy.

Although not literally a musical, the MGM Gene Kelly version in 1948 certainly *feels* like one. This is problematic, in this writer's opinion: George Sidney's direction is clumsy and Kelly's dueling choreography makes the fight scenes too distractingly like his dance routines, as if he were portraying Don Lockwood in *Singing in the Rain* rather than the character of D'Artagnan. Even if June Allyson's Constance never breaks into song, her every scene with Kelly is underscored conspicuously by Herbert Stothart's trashing of Tchaikovsky's *Romeo and Juliet*. Of particular interest, however, is that for the first time two scenes from the book's second half are depicted—D'Artagnan's midnight tryst with Milady (Lana Turner) and Milady's murder of

Constance. Portraying the Three Musketeers are Van Heflin, Gig Young, and Robert Coote.

The cynical 1970s saw the release of the grandest and best screen adaptation to date. Released as two separate movies in 1974–75—*The Three Musketeers* (*The Queen's Diamonds*) and *The Four Musketeers* (*The Revenge of Milady*)—Richard Lester's version had the biggest scale, the longest running time, and more story detail than any previous film. The witty screenplay by George MacDonald Fraser (author of the even more cynical and antiheroic *Flashman* books) was perfect for Lester, whose socially satiric humor meshed with Dumas's. The throwaway dialogue (especially from the servant and merchant classes) and inventive sight gags enhance its lampooning of the swashbuckler genre in general. Fight arranger William Hobbs does an outstanding job in staging fights that are never quite as graceful as classical fencing, mixing the swordplay with heavy-booted kicks to the body and elbows to the face. The combatants' priorities are, it is clear, more concerned with survival than chivalry. The first film is lighter in tone. The second film darkens, gathering power from a greater fidelity to the book's second half, which is less familiar to film viewers. Lester, who heretofore had responded primarily to the tale's irony, now acknowledges the book's considerable heart.

Dropping from the pinnacle to the pit, Lester's version was followed in 1993 by the worst of all, Stephen Herek's

Douglas Fairbanks in The Three Musketeers (1921, U.S.A.; AUTHOR'S COLLECTION)

version for Walt Disney, clearly aimed at the teen market, a swashbuckling clone of movies like *Young Guns*. Here, Richelieu (Tim Curry in the film's only delightful performance) plots to assassinate the king and take the throne. He disbands the Musketeers, but the Three (Kiefer Sutherland, Charlie Sheen, Oliver Platt) are the only ones who don't turn in their tunics. It's not so much that they're loyal to the throne, but that they're rebels on a sugar rush and vent on vandalism, joy-riding stolen vehicles, and hassling the authorities. In a word, they constitute a 17th-century street gang with D'Artagnan (Chris O'Donnell) as a mere hanger-on. When the movie opened, O'Donnell told a journalist, "I've never read the book, but I've eaten the candy bar." That's the hook: This version may be considered as the first film based on a candy bar.

Note: The issue of Dumas's sequels to *The Three Musketeers* and the pertinent Hollywood adaptations of same—including Fairbanks's *The Iron Mask*, James Whale's *The Man in the Iron Mask* (1939), Cornel Wilde's *At Sword's Point* (1951), and Lester/Fraser's *The Return of the Musketeers* (1989), to name just a few—is quite complicated and beyond the scope of this essay. For the record, however, Dumas wrote two magnificent sequels, *Twenty Years After* (1845) and *The Vicomte de Bragelonne, or Ten Years Later* (1848–50). These two novels are brilliantly conceived and rewarding tales of the changing lives and times of D'Artagnan and comrades. Due to its length, American publishers have confused things by frequently dividing the second sequel into three separate titles, *The Vicomte de Bragelonne, Louise de la Valliere,* and *The Man in the Iron Mask.* The reader is advised *not* to read the latter title without having read the first two volumes. In short, admirers of any of the films cited in this essay really need to go pick up a book.

Forward!

REFERENCES

Bell, A. Craig, *Alexandre Dumas—A Biography and Study* (Cassell, 1950); Sinyard, Neil, *The Films of Richard Lester* (Croom Helm, 1985); Tibbetts, John C., and James M. Welsh, *His Majesty the American: The Films of Douglas Fairbanks, Sr.* (A.S. Barnes, 1977).

—S.N.L.

THE TIME MACHINE (1895)

H.G. WELLS

The Time Machine (1960), U.S.A., directed by George Pal, adaptation by David Duncan; MGM.
The Time Machine (2002), U.S.A., directed by Simon Wells, adapted by John Logan; Dreamworks.

The Novel

The Time Machine is H.G. Wells's earliest published work of fiction. Since its first serialization in the *New Review*, from January through May 1895, it was an instant success

and has never been out of print. Widely regarded as one of the first modern science fiction stories, its qualities transcend mere genre. It was judged by contemporary novelist Israel Zangwill as "worthy of Swift"; and Jorge Luis Borges later declared that it would be incorporated, like the fables of Ahasuerus and Theseus, "into the general memory of the species and even transcend the fame of their creator or the extinction of the language" in which it was written.

The novel had a complex gestation period. Wells attempted no less than five versions, three of which appeared in print before the work was first published in book form in May 1895. The first version, titled *The Chronic Argonauts*, was begun in 1886 when Wells was just 21. Subsequent versions gradually introduced the characters and incidents we now know.

The action ranges from 1895 to the year 30,000,000. There are two narrators—Hillyer, the narrator, and the inventor known only as the Time Traveler. Hillyer's story begins in a residence of Richmond, a London suburb, where he and a group of assembled guests scoff incredulously at their host's theories of time travel. When the group meets again a week later, their host breaks into their midst, wild and dishevelled, with an incredible story to tell: He has returned from the year 802701, where he encountered what at first seemed an Edenic paradise of childlike humans called the Eloi. However, he soon learned that another race of subterranean creatures called Morlocks held the Eloi in a thrall of terror, feeding and clothing them, only to prey upon them for food. After several encounters with the bestial creatures, during which the Traveler's new friend, the beautiful Weena, is killed, the Traveler flees into the far future, where he encounters horrible monsters—"crab-like creatures" and things "like a huge white butterfly"—that have taken over the planet. Retreating still further into the future, he sets his machine to the year 30,000,000, where the world is an "abominable desolation" inhabited only by liverworts, lichens, and a lone animal, a round-bodied creature with tentacles that floats on a blood-red sea. Terror-stricken, the Traveler retreats back to the present. His story is ridiculed by his guests, despite the flowers in his pockets that had been a gift from Weena (and which cannot be classified by subsequent tests).

A few days later the Traveler tells the narrator of his intention to return to the future and secure proof of his story with his camera. The Traveler departs, leaving behind only the mysterious flowers, never to be heard from again.

The Films

Three film versions of the novel are listed in Harry M. Geduld's *The Definitive Time Machine*, two of which—a 1973 Canadian version and a 1979 adaptation by Henning Schellerup—are unavailable. The George Pal's reputation by the mid-1950s rested primarily on his special effects

H.G. Wells

fantasies, like *The War of the Worlds* (1953), adapted from H.G. Wells's novel. At that time the Wells estate approached Pal and offered him an option on any other Wells stories that interested him. He chose *The Time Machine* and commissioned David Duncan to write a screenplay. Pal had to wait six years, however, before he found an interested producer, Sol Siegel. Two relatively unknown actors, Rod Taylor and Yvette Mimieux, were chosen for the leads.

The theme of time is announced immediately. Over the opening credits we see a succession of different kinds of mechanical clocks (a sequence later imitated in the opening of *Back to the Future*, 1985). The film cuts to a shot of Big Ben, then cuts again to a room in the home of one "George" Wells, where dozens of clocks tick and bong away in a symphony of mainsprings. We are in England, at the turn of the 20th century. Wells has just burst in on a group of invited friends with an amazing story to tell.

The bulk of his narrative (told in Taylor's continuing voiceover) is taken up with events of the preceding week—when he took his first experimental ride in his Time Machine and journeyed forward in time, stopping at random moments in 1917, 1940 (during the London blitz), 1966 (just as an atomic explosion destroys London), and on forward to 802,701, to the world of the Morlocks and the Eloi. As his romance with the beautiful Weena develops, he also becomes aware of the deadly threat of the underground creatures. He leads the Eloi in a battle against them, but in the ensuing confusion loses track of Weena. He returns to London in the present day determined to go back and help the Eloi build a new world. After all, as his friend Filby (Alan Young) says, he "has all the time in the world."

Thus, although the film suggests some of the cataclysms Wells himself had envisioned (Pal's hindsight view enables the Traveler to witness two world wars and a nuclear holocaust), it ends on an optimistic note. By omitting the novel's finale, the memorable *fin du globe* sequence, Pal backs away from the book's bleak and pessimistic tone.

Commentator Harry M. Geduld misses the point when he dismisses the film as a "travesty" of Wells's ideas, "interesting primarily to movie buffs whose tastes run to special effects and *schlock*." True, Wells's satiric views on social class structure and his treatment of evolutionary science and dystopian themes are muted. But those "special effects" Geduld refers to are actually quite to the point. Beyond factors of plot and thematic transfer, both novel and film are bound at the hip by the "cinematic" sensibility they possess in common. It is no accident that Pal's time-travel sequences are visualized with a veritable arsenal of cinematic devices like strobe effects, forward and reverse motion, accelerated motion, stop-motion, and time-lapse photography. They are merely the visual correlatives of the descriptive effects found in Wells's original prose. One example among many suffices. In chapter 13 of the novel, the Time Traveler describes his return from the future to the laboratory of present day in terms that exactly convey the effect of accelerated movement and a reverse action in cinema:

> I think I have told you that when I set out, before my velocity became very high, Mrs. Wachett had walked across the room, travelling, it seemed to me, like a rocket. As I return, I passed again across that minute when she traversed the laboratory. But now every motion appeared to be the direct inverse of her previous ones. The door at the lower end opened and she glided quietly up the laboratory, back foremost, and disappeared behind the door by which she had previously entered.

At precisely the time he was writing the book in the early 1890s, Wells could not help but be aware of the cinematic experiments by Edison, Dickson, and others, in America, England, and France—filmstrips that demonstrated just these kinds of effects. "[T]he evidence is such that if [Wells's] story was not evolved directly from the experience of seeing the Kinetoscope [Edison's peep-show viewing device]," wrote film historian Terry Ramsaye, "it was indeed an amazing coincidence." Clearly, Wells came to regard the new film medium as a time-altering device—a *time machine*, as it were. It is the true subject of his novel. Proof of this is that on October 24, 1895, shortly after the publication of his book, Wells and his friend, the filmmaker Robert Paul, applied for a patent for a cinematic device—a kind of viewing apparatus—"whereby the spectators have presented to their view scenes which are supposed to occur in the future or past, while they are given the sensation of voyaging upon a machine through time . . ." Although nothing came of the project, it is obvious they were anticipating the experience of a modern motion picture theater.

Thus, Pal's film underscores the connections already implicit between Wells's idea of a time machine and our modern experience of cinema. The strobe-like flickering effects of the time-travel scenes remind us that movies are based on an *illusion* of movement arising from the intermittent passage of frames of film through the projector. The device of the Time Machine itself, designed by art director Bill Ferrari, is an artful blend of Victorian fancy and modern technology. It has a revolving wheel that resembles the reel of a movie projector; and the positioning of the Traveler in the saddle is like a spectator in a theater-seat who remains stationary amid the free flow of temporally displaced images. Rod Taylor's narrative voice describes the experience of time travel exactly as if describing a cinematic montage of shots: "I experienced the passage of months in just a few minutes." What is also emphasized is that as long as Taylor remains in the saddle of the machine, he will not be subject to time. He exists outside of temporal continuity. This is a point crucial to Wells's original story—that the Time Traveler never ages. Pal's film reinforces the ontological significance of film, i.e., that the individual images are frozen moments that are ageless and changeless. Like the images on Keats's Grecian Urn—and like Wells's Time Traveler—Rod Taylor will never grow old. His image on the filmstrip is outside of time.

The modern science fiction novel and the medium of film arrived at the same time. If Wells was a prophet for both, George Pal, in his own modest way, was its later fulfillment. Indeed, the time-travel theme is more than just a sub-genre in science fiction; according to Brooks Landon, it is "the most dramatic manifestation of the cinema's long-standing and inherent preoccupation with the displacement of temporal consciousness . . . Motion picture technology may itself be the most effective time machine of all."

One might have expected a respectful treatment of the novel from Wells's great-grandson, Simon Wells, but such was not the case. This version, while technically superior to the George Pal film, fails to generate any genuine char-

acter interest or tell a compelling story. Wells has taken a few of the main ideas—the invention of a time machine, a future world populated by the pacifist Eloi and the predatory Morlocks—and ventured off into melodramatic hokum that does a disservice to the original. The novel's nameless protagonist is here dubbed Alexander Hartdegen (Guy Pearce), a reclusive inventor living in New York in 1899. When his fiancée, Emma (Sienna Guillory), is accidentally killed during a robbery attempt, Alexander determines to build a machine that will enable him to travel backward in time so he can alter the course of history and save Emma. The attempt fails when Emma is killed in another accident. Realizing that he cannot alter the past, Alexander propels himself into the far future, where he finds an Earth populated by the Eloi, peace-loving people who live above ground, and the murderous, cannibalistic Morlocks, who dwell underground and prey upon the Eloi. After falling in love with an Eloi girl, Mara (Samantha Mumba), Alexander endeavors to free her people from the Morlocks (whose leader is played by Jeremy Irons). At this point the storyline veers wildly out of control, and the tussle between Alexander and the Morlock leader collapses into a series of chaotic confrontations. What began as a reasonably absorbing variant on the paradox of altering the past—a theme not found in the novel—becomes a tepid melodrama that barely limps to the finish line. Cinematographer Don McAlpine's camera work is splendid, and the time-travel sequences are notable for their special effects—the world around Alexander and his machine builds itself up and tears itself down in a series of spectacular transformations—but they cannot save an incoherent script. Time is indeed, in the words of the Bard, "out of joint."

REFERENCES

Geduld, Harry M., *The Definitive "Time Machine"* (Indiana University Press, 1987); Hickman, Gail Morgan, *The Films of George Pal* (A.S. Barnes, 1977); Johnson, William, ed., *Focus on the Science Fiction Film* (Prentice-Hall, 1972); Landon, Brooks, *The Aesthetics of Ambivalence: Rethinking Science Fiction Film in the Age of Electronic (Re) Production* (Greenwood Press, 1992).

—*J.C.T.*

THE TIN DRUM (1959)

GÜNTER GRASS

The Tin Drum (*Die Blechtrommel*) (1979), Germany, directed by Volker Schlöndorff, adapted by Schlöndorff, Günter Grass, Jean-Claude Carrière, and Franz Seitz; Biskop Film, Munich.

The Novel

Part one of Grass's three-part Danzig trilogy, *The Tin Drum*, his first (and arguably best) novel, appeared in 1959

with much fanfare. The novel was as controversial as it was successful, due in large part to its ribald language and outrageous protagonist. In fact, the city of Bremen withdrew the Literature Prize—awarded to Grass by jury—primarily due to objections to the novel's content. Nevertheless, the novel was both a critical and commercial success and was one of the first postwar books to deal so openly and directly with Germany's past.

The Tin Drum tells the story of Oskar, who out of disgust with the adult world wills himself to stop growing at the age of three. The story, divided into three books, opens in Danzig, home of the 30-year-old Oskar, who narrates his life story from a mental institution, where he has been incarcerated for a crime that he claims not to have committed.

Book one recounts his familial origins in the potato fields of Kashubia, as well as his own unique birth as "one of those clairaudient infants whose mental development is completed at birth and after that merely needs a certain amount of filling in." He witnesses the unstoppable rise of the petty bourgeois within the ranks of fascism, personified by his father, Alfred Matzerath. On his third birthday, Oskar is promised a tin drum—a toy and a weapon—which he uses as a means of protest against the absurd world around him. It also becomes an instrument for drumming up the past, thus enabling him to recreate history from his own perspective.

Book two relates both the story of Oskar's first love, Maria, as well as the war years, in which he joins the somnambulist Roswitha and a group of traveling circus performers. Upon returning home to Danzig, Oskar and his father hide from advancing Russians in the cellar, and Oskar forces Matzerath to swallow his Nazi Party pin to conceal his party affiliation. Once again, Oskar feels a sense of guilt and responsibility for the death of a parent, just as he did years before when his mother, Agnes, gorged herself to death on eels.

Book three covers Oskar's postwar life and his decision to grow, albeit into a hunchback. Working alternately as a black marketeer, a model, and a nightclub performer, Oskar winds up being accused of causing the death of his neighbor, Sister Dorothea. Ironically, testimony given in his defense serves only to damn him further, rendering him guilty by implication. Oskar agrees to be judged insane and to atone for a guilt not entirely his own.

The Film

Long considered to be unfilmable due to the nature of the lead character as well as the changing narrative perspective, *The Tin Drum* was finally filmed in 1979 by Volker Schlöndorff, one of the leading exponents of the German New Wave. Grass himself had rejected a number of screenplays for various artistic reasons, but agreed to work closely with Schlöndorff to adapt the text.

The problems involved in filming the book were numerous. First and foremost was the question of casting

the lead, someone who could play the part of an intellectually mature three-year-old. Schlöndorff rejected the idea of using a midget, and cast instead the son of one of Germany's leading actors, who also suffered from a growth impediment. The original idea was to have the child play Oskar for the first two-thirds, and then cast a dwarf to take over the role for book three. This plan was eventually abandoned, and Grass and Schlöndorff decided to film only the first two books of the novel, concentrating on Oskar's childhood and decision not to grow.

The second major problem inherent in the text was the nature of the changing narration as well as Grass's unique linguistic style. The novel was one of the first German texts to employ a sort of "magic realism," and indeed, Schlöndorff felt that this style was exactly what made the novel so powerful. To compensate, the film uses a first-person voiceover, which allows for Oskar's commentaries and presents Oskar's uniqueness as a "clairaudient infant." Schlöndorff works associatively in order to compensate for the novel's symbolism and linguistic brilliance. Stressing mythic and magical atmospheres, Schlöndorff opens and closes the film with the image of Oskar's grandmother, a Kashubian peasant woman who represents a certain "cyclical and inexorable fatality." She symbolizes the total life—in opposition to Oskar, "the child-man who is the perfect portrait of human regression."

The worldwide success of *The Tin Drum* reestablished Germany as a major force in cinema, and it was the first German film ever to win an Academy Award for best foreign film. It remains one of the crowning achievements of postwar German cinema.

REFERENCES

Reimer, Robert C., and Carol J., *Nazi-Retro Film: How German Narrative Cinema Remembers the Past* (Twayne, 1992); Orr, John and Colin Nicholson, ed., *Cinema and Fiction: New Modes of Adapting, 1950–1990* (Edinburgh University Press, 1992); Anton, Kaes, *From Hitler to Heimat: The Return of History as Film* (Harvard University Press, 1989); Elsaesser, Thomas, *New German Cinema: A History* (Rutgers, 1989).

—D.N.C.

TO HAVE AND HAVE NOT (1937)

ERNEST HEMINGWAY

To Have and Have Not (1944), U.S.A., directed by Howard Hawks, adapted by Jules Furthman and William Faulkner; Warner Bros.

The Breaking Point (1950), U.S.A., directed by Michael Curtiz, adapted by Ranald MacDougall; Warner Bros.

The Gun Runners (1958), U.S.A., directed by Don Siegel, adapted by Daniel Mainwaring and Paul Monash; Seven Arts/United Artists.

The Novel

Hemingway created this "novel" by adding a third, related short story to two previously published, interconnected short pieces from the 1930s. Published in mid-career, it is a relatively minor Hemingway work, notable mostly for its pre–*For Whom the Bell Tolls* representation of socialist politics. It is almost a potboiler, but is by no means the "worst thing he ever wrote" as Howard Hawks (and some early critics) would claim. Its focus on a character having to sacrifice personal integrity and commit crimes just to survive in the disastrous economy of Depression-era south Florida speaks to larger issues of society and politics, even if without a Steinbeck condemnation of corporations and capitalism.

Harry Morgan supports himself and his small family by chartering fishing boats for rich clients off the Florida Keys. When one of the wealthy and corrupt "haves" runs out on Harry before paying him, Harry, now a "have-not," turns to smuggling as the only way he can survive. One of Hemingway's classic "code heroes," an "isolato" struggling to maintain independence and integrity in a corrupt world, Harry sinks deeper into tragedy despite his valiant efforts to make enough money to support himself and his family.

The novel is comprised of three roughly connected pieces titled "Spring," "Autumn," and "Winter." The first two focus primarily on violence and estrangement as we see Harry cheated by the rich American Johnson; for money, Harry in turn brutally kills the leader of a Chinese smuggling operation; on a failed rum-running attempt, Harry is wounded and loses his arm. The third part of the novel details Harry's last and most desperate plan, ending in his own death, in which he plans to kill and rob four Cuban bank robbers who are working for the revolution—here Harry's macho independence meets the revolutionary fervor then rising in both Spain and Cuba. Morgan's famous last words—"a man alone ain't got no bloody chance" (words closely echoed in *The Breaking Point*)—represent Hemingway's thematic shift from his focus on the individual toward a concern with the larger society around him.

The Films

If you count John Huston's use of gunfighting scenes from this Hemingway novel to end his adaptation of Maxwell Anderson's play *Key Largo* (1948), *To Have and Have Not* has generated four adaptations, none very committed to the original text. Hemingway forever regretted not so much the adaptations' inaccuracies as the fact that he received only $10,000 for the rights.

Hawks repeatedly claimed that this project originated with a dare he made (while hunting and fishing with Hemingway) that he could make a good movie from Hemingway's worst novel. (Despite the numerous adaptations of his novels, Hemingway had not joined the many American writers of the 1930s and 1940s, including Faulkner, who went to Hollywood.) In fact, Hawks and screenwriters

Furthman and Faulkner seemed hardly interested in the original novel, and when American diplomatic sensitivity to the turbulent politics in Cuba forced them to change it from its 1937 Cuba and Florida setting, they easily opted for a World War II setting on Martinique where cynical gunrunner Harry Morgan, motivated only by a desire to make enough money to survive with his wife and daughters, is now a bachelor who learns to unselfishly help support the French Resistance and love the sexy Marie, or "Slim" (Lauren Bacall). Critics as early as James Agee complained that the film had little or nothing to do with the novel. Bacall, 19, made her sultry screen début, with her opening line, "Anybody got a match?," followed by a half-dozen other Hollywood one-liners huskily whispered to costar and future husband Humphrey Bogart. (Although Warners initially hired Andy Williams to do her singing, apparently it's Bacall's voice we hear accompanied by Hoagy Carmichael's piano.)

Many critics have noted the ways in which Hawks more closely followed Curtiz's immensely popular *Casablanca* (1942) than the Hemingway novel, and perhaps appropriately the trajectory of interconnected influences led five years after Hawks's adaptation to Curtiz's own (more accurate) version of the Hemingway original—the now little-known *The Breaking Point*. Some critics have termed this the best Hemingway adaptation, with John Garfield giving a superlative performance as Morgan. The film moves far from the original source, eliminating the political subtext, relocating the setting from Florida-Cuba to California-Mexico, and focusing on a love triangle absent from the novel.

Eight years later, Don Siegel used the novel's first section, "One Trip Across," and MacDougall's script for *The Breaking Point* as the basis for his version, *The Gun Runners* with Audie Murphy, a film neither Siegel nor any major critics found especially successful. It can claim to be the only adaptation that at least touched on the issue of Cuban revolutionaries.

Only the Hawks film still holds popular and critical interest (and it is the only one currently available), if for no other reason than its being one of the Bogart-Bacall campy cult melodrama classics, along with *The Big Sleep* (also Faulkner and Furthman's work on the script) and *Key Largo*. Hawks may have ignored most of Hemingway's (extremely cinematic) story, but he and the scenarists managed, with the possible exception of the ending, to build from the *Casablanca* tradition a taut tale of an initially cynical individual who gets caught up in a larger nexus of political, social, economic, and sexual forces than he had originally planned. Warners Bros. had a reputation in the 1930s for evoking social causes even in their gangster films, but by 1945, at the end of World War II, this film jumped on the jingoistic bandwagon and restricted its indictment to Nazis, not the capitalists Hemingway depicts in his novel. Similarly, the film seeks to eschew controversy as Hawks attenuates the overt racism of the original novel. However, the character studies (especially

Walter Brennan's Eddie), the sheer movie magic of the costars' romantic involvement, and the superb dialogue all work together to create a classic Hollywood period piece.

REFERENCES

Furthman, Jules, *To Have and Have Not* (University of Wisconsin Press, 1980); Laurence, Frank M., *Hemingway and the Movies* (Da Capo Press, 1981); McBride, Joseph, *Hawks on Hawks* (University of California Press, 1982); Mast, Gerald, *Howard Hawks, Storyteller* (Oxford University Press, 1982).

—*D.G.B.*

TO KILL A MOCKINGBIRD (1960)

HARPER LEE

To Kill a Mockingbird (1962), U.S.A., directed by Robert Mulligan, adapted by Horton Foote; Universal.

The Novel

On the advice of a New York literary agent, Harper Lee expanded a short story of hers into her first novel, *To Kill a Mockingbird*, for which she was awarded the Pulitzer Prize (1960). Largely autobiographical, the novel is set in Maycomb, Alabama, a town much like Lee's own Monroeville, Alabama, and is narrated by Jean Louise ("Scout") Finch, who, like Lee as a child, is a tomboy. Lee's neighborhood included a recluse inhabiting a mysterious house, like the fictional Arthur ("Boo") Radley and his home. Truman Capote, Lee's childhood friend, was the basis for Charles Baker ("Dill") Harris, and her father, whose middle name was Finch, closely resembled Atticus Finch in temperament, principles, profession, and character. Most significantly, Harper Lee grew up in a world where racial violence and bigotry were disturbingly real.

To Kill a Mockingbird is constructed around parallel plots. The first plot tells the story of Boo Radley, a tenderhearted recluse, generally thought deranged. The second story concerns Tom Robinson, a kind black man falsely accused of raping a white woman. The novel is narrated by the adult Scout, looking back on what happened when she was six. The narrative commendably combines the mature understanding of an adult with the memories of an intelligent child who only partially understands what she is witnessing.

Each summer Scout, her brother Jem, and their friend Dill would devise ways of making the enigmatic Boo Radley come out of his house. One day Jem's pants, ripped and abandoned during a childish prank, are found crudely sewn and neatly folded on their fence; and when Jem begins to find playthings left in the hole of a tree, the children are duly perplexed. At Christmas their father, Atticus, gives Scout and Jem air rifles, with the stipulation that they must never kill a mockingbird since they live only to make beautiful songs.

Attorney Atticus is assigned to defend Tom Robinson, who is falsely accused of raping Mayella Ewell, a white woman. Several townspeople, hating Robinson, form a lynch mob; however, the mob is embarrassed into disbanding when faced with young Jem's stalwart protection of his father and with the naive, natural candor of Scout. At trial Atticus proves that Tom could not have committed the crime, but the all-white jury convicts Robinson anyway. Angry that Atticus has exposed his daughter and him as liars, Mayella's father vengefully attacks Jem and Scout. The children are saved through the intersession of a shadowy figure, whom we later learn was Boo Radley.

The Film

There is only one film version of *To Kill a Mockingbird*, and in many ways, from its repeating confusion of point-of-view shots to its indiscriminate editing, *To Kill a Mockingbird* is a mediocre movie. Yet, despite its flaws the film

works on the hearts of its audience. Lee's book was published in 1960 and was an immediate popular success, remaining on best-seller lists for more than 80 weeks. Bidding for film rights to the novel was immediate, and Universal released *To Kill a Mockingbird* fewer than two years after the book's original publication. The movie appeared at the peak of the Civil Rights movement in America, and this social climate heightened the positive reception of the movie. With the exception of Pauline Kael and Bosley Crowther, critics at the time were unanimous in praising the film's handsome modesty of technique and the "decency" of its content.

To Kill a Mockingbird is a touching explication of American racial injustice as well as a sincere and faithful film adaptation. The harshness of the theme is counterpoised against the amiability of the children's world, the dignity and moral courage of their father, and the gentle lyricism of Elmer Bernstein's fine musical score. The film's director, Robert Mulligan, a former divinity student, is known

Philip Alford (left), Gregory Peck, and Mary Badham in To Kill a Mockingbird, *directed by Robert Mulligan* (1962, U.S.A.; UNIVERSAL)

for his leisurely, unobtrusive style, his sensitivity to moral themes, and his skillful work with actors. As Atticus Finch, Gregory Peck won an Oscar for his performance, and Mary Badham (Scout), nine years old and with no acting experience, won considerable critical praise. The movie was Robert Duvall's (Boo) first screen role. Collin Wilcox is convincing as Mayella Ewell, the young, poor, and very lonely white woman who makes sexual advances to a black man and consequently is beaten by her father.

While many of the outdoor shots are clearly Universal back lots, the interior shots are often quite credible, making us believe that we are in a small Alabama town at the height of the depression. This is especially true in the courtroom sequences: midsummer in the deep South, with the heat almost visible. The courtroom is segregated, with white people in the orchestra seats, where the air is somewhat cooler and the view better, and black people in the more sweltering balcony. Jem and Scout sit upstairs, and with their white faces standing out amid the black, we believe that racial harmony is possible, if only we teach our children well. When Tom Robinson is unfairly convicted, everyone seated upstairs stands in honor as Atticus leaves the courtroom defeated. This dignified, courageous, and nonviolent gesture contrasts with the later disgraceful and cowardly murder of Tom, shot while allegedly trying to escape.

The film's ending brings together the parallel plots. Bob Ewell, disgraced by Atticus in the courtroom, violently assaults Jem and Scout. Boo saves the children's lives by killing Ewell and carrying Jem safely home. Out on the porch, Atticus tells the sheriff that he will defend Boo; but the sheriff, understanding that Boo is incapable of sustaining the notoriety of a trial, tacitly ignores Atticus's offer and insists that Ewell fell on his knife. Witness to it all, Scout learns from the parallel stories of Boo Radley and Tom Robinson, that it is an egregious sin to kill a mockingbird.

REFERENCES

Bailey, Rebecca Luttrell, *You Can Go Home Again: The Focus of Family in the Works of Horton Foote* (P. Lang, 1993); Johnson, Claudia D., *To Kill a Mockingbird: Threatening Boundaries* (Twayne, 1994).

—L.C.C.

TORTILLA FLAT (1935)

JOHN STEINBECK

Tortilla Flat (1942), U.S.A., directed by Victor Fleming, adapted by Benjamin Glazer and John Lee Mahin; MGM.

The Novel

Tortilla Flat was Steinbeck's first critical and popular success, even though he himself called it "a second-rate book, written for relaxation." Though his characters are stereotypical "lazy Mexicans," Steinbeck attempts in his preface to endow Danny and his friends with the nobility of King Arthur and the Knights of the Roundtable.

When Danny inherits two houses, he is reluctant to accept the responsibility of ownership, but he decides to live in one house and rent the other to his friends. When the other house burns down, Danny's friends come to live with him. During the course of the novel, Danny and his friends have a series of adventures, with every episode providing them with a lesson that reinforces their belief in the evils of responsibility and the burden of property. Throughout the novel, the friends drink wine, fight, and steal, and only in the episodes involving the Pirate do they fully accept responsibility for another's well-being, by safeguarding the Pirate's money and helping him buy a candlestick for St. Francis of Assisi.

Eventually Danny tires of his new life and longs for the freedom he had before his inheritance. To cheer him up, his friends throw a legendary party. When he rushes out to fight "the Enemy who is worthy of Danny," he falls into a gulch and dies. With Danny's death, the tie that binds the friends together is gone. They set fire to Danny's house and each goes his own way.

The Film

Steinbeck's attempt to ennoble Danny and his friends by imbuing their actions with great import, though he does it affectionately, is ultimately patronizing, and the film lacks even the ennobling intentions of the author. In Fleming's poor adaptation, Pilon (Spencer Tracy) becomes the main character, and his actions seem manipulative rather than comic.

In the novel, Danny's romance with Sweets is only one of many episodes in the lives of the *paisanos*. The film, however, splits the action between Danny (John Garfield) and his ongoing pursuit of Sweets (Hedy Lamarr) and the adventures of Pilon, Pablo, and Jose Maria.

Several episodes in the novel are reproduced in the film, but are considerably altered. The charming scene in the woods, for example, in which the Pirate's dogs see a vision of St. Francis, becomes an exemplum to Pilon, whose deceit in trying to break up the romance between Danny and Sweets has caused Danny to be badly injured in a brawl.

By the end of the film, Pilon has been redeemed, Danny gets well, everyone is forgiven, and, predictably, Danny and Sweets wed. The final scene returns to the themes of the novel when a flame appears in the window of Danny's house, which he has given his friends, and the happy-go-lucky *paisanos* allow the house to burn, rejecting the burden of ownership.

REFERENCES

French, Warren, *John Steinbeck's Fiction Revisited* (Twayne, 1994); Hayashi, Tetsumaro, ed., *A Study Guide to Steinbeck: A Handbook to his*

Major Works (Scarecrow Press, 1974); Millichap, Joseph R., *John Steinbeck and Film* (Frederick Ungar, 1983).

—*J.S.H.*

TRAINSPOTTING (1993)

IRVINE WELSH

Trainspotting (1995), U.K., directed by Danny Boyle, adapted by John Hodge; Figment Films/Noel Gay Motion Picture Company for Channel Four.

The Novel

In Britain, *Trainspotting* was one of the most significant literary phenomena of the 1990s, selling over 450,000 copies and leading one reviewer from *The Face* to call Irvine Welsh the defining writer of the "chemical generation." Welsh, a former heroin user who grew up in an Edinburgh housing project, took much from his earlier experiences to put together the episodic events that make up his 1993 debut novel, which was shortlisted for the prestigious Booker Prize. Since then, Welsh has written more books and seen *Trainspotting* adapted for the stage and screen.

Written in what Welsh has called a "mixture of [Edinburgh] phonetics and street language," *Trainspotting* is a series of interconnected tales about a group of young Scottish heroin users as told by the characters themselves. The principal narrators, identifiable only by their language, perspective, and attitude, are Renton (who tries to kick the heroin habit several times), Sick Boy (the self-proclaimed suave one of the bunch and a Sean Connery buff), Spud (the amiably clueless character), and Begbie (the psychopath who "would rather do people than heroin"). Their stories, which can be as darkly humorous as they are simply depressing, generally revolve around the characters' daily experiences with sex, drugs, theft, music, violence, hilarity, and despair. Only later in the novel does a more extensive narrative unfold. In an attempt to give up heroin yet again, Renton leaves Edinburgh to pursue a more respectable life in London, only to be dragged back down by his old friends into a dubious drug deal. He ultimately betrays these friends, consequently severing all former ties to his hometown, in order to start life anew—with stolen money—in Amsterdam.

The Film

Trainspotting was adapted to film in 1995 by director Danny Boyle, producer Andrew Macdonald, and screenwriter John Hodge, the same team responsible for the British hit *Shallow Grave*. On a budget of $2.5 million, the whole film, shot mostly in a disused warehouse in Glasgow, was made in under seven weeks and became the most successful entirely British-backed movie of all time.

Perhaps the major problem that scriptwriter Hodge faced in adapting Welsh's work for the screen was organiz-ing these stories into a cohesive narrative, and while most critics agreed that he overcame this obstacle admirably, others, such as *New York Times* reviewer Janet Maslin, still found the film without "much narrative holding it together." Generally, however, critics were enthusiastic about the movie and commended Boyle for his striking cinematographic style and wickedly humorous approach, which strays from the social-realist bent of British contemporaries Ken Loach and Mike Leigh. Especially praised was the fine acting by Ewan McGregor (Renton), Robert Carlyle (Begbie), and Ewen Bremner (Spud), although the cameo by Welsh as the supplier of the opium suppositories went almost unnoticed. What did not go unnoticed, however, was the film's creative musical score, which astutely reflects changing times and attitudes toward various drugs with its move from the heroin-influenced music of Lou Reed and Iggy Pop to the ecstasy-infused techno of Leftfield. Along with the film, the play, the novel, and the published screenplay, this soundtrack has played an important part in creating the incredible success that is known collectively as *Trainspotting*.

REFERENCES

Kennedy, Harlan, "Kiltspotting: Highland Reels," *Film Comment*, July–August 1996, 28–33; MacNab, Geoffrey, "Geoffrey MacNab Talks to the Team That Made 'Trainspotting,'" *Sight and Sound*, February 1996, 8–11; O'Hagan, Andrew, "The Boys Are Back in Town," *Sight and Sound*, February 1996, 6–8; Reynold, Simon, "High Society," *Artforum*, summer 1996, 15–17.

TREASURE ISLAND (1883)

ROBERT LOUIS STEVENSON

Treasure Island (1918), U.S.A., directed by Chester M. Franklin and Sidney Franklin, adapted by Bernard McConville; Fox.

Treasure Island (1920), U.S.A., directed by Maurice Tourneur, adapted by Stephen Fox; Maurice Tourneur Productions.

Treasure Island (1934), U.S.A., directed by Victor Fleming, adapted by Johnny Lee Mahin; MGM.

Treasure Island (1950), U.K., directed by Byron Haskin, adapted by Lawrence Edward Watkin; Walt Disney/RKO.

Treasure Island (1972), U.K./France/Germany/Spain, directed by John Hough, adapted by Wolf Mankowitz and O.W. Jeeves; MGM-EMI.

Treasure Planet (2002), U.S.A., directed and adapted by John Musker and Ron Clements; Walt Disney Pictures.

The Novel

During the summer of 1881, Robert Louis Stevenson entertained his stepson by drawing up a detailed "treasure map" and then crafting a boy's adventure tale to accompany it. The resulting story so pleased Stevenson's imme-

diate family that Stevenson decided to seek a wider readership. The story, entitled *Treasure Island, or The Mutiny of the Hispaniola. By Captain George North*, was first presented in serial form to largely unfavorable public and critical response in the magazine *Young Folks* from October 1881 to January 1882. Stevenson himself was unhappy with the middle six chapters of the narrative, which he had composed under the twin burdens of ill health and a subsequent relocation from his native Scotland to Switzerland, so he undertook an extensive revision process before *Treasure Island* was published by Cassell in its final, more warmly received form in 1883. Thus, Stevenson's "light" summer diversion laboriously became the first novel of a versatile literary career that nevertheless kept returning to one of *Treasure Island*'s most striking themes: the duality of human nature as exemplified by its attractive villain, Long John Silver.

When fugitive seaman Billy Bones appears at the Admiral Benbow Inn for an extended stay, he warns young Jim Hawkins, the son of the inn's proprietor, to keep watch for a seafaring man with one leg. Soon, a sailor named Black Dog shows up, precipitating a horrible fight and so agitating Bones that he suffers a stroke. An ailing Bones takes Jim into his confidence, telling him that his former shipmates are pursuing him because he is in possession of a sea chest that formerly belonged to the infamous pirate Captain Flint. When Bones dies following another visit from one of his enemies, a sinister blind man named Pew, Jim and his mother open the sea chest and take from its contents an oilskin packet. The local authorities foil a raid by the pirates upon the inn, killing Pew. Jim and his allies, Dr. Livesey and Squire Trelawney, discover that the packet contains a treasure map. In Bristol, the squire charters a ship, the *Hispaniola*, to take Dr. Livesey, Jim, and a small crew to find the remote island marked on the map. The squire has engaged the service of a personable one-legged man named Long John Silver as cook; Silver turns out to be a former shipmate of Captain Flint who has manned the *Hispaniola* with his fellow pirates and means to corrupt the few remaining honest crewmembers. During the voyage, Jim, hiding in an apple barrel, overhears Silver plotting mutiny and murder and rushes to inform the doctor, the squire, and Captain Smollett just as the *Hispaniola* hails Treasure Island. The captain, concealing his knowledge of the impending mutiny, decides to let Silver and his men go ashore; Jim impulsively accompanies the landing party. On a lone journey to the island interior, Jim encounters Ben Gunn, another former shipmate of Flint's who has been marooned.

Meanwhile, the loyal crew leaves the ship to the pirates and takes up shelter in an abandoned stockade, at which point Jim rejoins his comrades. After a bloody skirmish between the loyal crew and the pirates and a failed parley with Silver, Jim decides to sneak away from the stockade and cut loose the *Hispaniola* from its anchor. Unable to reach shore because of the current, Jim boards the drifting *Hispaniola* and finds that the coxswain, Israel Hands, has killed the only other pirate aboard in a drunken brawl. Jim forces Hands to help beach the *Hispaniola* farther down the coast. The coxswain then attacks and wounds Jim, but Jim manages to fatally shoot Hands. Jim returns to the stockade to find that it has been mysteriously left to Silver and the remaining pirates. Silver, now in possession of the treasure map, forms an unlikely alliance with Jim to lead the pirates to the location of the treasure. Upon arrival, however, they find the treasure has already been excavated. The missing stockade defenders now rout the pirates, rescue Jim, and capture Silver. It is learned that Ben Gunn, in his years of exile, has hoarded the missing treasure in a cave and led the doctor, et al., to its location. Jim and his friends stow the treasure aboard the *Hispaniola* and set sail back to England. Long John Silver, however, manages to escape, taking as much gold as he can carry to aid him in his flight.

The Films

There are several different film adaptations of *Treasure Island*, including at least two from the silent era and four major sound releases. The 1918 version, directed by Chester M. Franklin and Sidney Franklin, stars Francis Carpenter as Jim Hawkins and Violet Radcliffe as Long John Silver. It also adds a new character, Squire Trelawney's daughter Louise (Virginia Corbin), who accompanies the expedition to Treasure Island. The 1920 Maurice Tourneur version, starring a female Shirley Mason as Jim, Charles Ogle as Silver, and Lon Chaney in the dual roles of Blind Pew and George Merry, sticks more closely to Stevenson's original cast of characters, although this time Jim is a stowaway on the *Hispaniola* instead of an official crewmember. Of the sound-era adaptations, the least satisfying is John Hough's 1972 British film, starring Kim Burfield as Jim and Orson Welles as Silver. In spite of its impressive set decoration, the film is notable mainly for what critics agree is one of Welles's worst performances. His Long John Silver is an incoherent grotesque devoid of the roguish charm so crucial to Silver's characterization. Since Silver's temptation of Jim is central to Stevenson's narrative, it is essential that the murderous, one-legged pirate also be a charismatic figure capable of eliciting Jim's reluctant affection. The other sound films portray the odd relationship much more effectively, though each version gives it differing nuances of interpretation. However, when viewers think of *Treasure Island*, they usually remember either the MGM or Walt Disney production.

The MGM version was directed in 1934 by Victor Fleming, who would go on to direct *Gone With the Wind*. Jackie Cooper stars as Jim Hawkins and Wallace Beery as Long John Silver. Lionel Barrymore plays alcoholic fugitive Billy Bones. Though Stevenson's story line is more or less intact here, the film opens with a scene not in the novel: Jim baking a cake for his widowed mother and becoming quite embarrassed when a local girl catches him performing such a "feminine" task. Jim seems to welcome

Treasure Island, *directed by Maurice Tourneur* (1920, U.S.A.; TOURNEUR PROD./JOE YRANSKI COLLECTION, DONNELL MEDIA CENTER)

the subsequent intrusion of the pirates upon his domestic burden as a providential chance for adventurous escape to the woman-free high seas. However, as a "pretty" child in a threateningly masculine environment, he remains feminized, at least according to the terms of this adaptation. In a scene at Silver's tavern possessing no analogue in the novel, Silver introduces Jim to Dandy Dawson, a stereotypically effeminate fop who likens himself and Jim to "two sister craft." Jim recoils from Dandy and gravitates toward the strong male and surrogate father, Long John Silver, to the extent that Jim, in spite of his weepy disillusionment in the face of Silver's villainy, takes an active hand in freeing Silver from confinement at the end of the film. Silver promises that their "courses will cross again" on a future treasure hunt: a promise sealed by the gift of his parrot to Jim. All of this is a sentimental overlay on Stevenson's basic plot.

In 1950, Walt Disney chose *Treasure Island* for his first fully live-action production, filmed in England. The Dis-

ney adaptation, which is the most well known, stars Robert Newton as the definitive Long John Silver and Bobby Driscoll as a strangely parentless Jim. The narrative has been stripped to a minimum, beginning at a later point than Stevenson's original—just as Billy Bones's pursuers locate him at the Admiral Benbow Inn. The mutiny, the stockade battle on Treasure Island, and Jim's shipboard fight with Israel Hands have also been considerably shortened into three intensely violent, darkly lit action set-pieces. (The violence gave Disney its first PG rating in the 1970s until some scenes were deleted.) Most significantly, however, Jim's subordination to the stratagems of the warring factions is complicated even further here than in Stevenson's novel. For example, Captain Smollett, patriarchal symbol of English justice, sends Jim ashore with Silver as a willing spy, whereas Jim's action is entirely impulsive in the novel. Jim's loyalties do however lie more with Silver. Silver's gift of a gun to an eagerly receptive Jim later proves instrumental to saving the lives of both. In

return, Jim's gift of stolen rum to Silver indirectly implicates Jim in the death of Mr. Arrow, the first mate whose weakness for alcohol is fatally exploited by Silver. The growing bond between the two culminates in Silver's climactic escape, when Silver decides not to shoot Jim, and Jim in return helps Silver cast off his beached longboat. Dr. Livesey articulates Jim's emotions (and the audience's) as Silver sails away: "Blast him. I could almost find it in my heart to hope he makes it."

Walt Disney's newest version sends Stevenson's classic soaring into the spaceways, featuring the voices of Joseph Gordon-Levitt as Jim Hawkins and Brian Murray as John Silver. After a storybook opening, when a young boy's reading of a book of pirate stories triggers a dazzling montage of dream images of freebooters in space, the film settles down to its central conceit—somewhere in a "never-land" of the cosmos, Spanish galleons fly the heavens, powered by solar winds and atomic engines and manned by bizarre aliens of all descriptions. After the desertion of his father, Jim Hawkins and his mother take care of the Ben Bow Inn. Jim is a restless lad, of late brought home by the robot-police because of his reckless cruising of the skies on his solar surfer.

Into his world crashes the dying Billy Bones, whose possession of Captain Flint's treasure map promises riches to whoever dares to seek it out. But his dying words warn Jim that an evil "cyborg" is on his trail. Jim flees the scene and, with his friend, Dr. Doppler (David Hyde Pierce), a newly recruited ship's cook, John Silver (a blustering chap with a robot eye and robotic arms and legs), and the ship's captain, the swashbuckling Captain Amelia (Emma Thompson), set out on their adventure. Reaching the Treasure Planet, Jim and the treacherous Silver—who is revealed as the villainous cyborg Jim had been warned about—find themselves in a desperate competition to find the gold. With the aid of a marooned robot named B.E.N. (Martin Short), they find that the treasure's location is in actuality a gateway to all points of the cosmos. On the way home, Jim takes pity on Silver and allows him to escape.

"We wanted our film to be as if Stevenson had written a science fiction fantasy," says director Ron Clements. Indeed, the action is straight out of Edgar Rice Burroughs, with a dash of graphic design influenced by the likes of H. R. Giger and N. C. Wyeth. Likewise, the film combines old-fashioned hand-drawn animation with modern computer-generated imagery. The treasure map is now a computer-generated globe that transforms into a dimensional cosmic chart. The two processes are combined in the character of Silver—the human parts of his body are hand-drawn and the robotic parts are computer-animated. Comic touches are provided by crazy B.E.N. (Bio-Electronic-Navigator), a whimsically deranged robot whose memory circuits have been damaged; and Silver's pet, no longer a parrot but a shape-changing entity called "Morph." The film tanked at the box office, but its inventive spin on Stevenson's story deserved a better fate.

REFERENCES

Hammond, J. R., *A Robert Louis Stevenson Companion: A Guide to the Novels, Essays, and Short Stories* (Macmillan Press, 1984); Street, Douglas, ed., *Children's Novels and the Movies* (Frederick Ungar, 1983).

—P.S.

THE TREASURE OF THE SIERRA MADRE (1935)

B. TRAVEN

The Treasure of the Sierra Madre (1948), U.S.A., directed and adapted by John Huston; Warner Bros.

The Novel

Novelist B. Traven concealed his identity because he abhorred the public's all-too-frequent concern with writers at the expense of their writing. Ironically, the criticism that has grown up around Traven has almost exclusively been concerned with his true identity and not his literary production. A man of several names, it is generally accepted that he was born in Germany, where he was known as a radical peace activist named Ret Marut. In 1924 he moved to Mexico, where he began writing novels under the Traven pseudonym. Between 1924 and 1939 he wrote 12 novels in German, of which *The Treasure of the Sierra Madre* was his third.

The setting is Tampico, Mexico. Three destitute drifters, Dobbs, Curtin, and Howard, decide to prospect the Sierra Madre for gold. They work hard and gather a small fortune. One day, another prospector, Robert Lacaud, arrives and demands that he be allowed to mine the area. Just as the men are about to kill the invader, bandits attack the encampment. After their rescue by the Mexican cavalry, the three men depart with their fortune, leaving Lacaud behind to work the claim. Lacaud is the very epitome of a modern-day alchemist whose relentless, yet fruitless search for gold ultimately destroys his reason. On the road, the three men are approached by Indians requesting medical help for one of their children. Howard agrees to accompany them back to their village. He cures the illness and becomes the Indians' medicine man. Dobbs, meanwhile, insane with greed, shoots Curtin and steals his gold. When he reaches the city, he is attacked by toughs and decapitated. The gold dust in his sacks is mistaken for worthless sand and emptied onto the ground. The *federales* arrive, capture Dobbs's killers, and execute them. At the end of the novel, the reunited Howard and Curtin (by now nursed back to health by the Indians) laugh over the irony of their hard-won gold scattered back to the earth.

The novel was warmly received in America by those sympathetic to its capitalist critique. "As long as they had owned nothing of value," writes Traven of the trio in their greedy accumulation of gold, "they had been slaves of their hungry bellies. All this was changed now. They had reached the first step by which man becomes the slave of his prop-

erty." Theirs can only be a fruitless pursuit, for, as Traven writes, "the glittering treasure you are hunting for day and night lies buried on the other side of that hill yonder."

The Film

Returning from World War II, and after filming several notable wartime documentaries, including *The Battle of San Pietro*, John Huston chose Traven's novel as the basis for his first postwar film. He had already displayed sympathy for the theme of the futile, destructive quest for wealth in his script for *The Maltese Falcon* in 1941, and in later years would return to it in films like *The Asphalt Jungle*, *Beat the Devil*, and *The Man Who Would Be King*. Always interested in location shooting, Huston persuaded Warner Bros. to let him shoot for 10 weeks in San Jose de Purua, an isolated village 140 miles north of Mexico City. It was an arduous shoot, according to Humphrey Bogart, who described Huston's obsession for gritty realism: "If we could go to a location site without fording a couple of streams and walking through snake-infested areas in the scorching sun, then it wasn't quite right."

Although his script was faithful to most of Traven's significant plot details, Huston preferred to investigate the effects of personal greed rather than launch a general critique of capitalism. Thus, the obsession of Dobbs (Humphrey Bogart) assumes center stage, while, by contrast, the characters of Howard (Walter Huston), Curtin (Tim Holt), and Lacaud (Bruce Bennett) become more sympathetic. The changes in Lacaud (renamed Cody) are especially significant. In the movie he is a married man who has left behind a peach farm in America. It is to this farm, the symbol of the contentment and prosperity afforded by the natural landscape, that Curtin goes after Cody's death. Thus, Huston's script tempers Traven's pessimism and positions the American homeland as a Utopian place where Cody (and now Curtin) can go once they've realized the folly of their unnatural greed.

Time regarded the film "as one of the best things Hollywood has done since it learned to talk," and Bosley Crowther in *The New York Times* wrote that "Huston has shaped a searching drama of the collision of civilization's vicious greeds with the instinct for self-preservation in an environment where all the barriers are down." In a dissenting note, critic John McCarten in *The New Yorker* complained that the film could be reduced to the simplistic idea that greed does not pay.

REFERENCES

Engell, John, "Traven, Huston and the Textual Treasures of the Sierra Madre," in *Reflections in a Male Eye: John Huston and the American Experience*, eds. Gaylyn Studlar and David Desser (Smithsonian Institution, 1993); Jameson, Richard T., "*The Treasure of the Sierra Madre*," in *Perspectives on John Huston*, ed. Stephen Cooper (G.K. Hall, 1994); Kaminsky, Stuart M., *American Film Genres* (Nelson-Hall, 1985).

—*W.M. and J.C.T.*

A TREE GROWS IN BROOKLYN (1943)

BETTY SMITH

A Tree Grows in Brooklyn (1945), U.S.A., directed by Elia Kazan, adapted by Tess Slesinger and Frank Davis; Twentieth Century-Fox.

The Novel

A Tree Grows in Brooklyn, Betty Smith's first novel, depicts life in the Williamsburg slum section of Brooklyn before and during World War I. The book received considerable critical acclaim and also became a popular best-seller. Many reviews applauded Smith for her characterizations and keen sense of storytelling, for she constructs a memorable and poignant tale of family relationships without slipping into sentimentality. While the book explores vulgarity, prejudice, and the grim reality of death, it also illuminates the courage, love, and devotion of the characters. As one critic notes, "the author sees the misery, squalor, and cruelty of slum life but sees them with understanding, pity, and sometimes with hilarious humor. A welcome relief from the latter-day fashion of writing about slum folk as if they were all brutalized morons."

Smith's novel is the coming-of-age story of Francie Nolan as well as a potpourri of enduring and interesting figures who touch her life. Both of her parents were born into poverty. Katie, her mother and the youngest of four sisters, possesses a fierce will to survive so that her children will have a better future, and Johnny, the father with a heart of gold, contributes his wages from his occasional jobs as a singing waiter, though he spends much of his time dreaming and drinking away his tips at the bar. In this richly textured ethnic neighborhood, Francie and her brother Neeley learn at an early age that life is a constant struggle. Children often leave school to get their working papers, rags are sold for pennies, hunger is commonplace, and immigrants are often taken advantage of due to a lack of English. But the Nolan children are tough, and as a neighbor once told Francie, she was "born to lick this life." While Francie and Neeley read each night and work hard in school in order to follow the American dream philosophy of their grandmother, Katie holds the family together the best she can, especially after Johnny dies. As Francie graduates from grammar school and works in a factory to help support the family, she sometimes is at odds with her mother, but she also learns from Katie and mirrors her in many ways. Like her mother, who determinedly scrubs floors in order to pay the rent, Francie fights and keeps her eyes on her future, even after she must forgo high school to provide a second income. Their financial situation improves, and the Nolans enjoy some basic comforts, particularly after Katie remarries. In her next stage of development, Francie begins to take summer courses while working full-time, has her heart broken, strikes up a special friendship, and qualifies for admission to a university

without a high school diploma. But she will miss Brooklyn terribly, the place that has become a part of her soul. She recognizes that things will never be the same, and she and Neeley reminisce about the many fun, albeit difficult, times they encountered. In the end, Francie sees her beloved tree growing again up through the cement, conveying the triumphant spirit of the novel.

The Film

It could be argued that Elia Kazan's 1945 adaptation of *A Tree Grows in Brooklyn* became one of the most endearing movie versions that has ever grown out of a popular novel. Writers Slesinger and Davis produced a script that received a nomination for best adapted screenplay, and Kazan pulled together a talented cast for this memorable production. James Dunn, who plays Johnny Nolan, secured the Oscar for best supporting actor, and Peggy Ann Garner received a special Oscar for outstanding child actress for her touching portrayal of Francie Nolan. In fact, one of the finest achievements of the movie is its depiction of the father/daughter relationship. According to one critic, through a "radiant performance by these two actors of a dreamy adoration between father and child is achieved a pictorial demonstration of emotion that is sublimely eloquent."

The film, along with such selections as *National Velvet* and *Meet Me in St. Louis*, was one of the first movies to be included in the film department of the Library of Congress because they "faithfully record, in one way or another, the contemporary life and tastes and preferences of the American people." However, in relation to *A Tree Grows in Brooklyn*, this statement is more applicable to the novel than to the film. Smith paints a detailed and realistic portrait of slum life, and she does not shy away from disagreeable subjects nor did she "prettify her subject." One may even be surprised at some of the content, considering that the book is ordinarily categorized as children's literature. Smith somberly stresses the reality of fatal disease, as evidenced by Francie seeing "something wrapped in a long somber cloak with a grinning skull, and bones for hands" waiting for a neighbor stricken with consumption. Then there is Joanna, the young woman who is stoned along with her baby by the women in the neighborhood for her status as an unwed mother. Perhaps one of the most striking sequences occurs when Francie is molested and Katie shoots her attacker. What could be included in the written form was not appropriate for the big screen in 1945, and while the film reveals the poverty of the era, it does so in an almost light and matter-of-fact manner. Likewise, while the film offers a glossed-over account of tenement life, the novel gets at the heart of the disadvantages and prejudices that immigrants faced. In a most offensive scene, a young doctor in charge of administering free immunizations to the disadvantaged asks the nurse "how that kind of people could survive; that it would be a better world if they were all sterilized and couldn't breed anymore."

Aside from omitting the brutal realism of the novel, the film does not really represent a coming-of-age story. The plot line stops after Francie graduates from grammar school, and the only glimpse of the future is at the soda shop where Francie gets invited on her first date. In fact, while the novel has closure, one feels as if Kazan could direct a sequel. Whereas the novel carefully tracks Francie's maturation over a decade, this version focuses on one small period. However, one slice that the film develops well is the relationship between Katie (Dorothy McGuire) and her mother and how they reconcile their differences during Katie's poignant labor scene. It also successfully constructs the dichotomy between pragmatism and wishful thinking through Katie and Johnny respectively.

With details that really give a glimpse of life at that time—corporal punishment in the schools, the custom of "slamming gates" at Thanksgiving, the importance of unions and the dynamics of working in a factory—Betty Smith's novel can be somewhat thought of as a social historical record of the early part of the 20th century. Furthermore, as Francie grows up, the author echoes her changes by sketching the transformation occurring in America, such as the war, the threat of prohibition, and modernization. As one character reflects, "The good old days! I guess they are gone forever!" The movie does situate the audience in a specific period with songs like "Take Me Out to the Ball Game." But the adaptation focuses on examining the relationships in the Nolan household, which it does skillfully. Finally, Kazan's adaptation neglects to include references to tensions in Europe, possibly because World War II was not yet over. In the novel, the Germans refer to anyone whom they dislike as "Jew," a German spy is caught at the Press Clipping Bureau, and Germanic names such as Hamburg Street and sauerkraut are Americanized. And the film hardly, if at all, makes a reference to World War I.

REFERENCES

Brown, Gene, ed., "First Films Picked for Congress Library," in *The New York Times Encyclopedia of Film: 1941–1946* (Times Books, 1984); Prescott, Orville, *In My Opinion: An Inquiry into the Contemporary Novel* (Books for Libraries Press, 1971); review of film in *The New York Times*, March 1, 1945; review of book in *The New Yorker*, August 21, 1943, 66.

—R.L.N.

THE TRIAL *(Der Prozess)* (1925)

FRANZ KAFKA

The Trial (1962), France/Germany/Italy, directed and adapted by Orson Welles; Paris Europa Productions (Paris), Hisa-Films (Munich), FI-C-IT (Rome).

The Trial (1993), Great Britain, directed by David Jones, adapted by Harold Pinter; BBC Films and Europanda Entertainment, released by Angelika Films.

The Novel

It's hard to find another early 20th-century writer who has been—and continues to be—as widely influential on subsequent writers as Kafka. *The Trial* stuns us with its very opening sentence: "Someone must have traduced Joseph K, for without having done anything wrong he was arrested one fine morning." Having had his reality irrevocably altered, the protagonist now spends all his energy in trying to find out what to do, and he does so in a ploddingly rational manner that, paradoxically, incorporates the extraordinary into the ordinary. His daily routine becomes the trial, as Gregor Samsa's becomes being an insect. Joseph K. attends interrogations, hires a lawyer, meets other accused men, and tries to attach himself to several women (Fraulein Burstner, Leni). He is told by a painter that "everything belongs to the Court" and that "there are Law Court offices in almost every attic." While he is submissive to the arrest, Joseph K. also takes the stance of rebel. At his first interrogation, he criticizes the sleaziness of the hearing; with the painter, he tries for an unprecedented definite acquittal; he later dismisses his lawyer; and he treats other accused with contempt for their abject grovelling. Finally, in the penultimate chapter, Joseph K. finds himself in a cathedral. There a priest tells him the fable of the man who seeks admittance to the Law and spends his entire life waiting to get in, but is always told "not now." Just before he dies, the gatekeeper tells the man "No one but you could gain admittance through this door, since this door was intended for you. I am now going to shut it." In the final chapter, on Joseph K.'s 31st birthday, exactly one year since his arrest, two men take Joseph K. away and execute him by stabbing him through the heart.

The Films

Orson Welles once said that filmmaking was 10 percent creativity and 90 percent fundraising, and, like all his projects after *The Magnificent Ambersons*, *The Trial* was a financial trial for the director/adapter. Because of the producer's bad credit, Welles could not build sets for *The Trial*; instead, he was forced to use an abandoned railroad station, the Gare d'Orsay in Paris. "Everything was invented at the last minute because physically my film had an entirely different conception," Welles explained to *Cahiers du cinema*.

> It was based on an absence of sets. And this giantism I have been reproached for is, in part, due to the fact that the only set I possessed was that old abandoned station. An empty railroad station is immense! The production, as I had sketched it, comprised sets that gradually disappeared. The number of realistic elements were to become fewer and fewer and the public would become aware of it, to the point where the scene would be reduced to free space as if everything had dissolved.

Welles was not intimidated by Kafka. "I do not share Kafka's point of view in *The Trial*. I believe that he is a good writer, but Kafka is not the extraordinary genius that people today see him as. That is why I was not concerned about excessive fidelity and could make a film by Welles." The boldness of Welles's conception of Kafka is evident at the beginning, when, through the pin-screen images of Alexandre Alexeieff and Claire Parker, Welles narrates the story of the man before the Law, so that it informs our perception of every subsequent scene (it is repeated in abbreviated form in the cathedral episode). In the novel the fable serves as a microcosm of Joseph K.'s situation, but because we encounter it near the end, we realize this only retroactively. A major challenge for the adapter is Kafka's point of view, which is severely restricted; we see/perceive only what K. sees and perceives. Welles has to externalize the interior action, and much of the film is visually striking: For example, when Joseph K. (Anthony Perkins) emerges from his first hearing, we see him leave the room through normal-sized doors; the reverse angle shot on the outside, however, shows him closing two gigantic doors triple his own height. At the end, the executioners throw away the knife and throw dynamite at K. The final images are small mushroom clouds.

Welles called *The Trial* "the best film I ever made," but the critics were more reserved in their reviews, which were decidedly mixed. Gill in *The New Yorker* criticized the film's Grand Guignol tone, while others derided Perkins's portrayal of Joseph K. Pauline Kael in *Film Quarterly* pointed out the atrocious sound and the messy structure. *Time* praised its "visual bravura" and complimented back-handedly: "*The Trial* is by no means a great film. It is founded on an aesthetic fallacy—the proposition that a camera can see what is unseeable: Meaning, Being, Mystery. But when Welles makes a mistake he makes it on a grand scale and in the grand manner. He is one of the greatest natural talents that ever looked through a lens, and *The Trial* gives vivid evidence that the prodigal is still a prodigy." Hartung in *The Commonweal* had no reservations, finding it a "spellbinding film," which "has caught the spirit of the book, its protest against bureaucracy and injustice; and its disturbing nightmare quality."

A later version adapted by Harold Pinter and directed by David Jones, with Kyle MacLachlan as Joseph K., was released in 1993, though not widely distributed in the United States. "Welles concentrated on the guilt and paranoia in Kafka, casting a jittery Anthony Perkins as his guilt-stricken leading man," Janet Maslin wrote, but Pinter and Jones offered "danger of a more mundane kind," framed as "political, religious, or psychological allegory." Kyle MacLachlan's "somewhat bland Josef K" was supported by some "colorful cameo appearances" by Anthony Hopkins (as the chaplain), Jason Robards (as Josef's ailing lawyer) and Polly Walker (as the nurse). The menace, the mystery, and the sexuality of Kafka are effectively made Pinteresque, while the film tells its story straightforwardly,

"as if it made sense." This approach is no less valid than that of Orson Welles.

REFERENCES

Bessy, Maurice, *Orson Welles*, tr. Ciba Vaughan (Crown, 1971); Hartung, Philip T., "Nightmare Alley," *The Commonweal*, March 15, 1963, 642; "In the Toils of the Law," *Time*, March 1, 1963, 79; Sarris, Andrew, *Interviews with Film Directors* (Avon, 1967); *The Trial, a Film by Orson Welles*, Nicholas Fry (Simon and Schuster, 1970).

—*U.W. and J.M. Welsh*

TROPIC OF CANCER (1934)

HENRY MILLER

Tropic of Cancer (1970), U.S.A., directed by Joseph Strick, adapted by Strick and Betty Botley; Paramount.

The Novel

This first work by the American writer and counterculture prophet Henry Miller was originally published in Paris but, because of its alleged pornography, was not legally available in the United States until the 1961 Grove Press edition. Loosely autobiographical, the novel draws from Miller's life as an impoverished writer in Paris in 1930–32. Its first-person picaresque narrative mixes varied accounts of the city and its denizens (especially expatriate Americans and Russians), flights of surrealist fantasy, and highly metaphorical exposition of the author's hedonistic philosophy.

The protagonist/narrator, identified as Henry Miller, spends his time cadging meals and lodgings from acquaintances; drinking and philosophizing with friends; engaging in uninhibited sex (mostly with prostitutes); occasionally working as a proofreader, hack writer, and teacher; and making notes for *The Last Book* (a work presumably similar to *Tropic of Cancer*), which will "put a bomb up the asshole of creation" and blow the world "to smithereens." He eventually achieves a "great golden peace," accepting the human situation in all its sordidness and mystery—symbolized for him by both female genitalia and the River Seine.

The book has been praised for its radical critique of bourgeois values, its imaginative blending of crude and lyrical language, and its candid treatment of sexuality. It has been attacked not only as pornographic but also for its casual racism and anti-Semitism, as well as its portrayal of women as mere instruments of male pleasure and objects of male fantasy.

The Film

Set in Paris in the late 1960s and mostly shot on location, Strick's *Tropic of Cancer* follows the plot of the novel fairly faithfully, and quotes extensively its ruminations on sex and society (in voiceover). The film illustrates the difficulties of cinematic adaptation of fiction and is heavily marked by the eccentric personality and ironic tones of a first-person narrator. The commentary often jars with the pictured action, and the unimaginative cinematic techniques (e.g., hackneyed flashbacks and jump-cuts) do not produce effects analogous to Miller's richly metaphorical prose.

The film effectively retells some of the novel's comic episodes. But it loses much of the flavor of the book by shifting the temporal setting from the depression era to the late 1960s, and by failing to depict the protagonist as a serious writer with complex, if controversial, views on modern life. The result, said Pauline Kael, is an "entertaining little sex comedy" that does not approach Miller's "Rabelaisian style." Stanley Myers's bouncy "Paris" music contributes to this superficiality. Rip Torn is miscast as Henry Miller, but James Callahan is excellent as the protagonist's American friend Fillmore.

REFERENCES

Kael, Pauline, "The Current Cinema: Recognizable Human Behavior," *The New Yorker*, March 7, 1970, 92–98; Millett, Kate, "Henry Miller," *Sexual Politics* (Doubleday, 1970), 294–313; Widmer, Kingley, *Henry Miller*, rev. (Twayne, 1990); Woolf, Michael, "Beyond Ideology: Kate Millett and the Case for Henry Miller," in *Perspectives on Pornography: Sexuality in Film and Literature*, ed. Gary Day and Clive Bloom (St. Martin's, 1988), 113–28.

—*W.S.W.*

TUCK EVERLASTING (1975)

NATALIE BABBITT

Tuck Everlasting (2002), U.S.A., directed by Jay Russell; adapted by Jeffrey Lieber and James V. Hart; Walt Disney.

The Novel

Author-illustrator Natalie Babbitt's many novels, picture books, and story collections—including *The Search for Delicious*, *Kneeknock Rise*, and *Goody Hall*—have made her a favorite with young readers worldwide. *Tuck Everlasting*, her fourth novel, published in 1975, has long been a particular favorite, garnering its author the Christopher Award for juvenile fiction and selling more than 1,750,000 copies to date. It, like all her works, takes its inspiration from the fairy tales she loved as a child, which speak to deeply rooted needs in all of us, young and old—the need to be loved, the need for growth and change, and the need to believe in things that must remain unexplainable. *School Library Journal* has placed *Tuck Everlasting* on its list of the One Hundred Books that Shaped the Century.

The year is 1880. Ten-year-old Winnie Foster is dissatisfied at her straitlaced, well-ordered existence. She

longs to escape her wealthy parents' tidy home and take to the road for adventures. When she meets 17-year-old Jesse Tuck, however, while wandering through the woodlands near her home, she cannot even begin to know what a strange adventure lies ahead. Jesse is taking a drink from a hidden spring when he sees Winnie. To her amazement, he seems frightened at being discovered. To her further amazement, when his parents, Mae and Angus Tuck, arrive on the scene, they hurriedly take her up in their wagon and speed away deeper into the forest. Her fears of being kidnapped are dispelled, however, when the Tucks prove to be a gentle family concerned about her welfare. They are keeping her overnight, explains Angus, because they need to make her understand why she must never reveal the existence of this family and the mysterious spring in the wood.

Thus ensues the history of the Tucks, a family journeying west who had found the spring and had drunk from it. Years passed, and they began to notice that they did not age as others did. The world changed day to day, but they never grew older than the day they imbibed the waters. In short, some mysterious property in the spring had granted them immortality. Moreover, they are indestructible—not even illness or injury can kill them. "It's no use trying to explain how this extraordinary gift came to us," says Mae Tuck. "I don't see how we deserve to be cursed, if it's a curse. Still—there's no use trying to figure why things fall the way they do. Things just are, and fussing don't bring changes." Indeed, this is not the blessing one might presume it to be, continues Mr. Tuck. Life everlasting condemns them to be outsiders in a world that that goes through the great turning wheel of life and death. "We're stuck, Winnie," explains Mr. Tuck. "Everywhere around us, things is moving and growing and changing. . . . But dying's part of the wheel, right there next to being born. . . . Being part of the whole thing, that's the blessing. But it's passing us by. . . . You can't have living without dying. So you can't call it living, what we got. We just *are*, we just *be*, like rocks beside the road." At this point, the reader may be forgiven a certain queasiness in the realization that Winnie's boyfriend, Jesse Tuck, is not the 17-year-old we have presumed him to be, but is, in actuality, 104 years old.

Meanwhile, unbeknownst to Winnie and the Tucks, a stranger dressed all in yellow has discovered the secret of the immortal spring. He has come into the wood to the Tuck's cabin to issue a terrible bargain: He has gained possession of these woods and the hidden spring. He intends to sell the waters of the immortal spring to the highest bidders. Worse, he will use the Tucks as a kind of sideshow to demonstrate the invulnerability the waters confer upon those who drink it. As he drags Winnie away from the cabin, Mae Tuck, seized by panic, fells him with the stock of a shotgun. At precisely that moment the local sheriff comes upon the scene. He takes Mae back with him to town, determined to prosecute and hang her for murder.

The horror of the moment is compounded by Winnie's realization that not only might Mae Tuck hang, she *cannot die*. Determined to help her new friends, Winnie helps them pull off a desperate midnight rescue of Mae. As the Tucks disappear into the night, Jesse's last urgent words still echo in Winnie's mind: He has given her a vial of the immortal spring's waters; and when she is 17, she should drink from them so that they might reunite and marry and live together forever.

In the brief epilogue, the time period shifts forward 60 years. The Tucks return to the area to find that the town is unrecognizable and the woodland and its mysterious tree (which, they learn, had been struck by lightning and plowed under) have disappeared. Angus Tuck approaches the cemetery and finds a grave stone marking the burial place of Winnie Foster. She has failed to drink the immortal waters.

The Film

Although the pacing is maddeningly slow and the music rather saccharine and sweet, Walt Disney's film version, directed by Jay Russell and adapted by Jeffrey Lieber and James V. Hart, remains true to Babbitt's novel in almost every point—Winnie's flight from her repressive, wealthy parents, her encounter with Jesse beside the magical fountain of youth, her discovery of the Tuck family secret (they inadvertently drank from this spring almost a century ago), the pursuit by the Yellow Suited Man and Winnie's parents, Mae's murder of the Yellow Suited Man, the Tucks' incarceration in town, their escape from the jail, and their final flight from the area, leaving Winnie behind to pursue her own life. Significantly, the Disney version emerges, appropriately enough, as a variant of the *Peter Pan* story—17-year-old Jesse Tuck as an immortal Pan who will never outgrow his boyhood, Winnie Foster as Wendy (the young girl he lures away from her cloistered existence), the Yellow Suited Man as Captain Hook (who's been fanatically pursuing the Tucks' secret of immortality), and Foster's Wood as the Never Land wherein the Tucks live. And true to form, Winnie must return to her family and her mortality, while Jesse and his family live on and on, returning 80 years later to visit her gravesite. Mr. Tuck's philosophical discussion about the wheel of life might have been voiced by Barrie himself: He reveals to Winnie that their inability to grow older has forced them to stand aside from the "wheel of life," the natural cycle of living and dying, and remain like rocks stuck in the river bank. Eternal life—and in the case of Jesse, eternal boyhood—becomes an endless curse. Helpless, they can only watch while the beloved mortals in their life wither, fade, and die.

The cast struggles against what critic Kathi Maio complains is a "boring" script which is "ponderous for children and too sappy and sentimental for most adults." Ben Kingsley as the pursuing Yellow Suited Man looks faintly ridiculous in his florid duds, a hat perched atop his long hair, a walking stick twirling in his hand. Amy Irving

stands in rigid silence most of the time, her features set, jaw clenched, awaiting the return of her errant daughter. William Hurt and Sissy Spacek cannot entirely escape their glamorous images for the homely, stodgy Mr. and Mrs. Tuck. And, unfortunately, the 20-year-old Alexis Bledel is far too old to portray convincingly a 10-year-old Winnie Foster, which throws the original dynamics of her relationship with Jesse into disarray. "Like Alice and Wendy and Oz's Dorothy before her," continues Maio, "Winnie is meant to be a valiant young girl, sturdy of foot, true of heart, and bound for adventure. The filmmakers at Disney betray their young heroine by defining her simply as a starry-eyed teenybopper finding and losing her first boyfriend." Meanwhile, Winnie and Jesse (Jonathan Jackson) have their own forest idyll—not exactly flying like Wendy and Peter, but skimming low over the meadows and climbing high on the rocks.

REFERENCES

Baskin, Barbara, "Tuck Everlasting" (review), *Booklist*, September 15, 1995, 184; *Twentieth Century Children's Writers*, 3d ed., (St. Martin's Press, 1989), 41–52; Maio, Kathy, "Don't Drink the Water, *The Magazine of Fantasy and Science Fiction* 104, no. 3 (March 2003): 5.

—J.C.T.

THE TURN OF THE SCREW (1898)

HENRY JAMES

The Innocents (1961), U.K., directed by Jack Clayton, adapted by William Archibald and Truman Capote; Twentieth Century-Fox.

The Novel

Recognized right away as one of the great ghost stories, *The Turn of the Screw* has also become notorious as a text that yields two mutually contradictory interpretations, like the visual paradox in which one act of perception sees a vase and another a pair of profiles facing each other. Few other texts lay bare the frustrations of interpretation as much as this one does. Everything hinges on the credibility of the governess, who narrates her own story, and who is aware, as she says, that "nobody in the house but the governess was in the governess's plight." If there are ghosts, then she is their victim, and the children are either victims too or are in collusion with them; if there are no ghosts, then she is making the children victims of her madness or delusion. James provides no external reference point outside the governess, who is recording her memories many years after the events.

James foregrounds the narrative with a group of people telling ghost stories in front of the fire many years later. Douglas, who as a young man met the governess when she took care of his sister, produces her manuscript; the narrator of the frame, in turn, presents it to us, the readers,

years later, after Douglas's death. By the time the story reaches us, more than half a century has passed since the events themselves. Douglas is the only character in the text who has known the governess, and that was 10 years after her Bly experience. "She was the most agreeable woman I've ever known in her position," he says, "I liked her extremely." He also tells the group that she was young, untried, and nervous when she applied for the job, and she was immediately swept off her feet by the children's guardian uncle: "a gentleman, a bachelor in the prime of life, such a figure as had never risen, save in a dream or an old novel, before a fluttered anxious girl out of a Hampshire vicarage." Douglas's character reference sets up the contradiction to come: The governess is young, innocent, and susceptible to fantasy; and she is herself likable, infatuating the younger Douglas (as the listening group immediately supposes), much as the children's uncle had infatuated her younger self, so that his characterization of her becomes as a result unreliable.

At Bly, the country estate where Flora and Miles live because the uncle does not want to be bothered with them, the governess is obsessed with pleasing the uncle through her good work. Flora seems to her at first to be an angelic child, and Miles too, despite his being sent home from school—permanently, according to a letter only the governess reads, and probably because of misbehavior, she surmises. One evening the governess sees a man atop a tower, she sees him again some days later outside a window. Told that there is no one on the estate other than people she has already met, she learns from the housekeeper Mrs. Grosse that the man she sees resembles Quint, the uncle's former valet who had died. She also begins to see a woman, who resembles Miss Jessel, the former governess, also dead, a suicide. Mrs. Grosse hints that there were unsavory goings-on between the two of them and that they may have been too free with the children. The governess now sees it as her duty to save the children from the evil influence of the ghosts. Her efforts eventually cause Flora to have a breakdown and Miles to die, apparently of a heart attack. There her narrative ends. We never return to the frame story.

The Film

As a ghost story, *The Turn of the Screw* has much appeal, as several TV productions have demonstrated, most recently the made-for-TV movie *The Haunting of Helen Walker* (1996), which, though hinting at the governess's possible derangement, eventually makes the ghosts real. The challenge is to preserve the irresolvable ambiguity of James's text in a medium that must show us the ghosts. William Archibald and Truman Capote's screenplay (based on Archibald's stage play) and Jack Clayton's direction do exactly that. Their title starts off the ambiguity: The innocents could refer to the children, or the governess, or all three; it could even refer to the ghosts. The film presents everything (with a few not really significant exceptions)

from the governess's perspective, thus establishing a very restricted third-person narration that approximates the governess's own account in James's text. Boyum finds this a "highly effective solution to the challenge of rendering the story's first-person perspective."

But the even more daunting challenge for the filmmakers is to make us doubt the reliability of the governess's perceptions at the same time that their film must show them to us. *The Innocents* does this by having other characters not see or hear what the governess does, by image distortion and heightening, by sound distortion, and, above all, by establishing at the outset that the governess falls head over heels in love with the uncle and is perhaps unstable as well. When she first arrives at Bly, there is a faint, almost inaudible woman's voice calling "Flora," followed by the governess's first glimpse of Flora as a reflection in the pond in front of her, rendered in an image of almost hallucinatory brightness (the film's glorious black and white CinemaScope photography is by Freddie Francis). The film is faithful to James's story structure, but it also embellishes, adding a scene in which the governess comes across pictures of Quint and Miss Jessel in order to explain her ability to describe their appearance so exactly; a scene with Miles on the same tower on which she first "sees" Quint; a scene of Miles riding a horse; a dream sequence; lots of flowers losing their petals. Most effective are two added scenes that strengthen the interpretation of the governess as a sexually repressed woman who is unconsciously destroying the children: While cutting roses, she discovers the statue of a cherub clasping a pair of hands broken from another statue, while a black beetle crawls out of the cherub's mouth, to her horror; while tucking Miles in, he plants a full kiss on her mouth, or so she perceives. The artistry of the film is, as Boyum points out, to make us believe in the actuality of what we are seeing while simultaneously making us doubt that very reality—and, even more effectively, "to make the uncertainty as to whether or not our perceptions are reliable somehow as frightening as those perceptions themselves."

The film's considerable achievement—in a medium that must simulate suggestion by showing—is to preserve all the ambiguity of James's text while not violating any of the viewer's generic expectations for a good old-fashioned ghost story.

"Why don't they leave poor Henry James *alone?*" Brendan Gill moaned when told of this film adaptation. Almost all of the reviews, with some scattered exceptions, were negative. Among the few exceptions was Pauline Kael, who called the film "a very good one, and maybe Deborah Kerr's performance should really be called great." She also called to task the reviewers who complained of the film's reduction of James's text. "The evidence that the screenwriters *haven't* slanted it is that the critics who complain of slanting are all complaining of different slants . . . As for the reviewers who have kept people away from the movie—perhaps the title includes them?" When reviewers pan adaptations for the very qualities that are admired in the source text, one has to wonder about their knowledge of that text. Or is it, as Boyum speculates, "a matter of the extent to which, even among those whose primary commitment and concern is movies, a bias against film and in favor of literature prevails, ending up distorting vision?"

REFERENCES

Allen, Jeanne Thomas, "*The Turn of the Screw* and *The Innocents:* Two Types of Ambiguity," in *The Classic American Novel and the Movies,* ed. Gerald Peary and Roger Shatzkin (Frederick Ungar, 1977), 132–42; Boyum, Joyce Gould, *Double Exposure: Fiction into Film* (New American Library, 1985); Palmer James W., "Cinematic Ambiguity: James's *The Turn of the Screw* and Clayton's *The Innocents,*" *Literature/Film Quarterly* 5 (1977): 189–215; Recchia, Edward, "An Eye for an I: Adapting Henry James's *The Turn of the Screw* to the Screen," *Literature/Film Quarterly* 15 (1987): 28–35.

—*U.W.*

TWENTY THOUSAND LEAGUES UNDER THE SEA *(Vingt mille lieues sous les mers)* (1870)

JULES VERNE

Twenty Thousand Leagues under the Sea (1907), France, directed by Georges Méliès.

Twenty Thousand Leagues under the Sea (1916), U.S.A., directed and adapted by Stuart Paton; Universal.

Twenty Thousand Leagues under the Sea (1954), U.S.A., directed by Richard Fleischer, adapted by Earl Felton; Buena Vista Productions.

The Novel

One of Jules Verne's most famous novels, *Twenty Thousand Leagues under the Sea* has only recently received a proper translation into English, a factor that may alleviate the novel's historically critical underestimation and dismissal as "children's literature" in the United States. Indeed, the novel has been marked by a rather confusing publication history, both in French and English. Over the period of 1869 through 1871, P.J. Hetzel serially published Jules Verne's novel *Vingt mille lieues sous les mers.* Soft-cover editions also appeared in 1869 and 1870, but the first officially recognized, illustrated French edition was published by Hetzel in 1871. An English translation, prepared by Mercier Lewis, suffered because of numerous inaccuracies and expurgations of Verne's detailed scientific material. To a greater or lesser extent, these errors have been repeated in all subsequent English translations. Walter James Miller has diligently worked to correct this unfortunate situation, first with his 1976 annotated edition of Mercier's translation, and then again with his and Frederick Paul Walter's 1993 translation of the original source material. Another recent translation (1991) by Emmanuel J. Mickel wisely returns to the 1871 Hetzel volume, the

definitive original of one of Verne's most accomplished scientific romances.

In 1866, numerous maritime reports of a vast, phosphorescent monster greatly excite public interest and provoke scientific controversy. However, when two ships are crippled by blows from a mysterious underwater force, the United States Navy commissions an armed frigate, the *Abraham Lincoln*, to settle the matter of the monster's existence once and for all. Distinguished French professor Pierre Aronnax and his manservant Conseil, both in the United States on a fossil-hunting expedition, are invited to accompany the frigate's crew, as is harpooner Ned Land. Following a long and fruitless search, the frigate sights the monster off the coast of Japan. In the ensuing chase and confrontation, the monster's collision with the frigate hurls Aronnax overboard. The loyal Conseil leaps into the sea to rescue him, but both men are left behind by the crippled *Abraham Lincoln*. Unbeknownst to Aronnax and Conseil, Ned Land has also been knocked from his harpooner's perch into the ocean. Ironically, all three escape drowning by clinging to the floating monster, which turns out to be a steel-plated submarine vessel. Eight masked men emerge from belowdecks to capture Aronnax, Conseil, and Ned. The three castaways are confined in a cell in the vessel's interior for an indeterminate length of time. The vessel's captain, a mysterious man known to them only as Nemo, finally allows them free reign of the submarine, the *Nautilus*, on the condition that they never leave.

So begins an extraordinary 10-month undersea voyage, which will cover a full 20,000 leagues and range from the Sea of Japan to the coast of Norway. The *Nautilus* crew and passengers successfully confront many dangers, including various attacks by Papuan natives, sharks, and giant squids. They also see great wonders: sunken Atlantis, the pearl banks of Ceylon, the South Pole. During the voyage, Aronnax learns many of the secrets of the *Nautilus*'s construction and motive power (electric), while Ned Land plots escape. Captain Nemo himself remains a misanthropic enigma, but the full extent of his antipathy toward the terran society he abandoned does not reveal itself until his frenzied attack upon a man-of-war, representative of an unnamed nation that slaughtered Nemo's family. Shortly thereafter, Ned, Aronnax, and Conseil steal the *Nautilus*'s launch just as the vessel is pulled into a maelstrom off the Norwegian coast. The three men survive, but the fate of Captain Nemo and his crew is unknown.

The Films

Three silent versions of *Twenty Thousand Leagues under the Sea* were filmed, the first an 18-minute, 1905 American Biograph short that, from all accounts, sticks closely to Verne's original scenario. Less faithful is the 1907 version, entitled *Twenty Thousand Leagues under the Sea; or, A Fisherman's Nightmare*, produced by Verne's fellow Frenchman and pioneering filmmaker Georges Melies. The film takes Verne's basic idea of a submarine voyage but recasts it as a whimsical fantasy wherein a fisherman dreams of encountering not only undersea monsters but also semi-naked mermaids and sea nymphs. In 1916, Stuart Paton retained Verne's serious tone but still departed considerably from the original, combining the plot lines of *Twenty Thousand Leagues* and its "sequel" *Mysterious Island* for his 105-minute adaptation. He also added an ending entirely of his own invention, in which Captain Nemo, identified here as Count Dakkar of India, attacks a Sudanese fort to free his captive daughter. This early version is quite technically advanced in its use of underwater photography—the first American film to do so—and full-scale mockups of the *Nautilus* and a giant octopus, but nevertheless suffers from a lack of existing technology to film some of Verne's more incredible scenes. Of necessity, the final product bears little resemblance to the novel. It was not until the 1950s that *Twenty Thousand Leagues under the Sea* received its most elaborate rendition to date.

In 1954, producer Walt Disney formed a new distribution company, Buena Vista, and needed a feature film to release. Instead of an animated film, he chose to produce a live-action adaptation of a recognized classic: Jules Verne's *Twenty Thousand Leagues under the Sea*. For his crucial first film for his new company, Disney budgeted a then-expensive $5 million; decided to shoot underwater in the Bahamas; selected an established director, Richard Fleischer; and cast Hollywood names such as James Mason (Captain Nemo) and Kirk Douglas (Ned Land). The result was a lucrative and critically well-received film that remains reasonably faithful to the general outlines of its source material and successfully establishes a period-piece atmosphere for a contemporary audience. Of course, there are some narrative alterations. Certain episodes from the book are missing entirely, such as Nemo's conquest of the South Pole, which by 1954 would not have seemed as novel to a cinema audience as to Verne's readers. Specific aspects of Nemo's technology are also updated for the 1950s audience: For example, the *Nautilus* runs on nuclear power, and the climactic maelstrom that swallows the vessel is generated by an atomic explosion detonated by Nemo to destroy his home base of Vulcania.

Perhaps the most substantial change, however, involves the shift in narrative emphasis from the Aronnax/Nemo relationship to Ned Land's heroics. For a 1950s American movie release, Aronnax is obviously too cerebral a protagonist, so Ned becomes the hypermasculine action hero of this production. As portrayed by Kirk Douglas, Ned drinks, whores (surprising in a Disney production), brawls, sings, and wisecracks his way through the film to ultimate superiority over not only Nemo's murderous obsessions but also Aronnax's intellectual abstractions. Conseil, now an apprentice scholar instead of Aronnax's unquestioning manservant, plots with Ned to "deprogram" Aronnax from his thralldom to Nemo. The power struggle for Aronnax's soul between strongmen Ned and Nemo dominates the narrative, culminating in Ned's message-in-a-bottle

scheme that alerts Nemo's enemies to the location of his secret home port. Aronnax, distressed because Nemo had been on the verge of turning over his scientific knowledge to the professor, at first castigates Ned for his actions, to which Ned indignantly retorts, "Someone had to strike a blow for freedom." Ned literally enacts this principle by first battling the *Nautilus's* crew and then rendering Aronnax unconscious when he refuses to leave the vessel without his journal. Aronnax himself, freed of Nemo's influence and having seen the awesome power of the atomic explosion that drowned the *Nautilus*, validates Ned's actions in a statement that undoubtedly had great resonance for the 1950s post-nuclear audience: "Perhaps you did mankind a service, Ned."

REFERENCES

Mickel, Emanuel J., introduction to *The Complete Twenty Thousand Leagues under the Sea* (Indiana University Press, 1991); Steinbrunner, Chris and Burt Goldblatt, *Cinema of the Fantastic* (Galahad Books, 1972).

—*P.S.*

2001: A SPACE ODYSSEY (1968)

ARTHUR C. CLARKE

2001: A Space Odyssey (1968), U.K., directed by Stanley Kubrick, adapted by Kubrick and Arthur C. Clarke; MGM.

The Novel

In 1948, Arthur C. Clarke—the prolific English writer of both popular science fiction and nonfiction works on space travel—wrote "The Sentinel," a short story focusing on man's discovery in 1996 of a large metallic pyramid on the moon; the narrator theorizes it was placed there by extraterrestrial aliens as a "sentinel" to mark the growth of man's intelligence. When Stanley Kubrick in 1964 wanted to make a film about alien intelligence, he turned to Clarke, and they then collaborated on a novel, an initial 130-page treatment, and a screenplay. Clarke has described their writing of novel and screenplay as one of constant interactive feedback.

Part one traces the experiences of a colony of prehistoric apes, the brightest of whom, Moon-Watcher, discovers the use of tools. Through his close encounter with an alien-placed transparent slab, the ape and his simian tribe gain an understanding of the power of weapons that propels his species toward world domination. Clarke explains the aliens' placement of the slab as one of many universe-wide experiments in generating intelligence on other worlds. Part two jumps to a futuristic space age (cf. Kubrick's famous match cut directly from an ape-tossed bone spinning against the blue sky to a space station in orbit) when American moon explorers uncover a second,

solid black monolith, which releases a radio message toward the stars.

Part three follows the HAL-9000 computer-controlled spaceship, the *Discovery*, on its mission to Jupiter and Saturn, under the command of David Bowman and Frank Poole. Parts four and five detail Bowman and Poole's increasing suspicion that the HAL-9000 computer is no longer working correctly; the murders of Poole and three hibernating astronauts by HAL; Bowman's lobotomy of HAL; and Bowman's subsequent solo trip to Saturn's moon Tapetus. Bowman makes a final voyage (part six) through a third giant slab, a "Star Gate," which—via a fourth monolith—carries out the last stage of the alien race's "experiment" with mankind that had started 3 million years earlier. This last stage, as in Clarke's *Childhood's End*, seems to be a kind of Emersonian "Oversoul" in which pure flesh and blood give way to a form of pure mind, spirit, or energy. In both novel and film, Bowman appears in the very corporeal form of himself as an embryonic baby—a "Star-Child"—overseeing the planet Earth as the "master of the world." One can easily read the novel's end as a utopian vision of man's future, or as a dystopian satire of technology and mankind. In Kubrick's film, the use of Richard Strauss's *Also Sprach Zarathustra* suggests the Nietzschean concept of a "superman" and similarly offers both straight and ironic readings.

Clarke later wrote three sequels, *2010: Odyssey Two*, *2061: Odyssey Three*, and *3001*—the first was the basis for a mediocre Peter Hyams adaptation, notable mainly for its efforts to "explain what happened" at the end of the first work.

The Film

2001 is not so much an adaptation as a Kubrick-Clarke collaborative product in which Kubrick takes the relatively straightforward prose of Clarke's science fiction tale and generates his own masterful film. (All of Kubrick's major films have been adaptations, and, with the possible exception of *Lolita*, have tended to move aesthetically far beyond their original sources.) Kubrick eliminated Clarke's "scientific" narrative explications, changing a relatively straightforward science fiction text into the more engaging metaphysical suggestiveness of the movie: The explicit has become the mythical and the mystical. Kubrick brilliantly directed a montage of special effects (with work by, among others, Douglas Trumbull), and it is the film's "visual poetry" (cinematography by Gregory Unsworth), the majestic synergy of image and soundtrack, that defines *2001*. According to Carolyn Geduld, Kubrick spent 18 months shooting 205 special-effects shots, using technical processes Kubrick himself created and designed.

While the film was an immediate cult hit that earned much critical praise, *2001* also received mixed reviews that complained about the slow-to-the-point-of-ponderous direction, the pseudomysticism, and (a common response to Kubrick's work) the cold and inhuman sensibility. Both

2001: A Space Odyssey, directed by Stanley Kubrick (1968, U.K.; MGM/THEATRE COLLECTION, FREE LIBRARY OF PHILADELPHIA)

contemporary critics and thousands of subsequent viewers have continued to debate exactly how to interpret the work, a possibly futile project given Kubrick's own defense of the film as a "non-verbal experience."

Given its origin as short story turned screenplay, then turned simultaneously to Kubrick's film and Clarke's novel, *2001* defies traditional adaptation theory. Rather, one can only compare the resulting contrasting tales as they suggest the nature of the respective media, and here the film entirely surpasses the prose. Kubrick has repeatedly described his film as a purely visual experience (best viewed on a full-size screen, or at least in letterbox); of the film's 140 minutes, only some 40 have dialogue. Clarke's novel, in contrast, reads as an almost ploddingly literal explication of all that might best have remained mysterious and magical. Kubrick's obscurity excites where Clarke's pedestrian explanations bore, and one can assume that the process of working simultaneously on novel and screenplay constrained Clarke's normally more evocative prose. HAL's nervous breakdown, for instance, is much more eerie as unexplained movie drama than as laboriously described "psychological panic." The "Frankenstein" implications of a more-human-than-human computer losing its "mind" and rebelling against its human superiors are much more compellingly evoked in the film than in the novel: Kubrick shot a brilliant point-of-view sequence in which we in effect become the paranoid HAL trying to read the lips of the two astronauts' conspiratorial whispering. Meanwhile, nothing in Clarke's prose approaches the 1960s psychedelic imagery of Bowman's final hallucinatory trip through space and time (shot with Kubrick's own-invented "Slit-Scan" machine), or the careful visual parallelism of prehistoric ape and 21st-century man.

2001 was a defining moment in the tradition of the science fiction film, especially in its conflation of thematic intelligence and visual construction, and it continues to influence science fiction films and television series.

REFERENCES

Agel, Jerome, *The Making of Kubrick's 2001* (New American Library, 1970); Bizony, Piers, *2001: Filming the Future* (Aurum Press, 1994); Clarke, Arthur C., *The Lost Worlds of 2001* (New American Library, 1972); Geduld, Carolyn, *Filmguide to 2001: A Space Odyssey* (Indiana University Press, 1973); Kagan, Norman, *The Cinema of Stanley Kubrick* (Continuum, 1989).

—D.G.B.

TYPEE (1846)

HERMAN MELVILLE

Enchanted Island (1958), U.S.A., directed by Allan Dwan, adapted by James Leicester and Harold Jacob Smith; Warner Bros.

The Novel

Typee: A Peep at Polynesian Life During a Four Month's Residence in a Valley of the Marquesas, Herman Melville's first novel, is based on the accounts of his first whaling voyage in the South Pacific. Melville always insisted that the incidents recorded in *Typee* were true, but modern criticism has demonstrated that *Typee* is more art than travelogue. Published in several versions, *Typee* first appeared in London (February 1846/John Murray). That text was expurgated for the first American edition (March 1846/Wiley

& Putnam, New York); and in August 1846 an even more fully expurgated version appeared ("American Revised Edition"), with changes Melville made under the pressure of John Wiley, whose more prudish readers insisted upon certain revisions. This edition included, for the first time, a sequel called "The Story of Toby." *Typee* was a bestseller and made the 26-year-old Melville famous, albeit briefly.

The novel begins with two sailors, Tom and Toby, who jump ship in the Marquesas Islands. Their dangerous and clandestine flight is followed by further perils and "strange visions of outlandish things." Tom becomes badly wounded and both men, near starvation, are compelled to give themselves up to a "race of savages," the Typee cannibals. The Typees, though indeed cannibals, turn out to be a gentle and childlike tribe, and most of the book is devoted to Melville's description of the "tranquil day[s] of ease," including accounts of Tom swimming merrily among the young and naked Typee "river nymphs"; of the Marquesan maids dancing in the moonlight; and of Tom's fellowship with both his servant Kory-Kory and Mehevi, king of the Typees. *Typee's* most memorable scene shows the lovely and natural Fayaway, in a canoe with Tom on a small lake, opening her robe and using it as a sail, with her bare body as the mast. Despite this, Tom feels obliged to escape Typee "captivity" and dramatically does.

The Film

There is one film version of the novel, *Enchanted Island* (1958), directed by Allan Dwan, one of Hollywood's most prolific directors, and starring Dana Andrews as "Abner Bedford" and Jane Powell as Fayaway. One other version was attempted by John Huston. Oddly, after Huston made Melville's *Moby Dick* (1956), he was so pleased with Gregory Peck's performance (as Ahab) that he wanted to film *Typee* and star Peck. However, Huston had to abandon the project as too expensive.

Enchanted Island is a very loose and saggy adaptation of Melville's work. Critics judged Jane Powell an "unconvincing Polynesian" and remarked that all the actors "were at sea." The real-life Austrian aristocrat Frederick Lebedur (Queequeg in Huston's *Moby Dick*) is absurd as the primitive Typee king Mehevi. Melville's lush, peculiar, and exotic world is served blanched, predictable, and safe. Most unforgivable of all is that, like the early bowdlerized versions of *Typee*, *Enchanted Island* empties Melville's work of all its deliciously suggestive details.

REFERENCES

Bogdanovich, Peter, *Allan Dwan: The Last Pioneer* (Praeger, 1971); Stern, Milton R., *The Fine Hammered Steel of Herman Melville* (University of Illinois Press, 1968).

—L.C.C.

ULYSSES (1922)

JAMES JOYCE

Ulysses (1967), U.S.A., directed by Joseph Strick, adapted by Strick and Fred Haines; Ulysses Film Productions, Inc.

The Novel

Joyce spent about seven years writing *Ulysses,* beginning in 1914. He published the first 12 episodes in the *Little Review* throughout 1918–19, but serialization ended when an issue was seized by American postal agents (U.S. publication was finally permitted in 1934). During the writing of the novel, Joyce also endured eye disease, poverty, and numerous changes of address. But he was vindicated. Many critics consider *Ulysses* the greatest novel written in English.

A day (June 16, 1904) in the life of three Dubliners: Leopold Bloom, a 38-year-old advertising salesman and cuckold; his wife, Molly, a singer and (today) an adulterer; and Stephen Dedalus, the budding poet from *A Portrait of the Artist as a Young Man.* After tracing the separate peregrinations of Stephen and Bloom, Joyce depicts their encounter in a brothel, after which Bloom takes the drunken Stephen to his home. Stephen leaves, and Bloom retires, yielding to Molly's monologue, an unpunctuated tour de force about sex, love, and marriage.

The plot is scarcely the point, however. An encyclopedia of novelistic techniques, *Ulysses* employs a different set of narrative strategies in each of its 18 episodes: a history of English prose, a play, a catechism and so on. *Ulysses* is hilariously funny; it is probably also unfilmable.

The Film

Strick was determined not to censor Joyce's sex and scatology. While he succeeded in that regard, his pedestrian, unimaginative adaptation fails in most other ways. The film begins with a faithful rendition of the opening episode, highlighted by T.P. McKenna's Buck Mulligan. But as the novel departs further from realism, the film becomes less and less satisfying. Strick fails even to exploit the novel's more cinematic scenes. For example, "Wandering Rocks," a 19-segment cross-section of Dublin in midafternoon, is full of montage-like connections and camera-ready narrative movements. But Strick offers only three blandly presented segments. The later episodes are even more disappointing: "Nausicaa" lacks all of the episode's marvelous language and falsifies Joyce's depiction of Gerty and Bloom's mutual arousal; the wonderful "Eumeaus" is omitted; "Oxen of the Sun" becomes merely a few drunken songs around a table.

Strick's film is also poorly paced: Too often we enter a scene, get a few minutes of dialogue, and then shuttle off to the next sequence before we've gathered what this episode is about. "Penelope" is expanded beyond its proportional length in the text. Barbara Jefford performs competently as Molly, but the script smooths out her temporal and attitudinal shifts, rendering her delightful soliloquy boring.

Strick's *Ulysses* has its moments. In "Aeolus," Strick ingeniously puts placards behind the characters to imitate Joyce's headlines. "Cyclops," though omitting the barfly's crude humor, successfully captures Bloom's differences from other Dubliners through blocking and low-angle shots during his escape and apotheosis. The film's highlight

475

is "Circe," which provocatively depicts Bloom's trials and transformations; but this section's ingenuity reveals the banality of the rest of the film.

Joyce was interested in movies (he opened the first cinema in Dublin), but resisted allowing *Ulysses* to be filmed. His masterpiece may some day be successfully adapted, but it will require a larger budget, more than a two-hour running time, and a better filmmaker than Joseph Strick. Even so, it is difficult to envision a movie that could do justice to a novel so dependent upon linguistic effects.

REFERENCES

Barsam, Richard, "When in Doubt Persecute Bloom," in eds. Michael Klein and Gillian Parker, *The English Novel and the Movies* (Ungar, 1981), 291–300; Bazargan, Susan, "The Headings in 'Aeolus': A Cinemagraphic View," *James Joyce Quarterly* 23 (1986): 343–50; Murray, Edward, *The Cinematic Imagination: Writers and the Motion Pictures* (Ungar, 1972), 124–34; Palmer, R. Barton, "Eisensteinian Montage and Joyce's *Ulysses:* The Analogy Reconsidered," *Mosaic* 18 (1985): 73–85.

—*M.W.O.*

THE UNBEARABLE LIGHTNESS OF BEING *(Nesnesitelna lehkost byti)* (1984)

MILAN KUNDERA

The Unbearable Lightness of Being (1988), U.S.A., directed by Philip Kaufman, adapted by Kaufman and Jean-Claude Carrière, Orion.

The Novel

In 1968 Milan Kundera was a professor of literature and film at the Institute for Advanced Cinematographic Studies in Prague, Czechoslovakia. In August Soviet tanks invaded Prague and shortly afterward Kundera lost his teaching post and his writings were banned. In 1975 Kundera and his wife moved to France, where he wrote *The Unbearable Lightness of Being.*

Set in 1968 Czechoslovakia, just prior to the Russian invasion, *The Unbearable Lightness of Being* centers on Tomas, a surgeon who approaches sexuality with pleasurable detachment. Unable to fall asleep with any of his numerous lovers, he remains in a long-term affair with only one of them, Sabina, an artist as dedicated to noncommitment and personal freedom as Tomas seems to be. He then meets Tereza while visiting a small Czech town. The two pass scarcely an hour talking together but still she trails him to Prague, where she and her heavy suitcase move in. Tomas is able to fall asleep with Tereza. He loves and marries her, but is unable and unwilling to give up his mistresses. Their lives are further complicated by the arrival of Soviet tanks in Prague on August 21, 1968. Tereza, a magazine photographer, takes alarming pictures of the invasion, but when she attempts to sell them they are rejected because the photostory is already old news. With the horror of Soviet occupa-

tion, Tereza and Tomas flee to Geneva, Switzerland, where Sabina is already living. However, when Tomas's continuous philandering becomes unbearable to Tereza, she returns to Czechoslovakia. In search of Tereza, Tomas returns too. His growing emotional awareness parallels his growing political awareness, and when Tomas refuses to repudiate an anti-Stalinist paper he wrote earlier, he is barred from practicing medicine and must earn his living as a window washer. Tereza, Tomas, and their dog Karenin go and work on a farm, where they find short-lived satisfaction and peace, ended when both are killed in a traffic accident.

Tomas, in his forties in the novel but much younger in the film, vacillates between extreme modes of living, weight, and lightness as demonstrated by pairs of polar opposites: wife and mistress, commitment and freedom, home and expatriation, and love and sex. Kundera understands that while weight can crush, it can also give rise to "life's most intense fulfillment." Conversely, the lighter we are the more we can soar to freeing heights, though these heights are deceptive, being only as freeing "as they are insignificant." Always drifting and floating in a lightness of being, Tomas begins to struggle with which to choose: weight or lightness.

The Film

In the novel Tomas's story is told by an unidentified narrator who has thought about him for many years and admits that only in the light of reflection is he able to see the situation clearly. This narrative method is central to Kundera's theory, borrowed from Nietzsche, of "eternal return," i.e., the ability to return endlessly to an experience, relive and, if desired, change it. In the acts of reflection and storytelling, the narrator has the capacity to revisit events, even change the choices that were made, see what would have happened if different decisions had been made. Kundera argues it is this capacity for "eternal return," a capacity that the narrator (art) has but Tomas (a "real" person) does not, which gives the necessary weight to life. Without eternal return, life's experiences are unbearably light. Kundera's narrative device, central not only to the aesthetic but also to the philosophical core of the novel, presents an immense problem for any cinematic translation of the novel. However, the movie handles this problem by simply dropping the device and reconstituting *The Unbearable Lightness of Being* as if it were a novel principally about story.

In the movie Tomas's story is largely a sexual adventure. Kundera's novel shows Tomas confused by being pulled simultaneously toward the opposing poles of weight and lightness—to Kundera the most mysterious set of polar opposites. In the novel Tomas himself doesn't understand why Sabina and his other mistresses, all figures of lightness and unbridled personal freedom, are not enough. He marries Tereza without understanding that she embodies the weight of intimacy, personal responsibility, conscience, and love. Tomas is not only confused by his own choices, but also at times oblivious to the fact that he is in

Lena Olin as Sabina in The Unbearable Lightness of Being, *directed by Philip Kaufman* (1987, U.S.A.; SAUL ZAENTZ COMPANY/THEATRE COLLECTION, FREE LIBRARY OF PHILADELPHIA)

The film is handsome and, unlike the novel, mostly free of pretension. With ingenuity and technical acumen it intersplices actual footage of the 1968 Soviet invasion of Prague into the film. However, this is not enough to sustain the movie's three-hour length, which can leave one with an unbearable heaviness.

REFERENCES

Ozer, J.S., ed., *"The Unbearable Lightness of Being," Film Review Annual* (J.S. Ozer, 1989), 1521–34; Rainer, Peter, ed., *Love and Hisses* (Mercury House, 1992).

—*S.C.C.*

UNCLE TOM'S CABIN (1852)

HARRIET BEECHER STOWE

Uncle Tom's Cabin (1903), U.S.A.; Lubin.
Uncle Tom's Cabin (1903), U.S.A.; directed by Edwin S. Porter; Edison.
The Barnstormers (1905), U.S.A.; Biograph.
Uncle Tom's Cabin (1910), U.S.A.; Thanhouser.
Uncle Tom's Cabin (1910), U.S.A.; Vitagraph.
Uncle Tom's Cabin (1913), U.S.A.; directed by Harry Pollard; IMP.
An Uncle Tom's Cabin Troupe (1913), U.S.A.; Biograph.
Uncle Tom's Cabin (1913), U.S.A.; Kalem.
Uncle Tom's Cabin (1914), U.S.A., directed by William Robert Daly; World.
Uncle Tom's Cabin (1918), U.S.A., directed and adapted by J. Searle Dawley; Paramount.
Uncle Tom's Cabin (1927), U.S.A., directed by Harry Pollard, adapted by A.P. Younger and Harvey Thew; Universal. Reissued in 1958 with sound effects, new scene.
Onkel Tom's Hutte (1965), West Germany, directed by Geza von Radvanyi [production information unavailable].
Uncle Tom's Cabin (1987), U.S.A., directed by Stan Lathan, adapted by John Gay; Showtime.

The Novel

Uncle Tom's Cabin was serialized in *The National Era*, a weekly antislavery newspaper, from June 1851 to April 1852. Published in book form in March of 1852, it quickly became a best-seller, was translated into more than 40 languages, and remains second only to the Bible in world popularity. After the start of the Civil War, Lincoln reportedly said to Stowe, "So you're the little woman who wrote the book that made this big war."

Although the passing of the Fugitive Slave Law in 1850 certainly motivated Stowe to write her masterpiece, even more important was the death from cholera of her infant Samuel. In a letter to an abolitionist, Stowe confided that "it was at his dying bed and at his grave that [she] learned

the thick of a metaphysical struggle. His confused grappling with large issues is often raucous and funny in parts, even dreamy, and in parts overtly philosophical. The film misses the multi-layered tone of Kundera's novel. Ironically, Daniel Day-Lewis, who agreed to play Tomas, stated that his first impression of Kundera's novel was that it was an unfilmable work.

Day-Lewis's Tomas seems too reserved to be a real rake and too trifling to make his final transformation credible. Lena Olin, beautiful as the eternally rootless Sabina, regrettably allows her performance to become an interplay of bowler hats and mirrors, too affected to be erotic. As Sabina's opposite, Juliette Binoche's Tereza is bright and sweetly affecting as the rooted and overly-dependent wife who nonetheless leaves her husband and the safety of Geneva in her greater need to return home to Russian-occupied Prague. The movie successfully transmits the warmth Kundera, a political expatriate himself, feels for exiles who later return to their country, no matter how foolhardy such a decision may be.

what a poor slave mother may feel when her child is torn away from her" and further revealed that the "book had its root in the awful scenes and bitter sorrow of that summer." So compelled was she to write it that she felt as if she were merely the channel through which God himself told the story of the separation of slave families.

After the Civil War, sales of the novel declined drastically, and eventually it went out of print altogether, not to reappear until 1948. However, as late as the 1930s, "tom shows" were being performed across the country, even occasionally in the South. These plays, which began to crop up soon after the novel was published, inspired film adaptations for 84 years.

Uncle Tom's Cabin traces the journey of two slaves Eliza, who flees north, and Uncle Tom, who is sold south. In general, these two plot strands alternate throughout the novel's 45 chapters. When the kindly Kentuckian Mr. Shelby falls into debt and must sell some of his slaves, the trader singles out little Harry, Eliza's child, and Uncle Tom, the most trusted, most educated slave on the plantation.

Eliza takes Harry and heads for the river. In chapter seven, one of the novel's most famous, she crosses the ice: "stumbling—leaping—slipping—springing upwards again!" until she miraculously reaches the Ohio side. Ultimately befriended by Quakers, Eliza is reunited with her husband, George, who had already fled his owner. After surviving a gun battle with the slave traders who pursue them, the three eventually make their way to Canada, passing for white, with Eliza disguised as a boy and Harry disguised as a girl.

As a devout Christian, however, Tom, unlike Eliza, is willing to submit to his fate, telling his wife that he is glad that she and the children are not in jeopardy. On the riverboat south, he meets Eva St. Clare, "the perfection of childish beauty," who pities him and wants her father to buy him. When Eva falls from the deck, Tom rescues her, and out of gratitude, St. Clare does buy him. Although Tom misses his family, their Christianity draws him and Eva together, and his time at the St. Clare mansion in New Orleans is happy. In this section of the novel we also meet Topsy, a mischievous slave child whom Eva tries to reform. Tom's relative bliss, however, is not to last. In chapter 26, Eva dies, having exacted a promise from her father to free Uncle Tom. Unfortunately, before he can make it so, St. Clare is fatally stabbed while trying to separate two brawling men. St. Clare's sister takes Topsy north; his wife Marie sells the other slaves; and Uncle Tom falls into the hands of Simon Legree.

At his Red River plantation, Legree proves to be the epitome of the cruel slavemaster. His theory is simple: "I don't go for savin' niggers. Use up, and buy more, 's my way." When Cassy and Emmeline, his mistresses, plan an ingenious escape and Tom refuses to tell Legree what he knows, Legree has his lackeys Quimbo and Sambo beat him to the point of death. Tom forgives all three and manages to convert both Quimbo and Sambo to Jesus before

he dies, just as young George Shelby arrives to buy him back.

Cassy escapes by impersonating a Creole lady, with Emmeline acting as her servant. On the boat north, she meets George Shelby who agrees to help. Also on the boat is a Madame de Thoux, who turns out to be the sister of George Harris, Eliza's husband. In yet another twist of fate, Cassy discovers that Eliza is her long-lost daughter. The novel ends with the Harris family leaving for Africa, and George Shelby, whose father has died, freeing his slaves.

The Films

Uncle Tom's Cabin was one of the first novels to be filmed. Before 1910, the adaptations were very short, all less than one reel. Of these, it is the Edwin S. Porter version of 1903 that receives the most commentary, partly because it was the first film to be subtitled and partly because it followed Porter's masterpiece *The Great Train Robbery*, also filmed in 1903. This 12-minute *Uncle Tom's Cabin* is divided into 14 sections, each introduced by a title. Unfortunately, Porter failed to continue the innovative work of his previous film: There is no parallel editing, no experiment with camera placement, no panning or tilting. The film does provide us, however, with a glimpse of what a turn of the century "tom show" must have looked like, including the fact that Uncle Tom had been reconceived as an old man, not the strong young father of the novel.

The 1914 World version was based on the popular 1853 play by George L. Aiken. This film's only other claim to fame is that it was the first mainstream film, and the last until 1927, to use black actors. In 1927, Universal cast Charles Gilpin, who had starred in O'Neill's *The Emperor Jones*, as Tom. Gilpin, however, refused to play the stereotypical "Uncle Tom" and was replaced by James B. Lowe. As Donald Bogle points out, Lowe's performance in the $2 million production was so effective "that he was sent to England on a promotional tour. . . . thus becoming the first black actor to be publicized by his studio." Yet even with these kudos, Thomas Gossett reminds us that "so many concessions had been made to white southerners that an unsophisticated viewer might draw the conclusion that slavery had been a northern and not a southern phenomenon."

Between 1927 and 1965, there were no new film adaptations, only the 1958 reissue of the 1927 version, with sound effects and an added scene at the end—Raymond Massey as Abraham Lincoln signing the Emancipation Proclamation. In 1944, Metro-Goldwyn-Mayer planned to star Lena Horne as Eliza, but the film was never produced. Different sections of *Uncle Tom's Cabin* did appear in other films: *Everybody Sing*, with Judy Garland; *The Dolly Sisters*, with Betty Grable and June Haver; *The Naughty Nineties*, with Abbott and Costello; *Dimples*, with Shirley Temple; and *The King and I*, with Rita Moreno. The parodies continued as Our Gang members staged the

death of Eva, and Felix the Cat portrayed Uncle Tom.

In 1965, *Onkel Tom's Hütte* was filmed in Yugoslavia, starring Herbert Lom, later of *Pink Panther* fame, as Simon Legree. In spite of numerous plot mutations (including Legree murdering St. Clare, Tom being run over by a team of horses, and Legree's slaves escaping to a nearby monastery where the monks help them to battle Legree and his henchmen), the film does capture some essential elements of the novel—not only the tragic plight of the slaves but also, as Frederick Douglass put it, "the infernal work" of "the fatal poison of irresponsible power" given to the white owners. The scene of Eliza crossing the river on floating blocks of ice is the best to date.

The 1987 version made for Showtime, directed by Stan Lathan, who is black, stars Phylicia Rashad as Eliza, Bruce Dern as St. Clare, Edward Woodward as Legree, and Avery Brooks as Tom. In general, this version closely follows the novel. Most importantly, it recuperates the character of Tom, presenting him, as Stowe intended, as "a large, broad-chested, powerfully made man," a man who submits to his fate not out of weakness but out of a deep commitment to God and to his family.

As early as 1853, the stage adaptations of Stowe's novel began to move away from the original text, becoming more and more racist and promoting negative stereotypes epitomized by the epithet "Uncle Tom." After the Civil War, images from the plays, not from the novel itself, insinuated themselves into the cultural consciousness. Misconceptions still exist. For example, a recent edition of a popular children's encyclopedia confuses the novel and the play by describing Uncle Tom as "a dignified old black slave."

The New Critics, with their emphasis on form and uniqueness, further pushed the novel into the shadows by disparaging it as maudlin and didactic. As Jane P. Tompkins argued in 1978, however, "the work of the sentimental writers is complex and significant in ways *other than* those which characterize the established masterpieces," the sentimental novel being, in fact, "a political enterprise, halfway between sermon and social theory, that both codifies and attempts to mold the values of its time." Moreover, its plot mirrors the archetypal story of fall and redemption, through which, according to Theodore Hovet, is disclosed "the meaning hidden in the seemingly random events of daily life." Because of these recent reappraisals, *Uncle Tom's Cabin* is now a staple of American literature courses, a position reflected in the 1987 adaptation whose source is, at long last, the novel itself.

REFERENCES

Ammons, Elizabeth, ed., *Uncle Tom's Cabin* (Norton Critical Edition, 1994); Bogle, Donald, *Toms, Coons, Mulattoes, Mammies, & Bucks: An Interpretive History of Blacks in American Films* (Bantam, 1973) Gossett, Thomas F., Uncle Tom's Cabin *and American Culture* (Southern Methodist, 1985); Hovet, Theodore R., *The Master Narrative: Harriet Beecher Stowe's Subversive Story of Master and Slave in* Uncle Tom's Cabin *and* Dred (University Press of America, 1989); Sundquist, Eric J., ed., *New Essays on* Uncle Tom's Cabin (Cambridge, 1986).

—*K.L.B.*

UNDER THE VOLCANO (1947)

MALCOLM LOWRY

Under the Volcano (1984), U.S.A., directed by John Huston; adapted by Guy Gallo; Twentieth Century-Fox.

The Novel

Malcolm Lowry is best known for *Under the Volcano*, a densely allusive, politically engaged, haunting novel about the last day in the life of an alcoholic British ex-consul in Mexico in 1938. Lowry had continually revised the novel from 1936 on, adding layers to what he considered the germ of the book, the mystery of a Mexican Indian bank messenger presumably murdered by fascists to prevent funds from reaching one of the people's farms created in Mexico's agrarian reforms of the '30s. In early drafts, the British ex-consul who encountered the Indian and his murderers was a simple fellow. His simplicity disappeared as Lowry revised, and it is the psychological and intellectual complexity of Geoffrey Firmin, the "Consul," that makes the novel compelling reading.

This story of the consul's self-destruction and the doomed efforts of his ex-wife Yvonne, his half-brother Hugh, and his friend Dr. Vigil to save him is set beneath the twin volcanic peaks Ixta and Popo in "Quauhnahuac" (Cuernavaca). The first, framing chapter takes place on the Day of the Dead, November 1, 1939; Geoffrey and Yvonne have been dead a year, and Hugh, a left-wing journalist, is probably dead in the Spanish Civil War by this time too. The recollections of Jacques Laruelle, expatriate French filmmaker who knew them all, along with those of Vigil and Sr. Bustamente, owner of the local cinema, form the frame. The remaining action all takes place on the Day of the Dead, November 1, 1938. Into this story of a failed marital rapprochement Lowry weaves Eastern and Western myth, caballah, literary allusion, cinematic and pop-cultural references, psychology and dream logic, wordplay, dark humor, painfully accurate glimpses of the daily psychomachia of the alcoholic, and reflections on the growth of pre–World War II Mexican and global fascism.

Point of view shifts with each chapter. The main action starts from Yvonne's, as she returns hopefully to Mexico to find the consul's alcoholism worse and his unease at their reunion evident. She helps him home, where the consul is unable to achieve sexual union with her; told from the consul's perspective, this scene reveals his deep ambivalence toward intimacy, and the extent to which alcohol now paradoxically both precludes and represents the possibility of love and meaning for him. Setting out for a fiesta in Tomalin, Hugh, Yvonne and the consul stop at Laruelle's house,

where the consul struggles with his inability to forgive Yvonne her past infidelities with Hugh and Laruelle. The consul is also tortured by memories of the SS *Samaritan* affair, in which as a World War I lieutenant commander he may—Lowry makes it ambiguous—have been responsible for the burning alive of six German officers in his ship's furnace. Through their respective stream-of-consciousness digressions and memories, we learn of Yvonne's film-star past and of Hugh's erstwhile careers (sailor, musician, seducer of married women) and of his plan to leave Mexico shortly on a probable suicide mission accompanying a shipment of explosives for the Loyalists in Spain. It is also through Hugh's eyes that we encounter the dead Indian and the fascist thugs who killed him and stole his money and horse.

At Tomalin the consul and Yvonne declare their love, vowing to start afresh in Canada. But the consul cannot sustain the requisite hope or trust. He begins downing mescal and accuses Yvonne and Hugh of adultery and of interfering with his drinking. He runs toward the Farolito, a dangerous cantina that is also a brothel and a local fascist headquarters. There the consul has intercourse with the prostitute Maria and, through a mixture of courage, ignorance, and terrible luck, incurs the suspicion of the thugs who killed the Indian. After he denounces their crime and their fascism, they shoot him for a "Jew spy" and throw him down the *barranca*, the deep ravine that runs through this part of Mexico (and the entire narrative). Pursuing the consul with Hugh, Yvonne is trampled to death by the horse the fascists stole from the Indian messenger.

Albert Finney in Under the Volcano, *directed by John Huston* (1984, U.S.A.; UNIVERSAL/THEATRE COLLECTION, FREE LIBRARY OF PHILADELPHIA)

The Film

Filmmakers had been eyeing *Under the Volcano* since the 1950s. More than one project had been abandoned prior to the successful Moritz Borman and Wieland Schulz-Keil production, which John Huston directed. Guy Gallo's screenplay is radically pared down, faithful only to the central plot elements and hence not truly faithful to this novel of suggestion, digression, and abundance. The screenplay evidently assumes that the novel's flashback structure and web of allusions are unfilmable, and that the film must sweep away the novel's ambiguity to uncover a linear narrative of alcoholic and marital disintegration. Characters' pasts are largely eliminated (the consul's torment over the *Samaritan* affair becomes a bit of luncheon conversation). Shot in and around Cuernavaca, the film also eliminates the character of Jacques Laruelle and his introductory recollections. Instead it establishes setting and the consul's character via a behind-the-credits dance of grotesque Day of the Dead skeleton-marionettes, an opening shot of Popo's cloudy peak, and the first sequence in which the consul (Albert Finney), in tux and dark glasses, strolls with a slightly lurching elegance through colorful celebrations of the Day of the Dead's Eve.

In one of the few outright embroideries on the novel, the consul scandalizes a Red Cross ball by haranguing the German ambassador and the crowd about Germany's covert financing of Mexico's Nazi movement. He is extricated by Dr. Vigil (played sensitively by Ignacio Tarzo) who leads him to a church to pray for Yvonne's return. The immediately subsequent cut to the bus bearing Yvonne (Jacqueline Bisset) toward the consul is nicely done and makes her presence seem an answer to prayer.

Chiefly through Hugh (Anthony Andrews), the film retains some of the novel's references to fascism and to the Spanish Civil War; Gallo even adds a scene in which Hugh strums and sings a moving Loyalist song about the defense of Madrid. But the pivotal affair of the murdered Indian is practically gutted of political implication. His probable link with the communal farm movement—established in the novel by Hugh's stream-of-consciousness musings—is wholly absent, so while his brutal murder by local fascists strikes a sinister note, it has a randomness not present in the novel. The consul's deeply mixed feelings about Hugh's brand of political intervention (his reservations about being a good samaritan, so to speak), and for that matter Hugh's suspicion of his own motives, are absent from the film, although Andrews plays Hugh with an appealing blend of idealism and self-deprecation.

The major exception to the film's eschewal of ambiguity is its treatment of Yvonne's adultery. Though little is certain in this novel, its aggregation of evidence points steadily to Yvonne's past affairs with Hugh and Laruelle, as well as with the shadowy Louis. But of these the film includes only Hugh, and the screenplay lets viewers decide whether the consul is right to suspect Hugh and Yvonne were lovers. Bisset and Andrews make the issue deliciously undecidable. Thus the film gives us an arguably far purer Yvonne. It also punishes her more cruelly, since unlike the novel the film brings Yvonne to the Farolito to be devastated, just before her death, by news of the consul's tryst with Maria.

Under the Volcano is in large part a stream-of-consciousness novel, and the consciousness is not single; readers get inside all the major characters' heads. Without constant voiceover, which it wisely avoids, the film cannot give us the many angles on the consul and his situation that are so subtly and gradually juxtaposed in the novel. Since it did not value, or could not devise a way to convey, the significant memories and histories of the characters, the screenplay presents us with people we understand far less than in the novel, and consequently have far less reason to care about. But Albert Finney's performance is astounding: He creates an alcoholic ex-diplomat who is dignified and helpless, endearing and offensive, witty and incoherent, loving and alienated. We don't know where this consul has come from historically or psychologically, but we watch him intently until the end, thanks to Finney.

REFERENCES

Binns, Ronald, *Malcolm Lowry* (Methuen, 1984); Pym, John, "Adaptations: Under the Volcano," *Sight and Sound*, summer 1984; Spender, Stephen, introduction to *Under the Volcano* (Lippincott, 1965).

—F.F.K.

THE UNFORGIVEN (1957)

ALAN LEMAY

The Unforgiven (1960), U.S.A., directed by John Huston, adapted by Ben Maddow; Hecht-Hill-Lancaster/ United Artists.

The Novel

Alan LeMay wrote *The Unforgiven* three years after writing *The Searchers*, filmed by John Ford in 1956. Originally titled "Kiowa Moon" when serialized in *The Saturday Evening Post*, it functions as a loose epilogue to *The Searchers* by dealing with questions left unanswered in the original novel and film version. How would white society treat a female brought up by the Indians as one of their own? *The Unforgiven* deals with the racial origins of 17-year-old Rachel Zachary who was adopted by a white family when she was found as a baby in a raid against the Kiowas. The Zacharys believe her to be white. But when

doubt is cast upon her racial origins, conflicts occur not only between the whites and Kiowas but also between the settlers themselves. In this neglected novel LeMay indicts not only white racism but also a careless white community who "let their children wander unwatched, and left their women alone for days while they forged off on senseless errands. They couldn't learn and wouldn't be told, and no amount of bloody murder ever changed that."

During March 1874, wandering squaw man Abe Kelsey casts doubt upon the paternity of the orphan, Rachel Zachary. Bearing a grudge against the family because they failed to help him find his captive son, Kelsey haunts the Texas Panhandle accusing Rachel of being a Kiowa. Brothers Ben and Cassius Zachary attempt to capture Kelsey but he escapes. Although a posse later hangs Kelsey for joining the Kiowas, the squaw man manages to influence Zeb and Hagar Rawlins against the Zachary family. When the Kiowas capture and brutally mutilate Effie Rawlins before her wedding, bad feelings erupt between both families. Rachel gradually comes to feel isolated in a family she once thought she belonged to and becomes tarnished as a "red nigger" by Zeb and Hagar Rawlins. The widowed Mrs. Matthilda Zachary keeps Rachel's origins a secret.

When white captive Seth (who has now become a Kiowa) and Rachel's purported brother, Lost Bird, attempt to purchase her, Ben orders them away from the ranch. Cassius attempts to get information about Rachel from the medicine man, Striking Horse. It results in the Kiowas demanding Rachel's return while Ben is away on a cattle drive. Rachel vainly attempts to leave the Zachary home to save them. When Cassius shoots Lost Bird the Indians attack. During the siege, Matthilda dies, younger brother Andy is wounded, and Cassius rides away for help but is killed by the Indians. Ben returns to find Rachel and Andy still alive after the Kiowa leaders, Seth and Wolf Saddle, have died in a close-quarters battle. He also finds Striking Horse's doeskin parchment, which reveals Rachel's true origins. Rather than reading it, Ben decides to destroy the information "that I don't even give a hoot about, one way or the other."

The Film

The Unforgiven was the one film John Huston actively disliked in his prolific career. Categorizing it as "inflated and bombastic," Huston failed to achieve his vision of a film about frontier racial prejudice. Since Hecht-Hill-Lancaster Productions wanted to make an action Western, the final result was an over-budgeted artistic disaster reinforcing the racist aspects LeMay criticized in the original novel.

Abe Kelsey (Joseph Wiseman) becomes a deranged Civil War veteran with overtones of Elijah from Huston's adaptation of *Moby Dick*. He often appears in a manner reminiscent of the Royal Dano character from *The Red Badge of Courage*, quoting biblical epithets such as "I am

the sword of vengeance . . . where by the wrong shall be righted and the truth be told." Unlike the novel, expert horserider Johnny Portugal (John Saxon) hunts Kelsey down after an Indian raid. The community decides to hang him. Before he can reveal further information about Rachel's (Audrey Hepburn) origins, Matthilda (Lillian Gish) silences him by hitting his horse with a branding iron. The suspicious Zeb Rawlins (Charles Bickford) attempts to get the female members of the community to strip Rachel before Ben (Burt Lancaster) intervenes. In the film, the Rawlins family loses their son Charlie (Albert Salmi) to the Indians rather than a daughter.

When Matthilda reveals the truth about Rachel's origins to her family, the racist Cassius (Audie Murphy) storms out after Ben prevents him from returning Rachel to the Kiowas. He does return in a one-man charge against the Kiowas at the end. Ben remains to guard the home. During the attack (shot by second-unit director Emilio Fernandez), the Indians drive a herd of cattle on to the roof of the Zachary home to collapse the roof. However, Ben prevents this by setting the roof on fire. After Indians and cattle depart, he has to dowse the flames with a bucket of water. These exciting and claustrophobic scenes are not in the novel. Another added scene has Matthilda playing classical music on a piano outside the home to counterpoint Indian war flutes. Rachel shoots her brother, Lost Bird (Carlos Rivas), at the climax in one of the most brutally racist images since D. W. Griffith's *Birth of A Nation*. Despite his aggressive actions, he only wants his sister back. Rachel's summary execution of her Indian brother who has only love for her in his last seconds of life fully justifies John Huston's disappointment over a film that could have been so much better.

REFERENCES

Folsom, James K., *The American Western Novel* (College and University Press, 1966); McCarty, John, *The Films of John Huston* (Citadel Press, 1987).

—T.W.

UNKNOWN GAMES (*Les Jeux Inconnus*) (1947)

FRANÇOIS BOYER

Jeux Interdits (Forbidden Games, The Secret Game) (1952), France, directed by René Clement, adapted by Clement, Jean Aurenche, and Pierre Bost; Silver Films.

The Novel

When François Boyer could not get his original script produced, he rewrote and published it as the novel *Les Jeux Inconnus*. It begins amid a World War II German air blitz in northern France where a young girl's parents and her small dog are killed. Eleven-year-old Paulette, understandably bewildered, wanders off, clutching her dead puppy. She comes upon young Michel who brings her back to his farm and coaxes his family to allow the newly orphaned child to stay. Almost immediately, the two children become close friends, and Michel finds ways of helping little Paulette express the grief she feels over the death of her family. Paulette and Michel devise "forbidden games." They cultivate their own cemetery in which first Paulette's dog Jock, then an assortment of other dead animals, are buried. The children decorate the graves with crosses, which they first crudely fashion and later, much to the adults' displeasure, they steal from the local cemetery.

The Film

Forbidden Games is now considered one of the greatest antiwar films and, in its thematic irony, scope of vision, and residual sadness, is often compared to *La Grande Illusion* (1937). Clement originally planned to use Boyer's story as one part of an antiwar film; however, while filming, he realized he had enough material to develop the story into a full-length feature film. His decision was based, in part, on the performance of five-year-old Brigitte Fossey (as Paulette), a performance that is beautifully luminescent in its simplicity and sincerity.

Clement shows Paulette and Michel (Georges Poujouly) as victims of the dangerous games played by adults—the wars between nations and the spats between neighbors. Paulette is a casualty of this adult war game; and although she is too young to understand that her need to enact the burial of animals is a form of transference, we understand that the animal cemetery is a precocious five-year-old's expression of mourning for and homage to her dead parents. The children bury animals they find dead and, later, ones that Michel kills for Paulette. In doing this, the children are unwittingly acting-out the random killing that they witness in the war. For the children the deaths and burials are not games, but serious business; for us they are ceremonies fraught with complexity, dignity, and profundity.

Forbidden Games makes us feel that we simply should know better than to wage war. The movie gently chides us for our global sins, for our *unforbidden* lethal games. René Clement reminds us that war will be an inevitable part of human existence until, like Paulette and Michel, we begin to revere life.

REFERENCES

Denitto, Dennis, and William Herman, *Film and the Critical Eye* (Macmillan, 1975); Kael, Pauline, *I Lost It at the Movies* (Bantam Books, 1966).

—L.C.C.

VALLEY OF THE DOLLS (1966)

JACQUELINE SUSANN

Valley of the Dolls (1967), U.S.A., directed by Mark Robson, adapted by Helen Deutsch and Dorothy Kingsley; Red Lion Productions/Twentieth Century-Fox.

The Novel

Jacqueline Susann's unabashedly trashy novel, *Valley of the Dolls*, sold over 10 million copies. Susann, a former television actress, is credited with having spawned a genre that lies somewhere between a Hollywood gossip column and a Harlequin romance. The quality of Susann's prose is unquestionably poor. In a review in *Book Week* Gloria Steinem wrote: "For the reader who has put away comic books but isn't ready for editorials in the *Daily News, Valley of the Dolls* may bridge an awkward gap."

The novel tells the story of three women as they suffer the slings and arrows of life in the entertainment industry. The plot takes the reader through their struggles with fame, failed romances, and addictions to alcohol and pills (the "dolls" of the title). Neely, a singer, is an instant success on the stage, but quickly succumbs to the lure of pills and booze, alternating between sanitariums and career comebacks. Jennifer makes her mark by starring in French skin-flicks. She finally finds true love and becomes engaged to a senator, only to commit suicide after being diagnosed with breast cancer. The novel is largely the story of Anne Welles. She begins as the secretary of a theatrical attorney and later is propelled into the world of glamour as the "Gillian Girl," the face of Gillian cosmet-ics. After a series of disastrous romances and other assorted difficulties, Anne realizes that money and fame aren't the key to happiness after all.

The Film

Like the novel, Mark Robson's film adaptation highlights the dangers of stardom, charting the ups and downs in the lives of three aspiring starlets. The film stars Sharon Tate as Jennifer North, Patty Duke as Neely O'Hara, and Barbara Parkins as Anne Welles, the most likable and substantial of the three characters (though that is not high praise). The film begins by following Anne Welles from her small town to New York City, where she crosses paths with Neely and Jennifer. After many trials and tribulations, Jennifer commits suicide, and Neely succumbs to addictions that undermine her career, but Anne manages to overcome her bout with pill addiction and live to tell the tale. Leaving her ambition and her theatrical lawyer lover behind, Anne returns to the small town she left at the film's outset. Though it retains the basic plot of the novel, the film is a bit more conservative both in its language and its depiction of the events in the novel. Because of the time constraint, the film adaptation condenses the sagas of each of its three main characters. Among other things, it dispenses with many of Anne's love affairs. Given how repetitive and nonsensical the episodes in the novel are, one hardly mourns their absence here.

Most critics seemed to agree that the most remarkable thing about the movie is that it managed to be worse than the novel. Roundly panned for its contrived plot, two-dimensional characters, stilted dialogue and atrocious acting, *Valley of the Dolls* nonetheless went on to be one of

Twentieth Century-Fox's biggest hits, grossing over $20 million. In 1981 the novel was again adapted, this time in a made-for-TV movie entitled *Jacqueline Susann's Valley of the Dolls*.

REFERENCES

Nash, Jay Robert, and Stanley Ralph Ross, *The Motion Picture Guide 1927–1983* (Cinebooks, 1987); Samudio, Josephine, *Book Review Digest* (H.W. Wilson, 1967); *The New York Times Film Reviews 1959–1968* (Times Books and Garland Publishing, 1990).

—L.M.

DIE VERLORENE EHRE DER KATHARINA BLUM (1974)

See THE LOST HONOR OF KATHARINA BLUM.

VERTIGO *(D'Entre des Morts)* (1954)

PIERRE BOILEAU AND THOMAS NARCEJAC

Vertigo (U.S.A.), 1958, directed by Alfred Hitchcock, adapted by Alec Coppel and Samuel Taylor; Paramount.

The Novel

Written by the authors of *Les Diaboliques*, *D'Entre des Morts* (From among the Dead) was first published in America as a Dell paperback in April 1958, just prior to the release of Hitchcock's film version. Translated by Geoffrey Sainsbury, the publishers retitled the novel *Vertigo*. So renowned has been Hitchcock's film adaptation, however, that the novel itself has received only scant attention. Critic Robin Wood, for example, has dismissed it as a "squalid exercise in sub-Graham Greenery." But Hitchcock biographer John Russell Taylor has pointed out that authors Pierre Boileau and Thomas Narcejac "deliberately designed it to attract Hitchcock's attention," working over the very themes that attracted Hitchcock, like male insecurity and the darker, sadomasochistic impulses behind love and sex.

During France's preparations for mobilization against Germany in 1939, wealthy shipbuilder Paul Gevigne asks his former college friend, Roger Flavieres, "to keep an eye" on his wife, Madeleine. Roger, an ex-cop, is plagued by a host of insecurities: As a young man he had endured taunts about his lack of virility; more recently he had felt remorse about his ineligibility for military service; and now he is haunted by the death of a colleague who, after taking Roger's place during the rooftop chase of a criminal, had slipped and fallen. Roger is obsessed with the dead hand of the past. "[I want] to discover the secrets that prevent people from living," he says.

Meanwhile, his quarry, Madeleine, is also in thrall to the past. She is supposedly possessed by the spirit of her great-grandmother, Pauline Lagerlac, who committed suicide a few months after she gave birth to a son. Roger begins to spy on her movements. He begins to imagine himself in his friend Paul's place, erotically conjoined with Madeleine. When she attempts to drown herself in the Seine, he rescues her. Now desperately in love with her, he compares her to a Eurydice whom he, Orpheus, has tried to rescue from the Underworld.

Despite his watchful vigil, Madeleine eludes him and runs away to a clock tower, where she plunges to her death. At least that's Roger's perception. Near mad with grief, Roger travels south for the duration of the war with "death in his soul." By the time he returns to Paris in 1944, an alcoholic, he learns that Paul has died in a car accident while under police investigation for Madeleine's death. Later, while viewing a newsreel of General de Gaulle's visit to Marseilles, he is astonished to see a woman resembling Madeleine. He tracks her down and learns her name is Renee Sourange. For a time he endeavors to transform her into a simulacrum of the dead Madeleine. But his illusions are shattered when he discovers her wearing Pauline Lagerlac's necklace. Her ruse discovered, Renee/Madeleine confesses her complicity with Paul in a plot to murder his wife, whom she strongly resembles. Roger strangles her after she refuses to reassume the "Madeleine" identity. The novel ends with Roger's arrest. As the police lead him away, he kisses the dead woman, pledging to her, "I shall wait for you."

The Film

Although *Vertigo* was not a box-office success on its initial release, it has come to be regarded as one of Hitchcock's greatest films, a superb union of thematic complexity and technical virtuosity. The novel's voyeurism ideally suited Hitchcock's own preoccupations, and his film adaptation may be regarded as the middle third of a voyeuristic "trilogy," consisting of *Rear Window*, *Vertigo*, and *Psycho*. "[It is] one of the four or five most profound and beautiful films the cinema has yet given us," writes critic Robin Wood.

The opening credits, designed by Saul Bass, immediately establish the theme of masks and shifting identities. A woman's face is fragmented into pieces, eyes and lips. The face itself is blank and masklike. When the camera spirals out from the depths of the eyes, the dizzying trajectory anticipates not only the vertigo that assails Scottie, but also the disruption throughout the film of the equilibrium between love and obsession, sanity and madness.

Hitchcock and his scenarists retained key plot elements and characters and transferred the action to San Francisco 13 years after the end of World War II. Roger is renamed Scottie (James Stewart). Like Roger, Scottie's pathological fear of heights is responsible for the fatal fall of a fellow police officer—a sequence that constitutes the movie's prologue. Scottie seeks solace in the company of his friend,

Midge (Barbara Bel Geddes)—a character invented for the movie—a college sweetheart to whom he has never been able to make an emotional commitment. When a former college friend, Gavin Elster (Tom Helmore), a wealthy shipbuilder, asks Scottie to shadow his supposedly suicidal wife Madeleine (Kim Novak), Scottie initiates a strange, increasingly obsessive pursuit that will continue throughout the rest of the movie. As he follows Madeleine around the city in a series of scenes that constitute a virtual travelogue of San Francisco—the Palace of Fine Arts, the Golden Gate Bridge, the Coit Tower, Fort Point, and other tourist sites—he learns that Madeleine believes herself to be possessed by the spirit of a suicidal maternal ancestor, Carlotta Valdez, the former mistress of a San Francisco capitalist who killed herself after he abducted her child. One day, as in the novel, Scottie rescues Madeleine from an attempted suicide by drowning. By now he is madly in love with her. She is everything his pal Midge is not—sensuous, enigmatic, elusive. But no sooner have they pledged their love, then she breaks away from him during a trip to an old Spanish mission and plunges to her death from a high bell tower.

Her death, coming midway through the film, is one of the most shocking events in the history of commercial cinema. Not just Scottie, but the viewer is caught off guard, unprepared for this brutal rupture that shatters expectations of how a conventional narrative should preserve its heroes and heroines until the finale. It is a vertigo of a sort that now assails even the viewer. Not even the death of Janet Leigh in Hitchcock's later film *Psycho*, which also comes relatively early in that film, can rival its impact.

Distraught, Scottie wanders like a lost soul around San Francisco. One day he encounters a shopgirl from Kansas, Judy Barton, who bears a startling resemblance to Madeleine. Gradually, with her grudging compliance, he transforms her into a replica of Madeleine, dyeing her hair blonde, coaching her in her deportment and speech, and purchasing the appropriate garments. But when he finds Judy wearing a necklace that had once belonged to Carlotta Valdez, he realizes he has been the victim of a conspiracy, that "Madeleine" was a look-alike substitute for Gavin's real wife, that her "suicide" was a hoax that had been staged by her and Gavin as a cover for Gavin's murder of his real wife. Scottie, in a rage, forces Judy to the top of the bell tower, where she accidentally falls to her death. Scottie is left standing transfixed, stunned, on the ledge of the tower.

Hitchcock shot an additional ending where Scottie returns to Midge, and they hear a radio broadcast announcing the arrest of Gavin Elster. This version was shown in some theaters in Europe.

There is a tragic intensity to *Vertigo* that transcends the drab pessimism of the novel. It is significant that, contrary to the novel, Hitchcock reveals the surprise twist of the conspiracy to frame Scottie in a flashback less than two-thirds through the movie. As Wood notes, it is with "lordly indifference" that the revelation comes; indeed, Hitchcock never bothers to tell us whether Gavin is ever caught for the murder of his wife. Obviously, it is not with such film-flammery that Hitchcock is concerned. Rather, he is drawn to the novel's depiction of Roger's obsession in transforming Renee into Madeleine: "He only wanted to remodel the shape of her head, giving it the noble line, the serenity of a Leonardo. To put it differently, he was painting the portrait of the Madeleine he remembered." Hitchcock puts a finer point on it. The essence of Hitchcockian sexuality is that it can exist only as obsession, an obsession that degrades women and literally deranges men. (In Scottie's case, the obsession with Judy also borders on necrophilia.) There's something at once poignant and pathetic in Judy's question to Scottie: "If I let you change we, will that do it? Will you love me?"

Although it is obvious that in this crucial point Hitchcock borrowed extensively from the novel's thematic elements, he made many significant alterations in the details and secondary incidents. Whereas the novel's Madeleine had brown hair streaked with henna, the film's Madeleine is a blonde in the classic Hitchcockian mold. Moreover, he added the introductory vertigo sequence, the visit to the museum, Scottie's mental breakdown (a nightmarish montage of animated images and nonlinear editing), the sequence with the sequoia trees, and the haunting images of the climax.

The memorable score by Bernard Herrmann, laced with tango rhythms, ostinato-like rhythmic patterns, whirring strings, and castanets, also takes its cue from the novel: "Vague snatches of music, an accordion, a mandolin, came to them from somewhere or other."

In the final analysis, *Vertigo* is about Hitchcock himself, who, like Roger in the novel and Scottie in the film, continually "made over" his leading ladies—Madeleine Carroll, Grace Kelly, Vera Miles, Novak, Tippi Hedren—into his archetype of the icy, ethereal blonde, dictating their hair color, their clothing style, their deportment, etc. "*Vertigo* in that respect," writes John Russell Taylor, "is alarmingly close to allegorized autobiography, a record of Hitch's obsessive pursuit of an ideal quite as much as a literal tale of love lost and found again."

REFERENCES

Auiler, Dan, *"Vertigo": The Making of a Hitchcock Classic* (St. Martin's Press, 1998); Lucas, Tim, "Vertigo before Hitchcock," *Video Watchdog*, 40 (1997), 70–71; Taylor, John Russell, *Hitch* (Pantheon Books, 1978); Wood, Robin, *Hitchcock's Films Revisited* (Columbia University Press, 1989).

—*T.W.*

VINGT MILLE LIEUES SOND LES MERS (1870)

See TWENTY THOUSAND LEAGUES UNDER THE SEA.

THE VIRGINIAN, A HORSEMAN OF THE PLAINS (1902)

OWEN WISTER

The Virginian (1914), U.S.A., directed by Cecil B. DeMille, adapted by Kirk La Shelle and Owen Wister; Jesse L. Lasky Feature Play Company.

The Virginian (1923), U.S.A., directed by Tom Forman, adapted by Hope Loring and Louis D. Lighton; B.P. Schulberg Productions.

The Virginian (1929), U.S.A., directed by Victor Fleming, adapted by Howard Estabrook and Edward E. Paramore Jr.; Paramount.

The Virginian (1946), U.S.A., directed by Stuart Gilmore, adapted by Frances Goodrich and Albert Hackett; Paramount.

The Novel

Commentators on Owen Wister's *The Virginian* have noted that when the novel appeared in 1902, it was some 10 years after the closing of the frontier and shortly after historian Frederick Jackson Turner offered his "safety-valve" thesis on the role played by the frontier in American history. Indeed, the book is often described as an expression of American society's need to recreate in symbolic form the safety-valve function of the West as a refuge for men and women wanting to start their lives anew, and as a last bastion of a primal American innocence as yet uncontaminated by the decadence of the European-influenced East Coast. In *The Virginian*, and other fictive treatments of the frontier, including the pulp fiction dime novel, the West that appears is mythic. Due to its great popularity and the esteem bestowed on it as a serious novel, Wister's *The Virginian* was central to enshrining the cowboy as a folk ideal and icon of American popular culture.

Growing out of seven short pieces published in *Harper's* and *The Saturday Evening Post* between 1893 and 1902, *The Virginian* was also responsible for establishing some of the Western genre's most basic motifs and conventions. The "East" versus "West" theme, for example, is made manifest in the relationship between the novel's unnamed title character, an enigmatic cowboy who works as foreman of a Wyoming cattle ranch during the late 1870s and 1880s, and his bride-to-be, the young Molly Wood, a schoolteacher from Vermont. In spite of their growing friendship, the possibility of romance is threatened when Wister's protagonist is forced to preside over the hanging of Steve, the Virginian's best friend who has been accused and convicted of cattle rustling. Since the sentence is meted out by a posse of ranchers because the local courts have been taken over by a gang of rustlers, Molly is horrified until the code of the West is explained to her by Judge Henry, the Virginian's employer. The Virginian is also shaken. But in balancing the virtue of friendship against the virtue of a transcendent yet informal kind of justice dictated by the Westerner's code of honor, the Virginian knows, as did Steve, that he is a man who did what a man had to do.

On the day before the Virginian's wedding to Molly, Trampas, an old enemy and leader of the pack of rustlers to which Steve belonged, vows to gun down the Virginian unless he leaves town by sunset, yet another convention of the genre. Molly warns her betrothed that she won't marry him if he meets Trampas in mortal combat. The Virginian, once more operating from the tacit authority of the Westerner's code, knows that his honor is at stake. Although caught in another difficult dilemma, once again he knows what a man has to do. He leaves Molly behind in the hotel in order to face his nemesis. Trampas fires first but misses. The Virginian returns the fire, killing Trampas. Relieved to find the Virginian alive, Molly forgets her threat. The two are married the next day.

Wister's idealization of the Westerner situates the site of American virtue in the West. In a manner suggesting the influence of Jean Jacques Rousseau, Wister views his protagonist as a primal man, often describing him as "natural" or "wild." At the same time, there is an element of Horatio Alger. It is significant that in contrast to the likable but ever wayward Steve, the Virginian, with his youthful indiscretions behind him, actually grows up, assumes responsibility, and makes a success of himself. The "East," although marginalized, is not without merit. Indeed, it is Molly and her books who help the Virginian achieve maturity.

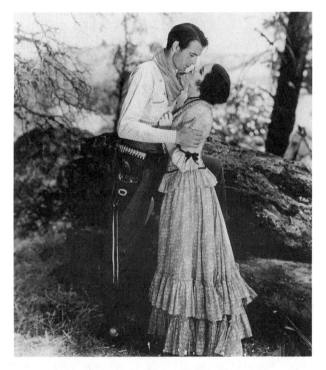

Gary Cooper and Mary Brian in The Virginian, *directed by Victor Fleming* (1929, U.S.A., PARAMOUNT)

The Films

In an incisive essay entitled "The Stage Goes West: Routes to *The Virginian*," film historian John Tibbetts makes a well-documented claim that it was the stage adaptation of *The Virginian*, coauthored by Wister and Kirke La Shelle in 1904, rather than the novel, that was seminal in shaping *The Virginian* for its first adaptation in 1914. In fact, the film was introduced with the inscription, "Jesse L. Lasky Presents Dustin Farnum in 'The Virginian' by Kirke La Shelle and Owen Wister." Farnum, not incidentally, had created the role of the Virginian on stage in 1904. Although burdened by excessive explanatory intertitles and obviously stagey interiors, the film is notable for DeMille's direction of the outdoor scenes, which Tibbetts suggests "fairly burst the bonds of the proscenium stage."

Tibbetts's point as to the critical influence of the play, in contrast to that of the novel, can likewise be extended to the 1923 and 1929 remakes of *The Virginian*. In the credits documented by the American Film Institute, the sources for the 1923 B.P. Schulberg production are first, the play, and second, the novel. For the 1929 version, only the play is listed. The novel has disappeared altogether. Of the two 1920s productions, it is the 1929 sound film that remains important. Produced by Paramount to take advantage of the new technology of synchronized sound, Victor Fleming's *The Virginian* is an interesting example of the new medium's assets and liabilities during the first years of the silent-to-sound transition period. Although calling it "an interesting film," genre historians George N. Fenin and William K. Everson state in *The Western* (1973) that Fleming's opus suffered from an overly relaxed tempo, a trait especially prevalent in early sound films aiming for high-class status. "A leisurely story in any case," they note, "it seemed almost artificially slow in its measured pace." On the plus side, they mention J. Roy Hunt's striking cinematography and the effective portrayals of the Virginian (Gary Cooper), Trampas (Walter Huston), and Steve (Richard Arlen).

Mary Brian's winsome portrayal of Molly is likewise memorable. So, too, is the well-known baby-switching scene perpetrated by Steve and the Virginian toward the beginning of the film. In terms of pacing, the prank provides an effective bit of comic relief. In terms of character development, it is critical in that it marks the Virginian's last adolescent caper and, therefore, the onset of his passage into the world of adult responsibility. Perhaps most indelible is the showdown between the Virginian and Trampas in which, thanks to sound, we hear Gary Cooper's Virginian warn, "When you call me that, *smile.*"

For the 1946 version, again from Paramount, Stuart Gilmore directed a competent yet undistinguished production. *Variety*, while noting that Joel McCrea followed soundly in the footsteps of Dustin Farnum and Gary Cooper as the Virginian, called the story dated as well as "a mite slow." Noting that the story hadn't changed much, an indication that the 1904 Kirke La Shelle-Owen Wister stage play was serving as the primary source for yet another adaptation, *Variety* described the film as "a pleasant, flavorsome western, with much of the old charm of a daguerreotype." Also featured were Brian Donlevy as Trampas, Sonny Tufts as Steve, and Barbara Britten as Molly.

REFERENCES

Cawelti, John C., *The Six-Gun Mystique* (Bowling Green University Popular Press, 1984); Fenin, George N, and William K. Everson, *The Western: From Silents to the Seventies* (Grossman, 1973); Munden, Kenneth W., ed., *The American Film Institute Catalog of Motion Pictures Produced in the United States: Feature Films 1921–1930* (1971); Tibbetts, John, "The Stage Goes West: Routes to *The Virginian*," *Indiana Social Studies Quarterly* 24, no. 2 (autumn 1981): 26–39.

—*C.M.B.*

WAGES OF FEAR *(Le Salaire de la peur)* (1950)

GEORGES ARNAUD

Le Salaire de la peur (1952), France, directed by Henri-
 Georges Clouzot, adapted by Clouzot and Jerome
 Geronimi; Cinedis/CICC Vera Films/Silver Films/
 Fono Roma.
Sorcerer (1977), U.S.A., directed by William Friedkin,
 adapted by Walon Green; Paramount Pictures/Uni-
 versal Pictures.

The Novel

Dedicated to a friend who died in 1941, *Le Salaire de la
peur* is Georges Arnaud's harshest work. Against the back-
ground of the underdeveloped Guatemalan city of Las
Piedras, Arnaud tells a grim tale of a mixed band of
vagrants who are hired to drive trucks loaded with ni-
troglycerin to burning oil fields nearby. It's a desperate
business, but the men—including the Irish-American,
O'Brien; the German, Hans Smerloff; the Spaniard, Johny
Mihalescu; the Italian, Bernardo Salvini—are all victims of
economic exploitation and have no choice but to take on
the assignment.

 When the first of the two trucks explodes along the
way, Johny and Gerard continue the journey; but their
nerves, already frayed, threaten to snap. When Johny,
who has proven himself to be a coward, dies, Gerard—now
the sole survivor—collects the $2,000 reward money. On
his return trip to Las Piedras, however, he dies in a fatal
accident.

The Films

Two adaptations have been made by two directors with
very different approaches to the story. Henri-Georges
Clouzot's version may be considered a masterpiece of
modern French cinema. Recently restored to its original
length of nearly three-hours running time, it is a sober dis-
section of the fatalistic entrapment awaiting the charac-
ters. Relying on the main plot line of the novel, the movie
shifts the scene to a bar in a squalid section of Venezuela,
devoting its first hour to introducing the main charac-
ters—Mario (Yves Montand), Jo (Charles Vanel), O'Brien
(William Tubbs), Smerloff (Jo Dest), and Linda (Vera
Clouzot). "It's like a prison here," declares Mario; and
indeed he is right. They have all reached a dead end, from
which there is seemingly no escape (a point emphasized by
Clouzot's consistent use of bars of shadow thrown across
their faces and forms). But when an oil-well fire breaks
out, four men accept the dangerous task of freighting
highly volatile explosives to the site in order to extinguish
the blaze. The film's second half is entirely taken up with
the trip. Here are memorable images aplenty, including the
breathless instant before the explosion of the one of the
trucks, which instantly vaporizes the drivers; the crushing
death of Jo under the truck's wheels in a pit of flowing oil;
and the climactic scene when Mario, returning after the
completion of the assignment, swerves the truck in a series
of euphoric zig-zags that ultimately lead to a smashup and
death.

 In a larger sense, Clouzot's concern with the exploita-
tion of underdeveloped countries by capitalist powers,
wherein individual lives count for nothing, is clear enough.
But he is also concerned with the democratizing and exis-

tential effects of sheer terror. The impact of the trip on these men strips away their surface pretenses, exposing their weaknesses and vulnerabilities. Fear infects them like a contagious, and fatal, disease. The macho Jo, for example, demonstrates that under his bluster and braggadocio, he is little more than an abject coward. In addition, in its most concrete terms, the film exposes the violence and nihilism of our world—its opening shots depicting the peasant boys' enjoyment of insects fighting to the death (a visual motif repeated later in Sam Peckinpah's *The Wild Bunch*) and concluding with the senseless apocalypse of Mario's immolation. For all these reasons, Clouzot's achievement has proven to be seminal, influencing the subsequent work of other modern masters like Peckinpah, Don Siegel, Andre Konchalovsky, and William Friedkin. (In its "acrid highway inventions" and "mean physicality," Manny Farber contends that it also owes much to the work of American predecessors like Raoul Walsh.)

Friedkin, indeed, remade the story in 1977. It is no accident that it was adapted by *Wild Bunch* screenwriter Walon Green (the film is dedicated to Clouzot). Rewritten as a vehicle for Steve McQueen, the Yves Montand role eventually went to Roy Scheider. Under French copyright restrictions, however, Friedkin's film could not duplicate anything Clouzot had devised. Thus, among the many changes, the texture and tone is quite different, inasmuch as the action transpires in rain forests under monsoon conditions (as opposed to the baked, sterile wastes of the Venezuelan scrub country). The film proved to be a miserable box-office failure, a debacle from which Friedkin's career has scarcely recovered.

REFERENCES

Cournot, M., *Le Premier spectateur* (Gallimard, 1957); Farber, Manny, *Negative Space* (Praeger, 1971); Lacasin, F., and Bellour, R., *Le Proces Clouzot* (Le Terrain Vague, 1964); Segaloff, Nat., *Hurricane Billy: The Stormy Life and Films of William Friedkin* (William Morrow, 1990).

—*C-A.L. and J.M. Welsh and J.C.T.*

WALKABOUT (1959)

JAMES VANCE MARSHALL

Walkabout (1971), Australia, directed by Nicolas Roeg, adapted by Edward Bond; Twentieth Century-Fox.

The Novel

James Vance Marshall's slim volume for young readers begins when an airplane has crashed on Sturt Plain in the center of the Northern Territory of Australia, an area "roughly twice the size of Texas." Two American children, Mary and her younger brother Peter, survive the wreck and find themselves stranded in the wilderness of the Outback. They know that Adelaide is to their south, so they start to walk. What they do not know is that the Plain is 1,400 miles north of Adelaide. They obviously need help in order to survive.

Help comes in the form of an Aboriginal boy proving his ability to survive on a ritual "walkabout," a walking journey of six months undertaken by bush boys as a test of manhood. The boy knows how to live off the land. Keeping death at bay "was the Aboriginals' full-time job; the job they'd been doing for twenty thousand years," Marshall writes. Peter manages to communicate with the bush boy, who has never seen white people before, but soon learns that they do not know how to find food and water. Peter adjusts to the ordeal of the walkabout more easily than Mary, apparently because he is a little man. The bush boy is so naive that he does not comprehend that Mary is a young woman until halfway through the book; but he knows that according to his "tribal timetable" he cannot take a woman until he has proved his manhood.

Peter regards the bush boy as an older brother, but Mary is afraid of him. When the boy sees terror in her eyes, he believes he has seen the Spirit of Death. The bush boy catches a cold from Peter and gets sick and withdrawn. He happens to see Mary bathing naked in a pool and watches her "with admiration." When Mary discovers "his staring, admiring eyes," she gets hostile and defensive. The boy then sees not only terror in her eyes but also "hatred," and his "will to live drained irrevocably away." But before he dies the boy points out to Peter an avenue of escape over a range of distant hills.

Peter and Mary bury the boy, then Peter proceeds to lead his sister out of the wilderness. Finally, after several days they encounter a group of friendly Aborigines who show them the way to a "white man's house." The novel today seems both sexist and racist in its attitude toward cultural difference and the "primitive," though it extols sentimentally and condescendingly the uncomplicated, "simple" life of the Aborigines.

The Film

The film by Nicolas Roeg is far more sophisticated then the adolescent novel that inspired it. Roeg turns the story into a meditation upon the artificial lives of the dominant, white, "civilized," transplanted Europeans (for the children are no longer from Charleston) as contrasted with the natural lives of the Aborigines. There is no airplane crash in the film. A father (John Meillon), driven quite crazy by the pressures of the industrial workplace, drives his children deep into the Outback and then attempts to shoot them. When the children escape, he shoots himself and immolates the car, leaving the children stranded, as in the novel.

A bush boy (David Gulpilil) discovers them in need of food and water, much as in the novel. The film is purely visual, since communication among the children is difficult and the brother and sister apparently have little to talk

about. Mary carries with her a battery-operated radio that keeps her in touch with the civilized world. The sexual tension is played out rather differently in the film since the viewer has no way of knowing the bush boy's thoughts, intentions, or motives. He leads Peter (Lucien John, Roeg's own son) and Mary (Jenny Agutter) to a deserted farmhouse on the edge of the wilderness and seems to suggest that he and Mary could set up housekeeping there on the boundary between civilizations, since the three of them constitute a natural family group.

The bush boy becomes disturbed when he witnesses white hunters (seen only by him) killing game senselessly for sport. When Mary then rejects his apparent proposal, for she immediately reverts to her "civilized" state, the bush boy paints his body with the design of his totemic father for a ritual death dance that confuses Peter and frightens Mary, since she has no idea whatsoever of what he is doing. Having prepared himself, the boy is found dead one morning, hanging in a tree. But before dying he has shown Peter an asphalt highway that will take them to civilization. They encounter no tribal Aborigines after the boy's death but walk into a relatively deserted mining town, where they encounter an unfriendly, overprotective caretaker.

While the novel centers upon Peter and his lessons about becoming a man, the film ends with a coda that shows Mary years later as a housewife, living in a condo that resembles her father's condo seen earlier in the film. As she prepares food in her kitchen, her memory flashes back to her ordeal in the Outback. When her husband arrives home excited about a promotion he has just earned at work, her memory flashes back to a fantasy of her bathing in a lagoon, along with Peter and the bush boy, a suggestion of what life could have been like in a more natural state. In the case of *Walkabout* the film changes the novel considerably, but for the better, for the film is far more interesting in what it has to suggest about the natural values of native culture.

REFERENCES

Boyle, Anthony, "Two Images of the Aboriginal: *Walkabout*, the Novel and Film," *Literature/Film Quarterly* 7, no. 1 (January 1979): 67–76; Esperin, John H., "Oneness with Nature: A Thematic Approach to *Walkabout*," *English Journal* 61 (January 1972): 110–12; Gow, Gordon, "Identity: An Interview with Nicolas Roeg," *Films & Filming* 18, no. 4 (January 1972): 18–24; Greenway, John, "No Sex, Abo Bushman," *National Review*, October 24, 1975, 1179–80; Izod, John, "*Walkabout*: A Wasted Journey?" *Sight & Sound* 49, no. 2 (spring 1980): 113–16; Lanza, Joseph, *Fragile Geometry: The Films, Philosophy, and Misadventures of Nicolas Roeg* (PAJ Publications, 1989).

—*J.M. Welsh*

THE WAR OF THE WORLDS (1898)

H.G. WELLS

The War of the Worlds (1953), U.S.A., directed by Byron Haskin, adapted by Barré Lyndon; Paramount.

The Novel

Wells took three years to write *The War of the Worlds*, but his ideas for the novel had been gestating for at least 10 years. He had speculated previously in print about the evolution of human intelligence, and interest in life on Mars was widespread following Schiaparelli's apparent discovery of Martian "canals" in 1877 and Percival Lowell's 1895 book, *Mars*. But the idea for the novel came from Wells's brother, Frank, who wondered in 1895 what would happen if "some beings from another planet were to drop out of the sky suddenly."

The War of the Worlds is composed of book one ("The Coming of the Martians"), book two ("The Earth Under the Martians"), and an epilogue. The narrator, an unnamed "philosophical writer," tells the story of his travails following a Martian invasion begun just outside London six years earlier, in the last years of the 19th century when the world "seemed safe and tranquil." The first of 10 Martian cylinders lands in Woking and soon becomes a public spectacle. A Martian (a "roundish bulk with tentacles") eventually tumbles out, and shortly thereafter the human onlookers are vaporized by a "Heat-Ray." The narrator flees home, ushers his wife to safety, then returns to observe even more cylinders arrive and more people killed by the inscrutable Martians. British troops arrive to stave off the invasion but have little success.

As he winds his way through the widespread panic, the narrator comes across a soldier who has just returned from the front lines, and together they make their way toward London. The Martians build colossal walking tripods that rapidly destroy all the people, artillery, and towns in their path. After several narrow escapes, the narrator runs into a foolish and stammering curate who becomes the catalyst for the narrator to express his views toward institutionalized religion: "What good is religion," he asks, "if it collapses under calamity?" Eventually he and the curate are trapped for days in an abandoned house when a Martian cylinder falls on it. When the curate finally panics, a bloodthirsty Martian drags him off. (The narrator also pauses to recall that at this same time his brother observed the evacuation of London, which had been assaulted by clouds of poisonous black smoke released by the Martians.) After escaping the abandoned house and meeting once again the soldier, who has become a paranoid "survivalist-authoritarian," the narrator makes his way to London, a city he finds "condemned and derelict." But he is the first to observe the demise of the Martians, who fall prey to bacterial infection, "slain, after all man's devices failed, by the humblest things that God, in his wisdom, has put on this earth."

The narrator returns home, finds his wife alive and well, and later returns to London, disillusioned by the people who roam its streets like ghosts of the past, "phantasms in a dead city, the mockery of life in a galvanised body."

The War of the Worlds, *directed by Byron Haskin* (1953, U.S.A.; PARAMOUNT/THEATRE COLLECTION, FREE LIBRARY OF PHILADELPHIA)

The Film

Paramount originally offered *The War of the Worlds* to Soviet director Sergei Eisenstein in 1930, but he never attempted an adaptation. Orson Welles's 1938 Mercury Theater radio production had resurrected interest in a film adaptation, but it wasn't until 1953 that George Pal found Byron Haskin to direct the film and Barré Lyndon to write the screenplay. Haskin and Lyndon's adaptation was, for its time, a special-effects marvel but on most other counts a film whose romantic and religious sentimentality corrupted the finer and more subtle themes of the novel. Wells had been incensed by Orson Welles's 1938 radio version of the novel, which had relocated its setting but remained fairly faithful to the novel's plot and themes, so he surely would have been beside himself had he been alive to see Haskin's film. Haskin argued that given the explosion of the Atomic Age, Wells's vision had to be modernized, the characters changed, and the plot entirely restructured to enhance audience identification. (Presumably a modern audience would not identify with Wells's "country folk.") So Haskin opted to add the obligatory romance (here between a physicist and a librarian who are reunited in a church at the end of the film while the Martians succumb to infection) and, like other alien invasion films of the fifties, to use the Martians as thinly disguised communists. Haskin admits that the film was a war picture even without the Martian shots: "if Russia and the United States had started hostilities, you could have substituted the Russian invasion and have had a hell of a war film."

As the film progresses we witness the utter failure of all the scientific and military firepower the United States can muster against the merciless invaders. By the end, the Martians begin destroying Los Angeles as the hero searches desperately for his lover, whom he finally finds in a church. All the survivors have finally turned to prayer and God for salvation, which saves them. David Hughes and John Geduld describe the finale aptly: "A shot of a cathedral towering over the city and the sounds of a choir chanting 'Amen' bring to an end the perversion of Wells's story into one of Hollywood's major Cold War sermons."

The epilogue to Wells's novel forecasts a bleak future for humanity. Humans roam the streets of London much like the Martian invaders had only a short time earlier. According to Hughes and Geduld, Wells adopted the epistemology of fin de siecle science, which as articulated by one of Wells's influences—T.H. Huxley—held that humans were but machines (a view dubbed "biological Calvinism"). Martian technology and brutality were merely conditioned responses to biological evolution and entropy: "In the Martians, Wells invented an analogue of what the intellectual history of the nineteenth century suggested to many as our own condition." Frank McConnell has likewise argued that Wells's Martians were not aliens, but "ourselves, mutated beyond sympathy, though not beyond recognition." *The War of the Worlds* has continuing relevance in an age when we must face the consequences of our colonialist past, our efficient, machinelike eradication of the "other."

REFERENCES

Hughes, David Y., and Harry M. Geduld, eds., *A Critical Edition of The War of the Worlds: H.G. Wells's Scientific Romance* (Indiana University Press, 1993); McConnell, Frank, *The Science Fiction of H.G. Wells* (Oxford University Press, 1981); Haskin, Byron, *Byron Haskin: Interviewed by Joe Adamson*, a Director's Guild of America Oral History (Scarecrow Press, 1984).

—D.B.

WASHINGTON SQUARE (1881)

HENRY JAMES

The Heiress (1949), U.S.A., directed by William Wyler, adapted by Ruth and Augustus Goetz; Paramount.
Washington Square (1997), U.S.A., directed by Agnieszka Holland, adapted by Carol Doyle; Walt Disney Productions/Buena Vista.

The Novel

Considered a relatively minor work of Henry James's first period, *Washington Square* was first serialized in 1880 in

Cornhill in England and *Harper's New Monthly Magazine* in the United States. It purportedly grew out of an anecdote told to James in England by the actress Fanny Kemble, about her impoverished brother's jilting of an heiress upon learning she was to be disinherited by her father if she persisted in her relationship with him. Despite the book's popularity, James was not very fond of *Washington Square*, criticizing it as too simple and manufactured. "He had, indeed, told it without varnish," writes biographer Leon Edel, "and with an unsparing economy, in a structure wholly scenic. . . . It is a perfect piece of psychological realism and with its four characters . . . achieves a considerable degree of intensity and pathos."

The story centers around Catherine Sloper, the sweet, trusting, but lackluster daughter of a prominent New York physician, Austin Sloper. Both live in wealth and comfort at 16 Washington Square in 1850s New York City. Catherine falls in love with Morris Townsend, a handsome, attentive, charming—and poor—suitor. When the couple announce plans to marry, Dr. Sloper, believing Morris to be a greedy opportunist, vows to disinherit her. Learning of Dr. Sloper's threat, Morris jilts Catherine, proving himself to be the heartless fortune hunter Sloper had supposed. A hardened and bitter Catherine succeeds in repaying Morris in kind when, 20 years later, the wealthy spinster cruelly rejects his advances. "Among the endings of James's novels," reports biographer Edel, "there is none more poignant than when Catherine, her interview with the middle-aged Morris Townsend over, picks up her morsel of fancy-work and seats herself with it again, 'for life, as it were.'"

The Films

When Hollywood director William Wyler saw the play version of *Washington Square* by Ruth and Augustus Goetz, a modest success on the Broadway stage in 1947, he immediately contracted them to adapt it for the screen. The only change he suggested was to make Morris Townsend at least appear to be a more sympathetic character.

Wyler is most frequently praised for his adaptations of plays and novels, and *The Heiress* is still generally considered the best filmic translation to date of any work by Henry James. Photography by Leo Tover, production design by Harry Homer, and music by Aaron Copland superbly complement the tight script. Two actors were retained from the stage production, Ralph Richardson as Dr. Sloper and Betty Linley as Morris Townsend's sister, Mrs. Montgomery. Olivia de Havilland and Montgomery Clift played the unfortunate lovers Catherine and Morris.

Whereas in the novel James carefully prevented Catherine from being too sympathetic a character—characteristically preserving a detached irony toward her—the play and film present her as a stronger, more likable heroine, a persona obviously tailored to the star power of Ms. de Havilland. Similarly, the greedy opportunism James so

obviously imputes to Morris is here muted and ambivalent, resulting in a more attractive character. The viewer is almost prepared to believe his motives genuine—until the film's end, when his villainy is exposed. As for Dr. Sloper, who occupies center stage throughout most of the novel, Ralph Richardson's performance retains Sloper's heartless, spiritual meanness and his morbid obsession with being right about Catherine's suitor.

Both play and film add crucial scenes not in the James original. Morris's failure to show up for a planned elopement with Catherine notches up the tension leading toward their final confrontation. At the story's conclusion, when a seemingly repentant Morris returns to Catherine, she seems at first to agree. But when the man shows up later, she refuses to answer the door. Adding to this intensity is the fact that the play and script foreshorten the period of time between Morris's jilting of Catherine and his final return, from 20 to only four years. It might have been sufficient for James to have Catherine reject a careworn, middle-aged Morris, but not so for the Wyler film. Her choice to reject a still-handsome and persuasive young man carries a dramatic power and conviction that surpasses James's intentions. To charges that these additions in the play and film vulgarize James's original intentions, commentator Michael Anderegg rightly points out that they serve to sharpen the conflict and climax that is needed in a medium like film. Thus, the film's title change from *Washington Square* to *The Heiress* is very appropriate: In the end Catherine Sloper has become heir not only to her mother's fortune but also to the cruel and cold nature of her father.

The Heiress received seven Academy Award nominations and won Oscars for Ms. de Havilland and for composer Aaron Copland.

The 1997 version directed by Agnieszka Holland (*Europa Europa, The Secret Garden*) stars Jennifer Jason Leigh as Catherine Sloper, Albert Finney as Dr. Sloper, and Ben Chaplin as Morris Townsend. The location exteriors, bright color palette, and fluid camera work immediately announce this film's liberation from theatrical origins. There is urgency in the powerful opening scene when, after prowling slowly above the house tops of the Washington Square neighborhood, the camera suddenly dives down toward a particular house, races through its doorway, and sweeps up the staircase. Screams and sobs are heard. There's a mystery in this house, perhaps a tragedy.

That "tragedy" is the birth of Catherine Sloper. It's a tragedy for Catherine's mother, who has to die in the process. It's a tragedy for her father, Dr. Sloper, who has lost his wife (Later, he insults his grown daughter with a line that makes you gasp: "How could it be that your mother had to die so you could inhabit a space in this world?") And it becomes a lifelong agony for Catherine, who has to bear the brunt of her father's relentless opprobrium. He blames Catherine for his wife's death, and she can't help growing up desperately seeking from him

some kind of loving touch and gesture of approval. Poor Catherine is thus an easy target for the attentions of dashing, exotically handsome Morris Townsend. In no time he's ardently courting her, while old Dr. Sloper angrily looks on, convinced he's only after her substantial inheritance.

Jennifer Jason Leigh tracks Catherine's development from a timid church mouse, stumbling over the garden gate at a party, to a passionate young woman, fiercely seeking Townsend's love. Under the close gaze of the camera, her face is an expressive map tracing the journey. As her father, Albert Finney's visage likewise tells a tale: His great, square block of a countenance, surmounted by bushy brows, presents the proverbial brick wall to any opposition. Ben Chaplin is the enigmatic, impoverished Morris Townsend, whose sensuous lips and dandy-ish manner keep the viewer guessing as to his true ambitions (in one scene, his sister fiercely denies to Dr. Sloper that Morris is a fortune hunter). Even when he acknowledges a certain amount of opportunism on his part, he does so in a candid and casual manner, as if he's balancing a ledger sheet: As he admits to Catherine with unembarrassed narcissism, aren't his own good looks adequate compensation for the money she brings to their marriage?

If this version frankly admits (and perhaps accepts) Morris's motives, so too it points up the fact that Catherine's love for Morris is as much an act of self-absorption as a romantic gesture. There's a telling scene when she faces her mirror image for a breathless moment, and then kisses it passionately.

Catherine's European journey and the dramatic confrontation with her father in the Alps—scenes deleted in the 1949 version—are here retained. The film's ending, likewise, is rather closer to the needlepoint poignance of James than the ending of the 1949 version: An indeterminate number of years have passed since Morris jilted Catherine. Now, disinherited save for the house, she spends her days in her sunny drawing room operating what looks to be a day-care center for the neighborhood children. When Morris arrives, somewhat threadbare, she rejects his proposal gently, but firmly. After he leaves, she remains, in prolonged full-screen closeup, her face an enigmatic mask. We have reached the terminus of that probing camera that opened the film. We have reached the end of the line, and it is the tragedy described by commentator Louis Menand: "The sense that there was something genuine between [Catherine and Morris] gives the movie's final scene, of his return and her rebuff, the right chill."

REFERENCES

Anderegg, Michael, *William Wyler* (Twayne, 1979); Edel, Leon, *Henry James: The Conquest of London: 1870–1881* (Harper and Row, 1985); Menand, Louis, "Not Getting the Lesson of the Master," *New York Review of Books*, December 4, 1997, 19–20.

—*L.C.C. and J.C.T.*

THE WHALE RIDER (1987)

WITI IHIMAERA

Whale Rider (2002), New Zealand, directed and written by Niki Caro, Newmarket.

The Novel

Acclaimed Maori writer Witi Ihimaera's novel blends fiction and myth in a story about a young girl's struggle to win her great-grandfather's acceptance and her place as the heir to her tribe's leadership. The prologue introduces the ancient relationship between the whale and the whale rider, who rides him to "the land long sought and now found." Seated astride the whale, the rider flings spears seaward, where they become eels, and landward, where they become pigeons. The rider, however, is unable to throw one spear until he prays that it will "flower when the people are troubled and it is most needed." The spear is needed in the present, when Kahu, the young Maori girl, becomes the "spear" that saves her people. The second chapter, entitled "Spring," concerns the ancient bull whale's nostalgic thoughts of his experience with the whale rider, thoughts described as a "siren call" to New Zealand, "the dangerous islands to the southwest." The remainder of the novel consists of two parallel lines of action, Kahu's story and the bull whale's return to New Zealand, which converge at the end of the novel.

Kahu's Uncle Rawiri, who narrates most of the novel, includes his adventures in Papua New Guinea, with his white friend Jeff. Though the New Guinea episodes do not directly relate to Kahu's problem, they do relate to the racism that permeates the Pacific Rim and prompt Rawiri to return to New Zealand, where the Maoris, represented by Koro Apirana, Kahu's great-grandfather, are having their own problems with the government.

Because Koro believes that the old ways of the Maoris are under cultural attack, he is dedicated to finding an appropriate person to follow in his footsteps. Porourangi, his oldest grandchild, and his wife, Rehua, have a child, but since it is a girl (Kahu), Koro rejects Kahu and blames the break in the male line of descent on his wife, Nanny Flowers, herself the descendant of a chief, Muriwai. At Rehua's insistence the girl is named Kahu to honor Kahutia Te Rangi, one of the village's ancestors whose carved figure is on the village meetinghouse. Despite Koro's objections, Nanny supports Rehua and has Kahu's birth cord ritually buried on the beach near the meetinghouse. After the ceremony is complete, Rawiri sees something like a "small spear" flying through the air and hears a whale sounding out at sea.

"Summer," the next section, begins with a short chapter that takes the audience inside the mind of the old bull whale, which is intent upon a return to New Zealand. Rawiri describes Kahu's progress from infancy, when she demonstrates a special kinship with Maori customs, to girlhood,

when she discovers that Koro will not include her in the Maori classes he is giving some young boys. Kahu does manage to eavesdrop and picks up some of the lore, but it is her intuitive understanding and her ability to communicate with the whales that establish her as the rightful heir.

"Autumn" begins with Rawiri's disillusionment with Papua New Guinea and his return to New Zealand, where Kahu is almost 10 years old. Koro is more determined than ever to find "the one who can pull the stone," the one to whom the position of chief must pass. Porourangi, who married Ana after Rehua died, has had another child, but it is also a girl. When the school year ends, Kahu plays a prominent part in the ceremonies and even gives a testimonial in Maori to Koro, who chooses not to attend the ceremony. The crucial event that identifies Kahu as the true heir occurs when the boys cannot retrieve a stone that Koro throws into deep water; with the aid of dolphins that seem to communicate with her, Kahu brings back the stone, but Nanny and Rawiri do not tell Koro about her success. Nanny comments, "He's not ready yet."

In "Winter" the old bull whale leads the whales to New Zealand, where they beach themselves and die, despite the heroic efforts led by Koro; but the old bull whale was not among the 200 whales who died, some of which were slaughtered. The ravaging of the dead and dying whales by some Maoris demonstrates the break in the relationship between the whales and the descendants of the whale rider. Then the "ancient, battle-scarred" whale with the "sacred sign," "a swirling tattoo," beaches himself and his followers. His survival, Koro explains, will depend upon the tribe's response: "If it dies, we die. Not only its salvation but ours is waiting out there." When the bull whale's death seems imminent, Kahu slips into the water, swims to the bull whale, communicates with it, and rides it as her ancestor had. The whale mistakes Kahu for his old master, the whale rider, and leads the other whales out to sea and safety. Ihimaera writes, "She was Kahutia Te Rangi," and she clings to the whale as it goes out to sea.

In the epilogue the other whales convince the bull whale that he is carrying not his old master, but the "seed of Paika," "the last spear," and the whales return her to Whangara, where the dolphins protect her until she is found three days later. She is taken to the hospital, where she recovers and is finally accepted and acknowledged as the next chief by Koro, who has been told that she was the one who recovered the stone from the sea. It only remains for Kahu to fulfill her destiny.

The Film

Niki Caro's adaptation of Ihimaera's novel contains most of the material from its source, but the alterations tighten the focus and the plot and also radically change Rawiri, the first-person narrator in the novel. There is no narrator in the film, but the focus stays on Kahu (Pai in the film), who is played with remarkable sensitivity and strength by Keisha Castle-Hughes. Rawiri (Grant Roa), her uncle, is not a member of the Headhunters motorcycle gang, but is an overweight, kindly man who has gone to seed but is persuaded to teach Pai stick-fighting skills and even gets into shape, much to the surprise of Koro (Rawiri Paratene), who had given up on him. The film omits Rawiri's Papua New Guinea adventures and keeps the camera on Pai, and then mostly when she is about 10, when the major events occur.

The film also alters the details of Pai's birth by having her be the twin who survives; her twin brother dies, suggesting that Pai is the stronger and the legitimate heir. Since Pai's mother dies giving birth to the twins, Pourourangi (Cliff Curtis) is distraught and leaves the child-rearing to Nanny (Vicky Haughton). He then goes to Germany, where he becomes an acclaimed sculptor and falls in love with a blonde German woman, who accompanies him back to New Zealand. In the novel, Pourourangi marries a Maori woman, who bears him a daughter. In both novel and film Pourourangi is not the father of a boy who will become the chief.

Pai demonstrates her fitness to lead in the film not only by her superior knowledge of Maori culture and language, but by learning the art of stick fighting. When Koro sees her defeat the best of the young would-be heirs, that boy is not even allowed to attempt to retrieve the amulet that Koro throws into the sea. As in the novel, Pai succeeds in diving deep into the sea to get the amulet. The film, however, does not show Pai's empathy for the whales nor her ability to communicate with the ancient bull whale. Given the differences between the media, Niki Caro opted for demonstrating Pai's physical strength, which can be shown, rather than her emotional and spiritual power, which resists representation.

There are significant omissions, such as the mythical and political contexts, as well as the "conversations" between the whales. The novel establishes the broken relationship between the tribe and the whales and ties this to whale hunting for profit, not survival. In the novel, some Maoris rush to slaughter some of the 200 whales who beach themselves. In the film, the only suggestion that the Maori culture is declining is the presence of some young Maori men who are drinking and cruising around in a kind of hot rod. Aside from the boy whom Pai defeats at stick fighting, there are no boys with any stamina or courage.

Koro attempts to stem the decline by educating the young boys in Maori culture, but his stubborn misogyny blinds him to Pai's leadership qualities. When he is given the amulet, he asks, "Who?" Koro wants to control Pourourangi, who is committed to his work, which is a blend of Maori and modern art. He shows his grandfather slides of his sculptures, but Koro does not want to see them. He wants to see a male great-grandson. The person who embodies Maori culture is Pai, who wins a speaking contest for a testimonial, which she gives in Maori, to her great-grandfather, who does not attend the ceremony. The camera keeps returning to the empty chair that was reserved for him.

In the film Pai seems to have called the whales, which beach themselves and resist the tribe's efforts to save them. Koro musters the tribe, but he cannot get the bull whale out to sea. Pai, whom Koro somehow blames for the beached whales, does not join the group effort, but slips unnoticed to the bull whale's side once the tribe has apparently given up its efforts. As in the novel, she climbs up on the whale, and the two go out to sea. She is found later, hospitalized, and reunited with Koro. At the end of the film Pai is clearly identified as the tribe's future leader. The large ceremonial ship with the carved figure of Kahutia Te Rangi, which had been beached and ignored throughout the film, except when Pai was photographed on it, is rolled to the sea by the tribe, which now seems united. Reconciliation is the order of the day: the young toughs help with the ship, and Pourourangi and his pregnant German wife are in the family circle. The last image of the film is of the ceremonial ship, newly decorated and refurbished, being rowed out to sea by the men of the tribe. Sitting in the seat of honor, with Koro by her side, is Pai. She has restored the relationship between the tribe and the whales, reinvigorated the tribe, and renewed the Maori culture.

Without extraordinary special effects, violence, sex, or foul language, the film appealed to audiences more interested in interpersonal relationships. Ihimaera wrote the book for his two daughters who complained about the lack of heroines in fiction and in so doing supplied a heroine, taught his audience about Maori culture, and wrote a cultural coming-of-age story. Niki Caro successfully transformed Ihimaera's fiction to film and was rewarded with critical acclaim. The film won prizes at film festivals in San Francisco, Rotterdam, and Seattle, and also won the World Cinema Audience Award at the Sundance Film Festival.

REFERENCES

Bardolph, Jacqueline, "An Invisible Presence: Three Maori Writers," *Third World Quarterly* 12, no. 2 (1990): 131–137; Mitchell, Elvis, "A Girl Born to Lead, Fighting the Odds," *New York Times*, June 6, 2003, A14; ———, "The Glow of Youth at the Toronto Film Festival," *New York Times*, September 16, 2002, E1.

—T.L.E.

WHAT DREAMS MAY COME (1978)

RICHARD MATHESON

What Dreams May Come (1998), U.S.A., directed by Vincent Ward, adapted by Ron Bass; PolyGram Filmed Entertainment.

The Novel

Richard Matheson is the renowned fantasist whose 16 *Twilight Zone* scripts, many short stories (including the classic "Born of Man and Woman"), screenplays (including the Roger Corman/Edgar Allan Poe cycle of the early 1960s), and novels (*I Am Legend* and *Hell House*) have established him as one of modern fantasy's greatest writers. Like his previous novel, *Bid Time Return* (1975), *What Dreams May Come* eschews the trappings of science fiction and gothic horror to chronicle a romance between two "soulmates" that is so strong that it transcends the barriers of time and mortality. As Charles Heffelfinger notes, "blending a love story with metaphysical theory . . . constituted something new in the fantasy fiction field, making it closer to the nonfiction studies of Raymond A. Moody Jr. and Elisabeth Kübler-Ross than to other works of fantasy." (Later, Matheson wrote a nonfiction book, *The Path: Metaphysics for the '90s*.)

A manuscript arrives at the home of Robert Nielsen. It purports to be a psychically dictated account of the death and afterlife of Robert's brother, Chris, a television writer who had died the year before in an automobile accident. Chris' strange story begins with his death and his witnessing of his own funeral. After unsuccessfully trying to communicate with his wife, Ann, who does not believe in an afterlife, Chris finds himself in a pleasant, idealized world similar to the one he left. The apparition of his deceased cousin, Albert, acts as a guide to this world, which he calls Summerland. But when Chris learns that his wife has committed suicide, and that she will be consigned to the "lower realm" (in essence, hell), he insists on Albert's guiding him there to try to reclaim her. Chris finds her in a run-down ruin, which resembles their former home now gone to seed. But because she does not believe in survival after death, she doesn't recognize Chris. It is only when Chris offers to make the ultimate sacrifice, agreeing to remain with her in hell, that she recognizes him. She escapes. Chris wakes up in Summerland and learns from Albert that Ann has returned to the living and been reincarnated as a newborn child in India. Desiring to be reunited with her, Chris also resolves to be reincarnated, choosing to be born to a family in Philadelphia, where (it is foretold) he will grow up to be a doctor, travel to India, and meet Ann. This for him is the ultimate act of courage: "Enough time has elapsed so that the idea of returning to flesh is no longer inviting to me. . . . For, in truth, it is not courageous to die. True courage is involved in being born voluntarily, leaving the manifold beauties of Summerland to plunge back into the depth of dark, imprisoning matter."

The Film

The screen adaptation by director Vincent Ward and writer Ron Bass considerably expands upon Matheson's story line. A backstory is added between Chris Nielsen (now Christy Nielsen, played by Robin Williams), a pediatric doctor, and his wife, Ann (Annabella Sciorra), a gallery owner and a successful painter. The mentoring duties of the Albert character are divided between Cuba Gooding, Jr. and Max Von Sydow (the latter

Robin Williams and Annabella Sciorra in What Dreams May Come, *directed by Vincent Ward* (1998, U.S.A., POLYGRAM FILMS)

assuming the role as guide to the regions of hell). Whereas Matheson depicted Summerland in vague abstractions—"I had never seen such scenery: a stunning vista of green-clad meadows, flowers, and trees"—the film devises a spectacular series of tableaux imitating the mystical landscapes of Ann's canvases (resembling an awkward cross between J.M.W. Turner and the modern "couch painter," Thomas Kincaid). Although the results smack rather too much of a celestial Disneyland theme park (aided and abetted by spectacular special-effects work), at least the theme of Chris's bond with Ann is visually confirmed. An added plot detail is Chris's search for the spirits of his two children—Jessica Brooks as Marie and Josh Paddock as Ian—killed several years before in an automobile accident. Contrary to the conclusion of Matheson's story, Chris and Ann are permitted to reunite in heaven. It is their mutual decision to be reincarnated to Life, where, in the final scene, their child selves meet each other, presumably to embark on another lifelong romance.

What Dreams May Come pulls out all the stops. It's just too darned big. Heaven here is a boundless void. You can't find yourself here because you're lost all the time. Chris's journey to hell, meanwhile, to retrieve the spirit of his wife affords the film's designers ample opportunity to alter the color palette from the lavenders and yellows of heavenly fields and flowers to a infernal slate-gray and iron mono-

chrome. Again, paintings are the models for the visual, only this time works by Gustave Doré and Hieronymous Bosch are the obvious antecedents.

Amidst these tasteless displays of paint-spattered heaven and iron-stained hell lurks the same kind of psychobabble that contaminates the sayings of our popular so-called spiritual gurus, from Kahlil Gibran to Rod McKuen. For example, when Chris tells Albert that he wants to see his children, Albert replies, "When you do, you will." And Albert is always saying things like, "When you win, you lose," or, "When you lose, you win." Other lines are just plain silly, as when a damned soul mutters, "It hasn't been a really good day." Little of Matheson's sober, rigorously researched mysticism remains.

Critic Joe Morgenstern summed up the general impression to what he called a "spellbindingly awful" film: Hell, he said "is having to see this movie again."

REFERENCES

Gjettum, Pamela, "Review of What Dreams May Come" [novel], *Library Journal* 103 (November 1, 1978): 2262; Holden, Stephen, "'What Dreams May Come': Apparently, the Afterlife Is Anything but Dead," *The New York Times*, October 2, 1998; *Magill's Guide to Science Fiction and Fantasy Literature* 4 (Salem Press, 1996), 1032–33; Morgenstern, Joe, "What Dreams May Come," *The Wall Street Journal*, October 2, 1998, W10.

—*J.C.T.*

WHERE ANGELS FEAR TO TREAD (1905)

E.M. FORSTER

Where Angels Fear to Tread (1991), U.K., directed by Charles Sturridge, adapted by Sturridge, Tim Sullivan, and Derek Granger; Rank/Sovereign/LWT/Stagescreen/Compact.

The Novel

In *Where Angels Fear to Tread*, Forster introduces his recurring theme of the repression and prejudice of middle-class Edwardian England. At the onset of the novel, Lilia Herriton is sent off to Italy by her in-laws. The Herritons—Mrs. Herriton, and her grown children, Philip and Harriet—embody the attitudes of suburban England. They are shocked to discover, soon after Lilia's departure, that she is engaged to an Italian despite what they hoped to be the sobering influence of her traveling companion, Caroline Abbott.

Philip is dispatched to Italy to break up the engagement; there he finds that Lilia has not only already married but has married Gino, a young, poor Italian. Philip returns home.

The Herritons later discover that Lilia has died in childbirth. The notion of a half-British child being raised in a "heathen" country sends Caroline, Philip, and Harriet off to Italy to fetch the child back to England.

The theme of the English "transfigured by Italy" comes into play as Philip, previously ambivalent, recognizes his love for Caroline and comes to the realization that Lilia's child should stay in Italy with Gino. However, Harriet—representing the destructive, imperialistic English—kidnaps the child, and in an accident the child is killed.

The final scene between Caroline and Philip shows an impassioned Philip ready to declare his love for Caroline just as Caroline proclaims her secret love for Gino.

The Film

Charles Sturridge, director of the acclaimed adaptations of Evelyn Waugh's *Brideshead Revisited* and *A Handful of Dust*, enters Merchant-Ivory territory with his 1991 adaptation of Forster's *Where Angels Fear to Tread*. Critics disagree about the reason for this film's lack of success, although it was released almost simultaneously with Merchant-Ivory's successful adaptation of *Howards End*.

The actors, particularly Helen Mirren as Lilia and Judy Davis as Harriet, capture the essence of the opposing Forsterian characters: one who abandons herself to spontaneity and one who confines herself to the strictures of Edwardian decorum. However, none of the characters are fully developed and become simply caricatures of certain types that Forster wished to mock. This is seen specifically in the scene in which Davis's Harriet "shushes" an Italian audience at an opera just as they give the performing diva a standing ovation.

Where Angels Fear to Tread sketches out themes that will later be played out with more success in the novels *Howards End* and *A Passage to India*. While the film pales in comparison to Merchant-Ivory's adaptation of *Howards End*, the viewing of these films together proves instructive in observing the growth of Forster as an author.

REFERENCES

Beauman, Nicola, *E.M. Forster: A Biography* (Knopf, 1994); Denby, David, review of *Where Angels Fear to Tread* in *New York Times* (March 9, 1992), 56; Simon, Richard Keller, "E.M. Forster's Critique of Laughter and the Comic: The First Three Novels as Dialectic," *Twentieth Century Literature: A Scholarly and Critical Journal* 31 (1985): 199–220.

—A.D.B.

WILHELM MEISTER'S APPRENTICESHIP *(Wilhelm Meisters Lehrjahre)* (1795–96)

JOHANN WOLFGANG VON GOETHE

Wrong Move (Falsche Bewegung) (1974), West Germany, directed by Wim Wenders, adapted by Peter Handke; Solaris Film.

The Novel

Johann Wolfgang von Goethe (1749–1842), Germany's 18th-century equivalent to Shakespeare, is mostly familiar to readers as the author of *Faust*, the verse classic relating the fate of a man who dares to stretch his limits. Goethe also wrote dramas and novels and is given credit as the founding father of the German *Bildungsroman* (novel of education), a uniquely German genre, typically concentrating on the experience of a central character in the external world. In the *Lehrjahre* Wilhelm Meister is "educated" from "illusion to clarity of vision." Most importantly, however, the problem of the artist and art itself are viewed by Goethe as part of the human condition.

As an 18th-century novel, *Lehrjahre* is predictably a long, convoluted book with a number of characters to match the sundry strands of the main story trajectory: Wilhelm's education itself. The first four "books" of the novel treat the presentation of Wilhelm's theatrical career; the last several books feature themes of the young man's self-realization and maturity. At the beginning Wilhelm is a restless son of a bourgeois businessman. He longs to "free" himself from his father's life and pursues a stage actress, Mariana, whom he courts but abandons under the pretext of her infidelity. This "crisis" gives Wilhelm an excuse to run away with a group of traveling players, among whom are Philina and Laertes, and both characters weave into

and out of Wilhelm's "free" and romantic life of artistic adventure. Wilhelm moves on to encounters with other less definable, mysterious persons who, in the best tradition of the Gothic or popular novel, appear to be figures from an "elemental" world, interventions or forces destined to influence the course of Wilhelm's education. Two outstanding examples here are the Harper and the young, androgynous Mignon. They suggest the ever-present role of the inexplicable in man's life. Wilhelm gives a strong presentation in a production of Hamlet, showing the practical application of theatrical criticism on the stage. Wilhelm reaches maturity with his initiation into a Masonic-influenced Society of the Tower. This secret fraternity has been monitoring and guiding his life all these years. Wilhelm accepts responsibility for his son (Mariana and Wilhelm's child) and gives up a career in art and theater.

The Film

Like *The Goalie's Anxiety at the Penalty Kick*, Wenders's film *Falsche Bewegung* (*Wrong Move*) shows the artistic and temperamental bonding of Wenders to Peter Handke who wrote (and eventually published) the initial screenplay. Wenders kept Handke's post-modernist adaptation of Goethe's classic text but made one important change. The film director rejected Handke's vision of a happy ending to Wilhelm Meister's search for a writer's career and thereby suggested that Wilhelm's destiny was to "drift on" and continue his alienation. Yet both Handke and Wenders remained committed to the reinterpretation (and the relevance) of Wilhelm's project of self-education. The literary source of Wenders's film was updated for a contemporary audience. Images of movement and motion, set within a geographical and physical context of modern Germany, are interwoven with dialogue and discussion that echo the existential human condition of Wilhelm's contemporaries.

The role of Wilhelm is played by repertory actor Rüdiger Vogler. Wenders and Handke retain the characters of Laertes (Hans Blech) and Mignon (Nastassja Kinski) along with a starring part for Hanna Schygulla as actress Therese Farmer. A close study of Handke's script, however, shows that many of Goethe's figures from the novel have been dropped; Therese Farmer, for example, is a composite character and symbol of the original Wilhelm's love affairs with many actresses. Therese's relationship with the modern Wilhelm is too problematic to resolve and he undergoes a writer's "block" that prevents further artistic progress, so he "gives up" further attachments to women. He is passive and unresponsive to others and even fails to kill Laertes who, in Handke's version, is revealed as an ex-Nazi. As Geist indicates, Wenders's film effectively shows that Wilhelm "lacks sins of commission, which corresponds to his lack of zeal and passion." At the end of the film, Wenders shows Wilhelm alone on the Zugspitze mountain peaks, in a position of stasis and negativity, wondering *how* and *why* his artistic education has been sub-verted. He has achieved scarcely any insight into his art or himself. He is ending this stage of events just as he had begun them, with a sense of despair and failure.

Harcourt calls Handke and Wenders's scenario and direction an "adaptation through inversion." What is "inverted" is the traditional ending or conclusion expected by the reading audience of Goethe's day, i.e., the author's having demonstrated (to everyone's satisfaction) that an "education" into society and the world had actually taken place. There is no such assurance in Wenders's film. In this modern adaptation, the protagonist is an anti-hero and there is no optimistic resolution whatever to relate to the literary text itself.

REFERENCES

Beicken, Peter, and Robert Phillip Kolker, *The Films of Wim Wenders* (Cambridge University Press, 1993); Harcourt, Peter, "Adaptation Through Inversion" in *Modern European Filmmakers and the Art of Adaptation*, ed. Andrew S. Horton, (Frederick Ungar, 1981); Reiss, Hans, *Goethe's Novels* (University of Miami Press, 1969); Geist, Kathe, *The Cinema of Wim Wenders* (UMI Research Press, 1988).

—R.A.F.

WINGS OF THE DOVE (1902)

HENRY JAMES

Wings of the Dove (1997), U.K., directed by Iain Softley, adapted by Hossein Amini; Miramax.

Under Heaven (1998), U.S.A., directed and adapted by Meg Richman; Banner Entertainment.

The Novel

Published in 1902, *Wings of the Dove* was the first of Henry James's three "major" novels (also including *The Ambassadors* and *The Golden Bowl*) that arrived with the new century. Its autobiographical elements—the character of the fatally stricken American heiress Milly Theale is probably based on James's orphan cousin, Minny Temple, to whom he apparently had had a deep attachment in his youth—and its unusual, relatively explicit treatment of sexual love has made it the favorite province of Jamesians everywhere. Critical opinion has been sharply divided. Whereas F.O. Matthiessen, in *Henry James: The Major Phase*, pronounced it his "masterpiece," the work "where his characteristic emotional vibration seems deepest," Maxwell Geismar, in *Henry James and the Jacobites*, attacked its "bag of literary tricks" and its "calculated, contrived, altogether esoteric literary method." The title, by the way, is taken from the words of the 55th Psalm: "Oh, that I had wings like a dove! For then would I fly away, and be at rest." Milly is that dove, flown too soon, leaving behind the wreckage of her lovers and conspirators.

After the death of her mother, Kate Croy goes to London to live with her wealthy maternal aunt Maude in Hyde

Park. Headstrong by nature, Kate finds herself under the repressive thumb of her aunt's strict social codes; for example, her romance with a penniless journalist, Merton Densher, is strongly discouraged in favor of another suitor, Lord Mark, a dissipated aristocrat who is willing to lend her a title in exchange for her money. Fearful of being disinherited, Kate reluctantly breaks off with Merton.

Onto the scene arrives a beautiful American heiress, Milly Theale. Knowing Milly to be terminally ill, Kate persuades Merton to follow Milly to Venice and make love to her. What presumably is a selfless act on Kate and Merton's part might possibly have a darker motive: If Merton succeeds in courting Milly, he would be in a position to inherit her money, which in turn would enable him to marry Kate. Kate, in the meantime, has denied to Milly that she herself loves Merton. Indeed, she has convinced herself that her plan is entirely unselfish—why should not Milly have beautiful romantic moments in the short time remaining to her?

Preposterous as the trappings of this lurid melodrama sound, so full of Old World schemes and conspiracies directed against a New World fairy princess—James had, at one point in the story's gestation, intended it for the stage—you can be sure that things won't rest there. The rest of the story is taken up with the growing relationship between Merton and Milly in Venice. Against the lambent glow of the ancient city, along the canals and inside the magnificent churches, Kate watches with growing anxiety while her two friends develop a strange and intense relationship. Merton, usually passive and indecisive, is finding at last the emotional fulfillment so long denied him; Milly, a death sentence hanging over her, blossoms into a radiant woman in love.

Now that Kate's plot has gone awry, she conspires to break up the relationship. She confesses to her aristocratic suitor, Lord Mark, that Merton has been her lover. When Merton gets wind of the betrayal, he rushes to Milly to deny everything. They reconcile, but Milly soon dies. A disconsolate Merton returns to London, but when he meets Kate, they make passionate love. Even though Merton offers to relinquish his claim on Milly's money, Kate makes one more demand on him: She wants to know if Merton is still in love with Milly's memory. When Merton falters, Kate dresses and leaves. Merton, presumably now endowed with Milly's money (the issue is left vague), returns to Venice alone. Apparently he will spend his days, as James puts it, in love with the memory, or "aftersense," of Milly, which "day by day, was his greatest reality."

The Films

Adapting Henry James to the screen has been the secret hope—and the inevitable bane—of many filmmakers. "What to do with James," asks critic Daphne Merkin rhetorically, "who, by his own admission, had trouble with what he called the 'solidity of specification,' and whose unique skill was his self-professed 'appeal to incalculabil-

Alison Elliott and Helena Bonham Carter in Wings of the Dove, *directed by Iain Softley* (1998, U.S.A.; MIRAMAX FILMS)

ity'—for intimating, in other words, that which is psychologically most oblique?"

Cast in Iain Softley's film version are Helena Bonham Carter as Kate Croy, Charlotte Rampling as Aunt Maude, Linus Roache as Merton, Alex Jennings as Lord Mark, and Alison Elliott as Milly Theale. The convolutions of the story are effectively sorted out into a relatively straightforward story line by screenwriter Hossein Amini (*Jude the Obscure*). His tight script—along with the very absence of the sort of camera trickery, outre dream sequences, and other virtuoso techniques that marred Jane Campion's *The Portrait of a Lady*—spares us (some of us, at least) James's interminably lingering stream-of-consciousness prose, the details of Milly's protracted death throes, and the repetitious meetings between Kate and Merton at the end. James's famous remark that he was troubled by an inability to achieve a "solidity of specification" in his prose is handily circumvented by production designer John Beard and cinematographer Eduardo Serra's fine eye for telling detail and scene. By eliminating the character of Aunt Maude from the Venice episodes—in the book she accompanied Kate and Milly as chaperone—Amini allows his trio of characters freer rein to explore their passions and deceptions. And in transposing the action from 1902 to 1910 he enriches the tale with fleeting references to a world poised on the rim of modernism: Sexual mores and fashions are changing, the London Underground is running, and electricity is transforming urban life.

In spite of these simplifications, or reductions, we gain a fair measure of the subtleties of James's characters and the torturous situation in which they are entangled. The film wisely refuses to grant us easy answers to the riddles. What, for example, are the true motivations of Kate's machinations? While she had recoiled in horror from Lord Mark's avowed machinations to marry Milly for her money (in order that he might eventually return to Kate), Kate nonetheless proves herself capable of contriving, with Merton's assistance, a similar plot against her. Her reasons seem altruistic, but it is clear—although not as clear as in the novel—that this will also clear a path to Milly's

fortune. But then, at the 11th hour, just as her plot is about to succeed, Kate does her best to wreck it. Did she not realize this would inevitably happen? Her plot has back-fired, and now she risks losing Merton's love entirely. What of Densher's willingness to allow Milly to think he was falling in love with her? Was this only part of his and Kate's plot? And what of poor departed Milly? Why did she will her fortune to Merton, in light of her own suspicions regarding his perfidy?

Wings of the Dove is drenched in Gilded Age atmosphere and detail. The London scenes were shot in stately homes at Luton Hoo and Knebworth at the Richmond Fellowship, as well as on the Serpentine in Hyde Park. For some of the Venetian scenes, the production chose the Palazzo Leporelli (also known as the Palazzo Barbaro), just off the Grand Canal—the very place where James stayed as a guest while writing portions of *Wings of the Dove*. Other locations included St. Mark's Square, the Basilica San Marco, and the Salute Church. By drawing upon the paintings of Venetian artist Ettore Tito for inspiration, cinematographer Serra creates a sumptuously luxurious glow suffused with more than a whiff of the exotic East. "Venice at the turn of the century was on the extreme of European culture," explains director Iain Softley. "It was multi-ethnic with a lot of Arab, African and gypsy influence, which Mussolini later tried to erase. There would have been Casbah-style markets. And there are the labyrinths of the canal system. . . ."

The cast is exceptionally fine. Alison Elliott may look a tad too robust for James's Milly—"a slim, constantly pale, delicately haggard, anomalously, agreeably angular young person"—but she effectively, and necessarily, commands the center of every scene in which she appears. As the frustrated, scheming Kate, Helena Bonham Carter nicely blends the contradictory elements of her fierce love for Merton, her loyalty to Milly, and her own tendency to self-destruct. For his part, Linus Roache (last seen in *Priest*) conveys the vacillations in Merton's character (who is, after all, James insists, rather weak-willed). When we first meet him, we think him an idealistic, progressive journalist (a working person, rather rare in James) and a headstrong suitor of Kate. But we learn soon enough he's really apathetic about his job and something less than a romantic lover ("I fake passion; I fake conviction"). He doesn't want to return from Venice ("there's nothing for me back in London") and he allows himself to be talked into the relationship with Milly. Throughout, he moves as if in a kind of trance.

These characters may seem, for all their inner turmoil, bloodless and distant. They are observers of their own lives more than active participants. As Maxwell Geismar has noted, James's characters usually refine away their physical passions, "converting the primary human drives into a sublimated sort of idealism, an ethereal sensibility." But it seems that in this movie, as in James's book, their placidly correct surfaces are only provisional barriers against darker, violent urges. In his own life, James himself seemed, outwardly at least, a pretty chilly character, suc-cessfully avoiding deep emotional attachments with women. He felt that passion and marriage threatened his art. "He had feared the love of woman," writes his biographer Leon Edel, "and learned to keep himself emotionally distant from all human relations lest he commit himself to unforeseen disasters." Yet, in a burst of courageous self-examination, James, nearing the end of his life, seemed to question his chosen philosophy. What happens, he asked in *Wings of the Dove*, when the fulfilling loves and passions of life are denied? The answers are troubling, for Merton and Kate must reap the tragic consequences of their emotional and moral confusion. Whereas once the lack of money had blocked their relationship, now the presence of money exacts the same prohibition. As for Milly and Merton, as their relationship deepens, the air grows darker and rains fall harder, as if the world and everyone in it were being choked in the constricting coils of a noose. Finally, Merton is left able to love only the dead Milly Theale, obsessed with a passion more exquisite than anything he could feel toward the living Kate.

The sexual encounter between Merton and Kate at the end of the movie, is, like the book, the set piece of the story, tying into a tight knot all the themes of the story. Suffice to note that it is a startling, profoundly moving scene, its graphic nudity and erotic passions wrenchingly undercut by a gruesome tangle of doubts and recriminations. Movies adapted from Henry James (François Truffaut's *The Green Room*, Jane Campion's *Portrait of a Lady*, Claude Chabrol's *The Bench of Desolation*, and Agnieszka Holland's *Washington Square* are a few recent examples) have never given us anything quite like this scene. For once, as nowhere else in James (and in Jamesian movies), the blaze of sexual passion burns bright. But it is ultimately, a cold flame. The figures grapple in the shadows, but their faces are turned away from each other. The moment lingers long in the viewer's memory—surely like the ghost of Milly that will continue to haunt each of the characters in the story. People in love, in James's work at least, are always in danger.

The second film version, a New Age retelling by director/adaptor Meg Richman, in her directorial debut, need not detain us long. The book has been shorn of its period trappings and thematic complexities. Updated to a modern Seattle setting, Kate and Merton are now Cynthia and Buck (Molly Parker and Aden Young), two slackers whose relationship drifts along in a haze of booze, drugs, and abject poverty. Milly is now Eleanor (Joely Richardson), who lives alone in a mansion above Puget Sound. Cynthia and Buck hatch their plot to seduce and deceive the terminally ill Eleanor, but when the intrigue is uncovered, no one seems to mind much. The threesome live harmoniously enough—Eleanor looks moodily on while Buck and Cynthia disport themselves about bedroom, garden, and meadow—until Eleanor has the grace and discretion to expire prettily in a Pre-Raphaelite pose.

While the sex scenes—including a startling moment when Eleanor reveals her double mastectomy to Buck—

are stronger than anything in James's novel, the rest of the movie has reduced the book's nastier implications into a kind of sentimental pablum. No one, including the screenwriter/director, seems to have the slightest idea of what these characters are really about. Never mind their various deceptions and opportunistic ambitions, they're all a pretty sweet bunch after all. Living with Eleanor impels cynical Cynthia into inviting her estranged family to move into the mansion, and it transforms boozy Buck into a devoted businessman who leaves Cynthia behind to start up his own landscaping business. Worst of all, the relationship between Buck and Cynthia has been flattened into a New Age cardboard cutout: They drifted together, loved, conspired against their best friend, and now drift apart again. Well, *whatever*. . . . Never mind all that; just think warm thoughts.

Although *Under Heaven* received a Grand Jury nomination at the 1998 Sundance Festival, the movie is a thin and tepid adaptation of James's novel. Worst of all, its insistence on a happy ending is a betrayal of James's intentions.

REFERENCES

Horne, Philip, "The James Gang," *Sight and Sound* 8, no. 1 (January 1998): 16–19; Menand, Louis, "Not Getting the Lesson of the Master," *New York Review of Books*, December 4, 1997, 19–20; Merkin, Daphne, "The Escape Artist," *The New Yorker*, November 10, 1997, 121–22.

—*J.C.T.*

WISE BLOOD (1952)

FLANNERY O'CONNOR

Wise Blood (1980), U.S.A./West Germany, directed by John Huston, adapted by Benedict Fitzgerald; Anthea/Ithaca/New Line.

The Novel

The first of O'Connor's two novels, *Wise Blood* seemed so unprecedented that it baffled critics, who could not connect this strange book to any identifiable tradition within American fiction and were puzzled about whether to take it seriously, though they praised O'Connor's style and imagery. In her note to the second edition (1962), O'Connor herself clarified her sought-for reader response: "The book was written with zest and, if possible, it should be read that way. It is a comic novel about a Christian *malgre lui*, and as such, very serious, for all comic novels that are any good must be about matters of life and death." Subsequent studies of O'Connor have placed her in the tradition of the grotesque, specifically Nathanael West, who "showed [O'Connor] the possibilities of indirection, the relationship between a nonrealistic approach to fiction and the explicit treatment of religious motifs, between serious intent and comic vision."

Wise Blood is a quest narrative centered on Hazel Motes, who, just discharged from the army, finds all his relatives dead and is consequently driven by "a longing for home." He travels to the city to find a "place to be." He is firmly convinced that he does not believe in Jesus—"Nothing matters but that Jesus don't exist"—and, in perverse imitation of the blind preacher Asa Hawks, begins to preach "the church of truth without Jesus Christ Crucified." Enoch Emery, another homeless young man, hears Motes's call. Enoch has "wise blood," inherited from his father, who "looks just like Jesus." Enoch responds instinctually to Hazel's message, enacting a grotesque parody of a born-again Christian. Hazel, meanwhile, is obsessed with Asa Hawks and his daughter Sabbath. Asa turns out to be not blind, and his daughter is a slut. When a con-man starts preaching a rival Holy Church of Christ Without Christ, Motes kills him, having identified him as his conscience. After a scene in which he stares into space for a long time, Motes blinds himself. The last chapter observes him through the sensibility of Mrs. Flood, his landlady, who tells him: "Well, it's not normal. It's like one of them gory stories, it's something that people have quit doing—like boiling in oil or being a saint or walling up cats . . . There's no reason for it. People have quit doing it." To which Motes replies, "They ain't quit doing it as long as I'm doing it"—a cleverly self-reflexive passage that readers can also see as a clue to O'Connor's fictional technique.

The Film

Many of Huston's films were literary adaptations, including his final film, a version of Joyce's "The Dead." O'Connor's novel would at first glance seem to be as unfilmable as Joyce's story, since so much of the "action" is interior. Yet, early reviewers of the book had commented on the cinematic nature of its imagery, and the adaptation by Benedict Fitzgerald respects O'Connor's visual style and episodic structure by staying very close to the book. Only one major restructuring occurs in the film version: Huston reverses the order of the train trip to the city (which happens first in the novel) and the flashbacks to Hazel Motes's visit to his deserted home (which occurs first in the film, and which has been called an homage to John Ford's *The Grapes of Wrath*, which begins the same way). The obvious fidelity of the screenplay to the novel may be explained by the fact that the adapter, Fitzgerald, is a son of O'Connor's literary executor and of the editor of her letters (as is the film's producer).

But fidelity is in itself not a guarantee of successful adaptation, for, as Boyum points out, the true challenge here is the highly emblematic nature of O'Connor's style—"the parable-like plots and heavy overlay of metaphor that have so delighted symbol-hunters." Huston tackled this problem by filming on location (in Macon, Georgia) and using some local actors (professional and amateur); he resists embellishing this found reality with "filmic" techniques such as unusual camera angles, self-conscious editing, or other

rhetorical devices (except in two instances: brief flashbacks of Hazel's preacher grandfather, played by Huston himself, and the final shot). Interestingly, literal adherence to the novel's action and dialogue does not obscure the figurative signposts that guide us toward what O'Connor herself called the "mystery" at the heart of the story.

Given generally favorable reviews, Huston's *Wise Blood* has also attracted attention from scholars interested in the problems of film adaptation. In her consideration of metaphor, symbol, and allegory, Boyum finds the film to be an especially successful example of how to meet the challenge of creating cinematic equivalents for verbal tropes. Huston's lightening of O'Connor's tone, "rather than betraying her," she writes, "releases and intensifies her sometimes elusive comedy" and "gives the work the feel of a comic tall tale." This is a contradiction, since Huston also emphasizes the realism of the novel's action and characters. "But *Wise Blood* is a movie whose accomplishment lies very much in the extent to which it has managed to bring off such contradictory effects." It is very much in the spirit of O'Connor's paradoxical observation that "all comic novels that are any good must be about matters of life and death."

REFERENCES

Asals, Frederick, *Flannery O'Connor: The Imagination of Extremity* (University of Georgia Press, 1982); Boyum, Joy Gould, *Double Exposure: Fiction into Film* (New American Library, 1985); Klein, Michael, "Visualization and Significance in John Huston's *Wise Blood: The Redemption of Reality*," *Literature/Film Quarterly* 12 (1984): 230–36; Menides, Laura Jehn, "John Huston's *Wise Blood* and the Myth of the Sacred Quest," *Literature/Film Quarterly* 9 (1981): 207–12.

—*U.W.*

WOE TO LIVE ON (1987)

DANIEL WOODRELL

Ride with the Devil (1999), U.S.A., directed by Ang Lee, adapted by James Schamus; Good Machine/Universal Pictures.

The Novel

Missouri author Daniel Woodrell's *Woe to Live On* (1987) is a grim tale of the Kansas-Missouri Border Wars in the early 1860s, culminating in the infamous Quantrill raid against Lawrence, Kansas, in 1863. The novel first appeared in short story form in *The Missouri Review* in 1983. The original short story is divided into three sections, "Coleman Younger, The Last Is Gone—1916"; "I Have Been Found in History Books"; and "Only for Them." Narrator Jakob Roedel, a second-generation German American, is an old man who lives with his son, Jefferson, and grandson, Karl, in Saint Bruno, Missouri. Jake has just learned that his old friend and comrade in arms,

Coleman Younger, has passed away. Younger's demise triggers Jake's memories of those bloody, violent days of the early 1860s when conflicts between Missouri pro-southern bushwhackers and Kansas free-state Jayhawkers led to the slaughter of thousands of citizens and soldiers and divided the loyalties of many families.

Central to the story is the theme of political, ethnic, and intergenerational conflict during time of war. Whereas Jake's father's generation of German immigrants sought to preserve its heritage and, at the same time, support the Union flag, Jake wanted only to assimilate into the culture and fight for the South. "I am an American of sorts," he declares; "Germans are not my breed." The resulting schisms are damaging and, ultimately, irreparable. Having survived a youth fraught with the scars and losses of war, all Jake can do in the end is whittle away at a piece of wood, seeking a form, a meaning, that has eluded him all his life. It's an effective metaphor that opens and closes the story. "My knife turned in patterns I could not foresee," Jake says at the story's opening, "and something I did not expect would come of it. The worst and best in this life are that way." By story's end, Jacob has reduced the block of wood to a few shavings. "The chips and curls would not mend. No other design would grow from them."

Woodrell's novel-length version was published in 1987. It expands the central section of the short story and confines the action to the years 1861–63, abandoning the structural device of the framing episodes involving Jake and his family. Nineteen-year-old Jake Roedel is riding under the black flag of the Missouri bushwhackers under the leadership of Black John Ambrose. From Jake's pro-southern perspective, the "enemies" are the Federals—described as "killer dupes from up the country two or more states away" whose presence "freed maniac Jayhawkers to ravage about the countryside, taking all of value back to Kansas with them"—and the Jayhawkers themselves, whose protestations of antislavery ideals Jake believes to be spurious.

Details of Jake's family history emerge. Years before, Jake's father had brought the family to Baltimore from Hamburg (Jake was born in midpassage) and proceeded inland to the "promised land" of Missouri: "Newspapers in the Old World printed glowing accounts of it and a rush of immigrants headed for the cheap land, thick-wooded rolling hills and good water of the state." When Jake's father went to work for Asa Chiles, a vineyard owner, Jake was unofficially "adopted" by Asa as a brother to Jack Bull. Jake grew up with a fine library at his disposal and a lesson in manners and gentility from his new "father." But the vineyard failed, as did so many ventures of other Dutchmen, and Jake struck out on his own.

One particularly violent episode, derived from the short story, details the Irregulars' capture of four Federals. They offer to spare them in exchange for the release of two bushwhackers, William Lloyd and Jim Curtin, who are about to be hanged in Lexington, Missouri. The offer is refused and the men in Lexington are hanged. In retri-

bution the bushwhackers brutally slaughter their captives. Only Alf Bowden is spared out of Jake's misguided sympathy for him. But Bowden later kills Jake's father in cold-blooded revenge.

During the long winter, he holes up with Jack Bull, George Clyde, and an ex-slave, a black man (a friend of Clyde's since boyhood) named Holt. A young widow, Sue Lee, from a nearby farm, comes calling and soon is carrying on a romance with Jack Bull. When Jack is killed during a Jayhawker ambush (he dies after a horrendous scene in which Jake tries to saw off his shattered arm), the bushwhackers leave. Sue Lee is left pregnant with Jack Bull's child.

In the spring and summer the wearisome conflicts grind on. Jake and Holt join up with the notorious William Clarke Quantrill—described by Jake as "a girlish man in appearance, with fine features and heavy-lidded eyes [who] killed in bulk and at every opportunity." Quantrill declares to his men his intentions to raid the Kansas free-state stronghold of Lawrence. The raiders, including Jake, Kit Dalton, Frank James, and Coleman Younger, attack Lawrence at dawn on the morning of August 21, 1863. Jake unabashedly remembers the romantic thrill of the moment.

But Jake makes a horrifying discovery: "There were no legions of soldiers to be found and damned few Jayhawkers were at home. I had come here, as had these other rebels, for a desperate fight, but there wasn't one to be had. It was only bad-luck citizens finding out just how bad luck can be." By noon the damage is done and almost 200 citizens lie dying amidst the burning ruins of the town. Word of approaching cavalry out of Leavenworth sends Quantrill's raiders, loaded with booty, out of town.

Quantrill's ruthless methods are defended by Jack Bull: "The boys love him. He leads well. He may truly be trash. Maybe you would not have spoken to him five years ago, but those days are gone, sir. Trash that fights mean now make up the best men on the border."

But now the senseless slaughter, which to Jake's and Holt's dismay includes blacks, weighs heavily on Jake. He and Holt return to a farm in Henry County, Missouri, where Sue Lee is now bringing up the baby of Jack Bull. With Jack dead, Jake agrees to marry the girl and bring up the child. The newlyweds, accompanied by Holt, strike out for the western territory. After a skirmish with the villainous Pitt Mackeson, they move on. Jake feels he's a changed man now, with the violence of war and youth behind him.

Jake's reformation has come gradually. Just before the Lawrence raid, he had admitted doubts about his place in this violent world. "My mind had broken the leash, spurred on by fatigue and busthead, and dragged back thoughts I never wanted. A quality I didn't care for came out in me. I pitied myself. I pitied myself and my lot in life. This is a mangy introspection and not one I petted much. But there it was, a weak thought languishing between my ears." Finally, as he leaves Missouri, he reflects, "I did not

like being run from my home, but now I wondered if it ever had been that. Boys do the quickest thing that comes to mind, and for me that had been to side with Jack Bull and rebellion, even against my own father and his ilk. From loyalty to a man, I would have murdered a people."

He faces a new life. "I knew it to my bones that my world had shifted, as it always shifts, and that a better orbit had taken hold of me. I had us steered toward a new place to live, and we went for it, this brood of mine and my dark comrade, Holt. This new spot for life might be but a short journey as a winged creature covers it, that is often said, but oh, Lord, as you know, I had not the wings, and it is a hot, hard ride by road."

Although *Woe to Live On* is told from a Missourian's point of view and, initially at least, adopts a sympathetic stance toward the secessionist cause, all distinctions between ethnicity, ideology, and nationality are quickly lost in the bloodbath of war. Thus, it is a serendipity of history, perhaps, that author Woodrell's story adopts the same hues of red (the color adopted by the Jayhawkers, who, because of their wearing of red leggings, came to be called redlegs) and black (the stark black flag carried by the Missouri guerrillas), that are employed in another novel of a sick, war-torn age, Stendhal's *The Red and the Black*. Jake Roedel, like Stendhal's doomed hero, Julien Sorel—who is conflicted between following the secular glories of Napoleon (symbolized by the color red) and the more spiritual values of the church (the color black)—chooses to follow the black, only to find to his dismay that distinctions between the redlegs and the black flag ultimately vanish in the face of the senseless bigotry, hate, and slaughter common to them both. Thus, Woodrell's story dramatizes what historian Michael Fellman amply demonstrates in *Inside War*, his invaluable history of the Border Wars—Jayhawkers and bushwhackers alike eventually not only "lost most of their ability to discriminate between guerrilla and civilian targets," but lost sight of their respective political and patriotic ideologies in the downward spiral of petty apolitical revenge and counter-revenge that destroyed them all.

The Film

Director Ang Lee was in Deauville, France, in 1994 for a screening of his recently completed *Eat Drink Man Woman* (1994) when Daniel Woodrell's *Woe to Live On* came to his attention. As Lee's producer/screenwriter, James Schamus, recalls, "[Lee] called me from the screening and said he was calling from a pay phone by the ladies' room, where a line of women were all crying after seeing the film. Ang said, 'Can't I just make one movie that won't make women cry?' Well, we started talking about stories about action, adventure, and war. And sure enough, Ann Carey, with Good Machine Productions, told us she had read a book that no one in Hollywood knew but which was a great read. Ang read it overnight. In fact, he got so engrossed in it that it interrupted his reading of the script for *Sense and*

Sensibility. He knew right away he had to make this movie."

Ironically, Lee's long-cherished "action" story turned out to be precisely the coming-of-age family drama Lee has long made his specialty. "At first I wanted to get away from a family drama and do something with more action and scope," he has explained. "But it turns out this story actually does both. Family values and the social system are tested by war. It's a family drama, but one where the characters represent a larger kind of 'family'—the warring factions of the Civil War and the divisions in the national character."

Schamus echoes Lee. "It really took a Southern perspective, and yet its politics were broader. It deals with the pro-Confederate cause, but in the transformation of Jake's character, it goes forward in a progressive way. It's one of the astonishing tricks of the book."

The film took its cue from the Woodrell novel. Significant historical events and characters have seldom been brought to the screen in such a casual, even offhand manner as in the retitled *Ride with the Devil.* It refuses to place the larger issues behind the conflicts between pro-Confederate Missouri "bushwhackers" and Unionist Kansas "Jayhawkers." Moreover, real-life events and characters, such as the Missouri guerrilla chieftain William Clarke Quantrill and his infamous raid on the "free-state" bastion of Lawrence, Kansas, are given a scant few minutes of screen time. Indeed, they are underplayed to the extent that they seem mere interruptions to the *real* drama in the foreground: incidents in the lives of the three central characters, Jake Roedel (Tobey Maguire), Dan Holt (Jeffrey Wright), and Sue Lee (Jewel).

These young people are displaced persons who find themselves on the wrong side of the struggle. As in Woodrell's book, 18-year-old Roedel is a first generation German American who, contrary to his father's Unionist political sympathies, rides with his Missouri guerrilla friends. Holt is a freed slave who, out of loyalty to the man who secured his freedom, also rides for the southern cause. And the woman who enters the lives of these men, Sue Lee, exists outside of the conflict entirely—she has concerns only for the fatherless child she must raise. In other words, issues dividing the North and the South are not what motivates these three; it is their loyalty to one another and their fight to stay alive in a world gone mad. At ground level, as Roedel observes not long after Quantrill's massacre of Lawrence, Kansas, abstract causes do not exist: "There's no right or wrong; things just *is.*"

Our protagonists are hardly the obligatory stock heroes of the standard historical film. Roedel and Holt greet the sufferings they incur and the killings they commit with an almost deadpan acceptance. For her part, Sue Lee is unapologetic in her needs for sex and for a husband, and she goes about her business with blunt and practical efficiency. They all see history from eye level, from the ground up, as it were, displaying not a trace of that self-conscious hindsight of events that all too often surfaces in pictures of this kind. They blend into the "ground" of history, as it were. At the same time, as director Ang Lee has noted in an interview, their very neutrality enables viewers to regard them as universal emblems of people who find themselves helplessly caught up in other wars at other times—be it the English Civil War of the 17th century or modern-day Bosnia and Kosovo.

Ride with the Devil emerges as a complex postmodernist blurring of the lines between figure and ground, reality and myth, frontier wilderness and domestic hearth; between history as violent pageant and history as a personalized individual story. Both novel and film are determined to smelt down the Civil War and its abstract political and ideological rhetoric to the intimate dimensions of a chamber drama of familial contexts and conflicts. This is the sort of thing Ang Lee has been doing all along, albeit in different historical and social contexts, in pictures like *Pushing Hands, The Wedding Banquet, Sense and Sensibility,* and *The Ice Storm.* Thus, it is hardly surprising—and this is very significant—that, like *The Wedding Banquet* and *Sense and Sensibility,* particularly, *Ride with the Devil* chooses to conclude not with violence and bloodshed, but with the promise of reconciliation and renewal. Perhaps this seems strangely upbeat, in the light of what has come before. But even in the face of war, these people stubbornly insist on getting on with their own lives.

Concluding the film is a lovely postscript, rather like a benevolent musical grace note. As Holt parts company with his friends, he turns in the saddle to lift his hat. It is the most beautiful salute in the history of the movies. Not since Henry Fonda doffed his stetson in honor of the schoolmarm in *My Darling Clementine,* have we had such a graceful gesture. It is a benediction that rises above the flames of war.

REFERENCES

Author's interview with Daniel Woodrell, March 24, 1998, Kansas City, Missouri; author's interview with Ang Lee, March 24, 1998, Kansas City, Missouri; author's interview with James Schamus, March 24, 1998, Kansas City, Missouri; Leslie, Edward E., *The Devil Knows How to Ride: The True Story of William Clarke Quantrill and His Confederate Raiders* (Random House, 1996); Tibbetts, John C., "Riding with the Devil: The Movie Adventures of William Clarke Quantrill," *Kansas History: A Journal of the Central Plains* 22, no. 3 (autumn 1999): 182–199; ———, "The Hard Ride: Jayhawkers and Bushwhackers in the Kansas-Missouri Border Wars," *Literature/Film Quarterly,* 27, no. 3 (1999): 189–195; Woodrell, Daniel, "Woe to Live On," *The Editors' Choice: New American Stories, Vol. 1,* Ed. George E. Murphy, Jr. (Bantam Books, 1985).

—*J.C.T.*

WOMEN IN LOVE (1920)

D.H. LAWRENCE

Women in Love (1969) U.K., directed by Ken Russell, adapted by Larry Kramer; Brandywine/United Artists.

The Novel

Lawrence explores individual consciousness and the intricacies of love relationships in this sequel to *The Rainbow* (1915). As in his other works, the essential themes of *Women in Love*, Lawrence's fifth novel, concern in commentator David Cavitch's estimation, "a sensual failure, a breakdown of the human will to live an individual life." Birkin, a thinly veiled portrait of Lawrence himself, seeks an equilibrium of self and other in his relationship with Ursula, yet also strives for a homoerotic bond with Gerald. As with Paul's relationship with his mother in *Sons and Lovers* (1913), Birkin's forbidden love ends in grief. The tragic conclusion evaluates the possibility of love and understanding between man and man as well as man and woman.

In *Women in Love* sisters Ursula and Gudrun Brangwen (from *The Rainbow*) return. Ursula, a schoolmistress, and Gudrun, an art instructress with aspirations to a bohemian lifestyle, dream of men and escape from the mundanities of their small coal town. The romantic pairings of Ursula with Rupert Birkin, a school inspector, and Gudrun with Gerald Crich, a coal magnate's son, form the novel's plot. Social activities—a wedding, country weekends, parties, and the like—bring the two couples together, revealing their personalities and desires. Conflict and the need for power are present in both couplings: Ursula wants to hear conventional declarations of love and finds Birkin's insistence on a "pure stable equilibrium" extremely unsatisfying; Gudrun and Gerald struggle for domination in an unhealthy, destructive relationship. To complicate matters, Birkin dreams of perfect love with a man: Although he and Gerald become intellectually and physically close, Gerald resists the "Blutbrüderschaft" that Birkin proposes.

A trip to Switzerland liberates the couples from the restraints of their social group and permits suppressed emotions to emerge. Birkin and Ursula's relationship thrives, but the tension between Gerald and Gudrun escalates into physical violence as each struggles for control. Gudrun's growing attraction to the strange artist Loerke enrages Gerald, whose spirit is slowly dying. After violating her

Glenda Jackson (lying down) and Jennie Linden in Women in Love, *directed by Ken Russell* (1969, U.K.; UA/JOE YRANSKI)

sexually, Gerald later attempts to strangle the defiant Gudrun, then wanders into the snow to die. Ursula and Birkin return to find Gudrun strangely unmoved. Sitting by Gerald's frozen corpse, Birkin mourns the loss of his friend and of his ideal of male love. Ursula is unable to comprehend his need for a masculine companion, and their misunderstanding over this tragic episode highlights one of the novel's main themes: the impossibility and undesirability of seeking control over the loved one. Ursula realizes that she cannot change the man she loves.

The Film

Ken Russell's visually striking adaptation captures the disparity between the two vastly different worlds that Lawrence's novel creates. Although the adaptation is not completely faithful to the text, Russell's cinematography establishes visible contrasts between the drab life of the Beldover collieries and the colorful, frivolous gaiety of the bourgeois and bohemian classes. As in the novel, the unbridgeable gap between social classes is subtly linked with the conflict between men and women in love relationships. Control over the subservient class or lover is beautifully translated by Russell in several scenes. The domination of animals becomes an eloquent metaphor for the control of the loved one: Gerald's treatment of the mare and the rabbit and Gudrun's strange dance before the cattle signal their internal needs for power over lesser creatures. Juxtaposed with their need for intellectual control are Birkin and Ursula, whom Russell continually places in a natural setting. Birkin strips and wanders through the forest, forcing his body into a communion with nature; when he and Ursula first make love, it is on the forest floor. Russell's tipped-camera sequence of their later romantic idyll again places them in a natural environment. The balance between human intellect and pure physicality is achieved only in their pairing. Russell's interpretation of Gerald and Birkin's wrestling match is more problematic: Although Russell denies the homosexual aspect of Birkin's desire the parallels between this scene and Birkin and Ursula's first sexual encounter are obvious. The scene is visually stunning: Flickering firelight and a quickly moving camera give their bout an erotic charge. Lying sweaty and exhausted as in the aftermath of sex, Gerald and Birkin still fail to come to an understanding. Although some social restrictions have been stripped away, they have not entirely vanished, as shown by Gerald's switching on of the electric lights and the juxtaposition of their split faces in the mirror.

Sexuality and the acceptance of the physical body are themes well expressed by Russell's cinematic vision. Frequently daring camera movement and creative use of dissolves and other editing techniques capture the pulse of life and the conflict between intellect and natural impulse that characterize Lawrence's novel. Well-chosen music and a lush mise-en-scène add to the film's theme and effect.

Russell's interpretation is not without its problems, however. *Women in Love* often suffers from a too-clever balancing of scenes: The juxtapositioning of Ursula and Birkin's post-coital bliss with the image of the drowned lovers is an overly obvious foreshadowing of Gerald's death. Russell's interpretation of Birkin's character as an outgrowth of Lawrence may be an oversimplification. The novel's Birkin is obsessed with the intellect and the outcome of his actions; the film's Birkin seems too blithely spontaneous and unconcerned. Despite these and other flaws, Russell's ambitious film is a success.

REFERENCES

Cavitch, David, "On Women in Love," in Leo Hamalian, ed., *D.H. Lawrence: A Collection of Critical Essays* (McGraw-Hill, 1973); Gomez, Joseph A., "Russell's Images of Lawrence's Vision," in Michael Klein and Gillian Parker, eds., *The English Novel and the Movies* (Ungar, 1981), 248–56; Hanke, Ken, *Ken Russell's Films* (Scarecrow, 1984).

—K.S.

THE WONDERFUL WIZARD OF OZ (1900)

L. FRANK BAUM

The Wizard of Oz (1925), U.S.A., directed by Larry Semon, adapted by Semon and L. Frank Baum Jr.; Chadwick Pictures.

The Wizard of Oz (1939), U.S.A., directed by Victor Fleming, adapted by Noel Langley, Florence Ryerson, and Edgar Allan Woolfe; MGM.

The Novel

L. Frank Baum was born in 1856 and grew up with his seven brothers and sisters on a large estate near Syracuse, in upstate New York. Because his father owned a string of theaters, the young man indulged his passion for the stage; and by the mid-1880s he was touring in melodramas and musical comedies. When the family fortunes took a downturn, Baum left the stage and tried and failed at a number of odd jobs, including salesman and newspaper reporter. His bent for storytelling proved to be more promising, however, and among the six books he wrote in 1899 were *Father Goose, His Book* and *The Wonderful World of Oz*. Over the next 19 years he wrote 62 books, most of them for children, of which 13 were Oz sequels.

In the preface to the first Oz book, Baum wrote that he wanted to create *modern* fairy tales by departing from the "fearsome" moral tone of "all the horrible and blood-curdling" tales by authors like the Brothers Grimm. "Modern education includes morality; therefore the modern child seeks only entertainment in its wonder tales and gladly dispenses with all disagreeable incident." He never

The Wizard of Oz, *directed by Victor Fleming* (1939, U.S.A.; MGM/MUSEUM OF MODERN ART FILM STILLS ARCHIVE)

quite lived up to his promise—there are certainly elements of moral instruction in the Oz stories and plenty of startling and (occasionally) gruesome incidents.

Six-year-old Dorothy lives in Kansas with her Aunt Em and Uncle Henry. One day a cyclone sweeps her and her dog Toto to Oz, a strange land, which, by contrast to gray and featureless Kansas, is divided into four "color-coded countries"—purple in the north, red in the south, yellow in the east, blue in the west—whose boundaries converge at the capital and geographical center, the Emerald City. Dorothy's arrival in the land of the Munchkins is fortuitous, since her airborne house accidentally crushes to death the Wicked Witch of the East, releasing the little people from her thrall. With the aid of the Good Witch of the North, who gives her the dead witch's magical silver slippers, the homesick Dorothy leaves for the Emerald City to seek the aid of the fabled Wizard in her quest to return home.

On the Yellow Brick Road Dorothy befriends the Scarecrow, the Tin Woodsman, and the Cowardly Lion, who have requests of their own—respectively, a brain, a heart, and courage. The four adventurers brave many dangers, including the monstrous Kalidahs and a deadly poppy field. The Wizard promises to grant their requests, but only on condition that they kill the Wicked Witch of the West. At the witch's castle, Dorothy kills the evil woman with a douse of water. Back in the Emerald City, Dorothy discovers the Wizard is a "humbug," a mere balloonist from Omaha brought to Oz long ago by ill winds. Before he blows away again in his balloon, he tells Dorothy's friends they already possess the attributes they desire. For Dorothy, however, he can do nothing. "It was easy to make the Scarecrow and the Lion and the Woodman happy," he says, "because they imagined I could do anything. But it will take more than imagination to carry Dorothy back to Kansas. . . ." She and her friends turn to

Glinda, the Good Witch of the South, for help. On the way they confront more dangers, including the Fighting Trees and the bellicose Quadlings. Finally, at Castle Glinda, the kindly sorceress tells Dorothy that her silver shoes could have carried her home all along. Dorothy says goodbye and departs in a whirlwind. Happy to be back in Kansas she finds that Uncle Henry has rebuilt their home. (In a later book, *The Emerald City of Oz* [1910], Dorothy relocates to Oz with her aunt and uncle in tow.)

So successful was the book—it sold 90,000 copies in the first two years—that Baum moved to California and spent the rest of his life cranking out sequels; and some of them, particularly *The Land of Oz*, are arguably superior to the original. After his death in 1919, his publishers commissioned Ruth Plumley Thompson to continue the series with 21 more titles. Although the books have been generally dismissed as trash by several generations of librarians and literary historians, the Oz saga continues to fascinate readers and social historians (one of whom, Henry Littlefield, has demonstrated that *The Wizard of Oz* is a densely textured parable on Populism!). "Baum was a true educator," writes Gore Vidal in his amiable essay on the Oz books, "and those who read his Oz books are often made what they were not—imaginative, tolerant, alert to wonders, life."

The Films

At the outset, L. Frank Baum was determined to see his Oz stories on the silver screen. Following several successful stage versions of *Wizard* and other Oz books, he announced plans to mount movie versions of the entire series. The Oz Film Manufacturing Company, with a new, well-equipped seven-acre studio on Santa Monica Boulevard in Los Angeles, shot *The Patchwork Girl of Oz* as its first production in 1914. Although Baum threw himself into the project, functioning as both writer and producer, the venture failed a year later, producing only two more Oz stories, *His Majesty, the Scarecrow of Oz* and *The Magic Cloak of Oz* (which survive in truncated form at the Library of Congress).

Comedian Larry Semon's 1925 version, produced by Chadwick Pictures, bears little resemblance to the literary original. Nearing her 18th birthday Dorothy (Dorothy Dwan) is swept from Kansas to Oz by a cyclone. Accompanying her are two hired men (Larry Semon and Oliver Hardy). In her possession is a letter proving her to be the Queen of the Realm. Arrayed against her assumption of the throne are the evil Prime Minister Kruel (Josef Swickard) and the eponymous wizard (Charles Murray). Coming to her aid are the two hired men in disguise as a scarecrow and a tin woodsman. After several adventures involving a lion, a jail escape, and an airplane, the whole narrative turns out to have been a child's dream. Purportedly, the film's special effects were its prime virtues.

A virtual cottage industry has grown up around the classic 1939 version from MGM, including hundreds of articles, books, a memorabilia bonanza, and a proposed theme park (near Kansas City, of course). While beyond the scope of this essay, it's worth noting that its complex and (occasionally) troubled production (No. 1060 in the studio logs)—depicted in detail in Aljean Harmetz's book, *The Making of the Wizard of Oz*—involved 10 scriptwriters (including Herman Mankiewicz and Ogden Nash); four directors, Victor Fleming (who gets the screen credit), George Cukor (who replaced Judy Garland's blond wig with brown braids), Richard Thorpe, and King Vidor (who directed the Kansas sequences); purported scandalous activities by the "Munchkin" actors; numerous casting problems (Shirley Temple was initially considered as Dorothy); and the near fatal accidents besetting Margaret Hamilton and Jack Haley.

More to the point, as Carol Billman has argued in her fine essay on the subject, the film focuses and ultimately transcends Baum's achievement. To be sure, the message that "success comes to those who believe in themselves" is the same. But Baum's meandering story line is reconfigured for a more focused narrative, and the episodic density involving four witches and numerous incidents in five separate territories (the countries of the Munchkins, the Winkies, the Quadlings, the Gillikins, and the region of the Emerald City itself) is simplified to two witches and two journeys to the Emerald City and the castle of the Wicked Witch. While Baum's novel minimized suspense—the confrontation between Dorothy (Judy Garland) and the Wicked Witch (Margaret Hamilton) transpires exactly in the middle of the tale—the script moves the Wicked Witch episodes to the final portions of the film, thus ensuring that Dorothy's victory removes the final barrier to her voyage home.

Whereas the novel's characters are psychologically flat, the film adds many complexities. For example, unlike the book, which insisted that Dorothy *actually traveled* to Oz, the movie, following the example of the 1925 version, reveals the whole adventure to have been Dorothy's dream. One could argue that this dream reveals the Dorothy's conflicted identification with her "mother" figure, Auntie Em: At two moments Auntie Em's features transform into those of the Wicked Witch, first when the tornado whisks Dorothy off to Oz and later when Dorothy stares into the Wicked Witch's crystal ball. In addition, three actors play dual roles: The Scarecrow (Ray Bolger), the Cowardly Lion (Bert Lahr), and Tin Woodsman (Jack Haley), who prove to be projections of the three farmhands Dorothy knows from her Kansas home—revelations, as it were, of the colorful, even bizarre personalities hidden beneath their deceptively mundane, plain-spoken features and manners. As to Dorothy's own wish to return home, an inexplicable ambition in Baum's novel, considering how drab and gray the area is described, that issue is resolved in the film's addition of a scene in the opening Kansas sequence where Dorothy runs away from home and returns, thoroughly homesick. In establishing this before she goes to Oz, the script makes it understandable why she wishes to return there as soon as she arrives in Oz. (Kansas itself, by the way, is depicted as a far cozier and comfortable place than in the book.)

The Technicolor palette, contrasting with the sepia tones of the Kansas sequences, is glorious, taking its cue from Baum's own "color-coded" imagination. Arnold Gillespie's special effects run rampant, including a 35 foot muslin cone that serves as the cyclone, a sky clotted with the dark shapes of winged monkeys, the glimmering vistas of the Emerald City, the blazing crimson of the poppy-field, and the sky-written message from the Wicked Witch, "Surrender Dorothy."

As a musical achievement, the film realizes Baum's own theatrical ambitions. In 1902–03 he had successfully staged it in Chicago and New York as a musical extravaganza. Now, under Herbert Stothart's supervision, the songs by Harold Arlen and E.Y. ("Yip") Harburg not only underscore the film's essentially optimistic message by reminding us that "somewhere over the rainbow" resides the promise of a better life, but also assist in integrating the characters and plot elements ("We're Off to See the Wizard" serving a structural leitmotif). Indeed, the only Academy Award to come to the film was for the song, "Over the Rainbow."

Subsequent related film adaptations of the Oz characters, if not the original novel, include a 1960–61 series of 130 short cartoons made by Videocraft International called *Tales of the Wizard of Oz*, a 1960 musical adaptation of *The Land of Oz* for television's "Shirley Temple Show," and the 1978 Universal film of the Broadway musical, *The Wiz* (more an adaptation of the 1939 film than of the book). *Under the Rainbow*, a 1981 production from Warner/Orion starring Chevy Chase and Carrie Fisher, was a heavy-handed attempt to depict the backstage misfortunes of the filming of the 1939 classic.

Oz purists, meanwhile, continued to be disappointed that all the Oz adaptations departed from the original visual conceptions of illustrator John R. Neill, who began his lifelong association with Baum with the second title. It was with rapturous applause, therefore, that they greeted Walt Disney's 1985 *Return to Oz*, which, among other things, was a stunning (if unacknowledged) tribute to Neill. Although it was based on two other Oz titles, *The Land of Oz* and *Ozma of Oz*, it contained more of the real Oz spirit and character than anything before or since.

REFERENCES

Billman, Carol, "I've Seen the Movie: Oz Revisited," *Literature/Film Quarterly* 9, no. 4 (1981): 241–50; Harmetz, Aljean, *The Making of the Wizard of Oz* (Alfred A. Knopf, 1978); Vidal, Gore, "The Oz Books," *The New York Review of Books*, September 29, October 13, 1977.

—*W.M. and J.C.T.*

THE WORLD ACCORDING TO GARP (1978)

JOHN IRVING

The World According to Garp (1982), U.S.A., directed by George Roy Hill, adapted by Steve Tesich; Warner Bros.

The Novel

John Irving's best-selling epic *The World According to Garp* is a detailed chronicle of the causes and effects of T.S. Garp's life, love, and writings related by an omniscient narrator. The story opens in 1942 with Jenny Fields, an independent young nurse who not only lacks emotions but also doesn't understand why other people feel them. However, she desires motherhood so she impregnates herself by a lobotomized soldier. Thus is born T.S. Garp. Garp grows up at Steering Academy, a boy's prep school where he meets the Percy family, including daughter "Cushie"—who awakens Garp sexually—and another daughter, "Pooh." He also meets bookworm Helen Holm, his eventual wife. After high school Garp and Jenny visit Vienna where Garp writes "The Pension Grillparzer," a story involving mystical misfits. Jenny writes an autobiography, *A Sexual Suspect*. Returning home, Garp marries Helen and has a son, Duncan. Jenny's book is so successful she inadvertently becomes a feminists' hero, and her family estate becomes a haven for troubled women, most particularly transsexual former football star Roberta Muldoon.

Garp writes unsuccessful novels and has a brief affair. A second son, Walt, is born and briefly Garp's life is normal. Helen has an affair with a bold graduate student. The tragic center of the story occurs when the student, parked in the Garp driveway, persuades Helen to perform oral sex on him as a farewell. Meanwhile, Garp, out with his sons, comes home, speeding into the driveway. His car slams into the student's car. The student's penis is amputated, Garp and Helen are injured, Duncan loses an eye, and Walt is killed.

Recuperating, Garp writes a commercially successful novel, *The World According to Bensenhaver*, a lurid story about a brutal rape. He grows closer to Helen again and they have a daughter. Jenny is shot and killed at a political rally. At a memorial service Garp is identified by Pooh Percy, now a radical "Ellen Jamesian," and he flees, encountering the actual Ellen James for whom the radical feminist group is named. The Garps return to Steering School where their lives seem to return to normal when Garp, at age 33, is shot dead by Pooh Percy.

The Film

Critics concur that the sheer size and complexity of *Garp* made it a novel extremely difficult to adapt to the screen. Screenwriter Tesich is quoted as saying that film professors use Garp as an example of a novel that could never be made into a movie.

The film retains but compresses most central settings, characters, and plot lines of the novel but omits others to reduce the novel to watchable movie length. The theme is softened for mass consumption as well. The film is a good abbreviation of the novel, referred to by one critic as a *Reader's Digest* version.

Most noticeably, the film does not focus on Garp as a writer. The stories within the novel demonstrate Garp's need to write about misfits and tragedy, but are all omitted from the film. Actually, the rights to the first story, "The Pension Grillparzer," were not sold along with the novel, so screenwriter Tesich developed a story, "The Magic Gloves," which suits the movie but lacks the weird creativity of the novel's stories.

Characters such as Jenny Fields and Roberta Muldoon are expanded for the movie, and both actors, Glenn Close and John Lithgow, received Academy Award nominations for their supporting roles. Other, weirder characters from the novel are completely missing (e.g., Mrs. Ralph and the Fletchers). The film's childhood Garp has a curiosity about his father, seemingly normal, but completely absent from the novel's Garp. Garp's wife Helen is not fully developed, and the film suffers for it. But some alterations work quite well, such as transplantation of the Vienna episode to New York and the depiction of some minor characters, such as Dean Bodger. Fans of the novel also appreciate touches such as Hill's use of the speeding plumber, O. Fecteau, from Garp's story.

Some episodes are likewise changed to fit the scope and theme of the film. Garp's first sexual encounter with Cushie Percy, unwitnessed in the book, is seen by Pooh Percy and Helen in the movie. This becomes a shorthand explanation for Helen's initial avoidance of Garp. It also makes Pooh Percy known to the audience—important since she eventually kills Garp. However, the film implies that this single experience somehow explains Pooh's fate.

The book intertwines characters and plots so readers understand motivations even though they can never really explain them. Garp's chasing of speeders is used comically in the film, but in the book the reader understands just *why* he does it. The book's foreshadowing isn't well translated. That feeling of looming tragedy, known as the "undertoad," is gently weaved into the book's story. In the film the "undertoad" idea is shouted at us. "Get it?" says the filmmaker.

The Garp of the novel writes and lives through some graphic, brutal tragedies: The horrors of rape run throughout the book but are mentioned only briefly in the film. The central tragedy, the car crash in the Garps' driveway, is shown up to a freeze frame of young Walt and resumed with the sadness of the aftermath. The fact that Helen's young lover had his penis bitten off is treated as an inside joke in a brief allusion.

The World According to Garp, is a wonderful, unadaptable book that made a good movie. One theme the film

effectively employs could be called "the feel of flying." The book's theme is Garp's happy and horribly tragic life as a writer, which proves even more effective. As Garp himself said: "Tell me *anything* that's ever happened to you, and I can improve on the story; I can make the details better than they were."

REFERENCES

Horton, Andrew, *The Films of George Roy Hill* (Columbia University Press, 1984); Shores, Edward, *George Roy Hill* (Twayne, 1983).

—S.C.C.

WUTHERING HEIGHTS (1847)

EMILY BRONTË

Wuthering Heights (1939), U.S.A., directed by William Wyler, adapted by Ben Hecht and Charles MacArthur; Goldwyn/UA.

Abismos de Pasion (1954), Mexico, directed by Luis Buñuel, adapted by Buñuel, Arduino Maiuri, and Julio Alejandro de Castro; Tepeyac Productions.

The Novel

Emily Brontë's novel baffled its original readers: Ahead of its time (and, in most respects, more psychologically advanced than the work of her sister Charlotte), *Wuthering Heights* is a psychosexual Gothic dynamo that required nearly a century before finding an understanding audience. Its treatment of such themes as the Doppelgänger (e.g., Catherine's blunt statement to Nelly, "I am Heathcliff!") and Gothic sibling relationships (cf. the quasi-sibling connection between Heathcliff and Catherine with that of Shelley's Frankenstein and Elizabeth Lavenza of Poe's Roderick and Madeleine Usher) makes *Wuthering Heights* one of the 19th century's most evocative novels.

The narrator is Lockwood, a boarder whose arrival at Wuthering Heights prompts Nelly Dean, a servant, to relate the dwelling's wretched history. The narrative flashes back to Mr. Earnshaw's bringing Heathcliff, a waif of mysterious origins to Wuthering Heights. There he is raised along with Earnshaw's daughter, Catherine, and son, Hindley. A strong attachment forms between Catherine and Heathcliff, and an equally strong antipathy grows between Heathcliff and Hindley.

On the death of Earnshaw, the house falls into disorder. Hindley treats Heathcliff as a servant and is cruel to Catherine. Catherine becomes enamored of the elegant residents of Thrushcross Grange. Her social pretensions lead her to remark on Heathcliff's unsuitability as a spouse, despite her love for him. Heathcliff, overhearing the comment, leaves. Catherine marries Edgar Linton, living happily until Heathcliff returns some years later, having achieved material prosperity. Heathcliff returns to Wuthering Heights, where the widowed and broken-down Hindley welcomes him.

Edgar Linton's sister, Isabella, falls in love with Heathcliff and marries him, prompting her brother to disown her. Catherine, expecting a child, falls ill and is visited by Heathcliff despite Edgar's forbidding it. Catherine dies in childbirth, leaving a daughter, Catherine Linton.

Isabella becomes miserable and leaves Heathcliff but bears Heathcliff's son, a weak child she names Linton. After some years Heathcliff forces Catherine Linton to marry his son Linton, whose death soon thereafter leaves Heathcliff in possession of both Wuthering Heights and Thrushcross Grange. The curses of Wuthering Heights and Thrushcross Grange seem to subside with the death of Heathcliff, permitting a relationship to grow between Catherine Linton and Hareton, the surviving son of Hindley Earnshaw.

The Films

The William Wyler adaptation of *Wuthering Heights* captures much of the romantic aura of the novel while leaving much of the plot and the more disturbing imagery behind. For instance, in Lockwood's dream vision of a young Catherine at his window in chapter three, he seizes the child's hand and drags her wrists across the broken glass, lacerating them. The film sanitizes this sadistic image, having Lockwood feel a sensation as if a cold hand has touched him.

Similarly, the protracted revenge of Heathcliff against two generations of Earnshaws and Lintons is cut short: Nelly Dean's narrative progresses only to the 17th of the novel's 34 chapters. Once the death of Catherine is related, Dr. Kenneth arrives to reveal that Heathcliff has died on the moors, and the film concludes with the famous image of Catherine and Heathcliff's spirits roaming the moors peacefully, as they had when they were young.

The 1939 version of *Wuthering Heights* has long been an extremely popular film, and Samuel Goldwyn described it as his favorite among his productions. The film was instrumental in launching Olivier as a Byronic romantic lead (it paved the way for his playing of moody heroes the following year in *Pride and Prejudice* and *Rebecca*). As an adaptation of Brontë's novel, however, the film resembles more of a "variation on a theme from Emily Brontë than a full adaptation of the novel. The termination of the film narrative at the novel's midpoint is abrupt, leaving unresolved the story lines related to Edgar, Isabella, and their offspring, as well as truncating Heathcliff's revenge plot in favor of a romantic (if paranormal) resolution.

Luis Buñuel's 1950s tenure in Mexico was one of his most fruitful periods. With *Los Olvidados* (1951), *Robinson Crusoe* (1952), and *El* (1953) already behind him, his Brontë adaptation, while well known, has until recently been generally unavailable to viewers.

Buñuel was attracted by what he regarded as the novel's heady mix of sadism, perversity, infanticide, and reincarna-

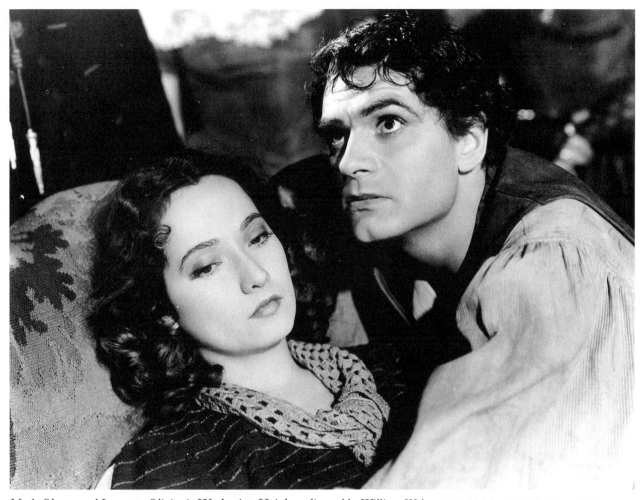

Merle Oberon and Laurence Olivier in Wuthering Heights, *directed by William Wyler* (1939, U.S.A.; GOLDWYN/NATIONAL FILM ARCHIVE, LONDON)

tion. Heathcliff (renamed Alejandro), portrayed by Jorge Mistral, is a rebel who avenges himself upon those who mistreated him as a poor foundling. Central to the movie is his love for Catalina—a prime example of *l'amour fou*—wherein each lover seems to enjoy the capacity to destroy the other. Catalina is already trapped in a loveless marriage to Edwardo, and because she is about to have a child, she refuses to leave him. The frustrated Alejandro marries Edwardo's sister, Isabel, instead. His marriage is also full of bitter recriminations. "These characters live in an entirely negative world, ruled by aggression, fear, and vengeance," writes Buñuel biographer Virginia Higginbotham. "They are people who are clearly out of reason's range." The most powerful scene in the film comes at the end, when Alejandro discovers Catalina lying ill in her room. Only now is he able to express his love. In her death scene, she, too, confesses her love. She soon dies in childbirth. Desperate with grief, he disinters her body at the graveyard and embraces the corpse. The movie concludes when Catalina's brother, Ricardo (whom Alejandro hallucinates as Catalina), approaches and shoots Alejandro.

Buñuel's film is stark, repellent, and abrasive, virtually every frame scored with gnarled and barren tree limbs crawling across the stripped, volcanic, uninhabitable landscape. To Buñuel's chagrin, music from *Tristan and Isolda* was added to the soundtrack. Nonetheless, says Higginbotham, "Buñuel's version stands as an attempt to record the ferocity, anguish, torment and hate that, as the Surrealists knew, defy reason." Buñuel himself, at the very least, regarded the adaptation as closer to the original than the Hollywood version.

REFERENCES

Collick, John, "Dismembering Devils: The Demonology of *Arashi ga oka* (1988) and *Wuthering Heights* (1939)," in *Novel Images: Literature in Performance*, ed. Peter Reynolds (Routledge, 1993), 37–47; Harrington, John, "Wyler as Auteur," in *The English Novel and The Movies*, eds. Michael Klein and Gillian Parker (Frederick Ungar, 1981); Higginbotham, Virginia, *Luis Buñuel* (Twayne, 1979); Olivier, Laurence, *Confessions of an Actor: An Autobiography* (Simon, 1982).

—*M.O. and J.C.T*

THE YEAR OF LIVING DANGEROUSLY (1978)

C.J. KOCH

The Year of Living Dangerously (1983), Australia, directed by Peter Weir, adapted by Weir, David Williamson, and C.J. Koch; MGM/UA.

The Novel

Christopher John Koch was for a number of years (1957–59, 1962–73) a radio producer for the Australian Broadcasting Commission, but since 1972 he has devoted his full time to writing. His work presents a contrast of Western and Eastern world views, one reflecting, in his opinion, Australia's position on the globe not only as a onetime colony of Great Britain but also as a nation influenced by Asian culture. These contrasting views tend \to see people as either good or evil or as a combination of good and evil. *The Year of Living Dangerously*, which "placed him in the front rank of contemporary Australian writers," in various ways embraces these contrasts.

Guy Hamilton is assigned by the Australian Broadcasting Commission to Jakarta in 1965, a year that will mark the end of the rule of President Sukarno. The novel takes its title "the Year of Living Dangerously," from the events of 1965, during which time Indonesia "was a major story . . . before the Vietnam war swallowed everything." At age 29 Guy needs to succeed in this post; otherwise, he will be relegated to a future of routine drudgery in a newsroom in Sydney. He meets and forms a partnership with the diminutive Billy Kwan, a freelance photographer, half-

Australian, half-Chinese, who obtains for Guy an exclusive interview with the leader of the PKI, the Communist Party in Indonesia, that launches Guy's career. Together, as eyes and ears, they report the news of Sukarno's attempts to establish his emerging country as an Asian power and of the accompanying anti-Western political demonstrations. Billy also introduces Guy to, and promotes a romance with, Jill Bryant, a secretary at the British Embassy who Billy hopelessly loves.

The narrator of the novel is "R.J.C." or Cookie, a newsman, one of the international set of reporters who gather regularly in the Wayang bar of the Hotel Indonesia. He reports events, looking back in time and distance from them, aided by files or dossiers, which Billy kept on his friends. A running metaphor of the book is of the *wayang kulit*, the ancient Indonesian shadow play in which hand puppets are locked in eternal struggle representing man's struggle with good and evil, love and war, illusion and reality—also reflected in the name of the hotel bar.

As Guy's relationship with Jill develops, Billy's liking for Guy and his admiration for Sukarno deteriorate. Billy, who had been caring for a native woman, Ibu, and her child, is disillusioned with Sukarno when the child dies and starvation becomes widespread. In addition, Billy, who sensed a great potential in Guy as "a man of light," turns against him when Guy uses news of an arms shipment from China to the PKI to advance his career. Later, Billy, who had planned to assassinate Sukarno, plunges to his death from a window of the Hotel. Jill leaves for Indonesia, but Guy remains to report on the failed PKI attempt to depose Sukarno. In front of the presidential palace, Guy is struck in the eye by the rifle butt of a guard, rescued by Jill's superior, Colonel Nelson, and sequestered at the

British Embassy. When he is finally reunited with Jill, Guy has learned to love, as Billy had wanted, and has become a well-known foreign correspondent, but has sacrificed an eye.

The Film

Like the novel, the film portrays the political upheaval of a third-world country, and it retains in the character of Billy, a spokesman for the reverence of human life, but it is also a romance, as Guy (Mel Gibson) and Jill (Sigourney Weaver) fall in love against a background of tumultuous events in Jakarta. The political detail of the novel is considerably and necessarily reduced, but the author's evocation of place, cited by critics as praiseworthy in all of his novels, is captured well by the camera. Indeed, the film is unusual for its period in showing the poverty and hunger of the third world—"the story," Billy comments, "you journalists don't tell"—even though the dramatic focus is on the community of foreign newsmen. Behind the opening credits the audience sees figures from a Shadow Play, which, as Billy will make clear later, are counterparts to Guy, Jill, and Billy. In effect, Billy, as he manipulates the romance of Guy and Jill, fancies himself as puppet or shadow master, even as he compares Sukarno to a puppet master, balancing the right and the left politically.

Some scenes or details from the novel have been shifted or condensed or combined to offset the leisurely pace of Koch's narrative. The narrator, Cookie, has been deleted, the story being presented by an objective camera and by Billy's voiceover commentary from his files, which are also reproduced photographically as a substitute for the book's words. The ending has been tightened, perhaps at some expense to the narrative. Guy betrays his potential by pursuing the story of the arms shipment, and after Billy's death his attempt to cover the PKI takeover leads to his smashed eye: Clearly he is an overreacher who suffers an obligatory, even mythic, wound as punishment, therefore becoming a better person through suffering. When his driver Hortono (Domingo Landicho) tells him as he rises from his sickbed that "you can now write all the stories you want," Guy chooses to go to the airport where he has promised to meet Jill. Distracting the guards by leaving his tape recorder for them to examine, he mounts the stairs to the plane where Jill awaits him.

A strength of the film not found on the printed page is the sexual magnetism created between Mel Gibson and Sigourney Weaver, as when he arrives at an embassy party just as it is breaking up, overwhelms her with kisses, and induces her to break curfew, even if all Jakarta knows of their liaison. Racing from the party, they crash through a government barricade and evade machine-gun fire, laughing. Clark Gable and Myrna Loy never did better.

The film uses a series of visual and verbal parallels. For instance, laughter echoes again as Guy and Kumar (Bembol Roco) outwit a guard at the airport to gain entry. Guy is slashed on the leg in his first successful filming with Billy of a riot, a foreshadowing of his later wounding (without Billy). Billy is disillusioned twice, about Guy and about Sukarno, and like Sukarno, whose headgear he wears in a party scene, Billy fails to save Ibu's child or initially to make Guy "a man of light." Guy is contrasted with the Americans Pete Curtis (Michael Murphy) and Wally Sullivan (Noel Ferrier) who sexually exploit third-world women and men (prostitutes and houseboys).

Pauline Kael characteristically dislikes the "gusts of wind about destiny, truth versus appearance and so on," which, of course, is what Koch's novel is about, but she recognizes the masterstroke of casting for the film, Linda Hunt, who she calls "maybe an acting genius," as Billy Kwan. Hunt was voted best supporting actress in 1983.

Billy is the spokesman for concerned Christianity (Luke 3:10 "What shall we do?") and human suffering but also for Weir's sense of the metaphysical. "The unseen is all around us, particularly here in Java," Billy states, and twice on the soundtrack Weir, who chooses music for his film unerringly, shows Billy listening to one of Strauss's Four Last Songs—"Beim Schlafengehen" by Hesse, about the unguarded soul wanting to soar in free flight—in a recording by a native New Zealander, Dame Kiri Te Kanawa. Clearly, a great deal is suggested visually and verbally in the film.

REFERENCES

Du Lane, Carole Lynn, *Contemporary Authors*, Vol. 127 (Gale 1989); Kael, Pauline, *Taking It All In* (Holt, Rinehart & Winston, 1984); Willis, John, *Screen World* (Crown, 1984).

—*J.V.D.C.*

ZORBA THE GREEK *(Bios kai politeia tou Alexi Zorba)* (1946)

NIKOS KAZANTZAKIS

Zorba the Greek (1964), U.S./Greece, directed and adapted by Michael Cacoyannis; International Classics—Twentieth Century-Fox.

The Novel

First published in English in 1952, *Zorba the Greek* is a popular and well-known novel by the Greek writer Nikos Kazantzakis. Like many of his novels, *Zorba the Greek* was written late in Kazantzakis's life, after years of extensive traveling, writing, and the study of philosophy and religion. The book's narrator is modeled on Kazantzakis the writer and intellectual, while the character of Zorba seems a personification of the élan vital or vital life-force in the philosophy of Henri Bergson, whose lectures Kazantzakis attended in Paris.

The novel is narrated by a writer and intellectual whose life has been preoccupied with books and ideas rather than living. To immerse himself in a life of action, he decides to reopen an abandoned mine on the island of Crete. Zorba, a large man full of passion and enthusiasm for life, finds the narrator waiting for his boat to Crete and asks him to impulsively take Zorba with him. With a sense that Zorba embodies the life that he is seeking, the narrator accepts Zorba as a companion and foreman for the mine. They are welcomed in the village and Zorba immediately develops a relationship with Madame Hortense, an aging French courtesan who reminisces about being the mistress of many admirals and others. While the narrator remains introspective and reserved, Zorba is boisterous and pursues every task and opportunity as an occasion for celebration. He desires many women, sings, dances, fights, plays his beloved *santuri*, eats and drinks without restraint, and works—all with the same delight and life-affirming spirit. Without illusions, and believing that men and women are brutes, and that churches and governments are full of lies. Zorba is a force of nature. He refuses to accept growing old and death but continues tasting the full range of experiences—good and bad—that life has to offer.

Few events take place in Kazantzakis's long, lyrical book. Zorba is insistent that the narrator pursue the village widow, who is hated by the villagers for her inaccessible beauty. Soon after the narrator spends a night with her, the body of a young man from the village is found after he has drowned himself because of the widow's rejection. Although Zorba fights to save her, the villagers blame the widow and attack her, killing her in sexualized scene of ritual sacrifice. When the narrator has promised Zorba's hand in marriage to Madame Hortense, Zorba gallantly agrees to their marriage because of the happiness of Madame Hortense, but she dies of pneumonia before the ceremony is performed. After swindling a deal with the corrupt and degraded monks from the nearby monastery for their mountain of trees, Zorba plans an elaborate contraption for transporting the lumber to the sea in the hope that he and the narrator will become rich. In the opening ceremony with the village people and local monks, the sharp descent of the mountain causes the transported logs to smash into useless bits while the villagers flee for their lives from the deadly flying logs. With the failure of

Zorba's operation, the narrator chooses to leave Crete and separate from Zorba, returning to his life of study and writing. Before they separate, the narrator requests that Zorba teach him to dance. In the years after, the narrator sporadically hears from Zorba and of his continued vigor for the pleasures of life until his death.

The Film

Greek filmmaker Michael Cacoyannis wrote the screenplay as well as directed *Zorba the Greek*. With Alan Bates as the narrator and Anthony Quinn as Zorba, Cacoyannis found the perfect pair to play the central characters of the novel. Quinn's portrayal of Zorba is irrepressible from the start of the film, when he finds the narrator ignoring the life around as he reads a book while waiting for his boat. Quinn is larger than life, full of experience and humor, and is both polite ("with your permission" as he says) and gruffly honest toward his boss. Although the narrator gets seasick watching a pretty young woman eating her lunch, Zorba excitedly points at a dolphin in the water. When the

narrator responds with no interest, Zorba responds accusingly "What kind of man are you?"

The film stays close to the events and moods of the book, eliminating the narrator's ongoing book and his friendship with Stavridaki, and emphasizing instead the vibrant and passionate village life in Crete. Zorba and the narrator are warmly welcomed by the villagers and Madame Hortense (played by Lila Kedrova) entertains them with her sad recollections of earlier loves. Zorba plunges into the village life, wooing and loving Madame Hortense, capturing the widow's goat away from the teasing village men, and relentlessly working the men of the mine. The trip to the monastery is transformed in the film into a humorous scene in which Zorba is mistaken for the devil by terrified monks and then is responsible for the miracle of turning the monk's water into wine. There are also scenes of the solitary Zorba excitedly planning his lumber transporting apparatus with a scale model and happily rolling stones down the mountain to gauge the incline and descent. Quinn wonderfully represents Zorba as having an unlimited range of emotions and experiences. His

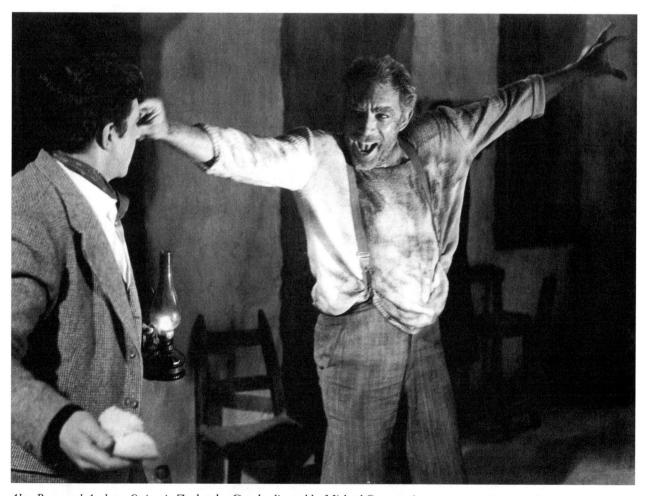

Alan Bates and Anthony Quinn in Zorba the Greek, *directed by Michael Cacoyannis* (1964, U.K.-GREECE; TCF-ROCKLEY-CACOYANNIS/PRINT AND PICTURE COLLECTION, FREE LIBRARY OF PHILADELPHIA)

facial expressions and moods rapidly and convincingly shift from the serious and somber to the joyful and ecstatic. He is genuinely angered by the narrator's refusal to visit the widow after she has sent them gifts, because it is for Zorba a cardinal sin to disappoint a woman who is waiting for love. When he cannot express himself in words, Zorba exuberantly dances as the villagers play in the background. Yet he speaks movingly of the death of his first son and of the barbarous acts of murder and rape, which he has wrongly committed as a soldier for the sake of his country. He touchingly comforts Madame Hortense in her final hours, yet is not disturbed that she will not be buried by the villagers since she is dead anyway. The movie appropriately concludes with Zorba and his boss joyfully dancing along on the beach in an image of deep friendship and joy in life.

Although most of the dialogue is in English, the movie has an authentic feel throughout, with the shots of the villagers, the fast-paced *santuri* music in the background, and the beautiful landscapes of Crete. Cacoyannis successfully interprets Zorba as an exhilarated, passionate older man who is neither a hero nor a hedonist but a human being full of folly, strong feelings, and happiness. His vigor is best illustrated in the rapid sequence of Zorba dancing as if possessed until the narrator halts the music fearing for Zorba's health. The scene of the widow's murder is one of the best in the movie in its depiction of the primitive bloodlust underlying the beliefs and conventions of organized religion and morality, with the camera quickly shifting between the narrator, the villagers, and the attacked widow. Zorba often fills the screen with his face and presence, as when he looks straight into the camera and our eyes early in the film, proclaiming "You think too much!" The viewer identifies with the narrator's deep love, admiration, and frustration toward Zorba who seems alternatively an insane man and a great soul. As a story of a remarkable friendship, the film succeeds in making Zorba into the friend whom we recall with affection and fondness.

REFERENCES

Bien, Peter, *Kazantzakis: The Politics of the Spirit* (Princeton University Press, 1990);———, *Nikos Kazantzakis Novelist* (Caratzas Publishers, 1989); Beaton, Roderick, *An Introduction to Modern Greek Literature* (Oxford University Press, 1994).

—*M.P.E.*

Appendix

Scenes from a Hollywood Life: The Novelist as Screenwriter

Isn't Hollywood a dump—in the human sense of the word? A hideous town, full of the human spirit at a new low of debasement.

—*F. Scott Fitzgerald*

You wait to get inside the gate, you wait outside the great man's office, you wait for your agent to make the deal, you wait for the assignment; you wait for the instructions on how to write what they want you to write . . . Eventually this waiting sawed you off at the base of your self-respect.

—The Disenchanted, *Budd Schulberg*

Michael Crichton, John Grisham, and Tom Clancy are only the most recent examples of prominent authors who have succumbed to the siren song of the movies. Their success notwithstanding, the record of writers who have enjoyed a less than satisfactory relationship with the film industry in general, or with Hollywood in particular, is a long and occasionally dismal one.

While Edith Wharton appears to have never entered a movie theater, her great friend, Henry James, saw several programs of newsreels and prizefights between 1898 and 1900. His reactions typify the sort of attraction-repulsion attitude to the upstart medium with which most subsequent novelists have struggled. "I hope," he wrote his niece, Peggy, after taking her to a program of Edison and Lumière pictures, "that some of the rather horrid figures and sounds that passed before us at the theatre didn't haunt your dreams. There were too many *ugly* ones. The next time I shall take you to something prettier." Nonetheless, it can be argued that his confrontation with what he called "excesses of light" influenced the vocabulary and imagery of his prose, particularly the short story, "Crapy Cornelia," written in 1909.

Joseph Conrad sold the American screen rights to his fiction on a single afternoon in 1919. He did so, as he was the first to admit, for the substantial increment to his income that the movie sales would bring. As a rule, he had no inclination to involve himself in the making of any of

the films based on his work. Nevertheless, he did make one try at writing a film scenario based on one of his stories.

In 1920, at the request of Famous Players-Lasky (later Paramount Pictures), he composed a screenplay entitled *The Strong Man*, based on "Gaspar Ruiz," his short story about a South American revolution. Conrad felt embarrassed about writing for the cinema, since he had always considered the film medium inferior to the art of fiction. Consequently, he expressed his embarrassment about composing a film scenario in a letter to a friend: "I am ashamed to tell you this," he wrote, "but one must live!" But since Conrad knew next to nothing about screenwriting, the resulting script, in the words of his biographer, Jeffrey Meyers, was filled with "stale phrases, windy rhetoric, and operatic melodrama." The studio accordingly rejected his script.

That same year F. Scott Fitzgerald sought to market several film scenarios, thus beginning what was to be a long, frustrating courtship of the movies. Although, like Conrad, he thought movies relatively inferior to fiction as an art form, he nevertheless was willing to serve time writing screenplays in order to subsidize his career as a serious fiction writer. Even if he ultimately failed at writing for the movies, his writing benefited from the new experiences and fresh material movies had provided him. Like Nathanael West, who spent his last years working in the Hollywood trenches (albeit for humbler studios along

Poverty Row) and who produced at the end of his life a classic novel of the Hollywood experience, *The Day of the Locust* (1939), Fitzgerald poured his experiences as an indentured servant of the studios into his final, unfinished novel, *The Last Tycoon* (1940), a dark fable about Hollywood as a land of unfulfilled ambitions and broken dreams. More on this later.

By contrast, Fitzgerald's friend and fellow novelist, Ernest Hemingway, was not inclined to write for the movies, although he was quick to accept the financial rewards. He firmly believed that when a writer went to Hollywood, he had to write as though he were "looking through a camera lens. All you think about is pictures, when you ought to be thinking about people." As far as he was concerned, the best way for a writer to deal with the movie industry was to arrange a rendezvous at the California border with the movie men who wanted to purchase a story: "You throw them your book, they throw you the money; then you jump into your car and drive like hell back the way you came." Hence, he steadfastly refused to cross the California state line to work as a Hollywood screenwriter—even when he was asked to collaborate on film adaptations of his own fiction.

"I tried to get Hemingway to write for pictures as Bill Faulkner had done for me on several occasions," filmmaker Howard Hawks once told this writer. "But Hemingway said that he was going to stick to the kind of writing he knew best." Hawks had wanted Hemingway to collaborate on the screen adaptation of his novel, *To Have and Have Not*; and so, when Hemingway declined, he hired William Faulkner.

Faulkner was fully aware of the intrinsic differences between the separate modes of fiction and film. "You can't say the same thing with a moving picture as you can with a book," he once told an interviewer; "any more than you can express with paint what you can with plaster. The media are different." He disliked having to work intermittently in Hollywood; but he too needed the income that movie writing could provide. Hence, he was prepared to return to Hollywood whenever his ailing finances required it—in spite of the fact that he felt the screenwriter was viewed as a second-class citizen in the film colony.

In his Hollywood novel, *The Disenchanted*, novelist-screenwriter Budd Schulberg imagines a producer handing a pencil to a distinguished novelist on the latter's first day at the studio with the comment, "I want to see this pencil worn down to *here* by quitting time." While Schulberg is playfully exaggerating the imperious behavior of the typical Hollywood producer, there is no question that movie moguls expected a full day's work for a full day's pay. In Faulkner's case, his abiding dislike for "Tinsel Town" has led some commentators to assume that he carried out his studio assignments hastily and carelessly, just to "take the money and run." Yet there is a great deal of evidence that Faulkner did conscientiously try to give the studios that hired him an honest effort for his wages. In fact, the sheer number and variety of the scenarios to which he applied his creative energies over the years attest to the seriousness with which he viewed his obligations.

As it happened, *Today We Live* (1933) is the only screenplay that Faulkner adapted from one of his own fictional works—a short story entitled "Turn About," The film is essentially a tale of romance and heroism during World War I, starring Gary Cooper and Joan Crawford. He also worked on two of Howard Hawks's classic films. The first, *To Have and Have Not*, was, as we know, derived from Hemingway's novel. It focuses on an American soldier of fortune named Harry (Humphrey Bogart) living in Martinique during World War II, who becomes involved with the French Resistance. For the record, *To Have and Have Not* represents the only time in cinema history that two Nobel Prize–winning authors "collaborated," as it were, on a motion picture. Faulkner went on to cowrite the screenplay for Hawks's topnotch thriller, *The Big Sleep* (1946). It was adapted from Raymond Chandler's celebrated detective novel, and Faulkner and his coscripters Leigh Brackett and Jules Furthman successfully preserved the cynical, hard-boiled flavor of their source material.

Although Faulkner would have been the first to concede that movie work could frequently be frustrating and unrewarding, he personally had reached the conclusion that if a scenarist were to survive in the film colony, he must realize that "a moving picture is by its nature a collaboration; and any collaboration is compromise; Because that is what the word means—to give and take." Perhaps that is why he merited a screen credit as a coauthor of no less than six films. He was an obliging collaborator on any script on which he labored. Indeed, Hawks described Faulkner as a "master of his work who does it without a fuss."

Unlike Faulkner, crime novelist Raymond Chandler very much resented the collaborative effort involved in writing a screenplay. As things developed, he was working with filmmaker Billy Wilder on the screen adaptation of James M. Cain's *Double Indemnity* (1944) at the same time that Faulkner was cowriting *The Big Sleep*. A morose, touchy man, Chandler preferred to work alone; so he deeply resented the script conferences that Wilder demanded. In fact, he detested what he termed these "goddawful jabber sessions." He had a decidedly low opinion of screen writing. "There is no art of the screenplay," he contended. Screenwriting, as far as Chandler was concerned, was "a loathsome job," consisting of "beating the hell out of the poor, tired lines and scenes until they have lost all meaning."

Years later Chandler wrote that his work with Wilder was "an agonizing experience and has probably shortened my life; but I learned from it as much about screen writing as I am capable of learning, which is not very much." Elsewhere, he added that *Double Indemnity* was his favorite among all the films he had been associated with, including Alfred Hitchcock's thriller, *Strangers on a Train* (1951).

Graham Greene was one of the first major literary talents to show a truly serious interest in writing for the movies. He always approached screenwriting as an exercise of the writer's creative abilities; and he had little time for writers who looked upon it as mere hack work. He was also aware of the subordinate position writers occupied in the film industry. He described the screenwriter as a "forgotten man" once the film went into production, since after that point other hands might make alterations in the screenplay. Still, Greene was a realist, and he never expected to exercise a significant amount of influence over the production of a film he had written. "It is impossible for the screenwriter to have the technical knowledge required to control the filming of a script," he told this writer. "This is a fact, not a complaint."

Nearly all Greene's screenplays were based on his own fiction. *The Fallen Idol* (1948) was the first of a trio of masterful adaptations that he made in collaboration with director Carol Reed—one of the most significant creative associations ever enjoyed between a writer and director. *The Fallen Idol* was based on Greene's short story, "The Basement Room," and deals with a boy who suspects the family butler of murdering his wife. It was one of Greene's favorite scripts. Adapting a short story promises better results than an entire novel: "Condensation is always dangerous, while expansion is a form of creation." Following this success, Greene and Reed went on to make *The Third Man* (1949), for which Greene wrote an original screenplay. The story about the black market in postwar Vienna won the Grand Prize at the Cannes Film Festival and subsequently spawned Greene's novelization of the screenplay. A decade later the two collaborators adapted another Greene novel, *Our Man in Havana*, an entertaining spy spoof about a British undercover agent working in pre-Castro Cuba.

More than one commentator has suggested that Greene's work as a screenwriter influenced his writing style. As Roger Sharock has written, "Long before they were made into film scripts, his narratives were crisply cut like cinema montage." Greene, however, disagreed with this view. "I don't think my style as a writer has been influenced by my work for the cinema. My style has been influenced by going to the cinema over the years." It is safe to say that the best of the films he scripted provided a fitting tribute to a writer who showed that an alliance between books and films can be a fruitful one.

F. Scott Fitzgerald's relationship with Hollywood provides one of the most detailed and representative instances of the problems faced by novelists in Hollywood, and it deserves our extended attention. All his life he was fascinated with movies. Although he never appeared in a film, he and his wife Zelda were impersonated two times—by Gary Cooper and Helen Vinson (Dora and Tony Barrett) in King Vidor's *The Wedding Night* (1935); and by Jason Miller and Tuesday Weld in *F. Scott Fitzgerald in Hollywood* (1976). As for Scott and his mistress, Sheilah Graham, they were portrayed by Gregory Peck and Deborah Kerr in *Beloved Infidel* (1958), based on Graham's autobiography. Moreover, Fitzgerald's early stories and novels were populated with characters who are moviegoers; and they are peppered with references to specific films and screen personalities. He spent his last years working in Hollywood, which he placed at the center of his unfinished novel, *The Last Tycoon.*

It is in Fitzgerald's letters that we find revealing insights into his troubled relationship with movies in general and Hollywood in particular. They both affirm and deny two aspects of Fitzgerald's Hollywood years—on the one hand, that he had become little more than a hack screenwriter; and on the other, that he was a noble artist, unappreciated and put-upon by his insensitive employers. Certainly it is true that not one of the screenplays he wrote from his own works was ever filmed. And among the dozens of movie projects he worked on, only one, *Three Comrades* (1938), gained him a screenwriting credit—a sad irony for one of the greatest prose stylists of the day. Yet it is a mistake to conclude that Scott's Hollywood years were a complete failure. The reality, as revealed by the letters, was much more complex.

From the beginning, Fitzgerald seems to have thought of his life and work as a kind of movie. Writing to a college chum in 1919, his description of himself reads like one of Hollywood's swift and improbable scenarios: "I am frightfully unhappy, look like the devil, will be famous within 12 months and, I hope, dead within 2." Not surprisingly, Hollywood beckoned after he published his first story for *The Saturday Evening Post*, "Head and Shoulders" (1919). In a letter dated February 24, 1920, he wrote Zelda that Metro had bought it for $2,500. (It was filmed a year later as *A Chorus Girl's Romance*, starring Viola Dana and Gareth Hughes.) That same year came two more films, *The Off-Shore Pirate*, also with Miss Dana (adapted from a story of that name), and *The Husband Hunter*, with Eileen Percy (adapted from "Myra Meets His Family"). And a screen version of his second novel, *The Beautiful and Damned*, was released in 1922, with Marie Prevost.

Encouraged by these early films, his letters show him actively speculating about the possibility of writing for the movies. In the winter of 1921 he claims in a letter to a Princeton roommate that he is writing a scenario for actress Dorothy Gish, for which he expected $10,000. Nothing came of it. In March 1922 David Selznick commissioned a story outline for *Transcontinental Kitty*, a vehicle for Elaine Hammerstein. Nothing came of this, either.

At first he could afford to dismiss airily these setbacks. In April 1925, when he was making $3,000 per story at *The Saturday Evening Post*, he wrote to a Princeton classmate: "I'm too much of an egotist + not enough of a diplomat ever to succeed in the movies." In order to do so, he continued with a touch of bravado, one "must begin by placing the tongue flat against the posteriors of such worthys [sic] as Gloria Swanson + Allan Dwan and commence a slow carressing [sic] movement."

Nonetheless, he found himself in Hollywood in 1927 for the first of what would be three trips during the next 13 years. He was commissioned to write an original screenplay for the popular actress, Constance Talmadge, to be entitled *Lipstick*. After a treatment was prepared, the project was cancelled. Later, in a letter to his daughter, dated July 1937, he looked back on the adventure and admitted the failure had been his fault. "I had been loafing for six months for the first time in my life and was confidant to the point of conciet [sic]. Hollywood made a big fuss over us and the ladies all looked very beautiful to a man of thirty . . . Total result—a great time + no work. I was to be paid only a small amount unless they made my picture—they didn't."

In 1931 he came back to work, this time to MGM under Irving Thalberg. The bravado was wearing off. It was a difficult time and Scott needed money. Zelda had been hospitalized the year before in the first of several mental breakdowns, and his own drinking problems were growing acute. He found himself saddled with a vehicle for Jean Harlow, *Red-Headed Woman*, but his efforts were rejected and he was replaced by veteran Anita Loos. In a letter to Max Perkins, dated November 8, 1934, he complains that other projects—treatments of *Tender Is the Night* and a project for comedienne Gracie Allen—were "no go." He left with the money but no work to show for it. In the aforementioned letter to his daughter Scottie, Fitzgerald noted that he had been "disillusioned and disgusted," that he vowed then never to go back. "I wanted to get east when the contract expired to see how your mother was," he added. "This was later interpreted as 'running out on them' + held against me."

Increasing debts forced him to reconsider a return to Hollywood in 1936. This was an altogether different Scott than the brash youth of a decade before. Alarmingly, his steady income from stories for the *Post* had dried up, and he could write nothing saleable. His desperation for film work is evident in several letters to his agent, Harold Ober, including one dated February 8, 1936, in which he beseeches Ober to use his connections to get him a job: "It seems odd having to sell you such a suggestion when once you would have taken it at my own valuation, but after these three years of reverses it seems necessary to reassure you that I have the stuff to do this job and not let this opportunity slide away with the rumor that 'Scott is drinking' or 'Scott is through.'" Finally he worked a six-month deal with MGM at $1,000 a week. He admitted in a letter to Anne Ober, dated July 26, 1937, that he would have to resist the distracting glamor of the place: "From now on I go nowhere and see no one because the work is hard as hell, at least for me and I've lost ten pounds. So farewell Miriam Hopkins who leans so close when she talks, so long Claudette Colbert as yet unencountered, mysterious Garbo, glamorous Dietric, exotic Shirley Temple—you will never know me."

After doing some revisions on the script for *A Yank at Oxford*, he finally scored his first and only screenwriting credit for an adaptation of Erich Remarque's *Three Comrades* (1938). He was delighted with the credit. "It's nice work if you can get it," he observed wryly to Anne Ober on Christmas 1937, "and you can get it if you try about three years." However, on January 20, 1938, Scott was reacting bitterly to producer Joseph L. Mankiewicz's tampering with his script. The passage is worth quoting at length.

> To say I'm disillusioned is putting it mildly. For nineteen years, with two years out for sickness, I've written best-selling entertainment, and my dialogue is supposedly right up at the top. But I learn from the script that you've suddenly decided that it isn't good dialogue and you can take a few hours off and do much better . . . You are or have been a good writer, but this is a job you will be ashamed of before it's over . . . over . . . Oh, Joe, can't producers ever be wrong? I'm a good writer—honest. I thought you were going to play fair.

Later in a letter to Anne Ober dated February 1938, he complained about the censors' cuts in the picture, concluding, "So what we have left has very little to do with the script on which people still congratulate me. However, I get a screen credit out of it, good or bad, and you can always blame a failure on somebody else."

Subsequent projects, however—all adaptations of other writers' works—were rejected or uncredited, including a Joan Crawford vehicle, *Infidelity*, a project that ran afoul of the Hays Office censors; *The Women*, based on Clare Boothe Luce's sophisticated Broadway comedy; a Garbo vehicle, *Madame Curie*; *Raffles*, a Goldwyn project with David Niven; and some retouching on Selznick's *Gone With the Wind*. In the summer of 1940 he composed a screenplay of his story, "Babylon Revisited," retitled *Cosmopolitan*. Nothing came of the attempt. (In 1954 MGM produced a movie version of "Babylon Revisited," retitled *The Last Time I Saw Paris* and written by Julius and Philip Epstein.)

Fitzgerald was never able to conquer or come to grips with the essentially collaborative nature of screenwriting. He sought complete control over his screenplays, expressing in many letters his hatred of the committee aspect of writing, of working in collaborative teams or in groups of three or more. "No single man with a serious literary reputation has made good there," he wrote Harold Ober on December 31, 1935. He added that he could work with someone else only if he were "some technical expert," someone who not only "knew the game, knew the people, but would help me tell and sell my story—not his." Instead, most of his assignments in Hollywood were to write screenplays of the work of others, or to rewrite screenplays begun by other writers. Purportedly, he had no real feel for story construction, tended to overplot, and indulged in excessive dialogue. As Billy Wilder noted, "He

made me think of a great sculptor who is hired to do a plumbing job."

The paradox is that despite these failures, Hollywood still represented for Fitzgerald a last chance for renewed fame and fortune. He was making money, more money per week than Nathanael West and, later, William Faulkner. The letters reveal that his earnings in 1939–40—in excess of $40,000—got him out of debt for the first time in nearly a decade. Indeed, they reveal hopes for more movie work and portray a man trying to regain control of his life—battling his alcoholism, recovering a faith in his writing, and trying to stabilize his relationship with columnist Sheilah Graham. While on the one hand, he could write to Alice Richardson on July 29, 1940, and attack the odiousness of the movie colony—"Isn't Hollywood a dump—in the human sense of the word? A hideous town, pointed up by the insulting gardens of its rich, full of the human spirit at a new low of debasement?"—he also wrote to Zelda on May 8, 1940, that he preferred writing for the movies to writing for magazines, that "the standard of writing from the best movies, like *Rebecca*, is, believe it or not, much higher at present than that in the commercial magazines such as *Colliers* and the *Post*."

It is also clear that the Hollywood years gave Scott a wealth of new material for his writing. As Tom Dardis notes in his book on Hollywood screenwriters, *Some Time in the Sun*, since the early 1930s Scott's prose fiction had gone stale: "Fitzgerald had not really lost his ability to write—what he needed most . . . was something new to write about." Thus, as Gene Phillips affirms in his study, *Fiction, Film, and F. Scott Fitzgerald*, "the time he spent there was not wasted . . . Indeed, his experiences in Hollywood often provided fodder for his fiction, both short and long." For example, there are many references in the letters to the genesis of the 17 "Pat Hobby" stories ("If you think I can't write, read these stories," he wrote Harold Ober on October 7, 1939). Pat is a seedy, down-at-the-heels scriptwriter, who, according to Fitzgerald, was not autobiographical so much as someone "to whom I am rather attached."

And of course there is Scott's growing enthusiasm for his new novel, *The Last Tycoon*. It began as a short story, "Crazy Sunday," and began to develop in novel form under the tentative title, *The Love of the Last Tycoon*. We learn from a letter to Max Perkins, dated May 22, 1939, that initially Scott was anxious that the book not be construed as being about Hollywood: "I am in terror that this misinformation may have been disseminated to the literary columns. If I ever gave any such impression it is entirely false: I said that the novel was about some things that had happened to me in the last two years." Perhaps Scott was afraid that if the news got out, future employment would be jeopardized. Later, in a long letter to Kenneth Littauer, fiction editor at *Collier's* magazine, dated September 29, 1939, Scott writes in great detail about *Tycoon*, admitting to what he called his "great secret"—that the character of Hollywood producer Monroe Stahr is indeed based on Irving Thalberg ("one of the half-dozen men I have known who were built on the grand scale"). Scott concludes on an optimistic note about the project: "There's nothing that worries me in the novel, nothing that seems uncertain . . . I hope it will be something new, arouse new emotions perhaps even a new way of looking at certain phenomena." Six chapters had been written when Fitzgerald died on December 21, 1940.

When the incomplete work was published a year later, Ernest Hemingway pronounced it a work of controlled craftsmanship and precision of language "unlike anything he had written before." And most observers today agree with Tom Dardis that *The Last Tycoon* is a heroic book, "a fascinating work that established beyond any question that Fitzgerald had indeed regained his ability to write as well as he ever had in the past."

It brought a curious kind of symmetry to his authorial career. Among the significant parallels between it and his early novel, *The Great Gatsby* (1924)—hinted at in Fitzgerald's letter to Kenneth Littauer—were the characters of, respectively, Hollywood producer Monroe Stahr and entrepreneur/racketeer Jay Gatsby. Both were handsome, confident, self-made men presiding over empires founded on illusion and glamour. Both were tragic figures rejected by their lovers and doomed by forces from the past. And both, at the cost of their lives, recovered their dignity and ideals. The same is true of F. Scott Fitzgerald, who found at last in the brittle dreams of Hollywood a new meaning and purpose.

REFERENCES

Bruccoli, Matthew, ed., *F. Scott Fitzgerald: A Life in Letters* (Charles Scribner's Sons, 1994); Chandler, Raymond, "Writers in Hollywood," in *Later Novels and Other Writings*, ed. Frank MacShane (Library of America, 1995); Dardis, Tom, *Some Time in the Sun* (Charles Scribner's Sons, 1976); Greene, Graham, *The Graham Greene Film Reader* (Applause Theater Books, 1995); Meyers, Jeffrey, *Joseph Conrad: A Biography* (Scribner's, 1991); Phillips, Gene, *Fiction, Film and Faulkner* (University of Tennessee Press, 1988); Phillips, Gene, *Fiction, Film and F. Scott Fitzgerald* (Loyola University Press, 1986); Tintner, Adeline R., "Henry James at the Movies," *The Markham Review*, Volume Six (Fall 1976), 1–8.

—*G.D.P. and J.C.T.*

Selected Bibliography

Adamson, Judith. *Graham Greene and Cinema*. Norman, Okla.: Pilgrim Books, 1984.

Andrew, Dudley. *Concepts in Film Theory*. New York: Oxford University Press, 1984.

Armes, Roy. *Film and Reality: An Historical Survey*. Baltimore, Md.: Penguin/Pelican Books, 1974.

Aycock, Wendall, and Michael Schoenecke, eds. *Film and Literature: A Comparative Approach to Adaptation*. Lubbock: Texas Tech University Press, 1988.

Beja, Morris. *Film and Literature: An Introduction*. New York: Longman, 1979.

Baskin, Ellen, and Mandy Hicken, eds. *Enser's Filmed Books and Plays*. Brookfield, Vt.: Ashgate, 1993.

Bluestone, George. *Novels into Film*. Berkeley: University of California Press, 1966.

Bordwell, David. *Narration in the Fiction Film*. Madison: University of Wisconsin Press, 1985.

Boyum, Joy Gould. *Double Exposure: Fiction into Film*. New York: New American Library/Plume. 1985.

Brady, John. *The Craft of the Screenwriter*. New York: Simon and Schuster/Touchstone, 1981.

Brooker-Bowers, Nancy. *The Hollywood Novel and Other Novels about Film, 1912–1982: An Annotated Bibliography*. New York: Garland, 1985.

Cardwell, Sarah. *Adaptation Revisited*. Manchester, U.K.: Manchester University Press, 2002.

Carrière, Jean-Claude. *The Secret Language of Film*, tr. Jeremy Leggart. New York: Pantheon, 1994.

Cartmell, Deborah, and Imelda Whelehan, eds. *Adaptations: From Text to Screen, Screen to Text*. New York: Routledge, 1999.

Chatman, Seymour. *Story and Discourse: Narrative Structures in Fiction and Film*. Ithaca, N.Y.: Cornell University Press, 1978.

Clark, Virginia M. *Aldous Huxley and Film*. Metuchen, N.J.: Scarecrow Press, 1987.

Cohen, Keith. *Film and Fiction: The Dynamics of Exchange*. New Haven, Conn.: Yale University Press, 1979.

Cohen, Keith, ed. *Writing in a Film Age: Essays by Contemporary Novelists*. Niwot: University Press of Colorado, 1991.

Corliss, Richard. *Talking Pictures: Screenwriters in the American Cinema, 1927–1973*. Woodstock, N.Y.: Overlook Press, 1974.

Corrigan, Timothy. *Film and Literature*. Upper Saddle River, N.J.: Prentice-Hall, 1999.

Dardis, Tom. *Some Time in the Sun*. New York: Charles Scribner's Sons, 1976.

Deveny, Thomas G. *Contemporary Spanish Film and Fiction*. Lanham, Md.: Scarecrow Press, 1999.

Dick, Bernard F. *Anatomy of Film*, 2nd ed. New York: St. Martin's Press, 1990.

———. *Hellman in Hollywood*. Rutherford, N.J.: Fairleigh Dickinson University Press, 1982.

Dixon, Wheeler Winston. *The Cinematic Vision of F. Scott Fitzgerald*. Ann Arbor, Mich.: UMI Research Press, 1986.

Eisenstein, Sergie. *Film Form and The Film Sense*, tr. Jay Leyda. Cleveland, Ohio.: World/Meridan, 1957.

Elliott, Kamilla. *Rethinking the Novel/Film Debate*. Cambridge, U.K.: Cambridge University Press, 2003.

Enser, A.G.S. *Filmed Books and Plays*. London: Andre Deutsch, 1968.

Fell, John L. *Film and the Narrative Tradition*. Norman: University of Oklahoma Press, 1974.

Faulkner, Sally. *Literary Adaptations in Spanish Cinema*. London: Tamesis, 2004.

Fleishman, Avrom. *Narrated Films: Storytelling Situations in Cinema History*. Baltimore: Johns Hopkins University Press, 1992.

Geduld, Harry M. *Authors on Film*. Bloomington: Indiana University Press, 1972.

Giannetti, Louis D. *Understanding Movies*, 2nd ed. Englewood Cliffs, N.J.: Prentice-Hall, 1976.

Giddings, Robert, and Erica Sheena, eds. *The Classic Novel from Page to Screen*. Manchester, U.K.: Manchester University Press, 2000.

Gifford, Denis. *Books and Plays in Films 1896–1915*. London: Mansell, 1991.

Griffin, Susan M., ed. *Henry James Goes to the Movies*. Lexington: University Press of Kentucky, 2002.

Harrington, John. *Film and/as Literature*. Englewood Cliffs, N.J.: Prentice-Hall, 1977.

Harwell, Richard, ed. *Gone with the Wind as Book and Film*. Columbia: University of South Carolina Press, 1983.

Hayward, Susan, and Ginette Vincendeau, eds. *French Films: Texts and Contexts*. London: Routledge, 1990.

Kawin, Bruce F. *Mindscreen: Bergman, Godard, and First-Person Film.* Princeton, N.J.: Princeton University Press, 1978.

———. *Telling It Again and Again: Repetition in Literature and Film.* Ithaca, N.Y.: Cornell University Press, 1972.

Klein, Michael, and Gillian Parker, eds. *The English Novel and the Movies.* New York: Frederick Ungar, 1981.

Kline, T. Jefferson. *Screening the Text: Intertextuality in New Wave French Cinema.* Baltimore, Md.: Johns Hopkins University Press, 1992.

Kozloff, Sarah. *Invisible Storytellers: Voice-over Narration in American Fiction Film.* Berkeley: University of California Press, 1988.

Laurence, Frank M. *Hemingway and the Movies.* Jackson: University Press of Mississippi, 1981.

Luhr, William. *Raymond Chandler and the Movies.* New York: Frederick Ungar, 1982.

Luhr, William, and Peter Lehman. *Authorship and Narrative in the Cinema.* New York: G. P. Putnam's Sons/Capricorn Books, 1977.

Lupack, Barbara Tepa. *Take Two: Adapting the Contemporary American Novel into Film.* Bowling Green, Ohio: Bowling Green University Popular Press, 1994.

McCaffrey, Donald W. *Assault on Society: Satirical Literature To Film.* Metuchen, N.J.: Scarecrow Press, 1992.

McConnell, Frank. *Storytelling and Mythmaking: Images from Film and Literature.* New York: Oxford University Press, 1979.

McDougal, Stuart Y. *Made into Movies: From Literature to Film.* New York: Holt, Rinehart and Winston, 1985.

McFarlane, Brian. *Novel to Film: An Introduction to the Theory of Adaptation.* Oxford: Clarendon Press, 1996.

———. *Words and Images: Australian Novels into Film.* Richmond, Victoria: Heinemann, 1983.

Macdonald, Gina, and Andrew F. Macdonald, eds. *Jane Austen on Screen.* Cambridge, U.K.: Cambridge University Press, 2003.

Magill, Frank N., ed. *Cinema: The Novel into Film.* Pasadena, Calif.: Salem Press, 1980.

Magny, Claude-Edmonde. *The Age of the American Novel,* tr. Eleanor Hochman. New York: Frederick Ungar, 1972.

Marcus, Fred H. *Film and Literature: Contrasts in Media.* Scranton, Pa.: Chandler Publishing, 1971.

Marcus, Millicent. *Filmmaking by the Book: Italian Cinema and Literary Adaptation.* Baltimore, Md.: Johns Hopkins University Press, 1993.

Mast, Gerald, and Marshall Cohen, eds. *Film Theory and Criticism: Introductory Readings.* New York: Oxford University Press, 1974.

Maynard, Richard A. *The Celluloid Curriculum.* Rochelle Park, N.J.: Hayden Book Co., 1971.

Mayne, Judith. *Private Novels, Public Films.* Athens: University of Georgia Press, 1988.

Metz, Christian. *Film Language: A Semiotics of the Cinema.* New York: Oxford University Press, 1974.

Miller, Gabriel. *Screening the Novel: Rediscovered American Fiction in Film.* New York: Frederick Ungar, 1980.

Millichap, Joseph R. *Steinbeck and Film.* New York: Frederick Ungar, 1983.

Morrissette, Bruce. *Novel and Film: Essays in Two Genres.* Chicago: University of Chicago Press, 1985.

Naremore, James, ed. *Film Adaptation.* New Brunswick, N.J.: Rutgers University Press, 2000.

Orr, John, and Colin Nicholson, eds. *Cinema and Fiction: New Modes of Adapting, 1950–1990.* Edinburgh, Scotland: Edinburgh University Press, 1992.

Pauly, Rebecca M. *The Transparent Illusion: Image and Ideology in French Text and Film.* New York: Peter Lang, 1993.

Peary, Gerald, and Roger Shatzkin, eds. *The Classic American Novel and the Movies.* New York: Frederick Ungar 1977.

———. *The Modern American Novel and the Movies.* New York: Frederick Ungar, 1978.

Phillips, Gene D. *Conrad and Cinema: The Art of Adaptation.* New York: Peter Lang, 1995.

———. *Fiction, Film, and Faulkner: The Art of Adaption.* Knoxville: University of Tennessee Press, 1988.

———. *Fiction, Film, and F. Scott Fitzgerald.* Chicago: Loyola University Press, 1986.

———. *Graham Greene: The Films of His Fiction.* New York: Teachers College Press, 1974.

———. *Hemingway and Film.* New York: Frederick Ungar, 1980.

Richardson, Robert. *Literature and Film.* Bloomington: Indiana University Press, 1969.

Robinson, W. R., ed. *Man and the Movies.* Baltimore, Md.: Penguin/Pelican Books, 1969.

Ross, Harris. *Film as Literature, Literature as Film: An Introduction to and Bibliography of Film's Relationship to Literature.* Westport, Conn.: Greenwood Press, 1987.

Ruchti, Ulrich, and Sybil Taylor. *Story into Film.* New York: Dell Laurell-Leaf, 1978.

Salamon, Julie. *The Devil's Candy: The Bonfire of the Vanities Goes to Hollywood.* Boston: Houghton Mifflin, 1991.

Schoeps, Karl-Heinz. *Literature and Film in the Third Reich.* Trans. Kathleen M. Dell'Orto. Rochester, N.Y.: Camden House, 2004.

Scholes, Robert. *Semiotics and Interpretation.* New Haven, Conn.: Yale University Press, 1982.

Sheridan, Marion C., Harold H. Owen Jr., et al. *The Motion Picture and the Teaching of English.* New York: Appleton-Century-Crofts, 1965.

Sinyard, Neil. *Filming Literature: The Art of Film Adaptation.* London: Croom Helm, 1986.

Smiley, Robin H. *Books into Film: The Stuff That Dreams Are Made Of.* Santa Barbara, Calif.: Capra Press, 2003.

Spiegel, Alan. *Fiction and the Camera Eye.* Charlottesville: University of Virginia Press, 1976.

Stam, Robert. *Reflexivity in Film and Literature: From Don Quixote to Jean-Luc Godard.* New York: Columbia University Press, 1992.

Stoneman, Patsy. *Brontë Transformations: The Cultural Dissemination of Jane Eyre and Wuthering Heights.* Hemel Hempstead, Hertfordshire: Prentice-Hall/Harvester Wheatsheaf, 1996.

Stover, Leon. *The Prophetic Soul: A Reading of H.G. Wells's Things To Come.* Jefferson, N.C.: McFarland, 1987.

Street, Douglas, ed. *Children's Novels and the Movies.* New York: Frederick Ungar, 1983.

Troost, Linda, and Sayre Greenfield, eds. *Jane Austen in Hollywood.* Lexington: University Press of Kentucky, 1998.

Wagner, Geoffrey. *The Novel and the Cinema.* Rutherford, N.J.: Fairleigh Dickinson University Press, 1975.

Welch, Jeffrey Egan. *Literature and Film: An Annotated Bibliography, 1909–1977.* New York: Garland, 1981.

———. *Literature and Film: An Annotated Bibliography, 1978–1988.* New York: Garland, 1993.

Welsh, James M., and Thomas L. Erskine, eds. *Literature/Film Quarterly,* 32 vols. Salisbury, Md.: Salisbury State University, 1973–97.

Wilson, George M. *Narration in Light: Studies in Cinematic Point of View.* Baltimore, Md.: Johns Hopkins University Press, 1986.

Wilt, David. *Hardboiled in Hollywood: Five Black Mask Writers and the Movies.* Bowling Green, Ohio: Bowling Green State University Popular Press, 1991.

—Compiled by J. M. Welsh

Contributors

A.D.B.—Alicia D. Brown is assistant to the director of Undergraduate Research Initiative at Carnegie Mellon University.

B.D.H.—Bruce Hutchinson is assistant professor of mass communications at the University of Central Arkansas.

B.F.—Ben Furnish is an editor for Bookmark Press at the University of Missouri, Kansas City.

C.A.B.—Cynthia A. Baron is currently a visiting assistant professor in the Performing Arts Department at Washington University, St. Louis.

C-A.L.—Claire-Antoinette Lindenlaub is assistant professor of French at Bradley University, Peoria, Illinois.

C.B.D.—Carol Berman D'Andrade is editorial associate of the journal *Film and Philosophy* and is the author of numerous articles on social philosophy and film.

C.C.—Constance Cook is assistant professor of Chinese language and literature at Lehigh University, Bethlehem, Pennsylvania.

C.K.P.—C. Kenneth Pellow is professor of English at University of Colorado-Colorado Springs and author of *Films as Critiques of Novels: Transformational Criticism* (1993).

C.M.B.—Charles M. Berg is a professor of theater and film at the University of Kansas and author of *An Investigation of the Motives for and Realization of Music to Accompany the American Silent Film* (1976).

C.R.—Charlene Regester, Ph.D., is a visiting assistant professor at the University of North Carolina-Chapel Hill.

C.T.P.—Charles T. Pridgeon Jr. is professor of English at Marietta College, Ohio.

D.B.—David Blakesley is an associate professor of English at Southern Illinois University, Carbondale.

D.G.B.—Douglas G. Baldwin is a doctoral student in the Yale English Department; he has written on Don DeLillo, Robert Coover, William Burroughs, Thomas Pynchon, and others.

D.G. Hagar—Darrell G. Hagar, a specialist in 18th-century literature, is a professor of English at Salisbury University in Maryland, where he has also served as graduate dean. He has read all of the novels of Patrick O'Brian.

D.N.C.—David N. Coury is assistant professor of German and humanistic studies at the University of Wisconsin-Green Bay.

D.P.H.—Dotty P. Hamilton is associate professor of communications at Avila College, Kansas City, Missouri.

E.T.J.—Edward T. Jones is professor of English and chair of the English and Humanities Department of York College of Pennsylvania.

F.F.K.—Fran Felice Koski is a doctoral candidate in early modern literature at Southern Illinois University at Carbondale.

F.A.H.—Fred Holliday is currently completing his Ph.D. in film studies at the University of Kansas.

F.T.—Frank Thompson is a freelance writer living in Los Angeles and author of *Alamo Movies* (1992) and *Lost Films* (1996), among other books.

G.B.—Greg Black is communications professor at the University of Missouri-Kansas City and author of several books on film censorship, including *Hollywood Censored* (1995).

G.D.P.—Gene D. Phillips, S.J., is professor of English and film at Loyola University, Chicago, and author of many articles and books on literature and film, including *Fiction, Film, and Faulkner* (1988).

G.R.E.—Gary R. Edgerton is professor and chair of the Communication and Theater Arts Department of Old Dominion University, Virginia.

H.A.—Heather Addison teaches communications at Western Michigan University.

J.A.A.—Joseph A. Alvarez teaches film criticism, American literature, and English composition at Central Piedmont Community College, Charlotte, N.C.

J.A.T.—Jeffrey A. Townsend teaches English at Southern Illinois University, Carbondale, Illinois.

J.C.T.—John C. Tibbetts is associate professor of theater and film at the University of Kansas and a contributing editor of *Literature/Film Quarterly*.

J.D.N.—Joanne Detore Nakamura is chair of the communications department at Brevard Community College in Melbourne, Florida.

J.L.—Julia Listengarten received her M.A. from the State Institute of Theatre Arts in Moscow, Russia, and her Ph.D. from the University of Michigan.

J.M. Wells—Jennifer M. Wells is a popular culture enthusiast and a compliance analyst with a mutual fund company in Pittsburgh, Pennsylvania.

J.M. Welsh—James M. Welsh teaches film and English studies at Salisbury University in Salisbury, Maryland, where he edits *Literature/Film Quarterly*.

J.S.H.—Jane Seay Haspel is the author of articles on film, literature, and drama for *Literature/Film Quarterly* and *American Playwrights, 1880–1945.*

J.V.D.C.—James Van Dyck Card was professor emeritus of English at Dominion University, author of *An Anatomy of Penelope* (1984), and contributor to *The Cult Film Experience* (1991).

J.W.M.—Jonathan W. Morrow is an adjunct instructor of English at the University of California-Davis.

K.E.K.—Kerstin Ketteman is an instructor of English at the University of Rhode Island and a contributor to the forthcoming *Critical Anthology on Irish Cinema.*

K.F.—Kathleen Fitzpatrick is a Ph.D. candidate in English and American literature at New York University.

K.L.B.—Kathleen L. Brown teaches English at Villa Julie College in Stevenson, Maryland, and is writing her dissertation at the Catholic University of America.

K.O.—Kathryn Osenlund is a professor of humanities at Holy Family College and serves on the board of directors of the Pennsylvania College English Association.

K.R.H.—Karen R. Hamer teaches at the University of Maine, Presque Isle.

K.S.—Kristen Sundell is a graduate student in the English department at the University of Notre Dame.

L.C.C.—Linda Costanzo Cahir is associate professor of English at Centenary College, N.J., and author of *Solitude and Society in the Works of Herman Melville and Edith Wharton* (1999). She is also serves as an editor for *Literature/Film Quarterly.*

L.M.—Laurie Marcus teaches composition at Long Island University and is completing a Ph.D. at New York University.

M.E.J.—Margaret E. Johnson is a graduate student in 20th-century literature at the University of Oregon.

M.O.—Michael J. O'Shea is professor and chair of English at Newberry College and is the author of *James Joyce and Heraldry* and coauthor of *The Fifty Secrets of Highly Successful Cats.*

M.P.E.—Michael P. Emerson is associate professor of philosophy at Hiram College, Michigan.

M.W.G.—Michael W. Given is a doctoral candidate in modern British literature at Southern Illinois University.

M.W.O—Mark W. Osteen is associate professor of English at Loyola College, Maryland, and author of *The Economy of Ulysses* (1995).

N.S.—Nelson Sager teaches at Sul Ross State University in Alpine, Texas.

P.A.L.—Peter A. Lev is professor of mass communication at Towson State University and past president of the Literature/Film Association.

P.S.—Philip Simpson is chair of communications at Brevard Community College in Palm Bay, Florida, and the author of *Psycho Paths: Tracking the Serial Killer through Contemporary Film and Fiction* (2000).

R.A.F.—Richard A. Firda is a retired professor of German at Georgia State University and author of studies on Erich Marie Remarque and Peter Handke.

R.C.K.—Richard C. Keenan is professor of English at the University of Maryland, Eastern Shore, and a contributing editor for *Literature/Film Quarterly.*

R.K.—Robert Knopf is a visiting assistant professor of theater at Purdue University and author of articles in *Theatre Journal* and *Theatre In Sight,* among others.

R.L.N.—Renée L. Nogales works for an international development program in Washington, D.C.

S.C.—Sandra Camargo is a Ph.D. candidate in English at the University of Missouri.

S.C.C.—Stephen C. Cahir is a civil litigation attorney in New Jersey and a perennial student of literature and film.

S.C.M.—Sarah Markgraf teaches English at Bergen Community College, Paramus, N.J.

S.C.M.—Stuart Minnis is assistant professor of Communications at Virginia Wesleyan College.

S.H.—Sarah Holmes teaches in the English department of the University of Rhode Island.

S.H.W.—Stephen H. Wells is a Ph.D. candidate at the School of Literature Arts at Duquesne University in Pittsburgh, Pennsylvania.

S.N.L.—Steven Lloyd works freelance in Chicago video production and reveres the works of Alexandre Dumas and Sam Peckinpah.

S.Sorensen—Sue Sorensen is an assistant professor of English at the University of Winnipeg. Her fields of interest include Henry James, Canadian literature, and 19th and 20th-century British literature. Her essay "Taking *Possession*" appeared in *Literature/Film Quarterly* in 2004.

T.B.M.—Teresa B. Maclellan is an instructor of English and cinema art at the Penn State Beaver Campus.

T.J.S.—Thomas J. Slater is assistant professor of English at Indiana University of Pennsylvania and author of *Handbook of Soviet and East European Films and Filmmakers* (1992).

T.L.E.—Thomas L. Erskine, professor emeritus and former dean of the Fulton School at Salisbury University in Maryland, is the founding coeditor of *Literature/Film Quarterly.* He is coauthor with Chuck Berg and Jim Welsh of *The Encyclopedia of Orson Welles* (Facts On File, 2003).

T.M.L.—Thomas M. Leitch is professor of English and director of film studies at the University of Delaware.

T.S-H.—Timothy Shuker-Haines teaches history at the Waldorf School of Garden City, New York, and is author of papers on American politics and popular culture.

T.W.—Tony Williams is associate professor of cinema studies at Southern Illinois University at Carbondale and author of *Hearths of Darkness: The Family in the American Horror Film* (1996).

T. Whalen—Novelist Tom Whalen has taught cinema studies at the University of Stuttgart in Germany.

U.W.—Ulrich Wicks is professor of English at the University of Maine and author of *Picaresque Narrative, Picaresque Fictions: A Theory and a Guide* (1989).

V.P.H.—Victor Paul Hitchcock is a doctoral candidate in modern postcolonial/continental literature at Southern Illinois University at Carbondale.

W.B.P.—Wendy B. Perkins is assistant professor of English at Prince George's Community College.

W.E.—Wendy Everett teaches French and cinema studies at The University of Bath in Britain and is a contributing editor of *Literature/Film Quarterly*.

W.G.C.—W. Gardner Campbell is associate professor of English at Mary Washington College in Fredericksburg, Virginia.

W.B.M.—William McLain is currently pursuing a master's degree at the University of Kansas.

W.M.—Walter Metz teaches of Montana State University and serves as an editor for *Literature/Film Quarterly*.

W.P.H.—William P. Helling is a project editor at IDG Books Worldwide and a Ph.D. candidate in French at the University of Kansas.

W.S.W.—Wallace S. Watson is professor of English and coordinator of the World Literature Program at Duquesne University.

Film Title Index

General Index